GARDNER'S
ART
THROUGH THE AGES
THE WESTERN PERSPECTIVE

ELEVENTH EDITION
VOLUME II

FRED S. KLEINER

CHRISTIN J. MAMIYA

RICHARD G. TANSEY

THOMSON
✦
WADSWORTH

Australia • Canada • Mexico • Singapore • Spain
United Kingdom • United States

THOMSON

✦

WADSWORTH

IN MEMORIAM

Richard G. Tansey

Art and Humanities Editor: John Swanson
Senior Development Editor: Stacey Sims
Assistant Editor: Amy McGaughey
Editorial Assistant: Rebecca Fay Green
Technology Project Manager: Melinda Newfarmer
Marketing Manager: Mark D. Orr
Marketing Assistant: Justine Ferguson
Advertising Project Manager: Vicky Chao
Project Manager, Editorial Production: Kathryn M. Stewart
Print Buyer: Judy Inouye
Production Service: Joan Keyes, Dovetail Publishing Services

Text Designer: Linda Beaupré
Photo Researcher: Carrie Ward
Copy Editor: Jan McDearmon
Cover Designer: Preston Thomas
Cover Image: PAUL CÉZANNE, *Monte Sainte-Victoire,* 1902–1904. Oil on canvas, 2′ 3$\frac{1}{2}$″ × 2′ 11$\frac{1}{4}$″. Philadelphia Museum of Art, Philadelphia (The George W. Elkins Collection).
Cover Printer: Lehigh
Compositor: Thompson Type
Printer: RR Donnelley & Sons Company

Printed in the United States of America
2 3 4 5 6 7 06 05 04 03

For more information about our products, contact us at:
Thomson Learning Academic Resource Center
1-800-423-0563
For permission to use material from this text, contact us by:
Phone: 1-800-730-2214
Fax: 1-800-730-2215
Web: http://www.thomsonrights.com

Library of Congress Control Number: 2002104452

ISBN 0-534-61094-3

Wadsworth/Thomson Learning
10 Davis Drive
Belmont, CA 94002-3098
USA

Asia
Thomson Learning
5 Shenton Way #01-01
UIC Building
Singapore 068808

Australia
Nelson Thomson Learning
102 Dodds Street
South Melbourne, Victoria 3205
Australia

Canada
Nelson Thomson Learning
1120 Birchmount Road
Toronto, Ontario M1K 5G4
Canada

Europe/Middle East/Africa
Thomson Learning
High Holborn House
50/51 Bedford Row
London WC1R 4LR
United Kingdom

Latin America
Thomson Learning
Seneca, 53
Colonia Polanco
11560 Mexico D.F.
Mexico

Spain
Paraninfo Thomson Learning
Calle/Magallanes, 25
28015 Madrid, Spain

CONTENTS

CHAPTER 17

CHAPTER 18

CHAPTER 19

CHAPTER 20

PREFACE

A PRIZE-WINNING CLASSIC IN A NEW FORMAT

HELEN GARDNER'S VISION In the mid 1920s, Helen Gardner had a vision—to provide students with a textbook that would introduce them to the artistic legacy of not only Europe and the United States, but of the entire globe. In 1926, Harcourt Brace and Company published that vision— Helen Gardner's *Art through the Ages.* From just before the introduction of the Model A automobile through the computer revolution and the dawn of a new millennium, Helen Gardner's book has been the most widely read introduction to the history of art in the English language. In 2001, to mark the seventy-fifth anniversary of the initial publication, Harcourt College Publishers released the eleventh edition of *Gardner's Art through the Ages.* That edition has enjoyed great critical acclaim. It was awarded both the 2001 Texty and McGuffey Book Prizes of the Text and Academic Authors Association as the best college textbook in the humanities and social sciences— the first art history book to win either award and the only title ever to win both prizes in the same year.

BY POPULAR DEMAND The response to the eleventh edition from instructors and students has also been very gratifying, and the 2001 edition of Helen Gardner's classic work is already the most successful in the book's long history. Nonetheless, a large number of our colleagues have reported that while they share our conviction that art is a global phenomenon and that a worldwide history of art such as *Art through the Ages* is needed more every year as the world becomes smaller, the courses they teach cover only art in the Western world. For them, a less expensive (and lighter) version of the eleventh edition that omitted the chapters on the art of Asia, Africa, Oceania, and the Native Americas would be ideal. In response to that demand, Harcourt's successor,

Wadsworth/Thomson Learning, decided to publish this alternate version of the eleventh edition under the name *Gardner's Art through the Ages: The Western Perspective.* Of the thirty-four chapters in the eleventh edition, this version contains the twenty-two chapters on the Western tradition and its roots in the ancient Near East and Egypt, plus the chapter on Islamic art. Corresponding changes have been made to the glossary, pronunciation guide, bibliography, and index, but the chapters themselves are identical to those in the unabridged edition. Like the global edition, the western version of the eleventh edition is available as a single hardcover book and as two paperback volumes.

TRADITION AND INNOVATION The twenty-three chapters and the Introduction are the work of Fred S. Kleiner, Professor of Art History and Archaeology at Boston University, who collaborated with Richard G. Tansey on the tenth edition of *Art through the Ages,* and Christin J. Mamiya, Professor of Art History at the University of Nebraska—Lincoln, coauthor of the eleventh edition. Professor Tansey passed away before his work on the eleventh edition could begin, but his contributions to *Art through the Ages* over three decades are evident throughout the book and remain an enduring legacy. His name remains on the title page as a tribute both to the man and his work.

The eleventh edition of *Art through the Ages* is the most extensively reviewed in the book's history and carries on the Gardner reputation of being the authoritative and up-to-date choice for introducing students to the history of art. The western version of *Art through the Ages* thus reflects the latest art historical research emphases, while maintaining the traditional strengths of Helen Gardner's classic text. While sustaining attention to style, chronology, iconography, and technique, we pay greater attention than ever before to function and context. We consider artworks with a view toward their

purpose and meaning in the society that produced them at the time at which they were produced. We also address the very important role of patronage in the production of art and examine the role of the individuals or groups who paid the artists and influenced the shape the monuments took. We give greater attention to the role of women and women artists in society. Throughout, we have aimed to integrate the historical, political, and social context of art and architecture with the artistic and intellectual aspects. Consequently, we now often treat painting, sculpture, architecture, and the so-called minor arts together, highlighting how they all reflect the conventions and aspirations of a common culture, rather than treating them as separate and distinct media.

ENHANCED ILLUSTRATION PROGRAM The eleventh edition of *Art through the Ages* contains more illustrations, more illustrations in color, and more full-page illustrations than any previous edition. This Western art version features approximately twelve hundred photographs, plans, and drawings. Nearly seventy percent of the photographs, including more than fifty full-page color illustrations (at least one in every chapter), are in color. Wadsworth has printed these photographs using the same five-color production process and high-quality paper as in the global edition of the work.

NEW MONUMENTS In this western version, as in the unabridged edition, we have introduced dozens of new monuments not included in previous editions of *Art through the Ages*. In our choice of artworks and buildings we have tried to reflect the increasingly wide range of interests of scholars today, while not rejecting the traditional list of "great" works or the very notion of a "canon." Recent discoveries, such as the world's oldest paintings, in the Chauvet Cave in France, are illustrated, as are recently cleaned works, like Leonardo da Vinci's *Last Supper* in Milan, Italy. The expanded selection of works encompasses every artistic medium. Some are famous works that have never appeared before in *Art through the Ages*. Many, however, are rarely illustrated works of high artistic and historical interest that significantly enrich the character of the traditional art history survey—for example, the costly vestments worn by Byzantine patriarchs and Ottoman emperors.

BOXED ESSAYS To include important background information and other material designed to enhance understanding, every chapter of *Art through the Ages* features boxed discussions focusing on selected themes and issues in the history of art. The boxes allow us to maintain a clear narrative thread throughout the text while providing students with concise information about terminology, technique, and iconography; an appreciation of the cultural and historical context of art and architecture; and an introduction to some of the major scholarly and ethical controversies of the new millennium. We present these short essays in six broad categories.

Architectural Basics provide students with a sound foundation for the understanding of all discussions of architecture. These essays are concise primers, with drawings and diagrams of the major aspects of design and construction. The information included is essential to an understanding of architectural technology and terminology. The boxes address questions of how and why various forms developed, the problems architects confronted, and the solutions they used to resolve them. Topics discussed include how the Egyptians built the pyramids, the orders of classical architecture, the revolutionary nature of Roman concrete construction, the origin and development of the mosque, and the construction of Gothic cathedrals.

Materials and Techniques essays explain the various media artists employed from prehistoric to modern times. Since materials and techniques often influence the character of works of art, these discussions also contain essential information on why many monuments look the way they do. Hollow-casting bronze statues, fresco painting, embroidery and tapestry, printmaking, perspective, and nineteenth-century color theory are among the many subjects treated.

Written Sources present and discuss key historical documents illuminating important monuments of art and architecture and the careers of some of the world's leading artists, architects, and patrons. The passages we quote permit voices from the past to speak directly to the reader, providing vivid and unique insights into the creation of artworks in all media. Examples include Saint Bernard of Clairvaux's treatise on sculpture in medieval churches, Sinan the Great's commentary on the mosque he built for Selim II, Vasari's biographies of Renaissance artists, Martin Luther's tract on religious art, as well as texts that bring the past to life, such as eyewitness accounts of the volcanic eruption that buried Roman Pompeii and of the fire that destroyed Canterbury Cathedral in medieval England.

Religion and Mythology boxes introduce students to the principal elements of several of the world's great religions, past and present, and to the representation of religious and mythological themes in painting and sculpture of all periods. These discussions of belief systems and iconography give readers a richer understanding of some of the greatest artworks ever created. The topics include the gods and goddesses of Egypt, Mesopotamia, Greece, and Rome; the life of Jesus in art; and Muhammad and Islam.

Art and Society essays treat the historical, social, political, cultural, and religious context of art and architecture. In some instances, specific monuments are the basis for a discussion of broader themes, as when we use the Hegeso stele to serve as the springboard for an exploration of the role of women in ancient Greek society. In other cases, we discuss how people's evaluation today of artworks can differ from those of the society that produced them, as when we examine the problems created by the contemporary market for undocumented archeological finds. Other subjects include Egyptian mummification, the art of freed Roman slaves, women as art patrons during the Renaissance, and the shifting fortunes of Vincent van Gogh.

Art in the News boxes present accounts of the latest archeological finds and discussions of current controversies in the history of art. Among the discoveries and issues we highlight are the excavation of the tomb of the sons of the pharaoh Ramses and the restoration of Michelangelo's frescoes in the Sistine Chapel.

SPECIAL VOLUME II REVIEW MATERIAL Because many students taking the second half of a year-long introductory art history survey course will only have the second volume of the paperbound edition of *Gardner's Art through the Ages: The Western Perspective*, we have provided a feature not found in any other textbook currently available: a special set of Volume II boxes on *Art and Society before 1300*. These discussions immediately follow the Preface and Introduction to Volume II and provide concise primers on religion and mythology and on architectural terminology and construction methods in the ancient and medieval worlds—information that is essential for understanding the history of art after 1300. The subjects of these special boxes are the Gods and Goddesses of Mount Olympus; the Life of Jesus in Art; Classical Architecture; and Medieval Churches.

MAPS AND TIMELINES As in the global edition of *Art through the Ages*, the Western art edition includes new or revised maps and timelines at the beginning of every chapter. We have taken great care to make sure that every site discussed in the text appears on our maps. These maps vary widely in both geographical and chronological scope. Some focus on a small region or even a single city, while others encompass a vast territory and occasionally bridge two or more continents. Several maps plot the art-producing sites of a given area over hundreds, even thousands, of years. In every instance, our aim has been to provide readers with maps that will easily allow them to locate the places where works of art originated or were found and where buildings were erected. To this end we have regularly placed the names of modern nations on maps of the territories of past civilizations. The maps, therefore, are pedagogical tools and do not constitute a historical atlas. A historical timeline does, however, accompany each map. At the top is a time rule and the names of historical periods. The central zone features thumbnail photographs of significant monuments in chronological order. The third zone lists important historical figures and major political, cultural, and religious events.

LANGUAGE, GLOSSARY, BIBLIOGRAPHY A group of college students carefully read many chapters of the eleventh edition of *Art through the Ages* when it was still in manuscript form to assure ease of comprehension and liveliness of expression. We have also provided more frequent headings and subheadings in the text to act as guides for both initial reading and subsequent reviewing for examinations. In addition, in order to aid our readers in mastering the vocabulary of art history, we have italicized and defined all art historical terms and other unfamiliar words at their first occurrence in the text—and at later occurrences too, whenever the term has not been used again for several chapters. Definitions of all terms introduced in the text appear once more in the Glossary at the back of the book, which includes pronunciations, a

popular new feature of the eleventh edition. We have also, as before, included a pronunciation guide to artists' names. In addition, *Art through the Ages* has a comprehensive bibliography of books in English, including both general works and a chapter-by-chapter list of more focused studies.

PHOTO CAPTIONS The captions to all of our twelve hundred illustrations contain a wealth of information, including the name of the artist or architect, if known; the formal title (printed in italics), if assigned, description of the work, or name of the building; the findspot or place of production of the object or location of the building; the date; the material or materials used; the size; and the present location if the work is in a museum or private collection. We urge readers to pay attention to the scales provided on all plans and to all dimensions given in the captions. The objects we illustrate vary enormously in size, from colossal sculptures carved into mountain cliffs and paintings that cover entire walls or ceilings to tiny figurines, coins, and jewelry that one can hold in the hand. Note too the location of the monuments discussed. Although many buildings and museums may be in cities or countries that a reader may never visit, others are likely to be close to home. Nothing can substitute for walking through a building, standing in the presence of a statue, or inspecting the brushwork of a painting close up. Consequently, we have made a special effort to illustrate artworks in geographically wide-ranging public collections.

ACKNOWLEDGMENTS

A work as extensive as this one could not be undertaken or completed without the counsel of experts in all areas of Western art. For contributions in the form of extended critiques of the tenth edition or of the penultimate drafts of the eleventh edition chapters, as well as other assistance of various sorts, we wish to thank Trudi Abram, California State University—Northridge; Paul Bahn, independent scholar; Barbara Barletta, University of Florida; Marina Belozerskaya, Radcliffe Institute for Advanced Study; Roberta Bernstein, State University of New York—Albany; Philip Betancourt, Temple University; Robert Bianchi, curator, author; Alan Birnholz, State University of New York—Buffalo; Robert Steven Bianchi, Broughton International; Ann Marie Bouche, Princeton University; Celeste Brusati, University of Michigan; Kathleen Burke-Kelly, Glendale Community College; Walter B. Cahn, Yale University; Anne-Marie Carr, Southern Methodist University; Derrick Cartwright, Hood Museum of Art, Dartmouth College; Michael Charlesworth, University of Texas—Austin; Petra Chu, Seton Hall University; John Clarke, University of Texas—Austin; Adam Cohen, University of California—Berkeley; Jeffrey Collins, University of Washington; Joan Coutu, University of Waterloo—Canada; Kathy Curnow, Cleveland State University; Anthony Cutler, Pennsylvania State University; Jadviga de Costa Nunes, Muhlenberg College; Nancy De-Grummond, Florida State University; Walter Denny, University of Massachusetts—Amherst; Marilyn Dunn, Loyola University; Susan Erickson, University of Michigan—Dearborn; Betsy Fahlman, Arizona State University; Claire Farago, University of Colorado—Boulder; Peter Fergusson, Wellesley College; Phyllis Floyd, Michigan State University; Mitchell

Frank, University of Toronto; Vivien Fryd, Vanderbilt University; Christopher Fulton, Southern Methodist University; Anthony Gully, Arizona State University; Peter Bacon Hales, University of Illinois—Chicago; Catherine Harding, University of Victoria; Jeanne Hokin, Arizona State University; Jeffrey Hughes, Webster University; Amelia Jones, University of California—Riverside; Christy Junkerman, San Jose State University; Deborah Kahn, Boston University; Richard Karberg, Cuyahoga Community College—East Campus; Karl Kilinski, Southern Methodist University; Joni L. Kinsey, University of Iowa; Phyllis Kozlowski, Moraine Valley Community College; David Ludley, Clayton College State University; Rita Parham McCaslin; Sheila McTighe, Columbia University; Patricia Mainardi, City University of New York; Joanne Mannell-Noel, Montana State University; Lynn R. Matteson, University of Southern California; Mark Meadow, University of California—Santa Barbara; Walter Melion, Johns Hopkins University; Arline Meyer, Ohio State University; Anne Mochon, University of Massachusetts—Amherst; Larry Nees, University of Delaware; Mary Pardo, University of North Carolina—Chapel Hill; Robert S. Petersen, Eastern Illinois University; Robert Poor, University of Minnesota; JoAnn Quillman, Louisiana State University; Nancy Ramage, Ithaca College; Ingrida Raudzens, Salem State College; Louise Rice, Duke University; Howard Risatti, Virginia Commonwealth University; Lilien F. Robinson, George Washington University; Mark Rose, *Archaeology Magazine*; Patricia Rose, Florida State University; John Russell, Massachusetts College of Art; Jeffrey Smith, University of Texas—Austin; Jack Spalding, Fordham University; Kristine Stiles, Duke University; Roberta Tarbell, Rutgers University—Camden campus; Jan Newstrom Thompson, San Jose State University; Thomas Toone, Utah State University; Bailey Van Hook, Virginia Polytechnic Institute and State University; Josephine Withers, University of Maryland; Marcilene Wittmer, University of Miami; and Paul Zimansky, Boston University. Innumerable other instructors and students have also sent us helpful reactions, comments, and suggestions for ways to improve the book. We are grateful for their interest and their insights.

Among those at Wadsworth/Thomson Learning who worked with us to produce this first edition of *Gardner's Art through the Ages: The Western Perspective* are the CEO and president, Susan Badger; senior vice president, editorial, Sean Wakely; vice president and editor-in-chief, Marcus Boggs; publisher, Clark Baxter; executive editor, David Tatom; acquisitions editor, John Swanson; technology project manager, Melinda Newfarmer; our developmental editors, Helen Triller and Stacey Sims; assistant editor, Amy McGaughey; editorial assistant, Rebecca Jackson; our copy editors, Kay Kaylor and Jan McDearmon; senior production project manager, Kathryn Stewart; our photo editor, Carrie Ward; our text designer, Linda Beaupré; our cover designer, Preston Thomas; and our print buyer, Judy Inouye. We are also grateful to the marketing staff for their dedication to making this edition a success: senior vice president, marketing, Jonathan Hulbert; director of marketing, Elana Dolberg; executive director of advertising and marketing communications, Margaret Parks; senior channel manager, school, Wadsworth Group, Pat Murphree; marketing manager, Mark Orr; and marketing assistant, Justine Ferguson. Recognition and thanks are also due to our proofreaders, Carolyn Crabtree and Katherine Hyde, and our indexer, Nancy Ball.

We also owe a deep debt of gratitude to our colleagues at Boston University and the University of Nebraska—Lincoln, and to the thousands of students and the scores of teaching fellows in our art history courses over many years in Boston and Lincoln, and at the University of Virginia and Yale University. From them we have learned much that has helped determine the form and content of *Gardner's Art through the Ages: The Western Perspective*.

Fred S. Kleiner
Christin J. Mamiya

GARDNER'S ART THROUGH THE AGES: THE WESTERN PERSPECTIVE
ANCILLARY PACKAGE

IN ADDITION TO THE WEALTH OF FEATURES IN *Gardner's Art through the Ages: The Western Perspective*, A VARIETY OF ANCILLARIES ARE AVAILABLE TO COMPLEMENT THE TEXTBOOK. CONTACT WADSWORTH FOR INFORMATION ON HOW TO OBTAIN THESE ITEMS.

EXCITING TECHNOLOGY BRINGS YOUR ART HISTORY CLASSROOM INTO THE 21ST CENTURY

FOR STUDENTS: The ArtStudy Student CD-ROM gives your students a truly interactive study tool. Developed in partnership with Saskia, Ltd., the premier supplier of visual resources to the art history marketplace, the CD-ROM gives students access to hundreds of high quality digital images that can be used to test their knowledge of the artist and the work, as well as their familiarity with places and dates. Students can make their own study sets by chapter, groups of chapters, or test themselves on many images for a midterm or final exam! Other study tools on this robust CD-ROM include quizzing and testing (short-answer, multiple-choice, and true/false) and drag-and-drop quizzing of geography and architecture. The CD-ROM can be value-bundled with every student copy of the text!

FOR INSTRUCTORS: Multimedia Presentation Manager: A Microsoft® PowerPoint® Link Tool. The easy way to create exciting, multimedia lectures!

This one-stop lecture tool makes it easy to assemble, edit, publish, and present custom lectures for your Art History survey courses using Microsoft PowerPoint. Multimedia Manager lets you bring together high quality digital images from Saskia, Ltd. (all images suitable for viewing on a slide projector), lecture outlines, and animations from this CD-ROM, the Web, and your own material—culminating in a powerful, personalized, media-enhanced presentation.

NEW! INFOTRAC COLLEGE EDITION *Gardner's Art through the Ages: The Western Perspective* comes packaged with free access to InfoTrac College Edition for four months and a fully searchable online library that contains full-text articles from nearly 4,000 scholarly and popular sources including *Art Bulletin, American Artists, Ceramics Monthly,* and *Art in America.* This invaluable resource enables students to conduct research for term papers, complete assignments, or catch up on current events through publications such as *TIME, Newsweek,* and *Forbes.*

NEW! INFOTRAC COLLEGE EDITION EXERCISES Organized by core topic in the art history course, this booklet helps students maximize use of the InfoTrac College Edition online library. Three-to-five exercises per core topic guide students to topic-related articles in the InfoTrac College Edition database.

NEW! STUDENT TEST PACKET This useful, inexpensive resource features one practice test per chapter, with answers and page references in the back. Each test contains 20–25 multiple-choice questions, 10–15 true/false questions, and 5–10 short-answer questions. Available in versions for Volume I and Volume II, as well as for the combined hardcover edition of the text.

WEB SITE Readers are urged to venture beyond the printed page and explore *Gardner's Art through the Ages: The Western Perspective* on the Internet at http://www.art.wadsworth.com. This unique resource provides a collection of hundreds of additional image views of the works discussed, timelines that chart developments across cultures and over longer periods of time, tips for researching art history on the Internet, and a teaching assistant's guide. It also includes an audio pronunciation guide, a glossary, self-assessment quizzes, and links to hundreds of other useful sites, all continuously updated. In addition, the twenty-three maps presented in the book have been prepared in an electronic format for access on the Web site.

WEBTUTOR Content rich and correlated chapter by chapter to the text, this incredible online resource gives instructors and students a virtual environment rich with study, course management, and communication tools. For instructors: WebTutor can provide a place to post virtual office hours, syllabi, set up threaded discussions, and track student progress. Customize WebTutor's content in any way desired, from uploading images and other resources, to adding Web links and creating materials. For students: WebTutor offers real-time access to many study tools, including flashcards (with audio), the Newbury House dictionary, practice quizzes, online tutorials, and Web links—all correlated to the text. Available in both WebCT and Blackboard platforms.

SLIDE SETS These carefully selected slides include more than 100 images from each volume for a total of more than 250 images in the combined text. A third set of over 75 slides consists of plans, sections, diagrams, and maps, also from the textbook.

VIDEO AND CD-ROM ART LIBRARY This extensive library of videos and CD-ROMs contains selections from every era along with a variety of media including architecture and photography. Videos and CD-ROMs are available covering civilizations from around the globe. Examples include *The Caves of Altamira; The Body of Christ in Art; Ancient Treasures;* and *Bauhaus: The Face of the 20th Century.*

GREAT ARTISTS CD-ROM Focuses on the works of eight major artists—William Blake, El Greco, Leonardo da Vinci, Pablo Picasso, Rembrandt, Vincent van Gogh, J.M.W. Turner, and Antonine Watteau. Students explore 40 famous paintings and discover the influences that inspired the artists. They examine each painting by date, type, and content and find out exactly how each was created. This CD-ROM includes 1,000 full-color images, 20 minutes of video, biographies of the artists, 500,000 words of descriptive text, 100 music and video clips, an examination of the artists' materials and methods, the ability to compare and contrast sections of different paintings, insight into composition and technique through video sequences and timelines. The Great Artists CD-ROM can be value-added to *Gardner's Art through the Ages: The Western Perspective* at a substantial discount to the student. Contact your sales representative for more information.

PRINT ANCILLARIES A comprehensive package of teaching and study aids accompanies *Gardner's Art through the Ages: The Western Perspective.* The *Study Guide* by Kathleen Cohen (San Jose State University) contains chapter-by-chapter drills on the identification of styles, terms, iconography, major art movements, geographical locations, time periods, and specific philosophical, religious, and historical movements as they relate to particular works of art examined in the textbook. Self-quizzes and discussion questions enable students to evaluate their grasp of the material. Lilla Sweatt (San Diego State University) is the author of the *Instructor's Manual/Test Bank,* which includes sample lecture topics for each chapter, a testbank of questions in formats ranging from matching to essay, studio projects, and lists of resources. An Internet guide, *Art H.I.T.S. on the Web* is also available with the book. It provides a general introduction to using the World Wide Web and covers Web browsers, search engines, the creation of personal homepages, and presents guidelines for conducting art historical research online as well as for navigating the Gardner Web site.

EXAMVIEW (WINDOWS/MACINTOSH) Computerized testing software allows creation and customization of test questions from the *Instructor's Manual/Test Bank* by Lilla Sweatt. Easily import questions and graphics, edit and maneuver existing questions, and change test layouts. Tests appear on screen just as they will when printed. The ExamView CD-ROM offers flexible delivery and the ability to test and grade online. Available on cross-platform CD-ROM (Windows/Macintosh).

Intro-1 FRANK GEHRY, interior of Guggenheim Museum, Bilbao, Spain, 1997.

INTRODUCTION

THE SUBJECTS AND VOCABULARY

OF ART HISTORY

ART, HISTORY, AND THE HISTORY OF ART

PEOPLE DO NOT OFTEN JUXTAPOSE THE terms *art* and *history*. They tend to think of history as the record and interpretation of past human actions, particularly social and political actions. Most think of art, quite correctly, as part of the present—as objects people can see and touch. People cannot, of course, see or touch history's vanished human events. But a visible and tangible artwork is a kind of persisting event. One or more artists made it at a certain time and in a specific place, even if no one now knows just who, when, where, or why. Although created in the past, an artwork continues to exist in the present, long surviving its times. The first painters and sculptors died thirty thousand years ago, but their works remain, some of them exhibited in glass cases in museums built only a few years ago.

Modern museum visitors can admire these relics of the remote past and the countless other objects humankind has produced over the millennia without any knowledge of the circumstances that led to the creation of those works. An object's beauty or sheer size can impress people, the artist's virtuosity in the handling of ordinary or costly materials can dazzle them, or the subject depicted can move them. Viewers can react to what they see, interpret the work in the light of their own experience, and judge it a success or a failure. These are all valid responses to a work of art. But the enjoyment and appreciation of artworks in museum settings (FIG. **Intro-1**) are relatively recent phenomena, as is the creation of artworks solely for museum-going audiences to view.

Today, it is common for artists to work in private studios and to create paintings, sculptures, and other objects commercial art galleries will offer for sale. Usually, someone the artist has never met will purchase the artwork and display it in a setting the artist has never seen. But although this is not a new phenomenon in the history of art—an ancient potter decorating a vase for sale at a village market stall also probably did not know who

would buy the pot or where it would be housed—it is not at all typical. In fact, it is exceptional. Artists created a high percentage of the paintings, sculptures, and other objects exhibited in museums today for specific patrons and settings and to fulfill a specific purpose. Often, no one knows the original contexts of those artworks. Although people may appreciate the visual and tactile qualities of these objects, they cannot understand why they were made or why they look the way they do without knowing the circumstances of their creation. *Art appreciation* does not require knowledge of the historical context of an artwork (or a building). *Art history* does.

Thus, a central aim of art historians is to determine the original context of artworks. They seek to achieve a full understanding not only of why these "persisting events" of human history look the way they do but also why the artistic "events" happened at all. What unique set of circumstances gave rise to the erection of a particular building or led a specific patron to commission an individual artist to fashion a singular artwork for a certain place? The study of history is therefore vital to art history. And art history is often very important to the study of history. Art objects and buildings are historical documents that can shed light on the peoples who made them and on the times of their creation in a way other historical documents cannot. Furthermore, artists and architects can affect history by reinforcing or challenging cultural values and practices through the objects they create and the structures they build. Thus, the history of art and architecture is inseparable from the study of history, although the two disciplines are not the same. In the following pages, we outline some of the distinctive subjects art historians address and the kinds of questions they ask, and explain some of the basic terminology art historians use when answering their questions. Armed with this arsenal of questions and words, the reader will be ready to explore the multifaceted world of art through the ages.

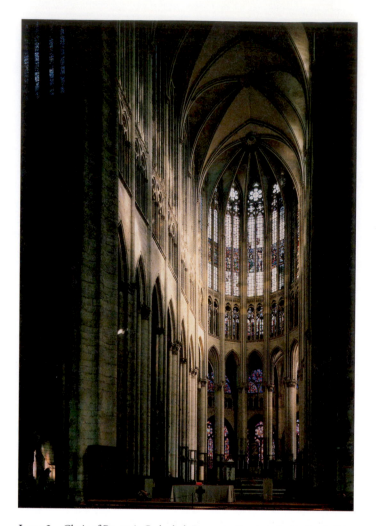

Intro-2 Choir of Beauvais Cathedral, Beauvais, France, rebuilt after 1284.

ART HISTORY IN THE TWENTY-FIRST CENTURY

Art historians study the visual and tangible objects humans make and the structures humans build. They traditionally have classified such works as architecture, sculpture, the pictorial arts (painting, drawing, printmaking, and photography), and the craft arts, or arts of design. The craft arts comprise utilitarian objects, such as ceramic and metal wares, textiles, jewelry, and similar accessories of ordinary living. Artists of every age have blurred the boundaries between these categories, but this is especially true today, when *multimedia* works abound.

From the earliest Greco-Roman art critics on, scholars have studied objects that their makers consciously manufactured as "artworks" and to which the artists assigned formal titles. But today's art historians also study a vast number of objects whose creators and owners almost certainly did not consider artworks. Few ancient Romans, for example, would have regarded a coin bearing their emperor's portrait as anything but money. Today, an art museum may exhibit that coin, and scholars may subject it to the same kind of art historical analysis as a portrait by an acclaimed Renaissance or modern sculptor or painter.

The range of objects art historians study is constantly expanding and now includes, for example, computer-generated images, whereas in the past almost anything produced using a machine would not have been regarded as "art." Most people still consider the performing arts—music, drama, and dance—as outside art history's realm because these arts are temporal, rather than spatial and static, media. But, recently, even this distinction between "fine art" and performance art has become blurred. Art historians, however, generally ask the same kinds of questions about what they study, whether they employ a restrictive or an expansive definition of art.

The Questions Art Historians Ask

HOW OLD IS IT? Before art historians can construct a history of art, they must be sure they know the date of each work they study. Thus, an indispensable subject of art historical inquiry is *chronology*, the dating of art objects and buildings. If researchers cannot determine a monument's age, they cannot place the work in its historical context. Art historians have developed many ways to establish, or at least approximate, the date of an artwork.

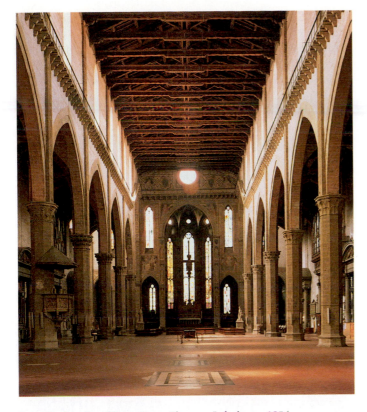

Intro-3 Interior of Santa Croce, Florence, Italy, begun 1294.

Physical evidence often reliably indicates an object's age. The material used for a statue or painting—bronze, plastic, or oil-based pigment, to name only a few—may not have been invented before a certain time, indicating the earliest possible date someone could have fashioned the work. Or artists may have ceased using certain materials—such as specific kinds of inks and papers for drawings and prints—at a known time, providing the latest possible dates for objects made of such materials. Sometimes the material (or the manufacturing technique) of an object or a building can establish a very precise date for an artwork or a building. Studying tree rings, for instance, usually can determine within a narrow range the date of a wood statue or a timber roof beam.

Documentary evidence also can help pinpoint the date of an object or building when a dated written document mentions the work. For example, official records may note when church officials commissioned a new altarpiece—and how much they paid to which artist.

Visual evidence, too, can play a significant role in dating an artwork. A painter might have depicted an identifiable person or a kind of hairstyle, clothing, or furniture fashionable only at a certain time. If so, the art historian can assign a more accurate date to that painting.

Stylistic evidence is also very important. The analysis of *style*—an artist's distinctive manner of producing an object, the way a work looks—is the art historian's special sphere. Unfortunately, because it is a subjective assessment, stylistic evidence is by far the most unreliable chronological criterion.

Still, art historians sometimes find style a very useful tool for establishing chronology.

WHAT IS ITS STYLE? Defining artistic style is one of the key elements of art historical inquiry, although the analysis of artworks solely in terms of style no longer dominates the field the way it once did. Art historians speak of several different kinds of artistic styles.

Period style refers to the characteristic artistic manner of a specific time, usually within a distinct culture, such as "Archaic Greek" or "Early Italian Renaissance." But many periods do not display any stylistic unity at all. How would historians define the artistic style of the 1990s in North America? Far too many crosscurrents existed in that decade for anyone to describe a period style of the late twentieth century—even in a single city such as New York.

Regional style is the term art historians use to describe variations in style tied to geography. Like an object's date, its *provenance,* or place of origin, can significantly determine its character. Very often two artworks from the same place made centuries apart are more similar than contemporaneous works from two different regions. To cite one example, usually only an expert can distinguish between an Egyptian statue carved in 2500 B.C. and one made in 500 B.C. But no one would mistake an Egyptian statue of 500 B.C. for a Greek or Olmec (Mexican) one of the same date.

Considerable variations in a given area's style are possible, however, even during a single historical period. In late medieval Europe during the so-called Gothic age, French architecture differed significantly from Italian architecture. The interiors of Beauvais Cathedral (FIG. **Intro-2**) and Santa Croce in Florence (FIG. **Intro-3**) typify the architectural styles of France and Italy, respectively, at the end of the thirteenth century. The rebuilding of the choir of Beauvais Cathedral began in 1284. Construction commenced on Santa Croce only ten years later. Both structures employ the characteristic Gothic pointed arch, yet they contrast strikingly. The French church has towering stone vaults and large expanses of stained-glass windows, while the Italian building has a low timber roof and small, widely separated windows. Because the two contemporaneous churches served similar purposes, regional style mainly explains their differing appearance.

Personal style, the distinctive manner of individual artists or architects, often decisively explains stylistic discrepancies among monuments of the same time and place. In 1930 the American painter GEORGIA O'KEEFFE produced a series of paintings of flowering plants. One of them was *Jack-in-the-Pulpit IV* (FIG. **Intro-4**), a sharply focused close-up view of petals and leaves. O'Keeffe captured the growing plant's slow, controlled motion while converting the organic form into a powerful abstract composition of lines, shapes, and colors (see our discussion of art historical vocabulary in the next section). Only a year later, another American artist, BEN SHAHN, painted *The Passion of Sacco and Vanzetti* (FIG. **Intro-5**), a stinging commentary on social injustice inspired by the trial and execution of two Italian anarchists, Nicola Sacco and Bartolomeo Vanzetti. Many people believed Sacco and Vanzetti had been unjustly convicted of killing two men in a holdup in 1920. Shahn's painting compresses time in a symbolic representation of the trial and its aftermath. The

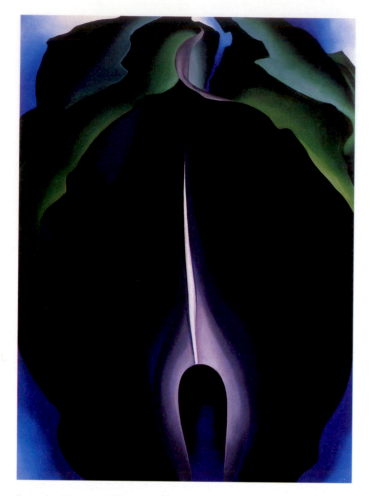

Intro-4 GEORGIA O'KEEFFE, *Jack-in-the-Pulpit IV,* 1930. Oil on canvas, 3′ 4″ × 2′ 6″. Formerly in the collection of Georgia O'Keeffe.

no subject, not even a setting. But when artists represent people, places, or actions, viewers must identify these aspects to achieve complete understanding of the works. Art historians traditionally separate pictorial subjects into various categories, such as religious, historical, mythological, *genre* (daily life), portraiture, *landscape* (a depiction of a place), *still life* (an arrangement of inanimate objects), and their numerous subdivisions and combinations.

Iconography—literally, the "writing of images"—refers both to the *content,* or subject of an artwork, and to the study of content in art. By extension, it also includes the study of *symbols,* images that stand for other images or encapsulate ideas. In Christian art, two intersecting lines of unequal length or a simple geometric cross can serve as an emblem of the religion as a whole, symbolizing the cross of Jesus Christ's crucifixion. A symbol also can be a familiar object the artist

two executed men lie in their coffins. Presiding over them are the three members of the commission (headed by a college president wearing academic cap and gown) who declared the original trial fair and cleared the way for the executions. Behind, on the wall of a columned government building, hangs the framed portrait of the judge who pronounced the initial sentence. Personal style, not period or regional style, sets Shahn's canvas apart from O'Keeffe's. The contrast is extreme here because of the very different subjects the artists chose. But when two artists depict the same subject, the results also can vary widely. The *way* O'Keeffe painted flowers and the *way* Shahn painted faces are distinctive and unlike the styles of their contemporaries. (See the "Who Made It?" discussion on page xviii.)

The different kinds of artistic styles are not mutually exclusive. For example, an artist's personal style may change dramatically during a long career. Art historians then must distinguish among the different period styles of a particular artist, such as the "Blue Period" and the "Cubist Period" of the prolific twentieth-century artist Pablo Picasso.

WHAT IS ITS SUBJECT? Another major concern of art historians is, of course, subject matter, encompassing the story, or *narrative;* the scene presented; the action's time and place; the persons involved; and the environment and its details. Some artworks, such as modern abstract paintings, have

Intro-5 BEN SHAHN, *The Passion of Sacco and Vanzetti,* 1931–1932. Tempera on canvas, 7′ $\frac{1}{2}$″ × 4′. Whitney Museum of American Art, New York (gift of Edith and Milton Lowenthal in memory of Juliana Force).

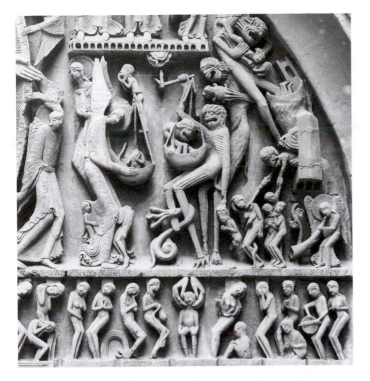

Intro-6 GISLEBERTUS, *The weighing of souls*, detail of *Last Judgment*, west tympanum of Saint-Lazare, Autun, France, ca. 1120–1135.

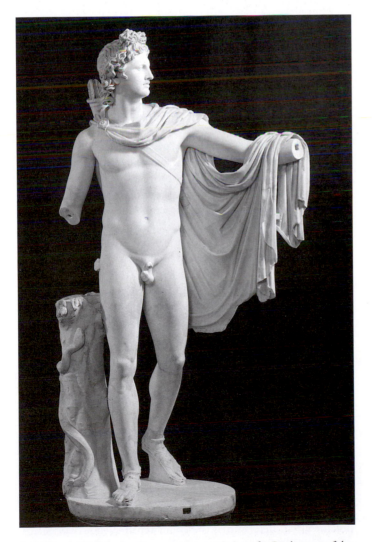

Intro-7 *Apollo Belvedere*, Roman copy or variation of a Greek statue of the mid-fourth century B.C. Marble, approx. 7′ 4″ high. Vatican Museums, Rome.

imbued with greater meaning. A balance or scale, for example, may symbolize justice or the weighing of souls on Judgment Day (FIG. **Intro-6**).

Artists also may depict figures with unique *attributes* identifying them. The Greek god Apollo (FIG. **Intro-7**), an archer, almost always carries a bow and quiver of arrows. In Christian art, each of the authors of the New Testament Gospels, the Four Evangelists (FIG. **Intro-8**), has a distinctive attribute. St. John is known by his eagle, Luke by an ox, Mark by a lion, and Matthew by a winged man.

Throughout the history of art, artists also used *personifications*—abstract ideas codified in bodily form. Worldwide, people visualize Liberty as a robed woman with a torch because of the fame of the colossal statue set up in New York City's harbor in the nineteenth century. *The Four Horsemen of the Apocalypse* (FIG. **Intro-9**) is a terrifying late-fifteenth-century depiction of the fateful day at the end of time when, according to the Bible's last book, Death, Famine, War, and Pestilence will cut down the human race. The artist, ALBRECHT DÜRER, personified Death as an emaciated old man with a pitchfork. Dürer's Famine swings the scales that will weigh human souls (compare FIG. Intro-6), War wields a sword, and Pestilence draws a bow.

Even without considering style and without knowing a work's maker, informed viewers can determine much about the work's period and provenance by iconographical and subject analysis alone. In *The Passion of Sacco and Vanzetti*

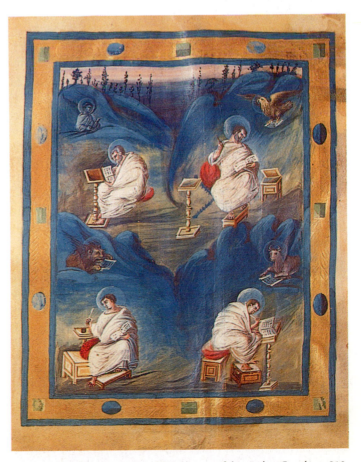

Intro-8 *The Four Evangelists*, folio 14 verso of the *Aachen Gospels*, ca. 810. Ink and tempera on vellum, 1′ × 9½″. Cathedral Treasury, Aachen.

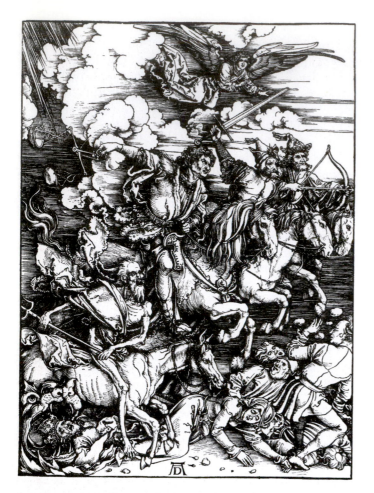

Intro-9 ALBRECHT DÜRER, *The Four Horsemen of the Apocalypse*, ca. 1498. Woodcut, approx. 1' 3¼" × 11". Metropolitan Museum of Art, New York (gift of Junius S. Morgan, 1919).

(FIG. Intro-5), for example, the two coffins, the trio headed by an academic, and the robed judge in the background are all pictorial clues revealing the painting's subject. The work's date must be after the trial and execution, probably while the event was still newsworthy. And because the two men's deaths caused the greatest outrage in the United States, the painter/social critic was probably American.

WHO MADE IT? If Ben Shahn had not signed his painting of Sacco and Vanzetti, an art historian could still assign, or *attribute,* the work to him based on knowledge of the artist's personal style. Although signing (and dating) works is quite common (but by no means universal) today, in the history of art countless works exist whose artists remain unknown. Since personal style can play a large role in determining an artwork's character, art historians often try to attribute anonymous works to known artists. Sometimes they attempt to assemble a group of works all thought to be by the same person, even though none of the objects in the group is the known work of an artist with a recorded name. Art historians thus reconstruct the careers of people such as "the Andokides Painter," the anonymous ancient Greek artist who painted the vases the potter Andokides produced. Scholars attribute works based on internal evidence, such as the distinctive way an artist draws or carves drapery folds, earlobes, or flowers. It re-

quires a keen, highly trained eye and long experience to become a *connoisseur,* an expert in assigning artworks to "the hand" of one artist rather than another. Attribution is, of course, subjective and ever open to doubt. At present, for example, international debate rages over attributions to the famous Dutch painter Rembrandt.

Sometimes a group of artists works in the same style at the same time and place. Art historians designate such a group as a *school.* "School" does not mean an educational institution. The term only connotes chronological, stylistic, and geographic similarity. Art historians speak, for example, of the Dutch school of the seventeenth century and, within it, of subschools such as those of the cities of Haarlem, Utrecht, and Leyden.

WHO PAID FOR IT? The interest many art historians show in attribution reflects their conviction that the identity of an artwork's maker is the major reason the object looks the way that it does. For them, personal style is of paramount importance. But in many times and places artists had little to say about what form their work would take. They toiled in obscurity, doing the bidding of their *patrons,* those who paid them to make individual works or employed them on a continuing basis. The role of patrons in dictating the content and shaping the form of artworks is also an important subject of art historical inquiry.

In the art of portraiture, to name only one category of painting and sculpture, the patron has often played a dominant role in deciding how the artist represented the subject, whether the patron or another person, such as a spouse, son, or mother. Many Egyptian pharaohs and some Roman emperors, for example, insisted artists depict them with unlined faces and perfect youthful bodies no matter how old they were when portrayed. In these cases, the state employed the sculptors and painters, and the artists had no choice but to depict their patrons in the officially approved manner. This is why Augustus, who lived to age seventy-six, looks so young in his portraits (FIG. **Intro-10**). Although Roman emperor for more than forty years, Augustus demanded artists always represent him as a young, godlike head of state.

All modes of artistic production reveal the impact of patronage. Learned monks provided the themes for the sculptural decoration of medieval church portals. Renaissance princes and popes dictated the subjects, sizes, and materials of artworks destined, sometimes, for buildings constructed according to their specifications. An art historian could make a very long list along these lines, and it would indicate that throughout the history of art, patrons have had diverse tastes and needs and demanded different kinds of art. Whenever a patron contracts an artist or architect to paint, sculpt, or build in a prescribed manner, personal style often becomes a very minor factor in how the painting, statue, or building looks. In such cases, knowing the patron's identity reveals more to art historians than does the identity of the artist or school. The portrait of Augustus illustrated here was the work of a virtuoso sculptor, a master wielder of hammer and chisel. But scores of similar portraits of that emperor exist today. They differ in quality but not in kind from this one. The patron, not the artist, determined the character of such artworks. Augustus's public image never varied.

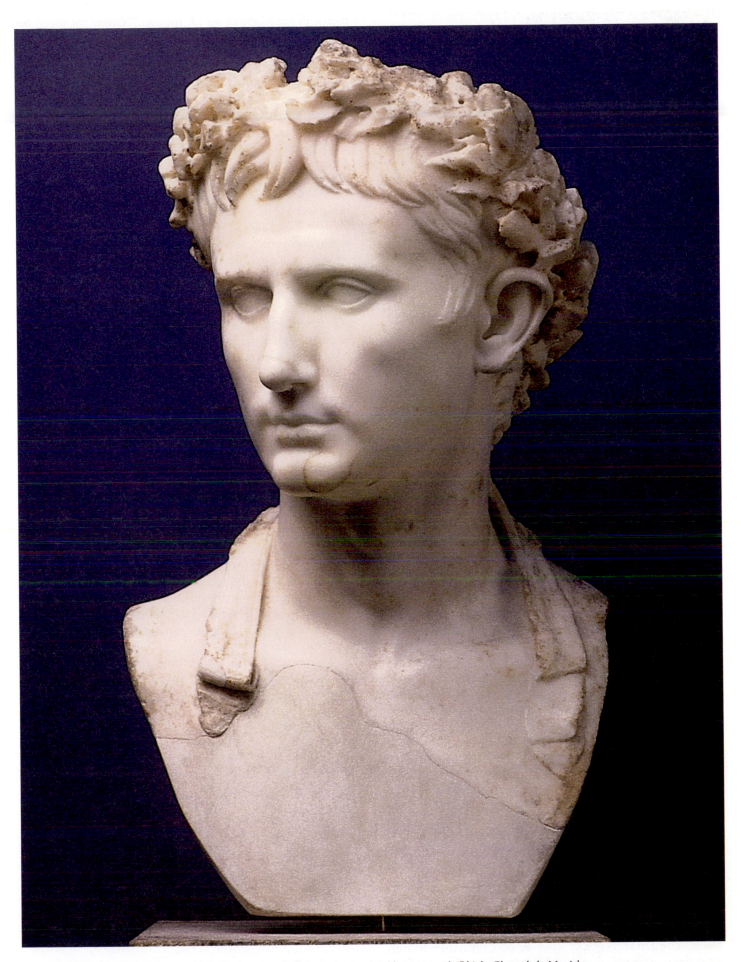

Intro-10 Augustus wearing *corona civica* (civic crown), early first century A.D. Marble, approx. 1′ 5″ high. Glyptothek, Munich.

The Words Art Historians Use

Like all specialists, art historians have their own specialized vocabulary. That vocabulary consists of hundreds of words, but certain basic terms are indispensable for describing artworks and buildings of any time and place, and we use those terms throughout this book. They make up the essential vocabulary of *formal analysis,* the visual analysis of artistic form. We define the most important of these art historical terms here. For a much longer list, consult the Glossary in this book's end material.

FORM AND COMPOSITION *Form* refers to an object's shape and structure, either in two dimensions (for example, a figure painted on a canvas) or in three dimensions (such as a statue carved from a marble block). Two forms may take the same shape but may differ in their color, texture, and other qualities. *Composition* refers to how an artist organizes (composes) forms in an artwork, either by placing shapes on a flat surface or arranging forms in space.

MATERIAL AND TECHNIQUE To create art forms, artists shape *materials* (pigment, clay, marble, gold, and many more) with *tools* (pens, brushes, chisels, and so forth). Each of the materials and tools available has its own potentialities and limitations. Part of all artists' creative activity is to select the medium and instrument most suitable to the artists' purpose—or to pioneer the use of new media and tools, such as bronze and concrete in antiquity and cameras and computers in modern times. The processes artists employ, such as applying paint to canvas with a brush, and the distinctive, personal ways they handle materials constitute their *technique.* Form, material, and technique interrelate and are central to analyzing any work of art.

LINE *Line* is one of the most important elements defining an artwork's shape or form. A line can be understood as the path of a point moving in space, an invisible line of sight or a visual *axis.* But, more commonly, artists and architects make a line concrete by drawing (or chiseling) it on a *plane,* a flat and two-dimensional surface. A line may be very thin, wirelike, and delicate, it may be thick and heavy, or it may alternate quickly from broad to narrow, the strokes jagged or the outline broken. When a continuous line defines an object's outer shape, art historians call it a *contour* line.

One can observe all of these line qualities in Dürer's *Four Horsemen of the Apocalypse* (FIG. Intro-9). Contour lines define the basic shapes of clouds, human and animal limbs, and weapons. Within the forms, series of short broken lines create shadows and textures. An overall pattern of long parallel strokes suggests the dark sky on the frightening day when the world is about to end.

COLOR Light reveals all colors. *Light* in the world of the painter and other artists differs from natural light. Natural light, or sunlight, is whole or *additive* light. As the sum of all the wavelengths composing the visible *spectrum,* it may be disassembled or fragmented into the spectral band's individual colors. The painter's light in art—the light reflected from pigments and objects—is *subtractive* light. Paint pigments produce their individual colors by reflecting a segment of the spectrum while absorbing all the rest. "Green" pigment, for example, subtracts or absorbs all the light in the spectrum except that seen as green, which it reflects to the eyes.

Hue is the property giving a color its name. Although the spectrum colors merge into each other, artists usually conceive of their hues as distinct from one another. Color has two basic variables—the apparent amount of light reflected and the apparent purity. A change in one must produce a change in the other. Some terms for these variables are *value* or *tonality* (the degree of lightness or darkness) and *intensity* or *saturation* (the purity of a color, its brightness or dullness).

A *color triangle* (FIG. **Intro-11**) clearly shows the relationships among the six main colors. Red, yellow, and blue, the *primary colors,* are the vertexes of the large triangle. Orange, green, and purple, the *secondary colors* resulting from mixing pairs of primaries, lie between them. Colors opposite each other in the spectrum—red and green, purple and yellow, and orange and blue here—are *complementary colors.* They "complement," or complete, each other, one absorbing colors the other reflects. When painters mix complementaries in the right proportions, a neutral tone or gray (theoretically, black) results.

TEXTURE *Texture* is the quality of a surface (such as rough or shiny) that light reveals. Art historians distinguish between *actual* textures, or the surface's tactile quality, and *represented* textures, as when painters depict an object as having a certain texture, even though the paint is the actual texture. Sometimes artists combine different materials of different textures on a single surface, juxtaposing paint with pieces of wood, newspaper, fabric, and so forth. Art historians refer to this *mixed-media* technique as *collage.* Texture is, of course, a key determinant of any sculpture's character. People's first impulse is usually to handle a piece of sculpture—even though museum signs often warn "Do not touch!" Sculptors plan for this natural human response, using surfaces varying in texture from rugged coarseness to polished smoothness. Textures are often intrinsic to a material, influencing the type of stone, wood, plastic, clay, or metal sculptors select.

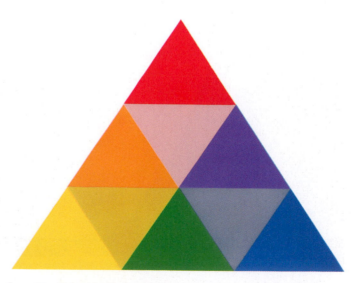

Intro-11 Color triangle developed by JOSEF ALBERS and SEWELL SILLMAN. Yale University Art Gallery, New Haven.

SPACE, MASS, AND VOLUME *Space* is the bounded or boundless "container" of objects. For art historians, space can be *actual,* the three-dimensional space occupied by a statue or a vase or contained within a room or courtyard. Or it can be *illusionistic,* as when painters depict an image (or illusion) of the three-dimensional spatial world onto a two-dimensional surface.

Mass and *volume* describe three-dimensional space. In both architecture and sculpture, mass is the bulk, density, and weight of matter in space. Yet the mass need not be solid. It can be the exterior form of enclosed space. "Mass" can apply to a solid Egyptian pyramid or wooden statue, to a church, synagogue, or mosque—architectural shells enclosing sometimes vast spaces—and to a hollow metal statue or baked clay pot. Volume is the space that mass organizes, divides, or encloses. It may be a building's interior spaces, the intervals between a structure's masses, or the amount of space occupied by three-dimensional objects such as sculpture, pottery, or furniture. Volume and mass describe both the exterior and interior forms of a work of art—the forms of the matter of which it is composed and the spaces immediately around the work and interacting with it.

PERSPECTIVE AND FORESHORTENING *Perspective* is one of the most important pictorial devices for organizing forms in space. Throughout history, artists have used various types of perspective to create an illusion of depth or space on a two-dimensional surface. The French painter CLAUDE LORRAIN employed several perspectival devices in *Embarkation of the Queen of Sheba* (FIG. **Intro-12**), a painting of a biblical episode set in a seventeenth-century European harbor with a Roman ruin in the left foreground. For example, the figures and boats on the shoreline are much larger than those in the distance. Decreasing an object's size makes it appear farther away from viewers. Also, the top and bottom of the port building at the painting's right side are not parallel horizontal lines, as they are in an actual building. Instead, the lines converge beyond the structure, leading viewers' eyes toward the hazy, indistinct sun on the horizon. These perspectival devices—the reduction of figure size, the convergence of diagonal lines, and the blurring of distant forms—have been familiar features of Western art since the ancient Greeks. But it is important to note at the outset that all kinds of perspective are only pictorial conventions, even when one or more types of perspective may be so common in a given culture

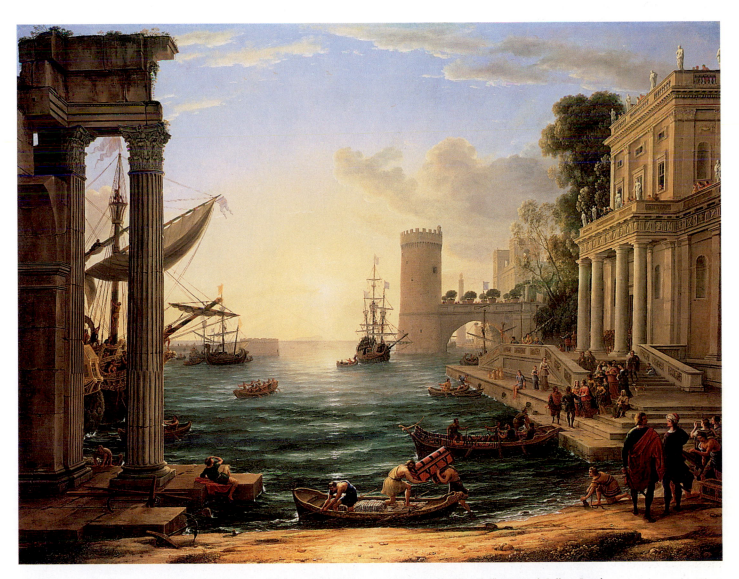

Intro-12 CLAUDE LORRAIN, *Embarkation of the Queen of Sheba,* 1648. Oil on canvas, approx. 4′ 10″ × 6′ 4″. National Gallery, London.

that they are accepted as "natural" or "true" means of representing the natural world.

In *Red Plum Blossoms* (FIG. **Intro-13**), a Japanese landscape painting, OGATA KORIN used none of these conventions. He showed the plum tree as seen from a position on the ground, while viewers look down on the stream from above. Less concerned with locating the tree and stream in space than with composing shapes on a surface, the painter played the water's gently swelling curves against the jagged contours of the branches and trunk. Neither the French nor the Japanese painting can be said to "correctly" project what viewers "in fact" see. One painting is not a "better" picture of the world than the other. The artists simply approached the problem of picture-making differently. Claude Lorrain's approach is, however, one of the distinctive features of the Western tradition in art that we examine exclusively in this book.

Artists also represent single figures in space in varying ways. When PETER PAUL RUBENS painted *Lion Hunt* (FIG. **Intro-14**) in the early seventeenth century, he used *foreshortening* for all the hunters and animals, that is, he represented their bodies at angles to the picture plane. When in life one views a figure at an angle, the body appears to contract as it extends back in space. Foreshortening is a kind of perspective. It produces the illusion that one part of the body is farther away than another, even though all the forms are on the same surface. Especially noteworthy in *Lion Hunt* are the gray horse at the left, seen from behind with the bottom of its left rear hoof facing viewers and most of its head hidden by its rider's shield, and the fallen hunter at the canvas's lower right corner, whose barely visible legs and feet recede into the distance.

The artist who carved the portrait of the ancient Egyptian official Hesire (FIG. **Intro-15**) did not employ foreshortening. That artist's purpose was to present the various human body parts as clearly as possible, without overlapping. The lower part of Hesire's body is in profile to give the most complete view of the legs, with both the heels and toes of the foot visible. The frontal torso, however, allows viewers to see its full shape, including both shoulders, equal in size, as in nature. (Compare the shoulders of the hunter on the gray horse or those of the fallen hunter in *Lion Hunt*'s left foreground.) The result, an "unnatural" ninety-degree twist at the waist, provides a precise picture of human body parts. The European painter and the Egyptian sculptor used very different means of depicting forms in space. Once again, neither is the "correct" manner, although foreshortening, like perspective, is one of the characteristic features of the Western artistic tradition.

PROPORTION AND SCALE *Proportion* concerns the relationships (in terms of size) of the parts of persons, build-

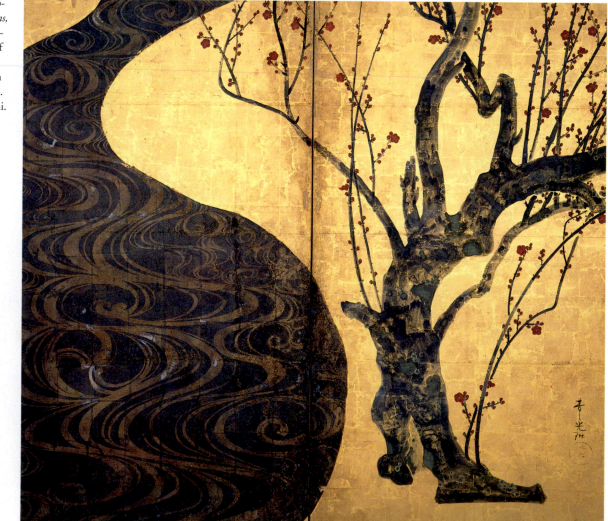

Intro-13 OGATA KORIN, *Red Plum Blossoms,* Edo period, ca. 1710–1716. One of a pair of twofold screens. Ink, color, and gold leaf on paper, 5′ 1 5/8″ × 5′ 7 7/8″. Museum of Art, Atami.

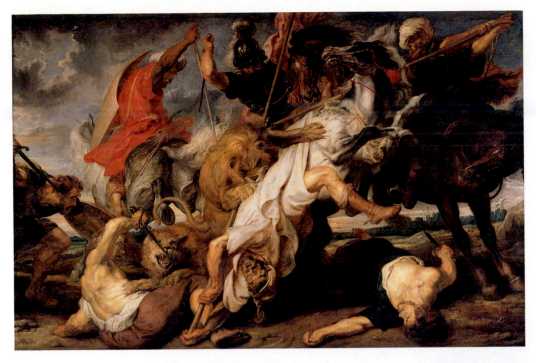

Intro-14 PETER PAUL RUBENS, *Lion Hunt*, 1617–1618. Oil on canvas, approx. 8′ 2″ × 12′ 5″. Alte Pinakothek, Munich.

ings, or objects. "Correct proportions" may be judged intuitively ("that statue's head seems the right size for the body"). Or proportion may be formalized as a mathematical relationship between the size of one part of an artwork or building and the other parts within the work. Proportion in art implies using a *module,* or basic unit of measure. When an artist or architect uses a formal system of proportions, all parts of a building, body, or other entity will be fractions or multiples of the module. A module might be a column's diameter, the height of a human head, or any other component whose dimensions can be multiplied or divided to determine the size of the work's other parts.

In certain times and places, artists have formulated *canons,* or systems, of "correct" or "ideal" proportions for representing human figures, constituent parts of buildings, and so forth. In ancient Greece, many sculptors formulated canons of proportions so strict and all-encompassing that they calculated the size of every body part in advance, even the fingers and toes, according to mathematical ratios (FIG. Intro-7). The ideal of human beauty the Greeks created based on "correct" proportions influenced the work of countless later artists in the Western world and endures to this day. Proportional systems can differ sharply from period to period, culture to culture, and artist to artist. Part of the task art history students face is to perceive and adjust to these differences.

In fact, many artists have used *disproportion* and distortion deliberately for expressive effect. In the medieval French depiction of the weighing of souls on Judgment Day (FIG. Intro-6), the devilish figure yanking down on the scale has distorted facial features and stretched, lined limbs with animal-like paws for feet. Disproportion and distortion make him appear "inhuman," precisely as the sculptor intended.

In other cases, artists have used disproportion to focus attention on one body part (often the head) or to single out a group member (usually the leader). These intentional

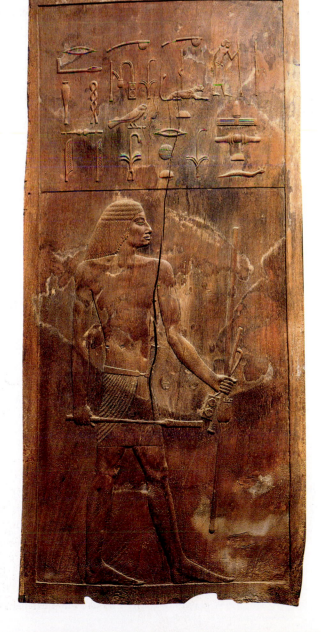

Intro-15 Hesire, from his tomb at Saqqara, Egypt, Dynasty III, ca. 2650 B.C. Wood, approx. 3′ 9″ high. Egyptian Museum, Cairo.

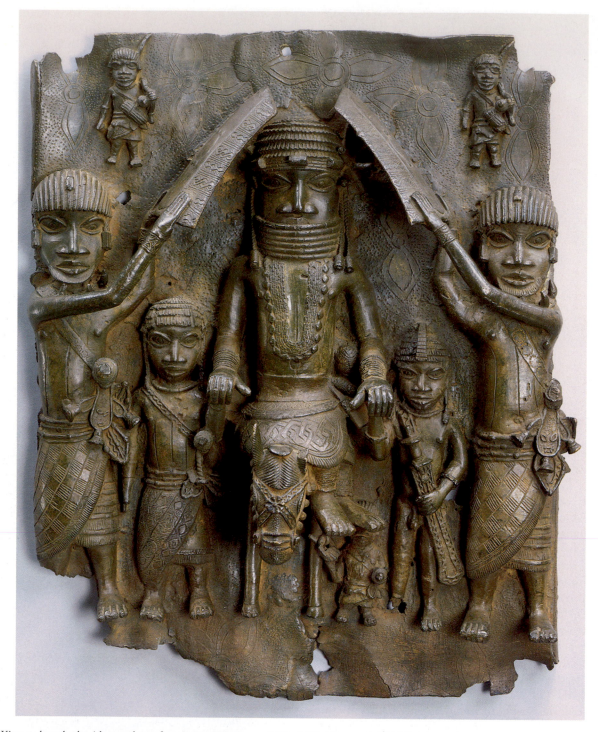

Intro-16 King on horseback with attendants, from Benin, Nigeria, ca. 1550–1680. Bronze, 1' 7½" high. Metropolitan Museum of Art, New York (Michael C. Rockefeller Memorial Collection, gift of Nelson A. Rockefeller).

"unnatural" discrepancies in proportion constitute what art historians call *hierarchy of scale,* the enlarging of elements considered the most important. On a bronze plaque from Benin, Nigeria (FIG. **Intro-16**), the sculptor enlarged all the heads for emphasis and also varied the size of each figure according to its social status. Central, largest, and therefore most important is the Benin king, mounted on horseback. The horse has been a symbol of power and wealth in many societies from prehistory to the present. That the Benin king is disproportionately larger than his horse, contrary to nature, further aggrandizes him. Two large attendants fan the king. Other figures of smaller size and status at the Benin court stand on the king's left and right and in the plaque's upper corners. One tiny figure next to the horse is almost hidden from view beneath the

king's feet. Hierarchy of scale is not unique to Africa or even to the non-Western world. On the Autun church portal (FIG. Intro-6), for example, the angels and the agents of the Devil are much larger than the souls awaiting judgment, because they are the more important figures in the composition.

CARVING AND CASTING Sculptural technique falls into two basic categories, *subtractive* and *additive. Carving* is a subtractive technique. The final form is a reduction of the original mass of a block of stone, a piece of wood, or another material. Wooden statues were once tree trunks, and stone statues began as blocks pried from mountains. In an unfinished sixteenth-century marble statue of a bound slave (FIG. **Intro-17**) by MICHELANGELO, the stone block's original shape

Intro-17 MICHELANGELO, unfinished captive, 1527–1528. Marble, 8′ 7½″ high. Accademia, Florence.

Intro-18 Head of a warrior, detail of a statue from the sea off Riace, Italy, ca. 460–450 B.C. Bronze, statue approx. 6′ 6″ high. Archeological Museum, Reggio Calabria.

is still visible. Michelangelo thought of sculpture as a process of "liberating" the statue within the block. All sculptors of stone or wood cut away (subtract) "excess material." When they finish, they "leave behind" the statue—in our example, a twisting nude male form whose head Michelangelo never freed from the stone block.

In additive sculpture, the artist builds up the forms, usually in clay around a framework, or *armature.* Or a sculptor may fashion a *mold,* a hollow form for shaping, or *casting,* a fluid substance such as bronze. The ancient Greek sculptor who made the bronze statue of a warrior found in the sea near Riace, Italy, cast the head (FIG. **Intro-18**), limbs, torso, hands, and feet in separate molds and then *welded* them (joined them by heating). Finally, the artist added features, such as the pupils of the eyes (now missing), in other materials. The warrior's teeth are silver and his lower lip is copper.

RELIEF SCULPTURE Statues that exist independent of any architectural frame or setting and that viewers can walk around are *freestanding* sculptures, or sculptures "in the round," whether the piece was carved (FIG. Intro-7) or cast (FIG. Intro-18). In *relief sculptures,* the subjects project from the background but remain part of it. In *high relief* sculpture, the images project boldly. In some cases, such as the weighing-of-souls relief at Autun (FIG. Intro-6), the relief is so high that not only do the forms cast shadows on the background, but some parts are actually in the round. The scale's arms are

fully detached from the background in places—which explains why some pieces broke off centuries ago. In *low relief,* or *bas-relief,* such as the wooden relief of Hesire (FIG. Intro-15), the projection is slight. In a variation of both techniques, *sunken relief,* the sculptor cuts the design into the surface so that the image's highest projecting parts are no higher than the surface itself. Relief sculpture, like sculpture in the round, can be produced either by carving or casting. The plaque from Benin (FIG. Intro-16) is a good example of bronze-casting in high relief. Artists also can make reliefs by hammering a sheet of metal from behind, pushing the subject out from the background in a technique called *repoussé.*

ARCHITECTURAL DRAWINGS Buildings are groupings of enclosed spaces and enclosing masses. People experience architecture both visually and by moving through and around it, so they perceive architectural space and mass together. These spaces and masses can be represented graphically in several ways, including as plans, sections, elevations, and cutaway drawings.

A *plan,* essentially a map of a floor, shows the placement of a structure's masses and, therefore, the spaces they bound and

enclose. A *section,* like a vertical plan, depicts the placement of the masses as if the building were cut through along a plane. Drawings showing a theoretical slice across a structure's width are *lateral sections.* Those cutting through a building's length are *longitudinal sections.* Illustrated here is the plan and half of the lateral section of Bourges Cathedral (FIG. **Intro-19**), a French Gothic church similar in character to Beauvais Cathedral (FIG. Intro-2). The plan shows not only the building's shape and the location of the piers dividing the aisles and supporting the vaults above but also the pattern of the crisscrossing vault *ribs.* The lateral section shows both the main area of the church and the vaults below the floor.

Other types of architectural drawings appear throughout this book. An *elevation* drawing is a head-on view of an external or internal wall. A *cutaway* combines an exterior view with an interior view of part of a building in a single drawing.

This overview of the art historian's vocabulary is not exhaustive, nor have artists used only painting, drawing, sculpture, and architecture as media over the millennia. Ceramics, jewelry, textiles, photography, and computer art are just some of the numerous other arts. All of them involve highly specialized techniques described in distinct vocabularies. These are considered and defined where they arise in the text.

Art History and Other Disciplines

By its very nature, the work of art historians intersects with that of others in many fields of knowledge, not only in the hu-

manities but also in the social and natural sciences. To "do their job" well today, art historians regularly must go beyond the boundaries of what the public and even professional art historians of previous generations traditionally have considered the specialized discipline of art history. Art historical research in the twenty-first century is frequently *interdisciplinary* in nature. To cite one example, in an effort to unlock the secrets of a particular statue, an art historian might conduct archival research hoping to uncover new documents shedding light on who paid for the work and why, who made it and when, where it originally stood, how its contemporaries viewed it, and a host of other questions. Realizing, however, that the authors of the written documents often were not objective recorders of fact but observers with their own biases and agendas, the art historian may also use methodologies developed in fields such as literary criticism, philosophy, sociology, and gender studies to weigh the evidence the documents provide.

At other times, rather than attempting to master many disciplines at once, art historians band together with other specialists in *multidisciplinary* inquiries. Art historians might call in chemists to date an artwork based on the composition of the materials used or might ask geologists to determine which quarry furnished the stone for a particular statue. X-ray technicians might be enlisted in an attempt to establish whether or not a painting is a forgery. Of course, art historians often contribute their expertise to the solution of problems in other disciplines. A historian, for example, might ask an art historian to determine—based on style, material, iconography, and other criteria—if any of the portraits of a certain king

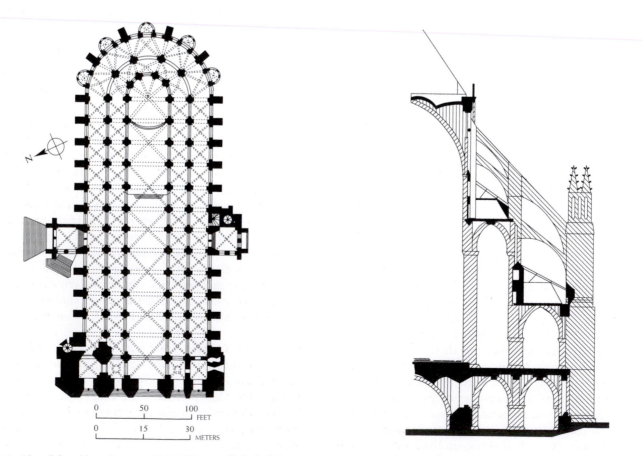

Intro-19 Plan *(left)* and lateral section *(right)* of Bourges Cathedral, Bourges, France, 1195–1255.

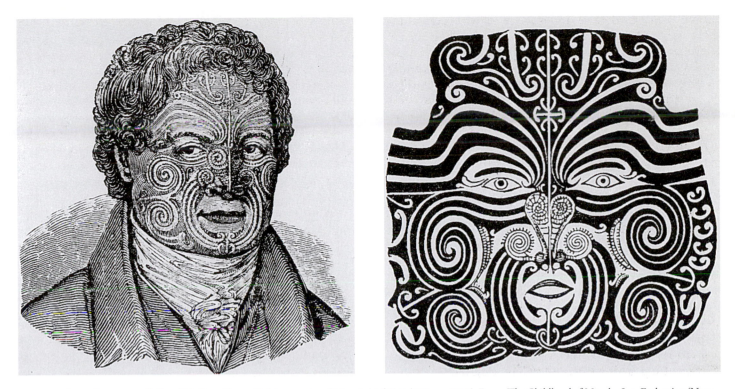

Intro-20 JOHN SYLVESTER *(left)* and TE PEHI KUPE *(right)*, portraits of Maori chief Te Pehi Kupe, 1826. From *The Childhood of Man*, by Leo Frobenius (New York: J. B. Lippincott, 1909).

were made after his death. That would help establish the ruler's continuing prestige during his successors' reigns. (Some portraits of Augustus, FIG. Intro-10, the Roman Empire's founder, postdate his death by decades, even centuries.)

DIFFERENT WAYS OF SEEING

The history of art can be a history of artists and their works, of styles and stylistic change, of materials and techniques, of images and themes and their meanings, and of contexts and cultures and patrons. The best art historians analyze artworks from many viewpoints. But no art historian (or scholar in any other field!), no matter how broad-minded in approach and no matter how experienced, can be truly objective. Like artists, art historians are members of a society, participants in its culture. How can scholars (and museum visitors and travelers to foreign locales) comprehend cultures unlike their own? They can try to reconstruct the original cultural contexts of artworks, but they are bound to be limited by their distance from the thought patterns of the cultures they study and by the obstructions to understanding their own thought patterns raise—the assumptions, presuppositions, and prejudices peculiar to their own culture. Art historians may reconstruct a distorted picture of the past because of culture-bound blindness.

A single instance underscores how differently people of diverse cultures view the world and how various ways of seeing can cause sharp differences in how artists depict the world. We illustrate two contemporaneous portraits of a nineteenth-century Maori chieftain side by side (FIG. **Intro-20**)—one by an Englishman, JOHN SYLVESTER, and the other by the New Zealand chieftain himself, TE PEHI KUPE. Both repro-

duce the chieftain's facial tattooing. The European artist included the head and shoulders and underplayed the tattooing. The tattoo pattern is one aspect of the likeness among many, no more or less important than the fact the chieftain is dressed like a European. Sylvester also recorded his subject's momentary glance toward the right and the play of light on his hair, fleeting aspects that have nothing to do with the figure's identity.

By contrast, Te Pehi Kupe's self-portrait—made during a trip to Liverpool, England, to obtain European arms to take back to New Zealand—is not a picture of a man situated in space and bathed in light. Rather, it is the chieftain's statement of the supreme importance of the design that symbolizes his rank among his people. Remarkably, Te Pehi Kupe created the tattoo patterns from memory, without the aid of a mirror. The splendidly composed insignia, presented as a flat design separated from the body and even from the head, is Te Pehi Kupe's image of himself. Only by understanding the cultural context of each portrait can viewers hope to understand why either looks the way it does.

As noted at the outset, the study of the context of artworks and buildings is one of the central aims of art history. Western art differs in many respects from other artistic traditions, but even within the Western world, each culture and each period is distinctive. Paintings, sculptures, buildings—indeed, all art forms—changed dramatically with each change of culture, locale, and date. Our purpose in writing *Gardner's Art through the Ages: The Western Perspective* is to present a history of art that will help readers understand not only the subjects, styles, and techniques of artworks and buildings in the Western tradition created during thirty millennia but also those monuments' cultural and historical contexts. That story now begins.

The Gods and Goddesses of Mount Olympus

The names of scores of Greek gods and goddesses appear already in Homer's epic tales of the war against Troy (*Iliad*) and of the adventures of the Greek hero Odysseus on his long and tortuous journey home (*Odyssey*). Even more are enumerated in the poems of Hesiod, especially his *Theogony (Geneaology of the Gods)* composed around 700 B.C.

The Greek deities most often represented in art are all ultimately the offspring of the two key elements of the Greek universe, Earth (*Gaia/Ge*; we give the names in Greek/Latin form) and Heaven (*Ouranos/Uranus*). Earth and Heaven mated to produce twelve Titans, including Ocean (*Okeanos/Oceanus*) and his youngest brother *Kronos (Saturn)*. Kronos castrated his father in order to rule in his place, married his sister *Rhea*, and then swallowed all his children as they were born, lest one of them seek in turn to usurp him (see FIG. 20-40). When *Zeus (Jupiter)* was born, Rhea deceived Kronos by feeding him a stone wrapped in clothes in place of the infant. After growing to manhood, Zeus forced Kronos to vomit up Zeus's siblings. Together they overthrew their father and the other Titans and ruled the world from their home on Mount Olympus, Greece's highest peak.

This cruel and bloody tale of the origin of the Greek gods has parallels in Near Eastern mythology and is clearly pre-Greek in origin, one of many Greek borrowings from the Orient. The Greek version of the creation myth, however, appears infrequently in painting and sculpture. Instead the later twelve *Olympian gods and goddesses*, the chief deities of Greece, figure most prominently in art—not only in Greek, Etruscan, and Roman times but also in the Middle Ages, the Renaissance, and down to the present.

THE OLYMPIAN GODS
(AND THEIR ROMAN EQUIVALENTS)

Zeus (Jupiter) King of the gods, Zeus (see FIGS. 5-36 and 21-42) ruled the sky and allotted the sea to Poseidon and the Underworld to Hades. His weapon was the thunderbolt, and with it he led the other gods to victory over the Giants (FIGS. 5-17 and 5-79), who had challenged the Olympians for control of the world.

Hera (Juno) Wife and sister of Zeus, Hera was the goddess of marriage and was often angered by Zeus's many love affairs. Her favorite cities were Mycenae, Sparta, and Argos, and she aided the Greeks in their war against the Trojans.

Poseidon (Neptune) Zeus's brother, Poseidon (see FIGS. 7-62 and 18-17) was one of the three sons of Kronos and Rhea and was lord of the sea. He controlled waves, storms, and earthquakes with his three-pronged pitchfork (*trident*).

Hestia (Vesta) Daughter of Kronos and Rhea and sister of Zeus, Poseidon, and Hera, Hestia was goddess of the hearth. In Rome, Vesta had an ancient shrine with a sacred fire in the Roman Forum. Her six *Vestal Virgins* were the most important priestesses of the state, drawn only from aristocratic families.

Demeter (Ceres) Third sister of Zeus, Demeter was the goddess of grain and agriculture. She taught humans how to sow and plow. The English word *cereal* derives from *Ceres*.

Ares (Mars) God of war, Ares was the son of Zeus and Hera and the lover of Aphrodite. In the *Iliad* he took the side of the Trojans. Mars, father of the twin founders of Rome, *Romulus* and *Remus* (see FIG. 6-10), looms much larger in Roman mythology and religion than Ares does in Greek.

Athena (Minerva) Goddess of wisdom and warfare, Athena (FIGS. 5-32, 5-44, and 5-79) was a virgin (*parthenos* in Greek) born not from the womb of a woman but from the head of her father, Zeus. Her city was Athens, and her greatest temple was the Parthenon (FIG. 5-42).

Hephaistos (Vulcan) God of fire and of metalworking, Hephaistos fashioned the armor Achilles wore in battle against Troy. He also provided Zeus his scepter and Poseidon his trident and was the "surgeon" who split open Zeus's head when Athena was born. In some accounts, Hephaistos is the son of Hera without a male partner. In others, he is the son of Hera and Zeus. Born lame and, uncharacteristically for a god, ugly, his wife Aphrodite was unfaithful to him.

Apollo (Apollo) God of light and music and a great archer, Apollo (see FIGS. Intro-7, 5-3, 5-57, and 19-63) was the son of Zeus with *Leto/Latona*, daughter of one of the Titans. His epithet *Phoibos* means "radiant," and the young, beautiful Apollo is sometimes identified with the Sun (*Helios/Sol*).

Artemis (Diana) Sister of Apollo, Artemis (see FIGS. 5-57 and 17-46) was goddess of the hunt and of wild animals. As Apollo's twin, she was occasionally regarded as the Moon (*Selene/Luna*).

Aphrodite (Venus) Daughter of Zeus and *Dione* (daughter of Okeanos and one of the *nymphs*—the goddesses of springs, caves, and woods), Aphrodite (FIGS. 5-60 and 5-83) was the goddess of love and beauty. In one version of her myth, she was born from the foam (*aphros* in Greek) of the sea (see FIG. 16-27). She was the mother of Eros by Ares and of the Trojan hero *Aeneas* by *Anchises*. Julius Caesar and Augustus traced their lineage to Venus through Aeneas.

Hermes (Mercury) Son of Zeus and another nymph, Hermes (FIGS. 5-58 and 5-62) was the fleet-footed messenger of the gods and possessed winged sandals. He was also the guide of travelers, including the dead journeying to the Underworld, and he carried the *caduceus,* a magical herald's rod entwined by serpents, and wore a traveler's hat, often also shown with wings.

Equal in stature to the Olympians was *Hades (Pluto)*, one of the children of Kronos who fought with his brothers against the Titans but who never resided on Mount Olympus. Hades was the lord of the Underworld and god of the dead.

Other important Greek gods and goddesses are *Dionysos (Bacchus,* see FIG. 17-37), the god of wine and the son of Zeus and a mortal woman; *Eros (Amor or Cupid)* (see FIGS. 5-48, 5-84, 17-43, and 19-85), the winged child god of love and the son of Aphrodite and Ares; and *Asklepios (Aesculapius)*, son of Apollo and a mortal woman, the Greek god of healing, whose serpent-entwined staff is the emblem of modern medicine.

Buddhism and Buddhist Iconography

The Buddha, or the Enlightened One, is the title given to Siddhartha Gautama, who also is called Sakyamuni, or the Wise Man of the Sakya Clan. The birth and death dates of this individual, the historical Buddha, are uncertain (different Buddhist sects give different dates). Current scholarship, however, places the Buddha's death around 400 B.C. Written down only many centuries after he died, the Buddha's life story records he was a minor Indian king's son destined to become either a great world conqueror or a great religious leader. He chose the latter. After living in opulence, he abandoned his wife and secular destiny to find enlightenment while meditating (in the yogic tradition) under a Bodhi Tree at Bodh Gaya in eastern India.

THE FOUR NOBLE TRUTHS

The Buddha's insight was that life is pain (*dukha*), including repeated death with each rebirth. Karmic actions of any kind—motivated by desire for love, children, food, power, or things—cause rebirth. The Buddha proposed a way (*marga* or *path*) to stop desire. This insight, formulated as the Four Noble Truths, stipulated that (1) everything is pain; (2) the origin of pain is desire; (3) the extinction of desire is nirvana; and (4) following the path or way the Buddha discovered leads to the ending of pain. In the Buddha's view, usually a person had to become a monk or nun and cultivate specific virtues to achieve nirvana. Some Buddhist sects believe people can attain nirvana within a single lifetime, while others feel it is virtually impossible even after multiple rebirths. At any rate, the Buddha's system is a monastic organization, and most Buddhist art in India is monastic. Laypeople support the monks where Buddhism thrives—giving them all they need to live, including food, clothing, and shelter—and in doing so create merit (or good karma) for their own better rebirth. Ironically, Buddhism died out almost completely in India by about the thirteenth century.

BUDDHISM OUTSIDE INDIA

The Buddha's teachings changed and developed over time and as they spread from India throughout Asia. One general change came with the development of the Mahayana (great vehicle) doctrines during the early centuries of the Christian era. Although formulated for other purposes, the Mahayana doctrines afforded laypeople new ways to achieve spiritual goals. For example, *bodhisattvas* (enlightened beings), special virtuous Mahayana deities, help people earn merit. Mahayana Buddhists worship the bodhisattvas independently of the Buddha. It is Mahayana Buddhism that spread to China, Korea, and Japan.

Yet another general shift in Buddhism, the development of Tantric teachings, involves secret or esoteric practices.

Tantric Buddhism is also important in East Asia and exists today in Tibet as well. One of the earliest forms of Buddhism, Theravada, continues in Sri Lanka and most of mainland Southeast Asia. A Buddha who acquired special importance in East Asia, Amitabha, Buddha of the West told followers he could grant salvation through entrance to his Pure Land paradise. Pure Land teachings maintain that people have no hope of attaining enlightenment on their own because of the corruption of their times. They can obtain rebirth in a heavenly realm, however, simply by faith in Amitabha's promise of salvation.

THE BUDDHA IN ART

The earliest Buddhist artists, although often depicting complex narrative scenes, did not show the Buddha in human form. Instead, they used symbols such as the wheel or the tree to suggest his presence. When artists began depicting the Buddha in human form around the first centuries B.C. and A.D., it was as a monk meditating or teaching. But they distinguished the Buddha from monks and bodhisattvas by *lakshanas*, bodily attributes or characteristics indicating the Buddha's superhuman nature. These distinguishing marks include an *urna*, or curl of hair between the eyebrows shown as a dot, and a *ushnisha*, a cranial bump shown as hair on the earliest images but later as an actual part of the head.

Episodes from the Buddha's life and death are among the most popular subjects in all Buddhist artistic traditions. No single text provides the complete or authoritative narrative of his life. Thus, numerous versions and variations exist, allowing for a rich artistic repertory. Some of the most popular scenes in Buddhist art, the Buddha's birth, enlightenment, first sermon, and death, took place at different locations (Lumbini, Bodh Gaya, Sarnath, and Kusinagara, now Kushinagar, respectively). The enlightenment at Bodh Gaya entails several different phases, but most paintings and sculptures present the Buddha seated in meditation or touching the earth under the Bodhi Tree.

Depictions of the first sermon show the Buddha teaching, his hands held together in front of his body to indicate the turning of the Wheel of the Law. A symbolic hand gesture, or *mudra*, also can indicate concepts such as meditation or reassurance. The Buddha set this Wheel rolling with his first sermon, and the Wheel marks with its track the geographic extent of his teaching. Often, artists depicted the Wheel of the Law as an actual wheel flanked by deer, a reference to the Deer Park at Sarnath. Finally, in scenes of his death (*parinirvana*), artists portrayed the Buddha as lying down.

Indian Buddhists erected monasteries and monuments at all four sites of these key events. Monks and lay pilgrims from throughout the Buddhist world continue to visit these places today.

The Life of Jesus in Art

Christians believe that Jesus of Nazareth was the son of God, the *Messiah* (Savior, *Christ*) of the Jews prophesied in the Old Testament. His life, from his miraculous birth from the womb of a virgin mother through his preaching and miracle working to his execution by the Romans and subsequent ascent to heaven, has been the subject of countless artworks from Roman times through the present day. The primary literary sources for these representations are the Gospels of the New Testament attributed to the four Evangelists, Saints Matthew, Mark, Luke, and John; later apocryphal works; and commentaries on these texts by medieval theologians.

Although many of the events of Jesus' life were rarely or never depicted during certain periods, the cycle as a whole has been one of the most frequent subjects of Western art, even after the revival of classical and secular themes in the Renaissance. Thus it is useful to summarize the entire cycle here in one place, giving selected references to illustrations of the various episodes, from late antiquity to the seventeenth century. We describe the events as they usually appear in the artworks.

INCARNATION AND CHILDHOOD

The first "cycle" of the life of Jesus consists of the events of his conception, birth, infancy, and childhood.

Annunciation to Mary (see FIGS. 9-33, 14-18, and 16-38) The archangel Gabriel announces to the Virgin Mary that she will miraculously conceive and give birth to God's son Jesus. God's presence at the *Incarnation* is sometimes indicated by a dove, the symbol of the *Holy Spirit*, the third "person" of the *Trinity* with God the Father and Jesus.

Visitation (see FIG. 13-24) The pregnant Mary visits Elizabeth, her older cousin, who is pregnant with the future Saint John the Baptist. Elizabeth is the first to recognize that the baby Mary is bearing is the Son of God, and they rejoice.

Nativity (see FIGS. 14-3 and 14-4), *Annunciation to the Shepherds* (see FIG. 11-28), and *Adoration of the Shepherds* (see FIG. 19-57) Jesus is born at night in Bethlehem and placed in a basket. Mary and her husband Joseph marvel at the newborn in a stable or, in Byzantine art, in a cave. An angel announces the birth of the Savior to shepherds in the field, who rush to Bethlehem to adore the child.

Adoration of the Magi (see FIG. 16-10) A bright star alerts three wise men *(magi)* in the East that the King of the Jews has been born. They travel twelve days to find the *Holy Family* and present precious gifts to the infant Jesus.

Presentation in the Temple In accordance with Jewish tradition, Mary and Joseph bring their first-born son to the temple in Jerusalem, where the aged Simeon, whom God said would not die until he had seen the Messiah, recognizes Jesus as the prophesied Savior of humankind.

Massacre of the Innocents and *Flight into Egypt* King Herod, fearful that a rival king has been born, orders the massacre of all infants in Bethlehem, but an angel warns the Holy Family and they escape to Egypt.

Dispute in the Temple Joseph and Mary travel to Jerusalem for the feast of *Passover* (the celebration of the release of the Jews from bondage to the pharaohs of Egypt). Jesus, only twelve years old at the time, engages in learned debate with astonished Jewish scholars in the temple, foretelling his ministry.

PUBLIC MINISTRY

The public ministry cycle comprises the teachings of Jesus and the miracles he performed.

Baptism (FIG. 8-4) The beginning of Jesus' public ministry is marked by his baptism at age thirty by John the Baptist in the Jordan River, where the dove of the Holy Spirit appears and God's voice is heard proclaiming Jesus as his son.

Calling of Matthew (see FIG. 19-19) Jesus summons Matthew, a tax collector, to follow him, and Matthew becomes one of his twelve *disciples,* or *apostles* (from the Greek for "messenger"), and later the author of one of the four Gospels.

Miracles In the course of his teaching and travels, Jesus performs many miracles, revealing his divine nature. These include acts of healing and the raising of the dead, the turning of water into wine, walking on water and calming storms, and the creation of wondrous quantities of food. In the miracle of loaves and fishes (FIG. 8-17), for example, Jesus transforms a few loaves of bread and a handful of fishes into enough food to feed several thousand people.

Delivery of the Keys to Peter (see FIG. 16-42) The fisherman Peter was one of the first Jesus summoned as a disciple. Jesus chooses Peter as his successor, the rock *(petra)* on which his church will be built, and symbolically delivers to Peter the keys to the kingdom of heaven.

Transfiguration (see FIG. 9-13) Jesus scales a high mountain and, in the presence of Peter and two other disciples, James and John the Evangelist, is transformed into radiant light. God, speaking from a cloud, discloses that Jesus is his son.

Cleansing of the Temple Jesus returns to Jerusalem, where he finds money changers and merchants conducting business in the temple. He rebukes them and drives them out of the sacred precinct.

PASSION

The Passion (from Latin *passio,* "suffering") cycle includes the episodes leading to Jesus' death, Resurrection, and ascent to heaven.

The Life of Jesus in Art (continued)

Entry into Jerusalem (FIG. 8-5) On the Sunday before his Crucifixion (Palm Sunday), Jesus rides triumphantly into Jerusalem on a donkey, accompanied by disciples. He is greeted enthusiastically by crowds of people who place palm fronds in his path.

Last Supper (see FIGS. 15-8, 16-39, 17-3, 17-52, and 18-4) and *Washing of the Disciples' Feet* In Jerusalem, Jesus celebrates Passover with his disciples. During this Last Supper, Jesus foretells his imminent betrayal, arrest, and death and invites the disciples to remember him when they eat bread (symbol of his body) and drink wine (his blood). This ritual became the celebration of *Mass (Eucharist)* in the Christian Church. At the same meal, Jesus sets an example of humility for his apostles by washing their feet.

Agony in the Garden Jesus goes to the Mount of Olives in the Garden of Gethsemane, where he struggles to overcome his human fear of death by praying for divine strength. The apostles who accompanied him there fall asleep despite his request that they stay awake with him while he prays.

Betrayal and Arrest (see FIG. 14-17) One of the disciples, Judas Iscariot, agrees to betray Jesus to the Jewish authorities in return for thirty pieces of silver. Judas identifies Jesus to the soldiers by kissing him, and Jesus is arrested. Later, a remorseful Judas hangs himself from a tree (FIG. 8-21).

Trials of Jesus (FIGS. 8-5 and 8-20) and *Denial of Peter* Jesus is brought before Caiaphas, the Jewish high priest, and is interrogated about his claim to be the Messiah. Meanwhile, the disciple Peter thrice denies knowing Jesus, as Jesus predicted he would. Jesus is then brought before the Roman governor of Judea, Pontius Pilate, on the charge of treason because he had proclaimed himself as King of the Jews. Pilate asks the crowd to choose between freeing Jesus or Barabbas, a murderer. The people choose Barabbas, and the judge condemns Jesus to death. Pilate washes his hands, symbolically relieving himself of responsibility for the mob's decision.

Flagellation and *Mocking* The Roman soldiers who hold Jesus captive whip (flagellate) him and mock him by dressing him as King of the Jews and placing a crown of thorns on his head.

Carrying of the Cross, Raising of the Cross, (see FIG. 19-34) and *Crucifixion* (see FIGS. 8-21, 9-20, 11-16, and 11-27) The Romans force Jesus to carry the cross on which he will be crucified from Jerusalem to Mount Calvary (Golgotha, the "place of the skull," where Adam was buried). He falls three times and gets stripped along the way. Soldiers erect the cross and nail his hands and feet to it. Jesus' mother, John the Evangelist, and Mary Magdalene mourn at the foot of the cross, while soldiers torment Jesus. One of them (the centurion Longinus) stabs his side with a spear. After suffering great pain, Jesus dies. The Crucifixion occurred on a Friday and Christians celebrate the day each year as Good Friday.

Deposition (see FIGS. 15-6 and 17-41), *Lamentation* (see FIGS. 9-27 and 14-9), and *Entombment* (see FIG. 12-33) Two disciples, Joseph of Arimathea and Nicodemus, remove Jesus' body from the cross (the Deposition); sometimes those present at the Crucifixion look on. They take Jesus to the tomb Joseph had purchased for himself, and Joseph, Nicodemus, the Virgin Mary, Saint John the Evangelist, and Mary Magdalene mourn over the dead Jesus (the Lamentation). (When in art the isolated figure of the Virgin Mary cradles her dead son in her lap, it is called a *Pietà* [Italian for *pity;* see FIGS. 13-53 and 15-19]). In portrayals of the Entombment, his followers lower Jesus into a sarcophagus in the tomb.

Descent into Limbo (see FIGS. 9-23 and 9-31) During the three days he spends in the tomb, Jesus, no longer a mortal human but now the divine Christ, descends into Hell, or Limbo, and triumphantly frees the souls of the righteous, including Adam, Eve, Moses, David, Solomon, and John the Baptist. In Byzantine art, this episode is often labeled *Anastasis* (*Resurrection* in Greek), although it refers to events preceding Christ's emergence from the tomb and reappearance on earth.

Resurrection (see FIG. 16-52) and *Three Marys at the Tomb* On the third day (Easter Sunday), Christ rises from the dead and leaves the tomb while the guards outside are sleeping. The Virgin Mary, Mary Magdalene, and Mary, the mother of James, visit the tomb, find it empty, and learn from an angel that Christ has been resurrected.

Noli Me Tangere, Supper at Emmaus, and *Doubting of Thomas* During the forty days between Christ's Resurrection and his ascent to heaven, he appears on several occasions to his followers. Christ warns Mary Magdalene, weeping at his tomb, with the words "Don't touch me" (*Noli me tangere* in Latin), but he tells her to inform the apostles of his return. At Emmaus he eats supper with two of his astonished disciples. Later, Thomas, who cannot believe that Christ has risen, is invited to touch the wound in his side that he received at his Crucifixion.

Ascension (see FIGS. 9-14 and 12-26) On the fortieth day, on the Mount of Olives, with his mother and apostles as witnesses, Christ gloriously ascends to heaven in a cloud.

Classical Architecture

Many of the elements of classical architectural design reappear in buildings from the Middle Ages to the present day. Below we illustrate and describe the most important components of the Greek architectural orders and of Roman vaulting systems.

The Greek Orders The Greeks developed two basic architectural *orders*, or design systems: the *Doric* and the *Ionic*. The forms of the columns and *entablature* (superstructure) generally differentiate the orders. Classical columns have two or three parts, depending on the order: the *shaft*, which is usually marked with vertical channels *(flutes)*; the *capital*; and, in the Ionic order, the *base*. The Doric capital consists of a round *echinus* beneath a square *abacus* block. Spiral *volutes* constitute

the distinctive feature of the Ionic capital. Classical entablatures have three parts: the *architrave*, the *frieze*, and the triangular *pediment* of the gabled roof. In the Doric order, the frieze is subdivided into *triglyphs* and *metopes*, while in the Ionic the frieze is left open.

The *Corinthian capital*, a later Greek invention very popular in Roman times, is more ornate than either the Doric or Ionic. It consists of a double row of acanthus leaves, from which tendrils and flowers emerge. Although this capital often is cited as the Corinthian order's distinguishing element, strictly speaking, no Corinthian order exists. Architects simply substituted the new capital type for the volute capital in the Ionic order.

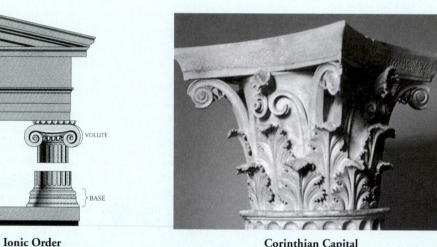

Doric Order **Ionic Order** **Corinthian Capital**

Roman Vaulting Although earlier architects used both arches and vaults, the Romans employed them more extensively and effectively than any other ancient civilization. The three main vault types the Romans built were the *barrel vault*, which is an extension of a simple arch, creating a semi-cylindrical ceiling over parallel walls; the *groin vault*, which is formed by the intersection at right angles of two barrel vaults of equal size; and the *hemispherical dome*, which may be described as a round

arch rotated around the full circumference of a circle, usually resting on a cylindrical *drum*. Barrel vaults resemble tunnels, and groin vaults usually occur in a series covering a similar *longitundinally* oriented interior space. Domes, on the other hand, crown *centrally* planned buildings, so named because the structure's parts are of equal or almost equal dimensions around the center.

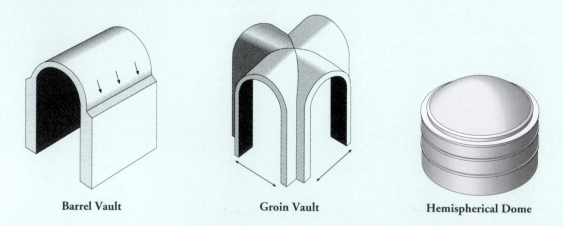

Barrel Vault **Groin Vault** **Hemispherical Dome**

Medieval Churches

Church design during the Middle Ages set the stage for ecclesiastical architecture from the Renaissance to the present. Both the longitudinal and central-plan building types of antiquity had a long post-classical history. We illustrate here the chief elements of medieval churches both in Western Europe and in Byzantium.

The Basilican Church In Western Christendom the typical church had a *basilican* plan, which evolved from the Roman columnar hall, or basilica. One of the earliest and most famous of these churches was Saint Peter's in Rome, begun ca. 320 and entirely rebuilt beginning in the fifteenth century. Old Saint Peter's was typical of Early Christian church design. Covered by a simple timber roof, it had a wide central columnar *nave* flanked by *aisles* and ending in an *apse*. Saint Peter's also had a *transept,* an area perpendicular to the nave. The nave and transept intersect at the *crossing.* Another feature of this church was a forecourt (whose plan is conjectural). In the later Middle Ages, such courtyards became rare and the faithful entered the nave and aisles directly through grand portals.

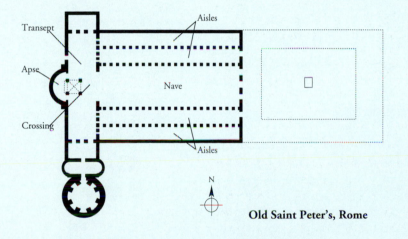

Old Saint Peter's, Rome

Our diagram of a typical medieval church portal shows the parts that, from the eleventh century on, sculptors regularly decorated. The *tympanum* is the prominent semicircular area above the doorway, comparable in importance to the triangular pediment of a classical temple. The *voussoirs* are the wedge-shaped blocks that together form the *archivolts* of the arch framing the tympanum. The *lintel* is the horizontal beam above the doorway, the *trumeau* is the center post supporting the lintel, and the *jambs* are the doorway's side posts. Sculptors also frequently placed reliefs on the doors themselves.

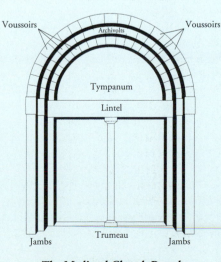

The Medieval Church Portal

Medieval Churches (continued)

The Gothic Cathedral The great European cathedrals of the later twelfth and thirteenth centuries were the immediate predecessors of the churches of the Renaissance and Baroque eras. They shared many of the basic elements of the Early Christian basilica, including the nave, aisles, apse, transept, and crossing, but also had many new features. To illustrate the key elements of Gothic design, we illustrate an "exploded" view of a typical Gothic cathedral and the plan of Chartres Cathedral in France, as rebuilt after 1194. In later medieval basilican churches, architects frequently extended the aisles around the apse to form an *ambulatory,* onto which opened *radiating*

chapels housing sacred relics. *Groin vaults* formed the ceiling of the nave, aisles, ambulatory, and transept alike. These vaults rested on *diagonal* and *transverse* ribs in the form of pointed arches. On the exterior, *flying buttresses* held the nave vaults in place. These masonry struts transferred the thrust of the nave vaults across the roofs of the aisles to tall piers frequently capped by pointed ornamental *pinnacles.* This structural system made it possible to open up the walls above the *nave arcade* more fully than ever before, with huge stained-glass *clerestory* windows beneath the nave vaults.

Typical Gothic Cathedral

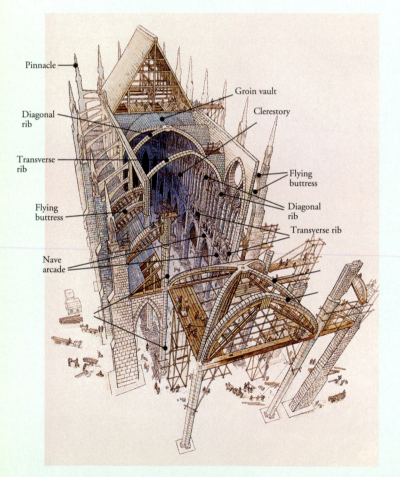

Pinnacle

Groin vault

Clerestory

Diagonal rib

Transverse rib

Flying buttress

Flying buttress

Diagonal rib

Transverse rib

Nave arcade

Chartres Cathedral

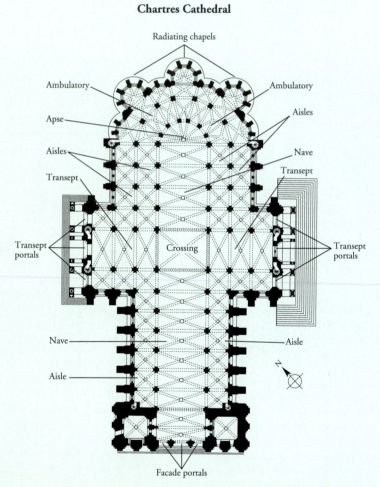

Radiating chapels

Ambulatory

Ambulatory

Apse

Aisles

Aisles

Nave

Transept

Transept

Transept portals

Crossing

Transept portals

Nave

Aisle

Aisle

Facade portals

Medieval Churches (continued)

The Central-Plan Church The domed central plan of classical antiquity dominated the architecture of the Byzantine Empire, but with important modifications. Because the typical Byzantine church, such as Saint Mark's in Venice, begun in 1063, took the form of a cross with arms of almost equal length, architects had to find a way to erect domes on square bases rather than on the circular bases (cylindrical drums) of Roman buildings. The solution was *pendentive* construction in which the domes rests on what is, in effect, a second, larger dome. The top portion and four segments around the rim of the larger dome are omitted, creating four curved triangles, or pendentives. The pendentives join to form a ring and four arches whose planes bound a square. (Saint Mark's has five domes that rest on pendentives.)

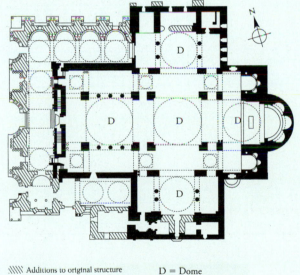

\\\\\\ Additions to original structure D = Dome

Saint Mark's, Venice

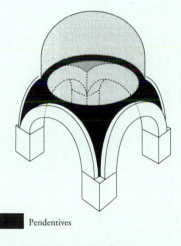

Pendentives

Dome on Pendentives

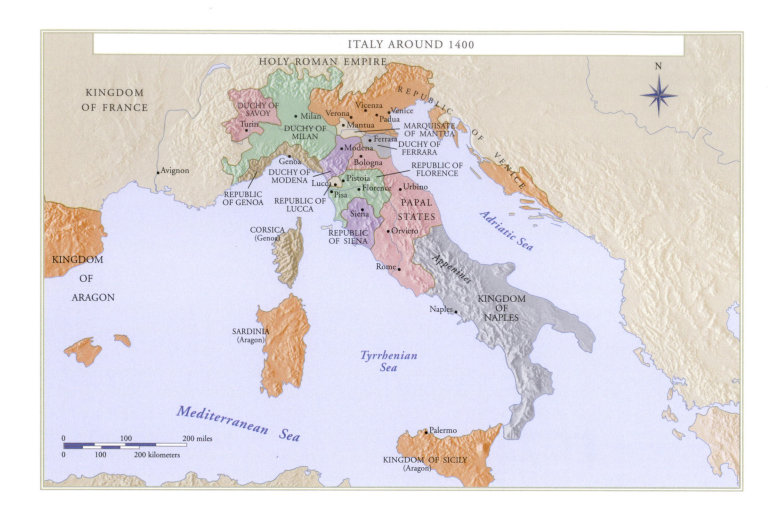

ITALY AROUND 1400

HOLY ROMAN EMPIRE

KINGDOM OF FRANCE

DUCHY OF SAVOY
Turin •
• Milan
DUCHY OF MILAN
Verona •
Vicenza •
Mantua •
Padua •
Venice •
MARQUISATE OF MANTUA
Ferrara •
DUCHY OF FERRARA
• Modena
Bologna •
Genoa •
DUCHY OF MODENA
REPUBLIC OF GENOA
REPUBLIC OF FLORENCE
Lucca •
Pistoia •
• Florence
REPUBLIC OF LUCCA
Pisa •
• Urbino
REPUBLIC OF VENICE

Avignon •

CORSICA (Genoa)

Siena •
REPUBLIC OF SIENA
PAPAL STATES
• Orvieto

Adriatic Sea

KINGDOM OF ARAGON

Rome •

Appenines

SARDINIA (Aragon)

KINGDOM OF NAPLES
Naples •

Tyrrhenian Sea

Mediterranean Sea

0 100 200 miles
0 100 200 kilometers

Palermo •

KINGDOM OF SICILY (Aragon)

N

1200	1225	1250	1300

FREDERICK II (HOLY ROMAN EMPEROR)

TRIUMPH OF THE PAPACY
FALL OF HOHENSTAUFEN HOLY ROMAN EMPERORS

Bonaventura Berlinghieri
Saint Francis Altarpiece, 1235

Palazzo Pubblico
Siena, 1288–1309

Giovanni Pisano
The Annunciation
and the Nativity, 1297–1301

Saint Dominic, ca. 1170–1221

Franciscan Order founded, 1209

Saint Francis of Assisi,
ca. 1181–1226

Dominican Order founded, 1215

Saint Thomas Aquinas, ca. 1225–1274
(Scholasticism)

Dante, 1265–1321, *The Divine Comedy*

14

FROM GOTHIC TO RENAISSANCE

THE FOURTEENTH CENTURY IN ITALY

1305	1338	1378	1400
AVIGNON PAPACY	HUNDRED YEARS' WAR BETWEEN FRANCE AND ENGLAND	GREAT SCHISM IN THE CHRISTIAN CHURCH	

Giotto
Lamentation, 1305

Florence Cathedral
begun 1296
Campanile designed 1334

Andrea Orcagna
Tabernacle, 1350–1360

Francesco Petrarch, 1304–1374, humanist poet

Papacy moved to Avignon, 1305

Giovanni Boccaccio, 1313–1375, humanist scholar and novelist

Saint Catherine of Siena, 1347–1380

Black Death, 1348–mid 1350s

Beginning of Great Schism, 1378

Election of Clement VII (Avignon), 1378

Election of Urban VI (Rome), 1378

THE CITY-STATES: POLITICS AND ECONOMICS

In the fourteenth century, Italy did not exist as a single unified entity. Rather, it consisted of numerous city-states, each functioning independently. This fragmentation, due in part to the difficult terrain (especially the Apennines, the mountain range that traverses the country's length), precluded easy travel and communication, thereby discouraging unification. Further, these Italian city-states forcibly resisted the efforts of the German emperors and the popes to bring them under imperial or papal control. From these struggles grew a confidence and self-sufficiency that led many city-states to claim independence from kings, nobles, and papacy alike.

REPUBLICS, DUCHIES, AND KINGDOMS Each city-state consisted of a geographic region, varying in size, dominated by a major city. For example, among the twelve city-states in the fourteenth century were the Duchy of Milan, the Republic of Venice, and the Kingdom of Naples. Most of the city-states, such as Venice, Florence, Lucca, and Siena, were republics. Other major cities—Genoa, Bologna, and Perugia—followed this governmental model at various intervals during the century as well. These republics were constitutional oligarchies—governed by executive bodies, advisory councils, and special commissions. Only a restricted group of citizens with political rights could serve on these governing boards, and because the number of these enfranchised citizens was very limited, the same individuals tended to rotate through the various legislative councils and decision-making bodies. Other powerful city-states included the Papal States, the Kingdom of Naples, and the Duchies of Milan, Modena, Ferrara, and Savoy. As their names indicate, these city-states were politically distinct from the republics.

EXPANDING TRADE AND COMMERCE By the beginning of the fourteenth century, Italy had established a thriving international trade and held a commanding position in the Mediterranean world. The uniqueness and independence of each city-state were underscored by their separate economies. Italy's port cities—Genoa, Pisa, and Venice—controlled the ever busier and more extended avenues of maritime commerce that connected the West with the lands of Islam, with Byzantium and Russia, and overland with China. Milan dominated the arms industry, while Florence assured its centrality to banking operations by making its gold florin the standard coin of exchange everywhere. Florence's economic prosperity was further enhanced by its control of the textile industry. Florence had a large share of the wool trade with England and the Netherlands and Florentine merchants exported fine finished cloth all over Europe.

The structured organization of economic activity extended to the many trades and professions. Guilds (associations of master craftspeople, apprentices, and tradespeople), which had emerged during the twelfth century, became prominent. These associations not only protected members' common economic interests against external pressures, such as taxation, but also provided them with the means to regulate their internal operations (for example, work quality and membership training). Although members' personal security and welfare were the guilds' primary concerns, these organizations dominated city governments as well.

DISRUPTION AND CHANGE

THE BLACK DEATH Despite the relative stability and prosperity established throughout the Italian peninsula, the eruption of the Black Death (bubonic plague) in the late 1340s threw this delicate balance into chaos. Historians generally agree that the Black Death originated in China and was introduced to Europe through Sicily by Genoese merchants returning from the Middle East. From there, it spread throughout southern Italy and up through France and Germany, extending to Scandinavia, Eastern Europe, and Russia. The most devastating natural disaster in European history, the Black Death eliminated between twenty-five percent and fifty percent of Europe's population in about five years. Italy was particularly hard hit. In large cities, where people lived in relatively close proximity, the death tolls climbed as high as fifty or sixty percent of the population. This disease's virulence may have been aided by widespread malnutrition at midcentury, the result of famine caused by disastrous weather conditions in the 1340s.

This plague wreaked havoc on all aspects of society. Ties among family members, neighbors, and communities were ripped asunder. One Sienese observer noted: "Father abandoned child, wife husband, one brother another, for the plague seemed to strike through breath and sight. And so they died. And no one could be found to bury the dead, for money or friendship."[1] People responded to the terror and hysteria in different ways. In *The Decameron*, Giovanni Boccaccio described the devil-may-care attitude adopted by some Italians, who lived "unrestrainedly." Others sought ways to earn God's forgiveness, since they saw the plague as divine punishment. Groups of flagellants, people who flogged themselves and one another with whips of hard knotted leather (sometimes with small iron spikes), roamed from town to town seeking forgiveness through their penance.

The Black Death had a significant effect on art. It stimulated religious bequests and encouraged the commissioning of devotional images. The focus on sickness and death also led to a burgeoning in hospital construction.

The Black Death's consequences were staggering. Because the disease indiscriminately afflicted various members of families and classes, the social disruption left in its wake was acute. Further, the significantly diminished population resulted in a severe labor shortage, exacerbating tension between landed nobility and peasants. Economic turmoil soon followed.

THE GREAT SCHISM Disruptions in the religious realm also contributed to the societal upheaval. In 1305, the College of Cardinals (the collective body of all cardinals) elected a French pope, Clement V, who settled in Avignon. Subsequent French popes remained in Avignon, despite their announced intentions to return to Rome. Understandably, this did not sit well with Italians, who saw Rome as the rightful capital of the universal church. The conflict between the French and Italians resulted in the election in 1378 of two popes—Clement VII, who resided in Avignon, and Urban VI (r. 1378–1389), who remained in Rome. Thus began what became known as the Great Schism. After forty years, a council convened by the Holy

Roman Emperor Sigismund managed to resolve this crisis in the church by electing a new Roman pope, Martin V (r. 1417–1431), who was acceptable to all.

LETTERS AND LEARNING

DEVELOPING A VERNACULAR LITERATURE
Concurrent with these momentous shifts in the economic, social, and religious realms was the development of a vernacular (everyday) literature, which dramatically affected Italy's intellectual and cultural life. Latin remained the official language of church liturgy and state documents. However, the creation of an Italian vernacular literature (based on the Tuscan dialect common in Florence) expanded the audience for philosophical and intellectual concepts because of its greater accessibility. Dante (1265–1321; the author of *The Divine Comedy*), the poet and scholar Francesco Petrarch (1304–1374), and Giovanni Boccaccio (1313–1375; as noted, the author of *Decameron*) were among those most responsible for establishing this vernacular literature.

HUMANISM: REVIVING CLASSICAL VALUES
Petrarch may be said to have first put forth the values of versatile individualism and humanism. His articulation of these ideas generated interest in humanism during the fourteenth century. However, not until the fifteenth and sixteenth centuries did humanism become a central component of much of Italian art. Humanism was more a code of civil conduct, a theory of education, and a scholarly discipline than a philosophical system. As the word *humanism* suggests, the chief concerns of its proponents were human values and interests as distinct from—but not opposed to—religion's otherworldly values. The study of the Latin classics, for their practical as well as aesthetic value, led to what might be called civil ethics. These guided the conduct of life in a self-governing republic; the ancient Roman ideal and model were always in view. The humanist enthusiasm for antiquity, as Cicero's elegant Latin and the Augustan age represented, involved a conscious emulation of what proponents thought were the Roman civic virtues. These included self-sacrificing service to the state, participation in government, defense of state institutions (especially the administration of justice), and stoic indifference to personal misfortune in the performance of duty. To resurrect the spirit of classical* antiquity, humanists culled through a trove of ancient manuscripts, which they hunted eagerly, edited, and soon reproduced in books made by the new process of mechanical printing. With the help of a new interest in and knowledge of Greek, the humanists of the late fourteenth and fifteenth centuries recovered a large part of the Greek as well as the Roman literature and philosophy that had been lost, left unnoticed, or cast aside in the Middle Ages. The humanists' greatest literary contribution was, perhaps, the translation of these works. But they also wrote commentaries on them, which they used as models for their own historical, rhetorical, poetic, and philosophical writings. What

the humanists perceived with great excitement in classical writing was a philosophy for living in this world, a philosophy primarily of human focus that derived not from an authoritative and traditional religious dogma but from reason.

Ideally, humanists sought no material reward for services rendered. The sole reward for heroes of civic virtue was fame, just as the reward for leaders of the holy life was sainthood. For the educated, the lives of heroes and heroines of the past became as edifying as the lives of the saints. Petrarch wrote a book on illustrious men, and his colleague Boccaccio complemented it with biographies of famous women—from Eve to his contemporary, Joanna, queen of Naples. Both Petrarch and Boccaccio were famous in their own day as poets, scholars, and men of letters—their achievements equivalent in honor to those of the heroes of civic virtue. In 1341, Petrarch was crowned in Rome with the laurel wreath, the ancient symbol of victory and merit. The humanist cult of fame emphasized the importance of creative individuals and their role in contributing to the renown of the city-state and of all Italy.

Yet humanism, with its revival of interest in antiquity's secular culture, was only part of the general humanizing tendency in life and art that began in the fourteenth century and became dominant in subsequent centuries. Italy, crowded with classical monuments and memorials, was the natural setting for receiving humanistic values recovered from antiquity's omnipresent influence. Dante, the supreme poet of the age, presented in the *Inferno* a whole theater of human sin and suffering. With passionate intensity, he characterized the throngs of actors in sharp, realistic detail. Significantly, he took as his guide through the infernal regions not a Christian saint but Vergil, the great Roman classical poet, who was the personification of the highest attainment of human reason. Petrarch, the careful and critical scholar of classical literature, was also the poet of an ardent personal love, freed from the conventions of the courtly kind the troubadours sang. His verses to his loved one, Laura, are intimate, emotionally complex, and psychologically insightful; they immensely influenced European literature in later centuries. Boccaccio, likewise a humanist scholar, gave in his *Decameron* a vivid narrative of the human scene in all varieties of incident, mood, and characterization, a lasting source of inspiration and material for later novelists and playwrights.

THE BIRTH OF A NEW ARTISTIC CULTURE
This litany of changes—political, social, economic, religious, and cultural—demonstrates that fourteenth-century Italy was in a period of transition. The artistic production of that century also can be seen as occupying a watershed position in the history of Italian art. This assessment is evident in the terminology used to describe late-thirteenth- and fourteenth-century Italian art. Although some scholars refer to this art as Late Gothic, connecting it with the medieval culture that preceded it, other scholars describe it as "Proto-Renaissance." The latter acknowledge the inception of a new artistic culture—the Renaissance (from the French word *renaissance* and the Italian word *rinascità*, both meaning "rebirth")—that flourished in the fifteenth and sixteenth centuries in Italy. Both of these characterizations have merit. Medieval conventions dominated late-thirteenth- and fourteenth-century art and architecture, but artists more assertively attempted to break away from these conventions.

*Note: In *Art through the Ages: The Western Perspective* the adjective "Classical," with uppercase *C*, refers specifically to the Classical period of ancient Greece, 480–323 B.C. Lowercase "classical" refers to Greco-Roman antiquity in general, that is, the period treated in Chapters 5–7.

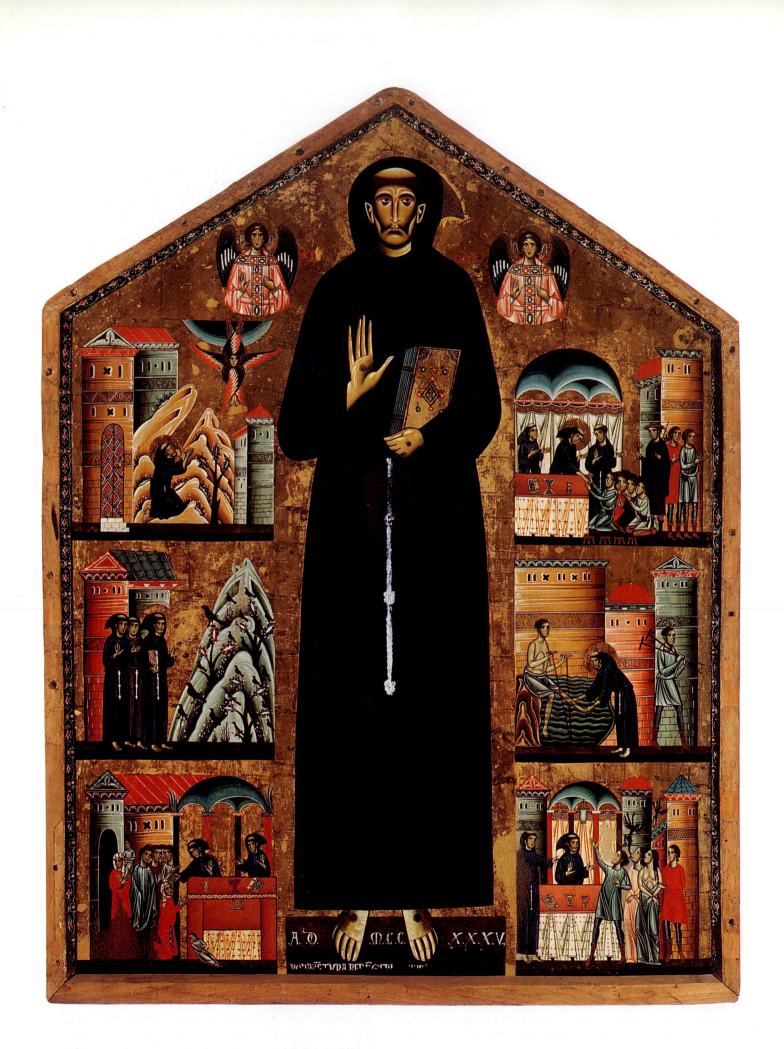

14-1 BONAVENTURA BERLINGHIERI, panel from the *Saint Francis Altarpiece,* San Francesco, Pescia, Italy, 1235. Tempera on wood, approx. 5′ × 3′ 6″.

Mendicant Orders and Confraternities

The pope's absence from Italy during much of the four-teenth century (the Avignon papacy) contributed to an in-crease in prominence of monastic orders and confraternities. Orders such as the Augustinians, Carmelites, and Servites be-came very active, ensuring a constant religious presence in the daily life of Italians. Of the monastic orders, the largest and most influential were the *mendicants* (begging friars)—the Franciscans, founded by Francis of Assisi (FIG. 14-1), and the Dominicans, founded by the Spaniard Dominic de Guzman (ca. 1170–1221). These mendicants renounced all worldly goods and committed themselves to spreading God's word, performing good deeds, and ministering to the sick and dy-ing. The Dominicans, in particular, contributed significantly to establishing urban educational institutions. The Francis-cans and Dominicans became very popular among Italian citi-zens because of their devotion to their faith and the more per-sonal relationship with God they encouraged.

Although both mendicant orders were working for the same purpose—the glory of God—a degree of rivalry still existed between the two. The Franciscans established their church, Santa Croce (see FIG. Intro-3), on Florence's eastern side, while the Dominicans built their church, Santa Maria Novella (FIGS. 14-14, 16-36, and 16-37), on the city's other side.

Confraternities, organizations comprised of laypeople who dedicated themselves to strict religious observance, also grew in popularity during the fourteenth and fifteenth centuries. The mission of confraternities included tending the sick, burying the dead, singing hymns, and performing other good works.

The mendicant orders and confraternities continued to play an important role in Italian religious life throughout the sixteenth century. They reinforced their presence by commis-sioning numerous artworks and monastic churches.

THE MOVEMENT AWAY FROM MEDIEVALISM IN ART

ECHOES OF BYZANTINE ART The fundamentally medieval nature of much of Italian art of this period is evident in a panel of the *Saint Francis Altarpiece* (FIG. 14-1) by BONAVENTURA BERLINGHIERI (active ca. 1235–1244). Throughout the Middle Ages, the Byzantine style dominated Italian painting. This Italo-Byzantine style, or *maniera greca* (Greek style), surfaced in Berlinghieri's altarpiece. Painted in tempera on wood panel, Saint Francis wears the belted clerical garb of the order he founded. He holds a large book and dis-plays the *stigmata*—marks like Christ's wounds—that ap-peared on his hands and feet. The saint is flanked by two an-gels, whose presentation—the frontality of their poses, prominent halos, and lack of modeling—indicates that Berlinghieri borrowed from Byzantine models. The painter enhanced this connection to earlier art forms with gold leaf (gold beaten into tissue-paper-thin sheets that then can be ap-plied to surfaces), which emphasizes the image's flatness and spiritual nature. Other scenes from Francis's life strongly sug-gest that their source is Byzantine illuminated manuscripts (compare FIG. 9-14). The central scene on the saint's right depicts Saint Francis preaching to the birds. The saint and his two attendants are aligned carefully against a shallow tower and wall, from Early Christian times a stylized symbol of a town or city. In front of the saint is another stage-scenery im-age of nested birds and twinkling plants. The composition's strict formality (relieved somewhat by the lively stippling—applied small dots or paint flecks—of the plants), the shallow space, and the linear flatness in the rendering of the forms are all familiar traits of a long and venerated tradition, soon sud-denly and dramatically replaced.

Berlinghieri's depiction of Saint Francis sheds light on more than aspects of style—it also highlights the increasingly prominent role of religious orders in Italy (see "Mendicant Orders and Confraternities," above). The Franciscan order, named after its founder, Saint Francis of Assisi (ca. 1181–1226), worked diligently to impress on the public the saint's valuable example and to demonstrate its commitment to teaching and to alleviating suffering. Berlinghieri's altar-piece, commissioned for the church of San Francesco (Saint Francis) in Pescia, was created nine years after the saint's death and is the earliest known signed and dated representation of Saint Francis. Appropriately, this image focuses on the aspects of the saint's life the Franciscans wanted to promote. Saint Francis believed he could get closer to God by rejecting worldly goods, and to achieve this he stripped himself bare in a public square and committed himself to a strict life of fast-ing, prayer, and meditation. The appearance of stigmata on his hands and feet (visible in Berlinghieri's painting) was per-ceived as God's blessing and led some followers to see Francis as a second Christ. The coarse habit he wears, tied at the waist with a rope, became the garb of the Franciscans.

THE INFLUENCE OF CLASSICAL ART Interest in the art of classical antiquity was not unheard of during the medieval period. For example, the Visitation group statues on the west facade of Reims Cathedral (see FIG. 13-24) show an unmistakable interest in Roman sculpture, even though the facial modeling reveals their Gothic origin. However, the thirteenth-century sculpture of NICOLA PISANO (active ca. 1258–1278), contemporary with the Reims statues, exhibits an interest in classical forms unlike that found in the works of his predecessors. This interest was perhaps due in part to the influence of the humanistic culture of Sicily under its king,

Artists' Names in Renaissance Italy

In contemporary societies, people have become accustomed to a standardized method of identifying individuals. Given names are coupled with family names, although the order of the two (or more) names sometimes varies. This practice is due in large part to the prevalence of bureaucracy (for example, birth certificates, driver's licenses, and wills) and the predominance of written documents.

However, such regularity in names was not the norm in Italy during the fourteenth and fifteenth centuries. Often, individuals adopted their hometowns as one of their names. For example, sculptor Nicola Pisano (FIGS. 14-2 and 14-3) was from Pisa, Giulio Romano (see FIG. 17-48) was from Rome, and painter Domenico Veneziano was from Venice. Leonardo da Vinci (see FIGS. 17-1 to 17-5) hailed from the small town of Vinci, while Andrea del Castagno (see FIG. 16-39) was from Castagno. This information was particularly valuable when meeting someone for the first time, especially once mobility

and travel increased in the fourteenth century. Such artists are often referred to by their given names, such as *Leonardo*.

Nicknames were also common. While Masaccio (see FIGS. 16-11, 16-12, and 16-13) was "Big Thomas," his fellow artist, Masolino, was "Small Thomas." Guido di Pietro is better known today as Fra Angelico (the Angelic Friar; FIG. 16-38), and Cenni di Pepo (FIG. 14-6) is remembered as Cimabue, meaning "bull's head." Artists sometimes derived their names from their renowned works. Jacopo della Quercia was familiar to early-fifteenth-century Italians as Jacopo del Fonte (Jacopo of the Fountain) for his impressive Fonte Gaia (Gay Fountain) in the public square in front of the Palazzo Pubblico in Siena.

Not only were names not standardized, but they were also impermanent and could be changed at will. This flexibility has resulted in significant challenges for historians, who often must deal with archival documents and records.

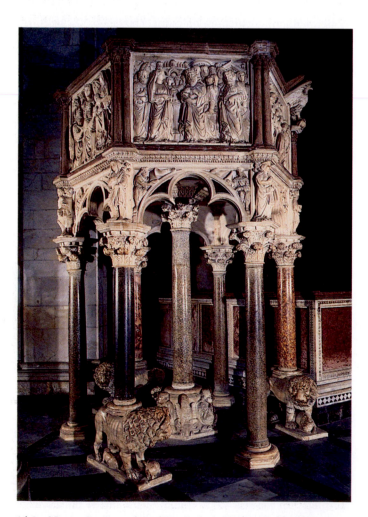

14-2 NICOLA PISANO, pulpit of Pisa Cathedral baptistery, Pisa, Italy, 1259–1260. Marble, approx. 15' high.

Holy Roman Emperor Frederick II. The king was known in his own time as "the wonder of the world" for his many intellectual gifts and other talents. Frederick's nostalgia for Rome's past grandeur fostered a revival of Roman sculpture and decoration in Sicily and southern Italy before the mid-thirteenth century. Because Nicola Pisano (see "Artists' Names in Renaissance Italy," above) may have received his early training in this environment, he may have been influenced by Roman artworks. After Frederick's death in 1250, Nicola Pisano traveled northward and eventually settled in Pisa, which was then at the height of its political and economic power. Although Florence soon emerged as the center of artistic innovation in Tuscany, artists continued to recognize Pisa as a locale for lucrative commissions (see "Art to Order: Commissions and Patronage," page 427).

Nicola Pisano's sculpture, unlike the French sculpture of the period, was not part of the extensive decoration of great portals. He carved marble reliefs and ornament for large pulpits, completing the first in 1260 for the baptistery of Pisa Cathedral (FIG. **14-2**). Some elements of the pulpit's design carried on medieval traditions (for example, the lions supporting some of the columns and the trilobed arches), but Nicola Pisano incorporated classical elements into this medieval type of structure. The large, bushy capitals are a Gothic variation of the Corinthian capital; the arches are round rather than pointed (ogival); and the large rectangular relief panels, if their proportions were altered slightly, could have come from the sides of Roman sarcophagi. The densely packed large-scale figures of the individual panels also seem to derive from the compositions found on Roman sarcophagi. In one of these panels, *The Annunciation and the Nativity* (FIG. **14-3**), the Virgin reclines in the fashion seen in Byzantine ivories,

Art to Order
Commissions and Patronage

Because of today's international open art market, the general public tends to see art as the creative expression of an individual—the artist. However, artists did not always enjoy this level of freedom. Historically, artists rarely undertook major artworks without a patron's concrete commission.

The patron could be a civic group, religious entity, or private individual. Guilds, although primarily economic commercial organizations, contributed to their city's religious and artistic life by subsidizing the building and decoration of numerous churches and hospitals. For example, the Arte della Lana (wool manufacturers' guild) oversaw the start of the Florence Cathedral (FIGS. 14-12 and 14-13) in 1296, and the Arte di Calimala (wool merchants' guild) supervised the completion of its dome (see FIG. 16-14).

Religious groups, such as the monastic orders, were also major art patrons. Certainly, the papacy had long been an important patron, and artists vied for the pope's prestigious commissions. The papacy's patronage became even more visible during the sixteenth and seventeenth centuries, and today the Vatican Museums hold one of the world's most spectacular art collections.

Wealthy families and individuals commissioned artworks for a wide variety of reasons. Besides the aesthetic pleasure these patrons derived from art, the images often also served as testaments to the patron's wealth, status, power, and knowledge. Art was commissioned for propagandistic, philanthropic, or commemorative purposes as well.

Because artworks during this period were the product of what was, in effect, a service contract, viewers must consider the patrons' needs or wishes when looking at commissioned art and architecture. From the few extant contracts, it appears artists normally were asked to submit drawings or models to their patrons for approval. Patrons expected artists to adhere to the approved designs fairly closely. Surviving contracts do not have the detail one might expect from a legal document. These contracts usually stipulate certain conditions, such as the insistence on the artist's own hand in the work's production, the pigment quality and amount of gold or other precious items to be used, completion date, payment terms, and penalties for failure to meet the contract's terms. Although it is clear patrons could have been very specific about the details of projects and often made many decisions about the works, those expectations are often absent from the written contracts. Regardless, the patron's role looms large in any discussion of art created before the seventeenth century, when an open art market developed.

mosaics, and paintings (for information on the Annunciation and the Nativity, see "The Life of Jesus in Art," Chapter 8, pages 238–239 or xxx–xxxi in Volume II). But the face types, beards, coiffures, and draperies, as well as the bulk and weight of the figures, were inspired by relief stronger than anything created in several centuries.

A SON'S SCULPTURAL RESPONSE Nicola Pisano's classicizing manner was countered by his son GIOVANNI PISANO (ca. 1250–1320). Giovanni's version of *The Annunciation and the Nativity* (FIG. 14-4), from the pulpit in Sant'Andrea at Pistoia, was finished some forty years after the one by his father in the Pisa baptistery. It offers a striking contrast to

14-3 NICOLA PISANO, *The Annunciation and the Nativity,* detail of Pisa baptistery pulpit, Pisa, Italy, 1259–1260. Marble relief, approx. 2′ 10″ × 3′ 9″.

14-4 GIOVANNI PISANO, *The Annunciation and the Nativity,* detail of the pulpit of Sant'Andrea, Pistoia, Italy, 1297–1301. Marble relief, approx. 2′ 10″ × 3′ 4″.

Nicola Pisano's thick carving and placid, almost stolid, presentation of the theme. Giovanni Pisano arranged the figures loosely and dynamically. An excited animation twists and bends them, and their motion is emphasized by spaces that open deeply between them, through which they hurry while gesticulating. In the Annunciation episode, which is combined with the Nativity (as in the older version), the Virgin shrinks from the angel's sudden apparition in a posture of alarm touched with humility. The same spasm of apprehension contracts her supple body as she reclines in the Nativity scene. The drama's principals share in a peculiar nervous agitation, as if they all suddenly are moved by spiritual passion. Only the shepherds and the sheep, appropriately, do not yet share in the miraculous event. The swiftly turning, sinuous draperies; the slender figures they enfold; and the scene's general emotionalism are features not found in Nicola Pisano's interpretation. Thus, the father and son's works show, successively, two novel trends of great significance for subsequent art—a new contract with classical antiquity and a burgeoning naturalism.

SCULPTURAL FORM IN PAINTING

The art of PIETRO CAVALLINI (active ca. 1273–1308) represented one style of the Roman school of painting. A great interest in the sculptural rendering of form characterized the style, as evidenced in a detail from Cavallini's badly damaged fresco, *Last Judgment* (FIG. **14-5**), in the church of Santa Cecilia in Trastevere in Rome. Cavallini, perhaps under the influence of Roman paintings now lost, abandoned Byzantine stylized dignity and replaced it with a long-lost impression of solidity and strength in *Seated Apostles.*

A FINAL SUMMARY OF BYZANTINE STYLE

Like Cavallini, CENNI DI PEPO, better known as CIMABUE (ca. 1240–1302; see "Artists' Names in Renaissance Italy," page 426), moved beyond the limits of the Italo-Byzantine style. Inspired by the same impulse toward naturalism as Giovanni Pisano and also influenced, no doubt, by Gothic sculpture, Cimabue challenged the conventions that dominated earlier art. The formality evident in Cimabue's *Madonna Enthroned with Angels and Prophets* (FIG. **14-6**) is appropriate to the dignity of the theme represented. The artist modeled his large image on Byzantine examples (see FIG. 9-15), revealed in the painting's careful structure and symmetry. However, Cimabue constructed a deeper space for the Madonna and the surrounding figures to inhabit. He used the gold embellishments common to Byzantine art to enhance the folds and three-dimensionality of the drapery. Despite such progressive touches as the throne's solid appearance, this vast altarpiece is a final summary of centuries of Byzantine art before its utter transformation.

A MATERIAL IMAGE OF A HEAVENLY BEING

A naturalistic approach based on observation was the major contribution of GIOTTO DI BONDONE (ca. 1266–1337), who made a much more radical break with the past. Scholars still debate the sources of Giotto's style, although one source must have been the style of the Roman school of painting Cavallini represented. Another formative influence on Giotto may have been the work of the man presumed to be his teacher, Cimabue. The art of the French Gothic sculptors (perhaps seen by Giotto himself but certainly familiar to him from the sculpture of Giovanni Pisano, who had spent time in Paris) and ancient Roman art, both sculpture and painting, must have contributed to Giotto's artistic education. Some believe that new developments in contemporaneous Byzantine art further influenced him.

Yet no synthesis of these varied influences could have produced the significant shift in artistic approach that has led some scholars to describe Giotto as the father of Western pictorial art. Renowned in his own day, his reputation has never

14-5 PIETRO CAVALLINI, *Seated Apostles,* detail of the *Last Judgment,* Santa Cecilia in Trastevere, Rome, Italy, ca. 1291. Fresco.

14-6 CIMABUE, *Madonna Enthroned with Angels and Prophets*, ca. 1280–1290. Tempera on wood, 12′ 7″ × 7′ 4″. Galleria degli Uffizi, Florence.

In nearly the same great scale as the Madonna Cimabue painted, Giotto depicted her (FIG. **14-7**) in a work that offers an opportunity to appreciate his perhaps most telling contribution to representational art—sculptural solidity and weight. The Madonna, enthroned with angels, rests within her Gothic throne with the unshakable stability of an ancient marble goddess. Giotto replaced Cimabue's slender Virgin, fragile beneath the thin ripplings of her drapery, with a sturdy, queenly mother, bodily of this world, even to the swelling of her bosom. Her body is not lost; it is asserted. The new art aimed, before all else, to construct a figure that has substance, dimensionality, and bulk. Works painted in the new style portray figures, like those in sculpture, that project into the light and give the illusion they could throw shadows. In Giotto's *Madonna Enthroned*, the throne is deep enough to contain the monumental figure and breaks away from the flat ground to project and enclose her.

VISUALIZING THE BODY AND THE SOUL

Projecting an illusion of solid bodies moving through space on a flat surface presents a double challenge. Constructing the illusion of a body also requires constructing the illusion of a

faltered. Regardless of the other influences on his artistic style, his true teacher was nature—the world of visible things.

Giotto's revolution in painting did not consist only of displacing the Byzantine style, establishing painting as a major art form for the next six centuries, and restoring the naturalistic approach invented by the ancients and largely abandoned in the Middle Ages. He also inaugurated a method of pictorial expression based on observation and initiated an age that might be called "early scientific." By stressing the preeminence of sight for gaining knowledge of the world, Giotto and his successors laid the path empirical science followed. They recognized that the visual world must be observed before it can be analyzed and understood. Praised in his own and later times for his fidelity to nature, Giotto was more than a mere imitator of it. He revealed nature while observing it and divining its visible order. In fact, he showed his generation a new way of seeing. With Giotto, Western artists turned resolutely toward the visible world as their source of knowledge of nature.

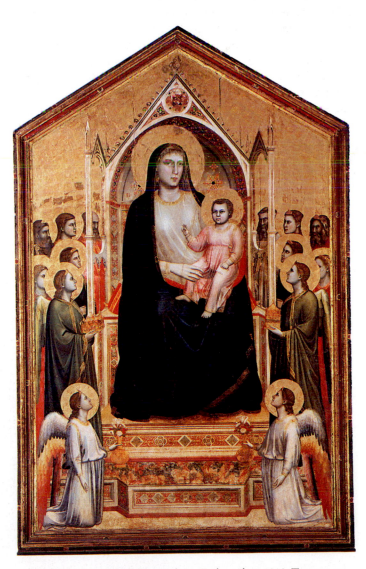

14-7 GIOTTO DI BONDONE, *Madonna Enthroned*, ca. 1310. Tempera on wood, 10′ 8″ × 6′ 8″. Galleria degli Uffizi, Florence.

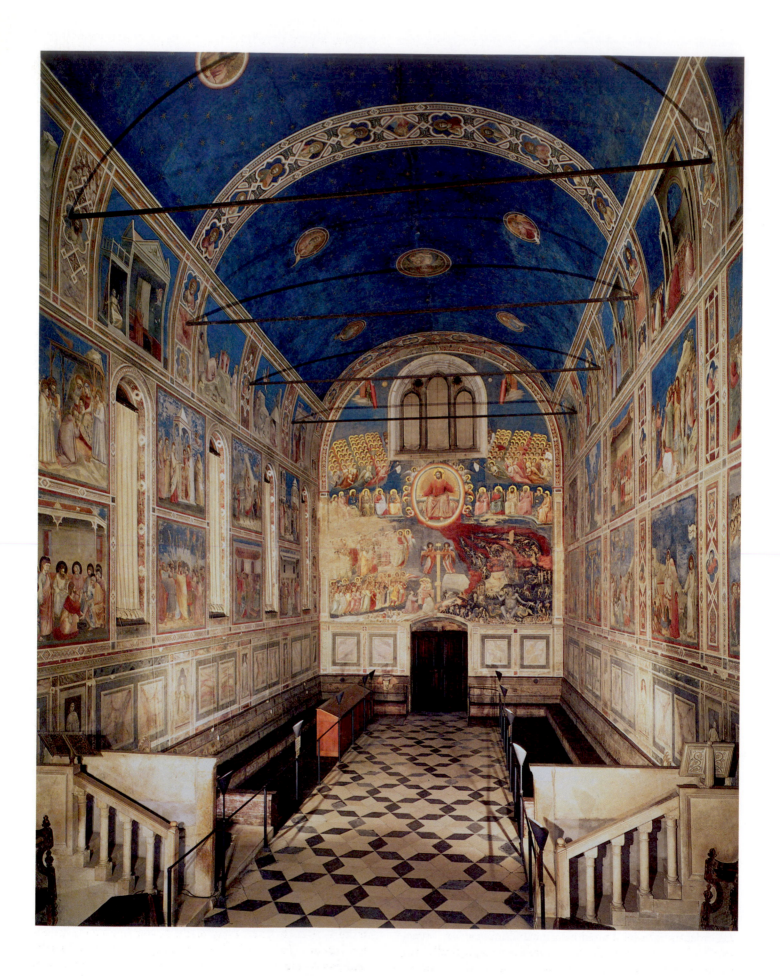

14-8 Interior of the Arena Chapel (Cappella Scrovegni), Padua, Italy, 1305–1306.

Fresco Painting

Fresco has a long history, particularly in the Mediterranean region, where the Minoans used it in Crete (see FIGS. 4-6 to 4-10) as early as 1650 B.C. Fresco (Italian for "fresh") is a mural-painting technique that involves applying permanent limeproof pigments, diluted in water, on freshly laid lime plaster. Because the pigments are absorbed into the wall's surface as the plaster dries, fresco is one of the most permanent painting techniques. The stable conditions of frescoes such as those in the Arena Chapel (FIGS. 14-8, 14-9, and 14-10) and in the Sistine Chapel (see FIGS. 17-12, 17-13, and 17-14), now hundreds of years old, testify to the longevity of this painting method. The colors have remained vivid (although dirt and soot have necessitated cleaning) because of the chemically inert pigments the artists used. In addition to this *buon fresco* ("true" fresco) technique, artists used *fresco secco* (dry fresco). Fresco secco involves painting on dried lime plaster. Although the finished product visually approximates buon fresco, the pigments are not absorbed into the wall and simply adhere to the surface, so fresco secco does not have buon fresco's longevity. Compare, for example, the current condition of Michelangelo's buon fresco Sistine Ceiling (see FIG. 17-13) with Leonardo da Vinci's *Last Supper* (see FIG. 17-3), executed largely in fresco secco (with experimental techniques and pigments).

The buon fresco process is time consuming and demanding and requires several layers of plaster. Although buon fresco methods vary, generally, the painting is built from a rough layer of lime plaster called the *trullisatio* (scratch coat), followed by the *arriccio* (brown coat), the *arenato* (sand coat), and, finally, the *intonaco* (painting coat). A cartoon (a full-sized preparatory drawing) of the composition is usually transferred to the wall after the arenato layer. Then, the intonaco is laid smoothly over the drawing in sections (called *giornate*, Italian for "days") only as large as the artist expects to complete in that session. The artist must paint fairly quickly because once the plaster is dry, it will no longer absorb the pigment. Any areas of the intonaco that remain unpainted after a session must be cut away so that fresh plaster can be applied for the next giornata.

In areas of high humidity, such as Venice, fresco was less appropriate because of the obstacle the moisture presented to the drying process. Over the centuries, fresco became less popular, although it did experience a revival in the 1930s with the Mexican muralists. Many of the older frescoes have been transferred from their original walls by lifting off the intonaco layer of plaster and readhering the images to other supports.

space sufficiently ample to contain that body. In Giotto's fresco cycles (he was primarily a muralist), he constantly strove to reconcile these two aspects of illusionistic painting. His frescoes (paintings on wet plaster; see "Fresco Painting," above) in the Arena Chapel (Cappella Scrovegni) at Padua (FIG. **14-8**) show his art at its finest. The Arena Chapel, which takes its name from an ancient Roman amphitheater nearby, was built for Enrico Scrovegni, a wealthy Paduan merchant, on a site adjacent to his now razed palace. This building, intended for the Scrovegni family's private use, was consecrated in 1305, and its design is so perfectly suited to its interior decoration that some scholars have suggested that Giotto himself may have been its architect.

The rectangular barrel-vaulted hall has six narrow windows in its south wall only, which left the entire north wall an unbroken and well-illuminated surface for painting. The entire building seems to have been designed to provide Giotto with as much flat surface as possible for presenting one of the most impressive and complete pictorial cycles of Christian Redemption ever rendered. With thirty-eight framed pictures, arranged on three levels, the artist related the most poignant incidents from the lives of the Virgin and her parents Joachim and Anna *(top level)*, the life and mission of Christ *(middle level)*, and his Passion, Crucifixion, and Resurrection *(bottom level)*. These three pictorial levels rest on a coloristically neutral base. Imitation marble veneer (reminiscent of ancient Roman wall decoration [see FIG. 7-14], which Giotto may have

seen) alternates with the Virtues and Vices painted in *grisaille* (monochrome grays, often used for modeling in paintings) to resemble sculpture. The climactic event of the cycle of human salvation, the Last Judgment, covers most of the west wall above the chapel's entrance.

The hall's vaulted ceiling is blue—an azure sky symbolic of Heaven; it is dotted with golden stars and medallions bearing images of Christ, Mary, and various prophets. Giotto painted the same blue in the backgrounds of the narrative panels on the walls below (some now faded or flaked). The color thereby functions as a unifying agent for the entire decorative scheme and renders the scene more realistic. For visitors to this remarkable chapel, the decorative ensemble's formal and coloristic unity become memorable standards for measuring other decorative schemes.

The individual panels are framed with decorative borders, which, with their delicate tracery, offer a striking contrast to the sparse simplicity of the images they surround. Subtly scaled to the chapel's space (only about one-half life-size), Giotto's stately and slow-moving actors present their dramas convincingly and with great restraint. *Lamentation* (FIG. **14-9**) provides a good example of his style's essentials. In the presence of angels darting about in hysterical grief, a congregation mourns over the dead body of the Savior just before its entombment. Mary cradles her son's body, while Mary Magdalene looks solemnly at the wounds in Christ's feet and Saint John the Evangelist throws his arms back dramatically. Giotto

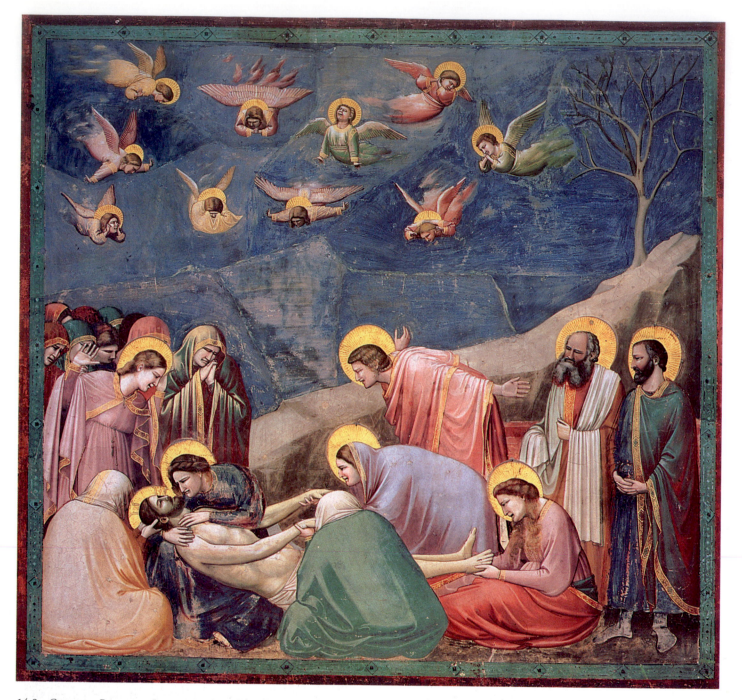

14-9 GIOTTO DI BONDONE, *Lamentation*, Arena Chapel, Padua, Italy, ca. 1305. Fresco, 6' 6¾" × 6' ¾".

arranged a shallow stage for the figures, bounded by a thick diagonal rock incline that defines a horizontal ledge in the foreground. Though rather narrow, the ledge provides firm visual support for the figures, while the steep slope indicates the picture's dramatic focal point at the lower left. The rocky landscape also links this scene with the adjoining one. Giotto connected the framed scenes throughout the fresco cycle with such formal elements. The figures are sculpturesque, simple, and weighty, but this mass did not preclude motion and emotion. Postures and gestures that might have been only rhetorical and mechanical here convincingly express a broad spectrum of grief. They range from Mary's almost fierce despair to the passionate outbursts of Mary Magdalene and John to the philosophical resignation of the two disciples at the right and the mute sorrow of the two hooded mourners in the fore-

ground (compare FIG. 9-27). Giotto constructed a kind of stage that served as a model for artists who depicted human dramas in many subsequent paintings. His style was far removed from the isolated episodes and figures seen in art until the late thirteenth century. In *Lamentation,* a single event provokes a single intense response. This integration of formality with emotional composition was rarely attempted, let alone achieved, in art before Giotto.

The formal design of the *Lamentation* fresco, the way the figures are grouped within the constructed space, is worth close study. Each group has its own definition, and each contributes to the rhythmic order of the composition. The strong diagonal of the rocky ledge, with its single dead tree (the tree of knowledge of good and evil, which withered at the Fall of Adam), concentrates the viewer's attention on the group

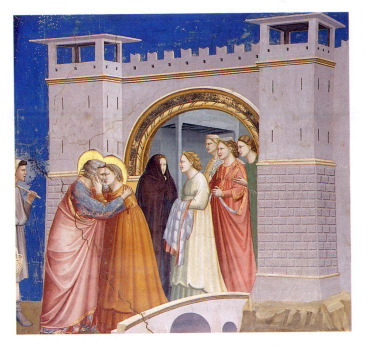

14-10 GIOTTO DI BONDONE, *The Meeting of Joachim and Anna*, Arena Chapel, Padua, Italy, ca. 1305. Fresco, 6' 6 3/4" × 6' 3/4".

called the "mystery" plays. The drama of the Mass was extended into one- and two-act tableaus and scenes and then into simple narratives offered at church portals and in city squares. (Eventually, confraternities also presented more elaborate religious dramas called *sacre rappresentazioni*—sacred representations.) The great increase in popular sermons to huge city audiences prompted a public taste for narrative, recited as dramatically as possible. The arts of illusionistic painting, of drama, and of sermon rhetoric with all their theatrical flourishes were developing simultaneously and were mutually influential. Giotto's art masterfully—perhaps uniquely—synthesized dramatic narrative, holy lesson, and truth to human experience in a visual idiom of his own invention, accessible to all.

THE MASTER'S LEGACY Giotto's frescoes served as textbooks for generations of Renaissance painters from Masaccio to Michelangelo and beyond. Another of Giotto's panels in the Arena Chapel, *The Meeting of Joachim and Anna* (FIG. 14-10), portrays Anna greeting Joachim to inform him that she has been chosen to bear the Virgin Mary. The composition is simple and compact. The figures are carefully related to the single architectural element (the Golden Gate), where the Virgin's parents meet in triumph in the presence of splendidly dressed ladies. The latter mock the cloaked servant who refused to believe the elderly Anna (Saint Anne) would ever bear a child. The story, related in the Apocrypha (biblical writings considered canonical—orthodox—by Catholics but not by Protestants), is managed with Giotto's usual restraint, clarity, and dramatic compactness.

Influenced by Giotto, TADDEO GADDI (ca. 1300–1366), his foster son and assistant for many years, produced a similar image. In Gaddi's version of the same subject (FIG. 14-11) in the Baroncelli Chapel in Florence's church of Santa Croce, the image (particularly the architecture) is more complex than Giotto's, and the shepherd and the court ladies are more

around the head of Christ, whose positioning is dynamically off center. All movement beyond this group is contained, or arrested, by the massive bulk of the seated mourner in the painting's left corner. The seated mourner to the right establishes a relation with the center group, who, by their gazes and gestures, draw the viewer's attention back to Christ's head. Figures seen from the back, which are frequent in Giotto's compositions, represent an innovation in the development away from the formal Italo-Byzantine style. These figures emphasize the foreground, aiding the visual placement of the intermediate figures farther back in space. This device, the very contradiction of the old frontality, in effect puts viewers behind the "observer" figures, who, facing the action as spectators, reinforce the sense of stagecraft as a model for painting.

Giotto's new devices for depicting spatial depth and bodily mass could not, of course, have been possible without his management of light and shade. He shaded his figures to indicate both the direction of the light that illuminates them and the shadows (the diminished light), giving the figures volume. In *Lamentation*, light falls upon the upper surfaces of the figures (especially the two central bending figures) and passes down to dark in their draperies, separating the volumes one from the other and pushing one to the fore, the other to the rear. The graded continuum of light and shade, directed by an even neutral light from a single steady source—not shown in the picture—was the first step toward the development of *chiaroscuro* (the use of dramatic contrasts of dark and light to produce modeling).

The stagelike settings made possible by Giotto's innovations in *perspective* (the depiction of three-dimensional objects in space on a two-dimensional surface) and lighting suited perfectly the dramatic narrative the Franciscans emphasized then as a principal method for educating the faithful in their religion. In the humanizing age, the old stylized presentations of the holy mysteries had evolved into what were

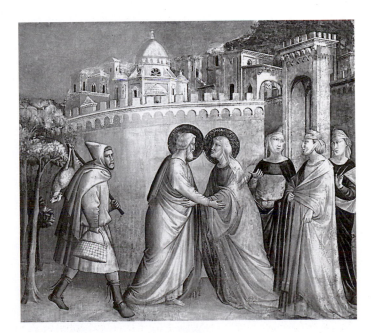

14-11 TADDEO GADDI, *Meeting of Joachim and Anna*, Baroncelli Chapel, Santa Croce, Florence, Italy, 1338. Fresco.

obtrusive. Yet, Gaddi made an important contribution to the investigation of pictorial light. In *Joachim and Anna* he took great pains to depict light falling not only on the figures but also on the architecture. A light-and-shade continuum determines the city wall's volume and curve into the background. Light strikes sharply on the facing planes of the arched gateway and the city's clustered buildings. From the light's low angle, viewers might even speculate as to the time of day represented, morning or evening.

The Republic of Florence

Among fourteenth-century Italian city-states, the Republics of Florence and Siena were notable for their strong commitment to art. Both Florence and Siena (the major cities of these two republics) were urban centers of bankers and merchants with widespread international contacts. Chroniclers and historians recognized early on the importance of these two cities for the development of art; discussions comparing their artistic contributions extend back into the fourteenth century.

THE "MOST BEAUTIFUL" TUSCAN CHURCH The Republic of Florence was a dominant city-state during the fourteenth century. This belief was reinforced by statements such as one by the early historian Giovanni Villani (ca. 1270–1348) that Florence was "the daughter and the creature of Rome," suggesting a preeminence inherited from the Roman Empire. Florentines prided themselves on what they perceived as economic and cultural superiority. They translated this pride into landmark buildings such as Florence Cathedral (FIG. **14-12**). Recognized as the center for the most important religious observances in Florence, the cathedral was begun in

1296 by ARNOLFO DI CAMBIO. Intended as the "most beautiful and honorable church in Tuscany," this structure reveals the competitiveness Florentines felt with cities such as Siena and Pisa. Cathedral authorities planned for the church to hold the city's entire population, and although it only holds about thirty thousand (Florence's population at the time was slightly less than one hundred thousand), it seemed so large that even the noted architect Leon Battista Alberti commented that it seemed to cover "all of Tuscany with its shade." Like the facade of San Miniato al Monte (see FIG. 12-17), the architects ornamented the building's surfaces, in the old Tuscan fashion, with marble-encrusted geometric designs. This matched it to the eleventh-century Romanesque Baptistery of San Giovanni nearby (see FIG. 12-16). The vast gulf that separates this Italian church from its northern European counterparts is strikingly evident when the former is compared with a full-blown German representative of the High Gothic style, such as Cologne Cathedral (see FIG. 13-46).

Cologne Cathedral's emphatic stress on the vertical produces an awe-inspiring upward rush of almost unmatched vigor and intensity. The building has the character of an organic growth shooting heavenward, its toothed upper portions engaging the sky. The pierced, translucent stone tracery of the spires merges with the atmosphere.

Florence Cathedral clings to the ground and has no aspirations to flight. All emphasis is on the design's horizontal elements, and the building rests firmly and massively on the ground. Simple geometric volumes are defined clearly and show no tendency to merge either into each other or into the sky. The dome, though it may seem to be rising because of its ogival section, has a crisp, closed silhouette that sets it off emphatically against the sky behind it. But because this dome is the monument with which architectural historians usually in-

14-12 ARNOLFO DI CAMBIO and others, Florence Cathedral (view from the south), Florence, Italy, begun 1296.

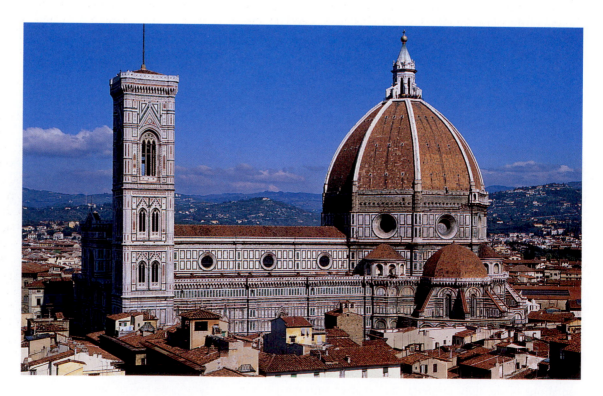

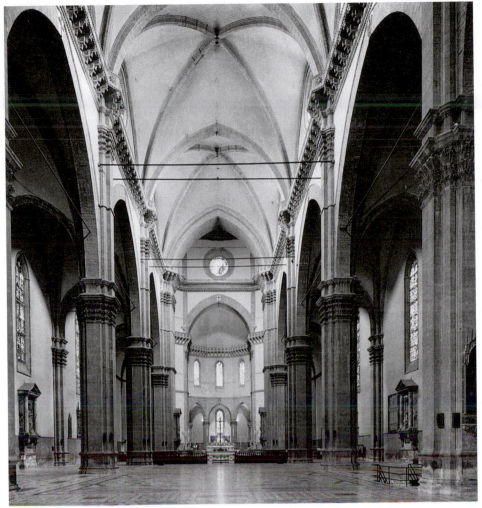

14-13 Nave of Florence Cathedral (view facing east), Florence, Italy, begun 1296.

troduce the Renaissance (it was built by Filippo Brunelleschi between 1420 and 1436), the following comparison of the campanile with the Cologne towers may be somewhat more appropriate in this discussion of fourteenth-century Italian art and architecture.

A TOWER OF BUILDING BLOCKS Designed by the painter Giotto di Bondone in 1334 (and completed with some minor modifications after his death), the Florence campanile (FIG. 14-12) stands apart from the cathedral in the Italian tradition. In fact, it could stand anywhere else in Florence without looking out of place; it is essentially self-sufficient. The same hardly can be said of the Cologne towers (see FIG. 13-46). They are essential elements of the building behind them, and it would be unthinkable to detach one of them and place it somewhere else. No individual element in the Cologne grouping seems capable of an independent existence. One form merges into the next in an unending series of rising movements that pulls the eye upward and never permits it to rest until it reaches the sky. This structure's beauty is formless rather than formal—a beauty that speaks to the heart rather than to the intellect.

The Italian tower is entirely different. Neatly subdivided into cubic sections, Giotto's tower is the sum of its clearly distinguished parts. Not only could this tower be removed from the building without adverse effects, but also each of the component parts—cleanly separated from each other by continuous moldings—seems capable of existing independently as an object of considerable aesthetic appeal. This compartmentalization is reminiscent of the Romanesque style, but it also forecasts the ideals of Renaissance architecture. Artists hoped to express structure in the clear, logical relationships of the component parts and to produce self-sufficient works that could exist in complete independence. Compared to Cologne's north towers, Giotto's campanile has a cool and rational quality that appeals more to the intellect than to the emotions.

In Florence Cathedral's plan, the nave almost appears to have been added to the crossing complex as an afterthought. In fact, the nave was built first, mostly according to Arnolfo's original plans (except for the vaulting), and the crossing was redesigned midway through the fourteenth century to increase the cathedral's interior space. In its present form, the area beneath the dome is the design's focal point, and the nave leads to it. To visitors from the north, the nave seems as strange as the plan; neither has a northern European counterpart. The Florence nave bays (FIG. **14-13**) are twice as deep as those of Amiens (see FIG. 13-19), and the wide arcades permit the shallow aisles to become part of the central nave. The result is an interior of unmatched spaciousness. The accent

14-14 *Nave of Santa Maria Novella, Florence, Italy,*
ca. 1246–1470.

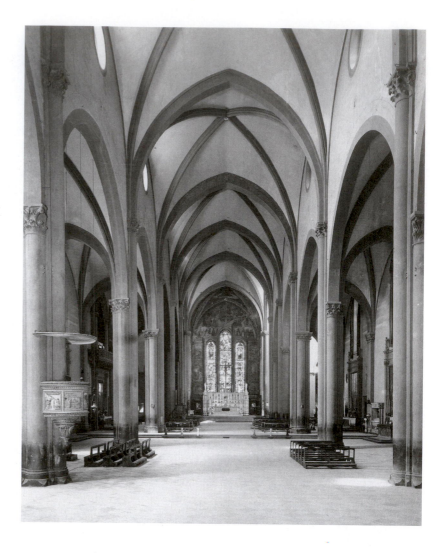

here, as on the exterior, is on the horizontal elements. The substantial capitals of the piers prevent them from soaring into the vaults and emphasize their function as supports.

The facade of Florence Cathedral was not completed until the nineteenth century and then in a form much altered from its original design. In fact, until the seventeenth century, Italian builders exhibited little concern for the facades of their churches, and dozens remain unfinished to this day. One reason for this may be that the facades were not conceived as integral parts of the structures but as screens that could be added to the church exterior at any time.

ACCOMMODATING THE FAITHFUL The increased importance of the mendicant orders during the fourteenth century led to the construction of large churches by the Franciscans (Santa Croce; FIG. Intro-3) and the Dominicans (see "Mendicant Orders and Confraternities," page 425) in Florence. The Florentine government and contributions from private citizens subsidized the commissioning of the Dominicans' Santa Maria Novella (FIG. 14-14) around 1246. The large congregations these orders attracted necessitated the expansive scale of this church. Marble striping along the ogival arches and small *oculi* (round openings) punctuate the nave. Originally, a screen *(tramezzo)* placed across the nave separated the friars from the lay audience; the Mass was performed on separate altars on each side of the screen. Church officials removed this screen in the mid-sixteenth century to encourage greater lay participation in the Mass. A powerful Florentine family, the Rucellai, commissioned the facade for Santa Maria Novella from architect Leon Battista Alberti in the mid-fifteenth century.

A MEMORIAL TO THE BLACK DEATH The tabernacle of the Virgin Mary in Florence's Or San Michele (FIG. 14-15) is the work of two "Giotteschi" (followers of Giotto), ANDREA DI CIONE, known as ORCAGNA (active 1343–1368) and BERNARDO DADDI (ca. 1290–1348). Orcagna produced the work's architecture and sculpture, and Bernardo Daddi painted the panel of the Madonna, which the tabernacle enshrines. Or San Michele was originally a grain market, a *loggia* (open-sided arcade) into the street; it was transformed into a church, confraternity building, and center for the city's guilds. After the plague in 1348, upper stories were added to house a granary. Or San Michele also functioned as a guild church, and each guild was assigned a niche on the building's exterior for a commissioned statue of its patron saint. Donations prompted by the plague funded the construction of Orcagna's tabernacle, which donors no doubt perceived as a kind of memorial to both the dead and the survivors. Individuals made bequests to a supposed miraculous portrait of the Virgin, which later burned and was replaced with the image by Bernardo Daddi. The

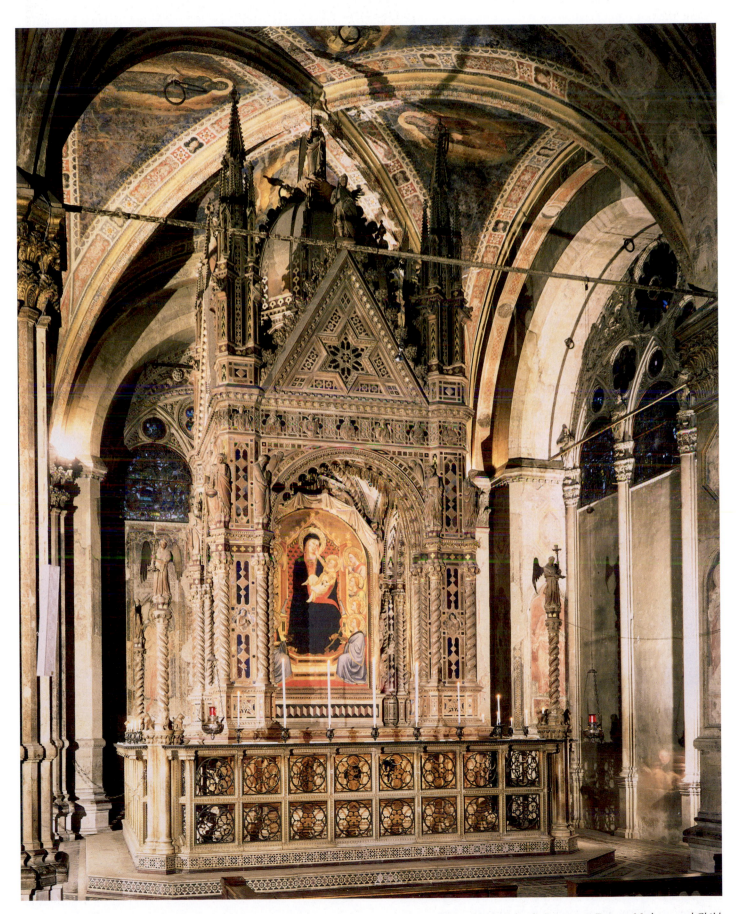

14-15 ANDREA ORCAGNA, tabernacle, Or San Michele, Florence, Italy, begun 1349. Mosaic, gold, marble, lapis lazuli. BERNARDO DADDI, *Madonna and Child with Saints,* painted panel insert, 1346–1347.

entire tabernacle, started in 1349, took ten years to complete, costing the vast sum of eighty-seven thousand gold florins.

Orcagna, an artistic virtuoso, was an architect, sculptor, and painter; he was familiar with the styles and practice of all the arts in post-Giotto Florence. The architectural enframement of the tabernacle recalls the polygonal piers and the slender spiral colonettes of the Florence Cathedral and campanile (FIG. 14-12), as well as the triangular pediment, fenestration, and pinnacles of a typical Italian Gothic facade (see FIG. 13-56). The planar surfaces sparkle with gold, lapis lazuli, mosaic, and finely cut marble, all inlaid in geometric patterns called *Cosmato work* (from *Cosmati,* the name given to craftsmen who worked in marble and mosaic in the twelfth to fourteenth centuries, many belonging to a family of that name). The effect is that of a gem-encrusted, scintillating shrine or reliquary, more the work of a jeweler than an architect.

The lavish ornamentation and costly materials recall the medieval association of precious material with holy things and themes, in this case with the original miracle-working image of the Virgin, which the new *Madonna and Child* replaced. Bernardo Daddi interpreted this most popular of Gothic subjects in a light, delicate, and charming manner appropriate to the humanizing of religion and to the emotional requirements of private devotion. Flanked by angels, two of whom swing censers filled with incense, the enthroned Virgin sits within a round arch with sculptured curtains. The Christ Child playfully touches his mother's face. The composition is conventional but softened by sentiment. The architectural enframement provides an illusionistic stage for the image, composing an ensemble of architecture, painting, and sculpture to serve Marian devotion (devotion to the Virgin Mary). This tabernacle attests to the versatility of Florentine artists after Giotto as they followed the various paths his original inspiration suggested.

The Republic of Siena

A MAJESTIC PAINTING OF MARY Siena, like Florence, was a commanding presence in fourteenth-century Italy. Particularly proud of their victory over the Florentines at the battle of Monteperti in 1260, the Sienese worshiped the Virgin Mary, whom they believed had sponsored their victory. Sienese devotion to the Virgin was paramount in the religious life of the city, whose citizens could boast of Siena's dedication to the Queen of Heaven as more ancient and venerable than that of all others. It is important that loyalty to the secular republican city-state was linked with devotion to its favorite saint. The Virgin became not only protector of every citizen but also of the city itself.

The works of DUCCIO DI BUONINSEGNA (active ca. 1278–1318) represent Sienese art in its supreme achievement. His immense altarpiece, the *Maestà,* was designed to replace a much smaller painting of the Virgin Mary. Duccio's inscription of his name at the base of the Virgin's throne in the *Maestà* is part of a prayer for himself and for the city of Siena, its cathedral, and its churches.

The *Maestà,* painted in tempera front and back and composed of many panels, was commissioned for the high altar of the Cathedral of Siena in 1308 and completed by Duccio and his assistants in 1311. As originally executed, it consisted of a seven-foot-high central panel (FIG. **14-16**), surmounted by seven pinnacles above, and a *predella,* or raised shelf, of panels at the base, altogether some thirteen feet high. Unfortunately, the work no longer can be seen in its entirety. It was dismantled in subsequent centuries, and many of its panels are now scattered as single masterpieces among the world's museums.

The main panel of the front side represents the Virgin enthroned in majesty (maestà) as Queen of Heaven amid cho-

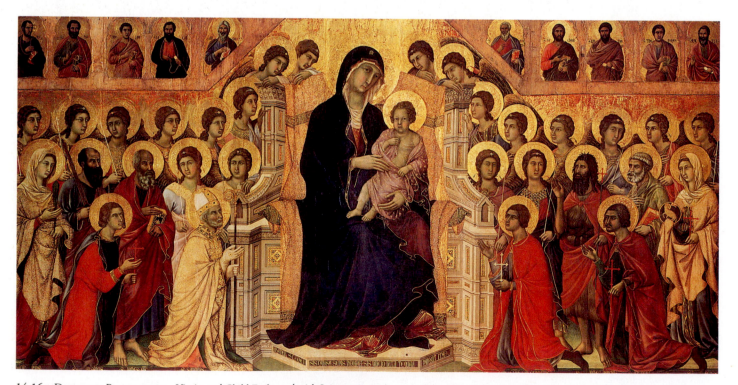

14-16 DUCCIO DI BUONINSEGNA, *Virgin and Child Enthroned with Saints,* principal panel of the *Maestà* altarpiece, from the Siena Cathedral, Siena, Italy, 1308–1311. Tempera on wood, panel 7′ × 13′. Museo dell'Opera del Duomo, Siena.

ruses of angels and saints. Duccio derived the composition's formality and symmetry, along with the figures and facial types of the principal angels and saints, from Byzantine tradition. But the artist relaxed the strict frontality and rigidity of the figures in the typical Byzantine icon and iconostasis, or apse mosaic; they turn to each other in quiet conversation. Further, Duccio individualized the faces of the four saints kneeling in the foreground who perform their ceremonial gestures without stiffness. Similarly, Duccio softened the usual Byzantine hard body outlines and drapery patterning. The drapery, particularly that of the female saints at both ends of the panel, falls and curves loosely. This is a feature familiar in northern Gothic works (see FIG. 13-37) and is a mark of the artistic dialogue that occurred between Italy and the north in the fourteenth century.

These changes are part of a new naturalism that only slowly made itself apparent in details. This is an altarpiece, and the artist respected the age-old requirement that as such it would occupy the very center of the sanctuary as the focus of worship. He knew it should be an object holy in itself—a work of splendor to the eyes, precious in its message and its materials. As such, its function naturally limited experimentation with depicting narrative action and producing illusionistic effects, such as Giotto's, by modeling forms and adjusting their placement in pictorial space.

Instead, the Queen of Heaven panel is a miracle of color composition and texture manipulation, unfortunately not apparent in a photo. Close inspection of the original reveals what the Sienese artists learned from new media and systems of ornament. In the thirteenth and fourteenth centuries, Italy was the distribution center for the great silk trade from China and the Middle East. After processing in city-states such as Lucca and Florence, merchants exported the silk throughout Europe to satisfy an immense market for sumptuous dress. (Dante, Petrarch, and many of the humanists decried the appetite for luxury in costume, which to them represented a decline in civic and moral virtue.) People throughout Europe (Duccio and other artists among them) prized fabrics from China, Persia, Byzantium, and the Islamic realms. In the *Maestà* panel, Duccio created the glistening and shimmering effects of textiles, adapting the motifs and design stratagems of exotic materials.

If on the front panel of the *Maestà* Duccio showed himself as the great master of the formal altarpiece, the small accompanying panels, front and back, reveal his powers as a narrative painter. In the numerous panels on the back, he illustrated the later life of Christ—his ministry (on the predella), his Passion (on the main panel), and his Resurrection and appearances to the disciples (on the pinnacles). In the small narrative pictures, Duccio relaxed the formalism appropriate to the iconic, symbolic representation of the maestà and revealed his ability not only as a narrator but also as an experimenter with new pictorial ideas. In a synoptic sequence on one of the small panels, *Betrayal of Jesus* (FIG. **14-17**), the

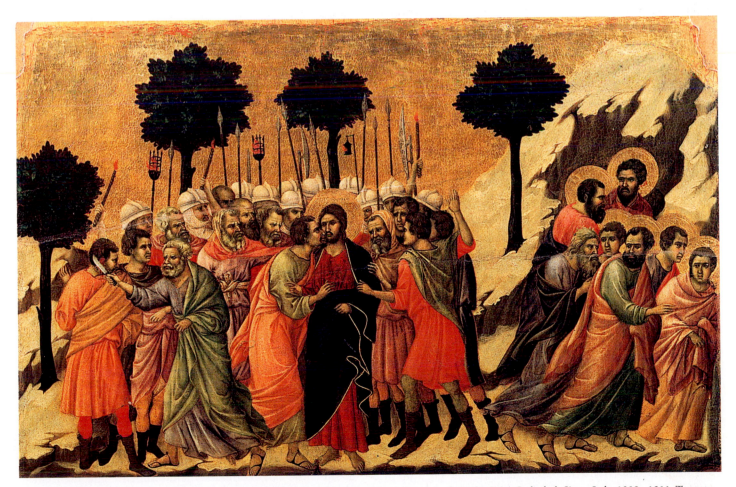

14-17 DUCCIO DI BUONINSEGNA, *Betrayal of Jesus*, detail from the back of the *Maestà* altarpiece, from the Siena Cathedral, Siena, Italy, 1309–1311. Tempera on wood, detail approx. 1' 10½" × 3' 4". Museo dell'Opera del Duomo, Siena.

A Majestic Altarpiece
Duccio's Maestà

Agnolo di Tura del Grasso provided one of the most complete records of the completion and installation of the *Maestà* in the Cathedral of Siena. Scholars consider his account reliable, as he was the keeper of the record books of Siena's chief financial magistracy. He described the pomp and ceremony that accompanied the transport of the altarpiece to the cathedral:

This [*Maestà*] was painted by master Duccio di Niccolò, painter of Siena, who was in his time the most skillful painter one could find in these lands. The panel was painted outside the Porta a Stalloreggi in the Borgo a Laterino, in the house of the Muciatti. The Sienese took the panel to the Cathedral at noontime on the ninth of June [1311], with great devotions and processions, with the bishop of Siena, Ruggero da Casole, with all of the clergy of the Cathedral, and with all the monks and nuns of Siena, and the Nove [that is, the Council of the Nine Lords], with the city officials, the Podestà and the Captain, and all the citizens with coats of arms and those with more distin-

guished coats of arms, with lighted lamps in hand. And thus, the women and children went through Siena with much devotion and around the Campo in procession, ringing all the bells for joy, and this entire day the shops stayed closed for devotions, and throughout Siena they gave many alms to the poor people, with many speeches and prayers to God and to his mother, Madonna ever Virgin Mary, who helps, preserves and increases in peace the good state of the city of Siena and its territory, as advocate and protectress of that city, and who defends the city from all danger and all evil. And so, this panel was placed in the Cathedral on the high altar. The panel is painted on the back with the Old Testament [sic], with the Passion of Jesus Christ, and on the front is the Virgin Mary with her son in her arms and many saints at the side. Everything is ornamented with fine gold; it cost three thousand gold florins.[1]

[1] James H. Stubblebine, *Duccio di Buoninsegna and His School* (Princeton, N.J.: Princeton University Press, 1979), 1:33–34.

artist represented several episodes of the event—the betrayal of Jesus by Judas's false kiss, the disciples fleeing in terror, and Peter cutting off the ear of the high priest's servant. Although the background, with its golden sky and rock formations, remains traditional, the style of the figures before it has changed quite radically. The bodies are not the flat frontal shapes of earlier Byzantine art. Duccio imbued them with mass, modeled them with a range from light to dark, and arranged their draperies around them convincingly. Even more novel and striking is how the figures seem to react to the central event. Through posture, gesture, and even facial expression, they display a variety of emotions. Duccio extended himself to differentiate among the anger of Peter, the malice of Judas (echoed in the faces of the throng about Jesus), and the apprehension and timidity of the fleeing disciples. These figures are actors in a religious drama that, in a lively performance, the artist interpreted in terms of thoroughly human actions and reactions. In this and similar narrative panels, Duccio took another decisive step toward the humanization of religious subject matter. The greatness of the *Maestà* did not have to wait for modern acclaim. A Sienese chronicler noted that nothing like it had been done anywhere else in Italy (see "A Majestic Altarpiece: Duccio's *Maestà*," above).

CREATING AN "INTERNATIONAL STYLE" Duccio's successors in the Sienese school displayed even greater originality and assurance than Duccio. SIMONE MARTINI (ca. 1285–1344) was a pupil of Duccio and a close friend of Petrarch, who praised him highly for his portrait of "Laura" (the woman to whom Petrarch dedicated his son-

nets). Martini worked for the French kings in Naples and Sicily and, in his last years, produced paintings for the papal court at Avignon, where he came in contact with northern painters. By adapting the insubstantial but luxuriant patterns of the French Gothic manner to Sienese art and, in turn, by acquainting northern painters with the Sienese style, Martini was instrumental in forming the so-called International Style. This new style swept Europe during the late fourteenth and early fifteenth centuries. It appealed to the aristocratic taste for brilliant colors, lavish costumes, intricate ornamentation, and themes involving splendid processions so knights and their ladies—complete with entourages, horses, and greyhounds—could glitter to advantage.

Martini's own style did not quite reach the full exuberance of the developed International Style, but his famous *Annunciation* altarpiece (FIG. **14-18**) provides a counterpoint to Giotto's style. Elegant shapes and radiant color; flowing, fluttering line; and weightless figures in a spaceless setting characterize the *Annunciation*. The complex etiquette of the European chivalric courts dictated the presentation. The angel Gabriel has just alighted, the breeze of his passage lifting his mantle, his iridescent wings still beating. The gold of his sumptuous gown heraldically represents the celestial realm whence he bears his message. The Virgin, putting down her book of devotions, shrinks demurely from Gabriel's reverent genuflection, an appropriate gesture in the presence of royalty. She draws about her the deep blue, golden-hemmed mantle, the heraldic colors she wears as Queen of Heaven. Despite the Virgin's modesty and diffidence and the tremendous import of the angel's message, the scene subordinates

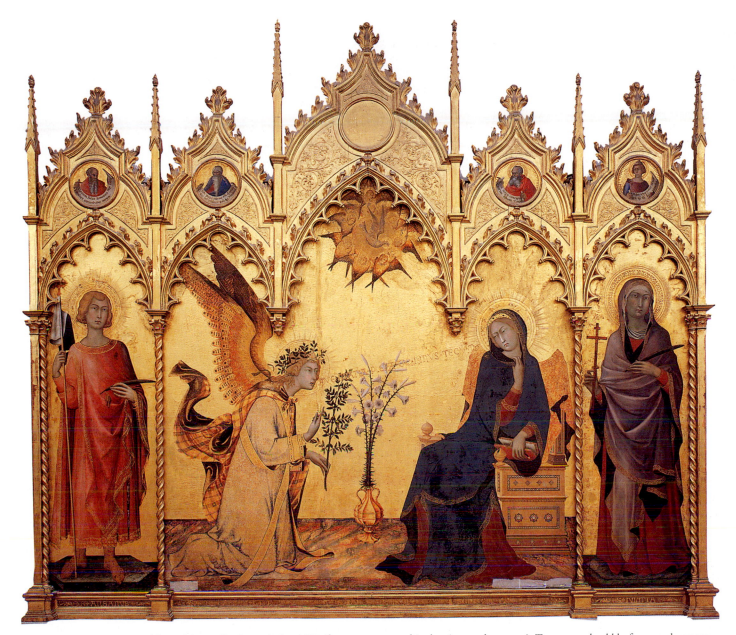

14-18 SIMONE MARTINI and LIPPO MEMMI(?), *Annunciation,* 1333 (frame reconstructed in the nineteenth century). Tempera and gold leaf on wood, approx. 10′ 1″ × 8′ 8$\frac{3}{4}$″. Galleria degli Uffizi, Florence.

drama to court ritual and structural experimentation to surface splendor. The intricate tracery of the richly tooled Late Gothic frame enhances the painted splendor. Of French inspiration, it replaced the more sober, clean-cut shapes traditional in Italy, and its appearance here is eloquent testimony to the two-way flow of transalpine influences that fashioned the International Style.

Simone Martini and his student and assistant, LIPPO MEMMI, signed the altarpiece and dated it (1333). Lippo's contribution to the *Annunciation* is still a matter of debate, but historians now generally agree he painted the two lateral saints, Saint Ansanus and Saint Margaret(?). Lippo drew these figures, which are reminiscent of the jamb statues of Gothic church portals, with greater solidity and without the linear elegance of Martini's central pair. Given

the medieval and Renaissance workshop practices, it is often next to impossible to distinguish the master's hand from those of assistants, especially if the master corrected or redid part of the latter's work (see "Mastering a Craft: Artistic Training in the Renaissance," page 442). This uncertainty is exacerbated by the fact that *Annunciation's* current architectural enframements are dated much later than the central panel.

SEEKING CONVINCING SPATIAL ILLUSION
The Lorenzetti brothers, also Duccio's students, shared in the general experiments in pictorial realism that characterized the fourteenth century, especially in their seeking of convincing spatial illusions. Going well beyond his master, PIETRO LORENZETTI (active 1320–1348) achieved remarkable success

Mastering a Craft
Artistic Training in the Renaissance

In fourteenth- through sixteenth-century Italy, training to become a professional artist (earning membership in the appropriate guild) was a laborious and lengthy process. Because Italians perceived art as a trade, they expected artists to be trained as they would in any other profession. Accordingly, aspiring artists started their training at an early age, anywhere from seven to fifteen years old. Their fathers would negotiate arrangements with specific master artists, whereby each youth lived with a master for a specified number of years, usually between five and six years. During that time, they served as apprentices to the masters in the workshop, learning the trade. This living arrangement served as a major obstacle for aspiring female artists. Certainly, it was considered inappropriate for young girls to live in a master's household.

The skills apprentices learned varied with the type of studio they joined. Those apprenticed to painters learned to grind pigments, draw, prepare wood panels for painting, gild, and lay plaster for fresco. Sculptors in training learned to manipulate different materials (for example, wood, stone, terracotta, wax, bronze, or stucco), although many sculpture workshops specialized in only one or two of these materials. For stone carving, apprentices learned their craft by blocking out the master's designed sculpture.

The guilds supervised this rigorous training. Not only did they want to ensure their professional reputations by admitting only the most talented members, but they also wanted to control the number of artists (to limit undue competition). Toward this end they frequently tried to regulate the number of apprentices working under a single master. Surely the quality of the apprentices a master trained reflected the master's competence. When encouraging a prospective apprentice to join his studio, the Paduan painter Francesco Squarcione boasted he could teach "the true art of perspective and everything necessary to the art of painting. . . . I made a man of Andrea Mantegna [see FIGS. 16-47, 16-48, 16-49, and 16-50] who stayed with me and I will also do the same to you."[1]

As their skills developed, apprentices took on more-difficult tasks. After completing their apprenticeships, artists entered the appropriate guilds. For example, painters, who ground pigments, joined the guild of apothecaries; sculptors were members of the guild of stoneworkers; and goldsmiths entered the silk guild, because gold often was stretched into threads wound around silk for weaving. Such memberships served as certification of the artists' competence. Once "certified," artists often affiliated themselves with established workshops, as assistants to master artists. This was largely for practical reasons. New artists could not expect to receive many commissions, and the cost of establishing their own workshops was high. In any case, this arrangement was not permanent, and workshops were not necessarily static enterprises. Although well-established and respected studios existed, workshops could be organized around individual masters (with no set studio locations) or organized for a specific project, especially an extensive decoration program.

Generally, assistants were charged with gilding frames and backgrounds, completing decorative work, and, occasionally, rendering architectural settings. Artists regarded figures, especially those central to the represented subject, as the most important and difficult parts of a painting, and the master retained responsibility for such figures. Assistants were allowed to paint some of the less important or marginal figures, but only under the master's close supervision.

Eventually, of course, artists hoped to attract patrons and establish themselves as masters. As the anonymity of medieval art moved toward artists' emancipation during the fifteenth and sixteenth centuries, artists rose in rank from artisan to artist-scientist. The value of their individual skills—and their reputations—became increasingly important to their patrons and clients. This apprentice system—the passing of knowledge from one generation to the next—accounts for the sense of continuity people experience when reviewing Italian Renaissance art.

[1]Giuseppe Fiocco, *Mantegna: La Cappella Ovetari nella Chiesa degli Eremitani* (Milan: A. Pizzi, 1974), 7.

in a large panel, *The Birth of the Virgin* (FIG. **14-19**). Like Duccio's *Maestà* and Simone Martini's *Annunciation*, the panel was painted for the Siena Cathedral as part of a program honoring the Virgin Mary, heavenly Queen of the Republic. Pietro Lorenzetti painted the wooden architectural members that divide the panel into three compartments as though they extend back into the painted space, as if viewers were looking through the wooden frame (apparently added later) into a boxlike stage, where the event takes place. That one of the vertical members cuts across one of the figures,

blocking part of it from view, strengthens the illusion. In subsequent centuries, artists exploited this use of architectural elements to enhance pictorial illusion. A long, successful history of such visual illusions produced by unifying both real and simulated architecture with painted figures evolved from these experiments.

Pietro Lorenzetti did not make just a structural advance here; his very subject represents a marked step in the advance of worldly realism. Saint Anne, reclining wearily as the midwives wash the child and the women bring gifts, is the

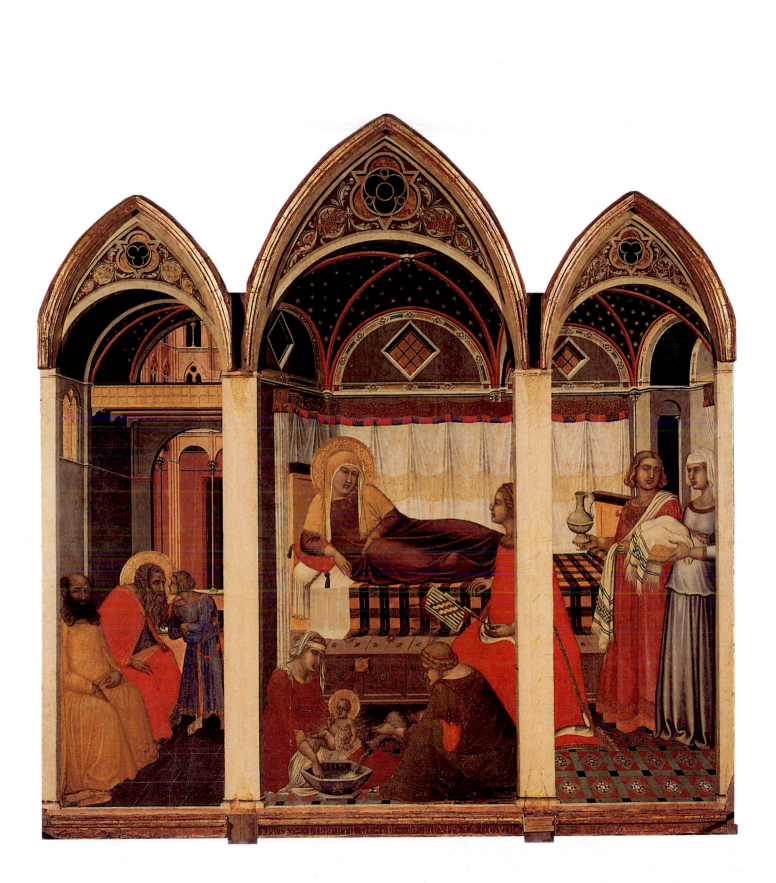

14-19 PIETRO LORENZETTI, *The Birth of the Virgin,* from Altar of Saint Savinus, Siena Cathedral, Siena, Italy, 1342. Tempera on wood, approx. 6′ 1″ × 5′ 11″. Museo dell'Opera del Duomo, Siena.

center of an episode that occurs in an upper-class Italian house of the period. A number of carefully observed domestic details and the scene at the left, where Joachim eagerly awaits the news of the delivery, place the event in an actual household, as if viewers had moved the panels of the walls back and peered inside. Pietro Lorenzetti joined structural innovation in illusionistic space with the new curiosity that led to careful inspection and recording of what lay directly before artists' eyes in the everyday world.

A BASTION OF STRENGTH AND POWER The Sienese were concerned about matters of both church and state. The city-state was a proud commercial and political rival of Florence. The secular center of the community, the town hall, was almost as much the object of civic pride as the cathedral. A building such as the Palazzo Pubblico of Siena (FIG. **14-20**) must have earned the admiration of Siena's citizens as well as of visiting strangers, inspiring in them respect for the city's power and success. More symmetrical in its design than most buildings of its type and period, it abuts a lofty tower, which (along with Giotto's campanile in Florence) is one of the finest in Italy. This tall structure served as lookout over the city and the countryside around it and as a bell tower for ringing signals of all sorts to the populace. The city, a self-contained political unit, had to defend itself against neighboring cities and often against kings and emperors. In addition, it had to be secure against internal upheavals common in the history of the Italian city-republics. Feuds between rich and powerful families, class struggle, even uprisings of the whole populace against the city governors were constant threats. The Italian town hall's heavy walls and bat-

tlements eloquently express how the city governors frequently needed to defend themselves against their own citizens. The high tower, out of reach of most missiles, includes machicolated galleries (galleries with holes in its floors to allow stones or hot liquids to be dumped on enemies below). These were built out on corbels around the top of the structures to provide openings for a vertical (downward) defense of the tower's base.

VISUALIZING GOOD AND BAD GOVERNMENTS Pietro Lorenzetti's brother AMBROGIO LORENZETTI (active 1319–1348) elaborated the Sienese advances in illusionistic representation in spectacular fashion in a vast fresco program in the Palazzo Pubblico. Ambrogio Lorenzetti produced three frescoes: *Allegory of Good Government*, *Bad Government and the Effects of Bad Government in the City*, and *Effects of Good Government in the City and in the Country*. The turbulent politics of the Italian cities—the violent party struggles, the overthrow and reinstatement of governments—certainly would have called for solemn reminders of fair and just administration. And the city hall was just the place for paintings such as Ambrogio Lorenzetti's.

In *Effects of Good Government in the City and in the Country*, the artist depicted the urban and rural effects of good government. *Peaceful City* (FIG. **14-21**) is a panoramic view of Siena, with its clustering palaces, markets, towers, churches, streets, and walls. The city's traffic moves peacefully, the guilds' members ply their trades and crafts, and a cluster of radiant maidens, hand in hand, perform a graceful circling dance. The artist fondly observed the life of his city, and its architecture gave him an opportunity to apply Sienese artists' rapidly growing knowledge of perspective. Passing through the city gate to the countryside beyond its walls, Ambrogio Lorenzetti's *Peaceful Country* (FIG. **14-22**) presents a bird's-eye view of the undulating Tuscan countryside—its villas, castles, plowed farmlands, and peasants going about their seasonal occupations. An allegorical figure of Security hovers above the landscape, unfurling a scroll that promises safety to all who live under the rule of the law. In this sweeping view of an actual countryside, *Peaceful Country* represented one of the first appearances of landscape in Western art since antiquity. The difference here is that the artist particularized the landscape—as well as the city view—by careful observation and endowed the painting with the character of a portrait of a specific place and environment. By combining some of Giotto's analytical powers with Duccio's narrative talent, Ambrogio Lorenzetti achieved more spectacular results than those of either of his two great predecessors.

The Black Death may have ended the careers of both Lorenzettis. They disappear from historical records in 1348, the year that brought so much horror to defenseless Europe. It is an irony of history that as Western societies drew both themselves and the world into ever-clearer visual focus, they realized even more clearly that material things are perishable. The ideas that gained momentum in the fourteenth century—humanism, direct observation, greater concern with the solidity of forms, and the interest in illusion—became prominent in the following centuries, during a period known as the Renaissance.

14-20 Palazzo Pubblico, Siena, Italy, 1288–1309.

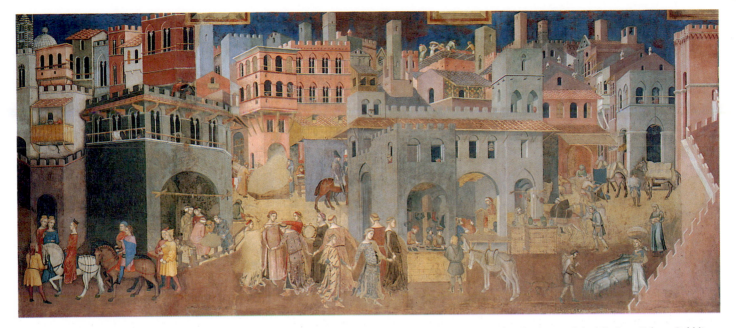

14-21 AMBROGIO LORENZETTI, *Peaceful City*, detail from the fresco *Effects of Good Government in the City and in the Country*, Sala della Pace, Palazzo Pubblico, Siena, Italy, 1338–1339.

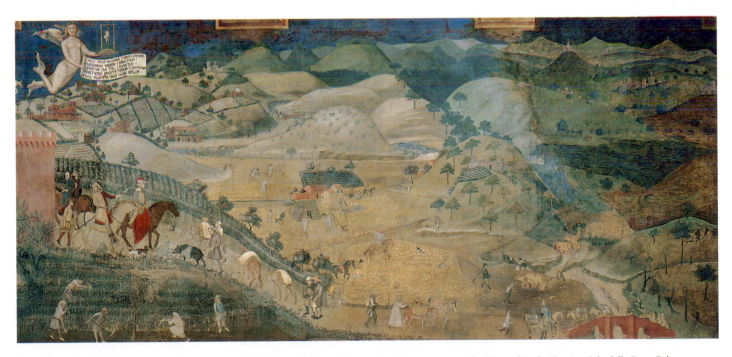

14-22 AMBROGIO LORENZETTI, *Peaceful Country*, detail from the fresco *Effects of Good Government in the City and in the Country*, Sala della Pace, Palazzo Pubblico, Siena, Italy, 1338–1339.

NORTHERN EUROPE AND SPAIN IN THE FIFTEENTH CENTURY

POLAND

ENGLAND

London

Ghent
Bruges
Antwerp
Ypres
FLANDERS
Louvain
Cologne

HOLY
ROMAN
EMPIRE

Kraków

Atlantic

Ocean

Creglingen
Nuremberg

Paris

Rhine R.

Danube R.

HUNGARY

Orléans

Isenheim
Colmar

Duchy of Burgundy
c. 1477

FRANCE

Beaune
Dijon

*Lake
Geneva*

Tarvisio (Tarvisium)

Riom

Geneva

Venice

Rhône R.

Avignon

Florence

PAPAL
STATES

OTTOMAN EMPIRE

Miraflores

Rome

PORTUGAL

Madrid

SPAIN

Mediterranean Sea

N

ARAB DOMINIONS

| 0 | 150 | 300 miles |
| 0 | 150 | 300 kilometers |

1375		1425
PHILIP THE BOLD (BURGUNDY)	JOHN THE FEARLESS	PHILIP THE GOOD

Claus Sluter
Well of Moses
1395–1406

Limbourg Brothers
May, from Très Riches Heures
1413–1416

Master of Flémalle
Mérode Altarpiece
ca. 1425–1428

Hundred Years' War begins, 1337

The papacy in Avignon, 1305–1378

The Great Schism in the Church, 1378–1417

The Netherlands under the dukes of Burgundy, 1384–1477

15

OF PIETY, PASSION, AND POLITICS

FIFTEENTH-CENTURY ART IN NORTHERN

EUROPE AND SPAIN

1467	1477		1500

Charles the Bold

Ferdinand (Aragon) and Isabella (Castile), Catholic Rulers of Spain

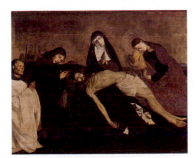

The Avignon Pietà
ca. 1455

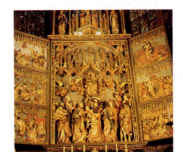

Veit Stoss
The Death and Assumption of the Virgin Mary
1477–1489

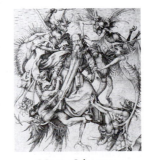

Martin Schongauer
Saint Anthony Tormented by Demons
ca. 1480–1490

Gil de Siloé
Christ Crucified
1496–1499

Hundred Years' War ends, 1453

Burgundy and Burgundian Netherlands pass to Holy
Roman Empire Maximilian I, Hapsburg emperor, 1486

Moorish kingdom of Granada falls to Spain, 1492

Columbus arrives in West Indies, 1492

French invade Italy, 1494

POLITICAL, ECONOMIC, AND RELIGIOUS DEVELOPMENTS IN THE FIFTEENTH CENTURY

In the Late Gothic world, western Europe beyond the Alps experienced the calamities of war, plague, and the social upheavals and dislocations that accompanied dying feudalism. The Black Death that ravaged Italy in 1348 also decimated much of the rest of Europe. The Hundred Years' War (1337–1453) contributed to the instability across the European continent. Primarily a protracted series of conflicts between France and England, the Hundred Years' War also involved Flanders. Technically, Flanders was a principality or county in the Netherlands, a country that consisted of what today is Belgium, the Netherlands (more commonly called Holland), Luxembourg, and part of northern France. However, during the fifteenth century, "Flanders" also referred more generally to a broader territory. During the Hundred Years' War, urban revolts erupted in this larger Flanders, England's chief market for raw wool. France's intervention in the Flemish problem threatened England's revenues, thereby intensifying the antagonism between France and England that underlay the long-simmering war.

CONSOLIDATING POLITICAL POWER Politically, the widespread European movement toward centralized government, begun in the twelfth century, continued apace. Structured bureaucracies, royal courts, and parliamentary assemblies were becoming the norm, creating conflicts with the lingering cumbersome arrangements of feudal governance. During the latter part of the fifteenth century, several kings successfully consolidated their authority over their respective countries, accounting for the label "new monarchies" used to describe the governmental systems in France, England, and Spain. Of course, European monarchies had existed for centuries, but these "new monarchs" exerted and expanded their authority in a more systematic and comprehensive way. For example, they suppressed the nobility, controlled the Christian Church, and insisted on the unwavering loyalty of their subjects.

EMERGING CAPITALISM Despite the age's calamities, a new economic system also evolved—the early stage of European capitalism. Responding to the financial requirements of trade, new credit and exchange systems created an economic network of enterprising European cities. The trade in money accompanied the trade in commodities, and the former financed industry. Both were in the hands of trading companies with central offices and international branches; the Medici of Florence (see Chapter 16, pages 478, 497–503) were a notable example of such a trading firm. The origin of the French word for *stock market* demonstrates the importance of Flanders to Europe's economic development. *Bourse* came from the name of the van der Beurse family, whose Bruges (now a Belgian city) residence was a center of economic activity. The first international commercial stock exchange, established in Antwerp in 1460, became pivotal for Europe's integrated economic activity. The thriving commerce, industry, and finance contributed to the evolution of cities, as did the migration of a significant portion of the rural population to urban centers.

DIVISIVENESS IN THE CHURCH Crisis in the religious realm exacerbated the period's political instability. The conflicts between those supporting the Avignon papacy in France and those agitating for the pope's return to Rome led to the Great Schism (see Chapter 14, pages 422–23). Because most fourteenth-century popes were French, establishing the papal residence in Avignon was not unexpected. The Italian insistence on the pope's presence in Rome also was foreseeable. This split in the Christian Church—the Great Schism—lasted from 1378 until 1417, when both sides agreed to the selection of Martin V as pope in Rome.

FRENCH MANUSCRIPT ILLUMINATION

For centuries, stained glass (see FIGS. 13-14 and 13-15) and the illuminated manuscript page (see FIGS. 13-34 and 13-35) had prevailed as the characteristic painted surfaces in northern Europe, especially in France. Northern Gothic architects had eliminated solid walls and left few continuous blank surfaces that invited painted decorations (see FIG. 13-26), unlike designers in Italy, where the climate and architecture favored mural painting in fresco (see FIG. 14-8). Northern artists had extensive experience at working not only in miniature but also with rich jewel-like colors that, especially in stained glass, have a profound luminosity, with light seemingly irradiating the forms. Manuscript illustration, working deep color into exquisitely tiny and intricate shapes and patterns, particularly showcased this color mastery. In addition, illuminations had begun to take on the character of independent paintings, expanding in size until they occupied pages completely.

TURNING THE PAGE TO A NEW ERA The work of Jean Pucelle in the early fourteenth century, discussed in Chapter 13, represented the first step toward illumination's size expansion within texts. A page from the *Belleville Breviary* (see FIG. 13-36) shows how the illustrator took command of the entire page. The borders, extended to invade the margins, include not only decorative tendrils and a profusion of spiky ivy and floral ornaments but also a myriad of insects, small animals, and grotesques. In addition, three narrative scenes encroach on the text columns, demonstrating that manuscript illustrators were feeling less constrained by the text, both physically on the page and figuratively in the relationship between the text and image.

AN OPULENT PRAYER BOOK In the early fifteenth century, the three LIMBOURG BROTHERS—POL (PAUL?), HENNEQUIN (JEAN? JAN?), and HERMAN—carried the size expansion of illustrations in manuscripts even further. These artists produced a gorgeously illustrated Book of Hours for Jean, the duke of Berry (1340–1416) and brother of King Charles V of France. The duke was an avid art patron and focused much of his collecting energy on manuscripts, jewels, and rare artifacts. An inventory of the duke's libraries revealed that he owned more than three hundred manuscripts, including the *Belleville Breviary* (see FIG. 13-36) and the *Hours of Jeanne d'Évreux.* The Limbourg brothers worked on the manuscript, *Les Très Riches Heures du Duc de Berry (The Very Sumptuous Hours of the Duke of Berry),* until their deaths in 1416. A Book of Hours, like a breviary, was a prayer book used for reciting prayers.

The centerpiece of a Book of Hours (see "Medieval Books," Chapter 11, page 322) was the "Office [prayer] of the Blessed Virgin," which contained liturgical passages to be read privately at seven set times during the day, from matins (dawn prayers) to compline (the last of the seven prayers recited daily). An illustrated calendar containing local religious feast days usually preceded the "Office of the Blessed Virgin." Penitential psalms, devotional prayers, litanies to the saints, and other prayers, including those of the dead and of the Holy Cross, followed the centerpiece. Such books became favorite possessions of the northern aristocracy during the fourteenth and fifteenth centuries. As prayer books, they replaced the traditional psalters, which had been the only liturgical books in private hands until the mid-thirteenth century.

The calendar pictures of *Les Très Riches Heures* are perhaps the most famous in the history of manuscript illumination. They represent the twelve months in terms of the associated seasonal tasks, alternating the occupations of nobility and peasantry. Above each picture is a lunette depicting the chariot of the sun as it makes its yearly round through the twelve months and zodiac signs. Representative is the colorful calendar picture for May (FIG. **15-1**). A cavalcade of patrician ladies and gentlemen, preceded by trumpeters, rides out to celebrate the first day of May, a spring festival that courts throughout Europe observed. Clad in springtime green and garlanded with fresh leaves, the riders sparkle with ornate finery. Behind them is a woodland and the château of Riom in south central France. Such great country estates, most belonging to the duke of Berry, loom in the backgrounds of most of the calendar pictures. The artists represented these estates so faithfully that those surviving can be easily recognized. The rich costume detail also speaks to the artists' careful observation and depiction of their subjects. The picture's spirit is lighthearted, chivalric, and pleasure loving. The entire book, as seen in *May*, reflects the illustrators' interest in precise detail and rich color.

Although all three Limbourg brothers worked on *Les Très Riches Heures,* art historians have never been able to ascertain which brother painted which images. Given the common practice of collaboration on artistic projects at this time, this determination of specific authorship is not very important. From what scholars know, all three brothers died in the same year, 1416, before completing this Book of Hours, and another court illustrator finished the manuscript about seventy years later. Despite this uncertainty regarding the authorship of specific pages, *Les Très Riches Heures* as a whole realized the emancipation of illustration from text. Further, the Limbourg brothers expanded the conventional range of subject matter to include genre subjects, and they gave these everyday scenes a prominent place, even in a religious book. This combination reflected the increasing integration of religious and secular concerns in both art and life at the time.

FIFTEENTH-CENTURY FLEMISH ART

The Burgundian Netherlands

EXPANDING BURGUNDIAN TERRITORIES The duke of Berry's grandnephew, Philip the Good (1396–1467), ruled a region known as the Duchy of Burgundy—hence his title, the duke of Burgundy. Burgundy was the fertile east-central region of France still known for its wines. In the late fourteenth century, one of Philip the Good's predecessors, Philip the Bold (1342–1404), had married the daughter of the count of Flanders, thereby acquiring counties in the Netherlands. With them came the rich industrial, commercial, and banking cities that together were pivotal for the economic development of northern and western Europe. The reigning duke of Burgundy wielded power over not just the county of Flanders proper but over the broader Flanders as well. Although the duke's official capital and court were at Dijon in Burgundy, the source of Burgundian wealth and power was at Bruges, the city that made Burgundy a dangerous rival of royal France.

Bruges derived its wealth from the wool trade and from banking. Until late in the fifteenth century, an arm of the North Sea, now silted up, reached inland to Bruges. There, ships brought raw wool from England and Spain and carried away fine woolen cloth that became famous throughout Europe. The wool brought bankers, among them representatives of the House of Medici, and Bruges became the financial clearinghouse for all of northern Europe. In its streets, merchants from Italy and the Near East rubbed shoulders with traders from Russia and Spain. Despite the flourishing economies of its sister cities—Ghent, Louvain, and Ypres—Bruges so dominated Flanders that the duke of Burgundy eventually chose to make the city his capital and moved his court there from Dijon in the early fifteenth century.

Due to the expanded territory and the prosperity of the "Burgundian Netherlands," the dukes of Burgundy were probably the most powerful rulers in northern Europe during the first three quarters of the fifteenth century. Although cousins of the French kings, they usually supported England (which they relied on for the raw materials used in their wool industry) during the Hundred Years' War and, at times, controlled much of northern France, including Paris. At the height of their power, the reigning duke's lands stretched from the Rhône River to the North Sea. Only the rash policies of the last of their line, Charles the Bold (1433–1477), and his death at the battle of Nancy in 1477 brought to an end the Burgundian dream of forming a strong middle kingdom between France and the Holy Roman Empire. After Charles's death, France reabsorbed the southern Burgundian lands, and the Netherlands passed to the Holy Roman Empire by virtue of the dynastic marriage of Charles's daughter, Mary of Burgundy, to Maximilian of Hapsburg.

SUBSIDIZING A MONASTERY Though all of the period's dukes of Burgundy felt a commitment to the arts, Philip the Bold, who ruled from 1364 to 1404, was among the greatest art patrons in northern Europe. His interests centered on illuminated manuscripts, arras tapestries (from Arras, a town in northeastern France famous for its fabric), and rich furnishings for his numerous castles and town houses, located throughout the duchy. He also maintained an entire workshop of sculptors. Philip's largest artistic enterprise was the building of the Chartreuse (Carthusian monastery) de Champmol, near Dijon. Founded in the late eleventh century by Saint Bruno, the Carthusian order consisted of monks who devoted their lives to solitary living and prayer. Saint Bruno established the order at Chartreuse, near Grenoble in

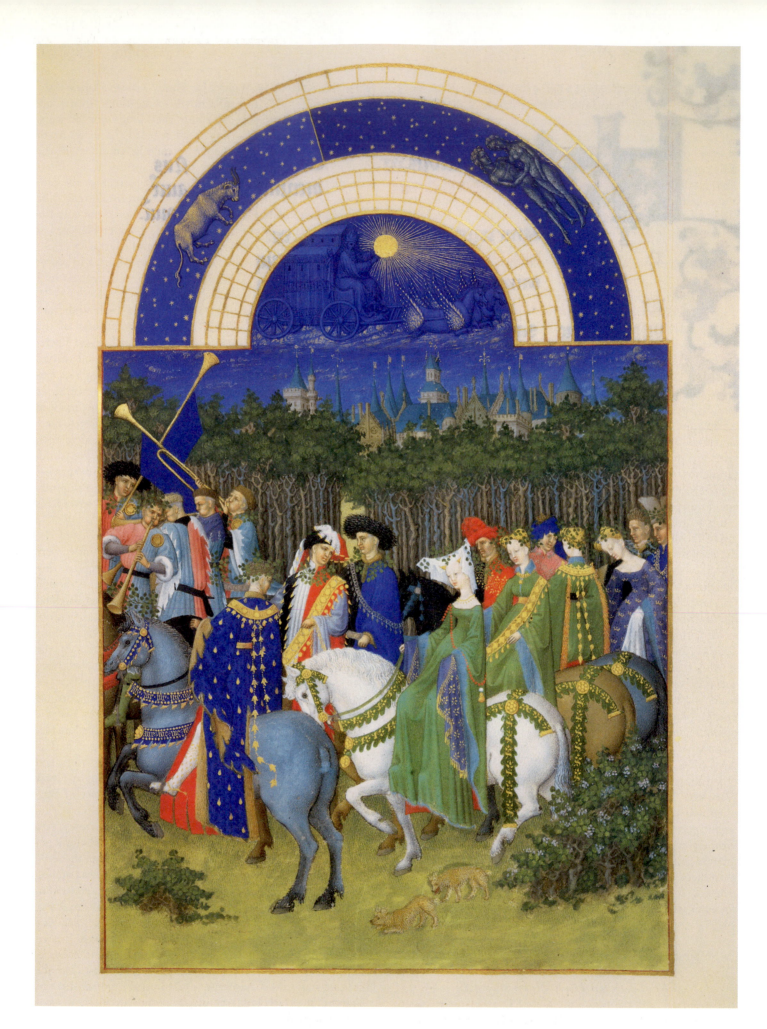

15-1 Limbourg Brothers (Pol, Hennequin, Herman), *May*, from *Les Très Riches Heures du Duc de Berry*, 1413–1416. Illumination, approx. $8\frac{1}{2}'' \times 5\frac{1}{2}''$. Musée Condé, Chantilly.

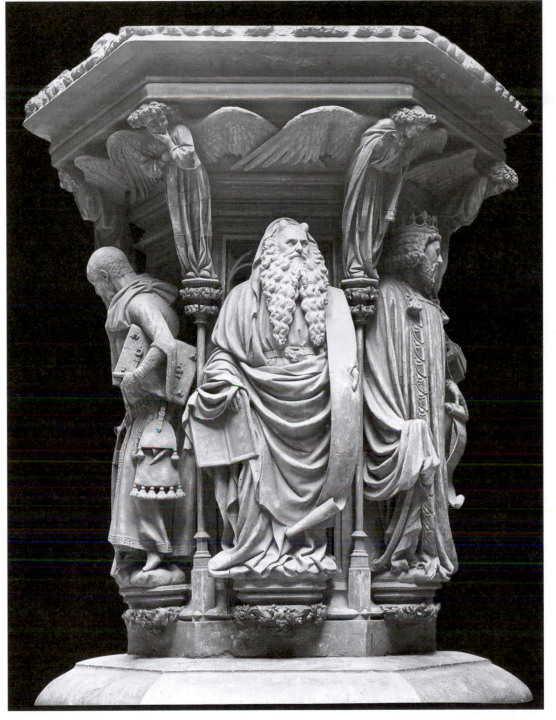

15-2 CLAUS SLUTER, *Well of Moses,* Chartreuse de Champmol, Dijon, France, 1395–1406. Stone, figures approx. 6′ high.

southeastern France; hence, the term *chartreuse* ("charter house" in English) refers to a Carthusian monastery. Because Carthusian monasteries did not generate revenues, Philip the Bold's endowment at Champmol was significant. Intended as a tomb repository for the important members of the Valois House of Burgundy, the Chartreuse's magnificent endowment attracted artists from all parts of northern Europe.

A SYMBOLIC FOUNTAIN OF LIFE Philip the Bold placed sculptor CLAUS SLUTER (active ca. 1380–1406) in charge of his sculpture workshop. For the cloister of the Chartreuse de Champmol, Sluter designed a large sculptural fountain located in a well. The well served as a water source for the monastery. It seems probable, however, that the fountain did not actually spout water, because the

Carthusian commitment to silence and prayer would have precluded anything that produced sound. Although the sculptor died before completing the entire fountain, he did finish *Well of Moses* (FIG. **15-2**). Moses, David, and four other prophets (Daniel, Isaiah, Jeremiah, and Zachariah) surround a base that once supported a Crucifixion group. Despite the nonfunctioning nature of this fountain, it had immense symbolic significance. The entire structure served as a symbolic fountain of life, with the blood of Christ (on the cross above) flowing down over the Old Testament prophets, washing away their sins and spilling into the well below. The *Well of Moses* thus represented the promise of everlasting life.

The six figures recall the jamb statues of the Gothic portals, but they far surpass even the most realistic of those (see

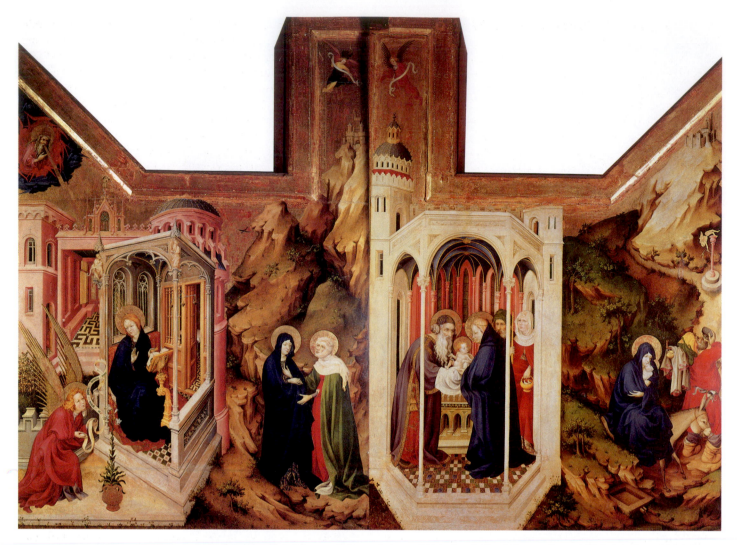

15-3 MELCHIOR BROEDERLAM, outer wings of the *Retable de Champmol. Annunciation and Visitation (left)* and *Presentation and Flight into Egypt (right),* from Chapel of the Chartreuse de Champmol, Dijon, France, installed 1399. Panels, each 5′ 5¾″ × 4′ 1¼″. Musée de la Ville, Dijon.

FIGS. 13-16 and 13-24). Sluter's intense observation of natural appearance provided him with the information necessary to render the figures in minute detail. Heavy draperies with voluminous folds, characteristic of Sluter's style, swath the life-size figures. The artist succeeded in making their difficult, complex surfaces seem remarkably naturalistic. He enhanced this effect by skillfully differentiating textures, from coarse drapery to smooth flesh and silky hair, and by the paint, which still adheres in places. This fascination with the specific and tangible in the visible world became one of the chief characteristics of fifteenth-century Flemish painting. Yet despite the realism of Sluter's figures, they do not evidence much physical movement or weight shift.

PANELS THAT PREFACE THE PASSION Philip the Bold also commissioned a major altarpiece for the main altar in the chapel of the Chartreuse. A collaborative project, this altarpiece consisted of a large sculptured shrine carved by Jacques de Baerze and a pair of exterior panels (FIG. **15-3**) painted by MELCHIOR BROEDERLAM (active ca. 1387–1409). The artist depicted *Annunciation and Visitation* on the left panel and *Presentation and Flight into Egypt* on the right panel (see "The Life of Jesus in Art," Chapter 8, pages 238–39 or xxx–xxxi in Volume II). Dealing with Christ's birth and infancy, these scenes introduce the Passion scenes (from Christ's last days on earth) de Baerze presented in the interior sculpture. The exterior panels are an unusual amalgamation of different styles, locales, and religious symbolism. The two paintings include both landscape and interior scenes, and the architecture of the structures varies from Romanesque to Gothic. Scholars have suggested that the juxtaposition of different architectural styles in the left panel is symbolic. The *rotunda* (round building, usually with a dome) refers to the Old Testament, while the Gothic porch relates to the New Testament. Stylistically, Broederlam's representation of parts of the landscape and architecture reveals an attempt to render three-dimensionality on the two-dimensional surface. Yet his staid treatment of the figures, their halos, and the flat gold background recall medieval pictorial conventions. Despite this interplay of various styles and diverse imagery, the altarpiece was a precursor of many of the artistic developments (such as the illusionistic depiction of three-dimensional objects and the representation of landscape) that preoccupied European artists throughout the fifteenth century.

The Artist's Profession in Flanders

THE ART OF BUILDING A CAREER As in Italy, guilds controlled the Flemish artist's profession. To pursue a craft, individuals had to belong to the guild controlling that craft. Painters, for example, sought admission to the Guild of Saint Luke, which included the saddlers, glassworkers, and mirrorworkers as well. The path to eventual membership in the guild began, for men, at an early age, when the father apprenticed his son in boyhood to a master, with whom the young aspiring painter lived. The master taught the fundamentals of his craft—how to make implements; how to prepare panels with gesso (plaster mixed with a binding material); and how to mix colors, oils, and varnishes. Once the youth mastered these procedures and learned to work in the master's traditional manner, he usually spent several years working as a journeyman in various cities, observing and absorbing ideas from other masters. He then was eligible to become a master and applied for admission to the guild. Through the guild, he obtained commissions. The guild also inspected his paintings to ensure he used quality materials and to evaluate workmanship and then secured him adequate payment for his labor. As a result of this quality control, Flemish artists soon gained a favorable reputation for their solid artisanship.

FLEMISH FEMALE ARTISTS Scholars know much less about the training of women artists than they do about that of men. Certainly, far fewer women participated in the art professions, although the membership records of the art guilds of Flemish cities such as Bruges list a substantial number of women in the fifteenth century and later.

Flemish women interested in pursuing art as a career most often received tutoring from fathers and husbands who were professionals and whom the women assisted in all the craft's technical procedures. Social and moral constraints would have forbidden women's apprenticeship in the homes of male masters and would have stringently limited their freedom of movement. Moreover, from the sixteenth century, when academic training courses supplemented and then replaced guild training, until the twentieth century, women would not as a rule expect or be permitted instruction in figure painting, insofar as it involved dissection of cadavers and study of the nude male model. Despite the lack of concrete information, it is clear women did not have access to the training and experience many male artists enjoyed. Yet Flemish women artists, such as Lavinia Teerlinc of Bruges, did manage to establish themselves. These artists ably negotiated the difficult path to acceptance as professionals, overcoming significant obstacles. Indeed, so successful was Teerlinc in pursuing an artistic career that she eventually was invited to England to paint miniatures for the courts of Henry VIII and his successors. There, she was a formidable rival of some of her male contemporaries and received greater compensation for her work than they did for theirs.

Public Devotional Imagery: Altarpieces

PIETY AND POLITICS Despite the resolution of the Great Schism in 1417 and the restoration of the papal seat in Rome, religion continued to play an extremely important role in Flemish lives. Accordingly, the religious orientation of art produced during the preceding Gothic period continued unabated. This commitment to religion and art pervaded all levels of Flemish society from authoritative ruler to lowly subject. Philip the Bold demonstrated his commitment to the Christian Church through commissions, generous charitable donations, and support for religious orders, such as the Carthusians (for example, the Chartreuse de Champmol commission). From his pinnacle of power, however, Philip the Bold's interest in the Church extended beyond his concern for his own salvation and setting a pious example for his subjects; he also sought to increase his power.

Using the Church to expand his authority was logical because the conflicts that precipitated the Great Schism were largely political rather than doctrinal in nature and focused on issues of power and control. Fifteenth-century sovereigns were well aware of this and recognized the value of the Church as an ally. Thus, secular leaders across Europe eagerly entered the fray between the pope in Avignon and the pope in Rome. Philip the Bold threw his support behind Clement VII in Avignon, confident that he could control that pope more easily than a pope hundreds of miles away in Rome. English support for Urban VI in Rome furthered Philip's resolve to see the Avignon papacy dominate.

This heightened politicization of the Church impacted the clergy as well. Because the duke of Burgundy determined upper-level Church appointments (for example, bishops, abbots, and deans of chapters), the political motivation that drove the duke infiltrated the clergy, many of whom owed their positions (and therefore their loyalty) to the duke. Clerical involvement in the political situation led to increased neglect of clerical functions, to immoral behavior, and to pursuit of material gain. The populace counteracted what it perceived as a decline in clerical spirituality with an upsurge in devotional practices. Pilgrimages and processions escalated, as did the worship of the Virgin Mary.

Thus, the reasons for the predominance of religious imagery in the art of fifteenth-century Flanders were numerous. Large-scale public altarpieces were among the most visible manifestations of piety. These altarpieces served a variety of functions, among them providing a backdrop for the Mass celebration, teaching church doctrine, and visually encouraging piety. A wide range of Flemish society—pious individuals, high officials, and organizations (religious orders and lay confraternities)—commissioned these devotional objects, which helped ensure the donor's eventual salvation and promoted greater devotion among the faithful. Guilds commonly commissioned art; through guilds, the middle class became more involved in art patronage.

SETTING THE STAGE FOR SALVATION These public altarpieces most often took the form of *polyptychs* (hinged multipaneled paintings) or carved relief panels. The hinges allowed users to close the polyptych's side wings over the central panel(s). Artists decorated both the exterior and interior of the altarpieces. This multi-imaged format provided artists the opportunity to construct narratives through a sequence of images, somewhat like manuscript illustration. Although scholars do not have concrete information about the specific circumstances when these altarpieces were opened or closed, evidence

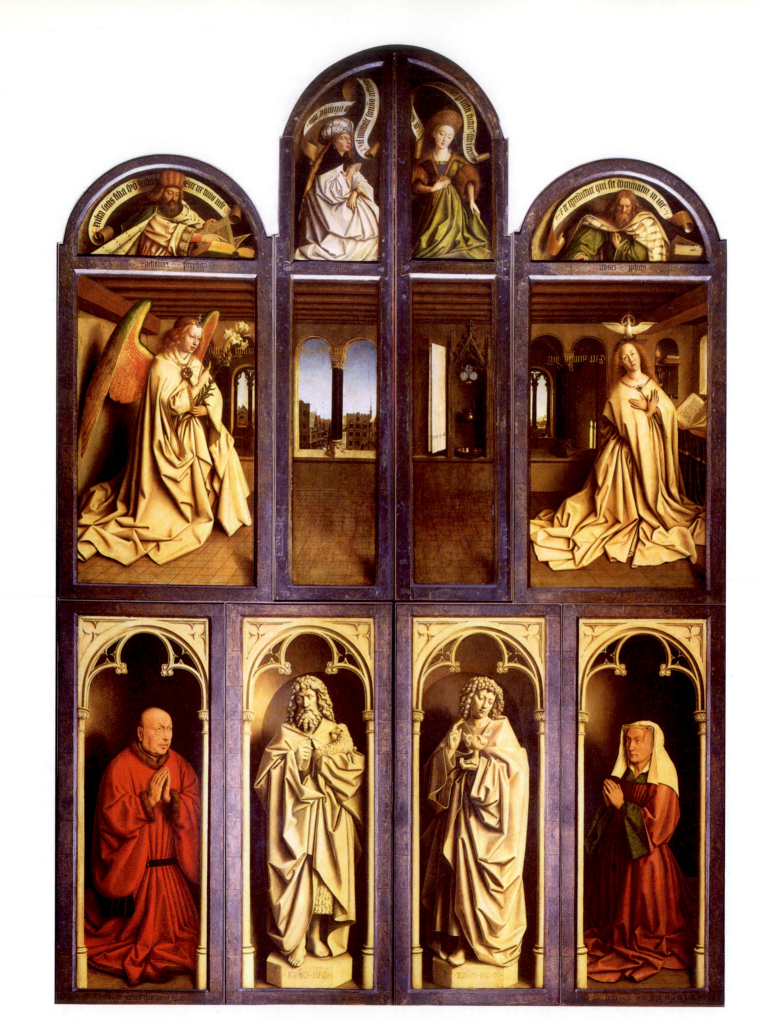

15-4 JAN VAN EYCK, *Ghent Altarpiece* (closed), Saint Bavo Cathedral, Ghent, Belgium, completed 1432. Oil on wood, height 11′ 5¾″.

Painters, Pigments, and Panels

The generic word *paint* or *pigment* encompasses a wide range of substances artists have used over the years. Fresco aside (see "Fresco Painting," Chapter 14, page 431), during the fourteenth century, egg tempera was the material of choice for most painters, both in Italy and northern Europe. Tempera consists of egg combined with a wet paste of ground pigment. In his influential guidebook *Il Libro dell'Arte* (*The Craftsman's Handbook*), Cennino Cennini, a contemporaneous painter, mentioned that artists mixed only the egg yolk with the ground pigment, but analysis of paintings from this period has revealed that some artists chose to use the whole egg. Images painted with tempera have a velvety sheen to them and exhibit a lightness of artistic touch because thick application of the pigment mixture results in premature cracking and flaking.

Scholars have discovered that artists used oil paints as far back as the eighth century, but not until the early fifteenth century did painting with this material become widespread. Flemish artists were among the first to employ oils extensively (often mixing them with tempera), and Italian painters quickly followed suit. The discovery of better drying components in the early fifteenth century enhanced the setting capabilities of oils. Rather than apply these oils in the light flecked brushstrokes that tempera encouraged, artists laid the oils down in transparent glazes over opaque or semiopaque underlayers. In this manner, painters could build up deep tones through repeated glazing. Unlike tempera, whose surface dries quickly due to water evaporation, oils dry more uniformly and slowly, providing the artist time to rework areas. This flexibility must have been particularly appealing to artists who worked very deliberately, such as Leonardo da Vinci (Chapter 17, pages 524–30). Leonardo also preferred oil paint because its gradual drying process and consistency permitted him to blend the pigments, thereby creating the impressive *sfumato* (smoky effect) that contributed to his fame.

Both tempera and oils can be applied to different surfaces. Through the early sixteenth century, wooden panels served as the foundation for most paintings. Italians painted on poplar, while northern artists used oak, lime, beech, chestnut, cherry, pine, and silver fir. Availability of these timbers determined the wood choice. Linen canvas became increasingly popular in the late sixteenth century. Although evidence suggests that artists did not intend permanency for their early images on canvas, the material proved particularly useful in areas such as Venice where high humidity made fresco unfeasible and warped wood panels. Further, until canvas paintings were stretched on wooden stretcher bars before framing or affixed to a surface, they were more portable than wood panels.

suggests that they remained closed on regular days and were opened on Sundays and feast days. This schedule would have allowed viewers to see both the interior and exterior—differing imagery at various times according to the liturgical calendar.

SEEKING SALVATION AND REDEMPTION The *Ghent Altarpiece* in the Cathedral of Saint Bavo in Ghent (FIG. 15-4) is one of the largest and most admired Flemish altarpieces of the fifteenth century. Jodocus Vyd (Joos Vijd), burgomaster (chief magistrate) of Ghent, and his wife Isabel (Elizabeth) Borluut commissioned this polyptych from JAN VAN EYCK (ca. 1390–1441). Completed in 1432, the *Ghent Altarpiece* functioned as the liturgical centerpiece of the endowment established in the chapel Vyd and Borluut built in the local church dedicated to Saint John the Baptist (now Saint Bavo Cathedral).

Two of the exterior panels of the *Ghent Altarpiece* depict the donors, appropriately, at the bottom. The husband and wife, painted in illusionistically rendered niches, kneel with their hands clasped in prayer. They gaze piously at illusionistic stone sculptures of Ghent's patron saints, Saint John the Baptist and Saint John the Evangelist (who was probably also Vyd's patron saint). An Annunciation scene appears on the upper register, with a careful representation of a Flemish town outside the center panel's painted window. In the uppermost arched panels, van Eyck depicted images of the Old Testament prophets Zachariah and Micah, along with sibyls, classical mythological prophetesses whose writings the Christian Church interpreted as prophesies of Christ.

When opened, the altarpiece (FIG. 15-5) reveals a sumptuous, superbly colored painting of the medieval conception of humanity's Redemption. In the upper register, God the Father—wearing the pope's triple tiara, with a worldly crown at his feet, and resplendent in a deep-scarlet mantle—presides in majesty. To God's right, van Eyck placed the Virgin, represented as the Queen of Heaven, with a crown of twelve stars upon her head. Saint John the Baptist sits to God's left. To either side is a choir of angels and on the right an angel playing an organ. Adam and Eve appear in the far panels. The inscriptions in the arches above Mary and Saint John extol the Virgin's virtue and purity and Saint John's greatness as the forerunner of Christ. The particularly significant inscription above the Lord's head translates: "This is God, all-powerful in his divine majesty; of all the best, by the gentleness of his goodness; the most liberal giver, because of his infinite generosity." The step behind the crown at the Lord's feet bears the inscription: "On his head, life without death. On his brow, youth without age. On his right, joy without sadness. On his left, security without fear." The entire altarpiece amplifies the central theme of salvation—though humans,

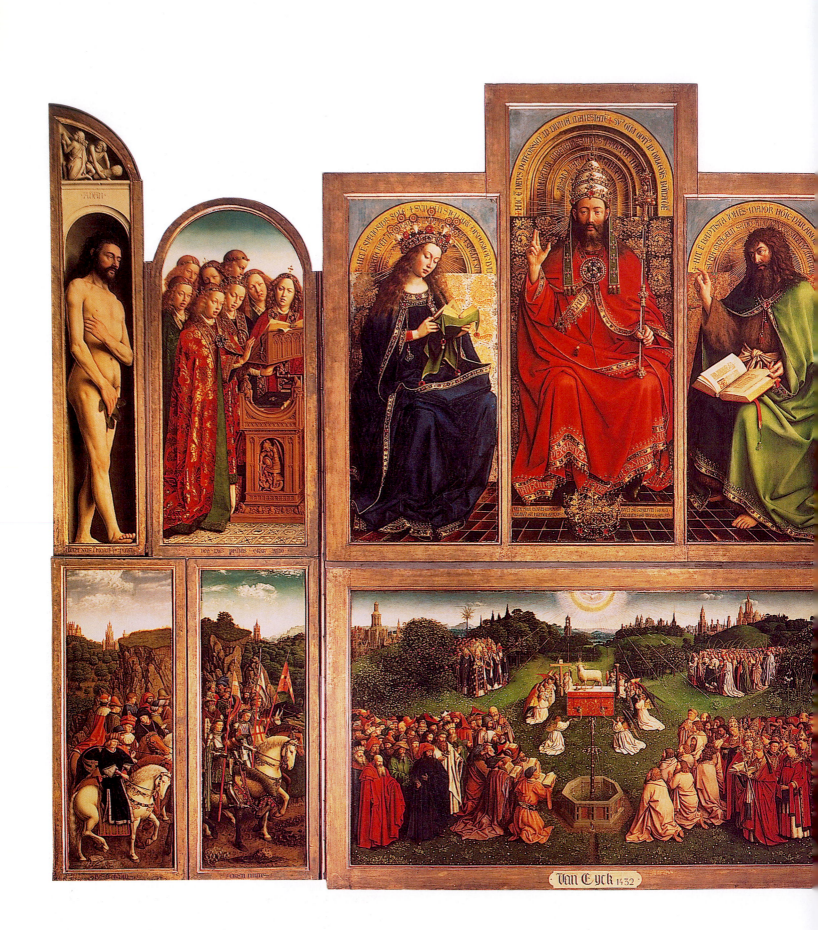

symbolized by Adam and Eve, are sinful, they will be saved because God, in his infinite love, will sacrifice his own son for this purpose.

The lower register panels extend the symbolism of the upper. In the central panel, the community of saints comes from the four corners of the earth through an opulent, flower-spangled landscape. They proceed toward the altar of the Lamb and toward the octagonal fountain of life. The Lamb symbolizes the sacrificed Son of God, whose heart bleeds into a chalice, while into the fountain spills the "pure river of water of life, clear as crystal, proceeding out of the throne of God and of the Lamb" (Rev. 22:1). On the right, the Twelve Apostles and a group of martyrs in red robes advance; on the left appear prophets. In the right background come the Virgin martyrs, and in the left background the holy confessors approach. On the lower wings, other approaching groups symbolize the four cardinal virtues: the hermits, Temperance; the pilgrims, Prudence; the knights, Fortitude; and the judges, Justice. The altarpiece celebrates the whole Christian cycle from the Fall to the Redemption, presenting the Church triumphant in heavenly Jerusalem.

Van Eyck rendered the entire altarpiece in a shimmering splendor of color that defies reproduction. No small detail escaped van Eyck, trained as a miniaturist. With pristine specificity, he revealed the beauty of the most insignificant object as if it were a work of piety as much as a work of art. He depicted the soft texture of hair, the glitter of gold in the heavy brocades, the luster of pearls, and the flashing of gems, all with loving fidelity to appearance.

THE DEVELOPING USE OF OIL PAINTS Oil paints facilitated the exactitude found in the work of van Eyck and others. Although traditional scholarship credited Jan van Eyck with the invention of oil painting, recent evidence has revealed that oil paints were known for some time and that Melchior Broederlam was using oils in the 1390s. Flemish painters built up their pictures by superimposing translucent paint layers, called *glazes,* on a layer of underpainting, which in turn had been built up from a carefully planned drawing made on a white-grounded panel. With the rediscovered medium, painters created richer colors than previously had been possible. Thus, a deep, intense tonality; the illusion of glowing light; and hard enamel-like surfaces characterized fifteenth-century Flemish painting. These traits differed significantly from the high-keyed color, sharp light, and rather matte surfaces of tempera (see "Painters, Pigments, and Panels," page 455).

The brilliant and versatile oil medium suited perfectly the formal intentions of the Flemish painters, who aimed for sharply focused, hard-edged, and sparkling clarity of detail in their representation of thousands of objects ranging in scale from large to almost invisible.

The apprentice training system throughout the continent ensured the transmission of information about surfaces and pigments from generation to generation, thereby guaranteeing the painting tradition's continued viability.

THE DRAMA OF CHRIST'S DEATH Like the art of van Eyck, that of ROGIER VAN DER WEYDEN (ca. 1400–1464) had a great impact on northern painting during the fifteenth century. In particular, Rogier (as scholars refer to

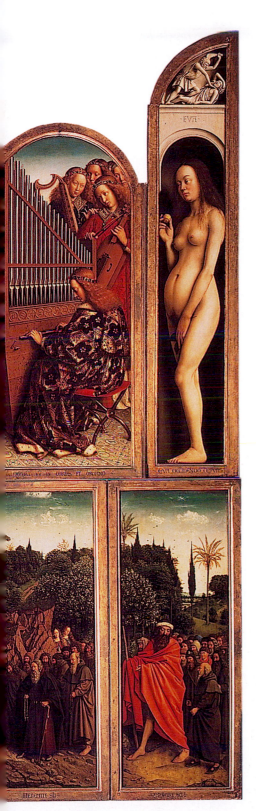

15-5 JAN VAN EYCK, *Ghent Altarpiece* (open), Saint Bavo Cathedral, Ghent, Belgium, completed 1432. Oil on wood, approx. 11′ 6″ × 15′ 1″.

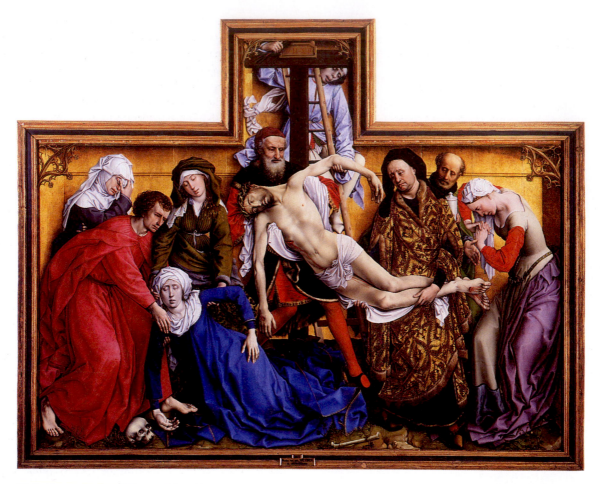

15-6 ROGIER VAN DER WEYDEN, *Deposition,*
from Notre-Dame hors-les-murs, Louvain,
Belgium, ca. 1435. Oil on wood, approx.
7′ 3″ × 8′ 7″. Museo del Prado, Madrid.

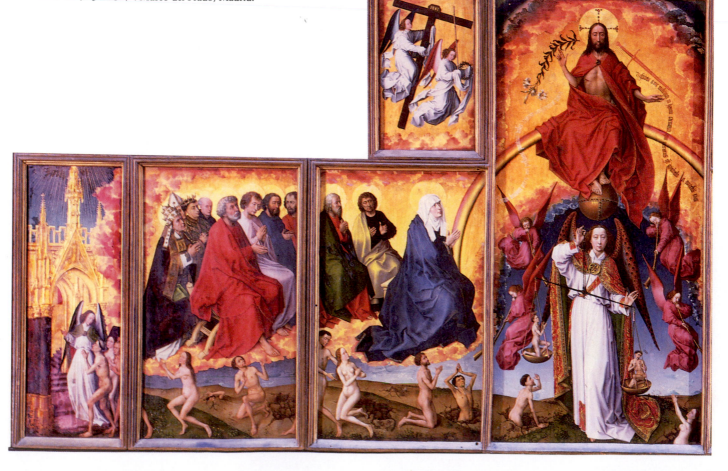

him) created fluid and dynamic compositions stressing human action and drama. He concentrated on themes such as the Crucifixion and the Pietà, moving observers emotionally by relating the sufferings of Christ.

Deposition (FIG. **15-6**) was the center panel of a *triptych* (three-paneled painting) the Archers' Guild of Louvain commissioned for the church of Notre Dame hors-les-murs in Louvain. Rogier acknowledged the patrons of this large painting by incorporating the crossbow (the guild's symbol) into the decorative spandrels in the corners.

This altarpiece nicely sums up Rogier's early style and content. Instead of creating a deep landscape setting, as Jan van Eyck might have, he compressed the figures and action onto a shallow stage to concentrate the observer's attention. Here, Rogier imitated the large sculptured shrines so popular in the fifteenth century, especially in Germany, and the device admirably serves his purpose of expressing maximum action within a limited space. The painting, with the artist's crisp drawing and precise modeling of forms, resembles a stratified relief carving. A series of lateral undulating movements gives the group a unity, a formal cohesion that Rogier strengthened by psychological means—by the desolating anguish common to all the figures. The similar poses of Christ and the Virgin Mary further unify *Deposition*. Few painters have equaled Rogier in the rendering of passionate sorrow as it vibrates through a figure or distorts a tear-stained face. His depiction of the agony of loss is among the most authentic in religious art. The emotional impact on viewers is immediate and direct.

SAVING LIVES AND SOULS IN A HOSPITAL

Rogier further demonstrated his immense talent at orchestrating emotional visualizations in complex compositions in the *Last Judgment Altarpiece* (FIG. **15-7**). Nicholas Rolin, whom Philip the Good had appointed chancellor of the Burgundian territories, commissioned this polyptych. Created for the Hôtel-Dieu (hospital) in Beaune (also founded by Rolin), this image served an important function in the treatment of hospital patients. The public often attributed the horrific medical maladies affecting people of all walks of life to God's displeasure and perceived such afflictions as divine punishment. Thus, the general populace embraced praying to patron saints as a viable treatment component. On the altarpiece's exterior (not illustrated), Rogier depicted Saints Anthony and Sebastian, both considered plague saints—saints whose legends made them appropriate intercessors for warding off or curing the plague. This work served many purposes. It demonstrated Nicholas Rolin's devotion and generosity, aided in patient therapy, and warned of the potential fate of people's souls should they turn away from the Christian Church.

Rogier visualized this warning on the altarpiece's interior (FIG. **15-7**), where he depicted the Last Judgment, a reminder of larger issues beyond earthly life and death—everlasting life or consignment to Hell. A radiant Christ appears in the center panel, above the archangel Michael, who holds the scales to weigh souls. The panels on both sides include numerous saints above the dead, while on the ends viewers witness the Saved ushered into Heaven on the left and the Damned

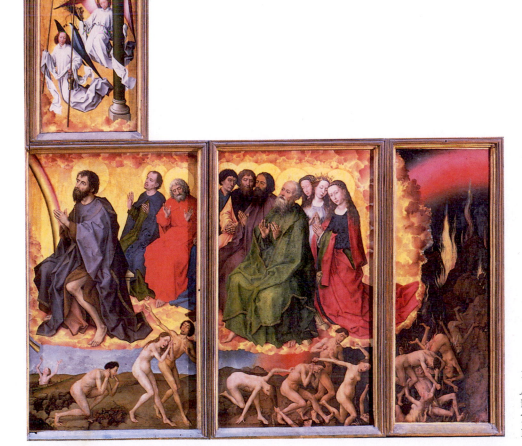

15-7 ROGIER VAN DER WEYDEN, *Last Judgment Altarpiece* (open), Hôtel-Dieu, Beaune, France, ca. 1444–1448. Panel, 7′ 4$\frac{5}{8}$″ × 17′ 11″. Musée de l'Hôtel-Dieu, Beaune.

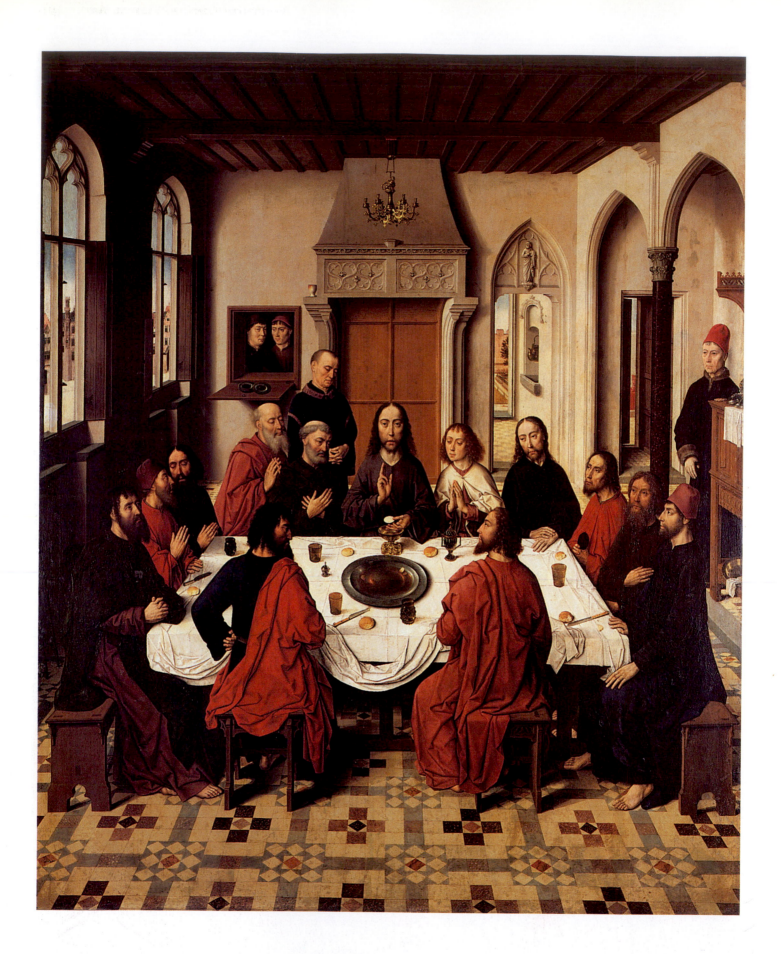

15-8 DIRK BOUTS, *Last Supper* (central panel of the *Altarpiece of the Holy Sacrament*), Saint Peter's, Louvain, Belgium, 1464–1468. Oil on wood, approx. 6′ × 5′.

thrown into the fires of Hell on the right. Because this altarpiece is largely horizontal, relying solely on the common convention of distinguishing the spiritual from the mundane by placing the figures in a vertical hierarchy would not have been very effective. Therefore, Rogier used both hierarchy and scale to emphasize the relative importance of the figures. Christ appears as the largest and highest figure in the altarpiece, while the naked souls are minuscule.

A NEW PERSPECTIVE ON THE LAST SUPPER

Although Rogier may have known about the Italian science of linear perspective, he apparently chose not to use it in his paintings. Recent studies tend to give precedence in this field to Petrus Christus (FIG. 15-14), from whom DIRK BOUTS (ca. 1415–1475) may have acquired his knowledge. In 1464, the Louvain Confraternity of the Holy Sacrament commissioned Bouts's *Altarpiece of the Holy Sacrament*. For a long time, scholars have believed the central panel of this altarpiece, *Last Supper* (FIG. **15-8**), was the first northern painting to demonstrate the use of a single vanishing point for constructing an interior. All of the depicted room's orthogonals lead to a single vanishing point in the center of the mantelpiece above Christ's head. This painting is not only the most successful fifteenth-century northern representation of an interior, but it was also the first northern one whose artist adjusted the figures' scale to correspond to the space they occupy. However, Bouts confined the perspectival unity to single units of space only. The small side room has its own vanishing point, and neither it nor the vanishing point of the main room falls on the horizon of the landscape seen through the windows. Bouts's tentative manner of solving his spatial problems suggests he arrived at his solution independently and that the Italian science of perspective had not yet reached the north, except perhaps in small fragments. Regardless, Bouts's works clearly show that, by midcentury, northern

artists had become involved with the same scientific formal problems that concerned Italian artists during most of the fifteenth century.

Scholars also have noted that Bouts's *Last Supper* was the first Flemish panel painting depicting this event. In this central panel, Bouts did not focus on the biblical narrative itself but instead presented Christ in the role of a priest performing a ritual from the liturgy of the Christian Church — the consecration of the Eucharistic wafer. This contrasts strongly with other Last Supper depictions, which often focused on Judas's betrayal or on Christ's comforting of John. Bouts also added to this image's complexity by including four servants (two in the window and two standing), all dressed in Flemish attire. These servants are most likely portraits of the confraternity's members responsible for commissioning the altarpiece.

FROM FLANDERS TO FLORENCE Flemish altarpieces surfaced in countries outside of Flanders. One large-scale triptych the patron installed in a family chapel in Florence was the *Portinari Altarpiece* (FIG. **15-9**). The artist, HUGO VAN DER GOES (ca. 1440–1482), was dean of the painters' guild of Ghent from 1468 to 1475 and an extremely popular painter.

Hugo painted the triptych for Tommaso Portinari, an Italian shipowner and Medici agent who appears on the wings of the altarpiece with his family and their patron saints. The central panel is titled *Adoration of the Shepherds*. On this large surface, Hugo displayed a scene of solemn grandeur, muting the high drama of the joyous occasion. The Virgin, Joseph, and the angels seem to brood on the suffering to come rather than to meditate on the Nativity miracle. Mary kneels, somber and monumental, on a tilted ground that has the expressive function of centering the main actors. From the right rear enter three shepherds, represented with powerful realism in attitudes

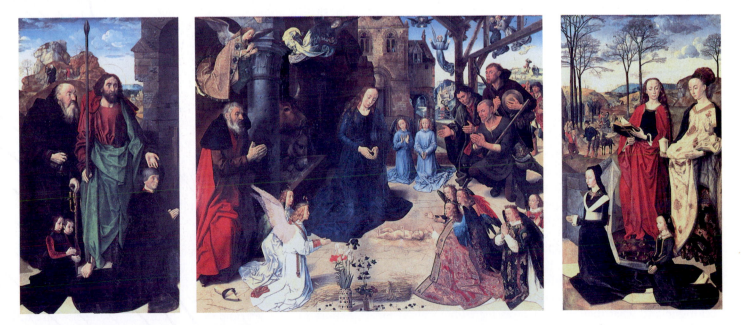

15-9 HUGO VAN DER GOES, *Portinari Altarpiece* (open), from Sant'Egidio, Florence, Italy, ca. 1476. Tempera and oil on wood, 8′ 3½″ × 10′ (center panel), 8′ 3½″ × 4′ 7½″ (each wing). Galleria degli Uffizi, Florence.

MATERIALS AND TECHNIQUES

Edges and Borders
Framing Paintings

Until recent decades, when painters began to complete their works by simply affixing canvas to wooden stretcher bars, artists considered the frame an integral part of the painting. Most fifteenth- and sixteenth-century paintings included elaborate frames that artists helped design and construct. Frames were frequently polychromed (painted) or gilded, adding to the expense. Surviving contracts reveal that as much as half of an altarpiece's cost derived from the frame. For small works, artists sometimes affixed the frames to the panels before painting, creating an insistent visual presence as they worked. Occasionally, a single piece of wood served as both panel and frame, and the artist carved the painting surface from the wood, leaving the edges as a frame.

Larger images with elaborate frames, such as altarpieces, required the services of a woodcarver or stonemason. The painter worked closely with the individual constructing the frame to ensure its appropriateness for the image(s) produced. Indeed, in some of their altarpieces, Giovanni Bellini (see FIG. 17-31) and Andrea Mantegna (Chapter 16, pages 515–18) duplicated the carved pilasters of their architectural frames in their paintings, thereby enhancing the illusion of space. This interest in illusion occasionally extended to the frames. For example, the inscription that seems chiseled into the frame of Jan van Eyck's *Man in a Red Turban* (FIG. 15-15) is actually painted.

Unfortunately, over time, many frames were removed from paintings. For instance, most scholars believe individuals concerned with conserving the *Ghent Altarpiece* (FIG. 15-4) removed its elaborately carved frame and dismantled the altarpiece in 1566 to protect it from Protestant iconoclasts. As ill luck would have it, when the panels were reinstalled in 1587, no one could find the frame, which probably was destroyed. Sadly, the absence of many of the original frames deprives viewers today of the complete artistic vision of painters and, sometimes, of their hired woodcarvers.

of wonder, piety, and gaping curiosity. Their lined plebeian faces, work-worn hands, and uncouth dress and manner seem immediately familiar. The symbolic architecture and a continuous wintry northern landscape unify the three panels. Symbols surface throughout the altarpiece. Iris and columbine flowers symbolize the Sorrows of the Virgin; the fifteen angels represent the Fifteen Joys of Mary; a sheaf of wheat stands for Bethlehem (the "house of bread" in Hebrew), a reference to the Eucharist; and the harp of David, emblazoned over the building's portal in the middle distance (just to the right of the Virgin's head), signifies the ancestry of Christ.

To stress the meaning and significance of the depicted event, Hugo revived medieval pictorial devices. Small scenes shown in the background of the altarpiece represent (from left to right) the Flight into Egypt, the Annunciation to the Shepherds, and the Arrival of the Magi. Hugo's variation in the scale of his figures to differentiate them by their importance to the central event also reflects older traditions. Still, he put a vigorous, penetrating realism to work in a new direction, characterizing human beings according to their social level while showing their common humanity.

After Portinari placed his altarpiece in the family chapel in the Florentine church of Sant'Egidio, it created a considerable stir among Italian artists. Although the painting as a whole may have seemed unstructured to them, Hugo's masterful technique and what they thought of as incredible realism for representing drapery, flowers, animals, and, above all, human character and emotion made a deep impression on them. At least one Florentine artist, Domenico Ghirlandaio, paid tribute to the northern master by using Hugo's most striking motif, the adoring shepherds, in one of his own Nativity paintings.

A CREATOR OF SUMPTUOUS ALTARPIECES The artistic community in Flanders held Hugo's contemporary, HANS MEMLING (ca. 1430–1494), in high esteem as well. Memling specialized in images of the Madonna; the many that survive are slight, pretty, and young princesses, each holding a doll-like infant Christ. A good example of his work is the *Saint John Altarpiece*, the central panel of which is *Virgin with Saints and Angels* FIG. **15-10**). The composition is balanced and serene; the color, sparkling and luminous; and the execution, of the highest technical quality. (Memling's paintings are among the best preserved from the fifteenth century.) The prevailing sense of isolation and the frail, spiritual human types contrast not only with Hugo's monumental and somber forms but also with van Eyck's robust ones. The patrons of this altarpiece—two brothers and two sisters of the Hospital of Saint John order in Bruges—appear on the exterior side panels (not illustrated). In the central panel, two angels, one playing a musical instrument and the other holding a book, flank the Virgin. To the sides of Mary's throne stand Saint John the Baptist on the left and Saint John the Evangelist on the right, and in the foreground are Saints Catherine and Barbara. The altarpiece exudes opulence due to the rich colors,

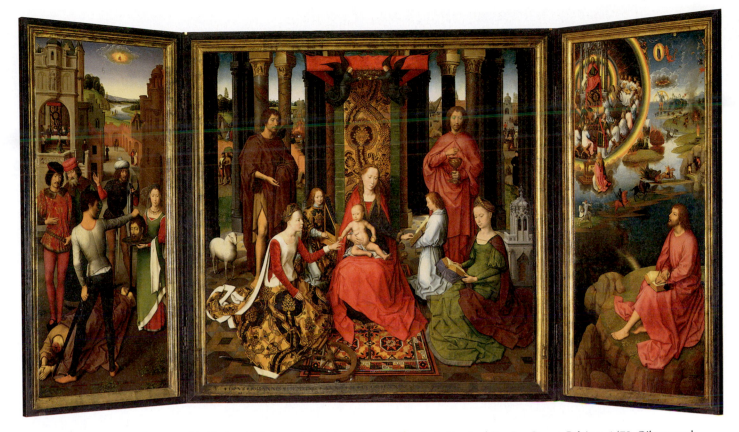

15-10 HANS MEMLING, *Altarpiece of the Virgin with Saints and Angels* (or *Saint John Altarpiece*), Hospitaal Sint Jan, Bruges, Belgium, 1479. Oil on wood, approx. 5′ 7¾″ × 5′ 7¾″ (center panel), 5′ 7¾″ × 2′ 7⅛″ (each wing).

carefully depicted tapestries and brocades, and the serenity of the figures. Works such as this earned Memling the following tribute after his death: "Johannes Memlinc [Memling] was the most accomplished and excellent painter in the entire Christian world."[1]

Private Devotional Imagery

IN THE PRIVACY OF THE HOME The Flemish did not limit their demonstrations of piety to the public realm. Individuals commissioned artworks for private devotional use in the home as well. Dissatisfaction with the clergy accounted, in part, for this commitment to private prayer. In addition, popular reform movements advocated personal devotion. So strong was the impetus for private devotional imagery that it seems, based on extant Flemish religious paintings, that lay patrons outnumbered clerical patrons by a ratio of two to one.

One of the more prominent features of these images commissioned for private use is the intersection of religious and secular concerns. Although the idea, for example, of depicting a biblical scene as transpiring in a Flemish house may seem inconsistent or even sacrilegious, religion was such an integral part of Flemish life that separating the sacred from the secular became virtually impossible. As Johan Huizinga, renowned modern historian on the fifteenth century, describes it:

All life was saturated with religion to such an extent that the people were in constant danger of losing sight of the distinction between things spiritual and things temporal. If, on the one hand, all details of ordinary life may be raised to a sacred level, on the other hand, all that is holy sinks to the commonplace, by the fact of being blended with everyday life . . . the demarcation of the spheres of religious thought and that of worldly concerns was nearly obliterated.[2]

Further, the presentation in religious art of familiar settings and objects no doubt strengthened the direct bond the patron or viewers felt with biblical figures.

THE SYMBOLIC AND THE SECULAR The *Mérode Altarpiece* (FIG. **15-11**) is a good example of a triptych commissioned for private use. Scholars continue to debate the identity of the artist, generally referred to as the "MASTER OF FLÉMALLE." Although many have claimed the artist is Robert Campin (ca. 1378–1444), the leading painter of the city of Tournai, others disagree. Similar in format to large-scale Flemish public altarpieces, the *Mérode Altarpiece* is considerably smaller (the central panel is roughly two feet square), which allowed the owners to close the wings and move the painting when necessary. The popular Annunciation theme (as prophesied in Isa. 7:14) occupies the triptych's central panel. The archangel Gabriel approaches Mary, who sits reading. The artist depicted a well-kept middle-class Flemish home as the site of the event. The carefully rendered architectural scene in the background of the right wing testifies to location.

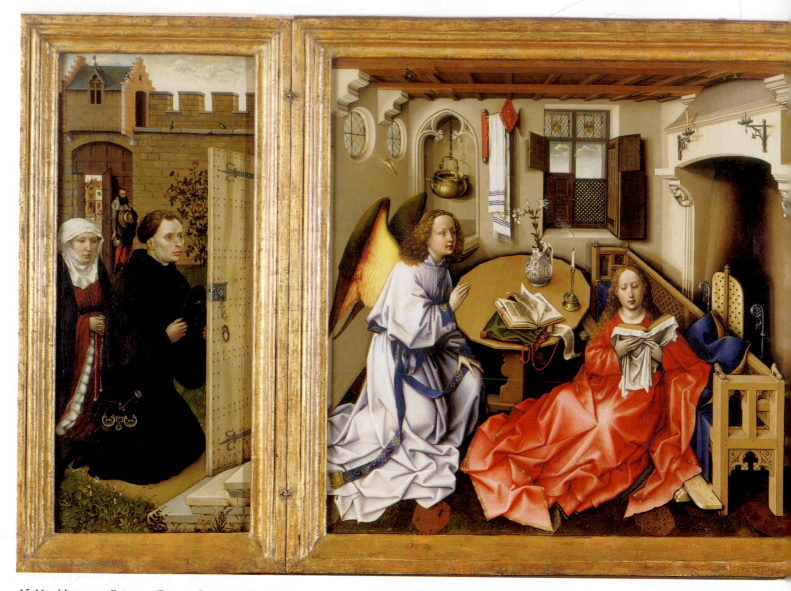

15-11 MASTER OF FLÉMALLE (ROBERT CAMPIN?), *Mérode Altarpiece* (open), *The Annunciation* (center panel), ca. 1425–1428. Oil on wood, center panel approx. 2′ 1″ × 2′ 1″. Metropolitan Museum of Art, New York (The Cloisters Collection, 1956).

The Master of Flémalle included accessories, furniture, and utensils to reinforce the setting's identification. However, the objects represented are not merely decorative. They also function as religious symbols, thereby reminding viewers of the event's miraculous nature. The book, extinguished candle, lilies, copper basin (in the corner niche), towels, fire screen, and bench symbolize, in different ways, the Virgin's purity and her divine mission. In the right panel, Joseph has made a mousetrap, symbolic of the theological tradition that Christ is bait set in the trap of the world to catch the Devil. The painter completely inventoried a carpenter's shop. The ax, saw, and rod in the foreground are not only tools of the carpenter's trade but also are mentioned in Isaiah 10:15. In the left panel, the altarpiece's donor, Peter Inghelbrecht (Engelbrecht), and his wife kneel and seem to be permitted to witness this momentous event through an open door. The Inghelbrechts, a devout, middle-class couple, appear in a closed garden, symbolic of Mary's purity, and the flowers depicted—strawberries, violets, and plantains—all relate to Mary's virtues, especially humility.

The careful conceptualization of this entire altarpiece is further suggested by the fact the Annunciation theme also refers to the patron's name—Engelbrecht ("angel bringer")—and the workshop scene in the right panel also refers to his wife's name, Schrinmechers ("shrine maker").

FOR BETTER, FOR WORSE The intersection of the secular and the religious in Flemish painting also surfaces in Jan van Eyck's double portrait *Giovanni Arnolfini and His Bride* (FIG. 15-12). Van Eyck depicted the Lucca financier (who had established himself in Bruges as an agent of the Medici family) and his betrothed in a Flemish bedchamber that is simultaneously mundane and charged with the spiritual. As in the *Mérode Altarpiece,* almost every object portrayed conveys the event's sanctity, specifically, the holiness of matrimony. Arnolfini and his bride, Giovanna Cenami, hand in hand, take the marriage vows. The cast-aside clogs indicate this event is taking place on holy ground. The little dog symbolizes fidelity (the common canine name Fido originated from the Latin *fido,* "to trust"). Behind the pair,

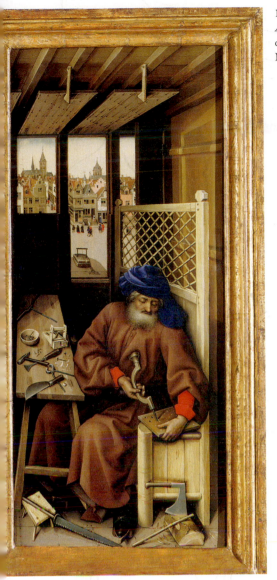

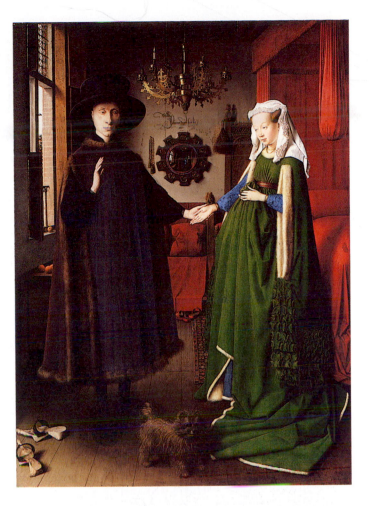

15-12 JAN VAN EYCK, *Giovanni Arnolfini and His Bride,* 1434. Oil on wood, approx. 2′ 8″ × 1′ 11½″. National Gallery, London.

15-13 JAN VAN EYCK, detail of *Giovanni Arnolfini and His Bride,* 1434.

the curtains of the marriage bed have been opened. The bedpost's *finial* (crowning ornament) is a tiny statue of Saint Margaret, patron saint of childbirth. From the finial hangs a whisk broom, symbolic of domestic care. The oranges on the chest below the window may refer to fertility, and the all-seeing eye of God seems to be referred to twice. It is symbolized once by the single candle burning in the left rear holder of the ornate chandelier and again by the mirror, where viewers see the entire room reflected (FIG. **15-13**). The small medallions set into the mirror's frame show tiny scenes from the Passion of Christ and represent God's ever-present promise of salvation for the figures reflected on the mirror's convex surface.

Flemish viewers would have been familiar with many of the objects included in *Giovanni Arnolfini and His Bride* because of traditional Flemish customs. Husbands traditionally presented brides with clogs, and the solitary lit candle in the chandelier was also part of Flemish marriage practices. Van Eyck's placement of the two figures suggests conventional gender roles—the woman stands near the bed and well into the

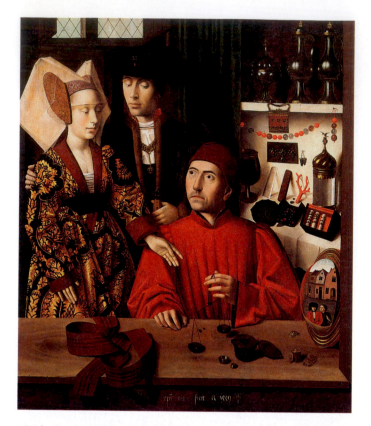

15-14 PETRUS CHRISTUS, *A Goldsmith in His Shop, Possibly Saint Eligius*, 1449. Oil on wood, approx. 3′ 3″ × 2′ 10″. Metropolitan Museum of Art, New York (the Robert Lehman Collection, 1975).

this painting and the scene depicted. Although the couple's presence suggests a marriage portrait, most scholars believe the goldsmiths' guild in Bruges commissioned this painting. Saint Eligius was the patron saint of gold- and silversmiths, blacksmiths, and metalworkers, all of whom shared a chapel in a building adjacent to their meetinghouse. This painting thus seems to fit into the tradition of vocational paintings produced for installation in guild chapels.

In *A Goldsmith in His Shop, Possibly Saint Eligius,* a goldsmith sits in his stall, showing an elegantly attired couple a selection of rings. The bride's betrothal girdle lies on the table, and the woman reaches for the ring the goldsmith weighs. The carefully depicted objects on the right side of the painting refer to the goldsmith's trade. The raw materials—precious stones, beads, crystal, coral, and seed pearls—are scattered among finished products, including rings, buckles, and brooches. Christus also meticulously painted the convex mirror in the foreground, which extends the painting's space into that of viewers, creating a greater sense of involvement.

A Goldsmith in His Shop, like the Arnolfini wedding portrait, incorporates both secular and religious elements. While focusing on an economic transaction and the goldsmith's profession, it calls attention to the sacrament of marriage and includes items such as a crystal container for Eucharistic wafers. Further, the artist's presentation of the goldsmith holding the scales easily could be read as a reference to the Last Judgment.

room, while the man stands near the open window, symbolic of the outside world.

Van Eyck enhanced the documentary nature of this painting by exquisitely painting each object. He carefully distinguished textures and depicted the light from the window on the left reflecting off various surfaces. The artist augmented the scene's credibility by including the convex mirror (FIG. 15-13), because viewers can see not only the principals, Arnolfini and his wife, but also two persons who look into the room through the door. One of these must be the artist himself, as the florid inscription above the mirror, "Johannes de Eyck fuit hic," announces he was present. The picture's purpose, then, seems to have been to record and sanctify this marriage. Although this has been the traditional interpretation of this image, some scholars recently have taken issue with this reading, suggesting that Arnolfini is conferring legal privileges on his wife to conduct business in his absence. Despite the lingering questions about the precise purpose of *Giovanni Arnolfini and His Bride,* the painting provides viewers today with great insight into both van Eyck's remarkable skill and Flemish life in the fifteenth century.

A GOLDEN MOMENT Like van Eyck's double portrait, *A Goldsmith in His Shop, Possibly Saint Eligius* (FIG. **15-14**) by PETRUS CHRISTUS (ca. 1410–1472) involves a couple and the holy sacrament of matrimony. Scholars know little of Christus's life, except that he may have been van Eyck's student and that he settled and worked in Bruges. As with many Flemish artworks, uncertainties remain about why Christus produced

Portraiture

MEETING THE VIEWER'S GAZE Despite the overwhelming incorporation of religion into Flemish everyday lives, the increasing prosperity produced by the economy's mercantilist orientation led some individuals to commission nonreligious landscapes and portraits. Two Flemish works shown so far, the *Ghent Altarpiece* (FIG. 15-4) and the *Mérode Altarpiece* (FIG. 15-11), include painted portraits of their donors. These paintings marked a significant revival of portraiture, a genre that had languished since antiquity. Jan van Eyck's *Man in a Red Turban* (FIG. **15-15**) is a completely secular portrait without the layer of religious interpretation common to Flemish painting. In this work (possibly a self-portrait), the image of a living individual apparently required no religious purpose for being—only a personal one. These private portraits began to multiply as both artists and patrons became interested in the reality (both physical and psychological) they revealed. As human beings confronted themselves in painted portraits, they objectified themselves as people. In this confrontation, the otherworldly anonymity of the Middle Ages faded away. The man van Eyck portrayed looks directly at viewers or, perhaps, at himself in a mirror. So far as studies show, this was the first Western painted portrait in a thousand years to do so. The level composed gaze, directed from a true three-quarter head pose, must have impressed observers deeply. The painter created the illusion that from whatever angle a viewer observes the face, the eyes return that gaze. Van Eyck, with his considerable observational skill and controlled painting style, injected a heightened sense of specificity to this portrait by including veins in the bloodshot left eye, the beard stubble, and the weathered and aged skin.

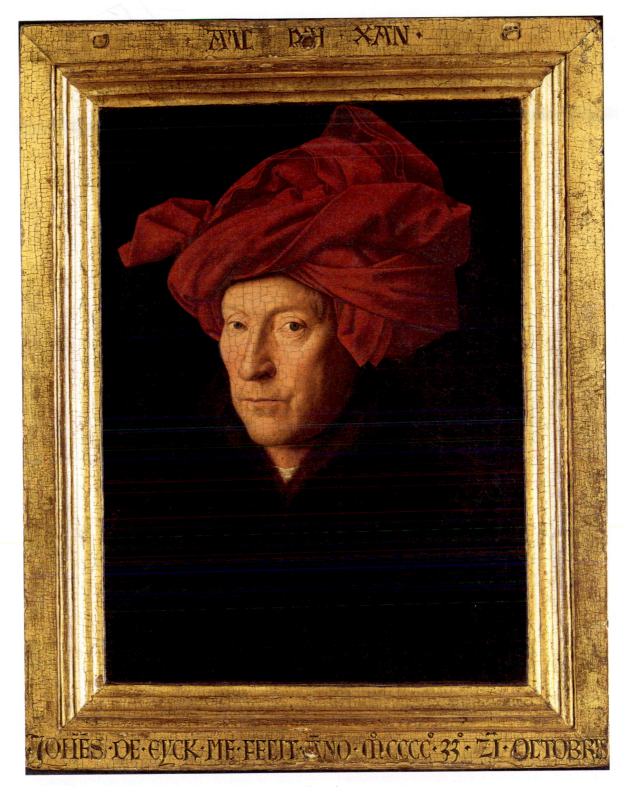

15-15 JAN VAN EYCK, *Man in a Red Turban*, 1433. Oil on wood, approx. $10\frac{1}{4}'' \times 7\frac{1}{2}''$. National Gallery, London.

Although a definitive identification of the sitter has yet to be made, the possibility *Man in a Red Turban* is a self-portrait seems reinforced by the frame's inscriptions (see "Edges and Borders: Framing Paintings," page 462). Across the top, van Eyck wrote "As I can" in Flemish using Greek letters, and across the bottom in Latin appears the statement "Jan van Eyck made me" and the date.

Admired artists, such as van Eyck, established portraiture among their principal tasks. Great patrons embraced the opportunity to have their likenesses painted for various reasons. They wanted to memorialize themselves in their dynastic lines; to establish their identities, ranks, and stations by images far more concrete than heraldic coats of arms; or to represent themselves at state occasions when they could not attend. They even used such paintings when arranging marriages. Royalty, nobility, and the very rich would send painters to "take" the likeness of a prospective bride or groom. Evidence reveals that when young King Charles VI of France sought a bride, a painter journeyed to three different royal courts to make portraits of the candidates for the king to use in making his choice.

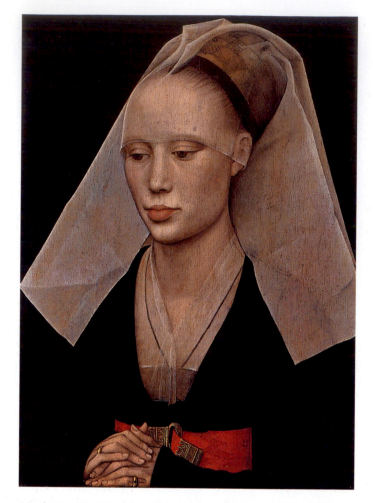

15-16 ROGIER VAN DER WEYDEN, *Portrait of a Lady,* ca. 1460. Oil on panel, 1′ 1⅜″ × 10 1/16″. National Gallery, Washington (Andrew W. Mellon Collection).

CAPTURING CLASS AND CHARACTER The commission details for Rogier van der Weyden's portrait of an unknown young lady (FIG. 15-16) remain unclear. Her dress and bearing imply noble rank. The artist provided viewers with a portrait that not only presented a faithful likeness of her somewhat plain features but also revealed her individual character. Her lowered eyes, tightly locked thin fingers, and fragile physique bespeak an introverted and devout personality. Rogier's honesty and directness, typical in the Flemish artist's approach, reveal much, despite the woman's reserved demeanor. This style contrasted with the formal Italian approach (see FIG. 16-30), derived from the profiles common to coins and medallions, which was sterner and conveyed little of the sitter's personality. Rogier was perhaps chief among the Flemish in his penetrating readings of his subjects, and, as a great pictorial composer, he made beautiful use here of flat, sharply pointed angular shapes that so powerfully suggest the rigidity of this subject's personality. Unlike Jan van Eyck, Rogier placed little emphasis on minute description of surface detail. Instead, he defined large, simple planes and volumes, achieving an almost "abstract" effect, in the modern sense, of dignity and elegance.

An Enigmatic Flemish Painter

LOVE AND MARRIAGE OR SEX AND SIN? Although certain themes in and genres of painting emerged so frequently during the fifteenth century in Flanders as to qualify as conventions, this country also produced one of the most fascinating and puzzling painters in history, HIERONYMUS BOSCH (ca. 1450–1516). Interpretations of Bosch differ widely. Was he a satirist, an irreligious mocker, or a pornographer? Was he a heretic or an orthodox fanatic like Girolamo Savonarola, his Italian contemporary? Was he obsessed by guilt and the universal reign of sin and death?

Bosch's most famous work, the so-called *Garden of Earthly Delights* (FIG. 15-17), is also his most enigmatic, and no interpretation of it is universally accepted. This large-scale work takes the familiar form of a triptych. More than seven feet high, the painting extends to more than twelve feet wide when opened. This triptych format seems to indicate a religious function for this work, but documentation reveals that *Garden of Earthly Delights* resided in the palace of Henry III of Nassau, regent of the Netherlands, seven years after its completion. This suggests a secular commission for private use. Scholars have proposed that such a commission, in conjunction with the central themes of marriage, sex, and procreation, points to a wedding commemoration, which, as seen in *Giovanni Arnolfini and His Bride* and in *A Goldsmith in His Shop, Possibly Saint Eligius,* was not uncommon. Any similarities between these paintings end there, however. While van Eyck and Christus grounded their depictions of betrothed couples in contemporary Flemish life and custom, Bosch's image portrays a visionary world of fantasy and intrigue.

In the left panel, God presents Eve to Adam in a landscape, presumably the Garden of Eden. Bosch complicated his straightforward presentation of this event by placing it in a wildly imaginative setting that includes an odd pink fountain-like structure in a body of water and an array of fanciful and unusual animals, which may hint at an interpretation involving alchemy—the medieval study of seemingly magical changes, especially chemical changes. The right panel, in contrast, bombards viewers with the horrors of Hell. Beastly creatures devour people, while others are impaled or strung on musical instruments, as if on a medieval rack. A gambler is nailed to his own table. A spidery monster embraces a girl while toads bite her. A sea of inky darkness envelops the entire range of horror. Observers must search through the hideous enclosure of Bosch's Hell to take in its fascinating though repulsive details.

Sandwiched between Paradise and Hell is the huge central panel, with nude people blithely cavorting in a landscape dotted with bizarre creatures and unidentifiable objects. The prevalence of fruit and birds (fertility symbols) throughout the scene suggests procreation, and, indeed, many of the figures are paired off as couples. The orgiastic overtones of *Garden of Earthly Delights,* in conjunction with the terrifying image of Hell, have led some scholars to interpret this triptych, like other Last Judgment images, as a warning to viewers of the fate awaiting the sinful, decadent, and immoral.

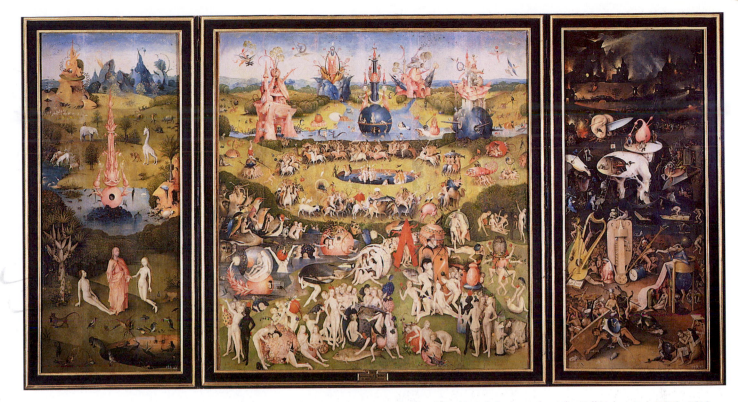

15-17 HIERONYMUS BOSCH, *Garden of Earthly Delights. Creation of Eve* (left wing), *Garden of Earthly Delights* (central panel), *Hell* (right wing), 1505–1510. Oil on wood, center panel 7′ 2⅝″ × 6′ 4¾″. Museo del Prado, Madrid.

FIFTEENTH-CENTURY FRENCH ART

In France, the Hundred Years' War decimated economic enterprise and prevented stability. The anarchy of war and the weakness of the kings gave rise to a group of duchies, each with significant power. The strongest of these, as mentioned earlier, was the Duchy of Burgundy. Despite this instability, French artists joined the retinues of the wealthiest nobility, the dukes of Berry, Bourbon, and Nemours and sometimes the royal court, where they could continue to develop their art.

PORTRAYING THE PIOUS Images for private devotional use were popular in France, as in Flanders. Among the French artists whose paintings were in demand was JEAN FOUQUET (ca. 1420–1481), who worked for King Charles VII (the patron and client of Jacques Coeur; FIG. 13-30) and for the duke of Nemours. Fouquet painted the portrait of Étienne Chevalier with his patron saint, Saint Stephen (FIG. 15-18), in a format commonly referred to as a donor portrait because an individual commissioned (or "gave") the portrait as evidence of devotion. The kneeling donor with his standing saint recalls Flemish art, as do the three-quarter stances and the sharp, clear focus of the portraits. Despite lowly origins, Chevalier elevated himself in French society, and in 1452 King Charles VII named him treasurer of France. In *Étienne Chevalier and Saint Stephen,* the donor appears appropriately devout. The artist depicted the saint holding the stone of his martyrdom (death by stoning) atop a volume of the Scriptures, ensuring viewer identification. Fouquet rendered the entire image in meticulous detail and included a highly ornamented architectural setting.

The parallels between this French portrait and Flemish painting also include the format; this panel was originally half of a diptych. The panels were separated some time ago, and each now resides in a different museum—one in Berlin, the other in Antwerp. The second panel, not illustrated here, depicts the Virgin Mary and Christ Child. As with the *Mérode Altarpiece,* the juxtaposition of these two panels allowed the patron to bear witness to the sacred.

A PROVENÇAL PIETÀ A French artist produced the *Avignon Pietà* (FIG. 15-19) in Provence, in the extreme south of France. Traditional scholarship has identified ENGUERRAND QUARTON (CHARONTON; ca. 1410–1466) as the artist. The *Avignon Pietà* resided, at one time, in the Chartreuse du Val de Bénédiction (the church of the Carthusians) in Villeneuve; the Carthusians supported the Avignon pope during the Great Schism. This documented placement of *Pietà* in this church thus contributes to the attribution of this work to Enguerrand Quarton, who produced other major works there. Despite this connection, much skepticism remains about the attribution.

Rogier van der Weyden's *Deposition* (FIG. 15-6) might come to mind quickly when viewing *Pietà.* Here, however, the artist chose a much more subdued, almost monochromatic, color scheme, and, unlike Rogier's placement of the figures in a box-like setting, this scene occurs in an ill-defined landscape with buildings in the far distance. The donor (whose identity remains unknown), a familiar presence in fifteenth-century depictions of sacred events, kneels at the left. His is a strikingly characteristic portrait, the face gnarled, oaken, and ascetic. The luminous gold background the artist silhouetted the figures against and incised the halos into recalls Byzantine art.

15-18 JEAN FOUQUET, *Étienne Chevalier and Saint Stephen* (from a diptych now divided), ca. 1450. Oil on wood, 3′ ½″ × 2′ 9½″. Gemäldegalerie, Staatliche Museen, Berlin.

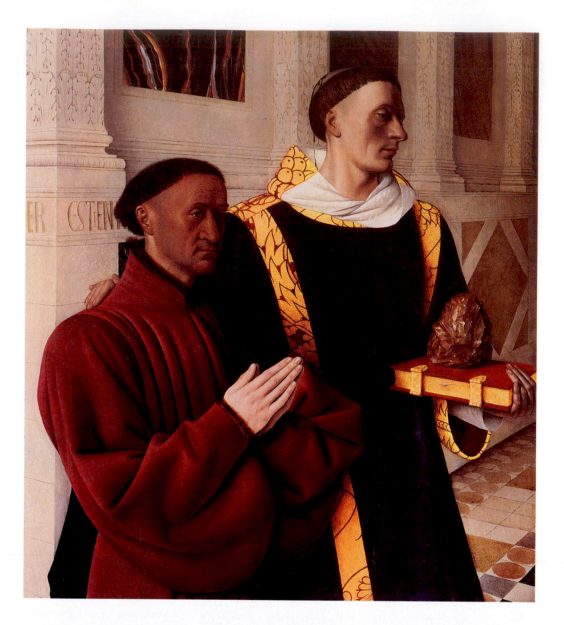

15-19 The *Avignon Pietà,* attributed to ENGUERRAND QUARTON (CHARONTON), ca. 1455. Oil on wood, approx. 5′ 4″ × 7′ 2″. Louvre, Paris.

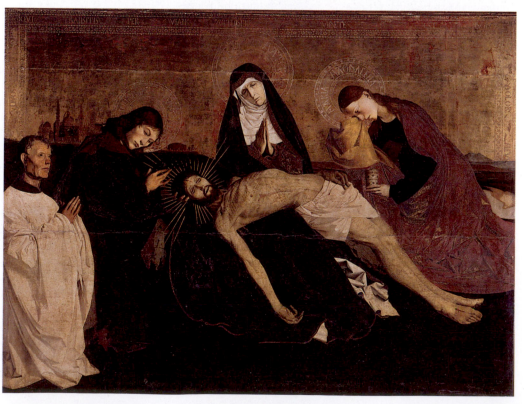

FIFTEENTH-CENTURY GERMAN ART

While the exclusive authority of the "new monarchies" in France, England, and Spain fostered cohesive and widespread developments in the arts of those countries, the lack of a strong centralized power in the Holy Roman Empire (whose core was Germany) led to provincial artistic styles that the strict guild structure perpetuated. Because the Holy Roman Empire did not participate in the long, drawn-out saga of the Hundred Years' War, its economy was stable and prosperous. Thus, in the absence of a dominant court culture to commission artworks and due to the flourishing of the middle class, wealthy merchants and clergy became the primary German patrons during the fifteenth century.

The geographic proximity of the Holy Roman Empire to Flanders (particularly the Duchy of Burgundy) nurtured artistic dialogue between artists of the two countries. A comparison of two German paintings of the Madonna, one earlier in the century (ca. 1430) and the other later (1473), will demonstrate the degree to which Flemish painting influenced German artists.

German Piety

A ROSE AMONG THORNS Most of the early years of STEPHAN LOCHNER (ca. 1400–1451) remain a mystery. Scholars have documented his artistic activity in Cologne in 1440, and by 1447 he had accrued sufficient respect to be named city councilor, representing the painters' guild.

15-21 MARTIN SCHONGAUER, *Madonna and Child in a Rose Arbor,* church of Saint Martin, Colmar, France, 1473. Oil on wood, 6′ 6¾″ × 3′ 9¼″.

15-20 STEPHAN LOCHNER, *Madonna in the Rose Garden,* ca. 1430–1435. Tempera on wood, approx. 1′ 8″ × 1′ 4″. Wallraf-Richartz Museum, Cologne.

Lochner's painting from the 1430s, *Madonna in the Rose Garden* (FIG. **15-20**), presents an extremely popular theme in the Rhineland. The artist depicted the Virgin Mary and Christ Child in a rose arbor, a traditional reference to Mary's holiness ("a rose among thorns") and a symbol of her purity. Lochner presented this subject using stylized conventions. He established a symmetrical and very structured composition, and the exquisite gold background again recalls Byzantine and medieval artworks. His use of established conventions can be attributed, in part, to the new patronage. Wealthy laypeople who desired such images for private devotional purposes or as status symbols relied on a familiar, recognizable iconography and presentation.

A FLEMISH-INFLUENCED PAINTING By the latter part of the century, Flemish artistic ideas had spread throughout Europe, including the Holy Roman Empire. *Madonna and Child in a Rose Arbor* (FIG. **15-21**) by MARTIN SCHONGAUER (ca. 1430–1491) reflects this influence. Although he moved frequently during his career, Schongauer spent a substantial amount of time in Colmar (originally part of western Germany), where he produced this painting for the church of Saint Martin in 1473. The artist represented the same theme as did Lochner, but his figures have a greater physical substance. The work of Dirk Bouts and Rogier van der Weyden surely inspired this treatment of the figures.

15-22 Konrad Witz, *Miraculous Draught of Fish*, from the *Altarpiece of Saint Peter*, from Chapel of Notre-Dame des Maccabées in the Cathedral of Saint Peter, Geneva, Switzerland, 1444. Oil on wood, approx. 4′ 3″ × 5′ 1″. Musée d'art et d'histoire, Geneva.

FISHING IN LAKE GENEVA As in Flanders, large-scale altarpieces were familiar sights in the Holy Roman Empire. Among the most notable of these is the *Altarpiece of Saint Peter* painted in 1444 for the chapel of Notre-Dame des Maccabées in the Cathedral of Saint Peter in Geneva. On one exterior wing of this triptych appears *Miraculous Draught of Fish* (FIG. **15-22**) by the Swiss painter Konrad Witz (ca. 1400–1446). The other exterior wing (not illustrated) depicts the release of Saint Peter from prison. The central panel has been lost, leaving viewers without a major component of this altarpiece. On the interior wings, Witz painted scenes of the Adoration of the Magi and of Saint Peter's presentation of the donor (Bishop François de Mies) to the Virgin and Child. *Miraculous Draught of Fish* is particularly significant because of the landscape's prominence. Witz showed precocious skill in the study of water effects—the sky glaze on the slowly moving lake surface, the mirrored reflections of the figures in the boat, and the transparency of the shallow water in the foreground. He observed and depicted the landscape so carefully that art historians have determined the exact location shown. Witz presented a view of the shores of Lake Geneva, with the town of Geneva on the right and Le Môle Mountain in the distance behind Christ's head. This painting is one of the first fifteenth-century works depicting a specific site.

WITNESSING THE VIRGIN'S ASSUMPTION The works of German artists who specialized in carving large wooden retables (altarpieces) reveal most forcefully the power of the Late Gothic style. The sculptor Veit Stoss (1447–

1533) carved a great altarpiece (FIG. **15-23**) for the church of Saint Mary in Kraków, Poland. In the central boxlike shrine, huge figures (some are nine feet high) represent the Virgin's death and Assumption, and on the wings Stoss portrayed scenes from the lives of Christ and Mary. The altar expresses the intense piety of Gothic culture in its late phase, when artists used every figural and ornamental design resource from the vocabulary of Gothic art to heighten the emotion and to glorify the sacred event's appearance. In *The Death and Assumption of the Virgin*, the disciples of Christ congregate around the Virgin, who sinks down in death. One of them supports her, while another, just above her, wrings his hands in grief. Stoss posed others in attitudes of woe and psychic shock, striving for minute realism in every detail. Moreover, he engulfed the figures in restless, twisting, and curving swaths of drapery whose broken and writhing lines unite the whole tableau in a vision of agitated emotion. The artist's massing of sharp, broken, and pierced forms that dart flame-like through the composition—at once unifying and animating it—recalls the design principles of Late Gothic architecture (see FIG. 13-28). Indeed, in the Kraków altarpiece, Stoss merged sculpture and architecture, enhancing their union with paint and gilding.

AN ORNATE SPIRITUAL VISION Tilman Riemenschneider (ca. 1460–1531) depicted the Virgin's Assumption in the center panel of the *Creglingen Altarpiece* (FIG. **15-24**), created for a parish church in Creglingen. He also incorporated intricate Gothic forms, especially in the altarpiece's elaborate canopy. By employing an endless and rest-

15-23 VEIT STOSS, *The Death and Assumption of the Virgin* (wings open), altar of the Virgin Mary, church of Saint Mary, Kraków, Poland, 1477–1489. Painted and gilded wood, 43′ × 35′.

less line that runs through the draperies of the figures in *The Assumption of the Virgin*, Riemenschneider succeeded in setting the whole design into fluid motion, and no individual element functions without the rest. The draperies float and flow around bodies lost within them, serving not as descriptions but as design elements that tie the figures to one another and to the framework. A look of psychic strain, a facial expression common to Riemenschneider's figures and consonant with the emerging age of disruption, heightens the spirituality of the figures, immaterial and weightless as they appear.

Graphic Art

GOING AGAINST THE GRAIN A new age blossomed in the fifteenth century with a sudden technological advance that shaped human experience—the German invention of the *letterpress,* printing with movable type. Printing had been known in China centuries before but had never developed, as it did in fifteenth-century Europe, into a revolution in written communication and in information generation and management. Printing provided new and challenging media for artists, and the earliest form was the *woodblock* or *woodcut print* (see "Graphic Changes: The Development of Printmaking," page 474). Using a gouging instrument, artists remove sections of wood blocks, sawing along the grain. They ink the ridges that carry the designs, and the hollows remain dry of ink and do not print. Artists produced woodblock prints well before the development of movable-type printing. But when the popularity of books (and accompanying illustrations) necessitated production on a grand

15-24 TILMAN RIEMENSCHNEIDER, *The Assumption of the Virgin,* center panel of the *Creglingen Altarpiece,* parish church, Creglingen, Germany, ca. 1495–1499. Carved lindenwood, 6′ 1″ wide.

MATERIALS AND TECHNIQUES

Graphic Changes
The Development of Printmaking

The popularity of prints over the centuries attests to the medium's enduring appeal. Generally speaking, a print is an artwork on paper, usually produced in multiple impressions. The set of prints an artist creates from a single print surface is often referred to as an *edition*. The printmaking process involves the transfer of ink from a printing surface to paper, which can be accomplished in several ways. During the fifteenth and sixteenth centuries, artists most commonly used the *relief* and *intaglio* methods of printmaking.

Artists produce relief prints by carving into a surface, usually wood. The oldest and simplest of the printing methods, relief printing requires artists to conceptualize their images negatively; that is, they remove the surface areas around the images. Thus, when the printmaker inks the surface, the carved-out areas remain clean, and a positive image results when the artist presses the printing block against paper. Because artists produce *woodcuts* through a subtractive process (*removing* parts of the material), it is difficult to create very thin, fluid, and closely spaced lines. As a result, woodcut prints tend to exhibit stark contrasts and sharp edges (see FIGS. Intro-9, 18-3, and 18-4).

In contrast to the production of relief prints, the intaglio method involves a positive process; the artist incises or scratches an image on a metal plate, often copper. The image can be created on the plate manually (*engraving* or *drypoint*) using a tool (*burin* or *stylus;* see FIGS. 15-26, 16-26, 18-6, 18-7, and 18-9) or chemically (*etching*). In the latter process, an acid bath eats into the exposed parts of the plate where the artist has drawn through an acid-resistant coating. When the artist inks the surface of the intaglio plate and wipes it clean, the ink is forced into the incisions. Then the artist runs the plate and paper through a roller press, and the paper absorbs the remaining ink, creating the print. Because the artist "draws" the image onto the plate, intaglio prints possess a character different from that of relief prints. Engravings, drypoints, and etchings generally present a wider variety of linear effects. They also often reveal to a greater extent evidence of the artist's touch, the result of the hand's changing pressure and shifting directions.

The paper and inks artists use also affect the finished look of the printed image. During the fifteenth and sixteenth centuries, European printmakers had papers produced from cotton and linen rags that papermakers mashed with water into a pulp. The papermakers then applied a thin layer of this pulp to a wire screen and allowed it to dry to create the paper. As contact with the Far East increased, printmakers made greater use of what was called Japan paper (of mulberry fibers) and China paper. Artists, then as now, could select from a wide variety of inks. The type and proportion of the ink ingredients affect the consistency, color, and oiliness of inks, which various papers absorb differently.

The portability of prints—paper is lightweight, and, until recently, the size of presses precluded large prints—has appealed to artists over the years. Further, the opportunity to produce many impressions from the same print surface is an attractive option. Relatively speaking, prints can be sold at cheaper prices than paintings or sculptures, significantly expanding the buying audience. Recently, scholars have attempted to ascertain the production processes, market value, and audience for prints during the fifteenth and sixteenth centuries. The limited amount of extant documentation, however, has hindered these efforts. Regardless, the number and quality of existing prints, both from northern Europe and Italy, attest to the print medium's importance during the Renaissance.

scale, artists met the challenge of bringing the woodcut picture onto the same page as the letterpress.

The illustrations (more than six hundred fifty of them!) for the so-called *Nuremberg Chronicle,* a history of the world produced in the shop of the Nuremberg artist MICHEL WOLGEMUT (1434–1519) document this achievement. The page illustrated (FIG. 15-25) represents Tarvisium, a town in the extreme northeast of Italy (modern Tarvisio), as it was in the "fourth age of the world" (the Latin inscription at top). The blunt, simple lines of the woodcut technique give a detailed perspective of Tarvisium, its harbor and shipping, its walls and towers, its churches and municipal buildings, and the baronial castle on the hill. Despite the numerous architectural structures, historians cannot determine whether this illustration represents the artist's accurate depiction of the city or his fanciful imagination. Artists often reprinted the same image as illustrations of different cities; hence, this depiction of Tarvisium was likely fairly general. Regardless, the work is a monument to a new craft, which expanded in concert with the art of the printed book.

DRAWING ON METAL The woodcut medium hardly had matured when the technique of *engraving* (inscribing on a hard surface) metal, begun in the 1430s and well developed by 1450, proved much more flexible (see "Graphic Changes: The Development of Printmaking," above). Predictably, in the second half of the century, engraving began to replace the woodcut process, both for making book illustrations and for widely popular single prints. Metal engraving produces an *intaglio* (incised) surface for printing, the incised lines (hollows) of the design, rather than the ridges, taking the ink. It is the reverse of the woodcut technique, which produces *rilievo* (relief).

Martin Schongauer was the most skilled and subtle northern master of metal engraving. His *Saint Anthony Tormented by Demons* (FIG. 15-26) shows both the medium's versatility and the artist's mastery of it. The stoic saint is caught in a revolving thornbush of spiky demons, who claw and tear at him furiously. With unsurpassed skill and subtlety, Schongauer created marvelous distinctions of tonal values and textures—from smooth skin to rough cloth, from the furry and feathery to the hairy and scaly. The method of describing forms with

15-25 (Left) MICHEL WOLGEMUT AND SHOP, "Tarvisium," page from the so-called *Nuremberg Chronicle*, 1493. Printed by Anton Koberger.

15-26 (Right) MARTIN SCHONGAUER, *Saint Anthony Tormented by Demons*, ca. 1480–1490. Engraving, approx. 1′ 1″ × 11″. Metropolitan Museum of Art, New York (Rogers Fund, 1920).

hatching that follows them, probably developed by Schongauer, became standard among German graphic artists. The Italians preferred parallel hatching (compare Antonio Pollaiuolo's engraving, FIG. 16-26) and rarely adopted the other method, which, in keeping with the general northern approach to art, tends to describe the surfaces of things rather than their underlying structures.

FIFTEENTH-CENTURY SPANISH ART

Spain's ascent to power in Europe began in the mid-fifteenth century with the marriage of Isabella of Castile (1451–1504) and Ferdinand of Aragon (1452–1516) in 1469. A dynastic union of two rulers, Ferdinand and Isabella worked to strengthen royal control of the Spanish government. Eventually, their descendants became the most powerful monarchs in Europe.

A RETABLE OF MEDIEVAL SPIRITUALITY The ultimate masterpiece of Late Gothic art in Spain is a large, resplendent retable (detail, FIG. **15-27**), the work of the sculptor GIL DE SILOÉ (active 1485–1501). The sculptor's origins remain a mystery, but the inscriptions of his name in documents suggest he might have come from Antwerp or from Orléans in France. His style incorporates mingled Flemish and north German influence, but the uniqueness of his vision is evident. Erected over the high altar of the Cartuja (Carthusian monastery) of Miraflores, near Burgos, the retable incorporates iconography that celebrates the mystery of the Eucharist, the Lord's Supper. Its circular compartments symbolize the holy wafer of the Communion. A great halo of angels encircles the crucified Christ, the retable's centerpiece. God the Father and the personified Holy Spirit support the arms of the cross. Mary and John stand at its foot. Above it perches the pelican, symbol of self-sacrifice. In Gil de Siloé's depiction of the body of the crucified Christ, rising out of the profusion of ministering angels, he rendered a realistic image of supreme anguish. The head expresses the pain, sorrow, and resignation of the Redeemer, who by his atonement for the sins of humanity, conquers Death. This work, created at the end of the fifteenth century, consummately embodies medieval spirituality.

The northern and Spanish art in the fifteenth century was the product of political, religious, social, and economic changes. The scope and focus of the art the Burgundian dukes and the Flemish merchant/bankers commissioned reveals their strength and wealth. This situation did not last long. Charles the Bold, who had assumed the title of duke of Burgundy in 1467, died in 1477, bringing to an end the dominance of the Burgundian Netherlands. France and the Holy Roman Empire divided the Burgundian territories. Eventually, through a series of fortuitous marriages, untimely deaths, and political shifts, Charles I, the grandson of Ferdinand and Isabella of Spain, united the three major dynastic lines—Hapsburg, Burgundian, and Spanish. This made him the most powerful ruler of the sixteenth century.

15-27 GIL DE SILOÉ, *Christ Crucified*, center detail of painted and gilded wooden altarpiece, Carthusian monastery, Miraflores, Spain, 1496–1499.

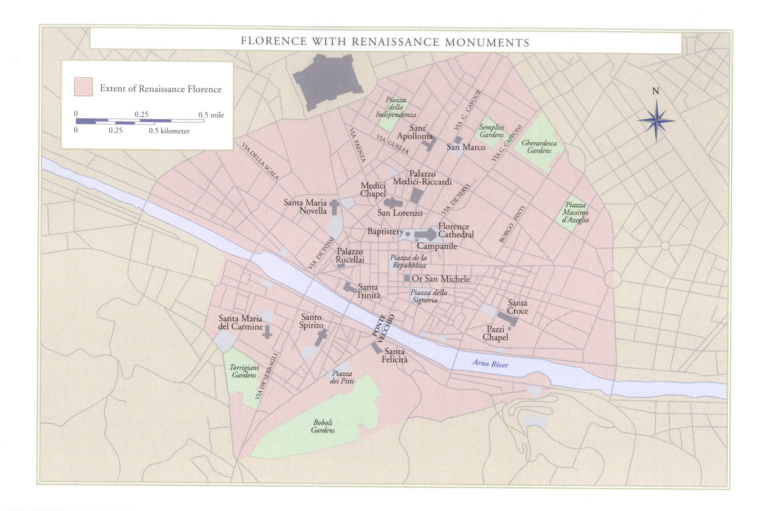

FLORENCE WITH RENAISSANCE MONUMENTS

Extent of Renaissance Florence

0 0.25 0.5 mile
0 0.25 0.5 kilometer

N

Piazza della Indipendenza

Sant' Apollonia

VIA C. CAVOUR

Semplici Gardens

San Marco

VIA G. CAPPONI

Gherardesca Gardens

VIA FAENZA

VIA GUELFA

VIA DELLA SCALA

Palazzo Medici-Riccardi

Medici Chapel

Santa Maria Novella

VIA DE'SERVI

San Lorenzo

Piazza Massimo d'Azeglio

Baptistery

Florence Cathedral

BORGO PINTI

VIA DE'FOSSI

Campanile

Palazzo Rucellai

Piazza de la Repubblica

Or San Michele

Santa Trinità

Piazza della Signoria

Santa Croce

Santa Maria del Carmine

Santo Spirito

PONTE VECCHIO

Pazzi Chapel

Santa Felicità

Arno River

Torrigiani Gardens

VIA DE'SERRAGLI

Piazza dei Pitti

Boboli Gardens

| 1420 | 1425 | 1430 |

EARLY RENAISSANCE

Nanni di Banco, Quattro Santi Coronati, Florence, ca. 1408

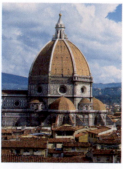

Filippo Brunelleschi Florence Cathedral Dome ca. 1420–1436

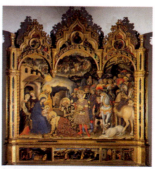

Gentile da Fabriano Adoraton of the Magi Santa Trinità, Florence, 1423

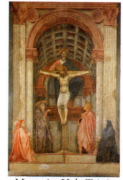

Masaccio, Holy Trinity Santa Maria Novella Florence, ca. 1428

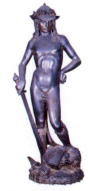

Donatello, David ca. 1428–1432

Giangaleazzo Visconti dies; Milanese armies withdraw from Tuscany, 1402

Battle of San Romano, 1432

King Ladislaus of Naples dies, 1414

End of Great Schism in Catholic Church, 1417

16

HUMANISM AND THE ALLURE OF ANTIQUITY

FIFTEENTH-CENTURY ITALIAN ART

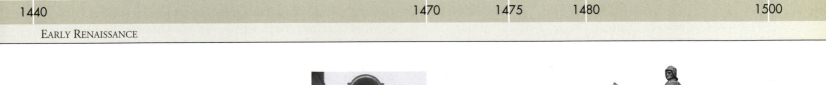

1440		1470	1475	1480		1500

EARLY RENAISSANCE

Uccello, *Battle of San Romano*
Florence, ca. 1455

Leon Battista Alberti
Sant'Andrea, Mantua, ca. 1470

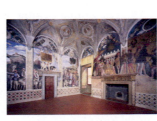

Andrea Mantegna
Camera degli Sposi
Palazzo Ducale, Mantua, 1474

Andrea del Verrocchio
Bartolommeo Colleoni
ca. 1483–1488

Marsilio Ficino, Neo-Platonic philosopher, 1433–1499

Invention of movable metal type by Johann Gutenberg, ca. 1445

Lorenzo de' Medici, 1449–1492

Conquest of Constantinople by Turks, 1453

Medici expelled from Florence, 1494

Girolamo Savonarola assumes
power, 1496; is burned at stake, 1498

France captures Milan, 1499

THE "REBIRTH" OF ITALIAN CULTURE

The fifteenth century in Italy witnessed the flourishing of a significantly new and expanded artistic culture. For this reason, art historians and others often refer to this century as the Early Renaissance (from the French *renaissance* and the Italian *rinascità,* both meaning "rebirth"). Despite the public's enduring fascination with Italian Renaissance art of the fifteenth and sixteenth centuries, this "rebirth" had its roots in the fourteenth century. Thus, many of the developments discussed in Chapter 14 matured into what is generally referred to as the Renaissance. The designation "proto-Renaissance" for describing the fourteenth century indicates its importance in laying down the foundation for subsequent centuries.

Several factors contributed to the rise of Renaissance culture, among them the spread of humanism, political and economic fluctuations throughout Italy, and a fortunate abundance of artistic talent.

THE SPREAD OF HUMANISM
The humanism Petrarch and Boccaccio popularized during the fourteenth century had greater impact as the fifteenth century progressed. Increasingly, Italians embraced the tenets underlying humanism—emphasis on education and on expanding knowledge (especially of classical antiquity), the exploration of individual potential and a desire to excel, and a commitment to civic responsibility and moral duty.

For humanists, the quest for knowledge began with the legacy of the Greeks and Romans—the writings of Plato, Socrates, Aristotle, Ovid, and others. The development of a vernacular (everyday) literature based on the Tuscan dialect expanded the audience for humanist writings. Further, the invention of movable metal type by the German Johann Gutenberg around 1445 facilitated the printing and far-reaching distribution of books. Italians enthusiastically embraced this new printing process; by 1464 Subiaco (near Rome) boasted a press, and by 1469 Venice had established one as well. Among the first books printed in Italy using this new press was Dante's vernacular classic, *The Divine Comedy.* The production of Dante's *Divine Comedy* editions in Foligno (1472), Mantua (1472), Venice (1472), Naples (1477 and 1478–1479), and Milan (1478) testifies to the widespread popularity during the fifteenth century of Dante's tale of Heaven, Purgatory, and Hell. The humanists did not restrict their learning to antique writings, however. They avidly acquired information in a wide range of fields, including science (such as botany, geology, geography, and optics), medicine, and engineering. Leonardo da Vinci's phenomenal expertise in many fields—from art and architecture to geology, aerodynamics, hydraulics, botany, and military science, among many others—explains his uncontested designation as a "Renaissance" man.

ENCOURAGING INDIVIDUAL ACHIEVEMENT
Humanism also fostered a belief in individual potential and encouraged individual achievement. Whereas people in medieval society had relinquished any attempt to change the course of their lives, attributing events to divine will, those in Renaissance Italy adopted a more secular stance. Humanists not only encouraged individual improvement but also re-

warded excellence with fame and honor. Achieving and excelling through hard work became moral imperatives.

GOOD CITIZENS
Despite the emphasis on individualism, humanism also had a civic dimension. Citizen participation in the social, political, and economic life of their communities was obligatory. The intersection of art with humanist doctrines during the Renaissance can be seen in the popularity of subjects selected from classical history or mythology, in the increased concern with developing perspectival systems and depicting anatomy accurately, in the revival of portraiture and other self-aggrandizing forms of patronage, and in citizens' extensive participation in civic and religious art commissions.

OF WEALTH AND POWER
Constant fluctuations in Italy's political and economic spheres contributed to these developments in Renaissance art as well. The shifting power relations among the numerous city-states fostered the rise of princely courts and control of cities by despots. *Condottieri* (military leaders) with large numbers of mercenary troops at their disposal played a major role in the ongoing struggle for power. Princely courts, such as those in Urbino and Mantua, emerged as cultural and artistic centers (see "Dukes, Despots, Fame, and Fortune: The Princely Courts," page 479). Certainly, high-level patronage required significant accumulated wealth, so, during the fifteenth century, individuals and families who had managed to prosper economically came to the fore. Among the best known was the Medici family, which acquired its vast fortune from banking. Not only did this money allow the Medici to wield great power, but it also permitted them to commission art and architecture on a scale rarely seen, then or since. Such lavish patrons of art and learning were the Medici that, to this day, the term "Medici" is widely used to refer to a generous patron of the fine arts.

The Medici, along with many other art patrons, princes, popes, and despots, expressed more than a passing interest in humanism. The association of humanism with education and culture appealed to accomplished individuals of high status.

The historical context that gave rise to this "rebirth" and the importance of patronage account for the character of Renaissance art. In addition, the sheer serendipity of the abundance of exceedingly talented artists also must be considered. Renaissance Italy experienced major shifts in artistic models. In part, these shifts were due to a unique artistic environment where skilled artists, through industriousness and dialogue with others, forever changed the direction and perception of art.

FLORENCE

Sculpture and Civic Pride in the Early Renaissance

The history of the Early Renaissance in art begins with a competition in 1401 for a design for the east doors of the Florence baptistery (see FIG. 12-16). Artists and public alike considered this commission particularly prestigious because of the intended placement of the doors on the baptistery's east side, facing the cathedral entrance. Even at this early date, many of the traits that characterized Renaissance art were evident.

Dukes, Despots, Fame, and Fortune
The Princely Courts

The absence of a single authoritative ruler in Italy and the fragmented nature of the independent city-states provided a fertile breeding ground for the ambitions of the power hungry. Fifteenth-century Italian society witnessed the expansion of princely courts throughout the peninsula. A prince was, in essence, the lord of a territory, and, despite this generic title, he could have been a duke, marquis, cardinal, pope, tyrant, or papal vicar. In the fifteenth century, major princely courts emerged in Milan, Naples, Ferrara, Savoy, Mantua, and papal Rome. Rather than denoting a specific organizational structure or physical entity, the term "princely court" referred to a power relationship between the prince and the territory's inhabitants based on imperial models. Each prince worked tirelessly not just to preserve but also to extend his control and authority, seeking to establish a societal framework of people who looked to him for jobs, favors, protection, prestige, and leadership. The importance of these princely courts derived from their role as centers of power and culture.

The efficient functioning of a princely court required a sophisticated administrative structure. Each prince employed an extensive household staff, ranging from counts, nobles, cooks, waiters, stewards, footmen, stable hands, and ladies-in-waiting to dog handlers, leopard keepers, pages, and runners (who did menial fetching chores). The duke of Milan had more than forty chamberlains to attend to his personal needs alone. Each prince also needed an elaborate bureaucracy to oversee political, economic, and military operations and ensure his continued control. These officials included secretaries, lawyers, captains, ambassadors, and condottieri. Burgeoning international diplomacy and trade made each prince the center of an active and privileged sphere. Their domain extended to the realm of culture, for they saw themselves as more than political, military, and economic leaders. The princes felt responsible for the vitality of cultural life in their territories, and art was a major component for developing a cultured populace. Visual imagery also appealed to them as effective propaganda for reinforcing their control. As undoubtedly the wealthiest individuals in their regions, princes possessed the means to commission numerous artworks and buildings. Thus, art functioned in several capacities—as evidence of princely sophistication and culture, as a form of prestige or commemoration, as public education and propaganda, as a demonstration of wealth, and as a source of visual pleasure.

Princes often researched in advance the reputations and styles of the artists and architects they commissioned. Such assurances of excellence were necessary, because the quality of the work reflected not just on the artist but on the patron as well. Yet despite the importance of individual style, princes sought artists who also were willing, at times, to subordinate their personal styles to work collaboratively on large-scale projects.

Princes bestowed on selected individuals the title of "court artist." Serving as a court artist had its benefits, among them a guaranteed salary (not always forthcoming), living quarters in the palace, and, on occasion, status as a member of the prince's inner circle, perhaps even a knighthood. For artists struggling to elevate their profession from the ranks of craftspeople, working for a prince presented a marvelous opportunity—until the sixteenth century, they were in the same class as small shopkeepers and petty merchants. Indeed, at court dinners, artists most often were seated with other members of the salaried household: tailors, cobblers, barbers, and upholsterers. Thus, the possibility of advancement was a powerful and constant incentive.

Princes demanded a great deal from court artists. Not only did artists create the frescoes, portraits, and sculptures that have become their legacies, but they also designed tapestries, seat covers, costumes, masks, and decorations for various court festivities. Because princes constantly entertained, received ambassadors and dignitaries, and had to maintain a high profile to reinforce their authority, lavish social functions were the norm. Artists often created gifts for visiting nobles and potentates. Recipients judged such gifts on both the quality of the work and the quality of the materials. By using expensive materials—gold leaf, silver leaf, lapis lazuli, silk, and velvet brocade—princes could impress others with their wealth and good taste.

The experiences of court artists varied widely; some princes treated them as mere servants, others as trusted colleagues. At one end of the spectrum was Perino del Vaga, whose life at the papal court biographer Giorgio Vasari described: "[he had] to draw day and night and to meet the demands of the Palace, and, among other things, to make the designs of embroideries, of engravings for banner-makers, and of innumerable ornaments required by the caprice of Farnese and other Cardinals and noblemen. In short, . . . being always surrounded by sculptors, masters in stucco, wood-carvers, seamsters, embroiderers, painters, gilders, and other suchlike craftsmen, he had never an hour of repose."[1] In contrast was Leonardo da Vinci's treatment at the hands of his last patron, King Francis I of France, in whose arms the great artist is said to have died.

For princes who harbored dreams of expanding their control and who wanted to craft suitable legacies, art was indispensable. Hence, the history of Renaissance art cannot be fully understood without serious consideration of courtly culture.

[1] Giorgio Vasari, *Lives of the Painters, Sculptors and Architects,* trans. Gaston du C. de Vere (New York: Alfred A. Knopf, 1996), 2: 184.

These include the development of a new pictorial illusionism, patronage as both a civic imperative and personal promotion, and the esteem increasingly accorded artists.

Andrea Pisano (ca. 1270–1348), unrelated to the thirteenth-century Italian sculptors Nicola (see FIGS. 14-2 and 14-3) and Giovanni (see FIG. 14-4), had designed the south doors of the same structure between 1330 and 1335. In 1401, the Arte di Calimala (wool merchants' guild) sponsored the competition for the second set of doors, requiring each entrant to submit a relief panel depicting the sacrifice of Isaac. This biblical event centers on God's order to Abraham that he sacrifice his son Isaac as a demonstration of Abraham's devotion to God. Just as Abraham is about to comply, an angel intervenes and stops him from plunging the knife into his son's throat.

The selection of this theme may not have been random. In the late 1390s, the despot Giangaleazzo Visconti of Milan began a military campaign to take over the Italian peninsula. By 1401, when the directors of the cathedral's artworks initiated this competition, Visconti's troops had virtually surrounded Florence, and its independence was in serious jeopardy. Despite dwindling water and food supplies, Florentine officials exhorted the public to defend the city's freedom. For example, the humanist chancellor, Coluccio Salutati, whose Latin style of writing was widely influential, urged his fellow citizens to adopt the republican ideal of civil and political liberty associated with ancient Rome and to identify themselves with its spirit. To be Florentine was to be Roman; freedom was the distinguishing virtue of both. Florentine faith and sacrifice were rewarded in 1402, when Visconti died suddenly, ending the invasion threat. The sacrifice of Isaac, with its theme of sacrificing for a higher cause, paralleled the message city officials had conveyed to inhabitants. It is certainly plausible the Arte di Calimala, asserting both its preeminence among Florentine guilds and its civic duty, selected the subject with this in mind.

Those supervising this project selected as semifinalists seven artists from among the many who entered the widely advertised competition for the commission. Only the panels of the two finalists, LORENZO GHIBERTI (1378–1455) and FILIPPO BRUNELLESCHI (1377–1446), have survived. In 1402, the selection committee awarded the commission to Ghiberti. Both artists used the same French Gothic quatrefoil frames Andrea Pisano had used for the baptistery's south doors and depicted the same moment of the narrative—the angel's halting of the action. Examining these two panels provides some stylistic indications of the direction Early Renaissance art was to take during the fifteenth century.

A FATHER'S EMOTIONAL SACRIFICE
Brunelleschi's panel (FIG. **16-1**) shows a sturdy and vigorous interpretation of the theme, with something of the emotional agitation Giovanni Pisano (see FIG. 14-4) favored. Abraham seems suddenly to have summoned the dreadful courage needed to kill his son at God's command—he lunges forward, draperies flying, exposing Isaac's throat to the knife. Matching Abraham's energy, the saving angel darts in from the left, grabbing Abraham's arm to stop the killing. Brunelleschi's figures demonstrate his ability to observe carefully and represent faithfully all of the elements in the biblical narrative.

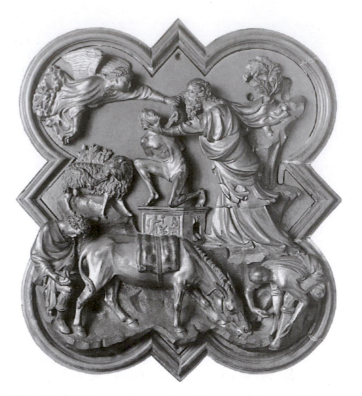

16-1 FILIPPO BRUNELLESCHI, *Sacrifice of Isaac,* competition panel for east doors, baptistery of Florence Cathedral, Florence, Italy, 1401–1402. Gilded bronze relief, 1′ 9″ × 1′ 5″. Museo Nazionale del Bargello, Florence.

A SACRIFICE IN RELIEF Where Brunelleschi imbued his image with dramatic emotion, Ghiberti emphasized grace and smoothness. In Ghiberti's panel (FIG. **16-2**), Abraham appears in the familiar Gothic S-curve pose and seems to contemplate the act he is about to perform, even as he draws his arm back to strike. The figure of Isaac, beautifully posed and rendered, recalls Greco-Roman statuary and could be regarded as the first truly classicizing nude since antiquity. (Compare, for example, the torsion of Isaac's body and the dramatic turn of his head with those of the Hellenistic statue of a Gaul thrusting a sword into his own chest, FIG. 5-80.) Unlike his medieval predecessors, Ghiberti revealed a genuine appreciation of the nude male form and a deep interest in how the muscular system and skeletal structure move the human body. Even the altar on which Isaac kneels displays Ghiberti's emulation of antique models. It is decorated with acanthus scrolls of a type that commonly adorned Roman temple friezes in Italy and throughout the former Roman Empire (see, for example, FIG. 7-30). These classical references reflect humanism's increasing influence.

Ghiberti's training included both painting and goldsmithery. His careful treatment of the gilded bronze surfaces, with their sharply and accurately incised detail, proves his skill as a goldsmith. As a painter, he was interested in spatial illusion. The rocky landscape seems to emerge from the blank panel toward viewers, as does the strongly foreshortened angel. Brunelleschi's image, in contrast, emphasizes the planar orientation of the surface.

That Ghiberti cast his panel in only two pieces (thereby reducing the amount of bronze needed) no doubt impressed the selection committee. Ghiberti's construction method differed from that of Brunelleschi, who built his from several cast

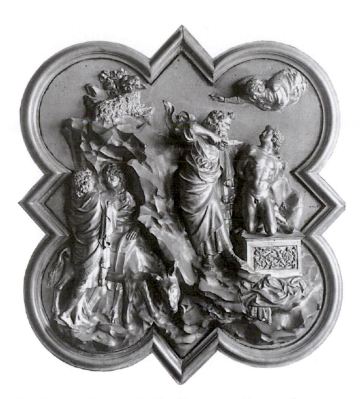

16-2 LORENZO GHIBERTI, *Sacrifice of Isaac,* competition panel for east doors, baptistery of Florence Cathedral, Florence, Italy, 1401–1402. Gilded bronze relief, 1′ 9″ × 1′ 5″. Museo Nazionale del Bargello, Florence.

pieces. Thus not only would Ghiberti's doors, as proposed, be lighter and more impervious to the elements, but they also represented a significant cost savings.

Ghiberti's submission clearly had much to recommend it, both stylistically and technically. Although Ghiberti's image was perhaps less overtly emotional than Brunelleschi's, it was more cohesive and presented a more convincing spatial illusion. Ghiberti further developed these pictorial effects, sometimes thought alien to sculpture, in his later work.

Understandably, the decision to award the commission to Ghiberti crushed Brunelleschi. Antonio Manetti, Brunelleschi's biographer, later claimed that Ghiberti's victory was due to the artist's collusion with the jury. Ghiberti's description of his award reflects the fame and glory increasingly accorded to individual achievement during the Early Renaissance:

> To me was conceded the palm of the victory by all the experts and by all . . . who had competed with me. To me the honor was conceded universally and with no exception. To all it seemed that I had at that time surpassed the others without exception, as was recognized by a great council and an investigation of learned men . . . highly skilled from the painters and sculptors of gold, silver, and marble. There were thirty-four judges. . . . The testimonial of the victory was given in my favor by all. . . . It was granted to me and determined that I should make the bronze door for this church.[1]

Ghiberti completed the twenty-eight door panels depicting scenes from the New Testament in 1424. Church officials eventually decided to move the doors to the baptistery's north side, where they remain today.

A FEAST IN PERSPECTIVE Like Ghiberti, DONA-TELLO (ca. 1386–1466) was another sculptor who carried forward most dramatically the search for innovative forms ca-

pable of expressing the new ideas of the Early Renaissance. Donatello shared the humanist enthusiasm for Roman virtue and form. His greatness lies in an extraordinary versatility and a depth that led him through a spectrum of themes fundamental to human experience and through stylistic variations that express these themes with unprecedented profundity and force. Donatello understood the different aesthetic conventions artists routinely invoked at the time to distinguish their depictions of the real from the ideal and the earthly from the spiritual. His expansive knowledge and skill allowed him to portray this sweeping range with great facility. Further, as an astute observer of human life, Donatello could, with ease, depict figures of diverse ages, ranks, and human conditions, such as childhood, the idealized human nude, practical men of the world, military despots, holy men, derelict prelates, and ascetic old age. Few artists could match this range. That Donatello advanced both naturalistic illusion and classical idealism in sculpture remains a remarkable achievement.

This illusionism, like that Ghiberti pursued in his *Sacrifice of Isaac* panel, is evident in Donatello's bronze relief, *Feast of Herod* (FIG. **16-3**), on the baptismal font in the Siena baptistery. Salome (to the right) still dances (no doubt because she was closely modeled on a series of dancing-maenad reliefs very popular in Roman times), even though she already has delivered the severed head of John the Baptist, which the kneeling executioner offers to King Herod. The other figures recoil in horror into two groups. At the right, one man covers his face with his hand; at the left, Herod and two terrified children shrink back in dismay. The psychic explosion drives the human elements apart, leaving a gap across which the emotional electricity crackles. This masterful stagecraft obscures another drama Donatello was playing out on the stage itself. The *Feast* marked the advent of rationalized perspective space, long prepared for in the proto-Renaissance of fourteenth-century Italy and recognized by Donatello and his generation as a way

16-3 DONATELLO, *Feast of Herod,* from the baptismal font of Siena Cathedral, Siena, Italy, ca. 1425. Gilded bronze relief, approx. 1′ 11″ × 1′ 11″.

MATERIALS AND TECHNIQUES

Depicting Objects in Space
Perspectival Systems in the Early Renaissance

Scholars long have noted the Renaissance fascination with perspective. In essence, portraying perspective involves constructing a convincing illusion of space in two-dimensional imagery while unifying all objects within a single spatial system. Renaissance artists were not the first to focus on depicting illusionistic space; both the Greeks and the Romans were well versed in perspectival rendering. However, the perspectival systems developed during the Renaissance contrasted sharply with the portrayal of space during the preceding medieval period. Those artists, because of the spiritual orientation of much of their art, largely had abandoned any concern for the illusionistic presentation of objects. Renaissance perspectival systems included both linear perspective and atmospheric perspective.

Developed by Brunelleschi, *linear perspective* allows artists to determine mathematically the relative size of rendered objects to correlate them with the visual recession into space. The artist first must identify a horizontal line that marks, in the image, the horizon in the distance (hence the term *horizon line*). The artist then selects a *vanishing point* on that horizon line (often located at the exact center of the line). By drawing *orthogonals* (diagonal lines) from the edges of the picture to the vanishing point, the artist creates a structural grid that organizes the image and determines the size of objects within the image's illusionistic space. Under this system of linear perspective, artists often foreshorten a figure as the body recedes back into an illusionistic space, as seen in Andrea Mantegna's *Dead Christ* (see FIG. 16-50). Among the works that provide clear examples of linear perspective are Masaccio's *Holy Trinity* (FIG. 16-13), Leonardo da Vinci's *Last Supper* (see FIG. 17-3), and Raphael's *School of Athens* (see FIG. 17-17).

Rather than rely on a structured mathematical system (as does linear perspective), *atmospheric perspective* involves optical phenomena. Artists using atmospheric (sometimes called *aerial*) perspective exploit the principle that the farther back the object is in space, the blurrier, less detailed, and bluer it appears. Further, color saturation and value contrast diminish as the image recedes into the distance. Leonardo da Vinci used atmospheric perspective to great effect, as seen in works such as *Virgin of the Rocks* (see FIG. 17-1) and *Mona Lisa* (see FIG. 17-4).

These two methods of creating the illusion of space in pictures are not exclusive, and Renaissance artists often used both to heighten the sensation of three-dimensional space.

to intensify the action's optical reality and the characterization of the actors. Donatello, using pictorial perspective, opened the space of the action well into the distance, showing two arched courtyards and groups of attendants in the background. This penetration of the panel surface by spatial illusion replaced the flat grounds and backdrop areas of the medieval past. Ancient Roman illusionism (compare FIG. 7-16) had returned.

KEEPING PERSPECTIVE Fourteenth-century Italian artists, such as Duccio and the Lorenzetti brothers, had used several devices to indicate distance, but with the invention of "true" linear perspective (a discovery generally attributed to Brunelleschi), Early Renaissance artists acquired a way to make the illusion of distance mathematical and certain (see "Depicting Objects in Space: Perspectival Systems in the Early Renaissance," above). In effect, they thought of the picture plane as a transparent window through which the observers look to see the constructed pictorial world. This discovery was enormously important, for it made possible what has been called the "rationalization of sight." It brought all of our random and infinitely various visual sensations under a simple rule people could express mathematically.

Indeed, the Renaissance artists' *rediscovery* of perspective (principles already known to the ancient Greeks and Romans) reflects the emergence of science itself, which is, put simply, the mathematical ordering of our observations of the physical world. Renaissance artists were often mathematicians, and one modern mathematician asserts that artists did the most creative work in mathematics in the fifteenth century. The observer's position of looking "through" a picture into the painted "world" is precisely that of scientific observers fixing their gazes on the carefully placed or located datum of their research. Of course, Early Renaissance artists were not primarily scientists; they simply found perspective a wonderful way to order and clarify their compositions.

Nonetheless, art viewers cannot doubt that perspective, with its new mathematical certitude, conferred a kind of aesthetic legitimacy on painting by making the picture *measurable* and exact. According to Plato, measure is the basis of beauty. The art of Greece certainly visualized this dictum. In the Renaissance, when humanists rediscovered Plato and eagerly read his works, artists once again exalted the principle of measure as the foundation of the beautiful in the fine arts. The projection of measurable objects on flat surfaces influenced the character of Renaissance paintings and made possible scale drawings, maps, charts, graphs, and diagrams—means of exact representation that made modern science and technology possible. Mathematical truth and formal beauty conjoined in the minds of Renaissance artists.

ADMIRING THE "GATES OF PARADISE" Many artists recognized the significance of Donatello's presentation of illusionistic space. Ghiberti, who demonstrated his interest in perspective in his *Sacrifice of Isaac,* embraced Donatello's innovations. Ghiberti's enthusiasm for a unified system for representing space is particularly evident in his famous east doors (FIG. 16-4) church officials commissioned in 1425 for the baptistery of Florence Cathedral. Michelangelo later declared these as "so beautiful that they would do well for the

16-4 Lorenzo Ghiberti, east doors ("Gates of Paradise"), baptistery, Florence Cathedral, Florence, Italy, 1425–1452. Gilded bronze relief, approx. 17′ high.

gates of Paradise."[2] Three sets of doors provide access to the baptistery (see FIG. 12-16). Andrea Pisano created the first set, on the south side, between 1330 and 1335. Ghiberti's first pair of doors (1403–1424), the result of the competition, was moved to the north doorway so that Ghiberti's second pair of doors (1425–1452) could be placed in the east doorway. In contrast to the south and north doors, Ghiberti abandoned the quatrefoil pattern in these "Gates of Paradise" and reduced the number of panels from twenty-eight to ten (probably due to time constraints). Each of the panels contains a relief set in plain moldings and depicts a scene from the Old Testament. The complete gilding of the reliefs creates an effect of great splendor and elegance.

The individual panels of Ghiberti's east doors, such as *Isaac and His Sons* (FIG. **16-5**), clearly recall painting techniques in their depiction of space as well as in their treatment of the narrative. Some exemplify more fully than painting many of the principles architect and theorist Leon Battista Alberti formulated in his 1435 treatise *On Painting*. In his relief, Ghiberti created the illusion of space partly by pictorial perspective and partly by sculptural means. He represented buildings according to a painter's one-point perspective construction, but the figures (in the bottom section of the relief, which actually projects slightly toward viewers) appear almost in the full round, some of their heads standing completely free. As the eyes progress upward, the relief increasingly flattens, concluding with the architecture in the background, which Ghiberti depicted in barely raised lines. In this manner, the artist created a sort of "sculptor's aerial perspective" with forms appearing less distinct the deeper they are in space. Ghiberti described the east doors as follows:

> I strove to imitate nature as closely as I could, and with all the perspective I could produce [to have] excellent compositions rich with many figures. In some scenes I placed about a hundred figures, in some less, and in some more. I executed that work with the greatest diligence and the greatest love. There were ten stories, all [sunk] in frames because the eye from a distance measures and interprets the scenes in such a way that they appear round. The scenes are in the lowest relief and the figures are seen in the planes; those that are near appear large, those in the distance small, as they do in reality. . . . Executed with the greatest study and perseverance, of all my work it is the most remarkable I have done and it was finished with skill, correct proportions, and understanding.[3]

Thus, like Donatello, Ghiberti harmonized an echo of the ancient and medieval past with the new science—he enhanced "proportions" and "skill" with "understanding." In these panels, Ghiberti achieved a greater sense of depth than had been possible in a relief. His principal figures, however, do not occupy the architectural space he created for them; rather, the artist arranged them along a parallel plane in front of the grandiose architecture. (According to Leon Battista Alberti, in his *De re aedificatoria — On the Art of Building —* the architecture's grandeur reflects the dignity of the events shown in the foreground.) Ghiberti's figure style mixes a Gothic patterning of rhythmic line, classical poses and motifs, and a new realism in characterization, movement, and surface detail. The medieval narrative method of presenting several episodes within a single frame persisted. In *Isaac and His Sons* (FIG.

16-5 LORENZO GHIBERTI, *Isaac and His Sons* (detail of FIG. 21-4), east doors, baptistery, Florence Cathedral, Florence, Italy, 1425–1452. Gilded bronze relief, approx. 2′ 7½″ × 2′ 7½″.

16-5), the group of women in the left foreground attends the birth of Esau and Jacob in the left background; Isaac sends Esau and his hunting dogs on his mission in the central foreground; and, in the right foreground, Isaac blesses the kneeling Jacob as Rebecca looks on (Gen. 25–27). Yet viewers experience little confusion because of Ghiberti's careful and subtle placement of each scene. The figures, in varying degrees of projection, gracefully twist and turn, appearing to occupy and move through a convincing stage space, which Ghiberti deepened by showing some figures from behind. The classicism derives from the artist's close study of ancient art. His biography says he admired and collected classical sculpture, bronzes, and coins. Their influence is seen throughout the panel, particularly in the figure of Rebecca, which Ghiberti based on a popular Greco-Roman statuary type. The beginning of the practice of collecting classical art in the fifteenth century had much to do with the appearance of classicism in Renaissance humanistic art.

FILLING THE NICHES WITH STATUES Ghiberti was just one of numerous artists who acknowledged Donatello's prodigious talent. Donatello's enviable skill at creating visually credible and engaging relief sculptures extended to sculpture in the round. His artistry impressed those in a position to commission art, a fact demonstrated by his participation, along with other esteemed sculptors, such as Ghiberti, in another major civic art program of the early 1400s—the decoration of Or San Michele.

Or San Michele was the early-fourteenth-century building that at various times housed a granary, the headquarters of the guilds, a church, and Orcagna's tabernacle (see FIG. 14-15). After construction of Or San Michele, city officials assigned

RELIGION AND MYTHOLOGY

From San Francisco to São Paulo
The Path to Sainthood

Saints are a ubiquitous element in modern society, surfacing in the names of geographic locations and churches, as well as appearing in artworks. Why is this, and what purpose do saints serve? What is the history of saints, and how does one achieve sainthood?

The word *saint* derives from the Latin word *sanctus,* meaning "made holy to God," or *sacred.* Thus, saints are people who have demonstrated a dedication to God's service. The first saints were martyrs—individuals who had suffered and died for Christianity—selected by public acclaim. The faithful called on these martyrs to intercede on their behalf. By the end of the fourth century A.D., the group of saints expanded to include confessors, individuals who merited honor for the Christian devotion they demonstrated while alive.

A more formal process of canonization emerged in the twelfth century (although the procedures in use today were established in 1634). The Roman Catholic Church derived the term *canonization* from the idea of a canon, or list, of approved saints. Canonization is a lengthy and involved process. Normally several years must pass before the Church will consider a deceased Catholic for sainthood. After a panel of theologians and cardinals of the Congregation for the Causes of Saints thoroughly evaluates the candidate's life, the pope proclaims an approved candidate "venerable" (worthy of reverence). Evidence of the performance of a miracle earns the candidate beatification (from the word *beatus,* meaning "blessed"). After proof of another miracle, the pope canonizes the candidate as a saint.

Despite the concept of a canon, no such thing as an authoritative register of all saints exists. Different groups have compiled various lists. For example, the Roman Martyrology, which is not comprehensive, contains more than forty-five hundred names. Indeed, during John Paul II's papacy alone (1978–), close to three hundred people have been canonized.

The inspiration saints provided and their teaching ability made them popular in art, especially in eras when religion dominated the lives of the populace. This was not idolatry, because viewers did not worship the images. The images simply encouraged and facilitated personal devotion. The pious called on saints to intercede on behalf of sinners (themselves or others).

The faithful admired each saint for certain traits or qualities, often having to do with the particulars of the saint's life or death. For example, the devout remembered Saint Theresa (see FIG. 19-9) for her transverberation (the piercing of her heart by the arrow of Divine Love), while they associated Saint Bartholomew (see FIGS. 17-25 and 19-28) with the manner of his martyrdom (he was flayed alive). Art viewers recognized saints by their attributes. For example, artists usually depicted Saint Sebastian—a Roman guard the emperor Diocletian ordered shot by archers for refusing to deny Christ—bound to a post or tree, his body pierced by numerous arrows. Other saints and their attributes follow:

Saint	*Depicted*
Francis of Assisi (see FIG. 14-1)	In a long robe tied at waist with rope; with stigmata
George (FIG. 16-6), patron saint of soldiers and armorers	As a young knight in armor, with red cross on shield
Peter (see FIG. 18-5)	With keys signifying the power to "bind and loose" (Matt. 16:19)
Jerome (see FIG. 18-21)	As either a scholar at his desk or a hermit in the wilderness
Stephen (see FIGS. 15-18 and 18-27)	With a stone, referring to his death by stoning
Augustine (see FIG. 18-27), patron saint of theologians and scholars	In a mitre (tall pointed hat) and bishop's vestments

each of the niches on the building's exterior to a specific guild for decoration with a sculpture of its patron saint (see "From San Francisco to São Paulo: The Path to Sainthood," above). Most of the niches languished empty. By 1406, guilds had placed statues in only five of the fourteen niches. Between 1406 and 1423, however, guilds filled the nine vacant niches with statues by Donatello, Ghiberti, and Nanni di Banco. How might historians account for this flurry of activity? First, city officials issued a dictum in 1406 requiring the guilds to comply with the original plan and fill their assigned niches. Second, Florence was once again under siege, this time by King Ladislaus (r. 1399–1414) of Naples. Ladislaus had marched north, had occupied Rome and the Papal States by 1409, and then had threatened to overrun Florence. As they had previously, Florentine officials urged citizens to stand firm and defend their city-state from tyranny. As had happened with Visconti a few years earlier, Ladislaus, on the verge of military success in 1414, fortuitously died, and Florence found itself spared yet again. The guilds no doubt viewed this threat as an opportunity to perform their civic duty by rallying their fellow Florentines while also promoting their own importance and position in Florentine society. The early-fifteenth-century niche sculptures thus served various purposes, and their public placement provided an ideal vehicle for presenting political, artistic, and economic messages to a wide audience. Examining a few of these Or San Michele sculptures demonstrates the stylistic and historical significance of all these works.

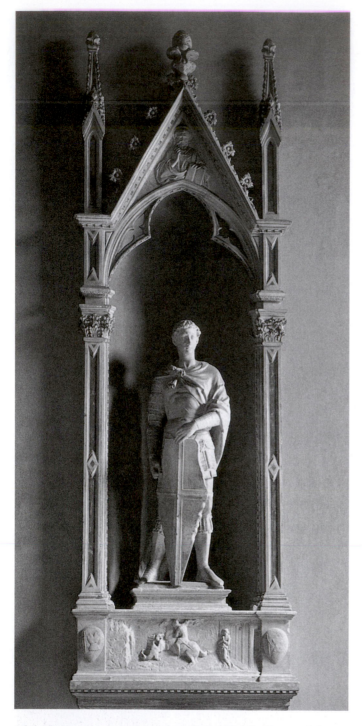

16-6 DONATELLO, *Saint George,* from Or San Michele, Florence, Italy, ca. 1415–1417. Marble (replaced in niche by a bronze copy), approx. 6' 10" high. Museo Nazionale del Bargello, Florence.

metal sword that projected outward from the niche into the street below. The accessories publicly identified both the figure and the guild, and the sword's positioning reinforced a greater physical connection between the warrior-saint and viewers than is evident today. Saint George's head is erect and turned slightly to his left. Beneath the furrowed brows, the dragon slayer's noble features are intent and concentrated. In its regal poise and tense anticipation, the figure contrasts sharply with the facade statues of medieval churches, which, consistent with the spiritual values of the Middle Ages, seem removed from the world and unaware of their surroundings. With *Saint George,* Donatello reasserted the prominence of individual personality that characterized the Early Renaissance in Italy.

Some art historians place *Saint George* within the chivalric traditions of the Late Gothic period; depictions of warrior-knights and knight-saints (such as Saint George and Saint Martin) were common in late medieval art. However, others argue that Donatello's *Saint George,* in addition to serving the needs of the armorers' guild, also conveyed a message of optimism in a time of military threat. When Donatello began his work on *Saint George* (this sculpture has been dated as early as 1410), Florence was in danger; Saint George, appropriately, looks ready but apprehensive. After completing the niche sculpture (and after Ladislaus's miraculous death in 1414), Donatello carved the relief sculpture at the base of the niche—a fitting relief that depicts a victorious George slaying the dragon.

FOUR MARTYRED SCULPTORS As had *Saint George,* other niche sculptures for Or San Michele promoted the themes of sacrifice and heroism. For example, the Florentine guild of sculptors, architects, and masons chose NANNI DI BANCO (ca. 1380–1421) to create four life-size marble statues of the guild's martyred patron saints. These four Christian sculptors had defied an order from the Roman emperor Diocletian to make a statue of a pagan deity. In response, the emperor ordered them put to death. Because they placed their faith above all else, these saints were perfect role models for the fifteenth-century Florentines whom city leaders exhorted to stand fast in the face of the invasion threat by Ladislaus.

Nanni's group, *Quattro Santi Coronati* (Four Crowned Saints; FIG. **16-7**), also represented an early attempt to solve the Renaissance problem of integrating figures and space on a monumental scale. The artist's positioning of the figures, which stand in a niche that is *in* but confers some separation *from* the architecture, furthered the gradual emergence of sculpture from its architectural setting. This process began with such works as the thirteenth-century statues of the west front of Reims Cathedral (see FIG. 13-24). The niche's spatial recess permitted a new and dramatic possibility for the interrelationship of the figures. By placing them in a semicircle within their deep niche and relating them to one another by their postures and gestures, as well as by the arrangement of draperies, Nanni arrived at a unified spatial composition. Further, a remarkable psychological unity connects these unyielding figures, whose bearing expresses the discipline and integrity necessary to face adversity. While the figure on the right speaks, pointing to his right, the two men opposite listen and the one next to him looks out into space, pondering

A KNIGHT IN MARBLE ARMOR In *Saint George* (FIG. **16-6**), one of the three sculptures Donatello created for Or San Michele, the artist provided an image of the proud idealism of youth. The armored soldier-saint, patron of the guild of armorers and swordmakers (which commissioned Donatello to carve the statue in 1415), stands with bold firmness—legs set apart, feet strongly planted, the torso slightly twisting so that the left shoulder and arm advance with a subtle gesture of haughty and challenging readiness. The figure once wore a metal helmet and in his right hand brandished a

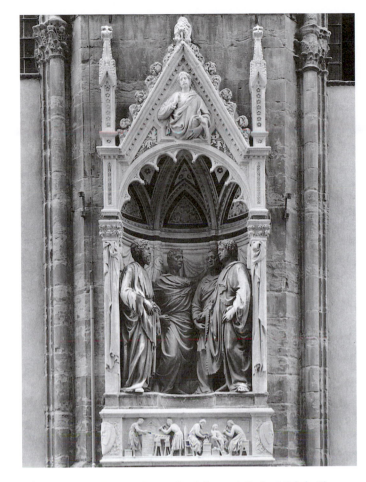

16-7 NANNI DI BANCO, *Quattro Santi Coronati,* Or San Michele, Florence, Italy, ca. 1408–1414. Marble, figures approx. life-size.

the meaning of the words. Later Renaissance artists, particularly Leonardo, exploited such reinforcement of a figural group's formal unity with psychological cross-references.

In *Quattro Santi Coronati,* Nanni also displayed a deep respect for and close study of Roman portrait statues. The emotional intensity of the faces of the two inner saints owed much to the extraordinarily moving portrayals in stone of Roman emperors of the third century A.D. (see FIG. 7-69), and the bearded heads of the outer saints reveal a familiarity with second-century A.D. imperial portraiture (see FIG. 7-60). Early Renaissance artists, like Donatello and Nanni di Banco, sought to portray individual personalities and characteristics. Roman models served as inspiration, but Renaissance artists did not simply copy them. Duplication was not the goal of Nanni and his contemporaries. Rather, they strove to interpret or offer commentary on their classical models in the manner of the humanist scholars dealing with classical texts.

SUGGESTING MOTION IN STONE Donatello's incorporation of Greek Classical principles surfaced in *Saint Mark* (FIG. **16-8**), commissioned for Or San Michele by the guild of linen drapers and completed in 1413. In this sculpture, Donatello took a fundamental step toward depicting motion in the human figure by recognizing the principle of weight shift. Earlier chapters established the importance of weight shift in the ancient world, when Greek sculptors, as

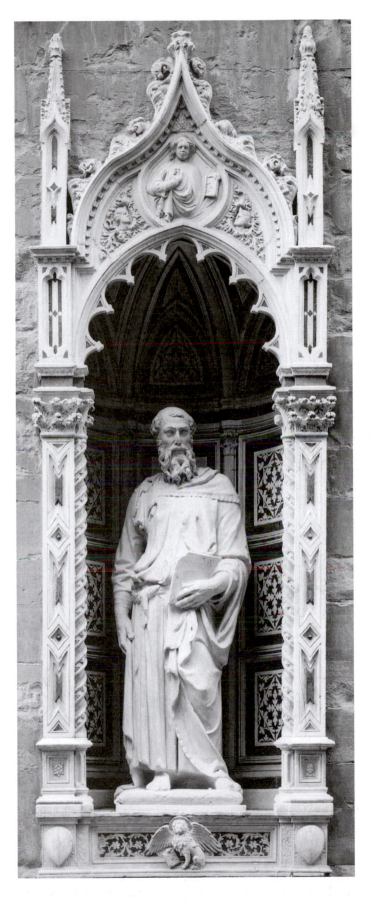

16-8 DONATELLO, *Saint Mark,* Or San Michele, Florence, Italy, 1411–1413. Marble, approx. 7′ 9″ high.

16-9 DONATELLO, prophet figure (Zuccone), from the campanile of Florence Cathedral, Florence, Italy, 1423–1425. Marble, approx. 6′ 5″ high. Museo dell'Opera del Duomo, Florence.

of support so that viewers sense the figure as a draped nude, not simply as an integrated column with arbitrarily incised drapery. This separates Donatello's *Saint Mark* from all medieval portal statuary. It was the first Renaissance figure whose voluminous drapery (the pride of the Florentine guild that paid for the statue) did not conceal but accentuated the movement of the arms, legs, shoulders, and hips. This development further contributed to the sculptured figure's independence from its architectural setting. Saint Mark's stirring limbs, the shifting weight, and the mobile drapery suggest impending movement out of the niche.

POWERFUL BELL TOWER FIGURES Between 1416 and 1435, Donatello carved five statues for niches on the *campanile* (bell tower) adjacent to Florence Cathedral—a project that, like the figures for Or San Michele, had originated in the preceding century. Unlike the Or San Michele figures, however, which were installed only slightly above eye level, the officials in charge of cathedral projects chose to place the campanile sculptures in niches at least thirty feet above the ground. At that distance, delicate descriptive details (hair, garments, and features) cannot be recognized readily. The campanile figures thus required massive garment folds that could be read from afar and a much broader, summary treatment of facial and anatomical features, all of which Donatello used to great effect. In addition, he took into account the elevated position of his figures and, with subtly calculated distortions, created images that are at once realistic and dramatic when seen from below.

The most striking of the five figures is a prophet generally known by the nickname Zuccone, or "pumpkin-head" (FIG. 16-9). This figure shows Donatello's power of characterization at its most original. The artist represented all of his prophets with a harsh, direct realism reminiscent of some ancient Roman portraits (compare FIGS. 7-6, 7-35, and 7-69). Their faces are bony, lined, and taut; Donatello carefully individualized each of them. The Zuccone is also bald, a departure from the conventional representation of the prophets but in keeping with many Roman portrait heads. Donatello's prophet wears an awkwardly draped and crumpled mantle with deeply undercut folds—a far cry from the majestic prophets of medieval portals. The head discloses a fierce personality; the deep-set eyes glare under furrowed brows, the nostrils flare, and the broad mouth is agape, as if the prophet were in the very presence of disasters that would prompt dire warnings.

Painting, Perspective, and Patronage

AN INTERNATIONAL STYLE ALTARPIECE The International Style (see FIG. 14-18), the dominant style in painting around 1400 that persisted well into the fifteenth century, developed side by side with the new styles. GENTILE DA FABRIANO (ca. 1370–1427) produced what may be the masterpiece of the International Style, his *Adoration of the Magi* (FIG. 16-10), an altarpiece in the sacristy of the church of Santa Trinità in Florence. Gentile's patron was Palla Strozzi, the wealthiest Florentine of his day, and the altarpiece, with its elaborate gilded Gothic frame, is testimony to Strozzi's lavish tastes. So, too, is the painting itself, with its gorgeous surface and sumptuously costumed kings, courtiers, captains,

shown in works such as the *Kritios Boy* (see FIG. 5-33) and the *Doryphoros* (see FIG. 5-38), grasped the essential principle that the human body is not rigid. It is a flexible structure that moves by continuously shifting its weight from one supporting leg to the other with its main masses moving in consonance. Donatello reintroduced this concept (known as *contrapposto*).

As the saint's body "moves," its drapery "moves" with it, hanging and folding naturally from and around bodily points

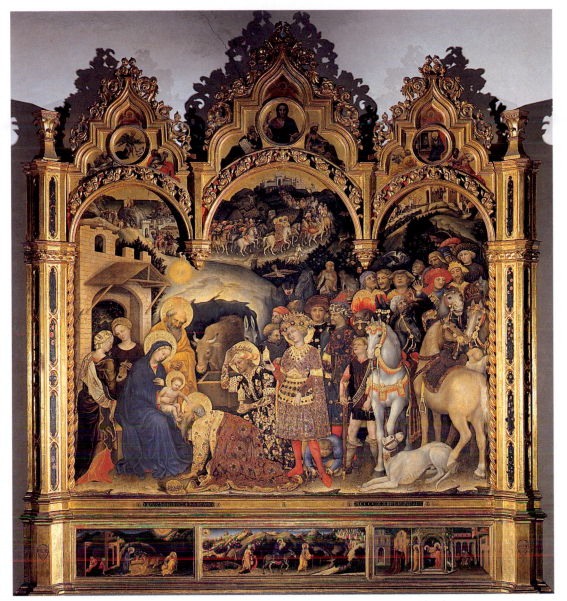

16-10 GENTILE DA FABRIANO, *Adoration of the Magi*, altarpiece from Santa Trinità, Florence, Italy, 1423. Tempera on wood, approx. 9′ 11″ × 9′ 3″. Galleria degli Uffizi, Florence.

and retainers accompanied by a menagerie of exotic and ornamental animals. Gentile portrayed all of these elements in a rainbow of color with extensive use of gold. The painting presents all the pomp and ceremony of chivalric etiquette in a scene that sanctifies the aristocracy in the presence of the Madonna and Child. Although the style is fundamentally Late Gothic, Gentile inserted striking bits of radical naturalism. Viewers encounter animals depicted from a variety of angles and foreshortened convincingly, as are tilted human heads and bodies (such as the man removing the spurs from the standing magus in the center foreground). On the right side of the predella (the ledge at the base of an altarpiece), Gentile placed the Presentation scene in a "modern" architectural setting. And on the left side of the predella, he painted what may have been the very first nighttime Nativity with the central light source—the radiant Christ Child—introduced into the picture itself. Although predominantly conservative, Gentile demonstrated he was not oblivious to contemporary experimental trends and that he could blend naturalistic and inventive elements skillfully and subtly into a traditional composition without sacrificing Late Gothic coloristic splendor.

MOMENTOUS CHANGES IN PICTORIAL STYLE

An artist much less compromising was TOMMASO GUIDI, known as MASACCIO (1401–1428). Indeed, scholars often identify Masaccio as the leading innovator in early fifteenth-century painting. Although his presumed teacher, Masolino da Panicale, had worked in the International Style, Masaccio moved suddenly, within the short span of six years, into wide-open and unexplored territory (see "Imitation and Emulation: Artistic Values in the Renaissance," page 490). Most art historians recognize no other painter in history to have contributed so much to the development of a new style in so short a time as Masaccio, whose creative career was cut short by his death at age twenty-seven. Masaccio was the artistic descendant of Giotto, whose calm monumental style he revolutionized with a whole new repertoire of representational devices that generations of Renaissance painters later studied and developed. Masaccio also knew and understood the innovations of his great contemporaries, Donatello and Brunelleschi, and he introduced new possibilities for both form and content.

The frescoes Masaccio painted in the Brancacci Chapel of Santa Maria del Carmine in Florence provide excellent

Imitation and Emulation
Artistic Values in the Renaissance

The natural human tendency is to interpret historical material from one's own vantage point and to generalize (for example, "Eastern religious beliefs" or "Third World economies"), especially when it comes to cultural or societal values. Doing so, however, results in the distortion of cultural practices and denies groups, countries, and societies their unique historical identities. Therefore, when studying material from other times and places, everyone must remain vigilant to avoid imposing their own learned and subjective values.

Among the concepts Renaissance artists most valued were *imitation* and *emulation*. The familiar premium that current Western society seems to place on originality is actually a fairly recent phenomenon. Although many Renaissance artists did develop unique, recognizable styles, convention, both in terms of subject matter and representational practices, predominated. In a review of Italian Renaissance art, certain themes, conceits, and artistic formats surface with great regularity, and the traditional training practices reveal the importance of imitation and emulation to aspiring Renaissance artists.

Imitation was the starting point in a young artist's training (see "Mastering a Craft: Artistic Training in the Renaissance," Chapter 14, page 442). Renaissance Italians believed that the best way to learn was to copy the works of masters. Accordingly, much of an apprentice's training consisted of copying exemplary artworks. Leonardo filled his sketchbooks with drawings of well-known sculptures and frescoes, while Michelangelo spent hours visiting churches around Florence and Rome and sketching the artworks he found there.

Emulation was the next step; emulation involved modeling one's art after another artist. While imitation still provided the foundation for this practice, an artist used features of another's art only as a springboard for improvements or innovations. Thus, developing artists went beyond previous artists and attempted to prove their own competence and skill by improving on established and recognized masters. Comparison and a degree of competition were integral to emulation. To evaluate the "improved" artwork, viewers had to know the original "model."

Ultimately, through this process of imitation and emulation, Renaissance artists believed that developing artists would arrive at their own unique style. Cennino Cennini (ca. 1370–1440) explained the value of this training procedure in a book he published in 1400, *Il Libro dell'Arte* (*The Craftman's Handbook*), that served as a practical guide to making art:

> Having first practiced drawing for a while as I have taught you above, that is, on a little panel, take pains and pleasure in constantly copying the best things which you can find done by the hand of great masters. And if you are in a place where many good masters have been, so much the better for you. But I give you this advice: take care to select the best one every time, and the one who has the greatest reputation. And, as you go on from day to day, it will be against nature if you do not get some grasp of his style and of his spirit. For if you undertake to copy after one master today and after another one tomorrow, you will not acquire the style of either one or the other, and you will inevitably, through enthusiasm become capricious, because each style will be distracting your mind. You will try to work in this man's way today, and in the other's tomorrow, and so you will not get either of them right. If you follow the course of one man through constant practice, your intelligence would have to be crude indeed for you not to get some nourishment from it. Then you will find, if nature has granted you any imagination at all, that you will eventually acquire a style individual to yourself, and it cannot help being good; because your hand and your mind, being always accustomed to gather flowers, would ill know how to pluck thorns.[1]

[1] Cennino Cennini, *The Craftman's Handbook (Il Libro dell'Arte)*, trans. D. V. Thompson Jr. (New York: Dover Publications, 1960), 14–15.

examples of his innovations. In *Tribute Money* (FIG. **16-11**), painted shortly before his death, Masaccio depicted a seldomly represented narrative from the Gospel of Matthew (17:24–27). As the tax collector confronts Christ at the entrance to the Roman town of Capernaum, Christ directs Saint Peter to the shore of Lake Galilee. There, as foreseen by Christ, Peter finds the half drachma tribute in the mouth of a fish and returns to pay the tax. Art historians have debated the reason for the selection of this particular biblical story. Most scholars believe that Felice Brancacci, owner of the family chapel in the early fifteenth century, commissioned the fresco. Why such an obscure narrative appealed to Brancacci or

Masaccio is unclear. Some scholars have suggested that *Tribute Money*, in which Christ condones taxation, served as a commentary on the *catasto* (state income tax) whose implementation Florentines were considering at the time. However, Brancacci's considerable wealth makes it unlikely he would have supported the *catasto*. Moreover, this fresco's placement in a private family chapel meant the public had only limited access. Therefore, because this fresco lacked the general audience enjoyed by, for example, the Or San Michele niche sculptures, it seems ill-suited for public statements.

Masaccio presented this narrative in three episodes within the fresco. In the center, Christ, surrounded by his disciples,

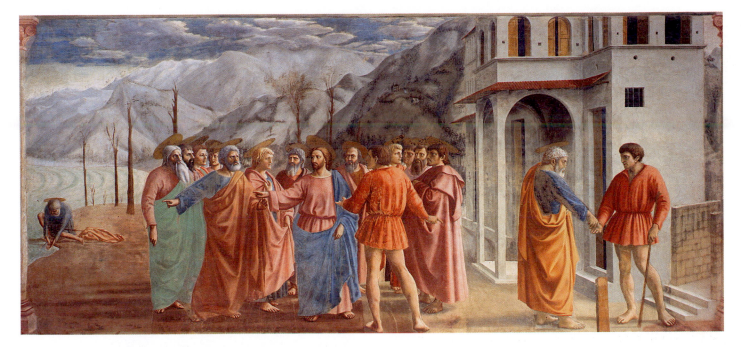

16-11 MASACCIO, *Tribute Money*, Brancacci Chapel, Santa Maria del Carmine, Florence, Italy, ca. 1427. Fresco, 8′ 1″ × 19′ 7″.

tells Saint Peter to retrieve the coin from the fish, while the tax collector stands in the foreground, his back to spectators and hand extended, awaiting payment. At the left, in the middle distance, Saint Peter extracts the coin from the fish's mouth, and, at the right, he thrusts the coin into the tax collector's hand. Masaccio's figures recall Giotto's in their simple grandeur, but they convey a greater psychological and physical credibility. Masaccio realized the bulk of the figures not through generalized modeling with a flat neutral light lacking an identifiable source but by a light coming from a specific source outside the picture. The light strikes the figures at an angle, illuminating the parts of the solids that obstruct its path and leaving the rest in deep shadow. This chiaroscuro gives the illusion of deep sculptural relief. Between the extremes of light and dark, the light appears as a constantly active but fluctuating force highlighting the scene in varying degrees, almost a tangible substance independent of the figures. In Giotto's frescoes, light is merely the modeling of a mass. In Masaccio's, light has its own nature, and the masses are visible only because of its direction and intensity. Viewers can imagine the light as playing over forms—revealing some and concealing others, as the artist directs it.

The individual figures in *Tribute Money* are solemn and weighty, but they also express bodily structure and movement, as do Donatello's statues. Masaccio's representations adeptly suggest bones, muscles, and the pressures and tensions of joints. Each figure conveys a maximum of contained energy. The figure of Christ and the two appearances of the tax collector make viewers understand what the Renaissance biographer Giorgio Vasari meant when he said: ". . . the works made before his [Masaccio's] day can be said to be painted, while his are living, real, and natural."[4]

Masaccio's arrangement of the figures is equally inventive. They do not appear as a stiff screen in the front planes. Instead, the artist grouped them in circular depth around Christ, and he placed the whole group in a spacious landscape, rather than in the confined stage space of earlier frescoes. The group itself generates the foreground space that the architecture on the right amplifies. Masaccio depicted this architecture in one-point perspective, locating the vanishing point, where all the orthogonals converge, to coincide with Christ's head. Aerial perspective, the diminishing of light and the blurring of outlines as the distance increases, unites the foreground with the background. Although ancient Roman painters used aerial perspective, medieval artists had abandoned it. Thus it virtually disappeared from art until Masaccio and his contemporaries rediscovered it, apparently independently. They came to realize that light and air interposed between viewers and what they see are parts of the visual experience called "distance."

A PICTURE OF SINNERS' ANGUISH In an awkwardly narrow space at the entrance to the Brancacci Chapel, Masaccio painted the *Expulsion of Adam and Eve from Eden* (FIG. 16-12), another fresco displaying the representational innovations of *Tribute Money*. For example, the sharply slanted light from an outside source creates deep relief, with lights placed alongside darks, and acts as a strong unifying agent. Masaccio also presented the figures moving with structural accuracy and with substantial bodily weight. Further, the hazy, atmospheric background specifies no locale but suggests a space around and beyond the figures. Adam's feet, clearly in contact with the ground, mark the human presence on earth, and the cry issuing from Eve's mouth voices her anguish. The angel does not force them physically from Eden. Rather, they stumble on blindly, driven by the angel's will and their own despair. The composition is starkly simple, its message incomparably eloquent.

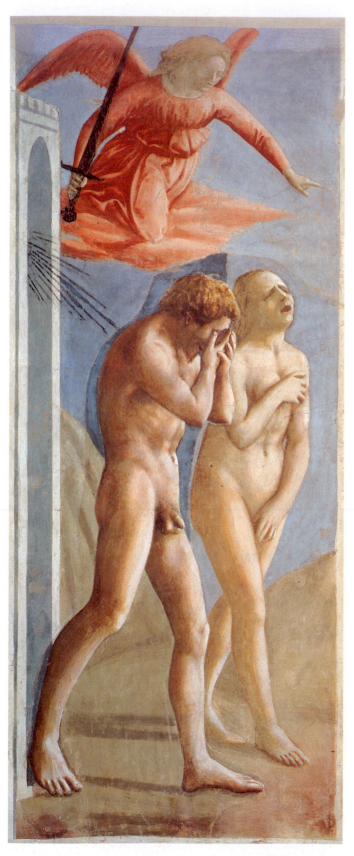

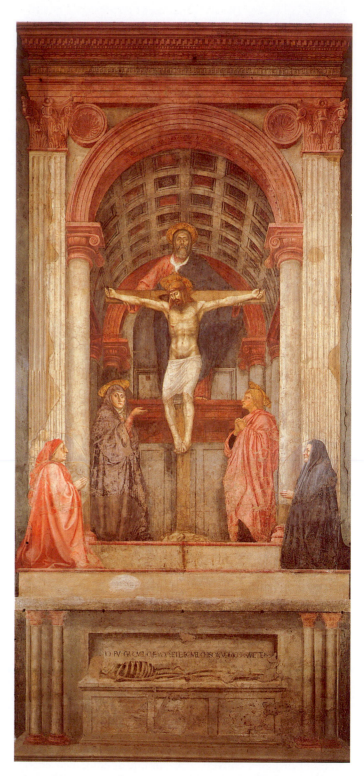

16-13 MASACCIO, *Holy Trinity,* Santa Maria Novella, Florence, Italy, ca. 1428. Fresco, 21′ × 10′ 5″.

16-12 MASACCIO, *Expulsion of Adam and Eve from Eden,* Brancacci Chapel, Santa Maria del Carmine, Florence, Italy, ca. 1425. Fresco, 7′ × 2′ 11″.

A CONVINCING VISION OF THE TRINITY Masaccio's *Holy Trinity* fresco (FIG. **16-13**) in Santa Maria Novella, whose dating is still disputed, embodies two principal Renaissance interests. One is realism based on observation and the other is the application of mathematics to pictorial organization in the new science of perspective. The artist painted the composition on two levels of unequal height. Above, in a coffered barrel-vaulted chapel reminiscent of a Roman triumphal arch, the Virgin Mary and Saint John appear on either side of the crucified Christ. God the Father emerges from behind Christ, supporting the arms of the cross. The Dove of the Holy Spirit hovers between God's head and Christ's head. Masaccio also included portraits of the donors of the painting, Lorenzo Lenzi and his wife, who kneel just in front of the pilasters that enframe the chapel. Below the altar—a masonry insert in the depicted composition—the artist painted a tomb containing a skeleton. An inscription in Italian painted above the skeleton reminds spectators that "I was once what you are, and what I am you will become."

Although the subject matter of *Holy Trinity* may not be dramatically innovative, the illusionism of Masaccio's depiction is breathtaking. He provided viewers with a brilliant demonstration of the principles of Brunelleschi's perspective. Indeed, this work is so much in the Brunelleschian manner that some historians have suggested that Brunelleschi may have directed Masaccio. Masaccio placed the vanishing point at the foot of the cross. With this point at eye level, spectators look up at the Trinity and down at the tomb. About five feet above the floor level, the vanishing point pulls the two views together, creating the illusion of an actual structure that transects the wall's vertical plane. While the tomb projects, the chapel recedes visually behind the wall and appears as an extension of the spectators' space. This adjustment of the pictured space to the position of viewers was a first step in the development of illusionistic painting, which fascinated many artists of the Renaissance and the later Baroque period. Masaccio was so exact in his metrical proportions that it is possible to actually calculate the dimensions of the chapel (for example, the span of the painted vault is seven feet; the depth of the chapel, nine feet). Thus, he achieved not only a successful illusion but also a rational measured coherence that, by maintaining the mathematical proportions of the surface design, is responsible for the unity and harmony of this monumental composition.

Despite Masaccio's commitment to pictorial illusionism, the *Holy Trinity* fresco in the Florentine church of Santa Maria Novella still instructs the faithful through its images. In an ascending pyramid of figures, viewers move from the despair of death to the hope of resurrection and eternal life.

Early-Fifteenth-Century Architecture

ENAMORED BY ROMAN ARCHITECTURE Filippo Brunelleschi's ability to codify a system of linear perspective derived in part from his skill as an architect. Although his biographer, Manetti, reported that Brunelleschi turned to architecture out of disappointment over the loss of the baptis-

tery commission, he continued to work as a sculptor for several years and received commissions for sculpture as late as 1416. It is true, however, that as the fifteenth century progressed, Brunelleschi's interest turned increasingly toward architecture. Several trips to Rome (the first in 1402, probably with his friend Donatello), where he was captivated by the Roman ruins, heightened his fascination with architecture. It may well be in connection with his close study of Roman monuments and his effort to make an accurate record of what he saw that Brunelleschi developed his revolutionary system of geometric linear perspective that fifteenth-century artists so eagerly adopted. It made him the first acknowledged Renaissance architect.

A CROWNING ACHIEVEMENT Brunelleschi's broad knowledge of Roman construction principles, combined with an analytical and inventive mind, permitted him to solve an engineering problem that no other fifteenth-century architect could have solved. The challenge was the design and construction of a dome for the huge crossing of the unfinished Florence Cathedral (FIGS. **16-14** and 14-12). The problem was staggering; the space to be spanned (one hundred forty feet) was much too wide to permit construction with the aid of traditional wooden centering. Nor was it possible (because of the crossing plan) to support the dome with buttressed walls. Brunelleschi seems to have begun work on the problem about

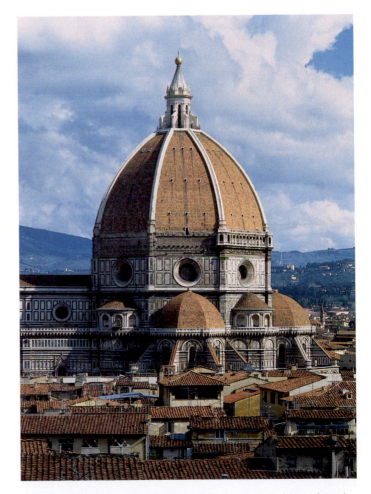

16-14 FILIPPO BRUNELLESCHI, dome of Florence Cathedral (view from the south), Florence, Italy, 1420–1436.

1417. In 1420, officials overseeing cathedral projects awarded Brunelleschi and Ghiberti a joint commission. The latter, however, soon retired from the project and left the field to his associate.

With exceptional ingenuity, Brunelleschi not only discarded traditional building methods and devised new ones, but he also invented much of the machinery necessary for the job. Although he might have preferred the hemispheric shape of Roman domes, Brunelleschi raised the center of his dome and designed it around an ogival (pointed arch) section, which is inherently more stable because it reduces the outward thrust around the dome's base. To minimize the structure's weight, he designed a relatively thin double shell (the first in history) around a skeleton of twenty-four ribs. The eight most important are visible on the exterior. Finally, in almost paradoxical fashion, Brunelleschi anchored the structure at the top with a heavy lantern, built after his death but from his design.

Despite Brunelleschi's knowledge of and admiration for Roman building techniques and even though the Florence Cathedral dome was his most outstanding engineering achievement, he arrived at the solution to this most critical structural problem through what were essentially Gothic building principles. Thus, the dome, which also had to harmonize in formal terms with the century-old building, does not really express Brunelleschi's architectural style. That is more apparent in subsequent designs when his ideas had matured.

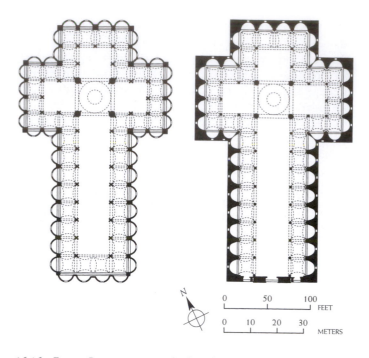

16-16 FILIPPO BRUNELLESCHI, early plan of Santo Spirito *(left)* and plan as constructed *(right)*, Florence, Italy.

APPLYING ROMAN MATHEMATICAL LOGIC

San Lorenzo and Santo Spirito, the two basilican churches Brunelleschi built in Florence, echo the clarity and classically inspired rationality that characterized much of his architecture. Of the two, the later Santo Spirito (FIGS. **16-15** and **16-16**), begun around 1436 and completed, with some changes, after Brunelleschi's death, shows the architect's mature style. Brunelleschi laid out this cruciform building in either multiples or segments of the dome-covered crossing square. The aisles, subdivided into small squares covered by shallow saucer-shaped vaults, run all the way around the flat-roofed central space. They have the visual effect of compressing the longitudinal design into a centralized one, because the various aspects of the interior resemble one another, no matter where observers stand. Originally, this centralization effect would have been even stronger; Brunelleschi had planned to extend the aisles across the front of the nave as well, as shown on the plan (FIG. 16-16, left). Because of the design's modular basis, adherence to it would have demanded four entrances in the facade, instead of the traditional and symbolic three, a feature hotly debated during Brunelleschi's lifetime and changed after his death. The appearance of the exterior walls also was modified later (compare the two plans in FIG. 16-16), when the recesses between the projecting semicircular chapels were filled in to convert the original highly sculptured wall surface into a flat one.

The major features of the interior (FIG. 16-15), however, are much as Brunelleschi designed them. He based the scale of each architectural element on a unit that served as the building block for the dimensions of every aspect of Santo Spirito. This unit, repeated throughout the interior, creates a rhythmic harmony. For example, the nave is twice as high as it is wide; the arcade and clerestory are of equal height, which means the arcade's height equals the nave's width; and so on. Crisp joinings delineate these basic facts about the building

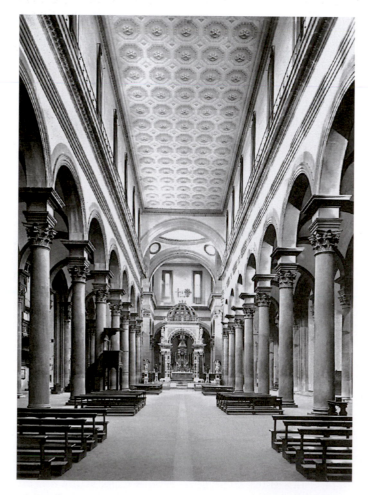

16-15 FILIPPO BRUNELLESCHI, interior of Santo Spirito (view facing east), Florence, Italy, begun ca. 1436.

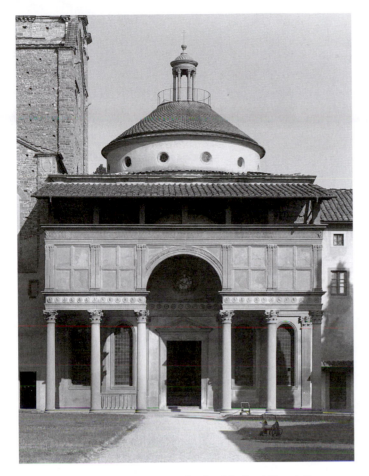

16-17 FILIPPO BRUNELLESCHI, west facade of the Pazzi Chapel, Santa Croce, Florence, Italy, begun ca. 1440.

does not reflect Brunelleschi's original design. The narthex, admirable as it is, seems to have been added as an afterthought, perhaps by the sculptor-architect GIULIANO DA MAIANO (1432–1490). Historians have suggested that the local chapter of Franciscan monks who held meetings in the chapel needed the expansion. Behind the narthex stands one of the first independent Renaissance buildings conceived basically as a central-plan structure. Although the plan (FIG. 16-18) is rectangular, rather than square or round, the architect placed all emphasis on the central dome-covered space. The short barrel-vault sections that brace the dome on two sides appear to be incidental appendages. The interior trim (FIG. 16-19) is done in gray stone, the so-called *pietra serena* ("serene stone"), which stands out against the white stuccoed walls and crisply defines the modular relationships of plan and elevation. As in his design for Santo Spirito, Brunelleschi used a basic unit that allowed him to construct a balanced, harmonious, and regularly proportioned space. Medallions with glazed terracotta reliefs representing the Four Evangelists in the dome's pendentives and the Twelve Apostles on the pilaster-framed wall panels provide the tranquil interior with striking color accents.

A PALACE FIT FOR A MEDICI It seems curious that Brunelleschi, the most renowned architect of his time, did not participate in the upsurge of palace building Florence experienced in the 1430s and 1440s. This proliferation of palazzi testified to the Florentine economy's stability and to the affluence and confidence of the city's leading citizens. Brunelleschi, however, confined his efforts in this field to work on the Palazzo di Parte Guelfa (headquarters of Florence's ruling "party") and to a rejected model for a new palace that Cosimo de' Medici intended to build.

for observers so that they can read them like mathematical equations. The austerity of the decor enhances the restful and tranquil atmosphere. Brunelleschi left no space for expansive wall frescoes that only would interrupt the clarity of his architectural scheme. The design's calculated logic echoes those of classical buildings such as Roman basilicas. Further, the rationality of Santo Spirito contrasts sharply with the soaring drama and spirituality of the vaults and nave arcades of Gothic churches. It even deviates from those in Italy, such as the Florence Cathedral nave (see FIG. 14-13), whose verticality is restrained in comparison to their northern counterparts. Santo Spirito fully expressed the new Renaissance spirit that placed its faith in reason rather than in the emotions.

A FAMILY GIFT WITH A CENTRAL DOME
Brunelleschi's apparent effort to impart a centralized effect to the interior of Santo Spirito suggests he was intrigued by the compact and self-contained qualities of earlier central-plan buildings, such as the Roman Pantheon (see FIG. 7-50). The chapel (FIGS. **16-17** to **16-19**) that was the Pazzi family's gift to the church of Santa Croce in Florence presented Brunelleschi with the opportunity to explore this interest in a structure much better suited to such a design than a basilican church. Brunelleschi began to design the Pazzi Chapel around 1440. It was not completed until the 1460s, long after his death (see "Honoring God and Family: Family Chapel Endowments," page 497). The exterior (FIG. 16-17) probably

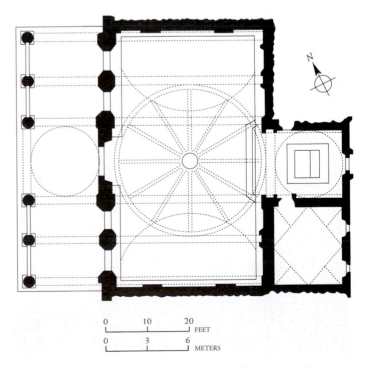

0 10 20 FEET
0 3 6 METERS

16-18 FILIPPO BRUNELLESCHI, plan of the Pazzi Chapel, Santa Croce, Florence, Italy.

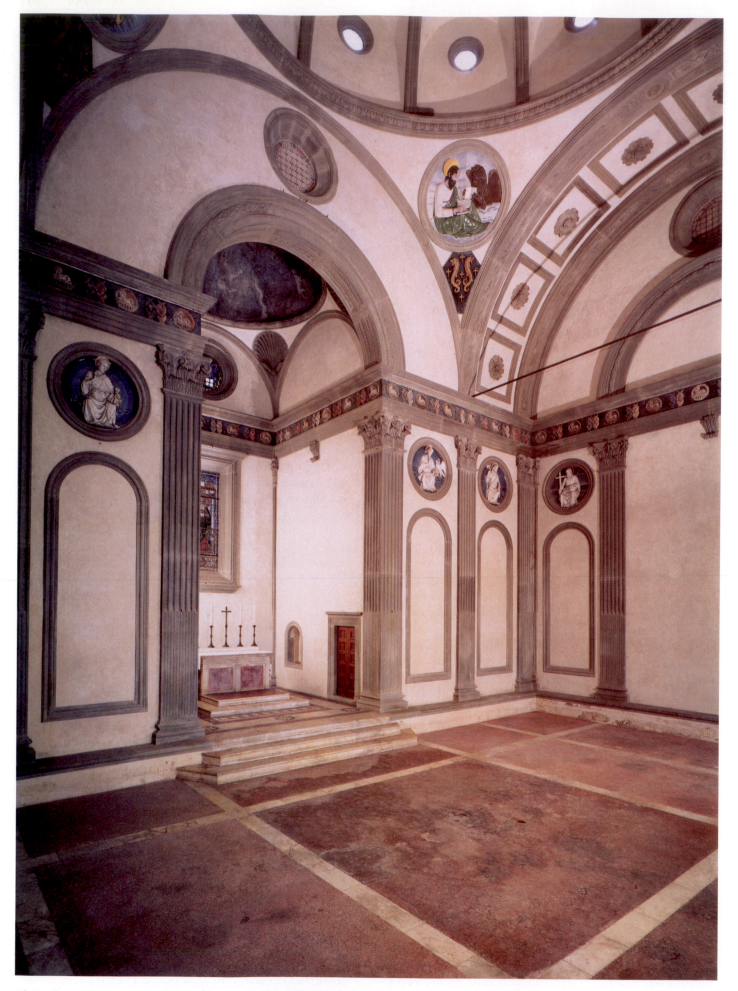

16-19 FILIPPO BRUNELLESCHI, interior of the Pazzi Chapel (view facing northeast), Santa Croce, Florence, Italy, begun ca. 1440.

Honoring God and Family
Family Chapel Endowments

During the fourteenth through sixteenth centuries in Italy, wealthy families regularly endowed chapels in or adjacent to major churches. These family chapels usually were located on either side of the choir near the altar at the church's east end. Particularly wealthy families endowed chapels in the form of separate buildings constructed adjacent to churches. For example, the Medici chapel (Old Sacristy) abuts San Lorenzo in Florence. Powerful banking families, such as the Baroncelli, Bardi, and Peruzzi, each sponsored chapels in the Florentine church of Santa Croce. The Pazzi commissioned a chapel (FIGS. 16-17, 16-18, and 16-19) adjacent to Santa Croce, and the Brancacci family sponsored the decorative program (FIGS. 16-11 and 16-12) of their chapel in Santa Maria del Carmine.

These families sponsored such chapels as expressions of piety and devotion. The chapels also served as burial sites for important family members and as spaces for liturgical celebrations and commemorative services. Chapel owners sponsored Masses for the dead, praying to the Virgin Mary and the saints for intercession on behalf of their deceased loved ones. Changes in Christian doctrine prompted these concerted efforts to improve individuals' chances for eternal salvation. Un-

til the thirteenth century, Christians believed that after death souls went either to Heaven or Hell. After that time, the concept of Purgatory—a way station between Heaven and Hell where souls could atone for sins before Judgment Day—increasingly won favor. Pope Innocent III recognized the existence of such a place in 1215 at the Fourth Lateran Council (a major church council that dealt with redefining church doctrine). Because Purgatory represented an opportunity for the faithful to improve their chances of eventually gaining admittance to Heaven, they eagerly embraced this opportunity. They extended this idea to improving their chances while alive, so charitable work, good deeds, and devotional practices proliferated. Family chapels provided the space necessary for the performance of devotional rituals. Most chapels included altars, as well as chalices, vestments, candlesticks, and other objects used in the Mass. Most patrons also commissioned decorations, such as painted altarpieces, frescoes on the walls, and sculptural objects.

Thus, families endowed these chapels to ensure the well-being of the souls of individual family members and ancestors. The gifts also honored the families themselves and burnished their images in the larger community.

Early in the fifteenth century, Giovanni de' Medici (ca. 1360–1429) had established the family fortune. Cosimo (1389–1464) expanded his family's financial control, which led to considerable political power as well. This consolidation of power in a city that prided itself on its republicanism did not go unchallenged. In the early 1430s, a power struggle with other wealthy families led to the Medici's expulsion from Florence. In 1434, the Medici returned, and Cosimo resumed his position as de facto ruler of Florence. However, aware of the importance of public perception, he attempted to maintain a lower profile and continued to wield his power from behind the scenes. In all probability, this attitude accounted for his rejection of Brunelleschi's design for the Medici residence. Cosimo evidently found Brunelleschi's project too imposing and ostentatious to be politically wise. Cosimo eventually awarded the commission to MICHE-LOZZO DI BARTOLOMMEO (1396–1472), a young architect who had been Donatello's collaborator in several sculptural enterprises. Although Cosimo chose Michelozzo instead of Brunelleschi, Brunelleschi's architectural style in fact deeply influenced the young architect. To a limited extent, the Palazzo Medici-Riccardi (FIG. 16-20) reflects Brunelleschian principles.

Later bought by the Riccardi family, who almost doubled the facade's length in the eighteenth century, the palace, both in its original and extended form, is a simple, massive structure. Heavy rustication on the ground floor accentuates its strength. Michelozzo divided the building block into stories of decreasing height by long, unbroken stringcourses (horizontal bands), which give it coherence. Dressed stone on the upper levels, which smoothens the surface with each successive story, modifies the severity of the ground floor. The building thus appears progressively lighter as the eye moves upward. The extremely heavy cornice, which Michelozzo related not to the top story but to the building as a whole, dramatically reverses this effect. Like the ancient Roman cornices that served as Michelozzo's models (compare, for example, FIGS. 7-30, 7-37, and 7-45), the Palazzo Medici-Riccardi cornice is a very effective lid for the structure, clearly and emphatically defining its proportions. Michelozzo also may have been inspired by the many extant examples of Roman rusticated masonry, and Roman precedents even exist for the juxtaposition of rusticated and dressed stone masonry on the same facade (see FIG. 7-32). However, nothing in the ancient world precisely compares to Michelozzo's design. The Palazzo Medici-Riccardi is an excellent example of the simultaneous

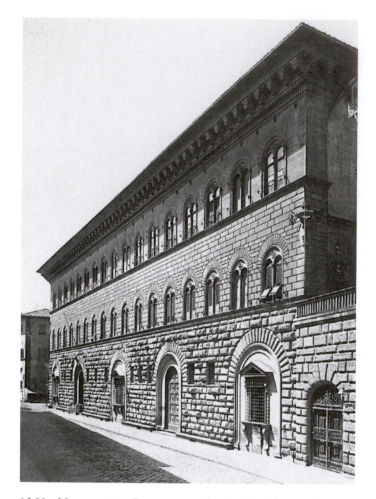

16-20 MICHELOZZO DI BARTOLOMMEO, facade of the Palazzo Medici-Riccardi, Florence, Italy, begun 1444.

respect for and independence from the antique that characterize the Early Renaissance in Italy.

The Palazzo Medici-Riccardi is built around an open colonnaded court (FIG. **16-21**) that clearly shows Michelozzo's debt to Brunelleschi. The round-arched colonnade, although more massive in its proportions, closely resembles other buildings by Brunelleschi. Ultimately, this internal court surrounded by an arcade was the first of its kind and influenced a long line of descendants in Renaissance domestic architecture.

THE MAGNIFICENT MEDICI The references to classical architecture in the Palazzo Medici-Riccardi's design were entirely appropriate for its patrons. The Medici were avid humanists. Cosimo began the first public library since the ancient world, and historians estimate that in some thirty years he and his descendants expended the equivalent of almost $20 million for manuscripts and books. Beyond their enthusiastic collecting of classical and Renaissance literature, the Medici were voracious art collectors. Scarcely a great architect, painter, sculptor, philosopher, or humanist scholar escaped the Medici's notice.

Cosimo was the very model of the cultivated humanist. His grandson Lorenzo (1449–1492), called "the Magnificent," achieved an even greater reputation for generosity than his grandfather, as his name suggests. A talented poet himself, Lorenzo gathered about him a galaxy of artists and gifted men in all fields, extending the library Cosimo had begun and revitalizing his academy for instructing artists. He also established what some have called the Platonic Academy of Philosophy

16-21 MICHELOZZO DI BARTOLOMMEO, interior court of the Palazzo Medici-Riccardi, Florence, Italy, begun 1444.

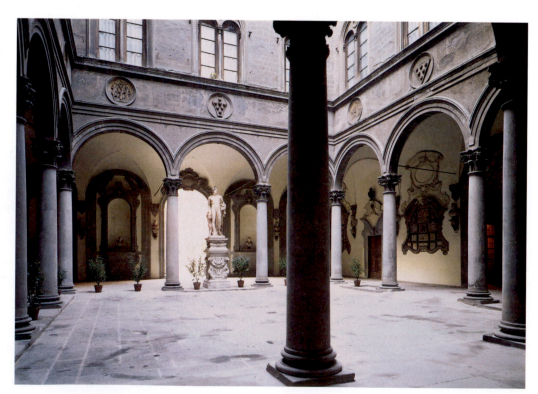

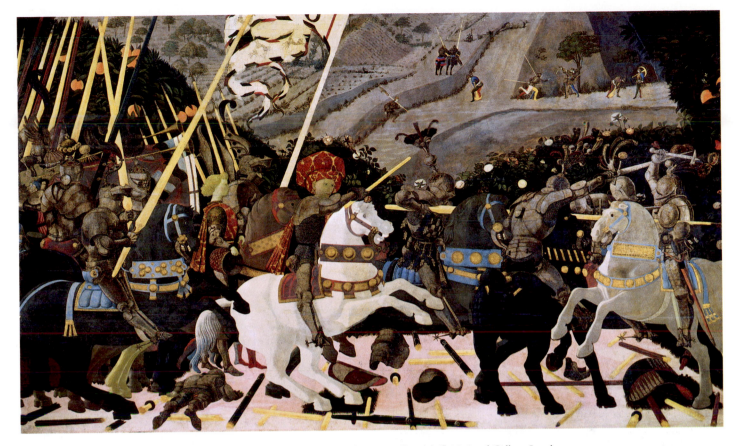

16-22 PAOLO UCCELLO, *Battle of San Romano*, ca. 1455. Tempera on wood, approx. 6′ × 10′ 5″. National Gallery, London.

(most likely an informal reading group), and lavished funds (often the city's own) on splendid buildings, festivals, and pageants. A review here of some of the hundreds of artworks the Medici commissioned reveals the family's interest in humanist ideas and its concern about its public image.

SIMULTANEOUSLY CHAOTIC AND ORDERED

PAOLO UCCELLO (1397–1475), a Florentine painter trained in the International Style, received a commission from Lorenzo de' Medici to produce a series of panel paintings. Uccello painted *Battle of San Romano* (FIG. **16-22**), one of three wood panels (all with the same title), to decorate Lorenzo the Magnificent's bedchamber. The scenes commemorate the Florentine victory over the Sienese in 1432. In the panel illustrated, Niccolò da Tolentino, a friend and supporter of Cosimo, leads the charge against the Sienese. Lorenzo may have selected this particular image to commemorate Tolentino, whose subsequent death perhaps was due to his friendship with the Medici. Although the painting focuses on Tolentino's military exploits, it also acknowledges the Medici. The reference appears in symbolic form. The bright orange fruit (appropriately placed) behind the unbroken and sturdy lances on the left were known as *mela medica* (medicinal apples). Given that the name Medici means "doctor," this fruit was a fitting symbol (one of many) of the family.

Uccello's obsession with perspective undoubtedly appealed to Lorenzo. The development of perspectival systems intrigued the humanists, because perspective represented the rationalization of vision. As staunch humanists, the Medici pursued all facets of expanding knowledge. In *Battle of San Romano*, Uccello created a composition that recalls the processional splendor of Gentile's *Adoration of the Magi* (FIG. 16-10). But in contrast with the surface decoration of Gentile's International Style, Uccello constructed his world of immobilized solid forms. He foreshortened broken spears, lances, and a fallen soldier and carefully placed them along the converging orthogonals of the perspective to create a base plane like a checkerboard, on which he then placed the larger volumes in measured intervals. This diligently created space recedes to a landscape that resembles the low cultivated hillsides between Florence and Lucca. The rendering of three-dimensional form, used by other painters for representational or expressive purposes, became for Uccello a preoccupation. For him, it had a magic of its own, which he exploited to satisfy his inventive and original imagination.

A CLASSICALLY INSPIRED DAVID

The Medici worked tirelessly to acquire art from the most esteemed artists, and they identified Donatello as among those worthy of receiving their coveted commissions. The bronze statue

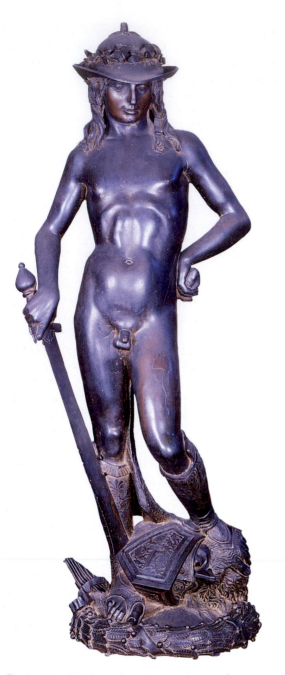

16-23 DONATELLO, *David,* ca. 1428–1432. Bronze, 5′ 2¼″ high. Museo Nazionale del Bargello, Florence.

The Medici were aware of Donatello's earlier *David,* a sculpture located in the Palazzo della Signoria, the center of political activity in Florence. The artist had produced it during the threat of invasion by King Ladislaus, and it became a symbol of Florentine strength and independence. Their selection of the same subject suggests that the Medici identified themselves with Florence or, at the very least, saw themselves as responsible for Florence's prosperity and freedom.

CELEBRATING THE MEDICI AND FLORENCE

Another David sculpture produced by one of the most important sculptors during the second half of the century, ANDREA DEL VERROCCHIO (1435–1488), reaffirms this identification of the Medici with Florence. A painter as well as a sculptor, with something of Donatello's versatility and depth, Verrocchio directed a flourishing *bottega* (studio-shop) in Florence that attracted many students, among them Leonardo da Vinci. Verrocchio, like Donatello, also had a broad repertoire. His *David* (FIG. 16-24) contrasts strongly in its narrative realism with the quiet, aesthetic classicism of Donatello's *David.* Verrocchio's *David*—made for Lorenzo de' Medici to exhibit in the Palazzo Medici—is a sturdy, wiry young apprentice

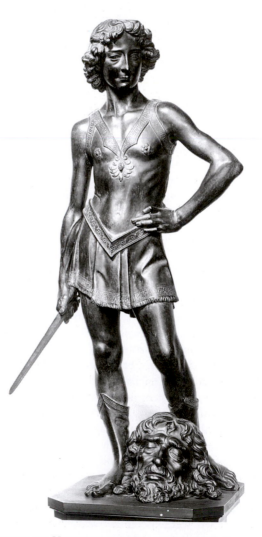

16-24 ANDREA DEL VERROCCHIO, *David,* ca. 1465–1470. Bronze, approx. 4′ 1½″ high. Museo Nazionale del Bargello, Florence.

David (FIG. 16-23), created between about 1428 and 1432 by Donatello for the Palazzo Medici courtyard, was the first freestanding nude statue since ancient times. The nude, as such, proscribed in the Christian Middle Ages as both indecent and idolatrous, had been shown only rarely—and then only in biblical or moralizing contexts, such as the story of Adam and Eve or descriptions of sinners in Hell. Donatello reinvented the classical nude, even though his subject is not a pagan god, hero, or athlete but the biblical David, the young slayer of Goliath and the symbol of the independent Florentine republic. David possesses both the relaxed classical contrapposto stance and the proportions and sensuous beauty of Greek Praxitelean gods (see FIG. 5-62), qualities absent from medieval figures. The invoking of classical poses and formats appealed to the humanist Medici.

Donatello's *David, Hercules and Antaeus* exhibits the stress and strain of the human figure in violent action. This sculpture departs dramatically from the convention of frontality that had dominated statuary art during the Middle Ages and the Early Renaissance. Not quite eighteen inches high, *Hercules and Antaeus* embodies the ferocity and vitality of elemental physical conflict. The group illustrates the Greek myth of a wrestling match between Antaeus (Antaios), a giant and son of Earth, and Hercules (Herakles). As seen earlier, Euphronios represented this story on an ancient Greek vase (see FIG. 5-21). Each time Hercules threw him down, Antaeus sprang up again, his strength renewed by contact with the earth. Finally, Hercules held him aloft, so that he could not touch the earth, and strangled him around the waist. Pollaiuolo strove to convey the final excruciating moments of the struggle—the straining and cracking of sinews, the clenched teeth of Hercules, and the kicking and screaming of Antaeus. The figures intertwine and interlock as they fight, and the flickering reflections of light on the dark gouged bronze surface contribute to the effect of agitated movement and a fluid play of planes. The subject matter, derived from Greek mythology, and the emphasis on human anatomy reveal the Medici preference for humanist-affiliated imagery. Even more specifically, Hercules had been represented on Florence's state seal since the end of the thirteenth century. As with commissions such as the two *David* sculptures, the Medici clearly embraced every opportunity to associate themselves with the glory of the Florentine republic, surely claiming much of the credit for it.

A GRAPHIC IMAGE OF BATTLING NUDES Although not commissioned by the Medici, Pollaiuolo's *Battle of the Ten Nudes* (FIG. 16-26) further demonstrates the artist's sustained interest in the realistic presentation of human figures in action. Earlier artists, such as Donatello and Masaccio, had dealt effectively with the problem of rendering human anatomy, but they usually depicted their figures at rest or in restrained motion. As is evident in his *Hercules and Antaeus*, Pollaiuolo took delight in showing violent action and found his opportunity in subjects dealing with combat. He conceived the body as a powerful machine and liked to display its mechanisms—knotted muscles and taut sinews activate the skeleton as ropes pull levers. To show this to best effect, Pollaiuolo developed a figure so lean and muscular that it appears *écorché* (as if without skin), with strongly accentuated delineations at the wrists, elbows, shoulders, and knees. His *Battle of the Ten Nudes* engraving shows this figure type in a variety of poses and from numerous viewpoints. The composition has no specific mythological or historical subject. Rather, it was an excuse for Pollaiuolo to demonstrate his prowess in rendering the nude male figure. In this, he was a kindred spirit of late-sixth-century Greek vase painters, such as Euthymides (see FIG. 5-22), who had experimented with foreshortening for the first time in history. If Pollaiuolo's figures, even though they hack and slash at each other without mercy, seem somewhat stiff and frozen, it is because Pollaiuolo shows *all* the muscle groups at maximum tension. Not until several decades later did an even greater anatomist, Leonardo, observe that only part of the body's muscle groups are involved in any one action, while the others are relaxed.

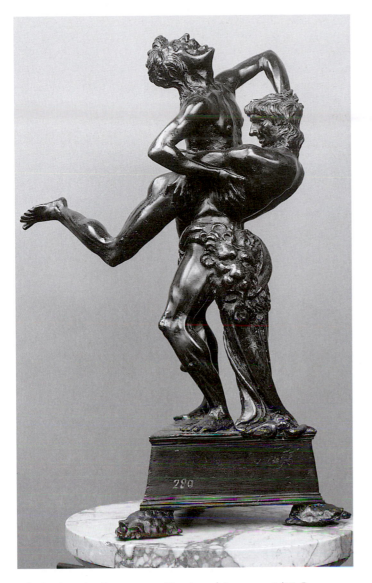

16-25 ANTONIO POLLAIUOLO, *Hercules and Antaeus*, ca. 1475. Bronze, approx. 18″ high with base. Museo Nazionale del Bargello, Florence.

clad in a leathern doublet who stands with a jaunty pride. As in Donatello's version, Goliath's head lies at David's feet. He poses like any sportsman who has just won a game or like a hunter with his kill. The easy balance of the weight and the lithe, still thinly adolescent musculature, with prominent veins, show how closely Verrocchio read the biblical text and how clearly he knew the psychology of brash and confident young men.

Lorenzo and Giuliano de' Medici eventually sold Verrocchio's bronze *David* to the Florentine *signoria* (a governing body) for placement in the Palazzo della Signoria. After the Medici were expelled from Florence, city officials appropriated Donatello's *David* for civic use and moved it to the Palazzo as well.

A MYTHIC WRESTLING MATCH Closely related in stylistic intent to Verrocchio's work is that of ANTONIO POLLAIUOLO (ca. 1431–1498). Pollaiuolo, who is also important as a painter and engraver, received a Medici commission in the 1470s to produce a small-scale sculpture, *Hercules and Antaeus* (FIG. 16-25). In contrast to the placid presentation of

16-26 ANTONIO POLLAIUOLO, *Battle of the Ten Nudes,* ca. 1465. Engraving, approx. 1' 3" × 1' 11". Metropolitan Museum of Art, New York (bequest of Joseph Pulitzer, 1917).

16-27 SANDRO BOTTICELLI, *Birth of Venus,* ca. 1482. Tempera on canvas, approx. 5' 8" × 9' 1". Galleria degli Uffizi, Florence.

As an engraving, Pollaiuolo's *Battle of the Ten Nudes* is a new medium, as discussed earlier, that northern European artists probably developed around the middle of the fifteenth century. But whereas German graphic artists, such as Martin Schongauer (see FIG. 15-26), described their forms with hatching that follows the forms, Italian engravers, such as Pollaiuolo, preferred parallel hatching. The former method was in keeping with the general northern approach to art, which tended to describe surfaces of forms, rather than their underlying structures, while the latter was better suited for the anatomical studies that preoccupied Pollaiuolo and his Italian contemporaries.

VISUAL POETRY SANDRO BOTTICELLI (1444–1510) remains among the best known of the artists who produced works for the Medici. One of the works he painted in tempera on canvas for the Medici was his famous *Birth of Venus* (FIG. **16-27**). A poem on that theme by Angelo Poliziano, one of the leading humanists of the day, inspired Botticelli to create this lyrical image. Zephyrus (the west wind) blows Venus, born of the sea foam and carried on a cockle shell, to her sacred island, Cyprus. There, the nymph Pomona runs to meet her with a brocaded mantle. The lightness and bodilessness of the winds move all the figures without effort. Draperies undulate easily in the gentle gusts, perfumed by rose petals that fall on the whitecaps. Botticelli's nude presentation of the Venus figure was in itself an innovation. As mentioned earlier, the nude, especially the female nude, had been proscribed during the Middle Ages. Its appearance on such a scale and the artist's use of an ancient Venus statue of the Venus *pudica* (modest Venus) type—a Hellenistic variant of Praxiteles' famous *Aphrodite of Knidos* (see FIG. 5-60)—as a model could have drawn the charge of paganism and infidelity. But in the more accommodating Renaissance culture and under the protection of the powerful Medici, the depiction went unchallenged.

Botticelli's style is clearly distinct from the earnest search many other artists pursued to comprehend humanity and the natural world through a rational and empirical order. Indeed, Botticelli's elegant and beautiful style seems to have ignored all of the scientific knowledge experimental art had gained (for example, in the areas of perspective and anatomy). His style paralleled the allegorical pageants staged in Florence as chivalric tournaments but structured around allusions to classical mythology; the same trend is evident in the poetry of the 1470s and 1480s. Artists and poets at this time did not directly imitate classical antiquity but used the myths, with delicate perception of their charm, in a way still tinged with medieval romance. Ultimately, Botticelli created a style of visual poetry, parallel to the Petrarchan love poetry Lorenzo de' Medici wrote. His paintings possess a lyricism and courtliness that appealed to cultured patrons such as the Medici.

As evidenced by these Medici commissions, the Florentine family did not restrict their collecting to any specific style or artist. Their acquisitions, as already noted, often incorporated elements associated with humanism, from mythological subject matter to concerns with anatomy and perspective. Collectively, the art of the Medici also makes a statement about the patrons themselves. Careful businessmen that they were, the Medici were not sentimental about their endowment of art

and scholarship. Cosimo acknowledged that his good works were not only for the honor of God but also to construct his own legacy. This is not to suggest that the Medici were solely self-serving—throughout the century, Medici family members demonstrated a sustained and sincere love of learning.

THE RISE OF PORTRAITURE

Portraiture in Florence

With humanism's increased emphasis on individual achievement and recognition, portraiture enjoyed a revival in the fifteenth century. Commemorative portraits of the deceased were common, and patrons also commissioned portraits of themselves. The profile pose was customary in Florence until about 1470, when three-quarter and full-face portraits began to replace it. Bust-length portraits based on Roman precedents also became prominent.

A PSYCHOLOGICAL PROFILE In about the last decade of the fifteenth century, Sandro Botticelli painted the nearly full-face *Portrait of a Youth* (FIG. **16-28**). Painters of northern Europe (see FIGS. 15-15 and 15-16) popularized three-quarter and full-face views earlier in the century. The Italian painters adopted these views believing that such poses

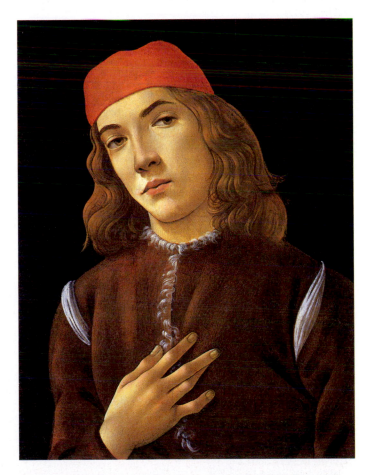

16-28 SANDRO BOTTICELLI, *Portrait of a Youth*, early 1480s. Tempera on panel, 1′ 4″ × 1′. National Gallery of Art, Washington (Andrew W. Mellon Collection).

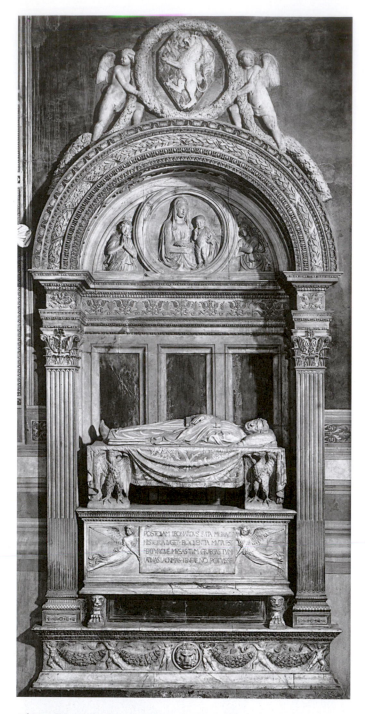

16-29 BERNARDO ROSSELLINO, tomb of Leonardo Bruni, Santa Croce, Florence, Italy, ca. 1445–1450. Marble, approx. 20′ high to top of arch.

form. Botticelli infinitely refined this method, and art historians recognize him as one of the great masters of line.

A TRIBUTE TO A HUMANIST SCHOLAR The tomb of Leonardo Bruni (1370–1444) in Santa Croce in Florence (FIG. **16-29**) beautifully expressed the prevailing dedication to the values of classical antiquity. Its sculptor, BERNARDO ROSSELLINO (1409–1464), like the man whose tomb he built, was at one time a resident of Arezzo, a city southeast of Florence. Rossellino aimed at nothing less than the immortalization of his fellow citizen. Wall tombs have a history that reaches back into the Middle Ages, but Rossellino's version was new and definitive—the expression of an age deliberately turning away from the medieval past.

Bruni was one of the most distinguished men of Italy and served as chancellor of Florence from 1427 until his death in 1444. When he died, people from far and wide mourned his passing. As a scholar in Greek and Latin, diplomat, and apostolic secretary to four popes, Bruni's career summed up the humanist ideal. The Florentines particularly praised him for his *History of Florence*. In his honor, citizens revived the funeral oration practice and the ancient custom of crowning the deceased with laurel. The historic event of the crowning of

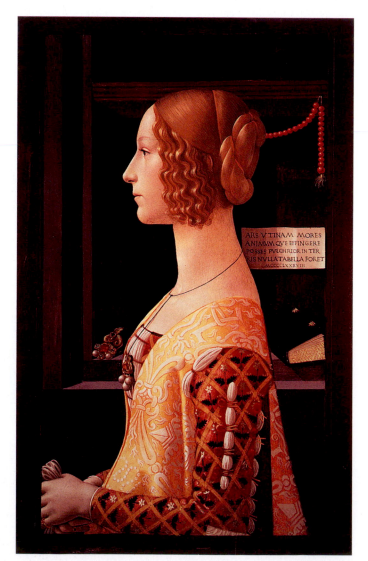

16-30 DOMENICO GHIRLANDAIO, *Giovanna Tornabuoni*(?), 1488. Oil and tempera on wood, approx. 2′ 6″ × 1′ 8″. Thyssen-Bornemisza Collection, Madrid, Spain.

increased the information available to viewers about the subject's appearance. Further, these poses permitted greater exploration of the subject's character, although Italian artists continued to favor an impersonal formality that concealed the private psychological person. An apparent exception, Botticelli's young man is highly expressive psychologically. The delicacy of the pose, the head's graceful tilt, the sidelong glance, and the elegant hand gesture compose an equivocal expression half musing and half insinuating. Botticelli merged feminine and masculine traits to make an image of rarefied beauty.

Botticelli was the pupil of Fra Filippo Lippi (FIG. 16-40), who must have taught him the method of "drawing" firm, pure outline with light shading within the contours. The effect is apparent in the portrait's explicit and sharply elegant

the dead humanist may have given Rossellino his theme so that the tomb was a kind of memorialization of the laureate scene.

The deceased lies on the *catafalque* (a supporting framework) in a long gown, the *History of Florence* on his breast, with imperial Roman eagles holding up his couch drapery at the ends. Winged *genii* (guardian spirits) at the summit of the arch above the catafalque hold a great *escutcheon* (an emblem bearing a coat of arms). On the side of the sarcophagus, other genii support a Latin inscription that describes the Muses' grief at the scholar's passing. Rossellino carved Roman funeral garlands on the narrow platform at the base of the niche. The only unmistakably Christian reference is a Madonna and Child with angels in the tympanum. The artist revealed his intimate familiarity with ancient Italian art by selecting motifs that have specific sources in Etruscan and Roman funerary monuments. Rossellino would not have had to travel far to study examples of sculptured marble figures on the lids of their sarcophagi (for example, FIG. 7-62), and the conceit of having the deceased hold a book (or a scroll) attesting to his achievements in life also came directly from antiquity (see FIG. 6-14). Winged Victories displaying engraved epitaphs, putti (cherubic little boys) bearing garlands, and eagles (who carry the deceased to a heavenly afterlife) were also staples on Roman sarcophagi—which, like Bruni's, usually were set into niches in walls. A humanist and pagan classicism controls the design's mood in an evocation of the ancient Greco-Roman world.

AN ELEGANT AND CULTURED WOMAN
Women were also portrait subjects. DOMENICO GHIRLANDAIO (1449–1494) produced a portrait of an aristocratic young woman (FIG. **16-30**), probably Giovanna Tornabuoni, a member of the powerful Albizzi family and wife of Lorenzo Tornabuoni. Although artists did not often employ the profile pose to convey a character reading, this portrait reveals the proud bearing of a sensitive and beautiful young woman. It tells viewers much about the advanced state of culture in Florence, the value and careful cultivation of beauty in life and art, the breeding of courtly manners, and the great wealth behind it all. The painting also shows the powerful attraction classical literature held for Italian humanists; in the background an epitaph (Giovanna Tornabuoni died in childbirth in 1488) quotes the ancient Roman poet Martial.

SUMMARIZING PICTORIAL DEVELOPMENTS
Although Domenico Ghirlandaio did not develop a very innovative style, his art provides viewers with significant insight into artistic developments, summarizing as it does the state of Florentine art toward the end of the fifteenth century. His works expressed his times to perfection, and, because of this, he enjoyed great popularity among his contemporaries. Ghirlandaio's paintings also reveal a deep love for Florence, with its spectacles and pageantry, its material wealth and luxury. Giovanni Tornabuoni, one of the wealthiest Florentines of his day, commissioned Ghirlandaio's most representative pictures, a cycle of frescoes depicting scenes from the lives of the Virgin and Saint John the Baptist, for the choir of Santa Maria Novella. In the illustrated painting, *Birth of the Virgin* (FIG. **16-31**), Mary's mother, Saint Anne, reclines in a palace room embellished with fine *intarsia* (wood inlay) and sculpture, while midwives prepare the infant's bath. From the left comes a grave procession of women led by a young Tornabuoni family member, probably Ludovica, Giovanni's daughter. This splendidly dressed beauty holds as prominent

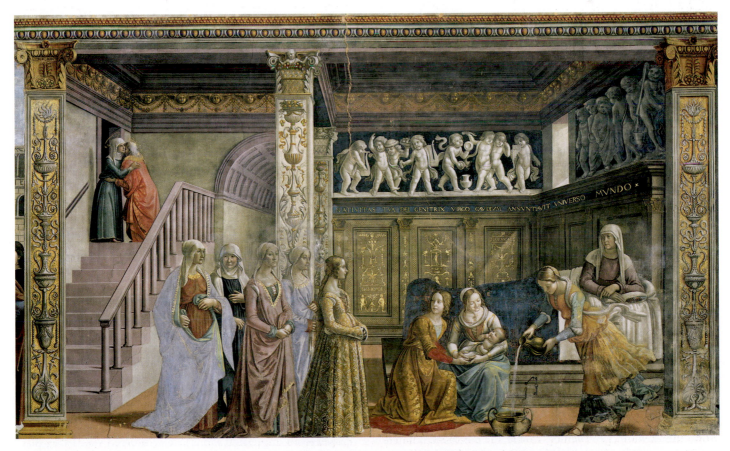

16-31 DOMENICO GHIRLANDAIO, *Birth of the Virgin*, Cappella Maggiore, Santa Maria Novella, Florence, Italy, 1485–1490. Fresco.

16-32 DONATELLO, *Gattamelata* (equestrian statue of Erasmo da Narni), Piazza del Santo, Padua, Italy, ca. 1445–1450. Bronze, approx. 11′ × 13′.

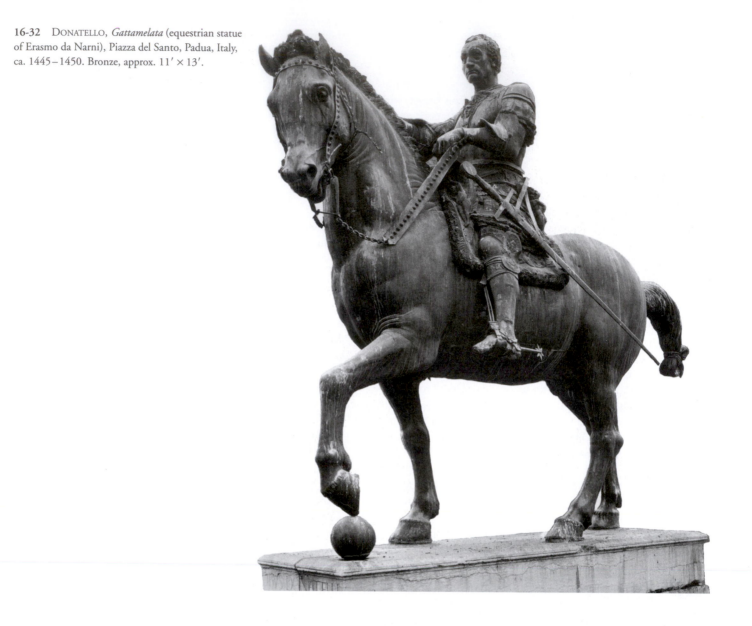

a place in the composition (close to the central axis) as she must have held in Florentine society. Her appearance in the painting (a different female member of the house appears in each fresco) is conspicuous evidence of the secularization of sacred themes—commonplace in art by this time. Artists depicted living persons of high rank not only as present at biblical dramas but also, as here, often stealing the show from the saints. The display of patrician elegance tempers the biblical narrative and subordinates the tableau's devotional nature.

Ghirlandaio's composition epitomizes the achievements of Early Renaissance painting: clear spatial representation; statuesque, firmly constructed figures; and rational order and logical relations among these figures and objects. If anything of earlier traits remains here, it is the arrangement of the figures, which still cling somewhat rigidly to layers parallel to the picture plane.

Portraiture outside of Florence

A CAT ON A HORSE In 1443, Donatello left Florence for northern Italy to accept a rewarding commission from the Republic of Venice to create a commemorative

monument in honor of the recently deceased Venetian condottiere Erasmo da Narni, nicknamed Gattamelata ("honeyed cat," a wordplay on his mother's name, Melania Gattelli). City officials asked Donatello to portray Gattamelata on horseback in a statue (FIG. **16-32**) to be erected in the square of Sant'Antonio in Padua. Although equestrian statues occasionally had been set up in Italy in the late Middle Ages, Donatello's *Gattamelata* is the first to rival the grandeur of the mounted portraits of antiquity, such as that of Marcus Aurelius (see FIG. 7-59), which the artist must have seen in Rome. Donatello's contemporaries, one of whom described Gattamelata as sitting "there with great magnificence like a triumphant Caesar,"⁵ recognized this reference to antiquity. The figure stands high on a lofty elliptical base, set apart from its surroundings, and almost celebrates sculpture's liberation from architecture. Massive and majestic, the great horse bears the armored general easily, for, unlike the sculptor of Marcus Aurelius, Donatello did not represent the Venetian commander as superhuman and more than life-size. The officer dominates his mighty steed by force of character rather than sheer size. Together, man and horse combine to convey an overwhelming image of irresistible strength and unlimited power—an impression Donatello reinforced visually by plac-

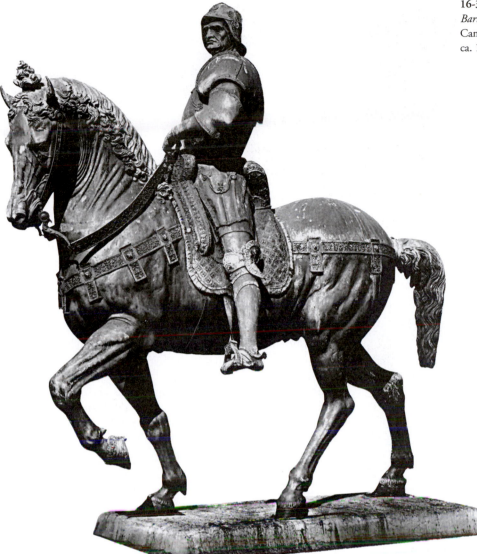

16-33 ANDREA DEL VERROCCHIO, *Bartolommeo Colleoni* (equestrian statue), Campo dei Santi Giovanni e Paolo, Venice, Italy, ca. 1483–1488. Bronze, approx. 13′ high.

ing the left forehoof of the horse on an orb, reviving a venerable ancient symbol for hegemony over the earth. The Italian rider, his face set in a mask of dauntless resolution and unshakable will, is the very portrait of the male Renaissance individualist. Such a man—intelligent, courageous, ambitious, and frequently of humble origin—could, by his own resourcefulness and on his own merits, rise to a commanding position in the world.

A DOMINATING MILITARY LEADER Verrocchio's equestrian statue of another condottiere of Venice, Bartolommeo Colleoni (FIG. **16-33**), provides a counterpoint to *Gattamelata*. Eager to garner the fame of *Gattamelata* by emulating Donatello's sculpture, Colleoni provided for the statue in his will. Both artists executed the statues after the death of their subjects, so neither Donatello nor Verrocchio knew personally the individual he portrayed. The result is a fascinating difference of interpretation (like that between the two *Davids,* FIGS. 16-23 and 16-24) as to the demeanor of a professional captain of armies. Verrocchio placed the statue of the bold equestrian general on a pedestal even higher than that Donatello used for *Gattamelata* so that viewers could see the dominating, aggressive figure above the rooftops from all ma-

jor approaches to the piazza (the Campo dei Santi Giovanni e Paolo). Silhouetted against the sky, *Bartolommeo Colleoni* with its fierce authority is unmistakable. In contrast with the near repose of *Gattamelata*, the *Colleoni* horse moves in a prancing stride, arching and curving its powerful neck, while the commander seems suddenly to shift his whole weight to the stirrups and, in a fit of impassioned emotion, to rise from the saddle with a violent twist of his body. The artist depicted the figures with an exaggerated tautness—the animal's bulging muscles and the man's fiercely erect and rigid body together convey brute strength. In *Gattamelata*, Donatello created a portrait of grim sagacity; Verrocchio's *Bartolommeo Colleoni* is a portrait of savage and merciless might. Machiavelli wrote in his famous political treatise of 1513, *The Prince,* that the successful ruler must combine the traits of the lion and the fox. It seems that Donatello's *Gattamelata* is a little like the latter and that Verrocchio's *Bartolommeo Colleoni* is much like the former.

LOOKING UP TO THE POPE Individuals in positions of religious authority also welcomed the opportunity to commission portraits. Pope Sixtus IV commissioned a series of frescoes for the Vatican Library in Rome from MELOZZO

16-34 MELOZZO DA FORLÌ, *Pope Sixtus IV, His Nephews, and the Librarian Platina*, 1480–1481. Fresco originally in the Vatican Library, Rome, Italy, transferred to canvas, 13′ 1″ × 10′ 4″. Pinacoteca Vaticana, Rome.

DA FORLÌ (1438–1494). In one of these frescoes (FIG. **16-34**), the artist depicted the seated pope receiving his nephews (including the future Pope Julius II in the center, wearing red cardinal's robes) and his librarian, Platina, who kneels before him. Melozzo's debt to Masaccio appears in his weighty and solemn figures, as well as in his interest in employing perspective to unify the painted space of his fresco with that of the surrounding room. Because the fresco has been removed from the wall and transferred to the picture gallery of the Vatican Museums, viewers no longer can study Melozzo's integration of pictorial and actual space in its original location. Nevertheless, it is clear the painting once occupied a position high on the wall, because spectators look up at the pope and his entourage from below. In the foreground, Platina points downward toward a Latin inscription he wrote praising the achievements of Sixtus IV. A steady rhythm of piers rendered in precise linear perspective leads the eye farther into the background.

FURTHER DEVELOPMENTS IN ARCHITECTURE

LEON BATTISTA ALBERTI (1404–1472) entered the profession of architecture rather late in life, but, nevertheless, he made a remarkable contribution to architectural design. He was the first to study seriously the treatise of Vitruvius (*De architectura*), and his knowledge of it, combined with his own archeological investigations, made him the first Renaissance architect to understand Roman architecture in depth. Alberti's most important and influential theoretical work, *De re aedificatoria* (written about 1450, published 1485), al-

though inspired by Vitruvius, contains much original material. Alberti advocated a system of ideal proportions and argued that the central plan was the ideal form for a Christian church. He also considered incongruous the combination of column and arch (which had persisted from Roman times, FIG. 7-51, to Brunelleschi in the fifteenth century). By arguing that the arch is a wall opening that should be supported only by a section of wall (a pier), not by an independent sculptural element (a column), Alberti (with a few exceptions) disposed of the medieval arcade used for centuries. The early impact of Alberti's ideas already was seen in the architectural backdrop of Ghiberti's *Isaac and His Sons* (FIG. 16-5) on the Florence baptistery's "Gates of Paradise."

BUILDING ON CLASSICAL ARCHITECTURE Alberti's own architectural style represents a scholarly application of classical elements to contemporary buildings. His Palazzo Rucellai in Florence (FIG. **16-35**) probably dates from the mid-1450s. Alberti organized the facade, built over three medieval houses, in a much more severe fashion than the Palazzo Medici-Riccardi facade (FIG. 16-20), another classically inspired building. Flat pilasters, which support full entablatures, define each story of the Palazzo Rucellai. A classical cornice crowns the palace. The rustication of the wall surfaces between the smooth pilasters is subdued and uniform. Alberti created the sense that the structure becomes lighter in weight toward its top by adapting the ancient Roman manner of using different capitals for each story. He chose Tuscan (the Etruscan variant of the Greek

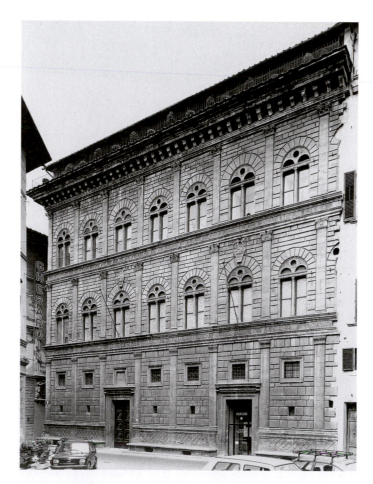

16-35 LEON BATTISTA ALBERTI, Palazzo Rucellai, Florence, Italy, ca. 1452–1470.

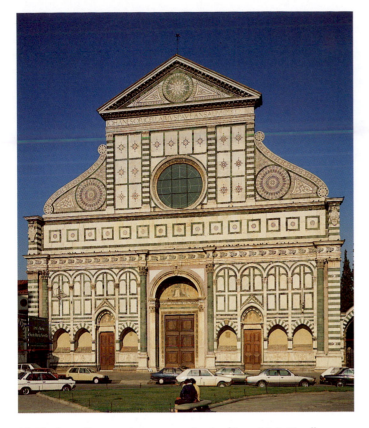

16-36 LEON BATTISTA ALBERTI, west facade of Santa Maria Novella, Florence, Italy, ca. 1458–1470.

16-37 LEON BATTISTA ALBERTI, diagrams of west facade, Santa Maria Novella, Florence, Italy.

ment tip) equals its width so that the entire facade can be inscribed in a square (FIG. 16-37, left). Throughout the facade, Alberti defined areas and related them to one another in terms of proportions that can be expressed in simple numerical ratios (1:1, 1:2, 1:3, 2:3, and so on). For example, the upper structure can be encased in a square one-fourth the size of the main square (for other squares, see the right diagram). The cornice of the entablature that separates the two levels halves the major square so that the lower portion of the building is a rectangle twice as wide as it is high. Further, the areas the columns on the lower level outline are squares with sides about one-third the main unit's width. In his treatise, Alberti wrote at length to promote the necessity of such harmonic relationships for designing beautiful buildings.

Alberti shared this conviction with Brunelleschi, and this fundamental dependence on classically derived mathematics distinguished their architectural work from that of their medieval predecessors. They believed in the eternal and universal validity of numerical ratios as the source of beauty. In this respect, Alberti and Brunelleschi revived the true spirit of the High Classical age of ancient Greece, as epitomized by the sculptor Polykleitos and the architect Iktinos, who produced canons of proportions for the perfect statue and the perfect temple. But it was not only a desire to emulate Vitruvius and the Classical masters that motivated Alberti to turn to mathematics in his quest for beauty. His contemporary, the Florentine humanist Giannozzo Manetti, had argued that Christianity itself possessed the order and logic of mathematics by insisting—in his 1452 treatise, *On the Dignity and Excellence of Man*—that Christian religious truths were as self-evident as mathematical axioms.

The Santa Maria Novella facade was an ingenious solution to a difficult design problem. On one hand, it adequately expressed the organization of the structure attached to it. On the other hand, it subjected preexisting and quintessentially medieval features, such as the large round window on the second level, to a rigid geometrical order that instilled a quality of classical calm and reason. This facade also introduced a feature of great historical consequence—the scrolls that simultaneously unite the broad lower and narrow upper level and screen the sloping roofs over the aisles. With variations, such spirals appeared in literally hundreds of church facades throughout the Renaissance and Baroque periods.

Doric order) for the ground floor, Composite (the Roman combination of Ionic volutes with the acanthus leaves of the Corinthian) for the second story, and Corinthian for the third floor. Alberti modeled his facade on the most imposing Roman ruin of all, the Colosseum (see FIG. 7-34), but he was no slavish copyist. On the Colosseum's facade the capitals employed are, from the bottom up, Tuscan, Ionic, and Corinthian. Moreover, Alberti adapted the Colosseum's varied surface to a flat facade, which does not allow the deep penetration of the building's mass that is so effective in the Roman structure. By converting his ancient model's *engaged columns* (half-round columns attached to a wall) into shallow pilasters that barely project from the wall, Alberti created a large-meshed linear net. Stretched tightly across the front of his building, it not only unifies the three levels but also emphasizes the wall's flat two-dimensional qualities.

OF RATIOS AND RATIONALITY The Rucellai family also commissioned from Alberti the design for the facade of the thirteenth-century Gothic church of Santa Maria Novella in Florence (FIGS. 16-36 and 16-37). Here, Alberti took his cue (just as Brunelleschi did occasionally) from a pre-Gothic medieval design—that of San Miniato al Monte (see FIG. 12-17). Following this Romanesque model, he designed a small, pseudoclassical, pediment-capped temple front for the facade's upper part and supported it with a broad base of pilaster-enframed arcades that incorporate the six tombs and three doorways of the extant Gothic building. But in the organization of these elements, Alberti took a long step beyond the Romanesque planners. The height of Santa Maria Novella (to the pedi-

16-38 FRA ANGELICO, *Annunciation,* San Marco, Florence, Italy, ca. 1440–1445. Fresco, 7′ 1″ × 10′ 6″.

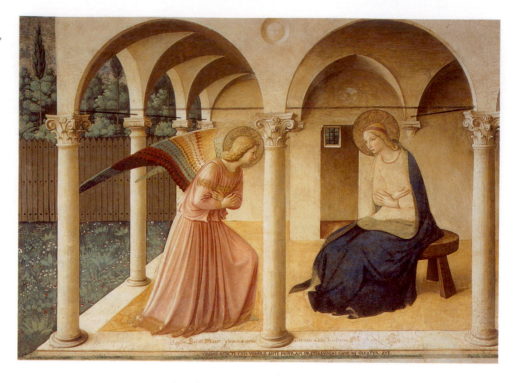

IMAGES OF PIETY AND DEVOTION

A VISUAL CALL TO PRAYER As is evident by the plethora of religious imagery produced during the fifteenth century, humanism and religion were not mutually exclusive. Yet for many artists, humanist concerns were not a primary consideration. FRA ANGELICO (ca. 1400–1455) was among those; as a friar at San Domenico at Fiesole, a village overlooking Florence, his art focused on serving the Roman Catholic Church. In the late 1430s, the abbots of the Dominican monastery of San Marco in Florence asked Fra Angelico to produce a series of frescoes for the monastery. The Dominicans of San Marco had dedicated themselves to lives of prayer and work, and the religious compound was mostly spare and austere to encourage the monks to immerse themselves in their devotional lives. Fra Angelico's frescoes illustrated a thirteenth-century text, *De modo orandi* (*The Way of Prayer*), which describes the nine ways of prayer Saint Dominic, the order's founder, used.

Among the works he completed was *Annunciation* (FIG. **16-38**), which appears at the top of the stairs leading to the friars' cells. Appropriately, Fra Angelico presented the scene of the Virgin Mary and the Archangel Gabriel with simplicity and serenity. The two figures appear in a plain loggia, and the artist painted all the fresco elements with a pristine clarity. As an admonition to heed the devotional function of the images, Fra Angelico included a small inscription at the base of the image that reads, "As you venerate, while passing before it, this figure of the intact Virgin, beware lest you omit to say a Hail Mary." Like most of Fra Angelico's paintings, *Annunciation*'s naive and tender charm still has an almost universal appeal and fully reflects the artist's simple and humble character.

DINING IN THE PRESENCE OF CHRIST ANDREA DEL CASTAGNO (ca. 1421–1457), like Fra Angelico, accepted a commission to produce a series of frescoes for a religious establishment. His *Last Supper* (FIG. **16-39**), painted in the refectory (dining hall) of Sant'Apollonia in Florence, a convent for Benedictine nuns, manifests both a commitment to the biblical narrative and an interest in perspective. The lavishly painted space Christ and his twelve disciples occupy suggests Castagno's absorption with creating the illusion of three-dimensional space. However, on scrutiny, inconsistencies are apparent, such as the fact Renaissance perspectival systems make it impossible to see both the ceiling and the roof, as Castagno depicted. Further, the two side walls do not appear parallel.

The artist chose a conventional compositional format, with the figures seated at a horizontally placed table. Castagno derived the apparent self-absorption of most of the disciples and the malevolent features of Judas (who sits alone on the outside of the table) from the Gospel of Saint John, rather than the more familiar version of the Last Supper recounted in the Gospel of Saint Luke. The prevalent exploration of perspective clearly influenced Castagno's depiction of the Last Supper, which no doubt was a powerful presence for the nuns during their daily meals.

A HUMANIZED MADONNA AND CHILD A younger contemporary of Fra Angelico, FRA FILIPPO LIPPI (ca. 1406–1469), was also a friar—but there all resemblance ends. From reports, Fra Filippo seems to have been an amiable man unsuited for monastic life. He indulged in misdemeanors ranging from forgery and embezzlement to the abduction of a pretty nun, Lucretia, who became his mistress and the mother of his son, the painter Filippino Lippi (1457–1504). Only the Medici's intervention on his behalf at the papal court preserved Fra Filippo from severe punishment and total disgrace. An orphan, Fra Filippo spent his youth in a monastery adjacent to the church of Santa Maria del Carmine, and, when about eighteen, he must have met Masaccio there and witnessed the Brancacci Chapel's decoration. Fra Filippo's early work survives only in

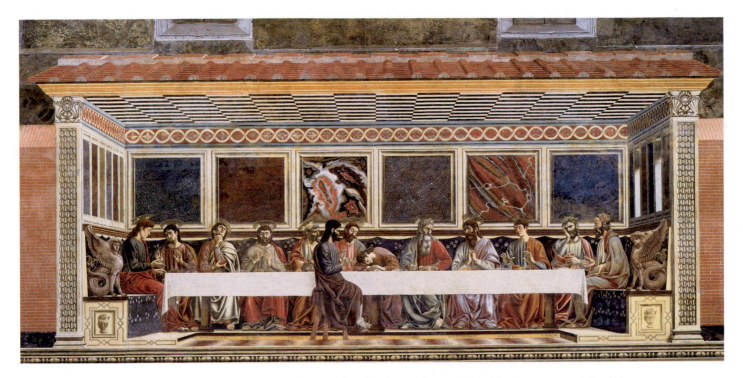

16-39 ANDREA DEL CASTAGNO, *Last Supper,* the Refectory, monastery of Sant'Apollonia, Florence, Italy, 1447. Fresco, approx. 15′ × 32′.

fragments, but these show he tried to work with Masaccio's massive forms. Later, probably under the influence of Ghiberti's and Donatello's relief sculptures, he developed a linear style that emphasized the contours of his figures and permitted him to suggest movement through flying and swirling draperies.

A painting from Fra Filippo's later years, *Madonna and Child with Angels* (FIG. **16-40**), shows his skill in manipulating line. A wonderfully fluid line unifies the composition and contributes to the precise and smooth delineation of forms. Few artists have surpassed Fra Filippo's skill in using line. He interpreted his subject here in a surprisingly worldly manner. The Madonna, a beautiful young mother, is not at all spiritual or fragile, and neither is the Christ Child, whom two angels hold up. One of the angels turns with the mischievous, puckish grin of a boy refusing to behave for the pious occasion. Significantly, all figures reflect the use of live models (that for the Madonna even may have been Lucretia). Fra Filippo plainly relished the charm of youth and beauty as he found it in this world. He preferred the real in landscape also, and the background, seen through the window, incorporates, despite some exaggerations, recognizable features of the Arno River valley. Compared with the earlier Madonnas by Giotto (see FIG. 14-7) and Duccio (see FIG. 14-16), this work shows how far artists had carried the humanization of the theme. Whatever the ideals of spiritual perfection may have meant to artists in past centuries, Renaissance artists realized such ideals in terms of the sensuous beauty of this world.

RELIEF SCULPTURE FOR THE MASSES During the latter half of the fifteenth century, increasing demand for devotional images for private chapels and shrines (rather than for large public churches) contributed to a growing seculariza-

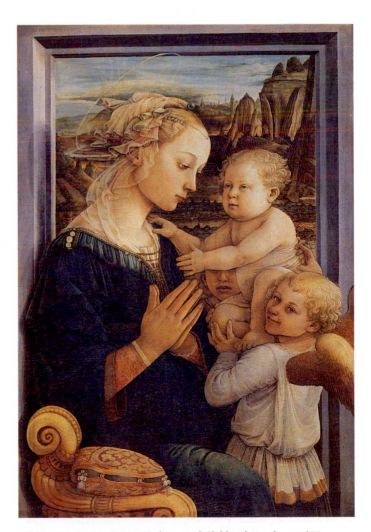

16-40 FRA FILIPPO LIPPI, *Madonna and Child with Angels,* ca. 1455. Tempera on wood, approx. 3′ × 2′ 1″. Galleria degli Uffizi, Florence.

16-41 LUCA DELLA ROBBIA, *Madonna and Child,* Or San Michele, Florence, Italy, ca. 1455–1460. Terracotta with polychrome glaze, diameter approx. 6′.

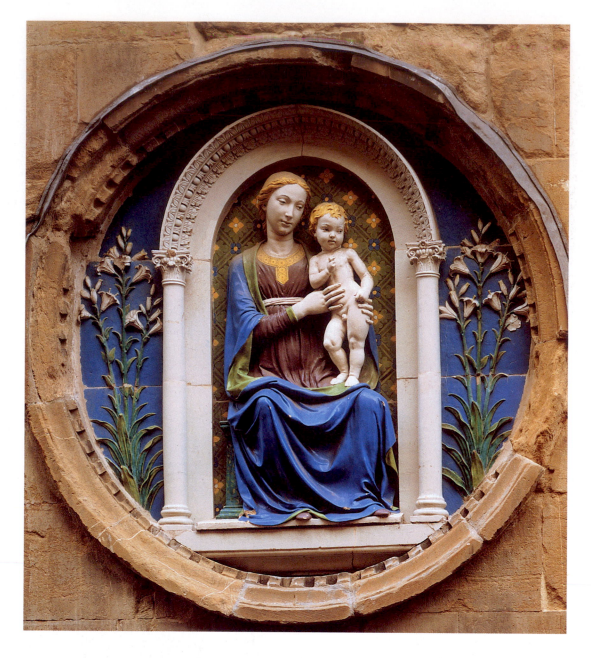

tion of traditional religious subject matter. LUCA DELLA ROBBIA (1400–1482) discovered a way to multiply Madonna images so that persons of modest means could buy them. His discovery (around 1430), involving the application of vitrified (heat fused) potters' glazes to sculpture, led to his production, in quantity, of glazed terracotta reliefs. He is best known for these works. Inexpensive, durable, and decorative, they became extremely popular and provided the basis for a flourishing family business. Luca's nephew Andrea della Robbia (1435–1525) and Andrea's sons, Giovanni della Robbia (1469–1529) and Girolamo della Robbia (1488–1566), carried on this tradition well into the sixteenth century. By then the product had become purely commercial; people still refer to it as "della Robbia ware."

An example of Luca's specialty is the *Madonna and Child* set into a wall of Or San Michele (FIG. **16-41**). The figures appear within a *tondo* (a circular painting or relief sculpture), a format that became popular with both sculptors and painters in the later part of the century. For example, Rossellino used it for the Madonna and Child of Leonardo

Bruni's tomb (FIG. 16-29), and Brunelleschi incorporated it into his design of the Pazzi Chapel's interior (FIG. 16-19), where most of the roundels are the work of Luca della Robbia himself. In his tondo for Or San Michele, Luca's introduction of high-key color into sculpture added a certain worldly gaiety to the Madonna and Child theme, and his customary light blue ground (and here the green and white of lilies and the white architecture) suggests in this work the festive Easter season and the freshness of May, the Virgin's month. Of course, the somber majesty of the old Byzantine style long since had disappeared. The young mothers who prayed before images such as this new form easily could identify with the Madonna and doubtless did. The distance between the observed and observers had vanished.

DECORATING THE NEW SISTINE CHAPEL Of course, the production of religious art extended beyond Florence. The pope's presence in Rome ensured an active artistic scene there as well. Between 1481 and 1483, Pope Sixtus

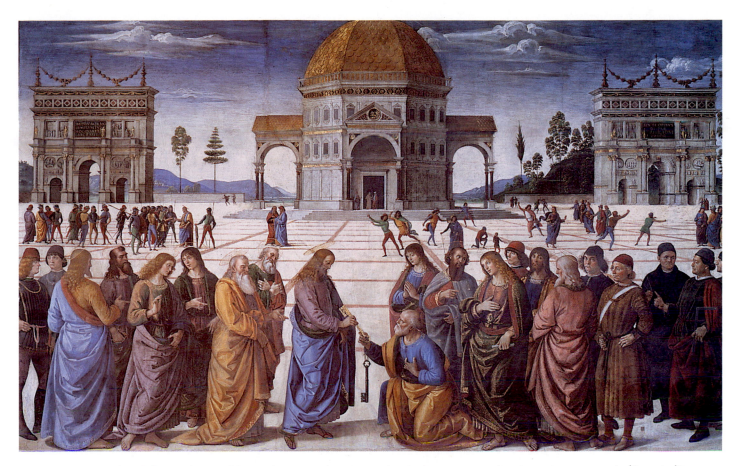

16-42 PERUGINO, *Christ Delivering the Keys of the Kingdom to Saint Peter,* Sistine Chapel, Vatican, Rome, Italy, 1481–1483. Fresco, 11′ 5½″ × 18′ 8½″.

IV summoned a group of artists, including Botticelli, Ghirlandaio, and Luca Signorelli, to Rome to decorate with frescoes the walls of the newly completed Sistine Chapel. PIETRO VANNUCCI, known as PERUGINO (ca. 1450–1523), was among this group and painted *Christ Delivering the Keys of the Kingdom to Saint Peter* (FIG. **16-42**). The papacy had, from the beginning, based its claim to infallible and total authority over the Roman Catholic Church on this biblical event. In Perugino's version, Christ hands the keys to Saint Peter, standing at the center of the Twelve Apostles and portraits of Renaissance contemporaries, who occupy the apron of a great stage space that extends into the distance to a point of convergence in the doorway of a central-plan temple. (Perugino used parallel and converging lines in the pavement to mark off the intervening space.) Figures in the middle distance complement the near group, emphasizing its density and order by their scattered arrangement. At the corners of the great piazza, duplicate triumphal arches serve as the base angles of a distant compositional triangle whose apex is in the central building. Perugino modeled the arches very closely on the Arch of Constantine (FIG. 7-76) in Rome. Although an anachronism in a painting depicting a scene from Christ's life, the arches remind viewers of the close ties between Constantine and Saint Peter and of the great basilica the first Christian emperor built over Saint Peter's tomb in Rome. Christ and Peter flank the triangle's central axis, which runs through the temple's doorway, the perspective's vanishing point. Thus, the composition interlocks both two-dimensional and three-dimensional space, and the placement of central actors emphasizes the axial center. This spatial

science allowed the artist to organize the action systematically. Perugino, in this single picture, incorporated the learning of generations.

THE PRINCELY COURTS

Mantua

Although virtually all the artworks discussed thus far in this chapter were Florentine, art production flourished throughout Italy in the fifteenth century. In particular, the princely courts that rulers established in cities such as Naples, Urbino, Milan, Ferrara, and Mantua deserve much credit for nurturing the arts. These princely courts consisted of the prince (lord of a territory), his consort and children, courtiers, household staff, and administrators (see "Dukes, Despots, Fame, and Fortune: The Princely Courts," page 479). The considerable wealth these princes possessed, coupled with their desire for recognition, fame, and power, resulted in major art commissions.

Marquis Ludovico Gonzaga (1412–1478) ruled one of these princely courts, the marquisate of Mantua in northern Italy. A famed condottieri, Gonzaga established his reputation as a fierce military leader while general of the Milanese armies. A visit to Mantua by Pope Pius II in 1459 stimulated the Marquis's determination to transform Mantua into a spectacular city. After the pope's departure, Gonzaga set about building a city that would be the envy of all of Italy.

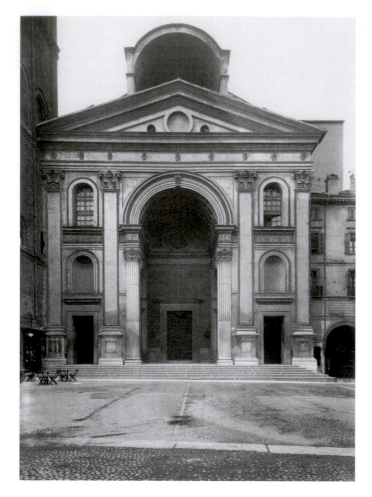

16-43 LEON BATTISTA ALBERTI, west facade of Sant'Andrea, Mantua, Italy, designed ca. 1470.

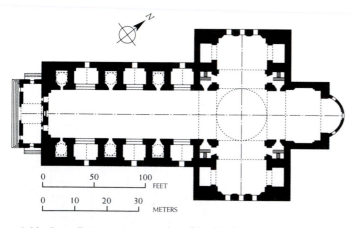

16-44 LEON BATTISTA ALBERTI, plan of Sant'Andrea, Mantua, Italy, designed ca. 1470.

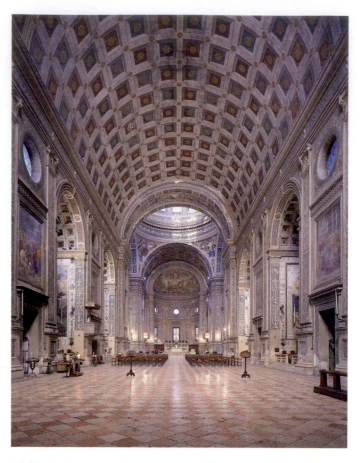

16-45 LEON BATTISTA ALBERTI, interior of Sant'Andrea, Mantua, Italy, designed ca. 1470.

AN EXPANSIVE MANTUAN CHURCH One of the major projects Gonzaga instituted was the redesigning of the church of Sant'Andrea in Mantua (FIGS. **16-43** to **16-45**) to replace an eleventh-century church. Gonzaga turned to Alberti for this important commission. In the ingeniously planned facade, which illustrates the culmination of Alberti's experiments, the architect locked together two complete Roman architectural motifs—the temple front and the triumphal arch. The combination was already a feature of classical architecture. Many Roman triumphal arches incorporated

a pediment over the arcuated passageway and engaged columns, including the Augustan arch at Rimini (FIG. **16-46**), illustrated here for comparison. Alberti's concern for proportion led him to equalize the facade's vertical and horizontal dimensions, which left it considerably lower than the church behind it. Because of the primary importance of visual appeal, many Renaissance architects made this concession not only to the demands of a purely visual proportionality in the facade but also to the facade's relation to the small square in front of it, even at the expense of continuity with the body of the building. Yet, structural correspondences to the building do exist in the Sant'Andrea facade. The facade pilasters are the same height as those on the nave's interior walls, and the central barrel vault over the main exterior entrance, with smaller barrel vaults branching off at right angles, introduces (in proportional arrangement but on a smaller scale) the interior system. The facade pilasters, as part of the wall, run uninterrupted through three stories in an early application of the "colossal" or "giant" order that became a favorite motif of Michelangelo.

The tremendous vaults in the interior of Sant'Andrea (FIG. 16-45) suggest that Alberti may have been inspired by the ruined Basilica Nova of Constantine in Rome (see FIG. 7-79)—erroneously thought in the Middle Ages and Renaissance to be a Roman temple. He abandoned the medieval columned arcade Brunelleschi used in Santo Spirito (FIG. 16-15). Thick walls alternating with vaulted chapels and interrupted by a massive dome over the crossing support the huge barrel vault. Because Filippo Juvara added the present dome in the eighteenth century, the effect may be somewhat differ-

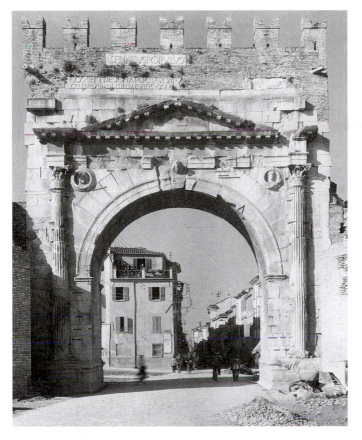

16-46 Arch of Augustus, Rimini, Italy, 27 B.C.

ent than Alberti planned. Regardless, the vault calls to mind the vast interior spaces and dense enclosing masses of Roman architecture. In his treatise, Alberti criticized the traditional basilican plan (with continuous aisles flanking the central nave) as impractical because the colonnades conceal the ceremonies from the faithful in the aisles. For this reason, he designed a single huge hall with independent chapels branching off at right angles (FIG. 16-44). This break with a Christian building tradition that had endured for a thousand years was extremely influential in later Renaissance and Baroque church planning.

A PALATIAL ROOM OF PAINTED SPLENDOR
Like other princes, Ludovico Gonzaga believed that an impressive palace was an important visualization of his authority. One of the most spectacular rooms in Palazzo Ducale was decorated by ANDREA MANTEGNA (ca. 1431–1506) of Padua, near Venice. In the so-called Camera degli Sposi (Room of the Newlyweds; FIG. **16-47**), originally the Camera Picta (Painted Room), Mantegna performed a triumphant feat of pictorial illusionism, producing the first completely consistent illusionistic decoration of an entire room. Using actual architectural elements, Mantegna painted away the room's walls in a manner that foretold later Baroque decoration. It recalls the efforts of Italian painters more than fifteen centuries earlier at Pompeii and elsewhere to integrate mural painting and actual architecture in frescoes of the so-called Second Style of Roman painting (see FIGS. 7-15 and 7-16).

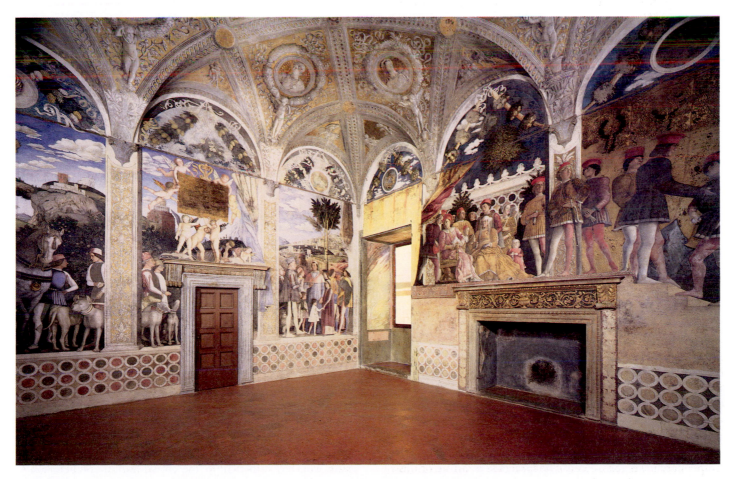

16-47 ANDREA MANTEGNA, interior of the Camera degli Sposi, Palazzo Ducale, Mantua, Italy, 1474. Fresco.

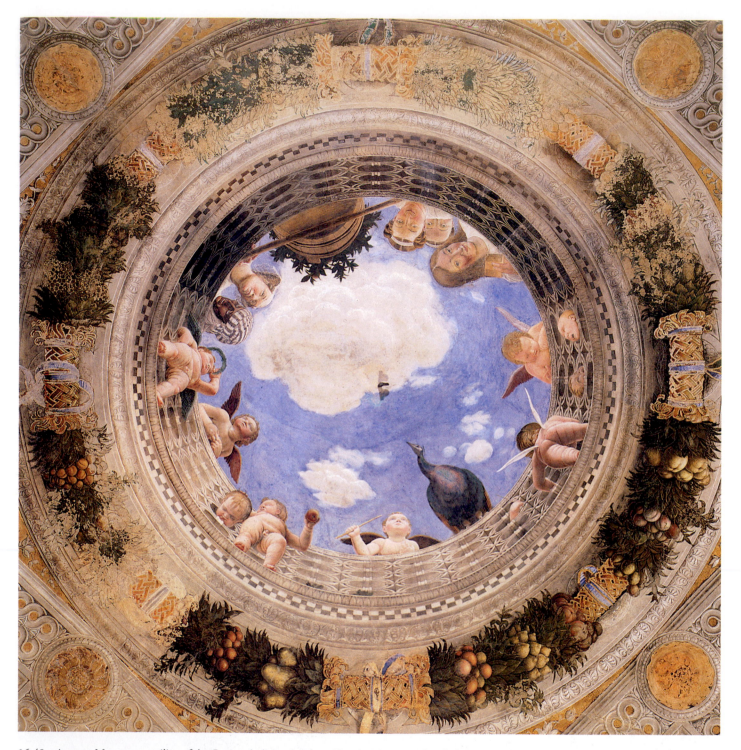

16-48 ANDREA MANTEGNA, ceiling of the Camera degli Sposi, Palazzo Ducale, Mantua, Italy, 1474. Fresco, 8′ 9″ in diameter.

Mantegna's *trompe l'oeil* (literally, "deceives the eye") design, however, went far beyond anything preserved from ancient Italy. The Renaissance painter's daring experimentalism led him to complete the room's decoration with the first *di sotto in sù* (from below upwards) perspective of a ceiling (FIG. **16-48**). Baroque ceiling decorators later broadly developed this technique. Inside the Room of the Newlyweds, viewers become the viewed as figures look down into the room. The oculus is itself an "eye" looking down. Cupids (the sons of Venus), strongly foreshortened, set the amorous mood as the painted spectators (who are not identified) smile down on the scene. The peacock is an attribute of Juno, Jupiter's bride, who oversees lawful marriages. This

tour de force of illusionism climaxes almost a century of experiment in perspective.

A SAINT VIEWED FROM BELOW While the Gonzaga frescoes showcase Mantegna's mature style, his earlier frescoes in the Ovetari Chapel in the Church of the Eremitani (largely destroyed in World War II) in Padua reveal Mantegna's early interest in illusionism and highlight the breadth of his literary, archeological, and pictorial learning. *Saint James Led to Martyrdom* (FIG. **16-49**) depicts the condemned saint stopping, even on the way to his own death, to bless a man who has rushed from the crowd and kneels before him (while a Roman soldier restrains others from coming for-

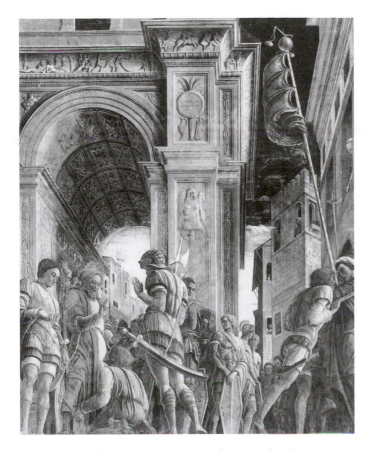

16-49 ANDREA MANTEGNA, *Saint James Led to Martyrdom,* Ovetari Chapel, Church of the Eremitani (largely destroyed, 1944), Padua, Italy, ca. 1455. Fresco, 10′ 9″ wide.

ward). Yet narrative does not seem to have been Mantegna's primary concern in this fresco. The painter strove for historical authenticity, much like the antiquarian scholars of the University of Padua. He excerpted the motifs that appear on the barrel-vaulted triumphal arch from the classical ornamental vocabulary. Antique attire served as the model for the soldiers' costumes.

Perspective also occupied Mantegna's attention. Indeed, he seemed to set up for himself difficult problems in perspective for the joy of solving them. Here, observers view the scene from a very low point, almost as if looking up out of a basement window at the vast arch looming above. The lines of the building to the right plunge down dramatically. Several significant deviations from true perspective are apparent, however, and establish that Mantegna did not view the scientific organization of pictorial space as an end in itself. Using artistic license, he ignored the third vanishing point (seen from below, the buildings should converge toward the top). Disregarding perspectival facts, he preferred to work toward a unified, cohesive composition whose pictorial elements relate to the picture frame. Mantegna partly compensated for the lack of perspectival logic by inserting strong diagonals in the right foreground (the banner staff, for example).

EXAMINING CHRIST'S WOUNDS One of Mantegna's later paintings, *Dead Christ* (FIG. **16-50**), is a work of overwhelming power, despite the somewhat awkward insertion (probably by a student) of the two mourning figures on the left. What seems to be a strikingly realistic study in foreshortening, however, the artist modified by reducing the size of the figure's feet, which, as he must have known, would

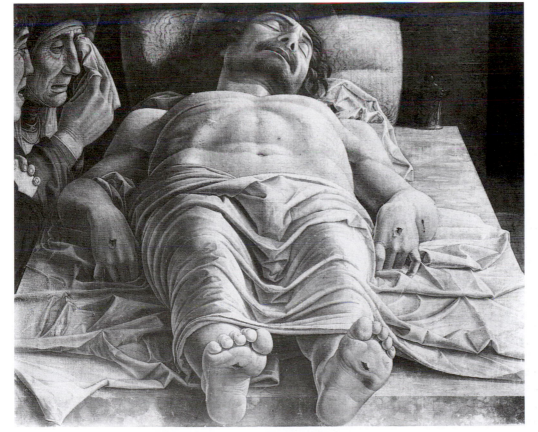

16-50 ANDREA MANTEGNA, *Dead Christ,* ca. 1501. Tempera on canvas, 2′ 2¾″ × 2′ 7⅞″. Pinacoteca di Brera, Milan.

cover much of the body if properly represented. Thus, tempering naturalism with artistic license, Mantegna presented both a harrowing study of a strongly foreshortened cadaver and an intensely poignant depiction of a biblical tragedy. The painter's harsh, sharp line seems to cut the surface as if it were metal and conveys, by its grinding edge, the theme's corrosive emotion. Remarkably, all the science of the fifteenth century here serves the purpose of devotion.

Artists in northern Italy, not only in Mantua but in Ferrara and Venice as well, attempted to follow in Mantegna's footsteps. His influence went even further, however, for he was also a great engraver (the line in the *Dead Christ* certainly suggests engraving). His prints found their way across the Alps to Germany, where they influenced Albrecht Dürer (see FIGS. 18-4 to 18-9), a leading figure in sixteenth-century art.

Urbino

Urbino, southeast of Florence across the Appenines, was another princely court; the patronage of Federico da Montefeltro (1422–1482) accounted for its status as a center of Renaissance art and culture. In fact, the humanist Paolo Cortese described Federico as one of the two greatest artistic patrons of the fifteenth century (the other was Cosimo de' Medici). Federico, like Ludovico Gonzaga, was a well-known condottieri. So renowned was Federico for his military skills that he was in demand by popes and kings across Europe, and soldiers came from across the continent to study with this military expert. One of the artists who received several commissions from Federico was PIERO DELLA FRANCESCA (ca. 1420–1492). His art projected a mind cultivated by mathematics. Piero believed that the highest beauty resides in forms that have the clarity and purity of geometric figures. Toward the end of his long career, Piero, a skilled geometrician, wrote the first theoretical treatise

on systematic perspective, after having practiced the art with supreme mastery for almost a lifetime. His association with the architect Alberti at Ferrara and at Rimini around 1450–1451 probably turned his attention fully to perspective (a science in which Alberti was an influential pioneer) and helped to determine his later, characteristically architectonic, compositions. This approach appealed to Federico, a patron fascinated by architectural space and its depiction. Observers can say fairly that Piero established his compositions almost entirely by his sense of the exact and lucid structures defined by mathematics. Within this context, however, he handled light and color with considerable sophistication, and color became the matrix of his three-dimensional forms, lending them a new density as well as fusing them with the surrounding space.

A LEGENDARY FRESCO STYLE Before this survey considers the work Piero produced for Federico in Urbino, Piero's earlier art merits examination. One of his most important works is the fresco cycle in the apse of the church of San Francesco in Arezzo, southeast of Florence on the Arno. Painted between 1452 and 1456, the cycle represents ten episodes from the legend of the True Cross (the cross on which Christ died) and is based on a thirteenth-century popularization of the Scriptures, the *Golden Legend* by Jacobus de Voragine. In the climactic scene of Piero's Arezzo cycle, the *Finding of the True Cross and Proving of the True Cross* (FIG. **16-51**), Saint Helena, mother of Constantine, accompanied by her retinue, oversees the unearthing of the buried crosses (at left) and witnesses (at right) how the True Cross miraculously restores a dead man (the nude figure) to life. The architectural background organizes and controls the grouping of the figures; its medallions, arches, and rectangular panels are the two-dimensional counterparts of the ovoid, cylindrical, and cubic forms placed in front of it. The careful delineation of architecture suggests an architect's vision, certainly that of a man entirely

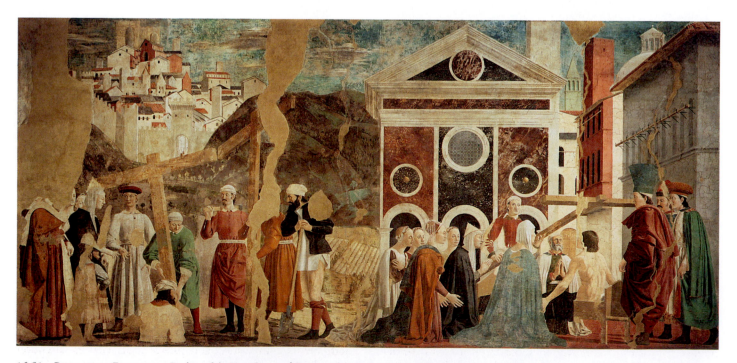

16-51 PIERO DELLA FRANCESCA, *Finding of the True Cross and Proving of the True Cross*, San Francesco, Arezzo, Italy, ca. 1455. Fresco, 11' 8 3/8" × 6' 4".

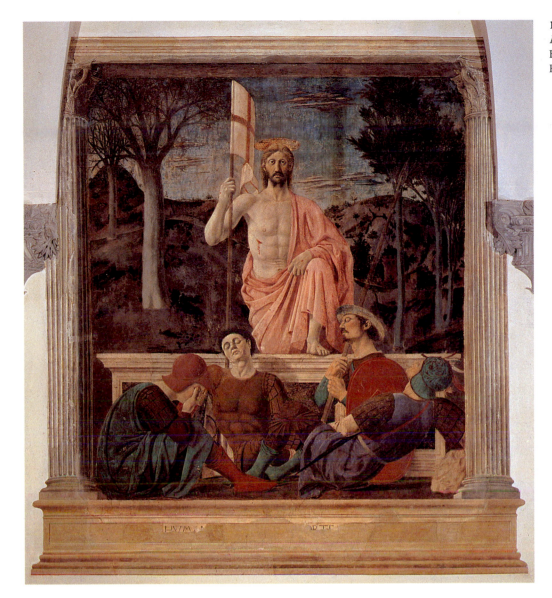

16-52 PIERO DELLA FRANCESCA, *Resurrection,* Palazzo Comunale, Borgo San Sepolcro, Italy, ca. 1463. Fresco, 7′ 5″ × 6′ 6½″.

familiar with compass and straightedge. As the architectonic nature of the abstract shapes controls the grouping, so, too, does it impart a mood of solemn stillness to the figures.

Piero's work shows, in addition, an unflagging interest in the properties of light and color. In his effort to make the clearest possible distinction between forms, he flooded his pictures with light, imparting a silver-blue tonality. To avoid heavy shadows, he illuminated the dark sides of his forms with reflected light. By moving the darkest tones of his modeling toward the centers of his volumes, he separated them from their backgrounds. With this technique, Piero's paintings lack some of Masaccio's relief-like qualities but gain in spatial clarity, as each shape forms an independent unit surrounded by an atmospheric envelope and movable to any desired position, like a figure on a chessboard.

RESURRECTING MASACCIO'S COMPOSITION

In the *Resurrection* fresco in the chapel of the town hall of Borgo San Sepolcro (FIG. **16-52**), Piero's birthplace in southern Tuscany, the artist used the compositional device—the figure triangle—Masaccio had used so successfully in *Holy Trinity* (FIG. 16-13) and that enjoyed great favor with later Re-

naissance artists. To stabilize the composition, Piero arranged his figures in a group that can be circumscribed by a triangle centrally placed in the painting. The risen Christ, standing with columnar strength in the attitude of eternal triumph at the edge of the tomb, occupies the upper portion of the triangular arrangement, which rests on the broad base of the sleeping soldiers in the foreground. This triangular massing of volumes around a picture's central axis gives a painting great compositional stability and is one of the keys to the symmetry and self-sufficiency Renaissance artists strove for in their work. Here, Piero involved spectators in his triangular composition by depicting the sleeping soldier at the lower right with his back to viewers so that the figure occupies the same position relative to Christ as that of spectators. His head and those of the two seated figures closest to Christ also are seen from below; viewers look up at them, and then their gazes linger on the triumphant resurrected Christ at the very center. Piero's sophisticated handling of color draws attention to Christ, too. The bright flesh, white banner, and pink mantle contrast sharply with the dark tones used for the sleeping soldiers in the foreground. Thus, both Piero's composition and palette focus viewers' attention immediately on the radiant haloed Christ.

16-53 PIERO DELLA FRANCESCA, *Enthroned Madonna and Saints Adored by Federico da Montefeltro (Brera Altarpiece),* ca. 1472–1474. Oil on panel, 8′ 2″ × 5′ 7″. Pinacoteca di Brera, Milan.

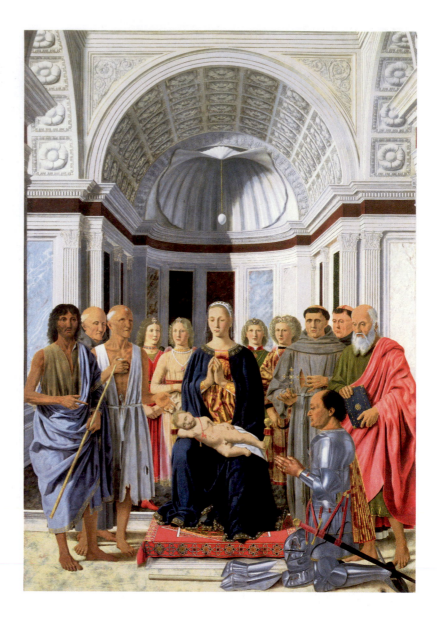

AN ARMORED PATRON AND THE MADONNA
Piero deployed all of his skills for the paintings Federico da Montefeltro commissioned. One of those works is *Enthroned Madonna and Saints Adored by Federico da Montefeltro,* also called the *Brera Altarpiece* (FIG. **16-53**). The clarity of Piero's earlier works is in full view here, as Federico, clad in armor, kneels piously at the Virgin's feet. Directly behind him stands Saint John the Evangelist, his patron saint. Where viewers would expect his wife, Battista Sforza, to appear (on the lower left, as a mirror image to Federico), no figure is present. Battista had died in 1472, shortly before Federico commissioned this painting. Thus, her absence clearly announces his loss. Piero further called attention to it by depicting Saint John the Baptist, Battista's patron saint, at the far left. The ostrich egg that hangs suspended from a shell over the Virgin's head was a common presence over altars dedicated to Mary. The figures appear in an illusionistically painted coffered barrel vault, which may have reflected the actual architecture of the painting's intended location, the church of San Bernadino degli Zoccolanti near Urbino. If such were the case, it would have enhanced the illusion, and viewers would be compelled to believe in Federico's presence before the Virgin, Christ Child, and saints. That Piero depicted Federico in profile was undoubtedly a concession to the patron. The right side of Federico's face had been badly injured in a tournament, and the resulting deformity made him reluctant to show that side of his face. The number of works (including other portraits) Piero executed for Federico reflects his success in accommodating his patron's wishes.

TURMOIL AT THE END OF THE CENTURY

A decade after Botticelli painted *Birth of Venus,* Florence underwent a political, cultural, and religious upheaval. Florentine artists and their fellow citizens responded then not only to humanist ideas but also to the incursion of French armies and especially to the preaching of the Dominican monk Girolamo Savonarola, the reforming priest-dictator who denounced the paganism of the Medici and their artists, philosophers, and poets. Savonarola exhorted the people of Florence to repent their sins, and, when Lorenzo de' Medici died in 1492 and the Medici fled, he prophesied the downfall of the city and of Italy and assumed absolute control of the state. Together with a large number of citizens, Savonarola believed that the Medici's political, social, and religious power had corrupted Florence and had invited the scourge of foreign invasion. Savonarola denounced humanism and encouraged

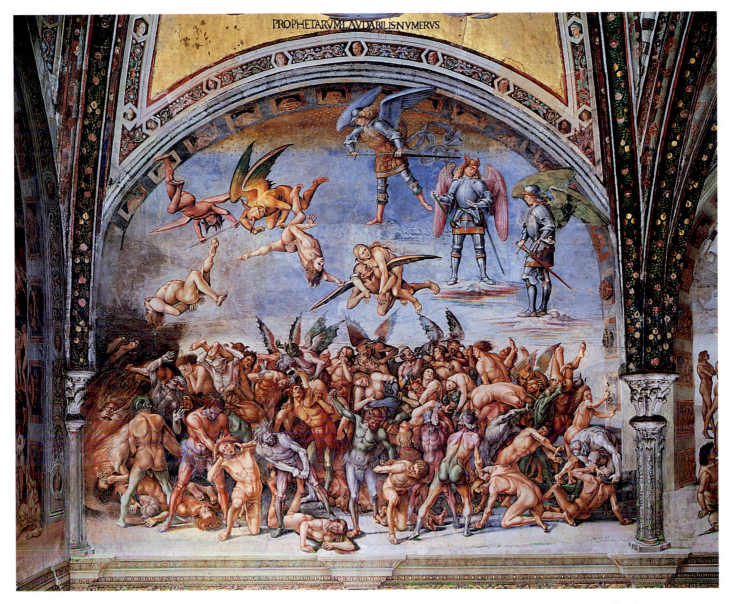

PROPHETARVM LAVDABILIS NVMERVS

16-54 LUCA SIGNORELLI, *Damned Cast into Hell*, San Brizio Chapel, Orvieto Cathedral, Orvieto, Italy, 1499–1504. Fresco, approx. 23' wide.

"bonfires of the vanities" for citizens to burn their classical texts, scientific treatises, and philosophical publications. Modern scholars still debate the significance of Savonarola's brief span of power. Apologists for the undoubtedly sincere monk deny that his actions played a role in the decline of Florentine culture at the end of the fifteenth century. But he did condemn humanism as heretical nonsense, and his banishing of the Medici, Tornabuoni, and other wealthy families from Florence deprived local artists of some of their major patrons. Certainly, the puritanical spirit that moved Savonarola must have dampened considerably the neopagan enthusiasm of the Florentine Early Renaissance.

A HORRIFYING VISION OF THE DAMNED Outside Florence, the fiery passion of the sermons of Savonarola found its pictorial equal in the work of the Umbrian painter LUCA SIGNORELLI (ca. 1445–1523). The artist further developed Antonio Pollaiuolo's interest in the depiction of muscular bodies in violent action in a wide variety of poses and foreshortenings. In the San Brizio Chapel in Orvieto Cathedral, Signorelli's painted scenes depicting the end of the world include *Damned Cast into Hell* (FIG. **16-54**). Few

figure compositions of the fifteenth century have the same awesome psychic impact. Saint Michael and the hosts of Heaven hurl the Damned into Hell, where, in a dense writhing mass, demons vigorously torture them. The horrible consequences of a sinful life had not been so graphically depicted since Gislebertus carved his vision of the Last Judgment in the west tympanum of Saint-Lazare at Autun (see FIGS. 12-25 and Intro-6) around 1130. The figures—nude, lean, and muscular—assume every conceivable posture of anguish. Signorelli's skill at foreshortening the human figure was one with his mastery of its action, and, although each figure is clearly a study from a model, he fit his theme to the figures in an entirely convincing manner. Terror and rage pass like storms through the wrenched and twisted bodies. The fiends, their hair flaming and their bodies the color of putrefying flesh, lunge at their victims in ferocious frenzy.

Doubtless, Signorelli influenced Michelangelo, who made the human nude his sole and sufficient expressive motif in the next century. The many artistic experiments and directions pursued by artists of the fifteenth century served as the foundation for the work of High Renaissance masters, such as Leonardo, Michelangelo, Raphael, and Titian, among many others.

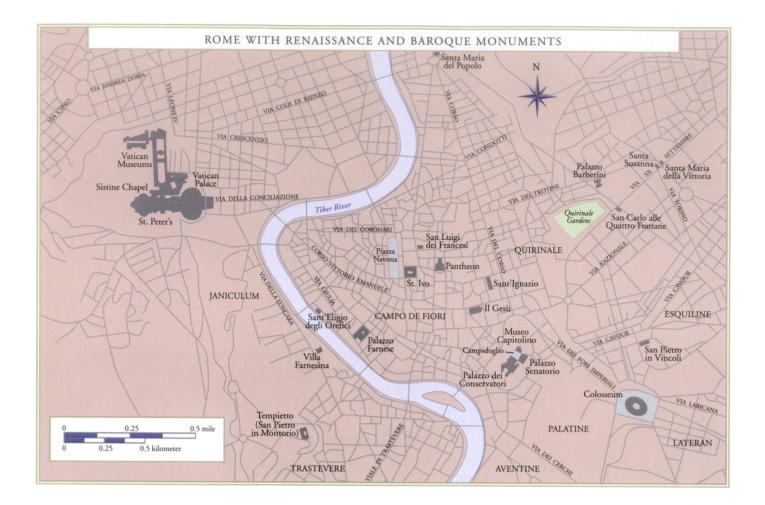

ROME WITH RENAISSANCE AND BAROQUE MONUMENTS

Santa Maria del Popolo

Vatican Museums

Sistine Chapel

Vatican Palace

St. Peter's

VIA CIPRO · VIA ANDREA DORIA · VIA LEONE IV · VIA COLA DI RIENZO · VIA CRESCENZIO · VIA DELLA CONCILIAZIONE · VIA CORSO · VIA CONDOTTI · VIA DEL TRITONE

Tiber River

JANICULUM

VIA DELLA LUNGARA

VIA GIULIA

CORSO VITTORIO EMANUELE

VIA DEI CORONARI

Piazza Navona

St. Ivo

San Luigi dei Francesi

Pantheon

CAMPO DE FIORI

Sant'Eligio degli Orefici

Palazzo Farnese

Villa Farnesina

Tempietto (San Pietro in Montorio)

Sant'Ignazio

Il Gesù

QUIRINALE

VIA DEL CORSO

Palazzo Barberini

Santa Susanna

Santa Maria della Vittoria

VIA XX SETTEMBRE

VIA TORINO

Quirinale Gardens

San Carlo alle Quattro Fontane

VIA NAZIONALE

VIA CAVOUR

ESQUILINE

San Pietro in Vincoli

Museo Capitolino

Campidoglio

Palazzo dei Conservatori

Palazzo Senatorio

VIA DEI FORI IMPERIALI

Colosseum

VIA LABICANA

PALATINE

LATERAN

TRASTEVERE

VIALE DI TRASTEVERE

VIA DEI CERCHI

AVENTINE

N

0 0.25 0.5 mile
0 0.25 0.5 kilometer

1500 1525

HIGH RENAISSANCE

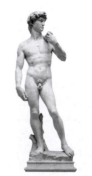

Michelangelo, David
1501–1504

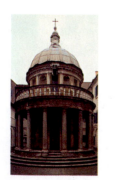

Bramante, Tempietto
San Pietro in Montorio
Rome, ca. 1502

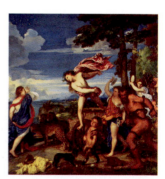

Titian, Meeting of Bacchus and
Ariadne, 1522–1523

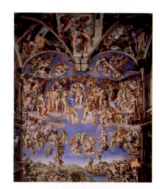

Michelangelo
Last Judgment
Sistine Chapel, 1534–1541

Niccolò Machiavelli (1469–1527), *The Prince*, 1532

Baldassare Castiglione (1478–1529), *The Courtier*, 1528

Pope Alexander VI (Borgia), r. 1492–1503

Pope Julius II (della Rovere), r. 1503–1513

Pope Leo X (Medici), r. 1513–1521

Protestant Reformation begins, 1517

Pope Clement VII (Medici), r. 1523–1534

Pope Paul III (Farnese), r. 1534–1549

Society of Jesus (the Jesuit Order) established, 1540

17

BEAUTY, SCIENCE, AND SPIRIT IN ITALIAN ART

THE HIGH RENAISSANCE AND MANNERISM

| 1550 | 1575 | 1600 |

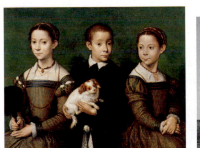

Sofonisba Anguissola
Portrait of the Artist's Sisters
and Brother, ca. 1555

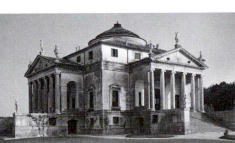

Andrea Palladio, Villa Rotonda
ca. 1566–1570

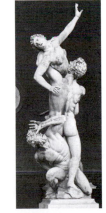

Giovanni da Bologna, Abduction of the
Sabine Women, completed 1583

Giorgio Vasari (1511–1574), *Lives of the Most Eminent Painters, Sculptors and Architects*, 1550

Council of Trent, 1545–1563

Pope Pius IV (Medici), r. 1559–1565

Pope Gregory XIII (Buoncompagni), r. 1572–1585

Pope Sixtus V (Peretti), r. 1585–1590

UPHEAVAL IN THE CHURCH

Sixteenth-century Italy witnessed major upheaval and change, particularly in the realm of religion. Widespread dissatisfaction with the leadership and policies of the Roman Catholic Church led to the Protestant Reformation, which historians often date as formally beginning in 1517. Led by clerics such as Martin Luther (1483–1546) and John Calvin (1509–1564) in the Holy Roman Empire, reformers directly challenged papal authority, especially regarding secular issues. Disgruntled Catholics voiced concerns about the sale of indulgences (pardons for sins, reducing the time a soul spent in Purgatory), nepotism (the appointment of relatives to important positions), and high Church officials pursuing personal wealth. This reform movement resulted in the establishment of Protestantism, with sects such as Lutheranism and Calvinism. Central to Protestantism was a belief in personal faith rather than adherence to decreed Church practices and doctrines. Because the Protestants believed the only true religious relationship was the personal relationship between individuals and God, they were, in essence, eliminating the need for Church intercession central to Catholicism.

The Catholic Church, in response, mounted a full-fledged campaign to counteract the migration of its members to Protestantism. This response, the Counter-Reformation, consisted of numerous initiatives. The Council of Trent, which met intermittently from 1545 through 1563, was a major component of this effort. Composed of cardinals, archbishops, bishops, abbots, and theologians, the Council of Trent dealt with issues of Church doctrine, including many the Protestants contested.

Another important facet of the Counter-Reformation was the activity of the Society of Jesus, known as the Jesuits. Ignatius of Loyola (1491–1556), a Spanish nobleman who dedicated his life to the service of God, founded the Jesuit order. He attracted a group of followers, and in 1540 the pope formally recognized this group as a religious order. The Jesuits were the papacy's invaluable allies in its quest to reassert the Catholic Church's supremacy. Particularly successful in the field of education, the order established numerous schools. Its commitment to education remains evident today in the many Jesuit colleges around the world. In addition, its members were effective missionaries and carried the message of Catholicism to the Americas, Asia, and Africa. The predominance of Catholicism in Latin America, the Philippines, and areas of Africa testifies to the Jesuit influence.

The Catholic Church's determination to win back adherents also led it to institute somewhat more extreme measures, such as the founding of the Holy Office of the Inquisition. The Inquisition was a Church court established specifically to deal with heretics. Zealous in its attempt to eradicate heresy, this court prosecuted non-Catholics, sometimes subjecting them to imprisonment or death.

The turmoil in the Church that led to both the Protestant Reformation and the Catholic Counter-Reformation provided the context for the prominence of papal art commissions during this period. Popes long had been aware of the power of visual imagery to construct and reinforce ideological claims, and sixteenth-century popes exploited this capability (see "The Role of Religious Art in Counter-Reformation Italy," page 525). Many of the major commissions came from the Church, and many of the popes initiated grandiose art programs.

THE HIGH RENAISSANCE

The Lasting Influence of Sixteenth-Century Artists

The fifteenth-century artistic developments in Italy (for example, the interest in perspectival systems and in depicting anatomy) matured during the sixteenth century, accounting for the designations "Early Renaissance" for the fifteenth century and "High Renaissance" for the sixteenth century. Although no singular style characterizes the High Renaissance, the art of those most closely associated with this period—Leonardo da Vinci, Raphael, Michelangelo, and Titian—exhibits an astounding mastery, both technical and aesthetic. High Renaissance artists created works of such authority that generations of later artists relied on these artworks for instruction.

These exemplary artistic creations further elevated the prestige of artists. Artists could claim divine inspiration, thereby raising visual art to a status formerly only given to poetry. Thus, painters, sculptors, and architects came into their own, successfully claiming for their work a high position among the fine arts. In a sense, sixteenth-century masters created a new profession with its own rights of expression and its own venerable character.

The Transition from Early Renaissance to High Renaissance

FROM A(NATOMY) TO Z(OOLOGY) The immense intellect, talent, and foresight of LEONARDO DA VINCI (1452–1519) allowed him to map the routes art and science were to take in the future. The scope and depth of his interests were without precedent—so great as to frustrate any hopes he might have had of realizing all his feverishly inventive imagination could conceive.

Although the discussion here focuses on Leonardo as an artist, exploring his art in conjunction with his other interests considerably enhances an understanding of his artistic production. Leonardo revealed his unquenchable curiosity in his voluminous notes, liberally interspersed with sketches dealing with botany, geology, geography, cartography, zoology, military engineering, animal lore, anatomy, and aspects of physical science, including hydraulics and mechanics. These studies informed his art. For example, Leonardo's in-depth exploration of optics provided him with an understanding of perspective, light, and color that he used in his painting. His scientific drawings are themselves artworks.

Leonardo's great ambition in his painting, as well as in his scientific endeavors, was to discover the laws underlying the processes and flux of nature. With this end in mind, he also studied the human body and contributed immeasurably to knowledge of physiology and psychology. Leonardo believed that reality in an absolute sense is inaccessible and that humans can know it only through its changing images. He considered the eyes the most vital organs and sight the most essential function, as, through these, individuals could grasp the images of reality most directly and profoundly. In his notes, he stated repeatedly that all his scientific investigations made him a better painter.

The Role of Religious Art in Counter-Reformation Italy

Both Catholics and Protestants took seriously the role of devotional imagery in religious life. However, their views differed dramatically. While Catholics deemed art as valuable for cultivating piety, Protestants believed such visual imagery could produce idolatry and could distract the faithful from their goal—developing a personal relationship with God (see Chapter 18, "Martin Luther on Religious Art," page 580). As part of the Counter-Reformation effort, Pope Paul III convened the Council of Trent in 1545 and directed them to review controversial Church doctrines. Among the council's conclusions was the following edict on the invocation (plea or call for help) of saints, the veneration of saints' relics, and the role of sacred images, published in *Canons and Decrees of the Council of Trent*:

> The holy council commands all bishops and others who hold the office of teaching and have charge of the *cura animarum* [literally, "cure of souls"—the responsibility of laboring for the salvation of souls], that in accordance with the usage of the Catholic and Apostolic Church, received from the primitive times of the Christian religion, and with the unanimous teaching of the holy Fathers and the decrees of sacred councils, they above all instruct the faithful diligently in matters relating to intercession and invocation of the saints, the veneration of relics, and the legitimate use of images. . . . Moreover, that the images of Christ, of the Virgin Mother of God, and of the other saints are to be placed and retained especially in the churches, and that due honor and veneration is to be given them; . . . because the honor which is shown them is referred to the prototypes which they represent, so that by means of the images which we kiss and before which we uncover the head and prostrate ourselves, we adore Christ and venerate the saints whose likeness they bear. That is what was defined by the decrees of the councils, especially of the Second Council of Nicaea, against the opponents of images.

> Moreover, let the bishops diligently teach that by means of the stories of the mysteries of our redemption portrayed in paintings and other representations the people are instructed and confirmed in the articles of faith, which ought to be borne in mind and constantly reflected upon; also that great profit is derived from all holy images, not only because the people are thereby reminded of the benefits and gifts bestowed on them by Christ, but also because through the saints the miracles of God and salutary examples are set before the eyes of the faithful, so that they may give God thanks for those things, may fashion their own life and conduct in imitation of the saints and be moved to adore and love God and cultivate piety. . . .

> And if at times it happens, when this is beneficial to the illiterate, that the stories and narratives of the Holy Scriptures are portrayed and exhibited, the people should be instructed that not for that reason is the divinity represented in picture as if it can be seen with bodily eyes or expressed in colors or figures. Furthermore, in the invocation of the saints, the veneration of relics, and the sacred use of images, all superstition shall be removed, all filthy quest for gain eliminated, and all lasciviousness avoided, so that images shall not be painted and adorned with a seductive charm, or the celebration of saints and the visitation of relics be perverted by the people into boisterous festivities and drunkenness, as if the festivals in honor of the saints are to be celebrated with revelry and with no sense of decency. . . .

> That these things may be the more faithfully observed, the holy council decrees that no one is permitted to erect or cause to be erected in any place or church, howsoever exempt, any unusual image unless it has been approved by the bishop; . . .[1]

[1] Robert Klein and Henri Zerner, *Italian Art 1500–1600: Sources and Documents* (Evanston, Ill.: Northwestern University Press, 1966), 120–21.

Born in the small town of Vinci, near Florence, Leonardo trained in the studio of Andrea del Verrocchio, but he left Florence around 1481, offering his services to Ludovico Sforza, duke of Milan, who accepted them. The political situation in Florence was uncertain, and Leonardo may have felt the artistic scene in Milan would be less competitive. He devoted most of a letter to the duke of Milan to advertising his competence and his qualifications as a military engineer, mentioning only at the end his abilities as a painter and sculptor:

> And in short, according to the variety of cases, I can contrive various and endless means of offence and defence. . . . In time of peace I believe I can give perfect satisfaction and to the equal of any other in architecture and the composition of buildings, public and private; and in guiding water from one place to another. . . . I can carry out sculpture in marble, bronze, or clay, and also I can do in painting whatever may be done, as well as any other, be he whom he may.[1]

This letter illustrates the fifteenth-century artist's relation to patrons, as well as Leonardo's breadth of competence. That he should select military engineering and design to interest a patron is an index of the period's instability. By this time, especially in northern Europe, weaponry had been developed to the point that the siege cannon threatened the feudal castles of those resisting wealthy and aggressive new monarchs. By the turn of the century, when aspiring kingdoms of Europe targeted Italy for acquisition, Italians of all walks of life—not only soldiers and architects but artists and humanists as well—expressed their concern with the problem of designing a fortification system that might withstand the terrible new weapon.

PAINTING THE SOUL'S INTENTION During his first sojourn in Milan, Leonardo painted *Virgin of the Rocks*

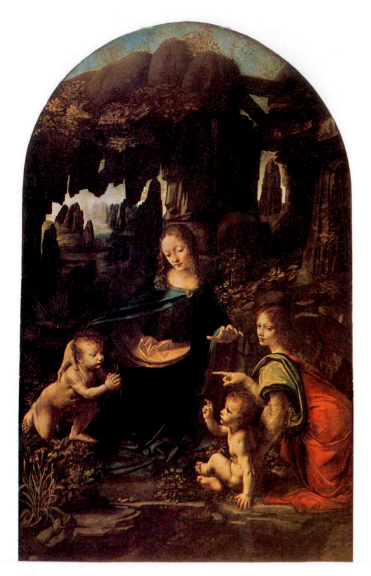

17-1 LEONARDO DA VINCI, *Virgin of the Rocks,* ca. 1485. Oil on wood (transferred to canvas), approx. 6′ 3″ × 3′ 7″. Louvre, Paris.

(FIG. **17-1**) as the central panel of an altarpiece for the chapel of the Confraternity of the Immaculate Conception (see "Mendicant Orders and Confraternities," Chapter 14, page 425) in San Francesco Grande. The painting incorporates Masaccio's great discovery of chiaroscuro, the subtle play of light and dark. Modeling with light and shadow and expressing emotional states were, for Leonardo, the heart of painting:

> A good painter has two chief objects to paint—man and the intention of his soul. The former is easy, the latter hard, for it must be expressed by gestures and the movement of the limbs. . . . A painting will only be wonderful for the beholder by making that which is not so appear raised and detached from the wall.[2]

Leonardo presented the figures in *Virgin of the Rocks* in a pyramidal grouping and, more notably, as sharing the same environment. This groundbreaking achievement—the unified representation of objects in an atmospheric setting—was a manifestation of his scientific curiosity about the invisible substance surrounding things. The Madonna, Christ Child, infant John the Baptist, and angel emerge through nuances of light and shade from the half-light of the cavernous visionary landscape. Light simultaneously veils and reveals the

forms, immersing them in a layer of atmosphere between them and viewers' eyes. Leonardo's effective use of atmospheric perspective is on full view here. The ambiguity of light and shade (familiar in dusk's optical haziness) serves the psychological ambiguity of perception. The group depicted, wrapped in subtle light and shade, eludes precise definition and interpretation. The figures pray, point, and bless, and these acts and gestures, although their meanings are not certain, visually unite the individuals portrayed. The angel points to the infant John and, through his outward glance, involves spectators in the tableau. John prays to the Christ Child and is blessed in return. The Virgin herself completes the series of interlocking gestures, her left hand reaching toward the Christ Child and her right hand resting protectively on John's shoulder. The melting mood of tenderness, enhanced by the caressing light, suffuses the entire composition. What the eye sees is fugitive, as are the states of the soul, or, in Leonardo's term, its "intentions."

A MAJESTIC PRELIMINARY DRAWING Leonardo's style fully emerges in a cartoon (a full-size preliminary drawing; see "*Disegno:* Drawing on Design Fundamentals," page 527), *Virgin and Child with Saint Anne and the Infant Saint John* (FIG. **17-2**). Here, the glowing light falls gently on the majestic forms, on a scene of tranquil grandeur and balance. Leonardo ordered every part of his cartoon with an

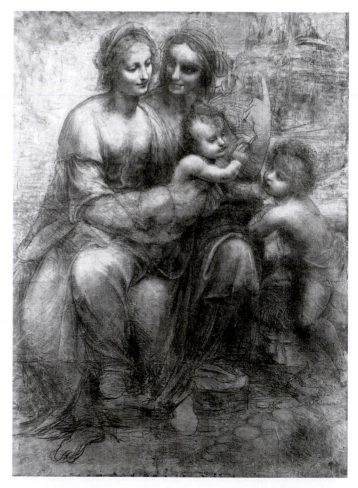

17-2 LEONARDO DA VINCI, cartoon for *Virgin and Child with Saint Anne and the Infant Saint John,* ca. 1505–1507. Charcoal heightened with white on brown paper, approx. 4′ 6″ × 3′ 3″. National Gallery, London.

Disegno
Drawing on Design Fundamentals

In the sixteenth century in Italy, drawing (or *disegno*) assumed a position of greater prominence than ever before in artistic production. Until the late fifteenth century, the lack of availability and expense of drawing surfaces limited the production of preparatory sketches. Most artists drew on parchment (prepared from the skins of calves, sheep, and goats) or on vellum (made from the skins of young animals and therefore very expensive). Because of the cost of these materials, drawings in the fourteenth and fifteenth centuries tended to be extremely detailed and meticulously executed. Artists often drew using *silverpoint* (a stylus made of silver) because of the fine line it produced and the sharp point it maintained. The introduction of less-expensive paper made of fibrous pulp, from the developing printing industry, allowed artists to experiment more and to draw with greater freedom. As a result, sketches abounded. Artists executed these drawings in pen and ink, chalk, charcoal, brush, and graphite or lead.

The importance of drawing, however, extended beyond the mechanical or technical possibilities drawing afforded artists. The term *disegno* also referred to design, an integral component of good art. Design was the foundation of art, while drawing was the fundamental element of design, linking the two. A statement by the artist Federico Zuccaro that drawing is the external physical manifestation *(disegno esterno)* of an internal intellectual idea or design *(disegno interno)* confirms this connection.

The design dimension of art production became increasingly important as artists cultivated their own styles. The early stages of artistic training largely focused on imitation and emulation (see "Imitation and Emulation: Artistic Values in the Renaissance," Chapter 16, page 490), but, to achieve widespread recognition, artists were expected to move beyond this dependence on previous models and develop their own styles. Although the artistic community and public at large acknowledged technical skill, the artwork's conceptualization—its theoretical and formal development—was paramount. *Disegno*, or *design* in this case, represented an artist's conceptualization and intention. In the period's literature, the terms writers and critics often invoked to praise esteemed artists included *invenzione* (invention), *ingegno* (ingenuity), *fantasia* (imagination), and *capriccio* (originality).

intellectual pictorial logic that results in an appealing visual unity. The figures are robust and monumental, the stately grace of their movements reminiscent of the Phidian statues of goddesses in the Parthenon's pediments (see FIG. 5-47). However, Leonardo and his contemporaries never saw those particular sculptures, because their acquaintance with classical art was limited to Etruscan and Roman monuments and Roman copies of Greek masterpieces unearthed in Italy.

DRAMA IN AN AUSTERE SETTING For the refectory of the church of Santa Maria delle Grazie in Milan, Leonardo painted *Last Supper* (FIG. **17-3**). Despite its ruined state (in part from the painter's unfortunate experiments with his materials) and although it often has been restored ineptly (see "Restoring the Glory of Renaissance Frescoes," page 540), the painting is both formally and emotionally his most impressive work. Christ and his twelve disciples are seated at a long table set parallel to the picture plane in a simple, spacious room. Leonardo amplified the painting's highly dramatic action by placing the group in an austere setting. Christ, with outstretched hands, has just said, "One of you is about to betray me" (Matt. 26:21). A wave of intense excitement passes through the group as each disciple asks himself and, in some cases, his neighbor, "Is it I?" (Matt. 26:22). Leonardo visualized a sophisticated conjunction of the dramatic "One of you is about to betray me" with the initiation of the ancient liturgical ceremony of the Eucharist, when Christ, blessing bread and wine, said, "This is my body, which is given for you. Do this for a commemoration of me. . . . This is the chalice, the new testament in my blood, which shall be shed for you" (Luke 22:19–20). The artist's careful conceptualization of the composition imbued this dramatic moment with force and lucidity.

In the center, Christ appears isolated from the disciples and in perfect repose, the still eye of the swirling emotion around him. The central window at the back, whose curved pediment arches above his head, frames his figure. The pediment is the only curve in the architectural framework, and it serves here, along with the diffused light, as a halo. Christ's head is the focal point of all converging perspective lines in the composition. Thus, the still, psychological focus and cause of the action is also the perspectival focus, as well as the center of the two-dimensional surface. One could say the two-dimensional, the three-dimensional, and the psychodimensional focuses are the same. Leonardo presented the agitated disciples in four groups of three, united among and within themselves by the figures' gestures and postures. The artist sacrificed traditional iconography to pictorial and dramatic consistency by placing Judas on the same side of the table as Jesus and the other disciples. His face in shadow, Judas clutches a money bag in his right hand and reaches his left forward to fulfill the Master's declaration: "But yet behold, the hand of him that betrayeth me is with me on the table" (Luke 22:21). The two disciples at the table ends are more quiet than the others, as if to bracket the energy of the composition, which is more intense closer to Christ, whose calm both halts and intensifies it.

The disciples register a broad range of emotional responses, including fear, doubt, protestation, rage, and love. Leonardo's numerous preparatory studies suggest he thought of each figure as carrying a particular charge and type of emotion. Like a skilled stage director (perhaps the first, in the modern sense), he read the gospel story carefully and scrupulously cast his

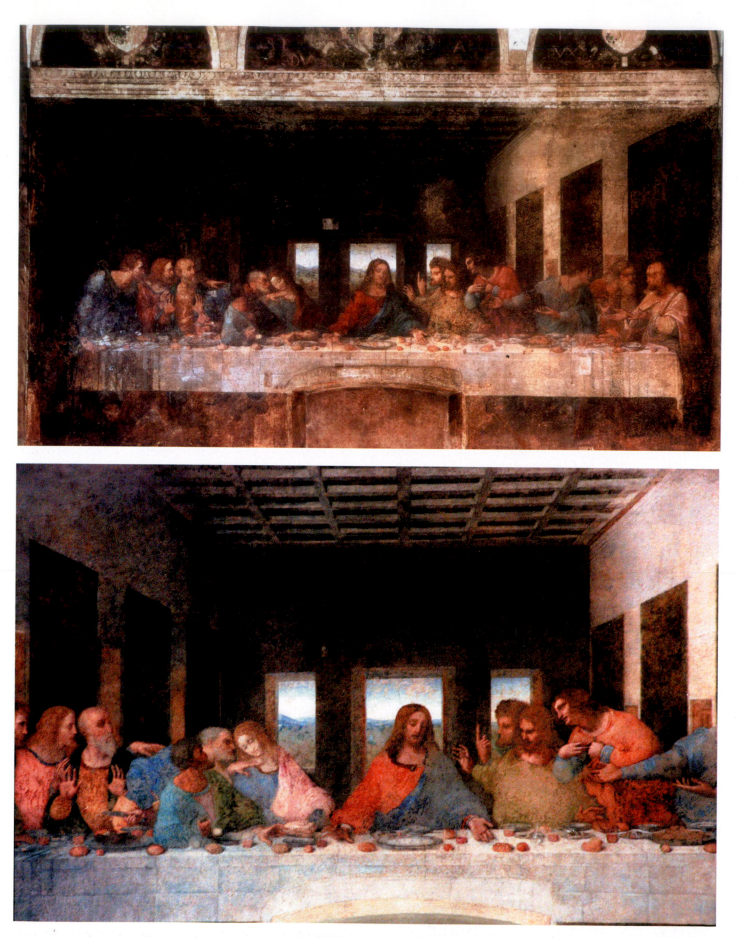

17-3 LEONARDO DA VINCI, *Last Supper* (*top,* uncleaned; *bottom,* cleaned), ca. 1495–1498. Fresco (oil and tempera on plaster), 29′ 10″ × 13′ 9″. Refectory, Santa Maria delle Grazie, Milan.

actors as the New Testament described their roles. Leonardo initiated this rhetoric of classical art that directed the compositions of generations of painters until the nineteenth century. The silence of Christ is one such powerful communication device. Indeed, art historian Heinrich Wölfflin saw that this classical element occurs precisely here, for in the silence following Christ's words, "the original impulse to the emotional excitement continues to echo, and the action is at once momentary, eternal and complete."[3] *Last Supper* and Leonardo's career leading up to it were at once a synthesis of fifteenth-century artistic developments and a first statement of the Italian High Renaissance style during the early sixteenth century.

A SMILE FOR THE AGES Leonardo's *Mona Lisa* (FIG. **17-4**) is probably the world's most famous portrait. The sitter's identity is still the subject of scholarly debate, but Renaissance biographer Giorgio Vasari asserted she is Lisa di Antonio Maria Gherardini, the wife of Francesco del Giocondo, a wealthy Florentine—hence, "Mona (an Italian contraction of *ma donna,* "my lady") Lisa." Vasari also claimed Leonardo took three years to complete the portrait after he returned to Florence from Milan. This was one of Leonardo's favorite pictures—one he could not bear to part with and that he still possessed when he died. Originally, the artist represented

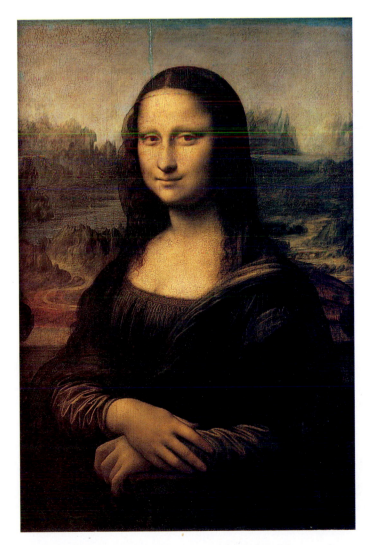

17-4 LEONARDO DA VINCI, *Mona Lisa,* ca. 1503–1505. Oil on wood, approx. 2′ 6″ × 1′ 9″. Louvre, Paris.

Mona Lisa in a loggia with columns. When the painting was trimmed (not by Leonardo), these columns were eliminated (the remains of the column bases may still be seen to the left and right of Mona Lisa's shoulders). She appears in half-length view, her hands quietly folded and her gaze directed at observers. The ambiguity of the famous "smile" is really the consequence of Leonardo's fascination and skill with chiaroscuro and atmospheric perspective, which he revealed in his *Virgin of the Rocks* (FIG. 17-1) and *Virgin and Child with Saint Anne and the Infant Saint John* (FIG. 17-2) groups. Here, they serve to disguise rather than reveal a human psyche. The artist subtly adjusted the light and blurred the precise planes—Leonardo's famous smoky *sfumato* (the misty haziness)—rendering the facial expression hard to determine.

The lingering appeal of *Mona Lisa* derives in large part from Leonardo's decision to set his subject against the backdrop of a mysterious uninhabited landscape. This landscape, with roads and bridges that seem to lead nowhere, is reminiscent of his *Virgin of the Rocks.* It also recalls Fra Filippo Lippi's "portrait," *Madonna and Child with Angels* (FIG. 16-40), with figures seated in front of a window viewers look through into a distant landscape.

THE BIRTH OF SCIENTIFIC ILLUSTRATION Leonardo completed very few paintings; his perfectionism, relentless experimentation, and far-ranging curiosity diffused his efforts. However, the drawings in his notebooks preserved an extensive record of his ideas. His interests focused increasingly on science in his later years, and he embraced knowledge of all facets of the natural world. His investigations in anatomy yielded drawings of great precision and beauty of execution. *Embryo in the Womb* (FIG. **17-5**), although it does not meet twenty-first-century standards for accuracy (for example, Leonardo regularized the uterus's shape to a sphere, and his characterization of the lining is incorrect), was an astounding achievement in its day. Analytical anatomical studies such as this epitomized the scientific spirit of the Renaissance, establishing that era as a prelude to the modern world and setting it in sharp contrast to the preceding Middle Ages. Although Leonardo may not have been the first scientist of the modern world (at least not in the modern sense of "scientist"), he certainly originated a method of scientific illustration, especially cutaway and exploded views. Art historian Erwin Panofsky stressed the importance of this: "Anatomy as a science (and this applies to all the other observational or descriptive disciplines) was simply not possible without a method of preserving observations in graphic records, complete and accurate in three dimensions."[4]

Leonardo was well known in his time as both architect and sculptor, although no actual buildings or surviving sculptures can be definitively attributed to him. From his many drawings of central-plan buildings, it appears he shared the interest of other Renaissance architects in this building type. As for sculpture, Leonardo left numerous drawings of monumental equestrian statues, and one resulted in a full-scale model for a monument to the Sforza (the duke of Milan's wealthy and influential family). The French used it as a target and shot it to pieces when they occupied Milan in 1499. Leonardo left Milan outraged at this treatment of his work and served for a while as a military engineer for Cesare Borgia, who, with the support of his father, Pope Alexander VI, tried to conquer the

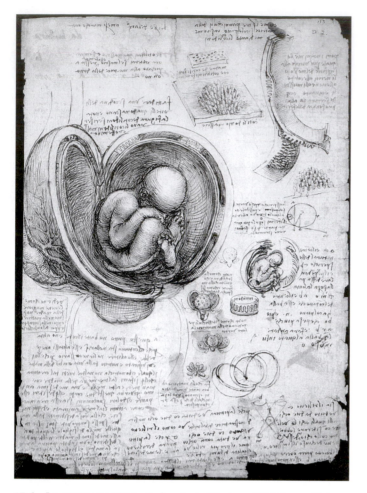

17-5 LEONARDO DA VINCI, *Embryo in the Womb,* ca. 1510. Pen and ink on paper. Royal Library, Windsor Castle.

cities of the Romagna region in north-central Italy and create a Borgia duchy. At a later date, Leonardo returned to Milan in the service of the French. At the invitation of King Francis I, he then went to France, where he died at the château of Cloux in 1519.

Julius II: A Warrior-Pope's Quest for Authority

Another individual whose interests and activities affected the course of the High Renaissance was Pope Julius II (Giuliano della Rovere, r. 1503–1513). An immensely ambitious man, Julius II's quest for authority extended beyond his responsibility as the spiritual leader of Christendom. His enthusiasm for engaging in battle, which earned him a designation as the "warrior-pope," reflected his desire for recognition as a temporal, as well as spiritual, leader. In addition, his selection of the name Julius, after Julius Caesar, reinforces the perception that the Roman Empire served as his governmental model.

Julius II's papacy is also notable for his contributions to the arts. He was an avid art patron and understood well the propagandistic value of visual imagery. After his election as pope, he immediately commissioned artworks that would present an authoritative image of his rule and reinforce the Catholic Church's primacy. Among the many projects he commissioned were a new design for Saint Peter's basilica, the construction of his tomb, the painting of the Sistine Chapel ceil-

ing, and the decoration of the papal apartments. These large-scale projects clearly required considerable financial resources. Many Church members perceived the increasing sale of indulgences as a revenue-generating mechanism to fund papal art, architecture, and lavish lifestyles. This perception, accurate or not, prompted disgruntlement among the faithful. Thus, Julius II's support for the arts, despite its exceptional artistic legacy, also contributed to the rise of the Reformation.

RE-CREATING THE ROME OF THE CAESARS One of the most important artistic projects Julius II initiated was his plan to replace the Constantinian basilica, Old Saint Peter's (see FIG. 8-7 or page xxxiii in Volume II), with a new structure. The earlier building had fallen into considerable disrepair and, in any event, did not suit this ambitious pope's taste for the colossal. Julius wanted to gain control over the whole of Italy and to make the Rome of the popes reminiscent of (if not more splendid than) the Rome of the caesars. As the symbolic seat of the papacy, Saint Peter's represented the history of the Church. Given this importance, Julius II carefully chose the architect DONATO D'ANGELO BRAMANTE (1444–1514) for this commission. Born in Urbino and trained as a painter (perhaps by Piero della Francesca), Bramante went to Milan in 1481 and, like Leonardo, stayed there until the French arrived in 1499. In Milan, he abandoned painting to become one of his generation's most renowned architects. Under the influence of Filippo Brunelleschi, Leon Battista Alberti, and perhaps Leonardo, all of whom strongly favored the art and architecture of classical antiquity, Bramante developed the High Renaissance form of the central-plan church.

Bramante originally designed the new Saint Peter's (FIG. 17-6) to consist of a cross with arms of equal length, each terminated by an apse. Julius II intended the new building to serve as a martyry to mark Saint Peter's grave and also hoped to have his own tomb in it. A large dome would have covered

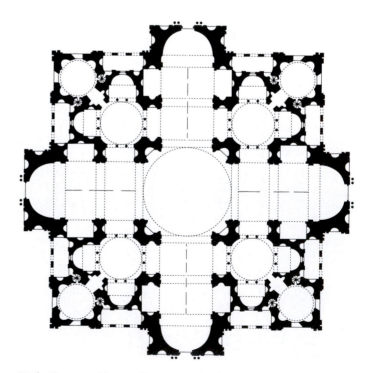

17-6 DONATO D'ANGELO BRAMANTE, plan for the new Saint Peter's, the Vatican, Rome, Italy, 1505.

the crossing, and smaller domes over subsidiary chapels would have covered the diagonal axes of the roughly square plan. Bramante's ambitious plan called for a boldly sculptural treatment of the walls and piers under the dome. His design for the interior space was complex in the extreme, with the intricate symmetries of a crystal. It is possible to detect in the plan some nine interlocking crosses, five of them supporting domes. The scale was titanic; according to sources, Bramante boasted he would place the Pantheon's dome (see FIG. 7-48) over the Basilica Nova (Basilica of Constantine; FIG. 7-79).

A commemorative medal by CHRISTOFORO FOPPA CARADOSSO (FIG. **17-7**) shows how Bramante's scheme would have attempted to do just that. The dome is hemispherical, like the Pantheon's, but, otherwise, the exterior, with two towers and a medley of domes and porticoes, breaks the massive unity, resulting in a design scaled down to human proportions in the Early Renaissance manner. In light of Julius II's interest in the Roman Empire, using the Pantheon as a model was entirely appropriate. The commemoration of Bramante's design for the new Saint Peter's on a medal is in itself significant. Such medals proliferated in the fifteenth century, reviving the ancient Roman practice of placing images of important imperial building projects on the reverses of Roman coins. Renaissance humanists prized these coins and avidly collected them; the Medici family's collection still forms the core of the coin cabinet of Florence's Archeological Museum.

During Bramante's lifetime, the actual construction of the new Saint Peter's basilica did not advance beyond the building of the crossing piers and the lower choir walls. After his death, the work passed from one architect to another and finally to Michelangelo (FIGS. 17-28 and 17-29), whom Pope Paul III appointed in 1546 to complete the building. Not until the seventeenth century, however, did the Church oversee the completion of Saint Peter's.

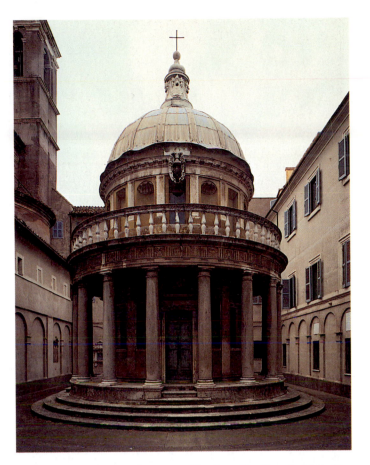

17-8 DONATO D'ANGELO BRAMANTE, Tempietto, San Pietro in Montorio, Rome, Italy, 1502(?).

REVIVING "BEAUTIFUL ARCHITECTURE" Julius II's selection of Bramante for this important commission reflected his confidence in the architect's ability to find a suitable architectural vocabulary to convey his vision of a temporal humanist authority. This vocabulary, based on Greek and Roman models, emerged in an earlier building by Bramante, often considered the perfect prototype of classical domed architecture for the Renaissance and subsequent periods. This building—the Tempietto (FIG. **17-8**)—received its name because, to contemporaries, it had the look of a small pagan temple from antiquity. "Little Temple" is, in fact, a perfectly appropriate nickname for the structure, because the round temples of Roman Italy Bramante would have known in Rome and in its environs (see FIG. 7-2) directly inspired its lower story.

King Ferdinand and Queen Isabella of Spain commissioned the Tempietto to mark the conjectural location of Saint Peter's crucifixion. Available information suggests the patrons asked Bramante to undertake the project in 1502, but some scholars have disputed that traditional dating of the building. In any case, evidence reveals that Bramante began construction of the Tempietto during the first decade of the sixteenth century.

The architect relied on the composition of volumes and masses and on a sculptural handling of solids and voids to set apart this building, all but devoid of ornament, from structures built in the preceding century. Standing inside the cloister alongside the church of San Pietro in Montorio, Rome, the Tempietto resembles a sculptured reliquary and would have looked even more like one inside the circular colonnaded courtyard Bramante planned for it but never executed. If one

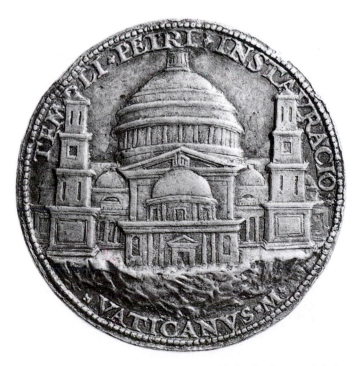

17-7 CHRISTOFORO FOPPA CARADOSSO, medal showing Bramante's design for the new Saint Peter's, 1506. British Museum, London.

WRITTEN SOURCES

The Merits of Painting versus Sculpture
The Views of Leonardo and Michelangelo

Leonardo da Vinci and Michelangelo each produced work in a variety of artistic media, earning enviable reputations not just as painters and sculptors but as architects and draughtsmen as well. However, despite their remarkable talents, their attitudes on artistic issues diverged dramatically. In particular, Leonardo, with his intellectual and analytical mind, preferred painting to sculpture, which he denigrated as manual labor. In contrast, Michelangelo, who worked in a more intuitive manner, saw himself primarily as a sculptor. Two excerpts from their writings reveal their positions on the relative merits and drawbacks of the two mediums.

Leonardo da Vinci wrote the following in "Comparison of Painting and Sculpture" from his so-called *Treatise on Painting:*

> Painting is a matter of greater mental analysis, of greater skill, and more marvelous than sculpture, since necessity compels the mind of the painter to transform itself into the very mind of nature, to become an interpreter between nature and art. Painting justifies by reference to nature the reasons of the pictures which follow its laws: in what ways the images of objects before the eye come together in the pupil of the eye; which, among objects equal in size, looks larger to the eye; which, among equal colors will look more or less dark or more or less bright; which, among things at the same depth, looks more or less low; which, among those objects placed at equal height, will look more or less high, and why, among objects placed at various distances, one will appear less clear than the other.

> This art comprises and includes within itself all visible things such as colors and their diminution which the poverty of sculpture cannot include. Painting represents transparent objects but the sculptor will show you the shapes of natural objects without artifice. The painter will show you things at different distances with variation of color due to the air lying between the objects and the eye; he shows you mists through which visual images penetrate with difficulty; he shows you rain which discloses within it clouds with mountains and valleys; he shows the dust which discloses within it and beyond it the combatants who stirred it up; he shows streams of greater or lesser density; he shows fish playing between the surface of the water and its bottom; he shows the polished pebbles of various colors lying on the washed sand at the bottom of rivers, surrounded by green plants; he shows the stars at various heights above us, and thus he achieves innumerable effects which sculpture cannot attain.

> The sculptor says that bas-relief is a kind of painting. This may be accepted in part, insofar as design is concerned, because it shares in perspective. But with regard to shadows and lights, it is false.[1]

Michelangelo wrote these excerpts in a letter to Benedetto Varchi in the late 1540s:

> I believe that painting is considered excellent in proportion as it approaches the effect of relief, while relief is considered bad in proportion as it approaches the effect of painting.

> I used to consider that sculpture was the lantern of painting and that between the two things there was the same difference as that between the sun and the moon. But . . . I now consider that painting and sculpture are one and the same thing

> Suffice that, since one and the other (that is to say, both painting and sculpture) proceed from the same faculty, it would be an easy matter to establish harmony between them and to let such disputes alone, for they occupy more time than the execution of the figures themselves. As to that man [Leonardo] who wrote saying that painting was more noble than sculpture, if he had known as much about the other subjects on which he has written, why, my serving-maid would have written better![2]

[1] Robert Klein and Henri Zerner, *Italian Art 1500–1600: Sources and Documents* (Evanston, Ill.: Northwestern University Press, 1966), 7–8.

[2] Michelangelo to Benedetto Varchi, ca. 1547; ibid., 13–14.

of the main differences between the Early and High Renaissance styles of architecture was the former's emphasis on detailing flat wall surfaces versus the latter's sculptural handling of architectural masses, then the Tempietto certainly broke new ground and stood at the beginning of a new High Renaissance era.

At first glance, the structure may seem severely rational with its sober circular stylobate and the cool Tuscan style of the colonnade, neither giving any indication of the placement of an interior altar or of the entrance. However, Bramante achieved a truly wonderful balance and harmony in the relationship of the parts (dome, drum, and base) to one another and to the whole. The balustrade echoes, in shorter beats, the colonnade's rhythm and averts a too-rapid visual ascent to the drum. The drum's pilasters repeat the ascending motif and lead the eye past the cornice to the dome's exposed ribs. The play of light and shade around the columns and balustrade and across the deep-set rectangular windows alternating with shallow shell-capped niches in the cella walls and drum enhances observers' experiences of the building as an interrelated sculptural mass. Although the Tempietto, superficially at least, may resemble a Greek *tholos* (a circular shrine; FIG. 5-71) and although antique models provided the inspiration for all of its details, the combination of parts and details was new and original (classical tholoi, for instance, had neither drum nor balustrade). Conceived as a tall domed cylinder projecting from the lower wider cylinder of its colonnade, this small building incorporates all the qualities of a sculptured monument.

Renaissance architects understood the significance of the Tempietto. The architect Andrea Palladio, an artistic descendant of Bramante, included it in his survey of ancient temples because Bramante was "the first to bring back to light the good and beautiful architecture that from antiquity to that time had been hidden."[5] Round in plan and elevated on a base that isolates it from its surroundings, the Tempietto conforms to Alberti's and Palladio's strictest demands for an ideal church, demonstrating "the Unity, infinite Essence, the Uniformity, and the Justice of God."[6]

A DOMINANT CREATOR OF TITANIC FORMS
The artist who Julius II deemed best able to convey his message was MICHELANGELO BUONARROTI (1475–1564), who received some of the most coveted commissions from the pope. Although he was an architect, a sculptor, a painter, a poet, and an engineer, Michelangelo thought of himself first as a sculptor, regarding that calling as superior to that of a painter because the sculptor shares in something like the divine power to "make man" (see "The Merits of Painting versus Sculpture: The Views of Leonardo and Michelangelo," page 532). Conceptually paralleling Plato's ideas, Michelangelo believed that the image the artist's hand produces must come from the idea in the artist's mind. The idea, then, is the reality that the artist's genius has to bring forth. But artists are not the creators of the ideas they conceive. Rather, they find their ideas in the natural world, reflecting the absolute idea, which, for the artist, is beauty. In this way, the strongly Platonic strain of the Renaissance theory of imitating nature makes it a revelation of the high truths hidden within nature. The theory that guided Michelangelo's hand, although never complete or entirely consistent, appears in his poetry. Two excerpts follow:

> To people of good judgment, every beauty
> seen here resembles, more than anything else does,
> that merciful fountain from which we all derive; . . .[7]

> My eyes, desirous of beautiful things,
> and my soul, likewise, of its salvation,
> have no other means to rise
> to heaven but to gaze at all such things.[8]

One of Michelangelo's best-known observations about sculpture is that the artist must proceed by finding the idea—the image locked in the stone, as it were—so, by removing the excess stone, the sculptor extricates the idea, like Pygmalion bringing forth the living form (see FIG. Intro-17). The artist, Michelangelo felt, works through many years at this unceasing process of revelation and "arrives late at novel and lofty things."[9]

Michelangelo did indeed arrive "at novel and lofty things," for he broke sharply from the lessons of his predecessors and contemporaries in one important respect. He mistrusted the application of mathematical methods as guarantees of beauty in proportion. Measure and proportion, he believed, should be "kept in the eyes." Biographer Vasari quotes Michelangelo as declaring that "it was necessary to have the compasses in the eyes and not in the hand, because the hands work and the eye judges."[10] Thus, Michelangelo set aside the ancient Roman architect Vitruvius, Alberti, Leonardo, and others who tirelessly sought the perfect measure and asserted that the artist's inspired judgment could identify other pleasing proportions. In addition, Michelangelo argued that the artist must not be bound, except by the demands made by realizing the idea. This insistence on the artist's own authority was typical of Michelangelo and anticipated the modern concept of the right to a self-expression of talent limited only by the artist's own judgment. The artistic license to aspire far beyond the "rules" was, in part, a manifestation of the pursuit of fame and success humanism fostered. In this context, Michelangelo created works in architecture, sculpture, and painting that departed from High Renaissance regularity. He put in its stead a style of vast, expressive strength conveyed through complex, eccentric, and often titanic forms that loom before viewers in

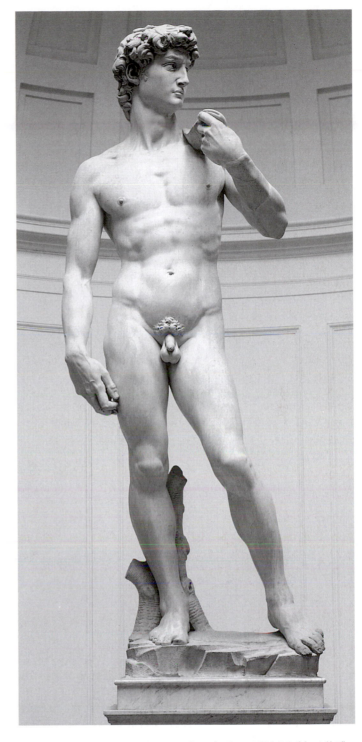

17-9 MICHELANGELO BUONARROTI, *David*, 1501–1504. Marble, 14′ 3″ high. Galleria dell'Accademia, Florence.

tragic grandeur. Michelangelo's self-imposed isolation, creative furies, proud independence, and daring innovations led Italians to speak of the dominating quality of the man and his works in one word—*terribilità*, the sublime shadowed by the awesome and the fearful.

SUBDUING A GIANT In 1501, the city of Florence asked Michelangelo to work a great block of marble, called "The Giant," left over from an earlier aborted commission. From this stone, Michelangelo crafted *David* (FIG. **17-9**), the defiant hero of the Florentine republic and, in so doing, assured his reputation then and now as an extraordinary talent. This early work reveals Michelangelo's fascination with the

17-10 Michelangelo Buonarroti, *Moses,* San Pietro in Vincoli, Rome, Italy, ca. 1513–1515. Marble, approx. 8′ 4″ high.

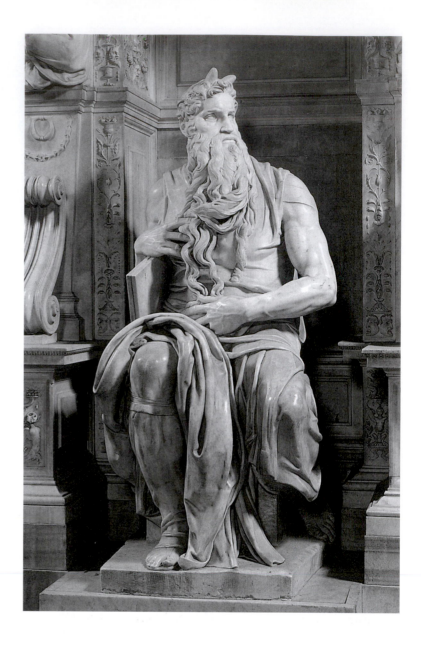

human form, and *David'*s formal references to classical antiquity surely appealed to Julius II, who associated himself with the humanists and with Roman emperors. Thus, this sculpture and the fame that accrued to Michelangelo on its completion called the artist to the pope's attention, leading to major papal commissions.

For *David,* Michelangelo took up the theme Donatello (see FIG. 16-23) and Andrea del Verrocchio (see FIG. 16-24) had used successfully, but Michelangelo's resolution was highly original. The artist chose to represent David not after the victory, with Goliath's head at his feet, but turning his head to his left, sternly watchful of the approaching foe. His whole muscular body, as well as his face, is tense with gathering power. *David* exhibits the characteristic representation of energy in reserve that imbues Michelangelo's later figures with the tension of a coiled spring. The young hero's anatomy plays an important part in this prelude to action. His rugged torso, sturdy limbs, and large hands and feet, alerting viewers to the strength to come, do not consist simply of inert muscle groups, nor did the sculptor idealize them by simplification into broad masses. They serve, by their active play, to enhance

the whole mood and posture of tense expectation. Each swelling vein and tightening sinew amplifies the psychological energy of the monumental David's pose.

Michelangelo doubtless had the classical nude in mind. He, like many of his colleagues, greatly admired Greco-Roman statues, his knowledge limited mostly to Roman sculptures and Roman copies of Greek art. In particular, classical sculptors' skillful and precise rendering of heroic physique impressed Michelangelo. In his *David,* Michelangelo, without strictly imitating the antique style, captured the tension of Lysippan athletes (see FIG. 5-65) and the psychological insight and emotionalism of Hellenistic statuary (see FIGS. 5-80 and 5-81). This David differs from those of Donatello and Verrocchio in much the same way later Hellenistic statues departed from their Classical predecessors. Michelangelo abandoned the self-contained compositions of the fifteenth-century David statues by giving David's head the abrupt turn toward his gigantic adversary. Michelangelo's *David* is compositionally and emotionally connected to an unseen presence beyond the statue; this, too, is evident in Hellenistic sculpture (see FIG. 5-86). As early as the *David,* then, Michelangelo invested his

efforts in presenting towering pent-up emotion rather than calm ideal beauty. He transferred his own doubts, frustrations, and passions into the great figures he created or planned. He was the spiritual heir not of Polykleitos and Phidias but of the masters of the Laocoön group (see FIG. 5-89).

IN MEMORY OF A WARRIOR-POPE The first project Julius II commissioned from Michelangelo in 1505 was the pontiff's own tomb. The original design called for a free-standing two-story structure with some twenty-eight statues. This colossal monument would have given Michelangelo the latitude to sculpt numerous human figures while providing the pope with a grandiose memorial (which Julius II intended to locate in Saint Peter's). Shortly after Michelangelo began work on this project, the pope, for unknown reasons, interrupted the commission, possibly because funds had to be diverted to Bramante's rebuilding of Saint Peter's. After Julius II's death in 1513, Michelangelo reduced the project's scale step-by-step until, in 1542, a final contract specified a simple wall tomb with fewer than one-third of the originally planned figures. Michelangelo completed the tomb in 1545 and saw it placed in San Pietro in Vincoli, Rome, where Julius II had served as a cardinal before his accession to the papacy. Given Julius's ambitions, it is safe to say that had he seen the final design of his tomb, or known where it was eventually located, he would have been bitterly disappointed.

The spirit of the tomb may be summed up in the figure *Moses* (FIG. **17-10**), which Michelangelo completed during one of his sporadic resumptions of the work in 1513. Meant to be seen from below, and balanced with seven other massive forms related in spirit to it, the *Moses* now, in its comparatively paltry setting, does not have its originally intended impact. Michelangelo depicted the Old Testament prophet seated, the Tablets of the Law under one arm and his hands gathering his voluminous beard. The horns that appear on Moses's head were a sculptural convention in Christian art and helped Renaissance viewers identify Moses (see FIG. 12-38). Here, again, Michelangelo used the turned head, which concentrates the expression of awful wrath that stirs in the mighty frame and eyes. The muscles bulge, the veins swell, and the great legs seem to begin slowly to move. If this titan ever rose to his feet, one writer said, the world would fly apart. To find such pent-up energy—both emotional and physical—in a seated statue, historians must turn once again to Hellenistic statuary (see FIG. 5-86).

STRUGGLING FOR FREEDOM OF EXPRESSION Originally, Michelangelo intended for some twenty sculptures of slaves, in various attitudes of revolt and exhaustion, to appear on the tomb. One such figure is *Bound Slave* (FIG. **17-11**). (Another such figure is FIG. Intro-17.) Considerable scholarly uncertainty about this sculpture (and three other "slave" figures) exists. Although conventional scholarship connected these statues with the Julius tomb, some art historians now doubt this. A lively debate also continues about the subject of these figures; many scholars reject their identification as "slaves" or "captives." Despite these unanswered questions, the "slaves," like *David* and *Moses,* represent definitive statements. Michelangelo made each body a different total expression of the idea of oppression, so these sculpted human figures do not so much represent a concept, as in medieval

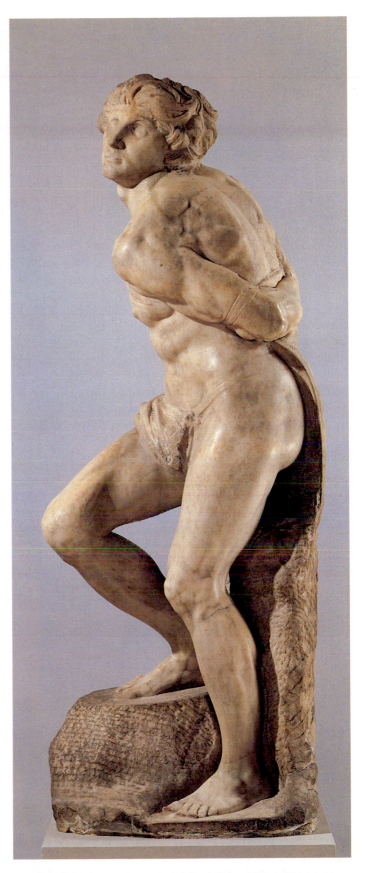

17-11 MICHELANGELO BUONARROTI, *Bound Slave*, 1513–1516. Marble, approx. 6' 10½" high. Louvre, Paris.

allegory, but are concrete realizations of intense feelings. Indeed, Michelangelo communicated his powerful imagination in every plane and hollow of the stone. In *Bound Slave,* the defiant figure's violent contrapposto is the image of frantic

but impotent struggle. As noted earlier, many Hellenistic artists shared Michelangelo's vision of the human form. (Compare, for example, the spiral composition of his *Bound Slave* with that of the suicidal Gallic chieftain, FIG. 5-80.) The influence of the Laocoön group (see FIG. 5-89), discovered in Rome in 1506, is especially clear in the struggling *Bound Slave*. Michelangelo based his whole art on his conviction that whatever can be said greatly through sculpture and painting must be said through the human figure.

THE SISTINE CEILING: A GRAND DRAMA

Julius II's artistic program continued unabated, despite the obstacles he encountered. With the suspension of the tomb project, Julius II gave the bitter and reluctant Michelangelo the commission to paint the ceiling of the Sistine Chapel (FIGS. **17-12** and **17-13**) in 1508. The artist, insisting that painting was not his profession (a protest that rings hollow after the fact, but Michelangelo's major works until then had been in sculpture, and painting was of secondary interest to him), assented in the hope the tomb project could be revived. Michelangelo faced enormous difficulties in painting the Sistine ceiling. He had to address his relative inexperience in the fresco technique; the ceiling's dimensions (some five thousand eight hundred square feet); its height above the pavement (almost seventy feet); and the complicated perspective problems the vault's height and curve presented. Yet, in less than four

years, Michelangelo produced an unprecedented work—a monumental fresco incorporating the patron's agenda, Church doctrine, and the artist's interests. Depicting the most august and solemn themes of all, the Creation, Fall, and Redemption of humanity (most likely selected by Julius II with input from Michelangelo and a theological adviser), Michelangelo spread a colossal decorative scheme across the vast surface. He succeeded in weaving together more than three hundred figures in an ultimate grand drama of the human race.

A long sequence of narrative panels describing the Creation, as recorded in the biblical book Genesis, runs along the crown of the vault, from *God's Separation of Light and Darkness* (above the altar) to *Drunkenness of Noah* (nearest the entrance to the chapel). The Hebrew prophets and pagan sibyls who foretold the coming of Christ appear seated in large thrones on both sides of the central row of scenes from Genesis, where the vault curves down. In the four corner pendentives, Michelangelo placed four Old Testament scenes with David, Judith, Haman, and Moses and the Brazen Serpent. Scores of lesser figures also appear. The ancestors of Christ fill the triangular compartments above the windows, nude youths punctuate the corners of the central panels, and small pairs of putti in grisaille support the painted cornice surrounding the entire central corridor. The conception of the whole design no doubt contributed to the perception of Julius II as a spiritual leader, temporal power, and cultured man. For example, in

17-12 Interior of the Sistine Chapel (view facing east), Vatican City, Rome, Italy, built 1473. Copyright © Nippon Television Network Corporation, Tokyo.

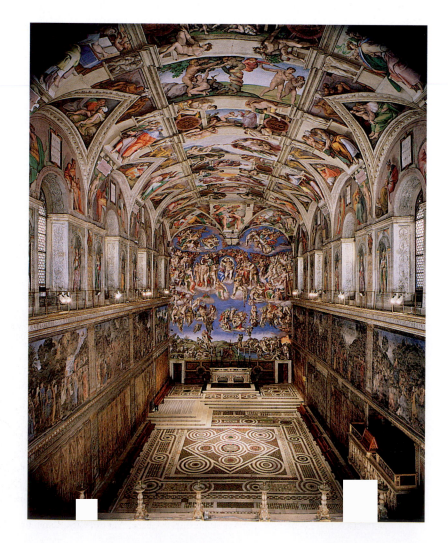

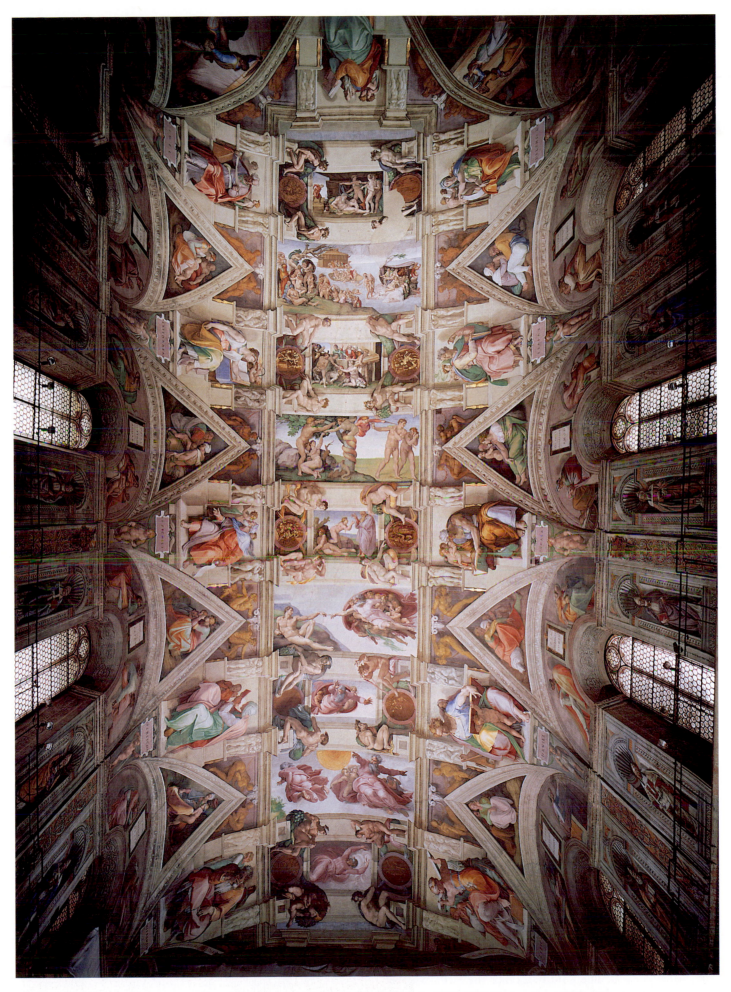

17-13 Michelangelo Buonarroti, ceiling of the Sistine Chapel, Vatican City, Rome, Italy, 1508–1512. Fresco, approx. 128′ × 45′.

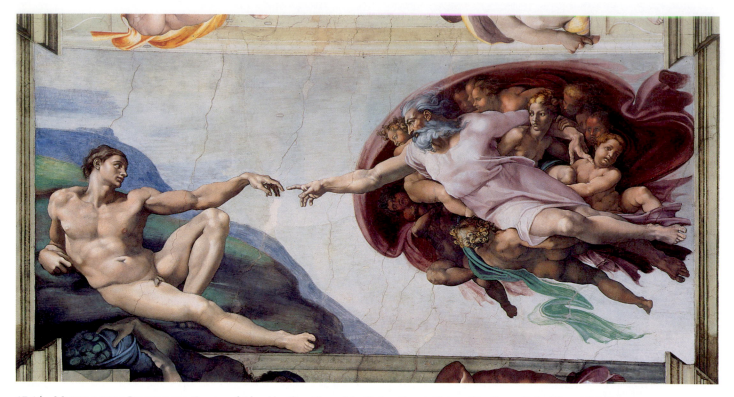

17-14 MICHELANGELO BUONARROTI, *Creation of Adam* (detail), ceiling of the Sistine Chapel, Vatican City, Rome, Italy, 1511–1512. Fresco, approx. 18′ 8″ × 9′ 2″.

the pendentives, the representation of David and Judith, Old Testament heroes who triumphed over oppressors, may allude to the pope's military exploits against invaders. Moses and Esther in the other two pendentives refer to Julius's position as a divinely ordained ruler. The conception of the entire design was astounding in itself and the articulation of it in its thousand details was a superhuman achievement.

Unlike Andrea Mantegna's decoration of the Camera degli Sposi in Mantua (see FIG. 16-48), the strongly marked unifying architectural framework in the Sistine Chapel does not construct "picture windows" enframing illusions just above. Rather, viewers focus on figure after figure, each sharply outlined against the neutral tone of the architectural setting or the plain background of the panels. Here, as in his sculpture, Michelangelo relentlessly concentrated his expressive purpose on the human figure. To him, the body was beautiful not only in its natural form but also in its spiritual and philosophical significance. The body was simply the manifestation of the soul or of a state of mind and character. Michelangelo represented the body in its most simple, elemental aspect—in the nude or simply draped, with no background and no ornamental embellishment. He always painted with a sculptor's eye for how light and shadow communicate volume and surface. It is no coincidence that many of the figures seem to be tinted reliefs or full-rounded statues.

VISUALIZING A TENET OF CHRISTIANITY
One of the ceiling's central panels is *Creation of Adam* (FIG. 17-14). Michelangelo did not paint the traditional representation but a bold, entirely humanistic interpretation of the momentous event. God and Adam confront each other in a primordial unformed landscape where Adam is still a material part, heavy as earth. The Lord transcends the earth, wrapped in a billowing cloud of drapery and borne up by his powers.

Life leaps to Adam like a spark from the extended and mighty hand of God. The communication between gods and heroes, so familiar in classical myth, is here concrete; made of the

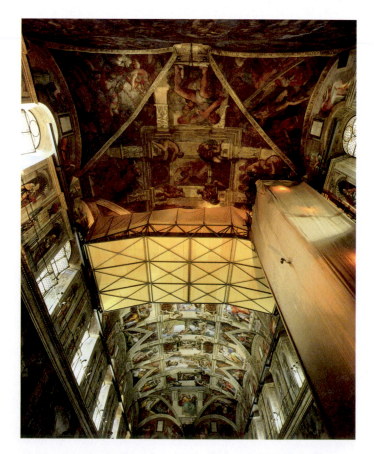

17-15 Cleaning of ceiling of Sistine Chapel, Vatican City, Rome, Italy, 1977–1989.

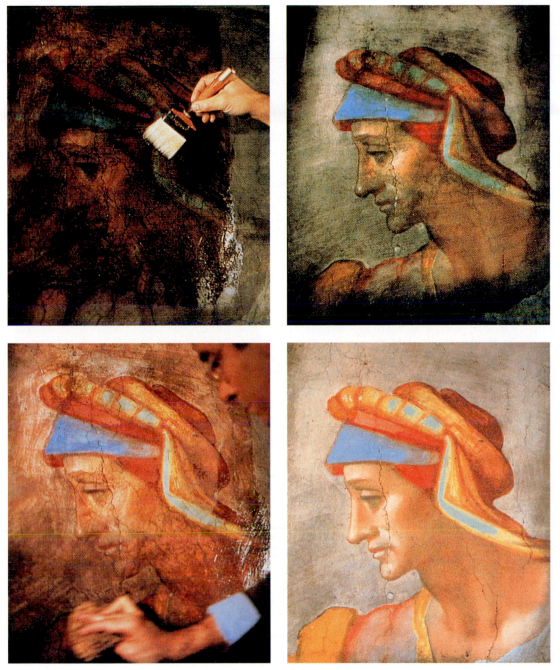

17-16 Detail of the Azor-Sadoch lunette's left side over one of the Sistine Chapel windows at various stages of the restoration process, Vatican City, Rome, Italy, 1977–1989. Copyright © Nippon Television Network Corporation, Tokyo.

same substance, both are gigantic. This blunt depiction of the Lord as ruler of Heaven in the Olympian pagan sense indicates how easily High Renaissance thought joined pagan and Christian traditions. Yet the classical trappings do not obscure the essential Christian message.

Beneath the Lord's sheltering left arm is a female figure, apprehensively curious but as yet uncreated. Scholars traditionally believed her to represent Eve but recently have suggested she may be the Virgin Mary (with the Christ Child at her knee). If the new identification is correct, it suggests Michelangelo incorporated into his fresco one of the essential tenets of Christian faith. This is the belief Adam's original sin eventually led to the sacrifice of Christ, which in turn made possible the redemption of all humankind. As God reaches out to Adam, viewers' eyes move from right to left, but Adam's extended left arm returns them back to the right, through the Lord's right arm, shoulders, and left arm to his left forefinger, which points to the Christ Child's face. The fo-

cal point of this right-to-left-to-right movement—the fingertips of Adam and the Lord—is dramatically off-center. Michelangelo replaced the straight architectural axes found in Leonardo's compositions with curves and diagonals. For example, the bodies of the two great figures are complementary—the concave body of Adam fitting the convex body and billowing "cloak" of God. Thus, motion directs not only the figures but also the whole composition. The reclining positions of the figures, the heavy musculature, and the twisting poses are all intrinsic parts of Michelangelo's style.

Visitors to the Sistine Chapel will encounter a cleaned ceiling (FIGS. 17-13 and **17-15**), revealing much brighter colors (see "Restoring the Glory of Renaissance Frescoes," page 540). Controversy accompanied the execution of this restoration, and the vivid colors (FIG. **17-16**) take many viewers aback. That reaction, however, probably derives from recent familiarity with the formerly soot- and grime-covered ceiling.

Restoring the Glory of Renaissance Frescoes

The year 1989 marked the completion of the cleaning and restoration of the Sistine Chapel ceiling—after twelve years of painstaking work. Restorers removed centuries of accumulated grime, overpainting, and protective glue, uncovering much of the artist's original craft in form, color, style, and procedure. Our before-and-after details of one of the lunettes over the windows (FIG. 17-16) depict four stages of the restoration process. In these semicircular spaces, Michelangelo painted figures representing the ancestors of Christ (Matt. 1:1–17). After computer assessment of the damage (including use of infrared and ultraviolet lights), the restorers worked carefully and slowly to clean the fresco of soot, dirt, dissolved salts, and various types of gums and varnishes made of animal glues. Over the centuries, restorers had used such varnishes to brighten the darkening fresco; unfortunately, over time the varnishes deteriorated, making the painting even darker. For the latest cleaning effort, the restorer first wet a small section of the fresco with distilled, deionized water. The application of a cleaning solution made of bicarbonates of sodium and ammonium and supplemented with an antibacterial, antifungal agent followed. Adding carboxymethylcellulose and water to this solution created a gel that clung to the ceiling fresco. After three minutes, restorers removed the gel. Our details (of the Azor-Sadoch lunette) reveal the startling product of the restorers' procedure, as the original work emerged from the dark film of time and faulty repairs.

These figures, once thought purposefully dark, now show brilliant colors of high intensity, brushed on with an astonishing freedom and verve. The fresh, luminous hues, boldly joined in unexpected harmonies, seem uncharacteristically dissonant to some experts and have aroused brisk controversy. Some believe the restorers removed Michelangelo's work along with the accumulated layers and that the apparently strident coloration cannot possibly be his. Others insist the restoration effort has revealed to modern eyes the artist's real intentions and effects—that in the Sistine Chapel Michelangelo already had paved the way for the Mannerist reaction to the High Renaissance examined later in this chapter. In any event, due to the restoration, scholars are now restudying and reassessing Michelangelo's pictorial art and its influence.

The restoration also has shed light on Michelangelo's manner of painting, because restorers constructed a bridgelike scaffolding (FIG. 17-15) similar to that the artist designed and used. Despite the persistence of stories that Michelangelo painted the ceiling lying on his back, those are merely myths. In his journals, Michelangelo complained bitterly of the pain and suffering from working on an overhead fresco while standing. One sonnet by the artist included a litany of complaints, among others: "In front my skin grows loose and long; behind, By bending it becomes more taut and strait; Crosswise I strain me like a Syrian bow."[1]

On completion of this monumental cleaning project, restorers turned their attention to Michelangelo's *Last Judgment* (FIG. 17-25) behind the altar in the Sistine Chapel. They completed their restoration of that large fresco in 1994.

The recent treatment of Leonardo's *Last Supper* (FIG. 17-3) in the refectory of Santa Maria delle Grazie in Milan presented restorers with an even greater challenge. Leonardo had mixed oil and tempera, applying much of it *a secco* (to dried, rather than wet, plaster). Thus, the wall did not absorb the pigment as in the *buon fresco* technique, and the paint quickly began to flake. The humidity of Milan further accelerated the deterioration. Over the centuries, the fresco has been subjected to frequent alterations. Napoleonic troops attacked the fresco; at other times, it was cleaned with a variety of materials. Consequently, current restorers confronted a monumental task. Their efforts, like those of the Sistine Chapel restorers, were painstaking and slow, involving extensive scholarly, chemical, and computer analysis. They recently finished their work, which took more than two decades, and they unveiled the cleaned fresco to the public in May 1999.

Like other restorations, this one was not without controversy. Dr. Pinin Brambilla Barcilon, who oversaw the cleaning project, declared: "What we have brought to light are Leonardo's original and brilliant colors. Nothing has been removed from the original painting, and nothing has been added."[2] Yet Dr. James Beck, a professor of art history at Columbia University, charges the painting is now "18–20 percent Leonardo and 80 percent by the restorer."[3] Viewers will have to judge the results for themselves. But to minimize future deterioration, viewing time is limited, and visitors are ushered through areas outfitted with special filtration systems and dust-absorbing carpets before entering the refectory.

The controversies have not put a damper on other restoration projects. Restorers have undertaken the cleaning of the frescoes in the Stanza della Segnatura in the Vatican Apartments in Rome, and the Vatican has scheduled the frescoes by Perugino and other artists in the Sistine Chapel for restoration.

[1] Robert Goldwater and Marco Treves, eds., *Artists on Art*, 3rd ed. (New York: Pantheon Books, 1958), 59.

[2] Piero Valsecchi, "It's Art, but Is It Leonardo's?" Milan Associated Press Wire, 28 May 1999.

[3] Ibid.

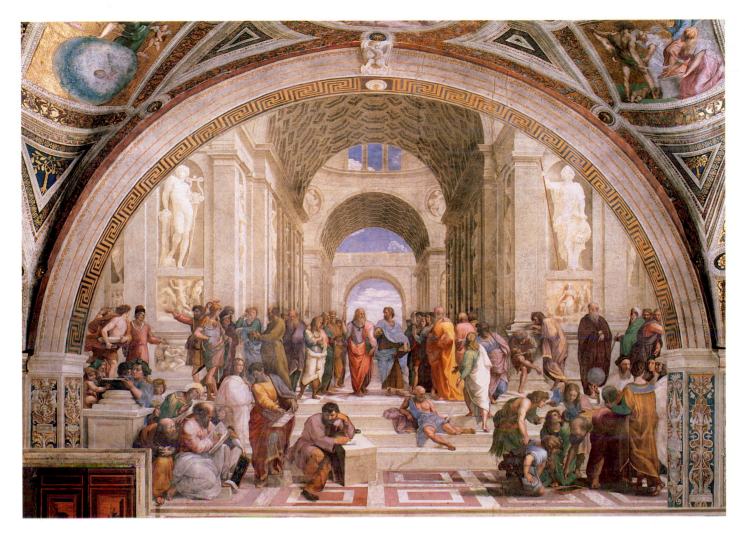

17-17 RAPHAEL, Philosophy *(School of Athens)*, Stanza della Segnatura, Vatican Palace, Rome, Italy, 1509–1511. Fresco, approx. 19′ × 27′.

A CONGREGATION OF CLASSICAL THINKERS
While Michelangelo was hard at work on the Sistine Chapel ceiling, Pope Julius II turned his attention to the papal apartments. In 1508, the pope called RAFFAELLO SANZIO, known as RAPHAEL (1483–1520), to the papal court in Rome, perhaps on the recommendation of Raphael's fellow townsman, Bramante. Born in a small town in Umbria near Urbino, Raphael probably learned the rudiments of his art from his father, Giovanni Sanzio, a provincial painter connected with the ducal court of Federico da Montefeltro.

Once in Rome, in competition with older artists such as Perugino and Luca Signorelli, Raphael received one of the largest commissions of the time—the decoration of the papal apartments in the Vatican. Of the suite's several rooms *(stanze)*, Raphael painted the Stanza della Segnatura (Room of the Signature—the papal library) and the Stanza d'Eliodoro (Room of Heliodorus). His pupils completed the others, following his sketches. On the four walls of the Stanza della Segnatura, under the headings of Theology (called *Disputà*), Law *(Justice)*, Poetry *(Parnassus)*, and Philosophy *(School of Athens)*, Raphael presented images that symbolize and sum up Western learning as Renaissance society understood it. The frescoes refer to the four branches of human knowledge and wisdom while pointing out the virtues and the learning appropriate to

a pope. Given Julius II's desire for recognition as both a spiritual and temporal leader, it is appropriate that the Theology and the Philosophy frescoes face each other. The two images present a balanced picture of the pope—as a cultured, knowledgeable individual, on the one hand, and as a wise, divinely ordained religious authority, on the other hand.

On one wall in Raphael's Philosophy mural, the so-called *School of Athens* (FIG. **17-17**), the setting is not a "school" but a congregation of the great philosophers and scientists of the ancient world. Raphael depicted these luminaries—rediscovered by Renaissance thinkers—conversing and explaining their various theories and ideas. In a vast hall covered by massive vaults that recall Roman architecture (and approximate the appearance of the new Saint Peter's in 1509, when the painting was executed), colossal statues of Apollo and Athena, patron gods of the arts and of wisdom, oversee the interactions. Plato and Aristotle serve as the central figures around whom Raphael carefully arranged the others. Plato holds his book *Timaeus* and points to Heaven, the source of his inspiration, while Aristotle carries his book *Nichomachean Ethics* and gestures toward the earth, from which his observations of reality sprang. Appropriately, ancient philosophers, men concerned with the ultimate mysteries that transcend this world, stand on Plato's side. On Aristotle's side are the philosophers

Giorgio Vasari on Raphael

Although Giorgio Vasari (1511–1574) established himself as a painter and architect, people today usually associate him with his landmark book, *Lives of the Most Eminent Painters, Sculptors and Architects,* first published in 1550. Scholars long have considered this book a major information source about Italian art and artists, although many of the details have proven inaccurate. Regardless, Vasari's *Lives* remains a tour de force— an ambitious, comprehensive book dedicated to recording the biographies of artists. The following excerpt reveals Vasari's admiration for Raphael. It also demonstrates the importance of the concepts of imitation and emulation (see "Imitation and Emulation: Artistic Values in the Renaissance," Chapter 16, page 490) to the development of artistic style.

He [Raphael] then, after having imitated in his boyhood the manner of his master, Pietro Perugino, which he made much better in draughtsmanship, coloring, and invention, believed that he had done enough; but he recognized, when he had reached a riper age, that he was still too far from the truth. For, after seeing the works of Leonardo da Vinci, who had no peer in the expressions of heads both of men and of women, and surpassed all other painters in giving grace and movement to his figures, he was left marveling and amazed; and in a word, the manner of Leonardo pleasing him more than any other that he had ever seen, he set himself to study it, and abandoning little by little, although with great difficulty, the manner of Pietro, he sought to the best of his power and knowledge to imitate that of Leonardo. . . . In time he [Raphael] found himself very much hindered and impeded by the manner that he had adopted from Pietro. . . . His being unable to forget it was the reason that he had great difficulty in learning the beauties of the nude and the methods of difficult foreshortenings from the cartoon that Michelangelo Buonarroti made for the Council Hall in Florence. . . . He then devoted himself to studying the nude and to comparing the muscles of anatomical subjects and of flayed human bodies with those of the living, which, being covered with skin, are not clearly defined, as they are when the skin has been removed; and going on to observe in what way they acquire the softness of flesh in the proper places, and how certain graceful flexures are produced by twisting the body from one view to another, and also the effect of inflating, lowering, or raising either a limb or the whole person, and likewise the concatenation [linkage] of the bones, nerves, and veins, he became excellent in all the points that are looked for in a painter of eminence. . . . To this, as Raffaello was well aware, may be added the enriching [of] those scenes with a bizarre variety of perspectives, buildings, and landscapes, the method of clothing figures gracefully, the making them fade away sometimes in the shadows, and sometimes come forward into the light, the imparting of life and beauty to the heads of women, children, young men and old, and the giving them movement and boldness, according to necessity. He considered, also, how important is the furious flight of horses in battles, fierceness in soldiers, the knowledge how to depict all the sorts of animals, and above all the power to give such resemblance to portraits that they seem to be alive, and that it is known whom they represent; with an endless number of other things, such as the adornment of draperies, footwear, helmets, armor, women's head-dresses, hair, beards, vases, trees, grottoes, rocks, fires, skies turbid or serene, clouds, rain, lightning, clear weather, night, the light of the moon, the splendor of the sun, and innumerable other things, which are called for every moment by the requirements of the art of painting. . . . Raffaello . . . devoted himself, therefore, not to imitating the manner of that master, but to the attainment of a catholic [all-inclusive] excellence in the other fields of art that have been described. . . . I have thought fit, almost at the close of this Life, to make this discourse, in order to show with what labor, study, and diligence this honored artist always pursued his art. . . .[1]

[1] Robert Klein and Henri Zerner, *Italian Art 1500–1600: Sources and Documents* (Evanston, Ill.: Northwestern University Press, 1966), 85–88.

and scientists concerned with nature and human affairs. At the lower left, Pythagoras writes as a servant holds up the harmonic scale. In the foreground, Heraclitus (probably a portrait of Michelangelo) broods alone. Diogenes sprawls on the steps. At the right, students surround Euclid, who demonstrates a theorem. This group is especially interesting; Euclid may be a portrait of the aged Bramante. At the extreme right, just to the right of the astronomers Zoroaster and Ptolemy, both holding globes, Raphael included his own portrait.

The groups appear to move easily and clearly, with eloquent poses and gestures that symbolize their doctrines and present an engaging variety of figural positions. Their self-assurance and natural dignity convey the very nature of calm reason, that balance and measure the great Renaissance minds so admired as the heart of philosophy.

Significantly, in this work, Raphael placed himself among the mathematicians and scientists, and certainly the evolution of pictorial science came to its perfection in *School of Athens.* Raphael created a vast perspectival space, within which human figures move naturally, without effort—each according to his own intention, as Leonardo might have said. The pictorial stage setting, so long in preparation, is completely realized here and this development contributed to the convincing presentation of human dramas in subsequent art. Raphael's projection of this stagelike space onto a two-dimensional surface was the consequence of the union of mathematics with pictorial science, here mastered completely.

The artist's psychological insight matured along with his mastery of the problems of physical representation. All characters in Raphael's *School of Athens,* like those in Leonardo's *Last*

Supper (FIG. 17-3), communicate moods that reflect their beliefs, and the artist's placement of each figure tied these moods together. Raphael carefully considered his design devices for relating individuals and groups to one another and to the whole. These compositional elements demand close study. From the center, where Plato and Aristotle stand, silhouetted against the sky within the framing arch in the distance, Raphael arranged the groups of figures in an elliptical movement. It seems to swing forward, looping around two foreground groups on both sides and then back again to the center. Moving through the wide opening in the foreground along the floor's perspectival pattern, the viewer's eye penetrates the assembly of philosophers and continues, by way of the reclining Diogenes, up to the here-reconciled leaders of the two great opposing camps of Renaissance philosophy. The perspectival vanishing point falls on Plato's left hand, drawing viewers' attention to *Timaeus*. In the Stanza della Segnatura, Raphael reconciled and harmonized not only the Platonists and Aristotelians but also paganism and Christianity, surely a major factor in his appeal to Julius II.

Pope Julius II was clearly a formidable force, and his selection of artists and art projects reveals his interests and agenda. Likewise, these projects—Saint Peter's, the Sistine ceiling, his tomb, and the papal apartments—provide insights into the unique contributions and skills of the artists and architects involved, individuals such as Bramante, Michelangelo, and Raphael.

Synthesizing the Period's Excellence

EPITOMIZING HIGH RENAISSANCE IDEALS
Raphael's artistic development recapitulated the fifteenth-century sequence of artistic tendencies. Although strongly influenced by Leonardo and Michelangelo, Raphael developed an individual style that, in itself, clearly depicts the ideals of High Renaissance art. His powerful originality prevailed while he learned from everyone; he assimilated what he best could use and rendered into form the classical instinct of his age. Among Raphael's early works was *Marriage of the Virgin* (FIG. **17-18**), which he painted for the Chapel of Saint Joseph in the church of San Francesco in Città di Castello, southeast of Florence. The subject is a fitting one. According to the *Golden Legend* (a thirteenth-century collection of stories about the saints' lives), Joseph competed with other suitors for Mary's hand. The high priest was to give the Virgin to whichever suitor presented to him a rod that had miraculously bloomed. Raphael depicted Joseph with his flowering rod and about to place Mary's wedding ring on her extended hand. Other virgins congregate at the left, and the unsuccessful suitors stand on the right. One of them breaks his rod in half over his knee in frustration, giving Raphael an opportunity to demonstrate his mastery of foreshortening and of the perspective system he learned from Perugino (see FIG. 16-42), his teacher. The temple in the background is Raphael's version of a centrally planned building. The painting is almost exactly contemporary to Bramante's Tempietto (FIG. 17-8), but Raphael employed Brunelleschian arcades rather than Bramante's more "modern" classicizing post-and-lintel system.

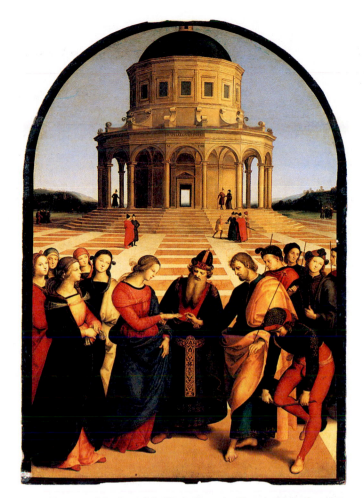

17-18 RAPHAEL, *Marriage of the Virgin*, from the Chapel of Saint Joseph in San Francesco in Città di Castello, near Florence, Italy, 1504. Oil on wood, 5′ 7″ × 3′ 10½″. Pinacoteca di Brera, Milan.

Raphael spent the four years from 1504 to 1508 in Florence. There, he discovered that the painting style he had learned so painstakingly from Perugino already was, like Brunelleschi's architectural style, outmoded. An artistic battle had developed between the two archrivals, Leonardo and Michelangelo. Crowds flocked to Santissima Annunziata to see Leonardo's recently unveiled cartoon of the Virgin, Christ Child, Saint Anne, and Saint John (probably an earlier version of *Virgin and Child with Saint Anne and the Infant Saint John*, FIG. 17-2). Michelangelo responded with the *Doni Madonna* (not illustrated). Around this time, Florentine officials commissioned both artists to decorate the council hall in the Palazzo Vecchio with frescoes memorializing Florentine victories of the past. Although neither artist completed his fresco and only some small preparatory sketches and small copies survive, this project must have had a considerable effect on artists in Florence, especially on one as gifted as Raphael (see "Giorgio Vasari on Raphael," page 542).

CHRISTIAN DEVOTION AND PAGAN BEAUTY
Under Leonardo's influence, Raphael began to modify the Madonna compositions he had learned in Umbria. In the

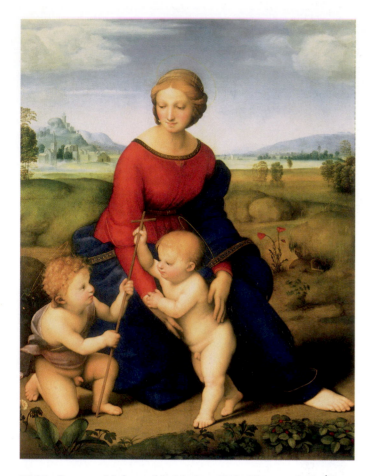

17-19 RAPHAEL, *Madonna of the Meadows,* 1505. Oil on panel, 3′ 8½″ × 2′ 10¼″. Kunsthistorisches Museum, Vienna.

noisseur. Raphael moved in the highest circles of the papal court, the star of a brilliant society. He was young, handsome, wealthy, and adulated, not only by his followers but also by Rome and all of Italy. Genial, even tempered, generous, and high minded, Raphael's personality contrasted strikingly with that of the aloof, mysterious Leonardo or the tormented and obstinate Michelangelo. The pope was not Raphael's only patron. His friend, Agostino Chigi, an immensely wealthy banker who managed the papal state's financial affairs, commissioned Raphael to decorate his palace on the Tiber with scenes from classical mythology. Outstanding among the frescoes Raphael painted in the small but splendid Villa Farnesina is *Galatea* (FIG. **17-20**), which Raphael based on *Metamorphoses* by the ancient Roman poet Ovid.

In Raphael's fresco, Galatea flees from her uncouth lover, the Cyclops Polyphemus, on a shell drawn by leaping dolphins. Sea creatures and playful cupids surround her. The painting erupts in unrestrained pagan joy and exuberance, an exultant song in praise of human beauty and zestful love. Compositionally, Raphael enhanced the image's liveliness by placing the sturdy figures around Galatea in bounding and dashing movements that always return to her as the energetic center. The cupids, skillfully foreshortened, repeat the circling motion. Raphael conceived his figures sculpturally, and Galatea's body—supple, strong, and vigorously in motion—contrasts with Botticelli's delicate, hovering, almost dematerialized Venus (see FIG. 16-27) while suggesting the spiraling compositions of Hellenistic statuary (see FIG. 5-80). Pagan myth presented in monumental form, in vivacious movement, and in a spirit of passionate delight resurrects the classical world's naturalistic art and poetry. Raphael revived the gods and heroes and the world they populated, not to venerate them but to transform them into art.

Madonna of the Meadows (FIG. **17-19**) of 1506, Raphael used the pyramidal composition of Leonardo's *Virgin of the Rocks* (FIG. 17-1). Further, Raphael may have based his modeling of faces and figures in subtle chiaroscuro on an earlier version of the theme in Leonardo's cartoon for *Virgin and Child with Saint Anne and the Infant Saint John* (FIG. 17-2). Yet, Raphael placed the large, substantial figures in a Peruginesque landscape, with the older artist's typical feathery trees in the middle ground. Although Raphael experimented with Leonardo's dusky modeling, he tended to return to Perugino's lighter tonalities. Raphael preferred clarity to obscurity, not fascinated, as Leonardo was, with mystery. His great series of Madonnas, of which this is an early example, unifies Christian devotion and pagan beauty. No artist ever has rivaled Raphael in his definitive rendering of this sublime theme of grace and dignity, of sweetness and lofty idealism.

OVID'S MYTH IN MONUMENTAL FORM Pope Leo X (Giovanni de' Medici, r. 1513–1521), the son of Lorenzo de' Medici, succeeded Julius II as Raphael's patron. Leo was a worldly, pleasure-loving prince who spent huge sums on the arts; as a true Medici, he was a sympathetic con-

COUNTING ON CHARACTER AND GENTILITY Raphael also excelled at portraiture. His subjects were the illustrious scholars and courtiers who surrounded Pope Leo X, among them his close friend Count Baldassare Castiglione (1478–1529), the author of a handbook on High Renaissance criteria for genteel behavior. In *Book of the Courtier,* Castiglione enumerated the perfect courtier's attributes—impeccable character, noble birth, military achievement, classical education, and knowledge of the arts. Castiglione then described a way of life based on cultivated rationality in imitation of the ancients. In Raphael's portrait of him (FIG. **17-21**), Castiglione, splendidly yet soberly garbed, looks directly at viewers with a philosopher's grave and benign expression, clear eyed and thoughtful. The figure is in half-length and three-quarter view, a pose made popular by *Mona Lisa* (FIG. 17-4). Both portraits exhibit the increasing attention High Renaissance artists paid to the subject's personality and psychic state. The muted and low-keyed tones befit the temper and mood of this reflective middle-aged man—the background is entirely neutral, without the usual landscape or architecture. The head and the hands wonderfully reveal the man, who himself had written so eloquently in *Courtier* of enlightenment from the love of beauty. Such love animated Raphael, Castiglione, and other artists of their age, and Michelangelo's poetry suggests he shared in this widely held belief.

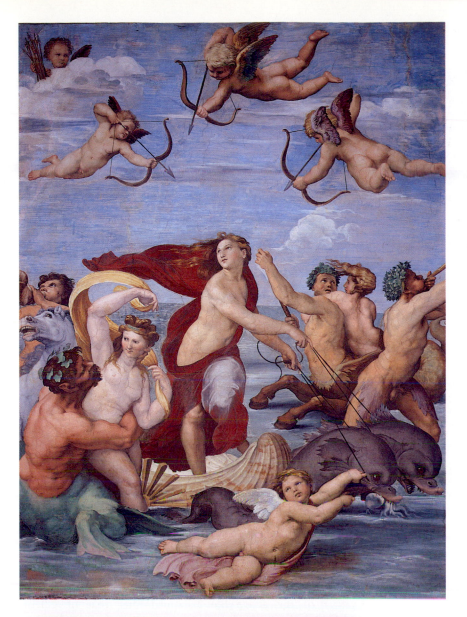

17-20 RAPHAEL, *Galatea*, Sala di
Galatea, Villa Farnesina, Rome, Italy,
1513. Fresco, 9′ 8″ × 7′ 5″.

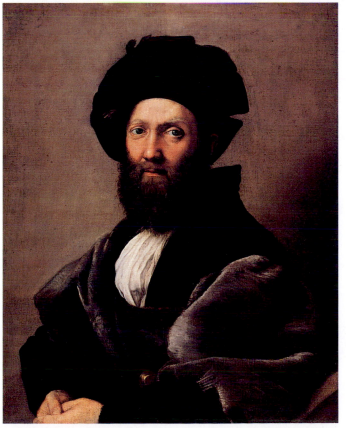

17-21 RAPHAEL, *Baldassare Castiglione*, ca. 1514. Oil on wood transferred
to canvas, approx. 2′ 6$\frac{1}{4}$″ × 2′ 2$\frac{1}{2}$″. Louvre, Paris.

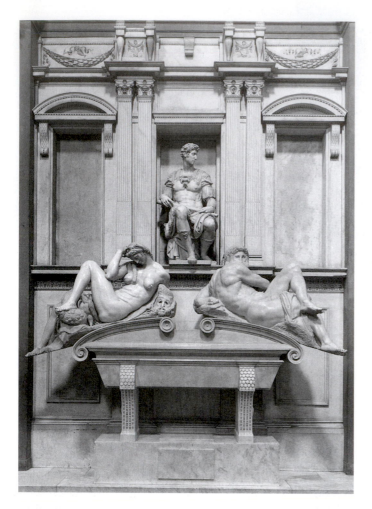

17-22 MICHELANGELO BUONARROTI, tomb of Giuliano de' Medici, New Sacristy (Medici Chapel), San Lorenzo, Florence, Italy, 1519–1534. Marble, central figure approx. 5′ 11″ high.

Michelangelo in the Service of the Medici

Following the death of Julius II, Michelangelo, like Raphael, went into the service of the Medici popes, Leo X and his successor Clement VII (Giulio de' Medici, r. 1523–1534). These Medici chose not to perpetuate their predecessor's fame by letting Michelangelo complete Julius's tomb; instead, they (Pope Leo X and the then cardinal Giulio de' Medici) commissioned him in 1519 to build a funerary chapel, the New Sacristy, in San Lorenzo in Florence.

TWO DUKES FACING OFF At opposite sides of the New Sacristy stand Michelangelo's sculpted tombs of Giuliano, duke of Nemours (south of Paris), and Lorenzo, duke of Urbino, son and grandson of Lorenzo the Magnificent. Giuliano's tomb (FIG. **17-22**) is compositionally the twin of Lorenzo's. Michelangelo finished neither tomb. Scholars believe he intended to place pairs of recumbent river gods at the bottom of the sarcophagi, balancing the pairs of figures that rest on the sloping sides. However, despite this contention, the composition of the tombs has been a long-standing puzzle. How were they to look ultimately? What do they signify? Unfortunately, scholars possess insufficient evidence to answer these questions.

Traditional art historical scholarship suggested that the arrangement Michelangelo planned, but never completed, can be interpreted as the soul's ascent through the levels of the

Neoplatonic universe. Neoplatonism, a school of thought based on Plato's idealistic, spiritualistic philosophy, experienced a renewed popularity in the sixteenth-century humanist community. The tomb's lowest level, represented by the river gods, would have signified the underworld of brute matter, the source of evil. The two statues on the sarcophagi would symbolize the realm of time—the specifically human world of the cycles of dawn, day, evening, and night. Humanity's state in this world of time was considered one of pain and anxiety, of frustration and exhaustion. At left, the female figure of Night and, at right, the male figure of Day appear to be chained into never-relaxing tensions. Both exhibit that anguished twisting of the body's masses in contrary directions, known as *figura serpentinata*, seen in the artist's *Bound Slave* (FIG. 17-11) and in his Sistine Chapel paintings. This contortion is a staple of Michelangelo's figural art. Day, with a body the thickness of a great tree and the anatomy of Hercules (or of a reclining Greco-Roman river god that may have inspired Michelangelo's statue), strains his huge limbs against each other, his unfinished visage rising menacingly above his shoulder. Night, the symbol of rest, twists as if in troubled sleep, her posture wrenched and feverish. The artist surrounded her with an owl, poppies, and a hideous mask symbolic of nightmares. Recent scholarship challenges this interpretation. These scholars argue that the personifications of night and day allude to the life cycle and the passage of time leading ultimately to death, rather than to humanity's pain.

On their respective tombs, sculptures of Lorenzo and Giuliano appear in niches at the apex of the structures. Transcending worldly existence, they represent the two ideal human types—the contemplative man (Lorenzo) and the active man (Giuliano). Together, they symbolize the two ways human beings might achieve union with God—through meditation or the active life fashioned after that of Christ. Michelangelo declined to make portraits of the actual dukes; who, he asked, would care what they looked like in a thousand years? The artist did not know the dukes personally and throughout his career demonstrated less interest in facial features and expressions than in the overall human form. The rather generic visages of the two Medici captains of the Church attest to this. The contemplation of what lies beyond the corrosion of time counted more. Giuliano, the active man (FIG. 17-22), his features quite generalized, sits clad in the armor of a Roman emperor and holding a commander's baton, his head turned alertly as if in council (he looks toward the statue of the Virgin at one end of the chapel). Across the room, Lorenzo, the contemplative man, sits wrapped in thought, his face in deep shadow. Like their predecessors, the sixteenth-century Medici made sure they enlisted the services of the best artists for constructing their legacy.

The Papacy of Pope Paul III

A PALACE FIT FOR A POPE Pope Paul III (Alessandro Farnese, r. 1534–1549) maintained the lavish lifestyle previous popes enjoyed. However, in the wake of the Reformation, he also initiated the Counter-Reformation, establishing the Council of Trent and the Inquisition, as well as formally recognizing the Jesuit order. Paul III also continued the papal tradition of extensive art patronage. An early major project he commissioned when he was still Cardinal Farnese was the

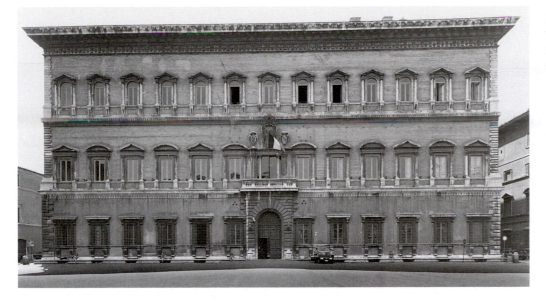

17-23 ANTONIO DA SANGALLO THE YOUNGER, Palazzo Farnese (view from the northwest), Rome, Italy, ca. 1530–1546.

construction of the Palazzo Farnese in Rome (FIG. **17-23**). To design the palazzo, the pope selected ANTONIO DA SANGALLO THE YOUNGER (1483–1546), who established himself as the favorite architect of Pope Paul III and therefore received many commissions that might have gone to Michelangelo. Antonio, the youngest of a family of architects, went to Rome around 1503 and became Bramante's draftsman and assistant. He is the perfect example of the professional architect; indeed, his family constituted an architectural firm, often planning and drafting for other architects. Antonio built fortifications for almost the entire papal state and received more commissions for military than for civilian architecture. Although he may not have invented it, Antonio certainly laid the foundation for the modern method of bastioned fortifications.

The Palazzo Farnese set the standard for the High Renaissance palazzo and fully expresses the classical order, regularity, simplicity, and dignity of the High Renaissance. The broad majestic front of the Palazzo Farnese asserts to the public the exalted station of a great family. This impressive facade encapsulates the aristocratic epoch that followed the stifling of the nascent, middle-class democracy of European cities (especially the Italian cities) by powerful kings heading centralized states. It is thus significant that Paul chose to enlarge greatly the original, rather modest, palace to its present form after his accession to the papacy in 1534, reflecting his ambitions both for his family and for the papacy. At Antonio's death in 1546, Michelangelo assumed control of the building's completion.

Facing a spacious paved square, the facade is the very essence of princely dignity in architecture. The *quoins* (rusticated building corners) and cornice frame firmly anchor the rectangle of the smooth front, while lines of windows (the central row with alternating triangular and segmental pediments, in Bramante's fashion) mark a majestic beat across it. The window casements are not flush with the wall, as in the Palazzo Medici-Riccardi (see FIG. 16-20), but project from its surface, so instead of being a flat, thin plane, the facade is a spatially active three-dimensional mass. Antonio designed each casement as a complete architectural unit, with a *socle* (a projecting undermember), engaged columns, and a pediment. The variations in his treatment of these units prevent the

symmetrical scheme from appearing rigid or monotonous. The rusticated doorway and second-story balcony, surmounted by the Farnese coat of arms, emphasize the central axis and bring the design's horizontal and vertical forces into harmony. This centralizing feature, absent from the palaces of Michelozzo di Bartolommeo (see FIG. 16-20) and Alberti (FIG. 16-35), is the external opening of a central corridor axis that runs through the entire building and continues in the garden beyond. Around this axis, Antonio arranged the rooms with strict regularity. The interior courtyard (FIG. **17-24**) displays

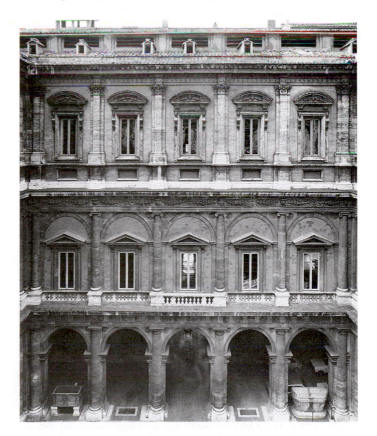

17-24 ANTONIO DA SANGALLO THE YOUNGER, courtyard of the Palazzo Farnese, Rome, Italy, ca. 1530–1546. Third story and attic by MICHELANGELO BUONARROTI, 1548.

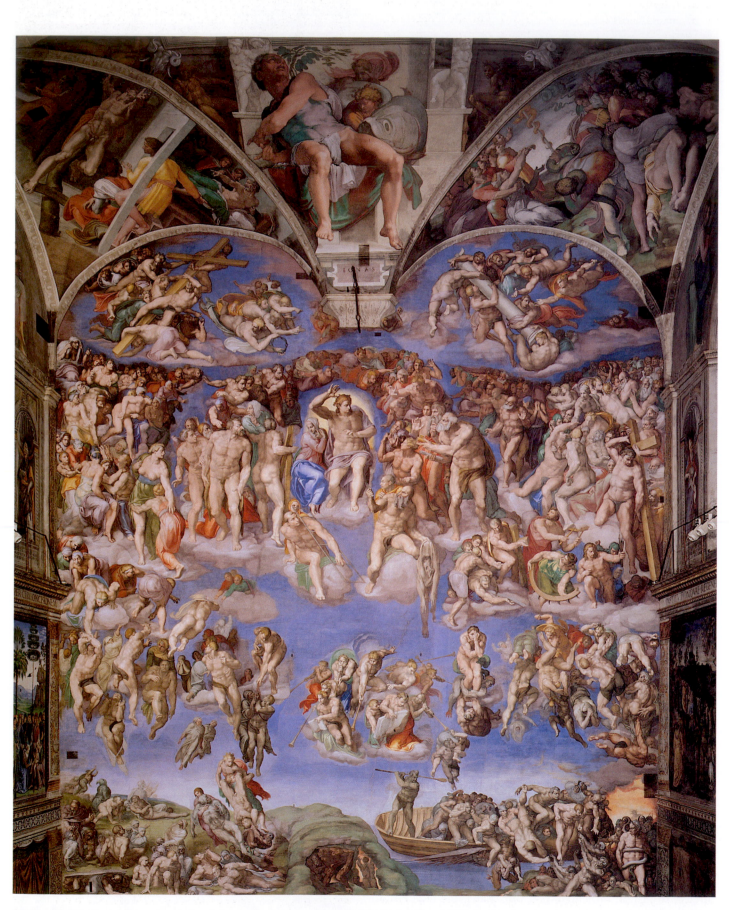

17-25 MICHELANGELO BUONARROTI, *Last Judgment,* fresco on the altar wall of the Sistine Chapel, Vatican City, Rome, Italy, 1534–1541. Copyright © Nippon Television Network Corporation, Tokyo.

stately column-enframed arches on the first two levels, as in the Roman Colosseum (see FIG. 7-34). On the third level, Michelangelo incorporated his sophisticated variation on that theme (based in part on the Colosseum's fourth-story Corinthian pilasters), with overlapping pilasters replacing the weighty columns of Antonio's design.

A MIGHTY CHRIST ON JUDGMENT DAY
Once Cardinal Farnese ascended to the papacy, he extended numerous commissions to artists in the hope of restoring prominence to the Catholic Church. Thus, these projects can be viewed as an integral part of the Counter-Reformation effort. Among Paul III's first papal commissions was a large fresco for the Sistine Chapel. Michelangelo agreed to paint the large-scale *Last Judgment* fresco (FIG. **17-25**; like the Sistine ceiling, newly cleaned and restored—see "Restoring the Glory of Renaissance Frescoes," page 540) on the chapel's altar wall. Here, Michelangelo depicted Christ as the stern Judge of the world—a giant whose mighty right arm is lifted in a gesture of damnation so broad and universal as to suggest he will destroy all creation, Heaven and earth alike. The choirs of Heaven surrounding him pulse with anxiety and awe. Trumpeting angels, the ascending figures of the just, and the downward-hurtling figures of the Damned crowd into the spaces below. On the left, the dead awake and assume flesh; on the right, demons, whose gargoyle masks and burning eyes revive the demons of Romanesque tympana (see FIG. 12-25), torment the Damned.

Michelangelo's terrifying vision of the fate that awaits sinners goes far beyond even Signorelli's gruesome images (see FIG. 16-54). Martyrs who suffered especially agonizing deaths crouch below the Judge. One of them, Saint Bartholomew, who was skinned alive, holds the flaying knife and the skin, its face a grotesque self-portrait of Michelangelo. The figures are huge and violently twisted, with small heads and contorted features. Yet while this immense fresco impresses on viewers Christ's wrath on Judgment Day, it also holds out hope. A group of saved souls—the elect—crowd around Christ, and on the far right appears a figure with a cross, most likely the Good Thief (crucified with Christ) or a saint martyred by crucifixion, such as Saint Andrew.

CAPITALIZING ON ROMAN HISTORY Driven by his restive genius, Michelangelo was rarely content to grapple with only a single commission. While he was executing the *Last Judgment* fresco, he received another flattering and challenging commission from Pope Paul III. In 1537, he undertook the reorganization of the Capitoline Hill (the Campidoglio) in Rome (FIG. **17-26**). The pope wished to transform the ancient hill, which once had been the site of the Roman Empire's spiritual capitol, the greatest temple to Jupiter in the Roman world, into a symbol of the power of the new Rome of the popes. Michelangelo confronted an immense challenge. He had to incorporate into his design two existing buildings—the medieval Palazzo dei Senatori (Palace of the Senators) on the east and the fifteenth-century Palazzo dei Conservatori (Palace of the Conservators) on the south. These buildings formed an eighty-degree angle. Such preconditions might have defeated a lesser architect, but Michelangelo converted what seemed a limitation into the most impressive design for a civic unit formulated during the entire Renaissance.

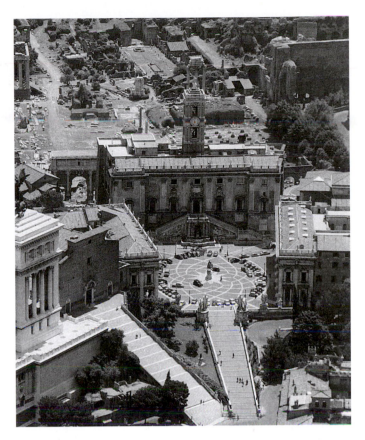

17-26 MICHELANGELO BUONARROTI, aerial view of Capitoline Hill (Campidoglio), Rome, Italy, designed ca. 1537.

He carried his obsession with human form over to architecture and reasoned that buildings should follow the human body's form. This meant organizing their units symmetrically around a central and unique axis, as the arms relate to the body or the eyes to the nose. "For it is an established fact," he once wrote, "that the members of architecture resemble the members of man. Whoever neither has been nor is a master at figures, and especially at anatomy, cannot really understand architecture."[11] It must have been with such arguments that he convinced his sponsors of the need to balance the Palazzo dei Conservatori, whose facade he was to redesign, with a similar unit on the square's north side. To achieve balance and symmetry in design, Michelangelo placed the new building (the Museo Capitolino, originally planned only as a portico with single rows of offices above and behind it) so that it stood at the same angle to the Palazzo dei Senatori as the Palazzo dei Conservatori. This yielded a trapezoidal, rather than a rectangular, plan for the piazza. Michelangelo subsequently adjusted all other design elements to this unorthodox but basic feature.

The ancient statue of Marcus Aurelius (see FIG. 7-59), the only equestrian statue of a Roman emperor to survive the Middle Ages, became the focal point for the whole design. The pope ordered it moved to the Capitoline Hill against the advice of Michelangelo, who might have preferred to carve his own centerpiece. The symbolic significance of the famous monument must have appealed to Paul III. Although the fifteenth-century humanists had rediscovered the statue's true identity (by comparison with Roman coins), the medieval identification of the portrait as Constantine the Great, the first Christian emperor, still lingered and was an integral part

of its fabled history. In the sixteenth century, the image of Marcus Aurelius on horseback carried a double significance. It was the ultimate symbol of the pagan Roman Empire over which Christianity had triumphed, but Italians also associated it with Constantine, Saint Peter, and the establishment of the papacy. In short, this equestrian portrait of an omnipotent yet benevolent Roman emperor encapsulated the city's whole history from antiquity to the early Christian Church to the sixteenth-century papacy. It was the ideal centerpiece for the new civic center of Renaissance Rome and beautifully served the needs of a humanist pope during the Counter-Reformation.

To connect this central monument with the surrounding buildings, Michelangelo provided it with an oval base and placed it centrally in an oval pavement design. Michelangelo's choice of the oval is noteworthy, as other Renaissance architects considered it an unstable geometric figure and therefore shunned it. Given the piazza's trapezoidal shape, however, Michelangelo deemed the oval (which combines centralizing and axial qualities) best suited to relate the design's various elements to one another. Later artists during the Baroque period adopted the oval as their favorite geometric figure.

Facing the piazza, the two lateral palazzi, the Palazzo dei Conservatori and Museo Capitolino (FIG. 17-27), have identical two-story facades. Michelangelo introduced viewers again to the giant order, the tall pilasters first seen in more reserved fashion in Alberti's Sant'Andrea in Mantua (see FIG. 16-43). Michelangelo used the giant order with much greater authority. The huge pilasters not only tie the two stories together but also provide a sturdy skeleton that actually functions as the structure's main support. Michelangelo all but eliminated walls. At ground level, he interposed columns to soften the transition from the massive bulk of the pilaster-faced piers to the deep voids between them. These columns carry straight lintels, in the manner Alberti earlier advocated, but Michelangelo used them with even greater logic and con-

sistency than Alberti did. For the third building on the piazza, the three-storied Palazzo dei Senatori (FIG. 17-26), the architect added a double flight of steps to the entrance. He also embellished the facade, employing the same design elements as the other two palazzi but in a less sculptural fashion. The axial building, with its greater height, thus became a distinctive and commanding accent for the ensemble, providing variety within the design without disrupting its unity.

Michelangelo might have made the piazza a roomlike enclosure, as Alberti, in his treatise, had advised for all piazzas. But the architect chose to leave one side open. He merely suggested a fourth wall with a balustrade and a thin screen of Classical statuary that effectively defines the piazza's limits without obstructing a panoramic view across the city's roofs toward the Vatican. The symbolism of this axis must have pleased the pope just as much as the piazza's dynamic design, and the sweeping vista also must have pleased Baroque planners later.

A SCULPTOR'S FINISHING TOUCH The last project Michelangelo undertook in 1546 for Pope Paul III was the supervision of the building of the new Saint Peter's. With the Church facing challenges to its supremacy, Paul III surely felt a sense of urgency about the completion of this project. Michelangelo's work on Saint Peter's, after efforts by a succession of architects following Bramante's death, apparently became a long-term show of dedication, thankless and without pay.

Among Michelangelo's difficulties was his struggle to preserve and carry through Bramante's original plan (FIG. 17-6), which he praised (although he did modify it). Michelangelo recognized the strength of the initial design (as he had with Antonio's project for the Palazzo Farnese, FIGS. 17-23 and 17-24) and chose to retain it as the basis for his design. With Bramante's plan for Saint Peter's, Michelangelo reduced the central component from a number of interlocking crosses to a

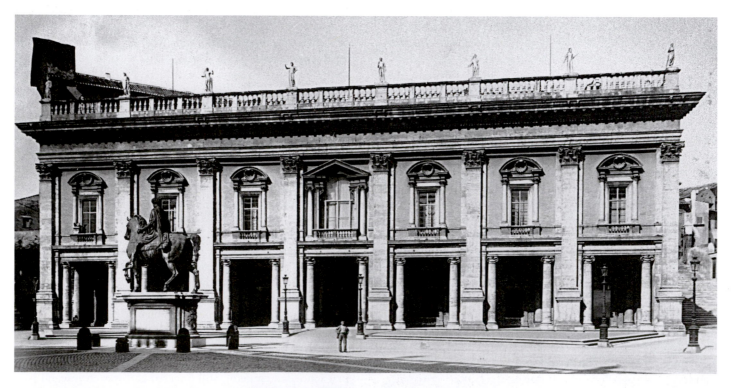

17-27 MICHELANGELO BUONARROTI, *Museo Capitolino*, Capitoline Hill, Rome, Italy, designed ca. 1537.

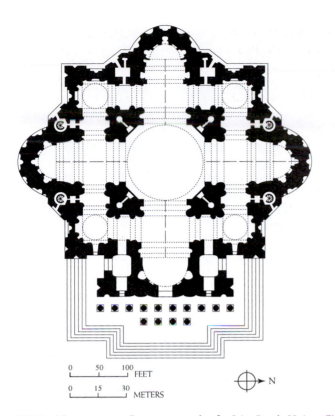

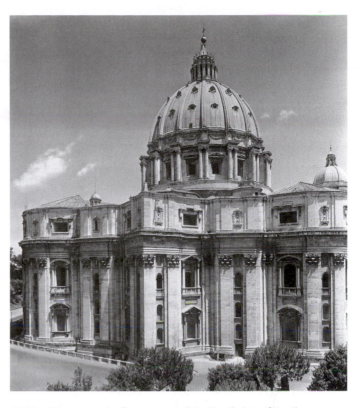

17-28 MICHELANGELO BUONARROTI, plan for Saint Peter's, Vatican City, Rome, Italy, 1546.

17-29 MICHELANGELO BUONARROTI, Saint Peter's (view from the northwest), Vatican City, Rome, Italy, 1546–1564. Dome completed by GIACOMO DELLA PORTA, 1590.

compact domed Greek cross inscribed in a square and fronted with a double-columned portico (FIG. **17-28**). Without destroying the centralizing features of Bramante's plan, Michelangelo, with a few strokes of the pen, converted its snowflake complexity into massive, cohesive unity.

Michelangelo's treatment of the building's exterior further reveals his interest in creating a unified and cohesive design. Because of later changes to the front of the church, the west (apse) end (FIG. **17-29**) offers the best view of his style and intention. The colossal order again served him nobly, as the giant pilasters seem to march around the undulating wall surfaces, confining the movement without interrupting it. The architectural sculpturing here extends up from the ground

through the attic stories and into the drum and the dome, unifying the whole building from base to summit. Baroque architects later learned much from this kind of integral design, which Michelangelo based on his conviction that architecture is one with the human form's organic beauty. The domed west end—as majestic as it is today and as influential as it has been on architecture throughout the centuries—is not quite as Michelangelo intended it. Originally, Michelangelo had planned a dome with an ogival section (raised silhouette), like that of Florence Cathedral (see FIG. 16-14). But in his final version he decided on a hemispheric (semicircular silhouette) dome (FIG. **17-30**) to temper the verticality of the design of the lower stories and to establish a balance between

17-30 MICHELANGELO BUONARROTI, drawing of south elevation of Saint Peter's, Vatican City, Rome, Italy, 1546–1564 (engraving by Étienne Dupérac, ca. 1569) Metropolitan Museum of Art, New York (Harris Brisbane Dick Fund, 1941).

dynamic and static elements. However, when GIACOMO DELLA PORTA (ca. 1537–1602) executed the dome after Michelangelo's death, he restored the earlier high design, ignoring Michelangelo's later version. Giacomo's reasons were probably the same ones that had impelled Brunelleschi to use an ogival section for his Florentine dome—greater stability and ease of construction. The result is that the dome seems to rise from its base, rather than rest firmly on it—an effect Michelangelo might not have approved. Nevertheless, Saint Peter's dome is probably the most impressive and beautiful in the world and has served as a model for generations of architects to this day.

Michelangelo's art began in the style of the fifteenth century, developed into the epitome of High Renaissance art, and, at the end, moved toward Mannerism and the Baroque. The longevity of his career has yet to be matched by more than a handful of artists. He was eighty-nine when he died in 1564, still hard at work on both the Capitoline Hill and Saint Peter's. Few artists, then or since, could escape his influence, and variations of his style provided the foundation of art production for centuries.

Early-Sixteenth-Century Venetian Art

Venice long had been a major Mediterranean coastal port and served as the gateway to the Orient. Reaching the height of its commercial and political power during the fifteenth century, Venice saw its fortunes decline in the sixteenth century. Even so, Venice and the Papal States were the only Italian sovereignties to retain their independence during the century of strife; either France or Spain dominated all others. Although the discoveries in the New World and the economic shift from Italy to Hapsburg Germany and the Netherlands were largely responsible for the decline of Venice, even more immediate and pressing events drained its wealth and power. After their conquest of Constantinople, the Turks began to vie with Venice for control of the eastern Mediterranean and evolved into a constant threat to Venice. Early in the century, the European powers of the League of Cambrai also attacked Venice. Formed and led by Pope Julius II, who coveted Venetian holdings on Italy's mainland, the League included Spain, France, and the Holy Roman Empire, in addition to the Papal States. Despite these challenges, Venice developed a flourishing, independent, and influential school of artists.

THE ROLE OF COLOR IN VENETIAN ART The effect of Venice's soft-colored light particularly interested artists in the maritime republic. Venetian artist GIOVANNI BELLINI (ca. 1430–1516) played an important role in developing the evocative use of color and contributed significantly to creating what is known as the Venetian style. Trained in the International Style (see Chapter 14, pages 440–41) by his father, Jacopo, a student of Gentile da Fabriano, Bellini worked in the family shop and did not develop his own style until after his father's death in 1470. His early independent works show the dominant influence of his brother-in-law Andrea Mantegna. But in the late 1470s, he came into contact with the work of the Sicilian-born painter Antonello da Messina (ca. 1430–1479), which impressed him. Antonello received his early training in Naples, where he must have come in close contact with Flemish painting and mastered using mixed oil (see Chapter 15, page 457). This more flexible

17-31 GIOVANNI BELLINI, *San Zaccaria Altarpiece*, San Zaccaria, Venice, Italy, 1505. Oil on wood transferred to canvas, approx. 16′ 5″ × 7′ 9″.

medium is wider in coloristic range than either tempera or fresco (see Chapter 14, "Fresco Painting," page 431). Antonello arrived in Venice in 1475 and during his two-year stay introduced his Venetian colleagues to the possibilities the new oil technique offered. As a direct result of Bellini's contact with him, Bellini abandoned Mantegna's harsh linear style and developed a sensuous coloristic manner that was to characterize Venetian painting in the late-fifteenth and sixteenth centuries.

Bellini earned great recognition for his many Madonnas, which he painted both in half-length (with or without accompanying saints) on small devotional panels and full-length on large, monumental altarpieces of the *sacra conversazione* (holy conversation) type. In the sacra conversazione, which gained great popularity as a theme for religious paintings from the middle of the fifteenth century on, a unified space joins saints from different epochs who seem to converse either with each other or with the audience. (Raphael employed much the same conceit in his *School of Athens*, FIG. 17-17, where he gathered Greek philosophers of different eras.) Bellini carried on the tradition in one of his large altarpieces, the *San Zaccaria Altarpiece* (FIG. **17-31**).

In the *San Zaccaria Altarpiece*, Bellini refined many of the compositional elements of his earlier altarpieces. As was conventional, the Virgin Mary sits enthroned, holding the Christ Child, with saints flanking her. Here, attributes aid the identification of all the saints but Saint Lucy—Saint Peter with his key and book, Saint Catherine with the palm of martyrdom and the broken wheel, and Saint Jerome with a

book (representing his translation of the Bible into Latin). At the foot of the throne sits an angel playing a viol. Bellini placed the group in a carefully painted shrine. The refinement of his style emerged in his use of color and light. The painting radiates a feeling of serenity and spiritual calm. Viewers derive this sense less from the figures (no interaction occurs among them) than from the harmonious and balanced presentation of color and light. Bellini's method of painting here became softer and more luminous than his earlier works. Line is not the chief agent of form; indeed, outlines dissolve in light and shadow. The impact of this work is due largely to glowing color—a soft radiance that envelops the forms with an atmospheric haze and enhances their majestic serenity.

A LUSHLY COLORED MYTHOLOGICAL PICNIC

The *San Zaccaria Altarpiece* is the mature work of an inquisitive artist whose paintings spanned the development of three artistic generations in Florence. At the very end of Bellini's long life, he was still willing and able to make changes in his style and approach to keep abreast of his times—thus, he began to deal with pagan subjects.

In painting *The Feast of the Gods* (FIG. **17-32**), Bellini actually drew from the work of one of his own students, Giorgione da Castelfranco (FIGS. 17-33 and 17-34), who developed his master's landscape backgrounds into poetic Arcadian reveries. Derived from Arcadia, an ancient district of the central Peloponnesus (peninsula in southern Greece), *Arcadian* referred, by the Renaissance, to an idyllic place of rural, rustic peace and simplicity. After Giorgione's premature death, Bellini embraced his student's interests and, in *The Feast of the Gods,* developed a new kind of mythological painting. The duke of Ferrara, Alfonso d'Este, commissioned this work for a room in the Palazzo Ducale. Although Bellini drew some of the figures from the standard repertoire of Greco-Roman art—most notably, the nymph carrying a vase on her head

17-32 GIOVANNI BELLINI and TITIAN, *The Feast of the Gods,* 1529. Oil on canvas, approx. 5′ 7″ × 6′ 2″. National Gallery of Art, Washington (Widener Collection).

and the sleeping nymph in the lower right corner—the Olympian gods appear as peasants enjoying a heavenly picnic in a shady northern glade. Bellini's source was Ovid's *Fasti,* which describes a banquet of the gods. The artist spread the figures across the foreground. Satyrs attend the gods, nymphs bring jugs of wine, a child draws from a keg, couples engage in love play, and the sleeping nymph with exposed breast receives amorous attention. The mellow light of a long afternoon glows softly around the gathering, caressing the surfaces of colorful draperies, smooth flesh, and polished metal. Here, Bellini communicated the delight the Venetian school took in the beauty of texture revealed by the full resources of gently and subtly harmonized color. Behind the warm, lush tones of the figures, a background of cool green tree-filled glades extends into the distance; at the right, a screen of trees creates a verdant shelter. (Scholars believe that the background was modified by Titian, discussed shortly.) The atmosphere is idyllic, a lush countryside providing a setting for the never-ending pleasure of the immortal gods.

Thus, with Bellini, Venetian art became the great complement of the schools of Florence and Rome. The Venetians' instrument was color; that of the Florentines and Romans was sculpturesque form. Scholars often distill the contrast between these two approaches down to *colorito* (colored or painted) versus *disegno* (drawing and design—see *"Disegno:* Drawing on Design Fundamentals," page 527). While most central Italian artists emphasized careful design preparation based on preliminary drawing, Venetian artists focused on color and the process of paint application. These two schools have run parallel—sometimes touching and intersecting—through the history of Western art from the Renaissance to the present. In addition, their themes, in general, differed. Venetian artists painted the poetry of the senses and delighted in nature's beauty and the pleasures of humanity. Artists in Florence and Rome gravitated toward more esoteric, intellectual themes—the epic of humanity, the masculine virtues, the grandeur of the ideal, and the lofty conceptions of religion involving the heroic and sublime. Much of the history of later Western art involved a dialogue between these two traditions.

Describing Venetian art as "poetic" is particularly appropriate, given the development of *poesia,* or painting meant to operate in a manner similar to poetry. Both classical and Renaissance poetry inspired Venetian artists, and their paintings focused on the lyrical and sensual. Thus, in many Venetian artworks, discerning concrete narratives or subjects (in the traditional sense) is virtually impossible.

17-33 GIORGIONE DA CASTELFRANCO (and/or TITIAN?), *Pastoral Symphony,* ca. 1508. Oil on canvas, approx. 3′ 7″ × 4′ 6″. Louvre, Paris.

17-34 GIORGIONE DA CASTELFRANCO, *The Tempest*, ca. 1510. Oil on canvas, 2' 7" × 2' 4¾". Galleria dell'Accademia, Venice.

POETRY IN MOTION A Venetian artist who deserves much of the credit for developing this poetic manner of painting was GIORGIONE DA CASTELFRANCO (ca. 1477–1510). Giorgione's so-called *Pastoral Symphony* (FIG. **17-33**; some believe it an early work by his student Titian, discussed next) exemplifies poesia and surely inspired the late Arcadian scenes by Bellini, his teacher. Out of dense shadow emerge the soft forms of figures and landscape. The theme is as enigmatic as the light. Two nude females, accompanied by two clothed young men, occupy the rich, abundant landscape through which a shepherd passes. In the distance, a villa crowns a hill. The artist so eloquently evoked the pastoral mood that viewers do not find the uncertainty about the picture's precise meaning distressing; the mood is enough. The shepherd symbolizes the poet; the pipes and the lute symbolize his poetry. The two women accompanying the young men may be thought of as their invisible inspiration, their muses. One turns to lift water from the sacred well of poetic inspiration. The voluptuous bodies of the women, softly modulated by

the smoky shadow, became the standard in Venetian art. The fullness of their figures contributes to their effect as poetic personifications of nature's abundance.

As a pastoral poet in the pictorial medium and one of the greatest masters in the handling of light and color, Giorgione praised the beauty of nature, music, women, and pleasure. Vasari reported that Giorgione was an accomplished lutist and singer, and adjectives from poetry and music seem best suited for describing his painting's pastoral air and muted chords. He cast a mood of tranquil reverie and dreaminess over the entire scene, evoking the landscape of a lost but never forgotten paradise. Lingering memories of Arcadia and its happy occupants have an enduring appeal. Among the Italians, the Venetians were foremost in expressing a love of nature and in realizing its potential for painters, although they never represented it uninhabited.

STORMY WEATHER Another Giorgione painting, *The Tempest* (FIG. **17-34**), manifests this same interest in the

Negotiating a Contract
Titian and the Battle of Cadore

The predominance of the patronage system (see "Art to Order: Commissions and Patronage," Chapter 14, page 427) during the Renaissance compelled artists to work diligently at cultivating patrons. The following letter, from Titian to the doge of Venice, was the culmination of a protracted negotiation between the artist and the Council of the Ten (an administrative council) in 1515 (or early 1516). Due to this letter, those involved settled on a final agreement, and Titian completed the painting, *Battle of Cadore,* in 1538. A fire in the Great Council Hall subsequently destroyed the painting.

> Having understood, Your Highness, that you have decided to let those canvases in the Great Council Hall be painted, and since I, Titian, servant of Your Highness, should like to display such a canvas painted in this fashion from my hand, and have actually started on one two years ago, and it is not the most difficult and laborious to do for this Hall, I bind myself by my own will to finish it as it ought to be, at my own expense; nor do I want any other payment before the completion of the work, except only for ten ducats' worth of paints, and three ounces of that blue which is kept in the Salt Office; and I want one of the two young men that will help me to be paid for me as an advance on my account, which only amounts to 4 ducats a month, while I bind myself to pay another out of my pocket, and to take charge of any other expenditure that will be required by the painting; Your Highness would make the Salt Office promise me that when the work was completed, they would pay me half of that which was once promised to Perugino, who was supposed to paint this canvas, which would come to 400 ducats, since he would not do it for 800, and that in time I should get the office of broker of the Association of German Merchants, as was decided in the Most Illustrious Council of November 28, 1514.[1]

[1] Titian to the doge of Venice, ca. December 1515–January 1516, *Italian Art 1500–1600: Sources and Documents,* by Robert Klein and Henri Zerner (Evanston, Ill.: Northwestern University Press, 1966), 47.

poetic qualities of natural landscape humans inhabit. Dominating the scene is a lush landscape, threatened by stormy skies and lightning in the middle background. Pushed off to both sides are the human figures—a young woman nursing a baby in the right foreground and a man carrying a halberd (a combination spear and battle-ax) on the left. Much scholarly debate has centered on this painting's subject, fueled by the fact that X rays of the canvas revealed a nude female originally stood where Giorgione subsequently placed the man. This flexibility in subject has led many to believe no definitive narrative exists, appropriate for a Venetian poetic rendering. Other scholars have suggested mythological narratives or historical events. Despite this uncertainty, the painting's enigmatic quality lends it an intriguing air.

A SUPREME MASTER OF COLOR Giorgione's Arcadianism passed not only to his much older yet constantly inquisitive master, Bellini, but also to TIZIANO VECELLI, whose name has been anglicized into TITIAN (ca. 1490–1576). Titian was the most extraordinary and prolific of the great Venetian painters, a supreme colorist who cultivated numerous patrons (see "Negotiating a Contract: Titian and the *Battle of Cadore,*" above). An important change occurring in Titian's time was the almost universal adoption of canvas, with its rough-textured surface, in place of wood panels for paintings. Titian's works established oil color on canvas as the typical medium of pictorial tradition thereafter. According to a contemporary of Titian, Palma il Giovane:

> Titian [employed] a great mass of colors, which served . . . as a base for the compositions. . . . I too have seen some of these, formed with bold strokes made with brushes laden with colors, sometimes of a pure red earth, which he used, so to speak, for a middle tone, and at other times of white lead; and with the same brush tinted with red, black and yellow he formed a highlight; and observing these principles he made the promise of an exceptional figure appear in four brushstrokes. . . . Having constructed these precious foundations he used to turn his pictures to the wall and leave them there without looking at them, sometimes for several months. When he wanted to apply his brush again he would examine them with the utmost rigor . . . to see if he could find any faults. . . . In this way, working on the figures and revising them, he brought them to the most perfect symmetry that the beauty of art and nature can reveal. . . . [T]hus he gradually covered those quintessential forms with living flesh, bringing them by many stages to a state in which they lacked only the breath of life. He never painted a figure all at once and . . . in the last stages he painted more with his fingers than his brushes.[12]

A GLORIOUS IMAGE OF THE VIRGIN Titian's remarkable coloristic sense and his ability to convey light through color emerges in a major altarpiece, *Assumption of the Virgin* (FIG. **17-35**), painted for the main altar of Santa Maria Gloriosa dei Frari in Venice. Commissioned by the prior of this Franciscan basilica, the monumental altarpiece (close to twenty-three feet high) appropriately depicts the glorious ascent of the Virgin's body to Heaven. Visually, the painting is a stunning tour de force. Golden clouds so luminous they seem to glow, radiating light into the church interior, envelop the

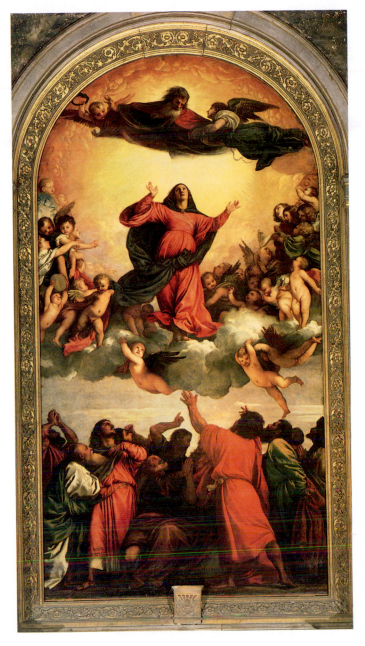

17-35 TITIAN, *Assumption of the Virgin*, Santa Maria Gloriosa dei Frari, Venice, Italy, ca. 1516–1518. Oil on wood, 22′ 6″ × 11′ 10″.

thereafter, Bishop Jacopo Pesaro commissioned Titian to paint *Madonna of the Pesaro Family* (FIG. **17-36**), which the patron presented to the church of the Frari. This work furthered Titian's reputation and established his personal style. Pesaro, bishop of Paphos in Cyprus and commander of the papal fleet, had led a successful expedition in 1502 against the Turks during the Venetian-Turkish war and commissioned this painting in gratitude. In a stately sunlit setting, the Madonna receives the commander, who kneels dutifully at the foot of her throne. A soldier (Saint George?) behind the commander carries a banner with the escutcheons (shields with coats of arms) of the Borgia (Pope Alexander VI) and of Pesaro. Behind him is a turbaned Turk, a prisoner of war of the Christian forces. Saint Peter appears on the steps of the throne, and Saint Francis introduces other Pesaro family members (all male—Italian depictions of donors in this era typically excluded women and children), who kneel solemnly in the right foreground.

The massing of monumental figures, singly and in groups, within a weighty and majestic architecture characterized, as already seen, the High Renaissance. But Titian did not compose a horizontal and symmetrical arrangement, as Leonardo did in *Last Supper* (FIG. 17-3) and Raphael in *School of Athens* (FIG. 17-17). Rather, he placed the figures on a steep diagonal, positioning the Madonna, the composition's focus, well off the central axis. Titian drew viewers' attention to her with the perspective lines, the inclination of the figures, and the directional lines of gaze and gesture. The banner inclining toward the left beautifully brings the design into equilibrium, balancing the rightward and upward tendencies of its main direction.

This kind of composition is more dynamic than those in the High Renaissance shown thus far and presaged a new kind of pictorial design—built on movement rather than rest. In his rendering of the rich surface textures, Titian gave a dazzling display of color in all its nuances. He entwined the human—especially the Venetian—scene with the heavenly, depicting the Madonna and saints honoring the achievements of a specific man in this particular world. A quite worldly transaction takes place (albeit beneath a heavenly cloud bearing angels) between a queen and her court and loyal servants. Titian constructed this tableau in terms of Renaissance protocol and courtly splendor.

Virgin. God the Father appears above, awaiting her with open arms. Below, apostles gesticulate wildly as they witness this momentous event. Titian painted this large-scale altarpiece with exceptional clarity. Through vibrant color, he infused the image with a drama and intensity that assured his lofty reputation, then and now.

A DAZZLING DISPLAY OF COLOR Trained by both Bellini and Giorgione, Titian learned so well from them that even today scholars cannot agree about the degree of his participation in their later works. However, it is clear Titian completed several of Bellini's and Giorgione's unfinished paintings. On Giovanni Bellini's death in 1516, the republic of Venice appointed Titian as its official painter. Shortly

BACCHANALIAN REVELRY In 1511, Alfonso d'Este, duke of Ferrara, asked Titian to produce a painting for his Camerino d'Alabastro (small room of alabaster). The patron had requested one bacchanalian scene each from Titian, Bellini, Raphael, and Fra Bartolommeo. Both Raphael and Fra Bartolommeo died before fulfilling the commission, and Bellini only painted one scene (FIG. 17-32), leaving Titian to produce three. One of these three paintings is *Meeting of Bacchus and Ariadne* (FIG. **17-37**). Bacchus, accompanied by a boisterous and noisy group, arrives to save Ariadne, whom Theseus has abandoned on the island of Naxos. In this scene, Titian revealed his debt to classical art; he derived one of the figures, entwined with snakes, in Bacchus's band of revelers from the ancient sculpture Laocoön (see FIG. 5-89). Titian's rich and luminous colors add greatly to the sensuous appeal of this painting, making it perfect for Alfonso's "pleasure chamber."

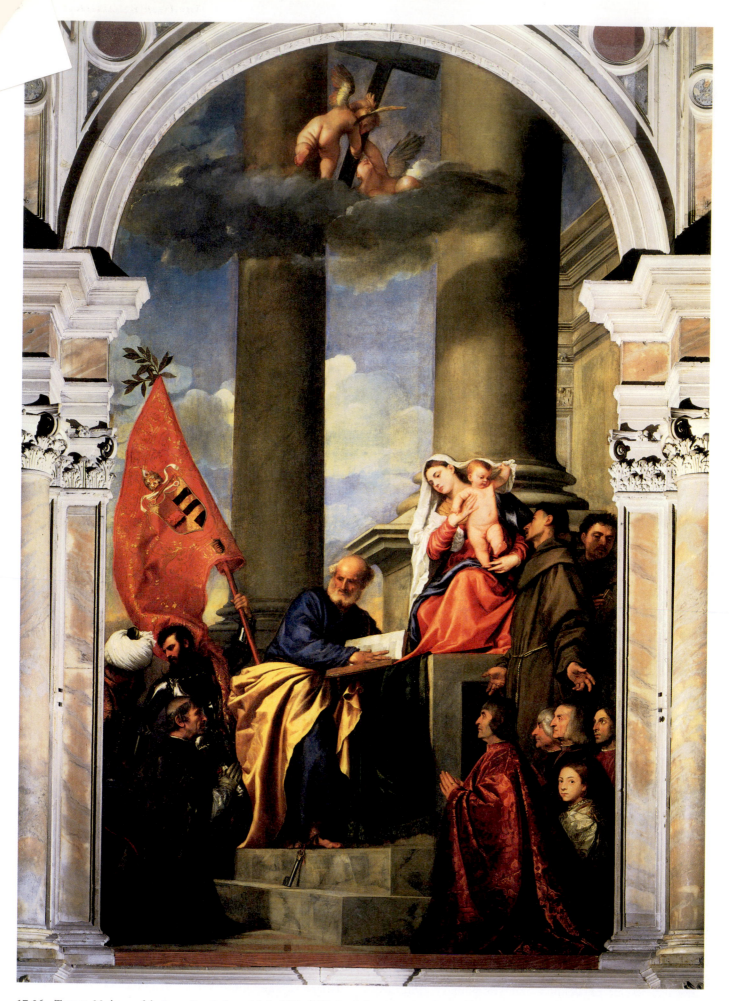

17-36 TITIAN, *Madonna of the Pesaro Family,* Santa Maria dei Frari, Venice, Italy, 1519–1526. Oil on canvas, approx. 16′ × 9′.

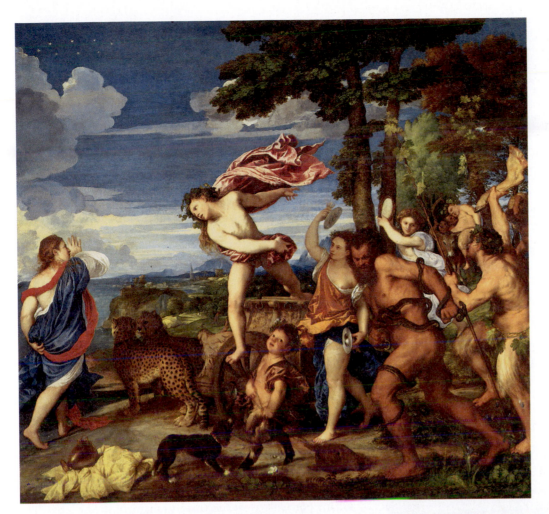

17-37 TITIAN, *Meeting of Bacchus and Ariadne,* 1522–1523. Oil on canvas, 5′ 9″ × 6′ 3″. National Gallery, London.

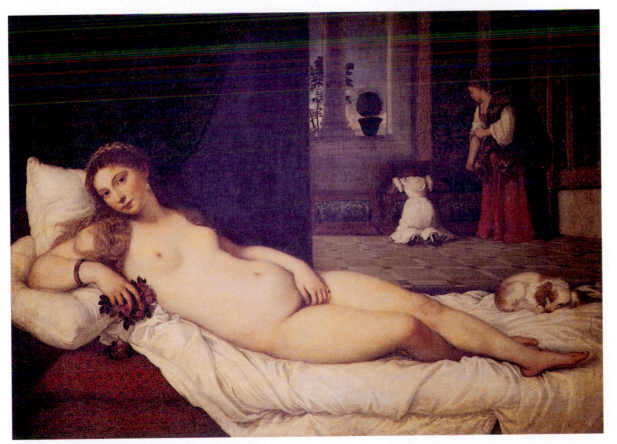

17-38 TITIAN, *Venus of Urbino,* 1538. Oil on canvas, approx. 4′ × 5′ 6″. Galleria degli Uffizi, Florence.

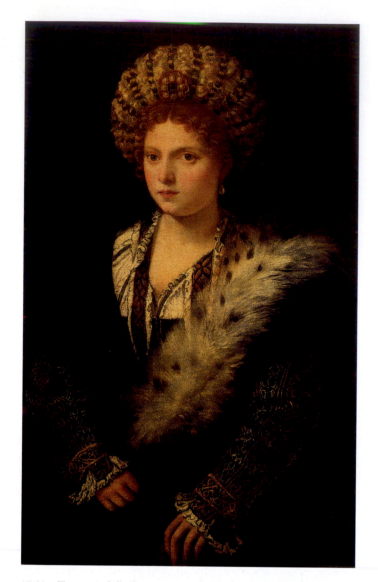

17-39 TITIAN, *Isabella d'Este*, 1534–1536. Oil on canvas, 3′ 4$\frac{1}{8}$″ × 2′ 1$\frac{3}{16}$″. Kunsthistorisches Museum, Vienna.

"Venus." Beyond them, a smaller vista opens into a landscape. Titian masterfully constructed the view backward into space and the division of the space into progressively smaller units. With his facility, he used all of the resources of pictorial representation to create original and exquisite effects of the sort that inspired generations of painters in Italy and the north.

As in other Venetian paintings, color plays a prominent role in *Venus of Urbino*. The red tones of the matron's skirt and the muted reds of the tapestries against the neutral whites of the matron's sleeves and of the kneeling girl's gown echo the deep Venetian reds set off against the pale neutral whites of the linen and the warm ivory gold of the flesh. Viewers must study the picture carefully to realize the subtlety of color planning. For instance, the two deep reds (in the foreground cushions and in the background skirt) function so importantly in the composition as a gauge of distance and as indicators of an implied diagonal opposed to the real one of the reclining figure. Here, Titian used color not simply for tinting preexisting forms but also to organize his placement of forms.

PRESENTING A POWERFUL PATRONESS Titian was also a highly esteemed portraitist and in great demand. Of his well more than fifty portraits surviving, one example, *Isabella d'Este* (FIG. **17-39**), suffices to illustrate his style (see "The Feminine Mystique: Women Patrons during the Renaissance," page 561). Isabella d'Este (1474–1539) was among the most powerful of women during the Renaissance. Daughter of the duke of Ferrara, she married Francesco Gonzaga, marquis of Mantua, and was instrumental in developing the Mantuan court into an important center of art and learning. Titian's portraits, as well as those of many of the Venetian and subsequent schools, generally make much of the artist's psychological reading of the body's most expressive parts—the head and the hands. Thus, Titian sharply highlighted Isabella's face, while her black dress fades into the background's undefined darkness. The unseen light source also illuminates Isabella's hands, and the artist painted her sleeves with incredible detail to further draw viewers' attention to her hands. This portrait reveals not only Titian's skill but the patron's wish as well. Painted when Isabella was sixty years of age, it depicts her in her twenties at her request. Titian used an earlier portrait of her as his guide, and Isabella appears not just young but also perfectly poised and self-assured.

Other Sixteenth-Century Italian Artists

ANTICIPATING BAROQUE DEVICES IN PARMA The towering achievements of Raphael and Michelangelo in Rome tend to obscure everything else created during their time. Nevertheless, aside from the flourishing Venetian school, excellent artists were active in other parts of Italy during the first part of the sixteenth century. ANTONIO ALLEGRI DA CORREGGIO (ca. 1489–1534) of Parma is almost impossible to classify. A solitary genius, Correggio pulled together many stylistic trends, including those of Leonardo, Raphael, and the Venetians. Yet he developed a unique personal style, which, if it must be labeled, might best be called "proto-Baroque." Historically, his most enduring contribution was his development of illusionistic ceiling perspectives to a point his Baroque emulators seldom surpassed. At Mantua, Man-

A VENETIAN VENUS In 1538, at the height of his powers, Titian painted the so-called *Venus of Urbino* (FIG. **17-38**) for Guidobaldo II, duke of Urbino. The title (given to the painting later) elevates what probably merely represents a courtesan in her bedchamber to the status of classical mythology. Indeed, no evidence suggests the duke intended the commission as anything more than a female nude for his private enjoyment. Whether the subject is divine or mortal, Titian based his version on an earlier (and pioneering) painting of Venus (not illustrated) by Giorgione. Here, Titian established the compositional elements and the standard for reclining female nude paintings, regardless of the many variations that ensued. This "Venus" reclines on the gentle slope of her luxurious pillowed couch, the linear play of the draperies contrasting with her body's sleek continuous volume. At her feet is a *pendant* (balancing) figure—in this case, a slumbering lap dog. Behind her, a simple drape both places her figure emphatically in the foreground and indicates a vista into the background at the right half of the picture. Two servants bend over a chest, apparently searching for garments (Renaissance households stored clothing in carved wooden chests called *cassoni*) to clothe

The Feminine Mystique
Women Patrons during the Renaissance

The dearth of acknowledged women artists in the Renaissance reflects the obstacles they faced. In particular, for centuries, training practices mandating residence at a master's house (see "Mastering a Craft: Artistic Training in the Renaissance," Chapter 14, page 442) precluded women from acquiring the necessary experience. In addition, social proscriptions, such as those preventing women from drawing from nude models, further hampered an aspiring female artist's advancement through the accepted avenues of artistic training.

However, despite the obstacles Renaissance women encountered as artists, they did have a significant impact on the arts in the realm of patronage. Scholars only recently have begun to explore systematically the role of women as patrons. As a result, current knowledge is sketchy at best but suggests women played a much more extensive role than previously acknowledged. Among the problems researchers face in their quest to clarify women's participation as patrons is that women often wielded their influence and decision-making power behind the scenes. Many of these women acquired their positions through marriage; their power was thus indirect and provisional, based on their husbands' wealth and status. Thus, documentation of the networks women patrons operated within and of the processes they used to exert power in a male-dominated society is less substantive than that available for male patrons.

One of the most important Renaissance patrons, male or female, was Isabella d'Este (1474–1539), marchioness of Mantua (FIG. 17-39). Brought up in the cultured princely court of Ferrara (southwest of Venice), Isabella married Francesco Gonzaga (1484–1519), marquis of Mantua, at age seventeen in 1490. Isabella's marriage gave her access to the position and wealth necessary to pursue her interest in becoming a major art patron. An avid collector, she enlisted the aid of agents who scoured Italy for appealing objects. Isabella did not limit her collection to painting and sculpture but included ceramics, glassware, gems, cameos, medals, classical texts, musical manuscripts, and musical instruments.

Isabella was undoubtedly a proud and ambitious woman well aware of how art could boost her fame and reputation. Accordingly, she commissioned several portraits of herself from the most esteemed artists of her day—Leonardo da Vinci, Andrea Mantegna, and Titian. The detail and complexity of many of her contracts with artists reveal her insistence on control over the artworks.

Another Renaissance woman who was a significant art patron was Caterina Sforza (1462–15??), daughter of Galeazzo Maria Sforza (heir to the Duchy of Milan) who married Girolamo Riario in 1484. The death of her husband, lord of Imola and count of Forlì, in 1488 gave Sforza access to power denied most women.

Lucrezia Tornabuoni (married to Piero di Cosimo de' Medici) was one of many Medici, both men and women, who earned reputations as unparalleled art patrons. Further archival investigation of women's roles in Renaissance Italy undoubtedly will produce more evidence of how women established themselves as patrons and artists and the extent they contributed to the flourishing of Renaissance art.

tegna created the illusion of a hole in the ceiling of the Camera degli Sposi (see FIG. 16-48). Some fifty years later, Correggio painted away the entire dome of the Parma Cathedral in *Assumption of the Virgin* (FIG. 17-40). Opening up the cupola, the artist showed his audience a view of the sky, with concentric rings of clouds where hundreds of soaring figures perform a wildly pirouetting dance in celebration of the Virgin's Assumption. Versions of these angelic creatures became permanent tenants of numerous Baroque churches in later centuries. Correggio was also an influential painter of religious panels, anticipating in them many other Baroque compositional devices. Correggio's contemporaries expressed little appreciation for his art. Later, during the seventeenth century, Baroque painters recognized him as a kindred spirit.

MANNERISM

Mannerism is a stylistic label that encompasses certain tendencies in later Renaissance art. The term derives from the Italian word *maniera* (manner) and initially referred to art produced "in the manner of" another artist (often Michelangelo). Over the years, scholars have refined their ideas about Mannerism, attempting to define this style's parameters. Chronologically, it is difficult to identify specific dates for Mannerism—it overlapped considerably with High Renaissance art, emerging in the 1520s.

Among the features most closely associated with Mannerism is *artifice*—an emphasis on staged, contrived imagery. Mannerist art evinces elegance and beauty, but not those derived directly from nature. Rather than relying on direct observation for their sources, Mannerists tended to look to earlier art, especially High Renaissance and Roman sculpture, as their models. Further, Mannerists displayed a preference for imbalanced compositions and unusual complexities, both visual and conceptual. Ambiguous space, departures from expected conventions, and unique presentations of traditional themes also surfaced frequently in Mannerist art and architecture. Where High Renaissance artists strove for balance, Mannerists sought instability. Mannerists replaced the calm equilibrium of the High Renaissance with a restlessness that led to distortions, exaggerations, and affected posturings on the one hand, and sinuous grace on the other hand. These artists, to the limits of their ingenuity and skill, abstracted forms they idealized further, so the typical Mannerist picture or statue

17-40 ANTONIO ALLEGRI DA CORREGGIO,
Assumption of the Virgin, dome fresco of Parma
Cathedral, Parma, Italy, 1526–1530.

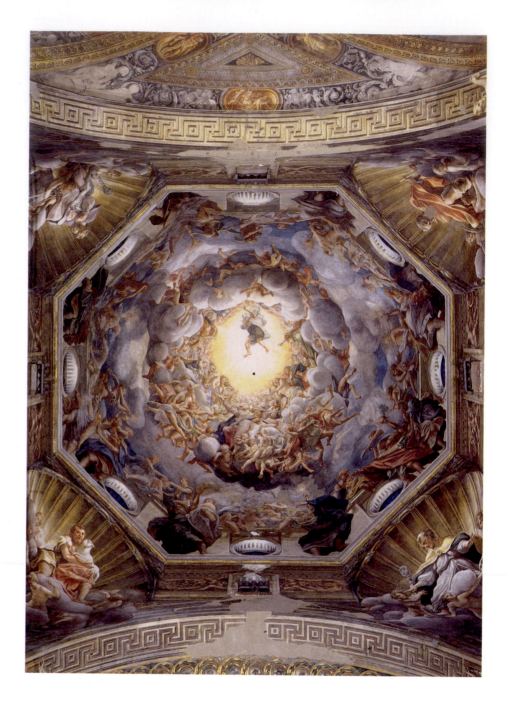

looks like an original essay in human form somewhat re-
moved from nature. Mannerism is almost exclusively an art of
the human figure. Mannerism's requirement of "invention"
led its practitioners to a self-conscious stylization involving
complexity, caprice, fantasy (the "conceit"), elegance, perfec-
tionism, and polish.

Mannerist Painting

DEPARTING FROM RENAISSANCE IDEALS *De-
scent from the Cross* (FIG. **17-41**) by JACOPO DA PONTORMO
(1494–1557) exhibits almost all of the stylistic features char-
acteristic of Mannerism's early phase in painting. The figures
crowd the composition, pushing into the front plane and al-
most completely blotting out the setting. Pontormo disposed
the figural masses around the frame of the picture, leaving a

void in the center, where High Renaissance artists had con-
centrated their masses. The composition has no clearly de-
fined focal point, and the figures seem randomly placed
around the painting's edges. The ambiguous representation of
space typifies the Mannerist style. The space seems too shal-
low to contain the action within it. For example, Pontormo
did not provide any space for the body belonging to the head,
seen in a three-quarter rear view, that appears immediately
above Christ's head.

The artist enhanced the painting's ambiguity with the curi-
ously anxious glances the figures cast in all directions. Athletic
bending and twisting characterize many of the figures, with
distortions (a torso cannot bend at the point the foreground
figure's does), elastic elongation of the limbs, and heads ren-
dered as uniformly small and oval. Clashing colors add to the
seeming dissonance of the image. The painting represented a
departure from the balanced, harmonious structured compo-
sitions of the earlier Renaissance.

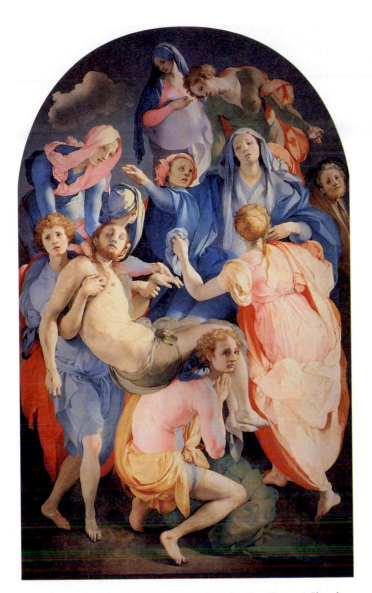

17-41 JACOPO DA PONTORMO, *Descent from the Cross*, Capponi Chapel, Santa Felicità, Florence, Italy, 1525–1528. Oil on wood, approx. 10′ 3″ × 6′ 6″.

MANNERISM'S ELEGANCE AND GRACE Correggio's pupil, GIROLAMO FRANCESCO MARIA MAZZOLA, known as PARMIGIANINO (1503–1540), achieved in his best-known work, *Madonna with the Long Neck* (FIG. **17-42**), the elegance that was a principal aim of Mannerism. He smoothly combined the influences of Correggio and Raphael in a picture of exquisite grace and precious sweetness. The Madonna's small oval head; her long, slender neck; the unbelievable attenuation and delicacy of her hand; and the sinuous, swaying elongation of her frame are all marks of the aristocratic, gorgeously artificial taste of a later phase of Mannerism. Parmigianino amplified this artificiality by expanding the Madonna's form as viewed from head to toe. On the left stands a bevy of angelic creatures, melting with emotions as soft and smooth as their limbs (the composition's left side is quite in Correggio's manner). On the right, the artist included a line of columns without capitals—an enigmatic setting for an enigmatic figure with a scroll, whose distance from the foreground is immeasurable and ambiguous.

AN ALLEGORICAL LOVE SCENE *Venus, Cupid, Folly, and Time,* also called *The Exposure of Luxury* (FIG. **17-43**), by AGNOLO DI COSIMO, called BRONZINO (1503–1572), also manifests all the points made thus far about Manneristic composition. A pupil of Pontormo, Bronzino was a Florentine and painter to Cosimo I, first grand duke of Tuscany. In this painting, he demonstrated the Mannerist's fondness for extremely learned and intricate allegories that often had lascivious undertones, a shift from the simple and monumental statements and forms of the High Renaissance. Bronzino depicted Cupid fondling his mother Venus, while Folly prepares to shower them with rose petals. Time, who appears in the upper right-hand corner, draws back the curtain to reveal the playful incest in progress. Other figures in the painting represent Envy and Inconstancy. The masks, a favorite device of the Mannerists, symbolize deceit. The picture seems to suggest that love—accompanied by envy and plagued by inconstancy—is foolish and that lovers will discover its folly in time. But, as in many Mannerist paintings, the meaning here is ambiguous, and interpretations of this image vary. Compositionally, Bronzino placed the figures around the front plane,

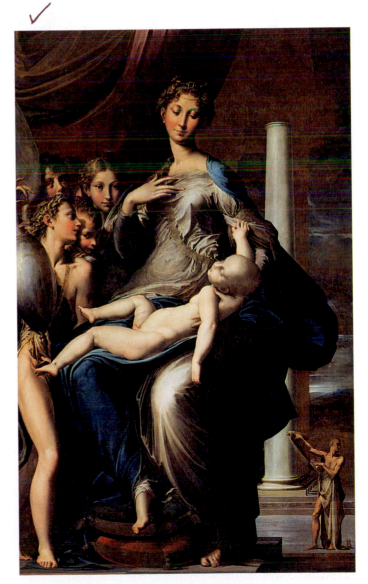

17-42 PARMIGIANINO, *Madonna with the Long Neck,* ca. 1535. Oil on wood, approx. 7′ 1″ × 4′ 4″. Galleria degli Uffizi, Florence.

17-43 BRONZINO, *Venus, Cupid, Folly, and Time (The Exposure of Luxury)*, ca. 1546. Oil on wood, approx. 5' 1" × 4' 8¾". National Gallery, London.

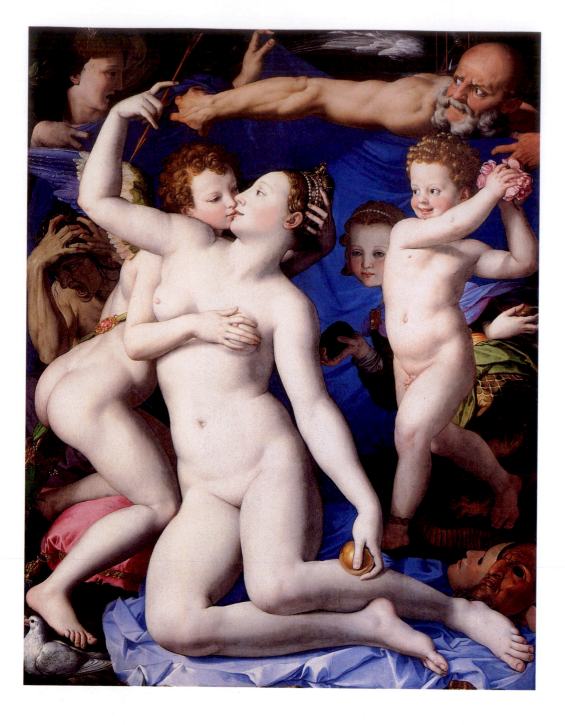

and they almost entirely block the space. The contours are strong and sculptural, the surfaces of enamel smoothness. Of special interest are the heads, hands, and feet, for the Mannerists considered the extremities the carriers of grace and the clever depiction of them evidence of artistic skill.

A MANNERED PORTRAIT Mannerist painters most often achieved the sophisticated elegance they sought in portraiture. Bronzino's *Portrait of a Young Man* (FIG. **17-44**) exemplifies Mannerist portraiture. The subject is a proud youth—a man of books and intellectual society, rather than a lowly laborer or a merchant. His cool demeanor seems carefully affected, a calculated attitude of nonchalance toward the observing world. This staid and reserved formality is a standard component of the Mannerist's portraits. It asserts the rank and station but not the personality of the subject. In

this portrait, the haughty poise, the graceful long-fingered hands, the book, the furniture's carved faces, and the severe architecture all suggest the traits and environment of the highbred, disdainful patrician. The somber Spanish black of the young man's doublet and cap (this is the century of Spanish etiquette) and the room's slightly acid olive green walls make for a deeply restrained color scheme. Bronzino created a muted background for the subject's sharply defined, asymmetrical Mannerist silhouette that contradicts his impassive pose.

PORTRAYING FAMILIAL INTIMACY The aloof formality of Bronzino's portrait is much relaxed in the portraiture of SOFONISBA ANGUISSOLA (1527–1625). A northern Italian from Cremona, Anguissola used the strong contours, muted tonality, and smooth finish familiar in Mannerist portraits. But she introduced, in a group portrait of irresistible

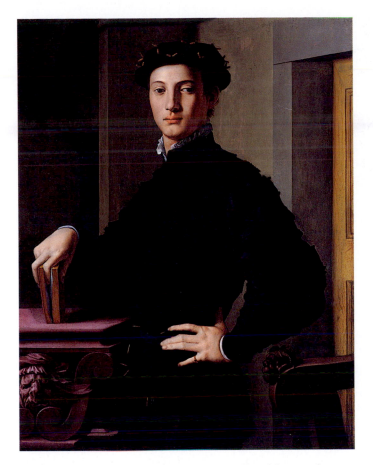

17-44 BRONZINO, *Portrait of a Young Man*, ca. 1530s. Oil on wood, approx. 3' 1½" × 2' 5½". Metropolitan Museum of Art, New York (H. O. Havemeyer Collection, bequest of Mrs. H. O. Havemeyer, 1929).

charm (FIG. **17-45**), an informal intimacy of her own. Like many of her other works done before she moved to Spain in 1559, this is a portrait of family members. Against a neutral ground, she placed her two sisters and brother in an affectionate pose meant not for official display but for private showing, much as they might be posed in a modern photo-studio portrait. The sisters, wearing matching striped gowns, flank their brother, who caresses a lap dog. The older sister (at the left) summons the dignity required for the occasion, while the boy looks quizzically at the portraitist with an expression of naive curiosity and the other girl diverts her attention toward something or someone to the painter's left.

Anguissola's use of natural poses and expressions; her sympathetic, personal presentation; and her graceful treatment of the forms did not escape the attention of her famous contemporaries. Vasari praised her art as wonderfully lifelike, declaring that Anguissola

> laboured at the difficulties of design with greater study and better grace than any other woman of our time, and she has not only succeeded in drawing, colouring, and copying from nature, and in making excellent copies of works by other hands but has also executed by herself alone some very choice and beautiful works of painting.[13]

Moreover, her "invention" inspired great praise. Although that word does not now have quite the meaning it had then, Anguissola did introduce the intimate, anecdotal, and realistic touches of *genre* painting (the painting of scenes from ordinary life) into formal portraiture. *Portrait of the Artist's Sisters and Brothers* could have been simply a good-natured portrayal of any happy middle-class family members; the figures do not

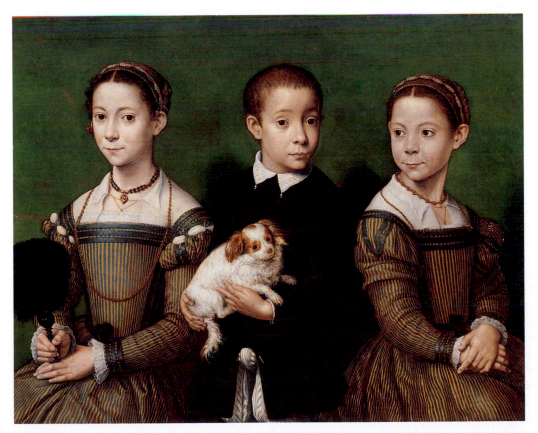

17-45 SOFONISBA ANGUISSOLA, *Portrait of the Artist's Sisters and Brother*, ca. 1555. Methuen Collection, Corsham Court, Wiltshire.

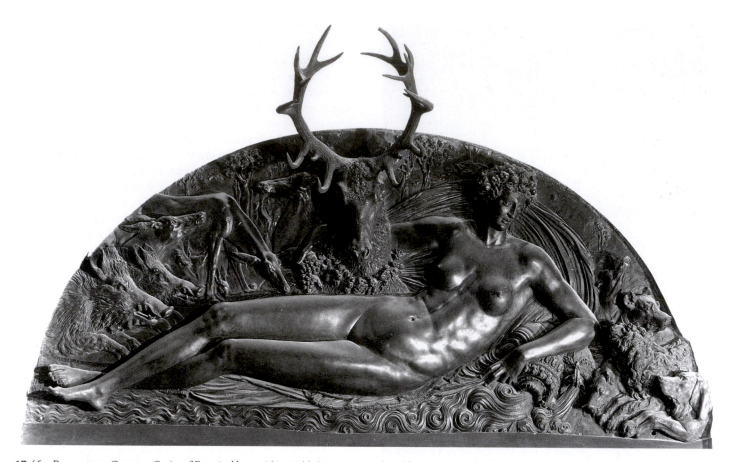

17-46 Benvenuto Cellini, *Genius of Fontainebleau*, 1543–1544. Bronze, more than life-size. Louvre, Paris.

flaunt names, titles, and elegance of dress to gain public respect. Anguissola lived a long life and enjoyed a successful career. She knew and learned from the aged Michelangelo, was court painter to Phillip II of Spain, and, at the end of her life, gave advice on art to a young admirer of her work, Anthony Van Dyck, the great Flemish master.

Mannerist Sculpture

A BRONZE GODDESS OF THE HUNT Mannerism extended beyond pictorial media; artists translated its principles into sculpture and architecture as well. BENVENUTO CELLINI (1500–1571) was among those who made their mark as Mannerist sculptors. To judge by his fascinating *Autobiography,* Cellini had an impressive proficiency as an artist, statesman, soldier, lover, and many other roles. He was, first of all, a goldsmith. Michelangelo's influence led Cellini to attempt larger works, and, in the service of Francis I, he cast in bronze *Genius of Fontainebleau* (FIG. **17-46**), which sums up Italian and French Mannerism. The female Genius, or spirit, is a composite of both Diana, the Greco-Roman goddess of the hunt, here embracing her animal the deer, and a classical personification of a spring leaning on an urn that spews forth water (compare FIG. 8-19). Her figure suggests the reclining figures in the Medici Chapel tombs (FIG. 17-22) and the female nudes, both Venuses and courtesans, that only recently had become popular subjects for Renaissance paintings (FIG. 17-38), but Cellini exaggerated their characteristics as the Mannerist's design sense dictated. The head is remarkably

small, the torso stretched out, and the limbs elongated. The contrapposto is more apparent than real, for the upper body does not compensate appropriately for the position shift of the lower body.

SPIRALING FIGURES Italian influence, working its way into France, drew a brilliant, young French sculptor, JEAN DE BOULOGNE, to Italy, where he practiced his art under the equivalent Italian name of GIOVANNI DA BOLOGNA (1529–1608). Giovanni's work provided the stylistic link between Michelangelo's sculptures and those of the Baroque master Gianlorenzo Bernini (see FIGS. 19-5 through 19-9). Giovanni's *Abduction of the Sabine Women* (FIG. **17-47**) wonderfully exemplifies Mannerism's principles of figure composition while revealing an impulse to break out of the Mannerist formulas of representation.

Drawn from early Rome's legendary history, the title—relating how the Romans abducted wives for themselves from their neighbors, the Sabines—was given to the group only after it was raised. Giovanni probably intended to present only an interesting figure composition involving an old man, a young man, and a woman, all nude in the tradition of ancient statues portraying mythological figures. This sculpture reveals the artist's knowledge of earlier art. Giovanni would have known Antonio Pollaiuolo's fifteenth-century work *Hercules and Antaeus* (see FIG. 16-25), whose Greek hero lifts his opponent off the ground. But here, unlike Giovanni's predecessor, he turned directly to classical sculpture for inspiration. *Abduction of the Sabine Women* includes references to the Laocoön

To fully appreciate the sculpture, visitors must walk around it, since the work changes radically according to the viewing point. One contributing factor to the shifting imagery is the prominence of open spaces that pass through the masses (for example, the space between an arm and a body), which have as great an effect as the solids. This sculpture was the first large-scale group since classical antiquity designed to be seen from multiple viewpoints, in striking contrast to Pollaiuolo's group, which the artist intended to be seen from the angle shown in our illustration. Giovanni's figures do not break out of this spiral vortex but remain as if contained within a cylinder. That they remain "enclosed" prevents historians from calling them Baroque. Yet the Michelangelesque potential for action and the athletic flexibility of the figures are there. Artists of the following Baroque period released their sculptured figures into full action.

Mannerist Architecture

A MANNERIST MANTUAN MANSION Mannerism in painting and sculpture has been studied fairly extensively since the early decades of the twentieth century, but only in the 1930s did scholars discover that the term also described much of sixteenth-century architecture. The body of Mannerist architecture they have compiled since then, however, is far from homogeneous. The fact Michelangelo used classical architectural elements in a highly personal and unorthodox manner does not necessarily make him a Mannerist architect. In his designs for Saint Peter's, he certainly strove for the effects of mass, balance, order, and stability that were the very hallmarks of High Renaissance design. Unorthodox use of classical elements, however, was the precise goal of GIULIO RO-MANO (ca. 1492–1546) when he designed the Palazzo del Tè in Mantua (FIG. 17-48) and, with it, formulated almost the entire architectural vocabulary of Mannerism.

Giulio Romano became Raphael's chief assistant in decorating the Vatican stanze. After Raphael's premature death in 1520, Giulio became his master's artistic executor, completing Raphael's unfinished frescoes and panel paintings. In 1524, Giulio went to Mantua, where he found a patron in Duke Federigo Gonzaga, for whom he built and decorated the Palazzo del Tè between 1525 and 1535.

Gonzaga intended the Palazzo del Tè to serve as both suburban summer palace and stud farm for his famous stables. Originally planned as a relatively modest country villa, Giulio's building so pleased the duke that he soon commissioned the architect to enlarge the structure. In a second building campaign, Giulio expanded the villa to a palatial scale by adding three wings, which he placed around a square central court. This once-paved court, which functions both as a passage and as the design's focal point, has a near-urban character. Its surrounding buildings form a self-enclosed unit with a large stable-flanked garden attached to it on the east side.

Giulio exhibited his Mannerist style in the facades that face the palace's interior courtyard (FIG. 17-48), where the divergences from architectural convention are so pronounced they constitute an enormous parody of Bramante's classical style. In a building laden with structural surprises and contradictions, the design of these facades is the most unconventional of all. The keystones (central voussoirs), for example, either

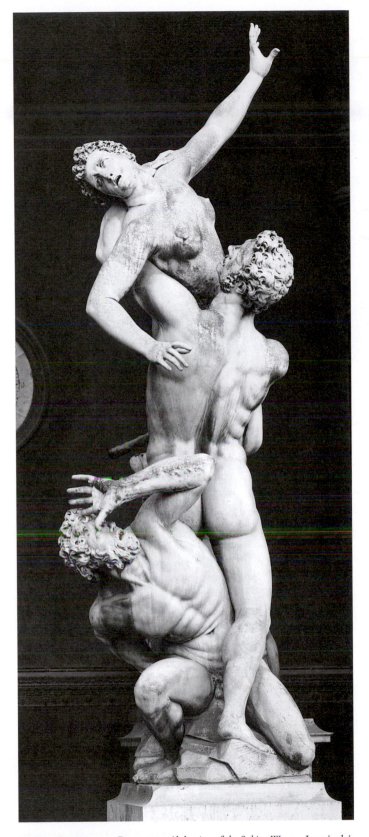

17-47 GIOVANNI DA BOLOGNA, *Abduction of the Sabine Women,* Loggia dei Lanzi, Piazza della Signoria, Florence, Italy, completed 1583. Marble, approx. 13′ 6″ high.

(see FIG. 5-89)—once in the crouching old man and again in the woman's flung up arm gesture. The three bodies interlock on a vertical axis, creating a spiral movement as viewers' eyes ascend the sculpture.

17-48 GIULIO ROMANO, interior courtyard facade of the Palazzo del Tè, Mantua, Italy, 1525–1535.

have not fully settled or seem to be slipping from the arches—and, more eccentric still, Giulio even placed voussoirs in the pediments over the rectangular niches, where no arches exist. The massive Tuscan columns that flank these niches carry incongruously narrow architraves. That these architraves break midway between the columns stresses their apparent structural insufficiency, and they seem unable to support the weight of the triglyphs above, which threaten to crash down on the head of anyone foolish enough to stand below them. To be sure, appreciating Giulio's joke requires a highly sophisticated audience, and recognizing some quite subtle departures from the norm presupposes a thorough familiarity with the established rules of classical architecture. It speaks well for the duke's sophistication that he accepted Giulio's form of architectural humor.

In short, in his design for the Palazzo del Tè, Giulio Romano deliberately flouted most of the classical rules of order, stability, and symmetry, and he made every effort to startle and shock beholders. This desire to create ambiguities and tensions is as typical of Mannerist architecture as it is of Mannerist painting, and many of the devices Giulio invented for the Palazzo del Tè became standard features in the formal repertoire of later Mannerist buildings.

LATER SIXTEENTH-CENTURY ARCHITECTURE

Acceptance of Mannerism's style in architecture was by no means universal, neither on the part of architects nor patrons. Indeed, later sixteenth-century designs more in keeping with the High Renaissance ideals proved to have a greater impact on seventeenth-century architecture in Italy than the more adventurous, yet eccentric, works by Giulio Romano and the other Mannerists.

SETTING THE STAGE FOR THE BAROQUE Probably the most influential building of the second half of the sixteenth century was the mother church of the Jesuit order, founded in 1534, in the pontificate of Paul III. As a major participant in the Counter-Reformation, the Jesuit order needed a church appropriate to its new prominence. Because Michelangelo was late in providing the plans for this church, called Il Gesù, or Church of Jesus (FIGS. **17-49** and **17-50**), the Jesuits turned to GIACOMO DA VIGNOLA (1507–1573), who designed the ground plan, and GIACOMO DELLA PORTA (ca. 1533–1602), who was responsible for the facade. These two architects designed and built Il Gesù between 1568 and 1584. Chronologically and stylistically, the building belongs to the late Renaissance, but its enormous influence on later churches marks it as one of the significant monuments for the development of Baroque church architecture. Its facade (FIG. 17-49) was an important model and point of departure for the facades of Roman Baroque churches for two centuries, and many churches throughout the Catholic countries, especially in Latin America, echoed its basic scheme. The facade's design was not entirely original. The union of the lower and upper stories, effected by scroll buttresses, harks back to Alberti's Santa Maria Novella in Florence (see FIG. 16-36). Its classical pediment is familiar in Alberti's work, as well as in the work of the Venetian architect Andrea Palladio, which is examined later. And its paired pilasters appear in Michelangelo's design for Saint Peter's (FIG. 17-30). Giacomo della Porta skillfully synthesized these already existing motifs. In his facade design, he unified the two stories, the horizontal march of the pilasters and columns builds to a dramatic climax at the central bay, and the facade's bays snugly fit the nave-chapel system behind them. The later dramatic Baroque facades of Rome were architectural variations on this basic theme.

The plan of Il Gesù (FIG. 17-50) reveals a monumental expansion of Alberti's scheme for Sant'Andrea in Mantua (see

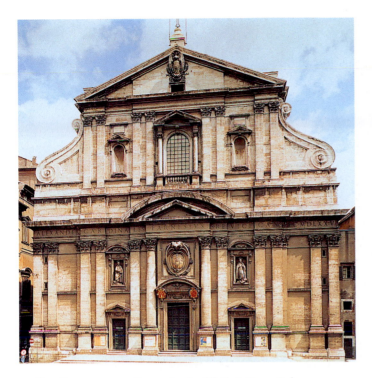

17-49 GIACOMO DELLA PORTA, facade of Il Gesù, Rome, Italy, ca. 1575–1584.

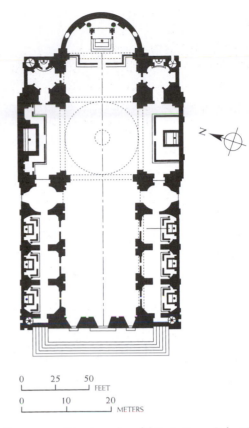

0 25 50
⌊_____⌋ FEET
0 10 20
⌊_____⌋ METERS

17-50 GIACOMO DA VIGNOLA, plan of Il Gesù, Rome, Italy, 1568.

FIG. 16-44). Here, the nave takes over the main volume of space, making the structure a great hall with side chapels. A dome emphasizes the approach to the altar. The wide acceptance of the Gesù plan in the Catholic world, even until modern times, speaks to its ritual efficacy. The opening of the church building into a single great hall provides an almost theatrical setting for large promenades and processions (that seemed to combine social with priestly functions). Above all, the space is adequate to accommodate the great crowds that gathered to hear the eloquent preaching of the Jesuits.

LATER SIXTEENTH-CENTURY VENETIAN ART AND ARCHITECTURE

MANNERIST DRAMA AND DYNAMISM Venetian painting of the later sixteenth century built on established Venetian ideas. JACOPO ROBUSTI, known as TINTORETTO (1518–1594), claimed to be a student of Titian and aspired to combine Titian's color with Michelangelo's drawing. Art historians often refer to Tintoretto as the outstanding Venetian representative of Mannerism. He adopted many Mannerist pictorial devices, but his dramatic power, depth of spiritual vision, and glowing Venetian color schemes seem to depart from the Mannerism's mold.

Tintoretto's art is always extremely dramatic. In his *Miracle of the Slave* (FIG. 17-51), Saint Mark hurtles downward to assist a Christian slave, who is about to be martyred for his faith, and shatters the torture instruments. The executioner holds up these instruments to the startled judge as the throng around the central action stares. Here, Tintoretto accelerated Titian's dynamism and constructed the composition using contrary motions; for any figure leaning in one direction, another figure counters it. At the extreme left, two men, a woman, and a child wind in counterpoint directions about a

column, resembling the Mannerist twisting of Giovanni da Bologna's *Abduction of the Sabine Women* (FIG. 17-47). The main group curves deeply back into space, but Tintoretto's most dynamic touch appears in the central trio of the slave, the executioner, and the inverted Saint Mark. The two earthly figures sweep together in a great upward serpentine curve, their motion checked by the plunging figure of Saint Mark moving in the opposite direction.

The entire composition is a kind of counterpoint of motion characteristic of Mannerism. However, the picture frame firmly contains the motion, and the figures' robustness, their solid structure and firm movement, the clearly composed space, and the coherent action have little to do with Mannerist presentation. The depiction of the miraculous event, which the artist dramatized forcefully and with conviction, conveys neither hesitation nor ambiguity. Tintoretto's skillful theatricality and sweeping power of execution set him apart from the Mannerists and made him a forerunner of the Baroque, the age of theater and opera. And the tonality—the deep golds, reds, and blues—is purely Venetian.

A GLOWING LAST SUPPER Toward the end of Tintoretto's life, his art became spiritual, even visionary, as solid forms melted away into swirling clouds of dark shot through with fitful light. In Tintoretto's *Last Supper* (FIG. 17-52), painted for the interior of Andrea Palladio's church of San Giorgio Maggiore (FIG. 17-59), the actors take part in a ghostly drama. They are as insubstantial as the shadows cast by the faint glow of their halos and the flame of a single lamp that seems to breed ghostly spirits. Only the incandescent glow around the head of Jesus identifies him as he administers the Sacrament to his disciples.

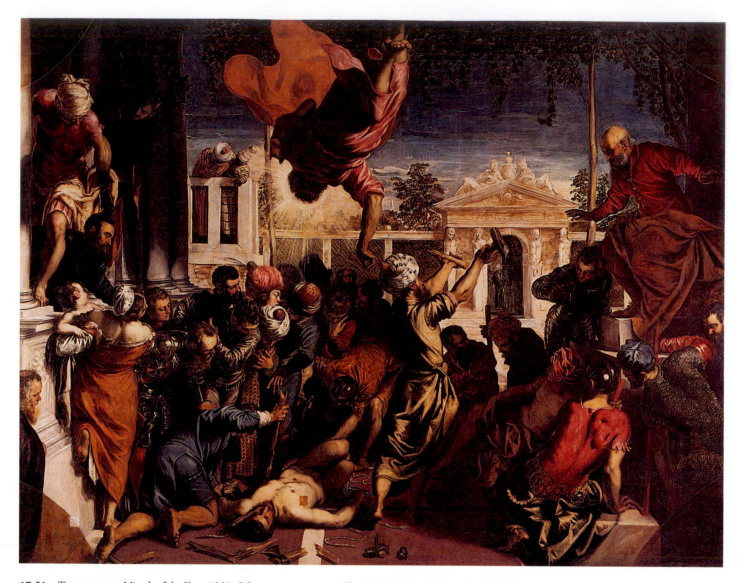

17-51 Tintoretto, *Miracle of the Slave*, 1548. Oil on canvas, approx. 14' × 18'. Galleria dell'Accademia, Venice.

The contrast with Leonardo's *Last Supper* (FIG. 17-3) is both extreme and instructive. Leonardo's composition, balanced and symmetrical, parallels the picture plane in a geometrically organized and closed space. The figure of Christ is the tranquil center of the drama and the perspectival focus. In Tintoretto's painting, Christ is above and beyond the converging perspective lines that race diagonally away from the picture surface, creating disturbing effects of limitless depth and motion. Viewers locate Tintoretto's Christ via the light flaring, beaconlike, out of darkness. Leonardo placed his Christ by geometric and perspectival centralization. The contrast of the two represents the direction Renaissance painting took in the sixteenth century, as it moved away from architectonic clarity of space and neutral lighting toward the dynamic perspectives and dramatic chiaroscuro of the coming Baroque.

A PROBLEMATIC PAINTING OF CHRIST Among the great Venetian masters was Paolo Cagliari of Verona, called Paolo Veronese (1528–1588). Where Tintoretto gloried in monumental drama and deep perspectives, Veronese specialized in splendid pageantry painted in superb color and set within majestic classical architecture. Like Tintoretto, Veronese painted on a huge scale, with canvases often as large

as twenty feet by thirty feet or more. His usual subjects, painted for the refectories of wealthy monasteries, afforded him an opportunity to display magnificent companies at table.

Christ in the House of Levi (FIG. **17-53**), originally called *Last Supper,* is a good example. Here, in a great open loggia framed by three monumental arches (the architectural style closely resembles the upper arcades of Jacopo Sansovino's State Library; FIG. 17-55), Christ sits at the center of the splendidly garbed elite of Venice. In the foreground, with a courtly gesture, the very image of gracious grandeur, the chief steward welcomes guests. Robed lords, their colorful retainers, clowns, dogs, and dwarfs crowd into the spacious loggia.

Painted during the Counter-Reformation, this depiction prompted criticism from the Catholic Church. The Holy Office of the Inquisition accused Veronese of impiety for painting such creatures so close to the Lord, and it ordered him to make changes at his own expense. Reluctant to do so, he simply changed the painting's title, converting the subject to a less solemn one. As Andrea Palladio (whose work is discussed later) looked to the example of classically inspired High Renaissance architecture, so Veronese returned to High

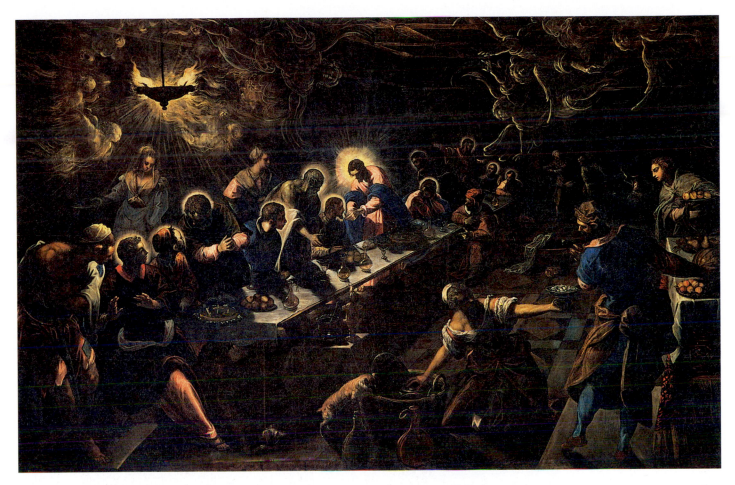

17-52 TINTORETTO, *Last Supper,* Chancel, San Giorgio Maggiore, Venice, Italy, 1594. Oil on canvas, 12′ × 18′ 8″.

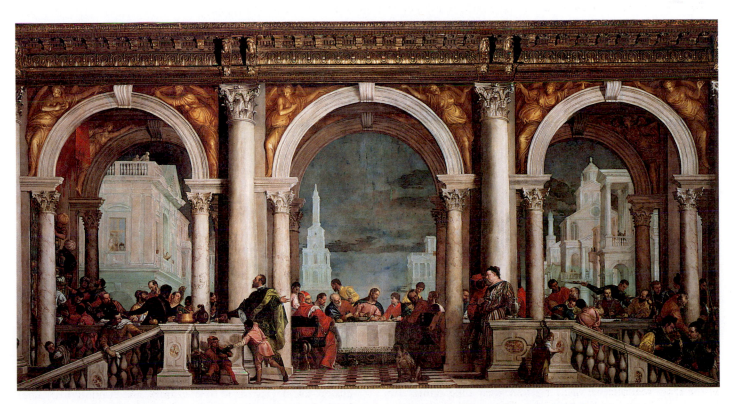

17-53 PAOLO VERONESE, *Christ in the House of Levi,* 1573. Oil on canvas, approx. 18′ 6″ × 42′ 6″. Galleria dell'Accademia, Venice.

17-54 PAOLO VERONESE, *Triumph of Venice,* ceiling of the Hall of the Grand Council, Palazzo Ducale, Venice, Italy, ca. 1585. Oil on canvas, approx. 29′ 8″ × 19′.

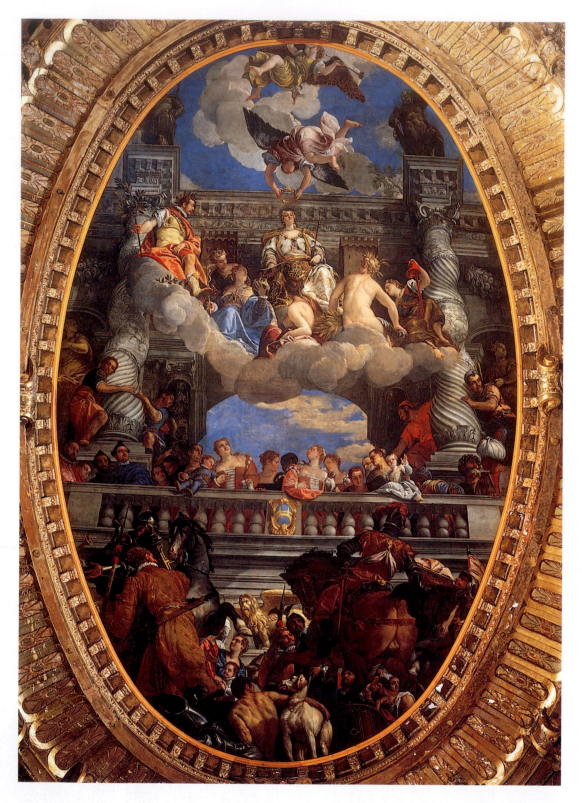

Renaissance composition, its symmetrical balance, and its ordered architectonics. His shimmering color is drawn from the whole spectrum, although he avoided solid colors for half shades (light blues, sea greens, lemon yellows, roses, and violets), creating veritable flower beds of tone.

A PICTORIAL GLORIFICATION OF VENICE
The Venetian Republic employed both Tintoretto and Veronese to decorate the grand chambers and council rooms of the Doge's Palace (see FIG. 13-57). A great and popular decorator, Veronese revealed himself a master of imposing illusionistic ceiling compositions, such as *Triumph of Venice* (FIG.

17-54). Here, within an oval frame, he presented Venice, crowned by Fame, enthroned between two great twisted columns in a balustraded loggia, garlanded with clouds, and attended by figures symbolic of its glories. This work represents one of the very first modern pictorial glorifications of a state—a subject that became very popular during the Baroque period that immediately followed. Veronese's perspective is not, like Mantegna's or Correggio's, projected directly up from below. Rather, it is a projection of the scene at a forty-five-degree angle to spectators, a technique many later Baroque decorators used, particularly the Venetian Giambattista Tiepolo in the eighteenth century.

MONEY AND MANUSCRIPTS The Florentine JACOPO TATTI, called JACOPO SANSOVINO (1486–1570), introduced Venice to the High Renaissance style of architecture. Originally trained as a sculptor under Andrea Sansovino (ca. 1467–1529), whose name he adopted, Jacopo went to Rome in 1518, where, under the influence of Bramante's circle, he turned increasingly toward architecture. When he arrived in Venice as a refugee from the sack of Rome in 1527, he quickly established himself as that city's leading and most admired architect. His buildings frequently inspired the architectural settings of the most prominent Venetian painters, including Titian and Veronese.

Sansovino's largest and most rewarding public commissions were the Mint (la Zecca) and the adjoining State Library (FIG. **17-55**) in the heart of the island city. The Mint, begun in 1535, faces the Canale San Marco with a stern and forbidding three-story facade. Its heavy rustication imbues it with an intended air of strength and impregnability. A boldly projecting, bracket-supported cornice reminiscent of the machicolated galleries of medieval castles emphasizes this fortresslike look.

Begun a year after the Mint, the neighboring State Library of San Marco, which Andrea Palladio referred to as "perhaps the most sumptuous and the most beautiful Edifice that has been erected since the time of the Ancients,"[14] exudes a very different spirit. With twenty-one bays (only sixteen were completed during Sansovino's lifetime), the library faces the Gothic Doge's Palace (see FIG. 13-57) across the Piazzetta, a lateral extension of Venice's central Piazza San Marco. The relatively plain ground-story arcade has Tuscan-style columns attached to the arch-supporting piers in the manner of the Roman Colosseum (see FIG. 7-34). A Doric frieze of metopes and triglyphs caps it—none "slide" out of place as in the frieze of the contemporary Palazzo del Tè in Mantua (FIG. 17-48). The lower story sturdily supports the higher, lighter, and much more decorative Ionic second story, which housed the reading room with its treasure of manuscripts, keeping them safe from not-uncommon flooding. On this second level, Sansovino softened the ground story's stern system by flanking the piers with Ionic colonnettes paired in depth, rather than in the plane of the facade. Two-thirds the height of the main columns, they rise to support the springing of arches, whose spans are two-thirds those of the lower arcade, accentuating the verticality of the second story. The main columns carry an entablature with a richly decorated frieze of putti, in strongly projecting relief, supporting garlands. The oval windows of an attic story punctuate this favorite decorative motif of the ancient Romans, seen earlier in Bernardo Rossellino's tomb of Leonardo Bruni (see FIG. 16-29). Perhaps the building's most striking feature is its roofline, where Sansovino replaced the traditional straight cornice with a balustrade (reminiscent of the one on Bramante's Tempietto, FIG. 17-8) interrupted by statue-bearing pedestals. The spacing of the latter corresponds to that of the orders below so that the sculptures are the sky-piercing finials of the building's vertical design elements. Sansovino's deft application of sculpture

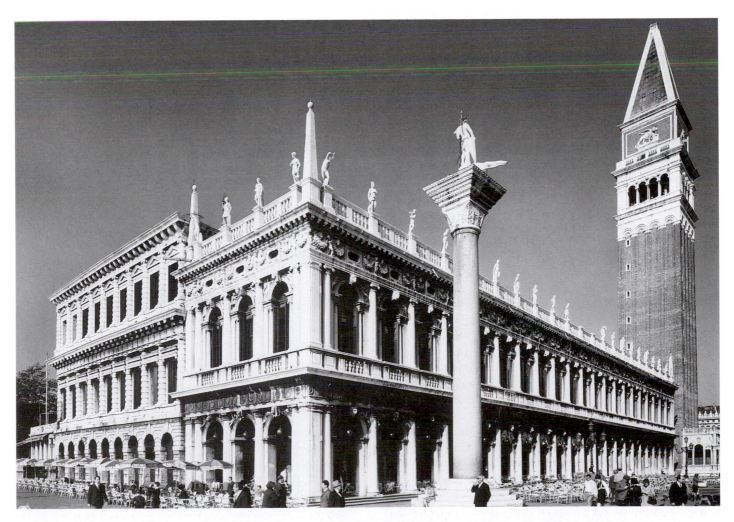

17-55 JACOPO SANSOVINO, the Mint (la Zecca), 1535–1545 *(left)* and the State Library *(right)*, begun 1536, Piazza San Marco, Venice.

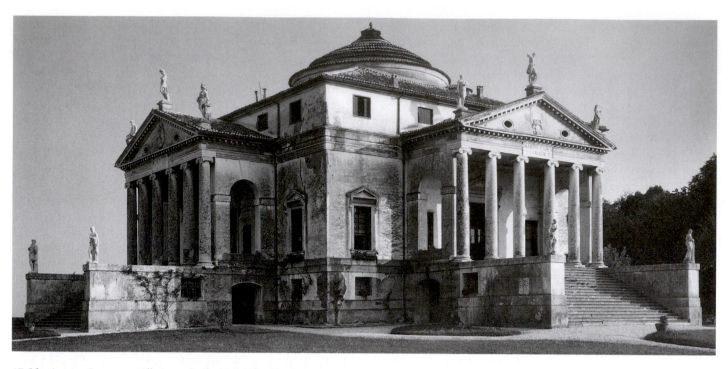

17-56 ANDREA PALLADIO, Villa Rotonda (formerly Villa Capra), near Vicenza, Italy, ca. 1566–1570.

to the building's massive framework (with no visible walls) relieves the design's potential severity and gives its aspect an extraordinary sculptural richness.

One feature rarely mentioned is how subtly the library echoes the design of the lower two stories of the decorative Doge's Palace (see FIG. 13-57) opposite it. Although Sansovino used a vastly different architectural vocabulary, he managed admirably to adjust his building to the older one. Correspondences include the almost identical spacing of the lower arcades, the rich and ornamental treatment of the second stories (including their balustrades), and the dissolution of the rooflines (with decorative battlements in the palace and a statue-surmounted balustrade in the library). It is almost as if Sansovino set out to translate the Gothic architecture of the Doge's Palace into a "modern" Renaissance idiom. If so, he was eminently successful; the two buildings, although of different spiritual and stylistic worlds, mesh to make the Piazzetta one of the most elegantly framed urban units in Europe.

AN ARCHITECT INSPIRED BY THE ANCIENTS

After Jacopo Sansovino's death, ANDREA PALLADIO (1508–1580) succeeded him as chief architect of the Venetian Republic. Beginning as a stonemason and decorative sculptor, at age thirty Palladio turned to architecture, the ancient literature on architecture, engineering, topography, and military science. Unlike the universal scholar Alberti, Palladio became more of a specialist. He made several trips to Rome to study the ancient buildings firsthand. He illustrated Daniele Barbaro's edition of *De architectura* by Vitruvius (1556), and he wrote his own treatise on architecture, *I quattro libri dell'architettura (The Four Books of Architecture)*, originally published in 1570, which had a wide-ranging influence on succeeding generations of architects throughout Europe. Palladio's influence outside Italy, most significantly in England and in colonial America, was stronger and more lasting than that of any other architect.

Palladio accrued his significant reputation from his many designs for villas, built on the Venetian mainland. Nineteen still

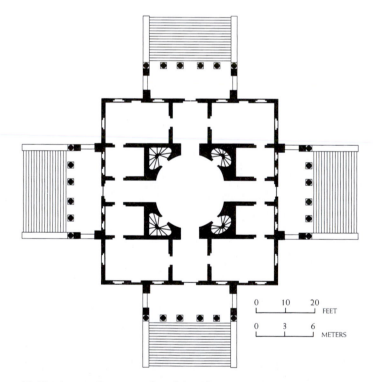

17-57 ANDREA PALLADIO, plan of the Villa Rotonda (formerly Villa Capra), near Vicenza, Italy, ca. 1566–1570.

stand, and they especially influenced later architects. The same Arcadian spirit that prompted the ancient Romans to build villas in the countryside, and that the Venetian painter Giorgione expressed so eloquently in his art, motivated a similar villa-building boom in the sixteenth century. One can imagine that Venice, with its very limited space, must have been more congested than any ancient city. But a longing for the countryside was not the only motive; declining fortunes prompted the Venetians to develop their mainland possessions with new land investment and reclamation projects. Citizens who could afford it were encouraged to set themselves up as aristocratic farmers

and to develop swamps into productive agricultural land. Wealthy families could look on their villas as providential investments. The villas were thus aristocratic farms (like the much later American plantations, which Palladio's architecture influenced) surrounded by service outbuildings Palladio generally arranged in long, low wings branching out from the main building and enclosing a large rectangular court area.

Although it is the most famous, Villa Rotonda (FIG. **17-56**), near Vicenza, is not really typical of Palladio's villa style. He did not construct it for an aspiring gentleman farmer but for a retired monsignor who wanted a villa for social events. Palladio planned and designed Villa Rotonda, located on a hilltop, as a kind of belvedere (a residence on a hill), without the usual wings of secondary buildings. Its central plan (FIG. **17-57**), with four identical facades and projecting porches, is, therefore, both sensible and functional. Each of the porches can be used as a platform for enjoying a different view of the surrounding landscape. In this design, the central dome-covered rotunda logically functions as a kind of circular platform for visitors to turn in any direction for the preferred view. The result is a building with functional parts systematically related to one another in terms of calculated mathematical relationships. Villa Rotonda embodies all the qualities of self-sufficiency and formal completeness most Renaissance architects sought. The works of Alberti and Bramante and the remains of classical architecture Palladio studied in Rome influenced the young architect in his formative years. Each facade of his Villa Rotonda resembles a Roman temple. In placing a traditional temple porch in front of a dome-covered interior, Palladio doubtless had the Pantheon (see FIG. 7-48) in his mind as a model. By 1550, however, he had developed his personal style, which mixed elements of Mannerism with the clarity and lack of ambiguity that characterized classicism at its most "correct."

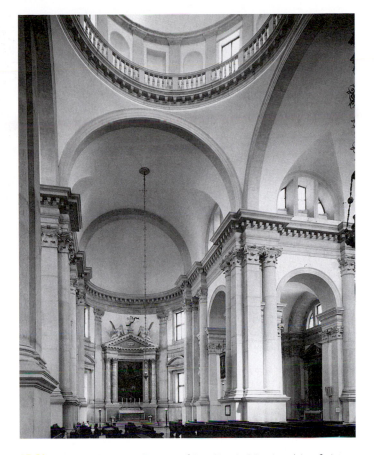

17-59 ANDREA PALLADIO, interior of San Giorgio Maggiore (view facing east), Venice, Italy, 1565.

SHADOW AND SURFACE, SEA AND SKY One of the most dramatically placed buildings in Venice is San Giorgio Maggiore (FIGS. **17-58** and **17-59**), directly across a broad canal from the Piazza San Marco. Dissatisfied with earlier solutions to the problem of integrating a high central nave and lower aisles into a unified facade design, Palladio solved it by superimposing a tall, narrow classical porch on a low broad one (FIG. 17-58). This solution reflects the building's interior arrangement (FIG. 17-59) and in that sense is coolly logical, but the intersection of two temple facades is irrational and ambiguous in Mannerist fashion. Palladio's design also introduced the illusion of three-dimensional depth, an effect the strong projection of the central columns and the shadows they cast intensify. The play of shadow across the building's surfaces, its reflection in the water, and its gleaming white against sea and sky create a remarkably colorful effect, prefiguring the Baroque. The interior of the church (FIG. 17-59) lacks the facade's ambiguity and exhibits strong roots in High Renaissance architectural style. Light floods the interior and crisply defines the contours of the rich wall decorations (pedestals, bases, shafts, capitals, and entablatures), all beautifully and "correctly" profiled—the exemplar of what classical architectural theory meant by "rational" organization.

The sixteenth century in Italy witnessed the triumph of architecture, sculpture, and painting. They achieved the status of fine arts, and High Renaissance artists, whose works have inspired generations of artists since, established an enduring tradition. The development of Mannerism, which contrasted with the rationality pervading much of High Renaissance art and architecture, paved the way for the Baroque's complexity in seventeenth-century Italy.

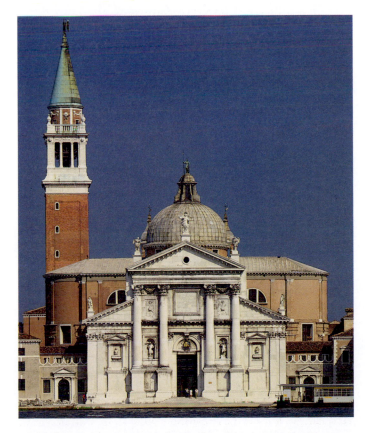

17-58 ANDREA PALLADIO, west facade of San Giorgio Maggiore, Venice, Italy.

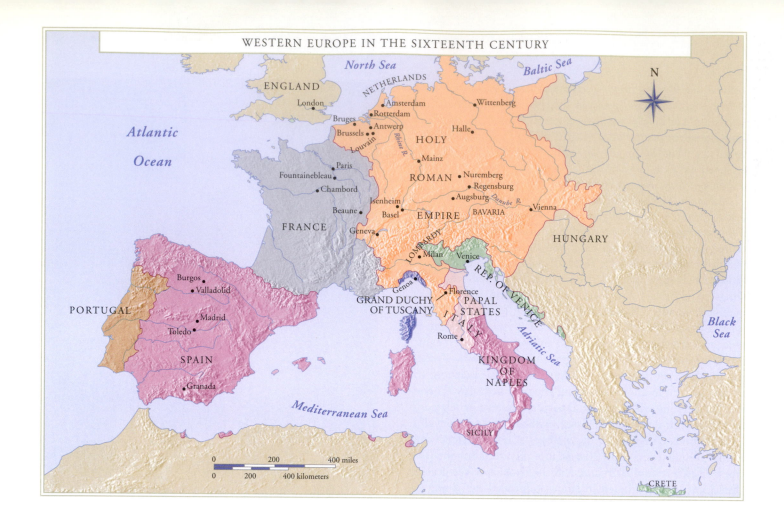

WESTERN EUROPE IN THE SIXTEENTH CENTURY

North Sea

ENGLAND
 • London

NETHERLANDS
 • Amsterdam
 • Rotterdam
• Bruges
• Antwerp
• Brussels
 Louvain

Atlantic Ocean

Baltic Sea

• Wittenberg

HOLY

• Halle

ROMAN

• Mainz
• Nuremberg
• Regensburg
• Augsburg

Danube R.

• Vienna

EMPIRE

BAVARIA

HUNGARY

• Paris
• Fountainebleau
• Chambord
• Beaune
• Isenheim
• Basel
• Geneva

FRANCE

LOMBARDY
• Milan
• Venice

REP. OF VENICE

PORTUGAL

• Burgos
• Valladolid
• Madrid
• Toledo

SPAIN

• Granada

GRAND DUCHY OF TUSCANY
Genoa
• Florence

PAPAL STATES

ITALY

• Rome

KINGDOM OF NAPLES

Adriatic Sea

Black Sea

Mediterranean Sea

SICILY

CRETE

0 200 400 miles
0 200 400 kilometers

N

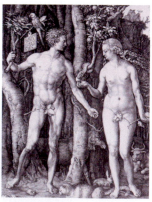

Albrecht Dürer, The Fall of Man (Adam and Eve), 1504

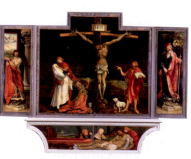

Matthias Grünewald Isenheim Altarpiece ca. 1510–1515

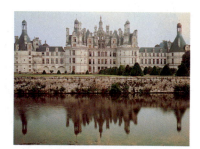

Château de Chambord begun 1519

Erasmus of Rotterdam, 1466–1536 John Calvin, 1509–1564

Duchy of Burgundy and the Netherlands absorbed by the Holy Roman Empire and France, 1477

Sir Thomas More, 1478–1535 Beginning of Protestant Reformation, 1517

Martin Luther, 1483–1546, posts theses against Indulgences Spanish conquest of Mexico and Peru, 1518–1536

Ulrich Zwingli, 1484–1531

House of Tudor, 1485–1603 Hapsburg-Valois Wars, 1521–1544

Spanish conquest of Muslim Granada, 1492

Hapsburg dynasty, 1493–(1918)

François Rabelais, ca. 1494–1553

Valois/Bourbon dynasty, 1498–1589/1589–(1830)

18

THE AGE OF
REFORMATION

SIXTEENTH-CENTURY ART IN NORTHERN

EUROPE AND SPAIN

1547	1550		1575	1600

OF SPANISH AMERICA	RUDOLPH II, HAPSBURG, HRE			
PHILIP II OF SPAIN (HAPSBURG) AND OF SPANISH AMERICA				
HENRY II	FRANCIS II	CHARLES IX	HENRY III	HENRY IV OF FRANCE (BOURBON)

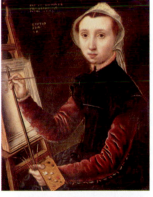

Caterina van Hemessen
Self-Portrait, 1548

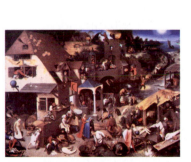

Peter Bruegel the Elder
Netherlandish Proverbs, 1559

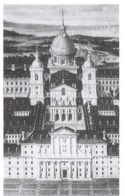

Juan de Herrera, Escorial
ca. 1563–1584

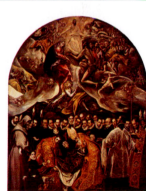

El Greco
The Burial of
Count Orgaz, 1586

Ignatius Loyola, 1491–1556, founded Jesuit Order, 1534

Spread of Calvinist Protestantism in France and Switzerland, 1530s

Henry VIII initiates Reformation in England, 1534

Council of Trent, 1545–1563

Spread of Calvinism in Scotland and the Netherlands, 1550s

Peace of Augsburg between Lutherans and Catholics, 1555

Wars of Religion in France, 1562–1598

Beginning of the revolt of the Netherlands
against Philip II of Spain, 1568

Formation of the Union of Arras, 1579

Formation of the Union of Utrecht, 1579

Netherlands House of Orange/Nassau,
1584–present

Philip II sends the Great Armada
against Holland and England, 1588

THE PROTESTANT REFORMATION

The dissolution of the Burgundian Netherlands in 1477 led to a realignment in the European geopolitical landscape in the early sixteenth century. France and the Holy Roman Empire (at the time consisting primarily of today's Germany) expanded their territories after this breakup of Flanders. Through calculated marriages, military exploits, and ambitious territorial expansion, Spain eventually became the dominant power in Europe. Monarchs increased their authority over their subjects and cultivated a stronger sense of cultural and political unity among the populace, thereby laying the foundation for the modern state or nation. Yet a momentous crisis in the Christian Church overshadowed these power shifts. As noted earlier, concerted attempts to reform the Church led to the Reformation and the establishment of Protestantism (as distinct from Catholicism), which in turn prompted the Catholic Church's response, the Counter-Reformation. Ultimately, the Reformation split Christendom in half and produced a hundred years of civil war between Protestants and Catholics.

Replacing Church Practices with Personal Faith

The Reformation, which came to fruition in the early sixteenth century, had its roots in long-term, growing dissatisfaction with Church leadership. The deteriorating relationship between the faithful and the Church hierarchy stood as an obstacle for the millions who sought a meaningful religious experience. Particularly damaging was the perception popes concerned themselves more with temporal power and material wealth than with the salvation of the Church's members. The fact many fifteenth-century popes and cardinals came from wealthy families, such as the Medici (for example, Clement VII, or Giulio de' Medici, and Leo X, or Giovanni de' Medici) intensified this perception. Not only those at the highest levels seemed to ignore their spiritual duties. Upper-level clergy (such as archbishops, bishops, and abbots) began to accumulate numerous offices, which increased their revenues. This practice of pluralism led to negligence, because these officeholders could not be in many places at once. Due to this absenteeism, much of the responsibility for maintaining the efficient operation of the Church and for attending to the devout's needs fell on the parish priests, who often felt overburdened. Many of these priests grew to resent their superiors, who did not provide adequate support or leadership and stood as impediments to priests' advancement in the Church hierarchy.

As their relationship to the organized church hierarchy deteriorated, people sought new ways to invigorate their spiritual commitment and to ensure their eventual salvation. In the fifteenth century, as seen in Chapter 15, these attempts included embarking on pilgrimages to holy sites, joining lay confraternities and orders, and commissioning artworks as visual aids in private devotions. The Modern Devotion movement contributed to the emphasis on personal religious rituals. This movement emerged in the fourteenth century and built on the trend toward more personal devotions that the mendicant orders (see "Mendicant Orders and Confraternities," Chapter 14, page 425) developed in the thirteenth century. Its increasing prominence in the fifteenth century attested to the growing disillusionment with Church leaders. Followers of Modern Devotion, especially the lay religious order the Brothers and Sisters of the Common Life, encouraged a more direct spiritual communion with God. Although they did not advocate rejection of Church doctrines or practices, these adherents' emphasis on developing a personal relationship with God clearly diminished the primacy of Church officials.

Ninety-Five Theses and Lutheranism

By the early sixteenth century, dissatisfaction with the Church had grown so widespread that the outspoken challenge to papal authority by German theologian Martin Luther (1483–1546) was sufficient to spark the Reformation. In 1517, in Wittenberg, Luther issued his Ninety-Five Theses, which enumerated his objections to Church practices, especially the sale of indulgences. Indulgences were remittances (or reductions) of time spent in Purgatory. The increasing frequency of their sale suggested people were buying their way into Heaven.

Luther's goal was significant reform and clarification of major spiritual issues, but his ideas ultimately led to the splitting of Christendom. According to Luther, the Catholic Church's extensive ecclesiastical structure needed casting out, for it had no basis in Scripture. The Bible and nothing else could serve as the foundation for Christianity. Luther declared the pope the Antichrist (for which the pope excommunicated him), called the Church the "whore of Babylon," and denounced ordained priests, along with the sacramental systems (accepting only two sacraments, baptism and the Eucharist, the Lord's Supper) they administered, as pagan obstacles to salvation. According to Luther, Christianity needed cleansing of all the impurities of doctrine that had collected through the ages to restore its original purity.

Central to the reformers' creed was the question of salvation—how to achieve it. Rather than perceive salvation as something weak and sinful humans must constantly strive for through good deeds under a punitive God's watchful eye, Luther proposed that faithful individuals attain redemption by God's bestowal of his grace. Therefore, people could not earn salvation. Accordingly, no ecclesiastical machinery with all its miraculous rites and indulgent forgivenesses could save sinners face-to-face with God. Only absolute faith in Christ could justify sinners and ensure salvation. Justification by faith alone, with the guidance of Scripture, was the fundamental doctrine of Protestantism. Further, Luther advocated the Bible as the source of all religious truth. The Bible—the sole scriptural authority—was the word of God, not the Church's councils, law, and rituals.

Calvinism, Anabaptism, and the Anglican Church

If Scripture alone, and not the Church, was the Christian's guide to salvation, then it was imperative each Christian read and interpret the Scriptures. It soon became evident Christians could differ in their interpretations of the sacred texts,

and this gave rise to serious differences among the reformers. Luther clashed with Ulrich Zwingli (1484–1531) over the meaning of the sixth chapter of John. The latter's followers called themselves Zwinglians. French scholar John Calvin (1509–1564) established the Calvinist Church, which paralleled Lutheranism in most of its major doctrines. The Calvinists' insistence on the absolute certainty of salvation contributed to their unshakable conviction they were doing God's work on earth. This belief led them to become particularly militant, filled with missionary zeal.

The Anabaptists were among the most radical of reformers. Because of their antipathy to uncontrolled authority (due to papal and clerical abuse of authority), they constructed a more democratic church structure. For example, church members selected ministers. Descendants of the Anabaptists include the Mennonites and the Amish. Thus, "Protestant," which originally referred to Luther's followers, eventually encompassed all reform movements that challenged papal authority at this time.

Once unleashed, the spirit of reform swept across Europe. Lutheranism was soon the primary religion in Denmark, Sweden, Norway, most of the Holy Roman Empire, and parts of Switzerland. Zwinglians were numerous in Switzerland and Calvinists in Geneva, France, the Netherlands, and Scotland. Sixteenth-century territorial and state politics influenced this Protestant sectarianism and the Catholic opposition. For instance, people's religious loyalty, whether Protestant or Catholic, could conflict with their loyalty to the religion of the ruler of the city, county, duchy, principality, or kingdom where they lived. By midcentury, subjects often felt compelled to either accept the religion of their sovereign or emigrate to a territory where the sovereign's religion corresponded with their own. For example, in predominantly Catholic France, some citizens embraced Protestantism, which King Francis I (r. 1515–1547) declared illegal in 1534. Consequently, the state persecuted these Protestants, the Huguenots, and drove them underground. Despite this minority status, the Huguenots' commitment to Protestantism eventually led to one of the bloodiest religious conflicts in European history when the Protestants and Catholics clashed in 1572 in a war that lasted until the end of the sixteenth century.

In England, King Henry VIII (r. 1509–1547), angered by Pope Clement VIII's refusal to annul his marriage to Catherine of Aragon, managed to force Parliament to pass the Act of Supremacy. This Act severed all ties with Rome and declared the king the "supreme head on earth of the Church of England," thereby establishing the Anglican Church.

Class distinctions also influenced religious affiliation, especially in the cities; the religion of the rich often differed from the religion of the poor. In wealthy cities such as Augsburg in the Holy Roman Empire, the merchants/bankers, publishers, printers, and artists—the city's bourgeois masters—were likely Catholic; the next lower societal levels, Lutheran; and the lowest-paid workers, Anabaptists. The German peasants, victims of a pitiless repression of the uprising they staged in 1525 demanding better economic and social conditions, saw Scripture as a liberating manifesto against feudal serfdom. Despite this view, Luther urged the Lutheran masters who quelled this revolt to "smite, slay and stab [the peasants], . . . remembering that nothing can be more poisonous, hurtful, or devilish than a rebel."[1] This incident and Luther's response

demonstrate how the Scriptures were interpreted in diverse ways and used for nonreligious ends. The Catholics also took this tone, and the story of the Reformation and Counter-Reformation tells of significant repression of dissenting voices.

In the 1540s, the Catholic Church mounted the Counter-Reformation, its campaign to counteract the popularity of Protestantism. Comprised of numerous initiatives, including the Council of Trent (convened 1545–1563 to produce needed reforms) and establishing the Jesuit order, Counter-Reformation endeavors continued well into the seventeenth century, and its effect on Italian art is discussed in Chapter 19.

Christian Humanism

Interestingly, despite the tumultuous religious conflict engulfing sixteenth-century Europe, the exchange of intellectual and artistic ideas continued to thrive. Catholic Italy and the (mostly) Lutheran Holy Roman Empire shared in a lively commerce—economic and cultural—and sixteenth-century art throughout Europe exhibited the benefits of that exchange. Humanism filtered up from Italy and spread throughout northern Europe. Northern humanists, like their southern counterparts, cultivated a knowledge of classical cultures and literature. However, they focused more on reconciling humanism with Christianity, so later scholars applied the general label "Christian humanists" to describe them.

Among the most influential Christian humanists were the Dutch-born Desiderius Erasmus (1466–1536) and the Englishman Thomas More (1478–1535). Erasmus demonstrated his interest in the intersection of Italian humanism and religion by his "philosophy of Christ," emphasizing education and scriptural knowledge. Equally well educated was Thomas More, who served King Henry VIII. Henry eventually ordered More's execution because of that humanist's opposition to England's break with the Catholic Church. In France, François Rabelais (ca. 1494–1553), a former monk who advocated rejecting stagnant religious dogmatism, disseminated the humanist spirit. The turmoil emerging during the sixteenth century lasted well into the seventeenth century and permanently affected the face of Europe. The concerted challenges to established authority and the persistent philosophical inquiry eventually led to the rise of new political systems (for example, the nation-state) and new economic systems (such as capitalism).

HOLY ROMAN EMPIRE (INCLUDING GERMANY)

Divergent Views on Religious Imagery

Largely because of Luther's presence, the Reformation initially had its greatest impact in the Holy Roman Empire. The seismic shifts occurring in all aspects of European life due to the Reformation affected the arts, particularly its patronage and the types of art commissioned. In addition to doctrinal differences, Catholics and Protestants took divergent stances on the role of visual imagery in religion. Catholics embraced church

Martin Luther on Religious Art

As part of Martin Luther's quest to clarify his religious concerns and to encourage personal relationships with God, he outlined his views on religious art in his 1525 tract *Against the Heavenly Prophets in the Matter of Images and Sacraments.* He explained his attitude toward religious imagery as follows:

> I approached the task of destroying images by first tearing them out of the heart through God's Word and making them worthless and despised. . . . For when they are no longer in the heart, they can do no harm when seen with the eyes. . . . I have allowed and not forbidden the outward removal of images, so long as this takes place without rioting and uproar and is done by the proper authorities. . . .

And I say at the outset that according to the law of Moses no other images are forbidden than an image of God which one worships. A crucifix, on the other hand, or any other holy image is not forbidden. . . . However, to speak evangelically of images, I say and declare that no one is obligated to break violently images even of God, but everything is free, and one does not sin if he does not break them with violence. One is obligated, however, to destroy them with the Word of God; that is . . . with the Gospel.[1]

[1] Wolfgang Stechow, *Northern Renaissance Art 1400–1600: Sources and Documents* (Englewood Cliffs, N.J.: Prentice Hall, 1966), 129–30.

decoration as an aid to communicating with God, as seen in Italian ceiling frescoes (see FIG. 17-13; see "The Role of Religious Art in Counter-Reformation Italy," Chapter 17, page 525) and German/Polish and Spanish altarpieces (see FIGS. 15-23 and 15-27). In contrast, Protestants believed such imagery could lead to idolatry and distracted viewers from focusing on the real reason for their presence in church—to communicate directly with God (see "Martin Luther on Religious Art," above). Because of this, Protestant churches were relatively bare, and the extensive church decoration programs found especially in Italy were not as prominent in Protestant churches. This does not suggest Protestants had no use for visual images; art, especially prints (which were inexpensive and easily circulated), was a useful and effective teaching tool. The difference between Catholic and Protestant uses of art can be demonstrated by comparing two artworks, one pre-Reformation and one produced in the years after the Reformation began. Major German artists of the sixteenth century created both—Matthias Grünewald and Lucas Cranach the Elder.

VISUALIZING SICKNESS AND SALVATION

MATTHIAS NEITHARDT, known conventionally as MATTHIAS GRÜNEWALD (ca. 1480–1528), worked for the archbishops of Mainz from 1511 on as court painter and decorator. He also served the archbishops as architect, hydraulic engineer, and superintendent of works. He eventually moved to northern Germany, where he settled at Halle in Saxony. Around 1510, Grünewald began work on the *Isenheim Altarpiece* (FIGS. **18-1** and **18-2**), a complex and fascinating monument.

The altarpiece, created for the monastic hospital order Saint Anthony of Isenheim, consists of a wooden shrine (carved by sculptor NIKOLAUS HAGENAUER in 1490) that includes gilded and polychromed statues of Saints Anthony Abbot, Augustine, and Jerome (FIG. 18-2). Grünewald's contribution, commissioned by the head administrator of the monastery, Guido Guersi, consists of two pairs of movable wings that open at the center. Hinged together at the sides,

one pair stands directly behind the other. Painted by Grünewald between 1510 and 1515, the exterior panels of the first pair (visible when the altarpiece is closed, FIG. 18-1) present four scenes—*Crucifixion* in the center, *Saint Sebastian* on the left and *Saint Anthony* on the right, and *Lamentation* in the predella. Opening these exterior wings, viewers encounter four additional scenes (not illustrated)—*Annunciation, Angelic Concert, Madonna and Child,* and *Resurrection.* Opening this second pair of wings reveals the interior shrine, flanked by *Meeting of Saints Anthony and Paul* and *Temptation of Saint Anthony* (FIG. 18-2).

The placement of this altarpiece in the choir of a church adjacent to the monastery hospital dictated much of the imagery. Saints associated with diseases such as the plague and with miraculous cures, such as Saint Anthony and Saint Sebastian, appear prominently both in the *Isenheim Altarpiece* and in Rogier van der Weyden's *Last Judgment Altarpiece* (see FIG. 15-7) at the Hôtel-Dieu at Beaune. Grünewald's panels, however, deal even more specifically with the themes of dire illness and miraculous healing and accordingly emphasize the suffering of the order's patron saint, Anthony. Grünewald's images served as warnings, like Rogier's *Last Judgment,* thereby encouraging increased devotion from monks and hospital patients. They also functioned therapeutically by offering some hope to the afflicted. Indeed, Saint Anthony's legend encompassed his role as both vengeful dispenser of justice (by inflicting disease) and benevolent healer. The artist enhanced the impact of this altarpiece by effectively using color. He intensified the contrasts of horror and hope by subtle tones and soft harmonies played off against shocking dissonance of color.

One of the most memorable scenes is *Temptation of Saint Anthony* (FIG. 18-2), immediately to the right of the interior sculptured shrine. It is a terrifying image of the five temptations, depicted as an assortment of ghoulish and bestial creatures in a dark landscape, attacking the saint. In the foreground Grünewald painted a grotesque image of a man, whose oozing boils, withered arm, and distended stomach all

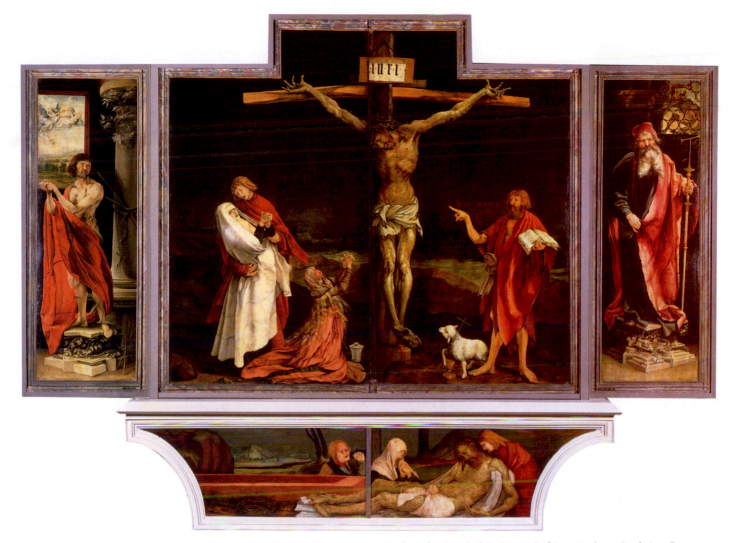

18-1 MATTHIAS GRÜNEWALD, *Isenheim Altarpiece* (closed), *Crucifixion* (center panel), from the chapel of the Hospital of Saint Anthony, Isenheim, Germany, ca. 1510–1515. Oil on panel, center panel 9′ 9½″ × 10′ 9″, each wing 8′ 2½″ × 3′ ½″, predella 2′ 5½″ × 11′ 2″. Musée d'Unterlinden, Colmar.

suggest a horrible disease. Medical experts have connected these symptoms with ergotism (a disease caused by ergot, a fungus that grows especially on rye). Although doctors did not discover the cause of this disease until about 1600, people lived in fear of its recognizable symptoms (convulsions and gangrene). The public referred to this illness as "Saint Anthony's Fire," and it was one of the major diseases treated at this hospital. The gangrene often compelled amputation, and scholars have noted that the two movable halves of the altarpiece's predella, if slid apart, make it appear as if Christ's legs have been amputated. The same observation can be made with regard to the two main exterior panels. Due to the off-center placement of the cross, opening the left panel "severs" one arm from the crucified figure.

Thus, Grünewald carefully selected and presented his altarpiece's iconography to be particularly meaningful for viewers at this hospital. In the interior shrine, the artist balanced the horrors of the disease and the punishments that awaited those who did not repent with scenes such as the *Meeting of Saints Anthony and Paul,* depicting the two saints, healthy and aged, conversing peacefully. Even the exterior panels (the closed altarpiece) convey these same concerns. The *Crucifixion* empha-

sizes Christ's pain and suffering, but the knowledge that this act redeemed humanity tempers the misery. In addition, Saint Anthony appears in the right wing as a devout follower of Christ who, like Christ and for Christ, endured intense suffering for his faith. As such, Saint Anthony's presence on the exterior reinforces the themes Grünewald intertwined throughout this entire altarpiece—themes of pain, illness, and death, as well as those of hope, comfort, and salvation.

The Protestant faith had not been formally established when Hagenauer and Grünewald produced the *Isenheim Altarpiece,* and the complexity and monumentality of the altarpiece must be viewed as Catholic in orientation. Further, Grünewald incorporated several references to Catholic doctrines, such as the lamb (symbol of the Son of God), whose wound spurts blood into a chalice in the exterior *Crucifixion* scene.

CATHOLICISM VERSUS PROTESTANTISM *Allegory of Law and Grace* (FIG. **18-3**; see "The Uses of Allegory," page 588) by LUCAS CRANACH THE ELDER (1472–1553) provides a meaningful contrast to the grandiose *Isenheim Altarpiece.* Produced in the years after the Reformation began,

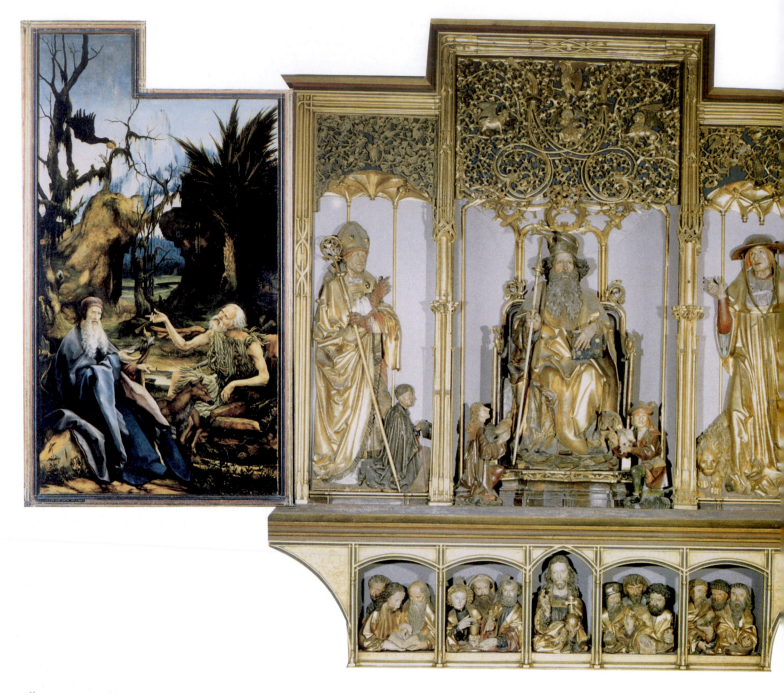

Allegory is a small woodcut print. In the early sixteenth century, northern Europe underwent a transition from handwritten manuscript (for example, illuminated manuscripts) to print media. In addition, the Protestant restrictions against visual imagery inhibited the production of large-scale altarpieces. However, Protestants viewed low-key images such as woodcut prints as useful devotional aids. Prints provided a prime opportunity for "educating the masses," because artists could print them easily, allowing the artists to sell numerous copies and to circulate them widely. In addition, woodcuts were among the least expensive of all the art forms, making them accessible to a wider audience than traditionally commissioned art, such as paintings or sculptures.

At Wittenberg, Cranach became a friend and follower of Martin Luther; indeed, his close association with Luther and the degree Luther influenced (if not guided) his imagery led scholars to refer to Cranach as the "painter of the Reformation." In *Allegory of Law and Grace,* Cranach visualized the differences between Catholicism (based on Old

Testament Law, according to Luther) and Protestantism (based on a belief in God's grace) in two images separated by a centrally placed tree. On the left half, Judgment Day has arrived, as represented by Christ's appearance at the top of the scene, hovering amid a cloud halo and accompanied by angels and saints. Christ raises his left hand in the traditional gesture of damnation, and, below, a skeleton drives off a terrified person to burn for all eternity in Hell. This person tried to live a good and honorable life, but, despite his efforts, he fell short. Moses stands to the side, holding the Tablets of the Law—the commandments Catholics follow in their attempt to attain salvation. In contrast to this Catholic reliance on good works and clean living, the Protestants emphasized God's grace as the source of redemption. Accordingly, God showers the sinner in the right half of the print with grace, as streams of blood flow from the crucified Christ. On the far right, Christ emerges from the tomb and promises salvation to all who believe in him.

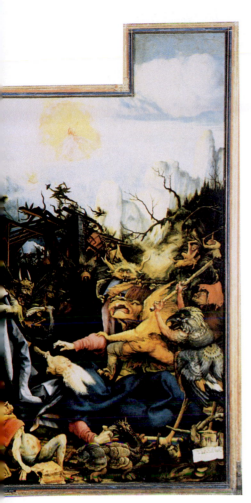

18-2 MATTHIAS GRÜNEWALD, *Isenheim Altarpiece* (open), center shrine carved by Nikolaus Hagenauer in 1490, from the chapel of the Hospital of Saint Anthony, Isenheim, Germany, ca. 1510–1515. Oil on panel, center panel 9′ 9½″ × 10′ 9″, each wing 8′ 2½″ × 3′ ½″, predella 2′ 5½″ × 11′ 2″. Musée d'Unterlinden, Colmar.

through his correspondence, and through a carefully kept, quite detailed, and eminently readable diary.

SUPPORTING THE LUTHERAN CAUSE A native of Nuremberg, one of the major cities in the Holy Roman Empire and a center of the Reformation, Dürer immersed himself in the current religious debates. Many of his works reveal his Lutheran sympathies. *Last Supper* (FIG. **18-4**) is a woodcut Dürer produced six years after Luther's issuance of his Ninety-Five Theses. Dürer's treatment of this traditional subject (see FIGS. 16-39 and 17-3) alludes to Lutheran doctrine about Communion, one of the sacraments. Rather than promote the doctrine of transubstantiation, the Catholic belief that when consecrated by the priest, the bread (Eucharist) and wine literally, miraculously, become the Body and Blood of Christ (see FIG. 19-20), Luther insisted Communion was commemorative, not a reenactment.

Dürer depicts this distinction in his *Last Supper*. The narrative moment he represented emphasizes sorrow and community; Christ has announced the betrayal, and only eleven disciples remain with Christ. The bread and wine appear prominently in the print's lower right corner, and the empty plate in the foreground refers to the commemorative, rather than literal, nature of Christ's sacrifice in the Mass. Traditional depictions often had a slaughtered lamb on the plate, conspicuously absent here.

The style of this woodcut is simple and straightforward. Compositionally, Dürer presented the figures in a conventional manner, seated behind a long horizontally placed table. Parallel lines extend throughout the entire image, with areas of crosshatching suggesting three-dimensionality. The regularity of the lines creates an evenness of value, contributing to the image's cohesiveness and directness.

EMPHASIZING THE BIBLE Dürer's support for Lutheranism surfaces in his painting *Four Apostles* (FIG. **18-5**). That he produced this work without commission and presented the two panels to the city fathers of Nuremberg in 1526 to be hung in the city hall suggests this work reflected his personal attitudes. John and Peter appear on the left panel, Mark and Paul on the right. The title, it can be argued, is something of a misnomer; Mark was an evangelist, despite conventional reference to him as an apostle. Dürer conveyed this painting's Lutheran orientation by his positioning of the figures; he relegated Saint Peter (as representative of the pope in Rome) to a secondary role by placing him behind John the Evangelist. John assumed particular prominence for Luther because of the evangelist's focus on Christ's person in his Gospel. In addition, Peter and John both read from the Bible, the single authoritative source of religious truth, according to Luther. Dürer emphasized the Bible's centrality by depicting it open to the legible passage "In the beginning was the Word, and the Word was with God, and the Word was God" (John 1:1). On the frames, Dürer included quotations from each of the Four Apostles' books in the German of Luther's translation of the New Testament. The excerpts warn against the coming of perilous times and the preaching of false prophets who will distort God's word. The individuality of each of the four men's faces, along with the detailed depiction of their attire and attributes, communicate an integrity and spirituality.

Widespread Acclaim for Exceptional Talent

The artist dominating the early sixteenth-century in the Holy Roman Empire was Grünewald's contemporary, ALBRECHT DÜRER (1471–1528). Dürer was the first artist outside Italy to become an international art celebrity. Well traveled and widely admired, he knew many of the leading humanists and artists of his time, among them Erasmus of Rotterdam and Giovanni Bellini. A man of exceptional talents and tremendous energy, Dürer achieved widespread fame in his own time and a lofty reputation ever since. Like Leonardo da Vinci, Dürer wrote theoretical treatises on a variety of subjects, such as perspective, fortification, and the ideal in human proportions. Unlike Leonardo, he both finished and published his writings. Through his prints, he exerted strong influence throughout Europe, especially in Flanders but also in Italy. Moreover, he was the first northern artist to leave a record of his life and career through several excellent self-portraits,

18-3 LUCAS CRANACH
THE ELDER, *Allegory of
Law and Grace,* ca. 1530.
Woodcut, $10\frac{5}{8}'' \times 1' \frac{3}{4}''$.
British Museum,
London.

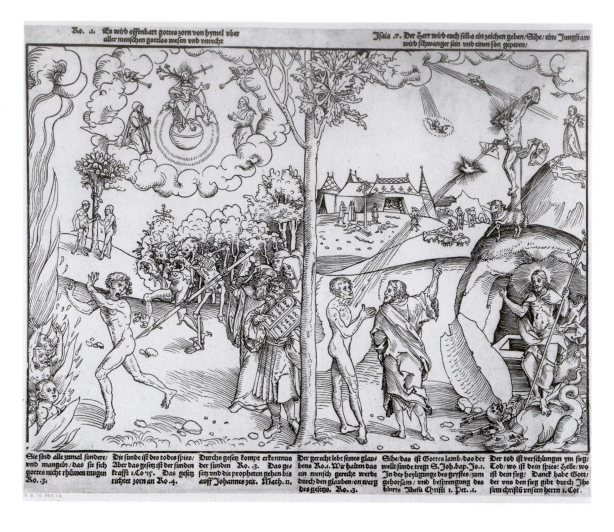

18-4 ALBRECHT DÜRER,
Last Supper, 1523. Wood-
cut, $8\frac{3}{8}'' \times 11\frac{13}{16}''$. British
Museum, London.

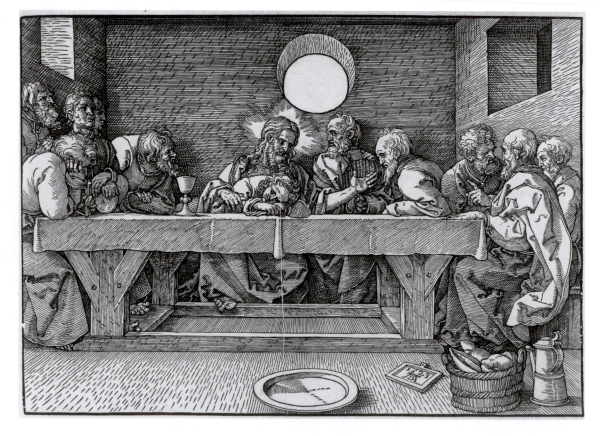

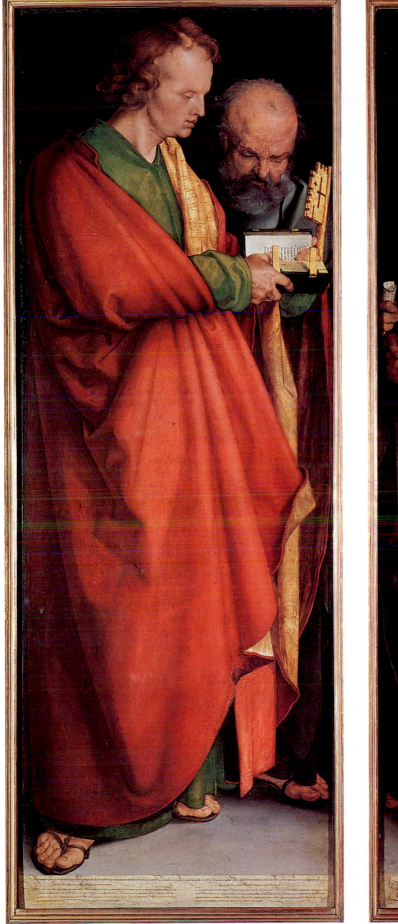
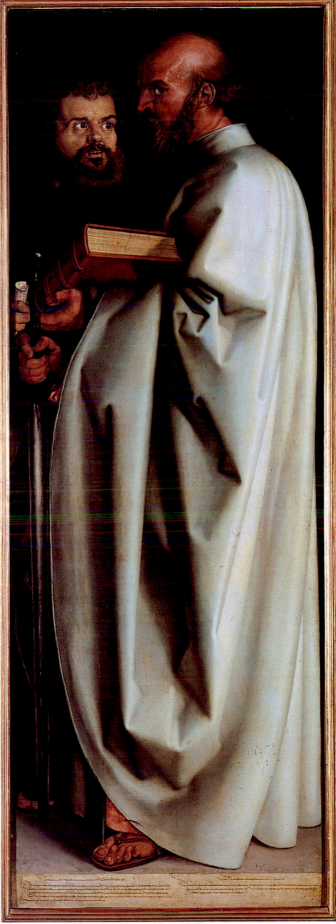

18-5 ALBRECHT DÜRER, *Four Apostles*, 1526. Oil on panel, each panel 7′ 1″ × 2′ 6″. Alte Pinakothek, Munich.

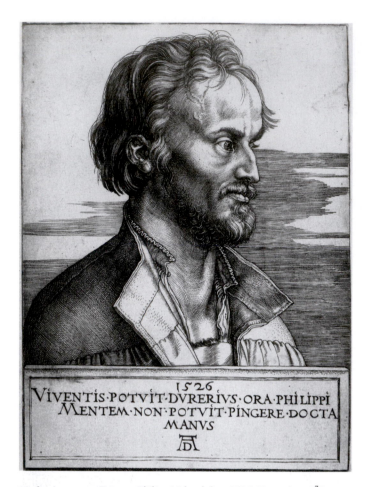

18-6 ALBRECHT DÜRER, *Philipp Melanchthon*, 1526. Engraving, $6\frac{7}{8}''$ × $5\frac{1}{16}''$. British Museum, London.

making, he developed an extraordinary proficiency in handling the burin, the engraving tool. This technical ability, combined with a feeling for the form-creating possibilities of line, enabled him to produce a body of graphic work in woodcut and engraving that seldom has been rivaled for quality and number. In addition to illustrations for books, Dürer circulated and sold prints in single sheets, which people of ordinary means could buy, expanding his audience considerably. The sale of prints also made him a wealthy man.

CLASSICAL IDEAS IN THE NORTH Fascinated with classical ideas as transmitted through Italian Renaissance artists, Dürer was among the first northern artists to travel to Italy expressly to study Italian art and its underlying theories at their source. After his first journey in 1494–1495 (the second was in 1505–1506), he incorporated many Italian Renaissance developments into his art. Art historians have acclaimed Dürer as the first northern artist to understand fully the basic aims of the Renaissance in Italy.

An engraving, *The Fall of Man* (*Adam and Eve*, FIG. **18-7**), represents the first distillation of his studies of the Vitruvian theory of human proportions, a theory based on arithmetic ratios. Clearly outlined against a northern forest's dark background, the two idealized figures of Adam and Eve stand in poses reminiscent of *Apollo Belvedere* (see FIG. Intro-7) and *Medici Venus* (not shown)—two ancient statues probably known to Dürer through graphic representations. Preceded by numerous geometric drawings, the artist's attempts to systematize sets of ideal human proportions in balanced contrapposto poses, the final print presents Dürer's 1504 concept of the "perfect" male and female figures. Yet Dürer tempered this idealization with naturalism—a commitment to observation.

Dürer demonstrated his well-honed observational skills in his rendering of the background foliage and animals. The gnarled bark of the trees and the feathery leaves authenticate the scene, as do the various creatures skulking underfoot. The animals populating the print are symbolic. The choleric cat, the melancholic elk, the sanguine rabbit, and the phlegmatic ox represent humanity's temperaments based on the "four humors," bodily fluids named by the ancient Greek physician Empedocles and a theory practiced in medieval physiology. The tension between cat and mouse in the foreground symbolizes the relation between Adam and Eve at the crucial moment in *The Fall of Man*.

Dürer agreed with Aristotle (and the new Renaissance critics) that "sight is the noblest sense of man."[2] Nature holds the beautiful, Dürer said, for the artist who has the insight to extract it. Thus, beauty lies even in humble, perhaps ugly, things, and the ideal, which bypasses or improves on nature, may not be truly beautiful in the end. Uncomposed and ordinary nature might be a reasonable object of an artist's interest, quite as much as its composed and measured aspect.

A PROTESTANT PORTRAIT OF INTELLECT Dürer also manifested his Lutheran sympathies in his portraits, which convey not only physical likeness but individual character as well. In addition to portraits of Reformation figures such as Erasmus, Dürer produced *Philipp Melanchthon* (FIG. **18-6**), an engraving of a scholar. Melanchthon (1497–1560) had arrived in Wittenberg in 1518 to teach Greek and Hebrew, but Luther's ideas captivated him, and he became a staunch supporter. Melanchthon established himself as a respected scholar, well known for reforming the German educational system. The practice of portraying such influential figures became common after Protestant leaders opposed the veneration of religious figures. Dürer depicted Melanchthon as a thoughtful, serious individual. Dürer's emphasis on Melanchthon's facial features refers to the sitter's intellect. In one of Melanchthon's eyes, a reflection of a window appears, perhaps a visualization of the notion of the eye as the window of the soul. Yet Dürer also humbly acknowledged the limitations of conventional portraiture—the inscription, in Latin, reads: "Dürer was able to depict Philipp's features as if living, but the practised hand could not portray his soul." Despite the artist's humility, he captured for perpetuity—immortalized—Philipp Melanchthon.

Through prints such as *Philipp Melanchthon*, Dürer became famous for his mastery of the graphic arts. Trained as a goldsmith by his father before he took up painting and print-

A PAINTING OF BOTANICAL ACCURACY Dürer allied himself with Leonardo's scientific studies when he painted an extremely precise watercolor study of a piece of turf; for both artists, observation yielded truth. Sight, sanctified by mystics such as Nicholas of Cusa and artists such as Jan van Eyck, became the secularized instrument of modern

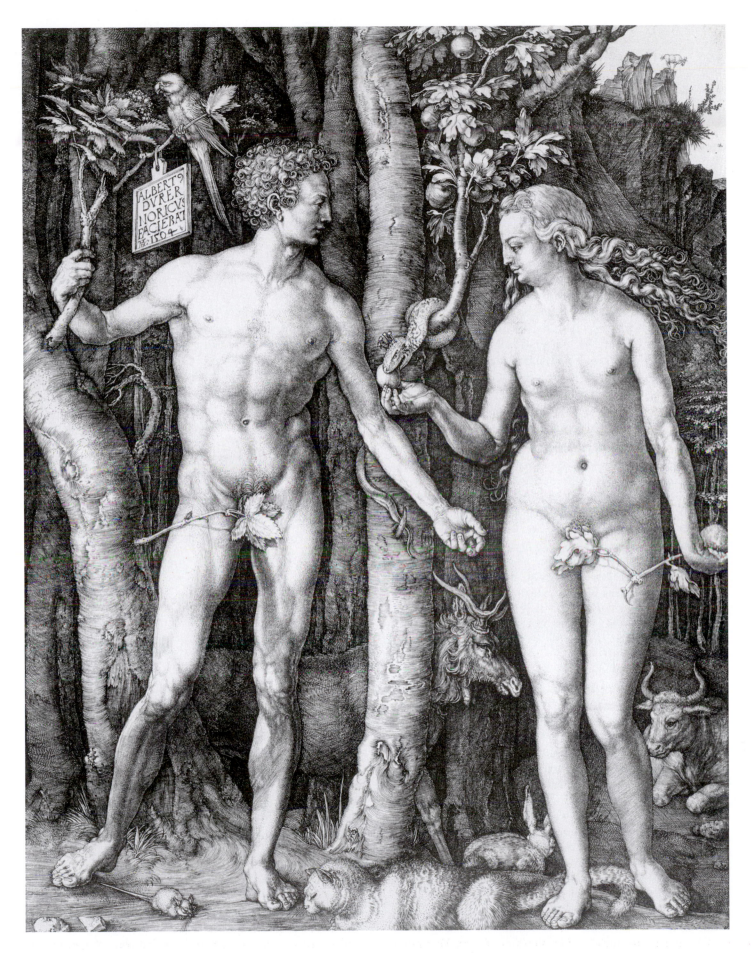

18-7 ALBRECHT DÜRER, *The Fall of Man (Adam and Eve)*, 1504. Engraving, approx. $9\frac{7}{8}'' \times 7\frac{5}{8}''$. Museum of Fine Arts, Boston (centennial gift of Landon T. Clay).

WRITTEN SOURCES

The Uses of Allegory

Western artists often employed allegory—the practice of imbuing narratives, images, or figures with symbolic meaning—to convey moral principles or philosophical ideas. For viewers to derive the deep connotations from allegorical images, the symbolic meanings of specific images had to be established as cultural convention. Among the numerous publications of Carel van Mander (1548–1606), a Netherlandish art historian and theoretician, is *Painter's Treatise* (1604), which contains a section with biographies of Netherlandish and German painters—the northern equivalent of Giorgio Vasari's *Lives of the Most Eminent Painters, Sculptors and Architects*. Van Mander outlines the functions and uses of allegory in *Handbook of Allegory*, originally published as the last section of *Painter's Treatise*. In this handbook, van Mander provides numerous examples of allegorical figures. His explication of the symbolic use of the goat and of the allegorical depiction of a common saying follow.

> The goat signifies good hearing; and some believe that she inhales and emits breath through her ears as well as through her nostrils. The goat—and this also includes the satyrs—signifies unchastity. The goat signifies the whore, who destroys the young people even as the goat gnaws off and ruins the young green sprouts. . . .
>
> In the above I have to some extent cleared the way for my young painters in order that they, without any special learning, can depict matters of significant meaning in images which all peoples with languages of their own, so far as they are at all intelligent or somewhat experienced, should be able to divine and understand; together with advice how to imagine and depict some special meaningful figures. . . . Among the common people one finds many who are amazed

when they see this kind of writing without letters, with signs or figures, in the manner of devices or verses often used by the rhetoricians. . . .

[Van Mander then takes "a common saying about the circular course of the world"—"Peace brings livelihood; livelihood, wealth; wealth, pride; pride, strife; strife, war; war, poverty; poverty, humility; humility brings peace"—and describes how a painter might render this saying allegorically through images.]

> First, peace may be represented by the cadeceus [winged staff] of Mercury or by a beehive-shaped helmet or an olive branch. Livelihood can be indicated by a coulter [plow blade], a ship's rudder, hammer, trowel, spool, and such necessary utensils, and these one could place upon the aforementioned beehive-like helmet or another peace emblem as proof that peace brings forth and supports livelihood. Above livelihood one may render wealth characterized by a purse. From the bag, or upon this purse, may rise three peacock feathers indicating pride. On the peacock feathers, loosely scattered arrows for discord or strife, with a two-headed body upon strife. A drawn bow with an arrow on the string for war. Clackdish [a dish with a moveable lid beggars often used], beggar's dish, bottle and plate for poverty that results from war. Upon poverty one may place humility, characterized by a foot stepping on a garland or a crown. This foot would then once more be followed by peace, as above; but it is unnecessary to show this again since everyone knows that it has to begin again from below, with peace as represented before.[1]

[1] Wolfgang Stechow, *Northern Renaissance Art 1400–1600: Sources and Documents* (Englewood Cliffs, N.J.: Prentice Hall, 1966), 71–72.

knowledge. The remarkable *The Great Piece of Turf* (FIG. **18-8**) is as scientifically accurate as it is poetic. Botanists can distinguish each springing plant and grass variety—dandelions, great plantain, yarrow, meadow grass, and heath rush. "[D]epart not from nature according to your fancy," Dürer said, "imagining to find aught better by yourself; . . . For verily 'art' is embedded in nature; he who can extract it, has it."[3]

ELEVATING THE ART OF ENGRAVING This lifelong interest in both idealization and naturalization surfaces in *Knight, Death, and the Devil* (FIG. **18-9**), one of three so-called Master Engravings Dürer made between 1513 and 1514. These works (the other two are *Melencolia I* and *Saint Jerome in His Study*) carry the art of engraving to the highest degree of excellence. Dürer used his burin to render differences in texture and tonal values that would be difficult to match even in the much more flexible medium of *etching* (corroding a design into metal), which artists developed later in the century. (Later in life Dürer also experimented with etching.)

Knight, Death, and the Devil depicts a mounted armored knight who rides fearlessly through a foreboding landscape. Accompanied by his faithful retriever, the knight represents a Christian knight—a soldier of God. Armed with his faith, this warrior can repel the threats of Death, who appears as a crowned decaying cadaver wreathed with snakes and shaking an hourglass as a reminder of time and mortality. The knight is equally impervious to the Devil, a pathetically hideous horned creature who follows him. The knight triumphs because he has "put on the whole armor of God that [he] may be able to stand against the wiles of the devil," as urged in Saint Paul's Epistle to the Ephesians (Eph. 6:11).

The monumental knight and his mount display the strength, movement, and proportions of the Renaissance equestrian statue. Dürer was familiar with Donatello's *Gattamelata* (see FIG. 16-32) and Verrocchio's *Bartolommeo Colleoni* (see FIG. 16-33) and had copied a number of Leonardo's sketches of horses. His highly developed feeling for the real and his meticulous rendering of it surface in the myriad details—the knight's armor and weapons, the horse's

anatomy, the textures of the loathsome features of Death and the Devil, and the rock forms and rugged foliage. Dürer realized this entire range of imagery with the dense hatching of fluidly engraved lines that rivals painting's tonal range. Erasmus could rightly compliment Dürer as the "Apelles [the ancient Greek master of painting] of black lines."[4]

Dürer's use of line, whether in oil, watercolor, woodcut, or engraving, was truly exceptional. He employed line not simply to describe but to evoke as well. This ability extended beyond his impressive technical facility with the different mediums. For example, in his woodcut *The Four Horsemen* (see FIG. Intro-9), Dürer created an image of pandemonium and doom as Death, Famine, War, and Pestilence wreak havoc on society. The lines that undulate and often shift direction abruptly contribute to the scene's energy. Further, Dürer's modulation of his lines, which swell, taper, and break, along with his careful grouping of these linear elements, create impressive light and shadow effects.

Dürer's art reveals an inspired, inquisitive mind and a phenomenally gifted talent. To this day, his work serves as a model for artists, and he deserves much of the credit for expanding graphic arts' capability of conveying intellectually and emotionally complex themes.

Commenting on History and Politics

INVOKING THE PAST TO ALTER THE FUTURE While the prominence of Reformation concerns in the Holy Roman Empire during the sixteenth century influenced the

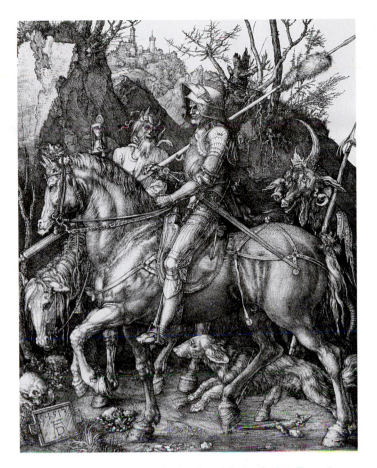

18-9 ALBRECHT DÜRER, *Knight, Death, and the Devil*, 1513. Engraving, $9\frac{5}{8}'' \times 7\frac{3}{8}''$. Metropolitan Museum of Art, New York.

period's art, artists also addressed historical and political issues. *The Battle of Issus* (FIGS. **18-10** and 5-69) by ALBRECHT ALTDORFER (ca. 1480–1538), for example, depicts the historical defeat of Darius in 333 B.C. by Alexander the Great at a town called Issus on the Pinarus River (announced in the inscription that hangs in the sky). The duke of Bavaria, Wilhelm IV, commissioned *The Battle of Issus* in 1528, concurrent with his commencement of a military campaign against the invading Turks. The parallels between the historical and contemporary conflicts were no doubt significant to the duke. Both involved societies that deemed themselves progressive engaged in battles against infidels—the Persians in 333 B.C. and the Turks in 1528. Altdorfer reinforced this connection by attiring the figures in contemporary armor and depicting them engaged in contemporary military alignments.

The scene reveals Altdorfer's love of landscape. The battle takes place in an almost cosmological setting. From a bird's eye view, the clashing armies swarm in the foreground, while in the distance craggy mountain peaks rise next to still bodies of water. Amid swirling clouds, a blazing sun descends. Despite the awesome spectacle of the topography, the artist used available historical information to produce this painting. Altdorfer derived his depiction of the landscape from maps. Specifically, he set the scene in the eastern Mediterranean with a view from Greece to the Nile in Egypt. In addition, Altdorfer may have acquired his information about this battle from an account written by Johannes Aventinus, a German scholar. In his text, Aventinus describes the bloody daylong battle and Alexander's ultimate victory. Appropriately, given Alexander's

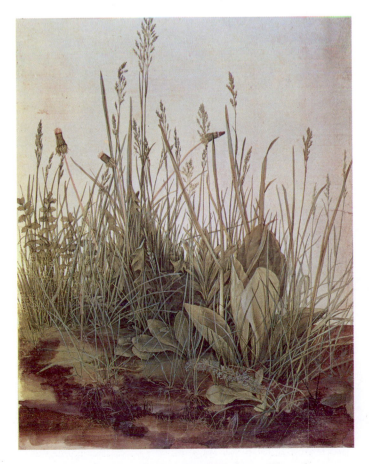

18-8 ALBRECHT DÜRER, *The Great Piece of Turf*, 1503. Watercolor, approx. $1' \, 4'' \times 1' \, \frac{1}{2}''$. Graphische Sammlung Albertina, Vienna.

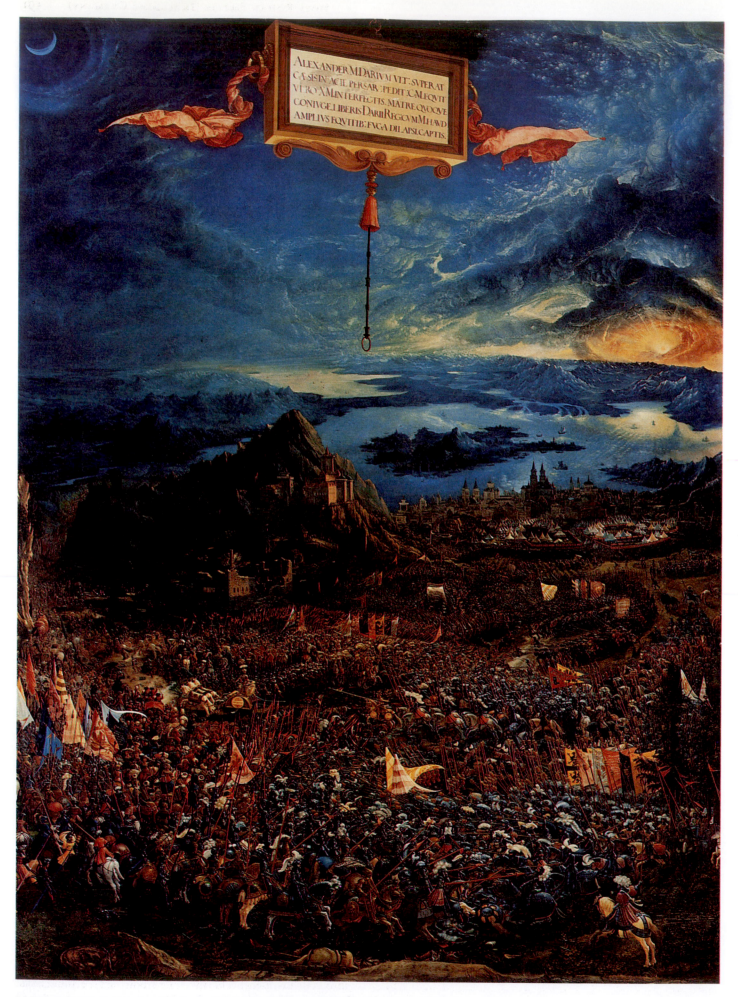

18-10 ALBRECHT ALTDORFER, *The Battle of Issus*, 1529. Oil on panel, 4′ 4¼″ × 3′ 11¼″. Alte Pinakothek, Munich.

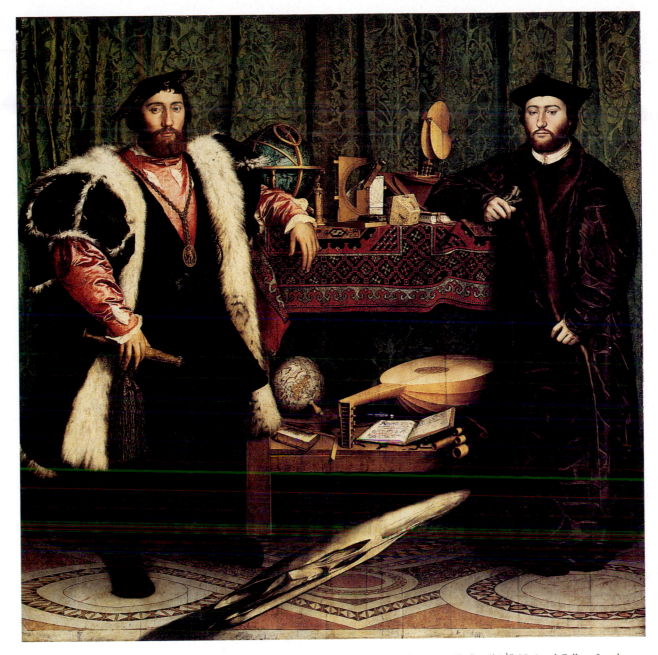

18-11 HANS HOLBEIN THE YOUNGER, *The French Ambassadors,* 1533. Oil and tempera on panel, approx. 6' 8" × 6' 9½". National Gallery, London.

designation as the "sun god," the sun sets over the victorious Greeks on the right, while a small crescent moon (a symbol of the Near East) hovers in the upper left corner over the retreating Persians.

A DIPLOMATIC SOLUTION Choosing less dramatic scenes, HANS HOLBEIN THE YOUNGER (ca. 1497–1543) excelled as a portraitist. Trained by his father, Holbein produced portraits that reflected the northern tradition of close realism that had emerged in fifteenth-century Flemish art. Yet he also incorporated Italian ideas about monumental composition, bodily structure, and sculpturesque form. The color surfaces of his paintings are as lustrous as enamel, his detail is exact and exquisitely drawn, and his contrasts of light and dark are never heavy.

Holbein began his artistic career in Basel, where he knew Erasmus of Rotterdam. Due to the immediate threat of a religious civil war in Basel, Erasmus suggested Holbein leave for England and gave him a recommendation to Thomas More, chancellor of England under Henry VIII. Holbein did move and became painter to the English court. While there, he produced a superb double portrait of the French ambassadors to England, Jean de Dinteville and Georges de Selve (FIG. **18-11**). *The French Ambassadors* exhibits Holbein's considerable talents—his strong sense of composition, his subtle linear patterning, his gift for portraiture, his marvelous sensitivity to color, and his faultlessly firm technique. This painting may have been Holbein's favorite; it is the only one signed with his full name. The two men, both ardent humanists, stand at each end of a side table covered with an oriental

rug and a collection of objects reflective of their worldliness and interest in learning and the arts. These include mathematical and astronomical models and implements, a lute with a broken string, compasses, a sundial, flutes, globes, and an open hymnbook with Luther's translation of *Veni, Creator Spiritus* and of the Ten Commandments.

Of particular interest is the long gray shape that slashes diagonally across the picture plane and interrupts the stable, balanced, and serene composition. This form is an *anamorphic* image, a distorted image recognizable when viewed with a special device, such as a cylindrical mirror, or by viewing the painting at an acute angle. Viewing this painting while standing off to the right reveals this gray slash is a skull. Although scholars do not agree on this skull's meaning, at the very least, it certainly refers to death. Artists commonly incorporated skulls into paintings as reminders of mortality; indeed, Holbein depicted a skull on the metal medallion on Jean de Dinteville's hat. Holbein may have intended the skulls, in conjunction with the crucifix that appears half hidden behind the curtain in the upper left corner, to encourage viewers to ponder death and resurrection.

This painting may allude to the growing tension between secular and religious authorities; Jean de Dinteville was a titled landowner, while Georges de Selve was a bishop. The inclusion of Luther's translations next to the lute with the broken string (a symbol of discord) may also subtly refer to the religious strife. Despite scholars' uncertainty about the precise meaning of *The French Ambassadors*, it is a painting of supreme artistic achievement. Holbein rendered the still-life objects with the same meticulous care as the men themselves, as the woven design of the deep emerald curtain behind them, and as the floor tiles, constructed in faultless perspective. He surely hoped this painting's elegance and virtuosity of skill (produced shortly after Holbein arrived in England) would impress Henry VIII.

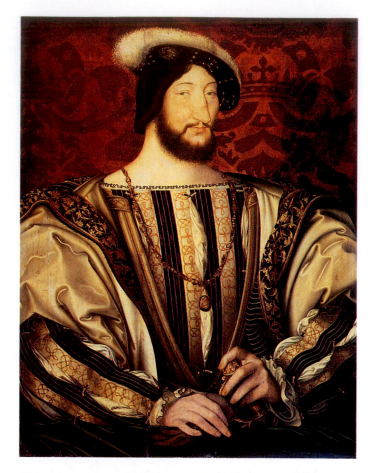

18-12 JEAN CLOUET, *Francis I,* ca. 1525–1530. Tempera and oil on panel, approx. 3′ 2″ × 2′ 5″. Louvre, Paris.

FRANCE

As *The French Ambassadors* illustrates, France in the early sixteenth century worked to secure widespread recognition as a political power. Decisive kings reorganized the country, which had been divided and harried throughout the fifteenth century. By the end of that century, France was strong enough to undertake an aggressive policy toward its neighbors. Under the rule of Francis I (r. 1515–1547), the French established a firm foothold in Milan and its environs. Francis waged a campaign (known as the Hapsburg-Valois Wars) against Charles V (the Spanish king and Holy Roman Emperor), which occupied him from 1521 to 1544. These wars erupted over disputed territories—southern France, the Netherlands, the Rhinelands, northern Spain, and Italy. Despite this distraction, Francis I also endeavored to elevate his country's cultural profile. To that end, he invited esteemed Italian artists such as Leonardo da Vinci and Andrea del Sarto to his court. Francis's attempt to glorify the state and himself meant that the religious art dominating the Middle Ages no longer prevailed, for the king and not the Christian Church held the power.

A MAGNIFICENT FRENCH MONARCH The portrait *Francis I* (FIG. **18-12**), painted by JEAN CLOUET (ca. 1485–1541), shows a worldly prince magnificently bedecked in silks and brocades, wearing a gold chain with a medallion of the Order of Saint Michael, and caressing the pommel of a dagger. Legend has it the "merry monarch" was a great lover and the hero of hundreds of "gallant" situations; appropriately, he appears suave and confident. Despite the careful detail, the portrait also exhibits an elegantly formalized quality. This characteristic is due to Clouet's suppression of modeling, resulting in a flattening of features, seen particularly in Francis's neck. The disproportion between the small size of the king's head in relation to his broad body, swathed in heavy layers of brocaded fabric, adds to the formalized nature.

A PAINTED AND PLASTERED PALACE The personal tastes of Francis and his court must have run to an art at once elegant, erotic, and unorthodox. Appropriately, Mannerism (pages 561–568) appealed to them most. Among the Italian artists who had a strong impact on French art were the Mannerists Rosso Fiorentino and Benvenuto Cellini. Rosso became the court painter of Francis I shortly after 1530. The king put ROSSO FIORENTINO (1494–1540), along with fellow Florentine FRANCESCO PRIMATICCIO (1504–1570), in charge of decorating the new royal palace at Fontainebleau. Scholars refer to the sculptors and painters who worked together on this proj-

ect as the school of Fontainebleau. When Rosso and Primaticcio decorated the Gallery of King Francis I at Fontainebleau (FIG. **18-13**), they combined painting, fresco, imitation mosaic, and stucco sculpture in low and high relief. The abrupt changes in scale and texture of the figurative elements are typically Mannerist, as are the compressed space, elongated grace, and stylized poses. The formalized elegance of the paintings also appears in the stucco relief figures and caryatids, while the shift in scale between the painted and the stucco figures adds tension. The combination of painted and stucco relief decorations became extremely popular from that time on and remained a favorite ornamental technique throughout the Baroque and Rococo periods of the seventeenth and early eighteenth centuries.

CHÂTEAUX: FORTRESSES TO MANSIONS

Francis I indulged an interest in building during his reign by commissioning several large-scale châteaux, among them the Château de Chambord (FIG. **18-14**) in Chambord. Reflecting the more peaceful times, these châteaux, developed from the old countryside fortresses, served as country houses for royalty, who usually built them near forests for use as hunting lodges. Construction on Chambord began in 1519, but Francis I never saw its completion. Chambord's plan, originally drawn by a pupil of Giuliano da Sangallo, imposes Italian concepts of symmetry and balance on the irregularity of the old French fortress. A central square block with four corridors, in the shape of a cross, has a broad, central staircase that gives access to groups of rooms—ancestors of the modern suite of rooms or apartments. At each of the four corners, a round tower punctuates the square plan, and a moat surrounds the whole. From the exterior, Chambord presents a carefully contrived horizontal accent on three levels, its floors separated by continuous moldings. Windows align precisely, one exactly over another. The Italian palazzo served as the model for this matching of horizontal and vertical features, but above the third level the structure's lines break chaotically into a jumble of high dormers, chimneys, and lanterns that recall soaring ragged Gothic silhouettes on the skyline.

REDESIGNING THE LOUVRE Chambord essentially retains French architectural characteristics. During the reign of Francis's successor, Henry II (r. 1547–1559), however, translations of Italian architectural treatises appeared, and Italian architects themselves came to work in France. Moreover, the French turned to Italy for study and travel. Such exchanges caused a more extensive revolution in style than earlier, although certain French elements derived from the Gothic tradition persisted. This incorporation of Italian architectural ideas can be seen in the redesigning of the Louvre in Paris, originally a medieval palace and fortress. Francis I initiated this project to update and expand the royal palace but died before the work was well under way. His architect, PIERRE LESCOT (1510–1578), continued under Henry II and, with the aid of the sculptor JEAN GOUJON (ca. 1510–1565), produced the classical style later associated with sixteenth-century French architecture.

Although Chambord incorporated the formal vocabulary of the Early Renaissance, particularly from Lombardy, Lescot and his associates were familiar with the sixteenth-century Renaissance architecture of Bramante and his school. As the Square Court's west facade (FIG. **18-15**) shows, each of the Louvre's stories forms a complete order, and the cornices project enough to furnish a strong horizontal accent. The arcading on the ground story reflects the ancient Roman use of arches and produces more shadow than in the upper stories due to its recessed placement, thereby strengthening the design's visual base. On the second story, the pilasters rising from bases and the alternating curved and angular pediments supported by consoles have direct antecedents in several High

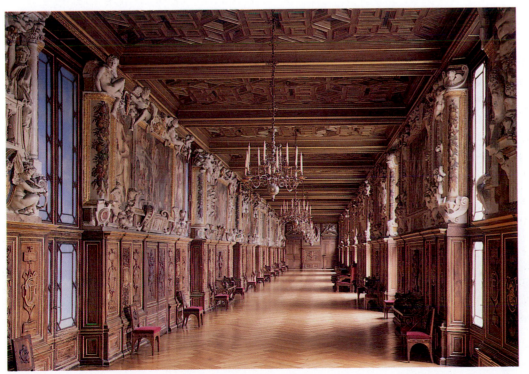

18-13 ROSSO FIORENTINO and FRANCESCO PRIMATICCIO, ensemble of architecture, sculpture, and painting, Gallery of King Francis I, Fontainebleau, France, ca. 1530–1540.

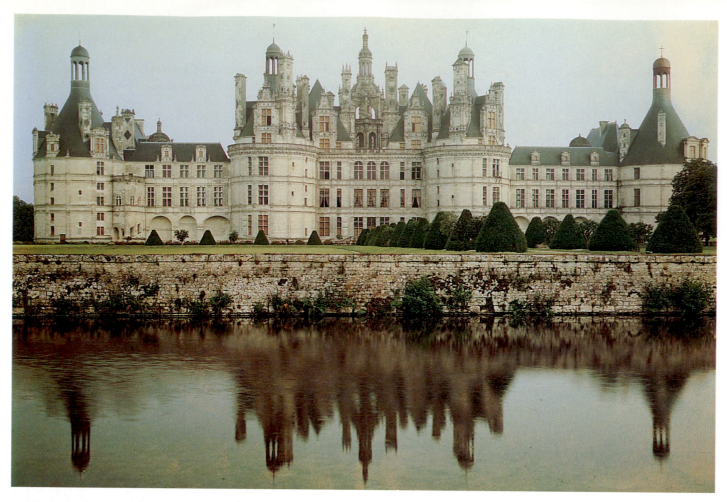

18-14 Château de Chambord, Chambord, France, begun 1519.

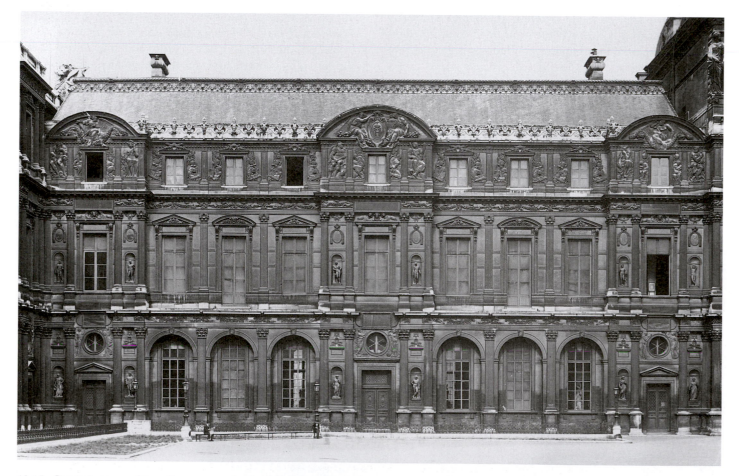

18-15 PIERRE LESCOT and JEAN GOUJON, west facade of the Square Court of the Louvre, Paris, France, begun 1546.

Renaissance palaces. Yet, the decreased height of the stories, the scale of the windows (proportionately much larger than in Renaissance buildings), and the steep roof suggest northern models. Especially French are the pavilions jutting from the wall. A feature the French long favored—double columns framing a niche—punctuates the pavilions. The building's vertical lines assert themselves. Openings deeply penetrate the wall, and sculptures abound. Other northern countries imitated this French classical manner—its double-columned pavilions, tall and wide windows, profuse statuary, and steep roofs—although with local variations. The modified classicism the French produced was the only classicism to serve as a model for northern architects through most of the sixteenth century. Some scholars believe the west courtyard facade of the Louvre is the best of French sixteenth-century architecture; eventually, the French purged their architecture of Italian features.

LIGHTNESS, EASE, AND GRACE The statues of the Louvre courtyard facade, now much restored, are Goujon's work. His *Nymphs* reliefs from the *Fountain of the Innocents* in Paris (FIG. **18-16**) originally decorated two facades of a fountain. Appropriately, the nymphs carry or stand next to vases of flowing water. Like the architecture of the Louvre, Goujon's nymphs recall the Italian (particularly Mannerist) canon of figural design. Certainly, their figura serpentinata poses are Mannerist. Their flowing, clinging draperies parallel the ancient "wet" drapery of Greek sculpture—the figures on the parapet of the Temple of Athena Nike (see FIG. 5-54), for example. Goujon's slender, sinuous figures perform their steps within a confined unspecified space, and they appear to make one continuous motion, an illusion produced by reversing the gestures, as they might be seen in a mirror. The style of Fontainebleau, and ultimately of Primaticcio and Cellini, guided the sculptor here, but Goujon learned the manner so

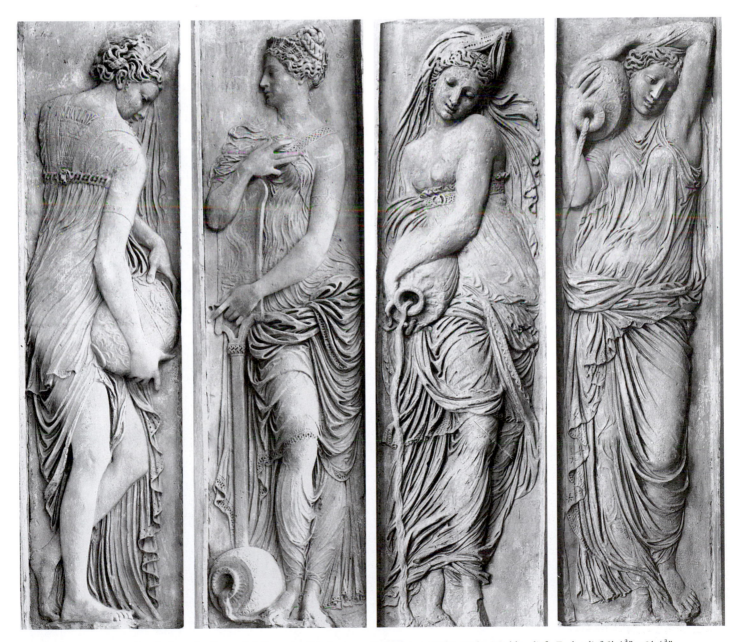

18-16 JEAN GOUJON, *Nymphs,* from the dismantled *Fountain of the Innocents,* Paris, France, 1548–1549. Marble reliefs. Each relief 6' 4¾" × 2' 4¾". Louvre, Paris.

well he created originally within it. The nymphs are truly French masterpieces, characterized by lightness, ease, and grace.

THE NETHERLANDS

With the demise of the Duchy of Burgundy in 1477 and the division of that territory between France and the Holy Roman Empire, the Netherlands at the beginning of the sixteenth century consisted of seventeen provinces (corresponding to modern Holland, Belgium, and Luxembourg). Through marriage of its rulers, the Netherlands had come under Spanish control. However, because of widespread cultural, linguistic, and religious differences, the Netherlands could hardly be considered a cohesive unit during this period. The seven northern provinces were predominantly Germanic in culture, Dutch speaking, and Calvinist, while the southern provinces were largely French and Flemish speaking, Catholic, and culturally linked to France.

Prosperous Provinces

The Netherlands was among the most commercially advanced and prosperous of European countries. Its easy access to the Atlantic Ocean and extensive network of rivers provided a setting conducive to overseas trade, and shipbuilding was one of the most profitable businesses. The geographic location of the region's commercial center changed toward the end of the fifteenth century. Partly from the silting of the Bruges estuary, traffic shifted to Antwerp, which became the hub of economic activity in the Netherlands after 1510. By midcentury, a jealous Venetian envoy had to admit that more business transactions took place in Antwerp in a few weeks than in a year in Venice. As many as five hundred ships a day passed through Antwerp's harbor, and large trading colonies from England, the Holy Roman Empire, Italy, Portugal, and Spain established themselves in the city.

The economic prosperity of the Netherlands served as a potent incentive for Philip II of Spain to strengthen his control over those provinces. He had inherited the region from his father, Charles V (r. 1519–1556), who had accumulated an expansive empire as Holy Roman Emperor. In 1566, responding to riots in the Netherlandish provinces, Philip sent ten thousand soldiers to enforce his rule. His heavy-handed tactics and repressive measures led in 1579 to further revolt, resulting in the formation of two federations. The Union of Arras, a Catholic union of southern Netherlandish provinces, remained under Spanish dominion, and the Union of Utrecht, a Protestant union of northern provinces, became the Dutch Republic.

The increasing number of Netherlandish citizens converting to Protestantism affected the arts, as evidenced by a corresponding decrease in large-scale altarpieces and religious works (although such works continued to be commissioned for Catholic churches). Much of Netherlandish art of this period provides viewers with a wonderful glimpse into the lives of various strata of society, from nobility to peasantry, capturing their activities, environment, and values.

REINTERPRETING CLASSICAL ANTIQUITY Developments in Italian Renaissance art interested many

Netherlandish artists. JAN GOSSAERT (ca. 1478–1535) associated with humanist scholars and visited Italy. There, Gossaert (who adopted the Latinized name MABUSE, after his birthplace of Maubeuge) became fascinated with classical antiquity and its mythological subjects. Giorgio Vasari, the Italian historian and Gossaert's contemporary, wrote that "Jean Gossart [sic] of Mabuse was almost the first who took from Italy into Flanders the true method of making scenes full of nude figures and poetical inventions;"[5] although it is obvious he derived much of his classicism from Dürer.

Indeed, Dürer's *The Fall of Man* (FIG. 18-7) inspired the composition and poses in Gossaert's *Neptune and Amphitrite* (FIG. **18-17**). However, unlike Dürer's exquisitely small engraving, Gossaert's painting is more than six feet tall and four feet wide. The artist executed the painting with expected Netherlandish polish, skillfully drawing and careful modeling of the figures. Gossaert depicted the sea god with his traditional attribute, the trident, and wearing a laurel wreath and an ornate conch shell, rather than Dürer's fig leaf. Amphitrite is fleshy and, like Neptune, stands in a contrapposto stance. The architecture is an unusual mix of classical elements. For example, parts of Doric and Ionic orders are combined with

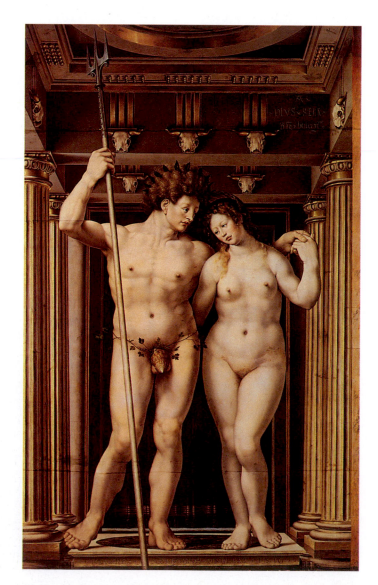

18-17 JAN GOSSAERT (MABUSE), *Neptune and Amphitrite*, ca. 1516. Oil on panel, 7' 2" × 4' 1". Gemäldegalerie, Staatliche Museen, Berlin.

egg-and-dart patterns and *bucrania* (ox skull decorations). Gossaert likely based this fanciful setting on sketches he had made of architectural structures while in Rome. He had traveled to Italy with the patron of this large-scale painting on panel, a Burgundian admiral.

BALANCING THE SECULAR AND SPIRITUAL

Antwerp's growth and prosperity, along with its wealthy merchants' propensity for collecting and purchasing art, attracted artists to the city. Among them was QUINTEN MASSYS (ca. 1466–1530), who became Antwerp's leading master after 1510. Son of a Louvain blacksmith, Massys demonstrated a willingness to explore the styles and modes of a variety of models, from van Eyck to Bosch and from van der Weyden to Dürer and Leonardo. Yet his eclecticism was subtle and discriminating, enriched by an inventiveness that gave a personal stamp to his paintings and made him a popular, as well as important, artist.

In *Money-Changer and His Wife* (FIG. **18-18**), Massys presented a professional man transacting business. He holds scales, checking the weight of coins on the table. His wife interrupts her reading of a prayer book to watch him. The artist's detailed rendering of the figures, setting, and objects suggests a fidelity to observable fact. Thus this work provides

viewers with a glimpse into the developing mercantilist activity. *Money-Changer and His Wife* also reveals Netherlandish values and mores. Although the painting highlights the financial transactions that were an increasingly prominent part of secular life in the sixteenth-century Netherlands, Massys tempered this focus on the material world with numerous references to the importance of a moral, righteous, and spiritual life. Not only does the wife hold a prayer book, but the artist also included other traditional religious symbols (for example, the carafe with water and candlestick). Two small vignettes Massys provided for viewers (not visible to the couple) refer to the balance this couple must establish between their worldly existence and their commitment to God's word. On the right, through a window, an old man talks with another man, suggesting idleness and gossip. The reflected image in the convex mirror on the counter offsets this image of sloth and foolish chatter. There, a man reads what is most likely a Bible or prayer book; behind him is a church steeple.

An inscription on the original frame (now lost) seems to have reinforced this message. According to a seventeenth-century scholar, this inscription read, "Let the balance be just and the weights equal" (Lev. 19:36), which applies both to the money changer's professional conduct and the eventual Last Judgment.

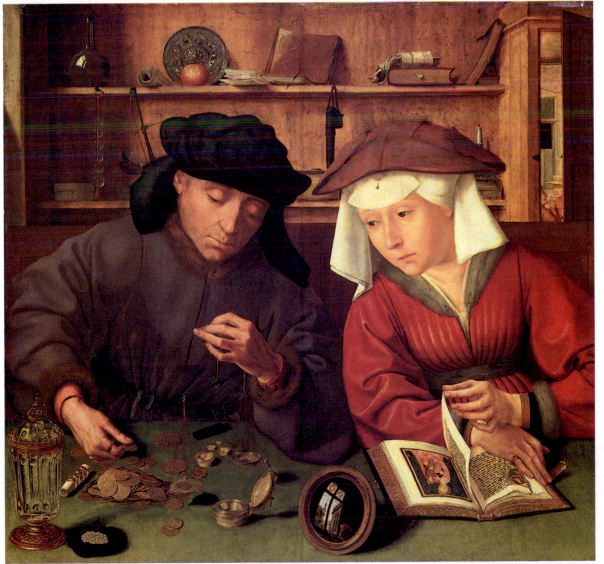

18-18

QUINTEN MASSYS, *Money-Changer and His Wife*, 1514. Oil on panel, 2′ 3¾″ × 2′ 2⅜″. Louvre, Paris.

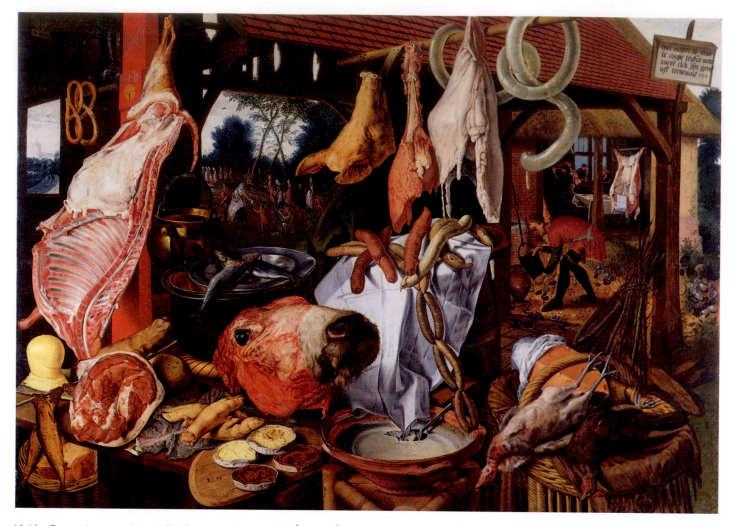

18-19 PIETER AERTSEN, *Meat Still-Life,* 1551. Oil on panel, 4' $\frac{3}{8}$" × 6' 5$\frac{3}{4}$". Uppsala University Art Collection, Uppsala.

MEETING SPIRITUAL OBLIGATIONS This ten-dency to inject reminders about spiritual well-being emerges in *Meat Still-Life* (FIG. **18-19**) by PIETER AERTSEN (ca. 1507–1575), who worked in Antwerp for more than three decades. At first glance, this painting appears to be a descriptive genre scene. Viewers encounter an array of meat products—a side of a hog, chickens, sausages, a stuffed intestine, pig's feet, meat pies, a cow's head, a hog's head, and hanging entrails. Also visible are fish, pretzels, cheese, and butter. Like Massys, Aertsen embedded strategically placed religious images as reminders to viewers. In the background of *Meat Still-Life,* Joseph leads a donkey carrying Mary and the Christ Child. The Holy Family stops to offer alms to a beggar and his son, while the people behind the Holy Family wind their way toward a church. Furthermore, the crossed fishes on the platter and the pretzels and wine in the rafters on the upper left all refer to "spiritual food" (pretzels often served as bread during Lent). Aertsen accentuated these allusions to salvation through Christ by contrasting them to their opposite—a life of gluttony, lust, and sloth. He represented this degeneracy with the oyster and mussel shells (believed by Netherlanders to possess aphrodisiacal properties) scattered on the ground on the painting's right side, along with the people seen eating and carousing nearby under the roof.

AN ACCOMPLISHED WOMAN ARTIST With the accumulation of wealth in the Netherlands, portraits increased in popularity. The self-portrait (FIG. **18-20**) by CATERINA VAN HEMESSEN (1528–1587) is purportedly the first known northern European self-portrait by a woman. Here, she confidently presented herself as an artist; she interrupts her painting to look toward viewers. She holds brushes, a palette, and a *maulstick* (a stick used to steady the hand while painting) in her left hand, and delicately applies pigment to the canvas with her right hand. Van Hemessen's father, Jan Sanders van Hemessen, a well-known painter, trained her. Caterina ensured proper identification (and credit) through the inscription in the painting: "Caterina van Hemessen painted me / 1548 / her age 20."

"A GOOD LANDSCAPE PAINTER" Landscape painting also flourished. Particularly well known for his landscapes was JOACHIM PATINIR (d. 1524). According to one scholar, the word *landscape (Landschaft)* first emerged in German literature as a characterization of an artistic genre when Dürer described Patinir as a "good landscape painter." In *Landscape with Saint Jerome* (FIG. **18-21**), Patinir subordinated the biblical scene to the exotic and detailed landscape. Saint Jerome, who removes a thorn from a lion's paw in the foreground, ap-

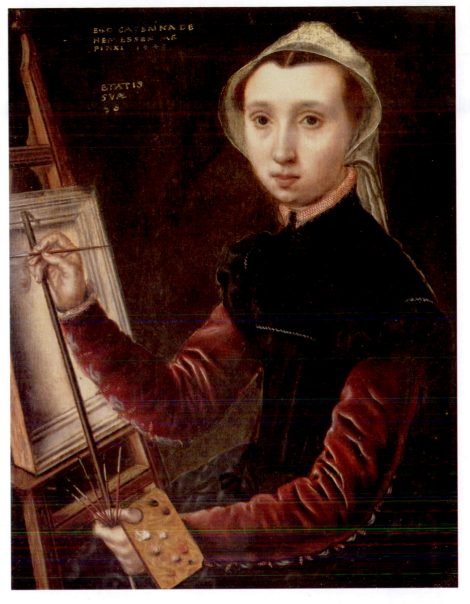

18-20 CATERINA VAN HEMESSEN, *Self-Portrait*, 1548. Panel, $1' \frac{3}{4}'' \times 9\frac{7}{8}''$. Kunstmuseum, Öffentliche Kunstsammlung Basel.

pears dwarfed by craggy rock formations, rolling fields, and expansive bodies of water in the background. Patinir amplified the sense of distance by masterfully using color to enhance the visual effect of recession and advance.

A WINTRY NETHERLANDISH LANDSCAPE The early high-horizoned "cosmographical" landscapes of PIETER BRUEGEL THE ELDER (ca. 1528–1569) reveal both an interest in the interrelationship of human beings and nature and Patinir's influence. But in Bruegel's paintings, no matter how huge a slice of the world he shows, human activities remain the dominant theme. Like many of his contemporaries, Bruegel traveled to Italy, where he seems to have spent almost two years, going as far south as Sicily. Unlike other artists, however, Bruegel chose not to incorporate classical elements into his paintings. The impact of his Italian experiences emerges in his work most frequently in the Italian or Alpine landscape features, which he recorded in numerous drawings during his journey.

Hunters in the Snow (FIG. **18-22**) is one of five surviving paintings of a series of six illustrating seasonal changes in the year. It shows human figures and landscape locked in winter cold; Bruegel's production of this painting in 1565 coincided with a particularly severe winter. The weary hunters return with their hounds, women build fires, skaters skim the frozen pond, the town and its church huddle in their mantle of snow, and beyond this typically Netherlandic winter scene lies a bit of Alpine landscape. Aside from this trace of fantasy, however, the artist rendered the landscape in an optically accurate manner. It develops smoothly from foreground to background and draws viewers diagonally into its depths. Bruegel's consummate skill in using line and shape and his subtlety in tonal harmony make this one of the great landscape paintings and an occidental counterpart of the masterworks of classical Chinese landscape.

PROVERBIAL NETHERLANDISH WISDOM Among the paintings that most comprehensively capture life

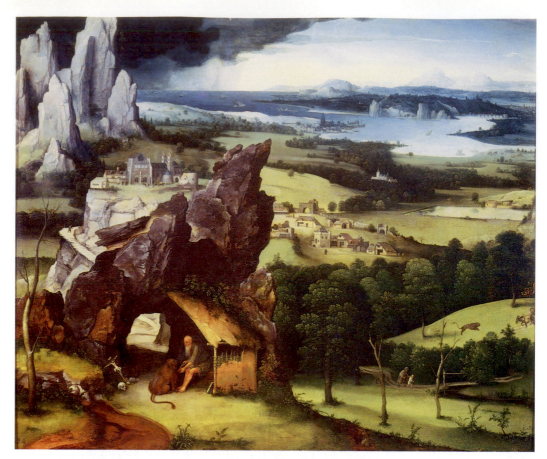

18-21 JOACHIM PATINIR, *Landscape with Saint Jerome*, ca. 1520–1524. Oil on panel, 2′ 5⅛″ × 2′ 11⅞″. Prado, Madrid.

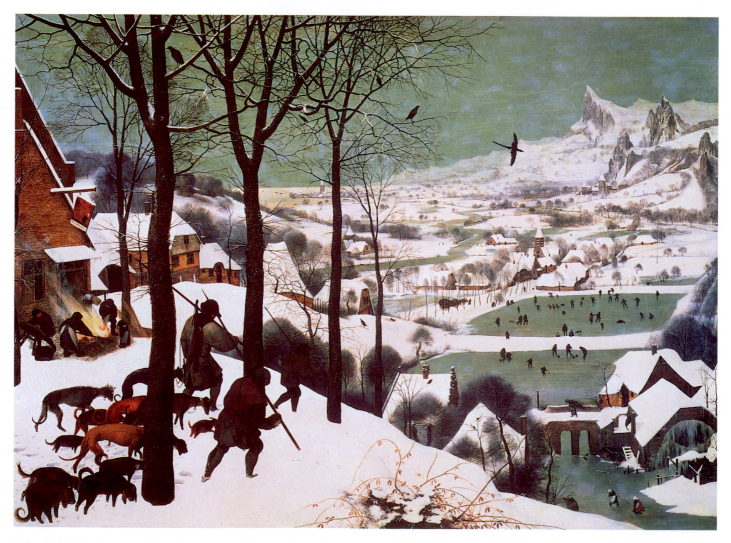

18-22 PIETER BRUEGEL THE ELDER, *Hunters in the Snow*, 1565. Oil on panel, approx. 3′ 10″ × 5′ 4″. Kunsthistorisches Museum, Vienna.

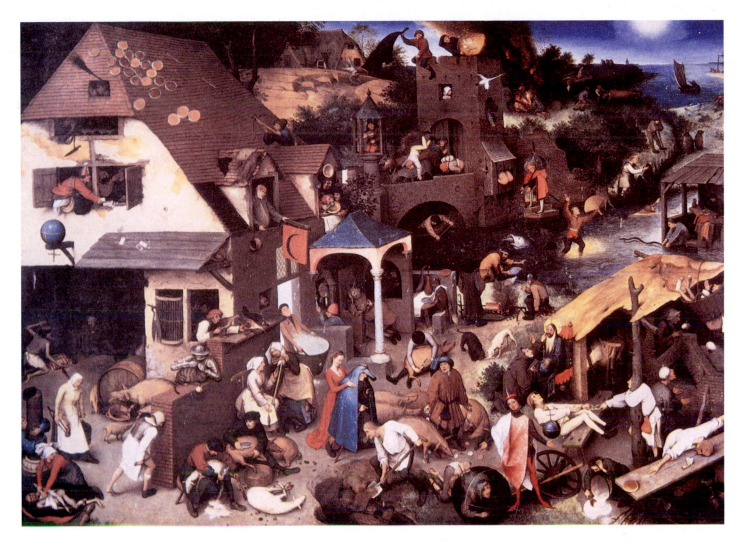

18-23 PIETER BRUEGEL THE ELDER, *Netherlandish Proverbs,* 1559. Oil on panel, 3′ 10″ × 5′ 4 $\frac{1}{8}$″. Gemäldegalerie, Staatliche Museen, Berlin.

in the Netherlands during the sixteenth-century is Bruegel's *Netherlandish Proverbs* (FIG. **18-23**). This work depicts a typical Netherlandish village populated by a wide range of people (nobility, peasants, and clerics). From a bird's eye view, spectators encounter a mesmerizing and mind-boggling array of activities. Beyond a mere vignette of village life, however, Bruegel illustrated more than one hundred proverbs in this one painting. It thus functions on another level and demands very close scrutiny. The proverbs depicted include, on the far left, a man in blue gnawing on a pillar ("He bites the column"—an image of hypocrisy); to his right, a man "beats his head against a wall" (an ambitious idiot); on the roof a man "shoots one arrow after the other, but hits nothing" (a shortsighted fool); and, in the far distance, the "blind lead the blind." *Netherlandish Proverbs* nicely summarizes more than just the physical facts of Netherlandish existence in the sixteenth century; it also captures the Netherlanders' morality and mentality. More generally, this artwork serves as a study of human nature.

Toward the end of his life, Bruegel's commentary on the human condition took on an increasingly bitter edge. The Netherlands, racked by religious conflict, became the seat of cruel atrocities, made even more terrible by Catholic Spain's attempts to extinguish the Reformation.

SPAIN

Spain emerged as the dominant European power at the end of the sixteenth century. Under Charles V of Hapsburg (r. 1516–1556) and his son, Philip II (r. 1556–1598), the Spanish Empire dominated a territory greater in extent than any ever known—a large part of Europe, the western Mediterranean, a strip of North Africa, and vast expanses in the New World. Spain acquired many of its New World colonies through aggressive overseas exploration. Among the most notable navigators sailing under the Spanish flag were Christopher Columbus (1451–1506), Vasco Nuñez de Balboa (ca. 1475–1517), Ferdinand Magellan (1480–1521), Hernán Cortés (1485–1547), and Francisco Pizarro (ca. 1470–1541). The Hapsburg Empire, enriched by the New World plunder, supported the most powerful military force in Europe. Spain defended and then promoted the Catholic Church's interests in its battle against the inroads of the Protestant Reformation; indeed, Philip II earned the nickname "Most Catholic King." The material and the spiritual exertions of Spain—the fanatical courage of Spanish soldiers and the ardent fervor of the great Spanish mystical saints—united. The soldiers became the terror of the Protestant and pagan worlds, while the saints served as the inspiration of the

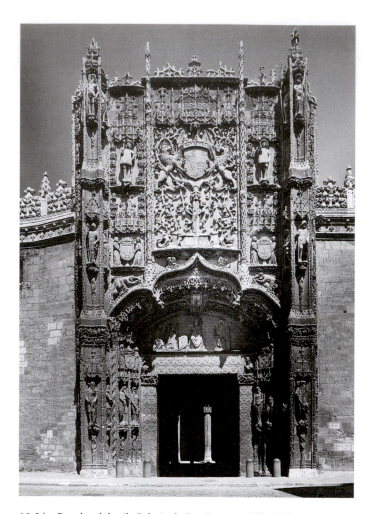

18-24 Portal and detail, Colegio de San Gregorio, Valladolid, Spain, ca. 1498.

Catholic faithful. Spain's crusading spirit, nourished by centuries of war with Islam, engaged body and soul in forming the most Catholic civilization of Europe and the Americas. In the sixteenth century, for good or for ill, Spain left the mark of Spanish power, religion, language, and culture on two hemispheres.

SILVERWORK-INSPIRED ARCHITECTURE During the fifteenth century and well into the sixteenth, a Late Gothic style of architecture, the Plateresque, prevailed in Spain. *Plateresque* derives from the Spanish word *platero,* meaning silversmith, and relates to the style because of the delicate execution of its ornament. The Colegio de San Gregorio (Seminary of Saint Gregory; FIG. **18-24**) in the Castilian city of Valladolid handsomely exemplifies the Plateresque manner. Great carved retables, like the German altarpieces that influenced them (see FIGS. 15-23 and 15-24), appealed to church patrons and architects in Spain. They thus made them a conspicuous decorative feature of their exterior architecture, dramatizing a portal set into an otherwise blank wall. The Plateresque entrance of San Gregorio is a lofty sculptured stone screen that bears no functional relation to the architecture behind it. On the entrance level, lacelike tracery reminiscent of Moorish design hems the flamboyant ogival arches. A great screen, paneled into sculptured compartments, rises above the tracery. In the center (FIG. 18-24, detail), the

branches of a huge pomegranate tree (symbolizing Granada, the Moorish capital of Spain captured by the Hapsburgs in 1492) wreathe the coat of arms of King Ferdinand and Queen Isabella. Cupids play among the tree branches, and, flanking the central panel, niches enframe armed pages of the court, heraldic wild men (wild men symbolized aggression, and here as heralds announce the royal intentions), and armored soldiers, attesting to Spain's new proud militancy. In typical Plateresque and Late Gothic fashion, the activity of a thousand intertwined motifs unifies the whole design, which, in sum, creates an exquisitely carved panel greatly expanded in scale.

A KING'S REVIVAL OF THE CLASSICAL Italianate classicism made its appearance in the unfinished palace of Charles V in the Alhambra in Granada (FIG. **18-25**), which is the work of the painter-architect PEDRO MACHUCA (active 1520–1550). Superposed Doric and Ionic orders, which support continuous horizontal entablatures rather than arches, ring the circular central courtyard. The ornament consists only of the details of the orders themselves, which Machuca rendered with the simplicity, clarity, and authority found in the work of Bramante and his school. The lower story recalls the ring colonnade of the Tempietto (see FIG. 17-8); although here the architect reversed the curve. This pure classicism, entirely exceptional in Spain at this time, may reflect Charles V's

personal taste acquired on one of his journeys to Italy. (The king, after all, was an enthusiastic patron of Titian.) Machuca may also have sojourned in Italy, and the courtyard may have been his attempt to incorporate elements of classical architecture.

A "DYNASTIC PANTHEON" Charles V's successor to the Spanish throne, Philip II, appreciated the streamlined clarity of Italian-derived classicism but desired a more unique style. His tastes emerged in the expansive complex called the Escorial (FIG. **18-26**), which JUAN BAUTISTA DE TOLEDO (d. 1567) and JUAN DE HERRERA (ca. 1530–1597), principally the latter, constructed for Philip II. In his will, Charles V stipulated that a "dynastic pantheon" be built to house the remains of past and future monarchs of Spain. Philip II, obedient to his father's wishes, chose a site some thirty miles northwest of Madrid in rugged terrain with barren mountains. Here, he built the Escorial, not only a royal mausoleum but also a church, a monastery, and a palace. Legend has it that the gridlike plan for the enormous complex, six hundred twenty-five feet wide and five hundred twenty feet deep, symbolized the gridiron where Saint Lawrence, patron of the Escorial, was martyred.

The whole vast structure is in keeping with Philip's austere and conscientious character, his passionate Catholic religiosity, his proud reverence for his dynasty, and his stern determination to impose his will worldwide. He insisted that the architect focus on simplicity of form, severity in the whole, nobility without arrogance, and majesty without ostentation in designing the Escorial. The result is a classicism of Doric severity, ultimately derived from Italian architecture and with

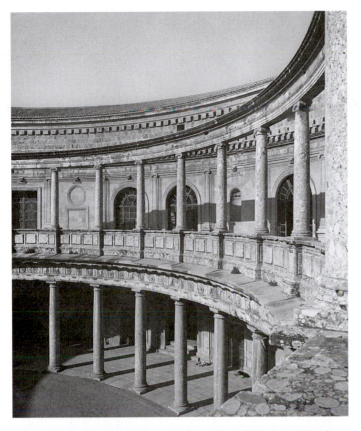

18-25 PEDRO MACHUCA, courtyard of the palace of Charles V, Alhambra, Granada, Spain, ca. 1526–1568.

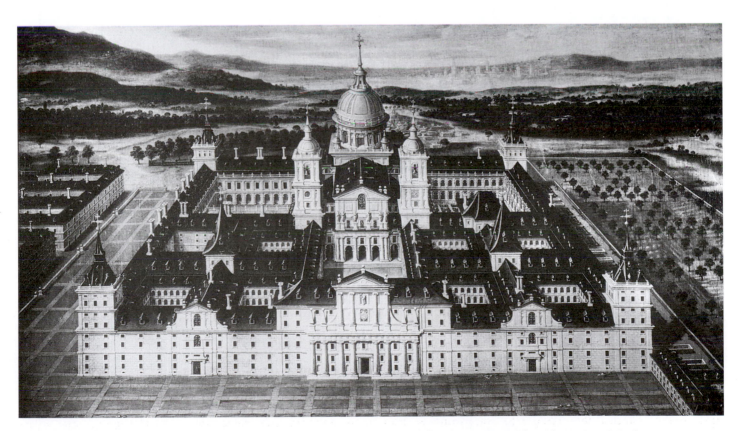

18-26 JUAN DE HERRERA, Escorial (bird's-eye view), near Madrid, Spain, ca. 1563–1584 (after an anonymous eighteenth-century painting).

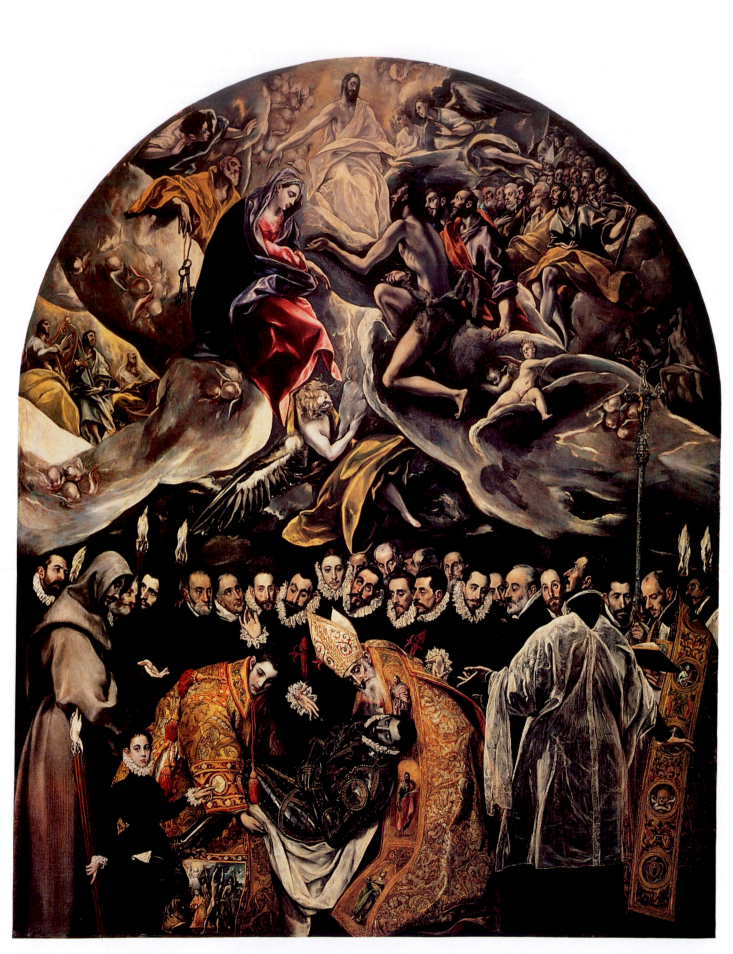

18-27 EL GRECO, *The Burial of Count Orgaz*, Santo Tomé, Toledo, Spain, 1586. Oil on canvas, approx. 16′ × 12′.

the grandeur of Saint Peter's implicit in the scheme. But it is unique in Spanish and European architecture—a matchless style, even though later structures reflect it.

Only the three entrances, with the dominant central portal framed by superposed orders and topped by a pediment in the Italian fashion, break the long sweep of the structure's severely plain walls. Massive square towers punctuate the four corners. The architect's stress on the central axis, with its subdued echoes in the two flanking portals, anticipates the three-part organization of later Baroque palace facades. The construction material for the entire complex (including the domed-cross church)—granite, a difficult stone to work—conveys a feeling of starkness and gravity. The church's massive facade and the austere geometry of the interior complex, with its blocky walls and ponderous arches produce an effect of overwhelming strength and weight.

The entire complex is a monument to the collaboration of a great king and a remarkably understanding architect. The Escorial stands as the overpowering architectural expression of Spain's spirit in its heroic epoch and of the character of Philip II, the extraordinary ruler who directed it.

A SPANISH MANNERIST DOMÉNIKOS THEOTOKÓ-POULOS, called EL GRECO (ca. 1547–1614), was born on Crete but emigrated to Italy as a young man. In his youth, he absorbed the traditions of Late Byzantine frescoes and mosaics. While still young, El Greco went to Venice, where he was connected with Titian's workshop, although Tintoretto's painting seems to have made a stronger impression on him. A brief trip to Rome explains the influences of Roman and Florentine Mannerism on his work. By 1577, he had left for Spain to spend the rest of his life in Toledo.

El Greco's art is a strong personal blending of Late Byzantine and Late Italian Mannerist elements. The intense emotionalism of his paintings, which naturally appealed to the pious fervor of the Spanish, the dematerialization of form, and a great reliance on color bound him to sixteenth-century Venetian art and to Mannerism. His strong sense of movement and use of light, however, prefigured the Baroque style. El Greco's art was not strictly Spanish (although it appealed to certain sectors of that society), for it had no Spanish antecedents and little effect on later Spanish painters. Nevertheless, El Greco's hybrid style captured the fervor of Spanish Catholicism. This statement is especially true of the artist's masterpiece, *The Burial of Count Orgaz* (FIG. 18-27), painted in 1586 for the church of Santo Tomé in Toledo. El Greco based the artwork on the legend that the count of Orgaz, who had died some three centuries before and who had been a great benefactor of

Santo Tomé, was buried in the church by Saints Stephen and Augustine, who miraculously descended from heaven to lower the count's body into its sepulcher.

In the painting, the brilliant Heaven that opens above irradiates the earthly scene; El Greco carefully distinguished the terrestrial and celestial spheres. He represented the terrestrial with a firm realism, while he depicted the celestial, in his quite personal manner, with elongated undulating figures, fluttering draperies, and a visionary swirling cloud. Below, the two saints lovingly lower the count's armor-clad body, the armor and heavy draperies painted with all the rich sensuousness of the Venetian school. A solemn chorus of black-clad Spanish personages fills the background. In the carefully individualized features of these figures, El Greco demonstrated that he was also a great portraitist. These men call to mind the conquistadores, who, earlier in the century, ventured to the New World and who, two years after the completion of this picture, led the Great Armada against both Protestant England and the Netherlands.

The upward glances of some figures below and the flight of an angel above link the painting's lower and upper spheres. The action of the angel, who carries the count's soul in his arms as Saint John and the Virgin intercede for it before the throne of Christ, reinforces this connection. El Greco's deliberate change in style to distinguish between the two levels of reality gives viewers the opportunity to see the artist's early and late manners in the same work, one below the other. His relatively sumptuous and realistic presentation of the earthly sphere is still strongly rooted in Venetian art, but the abstractions and distortions El Greco used to show the immaterial nature of the Heavenly realm characterized his later style. His elongated figures existing in undefined spaces, bathed in a cool light of uncertain origin, explain El Greco's usual classification as a Mannerist, but it is difficult to apply that label to him without reservations. Although he used Mannerist formal devices, El Greco's primary concerns were emotion and expressing his religious fervor or arousing that of observers. To make the inner meaning of his paintings forceful, he developed a highly personal style so that his tapering forms, swaddled in dynamic swirls of unearthly light and color, appear as spiritual visions.

Despite the conflicts between the various European countries, it is clear extensive dialogue transpired among artists of these countries, and artistic influence and ideas traveled in many directions. The widespread religious and political conflicts continued to impact the arts well into the next century, as modern nation-states and capitalist economies solidified.

SEVENTEENTH-CENTURY EUROPE

N

North Sea

Baltic Sea

Elbe R.

Vistula R.

Oder R.

ENGLAND

London

OXFORDSHIRE

HOLLAND
Haarlem
Leiden • Amsterdam
Dordrecht • Utrecht
• Breda
Antwerp
FLANDERS

UNITED PROVINCES OF THE NETHERLANDS

Staffelstein

Rhine R.

Danube R.

• Rohr

Munich

Atlantic Ocean

Seine R.
Versailles • • Paris

Loire R.
• Blois

FRANCE

SWITZER-LAND

Rhône R.

Turin •
Po R.
Trent •
Stra •

Bologna
Florence •
ITALY

Rome •

200 400 miles
200 400 kilometers

Ebro R.

SPAIN

• Madrid

• Seville

Mediterranean Sea

1600	1620	1630	1640	1650

PHILIP III OF SPAIN | PHILIP IV OF SPAIN

HENRY IV OF FRANCE | LOUIS XIII OF FRANCE (DOMINATED BY CARDINAL RICHELIEU, MARIE DE MEDICI, REGENT 1610–1614) | LOUIS XIV OF

JAMES I OF ENGLAND | CHARLES I OF ENGLAND | ENGLAND UNDER CROMWELL

Caravaggio, Conversion of Saint Paul, ca. 1601

Gerritt van Honthorst Supper Party, 1620

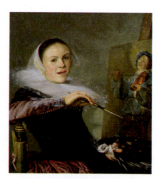

Judith Leyster Self-Portrait, ca. 1630

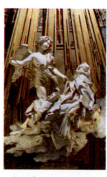

Gianlorenzo Bernini Ecstasy of Saint Theresa 1645–1652

William Shakespeare, 1564–1616

Pope Paul V, r. 1605–1621

Galileo Galilei refines telescope, 1609

Johannes Kepler's laws of planetary motion, 1609–1619

Thirty Years' War begins, 1618

Pope Urban VIII, r. 1623–1644

Blaise Pascal, 1623–1662

William Harvey discovers blood circulation, 1628

René Descartes, *Discourse on Method*, 1637

Pope Innocent X, r. 1644–1655

French Royal Academy of Painting and Sculpture founded, 1648

United Provinces of the Netherlands formed, 1648

Thirty Years' War ends, 1648

OF POPES, PEASANTS, MONARCHS, AND MERCHANTS

BAROQUE AND ROCOCO ART

1660	1670	1680	1690	1700	1710	1720	1730	1740	1750

CHARLES II OF SPAIN | PHILIP V | FERDINAND VI

FRANCE (DOMINATED BY CARDINAL MAZARIN UNTIL 1661) | LOUIS XV OF FRANCE

CHARLES II OF ENGLAND | JAMES II | WILLIAM AND MARY | ANNE | GEORGE I OF ENGLAND | GEORGE II OF ENGLAND

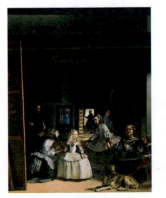

Diego Velázquez
Las Meninas, 1656

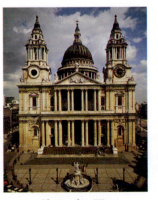

Christopher Wren
Saint Paul's Cathredral
London, 1675–1710

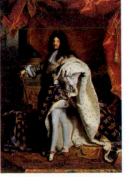

Hyacinthe Rigaud
Louis XIV, 1701

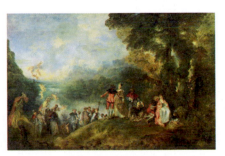

Antoine Watteau
Return from Cythera
1717–1719

Pope Alexander VII, r. 1655–1667

Royal Society founded in London, 1662

Sir Isaac Newton's laws of motion, gravitation, 1687

Excavation of Pompeii begins, 1748

THE "BAROQUE"

The cultural production of the seventeenth and early eighteenth centuries in the West is often described as "Baroque," a convenient blanket term. However, this term is problematic because the period encompasses a broad range of developments, both historical and artistic, across an expansive geographic area. Further, this term originally was used in a pejorative sense and thus had a connotation scholars long since have abandoned. (Although its origin is unclear, it may have come from the Portuguese word *barroco,* meaning an irregularly shaped pearl.) Use of the term *baroque* emerged in the late eighteenth and early nineteenth centuries, when critics disparaged the Baroque period's artistic production. This was due in large part to perceived deficiencies in comparison to the art (especially Italian Renaissance) of the period before it. Over time, this negative connotation faded, and the term is now used more generally as a period designation.

Because of the problematic associations of the term and because no commonalities can be ascribed to all of the art and cultures of this period, we have limited use of the term in this book. Wherever it is used, we have provided characteristics that anchor the term *Baroque* in particular cultures—for example, Italian Baroque as compared to Dutch Baroque.

The Shifting Geopolitical Landscape in Europe

WARRING FOR THIRTY YEARS—AND LONGER During the seventeenth and early eighteenth centuries, numerous geopolitical shifts occurred in Europe as the fortunes of the individual countries waxed and waned. In the early years of the seventeenth century, fragile alliances, reinforced through strategic marriages, had been established. Religious conflicts, especially between Catholics and Protestants, and the political animosity between the Hapsburgs and their enemies soon eroded any stability these alliances had helped build. This volatile situation erupted into the Thirty Years' War (1618–1648), which involved Spain, France, Sweden, Denmark, the Netherlands, Germany, Austria, Poland, the Ottoman Empire, and the Holy Roman Empire. The war, which concluded with the Treaty of Westphalia in 1648, was largely responsible for the political restructuring of Europe. As a result, the Austro-Hungarian empire emerged; the United Provinces of the Netherlands (the Dutch Republic), Sweden, and France expanded their authority; and Spain and Denmark's relative power diminished. The building of nation-states was emphatically under way.

Although the Thirty Years' War was not solely responsible for the modern state system's evolution, it did contribute to the momentum of that burgeoning development. The war's causes and effects also highlight the historical and ideological issues Europe grappled with at that time. That the Thirty Years' War was symptomatic of wider disruption is revealed in one historian's claim that between 1562 and 1721 all of Europe was at peace only four years.

MOVING TOWARD SECULARIZED GOVERNMENT One of the fundamental conflicts underlying the Thirty Years' War in particular and European turmoil in general was the ongoing friction between Catholics and Protestants. Aside from the reconfiguration of territorial boundaries, the Treaty of Westphalia in essence granted freedom of religious choice throughout Europe. This treaty thus marked the abandonment of the idea of a united Christian Europe, which the practical realities of secular political systems replaced.

Constant warfare also stimulated the movement toward the secularization of government. Military techniques had changed drastically since the medieval era. By the late sixteenth and early seventeenth centuries, warfare involved a greater use of firearms and cannons, increased flexibility and maneuverability in tactics, larger standing armies, and advanced artillery pieces that offered greater mobility during battle. The demands for expanded military forces necessitated large centralized bureaucracies to supervise military action and resources. The efficient coordination of these military operations reinforced the consolidation of power among secular authorities.

Advances in the Sciences

The growing secularization in the political realm coincided with (and certainly was linked to) the development of a new science. This new science challenged many fundamental religious tenets and emerged in astronomy, physics, biology, and mathematics. Grounded in mathematics and materialism (the belief the universe is composed of matter in motion), this momentous shift in the scientific realm laid the groundwork for the Enlightenment and its emphasis on empirical data, which is chronicled in Chapter 20.

EXPLORING THE UNIVERSE The new science rejected Aristotelian explanations of the universe, in large part because many of Aristotle's theories seemed incompatible with objective, observable fact. The great advances made in science during the late seventeenth and early eighteenth centuries relied on experimentation and tangible proof. The invention of logarithms, analytic geometry, and calculus transformed mathematics. In astronomy, Polish scientist Nicolaus Copernicus (1473–1543) argued that in contrast to traditional models of the cosmos, the Sun was the center of the universe and Earth merely a planet in orbit around it. Although this discovery occurred well before the beginning of the seventeenth century, not until his ideas were developed further by the German Johannes Kepler (1571–1630) and the Italian Galileo (1564–1642) was the notion of heliocentrism accepted throughout Europe. (Galileo provided visible proof of such astronomical conclusions with his improved tool, the telescope.)

CHEMICAL REACTIONS The study of chemical properties also advanced at a rapid pace, and discoveries in that field impacted medicine and, eventually, mechanization. For example, Englishman Robert Boyle (1627–1691) established the basis of the science of chemistry. In his book *The Sceptical Chymist,* which he published in 1661, Boyle presented an atomic explanation for matter, and he later explored the changes in atomic particles (which became known as the

chemical elements). These studies led Boyle to formulate the inverse relationship between the volume and pressure of a gas (Boyle's Law) and to invent the air pump. The anatomical inquiries of Englishman William Harvey (1578–1657) resulted in his proposed anatomy of the heart, with the heart functioning like a pump and circulating blood through the entire body.

Many of the related threads of this new type of science were brought together in the work of Sir Isaac Newton (1642–1727). Although his work had an immediate impact on scientific thought after publication of his ideas (for example, the concept of force and the laws of motion and gravity), its wider implications laid the groundwork for Enlightenment thought. Thus Newtonian physics are discussed with the Enlightenment in Chapter 20. Other scientists, such as Sir Francis Bacon (1561–1626), and French philosopher René Descartes (1596–1650) were also major figures in science's advancement. Bacon was one of England's leading supporters of scientific research. Descartes explored how skepticism could be used to produce certainty. His resulting philosophy, known as Cartesianism, was based on the dual existence of matter and mind.

Although discussion of and debate about these advancements took place primarily in scientific circles, these innovative ideas did have widespread ramifications. Because this new science was based on skepticism and an insistence on demonstrable fact, it encouraged atheistic beliefs. In a historical crucible of enduring conflict between Catholics and Protestants, such beliefs seemed appallingly heretical.

The Development of a Worldwide Market

By the seventeenth century, European societies began to coordinate their long-distance trade more systematically. The allure of expanding markets, rising profits, and access to a wider range of goods all contributed to the relentless economic competition between countries during this period. Much of the foundation for worldwide mercantilism—extensive voyaging and geographic exploration, improved cartography, and advances in shipbuilding—was laid in the previous century. In fact, by the end of the sixteenth century, all of the major trade routes had been established.

COFFEE OR TEA? In the seventeenth century, however, changes in financial systems, lifestyles, and trading patterns, along with expanding colonialism, fueled the creation of a worldwide marketplace. The Dutch founded the Bank of Amsterdam in 1609, which established a uniform rate of exchange for the various currencies traded in that city. This bank eventually became the center of European transfer banking, where merchant firms held money on account, relieving traders of having to transport precious metals as payment. Trading practices became more complex. Rather than simple reciprocal trading, triangular trade (trade between three parties) allowed for a larger pool of desirable goods. Exposure to an ever-growing array of goods affected European diets and lifestyles. Coffee (from island colonies) and tea (from China) became popular beverages during the early seventeenth century. Equally explosive was the growth of sugar use. Sugar, along with tobacco and rice, were slave crops, and the slave trade expanded to accommodate the demand for these goods. Africans were enslaved and imported to European colonies and the Americas to provide the requisite labor force for producing these commodities.

Some groups (for example, the landed elite or the salaried bureaucrats) disdained trade expansion. This antipathy to trade did not impede its growth, however, and the resulting worldwide mercantile system permanently changed the face of Europe. The prosperity such trading generated affected social and political relationships, necessitating new rules of etiquette and careful diplomacy. With increased disposable income, more of the newly wealthy spent money on art (among other things), expanding the number of possible patronage sources. By 1700, the growth of a moneyed class had contributed considerably to the emergence of Rococo, a decorative style associated with the wealthy and aristocratic.

BAROQUE ART OF THE SEVENTEENTH CENTURY

Italy

Although the Catholic Church launched the Counter-Reformation—its challenge to the Protestant Reformation—during the sixteenth century, the considerable appeal of Protestantism continued to preoccupy it throughout the succeeding century. The Treaty of Westphalia in 1648 had formally recognized the principle of religious freedom, serving to validate Protestantism (predominantly in the German states). With the popes and clergy continuing to serve as major artistic patrons, as in earlier centuries, much of Italian Baroque art was aimed at propagandistically restoring Catholicism's predominance and centrality. Whereas Italian Renaissance artists often had reveled in the precise, orderly rationality of classical models, Italian Baroque artists embraced a more dynamic and complex aesthetic. During the seventeenth century, dramatic theatricality, grandiose scale, and elaborate ornateness, all used to spectacular effect, characterized Italian Baroque art and architecture. Papal Rome's importance as the cradle of Italian Baroque art production further suggests the role art played in supporting the aims of the Church. The Council of Trent, one of the Counter-Reformation initiatives, firmly resisted Protestant objection to using images in religious worship, insisting on their necessity for teaching the laity. Therefore, Italian Baroque art commissioned by the Church was not merely decorative but didactic as well.

The Catholic Church waged a lengthy campaign to reestablish its preeminence. Pope Sixtus V (r. 1585–1590) contributed significantly to this initiative. He augmented the papal treasury and intended to construct a new and more magnificent Rome. Several strong and ambitious popes—Paul V, Urban VIII, Innocent X, and Alexander VII—succeeded Sixtus V and were largely responsible for building the modern city of Rome, which bears their Baroque mark everywhere. Italian seventeenth-century art and architecture visualized the renewed energy of the Catholic Counter-Reformation and communicated it to the populace.

19-1 CARLO MADERNO, Santa Susanna, Rome, Italy, 1597–1603.

A VERTICAL APPEAL TO A HIGHER POWER
The facade CARLO MADERNO (1556–1629) designed at the turn of the century for the Roman church of Santa Susanna (FIG. **19-1**) stands as one of the earliest manifestations of the Baroque spirit in Italian art and architecture. In its general appearance, Maderno's facade resembles Giacomo della Porta's immensely influential design for Il Gesù (see FIG. 17-49), the seat of the Jesuit order (which played a major role in Counter-Reformation education and did expansive overseas missionary work in the New World and the Far East). But the later facade has a greater verticality, concentrating and dramatizing the major features of its model. The facade's tall central section projects forward from the horizontal lower story, and the scroll buttresses that connect the two levels are narrower and set at a sharper angle. The elimination of an arch framing the pediment over the doorway further enhances the design's vertical thrust. Strong shadows cast by Santa Susanna's vigorously projecting columns and pilasters mount dramatically toward the emphatically stressed central axis. The recessed niches, which contain statues, heighten the sculptural effect.

RESTORING SAINT PETER'S GRANDEUR The drama inherent in Santa Susanna's facade appealed to Pope Paul V (r. 1605–1621), who commissioned Maderno in 1606 to complete Saint Peter's in Rome. As the symbolic seat of the papacy, Saint Peter's radiated enormous symbolic presence. In light of the lingering Counter-Reformation concerns, the desire of Baroque popes to conclude the extended rebuilding project and reestablish the force embodied in the mammoth structure is understandable. In many ways Maderno's facade of Saint Peter's (FIG. **19-2**) is a gigantic expansion of the elements of Santa Susanna's first level. But the compactness and verticality of the

19-2 CARLO MADERNO, facade of Saint Peter's, Vatican City, Rome, Italy, 1606–1612.

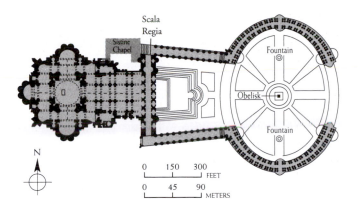

19-3 CARLO MADERNO, plan of Saint Peter's, Vatican City, Rome, Italy, with adjoining piazza designed by GIANLORENZO BERNINI.

smaller church's facade are not as prominent because Saint Peter's expansive width counterbalances them. Mitigating circumstances must be taken into consideration when assessing this design, however. The preexisting core of an incomplete building restricted Maderno, so he did not have the luxury of formulating a totally new concept for Saint Peter's. Moreover, his design for the facade was also never fully executed. The two outside bell-tower bays were not part of Maderno's original plan. Hence, had the facade been constructed according to the architect's initial design, it would have exhibited greater verticality and visual coherence.

Maderno's plan for Saint Peter's (FIG. **19-3**) also departed from the central plans designed for it during the Renaissance by Bramante (see FIG. 17-6) and, later, by Michelangelo (FIG. 17-28). Seventeenth-century clergy rejected a central plan for Saint Peter's because of its association with pagan buildings, such as the Pantheon (see FIG. 7-48). Paul V commissioned Maderno to add three nave bays to the earlier nucleus. This longitudinal plan reinforced the symbolic distinction between clergy and laity and provided a space for the processions (increasingly encouraged by the Jesuits) of ever-growing assemblies. Lengthening the nave, unfortunately, pushed the dome farther back from the facade, and the effect Michelangelo had planned—a structure pulled together and dominated by its dome—is not readily visible. When viewed at close range, the dome hardly emerges above the facade's soaring frontal plane; seen from farther back (FIG. 19-2), it appears to have no drum. Visitors must move back quite a distance from the front to see the dome and drum together and to experience the effect Michelangelo intended. Today, to truly see the structure as the sixteenth-century architect envisioned, people must view it from the back (see FIG. 17-29).

WELCOMING THE PIOUS IN ROME The design of Saint Peter's finally was completed (except for details) by GIANLORENZO BERNINI (1598–1680). Bernini was an architect, a painter, and a sculptor—one of the most important and imaginative artists of the Italian Baroque era and its most characteristic and sustaining spirit. Bernini's largest and most

19-4 Aerial view of Saint Peter's, Vatican City, Rome, Italy, 1506–1666.

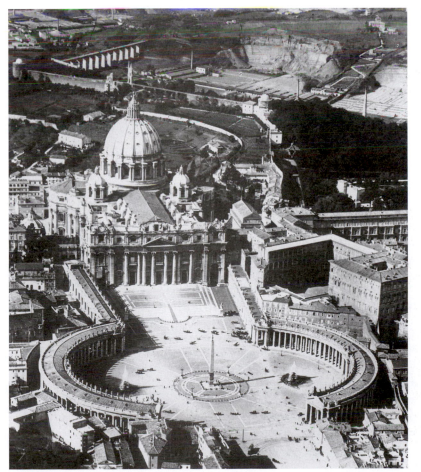

Centuries of Church History on View
Visiting Vatican City

The papacy long has been a force not only in religious matters but in the art world as well. For both of these reasons, a visit to Vatican City is a must on any trip to Italy. Vatican City is the smallest independent country in the world. It was formally established as a state in 1929 under terms of the Lateran Treaty. The complex of buildings that makes up Vatican City has more than one thousand rooms, with many open to the public.

In addition to experiencing the vast Baroque splendor of Saint Peter's (FIGS. 19-2, 19-3, 19-4, and 19-5) itself, visitors should not miss the opportunity to descend below ground (via stairs near the crossing) to view the crypts of the many popes interred there. Although Mass services are performed in Saint Peter's on occasion, opportunities to see the pope are rare. Traditionally, he makes a public appearance on Easter Sunday and, from the benediction *loggia* (the balcony) of the Saint Peter's facade, blesses the thousands who gather in the piazza.

Between the piazza and the papal apartments is the Scala Regia (FIG. 19-6) Bernini designed. Behind this staircase is the Sistine Chapel. The restoration of both the ceiling and the

Last Judgment are complete, allowing spectators to view Michelangelo's cleaned frescoes (see FIGS. 17-13, 17-14, 17-15, 17-16, and 17-25) unimpeded by scaffolding.

The Papal Palace houses the papal apartments, government offices of the Roman Catholic Church, several chapels, and a library. The library (officially named the Biblioteca Apostolica Vaticana) contains more than one million six hundred thousand books, along with manuscripts, prints, engravings, coins, and medals, and is available for scholarly use. Most rooms in the papal apartments are open for public viewing; the Stanza della Segnatura, with Raphael's frescoes (see FIG. 17-17) is a highlight.

Vatican City is also home to an extraordinary art collection scattered throughout several Vatican Museums. In addition to paintings and sculptures, these museums house maps, tapestries, historical items, Egyptian and Etruscan artifacts, and ethnographic objects that Catholic missionaries collected.

Together, these buildings, artworks, and collections speak of a long and storied history—of art and life in the service of religion.

impressive single project was the design for a monumental *piazza* (plaza; 1656–1667) in front of Saint Peter's (FIGS. 19-3 and **19-4**). In much the way Michelangelo was forced to reorganize the Capitoline Hill (see FIG. 17-26), Bernini had to adjust his design to some preexisting structures on the site—an ancient obelisk the Romans brought from Egypt (which Pope Sixtus V had relocated to the piazza in 1585 as part of his vision of Christian triumph in Rome) and a fountain Maderno designed. He used these features to define the long axis of a vast oval embraced by colonnades joined to the Saint Peter's facade by two diverging wings. Four rows of huge Tuscan columns make up the two colonnades, which terminate in severely Classical temple fronts. The dramatic gesture of embrace the colonnades make as viewers enter the piazza symbolizes the welcome the Roman Catholic Church gave its members during the Counter-Reformation. Bernini himself referred to his design of the colonnade as appearing like the welcoming arms of the church.

The wings that connect the Saint Peter's facade with the oval piazza flank a trapezoidal space also reminiscent of the Campidoglio (see FIG. 17-26), but here the latter's visual effect was reversed. As seen from the piazza, the diverging wings counteract the natural perspective and tend to bring the facade closer to observers. Emphasizing the facade's height in this manner, Bernini subtly and effectively compensated for its extensive width. Thus, a Baroque transformation expanded the compact central designs of Bramante and Michelangelo into a dynamic complex of axially ordered elements that reach out and enclose spaces of vast dimension. By its sheer scale and theatricality, the complete Saint Peter's

fulfilled Catholicism's needs in the seventeenth century by presenting an awe-inspiring and authoritative vision of the Church.

A SOARING BRONZE CANOPY Long before the planning of the piazza, Bernini had been at work decorating the interior of Saint Peter's. His first commission, completed between 1624 and 1633, called for the design and erection of the gigantic bronze baldacchino (FIG. **19-5**) above the main altar under the great dome. The canopy-like structure (*baldacco* is Italian for "silk from Baghdad," such as for a cloth canopy) marks the tomb of Saint Peter. Almost one hundred feet high (the height of an average eight-story building), the baldacchino serves as a focus of the church's splendor. It at once harmonizes with the tremendous proportions of the new church and visually bridges human scale to the lofty vaults and dome above. Its four spiral columns recall those of the ancient baldacchino over the same spot in Old Saint Peter's, thereby invoking the past to reinforce the Roman Catholic Church's primacy. Partially fluted and wreathed with vines, the columns seem to deny the mass and weight of the tons of bronze resting on them. (The metal was stripped from the Pantheon's portico—ideologically appropriate, given the Church's rejection of paganism.) At the top of the columns four colossal angels stand guard at the upper corners of the canopy. Forming the canopy's apex are four serpentine brackets that elevate the orb and the cross, symbols of the Church's triumph since the time of the emperor Constantine (see FIG. 7-82, right), builder of the original Saint Peter's basilica. The baldacchino also features numerous bees, symbols of the

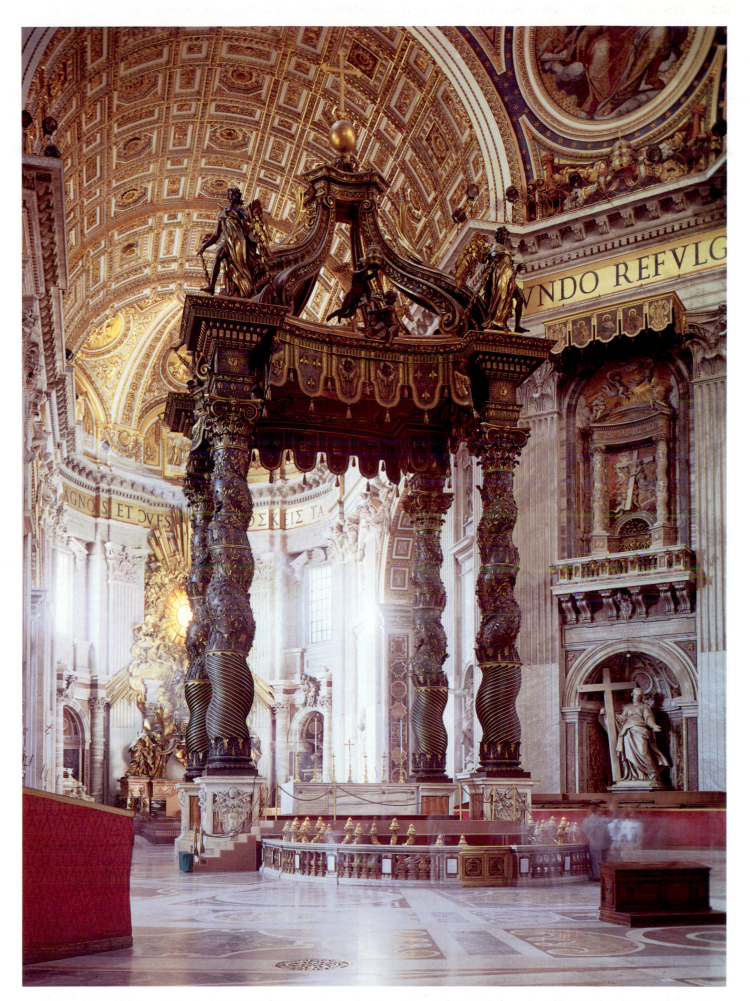

19-5 GIANLORENZO BERNINI, baldacchino, Saint Peter's, Vatican City, Rome, Italy, 1624–1633. Gilded bronze, approx. 100' high.

Barberini family. As the official patron of the work, Pope Urban VIII (Maffeo Barberini, r. 1623–1644) undoubtedly desired appropriate recognition. The structure effectively visualizes the triumph of Christianity and the papal claim to doctrinal supremacy.

The concepts of triumph and grandeur unified both the architecture and the design program of Saint Peter's during the seventeenth century (see "Centuries of Church History on View: Visiting Vatican City," page 612). Suggesting a great and solemn procession, the main axis of the complex traverses the piazza (marked but slowed by the central obelisk) and enters Maderno's nave. It comes to a temporary halt at the altar beneath the baldacchino, but it continues on toward its climactic destination at another great altar in the apse.

A STAIRWAY TO HEAVEN? Bernini demonstrated his impressive skill at transforming space in another project he undertook in Vatican City, the Scala Regia or Royal Stairway (FIG. **19-6**). This monumental corridor of steps connects the papal apartments to the portico and narthex of Saint Peter's. Because the original passageway was irregular, dark, and dangerous to descend, Pope Alexander VII (r. 1655–1667) commissioned Bernini to replace it. The stairway, its entrance

crowned by a sculptural group of trumpeting angels and the papal arms, is covered by a barrel vault (built in two sections) carried on columns that form aisles flanking the central corridor. By gradually reducing the distance between the columns and walls as the stairway ascends, Bernini actually eliminated the aisles on the upper levels while creating an illusion of width uniformity and aisle continuity for the whole stairway. Likewise, the space between the colonnades narrows with ascent, reinforcing the natural perspective and making the stairs appear longer than they actually are. To minimize this effect, Bernini made the lighting at the top of the stairs brighter, exploiting the natural human inclination to move from darkness toward light. To make the long ascent more tolerable, he inserted an illuminated landing that provides a midway resting point. The result is a highly sophisticated design, both dynamic and dramatic, that repeats on a smaller scale, perhaps even more effectively, the processional sequence found inside Saint Peter's.

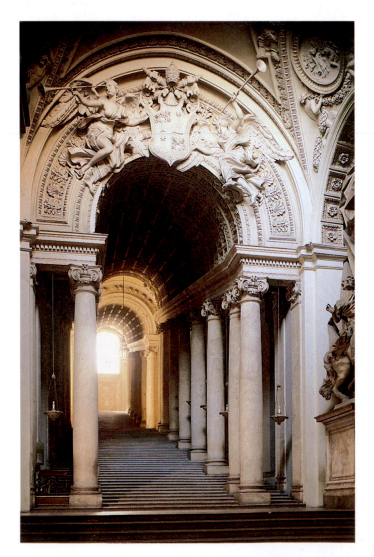

19-6 GIANLORENZO BERNINI, Scala Regia, Vatican City, Rome, Italy, 1663–1666.

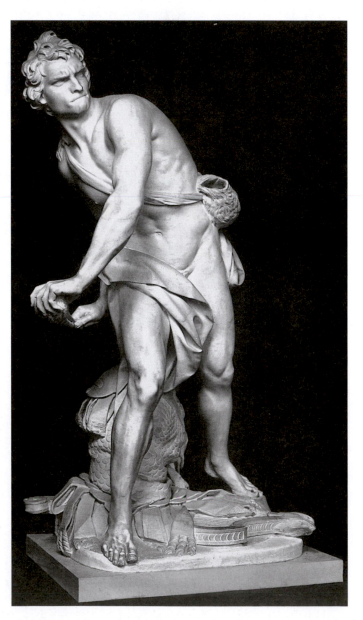

19-7 GIANLORENZO BERNINI, *David*, 1623. Marble, approx. 5′ 7″ high. Galleria Borghese, Rome.

DECISIVE AND DRAMATIC ACTION Bernini devoted much of his prolific career to the adornment of Saint Peter's, where his works combine sculpture with architecture. Although Bernini was a great and influential architect, his fame rests primarily on his sculpture, which, like his architecture, energetically expresses the Italian Baroque spirit. Bernini's sculpture is expansive and dramatic, and the element of time usually plays an important role in it. A sculpture that predates his work on Saint Peter's is his *David* (FIG. **19-7**), commissioned by Cardinal Scipione Borghese. This marble statue aims at catching the figure's split-second action and differs markedly from the restful figures of David portrayed by Donatello (see FIG. 16-23), Verrocchio (see FIG. 16-24), and Michelangelo (see FIG. 17-9). Bernini's *David,* his muscular legs widely and firmly planted, is beginning the violent, pivoting motion that will launch the stone from his sling. If the action had been a moment before, his body would have been in one position; the moment after, it would have been in a completely different one. Unlike Myron, the fifth-century B.C. Greek sculptor whose Diskobolus (see FIG. 5-37) is frozen in inaction, Bernini selected the most dramatic of an implied sequence of poses, so observers have to think simultaneously of the continuum and of this tiny fraction of it. The suggested continuum imparts a dynamic quality to the statue that conveys a bursting forth of the energy seen confined in Michelangelo's figures (see FIGS. 17-9 and 17-10). Bernini's statue seems to be moving through time and through space. This is not the kind of sculpture that can be inscribed in a cylinder or confined in a niche; its indicated action demands space around it. Nor is it self-sufficient in the Renaissance sense, as its pose and attitude direct the observer's attention beyond it to its surroundings (in this case, toward an unseen Goliath). Bernini's sculptured figure moves out into and partakes of the physical space that surrounds it and observers. Further, the almost ferocious expression on David's face is a far cry from the placid visages of previous Davids and augments this sculpture's dramatic impact.

AN ECSTATIC AND RADIANT VISION Another Bernini sculpture that displays the expansive quality of Italian Baroque art and its refusal to limit itself to firmly defined spatial settings is *Ecstasy of Saint Theresa* in the Cornaro Chapel (FIG. **19-8**) of the Roman church of Santa Maria della Vittoria. For this chapel, Bernini drew on the full resources of

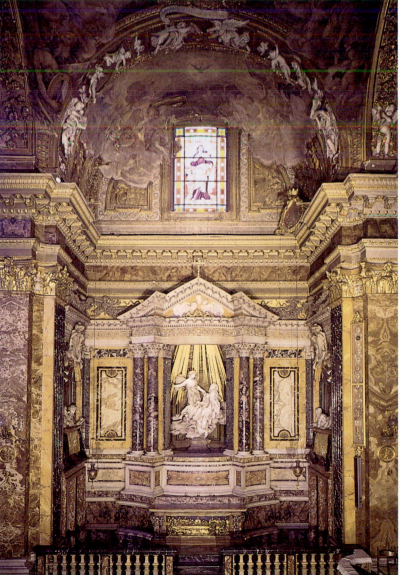

19-8 GIANLORENZO BERNINI, interior of the Cornaro Chapel, Santa Maria della Vittoria, Rome, Italy, 1645–1652.

architecture, sculpture, and painting to charge the entire area with dramatic tension. Saint Theresa was a nun of the Carmelite order and one of the great mystical saints of the Spanish Counter-Reformation. Her conversion occurred after the death of her father, when she fell into a series of trances, saw visions, and heard voices. Feeling a persistent pain, she attributed it to the fire-tipped arrow of Divine love that an angel had thrust repeatedly into her heart. In her writings, Saint Theresa described this experience as making her swoon in delightful anguish. The whole chapel became a theater for the production of this mystical drama. The niche in which it takes place appears as a shallow *proscenium* (the part of the stage in front of the curtain) crowned with a broken Baroque pediment and ornamented with polychrome marble. On either side of the chapel, relief-sculptured portraits of the Cornaro family behind draped praying desks attest to the piety of the patrons (Cardinal Federico Cornaro and his relatives) attending this heavenly drama. Bernini depicted the saint in ecstasy (FIG. **19-9**), unmistakably a mingling of spiri-

tual and physical passion, swooning back on a cloud, while the smiling angel aims his arrow. The entire sculptural group is made of white marble, and Bernini's supreme technical virtuosity is evident in the visual differentiation in texture among the clouds, rough monk's cloth, gauzy material, smooth flesh, and feathery wings. Light from a hidden window of yellow glass pours down on bronze rays that suggest the radiance of Heaven, whose painted representation covers the vault (FIG. 19-8). (Hidden lights have been installed near the top of the rays to ensure visitors to the chapel a consistent viewing experience.) The passionate drama of Bernini's sculpture correlated with the ideas disseminated by Ignatius Loyola, founder of the Jesuit order and later canonized as Saint Ignatius. In his book *Spiritual Exercises,* Ignatius argued that the re-creation of spiritual experiences for viewers would do much to increase devotion and piety. Thus, theatricality and sensory impact were useful vehicles for achieving Counter-Reformation goals. Bernini was an extremely devout Catholic, which undoubtedly contributed to his understanding of those

19-9 GIANLORENZO BERNINI, *Ecstasy of Saint Theresa,* Cornaro Chapel, Santa Maria della Vittoria, Rome, Italy, 1645–1652. Marble, height of group 11′ 6″.

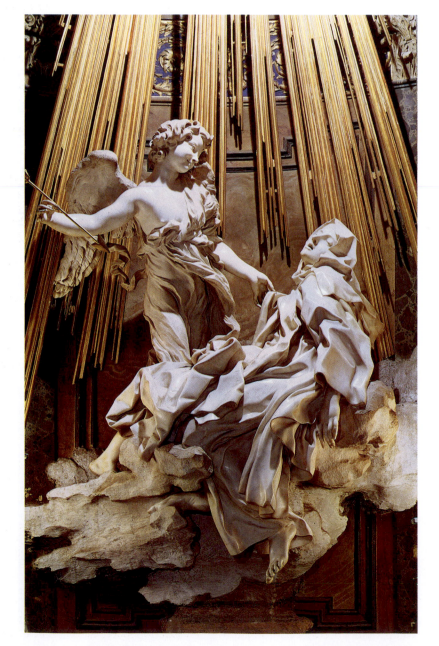

signed not to separate but to provide a fluid transition between the two. This functional interrelation of the building and its environment is underlined by the curious fact it has not one but two facades. The second, a narrow bay crowned with its own small tower, turns away from the main facade and, following the curve of the street, faces an intersection. (The upper facade was completed seven years after Borromini's death, and historians cannot be sure to what degree the present design reflects his original intention.)

The interior is not only an ingenious response to an awkward site but also a provocative variation on the theme of the centrally planned church. In plan (FIG. **19-11**) San Carlo looks like a hybrid of a Greek cross and an oval, with a long axis between entrance and apse. The side walls move in an undulating flow that reverses the facade's motion. Vigorously projecting columns define the space into which they protrude just as much as they do the walls attached to them. This molded interior space is capped by a deeply coffered oval dome that seems to float on the light entering through windows hidden in its base. Rich variations on the basic theme of the oval, dynamic relative to the static circle, create an interior that appears to flow from entrance to altar, unimpeded by the segmentation so characteristic of Renaissance buildings.

A COHESIVE SHELL EMBRACING THE PIOUS The unification of interior space is carried even further in Borromini's Chapel of Saint Ivo in the courtyard of the

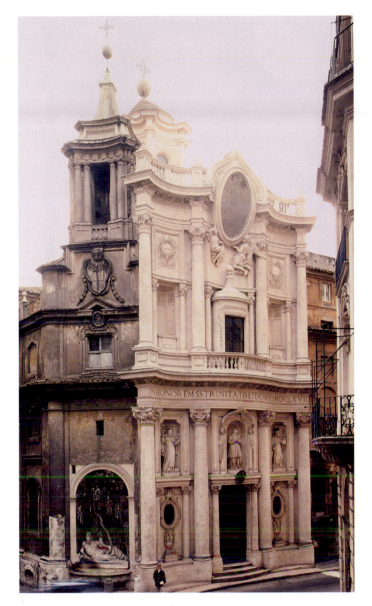

19-10 FRANCESCO BORROMINI, facade of San Carlo alle Quattro Fontane, Rome, Italy, 1665–1676.

goals. His inventiveness, technical skill, sensitivity to his patrons' needs, and energy account for his position as *the* quintessential Italian Baroque artist.

A CHURCH FACADE IN MOTION? FRANCESCO BORROMINI (1599–1667) took Italian Baroque architecture to even greater dramatic heights. A new dynamism appeared in the little church of San Carlo alle Quattro Fontane (Saint Charles of the Four Fountains; FIG. **19-10**), where Borromini went well beyond any of his predecessors or contemporaries in emphasizing a building's sculptural qualities. Although Maderno incorporated sculptural elements in his designs for the facades of Santa Susanna (FIG. 19-1) and Saint Peter's (FIG. 19-2), they still develop along relatively lateral planes. Borromini set his whole facade in undulating motion, forward and back, making a counterpoint of concave and convex elements on two levels (for example, the sway of the cornices). He emphasized the three-dimensional effect with deeply recessed niches. This facade is not the traditional flat frontispiece that defines a building's outer limits. It is a pulsating, engaging component inserted between interior and exterior space, de-

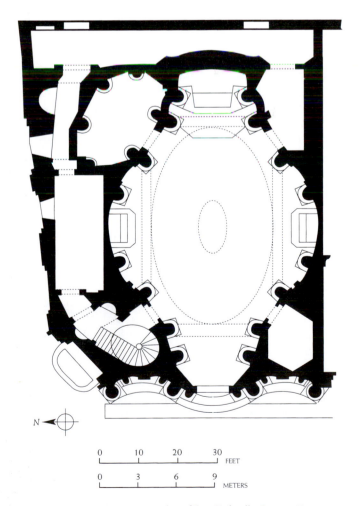

19-11 FRANCESCO BORROMINI, plan of San Carlo alle Quattro Fontane, Rome, Italy, 1638–1641.

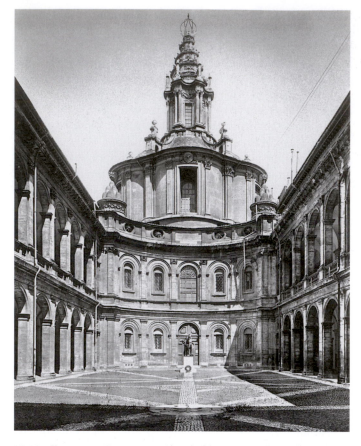

19-12 Francesco Borromini, Chapel of Saint Ivo, College of the Sapienza, Rome, Italy, begun 1642.

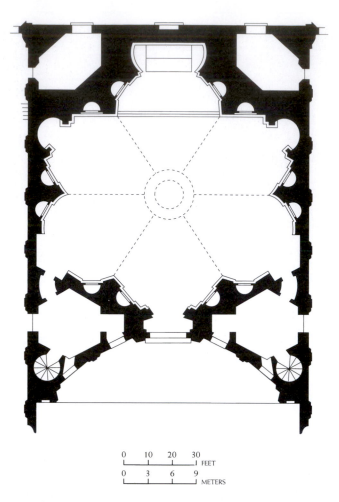

```
0      10     20     30
|      |      |      | FEET
0      3      6      9
|      |      |      | METERS
```

19-13 Francesco Borromini, plan of the Chapel of Saint Ivo, College of the Sapienza, Rome, Italy, begun 1642.

College of the Sapienza (Wisdom) in Rome (FIG. **19-12**). In his characteristic manner, Borromini played concave against convex forms on the upper level of this chapel's exterior. The lower stories of the court, which frame the bottom facade, were already there when Borromini began work. Above the facade's inward curve—its design adjusted to the earlier arcades of the court—rises a convex drumlike structure that supports the dome's lower parts. Powerful pilasters restrain the forces that seem to push the bulging forms outward. Buttresses above the pilasters curve upward to brace a tall, ornate lantern topped by a spiral that seems to fasten the structure, screw-like, to the sky.

The centralized plan of the Saint Ivo chapel (FIG. **19-13**) is that of a star, having rounded-off points and apses on all sides. Indentations and projections along the angled curving walls create a highly complex plan, with all the elements fully reflected in the interior elevation. From floor to lantern, the wall panels rise in a continuously tapering sweep halted only momentarily by a single horizontal cornice (FIG. **19-14**). Thus, the dome is not, as in the Renaissance, a separate unit placed on the supporting block of a building. It is an organic part that evolves out of and shares the qualities of the supporting walls, and it cannot be separated from them. This continuous complexity creates a dynamic and cohesive shell that encloses and energetically molds a scalloped fragment of universal space. Few architects have matched Borromini's ability to translate extremely complicated designs into such masterfully unified structures as Saint Ivo.

A TRIPARTITE FACADE The heir to Borromini's sculptured architectural style was GUARINO GUARINI (1624–1683), a priest, mathematician, and architect who spent the last seventeen years of his life in Turin converting that provincial Italian town into a showcase of architectural theories that later swept much of Europe. In his Palazzo Carignano (FIG. **19-15**), Guarini effectively applied Borromini's principle of undulating facades. He divided his long facade into three units, the central one curving much like the facade of San Carlo alle Quattro Fontane (FIG. 19-10) and flanked by two blocklike wings. This lateral three-part division of facades, characteristic of most Baroque palazzi, is probably based on the observation that the average person instinctively can recognize up to three objects as a unit. A greater number would require observers to count each object individually. A tripartite organization of extended surfaces thus allowed artists to introduce variety into their designs without destroying structural unity. It also permitted adding emphasis to the central axis, which Guarini did here most effectively by punching out deep cavities in the middle of his convex central block. He enhanced the variety of his design with richly textured surfaces (all executed in brick) and pilasters, which further subdivide his units into three bays each. High and low reliefs create shadows of different intensities and add to the decorative effect.

19-14 Chapel of Saint Ivo (view into dome), College of the Sapienza, Rome, Italy, begun 1642.

19-15 GUARINO GUARINI, Palazzo Carignano, Turin, Italy, 1679–1692.

A KALEIDOSCOPIC VISION OF HEAVEN Guarini's mathematical talents must have guided him when he designed the extraordinarily complex dome of the Chapel of the Santissima Sindone (Holiest Shroud), a small central-plan building attached to the Turin Cathedral. A view into this dome (FIG. **19-16**) reveals a bewildering display of geometric elements appearing to move in kaleidoscopic fashion around a circular focus containing a painting of the bright Dove of the Holy Spirit. Here, the architect transformed the traditional dome into a series of segmented intersecting arches. A comparison of Guarini's dome with that of the church of Sant'Eligio degli Orefici in Rome (FIG. **19-17**), attributed both to Bramante and to Raphael

and reconstructed about 1600, indicates that a fundamental change occurred. The pristine clarity of the latter's unmodified circular shape immediately recalls the Pantheon dome (see FIG. 7-50). Guarini converted the static "dome of Heaven" of Renaissance architecture and philosophy into the dynamic Italian Baroque design that conveys a dramatic spiritual presence.

The styles of Borromini and Guarini moved across the Alps and inspired architects in Austria and southern Germany (FIG. 19-76) in the late seventeenth and early eighteenth centuries. These styles were also particularly popular in the Catholic regions of Europe and the New World (especially in Brazil).

19-16 GUARINO GUARINI, Chapel of Santissima Sindone (view into dome), Turin, Italy, 1667–1694.

19-17 Dome of Sant'Eligio degli Orefici (view into dome), Rome, Italy, attributed to BRAMANTE and RAPHAEL, ca. 1509; reconstructed ca. 1600.

NATURALIZING RELIGIOUS ART Although sculpture and architecture provided the most obvious vehicles for manipulating space and creating theatrical effects, painting continued to be an important art form, as it was in previous centuries. Among the most noted Italian Baroque painters were Caravaggio and Annibale Carracci, whose styles, although different, were both thoroughly in accord with the period. MICHELANGELO MERISI, known as CARAVAGGIO (1573–1610) after the northern Italian town he came from, developed a unique style that had tremendous influence throughout Europe. His outspoken disdain for the classical masters (probably more vocal than real) drew bitter criticism from many painters, one of whom denounced him as the "anti-Christ of painting." Giovanni Pietro Bellori, the most influential critic of the age and an admirer of Carracci, felt that Caravaggio's refusal to emulate the models of his distinguished predecessors threatened the whole classical tradition of Italian painting that had reached its zenith in Raphael's work. Yet despite this criticism and the problems in Caravaggio's troubled life (reconstructed from documents such as police records), many paid Caravaggio the supreme compliment of borrowing from his innovations. His influence on later artists, as much outside Italy as within, was immense. In his art, Caravaggio naturalized both religion and the classics, reducing them to human dramas played out in the harsh and dingy settings of his time and place. His unidealized figures selected from the fields and the streets were, however, effective precisely because of the Italian public's familiarity with such figures.

STARK CONTRASTS OF LIGHT AND DARK
Caravaggio painted *Conversion of Saint Paul* (FIG. **19-18**) for the Cerasi Chapel in the Roman church of Santa Maria del Popolo. It illustrates the conversion of the Pharisee Saul to Christianity, when he became the disciple Paul. The saint-to-be appears amid his conversion, flat on his back with his arms thrown up. In the background, an old hostler seems preoccupied with caring for the horse. At first inspection, little here suggests the momentous significance of the spiritual event taking place. The painting's viewers seem to be witnessing a mere stable accident, not a man overcome by a great miracle. Although Caravaggio departed from traditional depictions of such religious scenes, the eloquence and humanity with which he imbued his paintings impressed many. As a result, Caravaggio found numerous sympathetic patrons both within the Roman Catholic Church and from secular realms.

Caravaggio also employed other formal devices to compel the viewer's interest and involvement in the event. In *Conversion of Saint Paul,* he used a perspective and a chiaroscuro intended to bring viewers as close as possible to the scene's space and action, almost as if they were participating in it. The sense of inclusion is augmented by the low horizon line. Caravaggio designed *Conversion of Saint Paul* for presentation on the chapel wall, positioned at the viewers' line of sight as they stand at the chapel entrance. In addition, the sharply lit figures are meant to be seen as emerging from the dark of the background. The actual light from the chapel's windows functions as a kind of stage lighting for the production of a vision, analogous to the rays in Bernini's *Ecstasy of Saint Theresa* (FIG. 19-9). Thus, Caravaggio, like Bernini, injected the theatrical into his art.

Caravaggio's use of light is certainly dramatic. The stark contrast of light and dark was the feature of Caravaggio's style that first shocked and then fascinated his contemporaries. Caravaggio's use of dark settings enveloping their occupants, which profoundly influenced European art, has been called *tenebrism,* from the Italian word *tenebroso,* or "shadowy" manner. Although tenebrism was widespread in seventeenth-century art, it made its most emphatic appearance in the art of

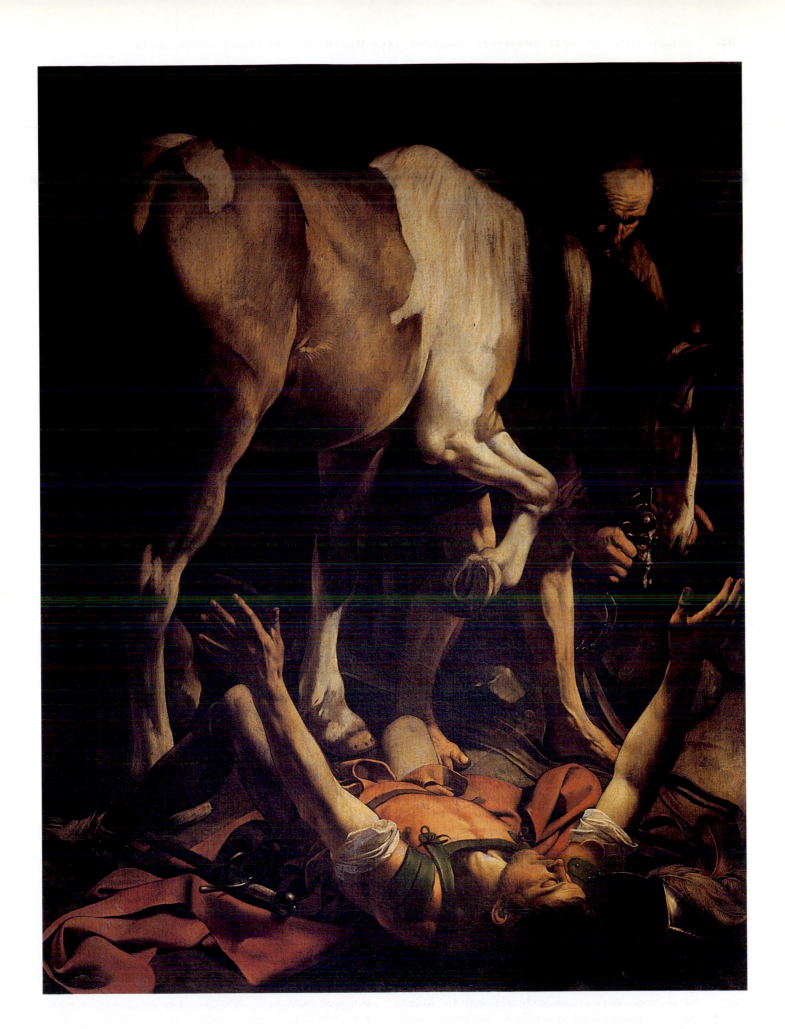

19-18 CARAVAGGIO, *Conversion of Saint Paul*, Cerasi Chapel, Santa Maria del Popolo, Rome, Italy, ca. 1601. Oil on canvas, approx. 7′ 6″ × 5′ 9″.

19-19 CARAVAGGIO, *Calling of Saint Matthew*, Contarelli Chapel, San Luigi dei Francesi, Rome, Italy, ca. 1597–1601. Oil on canvas, 11′ 1″ × 11′ 5″.

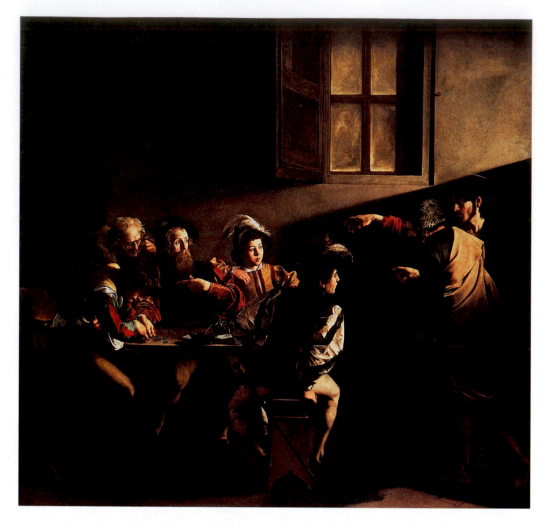

Spain and of the Netherlands. In Caravaggio's work, tenebrism also contributed mightily to the essential meaning of his pictures. In *Conversion of Saint Paul,* the dramatic spotlight shining down upon the fallen Pharisee is the light of divine revelation converting Saul to Christianity.

FROM TAX COLLECTOR TO DISCIPLE A piercing ray of light illuminating a world of darkness and bearing a spiritual message is also a central feature of one of Caravaggio's early masterpieces, *Calling of Saint Matthew* (FIG. **19-19**). It is one of two large canvases honoring Saint Matthew the artist painted for the side walls of the Contarelli Chapel in San Luigi dei Francesi in Rome. The commonplace setting is typical of Caravaggio—a bland street scene with a plain building wall serving as a backdrop. Into this mundane environment, cloaked in mysterious shadow and almost unseen, Christ, identifiable initially only by his indistinct halo, enters from the right. With a commanding gesture that recalls that of the Lord in Michelangelo's *Creation of Adam* on the Sistine Chapel ceiling (see FIG. 17-14), he summons Levi, the Roman tax collector, to a higher calling. The astonished tax collector, whose face is highlighted for viewers by the beam of light emanating from an unspecified source above Christ's head and outside the picture, points to himself in disbelief. Although Christ's extended arm is reminiscent of the Lord in *Creation of Adam,* the position of Christ's hand and wrist is similar to that of Adam. This reference is highly appropriate—theologi-

cally, Christ is the second Adam. While Adam was responsible for the Fall of Man, Christ is responsible for human redemption. The conversion of Levi (who became Matthew) brought his salvation.

VISUALIZING TRANSUBSTANTIATION In 1603, Caravaggio produced a large-scale painting, *Entombment* (FIG. **19-20**), for the Chapel of Pietro Vittrice at Santa Maria in Vallicella in Rome. This work includes all the hallmarks of Caravaggio's distinctive style: the plebeian figure types (particularly visible in the scruffy, worn face of Nicodemus—a Pharisee Christ taught who holds Christ's legs in the foreground), the stark use of darks and lights, and the invitation for viewers to participate in the scene. As in *Conversion of Saint Paul,* the action takes place here in the foreground. The artist positioned the figures on a stone slab whose corner appears to extend into the viewer's space. This suggests that Christ's body will be laid directly in front of viewers.

Beyond its ability to move its audience, such a composition also had theological implications. In light of the ongoing Counter-Reformation efforts, such implications cannot be overlooked. To viewers in the chapel, it appeared as though the men were laying Christ's body onto the altar, which was in front of the painting. This served to visualize the doctrine of *transubstantiation* (the transformation of the Eucharist and wine into the Body and Blood of Christ)—a doctrine central to Catholicism but rejected by Protestants. By depicting

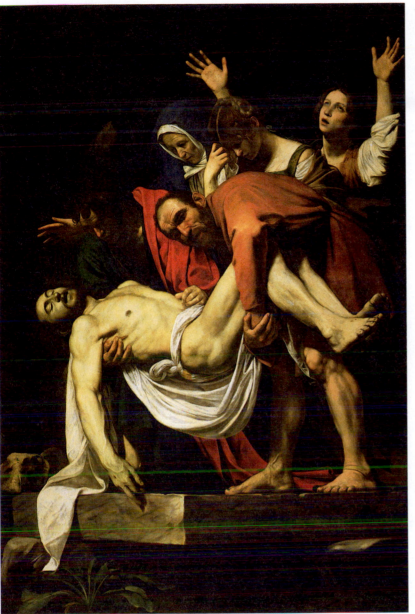

19-20 CARAVAGGIO, *Entombment,* from the chapel of Pietro Vittrice, Santa Maria in Vallicella, Rome, Italy, ca. 1603. Oil on canvas, 9′ 10⅛″ × 6′ 7¹⁵⁄₁₆″. Musei Vaticani, Pinacoteca, Rome.

Christ's body as though it were physically present during the Mass, Caravaggio visually articulated an abstract theological precept. Unfortunately, viewers no longer can experience this effect.

IN THE FOOTSTEPS OF CARAVAGGIO Caravaggio's style became increasingly popular, and his combination of naturalism and drama appealed both to patrons and artists. A significant artist often discussed as a "Caravaggista" (a close follower of Caravaggio) is ARTEMISIA GENTILESCHI (ca. 1593–1653). Gentileschi was instructed by her artist father Orazio, who was himself strongly influenced by Caravaggio. Her successful career, pursued in Florence, Venice, Naples, and Rome, helped to disseminate Caravaggio's manner throughout the peninsula.

 In her *Judith Slaying Holofernes* (FIG. **19-21**), Gentileschi used the tenebrism and what might be called the "dark" subject matter Caravaggio favored. Significantly, Gentileschi chose a narrative involving a heroic female, a favorite theme of hers. The story, from an Apocryphal work of the Old Testa-

ment, the Book of Judith, relates the delivery of Israel from its enemy, Holofernes. Having succumbed to Judith's charms, the Assyrian general Holofernes invited her to his tent for the night. When he fell asleep, Judith cut off his head. In this version of the scene (Gentileschi produced more than one image of Judith), Judith and her maidservant are beheading Holofernes. The event's drama cannot be evaded—blood spurts everywhere, and the strength necessary to complete the task is evident as the two women struggle with the sword. The tension and strain are palpable. The controlled highlights on the action in the foreground recall Caravaggio's work and heighten the drama here as well.

DRAWN TO THE CLASSICS In contrast to Caravaggio, ANNIBALE CARRACCI (1560–1609) not only studied but also emulated the Renaissance masters carefully. Carracci received much of his training at an academy of art in his native Bologna. Founded cooperatively by his family members, among them his cousin Ludovico Carracci (1555–1619) and brother Agostino Carracci (1557–1602), the Bolognese

19-21 ARTEMISIA GENTILESCHI, *Judith Slaying
Holofernes,* ca. 1614–1620. Oil on canvas, 6′ 6 $\frac{1}{3}$″ × 5′ 4″.
Galleria degli Uffizi, Florence.

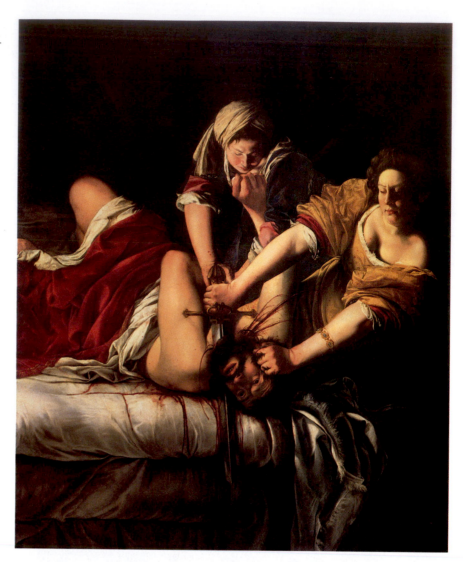

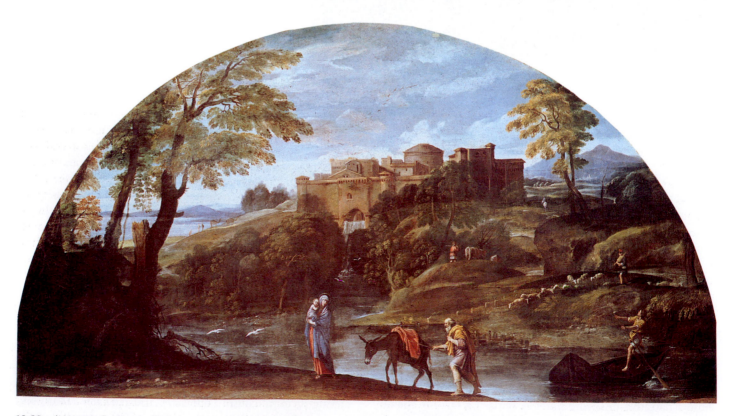

19-22 ANNIBALE CARRACCI, *Flight into Egypt,* 1603–1604. Oil on canvas, approx. 4′ × 7′ 6″. Galleria Doria Pamphili, Rome.

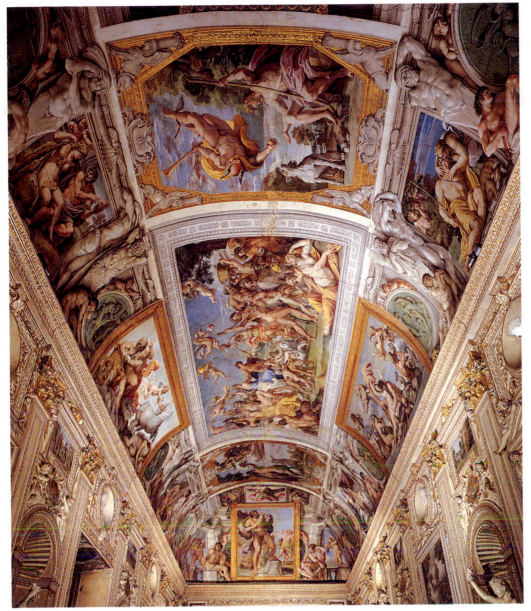

19-23 ANNIBALE CARRACCI, *Loves of the Gods,* ceiling frescoes in the gallery, Palazzo Farnese, Rome, Italy, 1597–1601.

academy was the first significant institution of its kind in the history of Western art. It was founded on the premises that art can be taught—the basis of any academic philosophy of art—and that its instruction must include the classical and Renaissance traditions in addition to studying anatomy and life drawing. Thus, in contrast to Caravaggio's more "naturalistic" style, Carracci embraced a more classically ordered style.

For example, in his *Flight into Egypt* (FIG. **19-22**), based on the biblical narrative from Matthew 2:13–14, Carracci created the "ideal" or "classical" landscape. Here he pictorially represented nature ordered by divine law and human reason. The style's roots are in the landscape backgrounds of Venetian Renaissance paintings (compare FIG. 17-33). Tranquil hills and fields, quietly gliding streams, serene skies, unruffled foliage, shepherds with their flocks—all the props of the pastoral scene and mood—expand in such paintings to fill the picture space. Carracci regularly included screens of trees in the foreground, dark against the sky's even light. In this scene, streams or terraces, carefully placed one above the

other and narrowed, zigzag through the terrain, leading the viewer's eyes back to the middle ground. There, many Venetian Renaissance landscape artists depicted architectural structures (as Carracci did in *Flight into Egypt*)—walled towns or citadels, towers, temples, monumental tombs, villas. Such constructed environments captured idealized antiquity and the idyllic life. Although the artists often took the subjects for these classically rendered scenes from religious or heroic stories, they seem to have given precedence to the pastoral landscapes over the narratives. Here, Mary, with the Christ Child, and Saint Joseph are greatly diminished in size, simply becoming part of the landscape as they wend their way slowly to Egypt after having been ferried across a stream (Matt. 2:13–14).

A CEILING FIT FOR THE GODS Among Carracci's most notable works is his decoration of the Palazzo Farnese gallery (FIG. **19-23**) in Rome. Cardinal Odoardo Farnese, a wealthy descendant of Pope Paul III, commissioned this ceiling fresco to celebrate the wedding of the cardinal's brother.

Appropriately, its iconographic program is titled *Loves of the Gods*—interpretations of the varieties of earthly and divine love in classical mythology.

Carracci arranged the scenes in a format resembling framed easel paintings on a wall, but here he painted them on the surfaces of a shallow curved vault. The Sistine Chapel ceiling (see FIG. 17-13), of course, comes to mind, although it is not an exact source. This type of simulation of easel painting for ceiling design is called *quadro riportato* (transferred framed painting). Carracci's great influence made it fashionable for more than a century. The framed pictures are flanked by polychrome seated nude youths, who turn their heads to gaze at the scenes around them, and by standing Atlas figures painted to resemble marble statues. Carracci derived these motifs from Michelangelo's Sistine Chapel ceiling. Notably, the chiaroscuro is not the same for both the pictures and the figures surrounding them. The painter modeled the figures inside the quadri in an even sculptured light. The outside figures seem to be lit from beneath, as if they were actual three-dimensional beings or statues illuminated by torches in the gallery below. This interest in illusion, already manifest in the Renaissance, continued in the grand ceiling compositions of the seventeenth century. In the crown of the vault, a long panel representing the *Triumph of Bacchus* is a quite ingenious mixture of Raphael and Titian. It reflects Carracci's adroitness in adjusting their authoritative styles to make something of his own.

A HEAVENLY SCENE BY A "DIVINE" ARTIST
Another artist trained in the Bolognese academy, GUIDO RENI (1575–1642), selected Raphael for his inspiration, as is evident in his *Aurora* (FIG. 19-24), a ceiling fresco in the Casino Rospigliosi in Rome. Aurora (Dawn) leads Apollo's chariot, while the Hours dance about it. Reni conceived *Aurora* in

quadro riportato, like the paintings in Carracci's *Loves of the Gods,* and painted a complex and convincing illusionistic frame. The fresco exhibits a suave, almost swimming, motion; soft modeling; and sure composition, without Raphael's sculpturesque strength. It is an intelligent interpretation of the master's style and of ancient classical art, for the ultimate sources of the composition were Roman reliefs (see FIG. 7-39) and coins depicting emperors in triumphal chariots accompanied by flying Victories and other personifications. Due to paintings such as *Aurora*, Reni was so much admired in his own day and well into the nineteenth century that he was known as "the divine Guido."

The impressive ceiling frescoes produced by Carracci and others inspired many artists and patrons to explore the capabilities of ceiling painting. The experience of looking up at a painting is different from simply looking at a painting hanging on a wall. The considerable height and the expansive scale of most ceiling frescoes induce a feeling of awe.

THE GLORY OF THE BARBERINI FAMILY Patrons who wanted to burnish their public images or control their legacies found monumental ceiling frescoes perfect vehicles for such statements. In 1633, Pope Urban VIII commissioned a ceiling fresco for the Gran Salone of the Palazzo Barberini in Rome. This project was the most important decorative commission of the 1630s, and thus artists highly coveted it. Urban VIII selected PIETRO DA CORTONA (1596–1669), a fellow Tuscan who had moved to Rome in about 1612. By the 1630s, Cortona had established himself as a respected artist. The grandiose and spectacular *Triumph of the Barberini* (FIG. 19-25) overwhelms spectators with the glory of the Barberini family (and Urban VIII in particular). The iconographic program for this fresco, designed by the poet Francesco Bracci-

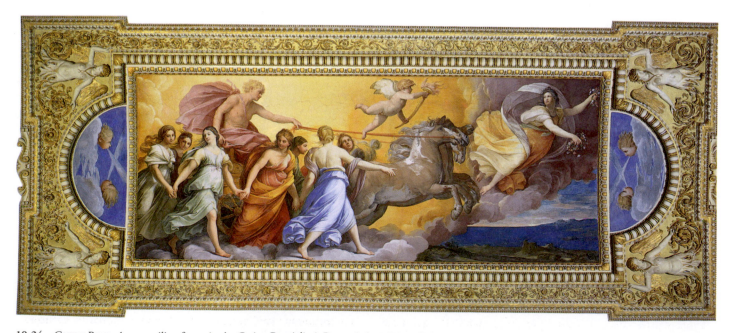

19-24 GUIDO RENI, *Aurora*, ceiling fresco in the Casino Rospigliosi, Rome, Italy, 1613–1614.

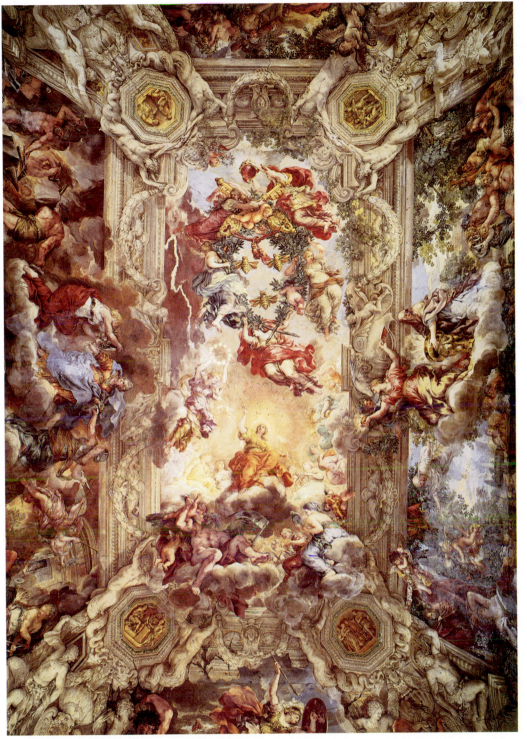

olini, centered on the accomplishments of the Barberini. Divine Providence appears in a halo of radiant light, directing Immortality, holding a crown of stars, to bestow eternal life on the Barberini family. The laurel wreath (also a symbol of immortality) reinforces the enduring Barberini legacy. It floats around the bees (the Barberini family's symbols, as already seen in Bernini's baldacchino, FIG. 19-5) and is supported by the virtues Faith, Hope, and Charity. The papal tiara and keys announcing the personal triumphs of Urban VIII are also clearly visible.

IN THE PRESENCE OF JESUS The dazzling spectacle of ceiling frescoes also proved very effective for commissions illustrating religious themes. Church authorities realized that such paintings, high above the ground, offered perfect opportunities to impress on viewers the Catholic Church's glory and power. In conjunction with the theatricality of Italian Baroque architecture and sculpture, frescoes spanning church ceilings contributed to creating transcendent spiritual environments well suited to the Church's needs in Counter-Reformation Italy.

A splendid example of the dramatic impact such ceiling frescoes could have is *Triumph in the Name of Jesus* (FIG. **19-26**), painted by GIOVANNI BATTISTA GAULLI (1639-1709). *Triumph* appears over the nave of the Church of Il Gesù in Rome (see FIGS. 17-49 and 17-50). As the mother church of the Jesuit order, Il Gesù played a prominent role in Counter-Reformation efforts. The visual effect Gaulli created is stunning. Gilded architecture opens up in the center of the ceiling to offer viewers a glimpse of Heaven. The artist represented Jesus as a barely visible monogram (IHS) in a blinding radiant light that floats heavenward. In contrast, sinners are violently thrown back down to Earth. The painter glazed the gilded architecture to suggest shadows, thereby enhancing the scene's illusionistic quality. To further heighten the illusion, Gaulli painted many of the sinners on three-dimensional stucco extensions which project outside the painting's frame.

A GLORIOUS TRIBUTE TO SAINT IGNATIUS
Another master of ceiling decoration was FRA ANDREA POZZO (1642–1709), a lay brother of the Jesuit order and a master of perspective, on which he wrote an influential treatise. Pozzo designed and executed the vast ceiling fresco *Glorifica-* *tion of Saint Ignatius* (FIG. **19-27**) for the church of Sant'Ignazio in Rome. Like Il Gesù, Sant'Ignazio was prominent in Counter-Reformation Rome because of its dedication to Saint Ignatius, the founder of the Jesuit order. As Gaulli did in *Triumph in the Name of Jesus* (FIG. 19-26), Pozzo created the illusion that Heaven is opening up above the congregation's heads. To accomplish this, the artist illusionistically continued the church's actual architecture into the vault so that the roof seems to be lifted off. As Heaven and Earth commingle, Saint Ignatius is carried to the waiting Christ in the presence of figures personifying the four corners of the world. A disk in the nave floor marks the standpoint for the whole perspectival illusion. For visitors looking up from this point, the vision is complete; they are truly in the presence of the heavenly and spiritual.

Thus, the effectiveness of Italian Baroque religious art depended on the drama and theatricality of individual images, as well as on the interaction and fusion of architecture, sculpture, and painting. Sound enhanced this experience. Churches were designed with acoustical effect in mind, and, in an Italian Baroque church filled with Baroque music, the power of both image and sound must have been immensely moving.

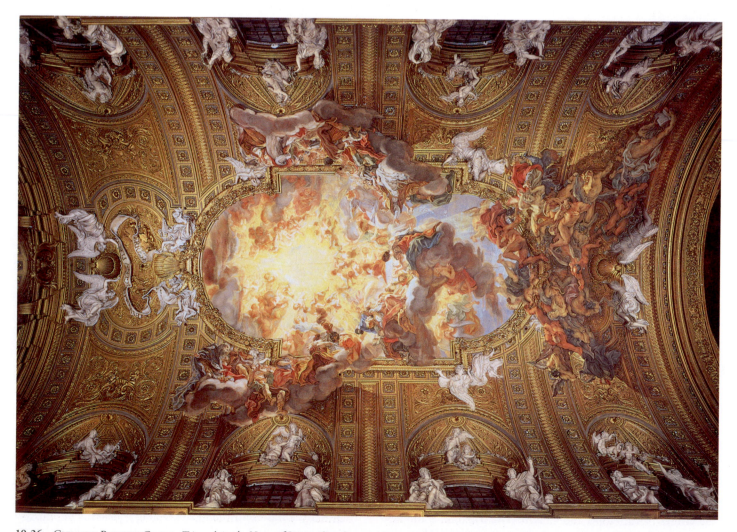

19-26 GIOVANNI BATTISTA GAULLI, *Triumph in the Name of Jesus,* ceiling fresco with stucco figures in the vault of the Church of Il Gesù, Rome, Italy, 1676–1679.

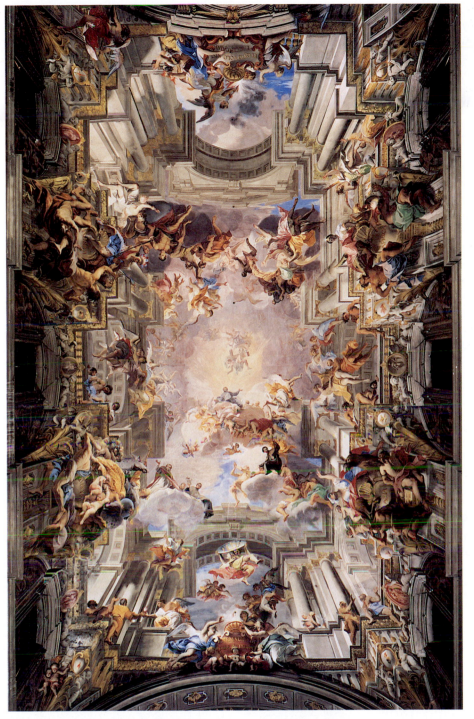

19-27 FRA ANDREA POZZO, *Glorification of Saint Ignatius,* ceiling fresco in the nave of Sant'Ignazio, Rome, Italy, 1691–1694.

Through simultaneous stimulation of both the visual and auditory senses, the faithful might well have been transported into a trancelike state that would, indeed, as England's contemporaneous poet John Milton eloquently stated in his *Paradise Lost,* "bring all Heaven before [their] eyes."

Spain

During the sixteenth century, Spain had established itself as an international power. The Hapsburg kings had built a dynastic state that encompassed Portugal, part of Italy, the Netherlands, and extensive areas of the New World. However, the animosity such dominance provoked among other European countries increased the challenges to Spanish hegemony. By the beginning of the seventeenth century, the Hapsburg empire was struggling, and although Spain mounted a very aggressive effort during the Thirty Years' War, by 1660 the imperial age of the Spanish Hapsburgs was over.

In part, the Spanish empire's demise was due to its reluctance to explore the possibility of mercantile expansion. During the height of Spanish power, the Hapsburgs had access to virtually unlimited amounts of capital, a growing population, rising consumer demand, and a far-flung overseas empire. Yet their failure to capitalize on trading opportunities allowed

other countries, particularly England and the Netherlands, to develop expansive and profitable economic systems.

Thus, the dawn of the Baroque period in Spain found the country's leaders struggling to maintain control of their dwindling empire. Realizing as they did the value of visual imagery in communicating to a wide audience, Philip III (r. 1598–1621) and his son Philip IV (r. 1621–1665) were avid art patrons.

Because Spain was predominantly Catholic, it also encountered the same Counter-Reformation issues confronting Italy. As in Italy, Spanish Baroque artists sought ways to move viewers and to encourage greater devotion and piety. Particularly appealing in this regard were scenes of death and martyrdom, which provided artists with opportunities both to depict and to instill in viewers extreme feelings. Spain prided itself on its saints (for example, Saint Theresa of Avila, FIG. 19-9, and Saint Ignatius Loyola, FIG. 19-27, were both Spanish born), and martyrdom scenes surfaced frequently in Spanish Baroque art.

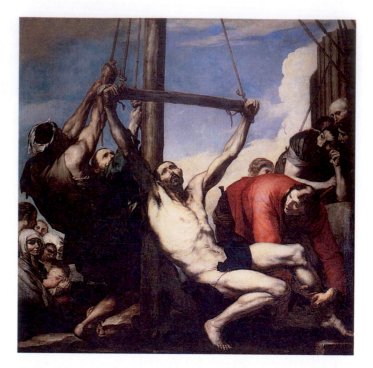

19-28 JOSÉ DE RIBERA, *Martyrdom of Saint Bartholomew*, ca. 1639. Oil on canvas, approx. 7′ 8″ × 7′ 8″. Museo del Prado, Madrid.

THE FLAYING OF A SAINT JOSÉ (JUSEPE) DE RIBERA (ca. 1588–1652) emigrated to Naples as a young man and settled there. For that reason, he sometimes was called by his Italian nickname, Lo Spagnoletto, "the little Spaniard." Influenced by Caravaggio, Ribera imbued his work with both a naturalism and compelling drama, which lend shock value to his often brutal themes. These themes express at once the harsh times of the Counter-Reformation and a Spanish taste for the representation of courageous resistance to pain. Ribera's *Martyrdom of Saint Bartholomew* (FIG. **19-28**) is grim and dark in subject and form. Executioners are hoisting into position Saint Bartholomew, who is about to suffer the torture of being skinned alive. The saint's rough, heavy body and swarthy, plebeian features express a kinship between him and his tormentors, who are similar to the type of figures found in Caravaggio's paintings. Here, Ribera scorned idealization of any kind. In an age of merciless religious fanaticism, torture to save stubborn souls was a common and public spectacle.

A MARTYR AT PEACE FRANCISCO DE ZURBARÁN (1598–1664) also knew Caravaggio's work through copies and works of Caravaggisti. In *Saint Serapion* (FIG. **19-29**), Zurbarán used Caravaggio's presentational strategies; the figure emerges from a dark background and fills the foreground. The bright light shining on the figure calls attention to the tragic death of Saint Serapion and increases the image's dramatic impact. Saint Serapion, who participated in the Third Crusade of 1196, was martyred while preaching the Gospel to Muslims. According to one account of his martyrdom, the monk was tied to a tree, tortured, and decapitated. In Zurbarán's painting, two tree branches are barely visible in the background, and a small note next to the saint identifies him for viewers. The coarse features of the Spanish monk (who was born in England) label him as common, no doubt evoking empathy from a wide audience. In this work, as in many others, Zurbarán conveyed the fierce devotion of Catholic Spain.

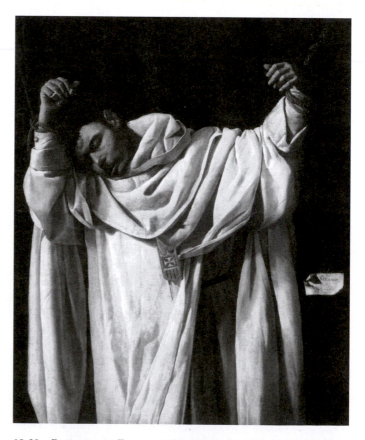

19-29 FRANCISCO DE ZURBARÁN, *Saint Serapion*, 1628. Oil on canvas, 3′ 11½″ × 3′ 4¾″. Wadsworth Atheneum, Hartford (The Ella Gallup Sumner and Mary Catlin Sumner Collection Fund).

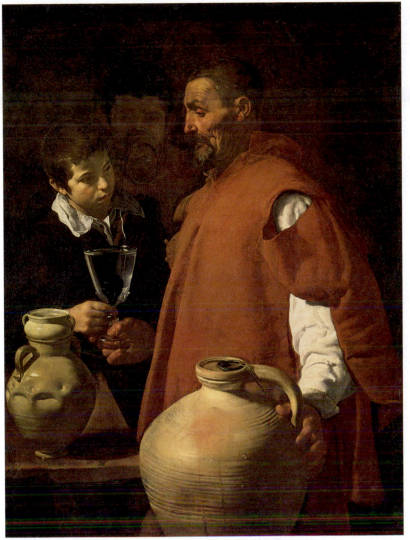

19-30 DIEGO VELÁZQUEZ, *Water Carrier of Seville*, ca. 1619. Oil on canvas, 3' 5½" × 2' 7½". Wellington Museum, London.

AN INFLUENTIAL COURT PAINTER The artist often extolled as the greatest Spanish painter of the age is DIEGO VELÁZQUEZ (1599–1660). Velázquez, like many other Spanish artists, produced religious pictures, but he is justifiably renowned for the work he painted for his major patron, King Philip IV. Trained in Seville, Velázquez was quite young when he came to the attention of Philip IV. The king was struck by the immense talent of Velázquez and named him to the position of court painter. With the exception of two extended trips to Italy and a few excursions, Velázquez remained in Madrid for the rest of his life. His close relationship with Philip IV and his high office as marshal of the palace gave him prestige and a rare opportunity to fulfill the promise of his genius with a variety of artistic assignments.

Velázquez's skill is evident in an early work, *Water Carrier of Seville* (FIG. 19-30), which he painted when he was only about twenty. The artist's command of his craft is impressive. He rendered the figures with clarity and dignity, and his careful depiction of the water jugs in the foreground, complete with droplets of water, adds to the scene's credibility. The contrast of darks and lights, along with the plebeian nature of the figures, reveal the influence of Car-avaggio, whose work Velázquez had studied. The artist presented this *genre scene* (one from everyday life) with such care and conviction that it seems to convey a deeper significance.

CELEBRATING A SPANISH VICTORY As official court painter, Velázquez produced many works for Philip IV. In 1635, he painted *Surrender of Breda* (FIG. 19-31) to commemorate the Spanish victory over the Dutch in 1625. Among the most troublesome situations for Spain was the conflict in the Netherlands. Determined to escape from Spanish control, the northern Netherlands succeeded in breaking away from the Spanish empire in the late sixteenth century. Skirmishes continued to flare up along the border between the northern (Dutch) and southern (Spanish) Netherlands, and in 1625 Philip IV sent General Ambrogio di Spínola to Breda to reclaim the town for Spain. Velázquez depicted the victorious Spanish troops, organized and well armed, on the right side of the painting. In sharp contrast, the defeated Dutch on the left appear bedraggled and disorganized. In the center foreground, the mayor of Breda, Justinus of Nassau, hands the city's keys to the Spanish general. The painting glorifies not only the strength of the Spanish

19-31 DIEGO VELÁZQUEZ,
Surrender of Breda, 1634–1635.
Oil on canvas, 10′ 1″ × 12′ $\frac{1}{2}$″.
Museo del Prado, Madrid.

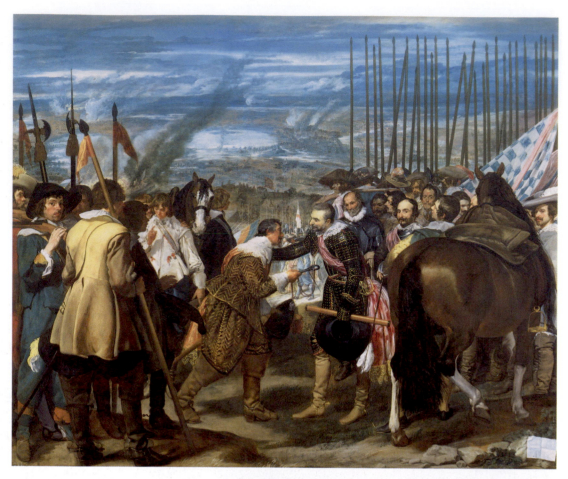

military but the benevolence of Spínola as well. Velázquez portrayed the general magnanimously patting Justinus on the shoulder — a kindly gesture, especially given the circumstances.

ENHANCING THE NOBILITY OF PHILIP IV

Propagandistic images such as *Surrender of Breda* were useful to Philip IV in his attempt to bolster his dwindling power. Also effective were portraits of the monarch, and Velázquez painted dozens. *King Philip IV of Spain* (FIG. **19-32**) is also known as the *Fraga Philip*, because it was painted in the town of Fraga in Aragon. Such a designation differentiates the many royal portraits from one another. Philip IV appears as a military leader, arrayed in red and silver campaign dress. Because the king was not a commanding presence and because he had inherited the large Hapsburg jaw (the result of dynastic inbreeding), Velázquez had to find creative ways to "ennoble" the monarch. He succeeded by focusing attention on the dazzling military regalia while not idealizing Philip's appearance.

OF ART AND ROYAL LIFE

After an extended visit to Rome from 1648 to 1651, Velázquez returned to Spain and painted his greatest masterpiece, *Las Meninas* (*The Maids of Honor*; FIG. **19-33**). In it, Velázquez showed his mastery of both form and content. The painter represented himself in his studio standing before a large canvas, on which he may be painting this very picture or, perhaps, the portraits of King Philip IV and Queen Mariana, whose reflections appear in the mirror on the far wall. The young *Infanta* (princess)

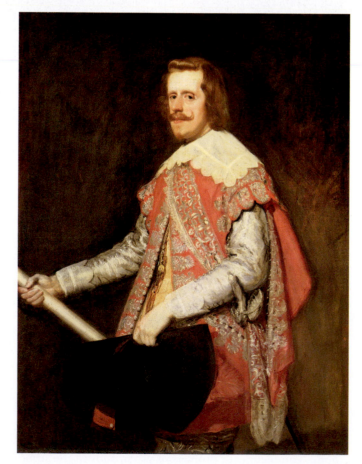

19-32 DIEGO VELÁZQUEZ, *King Philip IV of Spain (Fraga Philip)*, 1644. Oil on canvas, 4′ 3$\frac{1}{8}$″ × 3′ 3$\frac{1}{8}$″. The Frick Collection, New York.

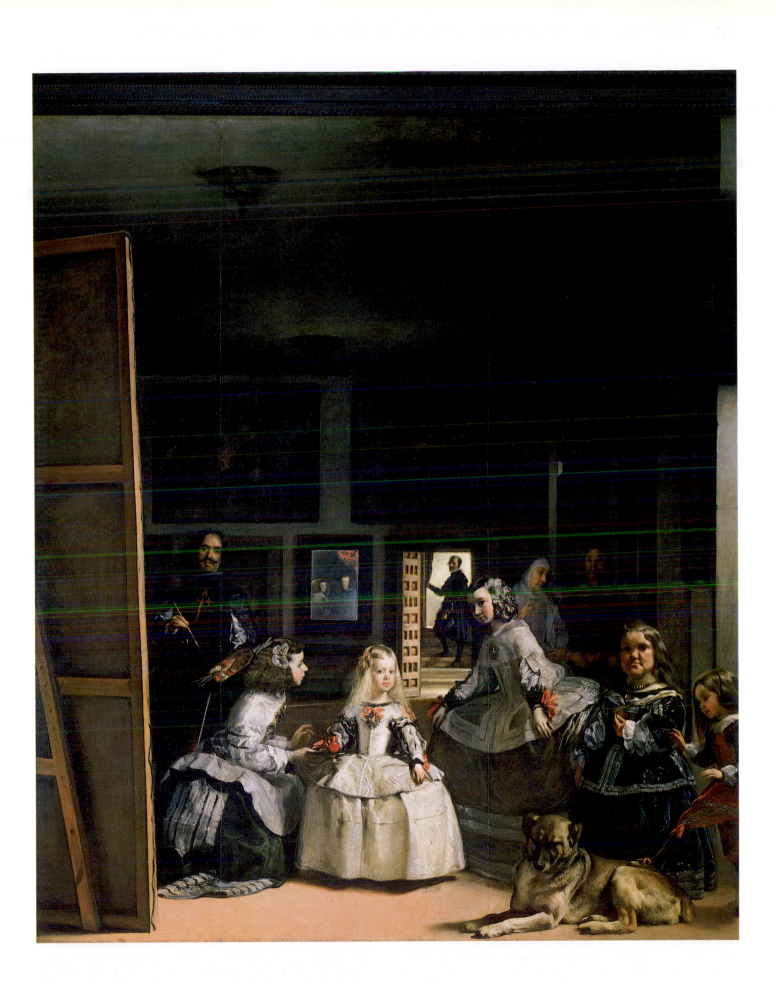

19-33 Diego Velázquez, *Las Meninas,* 1656. Oil on canvas, approx. 10′ 5″ × 9′. Museo del Prado, Madrid.

Margarita appears in the foreground with her two maids-in-waiting, her favorite dwarfs, and a large dog. In the middle ground are a woman in widow's attire and a male escort; in the background, a gentleman is framed in a brightly lit open doorway. The personages present have been identified, though we need not name them here. Noteworthy is how Velázquez extended the pictorial depth of his composition in both directions. The open doorway and its ascending staircase lead the eye beyond the artist's studio, and the mirror device and the outward glances of several of the figures incorporate the viewers' space into the picture as well. (Compare how the mirror in Jan van Eyck's *Giovanni Arnolfini and His Bride*, FIG. 15-12, also incorporates the area in front of the canvas into the picture, although less obviously and without a comparable extension of space beyond the room's rear wall.)

On the wall above the doorway and mirror in *Las Meninas*, two faintly recognizable pictures have been identified as copies of paintings by Peter Paul Rubens that represent the immortal gods as the source of art. Thus, a duality of theme exists in the Velázquez painting. It is both an informal family group portrait, seemingly casually arranged and naturalistic, and it is a genre painting—"A Visit to the Artist's Studio" would be an equally apt title. The room represented in the painting was in the palace of the Alcázar in Madrid. After the death of Prince Baltasar Carlos in 1646, Phillip IV ordered part of the prince's chambers converted into a studio for Velázquez.

As first painter to the king and as chief steward of the palace, Velázquez was conscious not only of the importance of his court office but also of the honor and dignity belonging to his profession as a painter. In this painting, he appears to have brought the roles together, asserting their equivalent value. Several pictures from the seventeenth century show painters with their royal patrons, for painters of the time continually sought to elevate their profession among the arts and to achieve by it appropriate rank and respect. Throughout his career, Velázquez hoped to be ennobled by royal appointment to membership in the ancient and illustrious Order of Santiago. Because he lacked some of the required patents of nobility, he gained entrance only with difficulty at the very end of his life, and then only through the pope's dispensation. In the painting, he wears the order's red cross on his doublet, painted there, legend says, by the king himself. The truth is that the artist painted it. In Velázquez's mind, *Las Meninas* might have embodied the idea of the great king visiting his studio, as Alexander the Great visited the studio of the painter Apelles in ancient times. The figures in the painting all acknowledge the royal presence. Placed among them in equal dignity is Velázquez, face-to-face with his sovereign. The location of the completed painting reinforced this act of looking—of seeing and being seen. *Las Meninas* hung in the personal office of Philip IV in another part of the palace. Thus, although occasional visitors admitted to the king's private quarters may have seen this painting, it was viewed primarily by Philip IV. And each time he did so, standing before the large canvas, he again participated in the work as the subject of Velázquez's painting in *Las Meninas* and as the object of the figures' gazes. The art of painting, in the person of the painter, was elevated here to the highest status. Velázquez sought ennoblement not for himself alone but for his art.

The interpretation that Velázquez, in the painting, is in the process of portraying the king and queen on the canvas before him, is standard and visually logical. Even further, Velázquez's optical report of the event, authentic in every detail, also pictorially summarizes the various kinds of images in their different levels and degrees of reality. He portrayed the realities of canvas image, of mirror image, of optical image, and of the two imaged paintings. This work—with its cunning contrasts of mirrored spaces, "real" spaces, picture spaces, and pictures within pictures—itself appears to have been taken from a large mirror reflecting the whole scene. This would mean the artist did not paint the princess and her suite as the main subjects of *Las Meninas* but himself in the process of painting them. In the Baroque period, when artists took Leonardo's dictum that "the mirror is our master" very seriously, it is not surprising to find mirrors and primitive camera-like devices used to achieve optimum visual fidelity in paintings. *Las Meninas* is a pictorial summary and a commentary on the essential mystery of the visual world, as well as on the ambiguity that results when different states or levels interact or are juxtaposed.

How did Velázquez achieve these results? Instead of putting lights abruptly beside darks, as Caravaggio had done, Velázquez allowed a great number of intermediate values of gray to come between the two extremes. His matching of tonal gradations approached effects the photography age later discovered. Velázquez did not think of figures as first drawn, next modeled into sculptural effects, and then colored. He thought of light and tone as the whole substance of painting—the solid forms only suggested, never really constructed. Observing this reduction of the solid world to purely optical sensations in a floating, fugitive skein of color tones, viewers could say the old sculpturesque form had disappeared here. The extreme thinness of Velázquez's paint and the light, almost accidental, touches of thick pigment here and there destroyed all visible structure. If viewers examine his canvas closely, everything dissolves to a random flow of paint.

Flanders

In the sixteenth century, the Netherlands had come under the crown of Hapsburg Spain when the emperor Charles V retired, leaving the Spanish throne and its Netherlandish provinces to his only son, Philip II. Philip's repressive measures against the Protestants led the northern provinces to break away from Spain and to set up the Dutch Republic. The southern provinces remained under Spanish control, and they retained Catholicism as their official religion. The political distinction between modern Holland and Belgium more or less reflects this original separation, which, in the Baroque period signalized not only religious but also artistic differences. The Baroque art of Flanders (the Spanish Netherlands) retained close connections to the Baroque art of Spain, while the Dutch schools of painting developed their own subjects and styles. This was consistent with their reformed religion and the new political, social, and economic structure of the middle-class Dutch Republic.

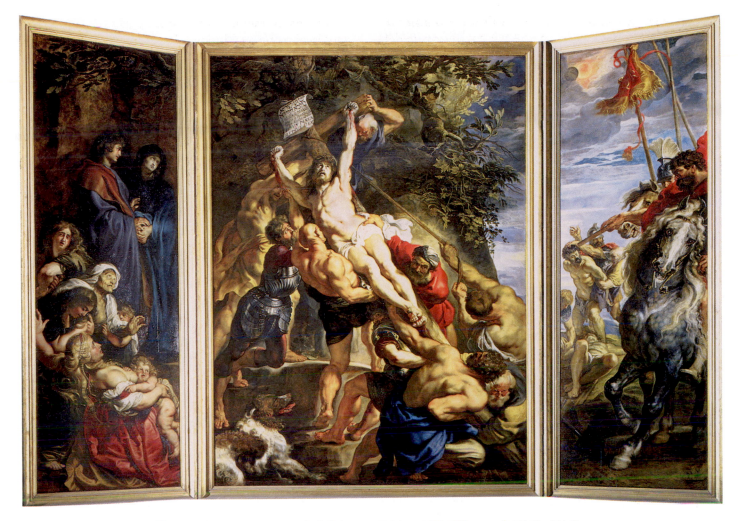

19-34 PETER PAUL RUBENS, *Elevation of the Cross*, Antwerp Cathedral, Antwerp, Belgium, 1610. Oil on panel, 15′ 2″ × 11′ 2″.

A PAN-EUROPEAN SYNTHESIS The renowned Flemish master PETER PAUL RUBENS (1577–1640) drew together the main contributions of the masters of the Renaissance (Michelangelo and Titian) and of the Italian Baroque (Carracci and Caravaggio) to synthesize in his own style the first truly pan-European manner. Rubens's art, even though it is the consequence of his wide study of many masters, is no weak eclecticism but an original and powerful synthesis. Ultimately, the influence of Rubens was international.

Among the most learned individuals of his time, Rubens possessed an aristocratic education, courtier's manner, diplomacy, and tact. All of this, along with his classical learning and language facility, made him the associate of princes and scholars. He became court painter to the dukes of Mantua (descended from Mantegna's patrons); friend of the king of Spain and his adviser on art collecting; painter to Charles I of England and Marie de' Medici, queen of France; and permanent court painter to the Spanish governors of Flanders. Rubens also won the confidence of his royal patrons in matters of state, and these patrons often entrusted him with diplomatic missions of the highest importance. In the practice of his art, scores of associates and apprentices assisted Rubens, turning out numerous paintings for an international clientele. In addition, he functioned as an art dealer, buying and selling contemporary artworks and classical antiquities. His many enterprises made him a rich man, with a magnificent town house and a château in the countryside. Wealth and honors,

however, did not spoil his amiable, sober, and self-disciplined character. Rubens was, like Raphael, a successful and renowned artist, a consort of kings, a shrewd man of the world, and a learned philosopher.

Rubens became a master in 1598 and went to Italy two years later, where he remained until 1608. During these years, he formulated the foundations of his style. Shortly after his return from Italy, he painted the *Elevation of the Cross* (FIG. **19-34**) for the church of Saint Walburga (and later moved to Antwerp Cathedral). This triptych reveals the result of his long study of Italian art, especially the works of Michelangelo, Tintoretto, and Caravaggio. The scene brings together tremendous straining forces and counterforces as heavily muscled men strain to lift the cross. Here, the artist had the opportunity to show foreshortened anatomy and the contortions of violent action reminiscent of the twisted figures Michelangelo sculpted and painted. Rubens placed the body of Christ on the cross as a diagonal that cuts dynamically across the picture while inclining back into it. The whole composition seethes with a power that comes from genuine exertion, from elastic human sinew taut with effort. The tension is emotional as well as physical, as reflected not only in Christ's face but also in the features of his followers in the triptych's wings. Strong modeling in dark and light, which heightens the drama, marks Rubens's work at this stage of his career; it gradually gave way to a much subtler coloristic style.

19-35 PETER PAUL RUBENS, drawing of Laocoön, ca. 1600-1608. Black-and-white chalk drawing with bistre wash, approx. 1′ 7″ × 1′ 7″. Ambrosiana, Milan.

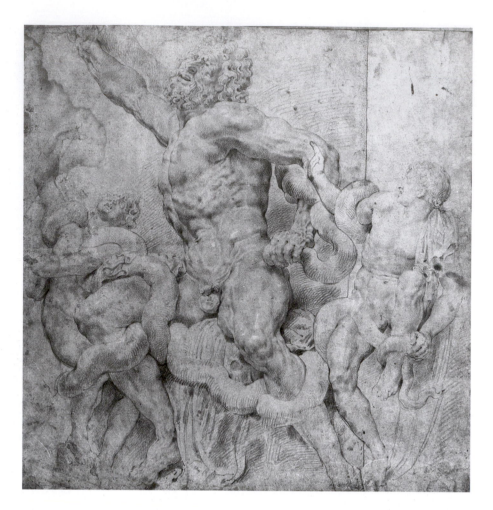

DRAWING ON THE MASTERS Rubens retained the vigor and passion of his early style throughout his career, although he modified the vitality of his work into less strained and more subtle forms, depending on the theme. One theme that remained a focus of Rubens's art was the human body, draped or undraped, male or female, and freely acting or free to act in an environment of physical forces and other interacting bodies. This interest, combined with his voracious intellect, led Rubens to copy the works of classical antiquity and of the Italian masters. These sources surfaced in Rubens's drawing of Laocoön (FIG. **19-35**), the classical sculpture discovered in 1506. Rubens apparently produced this drawing (one of a large group of drawings) sometime between 1606 and 1608, when he was in Rome. The ancient marble sculpture (FIG. 5-89) depicts the Trojan priest Laocoön and his two sons as they struggle mightily to free themselves from the death grip of sea serpents. Rubens's predominantly black chalk drawing demonstrates the artist's careful study of classical representations of the human form. In a Latin treatise he wrote titled *De imitatione statuarum (On the Imitation of Statues),* Rubens stated: "I am convinced that in order to achieve the highest perfection one needs a full understanding of the [ancient] statues, nay a complete absorption in them. . . ."[1]

THE POWER AND MAJESTY OF ROYALTY Rubens's interaction with royalty and aristocrats provided

him with an understanding of the ostentation and spectacle of Baroque (particularly Italian) art that were appealing to those of wealth and privilege. Rubens, the born courtier, reveled in the pomp and majesty of royalty. Likewise, those in power embraced the lavish spectacle that served the Catholic Church so well in Italy. The magnificence and splendor of such Baroque imagery reinforced their authority and right to rule. Marie de' Medici, a member of the famous Florentine house, commissioned Rubens to paint a series memorializing and glorifying her career and that of her late husband, the first of the Bourbon kings of France, Henry IV. Between 1622 and 1626, Rubens, working with amazing creative energy, produced twenty-one huge historical-allegorical pictures designed to hang in the queen's new palace, the Luxembourg, in Paris.

Perhaps the most vivacious of the series is the *Arrival of Marie de' Medici at Marseilles* (FIG. **19-36**); the others are similar in mood and style. In the painting, Marie has just arrived in France after the sea voyage from Italy. As she disembarks, surrounded by her ladies-in-waiting, an allegorical personification of France, draped in a cloak decorated with the fleur-de-lis (FIG. 19-66), welcomes her. The sea and sky rejoice at her safe arrival—Neptune and the *Nereids* (daughters of the sea god Nereus) salute her, and a winged, trumpeting Fame swoops overhead. Conspicuous in the galley's opulently carved stern-castle, under the Medici coat of arms, stands the

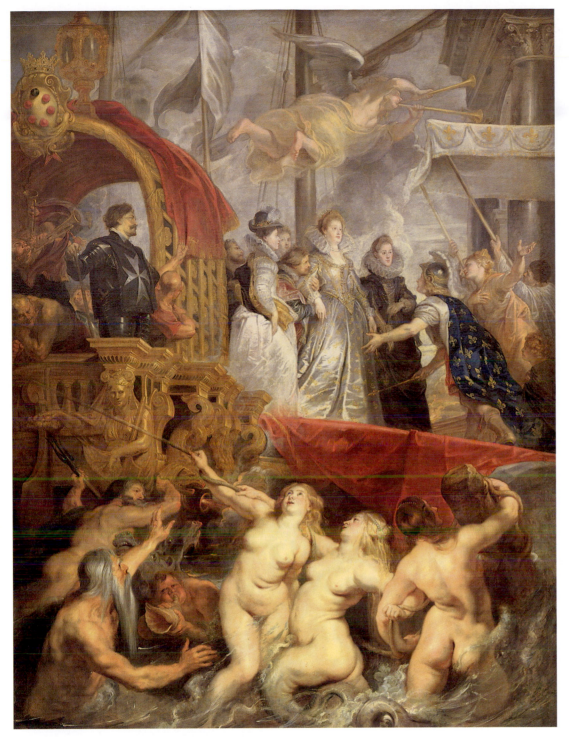

19-36 PETER PAUL RUBENS, *Arrival of Marie de' Medici at Marseilles,* 1622–1625. Oil on canvas, approx. 5′ 1″ × 3′ 9½″. Louvre, Paris.

imperious commander of the vessel. In black and silver, his figure makes a sharp accent amid the swirling tonality of ivory, gold, and red. He wears the cross of a Knight of Malta, which may identify this as a ship belonging to that order (similar to Velázquez's *Order of Santiago*). The only immobile figure in the composition, he could be director of and witness to the lavish welcome. The artist enriched his surfaces here with a decorative splendor that pulls the whole composition together. The audacious vigor that customarily enlivens Rubens's figures, beginning with the monumental twisting sea creatures, vibrates through the entire design.

PROTESTING WAR Rubens also derived great insight into European politics from his diplomatic missions, and he never ceased to promote peace. Throughout most of his career, war was constant. When commissioned in 1638 to produce a painting for Ferdinando II, the Grand Duke of Tuscany, Rubens took the opportunity to express allegorically his attitude toward war. Appropriately, Rubens finished his

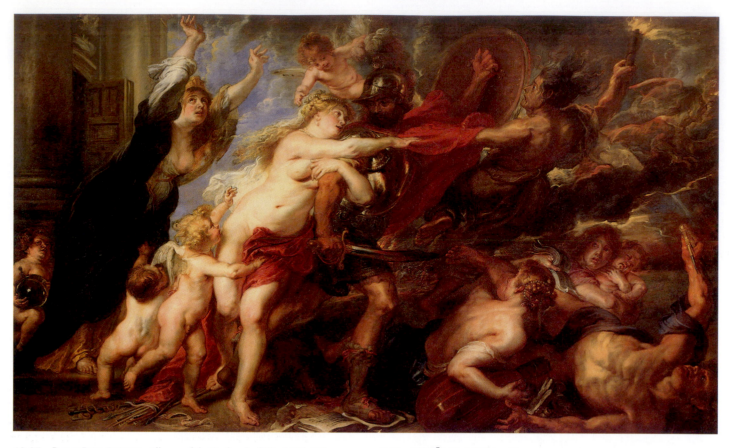

19-37 PETER PAUL RUBENS, *Allegory of the Outbreak of War*, 1638. Oil on canvas, 6′ 9″ × 11′ 3⅞″. Pitti Gallery, Florence.

artistic diatribe, *Allegory of the Outbreak of War* (FIG. **19-37**), during the Thirty Years' War. The fluid articulation of human forms and the energy that emanates from the chaotic scene are reminiscent of Rubens's other paintings. The artist's own description of the painting, written in a letter, provides the clearest explication of *Allegory*'s content and of his opinions on military conflict:

> The principal figure is Mars, who has left the temple of Janus open (which according to Roman custom remained closed in time of peace) and struts with his shield and his bloodstained sword, threatening all peoples with disaster; he pays little attention to Venus, his lady, who, surrounded by her little love-gods, tries in vain to hold him back with caresses and embraces. On the opposite side, Mars is pulled forward by the Fury Alecto with a torch in her hand. There are also monsters signifying plague and famine, the inseparable companions of war. Thrown to the ground is a woman with a broken lute, as a symbol that harmony cannot exist beside the discord of war; likewise a mother with a child in her arms indicates that fertility, procreation, and tenderness are opposed by war, which breaks into and destroys everything. There is furthermore an architect fallen backwards, with his tools in his hands, to express the idea that what is built in peace for the benefit and ornament of cities is laid in ruin and razed by the forces of arms . . . you will also find on the ground, beneath the feet of Mars, a book and a drawing on paper, to indicate that he tramples on literature and other refinements. . . . The sorrowing woman . . . clothed in black with a torn veil, and deprived of all her jewels and ornaments is unhappy Europe, which for so many years has suffered pillage, degradation, and misery affecting all of us so deeply that it is useless to say more about them.[2]

19-38 ANTHONY VAN DYCK, *Charles I Dismounted*, ca. 1635. Oil on canvas, approx. 9′ × 7′. Louvre, Paris.

ELEGANT PORTRAITS OF ENGLAND'S KING Most of Rubens's successors in Flanders were at one time his assistants. The most famous of these was ANTHONY VAN DYCK (1599–1641). Early on, the younger man, unwilling to be overshadowed by the master's undisputed stature, left his native Antwerp for Genoa and then London, where he became court portraitist to Charles I. Although Van Dyck created dramatic compositions of high quality, his specialty became the portrait. He developed a courtly manner of great elegance that was influential internationally. In one of his finest works, *Charles I Dismounted* (FIG. **19-38**), the ill-fated Stuart king stands in a landscape with the river Thames in the background. An equerry and a page attend Charles I. Although the king impersonates a nobleman out for a casual ride in his park, no one can mistake the regal poise and the air of absolute authority his Parliament resented and was soon to rise against. Here, King Charles turns his back on his attendants as he surveys his domain. The king's placement makes the composition exceedingly artful. He stands off center but balances the picture with a single keen glance at observers. Van Dyck even managed to portray Charles I in a position to look down on observers. In reality, the monarch's short stature forced him to exert his power in ways other than physical. Van Dyck's elegant style resounded in English portrait painting well into the nineteenth century.

The Dutch Republic

PROSPERITY IN THE PROVINCES The Dutch succeeded in securing their independence from the Spanish in the late sixteenth century. Not until 1648, however, after years of continual border skirmishes with the Spanish (as depicted in Velázquez's *Surrender of Breda,* FIG. 19-31) were the northern Netherlands officially recognized as the United Provinces of the Netherlands (the Dutch Republic). Despite attempts by the House of Orange to establish a monarchy, the republicans prevailed.

The ascendance of the Dutch Republic during the seventeenth century was largely due to its economic prosperity; Amsterdam had the highest per capita income in Europe. That city emerged as the financial center of Europe, having founded the Bank of Amsterdam in 1609. The Dutch economy benefited enormously from the country's expertise on the open seas, which facilitated establishing far-flung colonies. By 1650, Dutch trade routes extended beyond Europe proper and included North America, South America, the west coast of Africa, China, Japan, Southeast Asia, and much of the Pacific.

Due to this prosperity and in the absence of an absolute ruler, political power increasingly passed into the hands of an urban patrician class of merchants and manufacturers, especially in cities such as Amsterdam, Haarlem, and Delft. That these bustling cities were all located in Holland (the largest of the seven United Provinces) perhaps explains why the name "Holland" is used informally to refer to the entire country.

THE PROTESTANT OBJECTION TO ART Religious differences were a major consideration during the northern Netherlands' insistent quest for independence during the sixteenth and early seventeenth centuries. While Spain and the southern Netherlands were Catholic, the northern Netherlands were predominantly Protestant. The prevailing Calvinism demanded a puritanical rejection of art in churches, and thus artists produced relatively little religious art in the Dutch Republic at this time (especially in comparison to that created in areas dominated by Catholicism in the wake of the Counter-Reformation). Despite the Calvinist beliefs of much of the population, however, the Dutch were truly tolerant people, and artists (often Catholics) created the occasional religious image.

A MOVING RELIGIOUS SCENE HENDRICK TER BRUGGHEN (1588–1629), for example, painted *Calling of Saint Matthew* (FIG. **19-39**) in 1621, after returning from a trip to Italy. As a Catholic, ter Brugghen perhaps felt great affinity with artists such as Caravaggio, who painted the same

19-39 HENDRICK TER BRUGGHEN, *Calling of Saint Matthew,* 1621. Oil on canvas, 3′ 4″ × 4′ 6″. Centraal Museum, Utrecht (acquired with the aid of the Rembrandt Society).

The Butcher, the Baker, the Candlestick Maker
Dutch Patronage and Art Collecting

Art collecting often has been perceived as the purview of the wealthy, and, indeed, the money necessary to commission major artworks from esteemed artists can be considerable. During the seventeenth century in the Dutch Republic, however, the widespread prosperity enjoyed by a large proportion of Dutch society significantly expanded the range of art patronage. As a result, one of the distinguishing hallmarks of Dutch art production during the Baroque period was how it catered to the tastes of a middle-class audience.

The term "middle class" is used broadly here. An aristocracy and a patriciate—an upper class of large-ship owners, rich businesspeople, high-ranking officers, and directors of large companies—still existed. These groups continued to be major patrons of the arts. With the expansion of the Dutch economy, traders, craftspeople, low-ranking officers, bureaucrats, and soldiers—the middle and lower-middle class—also became art patrons.

While steeped in the morality and propriety central to the Calvinist ethic, members of the Dutch middle class sought ways to subtly announce their success and newly acquired status. House furnishings, paintings, tapestries, and porcelain were among the items collected and displayed in the home. The Dutch disdain for excessive ostentation, attributable to Calvinism, led these collectors to favor small, low-key works—portraits, still lifes, genre scenes, and landscapes. This contrasted with the Italian Baroque penchant for large-scale, dazzling ceiling frescoes and opulent room decoration.

This new middle-class clientele, in conjunction with the developing open market (see "Mercantile Prosperity: Developing an Open Art Market," page 649), influenced the direction of Dutch Baroque art. Not only did these patrons affect the type of art produced, but they also were responsible for establishing the current mechanisms and institutions for buying and selling art.

scene (FIG. 19-19). The moment of the narrative depicted, the astonishment of Levi (the tax collector), and the naturalistic presentation of the figures all echo Caravaggio's work. However, ter Brugghen dispensed with the stark contrasts of dark and light and instead presented viewers with a more colorful palette of soft tints. Further, the figures are crammed into a small but well-lit space, creating a claustrophobic effect that differs from Caravaggio's careful rendering of the dark street scene.

DIFFERENT PATRONS, DIFFERENT SUBJECTS
Given the absence of an authoritative ruler and the Calvinist concern for the potential misuse of religious art, commissions from royalty or from the Christian Church, prominent in the art of other countries, were uncommon in the United Provinces. With the new prosperity, an expanding class of merchant patrons emerged, and this shift led to an emphasis on different pictorial content. Dutch Baroque art centered on genre scenes, landscapes, portraits, and still lifes, all of which appealed to the prosperous middle class (see "The Butcher, the Baker, the Candlestick Maker: Dutch Patronage and Art Collecting," above). "Middle class" often is used as a conveniently broad term to describe this developing group of patrons. However, it is important to note that despite the absence of royalty,

19-40 GERRIT VAN HONTHORST, *Supper Party,* 1620. Oil on canvas, approx. 7′ × 4′ 8″. Galleria degli Uffizi, Florence.

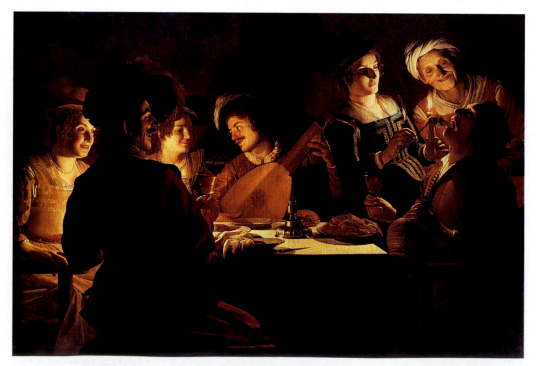

Dutch society was not totally egalitarian. The *patriciate* (leading merchants and large manufacturers) and the upper middle class (prosperous merchants, traders, and academics) were far more likely to collect art than were the middle and lower-middle classes (skilled craftspeople, workers, and servants). Regardless, art flourished in this mercantilist culture. The seventeenth century is referred to not only as the "Golden Age" of the Dutch Republic but as the "Golden Age" of Dutch art as well.

DEPICTING EVERYDAY LIFE IN HOLLAND

Typical of Dutch genre scenes is *Supper Party* (FIG. **19-40**), by GERRIT VAN HONTHORST (1590–1656) of Utrecht. In this painting, van Honthorst presented an informal gathering of unidealized human figures. While a musician serenades the group, his companions delight in watching a young woman feeding a piece of chicken to a man whose hands are both occupied—one holds a jug and the other a glass. Van Honthorst spent several years in Italy, and while there he carefully studied Caravaggio's work. The Italian artist's influence is evident in the mundane tavern setting and the nocturnal lighting. Fascinated by nocturnal effects, van Honthorst frequently placed a hidden light source in his pictures and used it as a pretext to work with dramatic and violently contrasted dark/light effects. Lighthearted genre scenes such as this were popular and widely produced in the Baroque period. Often, Dutch genre scenes could be read moralistically. For example, the *Supper Party* can be interpreted as a warning against the sins of gluttony (represented by the man on the right) and lust (the woman feeding the glutton is, in all likelihood, a prostitute with her aged procuress at her side). Or perhaps the painting represents the loose companions of the Prodigal Son (Luke 15:13)—panderers and prostitutes drinking, singing, strumming, and laughing. Strict Dutch Calvinists no doubt approved of such interpretations.

FACE-TO-FACE

Dutch Baroque artists also were justifiably esteemed for their skills in portraiture, another genre, or type, of art. FRANS HALS (ca. 1581–1666) was the leading painter in Haarlem and made portraits his specialty. Portrait artists traditionally had relied heavily on convention—for example, specific poses, settings, attire, and accoutrements—to convey a sense of the sitter. Because the subject was usually someone of status or note, such as a pope, king, or wealthy individual, the artist's goal was to produce an image appropriate to the subject's station in life. With the increasing numbers of Dutch middle-class patrons, the tasks for Dutch portraitists became more challenging. Not only were the traditional conventions inappropriate and thus unusable, but also the Calvinists shunned ostentation, instead wearing uniform, subdued, and dark clothing with little variation or decoration. Despite these difficulties, or perhaps because of them, Hals produced lively portraits that seem far more relaxed than the more formulaic traditional portraiture. Not only did Hals inject an engaging spontaneity into his images, but he captured the personalities of his sitters as well. His manner of execution intensified the casualness, immediacy, and intimacy in his paintings. The touch of Hals's brush was as light and fleeting as the moment when he captured the pose, so the figure, the highlights on clothing, and the facial expression all seem instantaneously created.

Hals also excelled at group portraits, which multiplied the challenges of depicting a single sitter. *Archers of Saint Hadrian* (FIG. **19-41**) is one such painting. The Archers of Saint Hadrian were one of many Dutch civic militia groups

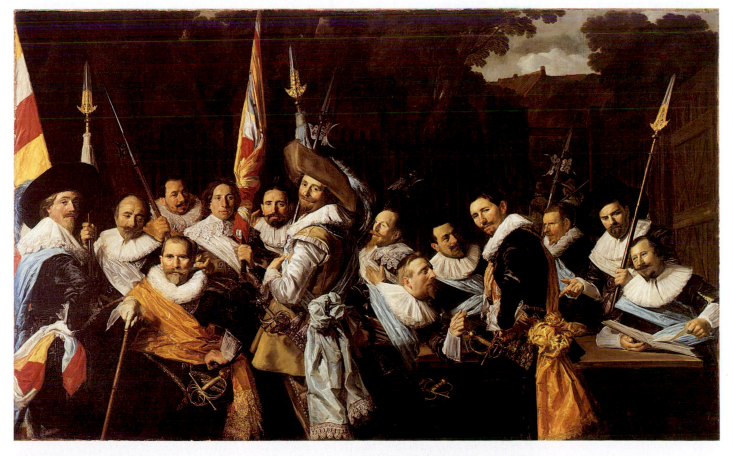

19-41 FRANS HALS, *Archers of Saint Hadrian*, ca. 1633. Oil on canvas, approx. 6′ 9″ × 11′. Frans Halsmuseum, Haarlem.

who claimed credit for liberating the Dutch Republic from Spain. Like other companies, the Archers met on its saint's feast day in dress uniform for a grand banquet. The celebrations sometimes lasted an entire week, prompting an ordinance limiting them to "three, or at the most four days." These events called for a group portrait, and such commissions gave Hals the opportunity to attack the problem of adequately representing each group member while retaining action and variety in the composition. Earlier group portraits in the Netherlands were rather ordered and regimented images. Hals sought to enliven the images, and the results can be seen in *Archers*. Here, each man is both a troop member and an individual with a distinct personality. Some engage viewers directly, while others look away or at a companion; where one is stern, another is animated. Each is equally visible and clearly recognizable. The uniformity of attire—black military dress, white ruffs, and sashes—does not seem to have deterred Hals from injecting a spontaneity into the work. Indeed, he used those elements to create a lively rhythm that extends throughout the composition and energizes the portrait. The impromptu effect—the preservation of every detail and fleeting facial expression—is, of course, due to careful planning. Yet Hals's vivacious brush appears to have moved instinctively, directed by a plan in his mind but not traceable in any preparatory scheme on the canvas.

PRIM AND PROPER DUTCH WOMEN Hals captured the character of straightlaced, devout Calvinist women in *The Women Regents of the Old Men's Home at Haarlem* (FIG. **19-42**). Unlike the looser, seemingly informal character of his other group portraits, *Women Regents* communicates a stern, puritanical, and composed sensibility. The women look out from the painting (only two meet the viewer's gaze) with expressions that range from dour disinterest to kindly concern. The sombre and virtually monochromatic palette, punctuated only by the white accents of the clothing, contributes to the painting's restraint. Although this portrait may lack the vitality and spontaneity of other portraits by Hals, his unerring ability to capture both the details of the individual sitters and their general cultural characteristics is truly impressive.

A SURGICAL LESSON REMBRANDT VAN RIJN (1606–1669), Hals's younger contemporary, was widely recognized as the leading Dutch painter of his time. Rembrandt's move from his native Leiden to Amsterdam around 1631 provided him with a more extensive clientele, contributing to a flourishing career. In his portraits, for which he became particularly prominent, Rembrandt delved deeply into the psyche and personality of his sitters. In *Anatomy Lesson of Dr. Tulp* (FIG. **19-43**), he deviated even further from the traditional staid group portrait than had Hals. Despite Hals's de-

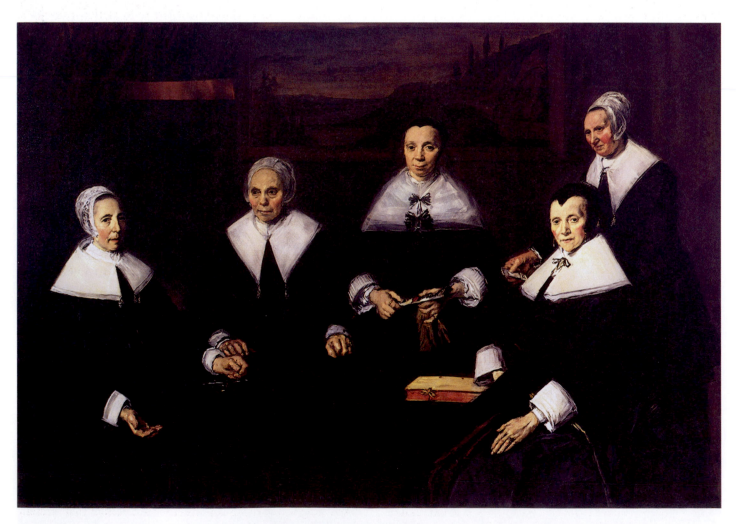

19-42 FRANS HALS, *The Women Regents of the Old Men's Home at Haarlem*, 1664. Oil on canvas, 5' 7" × 8' 2". Frans Halsmuseum, Haarlem.

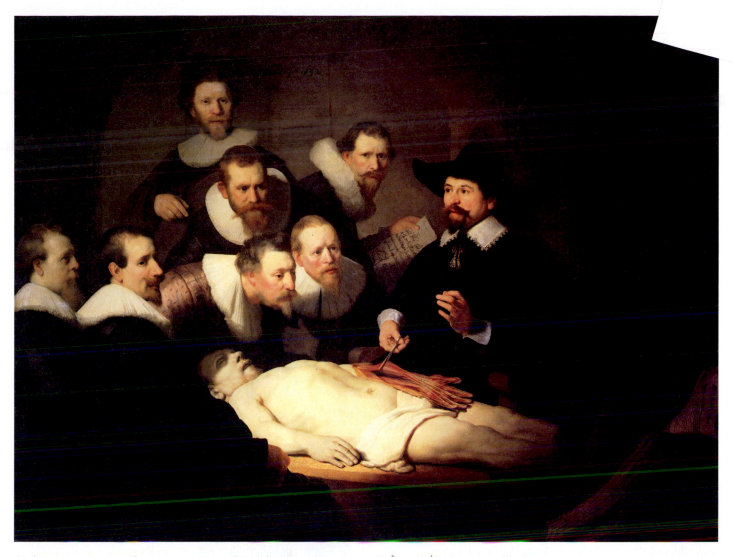

19-43 REMBRANDT VAN RIJN, *Anatomy Lesson of Dr. Tulp,* 1632. Oil on canvas, 5′ 3¾″ × 7′ 1¼″. Mauritshuis, The Hague.

termination to enliven his portraits, he still evenly placed his subjects across the canvas. In contrast, Rembrandt chose to portray the members of the surgeon's guild (who commissioned this group portrait) clustered together on the painting's left side. In the foreground appears the corpse that Dr. Tulp, a noted physician, is in the act of dissecting. Rembrandt diagonally placed and foreshortened the corpse, activating the space by disrupting the strict horizontal, planar orientation found in traditional portraiture. He depicted each of the "students" specifically, and although they wear virtually identical attire, their varying poses and facial expressions suggest unique individuals. In light of the fact Rembrandt produced this painting when he was twenty-six and just beginning his career, his innovative approach to group portraiture is all the more remarkable.

A MILITIA GROUP READYING FOR PARADE
Rembrandt amplified the complexity and energy of the group portrait in his famous painting of 1642, *The Company of Captain Frans Banning Cocq* (FIG. **19-44**), better known as *Night Watch.* This more commonly used title is, however, a misnomer—*Night Watch* is not a nocturnal scene. Rembrandt used light in a masterful way, and dramatic lighting certainly

enhances this scene. However, the painting's darkness (which led to the commonly used title) is due more to the varnish the artist used, which has darkened considerably over time, than to the subject depicted.

This painting was one of many civic-guard group portraits produced during this period. From the limited information available about the commission, it appears Rembrandt was asked to paint the two officers, Captain Frans Banning Cocq and his lieutenant Willem van Ruytenburch, along with sixteen members of this militia group (each contributing to Rembrandt's fee). This work was one of six paintings commissioned from different artists around 1640 for the assembly and banquet hall of the new Kloveniersdoelen (Musketeers' Hall) in Amsterdam. Some scholars have suggested that the occasion for these commissions was the visit of Queen Marie de' Medici to the Dutch city in 1638.

Rembrandt captured the excitement and frenetic activity as the men prepared for the parade. Comparing *The Company of Captain Frans Banning Cocq* to Hals's portrait of the *Archers of Saint Hadrian* (FIG. 19-41), another militia group, reveals Rembrandt's inventiveness in enlivening what was, by then, becoming a conventional portrait format. Rather than present assembled men, the artist chose to portray the company

19-44 Rembrandt van Rijn, *The Company of Captain Frans Banning Cocq (Night Watch)*, 1642. Oil on canvas (cropped from original size), 11′ 11″ × 14′ 4″. Rijksmuseum, Amsterdam.

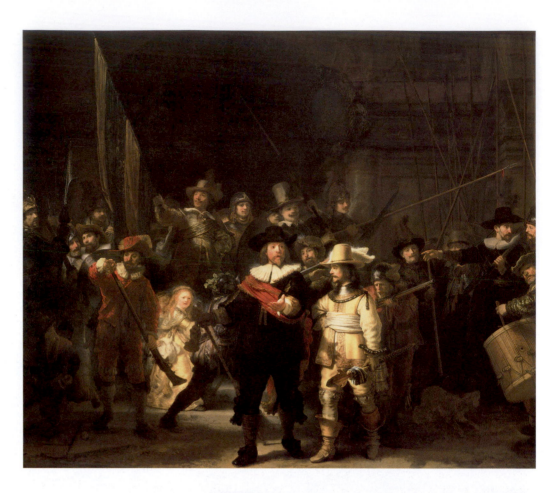

scurrying about in the act of organizing themselves, thereby animating the image considerably. Despite the prominence of the woman just to the left of center, scholars have yet to ascertain definitively her identity.

The large canvas was placed in the designated hall in 1642. Unfortunately, when the painting was subsequently moved in 1715 to the Amsterdam town hall, it was cropped on all sides, leaving viewers today with an incomplete record of the artist's final resolution to the challenge of portraying this group.

CELEBRATING THE HUMILITY OF JESUS Rembrandt's interest in probing the states of the human soul was not limited to portraiture. The Calvinist injunctions against religious art did not prevent him from making a series of religious paintings and prints. These images, however, are not the opulent, overwhelming art of Baroque Italy. Rather, his art is that of a committed Christian who desired to interpret biblical narratives in human (as opposed to lofty theological) terms. The spiritual stillness of Rembrandt's religious paintings is that of inward-turning contemplation, far from the choirs and trumpets and the heavenly tumult of Bernini or Pozzo. Rembrandt gave viewers not the celestial triumph of the Christian Church but the humanity and humility of Jesus. His psychological insight and his profound sympathy for human affliction produced, at the very end of his life, one of the most moving pictures in all religious art, *Return of the Prodigal Son* (FIG. **19-45**). Tenderly embraced by his forgiving father, the son crouches before him in weeping contrition, while three figures, immersed in varying degrees in the soft shadows, note the les-

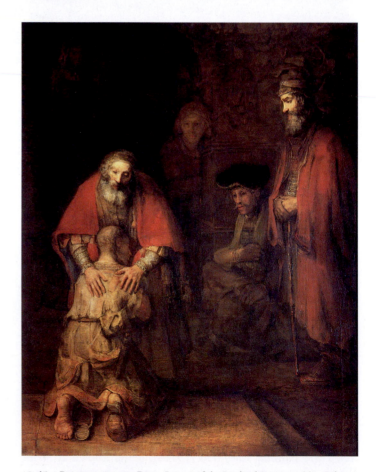

19-45 Rembrandt van Rijn, *Return of the Prodigal Son*, ca. 1665. Oil on canvas, approx. 8′ 8″ × 6′ 9″. Hermitage Museum, Saint Petersburg.

son of mercy. The light, everywhere mingled with shadow, directs the viewer's attention by illuminating the father and son and largely veiling the witnesses. Its focus is the beautiful, spiritual face of the old man; secondarily, it touches the contrasting stern face of the foremost witness. *Return* demonstrates the degree to which Rembrandt developed a personal style completely in tune with the simple eloquence of the biblical passage.

LIGHTING THE WAY From the few paintings by Rembrandt discussed thus far, it should be clear the artist's use of light is among the hallmarks of his style. Rembrandt's pictorial method involved refining light and shade into finer and finer nuances until they blended with one another. Earlier painters' use of abrupt lights and darks gave way, in the work of artists such as Rembrandt and Velázquez, to gradation. Although these later artists may have sacrificed some of the dramatic effects of sharp chiaroscuro, a greater fidelity to actual appearances offset those sacrifices. This technique is closer to reality because the eyes perceive light and dark not as static but as always subtly changing.

Generally speaking, Renaissance artists represented forms and faces in a flat, neutral modeling light (even Leonardo's shading is of a standard kind). They represented the idea of light, rather than the actual look of it. Artists such as Rembrandt discovered degrees of light and dark, degrees of differences in pose, in the movements of facial features, and in psychic states. They arrived at these differences optically, not conceptually or in terms of some ideal. Rembrandt found that by manipulating the direction, intensity, distance, and surface texture of light and shadow, he could render the most subtle nuances of character and mood, of persons, or of whole scenes. He discovered for the modern world that variation of light and shade, subtly modulated, could be read as emotional differences. In the visible world, light, dark, and the wide spectrum of values between the two are charged with meanings and feelings that sometimes are independent of the shapes and figures they modify. The theater and the photographic arts have used these discoveries to great dramatic effect.

Rembrandt carried over the spiritual quality of his religious works into his later portraits by the same means—what could be called the "psychology of light." Light and dark are not in conflict in his portraits—they are reconciled, merging softly and subtly to produce the visual equivalent of quietness. Their prevailing mood is that of tranquil meditation, of philosophical resignation, of musing recollection—indeed, a whole cluster of emotional tones heard only in silence.

AN ILLUMINATING SELF-PORTRAIT In a late-Rembrandt self-portrait (FIG. **19-46**), the light that shines from the upper left of the painting bathes the subject's face in soft light, leaving the lower part of his body in shadow. The artist depicted himself here with dignity and strength, and the portrait can be seen as a summary of the many stylistic and professional concerns that occupied him throughout his career. Not only is Rembrandt's distinctive use of light evident, but also the assertive brushwork suggests a confidence and self-assurance. He presented himself as a working artist holding his brushes, palette, and maulstick. He is clothed in

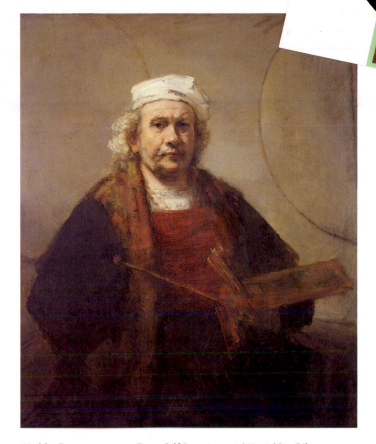

19-46 REMBRANDT VAN RIJN, *Self-Portrait*, ca. 1659–1660. Oil on canvas, approx. 3′ 8¾″ × 3′ 1″. The Iveagh Bequest, Kenwood House, London.

studio garb—a smock and painter's turban. The circles on the wall behind him (the subject of much scholarly debate) may allude to a legendary sign of artistic virtuosity—an ability to draw a perfect circle freehand. Ultimately, Rembrandt's abiding interest in revealing the human soul emerged here in his careful focus of the viewer's attention on his expressive visage. His controlled use of light and nonspecific setting contribute to this focus. Further, X rays of the painting have revealed that Rembrandt originally depicted himself in the act of painting. His final resolution, with the viewer's attention drawn to his face, produced a portrait not just of the artist but of the man as well.

COMPASSION MEMORABLY ETCHED Rembrandt's virtuosity also extended to the graphic media—in particular, to etching. Many artists rapidly took up etching when it was perfected early in the seventeenth century. They found it far more manageable than engraving, and it allowed greater freedom in drawing the design. For etching, a copper plate is covered with a layer of wax or varnish. The artist incises the design into this surface with an etching needle or any pointed tool, exposing the metal below but not cutting into its surface. The plate is then immersed in acid, which etches, or eats away, the exposed parts of the metal, acting the same as the burin in engraving. The medium's softness gives etchers greater carving freedom than woodcutters and engravers have working directly in their more resistant media of wood and

Separating the Real from the Fake
The Rembrandt Research Project

Rembrandt had an active workshop and shared stylistic traits and technical methods with numerous colleagues and pupils. As a result, authenticating Rembrandt's paintings has been difficult (as is the case with many other artists). In 1968, a team of Dutch scholars organized as the Rembrandt Research Project (RRP) and set about the task of assessing the paintings attributed to Rembrandt in museums and private collections throughout the world. Their ultimate goal is the compilation of a definitive *catalogue raisonné* (a comprehensive catalog of an artist's works). RRP has relied extensively on new scientific techniques, such as X-ray, microscopic, and chemical analysis of paint samples and *dendrochronology* (the dating of wood). Of course, stylistic analysis remains an important component in assessing authorship.

The results of their investigation, which still continues, have raised vehement debate, controversy, and consternation among art historians, museum curators, collectors, and deal-ers. Currently, the Rembrandt Research Project has published three volumes (of a projected five-volume collection) of *A Corpus of Rembrandt Paintings*. These three volumes cover Rembrandt's work from 1625 to 1642 and include not just evaluations of the numerous paintings attributed to the artist during these years but also introductory essays on Rembrandt's style, patrons, and workshop practices. Of the paintings they have examined thus far, the RRP scholars have concluded that one hundred forty-six of the paintings attributed to Rembrandt are indeed by his hand, twelve paintings are questionable, and one hundred twenty-two works previously accepted as Rembrandt's should not be attributed to him. None of this subtracts, of course, from the aesthetic value of Rembrandt's art, which certainly is inestimable. Nor does it in any way diminish his stature in the history of art. It does remind people once again that the "facts" of art history always are open to review and their interpretations open to revision.

metal. Thus, prior to the invention of the lithograph in the nineteenth century, etching was the most facile of the graphic arts and offered the greatest subtlety of line and tone.

If Rembrandt had never painted, he still would be renowned, as he principally was in his lifetime, for his prints. Prints were a major source of income for him, and he often reworked the plates so that they could be used to produce a new issue or edition. *Christ with the Sick around Him, Receiving the Children (Hundred Guilder Print;* FIG. **19-47**) is one of Rembrandt's most celebrated etchings. Indeed, the title by which the print is best known, *Hundred Guilder Print*, refers to the high price this work brought during Rembrandt's lifetime. Like his other religious works, this print is suffused with a deep and abiding piety. Christ appears in the center

19-47 REMBRANDT VAN RIJN, *Christ with the Sick around Him, Receiving the Children (Hundred Guilder Print)*, ca. 1649. Etching, approx. 11″ × 1′ 3¼″. Pierpont Morgan Library, New York.

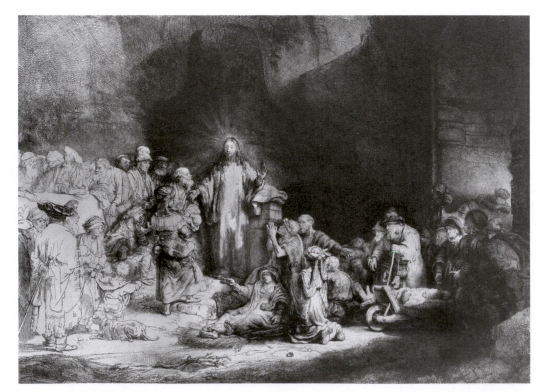

preaching compassionately to the blind, the lame, and the young. On the left, a group of Jews heatedly discuss issues among themselves. Like Rembrandt's *Return of the Prodigal Son* (FIG. 19-45), this image is about Christian humility and mercy.

Rembrandt's genius is undisputed. He is revered as an artist of great versatility, as a master of light and shadow, and as the unique interpreter of the Protestant conception of Scripture. Due to the esteem in which Rembrandt's art is held, his work and style have been the focus of many forgers. To counteract this, a group of scholars has launched the Rembrandt Research Project, whose goal is to provide definitive identification of the hundreds of works currently attributed to Rembrandt (see "Separating the Real from the Fake: The Rembrandt Research Project," page 646).

AT EASE IN FRONT OF AN EASEL JUDITH LEYSTER (1609–1660) developed a thriving career as a portraitist, like Hals, with whom she studied for a time. Her *Self-Portrait* (FIG. **19-48**) suggests the strong training she received; it is detailed, precise and accurate but also imbued with a spontaneity found in the works of Hals. In this painting, Leyster depicted herself as an artist, seated in front of a painting on an easel. The palette in her left hand and brush in her right make it clear the painting is her creation. She thus allowed viewers to evaluate her skill, which both the fiddler on the canvas and

the image of herself demonstrate as considerable. Her self-assurance is reflected in her quick smile and her relaxed pose as she stops her work to meet the viewer's gaze. Leyster produced a wide range of paintings, including genre scenes, still lifes, and floral pieces.

RECLAIMING THE LAND FROM THE SEA In addition to portraiture, the Dutch avidly collected landscapes, interior scenes, and still lifes. Each of these painting genres dealt directly with the daily lives of the urban mercantile public, accounting for their appeal. Landscape scenes abound in Dutch Baroque art. The Dutch had a unique relationship to the terrain, one that differed from other European countries due to topography and politics. After gaining independence from Spain, the Dutch undertook an extensive land reclamation project that lasted almost a century. Dikes and drainage systems cropped up across the landscape. Because of the effort expended on these endeavors, the Dutch developed a very direct relationship to the land. Further, the reclamation impacted Dutch social and economic life. The marshy and swampy nature of much of the land made it less desirable for large-scale exploitation, so the extensive feudal landowning system that existed elsewhere in Europe was never developed in the provinces. Most Dutch families owned and worked their own farms, cultivating a feeling of closeness to the Dutch terrain.

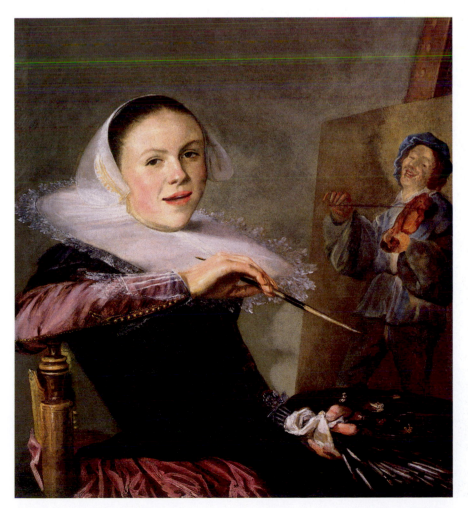

19-48 JUDITH LEYSTER, *Self-Portrait,* ca. 1630. Oil on canvas, 2′ 5⅜″ × 2′ 1⅝″. National Gallery of Art, Washington (gift of Mr. and Mrs. Robert Woods Bliss).

19-49 AELBERT CUYP, *A Distant View of Dordrecht, with a Milkmaid and Four Cows, and Other Figures (The "Large Dort")*, late 1640s. Oil on canvas, approx. 5′ 1″ × 6′ 4$\frac{7}{8}$″. National Gallery, London.

19-50 JACOB VAN RUISDAEL, *View of Haarlem from the Dunes at Overveen*, ca. 1670. Oil on canvas, approx. 1′ 10″ × 2′ 1″. Mauritshuis, The Hague.

Mercantile Prosperity
Developing an Open Art Market

With the expansion of the Dutch art market (see "The Butcher, the Baker, the Candlestick Maker: Dutch Patronage and Art Collecting," page 640), commissions, the mainstay of art production in Italy and Spain, became less prevalent (except for portraiture) in the United Provinces. Dutch artists produced paintings for an anonymous market, hoping to appeal to a wide audience. To ensure success, artists adapted to the changed conditions of art production and sales. They marketed their paintings in many ways, selling their works directly to buyers who visited their studios and through art dealers, exhibitions, fairs, auctions, and even lotteries. Because of the uncertainty of these sales mechanisms (as opposed to the certainty of an ironclad contract for a commission), artists became more responsive to market demands. Specialization became common among Dutch artists of the seventeenth century. For example, painters would limit their practice to painting portraits, still lifes, or landscapes—the most popular genres among middle-class patrons. Exact prices for Dutch paintings sold then are difficult to ascertain. Given the wide range of patrons, the prices no doubt ranged from very cheap to extravagantly expensive. Documented information about prices paid for artwork suggests that by 1700, genre scenes were the most expensive, on average, followed by history painting, religious scenes, landscapes, still lifes, and portraits. Another reason for the uncertainty about prices is that transactions often were conducted without cash. Artists frequently used their paintings to pay off loans or debts. Tavern debts, in particular, could be settled with paintings, which may explain why many art dealers (such as Jan Vermeer and his father before him) were also innkeepers. This connection between art dealing and other businesses eventually solidified, and innkeepers, for example, often would have art exhibitions in their taverns hoping to make a sale.

The institutions of the current open art market—dealers, galleries, auctions, estate sales—thus owe their establishment to the "Golden Age" of Dutch art.

A LANDSCAPE OF DORDRECHT A Dutch artist who established his reputation producing landscape paintings was AELBERT CUYP (ca. 1620–1691). His works were the products of careful observation and a deep respect for and understanding of the Dutch landscape. *A Distant View of Dordrecht, with a Milkmaid and Four Cows, and Other Figures* (FIG. **19-49**), often referred to as *The "Large Dort,"* is a good example of Cuyp's substantial skills. The title indicates that the location was important to the artist. Unlike the idealized classical landscapes that populate many Italian Renaissance paintings, this landscape is specified. In fact, the church in the background can be identified as the Grote Kerk in Dordrecht. The dairy cows, shepherds, and milkmaid in the foreground refer to a cornerstone of Dutch agriculture—the demand for dairy products such as butter and cheese, which increased with the development of urban centers. The credibility of such paintings rests on Cuyp's pristine rendering of each detail.

THE SKY'S THE LIMIT JACOB VAN RUISDAEL (ca. 1628–1682), like Cuyp, depicted the Dutch landscape with precision and sensitivity. In *View of Haarlem from the Dunes at Overveen* (FIG. **19-50**), van Ruisdael gave observers an overarching view of this major Dutch city. The specificity of the artist's image—the Saint Bavo church in the background, the numerous windmills that refer to the land reclamation efforts, and the figures in the foreground stretching linen to be bleached (a major industry in Haarlem)—endows the work with a sense of honesty and integrity. Yet this is, above all, a landscape. Although the scene is painted in an admirably clear and detailed manner, the inhabitants and dwellings are so minuscule that they blend into the land itself. Further, the horizon line is low, so the sky fills almost three-quarters of the picture space. And the landscape is illuminated only in patches, where the sun has broken through the clouds above. In *View of Haarlem,* as in his other landscape paintings, van Ruisdael not only captured a specific and historical view of Haarlem, but he also succeeded in imbuing the work with a quiet serenity that seems almost spiritual.

HOME IS WHERE THE HEART IS The sense of peace, familiarity, and comfort that Dutch landscape paintings seem to exude also emerged in interior scenes. These paintings provide viewers with glimpses into the lives of prosperous, responsible, and cultured citizens. The best-known and most highly regarded of the Dutch interior scene painters is JAN VERMEER (1632–1675) of Delft. Vermeer derived most of his income from his work as an innkeeper and art dealer (see "Mercantile Prosperity: Developing an Open Art Market," above), and he painted no more than thirty-five paintings that definitively can be attributed to him. Vermeer's pictures are small, luminous, and captivating. Fifteenth-century Flemish artists also had painted domestic interiors, but persons of sacred significance often occupied those scenes (see, for example, the *Mérode Altarpiece,* FIG. 15-11). In contrast, Vermeer and his contemporaries composed neat, quietly opulent interiors of Dutch middle-class dwellings with men, women, and children engaging in household tasks or some little recreation. These commonplace actions reflected the values of a comfortable domesticity that had a simple beauty.

19-51 Jan Vermeer, *The Letter*, 1666. Oil on canvas, 1' 5¼" × 1' 3¼". Rijksmuseum, Amsterdam.

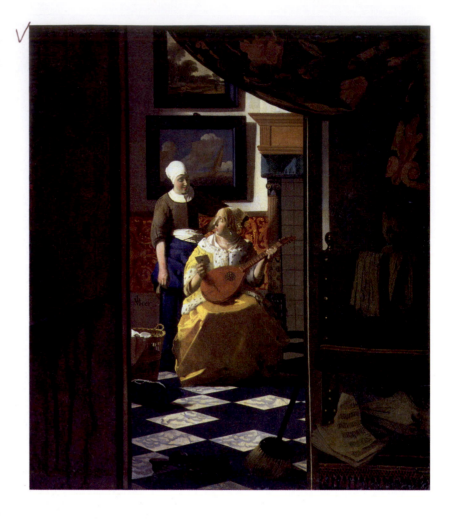

In *The Letter* (FIG. **19-51**), Vermeer ushers viewers into a room of a well-appointed Dutch house. The drawn curtain and open doorway through which they must peer reinforce the viewers' status as outsiders and affirm the scene's unplanned "normal" reality. A well-dressed woman sits framed by the doorway. Her lute playing has been interrupted by a maid, who has delivered a letter. The missive is a love letter; Vermeer included objects that would prompt this inference from a seventeenth-century Dutch audience. The lute was a traditional symbol of the music of love, and the calm seascape on the back wall served as a symbol of love requited. In the book *Love Emblems,* published in Amsterdam in 1634, the author wrote: "Love may rightly be compared to the sea, considering its changeableness. . . ."[3] Although the event depicted may not be historically momentous, Vermeer's care and directness in recording these scenes provides viewers with important insights about Dutch life and culture.

THE SCIENCE AND POETRY OF LIGHT Vermeer was a master of pictorial light and used it with immense virtuosity. He could render space so convincingly through his depiction of light that in his works, the picture surface functions as an invisible glass pane the viewer looks through into the constructed illusion. Historians know Vermeer used as tools both mirrors and the *camera obscura,* an ancestor of the modern camera based on passing light through a tiny pinhole or lens to project an image on a screen or the wall of a room. (In later versions, the image was projected on a ground-glass wall of a box whose opposite wall contained the pinhole or lens.) This does not mean that Vermeer merely copied the image. Instead, these aids helped him obtain results he reworked compositionally, placing his figures and the furniture of a room in a beautiful stability of quadrilateral shapes. This gives his designs a matchless classical serenity. This quality is enhanced by colors so true to the optical facts and so subtly modulated that they suggest Vermeer was far ahead of his time in color science. Close examination of his paintings shows that Vermeer realized that shadows are not colorless and dark, that adjoining colors affect each other, and that light is composed of colors. Thus, he painted reflections off of surfaces in colors modified by others nearby. It has been suggested that Vermeer also perceived the phenomenon modern photographers call "circles of confusion," which appear on out-of-focus negatives. Vermeer could have seen them in images projected by the camera obscura's primitive lenses. He approximated these effects with light dabs that, in close view, give the impression of an image slightly "out of focus." When the observer draws back a step, however, as if adjusting the lens, the color spots cohere, giving an astonishingly accurate illusion of a third dimension.

All of these technical considerations reflect the scientific spirit of the age, but they do not explain the exquisite poetry of form and surface, of color and light that could come only from a great artist's sensitivity. In Marcel Proust's *Swann's Way,*

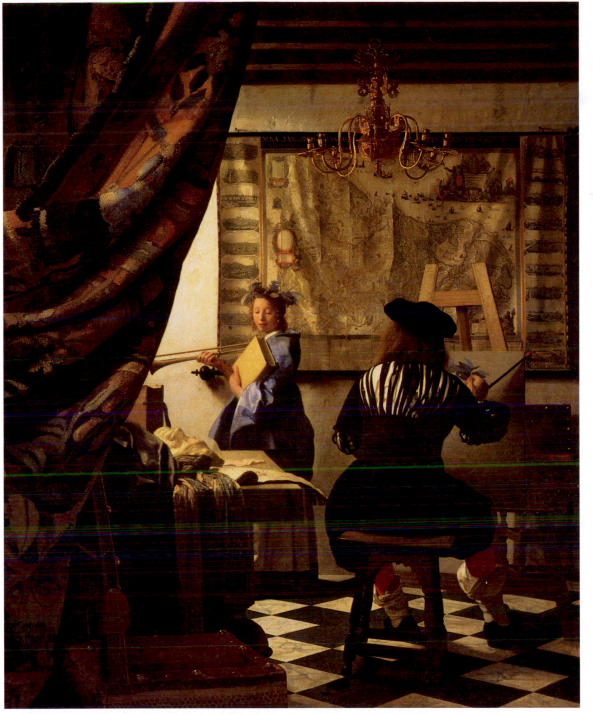

19-52 JAN VERMEER, *Allegory of the Art of Painting,* 1670–1675. Oil on canvas, 4′ 4″ × 3′ 8″. Kunsthistorisches Museum, Vienna.

the connoisseur hero, trying unsuccessfully to write a monograph on Vermeer, admits that no words could ever do justice to a single patch of sunlight on one of Vermeer's walls.

EXTOLLING THE ART PROFESSION Vermeer's stylistic precision and commitment to his profession surfaced in *Allegory of the Art of Painting* (FIG. **19-52**). The artist himself appears in the painting, with his back to the viewer and dressed in "historical" clothing (reminiscent of Burgundian attire). He is hard at work on a painting of the model who stands before him wearing a laurel wreath and holding a trumpet and book, traditional attributes of Clio, the Muse of History. The map of the provinces (an increasingly common

wall adornment in Dutch homes) on the back wall serves as yet another reference to history. As in *The Letter,* viewers are outside the space of the action, and the drawn curtain provides visual access. Some art historians have suggested that the light radiating from an unseen window on the left that illuminates both the model and the canvas being painted alludes to the light of artistic inspiration. Accordingly, this painting has been interpreted (as reflected in the title) as an allegory—a reference to painting inspired by history. This allegorical reading was affirmed when Vermeer's widow, wishing to retain this painting after the artist's death, listed it in her written claim as "the piece . . . wherein the Art of Painting is portrayed."[4]

19-53 JAN STEEN, *The Feast of Saint Nicholas,*
ca. 1660–1665. Oil on canvas, 2′ 8¼″ × 2′ 3¾″.
Rijksmuseum, Amsterdam.

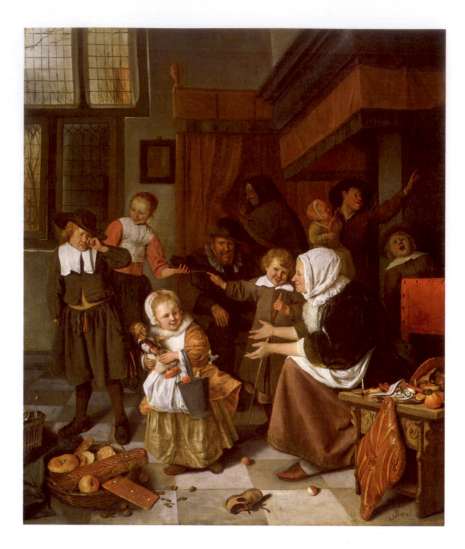

SATIRIZING DUTCH LIFE While Vermeer revealed the charm and beauty of Dutch domesticity, the work of JAN STEEN (ca. 1625–1679) provided a counterpoint. In *The Feast of Saint Nicholas* (FIG. **19-53**), rather than depicting a tidy, calm Dutch household, Steen painted a scene of chaos and disruption. Saint Nicholas has just visited this residence, and the children are in an uproar as they search their shoes for the gifts from Saint Nick. Some children are delighted—the little girl in the center clutches her gifts, clearly unwilling to share with the other children despite her mother's pleas. Others are disappointed—the boy on the left is in tears because all he has received is a birch rod. An appropriately festive atmosphere reigns, which contrasts sharply with the decorum that prevails in Vermeer's works. Like the paintings of other Dutch Baroque artists, Steen's lively scenes often take on an allegorical dimension or moralistic tone. Steen frequently used children's activities as satirical comments on foolish adult behavior. *The Feast of Saint Nicholas* can be seen as alluding to selfishness, pettiness, and jealousy.

OF BEAUTY AND DEATH The prosperous Dutch were justifiably proud of their accomplishments, and the popularity of still-life paintings—particularly images of ac-

cumulated material goods—reflected this pride. These still lifes, like Vermeer's interior scenes, are beautifully crafted images that are both scientific in their optical accuracy and poetic in their beauty and lyricism. Paintings such as *Still Life with Oysters, Rum Glass, and Silver Cup* (FIG. **19-54**) by WILLEM CLAESZ HEDA (ca. 1599–1680), reveal the pride Dutch citizens had in their material possessions, presented as if strewn across a tabletop or dresser. This pride is tempered, however, by the ever-present morality and humility central to the Calvinist faith. Thus, while appreciating and enjoying the beauty and value of the objects depicted, the artist reminded viewers of life's transience. He achieved this by including references to death. Paintings with such features are called *vanitas* paintings. In *Still Life,* references to mortality include the oysters, partially peeled fruit, broken glass, and tipped silver cup. All suggest a presence that has disappeared. Something or someone was here—and now is gone.

THE ALLURE OF PRECIOUS OBJECTS As Dutch prosperity increased, precious objects and luxury items made their way into still-life paintings. *Still Life with the Drinking Horn of Saint Sebastian's Archer's Guild* (FIG. **19-55**) by WILLEM KALF (1619–1693) reveals both the wealth Dutch

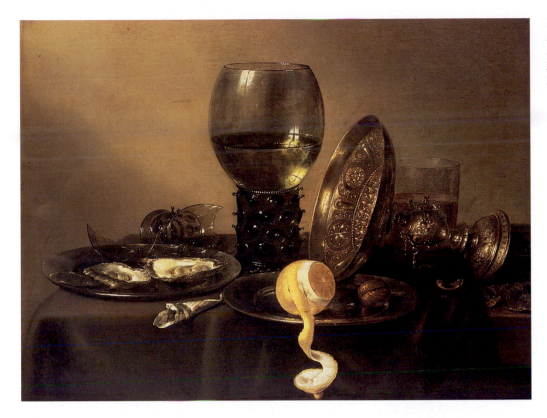

19-54 WILLEM CLAESZ HEDA, *Still Life with Oysters, Rum Glass, and Silver Cup,* Panel, 1' 5" × 2' 4⅞". Museum Boijmans-Van Beuringen, Rotterdam.

citizens had accrued and the exquisite skills—both technical and aesthetic—of Dutch Baroque artists. Kalf was enamored by highlights glinting off reflective surfaces and the lustrous sheen of fabric. His works, as is evident in this image, present an array of ornamental objects, such as the drinking horn. Kalf's inclusion of the lobster and peeled fruit suggests that these works, despite their opulence, also functioned as vanitas paintings.

19-55 WILLEM KALF, *Still Life with the Drinking Horn of Saint Sebastian's Archer's Guild,* ca. 1653. Oil on canvas, approx. 2' 9" × 3' 3⅞". National Gallery, London.

19-56 RACHEL RUYSCH, *Flower Still Life,* after 1700. Oil on canvas, 2′ 6″ × 2′. The Toledo Museum of Art, Toledo (purchased with funds from the Libbey Endowment, gift of Edward Drummond Libbey).

A BUDDING ARTIST Like still-life paintings, flower paintings were prominent in Dutch Baroque art. As living objects that soon die, flowers, particularly cut blossoms, appeared frequently in vanitas paintings. However, floral painting itself also flourished. Among the leading practitioners of this art was RACHEL RUYSCH (1663–1750). Ruysch's father was a professor of botany and anatomy, which may account for her interest in and knowledge of plants and insects. She acquired an international reputation for lush paintings such as *Flower Still Life* (FIG. **19-56**). In this image, the lavish floral arrangement is so full that many of the blossoms seem to be spilling out of the vase. Ruysch carefully constructed her paintings. Here, for example, the lower left to upper right diagonal created by her positioning of the flowers is offset by the opposing diagonal of the table edge. Ruysch became famous for her floral paintings and still lifes, and from 1708 to 1716 she served as court painter to the elector Palatine (the ruler of the Palatinate, a division of Bavaria) in Düsseldorf, Germany.

Dutch Baroque art has a unique character that sets it apart from, say, Italian Baroque, although commonalities can be uncovered. The appeal of Dutch Baroque art lies both in its beauty and its sincerity, as well as the insights it provides into Dutch life and history.

France

France's history during the Baroque period is essentially the culmination of increasing monarchical authority that had been developing for centuries. This consolidation of power was embodied in King Louis XIV (r. 1661–1715), whose ob-

sessive control determined the direction of French Baroque society and culture. The governmental investment of total authority in the absolute monarch proved France's downfall. The country's reluctance to expand economically made it unable to compete with rising powers such as the Dutch Republic. The stagnant political, economic, and social systems in France eventually led to the French Revolution in 1789.

Religious conflicts caused great tension throughout the sixteenth and seventeenth centuries. After the Reformation, Protestants in France challenged royal authority, which resulted in a sequence of religious wars between Catholics and Protestants. In 1598, King Henry IV (r. 1589–1610) issued the Edict of Nantes, which in effect decreed religious tolerance. Despite this edict, Protestants eventually were driven from the country.

REALISM, SPIRITUALISM, CLASSICISM Because of the prominence of religious issues and the value Catholics placed on the didactic capabilities of art (as in Baroque Italy), religious art did have a presence in France. Among the artists well known for their religious imagery was the painter GEORGES DE LA TOUR (1593–1652). La Tour's work, particularly his use of light, suggests a familiarity with Caravaggio's art, which he may have acquired through the Dutch school of Utrecht. Although La Tour used the devices of the northern Caravaggisti, his effects are strikingly different from theirs. His *Adoration of the Shepherds* (FIG. **19-57**) makes use of the night setting favored by that school, much as van Honthorst (FIG. 19-40) portrayed it. But here, the light, its source shaded by an old man's hand, falls upon a very different company in a very different mood. A group of humble men and women, coarsely clad, gather in prayerful vigil around a luminous baby Jesus. Without the aid of the title, this might be construed as a genre piece, a narrative of some event from peasant life. Nothing in the environment, placement, poses, dress, or attributes of the figures distinguishes them as the scriptural Virgin Mary, Joseph, Christ Child, or shepherds. The artist did not portray halos, choirs of angels, stately architecture, or resplendent grandees. The light is not spiritual but material; it comes from a candle. La Tour's scientific scrutiny of the effects of material light, as it throws precise shadows on surfaces

19-57 GEORGES DE LA TOUR, *Adoration of the Shepherds,* 1645–1650. Oil on canvas, approx. 3′ 6″ × 4′ 6″. Louvre, Paris.

that intercept it, had, nevertheless, religious intention and consequence. The light illuminates a group of ordinary people held in a mystic trance induced by their witnessing the miracle of the Incarnation. In this timeless tableau of simple people, La Tour eliminated the dogmatic significance and traditional iconography of the Incarnation. Still, these people reverently contemplate something they regard as holy. As such, the painting is readable to the devout of any religious persuasion, whether or not they know of this central mystery of the Christian faith.

The supernatural calm that pervades this picture is characteristic of the mood of Georges de La Tour's art. He achieved this by eliminating motion and emotive gesture (only the light is dramatic), by suppressing surface detail, and by simplifying body volumes. These stylistic traits are among those associated with classical art and art based on classical principles—for example, that of Piero della Francesca (see FIGS. 16-51, 16-52, and 16-53). Several apparently contrary elements meet in the work of La Tour: classical composure, fervent spirituality, and genre realism.

THE HARDSHIP OF PEASANT LIFE LOUIS LE NAIN (ca. 1593–1648) and his contemporary, La Tour, bear comparison with the Dutch. Subjects that in Dutch painting were opportunities for boisterous good humor the French treated with sombre stillness. *Family of Country People* (FIG. **19-58**) expresses the grave dignity of a family close to the soil, one made stoic and resigned by hardship. These drab country folk surely had little reason for merriment. The peasant's lot, never easy, was miserable during the time Le Nain painted. The constant warfare (*Family* was painted during the Thirty Years' War) took its toll on France. The anguish and frustration of the peasantry, suffering from the cruel depredations of unruly armies living off the country, often broke out in violent revolts that were savagely suppressed. This family, however, is pious, docile, and calm. Because Le Nain depicted peasants with dignity and subservience, despite their harsh living conditions, some scholars have suggested he intended to please wealthy urban patrons with these paintings.

19-58 LOUIS LE NAIN, *Family of Country People*, ca. 1640. Oil on canvas, approx. 3' 8" × 5' 2". Louvre, Paris.

A STARK ETCHING OF DEATH A record of the times appears in a series of etchings by JACQUES CALLOT (ca. 1592–1635) called *Miseries of War*. Callot confined himself almost exclusively to the art of etching and was widely influential in his own time and since; Rembrandt was among those who knew and learned from his work. Callot perfected the medium and the technique of etching, developing a very hard surface for the copper plate to permit fine and precise delineation with the needle. In one small print, he would assemble as many as twelve hundred figures, which only close scrutiny can discriminate. His quick, vivid touch and faultless drawing produced panoramas sparkling with sharp details of life—and death. In the *Miseries of War* series, he observed these coolly, presenting without comment sights he himself must have seen in the wars in his own region, Lorraine.

In one etching, he depicted a mass execution by hanging (FIG. **19-59**). The unfortunates in *Hanging Tree* may be war prisoners or defeated peasant rebels. The event takes place in the presence of a disciplined army, drawn up on parade with banners, muskets, and lances, their tents in the background.

19-59 JACQUES CALLOT, *Hanging Tree*, from the *Miseries of War* series, 1621. Etching, 3¾" × 7¼". Bibliothèque Nationale, Paris.

19-60 NICOLAS POUSSIN, *Et in Arcadia Ego*, ca. 1655. Oil on canvas, approx. 2′ 10″ × 4′. Louvre, Paris.

Hanged men sway in clusters from the branches of a huge cross-shaped tree. A monk climbs a ladder, holding up a crucifix to a man while the executioner adjusts the noose around the man's neck. At the foot of the ladder, another victim kneels to receive absolution. Under the crucifix tree, men roll dice on a drumhead for the belongings of the executed. (This may be an allusion to the soldiers who cast lots for the garments of the crucified Christ.) In the right foreground, a hooded priest consoles a bound man. Callot's *Miseries of War* were among the first realistic pictorial records of the human disaster of armed conflict.

INVOKING CLASSICAL ORDER The brisk animation of Callot's manner contrasts with the quiet composure in the art of La Tour and Le Nain, his exact contemporaries. Yet, although the art of La Tour and Le Nain exudes a calm simplicity and restraint, it remained for another contemporary, NICOLAS POUSSIN (1594–1665), to establish classical painting as an important manifestation in French Baroque art. Poussin, born in Normandy, spent most of his life in Rome. There, inspired by its monuments and countryside, he produced his grandly severe and regular canvases modeled on the work of Titian and Raphael. He also carefully worked out a theoretical explanation of his method.

Poussin's *Et in Arcadia Ego* (*I, Too, in Arcadia*, or *Even in Arcadia, I* [am present]; FIG. **19-60**) was informed by Raphael's rational order and stability and by antique statuary. Landscape, of which Poussin became increasingly fond, provides the setting for the picture. The foreground, however, is dominated by three shepherds, living in the idyllic land of Arcadia, who spell out an enigmatic inscription on a tomb as a statuesque female figure quietly places her hand on the shoulder of one of them. She may be the spirit of death, reminding these mortals, as does the inscription, that death is found even in Arcadia, supposedly a spot of Edenic bliss. The countless draped female statues surviving in Italy from Roman times supplied the models for this figure, and the youth with one foot resting on a boulder is modeled on Greco-Roman statues of Neptune, the sea god, leaning on his trident. The compact, balanced grouping of these figures; the even light; and the thoughtful, reserved, mournful mood set the tone for Poussin's art in its later, classical phase.

In notes for an intended treatise on painting, Poussin outlined the "grand manner" of classicism, of which he became the leading exponent in Rome. Artists must first of all choose great subjects: "The first requirement, fundamental to all others, is that the subject and the narrative be grandiose, such as

battles, heroic actions, and religious themes."⁵ Minute details should be avoided, as well as all "low" subjects, such as genre—"Those who choose base subjects find refuge in them because of the feebleness of their talents."⁶ Clearly, these directives rule out a good deal of both decorative and naturalistic art.

Poussin represents a theoretical tradition in Western art that goes back to the Early Renaissance. It asserts that all good art must be the result of good judgment—a judgment based on sure knowledge. In this way, art can achieve correctness and propriety, two of the favorite categories of the classicizing artist or architect. Poussin praised the ancient Greeks, who "produced marvelous effects" with their musical "modes." He observed that "[t]he word 'mode' really means the system, or the measure and form which we use in making something. It constrains us not to pass the limits, it compels us to employ a certain evenness and moderation in all things."⁷ "Evenness" and "moderation" are the very essence of French classical doctrine. In the age of Louis XIV, scholars preached this doctrine as much for literature and music as for art and architecture.

A GREEK GENERAL ABANDONED IN DEATH
Among Poussin's finest works is *Burial of Phocion* (FIG. **19-61**). As was typical of Poussin, he carefully chose its subject from the literature of antiquity. His source was Plutarch's *Life of Phocion,* a biography of the distinguished Athenian general whom his compatriots unjustly put to death for treason.

Eventually, the state gave him a public funeral and memorialized him. In the foreground, Poussin represented the hero's body being taken away, his burial on Athenian soil initially forbidden. The two massive bearers and the bier are starkly isolated in a great landscape that throws them into solitary relief, eloquently expressive of the hero abandoned in death. The landscape's interlocking planes slope upward to the lighted sky at the left. Its carefully arranged terraces bear slowly moving streams, shepherds and their flocks, and, in the distance, whole assemblies of solid geometric structures (temples, towers, walls, villas, and a central grand sarcophagus). The skies are untroubled, and the light is even and form revealing. The trees are few and carefully arranged, like curtains lightly drawn back to reveal a natural setting carefully cultivated for a single human action. Unlike van Ruisdael's *View of Haarlem* (FIG. 19-50), this scene was not intended to represent a particular place and time. It was Poussin's construction of an idea of a noble landscape to frame a noble theme, much like Annibale Carracci's classical landscape (FIG. 19-22). The *Phocion* landscape is nature subordinated to a rational plan.

A LANDSCAPIST PAR EXCELLENCE
CLAUDE GELLÉE, called CLAUDE LORRAIN (1600–1682), modulated in a softer style the disciplined rational art of Poussin, with its sophisticated revelation of the geometry of landscape. Unlike Poussin's pictures, the figures in Claude's landscapes tell no dramatic story, point out no moral, and praise no hero.

19-61 NICOLAS POUSSIN, *Burial of Phocion,* 1648. Oil on canvas, approx. 3′ 11″ × 5′ 10″. Louvre, Paris.

19-62 CLAUDE LORRAIN, *Landscape with Cattle and Peasants*, 1629. Oil on canvas, 3′ 6″ × 4′ 10½″. Philadelphia Museum of Art, Philadelphia (the George W. Elkins Collection).

Indeed, they often appear added as mere excuses for the radiant landscape itself. For Claude, painting involved essentially one theme—the beauty of a broad sky suffused with the golden light of dawn or sunset glowing through a hazy atmosphere and reflecting brilliantly off the rippling water.

The subject of his work often remains grounded in classical antiquity, as seen in *Landscape with Cattle and Peasants* (FIG. **19-62**). The figures in the right foreground chat in animated fashion, while in the left foreground, cattle relax contentedly and in the middle ground, cattle amble slowly away. The well-defined foreground, distinct middle ground, and dim background recede in serene orderliness, until all form dissolves in a luminous mist. Atmospheric and linear perspective reinforce each other to turn a vista into a typical Claudian vision, an ideal classical world bathed in sunlight in infinite space.

Claude's formalizing of nature with balanced groups of architectural masses, screens of trees, and sheets of water followed the great tradition of classical landscape. It began with the backgrounds of Venetian painting (see FIGS. 17-32 and 17-33) and continued in the art of Annibale Carracci (FIG. 19-22) and Poussin (FIG. 19-61). Yet, Claude, like the Dutch painters, studied the actual light and the atmospheric nuances of nature,

making a unique contribution. He recorded carefully in hundreds of sketches the look of the Roman countryside, its gentle terrain accented by stone-pines, cypresses, and poplars and by ever-present ruins of ancient aqueducts, tombs, and towers. He made these the fundamental elements of his compositions. Travelers could understand the picturesque beauties of the outskirts of Rome in Claude's landscapes.

The artist achieved his marvelous effects of light by painstakingly placing tiny value gradations, which imitated, though on a very small scale, the actual range of values of outdoor light and shade. Avoiding the problem of high-noon sunlight overhead, Claude preferred, and convincingly represented, the sun's rays as they gradually illuminated the morning sky or, with their dying glow, set the pensive mood of evening. Thus, he matched the moods of nature with those of human subjects. Claude's infusion of nature with human feeling, while recomposing it in a calm equilibrium, greatly appealed to the landscape painters of the eighteenth and early nineteenth centuries.

A GROTTO SCULPTURE FOR VERSAILLES Classicism also emerged in architecture and sculpture. FRANÇOIS GIRARDON (1628–1715) designed *Apollo Attended by the*

19-63 FRANÇOIS GIRARDON and THOMAS REGNAUDIN, *Apollo Attended by the Nymphs*, Grotto of Thetis, Park of Versailles, Versailles, France, ca. 1666–1672. Marble, life-size.

Nymphs (FIG. **19-63**) as a tableau group for the Grotto of Thetis in the gardens of Versailles. Both stately and graceful, the nymphs have a compelling charm as they minister to the god Apollo at the end of the day. (The three nymphs in the background are the work of THOMAS REGNAUDIN, 1622–1706.) Girardon's close study of Greco-Roman sculpture heavily conditioned his style for the figures, and Poussin's figure compositions (FIG. 19-60) inspired their arrangement. And if this combination did not suffice, the group's rather florid reference to Louis XIV as the "god of the sun" was bound to assure its success at court. Girardon's style and symbolism were well suited to France's glorification of royal majesty.

OFFICIAL SANCTION OF CLASSICISM In contrast, departure from the principles of classicism resulted in official rejection of the work of PIERRE PUGET (1620–1694). The strained dramatic and emotional qualities in Puget's work were not at all to the court's taste. His *Milo of Crotona* (FIG. **19-64**) represents the powerful ancient hero, his hand trapped in a split stump, helpless before the attacking lion. With physical and psychic realism, Puget presented a study of immediate and excruciating agony. This approach ran counter to the official taste for heroic design dictated by King Louis XIV and Charles Le Brun, the royal painter elevated to the post of "director and general guardian of His Majesty's cabinet of paintings and drawings."[8] Although Puget was very briefly in vogue, the most original French sculptor of his time never found acceptance at the French court.

A DIGNIFIED AND ORDERED BUILDING The classical bent asserted itself early in the work of FRANÇOIS MANSART (1598–1666), as seen in the Orléans wing of the

19-64 PIERRE PUGET, *Milo of Crotona*, 1671–1682. Marble, approx. 8' 10" high. Louvre, Paris.

19-65 FRANÇOIS MANSART, Orléans wing of the Château de Blois, Blois, France, 1635–1638.

Château de Blois (FIG. **19-65**), built in Blois between 1635 and 1638. The polished dignity evident here became the hallmark of French "Classical-Baroque," contrasting with the more daring and fanciful styles of the Baroque in Italy and elsewhere. The strong rectilinear organization and a tendency to design in repeated units suggest Italian Renaissance architecture (also permeated by the classical spirit), as do the insistence on the purity of line and the sharp relief of the wall joints. Yet the emphasis on focal points—achieved with the curving colonnades, the changing planes of the walls, and the concentration of ornament around the portal—is characteristic of French Baroque architectural thinking in general.

ART IN THE SERVICE OF ABSOLUTISM The establishment of the French classical style accelerated with the foundation of the Royal Academy of Painting and Sculpture in 1648. Also, King Louis XIV and his principal adviser, Jean-Baptiste Colbert (1619–1683), were determined to organize art and architecture in the service of the state. No pains were spared to raise great symbols and monuments to the king's absolute power and to regularize taste under the academy.

Louis XIV was a master of political strategy and propaganda. He ensured subservience by anchoring his rule to the principle of the divine right of kings, which stressed a king's absolute power as God's will, rendering Louis's authority uncontestable. So convinced was he of his importance and centrality to the French kingdom that he eagerly adopted the nickname "le Roi Soleil" ("the Sun King"). Like the sun, Louis was the center of the universe. He also established a carefully crafted and nuanced relationship with the nobility.

He allowed nobles sufficient benefits to keep them pacified but simultaneously maintained rigorous control to avoid insurrection or rebellion.

Louis's desire for control extended to all realms of French life, including art. The king understood well the power of art as propaganda and the value of visual imagery for cultivating a public persona. His numerous and extravagant commissions further revealed his interest in the arts.

The portrait of Louis XIV (FIG. **19-66**) by HYACINTHE RIGAUD (1659–1743), conveys the image of an absolute monarch in control. The king, sixty-three when this work was painted, looks out at viewers with directness. The suggestion of haughtiness is perhaps due to the pose—Louis XIV stands with his left hand on his hip and with his elegant ermine-lined coronation robes thrown over his shoulder. This portrait's majesty is also derived from the composition. The king is the unmistakable focal point of the image, and the artist placed him so that he seems to look down on the viewer. Given that Louis XIV was very short in stature—only five feet, four inches, a fact that drove him to invent the red-heeled shoes he wears in the portrait—it seems the artist catered to his patron's wishes. The carefully detailed environment the king stands in also contributes to the painting's stateliness and grandiosity. So insistent was Louis XIV that the best artists serve his needs, he maintained a workshop of artists, each with a specialization—faces, fabric, architecture, landscapes, armor, or fur. Thus, many of the king's portraits were a group effort.

REDESIGNING THE LOUVRE'S EAST FACADE Once he had formally ascended to power, the first project the

young Louis XIV and his adviser Colbert undertook was the closing of the east side of the Louvre court, left incomplete by Lescot in the sixteenth century. Bernini, as the most renowned architect of his day, was summoned from Rome to submit plans, but he envisioned an Italian palace on a monumental scale that would have involved the demolition of all previous work. His plan rejected, Bernini returned to Rome in high indignation. Instead, the Louvre's east facade (FIG. **19-67**) was a collaboration among CLAUDE PERRAULT (1613–1688), LOUIS LE VAU (1612–1670), and CHARLES LE BRUN (1619–1690). The design is a brilliant adjustment of French and Italian classical elements, culminating in a new and definitive formula. The French pavilion system was retained. The central pavilion is in the form of a classical temple front, and a giant colonnade of paired columns, resembling the columned flanks of a temple folded out like wings, is contained by the two salient pavilions at both ends. The whole is mounted on a stately basement, or podium. The designers favored an even roof line, balustraded and broken only by the central pediment, over the traditional French pyramidal roof. The emphatically horizontal sweep of this facade brushed aside all memory of Gothic verticality. Its stately proportions and monumentality were both an expression of the new official French taste and a symbol for centrally organized authority.

A HUNTING LODGE BECOMES A PALACE Work on the Louvre hardly had begun when Louis XIV decided to convert a royal hunting lodge at Versailles, a few miles outside Paris, into a great palace. A veritable army of architects, decorators, sculptors, painters, and landscape architects was assembled under the general management of former Poussin student Charles Le Brun. In their hands, the

19-66 HYACINTHE RIGAUD, *Louis XIV*, 1701. Oil on canvas, approx. 9′ 2″ × 6′ 3″. Louvre, Paris.

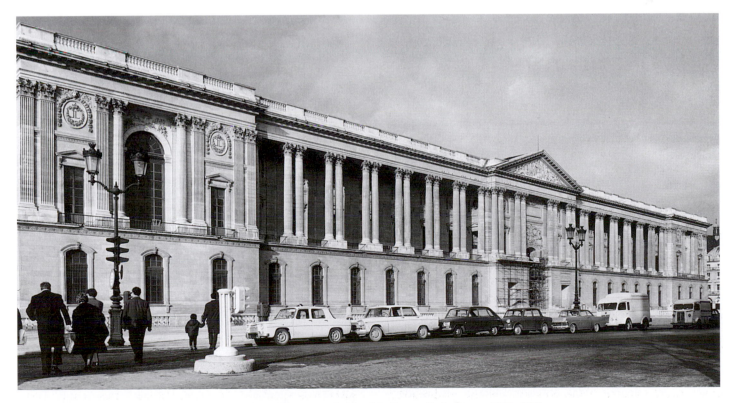

19-67 CLAUDE PERRAULT, LOUIS LE VAU, and CHARLES LE BRUN, east facade of the Louvre, Paris, France, 1667–1670.

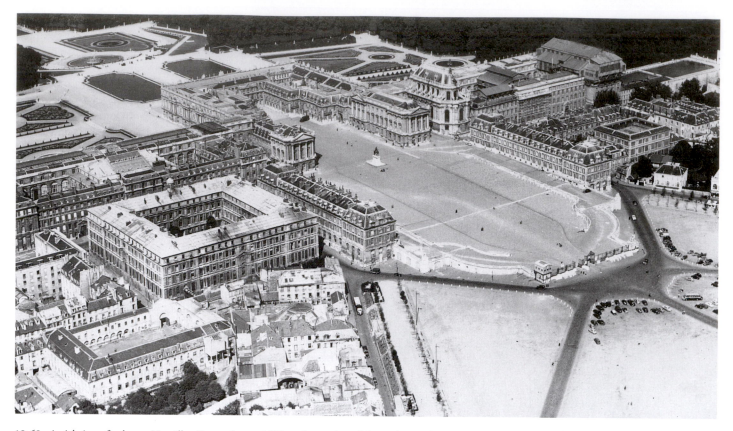

19-68 Aerial view of palace at Versailles, France, begun 1669, and a portion of the gardens and surrounding area. The white trapezoid in the lower part of the plan (FIG. 24-69) outlines the area shown here.

conversion of a simple lodge into the palace of Versailles (FIGS. **19-68** and **19-69**) became the greatest architectural project of the age—a defining statement of French Baroque style and an undeniable symbol of Louis XIV's power and ambition.

Planned on a gigantic scale, the project called not only for a large palace flanking a vast park but also for the construction of a satellite city to house court and government officials, military and guard detachments, courtiers, and servants (undoubtedly to keep them all under the king's close supervision). This town was laid out to the east of the palace along three radial avenues that converge on the palace structure itself; their axes, in a symbolic assertion of the ruler's absolute power over his domains, intersected in the king's bedroom. (As the site of the king's morning levee, this bedroom was actually an audience room, a state chamber.) The palace itself, more than a quarter of a mile long, was placed at right angles to the dominant east-west axis that runs through city and park.

Careful attention was paid to every detail of the extremely rich decoration of the palace's interior. The architects and decorators designed everything from wall paintings to doorknobs to reinforce the splendor of Versailles and to exhibit the very finest sense of artisanship. Of the literally hundreds of rooms within the palace, the most famous is the Galerie des Glaces, or Hall of Mirrors (FIG. **19-70**). This hall overlooks the park from the second floor and extends along most of the width of the central block. Although deprived of its original sumptuous furniture, which included gold and silver chairs and bejeweled trees, the Galerie des Glaces retains much of its splendor today. Its tunnel-like quality is alleviated by hundreds of mirrors, set into the wall opposite the

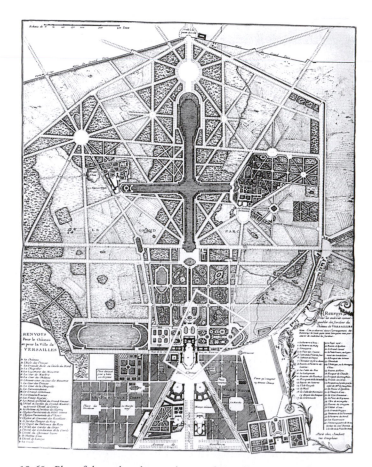

19-69 Plan of the park, palace, and town of Versailles, France, (after a seventeenth-century engraving by François Blondel). The area outlined in the white trapezoid (lower center) is shown in FIG. 24-68.

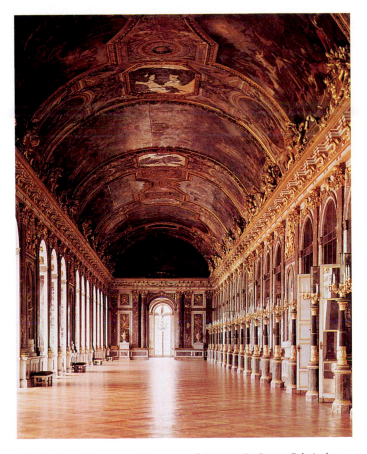

19-70 JULES HARDOUIN-MANSART and CHARLES LE BRUN, Galerie des Glaces (Hall of Mirrors), palace of Versailles, Versailles, France, ca. 1680.

windows, that illusionistically extend the room's width. The mirror, that ultimate source of illusion, was a favorite element of Baroque interior design; here, it also enhanced the dazzling extravagance of the great festivals Louis XIV was so fond of hosting.

CONTROLLING NATURE The enormous palace might appear unbearably ostentatious were it not for its extraordinary setting in the vast park that makes it almost an adjunct. The Galerie des Glaces is dwarfed by the sweeping vista (seen from its windows) down the park's tree-lined central axis and across terraces, lawns, pools, and lakes toward the horizon. The park of Versailles, designed by ANDRÉ LE NÔTRE (1613–1700), must rank among the world's greatest artworks in both size and concept. Here, an entire forest was transformed into a park. Although the geometric plan (FIG. 19-69) may appear stiff and formal, the park, in fact, offers an almost unlimited variety of vistas, as Le Nôtre used not only the multiplicity of natural forms but also the terrain's slightly rolling contours with stunning effectiveness.

The formal gardens near the palace provide a rational transition from the frozen architectural forms to the natural living ones. Here, the elegant forms of trimmed shrubs and hedges define the tightly designed geometric units. Each unit is different from its neighbor and has a focal point in the form of a sculptured group, a pavilion, a reflecting pool, or perhaps a fountain. Farther away from the palace, the design loosens as trees, in shadowy masses, screen or frame views of open countryside. Le Nôtre carefully composed all vistas for maximum effect. Dark and light, formal and infor-

mal, dense growth and open meadows—all play against one another in unending combinations and variations. No photograph or series of photographs can reveal the design's full richness; the park unfolds itself only to people who actually walk through it. In this respect, it is a temporal artwork. Its aspects change with time and with the relative position of observers.

As a symbol of the power of absolutism, Versailles is unsurpassed. It also expresses, in the most monumental terms of its age, the rationalistic creed—based on the mathematical philosophy of Descartes—that all knowledge must be systematic and all science must be the consequence of the intellect imposed on matter. The whole stupendous design of Versailles proudly proclaims the mastery of human intelligence (and the mastery of Louis XIV) over the disorderliness of nature.

A SUBDUED ROYAL CHAPEL After Le Vau's death, JULES HARDOUIN-MANSART (1646–1708), a great-nephew of François Mansart, completed the garden facade of the Versailles palace and in 1698 received a commission to add a Royal Chapel to the complex. The chapel's interior (FIG. 19-71) is essentially a rectangular building with an apse as high as the nave, giving the fluid central space a curved

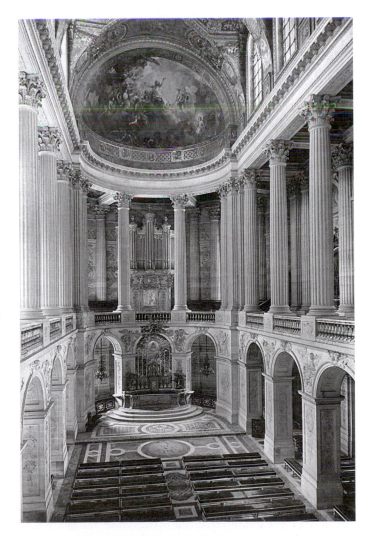

19-71 JULES HARDOUIN-MANSART, Royal Chapel, with ceiling decorations by ANTOINE COYPEL, palace of Versailles, Versailles, France, 1698–1710.

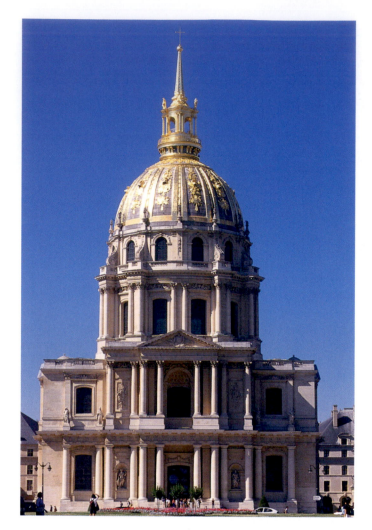

19-72 JULES HARDOUIN-MANSART, Église de Dôme, Church of the Invalides, Paris, France, 1676–1706.

tude, as is the way that its designer aimed for theatrical effects of light and space. The dome is built of three shells, the lowest cut off so that interior visitors look up through it to the one above, which is painted illusionistically with the *apotheosis* (deification) of Saint Louis, patron of France. This second dome, filled with light from hidden windows in the third, outermost dome, creates an impression of the open, limitless space and brightness of the heavens. Below, the building's interior is only dimly illuminated and is designed in a classicism only less severe than that of the Escorial (see FIG. 18-26).

England

The authority of the absolute monarchy that prevailed in France was not found in England. Common law and the Parliament kept royal power in check. Thus, during the seventeenth and early eighteenth centuries, England experienced the development of both limited monarchy and constitutionalism. Although religion was an important part of English life, religion was not the contentious issue it was on the continent. The religious affiliations of the English included Catholicism, Anglicanism, Protestantism, and *Puritanism* (the English version of Calvinism). In the economic realm, England was the one country (other than the Dutch Republic) to take advantage of the opportunities overseas trade offered. As an island country, England, like the Dutch Republic, possessed a powerful and large navy, as well as excellent maritime capabilities.

English Baroque art does not have the focused character of either Dutch or Italian Baroque art. The one area of cultural production England made great strides in was architecture, and much of it incorporated classical elements.

Baroque quality. But the light entering through the large clerestory windows lacks the directed dramatic effect of the Italian Baroque, instead illuminating the interior's precisely chiseled details brightly and evenly. Pier-supported arcades carry a majestic row of Corinthian columns that define the royal gallery. The royal pew occupies its rear, accessible directly from the king's apartments. The decoration is restrained, and, in fact, only the illusionistic ceiling decorations, added in 1708 to 1709 by ANTOINE COYPEL (1661–1722), suggest the drama and complexity of Italian Baroque art.

A CHURCH FOR DISABLED SOLDIERS References to Italian Baroque architecture also surface in Hardouin-Mansart's masterwork, the Église de Dôme, Church of the Invalides in Paris (FIG. **19-72**). An intricately composed domed square of great scale, the church is attached to the veterans' hospital Louis XIV set up for the disabled soldiers of his many wars. Two firmly separated levels, the upper one pedimented, comprise the frontispiece. The grouping of the orders and of the bays they frame is not unlike that in Italian Baroque. The compact facade is low and narrow in relation to the vast drum and dome, seeming to serve simply as a base for them. The overpowering dome, conspicuous on the Parisian skyline, is itself expressive of the Italian Baroque love for dramatic magni-

KEEPING UP WITH JONES The revolution in English building was primarily the work of one man, INIGO JONES (1573–1652), architect to the kings James I and Charles I. Jones spent considerable time in Italy. He greatly admired the classical authority and restraint of Palladio's structures and studied his treatise on architecture with great care. From Palladio's villas and palaces, Jones took many motifs, and he adopted Palladio's basic design principles for his own architecture. The nature of his achievement is evident in the buildings he did for his royal patrons, among them the Banqueting House at Whitehall (FIG. **19-73**) in London. For this structure, a symmetrical block of great clarity and dignity, Jones superimposed two orders, using columns in the center and pilasters near the ends. The balustraded roof line, uninterrupted in its horizontal sweep, predated the Louvre's facade (FIG. 19-67) by more than forty years. Palladio would have recognized and approved all of the design elements, but the building as a whole is not a copy of his work. While relying on the revered Italian's architectural vocabulary and syntax, Jones retained his own independence as a designer. For two centuries his influence was almost as authoritative in English architecture as Palladio's. In a fruitful collaboration recalling the combination of Veronese paintings and Palladian architecture in northern Italian villas, Jones's interior at Whitehall is adorned with several important Rubens paintings.

19-73 INIGO JONES, Banqueting House at Whitehall, London, England, 1619–1622.

A TOWERING ARCHITECTURAL TALENT Until almost the present, the dominant feature of the London skyline was the majestic dome of Saint Paul's Cathedral (FIG. **19-74**), the work of England's most renowned architect, CHRISTOPHER WREN (1632–1723). A mathematical genius and skilled engineer whose work won Isaac Newton's praise, Wren was appointed professor of astronomy in London at age twenty-five.

Mathematics led to architecture, and Charles II asked Wren to prepare a plan for restoring the old Gothic church of Saint Paul. Wren proposed to remodel the building based on Roman Structures. Within a few months, the Great Fire of London, which destroyed the old structure and many churches in the city in 1666, gave Wren his opportunity. He built not only the new Saint Paul's but numerous other churches as well.

19-74 CHRISTOPHER WREN, new Saint Paul's Cathedral, London, England, 1675–1710.

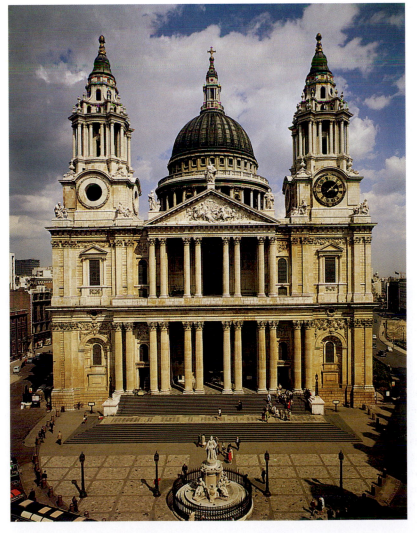

Although Jones's work strongly influenced Wren, he also traveled in France, where he must have been much impressed by the splendid palaces and state buildings being created in and around Paris at the time of the competition for the Louvre design. Wren also must have closely studied prints illustrating Baroque architecture in Italy, for he harmonized Palladian, French, and Italian Baroque features in Saint Paul's.

In view of its size, the cathedral was built with remarkable speed—in a little more than thirty years—and Wren lived to see it completed. The building's form was constantly refined as it went up, and the final appearance of the towers was not determined until after 1700. In the splendid skyline composition, two foreground towers act effectively as foils to the great dome. This must have been suggested to Wren by similar schemes that Italian architects devised to solve the problem of the facade/dome relation of Saint Peter's in Rome (see FIGS. 17-29 and 19-2). Certainly, the upper levels and lanterns of the towers are Borrominesque (FIG. 19-12), the lower levels are Palladian, and the superposed paired columnar porticoes recall the Louvre facade (FIG. 19-67). Wren's skillful eclecticism brought all of these foreign features into a monumental unity.

Wren's designs for the city churches were masterpieces of careful planning and ingenuity. His task was never easy, for the churches often had to be fitted into small, irregular areas. Wren worked out a rich variety of schemes to meet awkward circumstances. When designing the church exteriors, he concentrated his attention on the towers, the one element that would set the building apart from its crowding neighbors. The skyline of London, as Wren left it, is punctuated with such towers, which served as prototypes for later buildings both in England and in colonial America.

LATE BAROQUE ART OF THE EARLY EIGHTEENTH CENTURY

Late Baroque Architecture in England

In 1705, while Saint Paul's was being completed, the British government commissioned a monumental palace in Oxfordshire, Blenheim (FIG. 19-75), for John Churchill, duke of Marlborough. The palace was a reward for Churchill's military exploits; people throughout the country acclaimed his victory over the French in 1704 at the Battle of Blenheim during the War of the Spanish Succession. Designed by JOHN VANBRUGH (1664–1726), Blenheim was one of the largest of the splendid country houses built during the period of prosperity resulting from Great Britain's expansion into the New World. At that time, a small group of architects associated with the aging Sir Christopher Wren was responsible for briefly returning Italian Baroque complexity to favor over the streamlined Palladian classicism of Inigo Jones. Vanbrugh was the best known of this group. The picturesque silhouette he created for Blenheim, with its inventive architectural detail, recalls Italian Baroque architecture. The design demonstrates his love of variety and contrast, tempered by his ability to create focus areas such as those found so frequently in seventeenth-century architecture. The tremendous forecourt, the hugely projecting pavilions, and the extended colonnades simultaneously recall Saint Peter's and Versailles (FIGS. 19-4 and 19-68). Perhaps because Vanbrugh had begun his career as a writer of witty and popular comedies and as the builder of a theater for producing them, all of his architecture tended toward

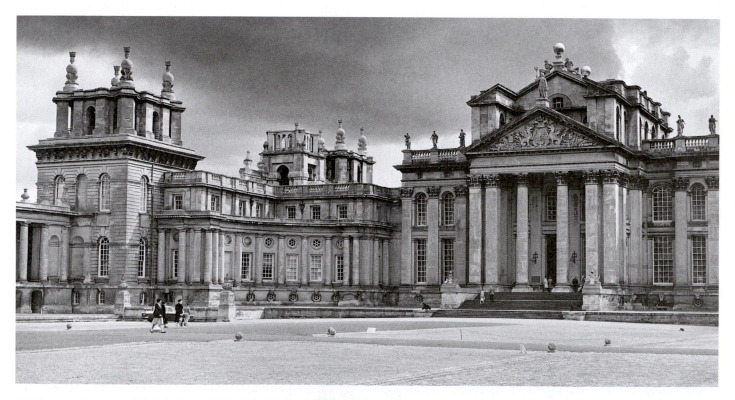

19-75 JOHN VANBRUGH, Blenheim Palace, Oxfordshire, England, 1705–1722.

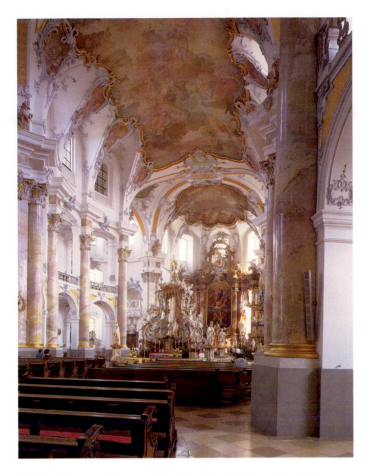

19-76 BALTHASAR NEUMANN, interior of the pilgrimage chapel of Vierzehnheiligen, near Staffelstein, Germany, 1743–1772.

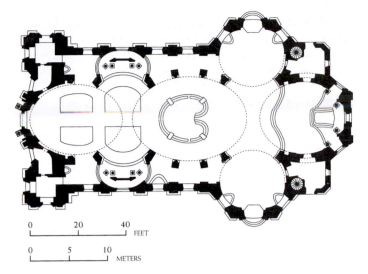

19-77 Plan of Vierzehnheiligen, near Staffelstein, Germany.

the theatrical on a mighty and extravagant scale. Like many Baroque architects, he even sacrificed convenience for dramatic effect, as in placing the Blenheim kitchen some two hundred feet from the majestic dining salon. Vanbrugh's architecture pleased his patrons in the beginning, but even before Blenheim was completed, critics were condemning what they considered its ponderous and bizarre qualities.

Late Baroque Art and Architecture in Germany and Italy

The work of Italians Borromini and Guarini strongly influenced the ecclesiastical architecture of southern Germany and Austria. One of the most splendid of the German buildings is the pilgrimage church of Vierzehnheiligen (Fourteen Saints) designed by BALTHASAR NEUMANN (1687–1753) and built near Staffelstein. Born in the German part of Bohemia, Neumann traveled in Austria and northern Italy and studied in Paris before returning home to become one of the most active architects working in his native land. Numerous large windows in the richly decorated but continuous walls of Vierzehnheiligen flood the interior with an even, bright, and cheerful light. The pilgrimage church sanctuary (FIG. **19-76**) exhibits a vivacious play of architectural fantasy that retains Italian Baroque's dynamic energy but banishes all its dramatic qualities.

Vierzehnheiligen's complexity is readable in its ground plan (FIG. **19-77**), which has been called one of the most ingenious pieces of architectural design ever conceived. The straight line seems to have been banished deliberately. The composition is made up of tangent ovals and circles, achieving a quite different interior effect within the essential outlines of the traditional Gothic church (apse, transept, nave, and western towers). Undulating space is in continuous motion, creating unlimited vistas bewildering in their variety and surprise effects. The structure's features pulse, flow, and commingle as if they were ceaselessly in the process of being molded. The design's fluency of line, the floating and hovering surfaces, the interwoven spaces, and the dematerialized masses combine to suggest a "frozen" counterpart to the intricacy of voices in a Bach fugue. The church is a brilliant ensemble of architecture, painting, sculpture, and music, dissolving the boundaries of the arts in a visionary unity.

SCULPTURE RENDERED WEIGHTLESS The desire to achieve this unity of various artistic mediums propelled architects and artists in Germany and Austria to explore further the illusionistic capabilities of each medium. EGID QUIRIN ASAM (1692–1750) created the group *Assumption of the Virgin* (FIG. **19-78**) for the space above the altar in the monastery church at Rohr, Germany. Asam designed the church in collaboration with his brother Cosmas Damian Asam (1686–1739). Influenced by the Late Baroque architecture they saw on a trip to Rome, the brothers returned to Germany with a feeling for illusionistic spectacle. In Egid Quirin Asam's *Assumption of the Virgin*, as in Bernini's *Ecstasy of Saint Theresa* (FIG. 19-9), the miraculous is made real before the viewer's eyes, a spiritual vision materially visible. The Virgin, effortlessly borne aloft by angels, soars to the glowing paradise above her, while the apostolic witnesses below gesticulate in astonishment around her vacant tomb. The figures ascending to Heaven have gilded details that set them apart from those remaining on Earth. The setting is a luxuriously ornamented theater. The scene itself is pure opera—an art perfected and very popular in

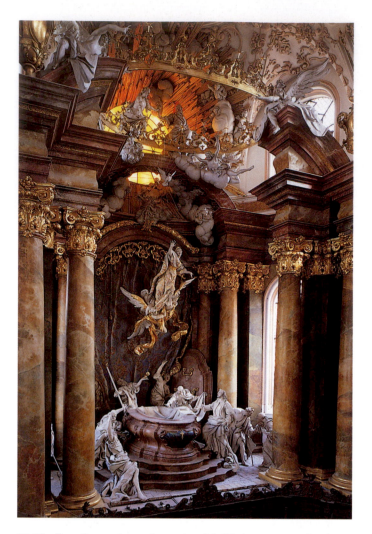

19-78 EGID QUIRIN ASAM, *Assumption of the Virgin,* monastery church at Rohr, Germany, 1723.

the eighteenth century. Here, sculpture dissolves into painting, theater, and music, its mass rendered weightless, its naturally compact composition broken up and diffused. In this instance, Asam used sculpture, paradoxically, to disguise substance and function, weight and tactility, in the interest of eye-deceiving mystical illusion.

PAINTED FESTIVALS FOR THE IMAGINATION
Illusion in painting, particularly for the ceilings of churches and palaces in Italy and France, was already a venerable tradition by the beginning of the eighteenth century. The ceilings of Late Baroque palaces sometimes became painted festivals for the imagination. The master of such works, GIAMBATTISTA TIEPOLO (1696–1770), was the last great Italian painter to have an international impact until the twentieth century. Of Venetian origin, Tiepolo worked for patrons in Austria, Germany, and Spain, as well as in Italy, leaving a strong impression wherever he went. His bright, cheerful colors and his relaxed compositions were ideally suited to Late Baroque architecture. *The Apotheosis of the Pisani Family* (FIG. **19-79**), a ceiling fresco in the Villa Pisani at Stra in northern Italy, shows airy populations fluttering through vast sunlit skies and fleecy clouds, their figures making dark accents

against the brilliant light of high noon. As *apotheosis* indicates, Pisani family members are elevated here to the rank of the gods in a heavenly scene that recalls the ceiling paintings of Correggio (see FIG. 17-40) and Pozzo (FIG. 19-27). While retaining the seventeenth-century illusionistic tendencies, Tiepolo softened the rhetoric and created pictorial schemes of great elegance and grace, unsurpassed for their sheer effectiveness as decor.

ROCOCO: THE FRENCH TASTE

The death of Louis XIV in 1715 brought many changes in French high society. The court of Versailles was at once abandoned for the pleasures of town life. Although French citizens still owed their allegiance to a monarch, the early eighteenth century saw a resurgence in aristocratic social, political, and economic power. Appropriately, some historians refer to the eighteenth century as the great age of the aristocracy. The nobility not only exercised their traditional privileges (for example, exemption from certain taxes and from forced labor on public works) but also sought to expand their power. This aristocratic resurgence extended to dominance as art patrons. The *hôtels* (town houses) of Paris soon became the centers of a new softer style called Rococo. The sparkling gaiety the new age cultivated (see "Of Knowledge, Taste, and Refinement: Salon Culture," page 670), associated with the regency that followed the death of Louis XIV and with the reign of Louis XV, found perfectly harmonious expression in this new style. Rococo appeared in France in about 1700, primarily as a style of interior design. The French Rococo exterior was most often simple, or even plain, but Rococo exuberance took over the interior. *Rococo* came from the French word *rocaille,* which literally means "pebble," but the term referred especially to the small stones and shells used to decorate grotto interiors. Such shells or shell forms were the principal motifs in Rococo ornament.

A PERMANENTLY "FESTIVE" ROOM A typical French Rococo room is the Salon de la Princesse (FIG. **19-80**) in the Hôtel de Soubise in Paris, designed by GERMAIN BOFFRAND (1667–1754). Comparing this room with the Galerie des Glaces at Versailles (FIG. 19-70) reveals (immediately) the fundamental difference. Boffrand softened the earlier style's strong architectural lines and panels into flexible, sinuous curves luxuriantly multiplied in mirror reflections. The walls melt into the vault. Irregular painted shapes, surmounted by sculpture and separated by the typical rocaille shells, replaced the hall's cornices. Painting, architecture, and sculpture combine to form a single ensemble. The profusion of curving tendrils and sprays of foliage blend with the shell forms to give an effect of freely growing nature, suggesting that the designer permanently decked the Rococo room for a festival.

Rococo was a style preeminently evident in small works. Artists exquisitely wrought furniture, utensils, and accessories of all sorts in the characteristically delicate, undulating Rococo line. French Rococo interiors were designed as lively total works of art with elegant furniture, enchanting small sculptures, ornamented mirror frames, delightful

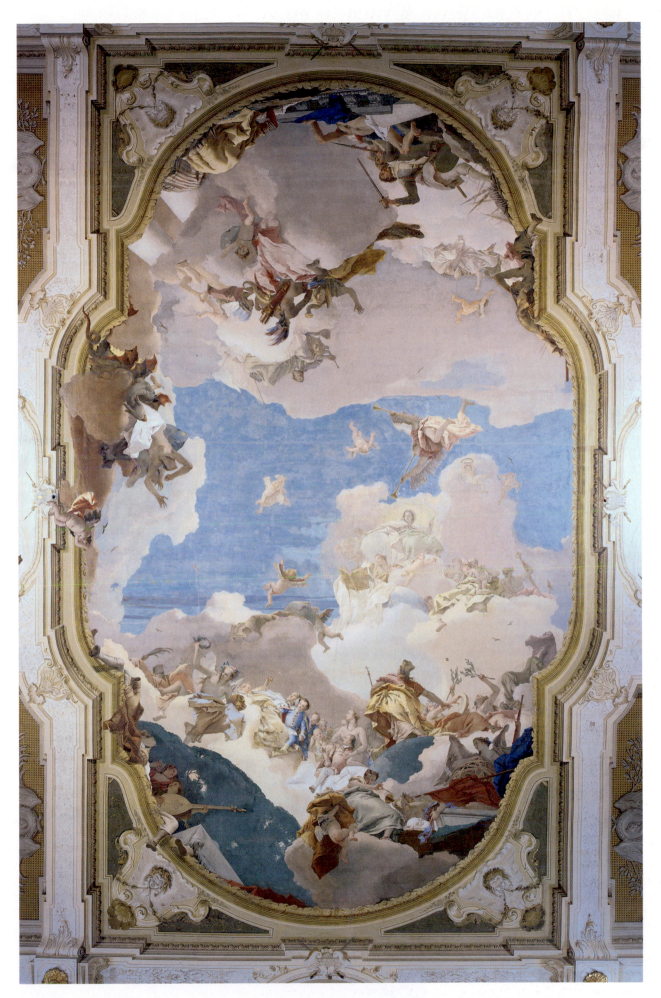

19-79 GIAMBATTISTA TIEPOLO, *The Apotheosis of the Pisani Family*, ceiling fresco in the Villa Pisani, Stra, Italy, 1761–1762.

WRITTEN SOURCES

Of Knowledge, Taste, and Refinement
Salon Culture

The feminine look of the Rococo style suggests that the age was dominated by the taste and social initiative of women—and, to a large extent, it was. Women—Madame de Pompadour in France, Maria Theresa in Austria, and Elizabeth and Catherine in Russia—held some of the highest positions in Europe, and female influence was felt in numerous smaller courts. The Rococo salon was the center of early-eighteenth-century Parisian society, and Paris was the social capital of Europe. Wealthy, ambitious, and clever society hostesses competed to attract the most famous and the most accomplished people to their salons. The medium of social intercourse was conversation spiced with wit, repartee as quick and deft as a fencing match. Artifice reigned supreme, and participants considered enthusiasm or sincerity in bad taste. These salon women referred to themselves as "femmes savantes," or "learned women." Among these learned women was Julie de Lespinasse (1732–1776), one of the most articulate, urbane, and intelligent French women of the time. She held daily salons from five o'clock until nine in the evening. The *Memoirs of Marmontel* documented the liveliness of these gatherings and the remarkable nature of this hostess:

> The circle was formed of persons who were not bound together. She had taken them here and there in society, but so well assorted were they that once there they fell into harmony like the strings of an instrument touched by an able hand. Following out that comparison, I may say that she played the instrument with an art that came of genius; she seemed to know what tone each string would yield before she touched it; I mean to say that our minds and our natures were so well known to her that in order to bring them into play she had but to say a word. Nowhere was conversation more lively, more brilliant, or better regulated than at her house. It was a rare phenomenon indeed, the degree of tempered, equable heat which she knew so well how to maintain, sometimes by moderating it, sometimes by quickening it. The continual activity of her soul was communicated to our souls, but measurably; her imagination was the mainspring, her reason the regulator. Remark that the brains she stirred at will were neither feeble nor frivolous. . . . Her talent for casting out a thought and giving it for discussion to men of that class, her own talent in discussing it with precision, sometimes with eloquence, her talent for bringing forward new ideas and varying the topic—always with the facility and ease of a fairy . . . these talents, I say, were not those of an ordinary woman. It was not with the follies of fashion and vanity that daily, during four hours of conversation, without languor and without vacuum, she knew how to make herself interesting to a wide circle of strong minds.[1]

[1] Jean François Marmontel, *Memoirs of Marmontel,* trans. Brigit Patmore (London: G. Routledge & Sons, 1930), 270.

19-80 GERMAIN BOFFRAND, Salon de la Princesse, with painting by CHARLES-JOSEPH NATOIRE and sculpture by J. B. LEMOINE, Hôtel de Soubise, Paris, France, 1737–1740.

19-81 FRANÇOIS DE CUVILLIÈS, Hall of Mirrors, the Amalienburg, Nymphenburg Palace park, Munich, Germany, early eighteenth century.

ceramics and silver, a few "easel" paintings, and decorative tapestry complementing the architecture, relief sculptures, and wall paintings. As seen today, French Rococo interiors, such as the Salon de la Princesse, have lost most of the moveable "accessories" that once adorned them. Viewers can imagine, however, how such rooms—with their alternating gilded moldings, vivacious relief sculptures, and daintily colored ornament of flowers and garlands—must have harmonized with the chamber music played in them, with the elaborate costumes of satin and brocade, and with the equally elegant etiquette and sparkling wit of the people who graced them.

FRENCH ROCOCO IN A GERMAN LODGE A brilliant example of French Rococo in Germany is the Amalienburg, a small lodge FRANÇOIS DE CUVILLIÈS (1695–1768) built in the park of the Nymphenburg Palace in Munich. Although Rococo was essentially a style of interior design, the Amalienburg beautifully harmonizes the interior and exterior elevations through the curving flow of lines and planes that cohere in a sculptural unity of great elegance. The most spectacular interior room in the lodge is the circular Hall of Mirrors (FIG. **19-81**), a silver-and-blue ensemble of architecture, stucco relief, silvered bronze mirrors, and crystal. It dazzles the eye with myriad scintillating motifs, forms, and figurations the

designer borrowed from the full Rococo ornamental repertoire. This room displays the style's zenith. Facets of silvery light, multiplied by windows and mirrors, sharply or softly delineate the endlessly proliferating shapes and contours that weave rhythmically around the upper walls and the ceiling coves. Everything seems organic, growing, and in motion, an ultimate refinement of illusion that the architect, artists, and artisans, all magically in command of their varied media, created with virtuoso flourishes.

A DELICATE DANCER The painter scholars most associate with French Rococo is ANTOINE WATTEAU (1684–1721). The differences between the Baroque age in France and the Rococo age can be seen clearly by contrasting Rigaud's portrait of Louis XIV (FIG. 19-66) with one of Watteau's paintings, *L'Indifférent* (*The Indifferent One;* FIG. **19-82**). Rigaud portrayed pompous majesty in supreme glory, as if the French monarch were reviewing throngs of bowing courtiers at Versailles. Watteau's painting, in contrast, is not as heavy or staid and is more delicate. The artist presented a languid, gliding dancer whose mincing minuet might be seen as mimicking the monarch's solemnity if the paintings were hung together. In Rigaud's portrait, stout architecture, bannerlike curtains, flowing ermine, and fleur-de-lis exalt the king. In Watteau's painting, the dancer

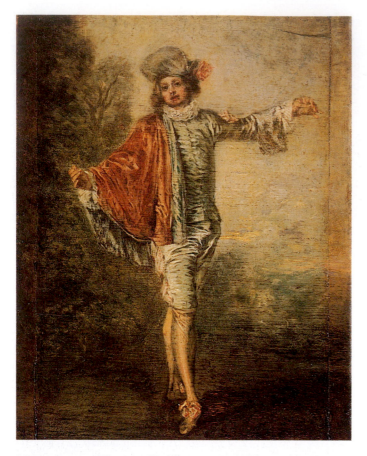

19-82 ANTOINE WATTEAU, *L'Indifférent,* ca. 1716. Oil on canvas, approx. 10″ × 7″. Louvre, Paris.

moves in a rainbow shimmer of color, emerging onto the stage of the intimate comic opera to the silken sounds of strings. The portrait of the king is very large, the "portrait" of "the indifferent one" quite small.

CELEBRATING THE GOOD LIFE Watteau was largely responsible for creating a specific type of Rococo painting, called a *fête galante* painting. These paintings depicted the outdoor entertainment or amusements of upper-class society. *View through the Trees in the Park of Pierre Crozat (La Perspective),* FIG. **19-83**, is such a painting. Although at first glance this may seem to be a genre scene, relatively few people lived such a privileged life, so this cannot be considered "everyday life." Watteau's style in this work is emphatically Rococo—soft and feathery brushstrokes, dainty figures, and muted colors. This painting exudes a graceful elegance and delicacy.

Watteau's masterpiece (painted in two versions) is *Return from Cythera* (FIG. **19-84**), completed between 1717 and 1719 as the artist's acceptance piece for admission to the Royal Academy. Watteau was Flemish, and his style was a beautiful derivative of Rubens's style—a kind of refinement of it.

At the turn of the century, the French Royal Academy was divided rather sharply between two doctrines. One doctrine upheld the ideas of Le Brun (the major proponent of French Baroque under Louis XIV), who followed Nicolas Poussin in teaching that form was the most important element in paint-

19-83 ANTOINE WATTEAU, *View through the Trees in the Park of Pierre Crozat (La Perspective),* ca. 1715. Oil on canvas, 1′ 6$\frac{3}{8}$″ × 1′ 9$\frac{3}{4}$″. Museum of Fine Arts, Boston (Maria Antoinette Evans Fund).

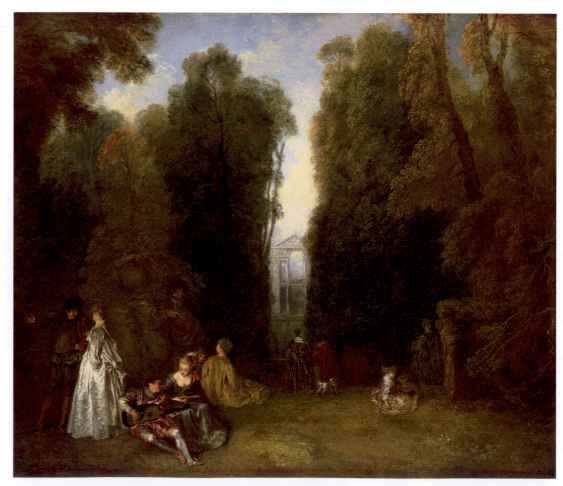

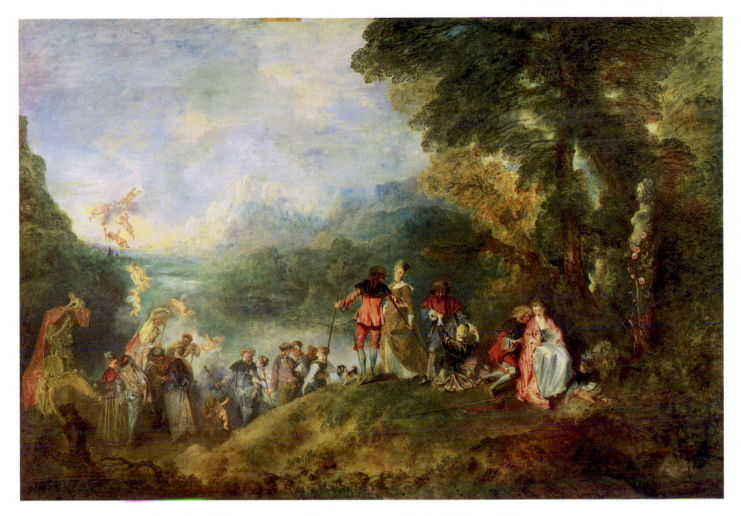

19-84 ANTOINE WATTEAU, *Return from Cythera*, 1717–1719. Oil on canvas, approx. 4′ 3″ × 6′ 4″. Louvre, Paris.

ing, while "colors in painting are as allurements for persuading the eyes," additions for effect and not really essential.[9] The other doctrine, with Rubens as its model, proclaimed the supremacy of color as natural and the coloristic style as the artist's proper guide. Depending on which side they took, academy members were called "Poussinistes" or "Rubénistes." With Watteau in their ranks, the Rubénistes carried the day, and they established the Rococo style in painting on the colorism of Rubens and the Venetians.

Watteau's *Return from Cythera* represents a group of lovers preparing to depart from the island of eternal youth and love, sacred to Aphrodite. Young and luxuriously costumed, they perform, as it were, an elegant, tender, and graceful ballet, moving from the protective shade of a woodland park, peopled with amorous cupids and voluptuous statuary, down a grassy slope to an awaiting golden barge. Watteau studied carefully the attitudes of the figures; no one has equaled his distinctive poses, which combine elegance and sweetness. He composed his generally quite small paintings from albums of superb drawings that have been preserved and are still in fine condition. These show he observed slow movement from difficult and unusual angles, obviously intending to find the smoothest, most poised, and most refined attitudes. As he sought nuances of bodily poise and movement, Watteau also strove for the most exquisite shades of color difference, defin-

ing in a single stroke the shimmer of silk at a bent knee or the iridescence that touches a glossy surface as it emerges from shadow.

Art historians have noted that the theme of love and Arcadian happiness (observed here since Giorgione and which Watteau may have seen in works by Rubens) in Watteau's pictures is slightly shadowed with wistfulness, or even melancholy. Perhaps Watteau, during his own short life, meditated on the swift passage of youth and pleasure. The haze of color, the subtly modeled shapes, the gliding motion, and the air of suave gentility were all to the taste of the Rococo artist's wealthy patronage.

A PLAYFUL ROCOCO FANTASY Watteau's successors never quite matched his taste and subtlety. Their themes were about love, artfully and archly pursued through erotic frivolity and playful intrigue. After Watteau's early death at age thirty-seven, his follower, FRANÇOIS BOUCHER (1703–1770), painter for Madame de Pompadour (the influential mistress of Louis XV), rose to the dominant position in French painting. Although he was an excellent portraitist, Boucher's fame rested primarily on his graceful allegories, with Arcadian shepherds, nymphs, and goddesses cavorting in shady glens engulfed in pink and sky blue light. *Cupid a Captive* (FIG. **19-85**) presents viewers with a rosy pyramid of infant and female

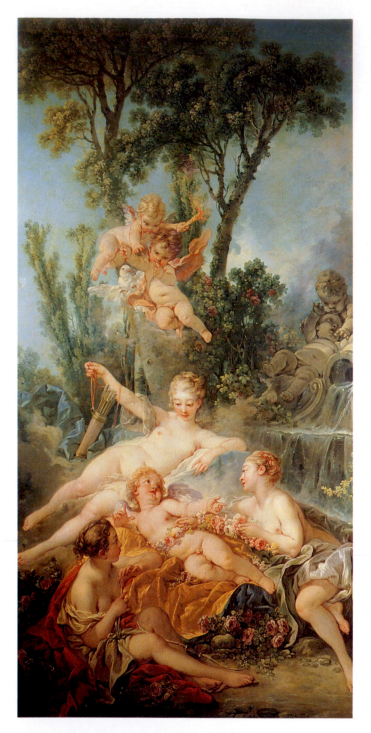

AN INTRIGUING FLIRTATION JEAN-HONORÉ FRAGONARD (1732–1806), Boucher's student, was a first-rate colorist whose decorative skill almost surpassed his master's. An example of his manner can stand as characteristic not only of him but also of the later Rococo in general. *The Swing* (FIG. **19-86**) is a typical "intrigue" picture. A young gentleman has managed an arrangement whereby an unsuspecting old bishop swings the young man's pretty sweetheart higher and higher, while her lover (and the work's patron), in the lower left-hand corner, stretches out to admire her ardently from a strategic position on the ground. The young lady flirtatiously and boldly kicks off her shoe at the little statue of the god of discretion, who holds his finger to his lips. The landscape setting is out of Watteau—a luxuriant perfumed bower in a park that very much resembles a stage scene for the comic opera. The glowing pastel colors and soft light convey, almost by themselves, the theme's sensuality.

ECHOES OF BERNINI IN SENSUOUS ROCOCO The Rococo mood of sensual intimacy also permeated many of the small sculptures designed for the eighteenth-century salons. Artists such as CLAUDE MICHEL, called CLODION (1738–1814), specialized in small, lively sculptures that combined the sensuous Rococo fantasies with lightened echoes of Bernini's dynamic figures. Perhaps historians should expect such influence in Clodion's works. He lived and worked in Rome for some years after discovering the city's charms during his tenure as the recipient of the cherished Prix de Rome. The Royal Academy annually gave the *Prix de Rome* (Rome Prize) to the artist who produced the best history painting, subsidizing the winning artist's stay in Rome (from three to five years).

Clodion's small group, *Nymph and Satyr* (FIG. **19-87**), has an open and vivid composition suggestive of its dynamic roots. But the artist overlaid that source with the erotic playfulness of Boucher and Fragonard to energize his eager nymph and the laughing satyr into whose mouth she pours a cup of wine. Here, the Rococo style's sensual exhilaration is caught in diminutive scale and inexpensive terracotta. As with so many Rococo artifacts, and most of Clodion's best work, the artist designed this group for a tabletop.

19-85 FRANÇOIS BOUCHER, *Cupid a Captive,* 1754. Oil on canvas, approx. 5′ 6″ × 2′ 10″. The Wallace Collection, London.

THE DIVERSE LEGACIES OF THE BAROQUE The art produced during the seventeenth and early eighteenth centuries was truly diverse, making any comprehensive summary of the "Baroque" period impossible. Each country encountered a different set of historical challenges, and even within country boundaries a wide variety of art forms emerged. Despite this period's lack of consistency in artistic development, its legacy was lasting. Many of the hallmarks of seventeenth-century and early-eighteenth-century art, such as direct observation, emotional intensity, and facility with light and color, laid the foundation for two styles that emerged in the late eighteenth century, Neoclassicism and Romanticism. Further, the influence of artists such as Caravaggio, Bernini, Velázquez, Rubens, Rembrandt, Vermeer, and Watteau, among many others, resonates in art to the present day.

flesh set off against a cool, leafy background, with fluttering draperies both hiding and revealing the nudity of the figures. Boucher used the full range of Italian and French Baroque devices to create his masterly composition: the dynamic play of crisscrossing diagonals, curvilinear forms, and slanting recessions. But in his work he dissected powerful Baroque curves into a multiplicity of decorative arabesques, dissipating Baroque drama into sensual playfulness. Lively and lighthearted, Boucher's artful Rococo fantasies became mirrors for his patrons, the wealthy French, to behold the ornamental reflections of their cherished pastimes.

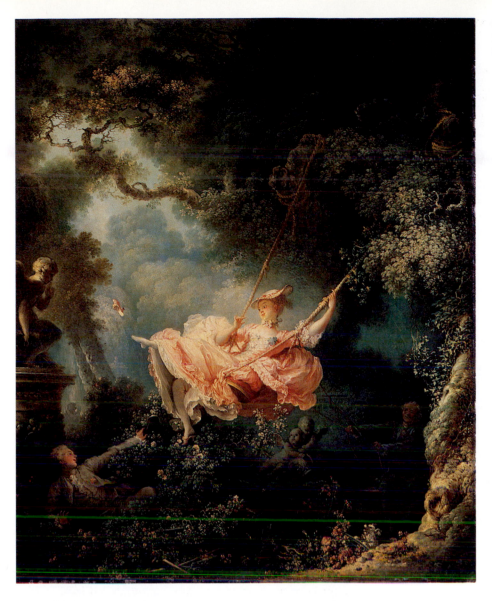

19-86 JEAN-HONORÉ FRAGONARD, *The Swing,* 1766. Oil on canvas, approx. 2′ 11″ × 2′ 8″. The Wallace Collection, London.

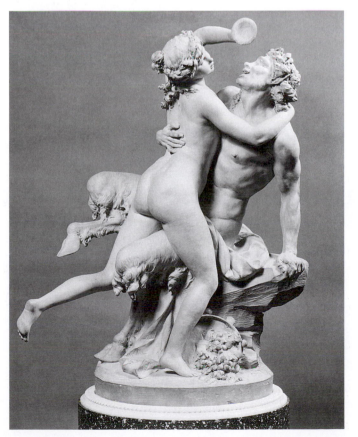

19-87 CLODION, *Nymph and Satyr,* ca. 1775. Terracotta, approx. 1′ 11″ high. Metropolitan Museum of Art, New York (bequest of Benjamin Altman, 1913).

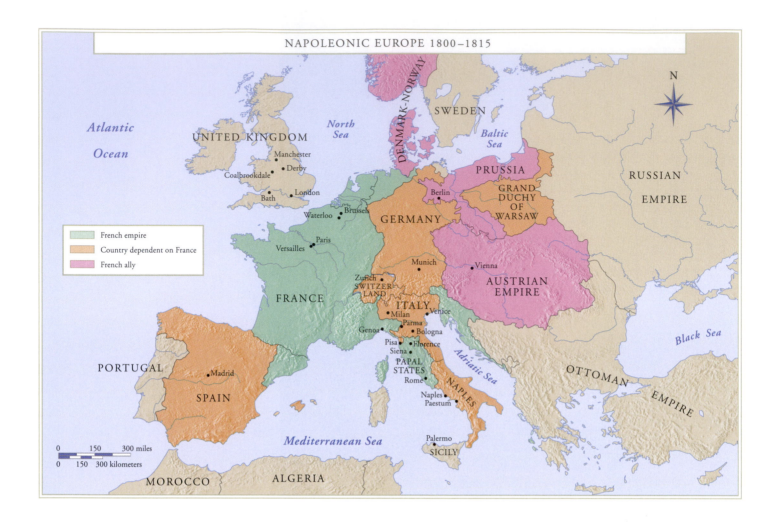

NAPOLEONIC EUROPE 1800–1815

Legend:
- French empire
- Country dependent on France
- French ally

0 150 300 miles
0 150 300 kilometers

Map labels: Atlantic Ocean, UNITED KINGDOM, Manchester, Derby, Coalbrookdale, London, Bath, North Sea, DENMARK-NORWAY, SWEDEN, Baltic Sea, PRUSSIA, Berlin, GRAND DUCHY OF WARSAW, RUSSIAN EMPIRE, Waterloo, Brussels, GERMANY, Versailles, Paris, Munich, Vienna, FRANCE, Zurich, SWITZERLAND, ITALY, Milan, Venice, AUSTRIAN EMPIRE, Genoa, Parma, Bologna, Pisa, Florence, Siena, Adriatic Sea, Black Sea, PORTUGAL, Madrid, SPAIN, PAPAL STATES, Rome, Naples, Paestum, OTTOMAN EMPIRE, Mediterranean Sea, Palermo, SICILY, MOROCCO, ALGERIA, N

Timeline:

| 1750 | 1770 | 1780 | 1790 |

GEORGE III OF ENGLAND

LOUIS XVI OF FRANCE FRENCH REVOLUTION THE DIRECTORY

*Jacques-Germain Soufflot
the Panthéon, 1755–1792*

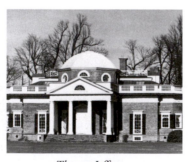
*Thomas Jefferson
Monticello, 1770–1806*

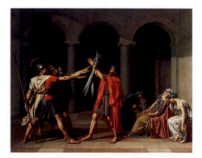
*Jacques-Louis David
Oath of the Horatii, 1784*

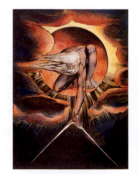
*William Blake
Ancient of Days, 1794*

Voltaire, 1694–1778

Jean-Jacques Rousseau, 1712–1778

Denis Diderot, 1713–1784,
 Encyclopédie, 1751–1780

Frederick II (The Great) of Prussia, r. 1740–1780

Johann Wolfgang von Goethe, 1749–1832

American Revolution, 1763–1783

England's Royal Academy of Arts founded, 1766

New steam engine patented, 1769

Sir Walter Scott, 1771–1832

French Revolution, 1789–1795

THE ENLIGHTENMENT AND ITS LEGACY

NEOCLASSICISM THROUGH THE

MID-NINETEENTH CENTURY

1800			1820		1830		1840			1851
GEORGE III OF ENGLAND					GEORGE IV		WILLIAM IV	VICTORIA		
FIRST REPUBLIC	NAPOLEON I (THE EMPIRE)		LOUIS XVIII		CHARLES X	LOUIS PHILIPPE			SECOND REPUBLIC	SECOND EMPIRE

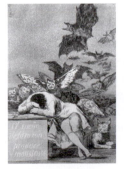

Francisco Goya
*The Sleep of Reason
Produces Monsters, ca. 1798*

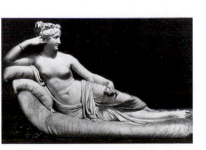

Antonio Canova
Pauline Borghese as Venus, 1808

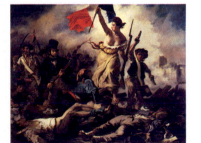

Eugène Delacroix
Liberty Leading the People, 1830

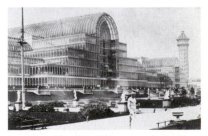

Joseph Paxton
Crystal Palace, 1850–1851

Napoleon Bonaparte, First Consul of France, 1800

Chateaubriand, *Genius of Christianity*, 1802

Napoleon crowned emperor, 1804

Napoleon abdicates, 1814

Battle of Waterloo, 1815

Restoration of the Bourbons, 1815

Revolution of 1830 in France

Constitutional monarchy in France, 1830–1848

Daguerreotype presented, 1839

Karl Marx, 1816–1883,
Communist Manifesto, 1848

Revolution of 1848 in France

THE ENLIGHTENMENT: PHILOSOPHY AND SOCIETY

During the eighteenth century, the expanding boundaries of European knowledge marked what has been called the Age of Enlightenment. The Enlightenment was in essence a new way of thinking critically about the world and about humankind, independently of religion, myth, or tradition. The new method was based on using reason to reflect on the results of physical experiments and involved the critical analysis of texts. It was grounded in empirical evidence. Enlightenment thought promoted the scientific questioning of all assertions and rejected unfounded beliefs about the nature of humankind and of the world. The enlightened mind was skeptical of doctrines and theories such as superstitions and old wives' tales that no verifiable evidence could prove. Thus the Enlightenment encouraged and stimulated the habit and application of mind known as the scientific method.

"THE DOCTRINE OF EMPIRICISM"
The Enlightenment had its roots in the seventeenth century, with the mathematical and scientific achievements of René Descartes, Blaise Pascal, Isaac Newton, and Gottfried Wilhelm von Leibnitz. England and France were the principal centers of the Enlightenment, though its dictums influenced the thinking of intellectuals throughout Europe and in the American colonies. Benjamin Franklin, Thomas Jefferson, and other American notables were educated in its principles. Of particular importance for Enlightenment thought was the work of Britons Isaac Newton (1642–1727) and John Locke (1632–1704).

In Newton's scientific studies, he insisted on empirical proof of his theories and encouraged others to avoid metaphysics and the supernatural—realms that extended beyond the natural physical world. This emphasis on both tangible data and concrete experience became a cornerstone of Enlightenment thought. In addition, Newton's experiments seemed to reveal a rationality in the physical world. Enlightenment thinkers transferred such concepts to the sociopolitical world by promoting a rationally organized society. John Locke, whose works acquired the status of Enlightenment gospel, developed these ideas further. What we know, wrote Locke, comes to us through sense perception of the material world and is imprinted on the mind as on a blank tablet. From these perceptions alone we form ideas. Our ideas are not innate or God given; it is only from experience that we can know (this is called the "doctrine of empiricism"). Locke believed human beings are born good, not cursed by original sin. The law of Nature grants them the natural rights of life, liberty, and property, as well as the right to freedom of conscience. Government is by contract, and its purpose is to protect these rights; if and when government abuses these rights, we have the further natural right of revolution. Locke's ideas empowered people to take control of their own destinies.

"THE DOCTRINE OF PROGRESS"
The work of Newton and Locke also inspired French intellectuals. New philosophies placing individuals and societies-at-large as part of physical nature were advanced by thinkers in France, who are still known by their French designation *philosophes*. They shared the conviction that the ills of humanity could be remedied by applying reason and common sense to human problems. They criticized the powers of church and state as irrational limits placed on political and intellectual freedom. They believed that, by the accumulation and propagation of knowledge, humanity could advance by degrees to a happier state than it had ever known. This conviction matured into the characteristically modern "doctrine of progress" and its corollary doctrine of the perfectibility of humankind. Previous societies, for the most part, perceived the future as inevitable—the life and death cycle and fate determined by religious beliefs. This notion of progress—the systematic and planned improvement of society—was developed first during the eighteenth century.

A COMPENDIUM OF KNOWLEDGE
Animated by their belief in human progress and perfectibility, the philosophes took the task of gathering knowledge and making it accessible to all who could read. Their program was, in effect, the democratization of knowledge. Denis Diderot's (1713–1784) brilliant, critical intelligence greatly influenced the Enlightenment's rationalistic and materialistic thinking. He became editor of the pioneering *Encyclopédie*, a compilation of articles and illustrations written by more than one hundred contributors, including all of the leading philosophes. The *Encyclopédie* was truly comprehensive (its formal title was *Systematic Dictionary of the Sciences, Arts, and Crafts*) and included all available knowledge—historical, scientific, and technical, as well as religious and moral—and political theory. The first volume was published in 1751, and the project (thirty-five volumes of text and illustrations) was completed in 1780. This notion of the accumulation and documentation of knowledge was new to Western society; such cultures had relied heavily on tradition and convention. The *Encyclopédie* was instrumental in shattering the complacency of Western thought.

Diderot's contemporary, Comte de Buffon (1707–1788), undertook a kind of encyclopedia of the natural sciences. His *Natural History,* a monumental work of forty-four volumes, was especially valuable for its zoological study and had the general effect of inspiring in the reading public an interest in the world of nature. These collections of information were consistent with the rationalistic and empiricist foundation of the Enlightenment.

REVOLUTIONARY CHANGE
The political, economic, and social consequences of this expanding knowledge were explosive. It is no coincidence that two of the major revolutions of recent centuries—the French Revolution and the Industrial Revolution in England—occurred during this period. The Enlightenment idea of a participatory and knowledgeable citizenry contributed to the revolt against the French monarchy in 1789. The immediate causes of the French Revolution were France's economic crisis and the clash between the Third Estate (bourgeoisie, peasantry, and urban and rural workers) and the First (clergy) and Second Estates (nobility). They fought over the issue of representation in the legislative body, the Estates-General, which had been convened to decide the taxation issue. However, the ensuing revolution revealed the instability of the monarchy and of the French society's traditional structure and resulted in a succession of republics and empires as France struggled to find a way to adjust to these decisive changes.

The celebration of "progress," along with technological advances, led to the Industrial Revolution. Although it is impossible to assign specific dates to the Industrial Revolution, technological innovations began to make their mark in the 1740s. By 1850, England had a manufacturing economy. This development was revolutionary because for the first time in history, societies were capable of producing a limitless supply of goods and services. England's production capability was due to the new manufacturing technology, along with advances in heating, lighting, and transportation.

These developments precipitated yet other major changes. The growth of cities and of an urban working class were two such changes. Colonialism expanded as the demand for cheap labor and raw materials increased. For example, England feuded with France over the North American continent and the subcontinent of India. This enthusiasm for growth eventually emerged in the newly established United States as well in the form of the doctrine of Manifest Destiny—the ideological justification for continued territorial expansion. As John L. O'Sullivan expounded in the earliest known use of the term in 1845: "Our manifest destiny [is] to overspread the continent allotted by Providence for the free development of our yearly multiplying millions."[1]

Thus, the Age of Enlightenment ushered in a new way of thinking and affected historical developments worldwide. Artists entered into this dialogue about the state and direction of society and played an important role in encouraging public consideration of these momentous changes. In the arts, this new way of thinking can be seen in the general label "modern" used to describe the art from the late eighteenth century on. Such a vague and generic term, covering centuries of art, renders any concrete definition of "modern art" virtually impossible. However, one defining characteristic scholars and critics traditionally have ascribed to the modern era is an awareness of history. People know their culture perpetuates or rejects previously established ideas or conventions. The concept of *modernity*—the state of being modern—involves being up to date, implying a distinction between the present and past. Recent art historical scholarship has posited an even earlier date for the inception of the modern era. Many art historians now assert that this historical consciousness was present in much earlier societies. This accounts for current use of the term "early modern" to describe Renaissance and even medieval cultures.

THE ENLIGHTENMENT: SCIENCE AND TECHNOLOGY

CHAMPION OF ENLIGHTENMENT THOUGHT François Marie Arouet, better known as Voltaire (1694–1778) became, and still is, the most representative figure—almost the personification—of the Enlightenment's spirit. Voltaire was instrumental in introducing Newton and Locke to the French intelligentsia. The sculptor JEAN-ANTOINE HOUDON (1741–1828) produced a famous marble bust of Voltaire as an old man (FIG. **20-1**). The smile Houdon recorded so strikingly reflects the grim satisfaction Voltaire must have felt at the changes of state and consciousness he brought about by his tireless critical activism. He hated, and attacked through his writings, the arbitrary despotic rule of kings, the selfish privileges of the nobility and the church, religious intolerance, and, above all, the injustice of the *ancien regime* (the "old order"). In his numerous books and pamphlets, which the authorities regularly condemned and burned, he protested against government persecution of the freedoms of thought and religion. Voltaire believed that the human race could never be happy until the traditional obstructions to the progress of the human mind and welfare were removed. His personal and public involvement in the struggle against established political and religious authority gave authenticity to his ideas. It converted a whole generation to the conviction that fundamental changes were necessary. This conviction paved the way for a revolution in France that Voltaire never intended, and he probably never would have approved of it. He was not convinced that "all men are created equal," the credo of Jean-Jacques Rousseau, Thomas Jefferson, and the American Declaration of Independence.

Voltaire was not a scientist ("natural philosopher" as it was then called), though he dabbled in experiments. Yet he declared that enlightenment was based on experience and physics and even asserted that all philosophy could be reduced to physics.

Mathematical physics ruled all the other sciences, so in the history of the natural sciences Voltaire can be considered one

20-1 JEAN-ANTOINE HOUDON, *Voltaire*, 1781. Marble, life-size. Victoria and Albert Museum, London.

of the great propagators because he lent all his prestige to their advancement.

ALL CREATURES GREAT AND SMALL Biomechanical and chemical studies of living nature advanced that field of human knowledge. In addition to Buffon's immense collection of information on plants and animals, his contemporary, the Swedish botanist Carolus Linnaeus (1707–1778), established a system of plant classification. It is still, despite its limitations, serviceable in arranging the vast universe of biological data. Biology's number of verifiable theories was far behind Newton's physical theories. It focused on the collection, description, and classification of the data, while physical theory was at once open to demonstration and could be the guide and model for all subsequent observation.

For the sciences of life, the study of the human body—its structure, function, and disorders—naturally would be at the center of scientific interest. Since the Renaissance, artists had been concerned with learning about the body by dissecting it. Historians long have recognized the part Leonardo played in inaugurating the descriptive science of anatomy (see FIG. 17-5). As that description became more exact and complete (FIG. **20-2**), the anatomical artist's skill became a specialty, an instrument for the education and practice of physicians and surgeons. As such, it was not simply a preliminary study, a guide for a painter or sculptor constructing an image of the human body, but a tool for specialists in an entirely different discipline. In this respect it made its contribution as a technological device, an art or craft applied to a science. The technological applications of drafting and model building proved indispensable to science's development well into the computer age.

20-2 WILLIAM HUNTER, *Child in Womb, drawing from dissection of a woman who died in the ninth month of pregnancy*, from *Anatomy of the Human Gravid Uterus*, 1774.

GROWTH OF TECHNOLOGY AND INDUSTRY Scientific investigation and technological invention opened up new possibilities for human understanding of the world and for control of its material forces. Research into the phenomena of electricity and combustion, along with the discovery of oxygen and the power of steam, had enormous consequences. Steam power as an adjunct to, or replacement for, human labor began a new era in world history. The invention of steam engines in England for industrial production and, later, their use for transportation marked the beginning of the technological and industrial revolutions, which occurred from about 1740 onward. All of Europe was destined to be transformed within a century by the harnessed power of steam, coal, oil, iron, steel, and electricity working in concert. These scientific and technological advances also affected the arts, particularly leading to the development of photography and changes in architecture.

THE WONDERS OF THE UNIVERSE Technological advance depended on the new enthusiasm for mechanical explanations for the wonders of the universe. The fascination it had for ordinary people as well as for the learned is the subject of *A Philosopher Giving a Lecture at the Orrery (in which a lamp is put in place of the sun*; FIG. **20-3**), by the English painter JOSEPH WRIGHT OF DERBY (1734–1797). Wright specialized in the drama of candlelit and moonlit scenes. He loved subjects such as the orrery demonstration, which could be illuminated by a single light from within the picture. In the painting, a scholar uses a special technological model (called an *orrery*) to demonstrate the theory that the universe operates like a gigantic clockwork mechanism. Light from the lamp, representing the sun, pours forth from in front of the boy silhouetted in the foreground to create dramatic light and shadows that heighten the scene's drama. Awed children crowd close to the tiny metal orbs that represent the planets within the arcing bands that symbolize their orbits. An earnest listener makes notes, while the lone woman seated at the left and the two gentlemen at the right look on with rapt attention. Everyone in Wright's painting is caught up in the wonders of scientific knowledge; an ordinary lecture takes on the qualities of a grand "history painting." Wright scrupulously rendered with careful accuracy every detail of the figures, the mechanisms of the orrery, and even the books and curtain in the shadowy background. His realism appealed to the great industrialists of his day. Scientific-industrial innovators such as Josiah Wedgwood and Sir Richard Arkwright often purchased works such as *Orrery*. (Wedgwood pioneered many techniques of mass-produced pottery; Wedgwood fine china and pottery are still produced today. Arkwright's spinning frame revolutionized the textile industry.) To them, Wright's elevation of the theories and inventions of the Industrial Revolution to the plane of history painting was exciting and appropriately in tune with the future.

BRIDGING THE AGES WITH IRON Eighteenth-century engineering, especially, foreshadowed the future, particularly its use of industrial materials. Two men first used iron in bridge design for the cast-iron bridge built in England over the Severn River, near the site at Coalbrookdale where ABRAHAM DARBY III (1750–1789) ran his family's cast-iron business. Previous bridges had been constructed of wood and

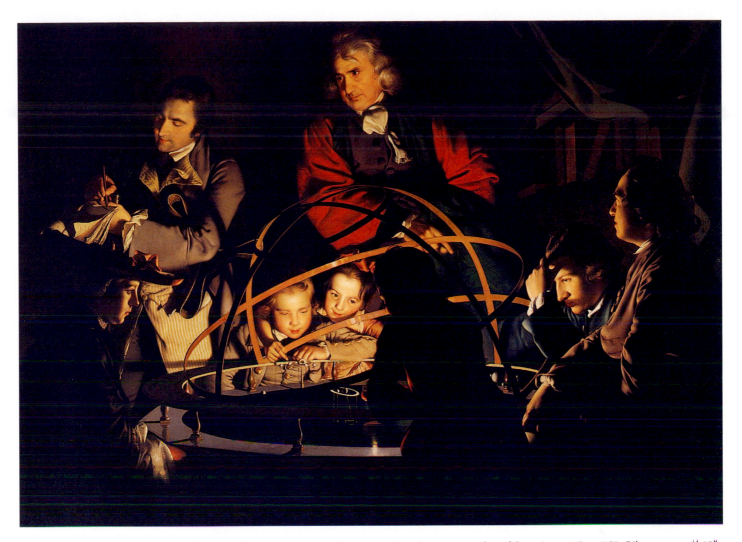

20-3 JOSEPH WRIGHT OF DERBY, *A Philosopher Giving a Lecture at the Orrery (in which a lamp is put in place of the sun)*, ca. 1763–1765. Oil on canvas, 4′ 10″ × 6′ 8″. Derby Museums and Art Gallery, Derby, Derbyshire.

spanned relatively short distances, limiting their use for high-volume industrial traffic. The Darby family had spearheaded the evolution of the iron industry in England, and they vigorously supported the investigation of new uses for the material. The fabrication of cast-iron rails and bridge elements inspired Darby to work with architect THOMAS F. PRITCHARD (1723–1777) in designing the Coalbrookdale Bridge (FIG. **20-4**). The cast-iron armature that supports the roadbed springs from stone pier to stone pier until it leaps the final one hundred feet across the Severn River gorge. The style of the graceful center arc echoes the grand arches of Roman aqueducts (see FIG. 7-31). At the same time, the exposed structure of the bridge's cast-iron parts prefigured the skeletal use of iron and steel in the nineteenth century. Such visible structural armatures became expressive factors in the design of buildings such as the Crystal Palace (FIG. 20-60) and the Eiffel Tower (see FIG. 21-57).

VOLTAIRE VERSUS ROUSSEAU: SCIENCE VERSUS THE TASTE FOR THE "NATURAL"

The name of Jean-Jacques Rousseau (1712–1778) is traditionally invoked along with that of Voltaire as representative of the French Enlightenment and as individuals instrumental in preparing the way ideologically for the French Revolution. Yet Voltaire, as has been noted, thought the salvation of humanity was in science's advancement and in society's rational improvement. In contrast, Rousseau declared that the arts, sciences, society, and civilization in general had corrupted "natural man"—people in their primitive state—and that humanity's only salvation was a return to something like "the ignorance, innocence and happiness" of its original condition. According to Rousseau, human capacity for feeling, sensibility, and emotions came prior to reason: "To exist is to feel; our feeling is undoubtedly earlier than our intelligence, and we had feelings before we had ideas." Nature alone must be the guide: "all our natural inclinations are right." Rousseau's basic point: "Man by nature is good . . . he is depraved and perverted by society." He rejected the idea of progress, insisting: "Our minds have been corrupted in proportion as the arts and sciences have improved."[2]

These and similar sentiments expressed by Rousseau shocked Voltaire, who responded to them with acid sarcasm in a letter to Rousseau that reveals their fundamentally different outlook.

I have received, Sir, your new book against the human race [*Dissertation on the Origin of Inequality*, 1755]. . . . You paint with very true

20-4 ABRAHAM DARBY III and
THOMAS F. PRITCHARD, iron bridge at
Coalbrookdale, England (first cast-iron
bridge over the Severn River),
1776–1779. 100′ span.

colors the horrors of human society. . . . Never has so much intelligence been used in seeking to make us stupid. One acquires the desire to walk on all fours when one reads your book. Nevertheless, since I lost this habit more than sixty years ago, I unfortunately feel that it is impossible for me to take it up again. [3]

The society Rousseau attacked and Voltaire defended in general terms was in fact the one they both knew and moved in; its center was Paris, ornamented in the Rococo style. Rousseau's views, widely read and popular, were largely responsible for the turning away from the Rococo sensibility and the formation of a taste for the "natural," as opposed to the artificial.

The "Natural" Landscape

The eighteenth-century public sought "naturalness" in artists' depictions of landscapes. Documentation of particular places became popular, in part due to growing travel opportunities and the expanding colonial imperative. Such depictions of geographic settings also served the needs of the many scientific expeditions mounted during the century and satisfied the desires of genteel tourists for mementos of their journeys. By this time, a "Grand Tour" of the major sites of Europe was considered part of every well-bred person's education (see "Grand Tour: Travel, Education, and Italy's Allure," page 684). Naturally, those on tour wished to leave with things that would help them remember their experiences and that would impress those at home with the wonders they had seen.

A PICTURESQUE VIEW OF VENICE The English were especially eager collectors of pictorial souvenirs. Certain artists in Venice specialized in painting the most characteristic scenes, or *vedute* (views), of that city to sell to British visitors. The *veduta* paintings of ANTONIO CANALETTO (1697–1768) were eagerly acquired by English tourists, who hung them on the walls of great houses such as Chiswick (FIG. 20-22) and

Blenheim (see FIG. 19-75) as visible evidence of their visit to the city of the Grand Canal. It must have been very cheering amid a gray winter afternoon in England to look up and see a sunny, panoramic view such as that in Canaletto's *Basin of San Marco from San Giorgio Maggiore* (FIG. **20-5**), with its cloud-studded sky, calm harbor, varied water traffic, picturesque pedestrians, and well-known Venetian landmarks all painted in scrupulous perspective and minute detail.

Canaletto had trained as a scene painter with his father, but his easy mastery of detail, light, and shadow soon made him one of the most popular *"vedutisti"* in Venice. Occasionally, he painted his scenes directly from life, but usually he made drawings "on location" to take back to his studio as sources for paintings. To help make the on-site drawings true to life, he often used a *camera obscura*. The *camera obscura* (see page 650) allowed Canaletto (and other artists) to create visually convincing paintings that included variable focus of objects at different distances. His paintings give the impression of capturing every detail, with no "editing." Actually, he presented each site within Renaissance perspectival rules and exercised great selectivity about which details to include and which to omit to make a coherent and engagingly attractive picture. In addition, the mood in each of his works was constructed carefully to be positive and alluring. Everything in the world Canaletto presented is clean and tidy. The sun always shines, and every aspect of the weather is serene; the viewer never got even a hint of the dreary rainy season in Venice.

The Taste for the "Natural" in France

Rousseau, in placing feelings above reason as the most primitive—hence most "natural"—of human expressions, called for the cultivation of sincere, sympathetic, and tender emotions. This led him to exalt the peasant's simple life, with its honest and unsullied emotions, as ideal and to name it as a model for imitation. The joys and sorrows of uncorrupted "natural" people, described everywhere in novels (for example,

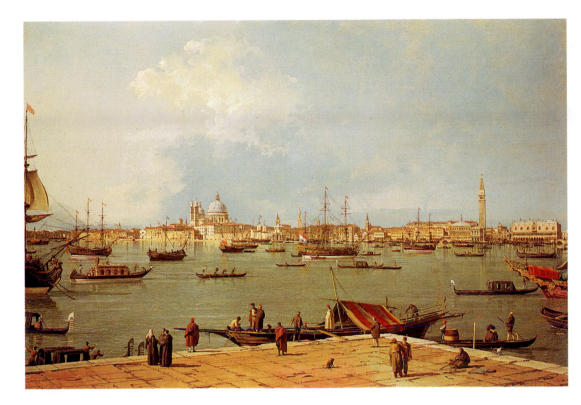

20-5 ANTONIO CANALETTO, *Basin of San Marco from San Giorgio Maggiore*, ca. 1740. Oil on canvas. The Wallace Collection, London.

Oliver Goldsmith's *The Vicar of Wakefield*, 1766, or Bernardin de Saint-Pierre's *Paul and Virginia*, 1787), soon drowned Europe in floods of tears. It became fashionable to weep, to fall to one's knees, and to languish in hopeless love. Hopelessly in love, Goethe's hero in *The Sorrows of Young Werther* (1774) kills himself under the moon.

THE SENTIMENTALITY OF RURAL ROMANCE

The sentimental narrative in art became the specialty of French artist JEAN-BAPTISTE GREUZE (1725–1805), whose most popular work, *The Village Bride* (FIG. **20-6**), sums up the genre's characteristics. The setting is an unadorned room in a rustic dwelling. In a notary's presence, the elderly father has passed his daughter's dowry to her youthful husband-to-be and blesses the pair, who gently take each other's arms. The old mother tearfully gives her daughter's arm a farewell caress, while the youngest sister melts in tears on the demure bride's shoulder. An envious older sister broods behind her father's

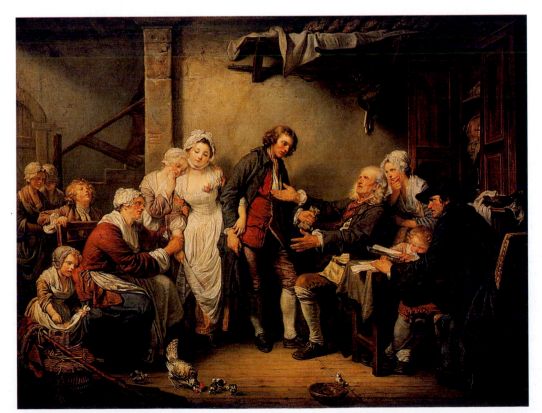

20-6 JEAN-BAPTISTE GREUZE, *The Village Bride*, 1761. Oil on canvas, 3' × 3' 10$\frac{1}{2}$". Louvre, Paris.

Grand Tour
Travel, Education, and Italy's Allure

Although travel throughout Europe was commonplace in the eighteenth century, Italy became a particularly popular travel site. This "pilgrimage" of aristocrats, the wealthy, politicians, and diplomats from France, England, Germany, Flanders, Sweden, the United States, Russia, Poland, and Hungary came to be known as the Grand Tour. Italy's allure fueled classicism's revival, which became most formalized in Neoclassicism. In turn, Neoclassicism's prominence drove this fascination with Italy. One British observer noted: "All our religion, all our arts, almost all that sets us above savages, has come from the shores of the Mediterranean."[1]

The Grand Tour was not simply leisure travel. The education available in Italy to the inquisitive mind made such a trip an indispensable experience for anyone who wished to play an important role in society. The Enlightenment had made knowledge of ancient Rome and Greece imperative, and a steady stream of Europeans and Americans traveled to Italy in the late eighteenth and early nineteenth centuries. These tourists aimed to increase their knowledge of literature and the arts (the visual arts, architecture, theater, and music), ancient and modern history, politics and economics, and customs and folklore. Given this extensive agenda, it is not surprising that a Grand Tour could take a number of years to complete, and most travelers moved from location to location, following an established itinerary.

The British were the most avid travelers, and they established the initial "tour code," including important destinations and required itineraries. Although they established Rome early on as the primary mecca, visitors traveled as far north as Venice and as far south as Naples. Eventually, Paestum, Sicily, Florence, Genoa, Milan, Siena, Pisa, Bologna, Parma, and Palermo all appeared in guidebooks and in *veduta* paintings. Joseph Mallord William Turner (FIG. 20-51) and Joseph Wright of Derby (FIG. 20-3) were among the many British artists to undertake a Grand Tour.

Eventually, the Grand Tour's scope extended well beyond Italian borders. In large part, the archeological discoveries at Herculaneum and Pompeii were responsible for whetting people's appetites to visit Greece. The Grand Tour eventually metamorphosed into package tours, which remain popular to the present day, revealing the continuing allure of Mediterranean and classical cultures.

[1]Cesare de Seta, "Grand Tour: The Lure of Italy in the Eighteenth Century," in *Grand Tour: The Lure of Italy in the Eighteenth Century*, eds. Andrew Wilton and Ilaria Bignamini (London: Tate Gallery, 1996), 13.

chair. Rosy-faced healthy children play around the scene. The picture's story is simple—the happy climax of a rural romance. The picture's moral is just as clear—happiness is the reward of "natural" virtue.

The audience—as said today—loved it. They carefully analyzed each gesture and each nuance of sentiment and reacted with tumultuous enthusiasm. At the Salon (the annual academy exhibition—see "The Academies: Defining the Range of Acceptable Art," Chapter 21, page 740) of 1761, Greuze's picture received enormous attention. The great compiler of the *Encyclopédie*, Diderot, who reviewed the picture for the press, declared that it was difficult to get near it because of the throngs of admirers.

THE CHARM OF THE COMMONPLACE Adherents to the taste for the "natural" often preferred narratives that taught moral lessons, dismissing the frivolities and indecent gallantries of the Rococo. The audience of French painter JEAN-BAPTISTE-SIMÉON CHARDIN (1699–1779) was gratified to find moral values in quiet scenes of domestic life. The artist seemed to praise the simple goodness of ordinary people, especially mothers and young children, who, in spirit, occupation, and environment, lived far from corrupt society. (In the eighteenth century, *taste* also could mean the appreciation of moral as well as aesthetic qualities.) Rousseau measured human quality in terms of the degree to which it was out of reach of soci-

ety's bad influence. He found it in country folk or, as here, in the urban middle class's unpretentious houses. In *Grace at Table* (FIG. **20-7**), Chardin ushers viewers into a modest room where a mother and her small daughters are about to dine. The mood of quiet attention is at one with the hushed lighting and mellow color and with the closely studied still-life accessories whose worn surfaces tell their own humble domestic history. Viewers witness a moment of social instruction, when mother and older sister supervise the younger sister in the simple, pious ritual of giving thanks to God before a meal. In his own way, Chardin was the poet of the commonplace and the master of its nuances. A gentle sentiment prevails in all of his pictures, an emotion not contrived and artificial but born of the painter's honesty, insight, and sympathy. (It is interesting that this picture was owned by King Louis XV, the royal personification of the Rococo in his life and tastes.)

PORTRAIT OF A WOMAN ARTIST *Self-Portrait* (FIG. **20-8**) by ÉLISABETH LOUISE VIGÉE-LEBRUN (1755–1842) is another variation of the "naturalistic" impulse in eighteenth-century French portraiture. In the new mode, Vigée-Lebrun looks directly at viewers and pauses in her work to return their gaze. Although her mood is lighthearted and her costume's details echo the serpentine curve beloved by Rococo artists and wealthy patrons, nothing about Vigée-Lebrun's pose or her mood speaks of Rococo frivolity. Hers is the self-confi-

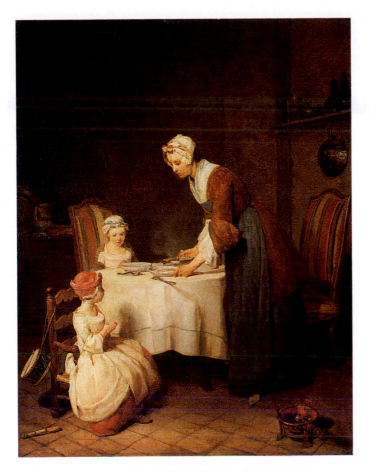

20-7 JEAN-BAPTISTE-SIMÉON CHARDIN, *Grace at Table*, 1740. Oil on canvas, 1′ 7″ × 1′ 3″. Louvre, Paris.

dent stance of a woman whose art has won her an independent role in her society. Like many of her contemporaries, Vigée-Lebrun lived a life of extraordinary personal and economic independence, working for the nobility throughout Europe. She was famous for the force and grace of her portraits, especially those of highborn ladies and royalty. She was successful during the age of the late monarchy in France and was one of few women admitted to the Academy (the established art school—see "The Academies: Defining the Range of Acceptable Art," Chapter 21, page 740). After the French Revolution, her membership in the Academy was rescinded, because women were no longer welcome in that organization. Vigée-Lebrun's continued success was indicative of her talent, her wit, and her ability to forge connections with those in power in the postrevolutionary period. For her self-portrait, Vigée-Lebrun painted herself in a close-up, intimate view at work on one of the portraits that won her renown, that of Queen Marie Antoinette. The naturalism and intimacy of her expression are similar to those in Thomas Gainsborough's portrait of Mrs. Sheridan (FIG. 20-10). Vigée-Lebrun's attitude reflects the ideals of independence and self-reliance she exhibited as a woman.

The Taste for the "Natural" in England

VISUALIZING MORALITY THROUGH SATIRE
The taste of the newly prosperous and confident middle class

in England was expressed in the art of WILLIAM HOGARTH (1697–1764), who satirized contemporary life with comic zest and with only a modicum of Rococo "indecency." With Hogarth, a truly English style of painting emerged. Traditionally, painters (such as Holbein, Rubens, and Van Dyck) were imported from the continent. Hogarth waged a lively campaign throughout his career against the English feeling of dependence on, and inferiority to, continental artists. Although Hogarth would have been the last to admit it, his own painting owed much to the work of his contemporaries across the channel in France, the Rococo artists. Yet his subject matter, frequently moral in tone, was distinctively English. It was the great age of English satirical writing, and Hogarth (who knew and admired this genre and included Henry Fielding, the author of *Tom Jones,* among his closest friends) clearly saw himself as translating satire into the visual arts.

Hogarth's favorite device was to make a series of narrative paintings and prints, in a sequence like chapters in a book or scenes in a play, that followed a character or group of characters in their encounters with some social evil. He was at his best in pictures such as the *Breakfast Scene* (FIG. **20-9**) from *Marriage à la Mode.* In it, the marriage of a young viscount, arranged through one father's social aspirations and through the need for money of the other, is just beginning to founder. The moment portrayed is just past noon; husband and wife are tired after a long night spent in separate pursuits. The music and the musical instrument on the overturned chair in the foreground and the disheveled servant straightening the chairs and tables in the room at the back indicate that the wife had stayed at home for an evening of cards and music making. She stretches with a mixture of sleepiness and coquettishness, casting a glance toward her young husband, who clearly had been away from the house for a night of suspicious business. Still dressed in hat and social finery, he slumps in discouraged boredom on a chair near the fire. His hands are thrust deep into the empty money-pockets of his breeches, while his wife's small dog sniffs inquiringly at a lacy woman's cap protruding from his coat pocket. A steward, his hands full of unpaid bills, raises his eyes to Heaven in despair at the actions of his noble master and mistress. The house is palatial, but Hogarth filled it with witty clues to the dubious taste of its occupants. The mantelpiece is crowded with tiny statuettes and a classical bust, which hide everything in the architecturally framed painting on the wall behind except a winged Eros figure. Paintings of religious figures hang on the upper wall of the distant room. This demonstration of piety is countered by the curtained canvas at the end of the row that, undoubtedly, depicts an erotic subject. Appropriately, this painting is discretely hidden from the eyes of casual visitors and ladies, according to the custom of the day, but is available at the pull of a curtain cord for the gaze of the master and his male guests. In this composition, as in all his work, Hogarth proceeded as a novelist might, elaborating on his subject with carefully chosen detail, whose discovery heightens the comedy. This scene is one in a sequence of six paintings that satirize the immoralities the moneyed classes in England practiced within marriage. Hogarth designed the marriage series to be published as a set of engravings. The prints of this and his other moral narratives were so popular that unscrupulous entrepreneurs produced unauthorized versions almost as fast as the artist created his originals.

20-8 Élisabeth Louise Vigée-Lebrun, *Self-Portrait,* 1790. Oil on canvas, 8′ 4″ × 6′ 9″. Galleria degli Uffizi, Florence.

20-9 WILLIAM HOGARTH, *Breakfast Scene*, from *Marriage à la Mode*, ca. 1745. Oil on canvas, approx. 2' 4" × 3'. National Gallery, London.

GRAND MANNER PORTRAITURE A contrasting blend of "naturalistic" representation and Rococo setting is found in the portrait of *Mrs. Richard Brinsley Sheridan* (FIG. **20-10**) by the British painter THOMAS GAINSBOROUGH (1727–1788). This portrait shows the lovely woman, dressed informally, seated in a rustic landscape faintly reminiscent of Watteau (see FIG. 19-84) in its soft-hued light and feathery brushwork. Gainsborough intended to match the natural landscape's unspoiled beauty with the subject's natural beauty. Her dark brown hair blows freely in the slight wind, and her clear unassisted "English" complexion and air of ingenuous sweetness contrast sharply with the pert sophistication of continental Rococo portraits. The artist originally had planned to give the picture "a more pastoral air" by adding several sheep, but he did not live long enough to paint them in. Even without this element, Gainsborough's deep interest in the landscape setting is evident. Although he won greater fame in his time for his portraits, he had begun as a landscape painter and always preferred painting scenes of nature to the depiction of human likenesses.

Such a portrait is representative of what became known as "Grand Manner portraiture," and Gainsborough was recognized as one of the leading practitioners of this genre. Although clearly depicting individualized people, Grand Manner portraiture also elevated the sitter by conveying refinement and elegance. Such grace and class were communicated through certain standardized conventions, such as the large scale of the figures relative to the canvas, the controlled poses, the landscape (often Arcadian) setting, and the low horizon line. Thus, despite the naturalism central to Gainsborough's portraits, he tempered it with a degree of artifice. This imbues the portraits with a sense of mastery and control, thereby revealing an important social function of such portraiture.

20-10 THOMAS GAINSBOROUGH, *Mrs. Richard Brinsley Sheridan*, 1787. Oil on canvas, approx. 7' 2$\frac{5}{8}$" × 5' $\frac{5}{8}$". National Gallery of Art, Washington (Andrew W. Mellon Collection).

THE VIRTUES OF HONOR AND VALOR Morality of a very different tone, yet in harmony with "naturalness," included the virtues of honor, valor, and love of country. Eighteenth-century Western societies believed that these virtues produced great people and great deeds. The concept of "nobility" especially as discussed by Rousseau referred to character, not to aristocratic birth. As the century progressed and people felt the tremors of coming revolutions, these virtues of courage and resolution, patriotism, and self-sacrifice assumed greater importance. The modern military hero, risen from humble origins, not the decadent aristocrat, brought the excitements of war into the company of the "natural" emotions.

DEFENDING THE ROCK OF GIBRALTAR SIR JOSHUA REYNOLDS (1723–1792) specialized in portraits of contemporaries who participated in the great events of the latter part of the century. Not least among these paintings was *Lord Heathfield* (FIG. **20-11**). Reynolds was at his best with a subject such as this burly, ruddy English officer, commandant of the fortress at Gibraltar. Heathfield doggedly had defended the great rock against the Spanish and the French, so he later was honored with the title Baron Heathfield of Gibraltar. His victory is symbolized here by the huge key to the fortress, which he holds thoughtfully. He stands in front of a curtain of dark smoke rising from the battleground, flanked by one cannon that points ineffectively downward and another whose tilted barrel indicates that it lies uselessly on its back. Reynolds portrayed the features of the general's heavy, honest

face and his uniform with a sense of unidealized realism. But Lord Heathfield's posture and the setting dramatically suggest the heroic theme of battle and refer to the actual revolutions (American and French) then taking shape in deadly earnest, as the old regimes faded into the past.

The Taste for the "Natural" in the United States

THE HEROIC DEATH OF GENERAL WOLFE American artists also addressed the "death in battle of a young military hero" theme, familiar in art and literature since the ancient Greeks. Although American artist BENJAMIN WEST (1738–1820) was born in Pennsylvania, on what was then the colonial frontier, he was sent to Europe early in life to study art and then went to England, where he met with almost immediate success. He was a cofounder of the Royal Academy of Arts and succeeded Sir Joshua Reynolds as its president. He became official painter to King George III and retained that position during the strained period of the American Revolution. While in England, West became well acquainted with the work of both Gainsborough and Reynolds. In *The Death of General Wolfe* (FIG. **20-12**), West depicted the mortally wounded young English commander just after his defeat of the French in the decisive battle of Quebec in 1759, which gave Canada to Great Britain. West chose to portray a contemporary historical subject, and his characters wear contemporary costume (although the military uniforms are not completely accurate in all details). However, West blended this realism of detail with the grand tradition of history painting by arranging his figures in a complex and theatrically ordered composition. His modern hero dies among grieving officers on the field of victorious battle in a way that suggests the death of a great saint. West wanted to present this hero's death in the service of the state as a martyrdom charged with religious emotions. His innovative combination of the conventions of traditional heroic painting with a look of modern realism was so effective that it won viewers' hearts in his own day and continued to influence history painting well into the nineteenth century.

PAUL REVERE, SILVERSMITH American artist JOHN SINGLETON COPLEY (1738–1815) matured as a painter in the Massachusetts Bay Colony. Like West, Copley later emigrated to England, where he absorbed the fashionable English portrait style. But unlike Grand Manner portraiture, Copley's *Portrait of Paul Revere* (FIG. **20-13**), painted before Copley left Boston, conveys a sense of directness and faithfulness to visual fact that marked the taste for "downrightness" and plainness many visitors to America noticed during the eighteenth and nineteenth centuries. When the portrait was painted, Revere was not yet the familiar hero of the American Revolution. In the picture, he is working at his everyday profession of silversmithing. The setting is plain, the lighting clear and revealing. The subject sits in his shirtsleeves, bent over a teapot in progress; he pauses and turns his head to look observers straight in the eye. The artist treated the reflections in the tabletop's polished wood with as much care as Revere's figure, his tools, and the teapot resting on its leather graver's pillow. Copley gave special prominence to the figure's eyes by reflect-

20-11 SIR JOSHUA REYNOLDS, *Lord Heathfield*, 1787. Oil on canvas, approx. 4′ 8″ × 3′ 9″. National Gallery, London.

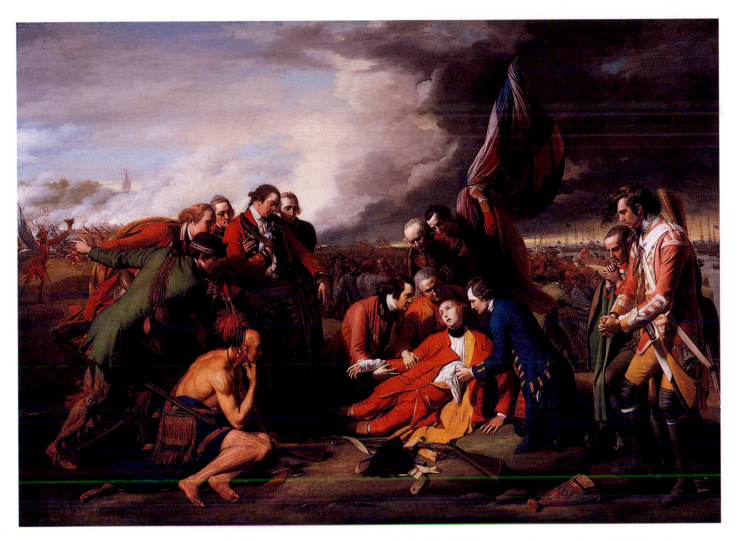

20-12 BENJAMIN WEST, *The Death of General Wolfe,* 1771. Oil on canvas, approx. 5′ × 7′ National Gallery of Canada, Ottawa (gift of the Duke of Westminster, 1918).

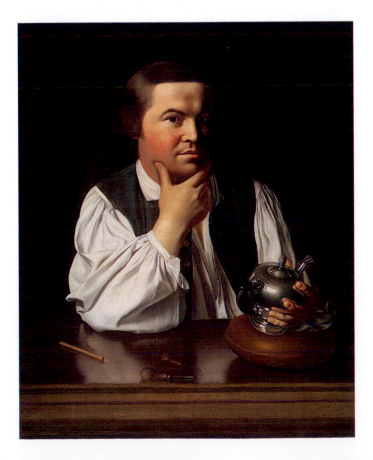

ing intense reddish light onto the darkened side of the face and hands. The informality and the sense of the moment link this painting to contemporaneous English and European portraits. But the spare style and the emphasis on the sitter's down-to-earth character differentiate this American work from its British and continental counterparts (FIG. 20-10).

THE REVIVAL OF INTEREST IN CLASSICISM

MODELS OF ENLIGHTENMENT One of the defining characteristics of the late eighteenth century was a renewed interest in classical antiquity. Although the Neoclassical movement in art that encompassed painting, sculpture, and architecture is often regarded as the most prominent manifestation of this interest, fascination with Greek and Roman culture was widespread and extended to the public culture of fashion and home decor. The Enlightenment's emphasis on rationality in part fueled this classical focus. The geometric harmony of classical art and architecture seemed to embody Enlightenment ideals. In addition, classical cultures

20-13 JOHN SINGLETON COPLEY, *Portrait of Paul Revere,* ca. 1768–1770. Oil on canvas, 2′ 11$\frac{1}{8}$″ × 2′ 4″. Museum of Fine Arts, Boston (gift of Joseph W., William B., and Edward H. R. Revere).

represented the height of civilized society, and Greece and Rome served as models of enlightened political organization. These cultures, with their traditions of liberty, civic virtue, morality, and sacrifice, served as ideal models during a period of great political upheaval. Given such traditional associations, it is not coincidental that Neoclassicism was particularly appealing during the French and American Revolutions. The public appetite for classicism was whetted further by the excavations of Herculaneum (begun in 1738) and Pompeii (1748), which the volcanic eruption of Mount Vesuvius in A.D. 79 had buried (see "Rising from the Ashes: The Excavation of Herculaneum and Pompeii," page 691).

The enthusiasm for classical antiquity permeated much of the scholarship of the time. In the late eighteenth century, the ancient world increasingly became the focus of scholarly attention. A visit to Rome stimulated Edward Gibbon to begin his monumental *Decline and Fall of the Roman Empire,* which appeared between 1776 and 1788. Earlier, in 1755, Johann Joachim Winckelmann, the first modern art historian, published his *Thoughts on the Imitation of Greek Art in Painting and Sculpture,* uncompromisingly designating Greek art as the most perfect to come from human hands. Winckelmann characterized Greek sculpture as manifesting a "noble simplicity and silent greatness."[4] In his *History of Ancient Art* (1764), he described each monument and positioned it within a huge inventory of works organized by subject matter, style, and period. Before Winckelmann, art historians had focused on biography, as reflected in Giorgio Vasari's *Lives of the Most Eminent Italian Architects, Painters and Sculptors* (first published in 1550). Winckelmann thus initiated one modern method thoroughly in accord with Enlightenment ideas of ordering knowledge. His was clearly a system of description and classification that provided a pioneering model for the understanding of stylistic evolution. As was the norm, Winckelmann's familiarity with classical art was derived predominantly from Roman works and Roman copies of Greek art. Yet Winckelmann was instrumental in bringing to scholarly attention the distinctions between Greek and Roman art. Thus, he paved the way for more thorough study of the unique characteristics of the art and architecture of these two cultures. Winckelmann's writings also laid a theoretical and historical foundation for the enormously widespread taste for Neoclassicism that lasted well into the nineteenth century.

Setting the Stage for Neoclassicism in Art

A ROMAN EXAMPLE OF VIRTUE In the art of ANGELICA KAUFFMANN (1741–1807), Greuze's simple figure types, homely situations, and contemporary settings in moral, "natural" pictures were transformed by a Neoclassicism that still contained echoes of the Rococo style. Born in Switzerland and trained in Italy, Kauffmann spent many of her productive years in England. A student of Sir Joshua Reynolds, and an interior decorator of many houses Robert Adam built, she was a founding member of the British Royal Academy of Arts and enjoyed a fashionable reputation. Her *Cornelia Presenting Her Children as Her Treasures,* or *Mother of the Gracchi* (FIG. **20-14**), is a kind of set piece of early Neoclassicism. Its subject is an informative *exemplum virtutis* (example or model of virtue) drawn from Greek and Roman history and literature. The

20-14 ANGELICA KAUFFMANN, *Cornelia Presenting Her Children as Her Treasures,* or *Mother of the Gracchi,* ca. 1785. Oil on canvas, 3′ 4″ × 4′ 2″. Virginia Museum of Fine Arts, Richmond (the Adolph D. and Wilkins C. Williams Fund).

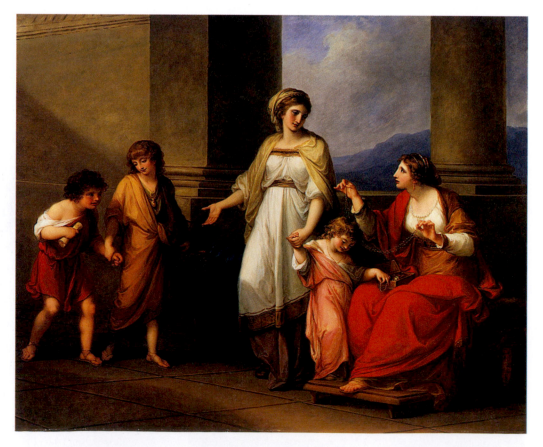

Rising from the Ashes
The Excavation of Herculaneum and Pompeii

Among the events that fueled the European fascination with classical antiquity were the excavations of two ancient cities, Herculaneum and Pompeii. The violent eruption of Mount Vesuvius in August A.D. 79 had buried both cities, located on the Bay of Naples, under volcanic ash and mud (see "An Eyewitness Account of the Eruption of Mount Vesuvius," Chapter 7, page 183). Although each of these cities had been "rediscovered" at various times during the following centuries, not until the mid-1700s did systematic excavation of both sites begin. Excavation of Pompeii, in particular, has been an extensive undertaking. That city holds the distinction as the oldest archeological site in more or less continuous excavation.

Because of how these cities were destroyed, their excavations produced unusually complete reconstructions of art and life in these Roman towns. Not only were buildings discovered, but paintings, sculptures, furniture, vases, silverware, small objects, and human skeletons were also unearthed. As a result, European imagination about and interest in ancient Rome grew tremendously.

Europeans acquired many of these uncovered objects. For example, Sir William Hamilton, British consul in Naples from 1764 to 1800, collected numerous vases and small objects, which he sold to the British Museum in 1772. The finds at Pompeii and Herculaneum, therefore, were available to a wide public.

Although the Enlightenment was largely responsible for the revival of interest in classical antiquity, these excavations were a major factor in stimulating the public's fascination with not just Rome but the entire ancient world. Soon, "Pompeian" style was all the rage, evident in the interior designs of Robert Adam (FIG. 20-25) and in the pottery designs of John Flaxman (1755–1826) and Josiah Wedgwood (1730–1795). Wedgwood established his reputation in the 1760s with his creamware inspired by ancient art. He eventually produced vases based on what were thought to be Etruscan designs and expanded his business by producing small busts of classical figures, as well as cameos and medallions adorned with copies of antique reliefs and statues. The archeological finds also affected garden and landscape designs. Fashion based on classical garb became popular, and Emma Hamilton, wife of Sir William Hamilton, often gave lavish parties dressed in floating and delicate Greek-style drapery.

Thus, despite the tragic demise of these two Roman cities ages ago, their importance has endured through the centuries, and their excavations in the eighteenth century did much to stimulate the Neoclassical taste.

moralizing pictures of Hogarth and Greuze already had marked a change in taste, but Kauffmann replaced the modern setting and characters of their works. She clothed her actors in ancient Roman garb and posed them in classicizing Roman attitudes within Roman interiors. The theme in this painting is the virtue of Cornelia, mother of the future political leaders Tiberius and Gaius Gracchus, who, in the second century B.C., attempted to reform the Roman Republic. Cornelia's character is revealed in this scene, which takes place after a lady visitor had shown off her fine jewelry and then haughtily requested that Cornelia show hers. Instead of rushing to get her own precious adornments, Cornelia brings her sons forward, presenting them as her jewels. The architectural setting is severely Roman, with no Rococo motif in evidence, and the composition and drawing have the simplicity and firmness of low-relief carving. Only the Rococo style's charm and grace linger—in the arrangement of the figures, in the soft lighting, and in Kauffmann's own tranquil manner.

Neoclassicism in France

PLANTING THE SEEDS OF GLORY The lingering echoes of Rococo disappeared in the work of JACQUES-LOUIS DAVID (1748–1825), the Neoclassical painter-ideologist of the French Revolution and the Napoleonic empire. David was a distant relative of Boucher and followed Boucher's style until a period of study in Rome won the younger man over to the classical art tradition. David favored the academic teachings about basing art elements on rules taken from the ancients and from the great Renaissance masters. In his individual style, David reworked the classical and academic traditions. He rebelled against the Rococo as an "artificial taste" and exalted classical art as the imitation of nature in her most beautiful and perfect form. He praised Greek art enthusiastically, although he, like Winckelmann, knew almost nothing about it firsthand: "I want to work in a pure Greek style. I feed my eyes on ancient statues, I even have the intention of imitating some of them."[5]

David concurred with the Enlightenment belief that subject matter should have a moral and should be presented so that the "marks of heroism and civic virtue offered the eyes of the people [will] electrify its soul, and plant the seeds of glory and devotion to the fatherland."[6] A milestone painting in David's career, *Oath of the Horatii* (FIG. **20-15**), depicts a story from pre-Republican Rome, the heroic phase of Roman history. The topic was not an arcane one for David's audience. This story of conflict between love and patriotism, first recounted by the ancient Roman historian Livy, had been retold in a play by Pierre Corneille performed in Paris several years earlier, making it familiar to David's viewing public. According to the story, the leaders of the warring cities of Rome and

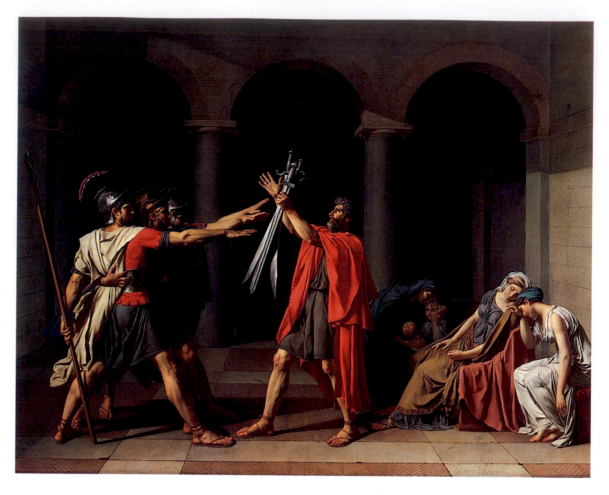

20-15 JACQUES-LOUIS DAVID, *Oath of the Horatii,* 1784. Oil on canvas, approx. 11′ × 14′. Louvre, Paris.

Alba decided to resolve their conflicts in a series of encounters waged by three representatives from each side. The Roman champions, the three Horatius brothers, were sent to face the three sons of the Curatius family from Alba. A sister of the Horatii, Camilla, was the bride-to-be of one of the Curatius sons, while the wife of the youngest Horatius was the sister of the Curatii.

David's painting shows the Horatii as they swear on their swords, held high by their father, to win or die for Rome, oblivious to the anguish and sorrow of their female relatives. In its form, *Oath of the Horatii* is a paragon of the Neoclassical style. Not only does the subject matter deal with a narrative of patriotism and sacrifice excerpted from Roman history, but the image is also presented with admirable force and clarity. David presented the scene in a shallow space much like a stage setting, defined by a severely simple architectural framework. The statuesque and carefully modeled figures are deployed across the space, close to the foreground, in a manner reminiscent of ancient relief sculpture. The rigid, angular, and virile forms of the men on the left effectively contrast with the soft curvilinear shapes of the distraught women on the right. This visually pits virtues the Enlightenment leaders ascribed to men (such as courage, patriotism, and unwavering loyalty to a cause) against the emotions of love, sorrow, and despair that the women in the painting express. The French viewing audience perceived such emotionalism as characteristic of the female nature. The message was clear and of a type readily identifiable to the prerevolutionary French public. The picture created a sensation when it was exhibited in Paris in 1785, and although it had been painted under royal patron-

age and was not intended as a revolutionary statement, its Neoclassical style soon became the revolution's semiofficial voice. David may have painted in the academic tradition, but he made something new of it. He created a program for arousing his audience to patriotic zeal.

ART IN THE SERVICE OF REVOLUTION When the French Revolution broke out in 1789, David was thrust amid this momentous upheaval. He believed "the arts must . . . contribute forcefully to the education of the public,"[7] and he realized that the emphasis on patriotism and civic virtue perceived as integral to classicism would prove effective in dramatic, instructive paintings. However, rather than continuing to create artworks that focused on scenes from antiquity, David began to portray scenes from the French Revolution itself.

The Oath of the Tennis Court (FIG. 20-16) is one such work and served not only to record an important event in the revolution but also to provide inspiration and encouragement to the revolutionary forces. David depicted the moment when delegates from the Third Estate (the middle and lower classes), rejecting the structure and voting policies of the Estates General (a representative governing body King Louis XVI convened), gathered on a nearby tennis court. Reconstituting themselves as the National Assembly, they vowed to remain as a permanent assembly until they had produced a new French constitution. David captured the moment's fervor and chaos. In contrast to the severe clarity and simplicity of his earlier Neoclassical works, this work is crowded with figures. The presiding figure is Jean-Sylvain Bailly, who became mayor

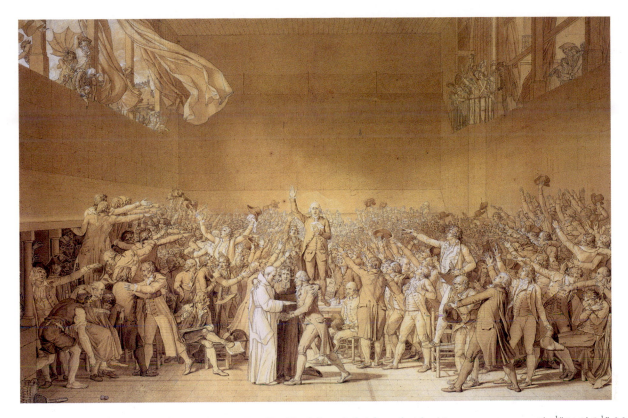

20-16 JACQUES-LOUIS DAVID, *The Oath of the Tennis Court*, 1791. Graphite, ink, sepia, heightened with white on paper, approx. 2′ 1½″ × 3′ 5⅓″. Musée national du Château de Versailles, Versailles.

of Paris. The curtain blowing in from the window on the upper left amplifies the drama and action that pervades the scene. It suggests the "fresh air" the revolution was introducing to the stagnant political structure then existing.

A radical and militant faction known as the Jacobins commissioned David to paint this subject, intending to hang the final work in the National Assembly building as a constant reminder of the ideals for which the revolutionaries were fighting. In large part because of the political situation's instability, David never finished the monumental painting (the foreground figures were to be life-sized), and viewers must be content with this preliminary drawing.

A MARTYRED REVOLUTIONARY David became increasingly involved with the revolution and threw in his lot with the Jacobins. He accepted the role of de facto minister of propaganda, organizing political pageants and ceremonies that included floats, costumes, and sculptural props. The tragic assassination of Jean-Paul Marat, a revolutionary radical, a writer, and David's personal friend, prompted David to paint another one of his French Revolution-inspired works: *The Death of Marat* (FIG. **20-17**). David depicted the martyred revolutionary after he was stabbed to death in his medicinal bath by Charlotte Corday, a member of a rival political faction. The artist ensured proper identification of this hero. The makeshift writing surface, the inscription on the writing stand, and the medicinal bath (Marat was afflicted with a painful skin disease) all provide specific references to Marat. David presented the scene with directness and clarity. The cold neutral space above Marat's figure, slumped in the tub, makes for a chilling oppressiveness. The painter vividly placed narrative details—the knife, the wound, the blood, the letter

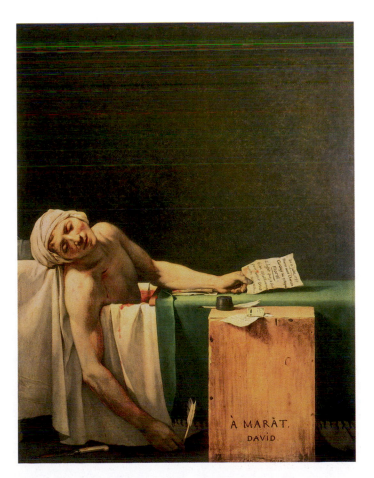

20-17 JACQUES-LOUIS DAVID, *The Death of Marat*, 1793. Oil on canvas, approx. 5′ 3″ × 4′ 1″. Musées Royaux des Beaux-Arts de Belgique, Brussels.

with which the young woman gained entrance—to sharpen the sense of pain and outrage and to confront viewers with the scene itself. Although David's depiction was based on historical events, his composition reveals his close study of Michelangelo, especially the Renaissance artist's Christ in the *Pietà* in Saint Peter's in Rome. *The Death of Marat* is convincingly real, yet it was masterfully composed to present Marat to the French people as a tragic martyr who died in the service of their state. In this way, the painting was meant to function as an "altarpiece" for the new civic "religion;" it was designed to inspire viewers with the saintly dedication of their slain leader. Rather than the grandiosity of spectacle characteristic of West's *The Death of General Wolfe* (FIG. 20-12), David's *Marat* was stripped to a severe Neoclassical spareness, yet it retains its drama and ability to move spectators.

THE GRANDEUR OF NAPOLEON'S CORONATION

At the fall of the French revolutionist Robespierre (1758–1794) and his party in 1794, David barely escaped with his life. He was tried and imprisoned, and after his release in 1795 he worked hard to resurrect his career. When Napoleon Bonaparte (1769–1821)—who had ascended to power due to the revolutionary disarray—approached David and offered him the position of First Painter of the Empire, David seized the opportunity. One of the major paintings David produced for Napoleon was *The Coronation of Napoleon* (FIG. **20-18**), a large-scale work that documents the pomp and pageantry of Napoleon's coronation in December of 1804.

The Coronation of Napoleon is a monumental (twenty feet by thirty-two feet) painting that reveals the interests of both patron and artist. Napoleon was well aware of the utility of art for constructing a public image and of David's skill in producing inspiring, powerful images. To a large extent, David adhered to historical fact regarding the coronation. He was present at this momentous event and recorded his presence in the painting (he appears in one of the tribunes, or loges, constructed for spectators). The ceremony was held in Notre-Dame Cathedral, whose majestic interior David faithfully reproduced. The artist also duly recorded those in attendance. In addition to Napoleon, his wife Josephine (being crowned), and Pope Pius VII (seated behind Napoleon), others present included Joseph and Louis Bonaparte, Napoleon's ministers, the retinues of the emperor and empress, and a representative group of the clergy. It is clear, however, from preliminary studies and drawings that David made changes at Napoleon's request. For example, Napoleon insisted that the painter depict the pope with his hand raised in blessing. Further, Napoleon's mother appears prominently in the center background, yet she had refused to attend the coronation and apparently was included in the painting at the emperor's insistence.

Despite the numerous figures and the lavish pageantry involved in this event, David retained the structured composition central to the Neoclassical style. Like David's *Oath of the Horatii*, the action here was presented as if on a theater stage. In addition, as with the arrangement of the men and women in *Oath*, David conceptually divided the painting to reveal polarities. In this case, the pope, prelates, and priests repre-

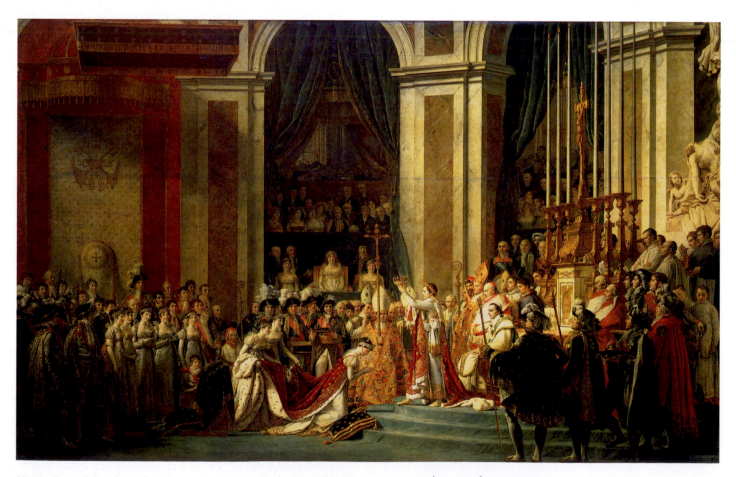

20-18 JACQUES-LOUIS DAVID, *The Coronation of Napoleon*, 1805–1808. Oil on canvas, 20' 4½" × 32' 1¾". Louvre, Paris.

senting the Catholic Church appear on the right, contrasting with members of Napoleon's imperial court on the left. The relationship between the Church and state was one of this period's most contentious issues. Napoleon's decision to crown himself, rather than allowing the pope to perform the coronation, as was traditional, revealed Napoleon's concern about the power relationship between church and state. Napoleon's insistence on emphasizing his authority is evidenced by his selection of the moment depicted; having already crowned himself, Napoleon places a crown on his wife's head. Thus, although this painting represents an important visual document in the tradition of history painting, it also represents a more complex statement about the changing politics in Napoleonic France.

It was not just David's individual skill but Neoclassicism in general that appealed to Napoleon. When Napoleon Bonaparte ascended to power, he embraced all links with the classical past as sources of symbolic authority for his short-lived imperial state. Such associations, particularly connections to the Roman Empire, served Napoleon well and were invoked in architecture and sculpture, as well as painting.

ROMAN GRANDEUR IN FRANCE Architecture provided an excellent vehicle for consolidating authority because of its public presence. Napoleon, however, was not the first to rely on classical models. Fairly early in the eighteenth century, architects began to turn away from the theatricality and ostentation of Baroque and Rococo design and embraced a more streamlined classicism. The Neoclassical portico of the Parisian church of Sainte-Geneviève (FIG. **20-19**), now the Panthéon, was designed by JACQUES-GERMAIN SOUFFLOT (1713–1780). It stands as testament to the revived interest in Greek and Roman cultures. The Roman ruins at Baalbek in Syria, especially a titanic colonnade, provided much of the inspiration for this portico. The columns, reproduced with studied archeological exactitude, are the first revelation of Roman grandeur in France. The walls are severely blank, except for a repeated garland motif near the top. The colonnaded dome, a Neoclassical version of the domes of Saint Peter's in Rome (see FIG. 17-29), the Church of the Invalides in Paris (see FIG. 19-72), and Saint Paul's in London (see FIG. 19-74), rises above a Greek-cross plan. Both the dome and vaults rest on an interior grid of splendid freestanding Corinthian columns, as if the portico's colonnade were continued within. Although the whole effect, inside and out, is Roman, the structural principles employed are essentially Gothic. Soufflot was one of the first eighteenth-century builders to suggest that Gothic engineering was highly functional structurally and could be applied to modern buildings. In his work, the curious, but not unreasonable, conjunction of Gothic and classical has a structural integration that foreshadowed nineteenth-century admiration of Gothic engineering.

A NAPOLEONIC "TEMPLE OF GLORY" La Madeleine (FIG. **20-20**) was briefly intended as a "temple of glory" for Napoleon's armies and a monument to the newly won glories of France. Begun as a church in 1807, at the height of Napoleon's power (some three years after he proclaimed himself emperor), the structure reverted again to a church after his defeat and long before its completion in 1842. Designed by PIERRE VIGNON (1763–1828), this

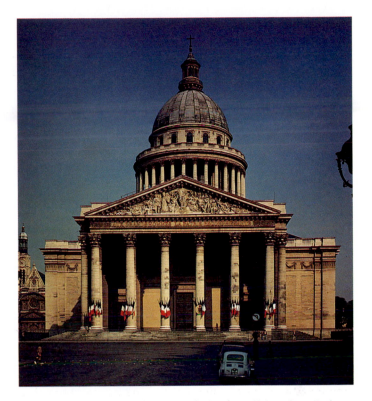

20-19 JACQUES-GERMAIN SOUFFLOT, the Panthéon (Sainte-Geneviève), Paris, France, 1755–1792.

grandiose temple includes a high podium and broad flight of stairs leading to a deep porch in the front. These architectural features, coupled with the Corinthian columns, recall Roman imperial temples (such as the Maison Carrée, FIG. 7-30, in Nîmes, France), making La Madeleine a symbolic link between the Napoleonic and Roman empires. Curiously, the building's classical shell surrounds an interior covered by a sequence of three domes, a feature found in Byzantine and Aquitanian Romanesque churches. It is as though Vignon clothed this Christian church in the costume of pagan Rome.

THE EMPEROR'S SISTER AS GODDESS Under Napoleon, classical models were prevalent in sculpture as well. The emperor's favorite sculptor was ANTONIO CANOVA (1757–1822), who somewhat reluctantly left a successful career in Italy to settle in Paris and serve the emperor. Once in France, Canova became Napoleon's admirer and made numerous portraits, all in the Neoclassical style, of the emperor and his family. Perhaps the best known of these works is the marble portrait of Napoleon's sister, *Pauline Borghese as Venus* (FIG. **20-21**). Initially, Canova had suggested depicting Borghese as Diana, goddess of the hunt. The subject of the work, however, insisted on being shown as Venus, the goddess of love. Thus she appears, reclining on a divan and gracefully holding the golden apple, a symbol of the goddess's triumph in the judgment of Paris. Although Canova clearly derived the figure from Greek art—the sensuous pose and drapery recall Greek sculpture—the work is not as idealized as might be expected. The sculptor's sharply detailed rendering of the couch and drapery suggest a commitment to naturalism as well.

The public perception of Pauline Borghese influenced the sculpture's design and presentation. Napoleon Bonaparte had

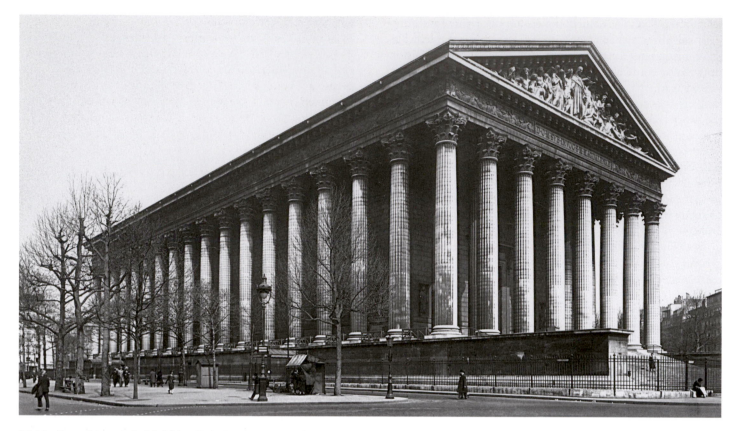

20-20 PIERRE VIGNON, La Madeleine, Paris, France, 1807–1842.

arranged the marriage of his sister to an heir of the noble Roman Borghese family. Once in Rome, Pauline's behavior was less than dignified, and the public gossiped extensively about her affairs. Her insistence on portrayal as the goddess of love reflected her self-perception. Due to his wife's questionable reputation, Prince Camillo Borghese, the work's official patron, kept the sculpture sequestered in the Villa Borghese. Relatively few people were allowed to see it (and then only by torchlight). Still, the sculpture increased both the artist and

subject's notoriety, although the sculpture's enduring fame was established only after Canova's death in 1822.

Neoclassicism in England

Classical antiquity's appeal extended well beyond French borders. The popularity of Greek and Roman cultures was due not only to their association with morality, rationality, and in-

20-21 ANTONIO CANOVA, *Pauline Borghese as Venus,* 1808. Marble, life-size. Galleria Borghese, Rome.

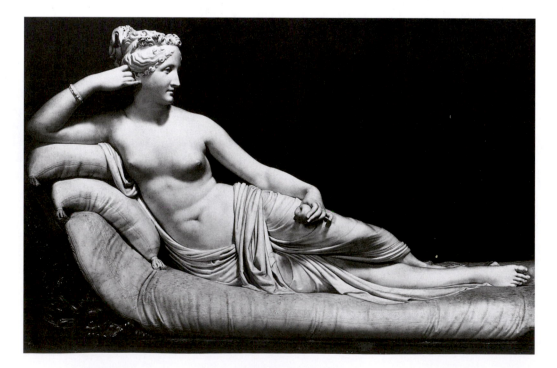

tegrity but also to their connection to political systems ranging from Athenian democracy to Roman imperial rule. Thus, in parliamentary England, as in revolutionary and imperial France, Neoclassicism was highly regarded. In England, Neoclassicism's appeal also may have been due to the Baroque style's connection with the showy rule of absolute monarchy—something to be played down in parliamentary England. In English architecture, the preference for a simple and commonsensical style led straight from the authority of the classical Roman architect Vitruvius, through Andrea Palladio's work (see FIGS. 17-56, 17-57, 17-58, and 17-59), and on to that of Inigo Jones (see FIG. 19-73). As Alexander Pope, in his *Fourth Moral Epistle* (1731), advised his friend, the statesman and architectural amateur RICHARD BOYLE, earl of Burlington (1695–1753):

> *You too proceed! make falling Arts your care,*
> *Erect new wonders, and the old repair,*
> *Jones and Palladio to themselves restore,*
> *And be whate'er Vitruvius was before.*[8]

INVOKING PALLADIO Lord Burlington took the advice and strongly restated Jones's Palladian doctrine in a new style in Chiswick House (FIG. **20-22**), which he built on London's outskirts with the help of the talented professional WILLIAM KENT (ca. 1686–1748). The way had been paved for this shift in style by, among other things, the publication of Colin Campbell's *Vitruvius Britannicus* (1715), three volumes of engravings of ancient buildings in Britain, prefaced by a denunciation of Italian Baroque and high praise for Palladio and Jones.

Chiswick House is a free variation on the theme of Palladio's Villa Rotonda (see FIG. 17-56). The exterior design provided a clear alternative to the colorful splendors of Versailles. In its simple symmetry, unadorned planes, right angles, and stiffly wrought proportions, Chiswick looks very classical and "rational." But, like so many Palladian villas in England, the effect is modified by its setting within informal gardens, where a charming irregularity of layout and freely growing uncropped foliage dominate the scene. Just as irregularity was cultivated in the landscaping surrounding English Palladian villas, early eighteenth-century building interiors sometimes were ornamented in a style more closely related to the Rococo decoration fashionable on the continent than to the severe classical Palladian exteriors. At Chiswick, the interior design creates a luxurious Late Baroque foil to the stern symmetry of the exterior and the plan. Despite such "lapses," Palladian Classicism prevailed in English architecture until about 1760, when it began to evolve into Neoclassicism.

A RESORT TOWN OF PALLADIAN SPLENDOR
At just about this time of change, John Wood the Elder (ca. 1704–1754) and his son JOHN WOOD THE YOUNGER (1728–1782) laid out an extensive complex of buildings for the fashionable resort town of Bath in Somersetshire. The structures are grouped around simple geometrical spaces—the square, circle, and semicircle—and are called Queen's Square, the Circus, and the Royal Crescent (FIG. **20-23**), the last exclusively the work of John Wood the Younger. These early ingenious solutions to the problems of urban design were intended not for royalty but for the well-to-do members of society who came "to take the waters" at the city's hot springs. Restored and operating in the eighteenth century, the baths had been famous since Roman times and had given Bath its name. In both the Circus and the Royal Crescent, the houses are linked into rows behind a single continuous Palladian facade, which transforms the joined units into one palatial edifice. The Royal Crescent joins thirty residences in a great semiellipse, originally intended to have a matching semiellipse facing it across an intersecting roadway, so as to suggest the ancient Roman Colosseum (see FIG. 7-34). Bath, with its ancient Roman associations, prompted the younger John Wood to refer to Rome not only for the Colosseum-like plan but also for the imperial scale and majesty of the building's elevation. Especially "Roman" is the sweeping parade of colossal Ionic columns along the lofty, curving basement; the roofline, punctuated regularly with clusters of chimney pots, is traditionally English. The Bath designs, with many variations, became a standard for British urban architecture for a century. Here, they announced a new classical Roman presence in what was still a Palladian edifice.

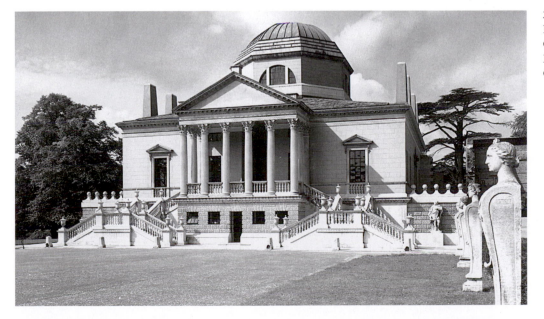

20-22 RICHARD BOYLE (earl of Burlington) and WILLIAM KENT, Chiswick House, near London, England, begun 1725. British Crown Copyright.

20-23 JOHN WOOD THE YOUNGER, the Royal Crescent, Bath, England, 1769–1775.

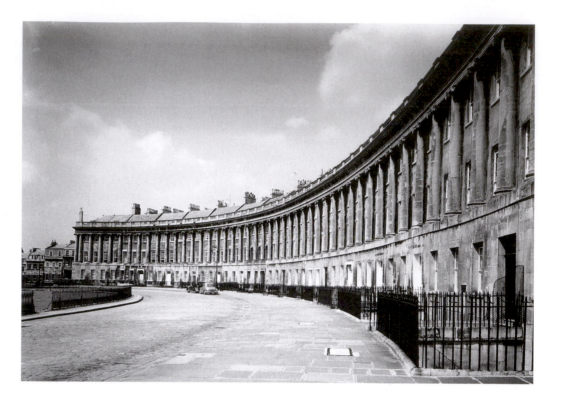

A GREEK PORTICO IN ENGLAND British painter and architect JAMES STUART (1713–1788), along with Nicholas Revett (1720–1804), also a painter and architect, introduced to Europe the splendor and originality of Greek art in the enormously influential *Antiquities of Athens,* whose first volume appeared in 1762. These volumes firmly distinguished Greek art from the "derivative" Roman style that had served as the model for classicism since the Renaissance. Stuart's design for the portico at Hagley Park (FIG. **20-24**) in Worcestershire, based on the Doric temple in Athens known as the Theseion, reflects his preference for Greek art and architecture.

NEOCLASSICISM MOVES INDOORS Eighteenth-century Neoclassical interiors also were directly inspired by new discoveries of "the glory that was Greece / And the grandeur that was Rome"[9] and summarized the conception of a noble classical world. The first great archeological event of modern times, the discovery and initial excavation of the ancient buried Roman cities of Herculaneum (see FIGS. 7-14, 7-22, and 7-24) and Pompeii (see FIGS. 7-9 to 7-13, 7-15, 7-21, and 7-23) in the 1730s and 1740s, startled and thrilled all of Europe (see "Rising from the Ashes: The Excavation of Herculaneum and Pompeii," page 691). The excavation of these cities was the veritable resurrection of the ancient world, not simply a dim vision of it inspired by a few moldering ruins. Historical reality replaced fancy with fact. The wall paintings and other artifacts of Pompeii inspired the slim, straight-lined, elegant "Pompeian" style that, after midcentury, almost entirely displaced the curvilinear Rococo.

ADAPTING POMPEIAN DECOR In England, the Pompeian manner emerged most recognizably in the work of ROBERT ADAM (1728–1792), whose interior architecture was influential throughout Europe. The Etruscan Room at Oster-

ley Park House (FIG. **20-25**) in Middlesex was begun in 1761. If compared with the Rococo salons of the Hôtel de Soubise (see FIG. 19-80) and the Amalienburg (see FIG. 19-81), this room shows how completely symmetry and rectilinearity returned. But this return was achieved with great delicacy and with none of the Louis XIV style's massive splendor. The architect took the decorative motifs (medallions, urns, vine scrolls, sphinxes, and tripods) from Roman art and, as in Roman stucco work, arranged them sparsely within broad, neutral spaces and slender margins (see FIGS. 7-18 and 7-20). Adam was an archeologist as well, and he had explored and written accounts of the ruins of Diocletian's palace at Split

20-24 JAMES STUART, Doric portico, Hagley Park, Worcestershire, England, 1758.

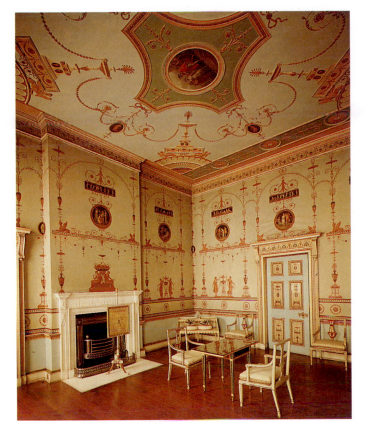

20-25 ROBERT ADAM, Etruscan Room, Osterley Park House, Middlesex, England, begun 1761. Victoria and Albert Museum, London.

(see FIG. 7-75). Kedleston House in Derbyshire, Adelphi Terrace in London, and a great many other structures he designed also show the Split palace's influence on his work.

Neoclassicism in the United States

JEFFERSONIAN IDEALISM Neoclassicism's versatility and the appeal of the qualities with which it was connected—morality, idealism, patriotism, and civic virtue—allowed Neoclassicism to be associated with everything from revolutionary aspirations for democratic purity to imperial ambitions for unshakable authority. Thus, Napoleon invoked classical references to serve his imperial agenda. Meanwhile, in the new American republic, THOMAS JEFFERSON (1743–1826) spearheaded a movement to adopt a symbolic Neoclassicism (a style he saw as representative of U.S. democratic qualities) as the national architecture.

Scholar, economist, educational theorist, statesman, and gifted amateur architect, Jefferson was, by nature, attracted to classical architecture. He worked out his ideas in his design for his own home, Monticello (FIG. 20-26), which was begun in 1770. Jefferson admired Palladio immensely and read carefully the Italian architect's *Four Books of Architecture*. Later, while minister to France, Jefferson studied French eighteenth-century classical architecture and city planning and visited the Maison Carrée, a Roman temple at Nîmes (see FIG. 7-30). After his European trip, Jefferson completely remodeled Monticello, which he first had designed in an English Georgian style. In his remodeling, he emulated Palladio's manner, with a facade inspired by Robert Adam's work. The final version of Monticello is somewhat reminiscent of the Villa Rotonda (see

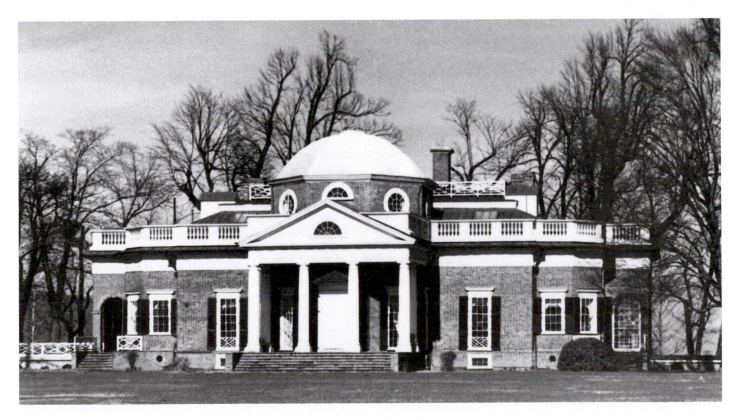

20-26 THOMAS JEFFERSON, Monticello, Charlottesville, United States, 1770–1806.

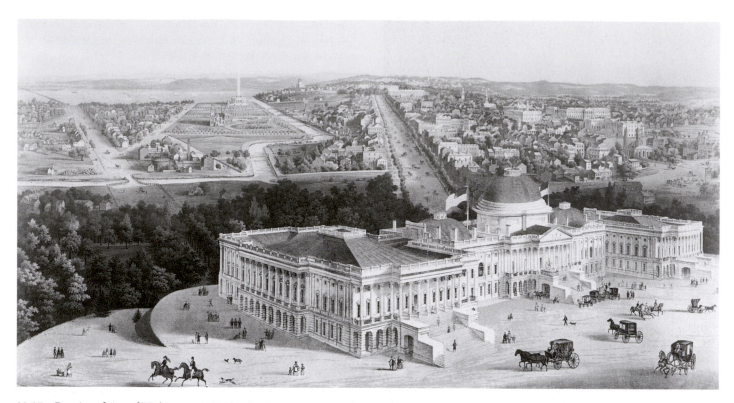

20-27 Drawing of view of Washington, 1852, showing BENJAMIN LATROBE'S Capitol (1803–1807) and MAJOR L'ENFANT'S plan (created in 1791) of the city.

FIG. 17-56) and of Chiswick House (FIG. 20-22), but its materials are the local wood and brick used in Virginia.

Turning from the private domain to public spaces, Jefferson began to carry out his dream of developing a classical style for the official architecture of the United States. Here, his Neoclassicism was an extension of the Enlightenment belief in the perfectibility of human beings and in art's power to help achieve that perfection. As secretary of state to George Washington, Jefferson supported the logically ordered city plan for Washington, D.C., created in 1791 by the French-American architect MAJOR PIERRE L'ENFANT (1724–1825). The plan extended earlier ordered designs for city sections, such as Wood's designs for Bath (FIG. 20-23), to an entire community. As an architect, Jefferson also incorporated the specific look of the Maison Carrée (see FIG. 7-30) into his design for the Virginia State Capitol in Richmond. He approved William Thornton's initial Palladian design for the federal Capitol in 1793. As president, in 1803 he selected BENJAMIN H. LATROBE (1764–1820) to take over the design of the structure (FIG. **20-27**), with the goal of creating "a building that would serve as a visible expression of the ideals of a country dedicated to liberty." Jefferson's choice of a Roman style was influenced partly by his admiration for its beauty and partly by his associations of it with an idealized Roman republican government and, through that, with ancient Greece's democracy. Latrobe committed himself to producing a building that "when finished will be a durable and honorable monument of our infant republic, and will bear favorable comparisons with the remains of the same kind of ancient republics of Greece and Rome."[10] To that end, in the Capitol's architecture, Latrobe transformed the Roman eagle symbol into the American bald eagle, and devised a special new Corinthian order that replaced acanthus leaves with corn plants. He also designed the sculptured representation of Liberty to abandon traditional trappings and to hold a liberty cap in one hand and rest her other hand on the Constitution.

GEORGE WASHINGTON AS GREEK GOD? The Neoclassical style's limitations are apparent in a statue of George Washington (FIG. **20-28**), by the American sculptor HORATIO GREENOUGH (1805–1852). Here, the Neoclassical style Jefferson had championed so successfully for the new democracy's architecture (FIG. 20-27) turned out to be less suitable for commemorative portraits. Commissioned by the United States Congress to honor Washington as the country's first president, the sculptor used as a model for the head a popular bust of Washington by Houdon (a work with the same lively realism as Houdon's *Voltaire*, FIG. 20-1). For the statue's body, Greenough aimed at the monumental majesty inspired by a lost, but famous, sculpture of the Greek god Zeus by Phidias. The sheathed sword, offered hilt forward, was intended to symbolize "Washington the peacemaker," rather than "Washington the revolutionary war general." The representation of the "father of his country," deified as a half-naked pagan god, however, was, at the time, beyond the American public's taste. The statue was considered a failure in Greenough's time precisely because it manifested, more than many Neoclassical sculptures, the contradictions that sometimes develop when idealistic and realistic illusion meet. While Canova appeared to harmonize these two trends in *Pauline Borghese as Venus* (FIG. 20-21), Greenough put them in opposition. Although Greenough's statue was never thrown into the Potomac River "to hide it from the world," as one congressman suggested, it also was never placed in its intended site beneath the Capitol dome. Today, the work is more highly regarded and is displayed at the National Portrait Gallery in Washington, D.C. Although to some it

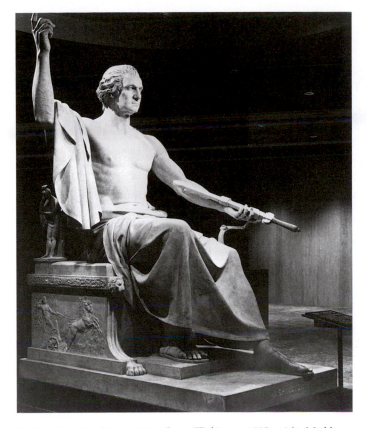

20-28 HORATIO GREENOUGH, *George Washington,* 1832–1841. Marble, approx. 11′ 4″ high. National Portrait Gallery, Smithsonian Institution, Washington.

may seem stiff, cold, or simply unconvincing, it does have an imperious majesty appropriate to its subject's national memory.

FROM NEOCLASSICISM TO ROMANTICISM

Given Jacques-Louis David's stature and prominence as an artist, along with the popularity of Neoclassicism, it is not surprising he attracted numerous students and developed an active and flourishing teaching studio. David gave practical instruction to and deeply influenced many important artists of the period, including the three discussed next. So strong was David's commitment to classicism that he encouraged all of his students to learn Latin so that they could better immerse themselves in and understand classical culture. Even further, David initially demanded that his pupils select their subjects from Plutarch, the ancient author of *Lives of the Great Greeks and Romans* and a principal source of standard Neoclassical subject matter. Due to this thorough classical foundation, David's students all produced work that, at its core, retains Neoclassical elements. Yet despite this apparent dogmatism, David was open minded and far from authoritarian in his teaching and encouraged his students to find their own visual voices.

A departure from the structured confines of Neoclassicism is evident in the work of Antoine-Jean Gros, Anne-Louis Girodet-Trioson, and Jean-Auguste-Dominique Ingres, each David's pupil. In moving beyond Neoclassicism, these artists

laid the foundation for the Romantic movement, discussed in detail later. They explored the realm of the exotic and the erotic and often turned to fictional narratives for the subjects of their paintings, as Romantic artists also did.

NAPOLEON AMONG THE SICK AND DYING Like his teacher David, ANTOINE-JEAN GROS (1771–1835) was aware of the benefits that could accrue to artists favored by those in power. Following David's lead, Gros produced several paintings that contributed to the growing mythic status of Napoleon Bonaparte in the early 1800s. In *Napoleon at the Pesthouse at Jaffa* (FIG. **20-29**), which Napoleon ordered Gros to paint, the artist referred to an outbreak of the bubonic plague that erupted during the Near Eastern campaigns of 1799. This fearsome disease struck both Muslim and French forces alike, and in March of 1799 Napoleon himself visited the pesthouse at Jaffa to quell the growing panic and hysteria. Gros depicted Napoleon's staff officers covering their noses against the stench of the place, while Napoleon, amid the dead and dying, is fearless and in control. He comforts those still alive, who are clearly awed by his presence and authority. Indeed, by depicting the French leader touching the sores of a plague victim, Gros almost seemed to confer on Napoleon the miraculous power to heal by invoking the king's legendary touch (the "*touche des écouelles*"). This exaltation of the French leader was necessary to counteract the negative publicity he was subject to at the time. Apparently, two months after his visit to the pesthouse, Napoleon ordered all plague-stricken French soldiers poisoned to relieve him of having to return them to Cairo or of abandoning them to the Turks. Some of the soldiers survived, and from their accounts the damaging stories about Napoleon began to circulate. Gros's large painting was a clear attempt at damage control—to resurrect the event and rehabilitate Napoleon's compromised public image.

Gros structured his composition in a manner reminiscent of David's major paintings, with the mosque courtyard's horseshoe arches and Moorish arcades providing a backdrop for the unfolding action. In addition, Gros's placement of Muslim doctors ministering to plague-stricken Muslims on the left is contrasted with Napoleon and his soldiers on the right, bathed in radiant light. David had used this polarized compositional scheme to great effect in works such as *Oath of the Horatii* (FIG. 20-15). However, Gros's fascination with the exoticism of the Near East, as evidenced by his attention to the unique architecture, attire, and terrain, represented a departure from Neoclassicism. This, along with the artist's emphasis on death, suffering, and an emotional rendering of the scene, presaged prominent aspects of Romanticism.

A TRAGIC SUICIDE IN LOUISIANA Another of David's students, ANNE-LOUIS GIRODET-TRIOSON (1767–1824), also produced works that conjured images of exotic locales and cultures. Moving further into Romanticism's domain, his painting *The Burial of Atala* (FIG. **20-30**) was based on a popular novel, *The Genius of Christianity,* by French writer Chateaubriand. The section of the novel dealing with Atala was published as an excerpt a year before the entire book's publication in 1802. Both the excerpt and the novel were enormously successful, and, as a result, Atala became almost a cult figure. In keeping with the movement

20-29 ANTOINE-JEAN GROS, *Napoleon at the Pesthouse at Jaffa*, 1804. Oil on canvas, approx. 17′ 5″ × 23′ 7″. Louvre, Paris.

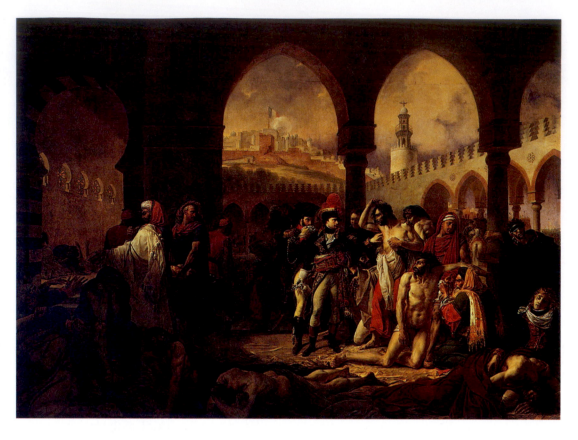

toward Romanticism, interest in *Genius of Christianity* was due in large part to the exoticism and eroticism integral to the narrative. Set in Louisiana, Chateaubriand's work focuses on two Native American youths, Atala and Chactas. The two, from different tribes, fall in love and run away together through the wilderness. The book is highly charged with erotic passion, and Atala, sworn to lifelong virginity, finally commits suicide rather than break her oath. Girodet's painting depicts this tragedy, as Atala is buried in the shadow of a cross by her grief-stricken lover, Chactas. Assisting in the burial is a cloaked priest, whose presence is appropriate given Chateaubriand's emphasis on the revival of Christianity (and the Christianization of the New World) in his novel. Like

Gros's depiction of the foreign Muslim world, Girodet's representation of American Indian lovers in the Louisiana wilderness appealed to the public's fascination (whetted by the Louisiana Purchase in 1803) with what it perceived as the passion and primitivism of Native American tribal life. *The Burial of Atala* speaks here to emotions, rather than inviting philosophical meditation or revealing some grand order of nature and form. Unlike David's appeal to the feelings that manifest themselves in public action in the *Oath of the Horatii* (FIG. 20-15), the appeal here is to the viewer's private world of fantasy and emotion.

A SUMMARY OF NEOCLASSICAL PRINCIPLES JEAN-AUGUSTE-DOMINIQUE INGRES (1780–1867) arrived at David's studio in the late 1790s after Girodet-Trioson had left to establish an independent career. Ingres's study there was to be short lived, however, as he soon broke with David on matters of style. This difference of opinion involved Ingres's adoption of what he believed to be a truer and purer Greek style than that David employed. The younger artist adopted flat and linear forms approximating those found in Greek vase painting. In many of Ingres's works, the figure is placed in the foreground, much like a piece of low-relief sculpture.

Ingres's huge composition, the *Apotheosis of Homer* (FIG. 20-31), was exhibited at the Salon of 1827. It presented in a single statement the doctrine of ideal form, of Neoclassical taste, and generations of academic painters remained loyal to that style. Enthroned before an Ionic temple, the epic poet Homer is crowned by Fame or Victory. At his feet are two statuesque women, who personify *The Iliad* and *The Odyssey*, the offspring of his imagination. Symmetrically grouped about him is a company of the "sovereign geniuses" — as Ingres called them — who expressed humanity's highest ideals in

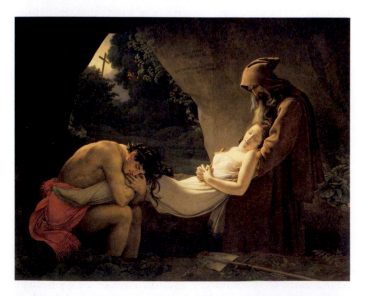

20-30 ANNE-LOUIS GIRODET-TRIOSON, *The Burial of Atala*, 1808. Oil on canvas, approx. 6′ 11″ × 8′ 9″. Louvre, Paris.

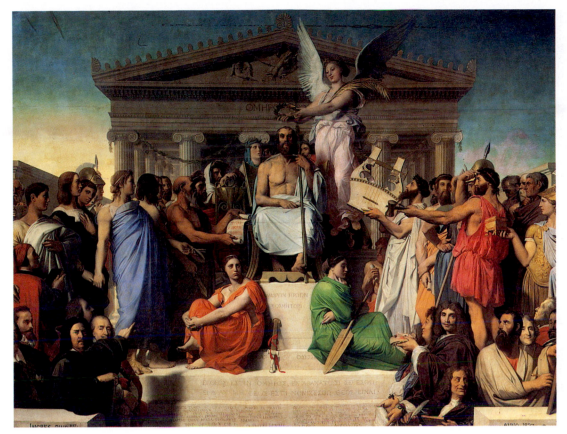

philosophy, poetry, music, and art. To Homer's left are Anacreon with his lyre, Phidias with his sculptor's hammer, and Plato, Socrates, and other ancient worthies. To his far right are Horace, Vergil, Dante, and, conspicuously, Raphael, the painter Ingres most admired. Among the forward group on the painting's left side are Poussin (pointing) and Shakespeare (half concealed), and at the right are French writers Jean Baptiste Racine, Molière, Voltaire, and François de Salignac de la Mothe Fénelon. Ingres had planned a much larger and more inclusive group, but the project was never completed. For years he agonized over whom to choose for this select company of humanities' heroes.

It is obvious that Raphael's *School of Athens* (see FIG. 17-17) inspired the idea for *Apotheosis* and, to a degree, the composition. As Ingres developed as an artist, he turned more and more to Raphael, perceiving in his art the essence of classicism. Ingres disdained, in proportion, the new "modern" styles (the "romantic" and the "realistic," as they were then called) as destructive of true art. "We must ever turn to the past," he said.

> Let me hear no more of that absurd maxim: "We need the new, we must follow our century, everything changes, everything is changed." Sophistry—all of that! Does nature change, do the light and air change, have the passions of the human heart changed since the time of Homer? "We must follow our century": but suppose my century is wrong.[11]

This was the cry of the great conservative, rejecting the modern. It expressed precisely the classicist's resistance to the new school of Romantic color and passion that changed the school of ideal form, of which Ingres had become high priest and first master.

COMBINING THE IDEAL WITH THE EXOTIC

Despite Ingres's commitment to ideal form and careful compositional structure, he also produced works that, like those of Gros and Girodet, his contemporaries saw as departures from Neoclassicism. One such painting is *Grande Odalisque* (FIG. 20-32). Ingres's subject, the reclining nude figure, is traditional enough and goes back to Giorgione and Titian (see FIG. 17-38). Further, the work shows his admiration for Raphael in his borrowing of that master's type of female head. The figure's languid pose, her proportions (small head and elongated limbs), and the generally cool color scheme also reveal his debt to such Mannerists as Parmigianino (see FIG. 17-42). However, by converting the figure to an *odalisque* (a member of a Turkish harem), the artist made a strong concession to the contemporary Romantic taste for the exotic.

This rather strange mixture of artistic allegiances—the precise adherence to classical form while incorporating Romantic themes—prompted confusion, and when *Grande Odalisque* was first shown in 1814, the painting drew acid criticism. In both form and content, critics initially saw Ingres as a kind of rebel; they did not cease their attacks until the mid-1820s, when another enemy of the official style, Eugène Delacroix, appeared. Then they suddenly perceived that Ingres's art, despite its innovations and deviations, still contained many elements that adhered to the official Neoclassicism—the taste for the ideal. Ingres soon led the academic forces in their battle against the "barbarism" of Théodore Géricault, Delacroix, and their "movement." Gradually, Ingres warmed to the role his critics had cast for him, and he came to see himself as the conservator of good and true art, a protector of its principles against its would-be "destroyers."

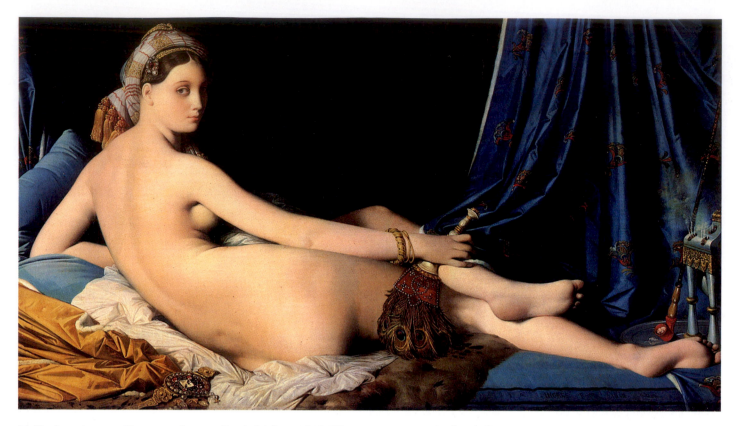

20-32 Jean-Auguste-Dominique Ingres, *Grande Odalisque*, 1814. Oil on canvas, approx. 2′ 11″ × 5′ 4″. Louvre, Paris.

DRAWN TO THE MUSIC In his many portraits, Ingres mingled the real and the ideal. He always insisted that he painted exactly what he saw, despite what one critic declared as his "genius for idealizing." Through the painted forms of Ingres's portraits, viewers sense the meticulous drawing. The value Ingres placed on the flow of the contour was a characteristic of his style throughout his career. Contour, which is simply shaded line, was everything for Ingres, and drawing was the means of creating contour. Ingres has been credited with the famous slogan that became his school's battle cry: "Drawing is the probity of art."[12] His pencil portrait of the great violin virtuoso Niccoló Paganini (FIG. **20-33**) speaks to this. Ingres was a creditable amateur violinist, passionately fond of music (he wanted to include Mozart among the immortals surrounding Homer—FIG. 20-31), and he knew Paganini personally. The portrait, executed with that marvelously crisp, clean descriptive line found in all of Ingres's portraits, painted or drawn, is entirely literal in its report of Paganini's features and demeanor. Ingres offered the musician's appearance as a kind of official likeness, enhanced by a suggestive likeness and sense of setting. Paganini, sharing a certain fragility and suppleness with his violin and bow, seems about to make his introductory bow to his audience. The portrait is formal, but it is a graceful, not stiff, formality. The musician is face-to-face with the public world, rising as always to the familiar occasion, which he knows he can command. The ideal of the great musician rises through Paganini's faithfully real likeness.

THE RISE OF ROMANTICISM

Neoclassicism's appeal and applicability were truly extensive. Yet although Neoclassicism's rationality reinforced Enlighten-

20-33 Jean-Auguste-Dominique Ingres, *Paganini*, 1819. Pencil drawing, approx. 1′ × 8½″. Louvre, Paris.

ment thought, particularly that promoted by Voltaire, Jean-Jacques Rousseau's ideas contributed to the rise of Romanticism. Rousseau's exclamation that "Man is born free, but is everywhere in chains!" summarizes a fundamental premise of Romanticism. This declaration appeared in the opening line of his *Social Contract* (1762), a book many of those involved in the late-eighteenth- and nineteenth-century revolutions carefully read and pondered. Romanticism emerged from a desire for freedom—not only political freedom, but also freedom of thought, of feeling, of action, of worship, of speech, and of taste, as well as all the other freedoms. Romantics asserted that freedom is the right and property of one and all, though for each individual the kind or degree of freedom might vary. In the opening paragraph of his *Confessions* (published posthumously 1781 to 1788), Rousseau made the following claim for each Romantic soul by making it for himself: "I am like no one in the whole world. I may be no better, at least I am different." Every individual's freedom and unique subjectivity combined was the first principle of Romanticism and key to the understanding of much that has happened and is believed in the modern world.

Those who affiliated themselves with Romanticism believed that the path to freedom was through *imagination* rather than reason and functioned through *feeling* rather than through thinking. The Romantic spirit's allure grew dramatically during the late eighteenth century. Since that time, scholars have debated the definition and the historical scope of Romanticism; to this day, the controversy has not ended. Many scholars refer to Romanticism as a phenomenon that began around 1750 and ended about 1850. The term *Romanticism* is also used more narrowly to denote a movement that rose and declined in the course of modern art, flourishing from about 1800 to 1840, between Neoclassicism and Realism. This book discusses Romanticism in general terms first to explain the nature and appeal of this mindset in the late eighteenth and early nineteenth centuries before dealing with the Romantic movement.

Though Rousseau was the prophet of Romanticism, he never knew it as such. The term *Romanticism* originated toward the end of the eighteenth century among German literary critics, who aimed to distinguish peculiarly "modern" traits from the Neoclassical traits that already had displaced Baroque and Rococo design elements.

"FEELING IS ALL!" Romanticism was preceded by the so-called Age of Sensibility, roughly 1750 to 1780, when thinkers such as Rousseau preached the value of sincere feeling and natural human sympathy over artful reason and the cold calculations of courtly societies. The slogan of sensibility was "Trust your heart rather than your head," or, as German writer Johann Wolfgang von Goethe (1749–1832) put it, "Feeling is all!" All that was false and artificial was to be banished as the enemy of honest emotion. Thus Romanticism was based on the predominance of feeling and imagination.

The transition from Neoclassicism to Romanticism was manifested in a shift in emphasis from reason to feeling, from calculation to intuition, and from objective nature to subjective emotion. Among Romanticism's manifestations were the interest in the "Gothick" and in the sublime. The Romantic imagination discovered the Middle Ages, the Gothick world, as it was then known and spelled. (We here use the eighteenth-century spelling of *Gothick* to identify a specific sensibility within the late eighteenth and nineteenth century and to avoid confusion with the actual medieval Gothic period.) For people living in the eighteenth century, the Middle Ages were the "dark ages," a time of barbarism, superstition, dark mystery, and miracle. The Gothick imagination stretched its apparition of the Middle Ages into all the worlds of fantasy

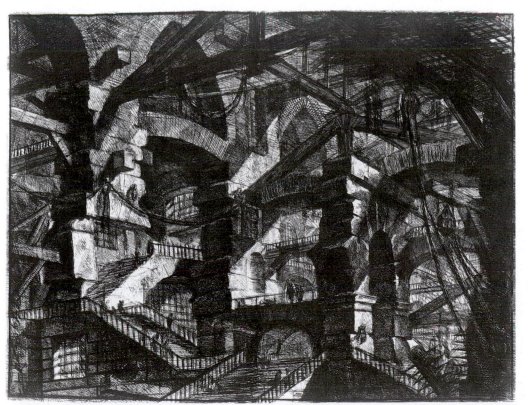

20-34 GIOVANNI BATTISTA PIRANESI, *Carceri 14,* ca. 1750. Etching, second state, approx. 1′ 4″ × 1′ 9″. Ashmolean Museum, Oxford.

open to it, including the ghoulish, the infernal, the terrible, the nightmarish, the grotesque, the sadistic, and all the remaining imagery that comes from the chamber of horrors when reason is asleep. Related to the Gothick was the period's notion of the "sublime." As articulated by Edmund Burke, the sublime inspires feelings of awe mixed with terror—the feelings people experience when they look on vast, impassable mountain peaks or great storms at sea. Accompanying this taste for the sublime was the taste for the fantastic, the occult, and the macabre—for the adventures of the soul voyaging into the dangerous reaches of consciousness.

A CLAUSTROPHOBIC DUNGEON A work that could illustrate Burke's theory of the sublime, laced with the infernal, is an etching (FIG. **20-34**) by GIOVANNI BATTISTA PIRANESI (1720–1778). It is the second state (a working version) of one of a series of prints of imaginary dungeons, the *Carceri* (prisons). Piranesi conjured awe-inspiring visions of bafflingly complicated architectural masses, piled high and spread out through gloomy spaces. In such pictures, vistas are multiplied and broken by a seeming infinity of massive arches, vaults, piers, and stairways. Small, insectlike human figures move stealthily through them. Despite wandering, soaring perspectives, a suffocating sense of enclosure overwhelms observers; the spaces are locked in, and no exit is visible. These grim places are filled with brooding menace and hopelessness. Within this series of etchings, Piranesi often darkened subsequent editions to make them even more sinister. Our picture, *Carceri 14,* is one of these. It reminds viewers that the Rococo's gaiety and the Enlightenment's rationality coexisted with an eighteenth-century sensibility for the sublime that returned in the nineteenth century to haunt the night imaginings of many a Romantic artist and poet.

A NIGHTMARISH VISION The concept of the nightmare is specifically addressed in *The Nightmare* (FIG. **20-35**) by HENRY FUSELI (1741–1825). Fuseli specialized in night moods of horror and in Gothick fantasies—in the demonic, in the macabre, and often in the sadistic. Swiss by birth, Fuseli settled in England and eventually became a member of the Royal Academy and an instructor there (see "The Academies: Defining the Range of Acceptable Art," Chapter 21, page 740). Largely self-taught, he contrived a distinctive manner to express the fantasies of his vivid imagination. *The Nightmare* is one of four versions of this terrifying theme. The beautiful young woman lies asleep, draped across the bed with her limp arm dangling over the side. An incubus, a demon believed in medieval times to prey, often sexually, on sleeping women, squats ominously on her body. In the background, a ghostly horse with flaming eyes bursts into the scene from beyond the curtain. Despite the temptation to see the painting's title as a pun because of this horse, the word *nightmare* is actually derived from the words *night* and *mara*. Mara was a spirit in northern mythology that was thought to torment and suffocate sleepers. As disturbing and perverse as Fuseli's art may be, he was among the first to attempt to depict the dark terrain of the human subconscious that became fertile ground for the Romantic artists to harvest.

In their images of the sublime and the terrible, artists often combined something of Baroque dynamism with natural details in their quest for grippingly moving visions. These preferences became the mainstay of Romantic art and contrasted with the more intellectual, rational Neoclassical themes and presentations. This is not to suggest that the two were mutually exclusive. As revealed in the earlier discussion of Gros, Girodet-Trioson, and Ingres, elements of Neoclassicism could be effectively integrated with Romanticism.

20-35 HENRY FUSELI, *The Nightmare,* 1781. Oil on canvas, 3′ 4″ × 4′ 2″. The Detroit Institute of the Arts (Founders Society Purchase with funds from Mr. and Mrs. Bert L. Smokler and Mr. and Mrs. Lawrence A. Fleishman).

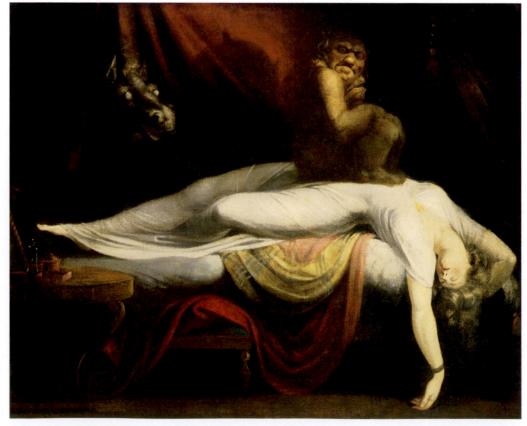

INSPIRED BY THE SPIRITS The visionary English poet, painter, and engraver WILLIAM BLAKE (1757–1827) is frequently classified as a Romantic artist. His work, however, incorporates classical references. Blake greatly admired ancient Greek art because it exemplified the mathematical and, thus, the eternal. Yet Blake did not align himself with prominent Enlightenment figures. Blake, like many other Romantic artists, also was drawn to the art of the Middle Ages—the Gothick mindset. Blake derived the compositions of many of his paintings and poems from spirits who visited him in dreams. The importance he attached to these experiences led him to believe that rationalism's search for material explanations of the world stifled human nature's spiritual side. He also believed the stringent rules of behavior imposed by orthodox religions killed the individual creative impulse. Blake's vision of the Almighty in *Ancient of Days* (FIG. **20-36**) combines his ideas and interests in a highly individual way. For Blake, this figure combined the concept of the Creator with that of wisdom as a part of God. *Ancient of Days*, printed as the frontispiece for Blake's book *Europe: A Prophecy,* was published with a quotation ("When he set a compass upon the face of the deep") from Proverbs (8:27) in the Old Testament. Most of that Bible chapter is spoken by Wisdom, identified as a female, who tells the reader how she was with the Lord through all the time of the Creation (Prov. 8:22–23, 27–30).

Energy fills Blake's composition. The Ancient of Days leans forward from a fiery orb, peering toward earth and unleashing power through his outstretched left arm into twin rays of light. These emerge between his spread fingers like an architect's measuring instrument. A mighty wind surges through his thick hair and beard. Only the strength of his "Michelangelesque" physique keeps him firmly planted within his heavenly perch. Here, ideal classical anatomy merges with the inner dark dreams of Gothick Romanticism, which were expressed often in the nineteenth century. With his independence and individual artistic vision, Blake was very much a man of the modern age.

Dramatic Action, Emotion, and Color

In the early nineteenth century, Romantic artists increasingly incorporated dramatic action, all the while extending their exploration of the exotic, erotic, fictional, or fantastic. One artist whose works reveal these compelling dimensions is the Spaniard FRANCISCO JOSÉ DE GOYA Y LUCIENTES (1746–1828). Goya was David's contemporary, but one scarcely could find two artists living at the same time and in adjacent countries who were so completely unlike each other. Goya, the great independent, disdained the Neoclassical and the model of classical antiquity, acknowledging only Velázquez, Rembrandt, and "nature" as his teachers.

RECONSIDERING REASON Goya did not arrive at his general dismissal of Neoclassicism without considerable thought about the Enlightenment and the Neoclassical penchant for rationality and order. This reflection emerges in works such as *The Sleep of Reason Produces Monsters* (FIG. **20-37**), an etching and aquatint from a series titled *Los Caprichos (The Caprices)*. In this print, Goya depicted himself asleep, slumped onto a table or writing stand, while threatening creatures converge on him. Seemingly poised to attack the artist are owls (symbols of folly) and bats (symbols of ignorance). Viewers might read this as a portrayal of what emerges when reason is suppressed and, therefore, as advocating Enlightenment ideals. However, it also can be interpreted as Goya's commitment to the creative process and the Romantic spirit—the unleashing of imagination, emotions, and even nightmares.

DEPICTING THE SPANISH ROYAL FAMILY The emotional art Goya produced during his long career stands as testimony not only to the allure of the Romantic vision but also to the turmoil in Spain and to the conflicts in Goya's own life. Goya's skills as a painter were recognized early on, and in 1786 he was appointed Pintor del Rey (Painter to the King). In this capacity (he was promoted to First Court Painter in 1799) Goya produced works such as *The Family of Charles IV* (FIG. **20-38**). Here King Charles IV and Queen Maria Luisa are surrounded by their children. As a court painter and artist enamored with the achievements of his predecessor Diego Velázquez, Goya appropriately used Velázquez's *Las Meninas* (see FIG. 19-33) as his inspiration for this image. As in *Las Meninas,* the royal family appears facing viewers in an interior space while the artist included himself on the left, dimly visible, in the act of painting on a large

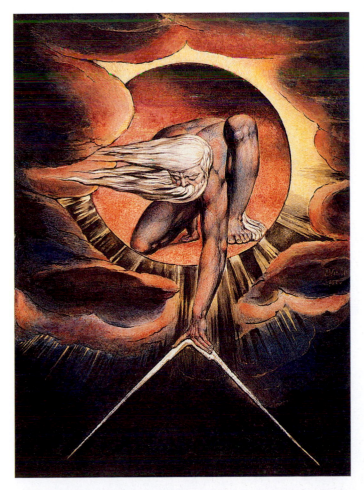

20-36 WILLIAM BLAKE, *Ancient of Days*, frontispiece of *Europe: A Prophecy,* 1794. Metal relief etching, hand colored, approx. $9\frac{1}{2}'' \times 6\frac{3}{4}''$. The Whitworth Art Gallery, The University of Manchester.

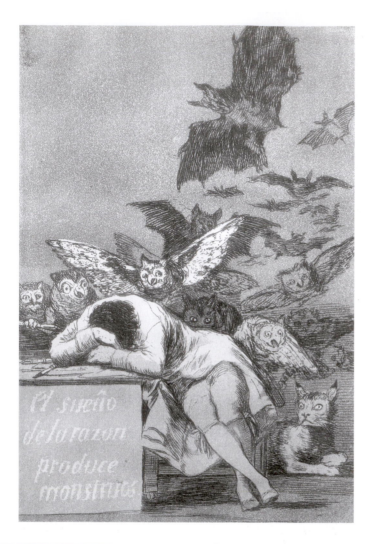

20-37 Francisco Goya, *The Sleep of Reason Produces Monsters*, from *Los Caprichos*, ca. 1798. Etching and aquatint, $8\frac{1}{2}'' \times 6''$. Metropolitan Museum of Art, New York (gift of M. Knoedler & Co., 1918).

canvas. Goya's portrait of the royal family has been subjected to intense scholarly scrutiny, resulting in a variety of interpretations. These range from naturalistic depiction to pointed commentary in a time of Spanish turmoil. It is clear his patrons authorized the painting's basic elements—the royal family members, their attire, and Goya's inclusion. Little evidence exists as to how this painting was received. Although some scholars have argued the royal family was dissatisfied with the portrait, others have suggested the painting confirmed the Spanish monarchy's continuing presence and strength and thus elicited a positive response from the patrons.

TURMOIL IN SPAIN As dissatisfaction with the rule of Charles IV and Maria Luisa increased, the political situation grew more tenuous. The Spanish people eventually threw their support behind Ferdinand VII, son of Charles IV and Maria Luisa, in the hope he would initiate reform. To overthrow his father and mother, Ferdinand VII enlisted the aid of Napoleon Bonaparte, whose authority and military expertise in France at that time were uncontested. Napoleon had designs on the Spanish throne and thus willingly sent French troops to Spain. Not surprisingly, once Charles IV and Maria Luisa were ousted, Napoleon revealed his plan to rule Spain himself by installing his brother Joseph Bonaparte on the Spanish throne.

20-38 Francisco Goya, *The Family of Charles IV,* 1800. Oil on canvas, approx. 9′ 2″ × 11′. Museo del Prado, Madrid.

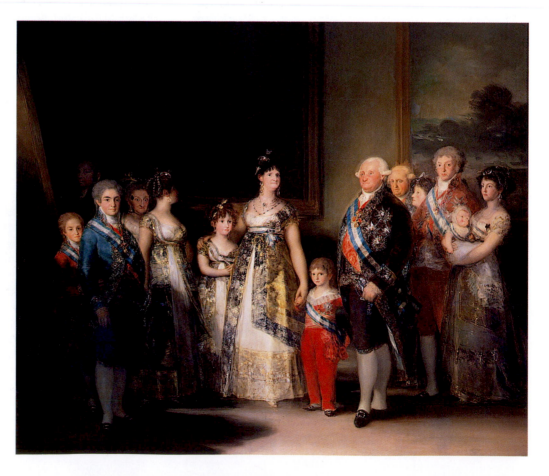

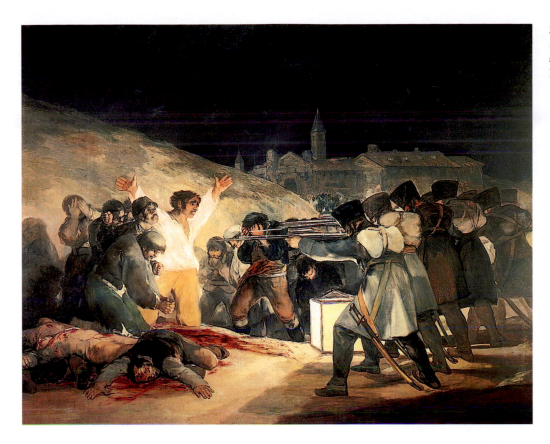

20-39 FRANCISCO GOYA, *The Third of May 1808,* 1814. Oil on canvas, approx. 8′ 8″ × 11′ 3″. Museo del Prado, Madrid.

THE MASSACRE OF MAY 3, 1808 The Spanish people, finally recognizing the French as invaders, sought a way to expel the foreign troops. On May 2, 1808, in frustration, the Spanish attacked the Napoleonic soldiers in a chaotic and violent clash. In retaliation and as a show of force, the French responded the next day by executing numerous Spanish citizens. This tragic event is the subject of Goya's most famous painting, *The Third of May 1808* (FIG. **20-39**).

In emotional fashion, Goya depicted the anonymous murderous wall of Napoleonic soldiers ruthlessly executing the unarmed and terrified Spanish peasants. The artist encouraged viewer empathy for the Spanish by portraying horrified expressions and anguish on their faces, endowing them with a humanity absent from the firing squad. Further, the peasant about to be shot throws his arms out in a cruciform gesture, providing a parallel to Christ.

Goya heightened the drama of this event through his stark use of darks and lights. In addition, Goya's choice of imagery extended the time frame and thus the tragedy's emotion. Although he captured a specific moment when one man is about to be executed, others lie dead at his feet, their blood staining the soil of Príncipe Pío hill, while many others have been herded together to be subsequently shot.

Its depiction of the resistance and patriotism of the Spanish people notwithstanding, *The Third of May 1808* was painted in 1814 for Ferdinand VII, who had been restored to the throne after the ouster of the French. Although the Spanish citizens had placed great faith in Ferdinand to install more democratic policies than were in place during the reign of his father Charles IV, Ferdinand VII increasingly emulated his father, resulting in the restoration of an authoritative monarchy.

PAINTINGS OF DARK EMOTIONS Over time, Goya became increasingly disillusioned and pessimistic; his declining health only contributed to this state of mind. Among his later works is a series of frescoes called the "Black Paintings." Goya painted these frescoes on the walls of his farmhouse in Quinta del Sordo, outside Madrid. Because Goya created these works solely on his terms and for his viewing, one could argue that they provide great insight into the artist's outlook. If so, the vision is terrifying and disturbing. *Saturn Devouring One of His Children* (FIG. **20-40**), one of the Black Paintings, depicts the raw carnage and violence of Saturn (the Greek god Kronos, see "The Gods and Goddesses of Mount Olympus," Chapter 5, page 99 or page xxviii in Volume II), wild eyed and monstrous, as he consumes one of his children. Because of the similarity of Kronos and Khronos (the Greek word for *time*), Saturn has come to be associated with time. This has led to an interpretation of Goya's painting about the artist's despair over the passage of time. Despite the image's simplicity, it conveys a wildness, boldness, and brutality that cannot help but evoke an elemental response from any viewer.

Goya's work, rooted both in a personal and a national history, presents darkly emotional images well in keeping with Romanticism. The demons that haunted Goya emerged in his art. As historian Gwyn Williams nicely sums up: "As for the grotesque, the maniacal, the occult, the witchery, they are precisely the product of the sleep of *human* reason; they are *human* nightmares. *That these monsters are human is, indeed, the point.*"[13]

DEATH AND DESPAIR ON A RAFT In France, Théodore Géricault and Eugène Delacroix were the artists most

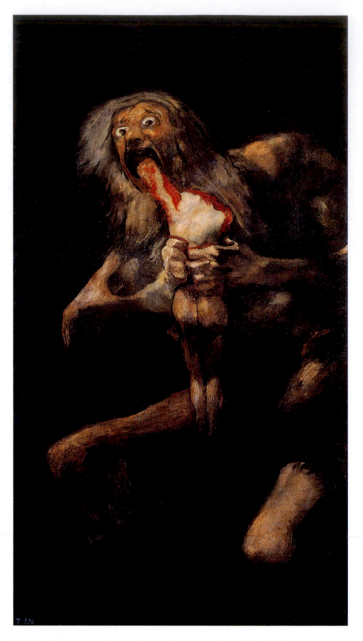

20-40 FRANCISCO GOYA, *Saturn Devouring One of His Children,* 1819–1823. Detail of a detached fresco on canvas, full size approx. 4′ 9″ × 2′ 8″. Museo del Prado, Madrid.

closely associated with the Romantic movement. THÉODORE GÉRICAULT (1791–1824) studied with an admirer of David, P. N. Guérin (1774–1833). Although Géricault retained an interest in the heroic and the epic and was well trained in classical drawing, he chafed at the Neoclassical style's rigidity, eventually producing works that captivate the viewer with their drama, visual complexity, and emotional force.

Géricault's most ambitious project was a large-scale (approximately sixteen feet by twenty-three feet) painting titled *Raft of the Medusa* (FIG. **20-41**). The painting's subject is a shipwreck that took place in 1816 off the African coast. The French frigate *Medusa,* carrying soldiers and settlers to the French colony of Senegal, ran aground on a reef due to the incompetence of the captain, a political appointee. Because of the limited number of lifeboats (which the captain and his officers commandeered), hundreds were left to fend for themselves on the sinking ship. As a last ditch effort to survive, 150 of those remaining built a makeshift raft from the disintegrat-

ing ship. The raft drifted for twelve days, and the number of survivors dwindled to 15. Without food or water and exposed to the elements, the raft's passengers succumbed quickly, and many of those who did not die were driven mad. The remaining people soon were forced to eat the flesh of corpses to survive. Finally, the raft was spotted and the emaciated survivors were rescued. This horrendous event became political dynamite once it became public knowledge.

In Géricault's huge painting, which took him eight months to complete, he sought to confront viewers with the tragedy's horror, chaos, and emotion while invoking the grandeur and impact of large-scale history painting. He depicted the few weak, despairing survivors as they summon what little strength they have left to flag down the passing ship far on the horizon. Géricault departed from the straightforward organization of Neoclassical compositions and instead presented a jumble of writhing bodies. The survivors and several corpses are piled onto one another in every attitude of suffering, despair, and death (recalling Gros's *Napoleon,* FIG. 20-29) and are arranged in a powerful X-shaped composition. One light-filled diagonal axis stretches from bodies at the lower left up to the black man raised on his comrades' shoulders and waving a piece of cloth toward the horizon. The cross axis descends from the storm clouds and dark wind-filled sail at the upper left to the shadowed upper torso of the body trailing in the open sea. Géricault's decision to place the raft at a diagonal so that a corner juts out toward viewers further compels their participation in this scene. Indeed, it seems as though some of the corpses are sliding off the raft into the viewing space. The subdued palette and prominent shadows lend an ominous pall to the scene.

Despite the theatricality and dramatic action that imbues this work with a Romantic spirit, Géricault did in fact go to great lengths to ensure a degree of accuracy. He visited hospitals and morgues to examine corpses, interviewed the survivors, and had a model of the raft constructed in his studio.

Géricault also took this opportunity to insert a comment on the practice of slavery. The artist was a member of an abolitionist group that sought ways to end the slave trade in the colonies. Given Géricault's antipathy to slavery, it is appropriate that he placed Jean Charles, a black soldier and one of the few survivors, at the top of the pyramidal heap of bodies.

PICTURING INSANITY Mental aberration and the irrational states of the mind hardly could have failed to interest the rebels against Enlightenment rationality. Géricault, like many of his contemporaries, examined the influence of mental states on the human face and believed, as others did, that a face accurately revealed character, especially in madness and at the instance of death. He made many studies of the inmates of hospitals and institutions for the criminally insane, and he studied the severed heads of guillotine victims. Scientific and artistic curiosity were not easily separated from the morbidity of the Romantic interest in derangement and death. Géricault's *Insane Woman (Envy),* FIG. **20-42**—her mouth tense, her eyes red rimmed with suffering—is one of several of his "portraits" of insane subjects that have a peculiar hypnotic power. These portraits present the psychic facts with astonishing authenticity, especially in contrast to earlier idealized commissioned portraiture. The more the Romantics became involved with nature, sane or mad, the more they hoped to reach the truth.

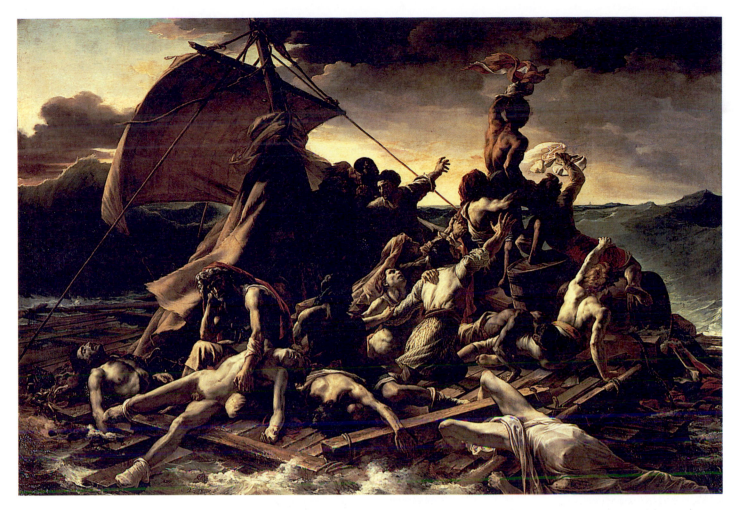

20-41 THÉODORE GÉRICAULT, *Raft of the Medusa,* 1818–1819. Oil on canvas, approx. 16′ × 23′. Louvre, Paris.

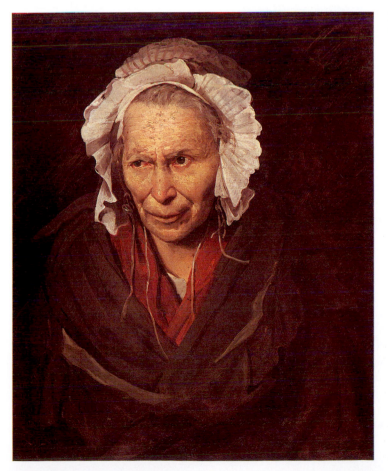

20-42 THÉODORE GÉRICAULT, *Insane Woman (Envy),* 1822–1823. Oil on canvas, approx. 2′ 4″ × 1′ 9″. Musée des Beaux-Arts, Lyon.

20-43 Eugène Delacroix, *Paganini*, 1831. Oil on cardboard on wood panel, 1′ 5⅝″ × 11⅞″. The Phillips Collection, Washington.

LINE VERSUS COLOR Like Géricault, Delacroix's name is consistently invoked in discussions of Romanticism. The history of nineteenth-century painting in its first sixty years often has been interpreted as a contest between two major artists—Ingres the draftsman and Eugène Delacroix (1798–1863) the colorist. Their dialogue reached back to the end of the seventeenth century in the quarrel between the Poussinistes and the Rubénistes. As discussed earlier, the Poussinistes were conservative defenders of academism who held drawing as superior to color, while the Rubénistes proclaimed color's importance over line (the line quality being more intellectual and thus more restrictive than color). Although the differences between Ingres and Delacroix were clear, it is impossible to make categorical statements about any artist. As shown, Ingres's work, though steeped in Neoclassical tradition, does incorporate elements of Romanticism. In the end, Ingres and his great rival Delacroix complemented rather than contradicted each other. Their work stands as visualizations of the great Neoclassical and Romantic dialogue.

A PORTRAIT OF MUSIC This dialogue is evident in a comparison of Ingres's pencil portrait of the great violin virtu-

oso Paganini (FIG. 20-33) with Delacroix's painted version of the same personality (FIG. **20-43**). These works disclose the difference in approach that separated the two artists. Ingres's objective formal public portrait of Paganini is a faithful likeness of the subject, historians believe, yet it is heightened into a kind of ideal image—"the Virtuoso." Delacroix's *Paganini* presents a likeness not of the virtuoso's form but of his performance. Forgetting his audience and no longer in formal confrontation with his listeners, Paganini yields himself completely to the whirlwind of his inspiration, which envelops his reedlike frame, making it vibrate in tune to his instrument's quivering strings. Delacroix tried to suggest the portrait, as it were, of Paganini's music as it plays to the musician's own ear and spirit. Ingres portrayed the outside aspect of his subject and tried to perfect the form as presented to the eye. Delacroix instead represented the inner substance—the musician transformed by his music—in an attempt to realize the truth as given to the imagination.

Critics now regard both masters as equally great. But Delacroix's celebration of the imagination, the faculty that captures the essential in life and transforms mundane experience, defined the fundamental difference between Ingres and Delacroix. Delacroix called the art of Ingres "the complete expression of an incomplete intellect," incomplete because he felt it was unleavened with imagination. In a passage from his famous *Journal*, Delacroix wrote: "Baudelaire [a well-known and influential nineteenth-century poet and art critic] . . . says that I bring back to painting the feeling . . . which delights in the terrible. He is right."[14] Delacroix, who knew and admired Géricault, greatly expanded the expressive possibilities of Romantic art by developing its themes and elaborating its forms in a direction of ever-greater emotional power.

INSPIRING FICTION AND VERSE Delacroix's works were products of his view that the artist's powers of imagination would in turn capture and inflame viewers' imagination. Literature of imaginative power served Delacroix (and many of his contemporaries) as a useful source of subject matter. The prominent Romantic critic and novelist, Théophile Gautier, recalled:

> In those days painting and poetry fraternized. The artists read the poets, and the poets visited the artists. We found Shakespeare, Dante, Goethe, Lord Byron and Walter Scott in the studio as well as in the study. There were as many splashes of color as there were blots of ink in the margins of those beautiful books which we endlessly perused. Imagination, already excited, was further fired by reading those foreign works, so rich in color, so free and powerful in fantasy.[15]

ORGIASTIC DESTRUCTION AND DEATH Delacroix's *Death of Sardanapalus* (FIG. **20-44**) is an example of pictorial grand drama. Undoubtedly, Delacroix was inspired by Lord Byron's 1821 narrative poem *Sardanapalus,* but the painting does not illustrate that text (see "The Romantic Spirit in Music and Literature," page 715). Instead, Delacroix depicted the last hour of the Assyrian king (who received news of his armies' defeat and the enemies' entry into his city) in a much more tempestuous and crowded setting than Byron described. Here, orgiastic destruction replaces the sacrificial suicide found in the poem. In the painting, the king

20-44 EUGÈNE DELACROIX, *Death of Sardanapalus*, 1826. Oil on canvas, approx. 12′ 1″ × 16′ 3″. Louvre, Paris.

watches gloomily from his funeral pyre, soon to be set alight, as all of his most precious possessions—his women, slaves, horses, and treasure—are destroyed in his sight. Sardanapalus's favorite concubine throws herself on the bed, determined to go up in flames with her master. The king presides like a genius of evil over the panorama of destruction. Most conspicuous are the tortured and dying bodies of the harem women. In the foreground, a muscular slave plunges his knife into the neck of one woman. This spectacle of suffering and death is heightened by the most daringly difficult and tortuous poses and by the richest intensities of hue. With its exotic and erotic overtones, *Death of Sardanapalus* taps into the fantasies of both the artist and some viewers.

LEADING THE MASSES IN UPRISING While *Death of Sardanapalus* reveals Delacroix's fertile imagination, like Géricault he also turned to current events, particularly tragic or sensational ones, for his subject matter. For example, he produced several images based on the Greek War for Independence (1821–1829). Certainly, the French perception of the Greeks locked in a brutal struggle for freedom from the cruel and exotic Ottoman Turks generated great interest. Closer to home, Delacroix captured the passion and energy of the Revolution of 1830 in his painting *Liberty Leading the People* (FIG. **20-45**). Based on the Parisian uprising against the rule of Charles X at the end of July 1830, it depicts the allegorical personification of Liberty, defiantly thrusting forth the republic's tricolor banner as she urges the masses to fight on. This struggle's urgency is reinforced by the scarlet Phrygian cap (the symbol of a freed slave in antiquity) she wears. Arrayed around her are bold Parisian types—the street boy brandishing his pistols, the menacing worker with a cutlass,

and the intellectual dandy in top hat with sawed-off musket. As in Géricault's *Raft of the Medusa*, dead bodies are strewn about. In the background, the Notre-Dame towers rise through the smoke and haze. The painter's inclusion of this recognizable Parisian landmark announces the specificity of locale and event. It also reveals Delacroix's attempt, like Géricault in *Raft*, to balance contemporary historical fact with poetic allegory (Liberty). This desire for balance is further revealed in the Salon title of this work, *The 28th of July: Liberty Leading the People*.

THE ALLURE OF MOROCCO An enormously influential event in Delacroix's life that affected his art in both subject and form was his visit to North Africa in 1832. Things he saw there shocked his imagination with fresh impressions that lasted throughout his life. He discovered, in the sun-drenched landscape and in the hardy and colorful Moroccans dressed in robes reminiscent of the Roman toga, new insights into a culture built on proud virtues. He believed it was a culture more classical than anything European Neoclassicism could conceive. "I have Romans and Greeks on my doorstep," he wrote to a friend, "it makes me laugh heartily at David's Greeks."[16] The gallantry, valor, and fierce love of liberty made the Moroccans, in Delacroix's eyes, "nature's noblemen"—unspoiled heroes uninfected by European decadence.

The Moroccan journey renewed Delacroix's Romantic conviction that beauty exists in the fierceness of nature, natural processes, and natural beings, especially animals. After Morocco, more and more of Delacroix's subjects involved combats between beasts and between beasts and men. He painted snarling tangles of lions and tigers, battles between horses, and clashes of Muslims with great cats in swirling hunting

20-45 EUGÈNE DELACROIX, *Liberty Leading the People,* 1830. Oil on canvas, approx. 8′ 6″ × 10′ 8″. Louvre, Paris.

20-46 EUGÈNE DELACROIX, *Tiger Hunt,* 1854. Oil on canvas, approx. 2′ 5″ × 3′. Louvre, Paris.

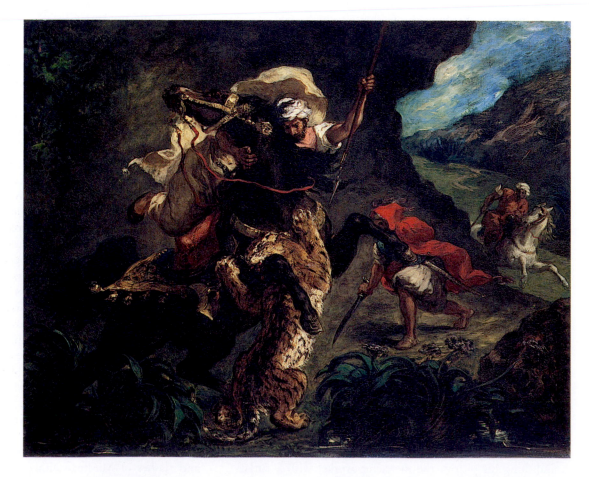

The Romantic Spirit in Music and Literature

The appeal of Romanticism, with its emphasis on freedom and feeling, extended well beyond the realm of the visual arts. In European music, literature, and poetry, the Romantic spirit was a dominant presence during the late eighteenth and early nineteenth centuries. These artistic endeavors rejected classicism's structured order in favor of the emotive and expressive. In music, the compositions of Franz Schubert (1797–1828), Franz Liszt (1811–1886), Frédéric Chopin (1810–1849), and Johannes Brahms (1833–1897) all emphasized the melodic or lyrical. These composers believed music had the power to express the unspeakable and to communicate the subtlest and most powerful human emotions.

In literature, Romantic poets such as John Keats (1795–1821), William Wordsworth (1770–1850), and Samuel Taylor Coleridge (1772–1834) published volumes of poetry that intersected with the Romantic interest in lyrical drama. *Ozymandias,* by Percy Bysshe Shelley (1792–1822), speaks of faraway, exotic locales. Lord Byron's poem of 1821, *Sardanapalus,* is set in the kingdom of Assyria in the seventh century B.C. It conjures images of eroticism and fury unleashed—images Delacroix visualized in his painting *Death of Sardanapalus* (FIG. 20-44). One of the best examples of the Romantic spirit is the engrossing novel *Frankenstein,* written in 1818 by Mary Wollstonecraft Shelley (1797–1851), who was married to Romantic poet Percy Bysshe Shelley. This fantastic tale of a monstrous creature run amok is filled with drama and remains popular to the present. As was true of many Romantic artworks, this novel not only embraces the emotional but also rejects the rationalism that underlay Enlightenment thought. Dr. Frankenstein's monster was a product of science, and this novel easily could have been interpreted as an indictment of the tenacious belief in science promoted by Enlightenment thinkers such as Voltaire. *Frankenstein* thus served as a cautionary tale of the havoc that could result from unrestrained scientific experimentation and from the arrogance of scientists like Dr. Frankenstein.

The imagination and vision that characterized Romantic paintings and sculptures were equally moving and riveting in musical or written form. The sustained energy of Romanticism is proof of the captivating nature of this movement and spirit.

scenes using compositions reminiscent of those of Rubens. One such work, *Tiger Hunt* (FIG. **20-46**), clearly speaks to the Romantic interest in faraway lands and exotic cultures.

DELACROIX'S COLORFUL LEGACY Delacroix's African experience also further heightened his already considerable awareness of the expressive power of color and light. What Delacroix knew about color he passed on to later painters of the nineteenth century, particularly the Impressionists. He observed that pure colors are as rare in nature as lines, that color appears only in an infinitely varied scale of different tones, shadings, and reflections, which he tried to recreate in his paintings. He recorded his observations in his *Journal,* which became a veritable body of knowledge of pre-Impressionistic color theory and was acclaimed as such by the Post-Impressionist painter Paul Signac. Delacroix anticipated the later development of Impressionist color science. But that art-science had to await the discoveries by Michel Eugène Chevreul and Hermann von Helmholtz of the laws of light decomposition and the properties of complementary colors before the problems of color perception and juxtaposition in painting could be properly formulated (see "Nineteenth-Century Color Theory," Chapter 21, page 762). Nevertheless, Delacroix's observations were significant, and he advised other artists not to fuse their brushstrokes, as the brushstrokes would appear to fuse naturally from a distance.

"PASSIONATELY IN LOVE WITH PASSION" No other painter of the time explored the domain of Romantic subject and mood as thoroughly and definitively as Delacroix. Delacroix's technique was impetuous, improvisational, and instinctive, rather than deliberate, studious, and cold. It epitomized Romantic-colorist painting, catching the impression quickly and developing it in the execution process. His contemporaries commented on how furiously Delacroix worked once he had an idea, keeping the whole painting progressing at once. The fury of his attack matched the fury of his imagination and his subjects. In the end, his friend Silvestre, in the language of Romanticism, delivered a eulogy that amounts to a definition of the Romantic artist:

> Thus died, almost with a smile on August 13, 1863, . . . Ferdinand Victor Eugène Delacroix, . . . who for forty years played upon the keyboard of human passions and whose brush—grandiose, terrible, or suave—passed from saints to warriors, from warriors to lovers, from lovers to tigers, and from tigers to flowers.[17]

The Dramatic in Sculpture

ALLEGORIZING OF FRANCE'S GLORY As one might expect, the Romantic spirit pervaded all of the media during the early nineteenth century. Many sculptors, like the period's painters, produced work that incorporated both

Neoclassical and Romantic elements. The colossal group *La Marseillaise* (FIG. **20-47**), mounted on one face of Chalgrin's Arc de Triomphe in Paris is one such sculpture. Its creator, FRANÇOIS RUDE (1784–1855), carved here an allegory of the national glories of revolutionary France by depicting the volunteers of 1792 departing to defend the nation's borders against the Revolution's foreign enemies. The Roman goddess of war, Bellona (who here personifies Liberty, as well as the revolutionary hymn, now France's national anthem), soars above patriots of all ages, exhorting them forward with her thundering battle cry. The figures recall David's classically armored (FIG. 20-15) or nude heroes, as do the rhetorical gestures of the wide-flung arms and the striding poses. Yet the densely packed, overlapping masses; the jagged contours; and violence of motion relate more closely to the compositional method of dramatic Romanticism, as found in Géricault (FIG. 20-41) and Delacroix (FIG. 20-45). La Marseillaise's allegorical figure is the spiritual sister of Delacroix's Liberty (FIG. 20-45); they share the same Phrygian cap, the badge of liberty. But, though the works are almost exactly contemporaneous, the figures in the sculpted group are represented in classical costume, while those in Delacroix's painting wear modern Parisian costumes. Both works are allegorical, but one looks to the past and the other to the present.

THE FEROCITY OF ANIMALS Delacroix's fascination with brute beauty and bestial violence is echoed in *Jaguar Devouring a Hare* (FIG. **20-48**), a much smaller group in bronze by ANTOINE-LOUIS BARYE (1795–1875). Painful as the subject is, Barye's work draws viewers irresistibly by its fidelity to brute nature. The belly-crouching cat's swelling muscles, hunched shoulders, and tense spine—even the switch of the tail—tell of the sculptor's long sessions observing the animals in the Jardin des Plantes, the Parisian zoo. This work shows the influence of the vast new geographies opening before the naturalistic eyes and temper of nineteenth-century artists while demonstrating Romanticism's obsession with strong emotion and untamed nature. Nineteenth-century sensibility generally prevented humans from showing animal ferocity but enthusiastically accepted its portrayal in Romantic depictions of wild beasts.

IMAGINATION AND MOOD IN LANDSCAPE PAINTING

Landscape painting came into its own in the nineteenth century as a fully independent and respected genre. Briefly eclipsed at the century's beginning by the taste for ideal form, which favored figural composition and history, landscape painting flourished as leading painters made it their profession.

The eighteenth-century artists had regarded the pleasurable, aesthetic mood natural landscape inspired as making the landscape itself "picturesque," that is, worthy of being painted. Early on, they considered the "natural" English garden picturesque. Later, the sensitive Romantic translated landscape vistas, colored by the viewer's mood, into aesthetic form, poetry, or painting. Rather than provide simple descriptions of nature, poets and artists often used nature as allegory. In this manner, artists commented on spiritual, moral, historical, or philosophical issues. Landscape painting was a particularly effective vehicle for such commentary because it allowed artists to "naturalize" conditions, thereby making such conditions appear normal, acceptable, or inevitable.

Landscape Painting in Germany

Early in nineteenth-century northern Europe, mainly Germany, most landscape painting to some degree expressed this Romantic, pantheistic view (first extolled by Rousseau) of nature as a "being" that included the totality of existence in organic unity and harmony. In nature—"the living garment of God," as German poet and dramatist Johann Wolfgang von Goethe called it—artists found an ideal subject to express the Romantic theme of the soul unified with the natural world. As all nature was mysteriously permeated by "being," landscape artists had the task of interpreting the signs, symbols, and emblems of universal "spirit" disguised within visible material things. Artists no longer merely beheld a landscape but participated in its spirit. No longer were they painters of mere things but translators of nature's transcendent meanings, arrived at through feelings landscapes inspired.

20-47 FRANÇOIS RUDE, *La Marseillaise*, Arc de Triomphe, Paris, France, 1833–1836. Approx. 42′ × 26′.

20-48 ANTOINE-LOUIS BARYE, *Jaguar Devouring a Hare*, 1850–1851. Bronze, approx. 1′ 4″ × 3′ 1″. Louvre, Paris.

THE REVERENTIAL LANDSCAPE CASPAR DAVID FRIEDRICH (1774–1840) was among the Northern European artists who were the first to depict the Romantic transcendental landscape. For Friedrich, landscapes were temples; his paintings themselves were altarpieces. The reverential mood of his works demands from viewers the silence appropriate to sacred places filled with a divine presence. *Cloister Graveyard in the Snow* (FIG. **20-49**) is like a solemn requiem. Under a winter sky, through the leafless oaks of a snow-covered cemetery, a funeral procession bears a coffin into the ruins of a Gothic chapel. The emblems of death are everywhere—the season's desolation, leaning crosses and tombstones, the black of mourning worn by the grieving and by the skeletal trees, the destruction time wrought on the chapel. The painting is a kind of meditation on human mortality, as Friedrich himself remarked: "Why, it has often occurred to me to ask myself, do I so frequently choose death, transience, and the grave as subjects for my paintings? One must submit oneself many times to death in order some day to attain life everlasting."[18] The artist's sharp-focused rendering of details demonstrates his keen perception of everything in the physical environment relevant to his message. Friedrich's work balances inner and outer experience. "The artist," he wrote, "should not only paint what he sees before him, but also what he sees within him."[19] Although Friedrich's works may not have the theatrical energy of the paintings of Géricault or Delacroix, they are pervaded by a resonant and deep emotion.

Landscape Painting in England

One of the most momentous developments in Western history—the Industrial Revolution—impacted the evolution of Romantic landscape painting in England. Although discussion of the Industrial Revolution invariably focuses on technological advances, factory development, and growth of ur-

20-49 CASPAR DAVID FRIEDRICH, *Cloister Graveyard in the Snow*, 1810. Oil on canvas, approx. 3′ 11″ × 5′ 10″ (painting destroyed during World War II).

ban centers, its effect on the countryside and the land itself was no less severe. The detrimental economic impact industrialization had on the prices for agrarian products produced significant unrest in the English countryside. In particular, increasing numbers of displaced farmers could no longer afford to farm their small land plots.

NOSTALGIC IMAGES OF AGRARIAN ENGLAND
This situation is addressed in the landscape paintings of JOHN CONSTABLE (1776–1837), perhaps the best known of the English landscape artists. *The Haywain* (FIG. **20-50**) is representative of Constable's art and reveals much about his outlook. In this large painting, Constable presented a placid, picturesque scene of the countryside. A small cottage appears on the left, and in the center foreground a man leads a horse and wagon across the stream. Billowy clouds float lazily across the sky, and the scene's tranquility is augmented by the muted greens and golds and by the delicacy of Constable's brushstrokes. The artist portrayed the oneness with nature the Romantic poets sought; the relaxed figures are not observers but participants in the landscape's being. Constable made countless studies from nature for each of his canvases, which helped him produce the convincing sense of reality in his works that his contemporaries praised. In his quest for the authentic landscape, Constable studied it like a meteorologist (which he was by avocation). His special gift was for capturing the tex-

ture the atmosphere (the climate and the weather, which delicately veil what is seen) gave to landscape. He also could reveal that atmosphere as the key to representing the ceaseless process of nature, which changes constantly through the hours and through shifts of weather and season. Constable's use of tiny dabs of local color, stippled with white, created a sparkling shimmer of light and hue across the canvas's surface—the vibration itself suggestive of movement and process.

The Haywain is also significant for precisely what it does not show—the civil unrest of the agrarian working class and the outbreaks of violence and arson that resulted. Indeed, this painting has a nostalgic, wistful air to it. To a certain extent, this scene (although carefully detailed) is linked to Constable's memories of a disappearing rural pastoralism. The artist came from a family of considerable wealth; his father was a rural landowner, and many of the scenes Constable painted (*The Haywain* included) depict his family's property near East Bergholt in Suffolk, East Anglia.

The people that populate Constable's landscapes blend into the scenes and are one with nature. Rarely do viewers see workers engaged in tedious labor. This nostalgia, presented in such naturalistic terms, renders Constable's works Romantic in tone. That Constable felt a kindred spirit with the Romantic artists is revealed by his comment: ". . . painting is but another word for feeling, . . ."[20]

20-50 JOHN CONSTABLE, *The Haywain*, 1821. Oil on canvas, 4′ 3″ × 6′ 2″. National Gallery, London.

THE HORRORS OF THE SLAVE TRADE JOSEPH MALLORD WILLIAM TURNER (1775–1851), Constable's contemporary in the English school of landscape painting, produced work that also responded to the encroaching industrialization. However, where Constable's paintings are serene and precisely painted, Turner's are composed of turbulent swirls of frothy pigment. The passion and energy of Turner's works not only reveal the Romantic sensibility that provided the foundation for his art, but also they clearly illustrate Edmund Burke's concept of the sublime—awe mixed with terror.

Among Turner's most notable works is *The Slave Ship* (FIG. **20-51**). Its subject is an incident that occurred in 1783 and was reported in a extensively read book titled *The History of the Abolition of the Slave Trade* by Thomas Clarkson. Because the book just had been reprinted in 1839, Clarkson's account probably prompted Turner's choice of subject for this 1840 painting. The incident involved the captain of a slave ship who, on realizing his insurance company would reimburse him only for slaves lost at sea but not for those who died en route, ordered the sick and dying slaves thrown overboard. Appropriately, the painting's full title is *The Slave Ship (Slavers Throwing Overboard the Dead and Dying, Typhoon Coming On)*. Turner's frenzied emotional depiction of this act matches

its barbaric nature. The sun is transformed into an incandescent comet amid flying scarlet clouds. The slave ship moves into the distance, leaving in its wake a turbulent sea choked with the bodies of slaves sinking to their death. The event's particulars are almost lost in the boiling colors; however, on closer inspection, the cruelty is evident. Viewers can see the iron shackles and manacles around the wrists and ankles of the drowning slaves, denying them any chance of saving themselves.

The Slave Ship is clearly more specifically a seascape rather than a landscape painting. Yet Turner's interest in the slave trade indicates his fascination with the Industrial Revolution's effects. In his other paintings, many of them landscapes, Turner revealed a more inquisitive attitude toward industrialization than did Constable.

Turner's style, often referred to as visionary, was deeply rooted in the emotive power of pure color. The haziness of his forms and the indistinctness of his compositions imbued color and energetic brushstrokes with greater impact. Turner was a great innovator whose special invention in works such as *The Slave Ship* was to release color from any defining outlines to express both the forces of nature and the painter's emotional response to them. In works such as

20-51 JOSEPH MALLORD WILLIAM TURNER, *The Slave Ship (Slavers Throwing Overboard the Dead and Dying, Typhoon Coming On)*, 1840. Oil on canvas, 2′ 11$\frac{11}{16}$″ × 4′ $\frac{5}{16}$″. Museum of Fine Arts, Boston (Henry Lillie Pierce Fund).

this, the reality of color is one with the reality of feeling. Turner's methods had an incalculable effect on modern art's development. His discovery of the aesthetic and emotive power of pure color and his pushing of the medium's fluidity to a point where the subject is almost manifest through the paint itself were important steps toward twentieth-century abstract art, which dispensed with shape and form altogether.

Landscape Painting in the United States

AMERICA'S FUTURE DIRECTION? In America, landscape painting was most prominently pursued by a group of artists known as the Hudson River School, because its members drew their subjects primarily from the uncultivated regions of the Hudson River valley. Many of these painters, however, depicted scenes from across the country and, thus, "Hudson River School" is actually too restrictive geographically. Like the early-nineteenth-century landscape painters in Germany and England, the Hudson River School artists not only presented Romantic panoramic landscape views but also participated in the ongoing exploration of the individual's and the country's relationship to the land. Acknowledging the unique geography and historical circumstances in each country and region, American landscape painters frequently focused on identifying qualities that rendered America unique. One American painter of English birth, THOMAS COLE (1801–1848), often referred to as the Hudson River School's leader, articulated this idea:

> Whether he [an American] beholds the Hudson mingling waters with the Atlantic—explores the central wilds of this vast continent, or stands on the margin of the distant Oregon, he is still in the midst of American scenery—it is his own land; its beauty, its magnificence, its sublimity—all are his; and how undeserving of such a birthright, if he can turn towards it an unobserving eye, an unaffected heart![21]

Another issue that surfaced frequently in Hudson River School paintings was the moral question of America's direction as a civilization. Cole presented viewers with this question in *The Oxbow* (*View from Mount Holyoke, Northampton, Massachusetts, after a Thunderstorm;* FIG. **20-52**). A splendid scene opens before viewers, dominated by the lazy oxbow turning of the Connecticut River. The composition is divided, with the dark, stormy wilderness on the left and the more developed civilization on the right. The miniscule artist in the bottom center of the painting (wearing a top hat), dwarfed by the landscape's scale, turns to viewers as if to ask for their input in deciding the country's future course. In their depiction of expansive wilderness, Cole's landscapes incorporated reflections and moods so romantically appealing to the public.

WILD, WILD WEST Other Hudson River artists used the landscape genre as an allegorical vehicle to address moral and spiritual concerns. ALBERT BIERSTADT (1830–1902) traveled west in 1858 and produced many paintings depicting the Rocky Mountains, Yosemite Valley, and other sites in California. These works, such as *Among the Sierra Nevada Mountains, California* (FIG. **20-53**), present viewers with breathtaking scenery and natural beauty. This panoramic view (the painting is ten feet wide) is awe inspiring. Deer and waterfowl appear at the edge of a placid lake, while rugged and steep mountains soar skyward on the left and in the distance. A stand of trees, uncultivated and wild, frame the lake on the right. To impress on viewers the almost transcendental nature of this scene, Bierstadt depicted the sun's rays breaking through the clouds overhead, which suggests a heavenly consecration of the land. That Bierstadt focused attention on the West is not insignificant. By calling national attention to the splendor and uniqueness of the regions beyond the Rocky Mountains, Bierstadt's paintings reinforced Manifest Destiny. This popular nineteenth-century doctrine held that westward expansion across the continent was the logical destiny of the

20-52 THOMAS COLE, *The Oxbow (View from Mount Holyoke, Northampton, Massachusetts, after a Thunderstorm)*, 1836. Oil on canvas, 4′ 3½″ × 6′ 4″. Metropolitan Museum of Art, New York (gift of Mrs. Russell Sage, 1908).

20-53 ALBERT BIERSTADT, *Among the Sierra Nevada Mountains, California*, 1868. Oil on canvas, 6′ × 10′. National Museum of American Art, Smithsonian Institution, Washington.

United States. Such artworks thereby muted growing concerns over the realities of conquest, the displacement of the Native Americans, and the exploitation of the environment. It should come as no surprise that among those most eager to purchase Bierstadt's work were mail-service magnates and railroad builders—entrepreneurs and financiers involved in westward expansion.

REAFFIRMING AMERICA'S RIGHTEOUSNESS FREDERIC EDWIN CHURCH (1826–1900) also has been associated with the Hudson River School. His interest in landscape scenes was not limited to America; during his life he traveled to South America, Mexico, Europe, the Middle East, Newfoundland, and Labrador. Church's paintings are instructive because, like the works of Cole and Bierstadt, they are firmly entrenched in the idiom of the Romantic sublime. Yet they also reveal contradictions and conflicts in the constructed mythology of American providence and character. *Twilight in the Wilderness* (FIG. **20-54**) presents an awe-inspiring panoramic view of the sun setting over the majestic landscape. Beyond Church's precise depiction of the spectacle of nature, the painting is remarkable for what it does not depict. Like John Constable, Church and the other Hudson River School painters worked in a time of great upheaval. *Twilight in the Wilderness* was created in 1860, when the Civil War was decimating the country. Yet not only does this painting not display evidence of turbulence or discord, but also it does not include even a trace of humanity. By constructing such an idealistic and comforting view, Church contributed to the national mythology of righteousness and divine providence—a

mythology that had become increasingly difficult to maintain in the face of conflict.

THE AFTERMATH OF CIVIL WAR That these American landscape paintings participated in the public discourse about philosophical, moral, and political issues is seen in the work of WINSLOW HOMER (1836–1910). Homer had firsthand knowledge of the Civil War; when it broke out in 1860, he joined the Union campaign as an artist-reporter for *Harper's Weekly*. In 1865 at the end of the Civil War, Homer painted *The Veteran in a New Field* (FIG. **20-55**). Although it is fairly simple and direct, this painting provides significant commentary on the effects and aftermath of this catastrophic national conflict. The painting depicts a man with his back to the viewer, harvesting wheat. That he is a veteran is clear not only from the painting's title but also from the uniform and canteen carelessly thrown on the ground in the lower right corner. The veteran's involvement in meaningful and productive work suggests a smooth transition from war to peace. Indeed, one could suggest that the veteran turned from harvesting men to harvesting wheat. This transition to work after the end of the Civil War and the fate of disbanded soldiers were of national concern. The *New York Weekly Tribune* commented: "Rome took her great man from the plow, and made him a dictator—we must now take our soldiers from the camp and make them farmers."[22] America's ability to effect a smooth transition was seen as evidence of its national strength. "The peaceful and harmonious disbanding of the armies in the summer of 1865," poet Walt Whitman wrote, was one of the "immortal proofs of democracy, unequall'd in

20-54 FREDERIC EDWIN CHURCH,
Twilight In the Wilderness, 1860s.
Oil on canvas, 3′ 4″ × 5′ 4″. Cleveland
Museum of Art, Cleveland, Ohio
(Mr. and Mrs. William H. Marlatt
Fund, 1965.233).

all the history of the past."[23] Homer's painting thus reinforced the perception of the country's greatness.

The Veteran in a New Field also comments symbolically about death—both the deaths of the soldiers and of Abraham Lincoln. By the 1860s, farmers used cradled scythes to harvest wheat. However, Homer chose not to insist on this historical reality and painted a single-bladed scythe. This transforms the veteran into a symbol of Death—the Grim Reaper himself—and the painting into an elegy to the thousands of soldiers who died in the Civil War and into a lamentation on the death of the recently assassinated president. As with *Twilight in the Wilderness,* Homer's landscape painting contributed to the continuing mythmaking about national conditions and to the mediation of national discourse in difficult times.

Landscape painting was immensely popular in the late eighteenth and early nineteenth centuries, in large part be-

cause it provided viewers with breathtaking and sublime spectacles of nature. Artists also could allegorize nature, and it was rare for a landscape painting not to touch on spiritual, moral, historical, or philosophical issues. Landscape painting became the perfect vehicle for artists (and the viewing public) to "naturalize" conditions, rendering debate about contentious issues moot and eliminating any hint of conflict.

VARIOUS REVIVALIST STYLES IN ARCHITECTURE

RECONSIDERING THE PAST As nineteenth-century scholars gathered the documentary materials of European history in extensive historiographic enterprises, each nation came to value its past as evidence of the validity of its ambitions

20-55 WINSLOW HOMER, *The
Veteran in a New Field,* 1865. Oil on
canvas, 2′ $\frac{1}{8}$″ × 3′ 2$\frac{1}{8}$″. Metropolitan
Museum of Art, New York (bequest of
Miss Adelaide Milton de Groot, 1967).

and claims to greatness. Intellectuals appreciated the art of the remote past as a product of cultural and national genius. In 1773, Goethe, praising the Gothic cathedral of Strasbourg in *Of German Architecture,* announced the theme by declaring that the German art scholar "should thank God to be able to proclaim aloud that it is German Architecture, our architecture." He also bid the observer, "approach and recognize the deepest feeling of truth and beauty of proportion emanating from a strong, vigorous German soul."[24] In 1802, the eminent French writer François René de Chateaubriand published his influential *Genius of Christianity,* which defended religion on the grounds of its beauty and mystery rather than on the grounds of truth. Gothic cathedrals, according to Chateaubriand, were translations of the sacred groves of the Druidical Gauls into stone and must be cherished as manifestations of France's holy history. In his view, the history of Christianity and of France merged in the Middle Ages.

RESTORING MEDIEVAL ARTISANSHIP Modern nationalism thus prompted a new evaluation of the art in each country's past. In London, when the old Houses of Parliament burned in 1834, the Parliamentary Commission decreed that designs for the new building be either "Gothic or Elizabethan." CHARLES BARRY (1795–1860), with the assistance of A. W. N. PUGIN (1812–1852), submitted the winning design (FIG. 20-56) in 1835. By this time, style had become a matter of selection from the historical past. Barry had traveled widely in Europe, Greece, Turkey, Egypt, and Palestine, studying the architecture in each place. He preferred the classical Renaissance styles, but he had designed some earlier Neo-Gothic buildings, and Pugin successfully influenced him in the direction of English Late Gothic. Pugin was one of a group of English artists and critics who saw moral purity and spiritual authenticity in the religious architecture of the Middle Ages. They glorified the careful medieval artisans who had produced it. The Industrial Revolution was flooding the market with cheaply made and ill-designed commodities. Machine work was replacing handicraft. Many, such as Pugin, believed

in the necessity of restoring the old artisanship, which had honesty and quality. The design of the Houses of Parliament, however, is not genuinely Gothic, despite its picturesque tower groupings (the Clock Tower, containing Big Ben, at one end, and the Victoria Tower at the other). The building has a formal axial plan and a kind of Palladian regularity beneath its Tudor detail. Pugin himself is reported to have said of it: "All Grecian, Sir. Tudor details on a classical body."[25]

THE IMPACT OF IMPERIALISM Although the Neoclassical and Neo-Gothic styles were dominant in the early nineteenth century, exotic new styles of all types soon began to appear, in part due to European imperialism. Great Britain's forays throughout the world, particularly India, had exposed English culture to a broad range of non-Western artistic styles. The Royal Pavilion (FIG. 20-57), designed by JOHN NASH (1752–1835), exhibits a wide variety of these styles. Nash was an established architect, known for Neoclassical buildings in London, when he was asked to design a royal pleasure palace in the seaside resort of Brighton for the prince regent (later King George IV). The structure's fantastic exterior is a conglomeration of Islamic domes, minarets, and screens that has been called "Indian Gothic," while sources ranging from Greece and Egypt to China influenced the interior decor. Underlying the exotic facade is a cast-iron skeleton, an early (if hidden) use of this material in noncommercial building. Nash also put this metal to fanciful use, creating life-size palm-tree columns in cast iron to support the Royal Pavilion's kitchen ceiling. The building, an appropriate enough backdrop for gala throngs pursuing pleasure by the seaside, served as the prototype for numerous playful architectural exaggerations still found in European and American resorts.

ADAPTING BAROQUE OPULENCE The Baroque also was adapted in architecture to convey a grandeur worthy of the riches acquired during this age of expansion by those who heeded the advice of the French historian and statesman

20-56 CHARLES BARRY and A. W. N. PUGIN, Houses of Parliament, London, England, designed 1835.

20-57 JOHN NASH, Royal Pavilion, Brighton, England, 1815–1818.

François Guizot to "get rich." The opulence reflected in the lives of these few was mirrored in the Paris Opéra (FIG. **20-58**), designed by J. L. CHARLES GARNIER (1825–1898). The Opéra parades a festive and spectacularly theatrical Neo-Baroque front that could be compared with the Louvre's facade (see FIG. 19-67), which it mimics to a degree. Garnier ingeniously planned the interior for the convenience of human traffic. Intricate arrangements of corridors, vestibules, stairways, balconies, alcoves, entrances, and exits facilitate easy passage throughout the building and provide space for entertainment and socializing at intermissions. The Baroque grandeur of the layout and of the opera house's ornamental appointments proclaims and enhances its function as a gathering place for glittering audiences in an age of conspicuous wealth. The style was so attractive to the moneyed classes who supported the arts that theaters and opera houses continued to reflect the Paris Opéra's design until World War I transformed society.

The epoch-making developments in architecture were more rational, pragmatic, and functional than the historical designs. As the years moved toward the end of the nineteenth century, architects gradually abandoned sentimental and Romantic designs from the historical past. They turned to honest expressions of a building's purpose. Since the eighteenth century, bridges had been built of cast iron (FIG. 20-4), and most other utility architecture—factories, warehouses, dockyard structures, mills, and the like—long had been built simply and without historical ornament. Iron, along with other industrial materials, permitted engineering advancements in the construction of larger, stronger, and more fire-resistant structures than before. The tensile strength of iron (and especially of steel, available after 1860) permitted architects to create new designs involving vast enclosed spaces, as in the great train sheds of railroad stations and in exposition halls.

IRONING OUT ARCHITECTURAL "DRAPERY"
The Bibliothèque Sainte-Geneviève (1843–1850), built by HENRI LABROUSTE (1801–1875), shows an interesting modification of a revived style—in this case, Renaissance—to accommodate the skeletal cast-iron elements (FIG. **20-59**). The row of arched windows in the facade recalls Renaissance buildings, and the division of its stories distinguishes its interior levels—the lower, reserved for stack space, and the upper, for the reading rooms. The latter consists essentially of two barrel-vaulted halls, roofed in terracotta and separated by a row of slender cast-iron columns on concrete pedestals. The columns, recognizably Corinthian, support the iron roof arches, which are pierced with intricate vine-scroll ornament out of the Renaissance architectural vocabulary. One scarcely could find a better example of how the peculiarities of the new structural material aesthetically transformed the forms of traditional masonry architecture. Nor could one find a better example of how reluctant the nineteenth-century architect was to surrender traditional forms, even when fully aware of new possibilities for design and construction. Architects scoffed at "engineers' architecture" for many years and continued to clothe their steel-and-concrete structures in the Romantic "drapery" of a historical style.

20-58 J. L. CHARLES GARNIER, the Opéra, Paris, France, 1861–1874.

20-59 HENRI LABROUSTE, reading room of the Bibliothèque Sainte-Geneviève, Paris, France, 1843–1850.

CRYSTALLIZING CONSTRUCTION TECHNIQUES

Completely "undraped" construction first became popular in the conservatories (greenhouses) of English country estates. JOSEPH PAXTON (1801–1865) built several such structures for his patron, the duke of Devonshire. In the largest—three hundred feet long—he used an experimental system of glass-and-metal roof construction. Encouraged by this system's success, Paxton submitted a winning glass-and-iron building plan to the design competition for the hall to house the Great Exhibition of 1851, organized to gather "Works of Industry of All Nations" together in London. Paxton's exhibition building, the Crystal Palace (FIG. **20-60**), was built with prefabricated parts. This allowed the vast structure to be erected in the then-unheard-of time of six months and dismantled at the exhibition's closing to avoid permanent obstruction of the

park. The plan borrowed much from ancient Roman and Christian basilicas, with a central flat-roofed "nave" and a barrel-vaulted crossing "transept." The design provided ample interior space to contain displays of huge machines as well as to accommodate such decorative touches as large working fountains and giant trees. The public admired the building so much that when it was dismantled, it was reerected at a new location on the outskirts of London, where it remained until fire destroyed it in 1936.

THE BEGINNINGS OF PHOTOGRAPHY

THE CAMERA'S IMPACT A technological device of immense consequence for the modern experience was invented shortly before midcentury: the camera, with its attendant art of photography. Almost everyone is familiar with what the camera equips them to do—report and record optical experience at will. People have come to assume that a very close correlation exists between the photographic image and the fragment of the visual world it records. The evidence of the photograph is proof that what people think they see is really there. Americans, for example, experience the authority and credibility their culture endows on photography in the form of driver's licenses, passport photos, and security cameras.

Photography was celebrated as embodying a kind of revelation of visible things from the time Frenchman Louis J. M. Daguerre and Briton Henry Fox Talbot announced the first practical photographic processes in 1839. The medium, itself a product of science, was an enormously useful tool for recording the century's discoveries. The relative ease of the process seemed a dream come true for scientists and artists, who for centuries had grappled with less satisfying methods for capturing accurate images of their subjects. Photography also was perfectly suited to an age that saw artistic patronage continue to shift away from the elite few toward a broader base of support. The growing and increasingly powerful

20-60 JOSEPH PAXTON, Crystal Palace, London, England, 1850–1851. Iron and glass. Victoria and Albert Museum, London.

middle class embraced both the comprehensible images of the new medium and its lower cost.

ARTISTIC RESPONSES TO PHOTOGRAPHY For the traditional artist, photography suggested new answers to the great debate about what is real and how to represent the real in art. It also challenged the place of traditional modes of pictorial representation originating in the Renaissance. Artists as diverse as Delacroix, Ingres, the Realist Jean Désiré Gustave Courbet, and the Impressionist Edgar Degas welcomed photography as a helpful auxiliary to painting. They increasingly were intrigued by how photography translated three-dimensional objects onto a two-dimensional surface. Other artists, however, saw photography as a mechanism capable of displacing the painstaking work of skilled painters dedicated to representing the optical truth of chosen subjects. Photography's challenge to painting, both historically and technologically, seemed to some an expropriation of the realistic image, until then painting's exclusive property. But just as some painters looked to the new medium of photography for answers on how best to render an image in paint, so some photographers looked to painting for suggestions about ways to imbue the photographic image with qualities beyond simple reproduction. The collaborative efforts of Delacroix and the photographer EUGÈNE DURIEU (1800–1874) as seen in *Draped Model* (*back view*; FIG. **20-61**), demonstrate the symbiotic relationship between painters and photographers. Although such a photograph provided Delacroix with a permanent image of the posed nude female model, photographers sometimes also attempted, as here, to create a mood through careful lighting and the draping of cloth.

DEVELOPING THE DAGUERREOTYPE "Reality," "truth," "fact"—that elusive quality artists throughout time sought with painstaking effort in traditional media such as paint, crayon, and pen-and-ink—could seemingly be captured readily and with breathtaking accuracy by the new mechanical medium of photography. Artists themselves were instrumental in the development of this new technology. As early as the seventeenth century, artists such as Vermeer (see FIGS. 19-51, 19-52) had used an optical device called the camera obscura (literally, "dark room") to help them render the details of their subjects more accurately. These instruments were darkened chambers (some virtually portable closets) with optical lenses fitted into a hole in one wall that light entered through to project an inverted image of a subject onto the chamber's opposite wall. The artist could trace the main details from this image for later reworking and refinement. In 1807, the invention of the *camera lucida* (lighted room) replaced the enclosed chamber. Instead, a small prism lens, hung on a stand, projected the image of the object it had been "aimed" downward at onto a sheet of paper. Artists using either of these devices found this process long and arduous, no matter how accurate the resulting work. All yearned for a more direct way to capture a subject's image. Two very different scientific inventions that accomplished this were announced, almost simultaneously, in France and England in 1839.

The first new discovery was the *daguerreotype process,* named for LOUIS-JACQUES-MANDÉ DAGUERRE (1789–1851), one of its two inventors. The second, the calotype process, is discussed later. Daguerre had trained as an architect before becoming a theatrical set painter and designer. This background led him to open (with a friend) a popular entertainment called the Diorama. Audiences witnessed performances of "living paintings" created by changing the lighting effects on a "sandwich" composed of a painted backdrop and several layers of painted translucent front curtains. Daguerre used a camera obscura for the Diorama, but he wanted to find a more efficient and effective procedure. Through a mutual acquaintance, he was introduced to Joseph Nicéphore Nièpce, who in 1826 had successfully made a permanent picture of the cityscape outside his upper-story window by exposing, in a camera obscura, a metal plate covered with a light-sensitive coating. Although the eight-hour exposure time needed to record Nièpce's subject hampered the process, Daguerre's excitement over its possibilities led to a partnership between the two men to pursue its development. Nièpce died in 1833, but Daguerre continued to work on his own. He made two contributions to the process. He discovered latent development, bringing out the image through chemical solutions, which considerably shortened the length of time needed for exposure. Daguerre also discovered a better way to "fix" the image (again, chemically) by stopping the action of light on the photographic plate, which otherwise would continue to darken until the image could no longer be discerned.

20-61 EUGÈNE DURIEU and EUGÈNE DELACROIX, *Draped Model (back view)*, ca. 1854. Albumen print, $7\frac{5}{16}'' \times 5\frac{1}{8}''$. J. Paul Getty Museum, Los Angeles.

The French government presented the new daguerreotype process at the Academy of Science in Paris on January 7, 1839, with the understanding that its details would be made available to all interested parties without charge (although the inventor received a large annuity in appreciation). Soon, people worldwide were taking pictures with the daguerreotype "camera" (a name shortened from *camera obscura*) in a process almost immediately christened *photography,* from the Greek *photos* (light) and *graphos* (writing). From the start, painters were intrigued with the possibilities of the process as a new art medium. Paul Delaroche, a leading painter of the day, wrote in an official report to the French government:

> Daguerre's process completely satisfies all the demands of art, carrying certain essential principles of art to such perfection that it must become a subject of observation and study even to the most accomplished painters. The pictures obtained by this method are as remarkable for the perfection of the details as for the richness and harmony of the general effect. Nature is reproduced in them not only with truth, but also with art.[26]

Each daguerreotype is a unique work, possessing amazing detail and finely graduated tones from black to white. Both qualities are evident in *Still Life in Studio* (FIG. **20-62**), one of the first successful plates Daguerre produced after perfecting his method. The process captured every detail—the subtle shapes, the varied textures, the diverse tones of light and shadow—in Daguerre's carefully constructed tableau. The three-dimensional forms of the sculptures, the basket, and the bits of cloth spring into high relief and are convincingly there within the image. Its composition was clearly inspired by seventeenth-century Dutch still lifes, such as those of Heda (see FIG. 19-54). Like Heda, Daguerre arranged his objects to reveal clearly their textures and shapes. Unlike a painter, however, Daguerre could not alter anything within his arrangement to effect a stronger image. However, he could suggest a symbolic meaning within his array of objects. Like the oysters and fruit in Heda's painting, Daguerre's sculptural and architectural fragments and the framed print of an embrace suggest that even art is vanitas and will not endure forever.

A PICTURE-PERFECT OPERATION In the United States, where the first daguerreotype was taken within two months of Daguerre's presentation in Paris, two particularly avid and resourceful advocates of the new medium were JOSIAH JOHNSON HAWES (1808–1901), a painter, and ALBERT SANDS SOUTHWORTH (1811–1894), a pharmacist and teacher. Together, they ran a daguerreotype studio in Boston that specialized in portraiture, then popular due to the shortened exposure time required for the process (although it was still long enough to require head braces to help subjects remain motionless while their photographs were taken).

The partners also, however, took their equipment outside the studio to record places and events of particular interest to them. One such image is *Early Operation under Ether, Massachusetts General Hospital* (FIG. **20-63**). This daguerreotype was taken from the vantage point of the gallery of a hospital operating room, putting viewers in the position of medical students looking down on a lecture-demonstration typical through the nineteenth century. An image of historic record, this early daguerreotype gives viewers a glimpse into the whole of Western medical practice. The focus of attention in *Early Operation* is the white-draped patient, who is surrounded by a circle of darkly clad doctors. The details of the figures and the room's furnishings are recorded clearly, but the slight blurring of several of the figures betrays motion during the exposure. The elevated viewpoint flattens the spatial perspective and emphasizes the relationships of the figures in ways the Impressionists, especially Degas, found intriguing.

20-62 LOUIS-JACQUES-MANDÉ DAGUERRE, *Still Life in Studio,* 1837. Daguerreotype. Collection Société Française de Photographie, Paris.

20-63 Josiah Johnson Hawes and Albert Sands Southworth, *Early Operation under Ether, Massachusetts General Hospital*, ca. 1847. Daguerreotype. Massachusetts General Hospital Archives and Special Collections, Boston.

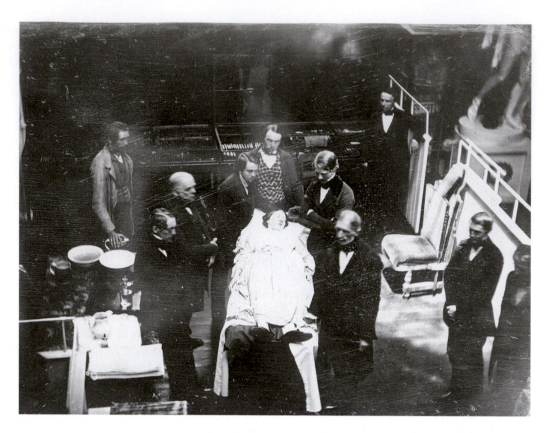

A BEAUTIFUL TYPE OF PHOTOGRAPHY The daguerreotype reigned supreme in photography until the 1850s, but the second major photographic invention was announced less than three weeks after Daguerre's method was unveiled in Paris and eventually replaced it. It was the ancestor of the modern negative-print system. On January 31, 1839, William Henry Fox Talbot (1800–1877) presented a paper on his "photogenic drawings" to the Royal Institution in London. As early as 1835, Talbot made "negative" images by placing objects on sensitized paper and exposing the arrangement to light. This created a design of light-colored silhouettes recording the places where opaque or translucent objects had blocked light from darkening the paper's emulsion. In his experiments, Talbot next exposed sensitized papers inside simple cameras and with a second sheet created "positive" images. He further improved the process with more light sensitive chemicals and a chemical development of the negative image. This technique allowed multiple prints. However, Talbot's process, which he named the *calotype* (a term he derived from the Greek term *kalos,* meaning "beautiful"), was limited by the fact its images incorporated the paper's texture. This produced a slightly blurred, grainy effect very different from the crisp detail and wide tonal range available with the daguerreotype. Aside from these drawbacks, the calotype image's widespread adoption primarily was prevented by the stiff licensing and equipment fees charged for many years after Talbot patented his new process in 1841. Due to both the look and the cost of the calotype, many photographers elected to stay with the daguerreotype until photographic technology could expand the calotype's capabilities.

CAPTURING AN ARTIST'S LIKENESS Portraiture was one of the first photography genres to use a technology that improved the calotype. Making portraits was an important economic component for most photographers, as Southworth and Hawes proved, but the greatest of the early portrait photographers was, undoubtedly, the Frenchman Gaspar-Félix Tournachon (1820–1910). Tournachon adopted the name Nadar for his professional career as novelist, journalist, enthusiastic balloonist, caricaturist, and, later, photographer. Photographic studies for his caricatures, which followed the tradition of Honoré Daumier's most satiric lithographs (see FIG. 21-5), led Nadar to open a portrait studio. So talented was he at capturing the essence of his subjects that the most important people in France, including Delacroix, Daumier, Courbet, and the Impressionist Édouard Manet, flocked to his studio to have their portraits made. Nadar said he sought in his work "that instant of understanding that puts you in touch with the model—helps you sum him up, guides you to his habits, his ideas, and character and enables you to produce . . . a really convincing and sympathetic likeness, an intimate portrait."[27]

Nadar's skill in the genre can be seen in *Eugène Delacroix* (FIG. **20-64**), which shows the painter at the height of his career. In this photograph, the artist appears with remarkable presence; even in half-length, his gesture and expression create a revealing mood that seems to tell viewers much about him. Perhaps Delacroix responded to Nadar's famous gift for putting his clients at ease by assuming the pose that best expressed his personality. The new photographic materials made possible the rich range of tones in Nadar's images. Glass negatives and albumen printing paper (prepared with egg white) could record finer detail and a wider range of light and shadow than Talbot's calotype process.

The new "wet-plate" technology (because this plate was exposed, developed, and fixed while wet) almost at once replaced both the daguerreotype and the calotype and became

20-64 NADAR (GASPARD-FÉLIX TOURNACHON), *Eugène Delacroix,* ca. 1855. Modern print from original negative in the Bibliothèque Nationale, Paris.

the universal way of making negatives up to 1880. However, wet-plate photography had drawbacks. The plates had to be prepared and processed on the spot. To work outdoors meant taking along a portable darkroom of some sort—a wagon, tent, or box with light-tight sleeves for the photographer's

arms. Yet, with the wet plate, artists could make remarkable photographs of battlefields, the Alps, and even the traffic flow in crowded streets (see FIG. 21-22).

DOCUMENTING THE TRAGEDY OF WAR The photograph's documentary power was immediately realized. Thus began the story of the medium's influence on modern life and the immense changes it brought to communication and information management. For the historical record it was of unrivaled importance. Great events could be recorded on the spot and the views preserved for the first time. The photographs taken of the Crimean War (1856) by Roger Fenton (1819–1869) and of the American Civil War by Matthew B. Brady (1823–1896), Alexander Gardner (1821–1882), and TIMOTHY O'SULLIVAN (1840–1882) are still unsurpassed as incisive accounts of military life, unsparing in their truth to detail and poignant as expressions of human experience.

Of the Civil War photographs, the most moving are the inhumanly objective records of combat deaths. Perhaps the most reproduced of these Civil War photographs is O'Sullivan's *A Harvest of Death, Gettysburg, July 1863* (FIG. **20-65**). Although viewers might see this image as simple reportage, it also functions to impress on people the war's high price. Corpses litter the battlefield as far as the eye can see. O'Sullivan presented a scene that stretches far to the horizon. As the photograph modulates from the precise clarity of the bodies of Union soldiers in the foreground, boots stolen and pockets picked, to the almost illegible corpses in the distance, the suggestion of innumerable other dead soldiers is unavoidable. This "harvest" is far more sobering and depressing than that in Winslow Homer's Civil War image, *The Veteran in a New Field* (FIG. 20-55). Though it was years before photolithography could reproduce photographs like this in newspapers, they were publicly exhibited and made an impression that newsprint engravings never could.

Photography continued to impact significantly many aspects of art and public perceptions of "reality." The issues of reality and realism were addressed specifically in the movement that followed on the heels of Romanticism, Realism.

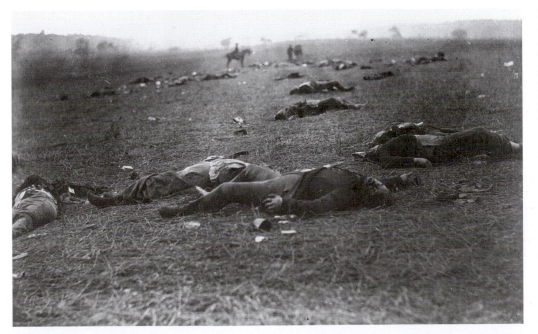

20-65 TIMOTHY O'SULLIVAN, *A Harvest of Death, Gettysburg, Pennsylvania, July 1863.* Negative by Timothy O'Sullivan. Original print by Alexander Gardner. The New York Public Library (Astor, Lenox and Tilden Foundations, Rare Books and Manuscript Division), New York.

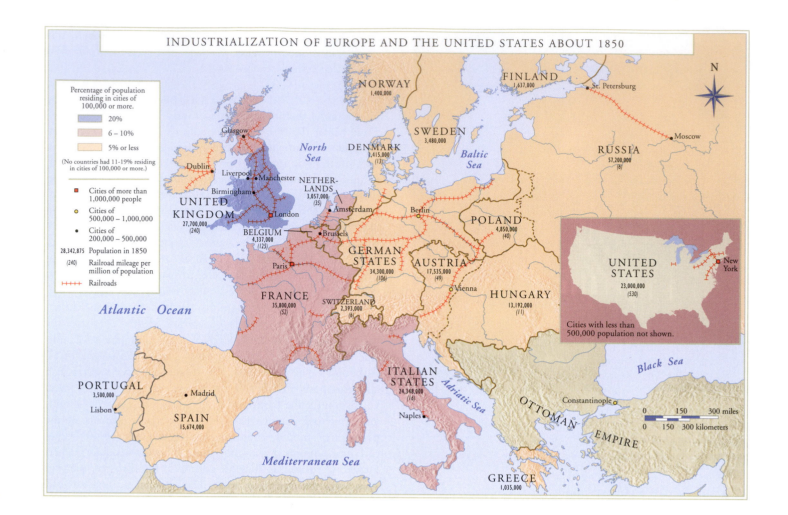

INDUSTRIALIZATION OF EUROPE AND THE UNITED STATES ABOUT 1850

Percentage of population residing in cities of 100,000 or more.

- 20%
- 6 – 10%
- 5% or less

(No countries had 11-19% residing in cities of 100,000 or more.)

- ■ Cities of more than 1,000,000 people
- ○ Cities of 500,000 – 1,000,000
- • Cities of 200,000 – 500,000

28,342,875 Population in 1850

(240) Railroad mileage per million of population

┼┼┼┼ Railroads

NORWAY 1,400,000

FINLAND 1,637,000

St. Petersburg

Moscow

SWEDEN 3,480,000

North Sea

DENMARK 1,415,000 (13)

Baltic Sea

RUSSIA 57,200,000 (8)

Glasgow

Dublin

Liverpool · Manchester

Birmingham

UNITED KINGDOM 27,700,000 (240)

London

NETHER-LANDS 3,057,000 (35)

Amsterdam

Berlin

POLAND 4,850,000 (40)

BELGIUM 4,337,000 (125)

Brussels

GERMAN STATES 34,300,000 (106)

AUSTRIA 17,535,000 (49)

Paris

FRANCE 35,800,000 (52)

SWITZERLAND 2,393,000 (6)

Vienna

HUNGARY 13,192,000 (11)

Atlantic Ocean

UNITED STATES 23,000,000 (530)

New York

Cities with less than 500,000 population not shown.

PORTUGAL 3,500,000

Madrid

Lisbon

SPAIN 15,674,000

ITALIAN STATES 24,348,000 (16)

Adriatic Sea

Naples

Black Sea

Constantinople

OTTOMAN EMPIRE

Mediterranean Sea

GREECE 1,035,000

N

0 150 300 miles
0 150 300 kilometers

1850	1860	1870	1880

VICTORIA SECOND REPUBLIC

NAPOLEON III (THE SECOND EMPIRE) THIRD REPUBLIC

Jean-Baptiste-Camille Corot
*The Harbor of La Rochelle
(Le Port de la Rochelle), 1851*

Édouard Manet
Olympia, 1863

Berthe Morisot
Villa at the Seaside, 1874

Eadweard Muybridge
Horse Galloping, 1878

Charles Darwin 1809–1882, *Origin of Species*, 1859

Karl Marx, 1818–1883

Fredrich Engels, 1820–1895

American Civil War 1861–1865

Paris Commune, 1870–1871

Franco-Prussian War, 1870–1871

Foundation of German Empire, 1871

Third Republic, 1871–1940

Unification of Italy, 1871

Clerk-Maxwell theory of electromagnetic radiation, 1873

THE RISE OF MODERNISM

THE LATER NINETEENTH CENTURY

| 1885 | 1890 | 1895 | 1900 | 1905 |

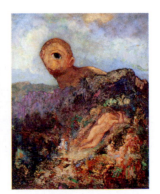

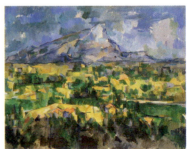

Alexandre Gustave Eiffel
Eiffel Tower, Paris, 1889

Edvard Munch
The Cry, 1893

Odilon Redon
The Cyclops, 1898

Paul Cézanne
Mont Sainte-Victoire, 1902–1904

First movie camera patented, 1891

European colonization
of African completed, 1900

INDUSTRIALIZATION, URBANIZATION, AND EXPANDING GLOBAL CONSCIOUSNESS

THE SECOND INDUSTRIAL REVOLUTION The momentous Western developments of the early nineteenth century—industrialization, urbanization, and increased economic and political interaction worldwide—matured quickly during the latter half of the century. The Industrial Revolution in England, which had distinguished that country from others on the European continent, spread throughout Europe and to the United States. Because of this dramatic expansion, the third quarter of the nineteenth century is often referred to as the Second Industrial Revolution. While the first Industrial Revolution centered on textiles, steam, and iron, the second was associated with steel, electricity, chemicals, and oil. The discoveries in these fields provided the foundation for developments in plastics, machinery, building construction, and automobile manufacturing and paved the way for the invention of the radio, electric light, telephone, and electric streetcar.

One of the most significant consequences of industrialization was urbanization. The number and size of Western cities grew dramatically during the latter part of the nineteenth century, largely due to migration from rural regions. Rural dwellers relocated to urban centers because of expanded agricultural enterprises that squeezed the smaller property owners from the land. The widely available work opportunities in the cities, especially in the factories, were also a major factor in this migration. In addition, the improving health and living conditions in the cities contributed to their explosive growth.

REAFFIRMING A FAITH IN SCIENCE An increasing emphasis on science was another characteristic of this period. Advances in industrial technology reinforced the Enlightenment's foundation of rationalism. The connection between science and progress seemed obvious to many, both in intellectual circles and among the general public, and, increasingly, people embraced empiricism (the search for knowledge based on observation and direct experience). Indicative of the widespread faith in science was the influence of positivism, a Western philosophical model that promoted science as the mind's highest achievement. Positivism was developed by the French philosopher Auguste Comte (1798–1857), who advocated a purely scientific, empirical approach to nature and society. Comte believed that scientific laws governed the environment and human activity and could be revealed through careful recording and analysis of observable data.

THE SURVIVAL OF THE FITTEST The English naturalist Charles Darwin (1809–1882) and his theory of natural selection did much to increase interest in science. Although the concept of evolution had been suggested earlier, Darwin and his compatriot Alfred Russel Wallace (1823–1913), working independently, articulated the theory of natural selection, which proposed a model for the process of evolution. They based this theory on mechanistic laws, rather than attributing evolution to random chance or God's plan, and argued for a competitive system in which only the fittest survived. Darwin's ideas, as presented in *Origin of Species* (1859), sharply contrasted with the biblical narrative of Cre-

ation and thus were highly controversial. By challenging traditional Christian beliefs, Darwinism contributed to a growing secular attitude.

Other theorists and social thinkers, most notably British philosopher Herbert Spencer, applied Darwin's principles to the rapidly changing socioeconomic realm. As in the biological world, they asserted, industrialization's intense competition led to the survival of the most economically fit companies, enterprises, and countries. This logic served to justify the rampant Western racism, imperialism, nationalism, and militarism that marked the late nineteenth and early twentieth centuries. Because of the pseudoscientific basis of this Social Darwinism, those who espoused this theory perceived such conflict and struggle as inevitable.

KARL MARX AND CLASS STRUGGLE The concept of conflict was central to the ideas of Karl Marx (1818–1883), another dominant figure of the period. Born to German-Jewish parents in Trier, Marx received a doctorate in philosophy from the University of Berlin. After moving to Paris, he met fellow German Friedrich Engels (1820–1895), who became his lifelong collaborator. Together they wrote the *Communist Manifesto* (1848), which called for the working class to overthrow the capitalist system. Like Darwin and other empiricists, Marx believed that scientific, rational law governed nature and, indeed, all human history. For Marx, economic forces based on class struggle induced historical change. Throughout history, insisted Marx, those who controlled the means of production conflicted with those whose labor was exploited to benefit the wealthy and powerful. This constant opposition—the dynamic he called "dialectical materialism"—caused change. Marxism's ultimate goal was to create a socialist state—the seizure of power by the working class and the destruction of capitalism. Marxism, which had great appeal to the oppressed as well as to many intellectuals, emphasized class conflict and was instrumental in the rise of trade unions and socialist groups.

COLONIZING THE WORLD Many of these important developments—for example, industrialization and Social Darwinism—help to explain this period's extensive imperialism. Industrialization required a wide variety of natural resources, and Social Darwinists easily translated their intrinsic concept of social hierarchy into racial and national hierarchies. These hierarchies provided Western leaders with justification for the colonization of peoples and cultures that they deemed "less advanced." By 1900, the major economic and political powers had divided up much of the world. The French had colonized most of North Africa and Indochina, while the British occupied India, Australia, and large areas of Africa, including Nigeria, Egypt, Sudan, Rhodesia, and the Union of South Africa. The Dutch were a major presence in the Pacific, and the Germans, Portuguese, Spanish, and Italians all established themselves in various areas of Africa.

MODERNITY AND MODERNISM The combination of the extensive technological changes and increased exposure to other cultures, coupled with the rapidity of these changes, led to an acute sense in Western cultures of the world's lack of fixity or permanence. The Darwinian ideas of evolution and Marx's emphasis on a continuing sequence of conflicts and

resolutions reinforced this awareness of a constantly shifting reality. These societal changes prompted a greater consciousness of and interest in modernity—the state of being modern. This avid exploration of the conditions of modernity and of people's position relative to a historical continuum permeated the Western art world as well, resulting in the development of *modernism*. Modernist art is differentiated from modern art by its critical function. Modern art, as discussed in Chapter 20, is more or less a chronological designation, referring to art of the past few centuries. Modern artists were and are aware of the relationship between their art and that of previous eras. Modernism developed in the second half of the nineteenth century and is "modern" in that modernist artists, then and now, often seek to capture the images and sensibilities of their age. However, modernism goes beyond simply dealing with the present and involves the artist's critical examination of or reflection on the premises of art itself. *Modernism* thus implies certain concerns about art and aesthetics that are internal to art production, regardless of whether or not the artist is producing scenes from contemporary social life.

Clement Greenberg, a twentieth-century American art critic, explained: "The essence of Modernism lies . . . in the use of the characteristic methods of a discipline to criticize the discipline itself—not in order to subvert it, but to entrench it more firmly in its area of competence."[1] He explains further what he means by "criticize the discipline:" "Realistic, illusionist art had dissembled [disguised] the medium, using art to conceal art. Modernism used art to call attention to art. The limitations that constitute the medium of painting—the flat surface, the shape of the support, the properties of pigment—were treated by the Old Masters as negative factors that could be acknowledged only implicitly or indirectly. Modernist painting has come to regard these same limitations as positive factors that are to be acknowledged openly."[2] The two major modernist art movements of the later nineteenth century were Realism and Impressionism, and both were conditioned by the historical and theoretical milieu in which they incubated.

This critical, modernist stance challenged the more conservative approach of the academies, where artists received traditional training. Eventually, toward the end of the century, the aggressiveness of modernism led to the development of the avant-garde—artists whose work emphatically rejected the past and transgressed the boundaries of conventional artistic practice. The subversive dimension of the avant-garde was in sync with the anarchic, revolutionary sociopolitical tendencies in Europe at the time. The art of the Post-Impressionists, such as Vincent van Gogh, Paul Gauguin, Georges Seurat, and Paul Cézanne, was among the first labeled "avant-garde." The end of the nineteenth century, with its unique *fin-de-siècle* (end of the century) culture, paved the way for the entrenchment of modernism and the avant-garde in the twentieth century.

REALISM: THE PAINTING OF MODERN LIFE

Realism was a movement that developed in France around midcentury. GUSTAVE COURBET (1819–1877), long regarded as the leading figure of the Realist movement in nineteenth-

century art, used the term "realism" when exhibiting his own works, even though he shunned labels. In and since Courbet's time, confusion about what Realism is has been widespread. Writing in 1857, Jules-François-Félix Husson Champfleury (1821–1889), one of the first critics to recognize and appreciate Courbet's work, declared: "I will not define *Realism*. . . . I do not know where it comes from, where it goes, what it is; . . . The name horrifies me by its pedantic ending; . . . there is enough confusion already about that famous word."[3] Confusion, or at least disagreement, about Realism still exists among historians of nineteenth- and, for that matter, twentieth-century art.

REDEFINING REALITY The work of the Realists, in essence, provides viewers with a reevaluation of "reality." Like the empiricists and positivists, Realist artists argued that only the things of one's own time, what people can see for themselves, are "real." Accordingly, Realists focused their attention on the experiences and sights of everyday contemporary life and disapproved of traditional and fictional subjects on the grounds that they were not real and visible and were not of the present world. Courbet declared in 1861:

> To be able to translate the customs, ideas, and appearances of my time as I see them—in a word, to create a living art—this has been my aim. . . . [T]he art of painting can consist only in the representation of objects visible and tangible to the painter . . . , [who must apply] his personal faculties to the ideas and the things of the period in which he lives. . . . I hold also that painting is an essentially *concrete* art, and can consist only of the representation of things both *real* and *existing*. . . . An *abstract* object, invisible or nonexistent, does not belong to the domain of painting. . . . Show me an angel, and I'll paint one.[4]

This sincerity about scrutinizing the world around them led the Realists to expand their repertoire of subject matter beyond the conventional, established themes and scenes. The Realists portrayed objects and images that until then had been deemed unworthy of depiction—the mundane and trivial, working class laborers and peasants, and so forth. Even further, the Realists depicted these scenes on a scale and with an earnestness and seriousness previously reserved for grand history painting.

THE LOWEST OF THE LOW In *The Stone Breakers* (FIG. **21-1**), Courbet presented viewers with a glimpse into the life of a rural toiler. Courbet captured on canvas in straightforward manner two males—one mature, the other very young—in the act of breaking stones, traditionally the lot of the lowest in society. Their menial labor is neither romanticized nor idealized but is shown with directness and accuracy. Courbet revealed to viewers the drudgery of this labor. His palette's dirty browns and grays convey the dreary and dismal nature of the task, while the angular positioning of the older stone breaker's limbs suggests a mechanical monotony.

This interest in the laboring poor as subject matter had special meaning for the mid-nineteenth-century French audience. In 1848, workers rebelled against the bourgeois leaders of the newly formed Second Republic and against the rest of the nation, demanding better working conditions and a redistribution of property. The army quelled the revolution in

21-1 GUSTAVE COURBET, *The Stone Breakers*, 1849. Oil on canvas, 5′ 3″ × 8′ 6″. Formerly at Gemäldegalerie, Dresden (destroyed in 1945).

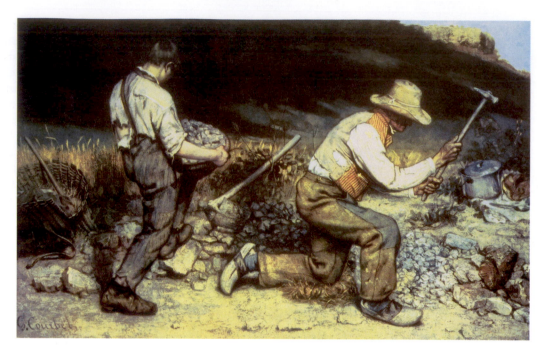

three days, but not without significant loss of life and long-lasting trauma. The Revolution of 1848 thus raised the issue of labor as a national concern and placed workers on center stage, both literally and symbolically. Courbet's depiction of stone breakers in 1849 was thus truly authentic and populist.

THE ANONYMITY OF PEASANT LIFE Also representative of Courbet's work is *Burial at Ornans* (FIG. 21-2), which depicts a funeral in a bleak provincial landscape attended by "common, trivial" persons, the type of people Honoré de Balzac and Gustave Flaubert presented in their novels.[5] While an officious clergyman reads the Office of the Dead, those attending cluster around the excavated gravesite, their faces registering all degrees of response to the situation.

Although the painting has the monumental scale of a traditional history painting, the subject's ordinariness and the starkly antiheroic composition horrified contemporary critics. Arranged in a wavering line extending across the broad horizontal width of the canvas, the figures are portrayed in groups—the somberly clad women at the back right, a semicircle of similarly clad men by the open grave, and assorted churchmen at the left. The observer's attention, however, is wholly on the wall of figures, seen at eye level in person, that blocks any view into deep space. The faces are portraits; some of the models were Courbet's friends. Behind and above the figures are bands of overcast sky and barren cliffs. The dark

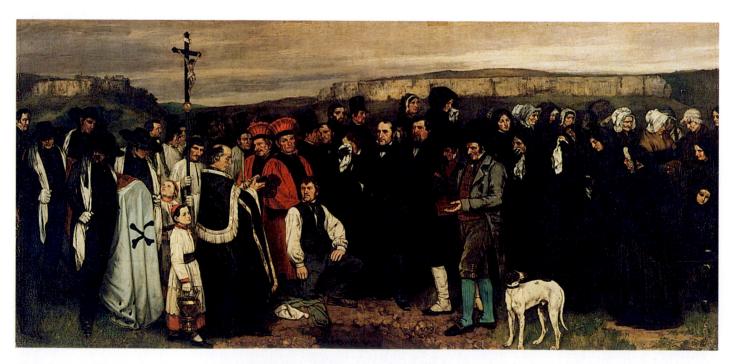

21-2 GUSTAVE COURBET, *Burial at Ornans*, 1849. Oil on canvas, approx. 10′ × 22′. Louvre, Paris.

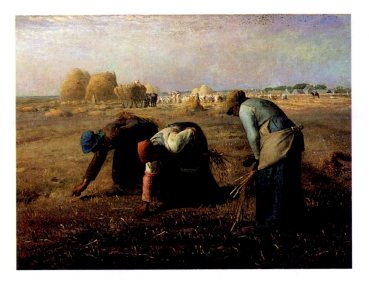

21-3 JEAN-FRANÇOIS MILLET, *The Gleaners*, 1857. Oil on canvas, approx. 2′ 9″ × 3′ 8″. Louvre, Paris.

pit of the grave opens into the viewer's space in the center foreground. Despite the unposed look of the figures, the artist controlled the composition in a masterful way by his sparing use of bright color. The heroic, the sublime, and the terrible are not found here—only the drab facts of undramatized life and death. In 1857, Champfleury wrote of *Burial at Ornans,* ". . . it represents a small-town funeral and yet reproduces the funerals of *all* small towns."[6] Unlike the superhuman or non-human actors on the grand stage of the Romantic canvas, this Realist work moves according to the ordinary rhythms of contemporaneous life.

EMPHASIZING THE PAINTED SURFACE Viewed as the first modernist movement by many scholars and critics,

Realism also involved a reconsideration of the painter's primary goals and departed from the established priority on illusionism. Accordingly, Realists called attention to painting as a pictorial construction by their pigment application or composition manipulation. Courbet's intentionally simple and direct methods of expression in composition and technique seemed unbearably crude to many of his more traditional contemporaries, and he was called a primitive. Although his bold, somber palette was essentially traditional, Courbet often used the palette knife for quickly placing and unifying large daubs of paint, producing a roughly wrought surface. His example inspired the young artists who worked for him (and later Impressionists such as Claude Monet and Auguste Renoir), but the public accused him of carelessness and critics wrote of his "brutalities."

Because of both the style and content of Courbet's paintings, they were not well received. The jury selecting work for the Paris International Exhibition in 1855 rejected two of his paintings on the grounds that his subjects and figures were too coarsely depicted (so much so as to be plainly "socialistic") and too large. In response, Courbet set up his own exhibition outside the grounds, calling it the Pavilion of Realism. Courbet's pavilion and his utterances amounted to the new movement's manifestoes. Although he maintained he founded no school and was of no school, he did, as the name of his pavilion suggests, accept the term "realism" as descriptive of his art.

A PAINTER OF COUNTRY LIFE Like Courbet, JEAN-FRANÇOIS MILLET (1814–1878) found his subjects in the people and occupations of the everyday world. Millet was one of a group of French painters of country life who, to be close to their rural subjects, settled near the village of Barbizon in the forest of Fontainebleau. This "Barbizon" school specialized in detailed pictures of forest and countryside. Millet,

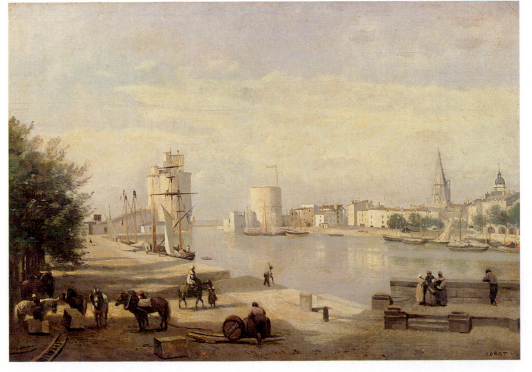

21-4 JEAN-BAPTISTE-CAMILLE COROT, *The Harbor of La Rochelle (Le Port de la Rochelle),* 1851. Oil on canvas, approx. 1′ 8″ × 2′ 4″. Yale University Art Gallery, New Haven (bequest of Stephen Carlton Clark, B.A., 1903).

perhaps their most prominent member, was of peasant stock and identified with the hard lot of the country poor. In *The Gleaners* (FIG. **21-3**), he depicted three peasant women performing the back-breaking task of gleaning the last wheat scraps. These women were members of the lowest level of peasant society, and such impoverished people were permitted to pick up the remainders left in the field after the harvest. Millet characteristically placed his monumental figures in the foreground, against a broad sky. Although the field stretches back to a rim of haystacks, cottages, trees, and distant workers and a flat horizon, viewers' attention is drawn to the gleaners quietly doing their tedious and time-consuming work.

Although Millet's works have a sentimentality absent from those of Courbet, the French public reacted to paintings such as *The Gleaners* with disdain and suspicion. In the aftermath of the Revolution of 1848, Millet's investing the poor with solemn grandeur did not meet with the approval of the prosperous classes. The middle-class mind linked it with the dangerous, newly defined working class, which was finding outspoken champions in men such as Karl Marx, Friedrich Engels, Pierre Proudhon, Honoré de Balzac, Gustave Flaubert, Émile Zola, and Charles Dickens. Socialism was a growing movement, and its views on property and its call for social justice, even economic equality, frightened the bourgeoisie. Millet's sympathetic depiction of the poor seemed to many like a political manifesto.

COROT'S PRECISE LANDSCAPES The Realist nature of *The Gleaners* is evident on comparing it to a landscape painting, *The Harbor of La Rochelle* (FIG. **21-4**) by JEAN-BAPTISTE-CAMILLE COROT (1796–1875), another French artist closely associated with the Barbizon school. Although both paintings share a calm mood and precise composition, Corot's interest in *The Harbor of La Rochelle* is clearly on the landscape as a setting, and the people depicted—small in

scale—populate the scene like any other object, the trees, barrels, or horses. For Millet, however, the gleaners and their laborious task were central. Corot is not generally viewed as a Realist, although his commitment to the faithful rendering of scenes he encountered allies him with the Realist spirit.

LAMPOONING THE POWERS THAT BE Because people widely recognized the power of art to serve political means, the political and social agitation accompanying the violent revolutions in France and the rest of Europe in the later eighteenth and early nineteenth centuries prompted the French people to suspect artists of subversive intention. A person could be jailed for too bold a statement in the press, in literature, in art—even in music and drama. Realist artist HONORÉ DAUMIER (1808–1879) boldly confronted authority with social criticism and political protest, and in response the authorities imprisoned the artist. Daumier—painter, sculptor, and, like Goya, one of the world's great masters of the graphic (print) medium—was a defender of the urban working classes, as Millet was a defender of the farming poor. The satirical lithographs Daumier contributed to the liberal French Republican journal *Caricature* found a wide audience. In these prints, he mercilessly lampooned the foibles and misbehavior of politicians, lawyers, doctors, and the rich bourgeoisie in general. His in-depth knowledge of the acute political and social unrest in Paris during the revolutions of 1830 and 1848 endowed his work with truthfulness and, therefore, impact.

His lithograph, *Rue Transnonain* (FIG. **21-5**), depicts an atrocity with the same shocking impact as Goya's *The Third of May, 1808* (see FIG. 20-39). The title refers to a street in Paris where an unknown sniper killed a civil guard, part of a government force trying to repress a worker demonstration. Because the fatal shot had come from a workers' housing block, the remaining guards immediately stormed the building

21-5 HONORÉ DAUMIER, *Rue Transnonain*, 1834. Lithograph, approx. $1' \times 1' 5\frac{1}{2}''$. Philadelphia Museum of Art, Philadelphia (bequest of Fiske and Marie Kimball).

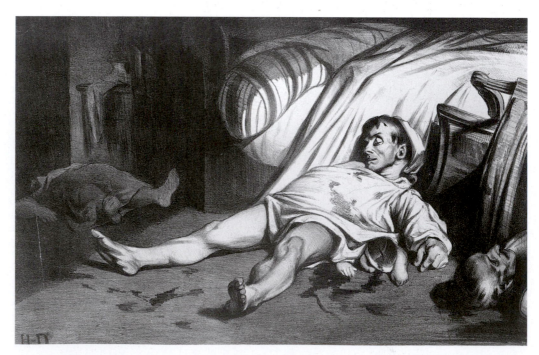

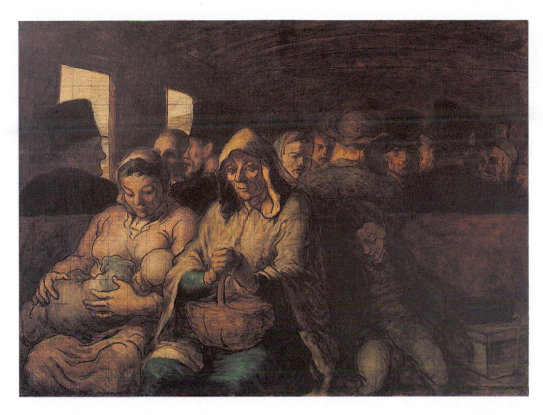

21-6 HONORÉ DAUMIER, *The Third-Class Carriage*, ca. 1862. Oil on canvas, 2′ 1¾″ × 2′ 11½″. Metropolitan Museum of Art, New York (H. O. Havemeyer Collection, bequest of Mrs. H. O. Havemeyer, 1929).

and massacred all of its inhabitants. With Goya's power, Daumier created a view of the atrocity from a sharp, realistic angle of vision. He depicted not the dramatic moment of execution but the terrible, quiet aftermath. The broken, scattered forms lie amid violent disorder, as if newly found. The print's significance lies in its factualness. It is an example of the period's increasing artistic bias toward using facts as subject, and not always illusionistically. Daumier's pictorial manner is rough and spontaneous; how it carries expressive exaggeration is part of its remarkable force. Daumier's work is true to life in content, but his style is uniquely personal.

THE PLIGHT OF THE URBAN POOR Daumier brought the same convictions exhibited in his graphic work to the paintings he did, especially after 1848. His unfinished *The Third-Class Carriage* (FIG. **21-6**) provides a glimpse into the cramped and grimy railway carriage of the 1860s. The riders are poor and can afford only third-class tickets. While first- and second-class carriages had closed compartments, third-class passengers were crammed together on hard benches that filled the carriage. The disinherited masses of nineteenth-century industrialism were Daumier's indignant concern, and he made them his subject repeatedly. He showed them in the unposed attitudes and unplanned arrangements of the millions thronging the modern cities—anonymous, insignificant, dumbly patient with a lot they could not change. Daumier saw people as they ordinarily appeared, their faces vague, impersonal, and blank—unprepared for any observers. He tried to achieve the real by isolating a random collection of the unrehearsed details of human existence from the continuum of ordinary life. Daumier's vision anticipated the spontaneity and candor of scenes captured with the modern snapshot camera by the end of the century.

PROMISCUITY IN A PARISIAN PARK? Like Gustave Courbet, the commitment of ÉDOUARD MANET (1832–1883) to Realist ideas was instrumental in affecting the course of modernist painting. Manet was a pivotal figure during the nineteenth century. Not only was his work critical for the articulation of Realist principles, but his art played an important role in the development of Impressionism in the 1870s. When attempting to explain the critique of the discipline central to modernism, art historians often have looked to Manet's paintings (FIGS. 21-7, 21-8, and 21-24) as prime examples. Manet's interest in Realism and in modernist principles is evident in *Le Déjeuner sur l'herbe*, or *Luncheon on the Grass* (FIG. 21-7).

Although historians can suggest precedents for the theme of *Le Déjeuner* (for example, the pastoral paintings of Giorgione, Titian, and Watteau), nothing about the painting's foreground figures recalls those earlier models. In fact, the foreground figures were all based on living, identifiable people. The seated nude is Victorine Meurend (Manet's favorite model at the time), and the gentlemen are his brother Eugène (with cane) and the sculptor Ferdinand Leenhof. The two men wear fashionable Parisian attire of the 1860s, and the foreground nude is not only a distressingly unidealized figure type, but she also seems disturbingly unabashed and at ease, looking directly at the viewer without shame or flirtatiousness.

This outraged the public—rather than a traditional pastoral scene, *Le Déjeuner* seemed merely to represent the promiscuous in a Parisian park. One hostile critic, no doubt voicing public opinion, said:

> A commonplace woman of the demimonde [the realm of the promiscuous woman, especially prostitutes], as naked as can be, shamelessly lolls between two dandies dressed to the teeth. These

21-7 ÉDOUARD MANET, *Le Déjeuner sur l'herbe (Luncheon on the Grass)*, 1863. Oil on canvas, approx. 7′ × 8′ 10″. Musée d'Orsay, Paris.

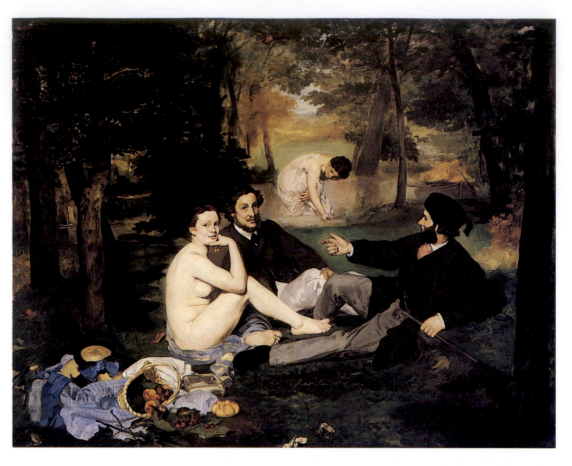

latter look like schoolboys on a holiday, perpetrating an outrage to play the man. . . . This is a young man's practical joke—a shameful, open sore.[7]

Manet's work would have been acceptable had he shown men and women as nymphs and satyrs in classical dress or undress, as did his contemporary Bouguereau (FIG. 21-9). In *Le Déjeuner*, Manet lifted the veil of allusion and bluntly confronted the public with reality.

The public and the critics disliked Manet's subject matter only slightly less than how he presented his figures. He rendered in soft focus and broadly painted the landscape, including the pool in which the second woman bathes, compared with the clear forms of the harshly lit foreground trio and the pile of discarded female attire and picnic foods at the lower left. The lighting creates strong contrasts between darks and highlighted areas. In the main figures, many values are summed up in one or two lights or darks. The effect is both to flatten the forms and to give them a hard snapping presence. Form, rather than a matter of line, is only a function of paint and light. Manet himself declared that the chief actor in the painting is the light. In true modernist fashion, Manet was using art "to call attention to art"—in other words, he was moving away from illusion and toward open acknowledgement of painting's properties, such as the flatness of the painting surface. The public, however, saw only a crude sketch without the customary "finish."

SCANDALOUS SHAMELESSNESS AND AUDACITY
Even more scandalous to the French viewing public was Manet's 1863 painting *Olympia* (FIG. **21-8**). This work depicts a young white woman reclining on a bed that extends across the foreground. Entirely nude except for a thin black

ribbon tied around her neck, a bracelet on her arm, an orchid in her hair, and fashionable mule slippers on her feet, Olympia meets viewers' eyes with a look of cool indifference. Behind her appears a black woman, who presents her a bouquet of flowers.

Public and critics alike were horrified. Although images of prostitutes were not unheard of during this period, viewers were taken aback by the shamelessness of Olympia and her look that verges on defiance. The depiction of a black woman was also not new to painting, but the viewing public perceived Manet's inclusion of both a black maid and a nude prostitute as evoking moral depravity, inferiority, and animalistic sexuality. One critic described Olympia as "a courtesan with dirty hands and wrinkled feet . . . her body has the livid tint of a cadaver displayed in the morgue; her outlines are drawn in charcoal and her greenish, bloodshot eyes appear to be provoking the public, protected all the while by a hideous Negress."[8]

From this statement, it is clear viewers were responding not just to the subject matter but to Manet's artistic style as well. Manet's brushstrokes are rougher and the shifts in tonality are more abrupt than those found in traditional academic painting (see "The Academies: Defining the Range of Acceptable Art," page 740). This departure from accepted practice exacerbated the audacity of the subject matter.

ACADEMIC ART'S CONVENTIONS AND APPEAL
To better explain the public's reaction to such modernist painting, a comparison of *Olympia* to a work by a highly acclaimed French academic artist of the time, ADOLPHE-WILLIAM BOUGUEREAU (1825–1905), is instructive. In works such as *Nymphs and Satyr* (FIG. **21-9**), Bouguereau depicted

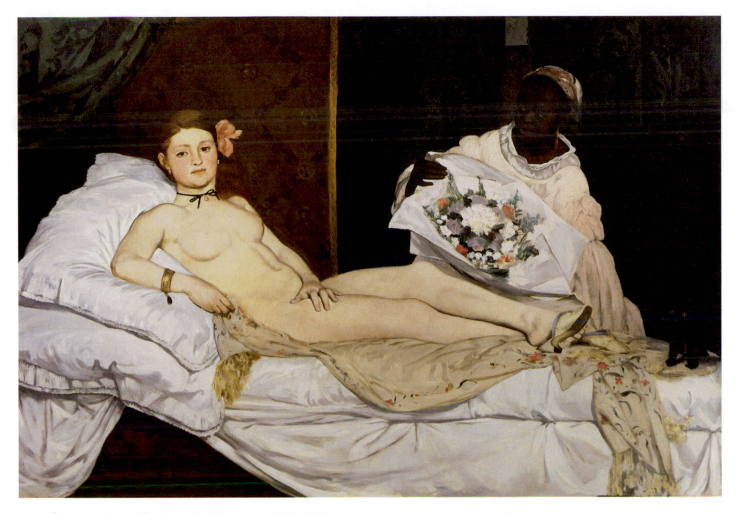

21-8 ÉDOUARD MANET, *Olympia,* 1863. Oil on canvas, 4′ 3″ × 6′ 3″. Musée d'Orsay, Paris.

classical mythological subjects with a polished illusionism. In this painting, the flirtatious and ideally beautiful nymphs strike graceful poses yet seem based as closely on nature as are the details of their leafy surroundings. They playfully pull in different directions the satyr, the mythical beast-man, with a goat's hindquarters and horns, a horse's ears and tail, and a man's upper body. Although Bouguereau arguably depicted this scene in a very naturalistic (visually realistic or illusionistic) manner, it is emphatically not Realist. His choice of a fictional theme and adherence to established painting conventions could have been seen only as staunchly traditional. Bouguereau was immensely popular during the later nineteenth century, enjoying the favor of state patronage throughout his career.

A REALIST PAINTER OF ANIMALS Another French artist who received great acclaim during her career was MARIE-ROSALIE (ROSA) BONHEUR (1822–1899). Awarded a Légion d'honneur (Legion of Honor) in 1865, Bonheur was the most celebrated woman artist of the nineteenth century. Although Bonheur's work contains Realist elements, she is perhaps more appropriately considered a "naturalist" as described by French critic Jules Castagnary. Trained as an artist by her father, Bonheur founded her career on his belief that as a woman and an artist, she had a special role to play in creating a new and perfect society. A Realist passion for accuracy in painting drove Bonheur, but she resisted depicting the

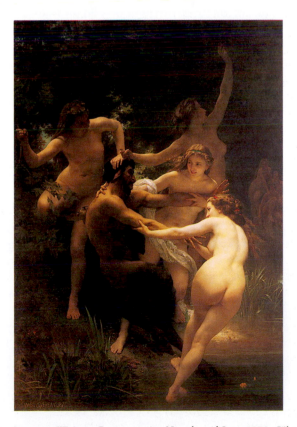

21-9 ADOLPHE-WILLIAM BOUGUEREAU, *Nymphs and Satyr,* 1873. Oil on canvas, approx. 8′ 6″ high. Sterling and Francine Clark Art Institute, Williamstown, Massachusetts.

The Academies
Defining the Range of Acceptable Art

Modernist art is often discussed in contrast to academic art. What is academic art? The term is used to refer to art sanctioned by the academies, established art schools such as the Royal Academy of Painting and Sculpture in France (founded in 1648) and the Royal Academy of Arts in Britain (founded in 1768). Both of these academies provided instruction for art students and sponsored exhibitions. During the long existence of these organizations, they exerted great control over the art scene. The annual exhibitions, called "Salons" in France (not the same as the seventeenth-century social salons), were highly competitive, as was membership in these academies. Subsidized by the government, the French Royal Academy thus supported a limited range of artistic expression, focusing on traditional subjects and highly polished technique. Because of the challenges modernist art presented to established artistic conventions, the Salons and other exhibitions often rejected it. In 1863, for example, Emperor Napoleon III established the Salon des Refusés (Salon of the Rejected) to show all of the works the academy's jury had not accepted for exhibition in the regular Salon. Works such as Manet's *Le Déjeuner sur l'herbe* (FIG. 21-7) were included in the Salon des Refusés and were met with derision by much of the public.

The Impressionists reinforced the perception of these academies as bastions of conservatism. After repeated rejections, these artists decided to form their own society in 1873 and began holding their own exhibitions in Paris. This decision allowed the Impressionists much freedom, for they did not have to contend with the academies' authoritative and confining viewpoint. The Impressionist exhibitions were held at one- or two-year intervals from 1874 until 1886. Another group of artists unhappy with the Salon's conservative nature adopted this same renegade idea. In 1884, these artists formed the Société des Artistes Indépendant (Society of Independent Artists) and held annual Salons des Indépendants.

social complexity and contradictions seen in the work of Courbet, Manet, and other Realists. Rather, she turned to the animal world. In her work, she combined a naturalist's knowledge of equine anatomy and motion with an honest love and admiration for the brute strength of wild and domestic animals. She went to great lengths to observe the anatomy of living horses at the great Parisian horse fair, where the animals were shown and traded, and also spent long hours studying the anatomy of carcasses in the Paris slaughterhouses. For her best-known work, *The Horse Fair* (FIG. **21-10**), she adopted a panoramic composition similar to that in Courbet's *Burial at Ornans* (FIG. 21-2), painted a few years earlier. In contrast to the still figures in *Burial,* Bonheur filled her broad canvas with the sturdy farm Percherons and their grooms seen on parade at

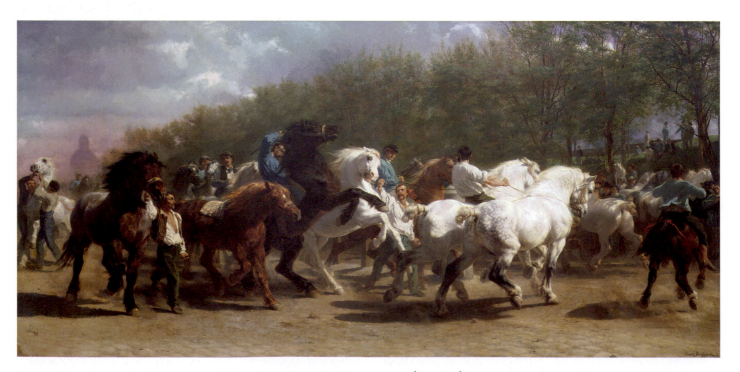

21-10 MARIE-ROSALIE (ROSA) BONHEUR, *The Horse Fair,* 1853–1855. Oil on canvas, $8' \frac{1}{4}'' \times 16' 7\frac{1}{2}''$. Metropolitan Museum of Art, New York (gift of Cornelius Vanderbilt, 1887).

the annual Parisian horse sale. Some horses, not quite broken, rear up; others plod or trot, guided on foot or ridden by their keepers. The uneven line of the march, the thunderous pounding, and the Percherons' seemingly overwhelming power clearly were based on close observation from life, even though Bonheur acknowledged some inspiration from the Classical model of the Parthenon frieze (see FIG. 5-48). The dramatic lighting, loose brushwork, and rolling sky also reveal her admiration of the style of Géricault (see FIG. 20-41). Bonheur's depiction of equine drama in *The Horse Fair* captivated viewers, who eagerly bought engraved reproductions of the work, making it one of the most well-known paintings of the century.

Despite the public's derision, the French Realists—Courbet, Millet, Daumier, Manet, and other artists—challenged the whole iconographic stock of traditional art and called public attention to what Baudelaire termed the "heroism of modern life."[9] In so doing, they not only changed the course of Western art, but they also left succeeding generations of viewers with a broader understanding of French life and culture in the later nineteenth century.

REALISM OUTSIDE FRANCE

Although French artists took the lead in promoting Realism and the notion that artists should depict the realities of modern life, this movement was not exclusively French. The Realist foundation in empiricism and positivism appealed to artists in many countries, including Germany, Russia, England, and the United States. Realism emerged in a variety of forms and places and was well established by the end of the century.

AN AMERICAN REALIST In the United States, a dedicated appetite for showing the realities of the human experience made THOMAS EAKINS (1844–1916) a master Realist portrait and genre painter. He studied both painting and medical anatomy in Philadelphia before undertaking further study under French artist Jean-Léon Gérôme (1824–1904). Eakins was resolutely a Realist; his ambition was to paint things as he saw them rather than as the public might wish them portrayed. This attitude was very much in tune with nineteenth-century American taste, combined an admiration for accurate depiction with a hunger for truth. These twin attributes are reflected in Ralph Waldo Emerson's observation that the American character delights in accurate perception and in Henry David Thoreau's insistence that the value of a fact is that it eventually flowers in a truth.

AN IMAGE NOT FOR THE SQUEAMISH The too-brutal Realism of Eakins's early masterpiece, *The Gross Clinic* (FIG. 21-11), prompted the art jury to reject it for the Philadelphia exhibition that celebrated the American independence centennial. The work presents the renowned surgeon Dr. Samuel Gross in the operating amphitheatre of the Jefferson Medical College in Philadelphia, where the painting now hangs. That Eakins chose to depict such an event testifies to the public's increasing faith in scientific and medical progress. Dr. Gross, with bloody fingers and scalpel, lectures

about his surgery on a young man's leg. The patient suffered from osteomyelitis, a bone infection. The surgeon, acclaimed for his skill in this particular operation, is accompanied by colleagues, all of whom historians have identified, and by the patient's mother, who covers her face. Indicative of the contemporaneity of this scene is the anesthetist's presence in the background, holding the cloth over the patient's face. Anesthetics had been introduced in 1846, and their development eliminated a major obstacle to extensive surgery. The painting is, indeed, an unsparing description of a contemporaneous event, with a good deal more reality than many viewers could endure. "It is a picture," one critic said, "that even strong men find difficult to look at long, if they can look at it at all."[10] It was true to the artistic program of "scenes from modern life," as Southworth and Hawes had been in their daguerreotype of a similar setting (see FIG. 20-63). Both images recorded a particular event at a particular time.

Eakins believed that knowledge—and where relevant, scientific knowledge—was a prerequisite to his art. As a scientist (in his anatomical studies), Eakins preferred a slow, deliberate method of careful invention based on his observations of the perspective, the anatomy, and the actual details of his subject. This insistence on scientific fact corresponded to the dominance of empiricism during the latter half of the nineteenth century. Eakins's concern for anatomical correctness led him to investigate the human form and humans in motion, both with regular photographic apparatuses and with a special camera that the French *kinesiologist* (a person who studies the physiology of body movement) Étienne-Jules Marey devised. Eakins's later collaboration with Eadweard Muybridge in the photographic study of animal and human action of all types drew favorable attention in France, especially from Degas, and anticipated the motion picture.

EVERYTHING BUT THE CLATTER OF HOOFS The Realist photographer and scientist EADWEARD MUYBRIDGE (1830–1904) came to the United States from England in the 1850s and settled in San Francisco, where he established a prominent international reputation for his photographs of the western United States. (His large-plate landscape images of the Yosemite region won him a gold medal at the Vienna Exposition of 1873.) In 1872, the governor of California, Leland Stanford, sought Muybridge's assistance in settling a bet about whether, at any point in a stride, all four feet of a horse galloping at top speed are off the ground. Through his sequential photography, as seen in *Horse Galloping* (FIG. 21-12), Muybridge proved they were. This experience was the beginning of Muybridge's photographic studies of the successive stages in human and animal motion—details too quick for the human eye to capture. These investigations culminated in 1885 at the University of Pennsylvania with a series of multiple-camera motion studies that recorded separate photographs of progressive moments in a single action. His discoveries received extensive publicity through the book *Animal Locomotion*, which Muybridge published in 1887. Muybridge's motion photographs earned him a place in the history of science, as well as art. His sequential motion studies, along with those of Eakins and Marey, influenced many other artists, including their contemporary, the painter and sculptor Edgar Degas, and twentieth-century artists such as Marcel Duchamp.

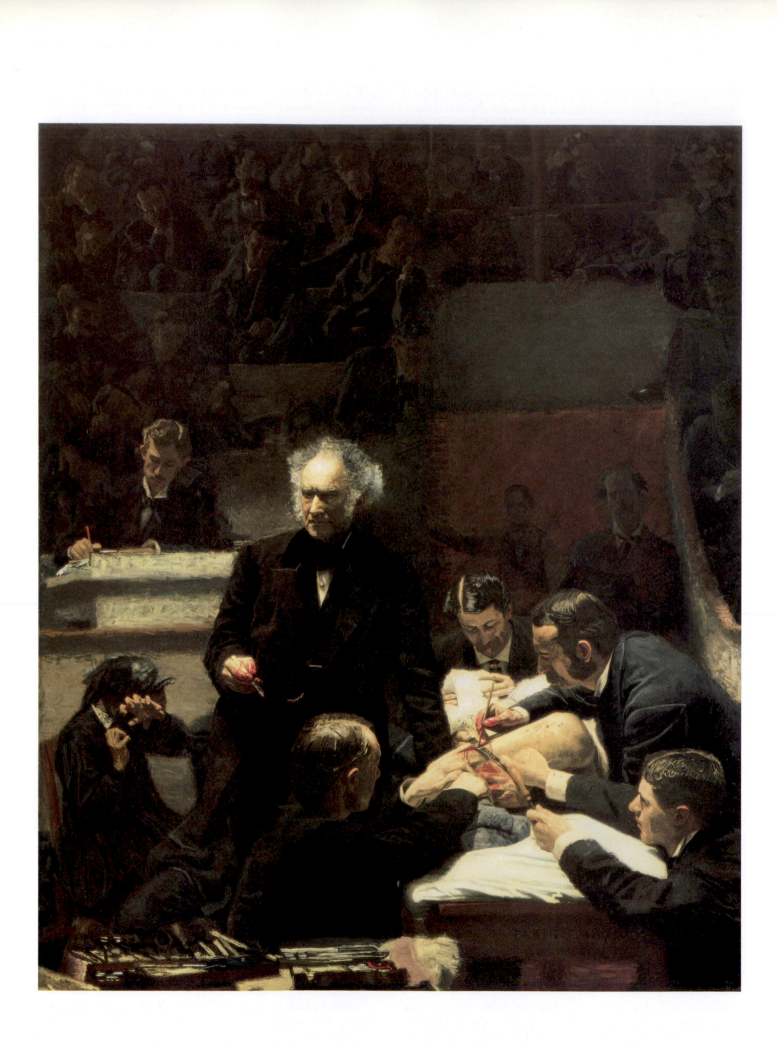

21-11 THOMAS EAKINS, *The Gross Clinic,* 1875. Oil on canvas, 8′ × 6′ 6″. Jefferson Medical College of Thomas Jefferson University, Philadelphia.

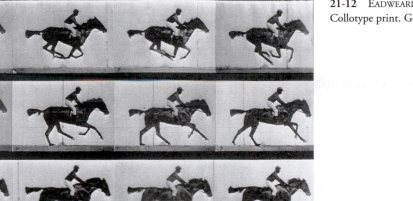

21-12 EADWEARD MUYBRIDGE, *Horse Galloping*, 1878. Collotype print. George Eastman House, Rochester, New York.

Muybridge presented his work to scientists and general audiences with a device called the zoopraxiscope, which he invented to project his sequences of images (mounted on special glass plates) onto a screen. The result was so lifelike one viewer said it "threw upon the screen apparently the living, moving animals. Nothing was wanting but the clatter of hoofs upon the turf."[11] The illusion of motion here was created by a physical fact of human eyesight called "persistence of vision." Stated simply, it means the brain holds whatever the eye sees for a fraction of a second after the eye stops seeing it. Thus, viewers saw a rapid succession of different images merging one into the next, producing the illusion of continuous change. This illusion lies at the heart of the "realism" of all cinema.

AMERICAN REALIST PORTRAITURE The expatriate American artist JOHN SINGER SARGENT (1856–1925) was a younger contemporary of Eakins and Muybridge. In contrast to Eakins's carefully rendered details, Sargent developed a looser, more dashing Realist portrait style. Sargent studied art in Paris before settling in London, where he was renowned both as a cultivated and cosmopolitan gentleman and as a facile and fashionable portrait painter. He learned his fluent brushing of paint in thin films and his effortless achievement of quick and lively illusion from his study of Velázquez, whose masterpiece, *Las Meninas* (see FIG. 19-33), may have influenced Sargent's family portrait *The Daughters of Edward Darley Boit* (FIG. **21-13**). The four girls (the children of one of Sargent's close friends) appear in a hall and small drawing room in their Paris home. The informal, eccentric arrangement of their slight figures suggests how much at ease they are within this familiar space and with objects such as the monumental Japanese vases, the red screen, and the fringed rug, whose scale subtly emphasizes the children's diminutive stature. Sargent must have known the Boit daughters well and liked them. Relaxed and trustful, they gave the artist an opportunity to record a gradation of young innocence. He sensitively captured the naive, wondering openness of the little girl in the foreground, the grave artlessness of the ten-year-old child, and the slightly self-conscious poise of the adolescents. Sargent's casual positioning of the figures and seemingly random choice of the setting communicate a sense of spontaneity. The children seem to be attending momentarily to an adult who has asked them to interrupt their activity and "look this way." Here is a most effective embodiment of the Realist belief that the artist's business is to record the modern being in modern context.

THE DEVOTION OF ORDINARY PEOPLE Typical of the Realist painter's desire to depict the lives of ordinary people is the early work of the American artist HENRY OSSAWA TANNER (1859–1937). Tanner studied art with Eakins before moving to Paris. There he combined Eakins's belief in careful study from nature with a desire to portray with dignity the life of the ordinary people he had been raised among as the son of an African-American minister in Pennsylvania. The mood in *The Thankful Poor* (FIG. **21-14**) is one of quiet devotion not far removed from the Realism of Millet (FIG. 21-3). In Tanner's painting, the grandfather, grandchild, and main objects in the room are painted with the greatest detail, while everything else dissolves into loose strokes of color and light. Expressive lighting reinforces the painting's reverent spirit, with deep shadows intensifying the man's devout concentration and golden light pouring in the window to illuminate the quiet expression of thanksgiving on the younger face. The deep sense of sanctity expressed here in terms of everyday experience became increasingly important for Tanner. Within a few years of completing *The Thankful Poor,* he began painting biblical subjects grounded in direct study from nature and in the love of Rembrandt that had inspired him from his days as a Philadelphia art student.

Over time, Realist artists throughout Europe and America expanded and diversified their subjects to embrace all classes and levels of society, all types of people and environments. These included the urban and rural working class, the big-city inhabitants, the small-town citizens, the leisure class at its resorts, and the rustics of the provinces. Added to the social sympathies found in the works of Daumier, Courbet, and Millet were motives of an anthropological kind, reflecting interest in national and regional characteristics, in folk customs and culture, and in the quaintness of local color.

21-13 JOHN SINGER SARGENT,
*The Daughters of Edward Darley
Boit,* 1882. Oil on canvas,
7′ 3⅜″ × 7′ 3⅝″. Courtesy of
Museum of Fine Arts, Boston
(gift of Mary Louisa Boit,
Florence D. Boit, Jane Hubbard
Boit and Julia Overing Boit, in
memory of their father, Edward
Darley Boit, 19.124).

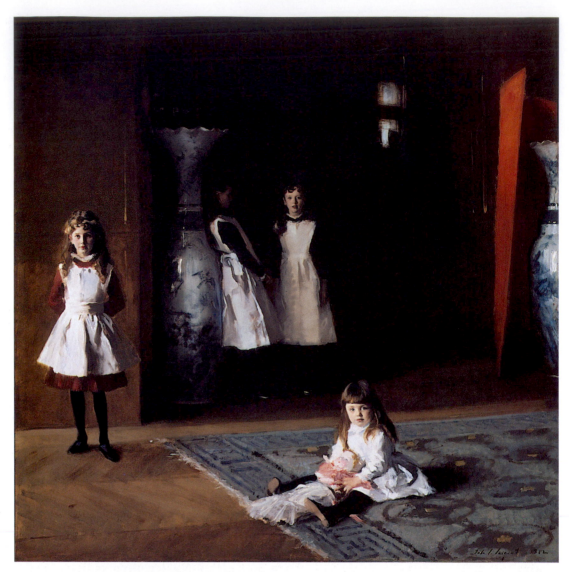

21-14 HENRY OSSAWA TANNER, *The
Thankful Poor,* 1894. Oil on canvas, 2′ 11½″ ×
3′ 8¼″. Collection of William H. and
Camille Cosby.

THE PRE-RAPHAELITE BROTHERHOOD

EMBRACING THE PRE-INDUSTRIAL PAST In England, JOHN EVERETT MILLAIS (1829–1896) was among a group of artists who refused to be limited to the contemporary scenes strict Realists portrayed. These artists chose instead to represent fictional, historical, and fanciful subjects but to do so using Realist techniques. So painstakingly careful was Millais in his study of visual facts closely observed from nature that Baudelaire called him "the poet of meticulous detail." Millais was a founder of the so-called Pre-Raphaelite Brotherhood. This group of artists, organized in 1848, wished to create fresh and sincere art, free from what they considered the tired and artificial manner the successors of Raphael propagated in the academies. Influenced by the influential critic, artist, and writer John Ruskin (1819–1900), Millais agreed with his distaste for the materialism and ugliness of the contemporary industrializing world and Millais also shared the Pre-Raphaelites' appreciation for the spirituality and idealism (as well as the art and artisanship) of past times, especially the Middle Ages and the Early Renaissance.

A SHAKESPEAREAN HEROINE DROWNED Millais's method is apparent in *Ophelia* (FIG. **21-15**), which he exhibited in the Universal Exposition in Paris in 1855, where Courbet set up his Pavilion of Realism. The subject, from Shakespeare's *Hamlet,* is the drowning of Ophelia, who, in her madness, is unaware of her plight:

> *Her clothes spread wide,*
> *And mermaidlike awhile they bore her up—*
> *Which time she chanted snatches of old tunes,*
> *As one incapable of her own distress.*
> (4.7.176–79)

Attempting to make the pathos of the scene visible, Millais became a faithful and feeling witness of its every detail, reconstructing it with a lyricism worthy of the original poetry. Although Millais's technique was optically realistic, orthodox nineteenth-century Realists would have complained the subject was not—that it was playacting. It may be that this conflict between what is actually seen or experienced and the realistic representation of fictitious or past events was eventually resolved in modern cinema. The kind of drama Millais depicted in *Ophelia,* which brought the fictive action of a theatrical event before viewers' eyes with optical fidelity, anticipated the dramatic motion pictures whose creators presented fictions and facts to the eye as equally real. Nineteenth-century Realists might have objected that picture dramas such as *Ophelia* were not paintings but stage productions and could only be judged as such.

A "PICTORIAL" PHOTOGRAPHIC METHOD Photography, the artificial eye, the medium created to serve the taste for visual fact, for realistic report of the world, was itself the creator of a new Realism. But it also could be manipulated by talented photographers to produce quite Romantic

21-15 JOHN EVERETT MILLAIS, *Ophelia,* 1852. Oil on canvas, 2′ 6″ × 3′ 8″. Tate Gallery, London.

effects. After the first great breakthroughs, which bluntly showed what was before the eye, photographers imitated Romantic arrangements of nature, filtering natural appearance through sentiment—soft-focusing it, as it were. In the later century, with much public approval, photography had a Romantic-Realist school of its own. The photographers thought of it as a "pictorial" method.

One of the leading practitioners of the Pictorial style in photography was the American GERTRUDE KÄSEBIER (1852–1934). Käsebier took up photography in 1897 after raising a family and working as a portrait painter. She soon became famous for photographs with symbolic themes, such as *Blessed Art thou Among Women* (FIG. **21-16**). The title repeats the phrase the angel Gabriel used in the New Testament to announce to the Virgin Mary that she will be the mother of Jesus. In the context of Käsebier's photography, the words suggest a parallel between the biblical "Mother of God" and the modern mother in the image, who both protects and sends forth her daughter. The white setting and the mother's pale gown shimmer in soft focus behind the serious girl, who

is dressed in darker tones and captured with sharper focus. Here, as in her other works, the ideas about naturalism in photography championed by photographer Peter Henry Emerson (1856–1936) influenced Käsebier. Yet she deliberately ignored his teachings about differential focusing, combining an out-of-focus background with a sharp or almost-sharp foreground, in favor of achieving an "expressive" effect by blurring the entire image slightly. In *Blessed Art thou*, the whole scene is invested with an aura of otherworldly peace by the soft focus, the appearance of the centered figures, the vertical framing elements, and the relationship between the frontally posed girl and her gracefully bending mother. As one contemporaneous critic wrote: "The manner in which modern dress was handled, subordinated, and made to play its proper part in the composition . . . evidenced great artistic feeling."[12] *Blessed Art thou* is a superb example of Käsebier's moving ability to invest scenes from everyday life with a sense of the spiritual and the divine.

IMPRESSIONISM: CAPTURING THE FUGITIVE IMAGES OF MODERN LIFE

Impressionism, both in content and style, was an art of industrialized, urbanized Paris. As such, it furthered some of the Realists' concerns and was resolutely an art of its time. But whereas Realism focused on the present, Impressionism focused even more acutely on a single moment. Although Impressionism often is discussed as a coherent movement, it was actually a nebulous and shifting phenomenon. People have perceived the Impressionists as a group largely because they exhibited together in the 1870s and 1880s. However, participation in these shows was a constant source of contention and debate among the artists.

IMPRESSIONISM AND THE SKETCH A hostile critic applied the label *Impressionism* in response to the painting *Impression: Sunrise* (FIG. **21-17**) by CLAUDE MONET (1840–1926). The artist exhibited this work in the first Impressionist show in 1874, and, although the critic intended the term to be derogatory, by the third Impressionist show in 1878 the artists themselves were using that label.

The term *impressionism* had been used in art before but in relation to sketches. Impressionist paintings incorporated the qualities of sketches—abbreviation, speed, and spontaneity. The Impressionist work thus was "finished" in the sense of a complete thought or the characterization of a specific moment, rather than through the polish and reworking typical of academic works. This is apparent in *Impression: Sunrise*. The brushstrokes are clearly evident; Monet made no attempt to blend the pigment to create smooth tonal gradations and an optically accurate scene. Although this painting is not a sketch, technically speaking, it has a sketchy quality. This increased concern with acknowledging the paint and the canvas surface continued the modernist direction the Realists began.

CAPTURING A FLEETING MOMENT The lack of pristine clarity characteristic of most Impressionist works is also historically grounded. The extensive industrialization and urbanization that occurred in France during the latter half of the nineteenth century can be described only as a brutal and

21-16 GERTRUDE KÄSEBIER, *Blessed Art thou Among Women*, 1899. Platinum print on Japanese tissue, $9\frac{3}{8}'' \times 5\frac{1}{2}''$. Museum of Modern Art, New York (gift of Mrs. Hermine M. Turner).

21-17 CLAUDE MONET, *Impression: Sunrise,* 1872. Oil on canvas, 1′ 7½″ × 2′ 1½″. Musée Marmottan, Paris.

chaotic transformation. The rapidity of these changes made the world seem unstable and insubstantial. As noted French poet Charles Baudelaire observed: "[M]odernity is the transitory, the fugitive, the contingent."[13] Accordingly, Impressionist works represent an attempt to capture a fleeting moment—not in the absolutely fixed, precise sense of a Realist painting but by conveying the elusiveness and impermanence of images and conditions.

THE RAILROADS AND PARISIAN LIFE That Impressionism was firmly anchored in the industrial development of the time and in the concurrent process of urbanization is also revealed by the artists' choice of subjects. Most of the Impressionists depicted scenes in and around Paris, where industrialization and urbanization had their greatest impact. Monet's *Saint-Lazare Train Station* (FIG. **21-18**) depicts a dominant aspect of Parisian life. The expanding railway

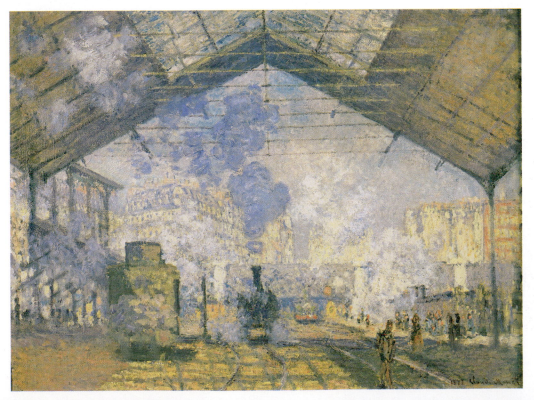

21-18 CLAUDE MONET, *Saint-Lazare Train Station,* 1877. Oil on canvas, approx. 2′ 5¾″ × 3′ 5″. Musée d'Orsay, Paris.

network had made travel more convenient, bringing throngs of people into Paris. Saint-Lazare Station was centrally located, adjacent to the Grands Boulevards, a bustling, fashionable commercial area. Monet captured the area's energy and vitality; the train, emerging from the steam and smoke it emits, comes into the station. Through the background haze, viewers can make out the tall buildings that were becoming a major component of the Parisian landscape. Monet's agitated paint application contributes to the sense of energy and conveys the atmosphere of urban life.

THE HAUSSMANIZATION OF PARIS Other Impressionists also represented facets of city life. GUSTAVE CAILLEBOTTE (1849–1893) depicted yet another scene in *Paris: A Rainy Day* (FIG. **21-19**). His setting is a junction of spacious boulevards that resulted from the redesigning of Paris begun in 1852. The city's population had reached close to one and a half million by midcentury, and to accommodate this congregation of humanity, Emperor Napoleon III ordered Paris rebuilt. The emperor named Baron Georges Haussmann, a city superintendent, to oversee the entire project; consequently, this process became known as "Haussmanization." In addition to new water and sewer systems, street lighting, and new residential and commercial buildings, a major component of the new Paris was the creation of wide, open boulevards. These great avenues, whose construction caused the demolition of thousands of ancient buildings and streets, transformed medieval Paris into the present modern city, with its superb vistas and wide uninterrupted arteries for the flow of vehicular and pedestrian traffic. Caillebotte chose to focus on these markers of the city's rapid urbanization.

The artist deliberately used an informal and asymmetrical composition. The figures seem randomly placed, with the frame cropping them arbitrarily. Well-dressed Parisians of the leisure class share the viewers' space. Viewers and subjects all participate in the same weather, which the painter carefully indicated, not only by the umbrellas but also by the wet cobblestones, puddles, and faint reflections that blend into the monochromatic tonality of a gray day. Caillebotte did not dissolve his image into the broken color and brushwork characteristic of Impressionism. But in the apparently chance arrangement of his figures, their motion suspended in a moment already passed, Caillebotte's *Paris: A Rainy Day* is certainly an "impression," an instant long gone.

A GLIMPSE OF A PARISIAN BOULEVARD SCENE Like Caillebotte, EDGAR DEGAS (1834–1917) took to the Parisian boulevards to watch the pedestrians, to catch the chance arrangements and the shifting patterns of their motion that his picture frame would crop as they passed. His *Viscount Lepic and His Daughters* (FIG. **21-20**) summarizes what the artist had learned from photography, from his own painstaking research, and from what his generation absorbed from the Japanese print—the clear, flat pattern; the unusual viewpoint; and the informal glimpse of contemporary life. Whatever his subject, Degas saw it in terms of clear line and pattern observed from a new and unexpected angle. In *Viscount Lepic and His Daughters,* the divergent movements of the father and his small daughters, of the man entering the picture at the left, and of the horse and carriage passing across the background provide a vivid pictorial account of a moment in time at a particular position in space. In another instant, this scene in real life would have disappeared, for each of the figures would have moved in a different direction and the group would have dissolved. Here again, Degas, like Caillebotte, made clever use of the street to integrate viewers into the

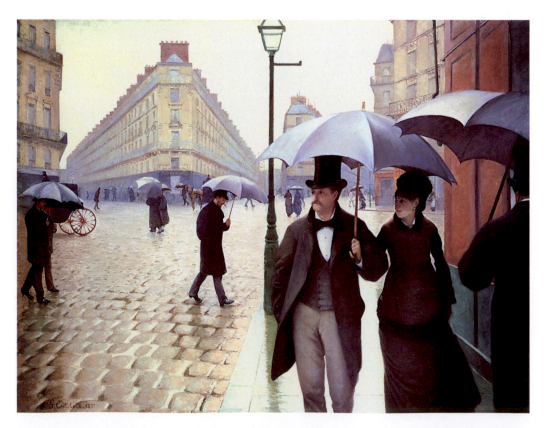

21-19 GUSTAVE CAILLEBOTTE, *Paris: A Rainy Day,* 1877. Oil on canvas, approx. 6′ 9″ × 9′ 9″. The Art Institute of Chicago, Chicago, Worcester Fund.

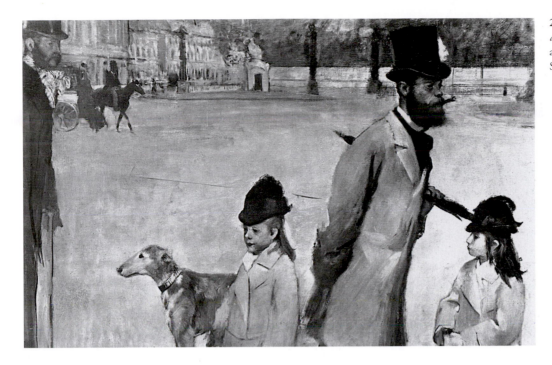

21-20 EDGAR DEGAS, *Viscount Lepic and His Daughters,* 1873. Oil on canvas, approx. 2′ 8″ × 3′ 11″. The Hermitage, Saint Petersburg.

space containing the figures. Actually, the painter seems to have taken into account the full sweep of a viewer's glance—everything one would see in a single split-second inspection.

A PANORAMA OF BUSTLING CROWDS *La Place du Théâtre Français* (FIG. **21-21**) is one of many panoramic scenes by CAMILLE PISSARRO (1830–1903) of the spacious boulevards and avenues that were the product of Haussmanization. In this painting, Pissarro recorded a panorama of blurred dark accents against a light ground that represents clearly his visual sensations of a crowded Paris square viewed from several stories above street level. Like many of the other Impressionists, Pissarro sought to capture a moment in time, but the moment in *La Place du Théâtre Français* is not so much of fugitive light effects as it is of the street life, achieved through a deliberate casualness in the figural arrangement.

Pissarro sometimes used the amazing "reality" of photography to supplement work directly from a model, like many of

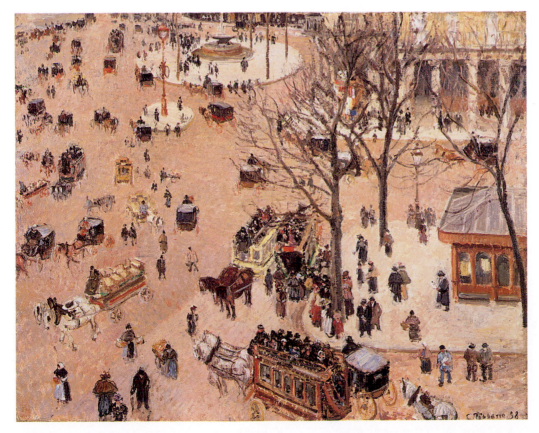

21-21 CAMILLE PISSARRO, *La Place du Théâtre Français,* 1898. Oil on canvas, 2′ 4½″ × 3′ ½″. Los Angeles County Museum of Art, Los Angeles (the Mr. and Mrs. George Gard De Sylva Collection).

21-22 Hippolyte Jouvin, *The Pont Neuf, Paris,* ca. 1860–1865. Albumen stereograph.

his fellow Impressionists. Although he may not have known the stereophotograph *The Pont Neuf, Paris* (FIG. **21-22**), its effect is remarkably similar to his *La Place du Théâtre*. With a special twin-lensed camera, Hippolyte Jouvin (active mid-1800s) made the stereograph, viewed with an apparatus, a stereoscope, to re-create the illusion of three dimensions. In this double image, the viewer's vantage point is from the upper story of a building along the roadway of the "New Bridge," which stretches diagonally from lower left to upper right. Hurrying pedestrians are dark silhouettes, and the scene moves from sharp focus in the foreground to soft focus in the distance. Because of the familiarity Pissarro and the other Im-

21-23 Pierre-Auguste Renoir, *Le Moulin de la Galette,* 1876. Oil on canvas, approx. 4′ 3″ × 5′ 8″. Louvre, Paris.

21-24 ÉDOUARD MANET, *A Bar at the Folies-Bergère*, 1882. Oil on canvas, approx. 3′ 1″ × 4′ 3″. The Courtauld Gallery, London.

pressionists had with photography, scholars have been quick to point out the visual parallels between Impressionist paintings and photographs. These parallels include, here, the arbitrary cutting off of figures at the frame's edge and the curious flattening spatial effect the high viewpoint caused.

LEISURE AND RECREATION Another facet of the new, industrialized Paris that drew the Impressionists' attention was the leisure activities of its inhabitants. Scenes of dining, dancing, the café-concerts, the opera, the ballet, and other forms of enjoyable recreation were mainstays of Impressionism. Although seemingly unrelated to industrialization, these activities were facilitated by it. With the advent of set working hours, people's schedules became more regimented, allowing them to plan their favorite pastimes.

SOCIALIZING AT A PARISIAN DANCE HALL *Le Moulin de la Galette* (FIG. **21-23**) by PIERRE-AUGUSTE RENOIR (1841–1919) depicts a popular Parisian dance hall. Throngs of people have gathered; some people crowd the tables and chatter, while others dance energetically. So lively is the atmosphere that viewers virtually can hear the sounds of music, laughter, and tinkling glasses. The whole scene is dappled by sunlight and shade, artfully blurred into the figures to produce just the effect of floating and fleeting light the Impres-

sionists so cultivated. Renoir's casual unposed placement of the figures and the suggested continuity of space, spreading in all directions and only accidentally limited by the frame, position viewers as participants, rather than as outsiders. Whereas classical art sought to express universal and timeless qualities, Impressionism attempted to depict just the opposite—reality's incidental, momentary, and passing aspects.

A PERPLEXING IMAGE OF A BARMAID Édouard Manet's masterpiece, *A Bar at the Folies-Bergère* (FIG. **21-24**), was painted in 1882. The Folies-Bergère was a popular Parisian café-concert (a café with music-hall performances). Not only were these cafés fashionable gathering places for the throngs of revelers, but many of the Impressionists also frequented these establishments. In *Folies-Bergère,* viewers are confronted by a barmaid, centrally placed, who looks back but who seems disinterested or lost in thought. This woman appears divorced from the patrons as well as from viewers.

Manet blurred and roughly applied the brushstrokes, particularly those in the background, and the effects of modeling and perspective are minimal. This painting method further calls attention to the surface by forcing viewers to scrutinize the work to make sense of the scene. On such scrutiny, visual discrepancies seem to emerge. For example, what initially

21-25 EDGAR DEGAS, *Ballet Rehearsal (Adagio)*, 1876. Oil on canvas, 1′ 11″ × 2′ 9″. Glasgow Museum, Glasgow (The Burrell Collection).

seems easily recognizable as a mirror behind the barmaid creates confusion throughout the rest of the painting. Is the woman on the right the barmaid's reflection? If so, it is impossible to reconcile the spatial relationship between the barmaid, the mirror, the bar's frontal horizontality, and the barmaid's seemingly displaced reflection. Manet's insistence on calling attention to the pictorial structure of this painting through these visual contradictions continued his Realist interest in examining the medium's basic premises. This radical break with tradition and redefinition of the function of the picture surface explains why many scholars position Manet as the first modernist artist.

OF MUSIC AND DANCE: BALLET IMAGES Impressionists also depicted more formal leisure activities. Edgar Degas's fascination with patterns of motion brought him to the Paris Opéra and its ballet school. There, his great observational power took in the formalized movements of classical ballet, one of his favorite subjects. In *Ballet Rehearsal (Adagio)*, FIG. **21-25**, Degas used several devices to bring observers into the pictorial space. The frame cuts off the spiral stair, the windows in the background, and the group of figures in the right foreground. The figures are not centered but rather, arranged in a seemingly random manner. The prominent diagonals of the wall bases and floorboards carry viewers into and along the directional lines of the dancers. Finally, as is customary in Degas's ballet pictures, a large, off-center, empty space creates the illusion of a continuous floor that connects observers with the pictured figures. By seeming to stand on the same surface with them, viewers are drawn into their space.

The often arbitrarily cutoff figures, the patterns of light splotches, and the blurriness of the images in this and other Degas works indicate the artist's interest in reproducing single moments. Further, they reveal his fascination with photogra-

phy. Degas not only studied the photography of others, but he also used the camera consistently to make preliminary studies for his works, particularly photographing figures in interiors. Other inspirational sources for paintings such as *Ballet Rehearsal* were eighteenth-century Japanese woodblock prints (see "Japonisme: The Allure of the Orient," page 754). The cunning spatial projections in Degas's paintings probably derived in part from Japanese prints, such as those by Suzuki Harunobu. Japanese artists used diverging lines not only to organize the flat shapes of figures but also to direct viewers' attention into the picture space. The Impressionists, acquainted with these prints as early as the 1860s, greatly admired their spatial organization, the familiar and intimate themes, and the flat unmodeled color areas and drew much instruction from them.

SAILING ALONG THE SEINE The Impressionists were drawn to painting outdoor leisure activity, and many of their prototypical works depict scenes from resort areas along the Seine River, such as Argenteuil, Bougival, and Chatou. Argenteuil was connected to Paris by the railway line that carried people to and from Saint-Lazare Station, so transportation was not an obstacle. Parisians often would take the train out to Argenteuil for a day of sailing, picnicking, and strolling along the Seine.

Claude Monet's many paintings of Argenteuil often have been seen as quintessentially Impressionist. In *Le Bassin d'Argenteuil (Argenteuil Basin*; FIG. **21-26**), sailboats float serenely on the intensely blue water. Sailing was a particularly popular recreational activity, and because the Seine was wider and deeper at Argenteuil than at other locations, it attracted those interested in boating.

Despite the rather static composition, the shimmering reflections of the boats on the water enliven the scene and impart a feeling of vibrancy. Monet enhanced this sense of

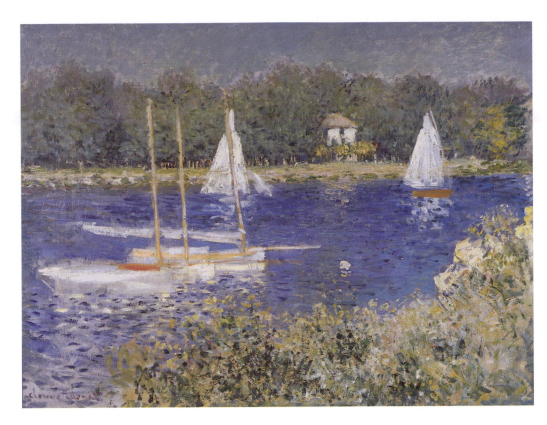

21-26 CLAUDE MONET, *Le Bassin d'Argenteuil,* ca.1875. Oil on canvas, approx. 1′ 9¾″ × 2′ 5¼″. Museum of Art, Rhode Island School of Design, Providence (gift of Mrs. Murray S. Danforth).

spontaneity with choppy brushstrokes, which suggest the breeze that plays across the surface of the water or through the trees and bushes, setting the leaves aflutter.

RELAXED LEISURE BY THE SEASIDE BERTHE MORISOT (1841–1895) regularly exhibited with the Impressionists and was well acquainted with those artists (Manet was her brother-in-law). Most of her paintings focus on domestic scenes, the one realm of Parisian life where society allowed an upper-class woman such as Morisot free access. Morisot's considerable skills are evident in *Villa at the Seaside* (FIG. **21-27**). Both the subject and style correlate well with

21-27 BERTHE MORISOT, *Villa at the Seaside,* 1874. Oil on canvas, approx. 1′ 8″ × 2′. Norton Simon Art Foundation, Los Angeles.

ART AND SOCIETY

Japonisme
The Allure of the Orient

Despite Europe and America's rampant colonization during the nineteenth century, Japan avoided Western intrusion until 1853–1854, when Commodore Matthew Perry and American naval forces exacted trading and diplomatic privileges from Japan. From the increased contact, Westerners became familiar with Japanese culture. So intrigued were the French with Japanese art and culture that a specific label—"Japonisme"—was introduced to describe the Japanese aesthetic. Japonisme appealed to the fashionable segment of Parisian society, which no doubt was attracted to both the beauty and the exoticism of this foreign culture. In 1867 at the Universal Exposition in Paris, the Japanese pavilion garnered more attention than any other. Soon, Japanese kimonos, fans, lacquer cabinets, tea caddies, folding screens, tea services, and jewelry flooded Paris. Japanese-themed novels and travel books were immensely popular as well. As demand for Japanese merchandise grew in the West, the Japanese began to develop import-export businesses, and the foreign currency that flowed into Japan helped to finance much of its industrialization.

Artists in particular were drawn to Japanese art. Among those the Japanese aesthetic influenced were most of the Impressionists and Post-Impressionists, especially Manet, James Abbott McNeill Whistler, Degas, Mary Cassatt, Vincent van Gogh, Paul Gauguin, and Henri de Toulouse-Lautrec. For the most part, the Japanese presentation of space in woodblock prints, which were more readily available to the West than any other art form, intrigued these artists. Because of the simplicity of the wood-block printing process—a separate block is made for each color, and each block is printed in sequence—these prints are characterized by areas of flat color with a limited amount of modulation or gradation. This flatness interested modernist painters, who sought ways to call attention to the picture surface. The right side of Degas's *The Tub* (FIG. 21-29) has this two-dimensional quality. Degas, in fact, owned a print by Japanese artist Torii Kiyonaga (1752–1815) titled *Women's Bath* (ca. 1780) that inspired *The Tub*. The decorative quality of Japanese images also appealed to the artists associated with Art Nouveau (FIGS. 21-52, 21-53, and 21-54) and intersected nicely with two fundamental principles of the Arts and Crafts movement (FIGS. 21-50 and 21-51). These were that art should be available to the masses and that functional objects should be artistically designed, which account for that group's interest.

Impressionist concerns. The setting is the shaded veranda of a summer hotel at a fashionable seashore resort. A woman elegantly but quietly dressed sits gazing out across the railing to a sunlit beach with its umbrellas and bathing cabins. Her child, its discarded toy boat a splash of red, is attentive to the passing sails on the placid sea. The mood is of relaxed leisure. Morisot used the open brushwork and the *plein-air* (outdoor) lighting characteristic of Impressionism. Her brushwork is telegraphic in its report of her quick perceptions. Everything is suggested by swift, sketchy strokes, and nowhere did Morisot linger on contours or enclosed details. She presented the scene in a slightly filmy soft focus that conveys a feeling of airiness. The composition is also reminiscent of the work of other Impressionists; the figures fall informally into place, as someone who shared their intimate space would perceive them. Morisot was both immensely ambitious and talented, as her ability to catch the pictorial moment demonstrates. She escaped the hostile criticism directed at most of the other Impressionists; people praised her work for its sensibility, grace, and delicacy.

MONET'S STUDIES OF LIGHT AND COLOR
Monet's experiences painting outdoors sharpened his focus on the roles light and color play in capturing an instantaneous representation of atmosphere and climate. Monet, of all the Impressionists, carried the systematic investigation of light and color furthest. However, all of the artists associated with this movement recognized the importance of carefully observing

and understanding how light and color operate. Such thorough study permitted the Impressionists to present images that truly conveyed a sense of the momentary and transitory.

Scientific studies of light and the invention of chemical pigments increased artists' sensitivity to the multiplicity of colors in nature and gave them new colors for their work. After scrutinizing the effects of light and color on forms, the Impressionists concluded that *local color*—an object's actual color—usually is modified by the quality of the light in which it is seen, by reflections from other objects, and by the effects juxtaposed colors produce. Shadows do not appear gray or black, as many earlier painters thought, but seem to be composed of colors modified by reflections or other conditions. If artists use complementary colors (see Introduction, page xl in combined volumes or page xx in Volume II) side by side over large enough areas, the colors intensify each other, unlike the effect of small quantities of adjoining mixed pigments, which blend into neutral tones. Furthermore, the juxtaposition of colors on a canvas for the eye to fuse at a distance produces a more intense hue than the same colors mixed on the palette. It is not strictly true the Impressionists used only primary hues, juxtaposing them to create secondary colors (blue and yellow, for example, to create green). But they did achieve remarkably brilliant effects with their characteristically short, choppy brushstrokes, which so accurately caught the vibrating quality of light. The fact that their canvas surfaces look unintelligible at close range and their forms and objects appear only when

the eye fuses the strokes at a certain distance accounts for much of the early adverse criticism leveled at their work. One such conjecture was that the Impressionists fired their paint at the canvas with pistols. Lila Cabot Perry, a student of Monet's late in his career, gave this description of Monet's approach:

> I remember his once saying to me: "When you go out to paint, try to forget what objects you have before you—a tree, a house, a field, or whatever. Merely think, here is a little square of blue, here an oblong of pink, here a streak of yellow, and paint it just as it looks to you, the exact color and shape, until it gives your own naïve impression of the scene before you." He said he wished he had been born blind and then had suddenly gained his sight so that he could have begun to paint in this way without knowing what the objects were that he saw before him.[14]

Monet's intensive study of the phenomena of light and color is especially evident in several series of paintings of the same subject. One series had some forty views of *Rouen Cathedral* (FIG. **21-28**). For each canvas in this series, Monet observed the cathedral from the same viewpoint but at differ-

ent times of the day or under various climatic conditions. With a scientific precision, he created an unparalleled record of the passing of time as seen in the movement of light over identical forms. Later critics accused Monet and his companions of destroying form and order for fleeting atmospheric effects, but Monet focused on light and color precisely to reach a greater understanding of form.

DEGAS'S PASTEL AND LINE DRAWING While color and light were major components of the Impressionist quest to capture fleeting sensations, these artists considered other formal elements as well. Degas, for example, became a superb master of line, so much so that his works often differ significantly from those of Monet and Renoir. Degas specialized in studies of figures in rapid and informal action, recording the quick impression of arrested motion, as is evident in *Ballet Rehearsal.* He often employed lines to convey this sense of movement. In *The Tub* (FIG. **21-29**), a young woman crouches in a washing tub. The artist outlined the major objects in the painting—the woman, tub, and pitchers—and covered all surfaces with linear hatch marks. Degas achieved this leaner quality with pastels, his favorite medium. Using these dry sticks of powdered pigment, Degas drew directly on the paper, as one would with a piece of chalk, thus accounting for the linear basis of this work. Further, although the applied pastel can be smudged, the colors tend to retain their autonomy, so they appear fresh and bright.

The Tub also reveals how Degas's work, like that of the other Impressionists, continues the modernist exploration of the premises of painting by acknowledging the artwork's surface. Although viewers clearly perceive the woman as a depiction of a three-dimensional form in space, the tabletop or shelf on the right of the image appears severely tilted, so much so that it seems to parallel the picture plane. The two pitchers on the table complicate this visual conflict between the table's flatness and the illusion of the bathing woman's three-dimensional volume. The limited foreshortening of the pitchers and their shared edge, in conjunction with the rest of the image, create a visual perplexity for viewers.

THE TENDERNESS OF MOTHER AND CHILD In the Salon of 1874, Degas admired a painting by a young American artist, MARY CASSATT (1844–1926), the daughter of a Philadelphia banker. "There," he remarked, "is someone who feels as I do."[15] Degas befriended and influenced Cassatt, who exhibited regularly with the Impressionists. She had trained as a painter before moving to Europe to study masterworks in France and Italy. As a woman, she could not easily frequent the cafés with her male artist friends, and she was responsible for the care of her aging parents, who had moved to Paris to join her, two facts limiting her subject choices. Because of these restrictions, Cassatt's subjects were principally women and children, whom she presented with a combination of objectivity and genuine sentiment. Works such as *The Bath* (FIG. **21-30**) show the tender relationship between a mother and child. Like Degas's *The Tub,* the visual solidity of the mother and child contrasts with the flattened patterning of the wallpaper and rug. Cassatt's style in this work owed much to the compositional devices of Degas and of Japanese prints, but the painting's design has an originality and strength all its own.

21-28 CLAUDE MONET, *Rouen Cathedral: The Portal (in Sun),* 1894. Oil on canvas, 3′ 3¼″ × 2′ 1⅞″. Metropolitan Museum of Art, New York (Theodore M. Davis Collection, bequest of Theodore M. Davis, 1915).

21-29 EDGAR DEGAS, *The Tub*, 1886.
Pastel, 1′ 11½″ × 2′ 8⅜″. Musée
d'Orsay, Paris.

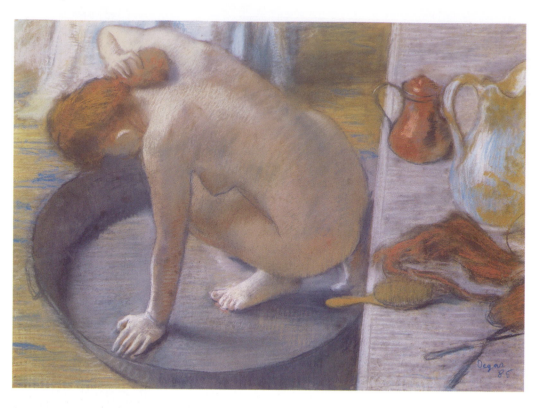

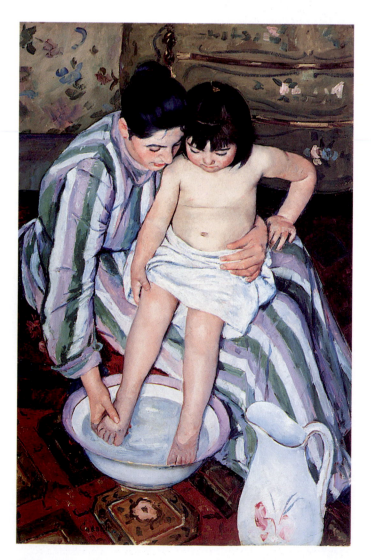

21-30 MARY CASSATT, *The Bath*, ca. 1892. Oil on canvas, 3′ 3″ × 2′ 2″.
The Art Institute of Chicago, Chicago (Robert A. Walker Fund).

EXPLORING THE NIGHTLIFE OF PARIS French artist HENRI DE TOULOUSE-LAUTREC (1864–1901) was interested in capturing the sensibility of modern life and deeply admired Degas. Because of this interest and admiration, his work intersects with that of the Impressionists. However, his work has an added satirical edge to it and often borders on caricature. Toulouse-Lautrec's art was, to a degree, the expression of his life. Self-exiled by his odd stature and crippled legs from the high society his ancient aristocratic name entitled him to enter, he became a denizen of the night world of Paris, consorting with a tawdry population of entertainers, prostitutes, and other social outcasts. He reveled in the energy of cheap music halls, cafés, and bordellos. In *At the Moulin Rouge* (FIG. **21-31**), the influences of Degas, of the Japanese print, and of photography can be seen in the oblique and asymmetrical composition, the spatial diagonals, and the strong line patterns with added dissonant colors. But Toulouse-Lautrec so emphasized or exaggerated each element, although he closely studied such scenes in actual life and they were already familiar to viewers in the work of the earlier Impressionists, that the tone is new. Compare, for instance, this painting's mood with the relaxed and casual atmosphere of Renoir's *Le Moulin de la Galette* (FIG. 21-23). Toulouse-Lautrec's scene is nightlife, with its glaring artificial light, brassy music, and assortment of corrupt, cruel, and masklike faces. (He included himself in the background—the tiny man with the derby accompanying the very tall man, his cousin.) Such distortions by simplification of the figures and faces anticipated Expressionism (Chapter 22, page 786), when artists' use of formal elements—for example, brighter colors and bolder lines than ever before—increased their images' impact on observers.

ORCHESTRATING ART JAMES ABBOTT MCNEILL WHISTLER (1834–1903) was an American expatriate artist

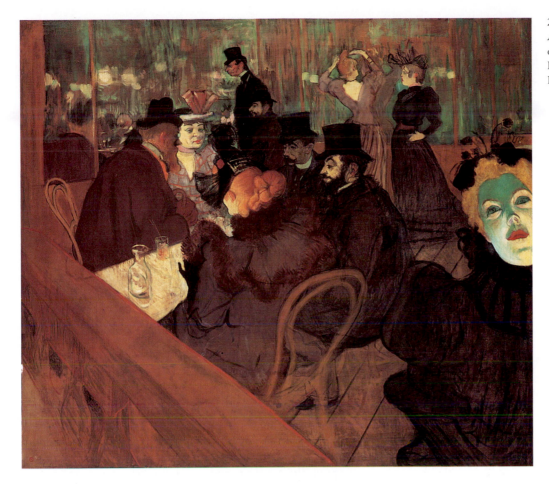

21-31 HENRI DE TOULOUSE-LAUTREC, *At the Moulin Rouge,* 1892–1895. Oil on canvas, approx. 4′ × 4′ 7″. The Art Institute of Chicago, Chicago (Helen Birch Bartlett Memorial Collection).

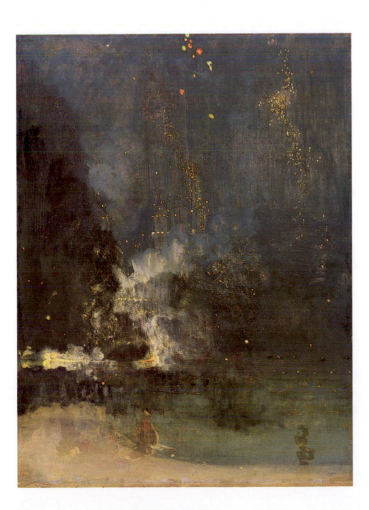

who worked on the European continent before settling finally in London. In Paris, he knew many of the Impressionists, and his art is an interesting mixture of some of their concerns and his own. Whistler shared their interests in the subject of contemporary life and the sensations color produces on the eye. To these influences he added his interest in creating harmonies paralleling those achieved in music:

> Nature contains the elements, in color and form, of all pictures, as the keyboard contains the notes of all music. But the artist is born to pick, and choose, and group with science, these elements, that the result may be beautiful—as the musician gathers his notes, and forms his chords, until he brings forth from chaos glorious harmony.[16]

To underscore his artistic intentions, Whistler began calling his paintings "arrangements" or "nocturnes." *Nocturne in Black and Gold (The Falling Rocket),* FIG. **21-32**, is a daring painting with gold flecks and splatters that represent the exploded firework punctuating the darkness of the night sky. The artist was clearly more interested in conveying the atmospheric effects than he was in providing details of the actual scene. He emphasized creating a harmonious arrangement of shapes and colors on the rectangle of his canvas, an approach that interested many twentieth-century artists.

21-32 JAMES ABBOTT MCNEILL WHISTLER, *Nocturne in Black and Gold (The Falling Rocket),* ca. 1875. Oil on panel, 1′ 11$\frac{5}{8}$″ × 1′ 6$\frac{1}{2}$″. Detroit Institute of Arts, Detroit (gift of Dexter M. Ferry Jr.).

"FLINGING PAINT IN THE PUBLIC'S FACE"
Such works angered many viewers. The British critic John Ruskin responded to this painting by writing a scathing review accusing Whistler of "flinging a pot of paint in the public's face" with his style. In reply, Whistler sued Ruskin for libel. During the trial, Whistler was asked about the subject of *Nocturne:*

> "What is the subject of the *Nocturne in Black and Gold?*"
> "It is a night piece and represents the fireworks at Cremorne," answered Whistler.
> "Not a view of Cremorne?"
> "If it were a view of Cremorne, it would certainly bring about nothing but disappointment on the part of the beholders. It is an artistic arrangement. . . . It is as impossible for me to explain to you the beauty of that picture as it would be for a musician to explain to you the beauty of a harmony in a particular piece of music if you have no ear for music."[17]

Although Whistler won the case, his victory had sadly ironic consequences for him. The judge in the case, showing where his—and perhaps the public's—sympathies lay, awarded the artist only one farthing (less than a penny) in damages and required him to pay all of the court costs, which ruined him financially. He continued to produce etchings and portraits for two decades after his bankruptcy.

POST-IMPRESSIONISM: EXPERIMENTING WITH FORM AND COLOR

By 1886, most critics and a large segment of the public accepted the Impressionists as serious artists. Just when their images of contemporary life no longer seemed crude and unfinished, however, some of these painters and a group of younger followers came to feel Impressionists were neglecting too many of the traditional elements of picture making in their attempts to capture momentary sensations of light and color on canvas. In a conversation with the influential art dealer Ambroise Vollard in about 1883, Renoir commented: "I had wrung [I]mpressionism dry, and I finally came to the conclusion that I knew neither how to paint nor how to draw. In a word, [I]mpressionism was a blind alley, as far as I was concerned."[18] By the 1880s, four artists in particular were much more systematically examining the properties and the expressive qualities of line, pattern, form, and color: Vincent van Gogh, Paul Gauguin, Georges Seurat, and Paul Cézanne. Both van Gogh and Gauguin focused their artistic efforts on exploring the expressive capabilities of formal elements, while Seurat and Cézanne were more analytical in orientation. Because their art diverged so markedly from earlier Impressionism (although each of these painters initially based their work on Impressionist precepts and methods), these four artists and others sharing their views have become known as the Post-Impressionists. This classification also signifies their chronological position in nineteenth-century Western painting.

"THE TERRIBLE PASSIONS OF HUMANITY"
VINCENT VAN GOGH (1853–1890) explored the capabilities of colors and distorted forms to express his emotions as he confronted nature. The son of a Dutch Protestant pastor, van Gogh believed he had a religious calling and did missionary work in the slums of London and in the mining districts of Belgium. Repeated professional and personal failures brought him close to despair (see "From Pariah to Paragon: The Shifting Fortunes of Vincent van Gogh," page 759). Although the image of van Gogh as a madman persists in the public imagination, van Gogh is better described as a tormented individual who suffered from epileptic seizures. Only after he turned to painting did he find a way to communicate his

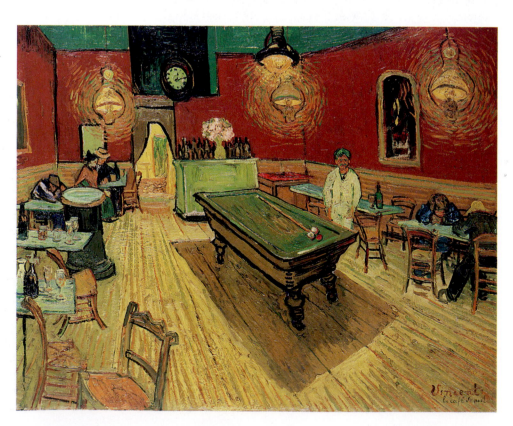

21-33 VINCENT VAN GOGH, *The Night Café,* 1888. Oil on canvas, approx. 2' 4$\frac{1}{2}$" × 3'. Yale University Art Gallery, New Haven (bequest of Stephen Carlton Clark, B.A., 1903).

From Pariah to Paragon
The Shifting Fortunes of Vincent van Gogh

When van Gogh died of a self-inflicted gunshot wound in 1890 at age 37, he considered himself a failure as an artist. He felt himself an outcast not only from artistic circles but also from society at large. The hostile reception to his work, both from fellow artists and the general public, no doubt reinforced this perception. Throughout his brief career, he encountered great difficulty selling his work; indeed, he sold only one painting during his lifetime.

Since his death, however, his reputation and the appreciation of his art have grown dramatically, and it is no exaggeration to state that van Gogh is today one of the most revered and respected artists. This reevaluation speaks volumes about his art, yet it actually says more about the fluctuations in public taste and the ongoing assessment central to the art historical enterprise. Taste, both cultural and personal, is notoriously unpredictable, as evidenced by the constantly and frequently shifting preferences in fashion, design, architecture, and art. Art history, as a discipline, is based on the continual study of previous art. Therefore, conclusions about the work of artists are always subject to change.

Today, van Gogh's work stands as an important contribution to the development of an expressionistic art, and it has deeply influenced generations of artists. Although monetary value does not necessarily reflect artistic value, it is worth noting that in recent years, van Gogh's paintings consistently have brought the highest prices at auction. In 1987, *Sunflowers* (1888) sold for $39.9 million to a Japanese insurance company. The following year, *Irises* (1889) was purchased for $53.9 million by Alan Bond, an Australian brewing and real estate tycoon. (Bond eventually defaulted on the payment for the painting, and the J. Paul Getty Museum in Los Angeles subsequently bought the work.) In 1990, *Portrait of Dr. Gachet* (1890) was sold to Ryoei Saito, a Japanese paper manufacturing magnate, for $82.5 million, the most ever paid for an artwork.

It is sobering to think an artist who has had such a dramatic impact on the direction of art and on the general public died thinking himself a failure.

experiences. In one of the many revealing letters he wrote to his brother, Theo, van Gogh admitted: "In both my life and in my painting, I can very well do without God but I cannot, ill as I am, do without something which is greater than I, which is my life—the power to create."[19] For van Gogh, the power to create involved the expressive use of color. As he wrote to Theo: "Instead of trying to reproduce exactly what I have before my eyes, I use color more arbitrarily so as to express myself forcibly."[20] In another letter, he explained that the color in one of his paintings was "not locally true from the point of view of the delusive realist, but color suggesting some emotion of an ardent temperament."[21]

Van Gogh's insistence on the expressive values of color led him to develop a corresponding expressiveness in his paint application. The thickness, shape, and direction of his brush strokes created a tactile counterpart to his intense color schemes. He moved the brush vehemently back and forth or at right angles, giving a textilelike effect, or squeezed dots or streaks onto his canvas from his paint tube. This bold, almost slapdash attack enhanced the intensity of his colors.

After relocating to Arles in southern France in 1888, van Gogh painted *The Night Café* (FIG. **21-33**), an interior scene. Although the subject is apparently benign, van Gogh invested it with a charged energy. As van Gogh described it, the painting was meant to convey an oppressive atmosphere— "a place where one can ruin oneself, go mad, or commit a crime. . . ."[22] He communicated this by selecting vivid hues whose juxtaposition augmented their intensity. Van Gogh described it in a letter to Theo:

I have tried to express the terrible passions of humanity by means of red and green. The room is blood red and dark yellow with a green

billiard table in the middle; there are four citron-yellow lamps with a glow of orange and green. Everywhere there is a clash and contrast of the most disparate reds and greens in the figures of little sleeping hooligans, in the empty, dreary room, in violet and blue. The blood-red and the yellow-green of the billiard table, for instance, contrast with the soft, tender Louis XV green of the counter, on which there is a pink nosegay. The white coat of the landlord, awake in a corner of that furnace, turns citron-yellow, or pale luminous green.[23]

The proprietor rises like a specter from the edge of the billiard table, which the painter depicted in such a steeply tilted perspective that it threatens to slide out of the painting into the viewers' space. Van Gogh took an innocuous scene and imbued it with "the terrible passions of humanity."

GLIMMERS OF HOPE? Just as illustrative of van Gogh's "expressionist" method is *Starry Night* (FIG. **21-34**), which the artist painted in 1889, the year before his death. At this time, van Gogh was living at Saint-Paul-de-Mausole, an asylum in Saint-Rémy where he had committed himself. In *Starry Night,* the artist did not represent the sky in a manner that can be described as realistic. Rather, he communicated the vastness of the universe, filled with whirling and exploding stars and galaxies of stars, the earth and humanity huddling beneath it. The church nestled in the center of the village below can be seen, perhaps, as van Gogh's attempt to express or reconcile his conflicted feelings about religion. Although van Gogh's style in *Starry Night* suggests a very personal vision, this work does correspond in many ways to the view available to the painter from the window of his room in Saint-Paul-de-Mausole. The existence of cypress trees and the placement of the constellations have been confirmed as matching the view that

21-34 VINCENT VAN GOGH, *Starry Night*, 1889. Oil on canvas, approx. 2′ 5″ × 3′ ¼″. Museum of Modern Art, New York (acquired through the Lillie P. Bliss Bequest).

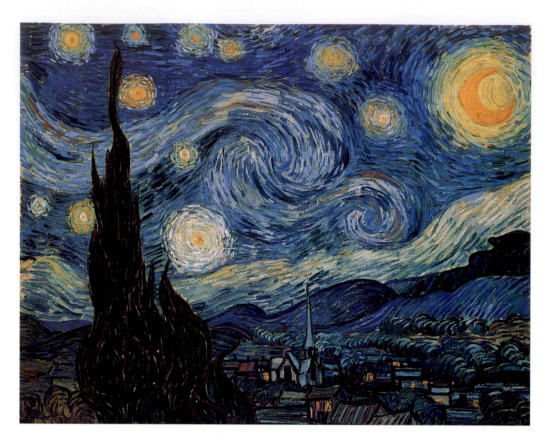

would have been visible to van Gogh during his stay in the asylum. Still, the artist took any visible objects and translated them into his unique vision. Given van Gogh's determination to use color to express himself forcibly, the dark, deep blue that pervades the entire painting cannot be overlooked. Together with the turbulent brushstrokes, the color suggests a quiet but pervasive depression. Van Gogh's written observation to his brother reveals his contemplative state of mind:

> Perhaps death is not the hardest thing in a painter's life. . . . [L]ooking at the stars always makes me dream, as simply as I dream over the black dots representing towns and villages on a map. Why, I ask myself, shouldn't the shining dots of the sky be as accessible as the black dots on the map of France? Just as we take the train to get to Tarascon or Rouen, we take death to reach a star.[24]

FROM IMPRESSIONISM TO FLAT COLOR Like van Gogh, the French painter PAUL GAUGUIN (1848–1903) rejected objective representation in favor of subjective expression. He also broke with the Impressionistic studies of minutely contrasted hues because he believed color above all must be expressive and that the artist's power to determine the colors in a painting was a seminal element of creativity. However, while van Gogh's heavy, thick brush strokes were an important component of his expressive style, Gauguin's color areas appear flatter, often visually dissolving into abstract patches or patterns. Gauguin had painted as an amateur, but after taking lessons with Pissarro, he resigned from his prosperous brokerage business in 1883 to devote his time entirely to painting.

In 1886, Gauguin moved to Pont-Aven in Brittany, the remotest province of France. There he painted a work that decisively rejects Realism and Impressionism, *The Vision after the Sermon*, or *Jacob Wrestling with the Angel* (FIG.

21-35). Gauguin was attracted to Brittany's unspoiled culture, its ancient Celtic folkways, and the still medieval Catholic piety of its people. In his view, these were "natural" men and women, perfectly at ease in their unspoiled peasant environment. The story of Jacob's encounter with the Angel (the Lord) is told in Genesis 32:24–30. The painting shows Breton women, wearing their starched white Sunday caps and black dresses, visualizing a sermon they have just heard at church on Jacob's encounter with the Holy Spirit. They pray devoutly before the apparition, as they would have before the roadside crucifix shrines that were familiar features of the Breton countryside.

Gauguin departed from an optical realism and composed the picture elements to focus viewers' attention on the idea and intensify its message. The images are not what the Impressionist eye would have seen and replicated but what memory would have recalled and imagination would have modified. Thus the artist twisted the perspective and allotted the space to emphasize the innocent faith of the unquestioning women, while he shrank Jacob and the Angel, wrestling in a ring enclosed by a Breton stone fence, to the size of fighting cocks. The women are spectators at a contest, which, like a cockfight, is for them perfectly real.

Gauguin did not unify the picture with a horizon perspective, light and shade, or a naturalistic use of color. Instead, he abstracted the scene into a pattern. Pure unmodulated color fills flat planes and shapes bounded by firm line. Here are the white caps, black dresses, and the red field of combat. The shapes are angular, even harsh. The caps, the sharp fingers and profiles, and the hard contours suggest the austerity of peasant life and ritual. Gauguin was receptive to the influences of Japanese prints, stained glass, and cloisonné enamels (see FIG. 11-2). These contributed to his own daring experiment to transform traditional painting and Impressionism into ab-

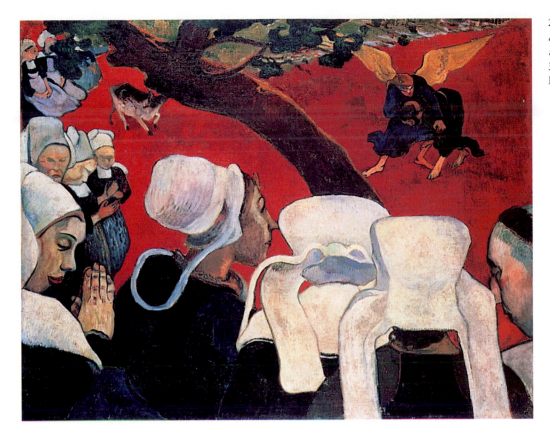

21-35 PAUL GAUGUIN, *The Vision after the Sermon* or *Jacob Wrestling with the Angel*, 1888. Oil on canvas, 2′ 4¾″ × 3′ ½″. National Gallery of Scotland, Edinburgh.

stract, expressive patterns of line, shape, and pure color. His revolutionary method found its first authoritative expression in *The Vision after the Sermon.*

After a brief period of association with van Gogh in Arles in 1888, Gauguin, in his restless search for provocative subjects and for an economical place to live, settled in Tahiti. He spent the last years of his life in the South Pacific, where he expressed his fascination with primitive life and brilliant color in a series of striking decorative canvases. Gauguin often based the design, although indirectly, on native motifs, and the color owed its peculiar harmonies of lilac, pink, and lemon to the tropical flora of the islands.

A SUMMARY OF LIFE AND ART Despite the allure of the South Pacific, Gauguin continued to struggle with life. His health suffered, and his art was not well received. In 1897, worn down by these obstacles, Gauguin decided to take his own life, but not before painting a large canvas titled *Where Do We Come From? What Are We? Where Are We Going?* (FIG. **21-36**). From the title and based on Gauguin's state of mind, this painting can be read as a summary of his artistic methods (especially the use of flat shapes of pure unmodulated color) and his views on life.

The scene is a tropical landscape, populated with native women and children. Although any message Gauguin

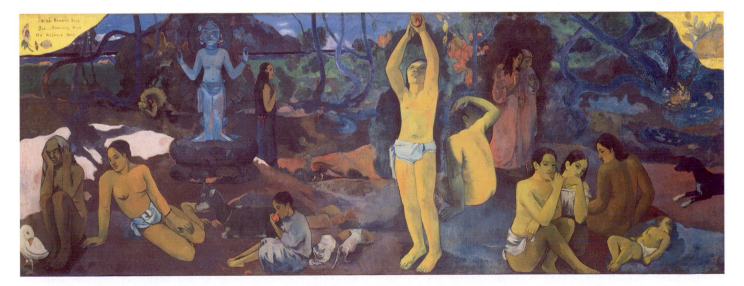

21-36 PAUL GAUGUIN, *Where Do We Come From? What Are We? Where Are We Going?*, 1897. Oil on canvas, 4′ 6¹³⁄₁₆″ × 12′ 3″. Museum of Fine Arts, Boston (Tompkins Collection).

Nineteenth-Century Color Theory

With the increasing reliance on science and industry during the latter half of the nineteenth century, the interest in the science of optics is not surprising. Many physicists, chemists, and aestheticians (experts in art and artistic principles) immersed themselves in studying optical reception and the behavior of the human eye in response to light of differing wavelengths. Painter Georges Seurat was well read and very familiar with the work of these artists and scientists, and he used many of their theories to develop pointillism (FIG. 21-37).

Discussions of color often focus on hue (for example, red, yellow, and blue), but it is important to consider the other facets of color—saturation (the hue's brightness or dullness) and value (the hue's lightness or darkness). Most artists during the nineteenth century understood the primary colors as red, yellow and blue and the complementary secondary colors as those produced by mixing pairs of these primaries—green (blue plus yellow), violet (red plus blue), and orange (red plus yellow). Chemist Michel-Eugène Chevreul extended artists' understanding of color dynamics by formulating the law of simultaneous contrast of colors, based on his observations as director of dyeing at the Gobelins tapestry workshops. Chevreul asserted that juxtaposed colors affect the eye's reception of each, making the two colors as dissimilar as possible, both in hue and value. For example, placing light green next to dark green has the effect of making the light green look even lighter and the dark green darker. Chevreul further provided an explanation of *successive contrasts*—the well-known phenomenon of colored afterimages. When a person looks intently at a color (green, for example) and then shifts to a white area, the fatigued eye momentarily perceives the complementary color (orange).

Seurat was probably also familiar with the work of aesthetician Charles Blanc, who coined the term "optical mixture" to describe the visual effect of juxtaposed complementary colors.

Blanc asserted that the smaller the areas of adjoining complementary colors, the greater the tendency for the eye to "mix" the colors, so that the viewer perceives a grayish or neutral tint. Seurat used this principle frequently in his paintings.

The observations of James Clerk Maxwell also were crucial for color theory development and for Seurat's color use. Maxwell was instrumental in designing an objective method of color measurements, using algebraic color-matching equations. Maxwell's studies, it should be noted, applied to the mixing of colored lights, not the mixing of colored pigments. In other words, Maxwell's explanations dealt with how the eye sees color, not how painters should combine pigments on their palettes.

Particularly influential for Seurat was the work of physicist Ogden Rood, who published his ideas in *Modern Chromatics, with Applications to Art and Industry* in 1879. Rood expanded on the ideas of Chevreul, Blanc, and Maxwell and constructed an accurate and understandable diagram of contrasting colors. Further (and particularly significant to Seurat), Rood explored representing color gradation. He suggested that placing small dots or lines of color side by side so that, when viewed from a distance, "the blending is more or less accomplished by the eye of the beholder" is one way to achieve gradation.[1]

Although these discoveries intrigued Seurat and he purchased a copy of Rood's book, making notes from one section of it, his goal was not solely to create a scientific painting method. Seurat's work, though characterized by discipline and a systematic approach, also incorporated his concerns about the emotional tone of the images. The investigations of these color theorists, however, continued to be important and impacted the development of art in the twentieth century.

[1] John Leighton and Richard Thomson, *Seurat and the Bathers* (London: National Gallery Publications, 1997), 49.

intended is ambiguous at best, statements he made in a letter to his friend, Charles Morice, shed light on his philosophical conclusions.

> Where are we going? Near to death an old woman. . . . What are we? Day to day existence. . . . Where do we come from? Source. Child. Life begins. . . . Behind a tree two sinister figures, cloaked in garments of sombre colour, introduce, near the tree of knowledge, their note of anguish caused by that very knowledge in contrast to some simple beings in a virgin nature, which might be paradise as conceived by humanity, who give themselves up to the happiness of living.[25]

Gauguin's description of this work as "comparable to the Gospels"[26] indicates the expansiveness of his vision, but *Where Do We Come From?* remains a sobering, pessimistic im-

age of the life cycle's inevitability. In terms of style, this painting demonstrates Gauguin's commitment to the expressive ability of color. Although the venue is recognizable as a landscape, most of the scene, other than the figures, is composed of flat areas of unmodulated color, which convey a lushness and intensity.

Gauguin's attempt to commit suicide was unsuccessful, and he ultimately died a few years later, in 1903, in the Marquesas Islands. Members of the younger generation especially felt the influence of Gauguin's art and ideas. Parisian artist Maurice Denis (1870–1943) wrote in "The Influence of Paul Gauguin" in 1903:

> Gauguin freed us from all the hindrances imposed upon our painters' instincts by the idea of copying. . . . For instance, if we could paint in vermillion that tree which appeared to us very reddish

at a certain moment, . . . [w]hy not stress even to the point of distortion the curve of a lovely shoulder, . . . stylize the symmetry of a branch . . . ?[27]

THE SCIENCE OF COLOR In contrast to the expressionistic nature of the work of van Gogh and Gauguin, the art of Frenchman GEORGES SEURAT (1859–1891) was resolutely intellectual. He devised a disciplined and painstaking system of painting that focused on color analysis. Seurat was less concerned with the recording of immediate color sensations than he was with their careful and systematic organization into a new kind of pictorial order. He disciplined the free and fluent play of color that characterized Impressionism into a calculated arrangement based on scientific color theory (see "Nineteenth-Century Color Theory," page 762). Seurat's system, known as *pointillism* or *divisionism,* involved carefully observing color and separating it into its component parts. The artist then applied these pure component colors to the canvas in tiny dots (points) or daubs (FIG. **21-37**). Thus, the shapes, figures, and spaces in the image only become totally comprehensible from a distance, when viewers' eyes blend the many pigment dots.

Pointillism was on view at the eighth and last Impressionist exhibition in 1886, when Seurat showed his *A Sunday on La Grande Jatte* (FIG. **21-38**). The subject of the painting is reminiscent of the Impressionist interest in recreational themes. And although Seurat was also interested in analyzing light and color (as were the Impressionists), this painting seems strangely rigid and remote, unlike the spontaneous representations of Impressionism. Seurat applied pointillism to produce a carefully composed and painted image. By using meticulously calculated values, the painter carved out a deep rectangular space. He played on repeated motifs to create both flat patterns and suggested spatial depth. Reiterating the profile of the female form, the parasol, and the cylindrical forms of the figures, Seurat placed each in space to set up a rhythmic movement in depth, as well as from side to side. The picture is filled with sunshine but not broken into transient patches

21-37 GEORGES SEURAT, detail of *A Sunday on La Grande Jatte,* 1884–1886.

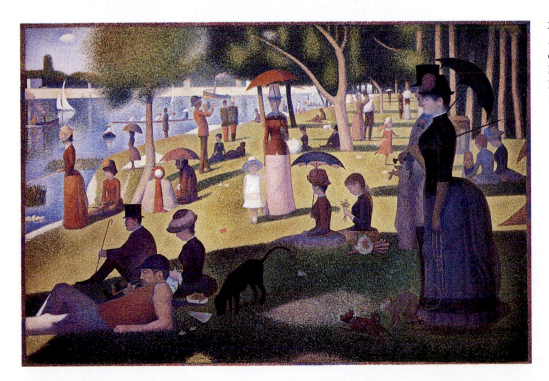

21-38 GEORGES SEURAT, *A Sunday on La Grande Jatte,* 1884–1886. Oil on canvas, approx. 6′ 9″ × 10′. The Art Institute of Chicago, Chicago (Helen Birch Bartlett Memorial Collection, 1926).

of color. Light, air, people, and landscape are fixed in an abstract design whose line, color, value, and shape cohere in a precise and tightly controlled organization.

Seurat's art is severely intellectual. He said of it, "They see poetry in what I have done. No, I apply my method, and that is all there is to it."[28] In *La Grande Jatte*, Seurat turned traditional pictorial stage space into a pattern by applying a color formula based on the belief that human optical experience of space can be only a function of color, which makes space a fairly unimportant variable. For previous artists, the reality was space with color something added, but for Seurat color was the reality and spaces and solids were merely illusion. Having found the formula of color relationships, artists no longer needed to rely on the dubious evidence of their impressions. Paul Signac, Seurat's collaborator in the design of the "neo-impressionist" method, described their discovery:

> By the elimination of all muddy mixtures, by the exclusive use of the optical mixture of pure colors, by a methodical divisionism and a strict observation of the scientific theory of colors, the neoimpressionist insures a maximum of luminosity, of color intensity, and of harmony—a result that had never yet been obtained.[29]

MAKING IMPRESSIONISM "DURABLE" Like Seurat, the French artist PAUL CÉZANNE (1839–1906) turned from Impressionism to developing a more analytical style. Although a lifelong admirer of Delacroix, Cézanne allied himself, early in his career, with the Impressionists, especially Pissarro, and at first accepted their color theories and their faith in subjects chosen from everyday life. Yet his own studies of the Old Masters in the Louvre persuaded him that Impres-

sionism lacked form and structure. Cézanne declared he wanted to "make of Impressionism something solid and durable like the art of the museums."[30]

The basis of Cézanne's art was his unique way of studying nature in works such as *Mont Sainte-Victoire* (FIG. **21-39**). His aim was not truth in appearance, especially not photographic truth, nor was it the "truth" of Impressionism but a lasting structure behind the formless and fleeting visual information the eye absorbs. Instead of employing the Impressionists' random approach when he was face-to-face with nature, Cézanne attempted to intellectually order his presentation of the lines, planes, and colors that comprised nature. He did so by constantly and painstakingly checking his painting against the part of the actual scene—he called it the "motif"—he was studying at the moment. When Cézanne wrote of his goal of "doing Poussin over entirely from nature,"[31] he apparently meant that Poussin's effects of distance, depth, structure, and solidity must be achieved not by traditional perspective and chiaroscuro but in terms of the color patterns an optical analysis of nature provides.

With special care, Cézanne explored the properties of line, plane, and color and their interrelationships. He studied the effect of every kind of linear direction, the capacity of planes to create the sensation of depth, the intrinsic qualities of color, and the power of colors to modify the direction and depth of lines and planes. To create the illusion of three-dimensional form and space, Cézanne focused on carefully selecting colors. He understood that the visual properties—hue, saturation, and value—of different colors vary (see Introduction, page xl in combined volumes or page xx in Volume II). Cool colors tend to recede, while

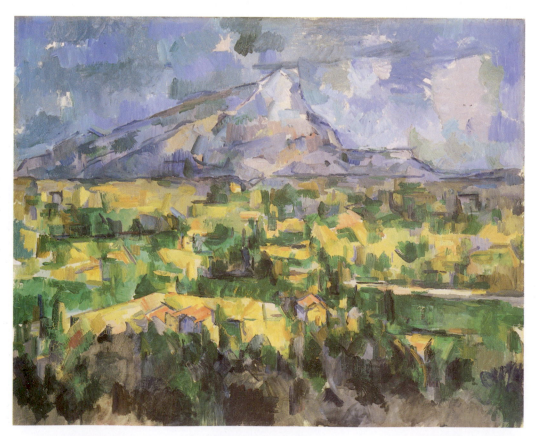

21-39 PAUL CÉZANNE, *Mont Sainte-Victoire*, 1902–1904. Oil on canvas, 2′ 3½″ × 2′ 11¼″. Philadelphia Museum of Art, Philadelphia (The George W. Elkins Collection).

21-40 PAUL CÉZANNE, *The Basket of Apples*, ca. 1895. Oil on canvas, $2' \frac{3}{8}'' \times 2' 7''$. The Art Institute of Chicago, Chicago (Helen Birch Bartlett Memorial Collection, 1926).

warm ones advance. By applying to the canvas small patches of juxtaposed colors, some advancing and some receding, Cézanne created volume and spatial depth in his works. On occasion, the artist depicted objects chiefly in one hue and achieved convincing solidity by modulating the intensity (or saturation). At other times, he juxtaposed contrasting colors—for example, green, yellow, and red—of like saturation (usually in the middle range, rather than the highest intensity) to compose specific objects, such as fruit or bowls.

Mont Sainte-Victoire is one of many views Cézanne painted of this mountain near his home in Aix-en-Provence. In it, he replaced the transitory visual effects of changing atmospheric conditions, effects that occupied Monet, with a more concentrated, lengthier analysis of the colors in large lighted spaces. The main space stretches out behind and beyond the canvas plane and includes numerous small elements, such as roads, fields, houses, and the viaduct at the far right, each seen from a slightly different viewpoint. Above this shifting, receding perspective rises the largest mass of all, the mountain, with an effect—achieved by equally stressing background and foreground contours—of being simultaneously near and far away. This portrayal approximates the actual experience a person observing such a view might have if apprehending the landscape forms piecemeal. The relative proportions of objects would vary, rather than being fixed by a strict one- or two-point perspective, such as that normally found in a photograph. Cézanne immobilized the shifting colors of Impressionism into an array of clearly defined planes that compose the objects and spaces in his scene. Describing his method in a letter to a fellow painter, he wrote:

Treat nature by the cylinder, the sphere, the cone, everything in proper perspective so that each side of an object or a plane is directed towards a central point. Lines parallel to the horizon give breadth, that is a section of nature. . . . Lines perpendicular to this horizon give depth. But nature for us men is more depth than surface, whence the need of introducing into our light vibrations, represented by reds and yellows, a sufficient amount of blue to give the impression of air.[32]

REVEALING THE UNDERLYING STRUCTURE In Cézanne's *The Basket of Apples* (FIG. **21-40**), the objects have lost something of their individual character as bottles and fruit and approach the condition of cylinders and spheres. The still life was another good vehicle for the artist's experiments, as he could arrange a limited number of selected objects to provide a well-ordered point of departure. So analytical was Cézanne in preparing, observing, and painting these still lifes (in contrast to the Impressionist emphasis on the idea of the spontaneous) that he had to abandon using real fruit and flowers because they tended to rot. In *The Basket of Apples,* he captured the solidity of each object by juxtaposing color patches. Cézanne's interest in the study of volume and solidity is evident from the disjunctures in the painting—the table edges are discontinuous, and various objects seem to be depicted from different vantage points. In his zeal to understand three-dimensionality and to convey the placement of forms relative to the space around them, Cézanne explored his still life arrangements from different viewpoints. This resulted in paintings that, while conceptually coherent, do not appear optically realistic. Cézanne created what might be called, paradoxically, an architecture of color.

In keeping with the modernist concern with the integrity of the painting surface, Cézanne's methods never allow viewers to disregard the actual two-dimensionality of the picture plane. In this manner, Cézanne achieved a remarkable feat—presenting viewers with two-dimensional and three-dimensional images simultaneously.

THE RISE OF THE AVANT-GARDE

REJECTING ARTISTIC CONVENTIONS Each successive modernist movement of the nineteenth century—Realism, Impressionism, and Post-Impressionism—challenged artistic conventions with greater intensity. This relentless challenge gave rise to the *avant-garde.* Use of this term has expanded over the years; it now serves as a synonym for any particularly new or cutting-edge cultural manifestation. *Avant-garde,* which means "front guard," derived from nineteenth-century French military usage. The avant-garde were soldiers sent ahead of the army's main body to reconnoiter and make occasional raids on the enemy. Politicians who deemed themselves visionary and forward thinking subsequently adopted the term. It then migrated to the art world in the 1880s, where it referred to artists who were ahead of their time and who transgressed the limits of established art forms. These artists were the vanguard, or trailblazers. The avant-garde were modernists in that they rejected the classical, academic, or traditional and they adopted a critical stance toward their respective media. Yet they departed from modernism in their art's extreme transgressiveness or subversiveness. Further, the avant-garde increasingly disengaged themselves from a public audience. In zealously exploring the premises and formal qualities of painting, sculpture, or other media, avant-garde artists created an insular community whose members seemed to speak only to one another in their work. The Post-Impressionists, whose work the general public found incomprehensible, were the first artists labeled avant-garde. Avant-garde principles appealed to greater numbers of artists (such as the Fauves, Cubists, and Dada artists) as the twentieth century dawned, and the momentum it gained made the avant-garde a major force throughout much of the past century.

SYMBOLISM: FREEDOM OF IMAGINATION, EXPRESSION, AND FORM

Modernist artists, in particular the Impressionists and Post-Impressionists, concentrated on using emotion and sensation to transform perceived nature. By the end of the nineteenth century, the representation of nature became completely subjectivized, to the point that artists did not imitate nature but created free interpretations of it. Artists rejected the optical world as observed in favor of a fantasy world, of forms they conjured in their free imagination, with or without reference to things conventionally seen. Technique and ideas were individual to each of these artists. Color, line, and shape, divorced from conformity to the optical image, were used as symbols of personal emotions in response to the world. These artists who rejected the visual world were solely concerned with expressing reality in accord with their spirit and intuition. Deliberately choosing to stand outside of convention and tradition, such artists spoke like prophets, in signs and symbols.

REALITY BEYOND THE TANGIBLE WORLD Many of the artists following this path adopted an approach to subject and form that associated them with a general European movement called Symbolism. The term had application to both art and literature, which, as critics in both fields noted, were in especially close relation at this time. Symbolists disdained the "mere fact" of Realism as trivial and asserted that fact must be transformed into a symbol of the inner experience of that fact. The task of Symbolist visual and verbal artists was not to see things but to see through them to a significance and reality far deeper than what superficial appearance gave. In this function, as the poet Arthur Rimbaud insisted, artists became beings of extraordinary insight. (One group of Symbolist painters, influenced by Gauguin, called it-

21-41 PIERRE PUVIS DE CHAVANNES, *The Sacred Grove,* 1884. Oil on canvas, 2′ 11½″ × 6′ 10″. The Art Institute of Chicago, Chicago (Potter Palmer Collection).

self Nabis, the Hebrew word for prophet.) Rimbaud, whose poems had great influence on the artistic community, went so far as to say, in his *Lettre du Voyant (Letter from a Prophet)*, that to achieve the seer's insight, artists must become deranged. In effect, they must systematically unhinge and confuse the everyday faculties of sense and reason, which served only to blur artistic vision. The artists' mystical vision must convert the objects of the commonsense world into symbols of a reality beyond that world and, ultimately, a reality from within the individual.

IMAGINATION, FANTASY, AND INNER VISION
The extreme subjectivism of the Symbolists led them to cultivate all the resources of fantasy and imagination, no matter how deeply buried or obscure. Moreover, they urged artists to stand against the vulgar materialism and conventional mores of industrial and middle-class society. Above all, by their philosophy of aestheticism, the Symbolists wished to purge literature and art of anything utilitarian, to cultivate an exquisite aesthetic sensitivity, and to make the slogan "art for art's sake" into a doctrine and a way of life.

The subjects of the Symbolists, conditioned by this reverent attitude toward art and exaggerated aesthetic sensation, became increasingly esoteric and exotic, mysterious, visionary, dreamlike, and fantastic. (Perhaps not coincidentally, contemporary with the Symbolists, Sigmund Freud, the founder of psychoanalysis, began the new century and the age of psychiatry with his *Interpretation of Dreams,* an introduction to the concept and the world of unconscious experience.)

Elements of Symbolism appeared in the works of both Gauguin and van Gogh, but their art differed from mainstream Symbolism in their insistence on showing unseen powers as linked to a physical reality, instead of attempting to depict an alternate, wholly interior, life. The writers overshadowed the artists who participated in the actual Symbolist movement, but two French artists—Gustave Moreau and Odilon Redon—had a strong influence on the movement. And several other painters, such as Puvis de Chavannes, followed the Symbolist-related path of imagination, fantasy, and inner vision in their works. Prominent figures in this latter group were the Frenchman Henri Rousseau and the Norwegian Edvard Munch. All of these artists were visionaries who anticipated the strong twentieth-century interest in creating art that expressed psychological truth.

THE "PROPHET" OF SYMBOLISM PUVIS DE CHAVANNES (1824–1898) was a French artist who rejected Realism and Impressionism and went his own way in the nineteenth century, serenely unaffected by these movements. Although he never formally identified himself with the Symbolists, he became the "prophet" of those artists. Puvis produced an ornamental and reflective art—a dramatic rejection of Realism's noisy everyday world. In *The Sacred Grove* (FIG. 21-41), he deployed statuesque figures in a tranquil landscape with a classical shrine. Their motion has been suspended in timeless poses, their contours are simple and sharp, and their modeling is as shallow as bas-relief. The calm and still atmosphere suggests some consecrated place, where all movements and gestures have a permanent ritual significance. The stillness and simplicity of the forms, the linear patterns their rhythmic contours create, and the suggestion of their symbolic import amount to a kind of program of anti-Realism.

The effect impressed younger painters such as Paul Gauguin and the Symbolists, who saw in Puvis the prophet of a new style that would replace Realism. Puvis had a double reputation. The Academy and the government accepted him for his classicism, and the avant-garde revered him for his vindication of imagination and his artistic independence from the world of materialism and the machine.

A DEATH-INDUCING VISION OF SPLENDOR
GUSTAVE MOREAU (1826–1898), an influential teacher, gravitated toward subjects inspired by dreaming solitude and as remote as possible from the everyday world, in keeping with Symbolist tenets. The artist presented these subjects sumptuously, and his natural love of sensuous design led him to incorporate gorgeous color, intricate line, and richly detailed shape.

Jupiter and Semele (FIG. 21-42) is one of Moreau's rare finished works. The mortal girl Semele, one of Jupiter's loves,

21-42 GUSTAVE MOREAU, *Jupiter and Semele,* ca. 1875. Oil on canvas, approx. 7′ × 3′ 4″. Musée Gustave Moreau, Paris.

21-43 ODILON REDON, *The Cyclops,* 1898. Oil on canvas, 2′ 1″ × 1′ 8″. Kröller-Müller Museum, Otterlo, The Netherlands.

picted the royal hall of Olympus as shimmering in iridescent color, with tabernacles filled with the glowing shapes that enclose Jupiter like an encrustation of gems. In *Jupiter and Semele,* the rich color is harmonized with the exotic hues of medieval enamels, Indian miniatures, Byzantine mosaics, and the designs of exotic wares then influencing modern artists. Semele, in Jupiter's lap, is overwhelmed by the apparition of the god, who is crowned with a halo of thunderbolts. Her languorous swoon and the suspended motion of all the entranced figures show the "beautiful inertia" that Moreau said he wished to render with all "necessary richness."

HAUNTED BY "IMAGINARY THINGS" Like Moreau, ODILON REDON (1840–1916) was a visionary. He had been aware of an intense inner world since childhood and later wrote of "imaginary things" that haunted him. Redon adapted the Impressionist palette and stippling brushstroke for a very different purpose. In *The Cyclops* (FIG. **21-43**), Redon projected a figment of the imagination as if it were visible, coloring it whimsically with a rich profusion of fresh saturated hues that harmonized with the mood he felt fitted the subject. The fetal head of the shy, simpering Polyphemus, with its huge loving eye, rises balloonlike above the sleeping Galatea. The image born of the dreaming world and the color analyzed and disassociated from the waking world come together here at the artist's will. As Redon himself observed: "My originality consists in bringing to life, in a human way, improbable beings and making them live according to the laws of probability, by putting—as far as possible—the logic of the visible at the service of the invisible."[33]

begged the god to appear to her in all his majesty, a sight so powerful that she died from it. The artist presented the theme within an operalike setting, a towering opulent architecture. (Moreau loved Wagner's music and, like that great composer, dreamed of a grand synthesis of the arts.) The painter de-

A POWERFUL WORLD OF PERSONAL FANTASY The imagination of the French artist HENRI ROUSSEAU (1844–1910) engaged a different but equally powerful world of personal fantasy. Gauguin had journeyed to the South Seas in search of primitive innocence; Rousseau was a "primitive"

21-44 HENRI ROUSSEAU, *The Sleeping Gypsy,* 1897. Oil on canvas, 4′ 3″ × 6′ 7″. Museum of Modern Art, New York (gift of Mrs. Simon Guggenheim).

without leaving Paris—an untrained amateur painter. Rousseau produced an art of dream and fantasy in a style that had its own sophistication and made its own departure from the artistic currency of the time. He compensated for his apparent visual, conceptual, and technical naiveté with a natural talent for design and an imagination teeming with exotic images of mysterious tropical landscapes. In perhaps his best-known work, *The Sleeping Gypsy* (FIG. **21-44**), the figure identified in the title occupies a desert world, silent and secret, and dreams beneath a pale, perfectly round moon. In the foreground, a lion that resembles a stuffed, but somehow menacing, animal doll sniffs at the Gypsy. A critical encounter impends—an encounter of the type that recalls the uneasiness when a person's vulnerable subconscious self is menaced during sleep.

DESCRIBING THE "MODERN PSYCHIC LIFE" Linked in spirit to the Symbolists was the Norwegian painter and graphic artist EDVARD MUNCH (1863–1944). Munch felt deeply the pain of human life. His belief that humans were powerless before the great natural forces of death and love and the emotions associated with them—jealousy, loneliness, fear, desire, and despair—became the theme of most of his art. Because Munch's goal was to describe the conditions of "modern psychic life," as he put it, Realist and Impressionist techniques were inappropriate, focusing as they did on the tangible world. In the spirit of Symbolism, Munch developed a style of putting color, line, and figural distortion to expressive ends.

ANGUISH AND DESPAIR Munch's well-known painting, *The Cry* (FIG. **21-45**), is an example of this style. The image is grounded in the real world—a man standing on a bridge or jetty in a landscape can be clearly discerned—but it departs significantly from a visual reality. Instead, the work evokes a visceral, emotional response from viewers because of Munch's dramatic presentation. The man in the foreground, simplified to almost skeletal form, emits a primal scream. The landscape's sweeping curvilinear lines reiterate the curvilinear shape of the mouth and head, almost like an echo, as it reverberates through the landscape. The fiery red and yellow stripes that give the sky an eerie glow also contribute to this work's resonance. The emotional impulse that led Munch to produce *The Cry* is revealed in an epigraph Munch wrote to accompany the painting: "I stopped and leaned against the balustrade, almost dead with fatigue. Above the blue-black fjord hung the clouds, red as blood and tongues of fire. My friends had left me, and alone, trembling with anguish, I became aware of the vast, infinite cry of nature."[34] Appropriately, this work originally was titled *Despair*.

Gauguin's work, not only his paintings but also the woodblocks he produced from them, had influenced Munch. Munch also made prints that carried the same high emotional charge as his painted works, and both his intense images and the print medium that carried them were major sources of inspiration for the German Expressionists in the early twentieth century.

SCULPTURE IN THE LATER NINETEENTH CENTURY

The three-dimensional art of sculpture was not readily adaptable to capturing the optical sensations many painters favored in the later nineteenth century. Its very nature—its tangibility and solidity—suggests permanence. Sculpture thus served predominantly as an expression of supposedly timeless ideals, rather than of the transitory. But that did not stop sculptors during this period from pursuing many of the ideas fundamental to movements such as Realism and Impressionism.

A SCULPTURAL VISION OF HELL In his sculptures, JEAN-BAPTISTE CARPEAUX (1827–1875) combined his interest in Realism with a love of Baroque and ancient sculpture and of Michelangelo's work. Carpeaux's group *Ugolino and His Children* (FIG. **21-46**) is based on a passage from Dante's *Inferno* and shows Count Ugolino with his four sons shut up in a tower to starve to death. In Hell, Ugolino relates to Dante how, in a moment of extreme despair,

> *I bit both hands for grief. And*
> *they, thinking I did it for hunger,*
> *suddenly rose up and said, "Father"...*
> *[and offered him their own flesh as food.]*
> (33. 58–75)

The powerful forms—twisted, intertwined, and densely concentrated—suggest the self-devouring torment of frustration and despair that wracks the unfortunate Ugolino. A careful student of Michelangelo's male figures, Carpeaux also said he had the Laocoön group (see FIG. 5-89) in mind. Certainly, the storm and stress of *Ugolino and His Children* recall similar

21-45 EDVARD MUNCH, *The Cry*, 1893. Oil, pastel, and casein on cardboard, 2′ 11¾″ × 2′ 5″. National Gallery, Oslo.

21-46 JEAN-BAPTISTE CARPEAUX, *Ugolino and His Children,* 1865–1867. Marble, 6′ 5″ high. Metropolitan Museum of Art, New York (Josephine Bay Paul and C. Michael Paul Foundation, Inc. and the Charles Ulrich and Josephine Bay Foundation, Inc., gifts, 1967).

21-47 AUGUSTUS SAINT-GAUDENS, *Adams Memorial*, Rock Creek Cemetery, Washington, 1891. Bronze, 5′ 10″ high.

characteristics of that group and other ancient "baroque" artworks, such as the battling gods and giants on the frieze of the Pergamon altar (see FIG. 5-79). Regardless of such influences, the sense of vivid reality about the anatomy of the *Ugolino* figures shows Carpeaux's interest in study from life.

A MAJESTIC PORTRAIT AUGUSTUS SAINT-GAUDENS (1848–1907), an American sculptor trained in France, used Realism effectively in a number of his portraits, where Realism was highly appropriate. However, when designing a memorial monument of Mrs. Henry Adams (FIG. 21-47), Saint-Gaudens chose, instead, a classical mode of representation, which he modified freely. The resultant statue is that of a woman of majestic bearing sitting in mourning, her classically beautiful face partly shadowed by a sepulchral drapery that voluminously enfolds her body. The immobility of her form, set in an attitude of eternal vigilance, is only slightly stirred by a natural, yet mysterious and exquisite, gesture.

OF SURFACE AND SUBSTANCE In contrast, French artist AUGUSTE RODIN (1840–1917) was imbued with the Realist spirit, and he conceived and executed his sculptures with that sensibility. Like Muybridge and Eakins, Rodin was fascinated by the human body in motion. He was also well aware

of artistic developments such as Impressionism. Although color was not a significant factor in Rodin's work, Impressionist influence manifested itself in the artist's abiding concern for the effect of light on the three-dimensional surface. When focusing on the human form, he joined his profound knowledge of anatomy and movement with special attention to the body's exterior, saying, "The sculptor must learn to reproduce the surface, which means all that vibrates on the surface, soul, love, passion, life. . . . Sculpture is thus the art of hollows and mounds, not of smoothness, or even polished planes."[35] Primarily a modeler of pliable material rather than a carver of hard wood or stone, Rodin worked his surfaces with fingers sensitive to the subtlest variations of surface, catching the fugitive play of constantly shifting light on the body. In his studio, he often would have a model move around in front of him, while he modeled sketches with coils of clay.

In the cast bronze *Walking Man* (FIG. 21-48), Rodin captured the sense of a body in motion. Headless and armless, the figure is caught in midstride at the moment when weight is transferred across the pelvis from the back leg to the front. As with many of his other early works, Rodin executed *Walking Man* with such careful attention to details of muscle, bone,

21-48 AUGUSTE RODIN, *Walking Man*, 1905, cast 1962. Bronze, 6′ 11¾″ high. Hirshhorn Museum and Sculpture Garden, Smithsonian Institution, Washington (gift of Joseph H. Hirshhorn, 1966).

21-49 Auguste Rodin, *Burghers of Calais*, 1884–1889, cast ca. 1953–1959. Bronze, 6′ 10½″ high, 7′ 11″ long, 6′ 6″ deep. Hirshhorn Museum and Sculpture Garden, Smithsonian Institution, Washington (gift of Joseph H. Hirshhorn, 1966).

and tendon that it is filled with forceful reality, augmented by his sketchy modeling of the torso. Rodin conceived this figure as a study for his sculpture *Saint John the Baptist Preaching,* part of his process for building his conception of how the human body would express the larger theme's symbolism.

A STUDY OF DESPAIR AND DEFIANCE Similarly, Rodin made many nude and draped studies for each of the figures in the life-size group *Burghers of Calais* (FIG. **21-49**). This cast bronze monument was commissioned to commemorate a heroic episode in the Hundred Years' War. During the English siege of Calais, France, in 1347, six of the city's leading citizens agreed to offer their lives in return for the English king's promise to lift the siege and spare the rest of the populace. Each of the bedraggled-looking figures is a convincing study of despair, resignation, or quiet defiance. Rodin achieved the psychic effects through his choreographic placement of the group members. Rather than clustering in a tightly formal composition, the burghers (middle-class citizens) seem to wander aimlessly. The roughly textured surfaces

add to the pathos of the figures and compel viewers' continued interest. Rodin designed the monument without the traditional high base in the hope that the citizens of Calais would be inspired by the sculptural representation of their ancestors standing eye-level in the city center and preparing eternally to set off on their sacrificial journey. The government commissioners found the Realism of Rodin's vision so offensive, however, that they banished the monument to a remote site and modified the work's impact by placing it high on an isolating pedestal.

Many of Rodin's projects were left unfinished or were deliberate fragments. Seeing the aesthetic and expressive virtue of these works, modern viewers and sculptors have developed a taste for how the sketch, the half-completed figure, the fragment, and the vignette lifted out of context all have the power of suggestion and understatement. Rodin's ability to capture the quality of the transitory through his highly textured surfaces while revealing larger themes and deeper, lasting sensibilities explains the impact he had on twentieth-century artists.

THE ARTS AND CRAFTS MOVEMENT

The decisive effects of industrialization were impossible to ignore, and although many artists embraced this manifestation of "modern life" or at least explored its effects, other artists decried the impact of rampant industrialism. One such response came from the Arts and Crafts movement in England. This movement, which developed during the last decades of the nineteenth century, was shaped by the ideas of art critic and writer John Ruskin (1819–1900) and WILLIAM MORRIS (1834–1896), an artist. Both of these men shared a distrust of machines and industrial capitalism, which they believed alienated workers from their own nature. Accordingly, they advocated an art "made by the people for the people as a joy for the maker and the user."[36] This condemnation of capitalism and support for manual laborers were compatible with socialism, and many artists in the Arts and Crafts movement considered themselves socialists and participated in the labor movement.

This democratic, or at least populist, attitude carried over to the art they produced as well. Members of the Arts and Crafts movement dedicated themselves to producing functional objects with high aesthetic value for a wide public. The style they advocated was based on natural, rather than artificial, forms and often consisted of repeated designs of floral or geometric patterns. For Ruskin, Morris, and others in the Arts and Crafts movement, quality artisanship and honest labor were crucial. This movement generated numerous guilds, workshops, and schools committed to the promotion of this ideal.

PATTERNS FROM FLOOR TO CEILING Morris wholeheartedly contributed to this more populist art by forming a decorating firm, Morris, Marshall, Faulkner, and Co., Fine Arts Workmen in Painting, Carving, Furniture, and Metals. This firm's services were in great demand, and they produced wallpaper, textiles, tiles, furniture, books, rugs, stained glass, and pottery. In 1867, Morris decorated the Green Dining Room (FIG. **21-50**) at London's South Kensington Museum (now the Victoria & Albert Museum), the center of public art education and home of decorative art collections. The range of room features—windows, lights, and wainscoting (paneling on the lower part of walls)—Morris decorated to create this unified, beautiful, and functional environment is overwhelming; nothing escaped Morris's eye. His design for this room also reveals the penchant of Arts and Crafts designers for intricate patterning.

21-50 WILLIAM MORRIS, Green Dining Room, 1867. Victoria & Albert Museum, London.

21-51 CHARLES RENNIE MACKINTOSH, reconstruction (1992–1995) of Ladies' Luncheon Room, Ingram Street Tea Room, Glasgow, Scotland, 1900–1912. Glasgow Museum, Glasgow.

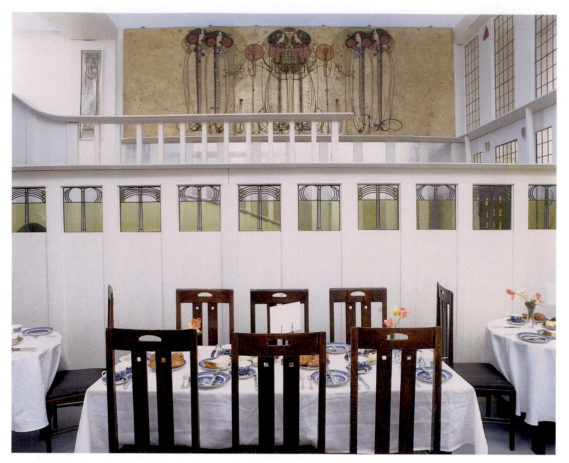

LUNCHING IN STYLE Numerous arts and crafts societies in America, England, and Germany carried on this ideal of artisanship. In Scotland, the work of CHARLES RENNIE MACKINTOSH (1868–1929) popularized this ideal. Mackintosh designed a number of tea rooms, including the Ladies' Luncheon Room (FIG. **21-51**) located in the Ingram Street Tea Room in Glasgow. As reconstructed by Glasgow Museum in 1992–1995, the room decor is consistent with Morris's vision of a functional, exquisitely designed art. The chairs, stained-glass windows, and large panels of colored gesso with twine, glass beads, thread, mother-of-pearl, and tin leaf (made by Margaret Macdonald Mackintosh, an artist-designer and Mackintosh's wife who collaborated with him on many projects) are all pristinely geometric and rhythmical in design.

ART NOUVEAU

METALLIC PLANT LIFE An architectural and design movement that developed out of the ideas the Arts and Crafts movement promoted was Art Nouveau. The international style of Art Nouveau took its name from a shop in Paris dealing with "L'Art Nouveau" (new art) and was known by that name in France, Belgium, Holland, England, and the United States. In other places, it had other names—Jugendstil in Austria and Germany (after the magazine *Der Jugend,* "youth"), Modernismo in Spain, and Floreale or Liberty in Italy. Proponents of this movement tried to synthesize all the arts in a determined attempt to create art based on natural forms that could be mass-produced for a large audience. The Art Nouveau style emerged at the end of the nineteenth cen-

tury and adapted the twining plant form to the needs of architecture, painting, sculpture, and all of the decorative arts. The mature Art Nouveau style was first seen in houses designed in Brussels in the 1890s by VICTOR HORTA (1861–1947). The staircase in the Van Eetvelde House (FIG. **21-52**), which Horta built in Brussels in 1895, is a good example of his Art Nouveau work. Every detail functions as part of a living whole. Furniture, drapery folds, veining in the lavish stone panelings, and the patterning of the door moldings join with real plants to provide graceful counterpoints for the twining plant theme. Metallic tendrils curl around the railings and posts, delicate metal tracery fills the glass dome, and floral and leaf motifs spread across the fabric panels of the screen (left background).

Several influences can be identified in Art Nouveau. In addition to the rich, foliated two-dimensional ornament of and artisan's respect for materials of the Arts and Crafts movement, the free, sinuous whiplash curve of Japanese print designs inspired Art Nouveau artists. Art Nouveau also borrowed from the expressively patterned styles of Vincent van Gogh (FIGS. 21-33 and 21-34), Paul Gauguin (FIGS. 21-35 and 21-36), and their Post-Impressionist and Symbolist contemporaries.

THE PEACOCK'S SWEEPING CURVES AUBREY BEARDSLEY (1872–1898) was one of a circle of English artists whose work existed at the intersection of Symbolism and Art Nouveau. For *Salomé,* an illustration for a book by Oscar Wilde, Beardsley drew *The Peacock Skirt* (FIG. **21-53**), a dazzlingly decorative composition perfectly characteristic of his

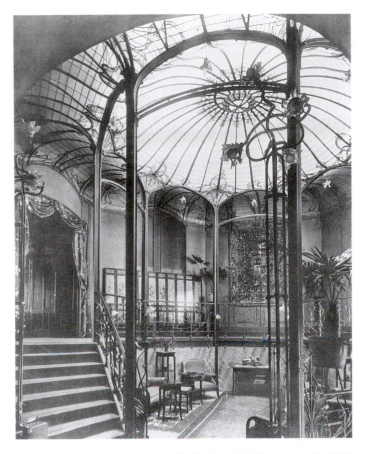

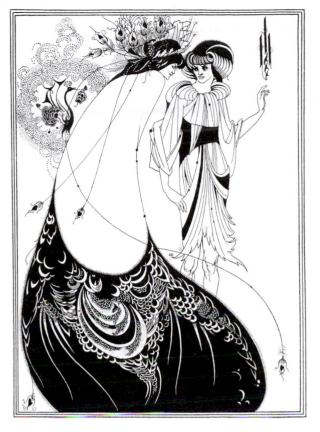

21-52 VICTOR HORTA, staircase in the Van Eetvelde House, Brussels, 1895.

21-53 AUBREY BEARDSLEY, *The Peacock Skirt*, 1894. Pen-and-ink illustration for Oscar Wilde's *Salomé*.

21-54 ANTONIO GAUDI, Casa Milá, Barcelona, 1907.

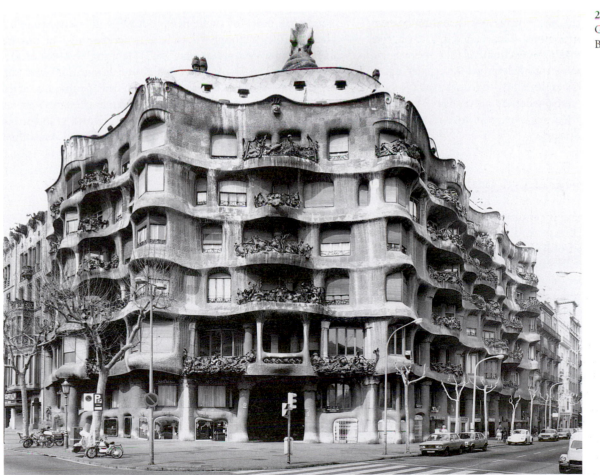

style. The Japanese print influence is obvious, although Beardsley assimilated it into his unique manner. Banishing Realism, he confined himself to lines and to patterns of black and white, eliminating all shading. His tense, elastic line encloses sweeping curvilinear shapes that lie flat on the surface—some left almost vacant, others filled with swirling complexes of mostly organic motifs. Beardsley's unfailing sense of linear rhythms and harmonies supports his mastery of calligraphic line. In his short lifetime—he died at age 26—he expressed in both his life and art the aesthete's ideal of "art for art's sake."

A BUILDING SEEMINGLY MOLDED FROM CLAY

Art Nouveau achieved its most personal expression in the work of the Spanish architect ANTONIO GAUDI (1852–1926). Before becoming an architect, Gaudi had trained as an ironworker. Like many young artists of his time, he longed to create a style that was both modern and appropriate to his country. Taking inspiration from Moorish-Spanish architecture and from the simple architecture of his native Catalonia, Gaudi developed a personal aesthetic. He conceived a building as a whole and molded it almost as a sculptor might shape a figure from clay. Although work on his designs proceeded slowly under the guidance of his intuition and imagination, Gaudi was a master who invented many new structural techniques that facilitated the actual construction of his visions. His apartment house, Casa Milá (FIG. **21-54**), is a wondrously free-form mass wrapped around a street corner. Lacy iron railings enliven the swelling curves of the cut-stone facade. Dormer windows peep from the undulating tiled roof, which is capped by fantastically writhing chimneys that poke energetically into the air above. The rough surfaces of the stone walls suggest naturally worn rock. The entrance portals look like eroded sea caves, but their design also may reflect the excitement that swept Spain following the 1879 discovery of Paleolithic cave paintings at Altamira. Gaudi felt that each of his buildings was symbolically a living thing, and the passionate naturalism of his Casa Milá is the spiritual kin of early-twentieth-century Expressionist painting and sculpture.

FIN-DE-SIÈCLE CULTURE

As the end of the nineteenth century neared, the momentous changes to which the Realists and Impressionists responded had become familiar and ordinary. As noted earlier, the term *fin-de-siècle,* which literally means "end of the century," is used to describe this period. This designation is not merely chronological but also refers to a certain sensibility. The cultures this term applies to experienced a significant degree of political upheaval toward the end of the nineteenth century. Moreover, prosperous wealthy middle classes dominated these societies—middle classes that aspired to the advantages the aristocracy already enjoyed. These people were determined to live "the good life," which evolved into a culture of decadence and indulgence. This fin-de-siècle culture was unrestrained and freewheeling, but the determination to enjoy life masked an anxiety prompted by the fluctuating political situation and uncertain future. The country most closely associated with fin-de-siècle culture was Austria.

THE SENSUALITY OF FIN-DE-SIÈCLE ART One Viennese artist whose works capture this period's flamboyance but temper it with unsettling undertones was GUSTAV KLIMT (1863–1918). In *The Kiss* (FIG. **21-55**), Klimt depicted a couple locked in an embrace. All that is visible of the couple, however, is a segment of each person's head. The rest of the painting dissolves into shimmering, extravagant flat patterning. This patterning has clear ties to Art Nouveau and to the Arts and Crafts movement. Such a depiction also is reminiscent of the conflict between two- and three-dimensionality intrinsic to the work of Degas and other modernists. Paintings such as *The Kiss* were visual manifestations of fin-de-siècle spirit because they captured a decadence conveyed by opulent and sensuous images. Yet, such images attempted to mask, with varying degrees of success, anxiety about an uncertain and foreboding future.

REBELLING AGAINST THE ESTABLISHMENT Klimt, along with eighteen other artists, formally banded together in 1897 to promote the arts, calling themselves the Vienna Secession. This group formed in opposition to (or seceded from) the established conservative artists' society in Vienna, a society that held a virtual monopoly on art exhibitions. Because these younger, more experimental artists faced repeated rejection from these exhibitions, they decided to create their own exhibition program. In addition, they called for greater integration between art objects and the surrounding interior environment (as did the Arts and Crafts movement). Architect JOSEPH MARIA OLBRICH (1867–1918), a founding member of the Secession, designed the Vienna Secession Building (FIG. **21-56**) in 1897–1898. To accommodate the unconventional needs of exhibiting members, Olbrich provided an interior of skylit flexible space with movable walls. The exterior, although formidable, incorporates the ornate and elaborate decoration that was a defining element of fin-de-siècle style. A lavish gilded laurel-leaf dome surmounts the large building. The dialogue between the geometric, staid building and the sensual, organic decorative elements reflects Olbrich's interest in invoking the solemnity and grandeur of classicism while expressing a unique and personal sensibility.

OTHER ARCHITECTURE IN THE LATER NINETEENTH CENTURY

The Beginnings of a New Style

In the later nineteenth century, new technology and the changing needs of urbanized, industrialized society affected architecture throughout the Western world. Since the eighteenth century, bridges had been built of cast iron (see FIG. 20-4), and most other industrial architecture—factories, warehouses, dockyard structures, mills, and the like—long had been built simply. Iron, along with other industrial materials, permitted engineering advancements in the construction of larger, stronger, and more fire-resistant structures. The tensile strength of iron (and especially of steel, available after 1860) permitted architects to create new designs involving vast enclosed spaces, as in the great train sheds of railroad stations and in exposition halls.

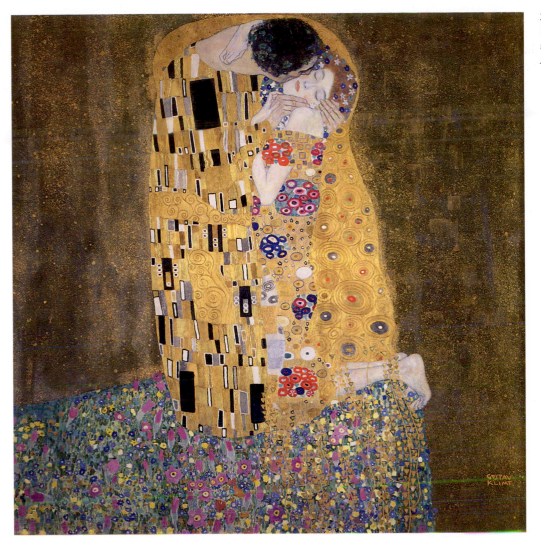

21-55 GUSTAV KLIMT, *The Kiss,* 1907–1908. Oil on canvas, approx. 5′ 10¾″ × 5′ 10¾″. Austrian Gallery, Vienna.

21-56 JOSEPH MARIA OLBRICH, Vienna Secession Building, Vienna, 1897–1898.

A SOARING METAL SKELETON The Realist impulse encouraged an architecture that honestly expressed a building's purpose, rather than elaborately disguising a building's function. The elegant metal skeleton structures of the French engineer-architect ALEXANDRE-GUSTAVE EIFFEL (1832–1923) can be seen as responses to this idea, and they constituted an important contribution to the development of the twentieth-century skyscraper. A native of Burgundy, Eiffel trained in Paris before beginning a distinguished career designing exhibition halls, bridges, and the interior armature for France's anniversary gift to the United States—Frédéric Auguste Bartholdi's *Statue of Liberty.* Eiffel designed his best-known work, the *Eiffel Tower* (FIG. **21-57**), for a great exhibition in Paris in 1889. Originally seen as a symbol of modern Paris and still considered a symbol of nineteenth-century civilization, the elegant metal tower thrusts its needle shaft nine hundred eighty-four feet above the city, making it at the time of its construction (and for some time to come) the world's highest structure. The tower's well-known configuration rests on four giant supports connected by gracefully arching open-frame skirts that provide a pleasing mask for the heavy horizontal girders needed to strengthen the legs. Visitors can take two elevators to the top, or they can use the internal staircase. Architectural historian Siegfried Giedion described well the effect of the tower when he wrote:

The airiness one experiences when at the top of the tower makes it the terrestrial sister of the aeroplane. . . . To a previously unknown extent, outer and inner space are interpenetrating. This effect can only be experienced in descending the spiral stairs from the top, when the soaring lines of the structure intersect with the trees, houses, churches, and the serpentine windings of the Seine. The interpenetration of continuously changing viewpoints create, in the eyes of the moving spectator, a glimpse into four-dimensional experience.[37]

This interpenetration of inner and outer space became a hallmark of twentieth-century art and architecture. At the time of their construction, however, Eiffel's metal skeleton structures and the iron skeletal frames designed by Labrouste (see FIG. 20-59) and Paxton (see FIG. 20-60) jolted some in the architectural profession into a realization that the new materials and new processes might germinate a completely new style and a radically innovative approach to architectural design.

The desire for greater speed and economy in building, as well as for a reduction in fire hazards, prompted the use of cast and wrought iron for many building programs, especially commercial ones. Designers in both England and the United States enthusiastically developed cast-iron architecture until a series of disastrous fires in the early 1870s in New York, Boston, and Chicago demonstrated that cast iron by itself was far from impervious to fire. This discovery led to encasing the metal in masonry, combining the first material's strength with the second's fire resistance.

In cities, convenience required closely grouped buildings, and increased property values forced architects literally to raise the roof. Even an attic could command high rentals if the building were provided with one of the new elevators, used for the first time in the Equitable Building in New York (1868–1871). Metal could support such tall structures, and the American skyscraper was born. With rare exceptions, however, as in Louis Sullivan's work (FIGS. 21-59 and 21-60), did designers treat successfully this innovative type of building and produce distinguished architecture.

A MASSIVE MASONRY MART Sullivan's predecessor, HENRY HOBSON RICHARDSON (1838–1886), frequently used heavy round arches and massive masonry walls. Because he was particularly fond of the Romanesque architecture of the Auvergne area in France, his work sometimes is thought of as a Romanesque revival. This designation does not do credit to the originality and quality of most of the buildings Richardson designed during the brief eighteen years of his practice. The Trinity Church in Boston and his smaller public libraries, residences, railroad stations, and courthouses in New England and elsewhere best demonstrate his vivid imagination and the solidity (the sense of enclosure and permanence) so characteristic of his style. However, his most important and influential building was the Marshall Field wholesale store (now demolished) in Chicago (FIG. **21-58**), which was begun in 1885. This vast building, occupying a city block and designed for the most practical of purposes, recalled historical styles without imitating them at all. The tripartite elevation of a Renaissance palace (see FIG. 16-20) or of the Roman aqueduct near Nîmes, France (see FIG. 7-31), may have been close to Richardson's mind. But he used no

21-57 ALEXANDRE-GUSTAVE EIFFEL, Eiffel Tower, Paris, 1889 (photo: 1889–1890). Wrought iron, 984' high.

21-58 HENRY HOBSON RICHARDSON, Marshall Field wholesale store (demolished), Chicago, 1885–1887.

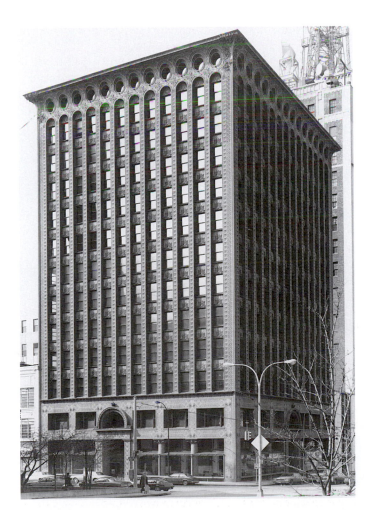

21-59 LOUIS SULLIVAN, Guaranty (Prudential) Building, Buffalo, 1894–1895.

classical ornament, made much of the massive courses of masonry, and, in the strong horizontality of the windowsills and the interrupted courses that defined the levels, stressed the long sweep of the building's lines, as well as its ponderous weight. Although the structural frame still lay behind and in conjunction with the masonry screen, the great glazed arcades opened up the walls of this large-scale building. They pointed the way to the modern total penetration of walls and the transformation of them into mere screens or curtains that serve both to echo the underlying structural grid and to protect it from the weather.

"FORM FOLLOWS FUNCTION" LOUIS HENRY SULLIVAN (1856–1924), who has been called the first truly modern architect, recognized Richardson's architectural innovations early in his career and worked forward from them when designing his tall buildings, especially the Guaranty (Prudential) Building in Buffalo, New York (FIG. **21-59**), built between 1894 and 1895. Here, he expressed the interior's subdivision on the exterior, as well as the skeletal (as opposed to the bearing-wall) nature of the supporting structure. Nothing more substantial than windows occupies most of the space between the terracotta-clad vertical members. In Sullivan's designs, viewers can be sure of an equivalence of interior and exterior design, not at all the case in Richardson's wholesale store or in Henri Labrouste's Library (see FIG. 20-59). Yet, Sullivan kept something of old convention; the Guaranty Building has a base and a cornice, even though the base is penetrated in such a way as to suggest the later free supports of twentieth-century architecture.

The building's form, then, began to express its function, and Sullivan's famous dictum that "form follows function," long the slogan of early-twentieth-century architects, found its illustration here. Sullivan did not mean by this slogan that a functional building is automatically beautiful, nor did he advocate a rigid and doctrinaire correspondence between exterior and interior design. Rather, he espoused a free and flexible relationship—one his pupil, Frank Lloyd Wright, later described as similar to that between the hand's bones and tissue.

TURNING A BUILDING INSIDE OUT Sullivan took a further step in unifying exterior and interior design in his Carson, Pirie, Scott Building in Chicago, Illinois (FIG. **21-60**), built between 1899 and 1904. A department store, this building required broad, open, well-illuminated display spaces. The minimal structural steel skeleton permitted the singular achievement of this goal. The relation of spaces and solids here is so logical that nothing had to be added for structural facing, and the skeleton is clearly revealed on the exterior. The decklike stories, decoratively faced in white ceramic slabs, seem to sweep freely around the building and show several irregularities (notably the stressed bays of the corner entrance) that help the design break out of the cubical formula of Sullivan's older buildings. The architect gave over the lowest two levels of the Carson, Pirie, Scott Building to an ornament in cast iron (of his invention) made of wildly fantastic motifs that bear little resemblance to anything traditional architecture could show. Sullivan led the general search for a new style at the end of the century. He gave as much attention to finding new directions in architectural ornament as in architecture

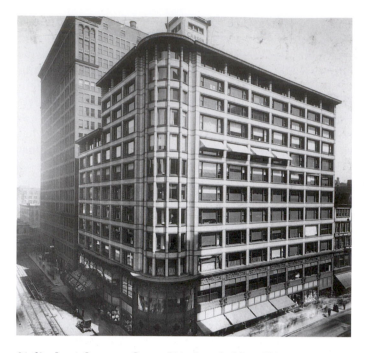

21-60 LOUIS SULLIVAN, *Carson, Pirie, Scott Building,* Chicago, 1899–1904.

itself. In this respect, he was an important figure in the Art Nouveau movement.

Although these new architectural models and materials were greatly important, these innovations were not immediately and widely accepted. Well into the twentieth century historical styles were still prominent in architectural design.

Especially in the nineteenth century's last decades, huge accumulations of wealth in the hands of industrialists and railway magnates permitted constructing lavishly expensive villas, mansions, and palatial town houses. Historical styles seemed appropriate to the newly rich who lived like medieval barons or Renaissance princes.

A "PALACE" IN AMERICA? RICHARD MORRIS HUNT (1827–1895) specialized in serving the building ambitions of America's new aristocracy. He brought Renaissance and Baroque form to the design of their ostentatious plans. Hunt had studied architecture in Switzerland and Paris and was happy to arbitrarily combine the historical styles to suit the tastes of his patrons. He built The Breakers (FIG. **21-61**) for Cornelius Vanderbilt II, the railroad king. It is a splendid private palace in Newport, Rhode Island, a favorite summer vacation spot for the affluent, who competed with one another in the magnitude and majesty of their mansions. Occupying a glorious promontory above the sea, with a splendid view of the incoming wave breakers, the residence resembles more a sixteenth-century Italian palazzo (with touches of French style) than a large summer cottage. The interior rooms are grand in scale and sumptuously rich in decor, each having its own variation of classical columns, painted ceilings, lavish fabrics, and sculptured trimmings. The entry hall, rising some forty-five feet above the majestic main stairway, signals the opulence of the rooms beyond. This hall and most of the main rooms offer magnificent views over the grounds and the ocean, views Hunt's positioning of the building on the property assured.

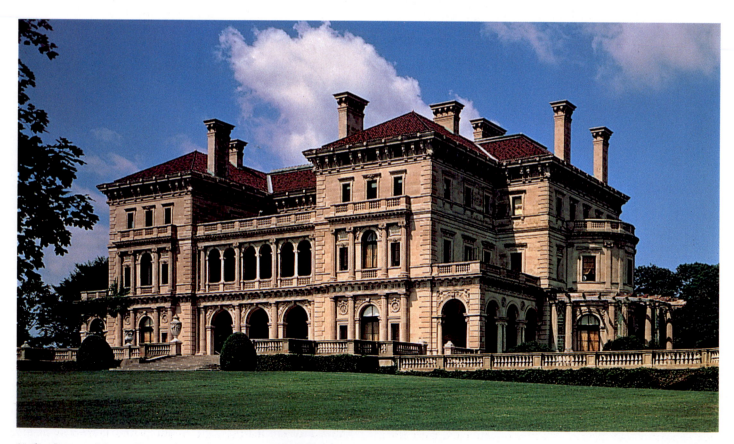

21-61 RICHARD MORRIS HUNT, *The Breakers,* Newport, Rhode Island, 1892.

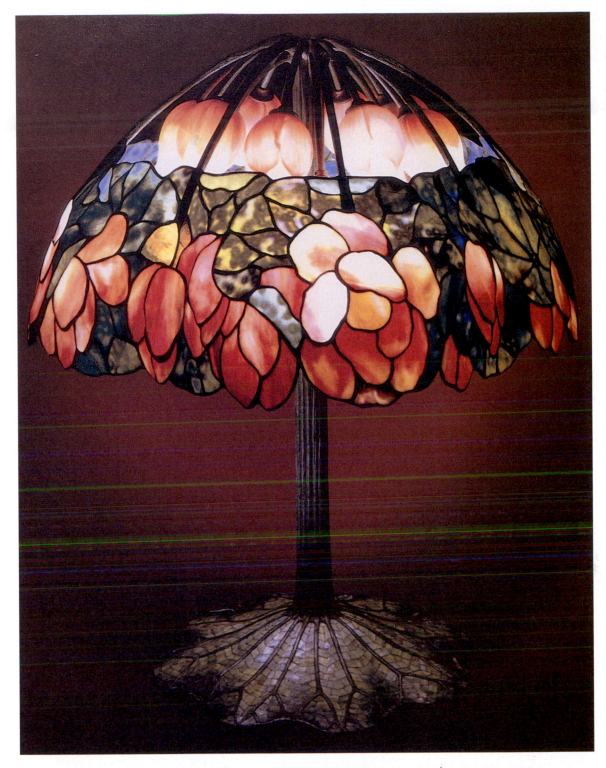

21-62 LOUIS COMFORT TIFFANY, Lotus table lamp, ca. 1905. Leaded Favrile glass, mosaic, and bronze, 2′ 10½″ high. Private collection.

FLORAL STAINED-GLASS LAMPS The period's extravagance and ostentation in architecture extended to the interior decor. Objects such as furniture, lights, rugs, and wallpaper with designs inspired by the sensuous opulence of Art Nouveau or fin-de-siècle art were popular. The stained-glass lamps of Louis Comfort Tiffany are one such example. His lotus table lamp (FIG. **21-62**), constructed of leaded glass, mosaic, and bronze, is based on the curvilinear floral forms of the lotus. Intended for wealthy buyers, this was the most expensive lamp ($750) Tiffany Studios produced in 1906. Because of the expense, labor, and time involved in producing this lamp, only one was made at a time. This ensured the quality artisanship so prized by the Arts and Crafts movement, whose ideas took root in America.

The grandeur and lavishness of this architectural and decorating style remained popular with the ultrarich until World War I shattered the bright period known as *la belle époque.*

COLONIAL EMPIRES ABOUT 1900

Arctic Ocean

GREENLAND

ICELAND

CANADA

RUSSIA

DENMARK

GREAT BRITAIN

NETHERLANDS

BELGIUM

GERMANY

FRANCE

UNITED STATES

Atlantic Ocean

PORTUGAL SPAIN

ITALY

JAPAN

SPANISH MOROCCO

OTTOMAN EMPIRE

RIO DE ORO

LIBYA

EGYPT

INDIA

BURMA

FRENCH INDO-CHINA

Pacific Ocean

HAWAII (U.S.)

GAMBIA (British)

FRENCH WEST AFRICA

ERITREA

ADEN

PORTUGUESE GUINEA

NIGERIA

SUDAN

BRITISH SOMALILAND

PHILIPPINES

Pacific Ocean

BRITISH GUIANAS FRENCH DUTCH

SIERRA LEONE

GOLD COAST CAMEROON

BELGIAN CONGO

ITALIAN SOMALILAND

BRITISH E. AFRICA

DUTCH EAST INDIES

ANGOLA

GERMAN E. AFRICA

Indian Ocean

Atlantic Ocean

GERMAN SOUTHWEST AFRICA

MADAGASCAR

MOZAMBIQUE

AUSTRALIA

UNION OF S. AFRICA

0 1500 3000 miles
0 1500 3000 kilometers

FALKLAND IS. (British)

NEW ZEALAND

Belgian Empire	Danish Empire	French Empire	Italian Controlled
British Empire	Dutch Controlled	German Empire	Japanese Empire

Ottoman Empire | Russian Empire | United States Controlled
Portuguese Empire | Spanish Controlled | Independent Nations

1900 1915 1925

Pablo Picasso
Les Demoiselles d'Avignon, 1907

Georges Braque
The Portuguese, 1911

Käthe Kollwitz
Memorial to Karl Liebknecht, 1919

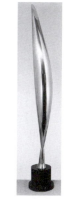

Constantin Brancusi
Bird in Space, 1928

Sigmund Freud, 1856–1939; *The Interpretation of Dreams*, 1900

Max Planck, 1858–1947; quantum theory, 1900

Die Brücke, formed 1905

Les Fauves, formed 1905

Albert Einstein, 1879–1955; theory of relativity, 1905–1915

Futurist Manifesto, 1909

Niels Bohr, 1885–1962; atomic theory, 1913

Die Blaue Reiter, formed 1911

Queen Victoria's reign ends, 1901

World War I, 1914–1918

First Transatlantic radio signal, 1901

Wright brothers' first flight, 1903

Russian Revolution, Communist regime, 1917–1921

Bauhaus founded, 1919

Treaty of Versailles, 1919–1921

Commercial television, 1920s

League of Nations, 1921–1939

Surrealist Manifesto, 1924

Mexican Revolution ends, 1924

U.S.S.R. officially established, 1923

THE TRIUMPH OF MODERNIST ART

THE EARLY TWENTIETH CENTURY

1930 1936 1940

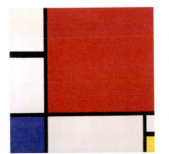

Piet Mondrian, Composition
(Blue, Red, and Yellow), 1930

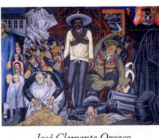

José Clemente Orozco
Epic of American Civilization:
Hispano-America, (panel 16)
ca. 1932–1934

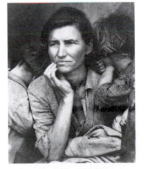

Dorothea Lange
Migrant Mother, Nipomo Valley, 1935

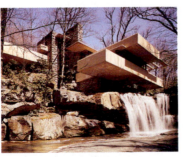

Frank Lloyd Wright
Kaufmann House (Fallingwater), 1936–1939

Carl Jung, 1875–1961 (analytical psychology)

Fascism in Italy, 1920–1930s

Stock market crashes, 1929

The Great Depression, 1930s

Rise of Nazism in Germany, 1930s

Roosevelt's "New Deal" in United States, 1933–1939

Spanish Civil War, 1936–1939

Japan invades China, 1937

World War II
1939–1945

The decisive changes that marked the nineteenth century—industrialization, urbanization, and the growth of nationalism and imperialism—are chronicled in Chapter 21. These developments continued to affect countries dramatically throughout the twentieth century. The rampant industrialization matured into international industrial capitalism, which fueled the rise of consumer economies.

As in the nineteenth century, these developments presented societies with great promise, as well as significant problems. Appropriately, these changes prompted both elation and anxiety. The combination of euphoria and alienation that was the hallmark of fin-de-siècle culture in Europe (Chapter 21, page 776) carried through the next decades. Momentous historical events—World War I, the Great Depression, the rise of totalitarianism, and World War II—exacerbated this rather schizophrenic attitude.

Twentieth-Century Intellectual Developments

In the early twentieth century, societies worldwide contended with discoveries and new ways of thinking in a wide variety of fields, including science, technology, economics, and politics. These new ideas forced people to radically revise how they understood their worlds. In particular, the values and ideals that were the legacy of the Scientific Revolution (during the Age of Newton) and the Enlightenment began to yield to innovative views. Thus, intellectuals questioned eighteenth- and nineteenth-century assumptions about progress and reason with ideas challenging traditional thoughts about the physical universe, the structure of society, and human nature.

CHALLENGING NEWTONIAN PHYSICS One of the fundamental Enlightenment beliefs was faith in science. Because it was based on empirical, or observable, fact, science provided a mechanistic conception of the universe, which reassured a populace finding traditional religions less certain. As promoted in the classic physics of Isaac Newton, the universe was a huge machine consisting of time, space, and matter. The early twentieth century witnessed an astounding burst of scientific activity challenging this model of the universe. It amounted to what has been called "the second scientific/technological revolution." Particularly noteworthy was the work of German physicist Max Planck (1858–1947), German-born Albert Einstein (1879–1955), and British physicist Ernest Rutherford (1871–1937) and Danish physicist Niels Bohr (1885–1962). With their discoveries, each of these scientists shattered the existing faith in the objective reality of matter and, in so doing, paved the way for a new model of the universe. Planck's quantum theory (1900) raised questions about the emission of atomic energy. He maintained that a heated body radiated energy discontinuously in irregular units he called "quanta." Einstein furthered these studies of thermodynamics. In his 1905 paper, *The Electrodynamics of Moving Bodies,* he outlined his theory of relativity. He argued that space and time are not absolute, as postulated in Newtonian physics. Rather, Einstein explained that time and space are relative to the observer and linked in what he called a four-dimensional space-time continuum. He also concluded that matter, rather than a solid, tangible reality, was actually an-

other form of energy. Einstein's famous equation $E = mc^2$, where E stands for energy, m for mass, and c^2 for the speed of light, provided a formula for understanding atomic energy. Rutherford's and Bohr's exploration of atomic structure between 1906 and 1913 contributed to this new perception of matter and energy. The 1896 discovery of radioactivity in uranium and later research opened the way for world-transforming electronic technology. Together, all these scientific discoveries constituted a changed view of physical nature and raised the curtain on the Atomic Age.

TECHNOLOGY: CHEMICAL AND ELECTRICAL Scientific developments were not limited to the realm of physics. Advances in chemistry, biology, biochemistry, microbiology, and medicine in the early twentieth century yielded knowledge of polymers, plastics, fertilizers, enzymes, viruses, vitamins, hormones, and antibiotics. Molecular biologists analyzed and described the structure of cells and tissues, as well as the electrical nature of the brain and nervous system. Their investigations into proteins and nucleic acids led to an understanding of the genetic structure of life.

The most conspicuous technological advances, which largely depended on the scientific discoveries, were in communication and transportation. People adapted to radios, radar, televisions, and talking cinema, as well as automobiles, airplanes—from propeller-driven to jet, electrified railway and municipal transit systems, and electrification of street lighting and home appliances.

Chemical technology became an industry as important as electrical technology. It had its greatest impact in the world of materials, in mining, metals, oil refining, textiles, pharmaceuticals, agriculture, food production and food processing. It was particularly useful in the fight against disease and famine, although at this time its long-term ecological effects were unknown.

The field of mechanical engineering experienced great advances as well. Mass production and the assembly line became indispensable to industry. Chemical and biological researchers found scientific instruments such as the electron microscope essential to their work. The requirements of calculation, vastly expanded by the new complexities of scientific research and the machine environment, demanded electronic instrumentation and control mechanisms. Cybernetic theory and early computer models were in place by midcentury.

MIND OVER MATTER In other realms of thought—philosophy, psychology, and economic theory—significant challenges to the primacy of reason and objective reality emerged. Friedrich Nietzsche (1844–1900), a German intellectual, rejected the rational. In his existentialist publications, he argued that Western society was decadent and incapable of any real creativity precisely because of its excessive reliance on reason at the expense of emotion and passion. Nietzsche blamed Christianity for much of Western civilization's decay, and he insisted societies only could attain liberation and renewal when they acknowledged God is dead.

Also instrumental in examining the irrational mind and destabilizing the entrenched belief in the rational nature of humanity and the world was the Viennese doctor Sigmund Freud (1856–1939). He developed the fundamental principles for what became known as psychoanalysis. In his book *The Inter-*

pretation of Dreams (1900), Freud argued that the unconscious and inner drives (of which people are largely unaware) control human behavior. He used both hypnosis and dream analysis to understand behavior. Freud concluded that this control by the unconscious is due to repression, or individuals mentally burying uncomfortable experiences or memories. This repression occurs in the brain due to a struggle between three forces— the id, the ego, and the superego. While the id contains unconscious drives and desires, the ego is rational and coordinates this struggle of forces. The superego consists of the inhibitions and values that societal forces, such as parents or friends, impose. Making patients aware of repressed memories or unconscious conflicts through psychoanalysis, Freud believed, could assure patients' mental well-being.

During the twentieth century, Freud's ideas gained popularity. Another very influential psychiatrist who expanded on Freud's theories was Carl Jung (1875–1961). This Swiss doctor felt Freud's theories were too narrowly focused. Instead, Jung proposed a model connecting a person's dreams in a unique arrangement he called "the process of individuation." Therapists could understand the behavior and personality of an individual by identifying this pattern of dreams. Further, Jung asserted that the unconscious is composed of two facets, a "personal unconscious" and a "collective unconscious." The collective unconscious comprises memories and associations all humans share, such as archetypes (original models) and mental constructions. According to Jung, the collective unconscious accounts for the development of myths, religions, and philosophies.

The Rise of Industrial Capitalism

The industrialization so prominent during the nineteenth century matured quickly. By the early part of the twentieth century, boards of directors controlled large-scale firms. These were often far-flung enterprises with enormous factories. The owners and managers of such industrial giants, known as "captains of industry," wielded extraordinary economic and political power. Due to the widening gap between these captains of industry and the laborers, Marxism (Chapter 21, page 732) grew in popularity. Marxism's championing of the working classes held great appeal, so enrollment in trade unions and socialist parties increased. Although the socialists did not have unified strategies, they all agreed the capitalist profit system exploited the workers and enriched the owners, causing the deplorable living and working conditions of most workers.

As dramatic as the societal changes were in the nineteenth century, twentieth-century individuals encountered even greater uncertainty and anxiety. Not only were the conditions of their lives very different, but also they faced fundamental, indeed revolutionary, challenges in how they viewed the world, prompted by thinkers such as Einstein, Freud, and Nietzsche.

World War I and the Russian Revolution

The development of advanced industrial societies in Europe and America led to frenzied imperialist expansion. Countries controlled far-flung empires and spread their spheres of influence worldwide. By the beginning of the twentieth century, Britain, France, Germany, Belgium, Italy, Spain, and Portugal all had footholds in Africa. In Asia, Britain ruled India, the Dutch controlled Indonesia's vast archipelago, the French held power in Indochina, and the Russians ruled Central Asia and Siberia. Japan began rising as a new and formidable Pacific power that would stake its claims to empire in the 1930s. Such imperialism was capitalist and expansionist, establishing colonies as raw-material sources, as manufacturing markets, and as territorial acquisitions. Imperialism also often had the missionary dimension of bringing the "light" of Christianity and civilization to "backward peoples" and educating "inferior races." This mission, driven by Social Darwinism (Chapter 21, page 732), based its beliefs on Charles Darwin's idea of the "survival of the fittest." Social Darwinism found its major proponent in the British philosopher Herbert Spencer (1820–1903), who argued that societies and cultures conflicted and only the strongest survived.

THE GREAT WAR Although many people optimistically hoped the development of nation-states would result in peace and harmony, this was not to be. Rather than cooperation, the prevalent nationalism and rampant imperialism led to competition. Eventually, countries negotiated alliances to protect their individual interests. The conflicts between the two major blocs—the Triple Alliance (Germany, Austria-Hungary, and Italy), and the Triple Entente (Russia, France, and Great Britain)—led to World War I. In July 1914, Austria-Hungary declared war on Serbia. The "Great War" lasted until 1918 and involved virtually all of Europe. Allegiances shifted with the changing fortunes of different countries; for example, Italy betrayed the rest of the Triple Alliance by entering the war in 1915 on the side of the Allies. The initial enthusiasm of the war effort revealed the strength of nationalist sentiments.

The slaughter and devastation soon destroyed any romantic illusions soldiers held about World War I. Not only were millions of men killed in battle, but the introduction of poison gas in 1915 also added to the horror of humankind's inhumanity to itself. Although the United States tried to remain neutral, it finally felt compelled to enter the war in 1917.

The twenty-seven Allied nations negotiated the official end of World War I in 1919. The national interests of the individual countries complicated these deliberations. Separate peace treaties with the various participants resulted in a fragile peace. The devastation of World War I brought widespread misery, social disruption, and economic collapse. All the world viewed the ultimate effects of nationalism, imperialism, and expansionist goals.

THE DEMISE OF THE TSAR IN RUSSIA The Russian Revolution exacerbated the global chaos when it erupted in 1917. Dissatisfaction with the regime of Tsar Nicholas II had led workers to stage a general strike, and the monarchy's rule ended with the tsar's abdication in March. In late 1917 the Bolsheviks wrested control of the country from the ruling Provisional Government. The Bolsheviks, a faction of Russian Social Democrats led by V. I. Lenin (1870–1924), promoted violent revolution and were eventually renamed the Communists. Once in power, Lenin nationalized the land and turned it over to the local rural soviets (councils of workers' and soldiers' deputies). After extensive civil war, the Communists succeeded in retaining control of Russia, officially renamed the Soviet Union in 1923.

The Great Depression and World War II

The resolution of World War I was indeed tenuous; the Great Depression of the 1930s dealt a serious blow to the stability of Western countries. Largely due to the international scope of banking and industrial capitalism, the economic depression deeply affected the United States and many European countries. By 1932, 25 percent of the British workforce was unemployed, while 40 percent of German workers were without jobs. Production in the United States plummeted by 50 percent.

THE UNHEEDED LESSONS OF WORLD WAR I
This economic disaster, along with the failure of postwar treaties and the League of Nations to keep the peace, provided a fertile breeding ground for dangerous forces to once again emerge. In the 1920s and 1930s, totalitarian regimes came to the fore in several European countries. Benito Mussolini (1883–1945) headed the Fascist regime in Italy, derived from a staunch nationalism. Mussolini explained: "Fascism is totalitarian, and the Fascist State, the synthesis and unity of all values, interprets, develops and gives strength to the whole life of the people."[1] Joseph Stalin (1879–1953) gained control of the Communist Party in the Soviet Union in 1929. Concurrently, Adolf Hitler (1889–1945) consolidated his power in Germany by building the National Socialist German Workers' Party (or Nazi for short) into a mass political movement.

These ruthless seizures of power and the desire to develop "total states" led to the many conflicts that evolved into World War II. This catastrophic struggle erupted in 1939 when Germany invaded Poland and in response Britain and France declared war on Germany. Eventually, this conflict earned its designation as a world war; while Germany and Italy fought most of Europe and the Soviet Union, Japan invaded China and occupied Indochina. After the Japanese bombing of Pearl Harbor in Hawaii in 1941, the United States declared war on Japan. Germany, in loose alliance with Japan, declared war on the United States. Although most of the concerns of individual countries participating in World War II were territorial and nationalistic, other agendas surfaced as well. The Nazis, propelled by Hitler's staunch anti-Semitism, were determined to build a racially exclusive Aryan state. This resolve led to the horror of the Holocaust, the killing of nearly two out of every three European Jews.

World War II drew to an end in 1945, when the Allied forces defeated Germany and the United States dropped atomic bombs on Hiroshima and Nagasaki in Japan. The shock of the war's physical, economic, and psychological devastation immediately tempered the elation people felt at the conclusion of these global hostilities.

The Evolution of Modernism and the Avant-Garde

Like other members of society, artists were deeply affected by the upheaval of the early twentieth century. At times, they responded with energy and optimism, while at other times they descended into bleak despair. Changes in the art world itself also influenced artistic developments. The challenges of Impressionism, Post-Impressionism, and the various renegade exhibitions diminished the academies' authority, although still a presence.

For artists, working within the crucible of historical turmoil, contending with shifting institutional structures within the art world, and acknowledging modernism's significance led to an incredibly fertile period for the evolution of art. In particular, the avant-garde (Chapter 21, page 766), first discussed in conjunction with the Post-Impressionists, became a major force. Like their nineteenth-century predecessors, early-twentieth-century avant-garde artists positioned themselves in the forefront by aggressively challenging traditional and often cherished notions about art and its relation to society. As the old social orders collapsed and new ones, from communism to corporate capitalism, took their places, one of the self-imposed tasks school after school of twentieth-century avant-gardes embraced was the search for new ways to communicate in a radically changed world. This does not suggest, however, that the avant-garde represented a unified group—far from it. Some avant-garde artists used their art to powerfully criticize political and social institutions. Because the term avant-garde emerged in art after its use in politics, these critiques prompted the general public to associate avant-garde artists with radical political thought and anarchism. In contrast, other avant-garde artists, in essence, withdrew from society and concentrated their attention on art as a unique activity, separate from society-at-large. These artists pursued an introspective examination of artistic principles and elements (continuing the modernist critique) which increasingly focused on formal qualities.

EXPRESSIONISM IN EARLY-TWENTIETH-CENTURY EUROPE

Aspects of all these avant-garde strains contributed to the emergence of "expressionism." The term *expressionism* has been used over the years to refer to a wide range of art. Simply put, *expressionism* refers to art that is the result of the artist's unique inner or personal vision and that often has an emotional dimension. This contrasts, for example, with art focused on visually describing the empirical world. The term first gained currency in the early twentieth century and was popularized in *Der Sturm*, an avant-garde periodical initially published in Munich. Herwarth Walden, the editor of *Der Sturm*, proclaimed: "We call the art of this century Expressionism in order to distinguish it from what is not art. We are thoroughly aware that artists of previous centuries also sought expression. Only they did not know how to formulate it."[2]

In this chapter and the next, several movements are classified as expressionist, from German Expressionism of the 1910s to Abstract Expressionism, which emerged in the United States in the 1940s. Some of this expressionist art evokes visceral emotional responses from viewers, while other such artworks rely on the artist's introspective revelations. One of the first movements to tap into this pervasive desire for expression was Fauvism. In their work, these artists explored both facets of expressionism. They combined outward expressionism in the form of a bold release of internal feelings through wild color and powerful, even brutal, brushwork and inward expressionism, awakening viewers' emotions by these very devices. Often the expressionists offended viewers and even critics, but the expressionists sought empathy—connection between the internal states of artists and viewers—not sympathy.

Fauvism

In 1905, the first signs of a specifically twentieth-century movement in painting appeared in Paris. In that year, at the third Salon d'Automne, a group of young painters under the leadership of Henri Matisse exhibited canvases so simplified in design and so shockingly bright in color that a startled critic described the artists as *fauves* (wild beasts). The Fauves were totally independent of the French Academy and the "official" Salon. The Fauve movement was driven by a desire to develop an art that had the directness and antitheoretical orientation of Impressionism but that also used intense color juxtapositions and their emotional capabilities, the legacy of artists such as van Gogh and Gauguin. The Fauves had seen the works of these two artists (shown in retrospective exhibitions in Paris in 1901 and 1903), but the Fauves went even further in liberating color from its descriptive function and using it for both expressive and structural ends. They produced portraits, landscapes, still lifes, and nudes of spontaneity and verve, with rich surface textures, lively linear patterns, and, above all, bold colors. The Fauves went beyond any earlier artist by newly intensifying color with startling contrasts of vermilion and emerald green and of cerulean blue and vivid orange held together by sweeping brush strokes and bold patterns.

The Fauve painters never officially organized, and the looseness of both personal connections and stylistic affinities caused the Fauve movement to begin to disintegrate almost as soon as it emerged. Within five years, most of the artists had departed from a strict adherence to Fauve principles and developed their own, more personal, styles. During its brief existence, however, the Fauve movement made a remarkable contribution to the direction of art by demonstrating color's structural, expressive, and aesthetic capabilities.

THE PRIMACY OF COLOR The Fauve use of color is particularly apparent in the work of HENRI MATISSE (1869–1954), who was the centrifugal force of this group. Matisse realized the primary role color could play in conveying meaning and focused his efforts on developing this notion. His *Woman with the Hat* (FIG. **22-1**) is an instructive example of this. Matisse depicted his wife, Amélie, in a rather conventional manner compositionally. However, the seemingly arbitrary colors immediately strike viewers. The entire image—the woman's face, clothes, hat, and background—consists of patches and splotches of color juxtaposed in ways that sometimes produce jarring contrasts. Matisse explained his approach: "What characterized fauvism was that we rejected imitative colors, and that with pure colors we obtained stronger reactions—more striking simultaneous reactions,

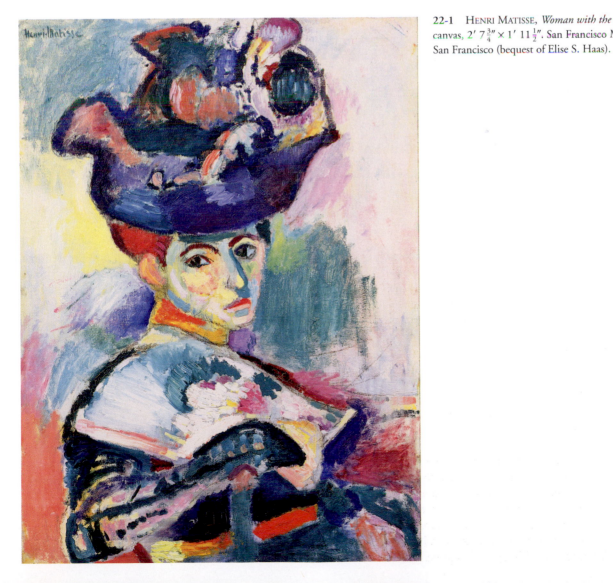

22-1 HENRI MATISSE, *Woman with the Hat*, 1905. Oil on canvas, 2' 7¾" × 1' 11½". San Francisco Museum of Modern Art, San Francisco (bequest of Elise S. Haas).

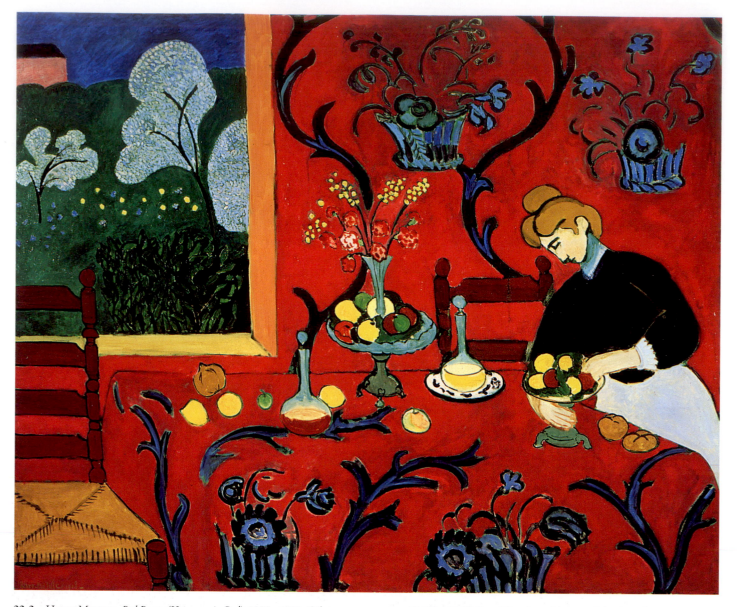

22-2 HENRI MATISSE, *Red Room (Harmony in Red)*, 1908–1909. Oil on canvas, approx. 5′ 11″ × 8′ 1″. State Hermitage Museum, Saint Petersburg.

and there was also the luminosity of our colors."[3] Matisse's reference to luminosity linked him to Cézanne, who argued that painters could not reproduce light but must represent it by color. For Matisse and the Fauves, therefore, color became the formal element most responsible for pictorial coherence and the primary conveyor of meaning.

FROM GREEN, TO BLUE, TO RED The maturation of these color discoveries can be seen in Matisse's *Red Room* (*Harmony in Red*; FIG. **22-2**). Here, viewers are confronted with the interior of a comfortable, prosperous household with a maid placing fruit and wine on the table. The artist's color selection and juxtapositions generate much of the feeling of warmth and comfort. He depicted objects in simplified and schematized fashion and flattened out the forms—for example, he eliminated the front edge of the table, making the table, with its identical patterning, as flat as the wall behind it. The colors, however, contrast richly and intensely. Matisse's process of overpainting reveals color's importance for striking the right chord in viewers. Initially, this work was

predominantly green, and then he repainted it blue. Neither color seemed appropriate to Matisse, and not until he repainted this work red did he feel he had struck the proper chord. Like van Gogh and Gauguin, Matisse expected color to provoke an emotional resonance in viewers. He declared: "Color was not given to us in order that we should imitate Nature. It was given to us so that we can express our own emotions."[4]

EXPRESSING CONTENT WITH COLOR ANDRÉ DERAIN (1880–1954), also a Fauve group member, worked closely with Matisse. Like Matisse, Derain worked to use color to its fullest potential—for aesthetic and compositional coherence, to increase luminosity, and to elicit emotional responses from viewers. *London Bridge* (FIG. **22-3**) is typical of Derain's art. The perspective appears distorted, and color delineates space. In addition, the artist indicated light and shadow not by differences in value, but by contrasts of hue. Finally, color does not describe the local tones of objects; instead, it expresses the picture's content.

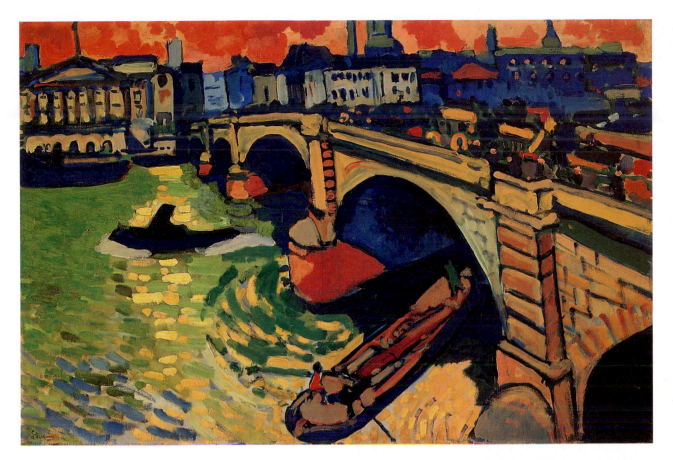

22-3 ANDRÉ DERAIN, *London Bridge,* 1906. Oil on canvas, 2′ 2″ × 3′ 3″. Museum of Modern Art, New York (gift of Mr. and Mrs. Charles Zadok).

FAUVE COLOR TO REVEAL SOCIAL TRUTHS French artist GEORGES ROUAULT (1871–1958) was not a member of the Fauve circle, but he did study with Gustave Moreau, the teacher who had so influenced Matisse's development. And he clearly based his works on a similar interest in the evocative power of color. However, although the work of the Fauves generally did not include strong social or political content, Rouault's work is moving precisely because it reveals social truths and comments on the forces that crush the spirit. Rouault is best known for his expressive portraits of clowns, prostitutes, and actors, all appearing as universal tragic figures. Given Rouault's strong religious convictions, it is not surprising many of his works have religious overtones. Rouault's intersection with the Fauve program comes from his use of intense colors to impart a lushness and luminosity to the images, adding to their power.

The evocative power of Rouault's work is manifested in *The Old King* (FIG. **22-4**). The artist painted the single figure of the king, whose fierce visage appears in sharp profile, in rich jewel tones—deep glowing reds, emerald greens, and midnight blues. Rouault divided the color areas and outlined the figure in harsh black lines, a mainstay of his style. The parallel of this style to stained-glass windows is not coincidental. Rouault worked as a glassmaker's apprentice as a youth and remained impressed by the depth and intensity of color

22-4 GEORGES ROUAULT, *The Old King,* 1916–1936. Oil on canvas, 2′ 6$\frac{1}{4}$″ × 1′ 9$\frac{1}{4}$″. Carnegie Museum of Art, Pittsburgh (Patrons Art Fund, 1940).

in glass. The king's severe aquiline features, dark complexion, and thick black hair suggest an authoritative despot in brooding reverie. The sharp and rugged simplification of the forms and harsh, hacked-out edges convey with blunt force an aspect of monarchic vengeance. Here, Rouault produced a powerful, defiant image of merciless authority, a ruler somewhat ravaged by time. Paradoxically, the king appears to clutch flowers in his fist.

German Expressionism: Die Brücke

The immediacy and boldness of the Fauve images appealed to many artists, including the German Expressionists. However, although color plays a prominent role in the work of the German Expressionists, the expressiveness of their images is due as much to the wrenching distortions of form, ragged outline, and agitated brushstrokes. This resulted in savagely powerful, emotional canvases in the years leading to World War I.

The first group of German artists to explore expressionist ideas gathered in Dresden in 1905 under the leadership of ERNST LUDWIG KIRCHNER (1880–1938). The group's members thought of themselves as paving the way for a more perfect age by bridging the old age to the new. They derived their name Die Brücke (The Bridge) from this concept. Kirchner's early studies in architecture, painting, and the graphic arts had instilled in him a deep admiration for German medieval art. Like the British artists associated with the Arts and Crafts movement, such as William Morris (see FIG. 21-50), this admiration stirred the group to model themselves on their ideas of medieval craft guilds by living together and practicing all

the arts equally. Kirchner described their lofty goals in a ringing statement:

> With faith in development and in a new generation of creators and appreciators we call together all youth. As youth, we carry the future and want to create for ourselves freedom of life and of movement against the long-established older forces. Everyone who with directness and authenticity conveys that which drives him to creation, belongs to us.[5]

These artists protested the hypocrisy and materialistic decadence of those in power. Kirchner, in particular, focused much of his attention on the detrimental effects of industrialization, such as the alienation of individuals in cities, which he felt fostered a mechanized and impersonal society. This perception was reinforced when most of the group, including Kirchner, moved to Berlin, a teeming metropolis. Further, the tensions leading to World War I exacerbated the discomfort and anxiety evidenced in the works of Die Brücke.

URBAN LIFE IN PREWAR DRESDEN Kirchner's *Street, Dresden* (FIG. **22-5**) provides viewers with a glimpse into the frenzied urban activity of a bustling German city before the First World War. Rather than the distant, panoramic urban view of the Impressionists, this street scene is jarring and dissonant. The women in the foreground loom large, approaching viewers somewhat menacingly. The steep perspective of the street, which threatens to push the women directly into the viewing space, increases their confrontational nature. Harshly rendered, the women's features make them appear zombielike and ghoulish, and the garish, clashing colors—juxtapositions of bright orange, emerald green, acrid chartreuse, and pink—add to the image's expressive impact.

22-5 ERNST LUDWIG KIRCHNER, *Street, Dresden,* 1908 (dated 1907). Oil on canvas, 4′ 11¼″ × 6′ 6⅞″. Museum of Modern Art, New York (purchase).

22-6 EMIL NOLDE, *Saint Mary of Egypt among Sinners,* 1912. Left panel of a triptych, oil on canvas, approx. 2'10" × 3'3". Hamburger Kunsthalle, Hamburg.

UNRESTRAINED RELIGIOUS IMAGES EMIL NOLDE (1867–1956) was much older than most Die Brücke artists, but because he was pursuing similar ideas in his work, he was invited to join the group in 1906 and became an important member for a year and a half. The content of Nolde's work centered, for the most part, on religious imagery. In contrast to the quiet spirituality and restraint of traditional religious images, however, Nolde's paintings are visceral and forceful. A good example is *Saint Mary of Egypt among Sinners* (FIG. 22-6). Mary, before her conversion, entertains lechers whose lust magnifies their brutal ugliness. The distortions of form and color (especially the jarring juxtaposition of blue and orange) and the rawness of the brushstrokes amplify the harshness of the leering faces.

Borrowing ideas from van Gogh, Munch, the Fauves, and African and Oceanic art, Die Brücke artists created a wide range of images. The harsh colors, aggressively brushed paint, and distorted forms expressed the painters' feelings about the injustices of society and their belief in a healthful union of human beings and nature. Their use of such diverse sources reflects the expanding scope of global contact from colonialism and international capitalism. By 1913, the group dissolved, and each member continued to work independently.

German Expressionism: Der Blaue Reiter

A second major German Expressionist group, Der Blaue Reiter (The Blue Rider) formed in Munich in 1911. The two founding members, VASSILY KANDINSKY (1866–1944) and FRANZ MARC (1880–1916), whimsically selected this name because of their mutual interest in the color blue and horses.

Like Die Brücke and other expressionist artists, this group produced paintings that captured their feelings in visual form while also eliciting intense visceral responses from viewers.

BLUEPRINTS FOR ENLIGHTENMENT Born in Russia, Vassily Kandinsky, one of the driving forces of Der Blaue Reiter, moved to Munich in 1896 and soon developed a spontaneous and aggressively avant-garde expressive style. Indeed, Kandinsky was one of the first artists to explore complete abstraction, as evidenced by *Improvisation 28* (FIG. 22-7). Kandinsky fueled his elimination of representational elements with his interest in theosophy (a religious/philosophical belief system incorporating a wide range of tenets from, among other sources, Buddhism and mysticism) and the occult, as well as with advances in the sciences. A true intellectual widely read in philosophy, religion, history, and the other arts, especially music, Kandinsky was also one of the few early modernists to read with some comprehension the new scientific theories of Einstein's era. Rutherford's exploration of atomic structure, for example, convinced Kandinsky that material objects had no real substance, thereby shattering his faith in a world of tangible things.

The painter articulated his ideas in an influential treatise, *Concerning the Spiritual in Art,* published in 1912. Artists, Kandinsky believed, must express the spirit and their innermost feelings by orchestrating color, form, line, and space. He produced numerous works like *Improvisation 28,* conveying feelings with color juxtapositions, intersecting linear elements, and implied spatial relationships. Ultimately, Kandinsky saw these abstractions as evolving blueprints for a more enlightened and liberated society emphasizing spirituality.

22-7 Vassily Kandinsky, *Improvisation 28* (second version), 1912. Oil on canvas, 3′ 7⅞″ × 5′ 3⅞″. Solomon R. Guggenheim Museum, New York (gift of Solomon R. Guggenheim, 1937).

EXPRESSING AN "INNER TRUTH" As noted earlier, Kandinsky's friend and cofounder of Der Blaue Reiter was Franz Marc. Like many of the other German Expressionists, Marc grew increasingly pessimistic about the state of humanity, especially as World War I loomed on the horizon. His perception of human beings as deeply flawed led him to turn to the animal world for his subjects. Animals, he believed, were "more beautiful, more pure" than humanity and thus more appropriate as a vehicle to express an inner truth.[6] In his quest to imbue his paintings with greater emotional intensity, Marc focused on color and developed a system of colors ex-

pressing specific feelings or ideas. In a letter to a fellow Blaue Reiter, Marc explained: "Blue is the *male* principle, severe and spiritual. Yellow is the *female* principle, gentle, happy and sensual. Red is *matter,* brutal and heavy. . . ."[7] He based this correspondence between colors and emotions on his perceptions. Marc's attempts to create, in a sense, an iconography (or representational system) of color links him to other avant-garde artists struggling to find new ways to communicate.

Fate of the Animals (FIG. **22-8**) represents the culmination of Marc's color explorations. It was painted in 1913, when the tension of impending cataclysm had pervaded society and

22-8 Franz Marc, *Fate of the Animals,* 1913. Oil on canvas, 6′ 4¾″ × 8′ 9½″. Kunstmuseum, Basel.

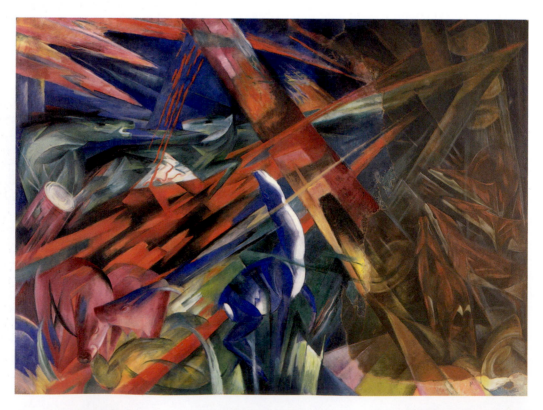

emerged in Marc's art. The animals appear trapped in a forest, some apocalyptic event destroying them. The entire scene is distorted—shattered into fragments. More significantly, the lighter and brighter colors—the passive, gentle, and cheerful ones—are absent, and the colors of severity and brutality dominate the work. Marc discovered just how well his painting portended war's anguish and tragedy when he ended up at the front the following year. His experiences in battle prompted him to write to his wife that *Fate of the Animals* "is like a premonition of this war—horrible and shattering. I can hardly conceive that I painted it."[8] His contempt for people's inhumanity and his attempt to express that through his art ended, with tragic irony, in his death in action in World War I in 1916.

EARLY EXPRESSIONIST SCULPTURE

CLASSICAL GRACE AND BEAUTY Just as painters sought maximum expressive effect through line, color, and manipulation of shape, many early-twentieth-century sculptors pursued a similar direction. They moved away from literally depicting objects and sought to imbue their works with greater emotional resonance. The French sculptor ARISTIDE MAILLOL (1861–1944) wanted his sculptures, predominantly figurative, to embody the abstractions of beauty, repose, and tranquility. His works, such as *The Mediterranean* (FIG. **22-9**), capture the essence of those ideals through a graceful simplicity of pose and gesture. The clean lines and apparent timelessness of Maillol's sculpture reveal that he deeply imbued his art with the classical spirit. In fact, it has been suggested *The Mediterranean* is a metaphor of cultural geography in how it captures the character of the Greek and Roman cultures once populating the Mediterranean region. Maillol was born in Banyuls, a Mediterranean fishing village near the Spanish border, which well may explain his sensitivity to the classical legacy.

EMBRACING ABSTRACTION

A Spanish artist whose importance in the history of art is uncontested is PABLO PICASSO (1881–1973). His extensive artistic production during his lengthy career covered a wide range of media (painting, sculpture, ceramics, prints, and drawings) and styles. He made staggering contributions to the development of abstraction and to new ways of representing the surrounding world.

Picasso was a precocious student who had mastered all aspects of late-nineteenth-century Realist technique by the time he entered the Barcelona Academy of Fine Art in the late 1890s. His prodigious talent led him to experiment with a wide range of visual expression, first in Spain and then in Paris, where he settled in 1904. Throughout his career, Picasso remained a traditional artist in making careful preparatory studies for each major work. He characterized the modern age, however, in his enduring quest for innovation, his lack of complacency, and his insistence on constantly challenging himself and those around him. Picasso revealed this modernity in his constant experimentation, in his sudden shifts from one style to another, and in his startling innovations in painting, graphic art, and sculpture, among other media. By the time he settled permanently in Paris, his work had evolved from Spanish painting's sober Realism through an Impressionistic phase (for a time, influenced by Toulouse-Lautrec's early works) to the so-called Blue Period (1901–1904). Picasso's melancholy state of mind prompted the Blue Period, when he used primarily blue colors to depict worn, pathetic, and alienated figures.

22-9 ARISTIDE MAILLOL, *The Mediterranean*, 1902–1905 (base ca. 1951–1953). Bronze, 3′ 5″ high; base, 3′ 9″ × 2′ 5″. Museum of Modern Art, New York (gift of Stephen C. Clark).

22-10 PABLO PICASSO, *Gertrude Stein*, 1906–1607. Oil on canvas, 3′3$\frac{3}{8}$″ × 2′8″. Metropolitan Museum of Art, New York (bequest of Gertrude Stein, 1947).

The Fragmentation of Forms in Space

A PLANAR PORTRAIT OF A WRITER By 1906, Picasso was searching restlessly for new ways to depict form. He found clues in African sculpture, in ancient Iberian sculpture, and in the late paintings of Cézanne. (The expansion of colonial empires in the late nineteenth and early twentieth centuries resulted in wider exposure of European and American artists to art from Africa, India, and other faraway locales.) Inspired by these sources, Picasso returned to a portrait of Gertrude Stein (FIG. **22-10**), his friend and patron (see "Nurturing the Avant-Garde: Gertrude and Leo Stein as Art Patrons," page 797). Picasso had started the painting earlier that year but had left it unfinished after more than eighty sittings by Stein because, the artist told her, "I can't see you any longer when I look."[9] On resuming his work on the portrait, Picasso painted Stein's head as a simplified planar form, incorporating aspects derived from his wide-ranging sources.

22-11 PABLO PICASSO, *Les Demoiselles d'Avignon*, June–July 1907. Oil on canvas, 8′ × 7′ 8″. Museum of Modern Art, New York (acquired through the Lillie P. Bliss Bequest).

"I PAINT FORMS AS I THINK THEM" The influence of African, Iberian, and European art also surfaces in *Les Demoiselles d'Avignon* ("the young ladies of Avignon"; FIG. **22-11**), which opened the door to a radically new method of representing form in space. Picasso began the work as a symbolic picture to be titled *Philosophical Bordello,* portraying male clients intermingling with women in the reception room of a brothel (Avignon Street in Barcelona was located in the red-light district). By the time the artist finished, he had eliminated the male figures and simplified the room's details to a suggestion of drapery and a schematic foreground still life. Picasso had become wholly absorbed in the problem of finding a new way to represent the five female figures in their interior space. Instead of representing the figures as continuous volumes, he fractured their shapes and interwove them with the equally jagged planes that represent drapery and empty space. Indeed, the space, so entwined with the bodies, is virtually illegible. Here Picasso pushed Cézanne's treatment of form and space to a new tension. The tension between Picasso's representation of three-dimensional space and his statement of painting as a two-dimensional design lying flat on the surface of a stretched canvas is a tension between representation and abstraction.

The artist extended the radical nature of *Les Demoiselles d'Avignon* even further by inconsistently depicting the figures. The calm, ideal features of the three young women at the left were inspired by ancient Iberian sculptures, which Picasso saw during summer visits to Spain. The energetic, violently striated features of the two heads to the right emerged late in Picasso's production of the work and grew directly from his increasing fascination with the power of African sculpture. Perhaps responding to the energy of these two new heads, Picasso also revised their bodies. He broke them into more ambiguous planes suggesting a combination of views, as if the figures are seen from more than one place in space at once. The woman seated at the lower right shows these multiple views most clearly, seeming to present observers simultaneously with a three-quarter back view from the left, another from the right, and a front view of the head that suggests seeing the figure frontally as well. Gone is the traditional concept of an orderly, constructed, and unified pictorial space that mirrors the world. In its place are the rudimentary beginnings of a new representation of the world as a dynamic interplay of time and space. Clearly, *Les Demoiselles d'Avignon* represents a dramatic departure from the careful presentation of a visual reality. Explained Picasso: "I paint forms as I think them, not as I see them."[10]

For many years, Picasso showed *Les Demoiselles* only to other painters. One of the first to see it was GEORGES BRAQUE (1882–1963), a Fauve painter who was so agitated and challenged by it that he began to rethink his own painting style. Using the painting's revolutionary ideas as a point of departure, together Braque and Picasso formulated Cubism around 1908.

Cubism

Cubism represented a radical turning point in the history of art, nothing less than a dismissal of the pictorial illusionism that had, over the years, dominated Western art. The Cubists rejected naturalistic depictions, preferring compositions of shapes and forms "abstracted" from the conventionally perceived world. These artists pursued the analysis of form central to Cézanne's artistic explorations, and they adopted Cézanne's suggestion that artists use the simple forms of cylinders, spheres, and cones to represent nature in art. They dissected life's continuous optical spread into its many constituent features, which they then recomposed, by a new logic of design, into a coherent aesthetic object. For the Cubists, the art of painting had to move far beyond the description of visual reality. This rejection of accepted artistic practice illustrates both the period's aggressive avant-garde critique of pictorial convention and the public's dwindling faith in a safe, concrete Newtonian world, fears fostered by the physics of Einstein and others. Although not immune to the effects of the societal turbulence of the early twentieth century, the Cubists increasingly directed their energies into their critique of traditional aesthetics. The French writer and theorist Guillaume Apollinaire summarized well the central Cubism concepts in 1913:

> Authentic Cubism [is] the art of depicting new wholes with formal elements borrowed not from the reality of vision, but from that of conception. This tendency leads to a poetic kind of painting which stands outside the world of observation; for, even in a simple cubism, the geometrical surfaces of an object must be opened out in order to give a complete representation of it. . . . Everyone must agree that a chair, from whichever side it is viewed, never ceases to have four legs, a seat and back, and that if it is robbed of one of these elements, it is robbed of an important part.[11]

The new style received its name after Matisse described some of Braque's work to a critic, Louis Vauxcelles, as having been painted "avec des petits cubes" (with little cubes), and the critic went on in his review to speak of "cubic oddities."[12] Thus, critics, through their choice of labels, in part formed public understanding of this original and trailblazing painting method.

Analytic Cubism

Historians often refer to the first phase of Cubism, developed jointly by Picasso and Braque, as Analytic Cubism. Because Cubists could not achieve the kind of total view Apollinaire described by the traditional method of drawing or painting models from one position, these artists began to dissect the forms of their subjects. They presented that dissection for viewers to inspect across the canvas surface. In simplistic terms, Analytic Cubism involves analyzing form and investigating the visual vocabulary (that is, the pictorial elements) for conveying meaning.

A SHIFTING PORTRAIT OF A MUSICIAN Georges Braque's painting *The Portuguese* (FIG. **22-12**) is a striking example of Analytic Cubism. The artist derived the subject from his memories of a Portuguese musician seen years earlier in a bar in Marseilles. In this painting, Braque concentrated his attention on dissecting the form and placing it in dynamic interaction with the space around it; he reduced color to a monochrome of brown tones. Unlike the high-keyed paintings of the Fauves and German Expressionists, the Cubists used subdued hues to focus viewers' attention on form. In *The Portuguese,* the artist carried his analysis so far that viewers must work diligently to discover clues to the

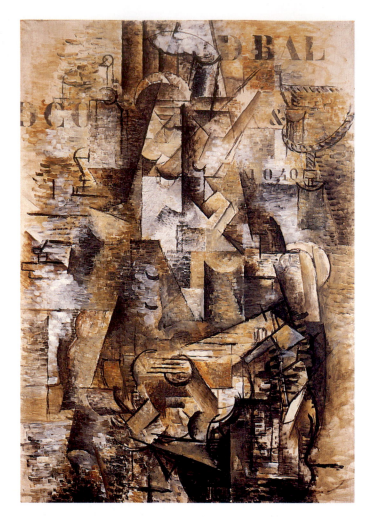

22-12 GEORGES BRAQUE, *The Portuguese,* 1911. Oil on canvas, 3′ 10 $\frac{1}{8}$″ × 2′ 8″. Öffentliche Kunstsammlung Basel, Kunstmuseum, Basel (gift of Raoul La Roche, 1952).

subject. The construction of large intersecting planes suggests the forms of a man and a guitar. Smaller shapes interpenetrate and hover in the large planes. The way Braque treated light and shadow reveals his departure from conventional artistic practice. Light and dark passages suggest both chiaroscuro modeling and transparent planes that allow viewers to see through one level to another. As observers look, solid forms emerge only to be canceled almost immediately by a different reading of the subject.

The stenciled letters and numbers add to the painting's complexity. Letters and numbers are flat shapes. On a book's pages, they exist outside three-dimensional space, but as shapes in a Cubist painting such as *The Portuguese,* they allow the painter to play with viewers' perception of two- and three-dimensional space. The letters and numbers lie flat on the painted canvas surface, yet the image's shading and shapes seem to flow behind and underneath them, pushing the letters and numbers forward into the viewing space. Occasionally, they seem attached to the surface of some object within the painting. Picasso and Braque pioneered precisely this exploration of visual vocabulary—for example, composition, two-dimensional shape, three-dimensional form, color, and value—and its role in generating meaning. Ultimately, the constantly shifting imagery makes it impossible to arrive at any definitive or final reading of the image. Even today, examining such a painting is a disconcerting excursion into ambiguity and doubt.

KALEIDOSCOPIC COLORED SHARDS Picasso and Braque avoided bright color in their Analytic Cubist works. Artists and art historians generally have seen this suppression of color as crucial to Cubism's success. These two artists employed this strategy to unify paintings that radically disrupted viewer expectations about the representation of time and space. Their contemporary, ROBERT DELAUNAY (1885–1941), worked toward a kind of color Cubism. The French poet Guillaume Apollinaire called this art style Orphism, after Orpheus, the Greek god with magical powers of music. Apollinaire believed art, like music, was divorced from representation of the visible world. *Champs de Mars,* or *The Red Tower* (FIG. **22-13**), is one of many paintings Delaunay produced between 1909 and 1912 depicting the Eiffel Tower. People in the early twentieth century still considered this tower, constructed in 1889, a marvel of modern engineering technology. The title *Champs de Mars* refers to the Parisian field in which the Eiffel Tower is located, named after the Campus Martius (Field of Mars) located outside the walls of Republican Rome.

The artist broke the monument's perceptual unity into a kaleidoscopic array of colored shards, which variously leap forward or pull back according to the relative hues and values of the broken shapes. The structure ambiguously rises and collapses. Beyond its formal links to Cubism, the fragmentation of the Eiffel Tower in *Champs de Mars* also has been interpreted in political terms as a commentary on the societal collapse in the years leading to World War I. In unedited notes, Delaunay himself described the collapsing tower imagery as "the synthesis of a period of destruction; likewise a prophe-

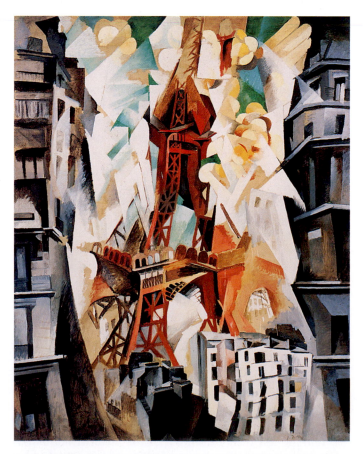

22-13 ROBERT DELAUNAY, *Champs de Mars* or *The Red Tower,* 1911. Oil on canvas, 5′ 3″ × 4′ 3″. Art Institute of Chicago, Chicago.

Nurturing the Avant-Garde
Gertrude and Leo Stein as Art Patrons

The rebellious and antagonistic stance avant-garde artists adopted in all media understandably engendered much hostility and resistance to their art by the public. This response rather restricted the social circles within which avant-garde artists traveled. Gertrude (1874–1946) and Leo (1872–1947) Stein played a pivotal role in the history of the avant-garde in the early twentieth century because they provided, in their Paris house, a hospitable environment. Artists, writers, musicians, collectors, and critics interested in progressive art and ideas could meet there to talk and socialize. Born in Pennsylvania, brother and sister Leo and Gertrude moved to Paris in 1903, setting up a home at 27, rue de Fleurus. Gertrude's experimental writing stimulated her interest in the latest developments in the arts; conversely, the avant-garde ideas discussed at the Steins's house influenced her unique poetry, plays, and other literary forms. She is perhaps best known for *The Autobiography of Alice B. Toklas* (1933), a unique memoir written in the persona of her longtime companion.

The Steins's interest in the exciting and invigorating debates taking place in avant-garde circles led them to welcome visitors to their Saturday salons, which included lectures, thoughtful discussions, and spirited arguments. Often, these "salon" gatherings lasted until dawn. They became renowned and included not only the French but also visiting Americans, British, Swedes, Germans, Hungarians, Spaniards, Poles, and Russians. Among the hundreds who welcomed the opportunity to visit the Steins's were the artists Matisse, Picasso, Georges Braque, Cassatt, Duchamp, Alfred Stieglitz, and Arthur B. Davis; the writers Ernest Hemingway, F. Scott Fitzgerald, John dos Passos, Jean Cocteau, and Guillaume Apollinaire; art dealers Daniel Kahnweiler and Ambroise Vollard; critics Roger Fry and Clive Bell; and collectors Sergei Shchukin and Ivan Morosov.

The art decorating the walls of 27, rue de Fleurus also attracted many visitors. The Steins were avid art collectors. One of the first paintings Leo purchased was Matisse's notorious *Woman with the Hat* (FIG. 22-1), and he subsequently bought numerous important paintings by Matisse and Picasso, along with works by Gauguin, Cézanne, Renoir, and Braque. Picasso, who developed a close friendship with Gertrude, asked to paint her portrait, and the well-known painting (FIG. 22-10), which he finished in 1907 after more than one year of work and numerous sittings by Gertrude, today hangs in the Metropolitan Museum of Art. So taken by the completed portrait, Gertrude kept it by her all her life and bequeathed it to the Metropolitan only after her death in 1946.

Ultimately, Gertrude and Leo Stein played a central role in the avant-garde's development in the early twentieth century, both as collectors and as facilitators of interaction among avant-garde artists, writers, musicians, and others in the art world. Their passion for and fascination with the international art scene undeniably contributed to the history of twentieth-century art.

tic vision with social repercussions: war, and the base crumbles."[13] This statement encapsulates well the social and artistic climate during these years—the destruction of old world orders and of artistic practices deemed obsolete, as well as the avant-garde's prophetic nature and its determination to subvert tradition.

Ultimately, Delaunay's experiments with color dynamics strongly influenced the Futurists (discussed later) and the German Expressionists (he exhibited with Der Blaue Reiter, as well as with Cubists). These artists found in his art means for intensifying expression by suggesting violent motion through shape and color.

Synthetic Cubism

ILLUSION OR REALITY? In 1912, Cubism entered a new phase when the style no longer relied on a decipherable relation to the visible world. In this new phase, called Synthetic Cubism, artists constructed paintings and drawings from objects and shapes cut from paper or other materials to represent parts of a subject. The work marking the point of departure for this new style was Picasso's *Still Life with Chair-Caning* (FIG. **22-14**), a painting that included a piece of oil-cloth pasted on the canvas after it was imprinted with the photolithographed pattern of a cane chair seat. It is framed with a piece of rope. This work challenges viewers' understanding of "reality." The photographically replicated chair caning seems so "real" that one expects the holes to break any brush strokes laid upon it. But the chair caning, although optically suggestive of the real, is actually only an illusion or representation of an object. In contrast, the painted abstract areas do not refer to tangible objects in the real world. Yet the fact they do not imitate anything makes them more "real" than the chair caning—no pretense exists. Picasso extended the visual play by making the letter *U* escape from the space of the accompanying *J* and *O* and partially covering it with a cylindrical shape that pushes across its left side. The letters *JOU* appear in many Cubist paintings; these letters formed part of the masthead of the daily French newspapers (journals) often found among the objects represented. Picasso and Braque especially delighted in the punning references to *jouer* and *jeu*—the French words for "to play" and "game."

PAPER GLUED ON CANVAS After *Still Life with Chair-Caning*, both Picasso and Braque continued to explore the new medium of collage introduced in that work. From the French word meaning "to stick," a collage is a composi-

22-14 PABLO PICASSO, *Still Life with Chair-Caning*, 1911–1912. Oil and oilcloth on canvas on canvas, $10\frac{5}{8}'' \times 1' \, 1\frac{3}{4}''$. Musée Picasso, Paris.

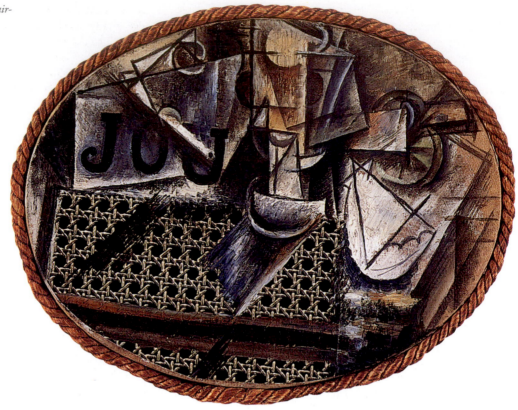

tion of bits of objects, such as newspaper or cloth, glued to a surface. Its possibilities also can be seen in Braque's *Fruit Dish and Cards* (FIG. **22-15**), done in a variant of collage called *papier collé* (stuck paper), or gluing assorted paper shapes to a drawing or painting. Here, charcoal and pencil lines and shadows provide clues to the Cubist multiple views of table, dishes, playing cards, and fruit. Roughly rectangular strips of wood-grained, gray, and black paper run vertically up the composition. They overlap each other to create a layering of unmistakably flat planes that both echo the space the lines suggest and establish the flatness of the work's surface. All shapes in the image seem to oscillate, pushing forward and dropping back in space. Shading seems to carve space into flat planes in some places and to turn planes into transparent surfaces in others. The bottom edge of the ace of clubs, for example, seems to extend forward over a strip of wood-grained paper, while its top corner appears to slip behind a filmy plane.

Viewers of *Fruit Dish and Cards* are kept aware that this is an artwork an artist created and that they must enter the visual game to decipher all levels of representation. Braque no longer analyzed the three-dimensional qualities of the physical world. Here, he constructed or synthesized objects and space alike from the materials he used. Picasso stated his views on Cubism at this point in its development: "Not only did we try to displace reality; reality was no longer in the object. . . . [In] the *papier collé* . . . [w]e didn't any longer want to fool the eye; we wanted to fool the mind. . . . If a piece of newspaper can be a bottle, that gives us something to think about in connection with both newspapers and bottles, too."[14]

Like all collage, the papier collé technique was modern in its medium—mass-produced materials never before found in "high" art—and modern in how the artist embedded the art's "message" in the imagery and in the nature of these everyday

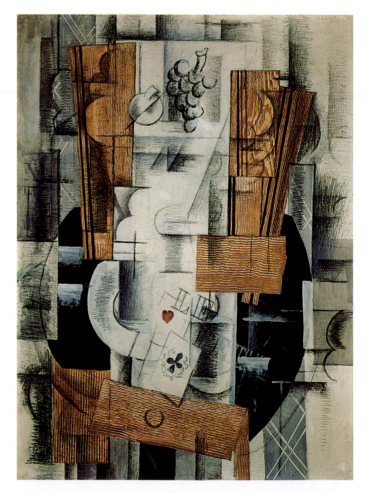

22-15 GEORGES BRAQUE, *Fruit Dish and Cards*, 1913. Oil, pencil, paper collage, and charcoal on canvas, $2' \, 7\frac{7}{8}'' \times 1' \, 11\frac{5}{8}''$. Musée Nationale d'Art Moderne, Centre Georges Pompidou, Paris (gift of Paul Rosenberg).

materials. Although most discussions of Cubism and collage focus on the formal innovations they represented, it is important to note that the public also viewed the revolutionary and subversive nature of Cubism in sociopolitical terms. Cubism's attacks on artistic convention and tradition were easily expanded to encompass an attack on society's complacency and status quo. Many artists and writers of the period allied themselves with various anarchist groups whose social critiques and utopian visions appealed to progressive thinkers. It was, therefore, not a far leap to see radical art, like Cubism, as having political ramifications. Indeed, many critics in the French press consistently equated Cubism with anarchism, revolution, and disdain for tradition. The impact of Cubism thus extended beyond the boundaries of the art world itself.

A WHIMSICAL MUSICAL TRIO Braque and Picasso eventually used found materials in collages to reintroduce color into their work. In the 1920s, Picasso developed a colorful variant of Synthetic Cubism into a highly personal painting style that mimicked the look of the earlier pasted works. In paintings such as *Three Musicians* (FIG. **22-16**), Picasso constructed figures from simple flat shapes that interlock and interpenetrate in a composition that whimsically combined a modernist statement of the canvas's flat plane with traditional modes of representation. The floor and walls of the room where this lively musical trio performs suggest Renaissance perspective gone slightly awry, while the table, with an unexpected still life resting on its surface, appears in reverse perspective. A jumble of flat shapes materializes into the figures

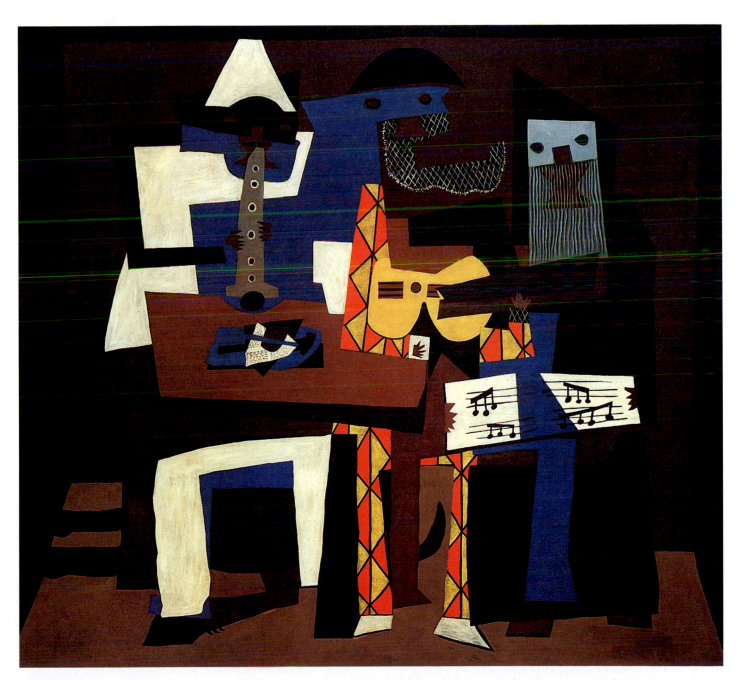

22-16 PABLO PICASSO, *Three Musicians*, Fontainebleau, summer 1921. Oil on canvas, 6′ 7″ × 7′ 3″. Museum of Modern Art, New York, (Mrs. Simon Guggenheim).

of Pierrot (the French pantomine character in white) on clarinet, Harlequin (a French clown in mask and tights) on guitar, and a mysterious masked monk as vocalist. Miraculously, the flat irregular yet rhythmic shapes give each musician a different personality and simultaneously suggest the sprightly tune they are performing. Careful inspection reveals an alert dog sprawled behind the troupe, apparently beating its tail vigorously in time to the music. By the 1920s, Picasso and Braque were going their separate ways as artists, but their Cubist contributions had dramatic and widespread impact, and each continued to produce significant artworks for many years.

Cubist Sculpture

DISSOLVING THREE-DIMENSIONAL FORM
Cubism did not just open new avenues for representing form on two-dimensional surfaces; it also inspired new approaches to sculpture. Picasso explored Cubism's possibilities in sculpture throughout the years he and Braque developed the style.

22-17 JACQUES LIPCHITZ, *Bather,* 1917. Bronze, 2′ 10¾″ × 1′1¼″ × 1′1″. Nelson-Atkins Museum of Art, Kansas City (gift of the Friends of Art). Copyright © Estate of Jacques Lipchitz/Licensed by VAGA, New York/ Marlborough Gallery, NY.

22-18 ALEKSANDR ARCHIPENKO, *Woman Combing Her Hair,* 1915. Bronze, approx. 1′1¾″ high. Museum of Modern Art, New York (bequest of Lillie P. Bliss).

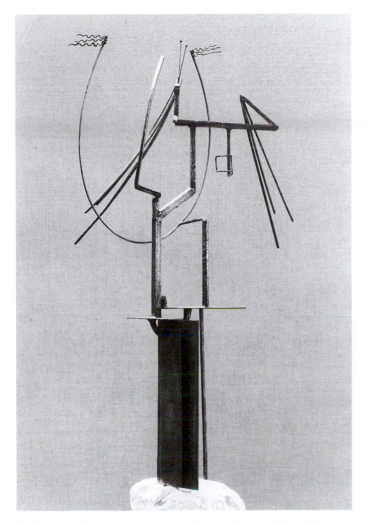

22-19 JULIO GONZÁLEZ, *Woman Combing Her Hair*, ca. 1930–1933. Iron, 4′ 9″ high. Moderna Museet, Stockholm.

the body when the hand rests on the hip, as in Verrocchio's *David* (see FIG. 16-24). But here the space penetrates the figure's continuous mass and is a defined form equal in importance to the mass of the bronze. It is not simply the negative counterpart to the volume. Archipenko's figure shows the same fluid intersecting planes seen in Cubist painting, and the relation of the planes to each other is similarly complex. Thus, in painting and sculpture, the Cubists broke through traditional limits and transformed the medium. Archipenko's figure is still somewhat representational, but sculpture (like painting) executed within the Cubist idiom tended to cast off the last vestiges of representation.

WELDED METAL SCULPTURES OF THE 1930s

A friend of Picasso, JULIO GONZÁLEZ (1876–1942) shared his interest in the artistic possibilities of new materials and new methods borrowed from both industrial technology and traditional metalworking. Born into a family of metalworkers in Barcelona, Spain, González helped Picasso construct a number of welded sculptures. This contact with Picasso, in turn, allowed González to refine his own sculptural vocabulary. Using ready-made bars, sheets, or rods of welded or wrought iron and bronze, González created dynamic sculptures with both linear elements and volumetric forms. In his *Woman Combing Her Hair* (FIG. **22-19**; compare with Archipenko's version of the same subject), the figure is reduced to an interplay of curves, lines, and planes— virtually a complete abstraction. Although González's sculpture received limited exposure during his lifetime, it became particularly important for sculptors in subsequent decades who focused their attention on the capabilities of welded metal.

One of the most successful sculptors to adapt into three dimensions the planar, fragmented dissolution of form central to Analytic Cubist painting was JACQUES LIPCHITZ (1891–1973). Born in Latvia, Lipchitz resided for many years in France and the United States. He worked out his ideas for many of his sculptures in clay before creating them in bronze or in stone. *Bather* (FIG. 22-17) is typical of his Cubist style. Lipchitz broke the continuous form in this work into cubic volumes and planes. The interlocking and gracefully intersecting irregular facets and curves recall the paintings of Picasso and Braque and represent a parallel analysis of dynamic form in space. Lipchitz later produced less volumetric sculptures that included empty spaces outlined by metal shapes. In these sculptures, Lipchitz pursued even further the Cubist notion of spatial ambiguity and the relationship between solid forms and space.

THE INTERPLAY OF MASS AND SPACE

The Russian sculptor ALEKSANDR ARCHIPENKO (1887–1964) explored similar ideas, as seen in *Woman Combing Her Hair* (FIG. **22-18**). This statuette introduces, in place of the head, a void with a shape of its own that figures importantly in the whole design. Enclosed spaces always have existed in figurative sculpture—for example, the space between the arm and

Purism

THE MACHINE AESTHETIC Charles Edouard Jeanneret, known as Le Corbusier, is today best known as one of the most important modernist architects (see later discussion, pages 838–39). But also a painter, he founded in 1918 a movement called Purism, which opposed Synthetic Cubism on the grounds that it was becoming merely an esoteric, decorative art out of touch with the machine age. Purists maintained that machinery's clean functional lines and the pure forms of its parts, should direct the artist's experiments in design, whether in painting, architecture, or industrially produced objects. This "machine esthetic" inspired FERNAND LÉGER (1881–1955), a French painter who had early on painted with the Cubists. He devised an effective compromise of tastes, bringing together meticulous Cubist analysis of form with the Purist's broad simplification and machinelike finish of the design components. He retained from his Cubist practice a preference for cylindrical and tube-shaped motifs, suggestive of machined parts such as pistons and cylinders.

Léger's works have the sharp precision of the machine, whose beauty and quality he was one of the first artists to discover. His contemporary, modern composer George Antheil, wrote a score for a Léger film, *Ballet Mécanique* (1924). The film contrasted inanimate objects such as functioning machines with humans in dancelike variations. Preeminently the

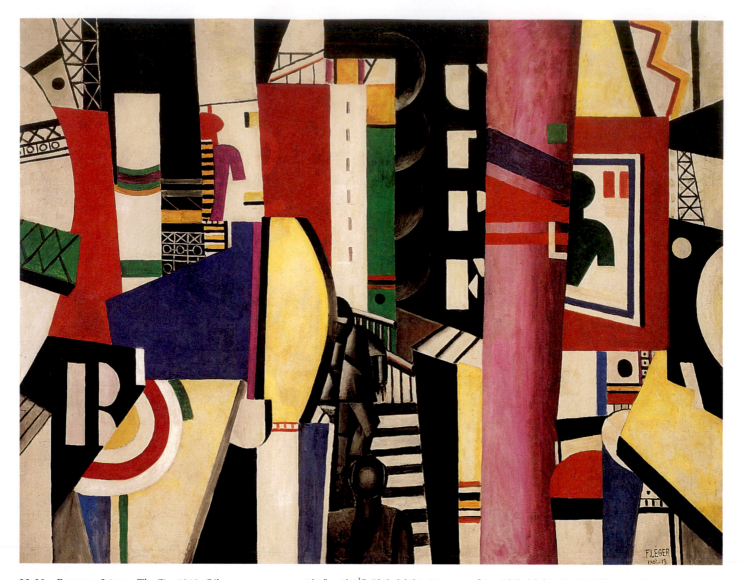

22-20 FERNAND LÉGER, *The City,* 1919. Oil on canvas, approx. 7′ 7″ × 9′ 9½″. Philadelphia Museum of Art, Philadelphia (A. E. Gallatin Collection).

painter of modern urban life, Léger incorporated into his work the massive effects of modern posters and billboard advertisements, the harsh flashing of electric lights, the noise of traffic, and the robotic movements of mechanized people. These effects appear in an early work—modulated, however, by the aesthetic of Synthetic Cubism—*The City* (FIG. **22-20**). Its monumental scale suggests that Léger, had he been given the opportunity, would have been one of the great mural painters of his age. In a definitive way, he depicted the mechanical commotion of contemporary cities then and now.

Futurism

Artists associated with another early-twentieth-century movement, Futurism, pursued many of the ideas the Cubists explored. The contributions of the Futurists, however, were not only artistic. These artists also had a well-defined sociopolitical agenda. Inaugurated and given its name by the charismatic Italian poet and playwright Filippo Tommaso Marinetti in

1909, Futurism began as a literary movement but soon encompassed the visual arts, cinema, theater, music, and architecture. Indignant over the political and cultural decline of Italy, the Futurists published numerous manifestoes in which they aggressively advocated revolution, both in society and in art. Like Die Brücke and other avant-garde artists, the Futurists aimed at ushering in a new, more enlightened era.

In their quest to launch Italian society toward a glorious future, the Futurists championed war as a means of washing away the stagnant past. Indeed, they saw war as a cleansing agent. Marinetti declared: "We wish to glorify war—sole hygiene to the world."[15] The Futurists agitated for the destruction of museums, libraries, and similar institutions, which they described as mausoleums. They also called for radical innovation in the arts. Of particular interest to the Futurists were the speed and dynamism of modern technology. Marinetti insisted that "a speeding automobile. . . is more beautiful than the Nike of Samothrace" (see FIG. 5-82, by then representative of Classicism and the glories of past civilizations).[16] Appropriately, Futurist art often focuses on motion in time and space, incorporating the Cubist discoveries from analyzing form.

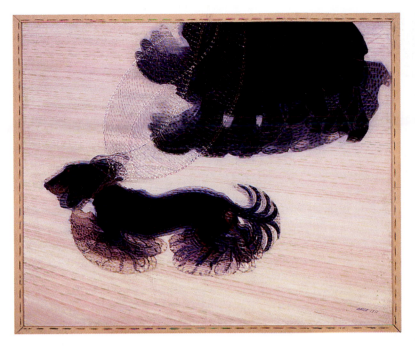

22-21 GIACOMO BALLA, *Dynamism of a Dog on a Leash,* 1912. Oil on canvas, 2′11\frac{3}{8}″ × 3′ 7\frac{1}{4}″. Albright-Knox Art Gallery, Buffalo, New York (bequest of A. Conger Goodyear, gift of George F. Goodyear, 1964).

SIMULTANEITY OF VIEWS The Futurists' interest in motion and in the Cubist dissection of form is evident in *Dynamism of a Dog on a Leash* (FIG. **22-21**) by GIACOMO BALLA (1871–1958). Here, observers focus their gazes on a passing dog and its owner, whose skirts the artist placed just within visual range. Balla achieved the effect of motion by repeating shapes, as in the dog's legs and tail and in the swinging line of the leash. Simultaneity of views, as demonstrated here, was central to the Futurist program.

CAPTURING THE SENSATION OF MOTION UMBERTO BOCCIONI (1882–1916) applied Balla's representational technique to sculpture. What we want, he claimed, is not fixed movement in space but the sensation of motion itself: "Owing to the persistence of images on the retina, objects in motion are multiplied and distorted, following one another like waves in space. Thus, a galloping horse has not four legs, it has twenty."[17] Clearly, this description applies to *Dynamism of a Dog on a Leash.* Though Boccioni in this instance was talking about painting, his observation helps explain what is perhaps the definitive work of Futurist sculpture, his *Unique Forms of Continuity in Space* (FIG. **22-22**).

This piece highlights the formal and spatial effects of motion rather than their source, the striding human figure. The "figure" is so expanded, interrupted, and broken in plane and contour that it disappears, as it were, behind the blur of its movement. Boccioni's search for sculptural means for expressing dynamic movement reached a monumental expression here. In its power and sense of vital activity, this sculpture surpasses similar efforts in painting (by Boccioni and his Futurist companions) to create images symbolic of the dynamic quality of modern life. To be convinced by it, people need only reflect on how details of an adjacent landscape appear in their peripheral vision when they are traveling at great speed on a highway or in a low-flying airplane. Although Boccioni's figure bears a curious resemblance to the ancient *Nike of Samothrace* (see FIG. 5-82), a cursory comparison reveals how far the modern work departs from the ancient one.

This Futurist representation of motion in sculpture has its limitations. The eventual development of the motion picture, based on the rapid sequential projection of fixed images,

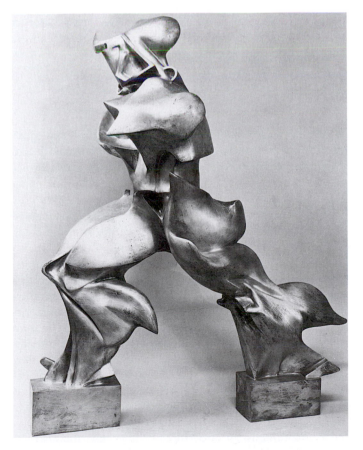

22-22 UMBERTO BOCCIONI, *Unique Forms of Continuity in Space,* 1913 (cast 1931). Bronze, 3′ 7\frac{7}{8}″ high × 2′ 10\frac{7}{8}″ × 1′ 3\frac{3}{4}″. Museum of Modern Art, New York (acquired through the Lillie P. Bliss Bequest).

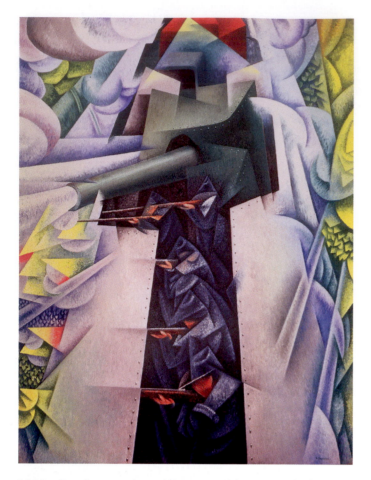

22-23 GINO SEVERINI, *Armored Train,* 1915. Oil on canvas, $3'10'' \times 2'10\frac{1}{8}''$. Collection of Richard S. Zeisler, New York.

produced more convincing illusions of movement. And several decades later in sculpture, Alexander Calder (FIG. 22-73) pioneered the development of kinetic sculpture—with actual moving parts. However, in the early twentieth century, Boccioni's sculpture was notable for its ability to capture the sensation of motion.

"WAR—SOLE HYGIENE TO THE WORLD" *Armored Train* (FIG. **22-23**) by GINO SEVERINI (1883–1966) nicely encapsulates the Futurist program, both artistically and politically. The artist depicted a high-tech armored train with its rivets glistening and a huge booming cannon protruding from the top. Submerged in the bowels of the train, a row of soldiers train guns at an unseen target. Severini's painting reflects the Futurist faith in the cleansing action of war. Not only are the colors predominantly light and bright, but the artist also omitted death and destruction—the tragic consequences of war—from the image. This sanitized depiction of war contrasts sharply with Francisco Goya's *Third of May 1808* (see FIG. 20-39), which also depicts a uniform row of anonymous soldiers in the act of shooting. Goya, however, graphically presented the dead and those about to be shot, and the dark tones of the work cast a dramatic and sobering pall. *Armored Train* captures the dynamism and motion central to Futurism. In Cubist fashion, Severini depicted all of the objects, from the soldiers to the smoke emanating from the cannon, broken into facets and planes, suggesting action and movement.

Once World War I broke out, the Futurist group began to disintegrate, largely because so many of them felt compelled to join the Italian Army. Some of them, including Umberto Boccioni, were killed in the war. The ideas the Futurists promoted became integral to the fascism that emerged in Italy shortly thereafter.

CHALLENGING ARTISTIC CONVENTIONS

Although the Futurists celebrated the war and the changes they hoped it would effect, the mass destruction and chaos of World War I horrified other artists. Humanity had never before witnessed such wholesale slaughter on so grand a scale over such an extended period. Millions were killed, wounded, or missing (blown to bits) in great battles. For example, in 1916, the battle of Verdun (lasting five months) left five hundred thousand casualties. On another day in 1916, the British lost sixty thousand men in the opening battle of the Somme. The new technology of armaments, bred of the age of steel, made it a "war of the guns" (as in Severini's *Armored Train*). In the face of massed artillery hurling millions of tons of high explosives and gas shells and in the sheets of fire from thousands of machine guns, attack was suicidal, and battle movement congealed into the stalemate of trench warfare, stretching from the English Channel almost to Switzerland. The mud, filth, and blood of the trenches, the pounding and shattering of incessant shell fire, and the terrible deaths and mutilations were a devastating psychological, as well as physical, experience for a generation brought up with the doctrine of progress and a belief in the fundamental values of civilization.

Dada

With the war as a backdrop, many artists contributed to an artistic and literary movement that became known as Dada. This movement emerged, in large part, in reaction to what many of these artists saw as nothing more than an insane spectacle of collective homicide. They clearly were "revolted by the butchery of the World War."[18] The international scope of Dada proves this revulsion was widespread; although Dada began independently in New York and Zurich, it also emerged in Paris, Berlin, and Cologne, among other cities. Dada was more a mind-set or attitude than a single identifiable style. As André Breton, founder of the slightly later Surrealist movement, explained: "Cubism was a school of painting, futurism a political movement: DADA is a state of mind."[19] The Dadaists believed reason and logic had been responsible for the unmitigated disaster of world war, and they concluded that the only route to salvation was through political anarchy, the irrational, and the intuitive. Thus, an element of absurdity is a cornerstone of Dada, even reflected in the movement's name. "Dada" is a term unrelated to the movement; according to an often repeated anecdote, the Dadaists chose the word at random from a French-German dictionary. Although *dada* does have meaning—it is French for a child's hobby horse—it satisfied the Dadaists' desire for something

irrational and nonsensical. (It should be noted, however, that this is just one among many explanations for the name selected for this movement.)

Further, the pessimism and disgust of these artists surfaced in their disdain for convention or tradition, characterized by a concerted and sustained attempt to undermine cherished notions and assumptions about art. Because of this destructive dimension, art historians often describe Dada as a nihilistic enterprise. This nihilism, Dada's contempt for all traditional and established values, and its derisive iconoclasm can be read at random from its numerous manifestoes and declarations of intent:

> Dada knows everything. Dada spits on everything. Dada says "knowthing," Dada has no fixed ideas. Dada does not catch flies. Dada is bitterness laughing at everything that has been accomplished, sanctified. . . . Dada is never right. . . . No more painters, no more writers, no more religions, no more royalists, no more anarchists, no more socialists, no more police, no more airplanes, no more urinary passages. . . . Like everything in life, Dada is useless, everything happens in a completely idiotic way. . . . We are incapable of treating seriously any subject whatsoever, let alone this subject: ourselves. [Dadaists, describing their own movement, said] Dada was a phenomenon bursting forth in the midst of the post-war economic and moral crisis, a savior, a monster, which would lay waste to everything in its path. [It was] a systematic work of destruction and demoralization. . . . In the end it became nothing but the act of sacrilege.[20]

Although the artists' cynicism and pessimism inspired Dada, what developed was phenomenally influential and powerful. By attacking convention and logic, the Dada artists unlocked new avenues for creative invention, thereby fostering a more serious examination of the basic premises of art than had prior movements. Dada was, in its subversiveness, extraordinarily avant-garde and tremendously liberating. In addition, although horror and disgust about the war initially prompted Dada, an undercurrent of humor and whimsy— sometimes sardonic or irreverent—runs through much of the art. For example, Marcel Duchamp painted a moustache on a reproduction of Leonardo's *Mona Lisa*. The French painter Francis Picabia (1879–1953), Duchamp's collaborator in setting up Dada in New York, nailed a toy monkey to a board and labeled it *Portrait of Cézanne*.

In its emphasis on the spontaneous and intuitive, Dada paralleled the psychoanalytic views of Sigmund Freud, Carl Jung, and others. Particularly interested in the exploration of the unconscious Freud promoted, the Dada artists believed art was a powerfully practical means of self-revelation and catharsis. In addition, they were convinced the images arising out of the subconscious mind had a truth of their own independent of conventional vision. A Dada filmmaker, Hans Richter, summarized the attitude of the European Dadaists:

> Possessed, as we were, of the ability to entrust ourselves to "chance," to our conscious as well as our unconscious minds, we became a sort of public secret society. . . . We laughed at everything. . . . But laughter was only the expression of our new discoveries, not their essence and not their purpose. Pandemonium, destruction, anarchy, anti-everything of the World War? How could Dada have been anything but destructive, aggressive, insolent, on principle and with gusto?[21]

THE ANARCHY OF CHANCE CREATIONS A Dada artist whose works serve as good examples of the "chance" Richter refers to is the Zurich-based artist JEAN (HANS) ARP (1887–1966). Arp pioneered the use of chance in composing his images. Tiring of the look of some Cubist-related collages he was making, he took some sheets of paper, tore them into roughly shaped squares, haphazardly dropped them to a sheet of paper on the floor, and glued them into the resulting arrangement. The rectilinearity of the shapes guaranteed a somewhat regular design, but chance had introduced an imbalance that seemed to Arp to restore to his work a special mysterious vitality he wanted to preserve. *Collage Arranged According to the Laws of Chance* (FIG. 22-24) is a work he created by this method. The operations of "chance" were for Dadaists a crucial part of this kind of improvisation. As Richter stated: "For us chance was the 'unconscious mind' that Freud had discovered in 1900. . . . Adoption of chance had another purpose, a secret one. This was to restore to the work of art its primeval magic power and to find a way back to the immediacy it had lost through contact with . . . classicism."[22] Further, in its renunciation of artistic control, Arp's reliance on chance when creating his compositions reinforced the anarchy and subversiveness inherent in Dada.

FREEING ART FROM CONVENTION Perhaps the most influential of all the Dadaists was Frenchman MARCEL

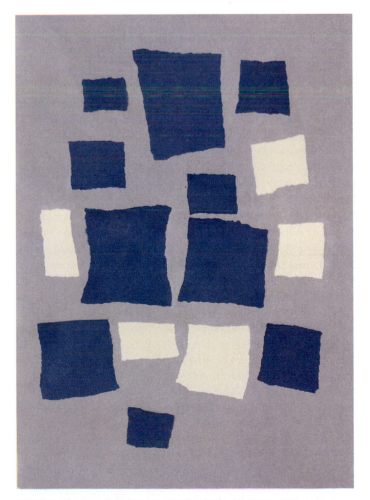

22-24 JEAN ARP, *Collage Arranged According to the Laws of Chance*, 1916–1917. Torn and pasted paper, $1' 7\frac{1}{8}'' \times 1' 1\frac{5}{8}''$. Museum of Modern Art, New York (purchase).

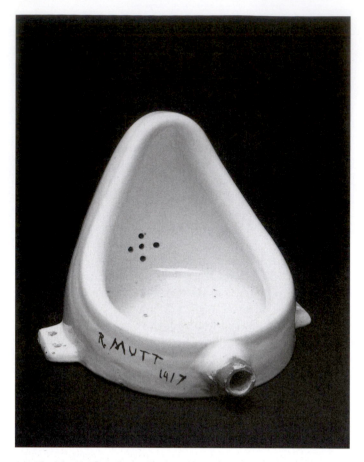

22-25 MARCEL DUCHAMP, *Fountain, (second version)*, 1950. Ready-made glazed sanitary china with black paint, 12″ high. *Philadelphia Museum of Art, Philadelphia (purchased with proceeds from the sale of deaccessioned works of art).*

DUCHAMP (1887–1968), the central artist of New York Dada and active in Paris at the end of the Dada movement. In 1913, he exhibited his first "ready-made" sculptures, which were mass-produced common objects the artist selected and sometimes "rectified" by modifying their substance or combining them with another object. Such works, he insisted, were created free from any consideration of either good or bad taste, qualities shaped by a society he and other Dada artists found aesthetically bankrupt. Perhaps his most outrageous ready-made was *Fountain* (FIG. **22-25**), a porcelain urinal presented on its back, signed "R. Mutt," and dated. The "artist's signature" was, in fact, a witty pseudonym derived from the Mott plumbing company's name and that of the short half of the Mutt and Jeff comic-strip team. As with Duchamp's other ready-mades, he did not select this object for exhibition because of its aesthetic qualities. The "artness" of this work lies in the artist's choice of this object, which has the effect of conferring the status of art on it and forces viewers to see the object in a new light. As he wrote in a "defense" published in 1917, after the exhibition committee for an unjuried show rejected *Fountain* for display: "Whether Mr. Mutt with his own hands made the fountain or not has no importance. He chose it. He took an ordinary article of life, placed it so that its useful significance disappeared under the new title and point of view—created a new thought for that object."[23] It is hard to imagine a more aggressively avant-garde approach to art; Dada persistently presented staggering challenges to artistic conventions.

Duchamp (and the generations of artists after him profoundly influenced by his art and especially his attitude) considered life and art matters of chance and choice freed from the conventions of society and tradition. Within his approach to art and life, each act was individual and unique. Every person's choice of found objects would be different, for example, and each person's throw of the dice would be at a different instant and probably would yield a different number. This philosophy of utter freedom for artists was fundamental to the history of art in the twentieth century. Duchamp spent much of World War I in New York, inspiring a group of American artists and collectors with his radical rethinking of the role of artists and of the nature of art.

A VIEW OF "THE GREAT DADA WORLD" Dada spread throughout much of western Europe, arriving as early as 1917 in Berlin, where it soon took on an activist political edge, partially in response to the economic, social, and political chaos in that city in the years at the end of and immediately after World War I. The Berlin Dadaists developed to a new intensity a technique used earlier in popular art postcards. Pasting parts from many pictures together into one image, the Berliners christened their version of the technique *photomontage*. The technique of creating a composition by pasting together pieces of paper had been used in private and popular arts long before the twentieth century. A few years earlier, the Cubists had named the process "collage." Unlike Cubist collage, the parts of a Dada collage were made almost entirely of "found" details, such as pieces of magazine photographs, usually combined into deliberately antilogical compositions. Collage lent itself well to the Dada desire to use chance when creating art and antiart, but not all Dada collage was as savagely aggressive as that of the Berlin photomontagists.

One of the Berlin Dadaists who perfected this photomontage technique was HANNAH HÖCH (1889–1978). Höch's photomontages were particularly incisive because they operated at the intersection of so many timely discourses. Her works not only advanced the absurd illogic of Dada by presenting viewers with chaotic, contradictory, and satiric compositions, but they also provided scathing and insightful commentary on two of the most dramatic developments during the Weimar Republic (1918–1933) in Germany—the redefinition of women's social roles and the explosive growth of mass print media. She revealed these combined themes in her powerful photomontage *Cut with the Kitchen Knife Dada through the Last Weimar Beer Belly Cultural Epoch of Germany* (FIG. **22-26**). The artist arranged an eclectic mixture of cutout photos in seemingly haphazard fashion. On closer inspection, however, viewers can see Höch carefully placed photographs of some of her fellow Dadaists among images of Marx, Lenin, and other revolutionary figures in the lower right section, aligning this movement with other revolutionary forces. She promoted Dada in prominently placed cutout lettering— "Die grosse Welt dada" ("The great Dada world"). Certainly, juxtaposing the heads of German military leaders with exotic dancers' bodies provided the wickedly humorous critique central to much of Dada. Höch also positioned herself in this topsy-turvy world she created. A photograph of her head appears in the lower right corner, juxtaposed to a map of Europe showing the progress of women's enfranchisement. Aware of the power both women and Dada had to destabilize society, Höch made forceful visual manifestations of that belief.

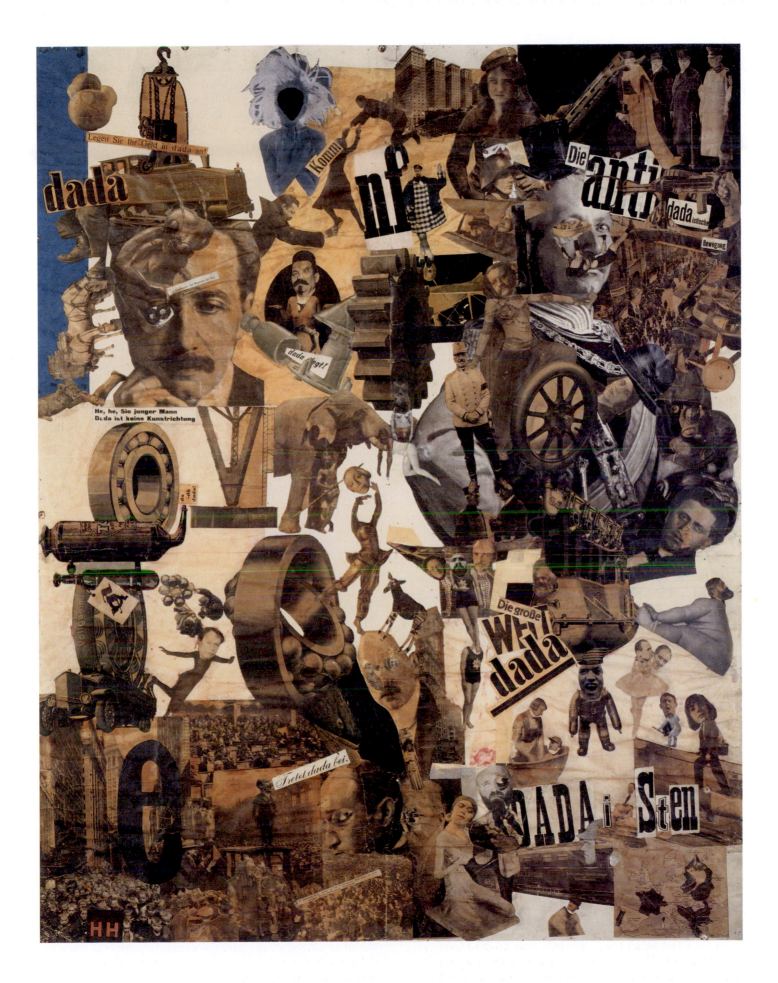

22-26 Hannah Höch, *Cut with the Kitchen Knife Dada through the Last Weimar Beer Belly Cultural Epoch of Germany,* 1919–1920. Photomontage, 3′ 9″ × 2′ 11½″. Neue Nationalgalerie, Staatliche Museen, Berlin.

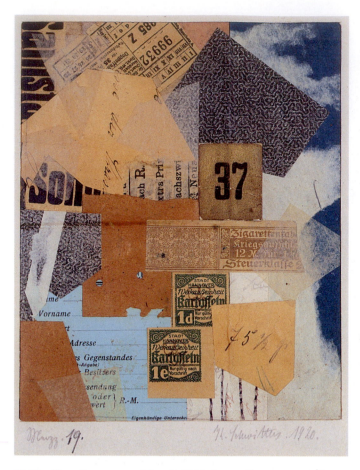

22-27 KURT SCHWITTERS, *Merz 19*, 1920. Paper collage, approx. $7\frac{1}{4}''$ × $5\frac{7}{8}''$. Yale University Art Gallery, New Haven, (gift of Collection Société Anonyme).

THE VISUAL POETRY OF RUBBISH The Hanover Dada artist KURT SCHWITTERS (1887–1948) followed a gentler muse. Inspired by Cubist collage but working nonobjectively, Schwitters found visual poetry in the cast-off junk of modern society and scavenged in trash bins for materials, which he pasted and nailed together into designs such as *Merz 19* (FIG. **22-27**). The term *merz*, which Schwitters used as a generic title for a whole series of collaged images, derived, nonsensically, from the word *kommerzbank* (commerce bank) and appeared as a word fragment in one of his collages. Although nonobjective, his compositions still resonate with the "meaning" of the fragmented found objects they contain. The recycled elements of Schwitters's collages, like Duchamp's ready-mades, acquire new meanings through their new uses and locations. Elevating objects that are, essentially, trash to the status of high art certainly fits within the parameters of the Dada program and parallels the absurd dimension of much of Dada art. Contradiction, paradox, irony, and even blasphemy are Dada's bequest. They are, in the view of Dada and its successors, the free and defiant artist's weapons in what has been called the hundred years war with the public.

TRANSATLANTIC ARTISTIC DIALOGUES

The energy and enthusiasm of artists undertaking these avant-garde experiments were not limited to Europe. A wide range

of artists engaged in a lively exchange of artistic ideas and significant transatlantic travel. In the latter part of the nineteenth century, American artists such as John Singer Sargent, James Abbott McNeil Whistler and Mary Cassatt spent much of their productive careers in Europe, while many European artists ended their careers in America, especially in anticipation of and, later, in the wake of World War I.

The Armory Show and Its Legacy

CHALLENGING ARTISTIC REGIMENTATION One of the major vehicles for disseminating information about European artistic developments in the United States was the Armory Show, which occurred in early 1913. This large-scale and ambitious endeavor got its name from its location. After a year of searching for a suitable site, the exhibition's coordinators settled on the armory of the New York National Guard's 69th Regiment. Organized in large part by two artists, Walt Kuhn and Arthur B. Davies, the Armory Show (FIG. **22-28**) contained more than sixteen hundred artworks both by American and European artists. Among the European artists represented were Matisse, Derain, Picasso, Braque, Duchamp, Kandinsky, Kirchner, and expressionist sculptor Wilhelm Lehmbruck and organic sculptor Constantin Brancusi, both discussed later. In addition to exposing American artists and the public to the latest in European artistic developments, this show also provided American artists with a prime showcase for their work.

AN "EXPLOSION IN A SHINGLE FACTORY" On its opening, this provocative exhibition served as a lightning rod for commentary, immediately attracting heated controversy. The *New York Times* described the show as "pathological," and other critics demanded closing the exhibition as a menace to public morality. The work the press most maligned was Marcel Duchamp's *Nude Descending a Staircase* (FIG. **22-29**). The painting, a single figure in motion down a staircase in a time continuum, suggests the effect of a sequence of overlaid film stills. Although earlier discussion of Duchamp focused on his contributions to the Dada movement, *Nude Descending a Staircase* has more in common with the work of the Cubists and the Futurists. The monochromatic palette is reminiscent of Analytic Cubism, as is Duchamp's faceted presentation of the human form. The artist's interest in depicting the figure in motion reveals an affinity to the Futurists' ideas. One critic described this work as "an explosion in a shingle factory,"[24] and newspaper cartoonists had a field day lampooning the painting.

A PHOTOGRAPHER'S AVANT-GARDE GALLERY The Armory Show traveled to Chicago and Boston after it closed in New York and was a significant catalyst for discussion and serious thought about recent developments in art. Another catalyst in the period's artistic ferment was the artist ALFRED STIEGLITZ (1864–1946). Committed to promoting the avant-garde in the United States, Stieglitz established an art gallery at 291 Fifth Avenue in New York, which eventually became known simply as "291." His gallery was renowned for

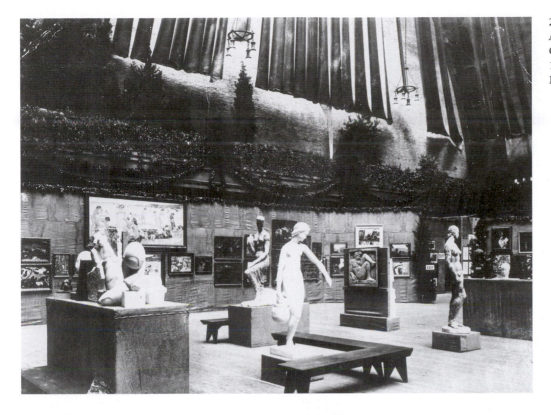

22-28 Installation photo of the Armory Show, New York National Guard's 69th Regiment, New York, 1913. Courtesy of the Museum of Modern Art, New York.

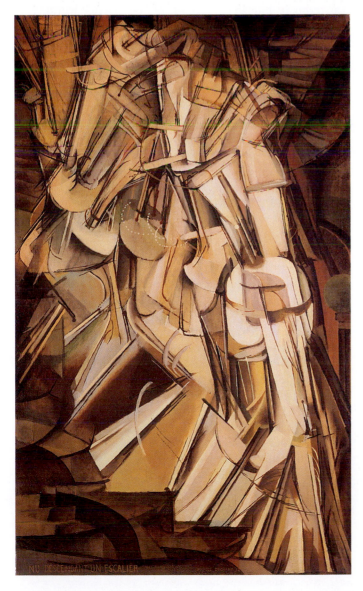

22-29 MARCEL DUCHAMP, *Nude Descending a Staircase, No. 2,* 1912. Oil on canvas, approx. 4′ 10″ × 2′ 11″. Philadelphia Museum of Art, Philadelphia (Louise and Walter Arensberg Collection).

exhibiting the latest in both European and American art and, thus, like the Armory Show, played an important role in the history of early-twentieth-century art in America.

Stieglitz also channeled his artistic energies into producing photography. Taking his camera everywhere he went, he photographed whatever he saw around him, from the bustling streets of New York City to cloudscapes in upstate New York and the faces of friends and relatives. He believed in making only "straight, unmanipulated" photographs.[25] Thus, he exposed and printed them using basic photographic processes, without resorting to techniques such as double-exposure or double-printing that would add information not present in the subject when he released the shutter. Stieglitz said he wanted the photographs he made with this direct technique "to hold a moment, to record something so completely that those who see it would relive an equivalent of what has been expressed."[26]

He began a lifelong campaign to win a place for photography among the fine arts while a student of photochemistry in Germany. Returning to New York, he founded the Photo-Secession group, which mounted traveling exhibitions in the United States and sent loan collections abroad, and he also published an influential journal titled *Camera Work.* In his own works, Stieglitz specialized in photographs of his environment and saw these subjects in terms of form and of the "colors" of his black-and-white materials. He was attracted above all to arrangements of form that stirred his deepest emotions. His aesthetic approach crystallized during the making of one of his best-known works, *The Steerage* (FIG.

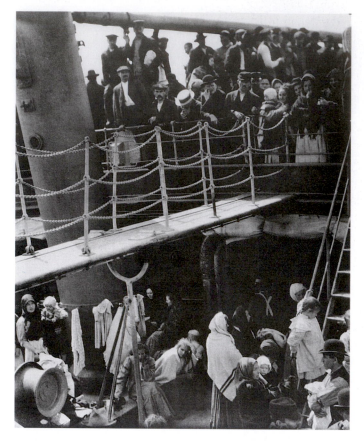

22-30 ALFRED STIEGLITZ, *The Steerage*, 1907 (print 1915). Photogravure (on tissue), 1' $\frac{3}{8}$" × 10 $\frac{1}{8}$". Courtesy of Amon Carter Museum, Fort Worth.

22-30), taken during a voyage to Europe with his first wife and daughter in 1907. Traveling first class, Stieglitz rapidly grew bored with the company of the prosperous passengers in the ship's first-class section. He walked as far forward on that level as he could, when the rail around the opening onto the lower deck brought him up short. This level was reserved for "steerage" passengers the government was returning to Europe after refusing them entrance into the United States for any one of many reasons. Later, Stieglitz described what happened next:

> The scene fascinated me: A round hat; the funnel leaning left, the stairway leaning right; the white drawbridge, its railing made of chain; white suspenders crossed on the back of a man below; circular iron machinery; a mast that cut into the sky, completing a triangle. I stood spellbound. I saw shapes related to one another—a picture of shapes, and underlying it, a new vision that held me: simple people; the feeling of ship, ocean, sky; a sense of release that I was away from the mob called rich. Rembrandt came into my mind and I wondered would he have felt as I did. . . . I had only one plate holder with one unexposed plate. Could I catch what I saw and felt? I released the shutter. If I had captured what I wanted, the photograph would go far beyond any of my previous prints. It would be a picture based on related shapes and deepest human feeling—a step in my own evolution, a spontaneous discovery.[27]

The finished print fulfilled Stieglitz's vision so well that it shaped his future photographic work, and its haunting mixture of found patterns and human activity has continued to stir viewers' emotions to this day.

MOVING TOWARD ABSTRACTION Stieglitz's concern for positioning photography as an art form with the same fine art status as painting and sculpture was also pursued by EDWARD WESTON (1886–1958). In addition to "straight" photography, like that Stieglitz produced, Weston experimented with photographs that moved toward greater abstraction, paralleling developments in other media. *Nude* (FIG. **22-31**) is a good example of this photographic style. The image's simplicity and the selection of a small segment of the human body as the subject result in a lyrical photograph of dark and light areas that at first glance suggests a landscape. Further inspection reveals the fluid curves and underlying skeletal armature of the human form. This photograph, in its reductiveness, formally expresses a study of the body that verges on the abstract.

A WICKEDLY FUNNY GIFT The American artist MAN RAY (1890–1976), who worked closely with Duchamp through the 1920s, produced art with a decidedly Dada spirit. Man Ray incorporated found objects into many of his paintings, sculptures, movies, and photographs. Trained as an architectural draftsman and engineer, Man Ray earned his living as a graphic designer and portrait photographer. He brought to his personal work an interest in mass-produced objects and technology, as well as a dedication to exploring the psychological realm of human perception of the exterior world. Like Schwitters, Man Ray used chance and the dislocation of ordinary things from their everyday settings to surprise his viewers into new awareness. His displacement of found objects was particularly effective in works such as *Cadeau* (*Gift*; FIG. **22-32**). For this sculpture, he equipped a laundry iron with a row of wicked-looking spikes, subverting its proper function of smoothing and pressing. The malicious humor of *Cadeau (Gift)*—seen throughout Dada and, indeed, in much of contemporary art—gives it a characteristic edge that can cut the unwary.

SYNCOPATED CUBISM Other American artists developed personal styles that intersected with movements such as Cubism. STUART DAVIS (1894–1964), for example, created what he believed was a modern American art style by combining the flat shapes of Synthetic Cubism with his sense of jazz tempos and his perception of the energy of fast-paced American culture. *Lucky Strike* (FIG. **22-33**) is one of several Tobacco still lifes Davis began in 1921. A heavy smoker, Davis was fascinated by tobacco products and their packaging. He insisted the late-nineteenth-century introduction of packaging was evidence of high civilization and, therefore, he concluded, of the progressiveness of American culture. Davis depicted the Lucky Strike package in fragmented form, reminiscent of Synthetic Cubist collages. However, although the work does incorporate flat printed elements, these are illusionistically painted, rather than glued onto the canvas surface. The discontinuities and the interlocking planes imbue *Lucky Strike* with a dynamism and rhythm not unlike American jazz or the pace of life in a lively American metropolis. This work is both resolutely American and modern.

A VOICE OF THE HARLEM RENAISSANCE Also deriving his personal style from Synthetic Cubism was African-American artist AARON DOUGLAS (1898–1979), who used the

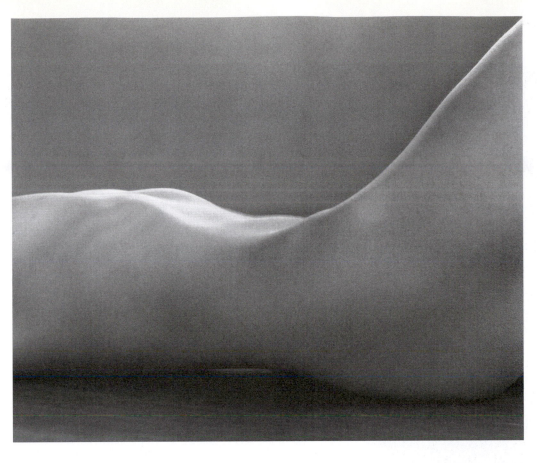

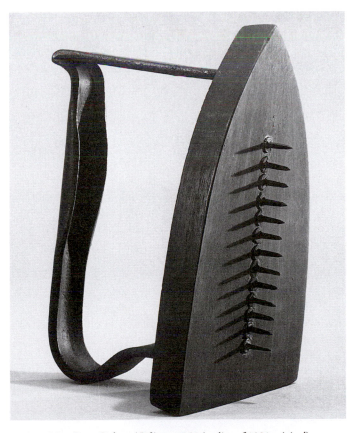

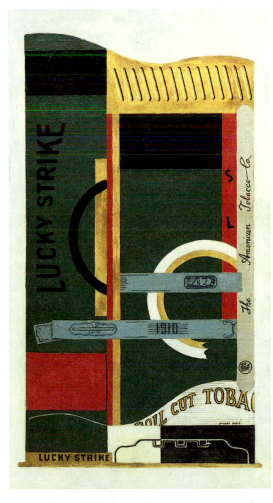

22-31 EDWARD WESTON, *Nude,* 1925. Platinum print. Collection, Center for Creative Photography, University of Arizona, Tucson.

22-32 MAN RAY, *Cadeau (Gift),* ca. 1958 (replica of 1921 original). Painted flatiron with row of 13 tacks with heads glued to the bottom, $6\frac{1}{8}''$ high, $3\frac{5}{8}''$ wide, $4\frac{1}{2}''$ deep. Museum of Modern Art, New York (James Thrall Soby Fund).

22-33 STUART DAVIS, *Lucky Strike,* 1921. Oil on canvas, $2' 9\frac{1}{4}'' \times 1' 6''$. Museum of Modern Art, New York (gift of The American Tobacco Company, Inc.). Copyright © Estate of Stuart Davis/Licensed by VAGA,

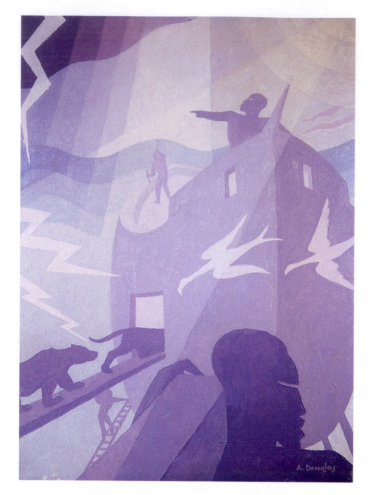

22-34 Aaron Douglas, *Noah's Ark*, ca. 1927. Oil on masonite, 4′ × 3′. Fisk University Galleries, Nashville, Tennessee.

intrigued by the latest European avant-garde art, from Cubism to Dada. However, these artists did not just absorb passively the ideas transported across the Atlantic. For many American artists, the challenge was to understand the ideas this modernist European art presented and then filter them through an American sensibility. Ultimately, many American artists set as their goal the development of a uniquely American art.

One group of such artists became known as Precisionists. This was not an organized movement, and these artists rarely exhibited together (although once the similarities in their work were revealed they were grouped together in shows), but they did share certain thematic and stylistic traits in their art. Precisionism developed in the 1920s out of a fascination with the machine's precision and importance in modern life. Although many European artists (for example, the Futurists) had demonstrated interest in burgeoning technology, Americans, generally, seemed more enamored by the prospects of a mechanized society than did Europeans. Even French artist Francis Picabia (associated with both Cubism and Dada) noted: "Since machinery is the soul of the modern world, and since the genius of machinery attains its highest expression in America, why is it not reasonable to believe that in America the art of the future will flower most brilliantly?"[28] The efforts of others in the art world also supported this observation. Alfred Stieglitz's gallery 291 was instrumental in exhibiting mechanistically oriented works, thereby championing the "age of the machine."

style to represent symbolically the historical and cultural memories of African Americans. Born in Kansas, he studied in Nebraska and Paris before settling in New York City, where he became part of the flowering of art and literature in the 1920s known as the Harlem Renaissance. Encouraged by the German artist Winold Reiss to create art that would express the cultural history of his race, Douglas incorporated motifs from African sculpture into compositions painted in a version of Synthetic Cubism that stressed transparent angular planes. *Noah's Ark* (FIG. **22-34**) was one of seven paintings based on a book of poems by James Weldon Johnson called *God's Trombones: Seven Negro Sermons in Verse*. Douglas used flat planes to evoke a sense of mystical space and miraculous happenings. In *Noah's Ark*, lightning strikes and rays of light crisscross the pairs of animals entering the ark, while men load supplies in preparation for departure across the heaving seas. The artist suggested deep space by differentiating the size of the large human head and shoulders of the worker at the bottom and the small person at work on the far deck of the ship. Yet, the composition's unmodulated color shapes create a pattern on the masonite surface that cancels any illusion of three-dimensional depth. Here, Douglas used Cubism's formal language to express a powerful religious vision.

Precisionism

It is obvious from viewing the American art in the period immediately after the Armory Show that American artists were

22-35 Charles Sheeler, *Upper Deck,* 1929. Oil on canvas, 2′ 5⅛″ × 1′ 10⅛″. Courtesy of the Fogg Art Museum, Harvard University Art Museums, Cambridge, Massachusetts (Louise E. Bettens Fund).

Precisionism, however, expanded beyond the exploration of machine imagery. Many artists associated with this group gravitated toward Synthetic Cubism's flat, sharply delineated planes as an appropriate visual idiom for their imagery, adding to the clarity and precision of their work. Eventually, Precisionism was characterized by a merging of a familiar native style in American architecture and artifacts with a modernist vocabulary largely derived from Synthetic Cubism.

A TIGHTLY ORDERED GEOMETRY *Upper Deck* (FIG. **22-35**) by CHARLES SHEELER (1883–1965) is a pristinely and meticulously rendered image of a ship's ventilation system. More visually coherent than many Synthetic Cubist images, this particular painting was based on a commissioned photograph Sheeler took on board the German ocean liner S.S. *Majestic* for a publicity brochure and is thus firmly grounded in a specific visual reality. Still, a tightly ordered geometry pervades the work. *Upper Deck* was special for Sheeler; it represented his attainment of an artistic goal. "I had come to feel that a picture could have incorporated in it the structural design implied in abstraction and be presented in a wholly realistic manner."[29]

AMERICAN PYRAMIDS? More informed by Synthetic Cubism is the work of CHARLES DEMUTH (1883–1935). Demuth had spent the years 1912–1914 in Paris and thus had firsthand exposure to Cubism and other avant-garde directions in art. He incorporated the spatial discontinuities characteristic of Cubism into his work, focusing much of it on industrial sites near his native Lancaster, Pennsylvania. *My Egypt* (FIG. **22-36**) is a prime example of Precisionist painting. Demuth depicted the John W. Eshelman and Sons grain elevators, which he reduced to simple geometric forms. The grain elevators remain insistently recognizable and solid. However, the painting is disrupted by the "beams" of transparent planes and the diagonal force lines that threaten to destabilize the image and that correspond to Cubist fragmentation of space. Not only does this adaptation of Cubist vocabulary place Demuth in the more progressive ranks of American artists of the time, but it also reveals his sensitivity to the effects of the expanding technology. A writer described these effects:

> [A]ll these instruments: telephone, microscope, magnifying glass, cinematograph, lens, microphone, gramophone, automobile, kodak, aeroplane, are not merely dead objects. [These] machines become part of ourselves, interposing themselves between the world and us, filtering reality as the screen filters radium emanations. Thanks to them we have no longer a simple, clear, continuous, constant notion of an object. . . . The world for people today is like descriptive geometry, with its infinite planes of projection."[30]

Although this passage was not written about Demuth's painting, *My Egypt* provides a perfect illustration of an industrial site "filtering reality" and its "descriptive geometry, with its infinite planes of projection." The degree to which Demuth intended to extol the American industrial scene is unclear. The title, *My Egypt,* is sufficiently ambiguous in tone to accommodate differing readings. On the one hand, Demuth could have been suggesting a favorable comparison between

22-36 CHARLES DEMUTH, *My Egypt*, 1927. Oil on composition board, 2' 11 $\frac{3}{4}$" × 2' 6". Collection of Whitney Museum of American Art, New York (purchase, with funds from Gertrude Vanderbilt Whitney).

22-37 GEORGIA O'KEEFFE, *New York, Night,* 1929. Oil on canvas, 3′ 4⅛″ × 1′ 7⅛″. Sheldon Memorial Art Gallery, Lincoln, Nebraska (Nebraska Art Association, Thomas C. Woods Memorial Collection).

the Egyptian pyramids and American grain elevators as cultural icons. On the other hand, the title could be read cynically, as a negative comment on the limitations of American culture.

CAPTURING THE RHYTHM OF CITY LIFE
The work of GEORGIA O'KEEFFE (1887–1986), like that of many artists, changed stylistically throughout her career. During the 1920s, O'Keeffe was affiliated with Precisionism. She had moved from the tiny town of Canyon, Texas, to

New York City in 1918 (although she had visited on occasion previously), and what she found there both overwhelmed and excited her. "You have to live in today," she told a friend, "Today the city is something bigger, more complex than ever before in history. And nothing can be gained from running away. I couldn't even if I could."[31] While in New York, O'Keeffe met Alfred Stieglitz, who had seen and exhibited some of her earlier work, and she was drawn into the circle of painters and photographers surrounding Stieglitz and his gallery. Stieglitz became one of O'Keeffe's staunchest supporters and, eventually, her husband. The interest of Stieglitz and his circle in capturing the sensibility of the machine age intersected with O'Keeffe's fascination with the fast pace of city life, and she produced paintings during this period, such as *New York, Night* (FIG. **22-37**), that depict the soaring skyscrapers dominating the city. Like other Precisionists, O'Keeffe reduced her images to flat planes, here punctuated by small rectangular windows that add rhythm and energy to the image, countering the monolithic darkness of the looming buildings.

THE PURE FORM OF GROWING PLANTS Despite O'Keeffe's affiliation with the Precisionist movement, she is probably best known for her paintings of cow skulls and of flowers. One such painting, *Jack in the Pulpit IV* (FIG. Intro-4) reveals the artist's interest in stripping her subjects to their purest forms and colors to heighten their expressive power. In this work, O'Keeffe reduced the incredible details of her subject to a symphony of basic colors, shapes, textures, and vital rhythms. Exhibiting the natural flow of curved planes and contour, O'Keeffe simplified the form almost to the limit of the flower's identity. The fluid planes unfold like undulant petals from a subtly placed axis—the white jet-like streak— in a vision of the slow, controlled motion of growing life. O'Keeffe's painting, in its graceful, quiet poetry, reveals the organic reality (Brancusi would say its "essence") of the object by strengthening its characteristic features, in striking contrast with either Kandinsky's explosions (FIG. 22-7) or Mondrian's rectilinear absolutes (FIG. 22-56). In 1946, O'Keeffe moved permanently to New Mexico and continued to paint for decades.

EUROPEAN EXPRESSIONISM IN THE WAKE OF WORLD WAR I

That American artists could focus on these modernist artistic endeavors with such commitment was due to the fact World War I was fought entirely on European soil. Thus, its effects were not as devastating as they were both on Europe's geopolitical terrain and on individual and national psyches. After the war concluded, many European artists were drawn to the expressionist idiom (as developed by the Fauves and the German Expressionists) both to express and to deal with the trauma of world war.

Neue Sachlichkeit

As shown earlier, the war severely impacted many artists, notably those associated with German Expressionism and Dada. Neue Sachlichkeit (New Objectivity) grew directly out of the

war experiences of a group of German artists. All of the artists associated with Neue Sachlichkeit served, at some point, in the German army and thus had firsthand involvement with the military. Their military experiences deeply influenced their world views and informed their art. This was not an organized movement, and the label "Neue Sachlichkeit" was coined by museum director G. F. Hartlaub in 1923. The label does, however, capture their aim—to present a clear-eyed, direct, and honest image of the war and its effects. As George Grosz, one of the Neue Sachlichkeit artists, explained: "I am trying to give an absolutely realistic picture of the world. . . ."[32]

SCATHING DEPICTIONS OF THE MILITARY

GEORGE GROSZ (1893–1958) was, for a time, associated with the Dada group in Berlin, but his work, with its harsh and bitter tone, seems more appropriately linked with Neue Sachlichkeit. Grosz observed the onset of World War I with horrified fascination, but that feeling soon turned to anger and frustration. He reported:

> Of course, there was a kind of mass enthusiasm at the start. But this intoxication soon evaporated, leaving a huge vacuum. . . . And then after a few years when everything bogged down, when we were defeated, when everything went to pieces, all that remained, at least for me and most of my friends, were disgust and horror.[33]

Grosz produced numerous paintings and drawings, such as *Fit for Active Service* (FIG. **22-38**), that were caustic indictments of the military. In these works, he often depicted military officers as heartless or incompetent. This particular drawing may relate to Grosz's personal experience. On the verge of

a nervous breakdown in 1917, he was sent to a sanatorium where doctors examined him and, much to his horror, declared him "fit for service." In this biting and sarcastic drawing, an army doctor proclaims the skeleton before him "fit for service." None of the other military officers or doctors attending seem to dispute this evaluation. The spectacles perched on the skeleton's face, very similar to the gold-rimmed glasses Grosz wore, further suggests he based this on his experiences. The simplicity of the line drawing contributes to the directness and immediacy of the work, which scathingly portrays the German army.

WORLD VIOLENCE INVADES THE HOME MAX BECKMANN (1884–1950), like Grosz, enlisted in the German army and initially rationalized the war. He believed the chaos would lead to a better society, but over time the mass destruction increasingly disillusioned him. Soon his work began to emphasize the horrors of war and of a society he saw descending into madness. His disturbing view of society is evident in *Night* (FIG. **22-39**). As best described, *Night* depicts a cramped room three intruders have forcefully invaded. The bound woman apparently was raped. Her husband appears on the left; one of the intruders hangs him, while another one twists his left arm out of its socket. An unidentified woman cowers in the background. On the far right, the third intruder prepares to flee with the child.

Although this image does not depict a war scene, the wrenching brutality and violence pervading in the home is a searing and horrifying comment on society's condition. Beckmann also injected a personal reference by using himself, his wife, and his son as the models for the three family members.

22-38 GEORGE GROSZ, *Fit for Active Service*, 1916–1917. Pen and brush and ink on paper, 1′ 8″ × 1′ 2⅜″. Museum of Modern Art, New York (A. Conger Goodyear Fund). Copyright © Estate of George Grosz/Licensed by VAGA, New York, NY.

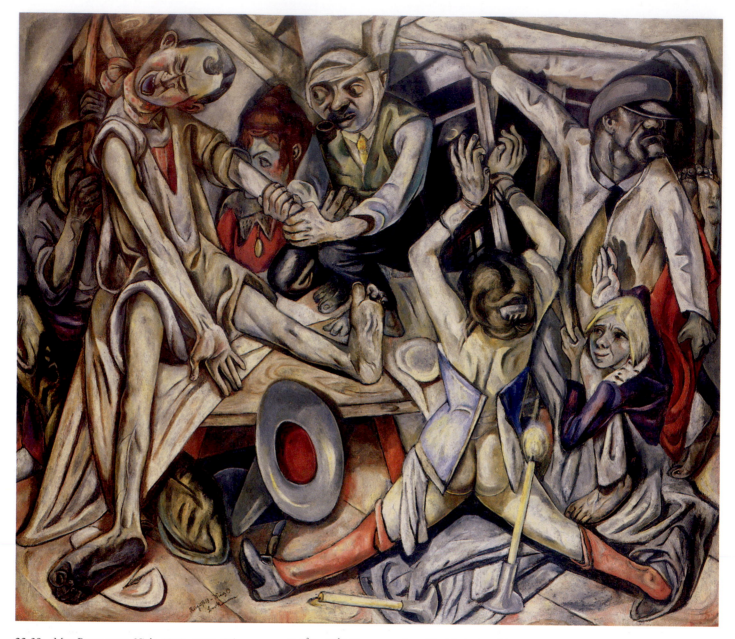

22-39 MAX BECKMANN, *Night*, 1918–1919. Oil on canvas, 4′ 4⅜″ × 5′ ¼″. Kunstsammlung Nordrhein-Westfalen, Düsseldorf.

The stilted angularity of the figures and the roughness of the paint surface contribute to the image's savageness. In addition, the artist's treatment of forms and space reflects the world's violence. Objects seem dislocated and contorted, and the space appears buckled and illogical. For example, the woman's hands are bound to the window that opens from the room's back wall, but her body appears to hang vertically, rather than lying across the plane of the intervening table. Despite the fact images such as *Night* do not directly depict war's carnage or violence, Beckmann's art is undeniably powerful and honest.

THE DEVASTATION OF WAR OTTO DIX (1891–1959) was the third artist who, along with Beckmann and Grosz, most closely was associated with Neue Sachlichkeit. Although Beckmann, for the most part, avoided specific war imagery, Dix embraced it. Having served as both a machine gunner and an aerial observer, he was well acquainted with war's effects. Like Grosz, he initially tried to find redeeming value in the apocalyptic event. Dix explained: "The war was a horrible thing, but there was something tremendous about it, too. . . . You have to have seen human beings in this unleashed state to know what human nature is. . . . I need to experience all the depths of life for myself, that's why I go out, and that's why I volunteered."[34] This idea of experiencing the "depths of life" stemmed from Dix's interest in the philosophy of Friedrich Nietzsche, best known for his existentialist writings. In particular, Dix avidly read Nietzsche's *The Joyous Science*, deriving from it a belief in life's cyclical nature—procreation and death, building up and tearing down, and growth and decay.

As the war progressed, however, Dix's faith in the potential improvement of society dissipated, and he began to produce unflinchingly direct and provocative artworks. His *Der Krieg* (*The War*; FIG. **22-40**) vividly captures the panoramic devastation war inflicts, both on the terrain and on humans. In the

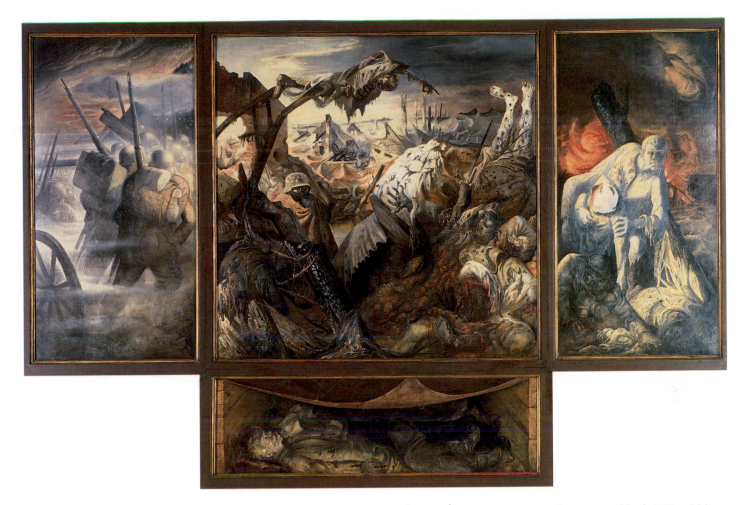

22-40 OTTO DIX, *Der Krieg (The War)*, 1929–1932. Oil and tempera on wood, 6′ 8⅓″ × 13′ 4¾″. Staatliche Kunstsammlungen, Gemäldegalerie Neue Meister, Dresden.

left panel, armed and uniformed soldiers march off into the distance. Dix graphically displayed the horrific results in the center and right panels, where mangled bodies, many riddled with bullet holes, are scattered throughout the eerily lit apocalyptic landscape. As if to emphasize the intensely personal nature of this scene, the artist painted himself into the right panel as the ghostly but determined soldier who drags a comrade to safety. In the bottom panel, in a coffinlike bunker, lie soldiers asleep—or perhaps dead. Dix significantly chose to present this sequence of images in a triptych format, and the work recalls triptychs such as Matthias Grünewald's *Isenheim Altarpiece* (see FIG. 18-1). Christ's death and suffering there serve as reference points for Dix's dead soldiers. However, the hope of salvation extended to viewers of *Isenheim Altarpiece* through Christ's eventual Resurrection is absent from *Der Krieg (The War)*. Like his fellow Neue Sachlichkeit artists, Dix felt compelled to lay bare the realities of his time, which the war's violence dominated. Even years later, Dix still maintained:

> You have to see things the way they are. You have to be able to say yes to the human manifestations that exist and will always exist. That doesn't mean saying yes to war, but to a fate that approaches you under certain conditions and in which you have to prove yourself. Abnormal situations bring out all the depravity, the bestiality of human beings. . . . I portrayed states, states that the war brought about, and the results of war, as states.[35]

Other Postwar Expressionist Art in Germany

POIGNANT PRINTS The emotional range of German Expressionism extends from passionate protest and satirical bitterness to the poignantly expressed pity for the poor in the woodblock prints of the independent artist KÄTHE KOLLWITZ (1867–1945). The graphic art of Gauguin and Munch stimulated a revival of the print medium in Germany, especially the woodcut, and the forceful block prints cut in the days of the German Reformation, such as those of Holbein, proved inspiring models. The harsh, black, and splintered lines of woodblock prints were ideal for the stark forms and blunt emphasis of message the modern expressionists prized. In her *Memorial to Karl Liebknecht* (FIG. **22-41**), Kollwitz represented the sorrowing poor gathered around the bier of the assassinated leader of the 1919 socialist revolution. When World War I concluded, Liebknecht, along with Rosa Luxemburg and other radical left-wing socialists, formed the German Communist Party. The Communists challenged the Social Democrats for control of Germany but were brutally suppressed. Kollwitz was not formally affiliated with Neue Sachlichkeit or any of the organized German Expressionist groups. However, this is a classic of expressionism, a masterful presentation of the theme of mourning for the lost leader and a strong political protest presented in a moving, eloquent visual statement.

22-41 KÄTHE KOLLWITZ, *Memorial to Karl Liebknecht*, 1919. Woodcut. Käthe Kollwitz Museum, Berlin.

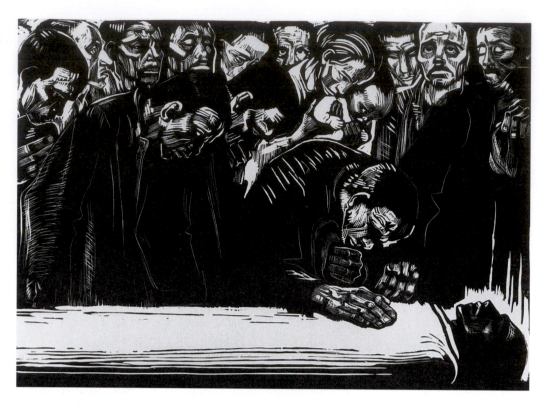

AN ELONGATED, EXPRESSIVE SCULPTURE Like Kollwitz, the war deeply affected German artist WILHELM LEHMBRUCK (1881–1919). His figurative sculpture exudes a quiet mood but still possesses a compelling emotional sensibility. Lehmbruck studied sculpture, painting, and the graphic arts in Düsseldorf before moving to Paris in 1910, where he developed the style of his *Seated Youth* (FIG. 22-42). His sculpture combines the expressive qualities he much admired in the work of two fellow sculptors—the classical idealism of Maillol (FIG. 22-9) and the psychological energies of Rodin (see FIGS. 21-48 and 21-49). In Lehmbruck's *Seated Youth,* the poignant elongation of human proportions, the slumped shoulders, and the hands that hang uselessly all impart an undertone of anguish to the rather classical figure. Lehmbruck's figure communicates by pose and gesture alone. Although its extreme proportions may recall Mannerist attenuation (such as Parmigianino's *Madonna with the Long Neck*; FIG. 17-42), its distortions announce a new freedom in interpreting the human figure. For Lehmbruck, as for Rodin, the human figure could express every human condition and emotion. The quiet, contemplative nature of this sculpture serves both as a personal expression of Lehmbruck's increasing depression and as a powerful characterization of the general sensibility in the wake of World War I. Appropriately, *Seated Youth* was originally titled *The Friend,* in reference to the artist's many friends who lost their lives in the war. After Lehmbruck's tragic suicide in 1919, officials placed this sculpture as a memorial in the soldiers' cemetery in Lehmbruck's native city of Duisburg.

A SUSPENDED, HAUNTING MEMORIAL OF WAR A work more spiritual in its expression is the *War Monument* (FIG. 22-43) the German sculptor ERNST BARLACH (1870–1938) created for the cathedral in his hometown of Güstrow in 1927. Working often in wood, Barlach sculpted single figures usually dressed in flowing robes and portrayed in strong, simple poses that embody deep human emotions and experiences such as grief, vigilance, or self-comfort. Barlach's works combine sharp, smoothly planed forms with intense expression. The cast-bronze hovering figure of his *War Monument* is

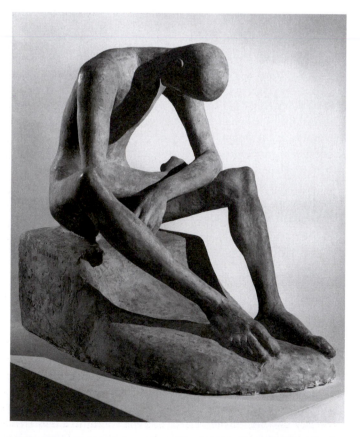

22-42 WILHELM LEHMBRUCK, *Seated Youth,* 1917. Composite tinted and plaster, 3′ 4$\frac{5}{8}$″ × 2′ 6″ × 3′ 9″. National Gallery of Art, Washington. (Andrew W. Mellon Fund).

22-43 ERNST BARLACH, *War Monument*, from Güstrow Cathedral, Güstrow, Germany, 1927. Bronze. Schildergasse Antoniterkirche, Cologne.

one of the poignant memorials of World War I. Unlike traditional war memorials depicting heroic military figures, often engaged in battle, Barlach created a hauntingly symbolic figure that speaks to the experience of all caught in the conflict of war. The floating human form, suspended above a tomb inscribed with the dates 1914–1918 and the later added 1939–1945, suggests a dying soul at the moment when it is about to awaken to everlasting life—the theme of death and transfiguration. The rigid economy of surfaces concentrates attention on the simple but expressive head. The spiritual anguish the disaster of war evokes and the release from that anguish through hope of salvation rarely have been expressed as movingly as in *War Monument*. So powerful was this sculpture that the Nazis had it removed from the cathedral in 1937 and melted down for ammunition. Luckily, a friend hid another version by Barlach; a Protestant parish in Cologne purchased this surviving cast, from which a new cast was made for the Güstrow cathedral.

Surrealism and Fantasy Art

The exuberantly aggressive momentum of the Dada movement that emerged during World War I was only sustained for a short time. By 1924, with the publication in France of the *First Surrealist Manifesto,* most of the artists associated with Dada joined the Surrealist movement and its determined exploration of ways to express in art the world of

dreams and the unconscious. Given this transition, it is not surprising the Surrealists incorporated many of the Dadaists' improvisational techniques. They believed these methods important for engaging the elements of fantasy and activating the unconscious forces that lie deep within every human being. The Surrealists were determined to explore the inner world of the psyche, the realm of fantasy and the unconscious. Inspired in part by the ideas of the psychoanalysts Sigmund Freud and Carl Jung, the Surrealists especially were interested in the nature of dreams. They viewed dreams as occurring at the level connecting all human consciousness and as constituting the arena in which people could move beyond their environment's constricting forces to reengage with the deeper selves society had long suppressed. In 1924, one of the leading Surrealists thinkers, the young Parisian writer André Breton, provided a definition of Surrealism:

> Pure psychic automatism, by which one intends to express verbally, in writing, or by any other method, the real functioning of the mind. Dictation by thought, in the absence of any control exercised by reason, and beyond any esthetic or moral preoccupation. . . . Surrealism is based on the belief in the superior reality of certain forms of association heretofore neglected, in the omnipotence of dreams, in the undirected play of thought. . . . I believe in the future resolution of the states of dream and reality, in appearance so contradictory, in a sort of absolute reality, or surreality.[36]

Thus, the Surrealists' dominant motivation was to bring the aspects of outer and inner "reality" together into a single position, in much the same way life's seemingly unrelated fragments combine in the vivid world of dreams. The projection in visible form of this new conception required new techniques of pictorial construction. The Surrealists adapted some Dada devices and invented new methods such as automatic writing and various types of planned "accidents" not so much to reveal a world without meaning as to provoke reactions closely related to subconscious experience.

Surrealism developed along two lines. Some artists gravitated toward an interest in biomorphic (life forms) Surrealism with automatism—"dictation of thought without control of the mind"—predominating. Biomorphic Surrealists such as Joan Miró produced largely abstract compositions, although they sometimes suggested organisms or natural forms. Naturalistic Surrealists, in contrast, presented recognizable scenes that seem to have metamorphosed into a dream or nightmare image. The artists Salvador Dalí and René Magritte are most closely associated with this variant of Surrealism.

METAPHYSICAL PAINTING The Italian painter GIORGIO DE CHIRICO (1888–1978) produced emphatically ambiguous works that position him as a precursor of Surrealism. De Chirico's paintings of cityscapes and shop windows were part of a movement called *pittura metafisica,* or Metaphysical Painting. Returning to Italy after study in Munich, de Chirico found hidden reality revealed through strange juxtapositions, such as those seen on late autumn afternoons in the city of Turin, when the setting sun's long shadows transformed vast open squares and silent public monuments into "the most metaphysical of Italian towns." De Chirico translated this vision into paint in works such as *Melancholy and*

22-44 GIORGIO DE CHIRICO, *Melancholy and Mystery of a Street*, 1914. Oil on canvas, 2' 10¼" × 2' 4½". Private collection.

Mystery of a Street (FIG. **22-44**), where the squares and palaces of Roman and Renaissance Italy evoke a disquieting sense of foreboding. The choice of the term "metaphysical" to describe de Chirico's paintings suggests that these images transcend their physical appearances. *Melancholy and Mystery of a Street,* for all of its clarity and simplicity, takes on a rather sinister air. Only a few inexplicable and incongruous elements punctuate the scene's solitude—a small girl with her hoop in the foreground, the empty van, and the ominous shadow of a man emerging from behind the building. The sense of strangeness de Chirico could conjure with familiar objects and scenes recalls Nietzsche's "foreboding that underneath this reality in which we live and have our being, another and altogether different reality lies concealed."[37]

De Chirico's paintings were reproduced in periodicals almost as soon as he completed them, and his works quickly influenced artists outside Italy, including both the Dadaists and, later, the Surrealists. The incongruities in his work intrigued the Dadaists, while the eerie mood and visionary quality of paintings such as *Melancholy and Mystery of a Street* excited and inspired Surrealist artists who sought to portray the world of dreams.

SEEKING THE SENSE OF THE PSYCHIC Originally a Dada activist in Cologne, Germany, MAX ERNST (1891–1976) became one of the early adherents of the Surrealist circle Breton anchored. As a child living in a small community near Cologne, Ernst had found his existence fantastic and filled with marvels. In autobiographical notes, written mostly in the third person, he said of his birth: "Max Ernst had his first contact with the world of sense on the 2nd April 1891 at 9:45 A.M., when he emerged from the egg which his mother had laid in an eagle's nest and which the bird had incubated for seven years."[38] Ernst's service in the German army during World War I swept away his early success as an expressionist; in his own words:

Max Ernst died on 1st August 1914. He returned to life on 11th November 1918, a young man who wanted to become a magician and find the central myth of his age. From time to time he consulted the eagle which had guarded the egg of his prenatal existence. The bird's advice can be detected in his work.[39]

Before joining the Surrealists, Ernst explored every means to achieve the sense of the psychic in his art. Like other Dadaists,

22-45 MAX ERNST, *Two Children Are Threatened by a Nightingale,* 1924. Oil on wood with wood construction, 2' 3½" high, 1' 10½" wide, 4½" deep. Museum of Modern Art, New York (purchase).

he set out to incorporate found objects and chance into his works. Using a process called *frottage,* he created some works by combining the patterns achieved by rubbing a crayon or another medium across a sheet of paper placed over a surface with a strong and evocative textural pattern. In other works, he joined fragments of images he had cut from old books, magazines, and prints to form one hallucinatory collage.

Ernst soon began making paintings that shared the mysterious dreamlike effect of his collages. In 1920, his works brought him into contact with Breton, who instantly recognized Ernst's affinity with the Surrealist group. In 1922, Ernst moved to Paris. His *Two Children Are Threatened by a Nightingale* (FIG. **22-45**) manifests many of the creative bases of Surrealism. Here, Ernst displayed a private dream that challenged the post-Renaissance idea that a painting should resemble a window looking into a "real" scene rendered illusionistically three-dimensional through mathematical perspective. In *Two Children Are Threatened,* the artist painted the landscape, the distant city, and the tiny flying bird in conventional fashion; he followed all the established rules of aerial and linear perspective. The three sketchily rendered figures, however, clearly belong to a dream world, and the liter-

ally three-dimensional miniature gate, the odd button knob, and the strange closed building "violate" the bulky frame's space. Additional dislocation occurs in the traditional museum identification label, which Ernst displaced into a cutaway part of the frame. Handwritten, it announces the work's title (taken from a poem Ernst wrote before he painted this), adding another note of irrational mystery.

Like the title of many Surrealist works, *Two Children Are Threatened by a Nightingale* is ambiguous and uneasily relates to what spectators see. Viewers must struggle to decipher connections between the image and words. When Surrealists (and Dadaists and Metaphysical artists before them) used such titles, they intended for the seeming contradiction between title and picture to act like a "blow to the mind," knocking spectators off balance with all expectations challenged. Much of the impact of Surrealist works begins with viewers' sudden awareness of the incongruity and absurdity of what is pictured.

A DISTURBING BLUE DREAMSCAPE Spaniard SALVADOR DALÍ (1904–1989), an established Surrealist painter, also explored his psyche and dreams in his paintings,

22-46 SALVADOR DALÍ *The Persistence of Memory*, 1931. Oil on canvas, $9\frac{1}{2}$" × 1' 1". Museum of Modern Art, New York (given anonymously).

sculptures, jewelry, and designs for furniture and movies. Dalí probed a deeply erotic dimension through his work, studying the writings of Sigmund Freud and Richard von Krafft-Ebing and inventing what he called the "paranoiac-critical method" to assist his creative process. As he described it, in his painting he aimed "to materialize the images of concrete irrationality with the most imperialistic fury of precision . . . in order that the world of imagination and of concrete irrationality may be as objectively evident . . . as that of the exterior world of phenomenal reality."[40] All these aspects of Dalí's style can be seen in *The Persistence of Memory* (FIG. **22-46**). Here, he created a haunting allegory of empty space where time has ended. An eerie never-setting sun illuminates the barren landscape. An amorphous creature sleeps in the foreground; it is based on a figure in the Paradise section of Hieronymous Bosch's *Garden of Earthly Delights* (see FIG. 15-17). Dalí draped his creature with a limp pocket watch. Another watch hangs from the branch of a dead tree that springs unexpectedly from a blocky architectural form. A third watch hangs half over the edge of the rectangular form, beside a small timepiece resting dial-down on the block's surface. Ants swarm mysteriously over the small watch, while a fly walks along the face of its large neighbor, almost as if this assembly of watches were decaying organic life—soft and sticky. Dalí rendered every detail of this dreamscape with precise control, striving to make the world of his paintings as convincingly real as the most meticulously rendered landscape based on an actual scene from nature.

WORDS CONTRADICTING IMAGES The Belgian painter RENÉ MAGRITTE (1898–1967) also expressed in ex-

emplary fashion the Surrealist idea and method—the dream-like dissociation of image and meaning. His works administer disruptive shocks because they subvert viewers' expectations based on logic and common sense. The danger of relying on rationality when viewing a Surrealist work is glaringly apparent in Magritte's *The Treachery (or Perfidy) of Images* (FIG. **22-47**). Magritte presented a meticulously rendered trompe l'oeil depiction (a very illusionistic rendering; literally, "fools the eye") of a briar pipe. The caption beneath the image, however, contradicts what seems obvious: "Ceci n'est pas une pipe" ("This is not a pipe"). The discrepancy between image and caption clearly challenges the assumptions underlying the reading of visual art. Like the other Surrealists' work, this painting wreaks havoc on viewers' reliance on the conscious and the rational.

FUZZY LOGIC The Surrealists also were enamored with sculpture, whose concrete tangibility made their art all the more disquieting. *Object (Le Déjeuner en fourrure)*, translated as "Luncheon in fur" (FIG. **22-48**), by Swiss artist MERET OPPENHEIM (1913–1985) captures the incongruity, humor, visual appeal, and, often, eroticism characterizing Surrealism. The artist presented a fur-lined teacup inspired by a conversation she had with Picasso. After admiring a bracelet Oppenheim had made from a piece of brass covered with fur, Picasso noted that anything might be covered with fur. When her tea grew cold, Oppenheim responded to Picasso's comment by ordering "un peu plus de fourrure" ("a little more fur"), and the sculpture had its genesis. *Object (Le Déjeuner en fourrure)* takes on an anthropomorphic quality, animated by the quirky combination of the fur with a functional ob-

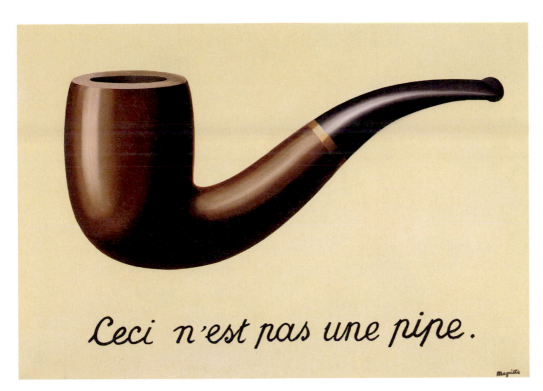

22-47 RENÉ MAGRITTE, *The Treachery (or Perfidy) of Images*, 1928–1929. Oil on canvas, 1' 11$\frac{5}{8}$" × 3' 1". Los Angeles County Museum of Art, Los Angeles (purchased with funds provided by the Mr. and Mrs. William Preston Harrison Collection).

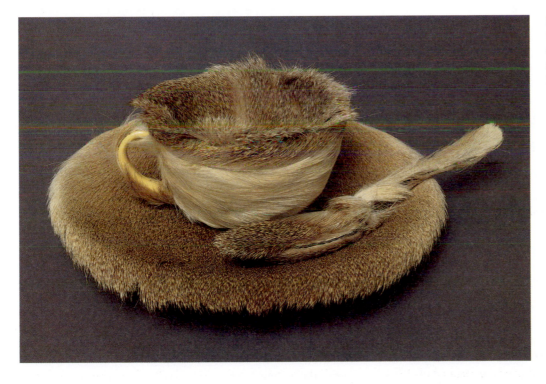

22-48 MERET OPPENHEIM, *Object (Le Déjeuner en fourrure)*, 1936. Fur-covered cup, 4$\frac{3}{8}$" in diameter; saucer, 9$\frac{3}{8}$" in diameter; spoon, 8". Museum of Modern Art, New York (purchase).

ject. Further, the sculpture captures the Surrealist flair for al-chemical, seemingly magical or mystical, transformation. It incorporates a sensuality and eroticism (seen here in the se-ductively soft, tactile fur lining the concave form) that are also components of much of Surrealist art. That visitors to the Surrealist exhibition at the Museum of Modern Art in New York in 1937 selected *Object* as the quintessential Surre-alist symbol reveals that it seemed to epitomize the Surrealist vision.

WEARING HER HEART ON HER SLEEVE The Mexican painter FRIDA KAHLO (1907–1954), who used the details of her life as powerful symbols for the psychological pain of human existence, often has been discussed as a Surre-alist. The psychic and autobiographical issues she dealt with in her art account for this association. Indeed, Breton himself deemed her a natural Surrealist. Yet Kahlo consciously dis-tanced herself from the Surrealist group, and it was left to oth-ers to impose Surrealist connections on her. Kahlo began

22-49 FRIDA KAHLO,
The Two Fridas, 1939. Oil on
canvas, 5′ 7″ × 5′ 7″.
Collection of the Museo de
Arte Moderno, Mexico City.

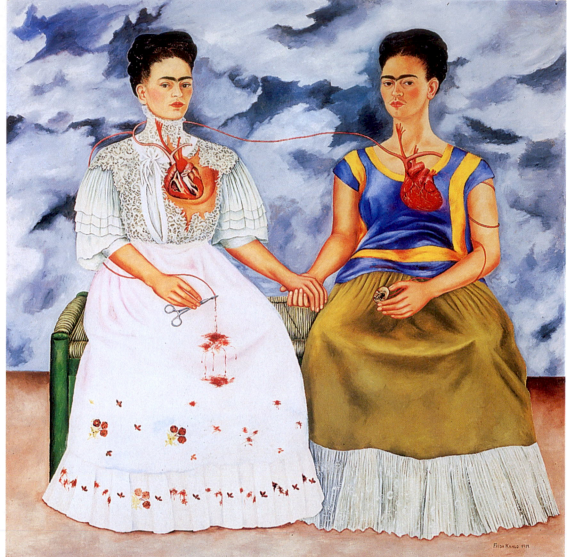

painting seriously as a young student, during convalescence from an accident that tragically left her in constant pain. Her life became a heroic and tumultuous battle for survival against illness and stormy personal relationships. *The Two Fridas* (FIG. **22-49**), one of the few large-scale canvases Kahlo ever produced, is typical of her long series of unflinching self-portraits. The twin figures sit side by side on a low bench in a barren landscape under a stormy sky. One figure wears a simple Mexican costume, while the other is dressed in what might be an elaborate wedding dress. The figures suggest different sides of the artist's personality, inextricably linked by the clasped hands and by the thin artery that stretches between them, joining their exposed hearts. The artery ends on one side in surgical forceps and on the other in a miniature portrait of her husband, the artist Diego Rivera (FIG. 22-81), as a child. Kahlo's deeply personal paintings touch sensual and psychological memories in her audience.

THE CONSCIOUS AND THE UNCONSCIOUS
Like the Dadaists, the Surrealists used many methods to free the creative process from reliance on the kind of conscious control they believed society had shaped too much. Dalí used his paranoiac-critical approach to encourage the free play of

association as he worked. Other Surrealists used automatism—the creation of art without conscious control and various types of planned "accidents" to provoke reactions closely related to subconscious experience. The Spanish artist JOAN MIRÓ (1893–1983) was a master of this approach. Although Miró resisted formal association with any movement or group, including the Surrealists, André Breton identified him as "the most Surrealist of us all."[41] From the beginning, his work contained an element of fantasy and hallucination. Introduced to using chance to create art by Surrealist poets in Paris, the young Spaniard devised a new painting method that allowed him to create works such as *Painting* (FIG. **22-50**). Miró began this painting by making a scattered collage composition with assembled fragments cut from a catalogue for machinery. The shapes in the collage became motifs the artist freely reshaped to create black silhouettes—solid or in outline, with dramatic accents of white and vermilion. They suggest, in the painting, a host of amoebic organisms or constellations in outer space floating in an immaterial background space filled with soft reds, blues, and greens.

Miró described his creative process as a switching back and forth between unconscious and conscious image making: "Rather than setting out to paint something, I begin painting

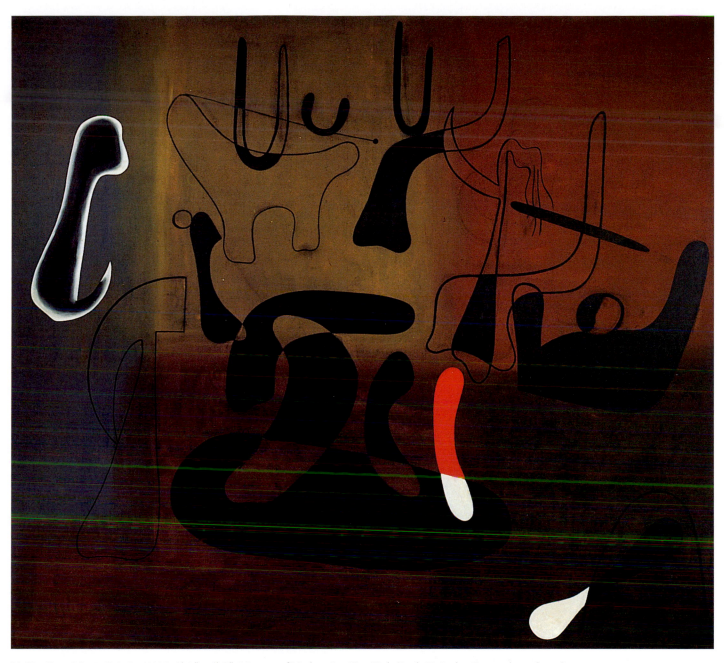

22-50 JOAN MIRÓ, *Painting*, 1933. 5′ 8″ × 6′ 5″. Museum of Modern Art, New York (Loula D. Lasker Bequest by exchange).

and as I paint the picture begins to assert itself, or suggest itself under my brush. The form becomes a sign for a woman or a bird as I work. . . . The first stage is free, unconscious. . . . The second stage is carefully calculated."[42] Even the artist could not always explain the meanings of pictures such as *Painting*. They are, in the truest sense, spontaneous and intuitive expressions of the little-understood, submerged unconscious part of life.

MECHANICAL BIRDS Perhaps the most inventive artist using fantasy images to represent the non-visible world was the Swiss-German painter PAUL KLEE (1879–1940). Like Miró, he shunned formal association with groups such as the Dadaists and Surrealists but pursued their interest in the subconscious. Klee shared the widespread modern apprehension about the rationalism driving a technological civilization that could destroy as much as construct. As do some psychologists,

he sought clues to humanity's deeper nature in primitive shapes and symbols. Like Jung, Klee seems to have accepted the existence of a collective unconscious that reveals itself in archaic signs and patterns and that is everywhere evident in the art of so-called "primitive" cultures (see "'Primitivism,' Colonialism, and Early-Twentieth-Century Western Art," page 826). The son of a professional musician and himself an accomplished violinist, Klee thought of painting as similar to music in its expressiveness and in its ability to touch its viewers' spirit through a studied use of color, form, and line:

Art does not reproduce the visible; rather it makes visible. . . . The formal elements of graphic art are dot, line, plane and space—the last three charged with energy of various kinds. . . . Formerly we used to represent things visible on earth, things we either liked to look at or would have liked to see. Today we reveal the reality that is behind visible things. . . . By including the concepts of good and evil, a moral sphere is created. . . . Art is a simile of the Creation.[43]

ART AND SOCIETY

"Primitivism," Colonialism, and Early-Twentieth-Century Western Art

Many scholars have noted that one of the major sources for much of early-twentieth-century art is non-Western culture. Picasso, Matisse, the German Expressionists, Brancusi, Klee, the Dadaists, and the Surrealists all incorporated stylistic elements from the artifacts of Africa, Oceania, and the native peoples of the Americas.

These artists benefited from the numerous non-Western objects displayed in European and American collections and museums. During the second half of the nineteenth century, anthropological and ethnographic museums began to proliferate. In 1882, the Musée d'Ethnographie (now the Musée de l'Homme, the Museum of Man) in Paris opened its doors to the public. The Musée Permanent des Colonies (now the Musée national des Arts d'Afrique et d'Oceanie) in Paris also provided the public with a wide array of objects—weapons, tools, basketwork, headdresses—from colonial territories, as did the Musée Africain in Marseilles. In Germany, the Berlin Museum für Völkerkunde (Museum of Ethnology) housed close to ten thousand African tribal objects by 1886, when it opened for public viewing. In addition, private collecting of such material was fairly widespread—even Matisse and Picasso collected African and Oceanic artifacts. The Expositions Universelles, regularly scheduled exhibitions in France designed to celebrate industrial progress, included products from Oceania and Africa after 1851, familiarizing the public with these cultures. By the beginning of the twentieth century, significant non-Western collections were on view in museums in Liverpool, Glasgow, Edinburgh, London, Hamburg, Stuttgart, Vienna, Berlin, Munich, Leiden, Copenhagen, and Chicago.

The availability of these collections and materials was due to the rampant colonialism central to the geopolitical dynamics of the nineteenth century and much of the twentieth century. Most of the Western powers maintained colonies. For example, the Dutch, Americans, and French all kept a colonial presence in the Pacific. Britain, France, Germany, Belgium, Holland, Spain, and Portugal divided up the African continent. People often perceived these colonial cultures as "primitive," and many of the non-Western artifacts displayed in museums were referred to as "artificial curiosities" or seen as fetish objects. Indeed, the exhibition of these objects collected during expeditions to the colonies served to reinforce the "need" for a colonial presence in these countries. As previously noted, colonialism often had a missionary dimension. These objects, which often seemed to depict strange gods or creatures, reinforced the perception that these peoples were "barbarians" who needed to be "civilized" or "saved," thereby justifying colonialism worldwide.

Whether avant-garde artists were aware of the imperialistic implications of their appropriation of non-Western culture is unclear. Certainly, however, many artists reveled in the energy and freshness of non-Western images and forms. These different cultural products provided Western artists with new ways of looking at their own art. Matisse always maintained he saw African sculptures as simply "good sculptures . . . like any other."[1] Picasso, in contrast, believed these objects were "magical things," "mediators" between humans and the forces of evil.[2] Further, "primitive" art seemed to embody a directness, closeness to nature, and honesty that appealed to modernist artists determined to reject conventional models. Ultimately, non-Western art served as an important revitalizing and energizing force in Western art, and this influence continues to the present.

[1] Jean-Louis Paudrat, "From Africa," in *"Primitivism" in 20th Century Art: Affinity of the Tribal and the Modern,* ed. William Rubin (New York: Museum of Modern Art, 1984), 1:141.

[2] Ibid.

To penetrate the reality behind visible things, Klee studied nature avidly, taking special interest in analyzing processes of growth and change. He coded these studies in diagrammatic form in notebooks, and the knowledge he gained in this way became so much a part of his consciousness that it influenced the "psychic improvisation" he used to create his art.

Klee's works, such as *Twittering Machine* (FIG. **22-51**), are small and intimate in scale. A viewer must draw near to decipher the delicately rendered forms and enter this mysterious dream world. The artist joined the ancient world of nature and the modern world of machines in this picture. Four diagrammatic birds, like those in a cuckoo clock, appear forced into twittering action—in this case, by the turning of a crank-driven mechanism. It is not too far-fetched to associate birds with life and machines with the human ability to control nature. (Indeed, a 1921 drawing by Klee called *Concert*

on a Twig shows these four birds with their double-curved perch clearly attached to a tree.) In *Twittering Machine,* however, Klee linked the birds permanently to the machine, creating an ironic vision of existence in the modern age. Each bird responds in such an individual way that viewers may see all of them as metaphors for themselves—beings trapped by the operation of the industrial society they either created or maintain. Some observers see an even darker meaning in *Twittering Machine.* The individual birds may represent the four temperaments of the ancient, medieval, and Renaissance periods, while their loony appearance also features avian shapes capable of luring real birds into a trap in the rectangular trough at the bottom of the image. Perhaps no other artist of the twentieth century matched Klee's subtlety as he deftly created a world of ambiguity and understatement that draws each viewer into finding a unique interpretation of the work.

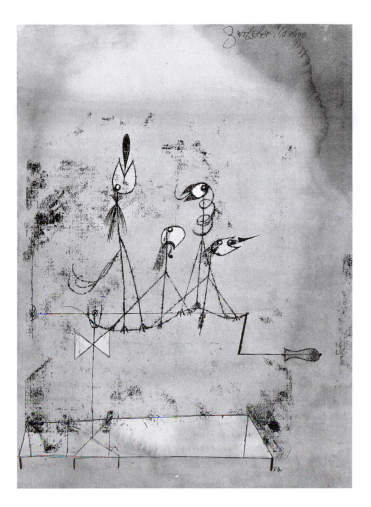

22-51 PAUL KLEE, *Twittering Machine*, 1922. Watercolor and pen and ink, on oil transfer drawing on paper, mounted on cardboard, 2′ 1″ × 1′ 7″. Museum of Modern Art, New York (purchase).

MEMORIES OF A RUSSIAN CHILDHOOD Not formally associated with either Dada or Surrealism but sharing their philosophy of the primacy of the subconscious in artistic creation was the Russian artist MARC CHAGALL (1887–1985). He maintained a more-or-less independent stance, producing his personal world of free fantasy. He created works filled with the extremes of visionary joy and despair, achieved through both symbols and fantasy. Chagall studied and worked in Paris and Berlin and incorporated into his work elements of expressionism, Cubism, and Fauvism. However, he never forgot his early years in the small Russian village of Vitebsk, and themes from his childhood emerge repeatedly in his art as if in dreams and memories. Some, gay and fanciful, suggest the simpler pleasures of folk life; others, somber and even tragic, recall the trials and persecutions of the Jewish people. Through all of his work runs a sense of deep religious experience, an integral part of his early life. In *I and the Village* (FIG. **22-52**) Chagall portrayed an assortment of images from his memories of his homeland—peasants and their families, a woman milking a cow, and a row of houses. These variously sized images overlap with others, all depicted in Fauve colors and Cubist fragmented space. The painting, clearly a mental construct rather than a logical narrative, has a fairy-tale, lyrical quality to it. A highly individual artist,

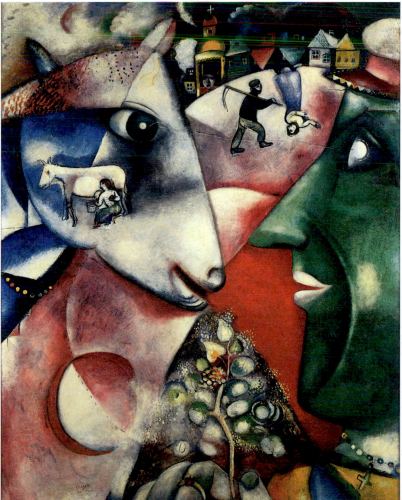

22-52 MARC CHAGALL, *I and the Village*, 1911. Oil on canvas, 6′ 3⅝″ × 4′ 11⅝″. Museum of Modern Art, New York (Mrs. Simon Guggenheim Fund).

Chagall intuitively used diverse avant-garde styles to help him transform the personal themes of his Russian childhood into symbols suggesting broader human experience.

NEW ART FOR A NEW SOCIETY— UTOPIAN IDEALS

The pessimism and cynicism of movements such as Dada are thoroughly understandable in light of the historical circumstances. However, not all artists gravitated toward alienation from society and its profound turmoil. Some avant-garde artists promoted utopian ideals, believing staunchly in art's ability to contribute to improving society and all humankind. These efforts often surfaced in the face of significant political upheaval, illustrating the link established early on between revolution in politics and revolution in art. Among the art movements espousing utopian notions were Suprematism and Constructivism in Russia, De Stijl in Holland, and the Bauhaus in Germany.

Suprematism and Constructivism

THE SUPREMACY OF PURE FEELING Although Russia was geographically far removed from Paris, the center of the international art world in the early twentieth century, Russians had a long history of cultural contact and interaction with the West. Russian artists were thus well aware of early-twentieth-century artistic developments, especially Fauvism, Cubism, and Futurism. Among the artists who pursued the

avant-garde direction Cubism introduced was the Russian painter KAZIMIR MALEVICH (1878–1935). Malevich developed an abstract style to convey his belief that the supreme reality in the world is pure feeling, which attaches to no object. Thus, this belief called for new, nonobjective forms in art— shapes not related to objects in the visible world. Malevich had studied painting, sculpture, and architecture and had worked his way through most of the avant-garde styles of his youth before deciding none were suited to expressing the subject he found most important—"pure feeling." He christened his new artistic approach Suprematism, explaining: "Under Suprematism I understand the supremacy of pure feeling in creative art. To the Suprematist, the visual phenomena of the objective world are, in themselves, meaningless; the significant thing is feeling, as such, quite apart from the environment in which it is called forth. . . . The Suprematist does not observe and does not touch—he feels."[44]

The basic form of Malevich's new Suprematist nonobjective art was the square. Combined with its relatives, the straight line and the rectangle, the square soon filled his paintings, such as *Suprematist Composition: Airplane Flying* (FIG. **22-53**). In this work, the brightly colored shapes float against and within a white space, and the artist placed them in dynamic relationship to one another. Malevich believed all peoples easily would understand his new art because of the universality of its symbols. It used the pure language of shape and color that everyone could respond to intuitively. Having formulated his artistic approach, Malevich welcomed the Russian Revolution, which broke out in 1917, as a political act that would wipe out past traditions and begin a new culture. He believed his art could play a major role because of its universal accessibility. In actuality, after a short period when the new regime heralded avant-garde art, the political leaders of the postrevolution Soviet Union decided the new society needed a more "practical" art. This art would teach citizens about their new government or produce goods that would improve their lives. Malevich was horrified; to him, true art was forever divorced from such practical connections with life. As he explained, "Every social idea, however great and important it may be, stems from the sensation of hunger; every art work, regardless of how small and insignificant it may seem, originates in pictorial or plastic feeling. It is high time for us to realize that the problems of art lie far apart from those of the stomach or the intellect."[45]

Disappointed and unappreciated in his own country, Malevich eventually stopped painting and turned his attention to other things, such as mathematical theory and geometry, logical fields given his interest in pure abstraction.

THE ABSOLUTE REALITY OF SPACE/TIME Like Malevich, the Russian-born sculptor NAUM GABO (1890–1977) wanted to create an innovative art to express a new reality, and, also like Malevich, Gabo believed such art would spring from sources separate from the everyday world. For Gabo, the new reality was the space/time world described by early-twentieth-century advances in science. As he wrote in *Realistic Manifesto,* published with his brother Anton Pevsner in 1920: "Space and time are the only forms on which life is built and hence art must be constructed." Later, he explained: "We are realists, bound to earthly matters. . . . The shapes we are creating are not abstract, they are absolute. They are released from any already existent thing in nature and their con-

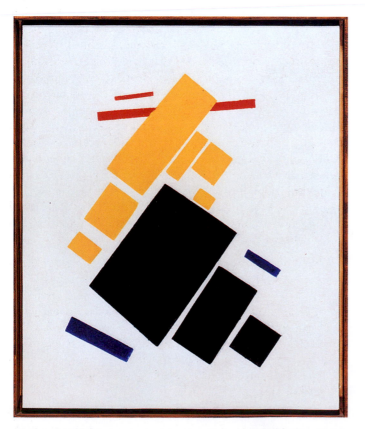

22-53 KAZIMIR MALEVICH, *Suprematist Composition: Airplane Flying,* 1915 (dated 1914). Oil on canvas, $1'10\frac{7}{8}'' \times 1'\,7''$. Museum of Modern Art, New York (purchase).

tent lies in themselves. . . . It is impossible to comprehend the content of an absolute shape by reason alone. Our emotions are the real manifestation of this content."[46]

Gabo was associated with a group of Russian sculptors known as Constructivists. The name *Constructivism* may have come originally from the title *Construction,* which the Russian artist Vladimir Tatlin had used for some relief sculptures he made in 1913 and 1914. According to Gabo, he called himself a Constructivist partly because he built up his sculptures piece by piece in space, instead of carving or modeling them in the traditional way. This method freed the Constructivists to work with "volume of mass and volume of space" as "two different materials" for creating compositions filled with the "kinetic rhythms" humans perceive as "real time."[47]

Although Gabo experimented briefly with real motion in his work, most of his sculptures relied on the relationship of mass and space to suggest the nature of space/time. To indicate the volumes of mass and space more clearly in his sculpture, Gabo used some of the new synthetic plastic materials, including celluloid, nylon, and lucite, to create constructions whose space seems to flow through as well as around the transparent materials. In works such as *Column* (FIG. 22-54), the sculpture's depth is visible, because the sculptor opened up the column's circular mass so that view-

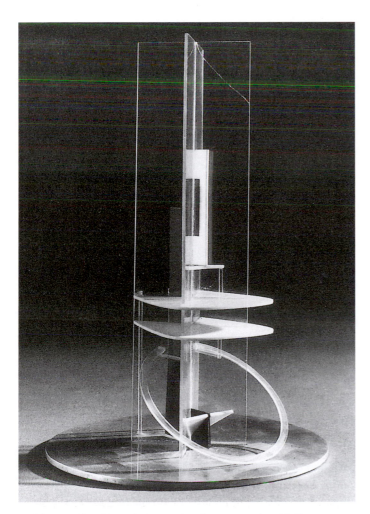

22-54 NAUM GABO, *Column,* ca. 1923 (reconstructed 1937). Perspex, wood, metal, glass, 3′ 5″ × 2′ 5″ × 2′ 5″. Solomon R. Guggenheim Museum, New York.

ers can experience the volume of space it occupies. Two transparent planes extend through its diameter, crossing at right angles at the center of the implied cylindrical column shape. The opaque colored planes at the base and the inclined open ring set up counter rhythms to the crossed upright planes. They establish the sense of dynamic kinetic movement Gabo always sought to express as an essential part of reality.

"THE CULTURE OF MATERIALS" In the years immediately following the Russian Revolution, a new art movement emerged in the Soviet Union whose members devoted their talents to designing a better environment for human beings. The Russians called their movement Productivism. It developed as an offshoot of the Constructivist movement, and one of its most gifted leaders was VLADIMIR TATLIN (1885–1953). Influenced by Cubism's formal analysis, the dynamism of Futurism, and the rhythmic compositions of flat curved planes in traditional Russian icon paintings (see FIG. 9-29), Tatlin produced abstract relief constructions and models for stage sets. He experimented with every kind of material—glass, iron, sheet metal, wood, and plaster—to lay the basis for what he called the "culture of materials."

The revolution had been the signal to Tatlin and other avant-garde artists in Russia that the hated old order was ending. They were determined to play a significant role in creating a new world, one that would fully use the power of industrialization to benefit all the people. Initially, like Malevich and Gabo, Tatlin believed nonobjective art was ideal for the new society, free as such art was from any past symbolism. For a few years, all Russian avant-garde artists worked together designing public festivals and demonstrations. They presented plays and exhibitions intended to help educate the public about their new government and the possibilities for their future. The Russian Futurist-Constructivist poet Vladimir Mayakovsky proclaimed their new goal: "We do not need a dead mausoleum of art where dead works are worshiped, but a living factory of the human spirit—in the streets, in the tramways, in the factories, workshops, and workers' homes."[48]

These artists reorganized art schools such as the College of Painting, Sculpture, and Architecture in Moscow, combining them with craft schools to form new educational programs—they renamed the one in Moscow Vkhutemas (Higher Artistic-Technical Studios). Tatlin, Malevich, and Gabo's brother, Pevsner, had studios there. Gabo (a frequent visitor) described the school's activities, which were much like those of Germany's Bauhaus, discussed later:

> [It was] both a school and a free academy where not only the current teaching of special professions was carried out (. . . painting, sculpture, architecture, ceramics, metalwork, and woodwork, textile, and typography) but general discussions were held and seminars conducted amongst the students on diverse problems where the public could participate, and artists not officially on the faculty could speak and give lessons. . . . During these seminars . . . many ideological questions between opposing artists in our abstract group were thrashed out.[49]

As Gabo's statement indicates, a split was developing among avant-garde members. On one side were Malevich, Gabo, Kandinsky (who had returned to Moscow in 1914), and all the other artists who believed art was an expression of

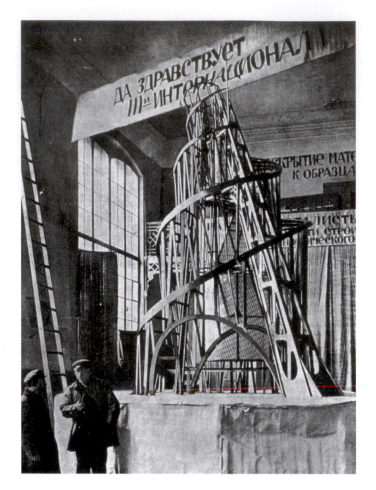

22-55 VLADIMIR TATLIN, *Monument to the Third International,* 1919–1920. Model in wood, iron, and glass. Re-created in 1968 for exhibition at the Moderna Museet, Stockholm. Copyright © Estate of Vladimir Tatlin/Licensed by VAGA, New York, NY.

for a different type of governmental activity and rotating at a different speed. The one at the bottom, a huge cylindrical glass structure for lectures and meetings, was to revolve once a year. Higher up was a cone-shaped chamber intended for administrative functions and monthly rotations. At the top, a cubic information center would have revolved daily, issuing news bulletins and proclamations via the most modern means of communication. These included an open-air news screen (illuminated at night) and a special instrument designed to project words on the clouds on any overcast day. The proposed decreasing size of the chambers as visitors ascended the monument paralleled the decision-making hierarchy in the political system, with the most authoritative, smallest groups near the building's apex.

Tatlin's design thus served as a visual reinforcement of a social and political reality. Tatlin envisioned the whole complex as a dynamic communications center perfectly suited to the exhilarating pace of the new age. In addition, the design's reductive geometry demonstrates Tatlin's connection to the artistic programs of the Suprematists and the Constructivists. Due to the desperate economic situation in Russia during these years, Tatlin's ambitious design was never realized as a building. It existed only in metal-and-wood models exhibited on various official occasions before disappearing. The only records of the models are found in a few drawings, photographs, and recent reconstructions.

De Stijl

In 1917, a group of young artists in Holland formed a new movement and began publishing a magazine, calling both movement and magazine De Stijl (The Style). The group was cofounded by the painters PIET MONDRIAN (1872–1944) and Theo van Doesburg (1883–1931). Group members promoted utopian ideals and believed in the birth of a new age in the wake of World War I. They felt it was a time of balance between individual and universal values, when the machine would assure ease of living: "There is an old and a new consciousness of the age. The old one is directed toward the individual. The new one is directed toward the universal."[50] The goal was a total integration of art and life:

> We must realize that life and art are no longer separate domains. That is why the "idea" of "art" as an illusion separate from real life must disappear. The word "art" no longer means anything to us. In its place we demand the construction of our environment in accordance with creative laws based upon a fixed principle. These laws, following those of economics, mathematics, technique, sanitation . . . are leading to a new, plastic unit.[51]

THE UNIVERSALITY OF NONOBJECTIVITY
Toward this goal of integration, Piet Mondrian created a resolutely monistic style—that is, it was based on a single ideal principle. The choice of the term *De Stijl* reflected Mondrian's confidence that this style revealed the underlying eternal structure of existence. De Stijl artists reduced their artistic vocabulary to simple geometric elements. Study in Paris, just before World War I, introduced Mondrian to modes of abstraction in avant-garde art such as Cubism. However, as his attraction to contemporary theological writings grew, Mon-

humanity's spiritual nature. On the other side were the Productivists—Tatlin and other artists who felt artists must direct art toward creating useful products for the new society. The Productivists connected their position to that of a group called Proletkult (Organization for Proletarian Culture). Founded in 1906, it became free to follow its primary doctrine ("Art is a social product, conditioned by the social environment") only after the 1917 revolution. Tatlin enthusiastically abandoned abstract art for functional art by designing such products as an efficient stove and a "functional" set of worker's clothing. For a time, he even worked in a metallurgical factory near Petrograd (after 1989 once again Saint Petersburg).

Tatlin's most famous work is his design for *Monument to the Third International* (FIG. **22-55**), commissioned by the Department of Artistic Work of the People's Commissariat for Enlightenment early in 1919 to honor the Russian Revolution. His concept was for a huge glass-and-iron symbol building that would have been twice as high as the Empire State Building. Widely influential, "Tatlin's Tower," as it became known, was viewed as a model for those seeking to encourage socially committed and functional art. On its proposed site in the center of Moscow, it would have served as a propaganda and news center for the Soviet people. Within a dynamically tilted spiral cage, three geometrically shaped chambers were to rotate around a central axis, each chamber housing facilities

drian sought to purge his art of every overt reference to individual objects in the external world. (He especially favored the teachings of theosophy, a tradition basing knowledge of nature and the human condition on knowledge of the divine nature or spiritual powers.) His fellow theosophist, Vassily Kandinsky (FIG. 22-7) was pursuing a similar path. Mondrian turned toward a conception of nonobjective or pictorial design—"pure plastic art"— he believed expressed universal reality. He articulated his credo with great eloquence in 1914:

> What first captivated us does not captivate us afterward (like toys). If one has loved the surface of things for a long time, later on one will look for something more. . . . The interior of things shows through the surface; thus as we look at the surface the inner image is formed in our soul. It is this inner image that should be represented. For the natural surface of things is beautiful, but the imitation of it is without life. . . . Art is higher than reality and has no direct relation to reality. Between the physical sphere and the ethereal sphere there is a frontier where our senses stop functioning. . . . The spiritual penetrates the real . . . but for our senses these are two different things. To approach the spiritual in art, one will make as little use as possible of reality, because reality is opposed to the spiritual. We find ourselves in the presence of an abstract art. Art should be above reality, otherwise it would have no value for man.[52]

Mondrian soon moved beyond Cubism because he felt "Cubism did not accept the logical consequences of its own discoveries; it was not developing towards its own goal, the expression of pure plastics."[53] Caught by the outbreak of hostilities while on a visit to Holland, Mondrian remained there during World War I, developing his theories for what he called Neoplasticism—the new "pure plastic art." He believed all great art has polar but coexistent goals, the attempt to create "universal beauty" and the desire for "aesthetic expression of oneself."[54] The first goal is objective in nature, while the second is subjective, existing within the individual's mind and heart. To create such a universal expression, an artist must communicate "a real equation of the universal and the individual."[55] To express this vision, Mondrian eventually limited his formal vocabulary to the three primary colors (red, blue, and yellow), the three primary values (black, white, and gray), and the two primary directions (horizontal and vertical). Basing his ideas on a combination of teachings, he concluded that primary colors and values are the purest colors and therefore are the perfect tools to help an artist construct a harmonious composition. Using this system, he created numerous paintings locking color planes into a grid of intersecting vertical and horizontal lines, as in *Composition in Red, Blue, and Yellow* (FIG. 22-56). In each of these paintings, Mondrian altered the grid patterns and the size and placement of the color planes to create an internal cohesion and harmony. This did not mean inertia; rather, Mondrian worked to maintain a dynamic tension in his paintings from the size and position of lines, shapes, and colors.

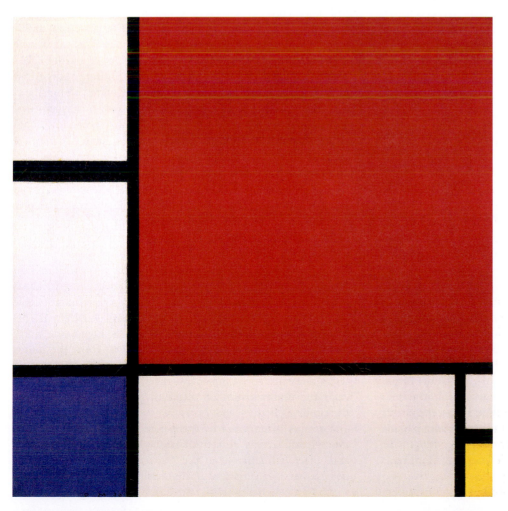

22-56 PIET MONDRIAN, *Composition in Red, Blue, and Yellow*, 1930. Oil on canvas, 2' 4⅝" × 1' 9¼". Private Collection.

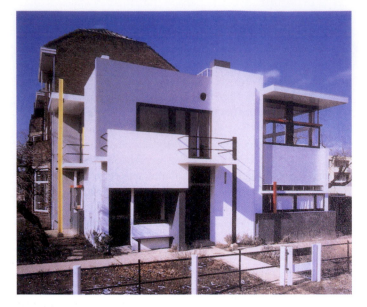

22-57 GERRIT RIETVELD, Schröder House, Utrecht, the Netherlands, 1924.

DE STIJL STYLE IN SPACE Architects also explored many of the ideas Mondrian and De Stijl artists pursued. One of the masterpieces of De Stijl architecture is the Schröder House in Utrecht, Holland (FIG. **22-57**), built in 1924 by GERRIT THOMAS RIETVELD (1888–1964). Rietveld came to the group as a cabinetmaker and made De Stijl furnishings throughout his career. His architecture carries the same spirit into a larger integrated whole and perfectly expresses van Doesburg's definition of De Stijl architecture:

> The new architecture is anti-cubic, i.e., it does not strive to contain the different functional space cells in a single closed cube, but it throws the functional space (as well as canopy planes, balcony volumes, etc.) out from the centre of the cube, so that height, width, and depth plus time become a completely new plastic expression in open spaces. . . . The plastic architect . . . has to construct in the new field, time-space.[56]

The main living rooms of the Schröder House are on the second floor, with more private rooms on the ground floor. However, Rietveld's house has an open plan and a relationship to nature more like the houses of his contemporary, the American architect Frank Lloyd Wright (FIG. 22-67 and FIG. 22-69). Rietveld designed the entire second floor with sliding partitions that can be closed to define separate rooms or pushed back to create one open space broken into units only by the furniture arrangement. This shifting quality appears also on the outside, where railings, free-floating walls, and long rectangular windows give the effect of cubic units breaking up before viewers' eyes. Rietveld's design clearly links all the arts. Rectangular planes seem to slide across each other on the Schröder House facade like movable panels, making this structure a kind of three-dimensional projection of the rigid but carefully proportioned flat planes in Mondrian's paintings.

The Bauhaus

The De Stijl group developed not only an appealing simplified geometric style, but it also promoted the notion that art should be thoroughly incorporated into living environments. As Mondrian had insisted, "Art and life are *one;* art and life are both expressions of truth."[57] In Germany, a particular vision of "total architecture" was developed by the architect WALTER GROPIUS (1883–1969), who made this concept the foundation not only of his own work but also of the work of generations of pupils under his influence at a school called the Bauhaus. In 1919, Gropius was appointed the director of the Weimar School of Arts and Crafts in Germany, founded in 1906. Under Gropius, the school was renamed Das Staatliche Bauhaus (roughly translated as "State School of Building") and referred to as the Bauhaus.

Gropius's goal was to train artists, architects, and designers to accept and anticipate twentieth-century needs. He designed an extensive curriculum based on certain principles. First, Gropius staunchly advocated the importance of strong basic design (including principles of composition, two- and three-dimensionality, and color theory) and craftsmanship as fundamental to good art and architecture. Declared Gropius: "Architects, sculptors, painters, we must all go back to the crafts. . . . There is no essential difference between the artist and the craftsman."[58] To achieve this, both a technical instructor and a "teacher of form"—an artist—taught each department.

Second, Gropius promoted the unity of art, architecture, and design. "Architects, painters, and sculptors," he insisted, "must recognize anew the composite character of a building as an entity."[59] To encourage eliminating boundaries that traditionally separated art from architecture and art from craft, the Bauhaus offered courses in a wide range of artistic disciplines. These included weaving, pottery, bookbinding, carpentry, metalwork, stained glass, mural painting, stage design, and advertising and typology, in addition to painting, sculpture, and architecture.

Third, because Gropius wanted the Bauhaus to produce graduates who could design progressive environments that satisfied twentieth-century needs, he emphasized thorough knowledge of machine-age technologies and materials. He felt that to produce truly successful designs, the artist/architect/craftsperson had to understand industry and mass production. Ultimately, Gropius hoped for a marriage between art and industry—a synthesis of design and production.

Like the De Stijl movement, the Bauhaus was founded on utopian principles. Gropius's declaration reveals the idealism of the entire Bauhaus enterprise: "Together let us conceive and create the new building of the future, which will embrace architecture and sculpture and painting in one unity and which will rise one day toward heaven from the hands of a million workers like a crystal symbol of a new faith."[60] In its reference to a unity of workers, this statement also reveals the undercurrent of socialism present in Germany at the time.

Gropius hired some of the period's most innovative and avant-garde artists and thinkers to teach at the Bauhaus, and their influence—at the Bauhaus and long after its demise, as a group and individually—was monumental.

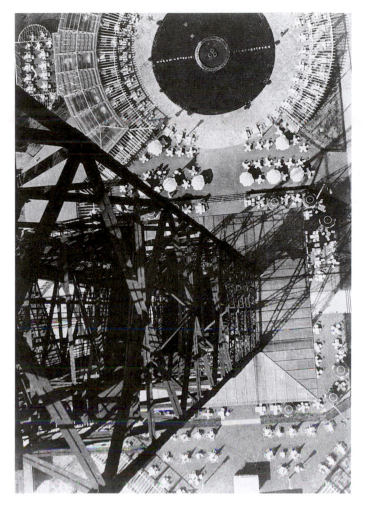

22-58 LÁSZLÓ MOHOLY-NAGY, *From the Radio Tower Berlin*, 1928.
Gelatin silver print. The Art Institute of Chicago, Chicago.

Given this fascination with space/time relationships, it is not surprising Moholy-Nagy increasingly turned his attention to photography and film. Not only does *From the Radio Tower Berlin* (FIG. 22-58) depict a marvel of the modern age—a radio tower—but the photo also exercises his "new vision," taken as it is from the top looking straight down. This vertical aerial viewpoint presented viewers with a new perspective on the world (an increasingly common one with the development of aerial flight) and new formal patterns and visual relationships.

THE PRIMACY OF DESIGN PRINCIPLES Another Bauhaus teacher who left a lasting legacy is the German artist JOSEF ALBERS (1888–1976). Although he initially worked in the Bauhaus's glass and furniture workshops, his greatest contribution to the school was his revision of the basic design course required of all students. There he refined his ideas, declaring: "We learn which formal qualities are important today: harmony or balance, free or measured rhythm, geometric or arithmetic proportion, symmetry or asymmetry, central or peripheral emphasis."[62] This systematic and thorough investigation of art's formal aspects characterized his own work, as evidenced in his best-known series *Homage to the Square* (FIG. 22-59). Although Albers executed this series between 1950 and 1976, some time after his departure from the Bauhaus and his emigration to the United States in 1933, it encapsulates the design concepts he developed while at the Bauhaus. Consisting of hundreds of paintings that were simply color variations on the same composition of concentric squares, *Homage to the Square* reflected Albers's belief that art originates in "the discrepancy between physical fact and psychic effect."[63]

Among these teachers were Vassily Kandinsky (FIG. 22-7), Paul Klee (FIG. 22-51), and the De Stijl artists Theo van Doesburg and Piet Mondrian (participating as a guest teacher; FIG. 22-56).

EXPLORING SPACE/TIME RELATIONSHIPS
One of the most important Bauhaus teachers was Hungarian-born artist LÁSZLÓ MOHOLY-NAGY (1895–1946), who embraced Gropius's notion that art should be all encompassing. Accordingly, Moholy-Nagy produced paintings, sculptures, prints, photograms, advertisements, set designs, photographs, and special effects for film. He was particularly interested in the character of the modern age and believed society was

> heading toward a kinetic, time-spatial existence; toward an awareness of the forces plus their relationships which define all life and of which we had no previous knowledge and for which we have as yet no exact terminology. . . . Space-time stands for many things: relativity of motion and its measurement, integration, simultaneous grasp of the inside and outside, revelation of the structure instead of the facade. It also stands for a new vision concerning materials, energies, tensions, and their social implications.[61]

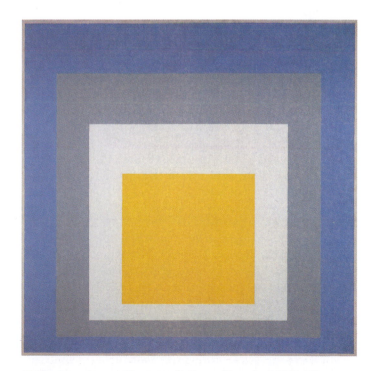

22-59 JOSEF ALBERS, *Homage to the Square: "Ascending"*, 1953. Oil on composition board, 3′ 7½″ × 3′ 7½″. Collection of Whitney Museum of American Art, New York (purchase).

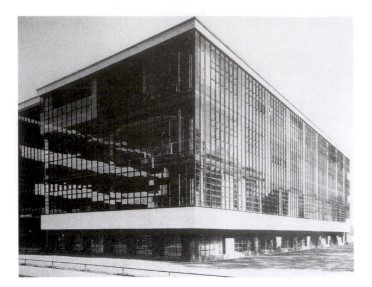

22-60 WALTER GROPIUS, Shop Block, the Bauhaus, Dessau, Germany, 1925–1926.

The building Gropius designed for the Bauhaus at Dessau visibly expressed these goals and can be seen as the Bauhaus's architectural manifesto. The building consisted of workshop and class areas, a dining room, a theater, a gymnasium, a wing with studio apartments, and an enclosed two-story bridge housing administrative offices. Of the major wings, the most dramatic was the Shop Block (FIG. 22-60). The Nazi government tore down this building, but the Bauhaus's main buildings were later reconstructed. Three stories tall, the Shop Block housed a printing shop and dye works facility, in addition to other work areas. The builders constructed the skeleton of reinforced concrete but set these supports well back, sheathing the entire structure in glass, creating a streamlined and light effect. This design's simplicity followed Gropius's dictum that architecture should avoid "all romantic embellishment and whimsy." Further, he realized the "economy in the use of space" articulated in his list of principles in his interior layout of the Shop Block, which consisted of large areas of freeflowing undivided space. Gropius believed such a spatial organization encouraged interaction and the sharing of ideas. One student described the "wonderful community spirit" such a layout generated.

The former interior decor of this Dessau building also reveals the comprehensiveness of the Bauhaus program. Because carpentry, furniture design, and weaving were all part of the Bauhaus curriculum, Gropius gave students and teachers the task of designing furniture and light fixtures for the building.

TUBULAR STEEL BAUHAUS FURNITURE One of the memorable furniture designs that emerged from the Bauhaus was the tubular steel chair (FIG. 22-61) crafted by the Hungarian MARCEL BREUER (1902–1981). Breuer supposedly was inspired to use tubular steel while riding his bicycle and admiring the handlebars. In keeping with Bauhaus

Because the composition in each of these paintings remains constant, the works succeed in revealing the relativity and instability of color perception. Albers varied the hue (color), saturation (brightness or dullness), and value or tone (lightness or darkness) of each square in the paintings in this series. As a result, the sizes of the squares from painting to painting appear to vary (although they remain the same), and the sensations emanating from the paintings range from clashing dissonance to delicate serenity. Albers explained his motivation for focusing on color juxtapositions: "They [the colors] are juxtaposed for various and changing visual effects. . . . Such action, reaction, interaction . . . is sought in order to make obvious how colors influence and change each other; that the same color, for instance—with different grounds or neighbors—looks different. . . . Such color deceptions prove that we see colors almost never unrelated to each other . . ."[64]

In keeping with the Bauhaus's encouragement of proficiency in a wide range of media, Albers produced versions of *Homage* in oil painting on masonite, in lithographs, in screenprints, on Aubusson (French densely patterned carpet) and other tapestries, and on large interior walls. Albers's ideas about design and color were widely disseminated, not only during his years at the Bauhaus but also during his subsequent residency in the United States.

THE BAUHAUS MOVES TO DESSAU After encountering increasing hostility from a new government elected in 1924, the Bauhaus was forced to move north to Dessau in early 1925. By this time, the Bauhaus program had matured. In a statement, Walter Gropius listed the school's goals more clearly:

- A decidedly positive attitude to the living environment of vehicles and machines.
- The organic shaping of things in accordance with their own current laws, avoiding all romantic embellishment and whimsy.
- Restriction of basic forms and colours to what is typical and universally intelligible.
- Simplicity in complexity, economy in the use of space, materials, time, and money.[65]

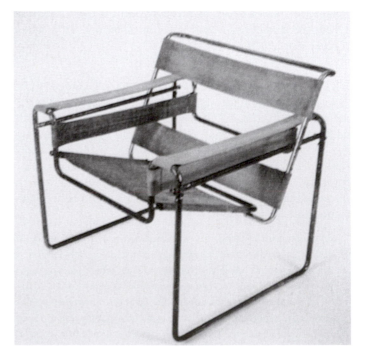

22-61 MARCEL BREUER, tubular chair, 1925.

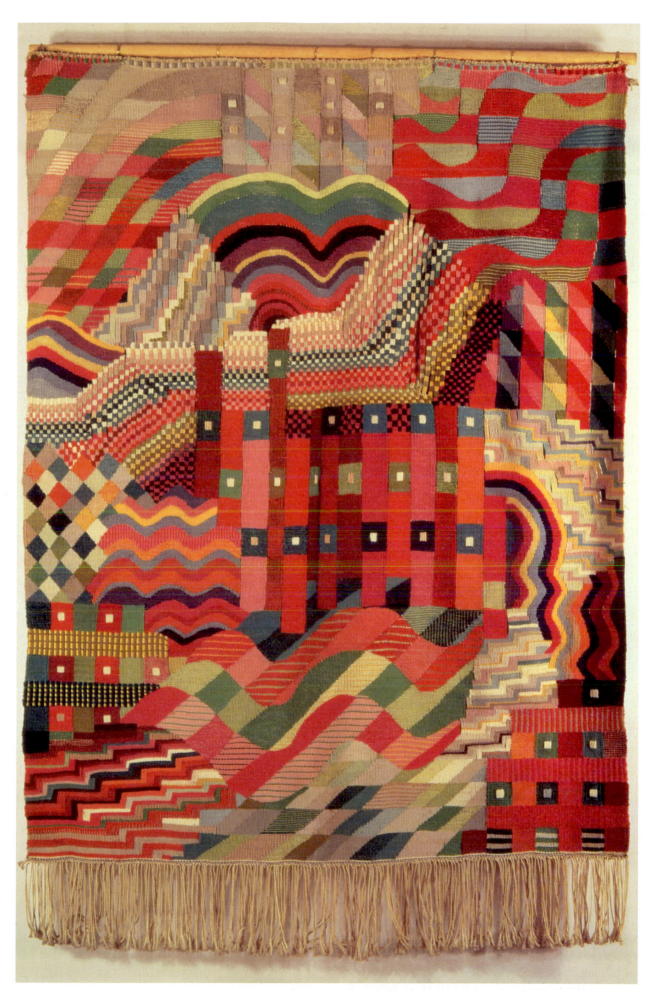

22-62 GUNTA STÖLZL, Gobelin tapestry, 1926–1927. Linen and cotton.

aesthetics, his chairs have a streamlined, simple geometric look to them, and the leather or cloth supports add to the furniture's comfort and functionality. These chairs also were easily mass produced and thus stand as epitomes of the Bauhaus program.

This reductive, spare geometric aesthetic served many purposes—artistic, practical, and social. Bauhaus and De Stijl artists alike championed this style. Theo van Doesburg, an important De Stijl member, promoted this simplified artistic vocabulary, in part accepted because of its association with the avant-garde and progressive thought. Such an aesthetic also evoked the machine. Appropriately, it easily could be applied to all art forms, from stage design to advertising to architecture, and therefore was perfect for mass production. Even further, this aesthetic fit in well with Gropius's directive that artists, architects, and designers restrict their visual vocabulary "to what is typical and universally intelligible," revealing the social dimension of the Bauhaus agenda in its adherence to socialist principles.

THE VITALITY OF BAUHAUS FIBER CRAFTS

The universal applicability of this aesthetic is seen in a tapestry (FIG. **22-62**) designed by GUNTA STÖLZL (1897–1983), the only woman on the Bauhaus staff. More lively than many of the other Bauhaus-produced designs, this intricate and colorful work retains the emphasis on geometric patterns and clear intersection of verticals and horizontals. Stölzl was largely responsible for the vitality of the weaving workshop at the Bauhaus, creating numerous handwoven carpets, curtains, and runners. In accordance with Bauhaus principles, she also designed weavings for machine production. In terms of establishing production links with outside businesses, her department was one of the most successful at the school.

"LESS IS MORE"

In 1928, Gropius left the Bauhaus, and architect LUDWIG MIES VAN DER ROHE (1886–1969) eventually took over the directorship, moving the school to Berlin. In his architecture and furniture, he made such a clear and elegant statement of the International Style (FIGS. 22-64 and 22-65) that his work had enormous influence on modern architecture. Taking as his motto "less is more" and calling his architecture "skin and bones," his aesthetic was already fully formed in the model for a glass skyscraper building he conceived in 1921 (FIG. **22-63**). This model received extensive publicity when it was exhibited at the first Bauhaus exhibition in 1923. Working with glass provided Mies van der Rohe with new freedom and many expressive possibilities.

In the glass model, three irregularly shaped towers flow outward from a central court designed to hold a lobby, a porter's room, and a community center. Two cylindrical entrance shafts rise at the ends of the court, each containing elevators, stairways, and toilets. Wholly transparent, the perimeter walls reveal the regular horizontal patterning of the cantilevered floor planes and their thin vertical supporting elements. The bold use of glass sheathing and inset supports was, at the time, technically and aesthetically adventurous. A few years later, Gropius pursued it in his design for the Bauhaus building in Dessau. The weblike delicacy of the lines of the glass model, its radiance, and the illusion of movement created by reflection and by light changes seen through it pre-

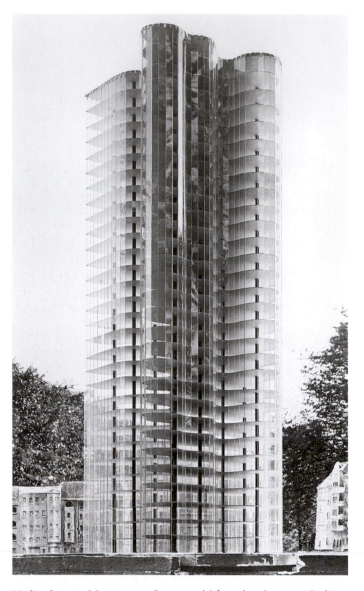

22-63 LUDWIG MIES VAN DER ROHE, model for a glass skyscraper, Berlin, Germany, 1922 (no longer extant).

figured many of the glass skyscrapers found in major cities throughout the world today.

THE DEMISE OF THE BAUHAUS

In 1933, the Nazis finally occupied the Bauhaus and closed the school for good, one of Hitler's first acts after coming to power (see " 'Degenerate Art,' " page 837). During its fourteen-year existence, the beleaguered school graduated fewer than five hundred students, yet it achieved legendary status. Its phenomenal impact extended beyond painting, sculpture, and architecture to interior design, graphic design, and advertising. Even further, the Bauhaus greatly influenced art education, and art schools everywhere structured their curricula in line with that the Bauhaus pioneered. The Bauhaus philosophy and aesthetic were disseminated widely, in large part by the numerous instructors who fled Nazi Germany, many to the United States. Walter Gropius and Marcel Breuer ended up at Harvard University, while Mies van der Rohe and László Moholy-Nagy moved to Chicago and taught there. Josef Albers moved to the United States in 1993, teaching at Black Mountain College in North Carolina and later at Yale University.

"Degenerate Art"

Estrangement between the avant-garde and the public evolved into a defining characteristic of their relationship—a distance artists often consciously cultivated because they perceived it as confirming the innovative nature of their art. Despite the avant-garde's strong commitment to its art, such constant ridicule by and hostility from the public (and the art world's more conservative segment) must have been difficult and wearying.

At times, this hostility went beyond mere derision to outright political persecution. The Bauhaus endured years of harassment by the National Socialists (Nazis) before they forced it to close its doors in 1933. But perhaps the most dramatic and moving example of the persecution avant-garde artists suffered is the infamous *Entartete Kunst* (Degenerate art) exhibition Adolf Hitler and the Nazis mounted in 1937.

Hitler aspired to become an artist himself, producing numerous drawings and paintings. These works reflected Hitler's firm belief that nineteenth-century realistic genre painting represented the zenith of Aryan art development. Accordingly, he denigrated anything that did not conform to that standard—in particular, avant-garde art. Hitler ordered confiscation of more than sixteen thousand artworks he considered "degenerate," and to publicize his condemnation of this art, he ordered his minister for public enlightenment and propaganda (and second in command) Joseph Goebbels to organize a massive exhibition of this "degenerate art." Hitler defined "degenerate art" as works that "insult German feeling, or destroy or confuse natural form, or simply reveal an absence of adequate manual and artistic skill."[1] The term "degenerate" also had other specific connotations at the time and was used to designate supposedly inferior racial, sexual, and moral types. Hitler's order to Goebbels to target twentieth-century avant-garde art for inclusion in this exhibition was intended to impress on viewers the general inferiority of these individuals. To make this point all the more dramatic, Hitler ordered the organization of another exhibition, the *Grosse Deutsche Kunstausstellung* (Great German art exhibition), which ran concurrently and presented an extensive array of Nazi-approved conservative art.

Entartete Kunst opened in Munich on July 19, 1937, and included more than 650 paintings, sculptures, prints, and books. Among the 112 artists whose works the Nazis presented for ridicule were Ernst Barlach, Max Beckmann, Marc Chagall, Otto Dix, Max Ernst, George Grosz, Vassily Kandinsky, Ernst Kirchner, Paul Klee, Wilhelm Lehmbruck, Franz Marc, László Moholy-Nagy, Piet Mondrian, Emil Nolde, and Kurt Schwitters. The photograph here shows Hitler visiting the exhibition, pausing in front of the Dada wall, where works by Schwitters, Klee, and Kandinsky were initially deliberately hung askew. No avant-garde or even modernist artist was safe from Hitler's attack; only six of the artists in the exhibition were Jewish. Indeed, despite his status

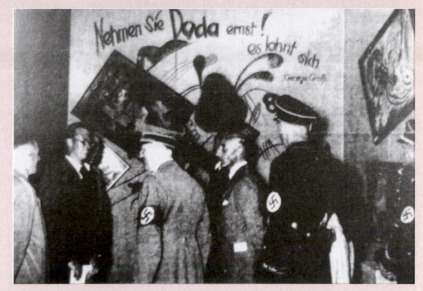

Adolf Hitler, accompanied by Nazi commission members photographer Heinrich Hoffmann, Wolfgang Willrich, Walter Hansen, and painter Adolf Ziegler, viewing the *Entartete Kunst* show on July 16, 1937. The curators deliberately hung askew these works by Kandinsky, Klee, and Schwitters (although the paintings were subsequently straightened for the duration of the exhibition).

as a charter member of the Nazi party, Emil Nolde was singled out for particularly harsh treatment. The Nazis confiscated more than one thousand of Nolde's works from German museums and included twenty-seven of them in the exhibition, more than almost any other artist.

Entartete Kunst was immensely popular; roughly twenty thousand viewers visited the show daily. By the end of its four-month run, it had attracted more than two million viewers, and nearly a million more viewed it as it traveled through Germany and Austria.

Clearly, artists needed monumental courage to defy tradition and produce avant-garde art. Commitment to the avant-garde demanded a resoluteness that extended beyond issues of aesthetics and beyond the confines of the art world. Such persecution exacted an immense toll on these artists. Kirchner, for example, responded to the stress of Nazi pressure by destroying all of his woodblocks and burning many of his works. A year later, in 1938, he committed suicide. Beckmann and his wife fled to Amsterdam on the exhibit's opening day, never to return to their homeland. Although *Entartete Kunst* was just a fragment of the tremendous destruction of life and spirit Hitler and the Nazis wrought, Hitler's insistence on suppressing and discrediting this art dramatically demonstrates art's power to affect viewers.

[1] Stephanie Barron, *"Degenerate Art": The Fate of the Avant-Garde in Nazi Germany* (Los Angeles: Los Angeles County Museum of Art, 1991), 19.

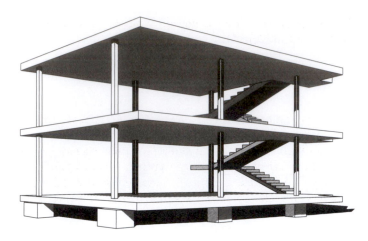

22-64 LE CORBUSIER, perspective drawing for Domino House project, Marseilles, France, 1914.

The International Style

DESIGNING FUNCTIONAL LIVING SPACES The simple streamlined aesthetic Gropius and Mies van der Rohe developed became known as the International Style (different from the Early Renaissance painting style) because of its widespread popularity. Of the architectural purists—perhaps, puritans—of this style, the first and staunchest adherent was the Swiss architect CHARLES-EDOUARD JEANNERET (1887–1965), called LE CORBUSIER. Trained in Paris and Berlin, he was also a painter (see page 801) but was best known as an influential architect and theorist on modern architecture. As such, he applied himself to designing a "functional" living space, which he described as a "machine for living."[66]

The drawing for his Domino House project (FIG. **22-64**) shows the skeleton of his ideal dwelling. Every level can be used. Reinforced concrete slabs serve the double function of ceiling and floor, supported by thin steel columns rising freely inside the perimeter of the structure's interior spaces. The whole building is raised above ground on short blocks so that the design uses the space underneath, as well as that on the roof. Exterior walls can be suspended from the projecting edges of the concrete slabs in this model, like free-hanging curtains. Because the skeleton supports itself, architects using this plan have complete freedom to subdivide the interior, wherever desired, with light walls that bear no structural load. This drawing illustrates one of the major principles associated with the International Style—eliminating the bearing wall. New structural systems using materials such as structural steel and ferroconcrete (reinforced concrete) made this idea possible.

The scheme allows architects to provide for what Le Corbusier saw as the basic physical and psychological needs of every human being—sun, space, and vegetation combined with controlled temperature, good ventilation, and insulation against harmful and undesired noise. He also believed in basing dwelling designs on human scale, because the house is humankind's assertion within nature. The Domino House system's main principles were anticipated about half a decade earlier in the designs of the German architects Walter Gropius and Peter Behrens (with whom Le Corbusier worked early in his career). However, Le Corbusier's drawing depicts their ideas with such elegant simplicity that it has had enormous influence. It is the primary statement of the design concepts governing the structural principles used in many modern office buildings and skyscrapers.

A "PURIST" HOUSE Le Corbusier used the basic ideas of the Domino House project in many single-family dwellings. The most elegant is the Villa Savoye (FIG. **22-65**), located at Poissy-sur-Seine near Paris. This country house sits conspicuously within its site, tending to dominate it, and has a broad view of the landscape. A cube of lightly enclosed and deeply penetrated space, the Villa Savoye has only a partially

22-65 LE CORBUSIER, Villa Savoye, Poissy-sur-Seine, France, 1929.

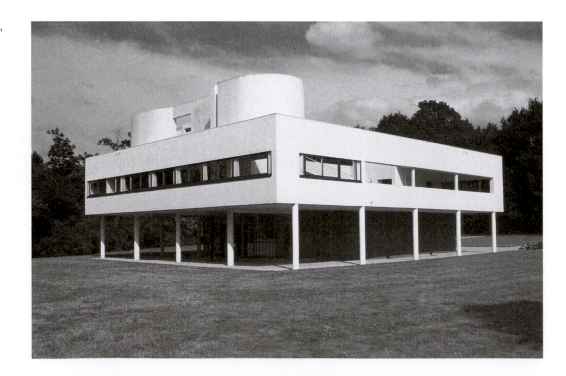

confined ground floor (containing a three-car garage, bed-rooms, a bathroom, and utility rooms). Much of the house's interior is open space, with the thin columns supporting the main living floor and the roof garden area. The major living rooms in the Villa Savoye are on the second floor, wrapping around an open central court and lighted by strip windows that run along the membranelike exterior walls. From the second floor court, a ramp leads up to a flat roof-terrace and garden protected by a curving windbreak along one side. The ostensible approach to Villa Savoye does not define an entrance; the building has no traditional facade. People must walk around and through the house to comprehend its layout. Spaces and masses interpenetrate so fluently that "inside" and "outside" space intermingle. The machine-planed smoothness of the surfaces, entirely without adornment; the slender "ribbons" of continuous windows; and the buoyant lightness of the whole fabric—all combine to reverse the effect of traditional country houses (compare Andrea Palladio's Villa Rotunda, FIG. 17-56, and John Vanbrugh's Blenheim, FIG. 19-75).

Le Corbusier inverted the traditional design practice of placing light elements above and heavy ones below by refusing to enclose the ground story of the Villa Savoye with masonry walls. This openness makes the "load" of the Villa Savoye's upper stories appear to hover lightly on the slender column supports. Le Corbusier used several colors on this building's exterior—originally, a dark-green base, cream walls, and a rose-and-blue windscreen on top. They were a deliberate analogy for the colors in the contemporary machine-inspired Purist style of painting (FIG. 22-20) he actively practiced.

EFFICIENT AND HUMANE CITY PLANNING
The Villa Savoye was a marvelous house for a single family, but, like the De Stijl architects, Le Corbusier also dreamed of extending his ideas of the house as a "machine for living" to designs for efficient and humane cities. He saw great cities as spiritual workshops and he proposed to correct the deficiencies in existing cities caused by poor traffic by circulation, inadequate living units, and the lack of space for recreation and exercise. Le Corbusier suggested replacing such cities with three types of new communities. Vertical cities would house workers and the business and service industries. Linear-industrial cities would run as belts along the routes between the vertical cities and would serve as centers for the people and processes involved in manufacturing. Finally, separate centers would be constructed for people involved in intensive agricultural activity. Le Corbusier's cities would provide for human cultural needs in addition to serving every person's physical, mental, and emotional comfort needs.

The Domino House project was a key part of Le Corbusier's thinking because the module design could be repeated almost indefinitely, both horizontally and vertically. Its volumes could be manipulated and interlocked to provide interior spaces of different sizes and heights. It was not site specific and could stand comfortably in any setting. Later in Le Corbusier's career, he designed a few of his vertical cities, most notably the Unité d'Habitation in Marseilles (1945–1952). He also created the master plan for the entire city of Chandigarh, the capital city of the Punjab, India (1950–1957). He ended his career with a personal expressive style in his design

of the Chapel of Notre Dame du Haut at Ronchamp (see FIGS. 23-40 and 23-41).

Art Deco

In theory and practice, the new architecture (particularly that associated with the Bauhaus) rejected ornament of any kind. Pure form emerged from functional structure and required no decoration. Yet popular taste still favored ornamentation, especially in public architecture. A movement in the 1920s and 1930s sought to upgrade industrial design in competition

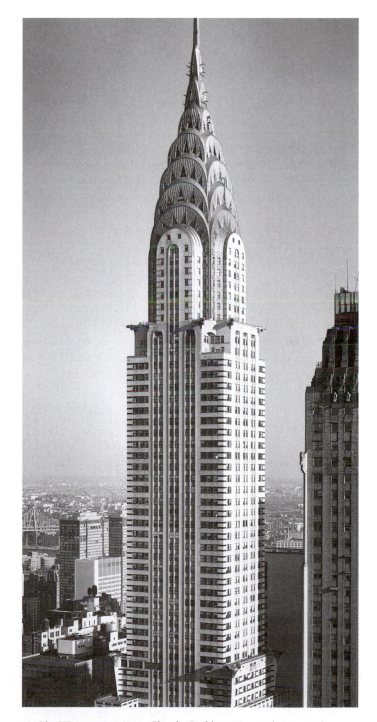

22-66 WILLIAM VAN ALEN, Chrysler Building, New York, New York, 1928–1930. Spire of stainless steel, overall height 1,048'.

with "fine art." Proponents wanted to work new materials into decorative patterns that could be either machined or handcrafted and that could, to a degree, reflect the simplifying trend in architecture. A remote descendant of Art Nouveau, this movement became known as Art Deco. (Like its predecessor, it was an event in the history of industrial design, not in the history of architecture.) Art Deco had universal application—to buildings, interiors, furniture, utensils, jewelry, fashions, illustration, and commercial products of every sort. Art Deco products have a "streamlined," elongated symmetrical aspect; simple flat shapes alternate with shallow volumes in hard patterns simulating mainline modern architecture. As a cultural phenomenon, it is associated with Jazz Age flair, flippancy, and elegance and with the gorgeous salons of the great ocean liners ferrying the carefree rich in the days of the "lost generation."

A GLITTERING SPIRE OF STAINLESS STEEL
Art Deco's exemplary masterpiece is the stainless-steel spire of the Chrysler Building in New York City (FIG. **22-66**), designed by WILLIAM VAN ALEN (1882–1954). The building and spire are monuments to the fabulous twenties, when American millionaires and corporations competed with one another to raise the tallest skyscrapers in the biggest cities. Built up of diminishing fan shapes, the spire glitters triumphantly in the sky, a resplendent crown honoring the business achievements of the great auto manufacturer. As a temple of commerce, the Chrysler Building was dedicated to the principles and success of American business, before its chastening in the Great Depression.

EMPHASIZING THE ORGANIC

It was impossible for early-twentieth-century artists to ignore the increasingly intrusive expansion of mechanization and growth of technology. However, not all artists embraced these developments, as had the Futurists. In contrast, many artists attempted to overcome the predominance of mechanization in society by immersing themselves in a search for the organic and natural.

Organic Architecture

One of the most striking personalities in the development of early-twentieth-century architecture was FRANK LLOYD WRIGHT (1867–1959). Born in Wisconsin, Wright attended a few classes at the University of Wisconsin in Madison before moving to Chicago, where he eventually joined the firm headed by Louis Sullivan (see FIGS. 21-59 and 21-60). Wright set out to create "architecture of democracy."[67] Early influences were the volumetric shapes in a set of educational blocks the German educator Friedrich Froebel (from Wright's childhood) designed, the organic unity of a Japanese building Wright saw at the Columbian Exposition in Chicago in 1893, and a Jeffersonian belief in individualism and populism. Always a believer in architecture as "natural" and "organic," Wright saw it as serving free individuals who have the right to move within a "free" space, envisioned as a nonsymmetrical design interacting spatially with its natural surroundings. He

sought to develop an organic unity of planning, structure, materials, and site. Wright identified the principle of continuity as fundamental to understanding his view of organic unity: "Classic architecture was all fixation. . . . Now why not let walls, ceilings, floors become seen as component parts of each other? . . . You may see the appearance in the surface of your hand contrasted with the articulation of the bony structure itself. This ideal, profound in its architectural implications . . . I called . . . continuity.[68]

Wright manifested his vigorous originality early, and by 1900 he had arrived at a style entirely his own. In his work during the first decade of the twentieth century, his cross-axial plan and his fabric of continuous roof planes and screens defined a new domestic architecture.

A "WANDERING" HOUSE ON THE PRAIRIE
Wright fully expressed these elements and concepts in Robie House (FIG. **22-67**), built between 1907 and 1909. Like other buildings in the Chicago area he designed at about the same time, this was called a "prairie house." Wright conceived the long, sweeping ground-hugging lines, unconfined by abrupt wall limits, as reaching out toward and capturing the expansiveness of the Midwest's great flatlands. Abandoning all symmetry, the architect eliminated a facade, extended the roofs far beyond the walls, and all but concealed the entrance. Wright filled the "wandering" plan of the Robie House (FIG. **22-68**) with intricately joined spaces (some large and open, others closed), grouped freely around a great central fireplace. (He believed strongly in the hearth's age-old domestic significance.) Wright designed enclosed patios, overhanging roofs, and strip windows to provide unexpected light sources and glimpses of the outdoors as people move through the interior space. These elements, together with the open ground plan, create a sense of space-in-motion inside and out. Wright matched his new and fundamental interior spatial arrangement in his exterior treatment. He set masses and voids in equilibrium; the flow of interior space determined the exterior wall placement. The exterior's sharp angular planes meet at apparently odd angles, matching the complex play of interior solids, which function not as inert containing surfaces but as elements equivalent in role to the design's spaces.

INTEGRATING INTERIOR AND EXTERIOR The Robie House is a good example of Wright's "naturalism," his adjusting of a building to its site. However, in this particular case, the confines of the city lot constrained the building-to-site relationship more than did the sites of some of Wright's more expansive suburban and country homes. The Kaufmann House, nicknamed "Fallingwater" (FIG. **22-69**) and designed as a weekend retreat at Bear Run near Pittsburgh, is a prime example of the latter. Perched on a rocky hillside over a small waterfall, this structure extends the Robie House's blocky masses in all four directions. The contrast in textures between concrete, painted metal, and natural stones in its walls enliven its shapes, as does Wright's use of full-length strip windows to create a stunning interweaving of interior and exterior space.

The implied message of Wright's new architecture was space, not mass—a space designed to fit the patron's life and enclosed and divided as required. Wright took special pains to meet his clients' requirements, often designing all the accessories of a house (including, in at least one case, gowns for his

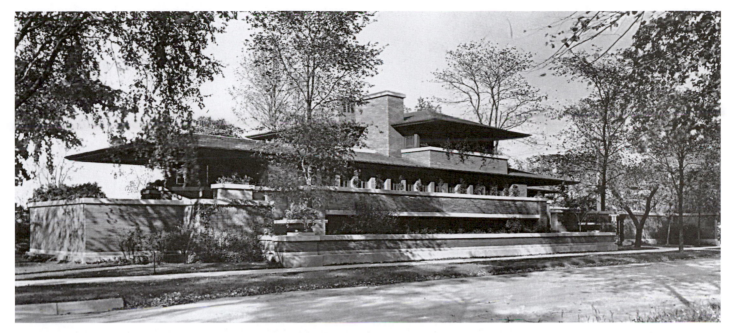

22-67 FRANK LLOYD WRIGHT, Robie House, Chicago, Illinois, 1907–1909.

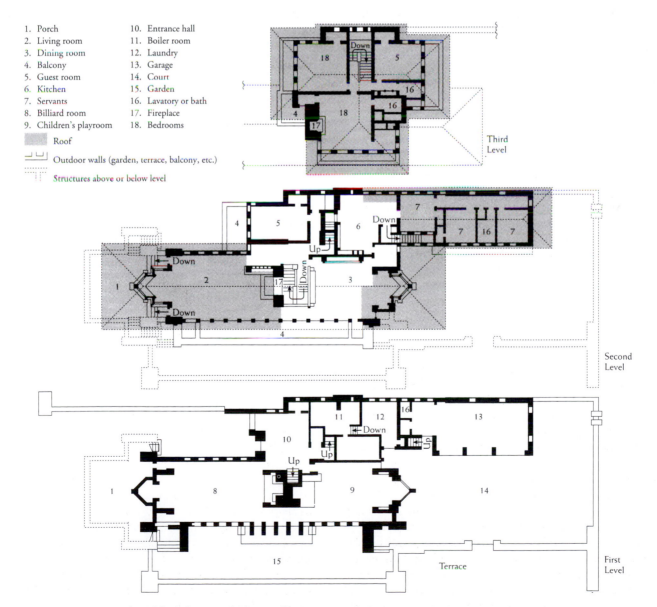

1. Porch
2. Living room
3. Dining room
4. Balcony
5. Guest room
6. Kitchen
7. Servants
8. Billiard room
9. Children's playroom
10. Entrance hall
11. Boiler room
12. Laundry
13. Garage
14. Court
15. Garden
16. Lavatory or bath
17. Fireplace
18. Bedrooms

Roof

Outdoor walls (garden, terrace, balcony, etc.)

Structures above or below level

22-68 FRANK LLOYD WRIGHT, plan of the Robie House, Chicago, Illinois, 1907–1909.

22-69 FRANK LLOYD WRIGHT, Kaufmann House (Fallingwater), Bear Run, Pennsylvania, 1936–1939.

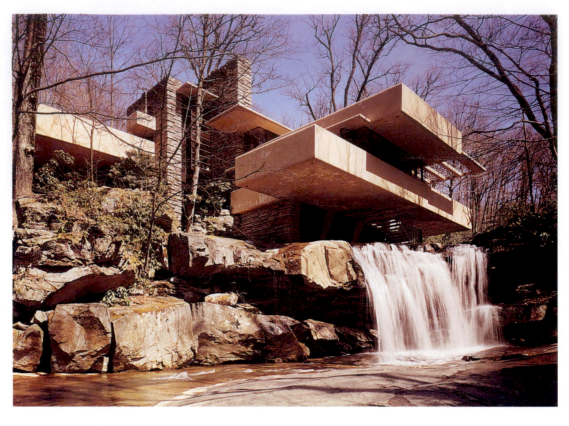

client's wife!). In the late 1930s, he acted on a cherished dream to provide good architectural design for less prosperous people by adapting the ideas of his prairie house to plans for smaller, less-expensive dwellings.

The publication of Wright's plans brought him a measure of fame in Europe, especially in Holland and Germany. The issuance in Berlin in 1910 of a portfolio of his work and an exhibition of his designs the following year stimulated younger architects to adopt some of his ideas about open plans that afforded clients freedom. Some forty years before his career ended, his work was already of revolutionary significance. The modern architect Mies van der Rohe wrote in 1940 that the "dynamic impulse from [Wright's] work invigorated a whole generation. His influence was strongly felt even when it was not actually visible."[69]

Organic Sculpture

SEEKING THE ESSENCE OF FLIGHT Romanian artist CONSTANTIN BRANCUSI (1876–1957) was one of many sculptors eager to produce works emphasizing the natural or organic. Often composed of softly curving surfaces and ovoid forms, his sculptures refer, directly or indirectly, to the cycle of life. Brancusi sought to move beyond surface appearances to capture the essence or spirit of the object depicted. He claimed: "What is real is not the external form but the essence of things. Starting from this truth it is impossible for anyone to express anything essentially real by imitating its exterior surface."[70] Brancusi's ability to design rhythmic, elegant sculptures conveying the essence of his subjects is evident in *Bird in Space* (FIG. **22-70**). Clearly not a literal depiction of a bird, the work is the final result of a long process. Brancusi started with the image of a bird at rest with its wings folded at its sides and ended with an abstract columnar form sharply ta-

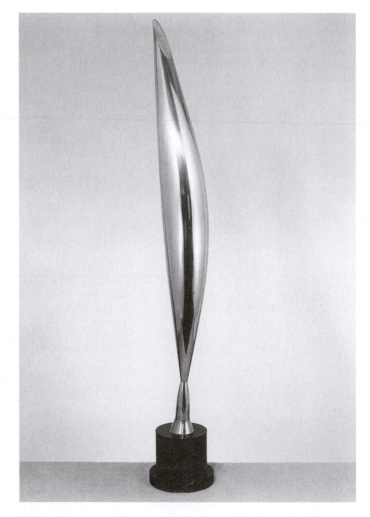

22-70 CONSTANTIN BRANCUSI, *Bird in Space,* 1928. Bronze (unique cast), 4′ 6″ × 8″ × 6″ high. Museum of Modern Art, New York (given anonymously).

pered at each end. Despite the abstraction, the sculpture retains the suggestion of a bird about to soar in free flight through the heavens. Even further, Brancusi succeeded in capturing the essence of flight. The highly reflective surface of the polished bronze does not allow the eye to linger on the sculpture itself (as do, for example, Rodin's agitated and textured surfaces; FIG. 21-48). Instead, viewers' eyes follow the gleaming reflection along the delicate curves right off the tip of the work, thereby inducing a feeling of flight. Brancusi stated: "All my life I have sought the essence of flight. Don't look for the mysteries. I give you pure joy. Look at the sculptures until you see them. Those nearest to God have seen them."[71]

Despite the seeming grandiosity of those claims, Brancusi was deeply immersed in exploring the emotional chords sculpture could strike in its viewers. Indeed, he envisioned many of his works, including this one, enlarged to monumental scale. The subtitle for this work was *Project of Bird Which, When Enlarged, Will Fill the Sky,* and the sculptor spoke of the work's ability on that scale to fill viewers with comfort and peace. Brancusi always paid special attention to the intrinsic qualities of the materials he used. He made sculptures in wood, marble, stone, and bronze. In each medium, he tried to create forms that respected and worked with the nature of the material, extracting from it its maximum expressive effect.

EVOKING ORGANIC VITALITY BARBARA HEPWORTH (1903–1975) developed her own kind of essential sculptural form, combining pristine shape with a sense of organic vitality. She sought a sculptural idiom that would express her sense both of nature and the landscape and of the person who is in and observes nature:

> The forms which have had special meaning for me since childhood have been the standing form (which is the translation of my feeling towards the human being standing in landscape); the two forms (which is the tender relationship of one living thing beside another); and the closed form, such as the oval, spherical, or pierced form (sometimes incorporating colour) which translates for me the association and meaning of gesture in the landscape. . . . In all these shapes the translation of what one feels about man and nature must be con-

veyed by the sculptor in terms of mass, inner tension, and rhythm, scale in relation to our human size, and the quality of surface which speaks through our hands and eyes.[72]

Three Forms (FIG. **22-71**) was the first in a series of works Hepworth began soon after she became the mother of triplets in 1934, an experience that perhaps stimulated her to explore the relationship of size, shape, and position in space among three elements arranged on a thin base. In this piece, a small ovoid form nestles close to a larger form, a kind of inflated relative of it. A petite sphere rests on the corner of the base farthest from the other two forms. The artist gathered here the basic organic forms that had special meaning for her. Although human hands have shaped these smooth marble forms, they have a simplicity and "naturalness" to them. Like the forms in all of Hepworth's mature works, those in *Three Forms* are basic and universal, expressing a sense of eternity's timelessness.

CELEBRATING THE NATURAL CONDITION
The English sculptor HENRY MOORE (1898–1986) shared Brancusi's profound love of nature and knowledge of organic forms and materials. Moore was interested in vitalism—a philosophy that celebrated the natural condition. He maintained that every "material has its own individual qualities" and that these qualities could play a role in the creative process. "It is only when the sculptor works direct, when there is an active relationship with his material, that the material can take its part in the shaping of an idea."[73] Accordingly, the forms and lines of Moore's lead and stone sculptures tend to emphasize the material's hardness and solidity, while his fluid wood sculptures draw attention to the flow of the wood grain. One major recurring theme in Moore's work is the reclining female figure with simplified and massive forms. A tiny photograph of a Chac Mool figure from pre-Columbian Mexico originally inspired this motif. Thought perhaps to represent gods or worshipers bearing offerings, Chac Mool figures usually were carved in stone, in semireclining positions, with their heads turned abruptly to one side.

Although viewers can recognize a human figure in most of Moore's works, the artist simplified and abstracted the figure, attempting to express a universal truth beyond the physical

22-71 BARBARA HEPWORTH, *Three Forms,* 1935. Marble. Tate Gallery, London.

22-72 HENRY MOORE, *Reclining Figure*, 1939. Elm wood, 3′ 1″ × 6′ 7″ × 2′ 6″. Detroit Institute of Arts, Detroit (Founders Society purchase with funds from the Dexter M. Ferry, Jr. Trustee Corporation).

world. He summarized his feelings about abstract figurative form in two passages from essays written in the 1930s:

> Because a work does not aim at reproducing natural appearances, it is not, therefore, an escape from life—but may be a penetration into reality. . . . My sculpture is becoming less representational, less an outward visual copy . . . but only because I believe that in this way I can present the human psychological content of my work with greatest directness and intensity.[74]

Reclining Figure (FIG. **22-72**) is a wonderful example of Moore's handling of the human form and his responsiveness to his chosen material—elm wood. The figure's massive shapes suggest Surrealist biomorphic forms (FIG. 22-50), but Moore's recumbent woman is also a powerful earth mother whose undulant forms and hollows suggest nurturing human energy. Similarly, they evoke the contours of the Yorkshire hills where Moore was raised and the wind-polished surfaces of weathered wood and stone. The sculptor heightened the allusions to landscape and to Surrealist organic forms in his work by interplaying mass and void, based on the intriguing qualities of cavities in nature. As he explained, "The hole connects one side to the other, making it immediately more three-dimensional. . . . The mystery of the hole—the mysterious fascination of caves in hillsides and cliffs."[75] The concern with the void—the holes—recalls the sculpture of artists such as Aleksandr Archipenko (FIG. 22-18). The contours and openings of *Reclining Figure* follow the grain of the wood. Above all, the work combines the organic vocabulary central to Moore's philosophy—bone shapes, eroded rocks, and geologic formations—to communicate the human form's fluidity, dynamism, and evocative nature.

LARGE-SCALE KINETIC SCULPTURES The belief of Moholy-Nagy (FIG. 22-58) that modern experience is spa-

tial-temporal and his interest in new materials could have served as a program for the American sculptor ALEXANDER CALDER (1898–1976). Using his thorough knowledge of engineering techniques, Calder combined nonobjective organic forms and motion, to create a new kind of sculpture that expressed reality's innate dynamism. Both the artist's father and grandfather were sculptors, but Calder initially studied mechanical engineering. Fascinated all his life by motion, he explored that phenomenon and its relationship to three-dimensional form in much of his sculpture.

As a young artist in Paris in the late 1920s, Calder invented a circus full of wire-based miniature performers he activated into realistic analogues of the motion of their counterparts in life. After a visit to Mondrian's studio in the early 1930s, Calder was filled with a desire to set the brightly colored rectangular shapes in the Dutch painter's compositions into motion. (Marcel Duchamp, intrigued by Calder's early motorized and hand-cranked examples of moving abstract pieces, named them mobiles.) Calder's engineering skills soon helped him to fashion a series of balanced structures hanging from rods, wires, and colored organically shaped plates, such as *125* (FIG. **22-73**), designed much later for New York's John F. Kennedy International Airport. The sculptor carefully planned each nonmechanized mobile so that any air current would set the parts moving to create a constantly shifting dance in space. When air currents activate the sculpture, its patterns suggest clouds, leaves, or waves blown by the wind.

Mondrian's work may have provided the initial inspiration for the mobiles, but their organic shapes resemble those in Joan Miró's Surrealist paintings (FIG. 22-50) and Calder's love of nature actually generated them. Indeed, Calder's forms can be read either as geometric or organic. Geometrically, the lines suggest circuitry and rigging, while the shapes are irregular

22-73 ALEXANDER CALDER, *125*, 1957. Approx. 42′ long. John F. Kennedy International Airport, New York.

sections of the cone. Organically, the lines suggest nerve axons, and the shapes are cells, leaves, fins, wings, and other bioforms.

ART AS POLITICAL STATEMENT IN THE 1930S

Throughout history, art regularly has served political ends and addressed political themes and issues. With the phenomenal upheaval the Western world experienced during the first half of the twentieth century—for example, World War I, the Russian Revolution, the Spanish Civil War, and World War II— numerous artists felt compelled to speak out and use their art to make a political statement.

DEPICTING SOCIAL INJUSTICE The American painter BEN SHAHN (1898–1969) used photographs as a point of departure for semi-abstract figures he felt would express the emotions and facts of social injustice that were his main subject throughout his career. Shahn came to the United States from Lithuania in 1906 and trained as a lithographer before broadening the media in which he worked to include easel painting, photography, and murals. He focused on the lives of ordinary people and the injustices often done to them by the structure of an impersonal society. In the early 1930s, he completed a cycle of twenty-three paintings and prints inspired by the trial and execution of the two Italian anarchists Nicola Sacco and Bartolomeo Vanzetti. Accused of killing two men in a holdup in 1920 in South Braintree, Massachusetts, the Italians were convicted in a trial that many people thought resulted in a grave miscarriage of justice. Shahn felt he had found in this story a subject the equal of any in Western art history: "Suddenly I realized . . . I was living through another crucifixion."[76] Basing many of

the works in this cycle on newspaper photographs of the events, Shahn devised a style that adapted his knowledge of Synthetic Cubism and his training in commercial art to an emotionally expressive use of flat, intense color in figural compositions filled with sharp, dry, angular forms. The major work in the series was called simply *The Passion of Sacco and Vanzetti* (see FIG. Intro-5). This tall, narrow painting condenses the narrative in terms of both time and space. The two executed men lie in coffins at the bottom of the composition. Presiding over them are the three members of the commission chaired by Harvard University president A. Laurence Lowell, who declared the original trial fair and cleared the way for the executions to take place. A framed portrait of Judge Webster Thayer, who handed down the initial sentence hangs on the wall of a simplified government building. The gray pallor of the dead men, the stylized mask-faces of the mock-pious mourning commissioners, and the sanctimonious, distant judge all contribute to the mood of anguished commentary that makes this image one of Shahn's most powerful works.

Guernica and the Spanish Civil War

A MONUMENTAL OUTCRY OF HUMAN GRIEF Although previous discussion of Pablo Picasso focused on his immersion in aesthetic issues, he also maintained a political commitment throughout his life. He declared: "Painting is not made to decorate apartments. It is an instrument for offensive and defensive war against the enemy."[77] This political commitment became more acute as Picasso watched his homeland descend into civil war in the late 1930s. In January 1937, the Spanish Republican government in exile in Paris asked Picasso to produce the work for the Spanish pavilion at the Paris International Exposition that summer. Like the Mexican muralists (FIGS. 22-80 and 22-81), artists interested in disseminating political and so-

22-74 PABLO PICASSO, *Guernica*, 1937. Oil on canvas, 11′ 5½″ × 25′ 5¾″. Museo Nacional Centro de Arte Reina Sofia, Madrid.

cial messages with their art realized the importance of placing their work in public arenas. Picasso also was well aware of the immense visibility and large international audience this opportunity afforded him. He therefore accepted this invitation but was not inspired to work on the project until he received word the Basque capital, Guernica, had been almost totally destroyed in an air raid on April 26 by Nazi bombers acting on behalf of the rebel general Francisco Franco. Not only did the Germans decimate the city itself, but also, because they attacked at the busiest hour of a market day, they killed or wounded many of the seven thousand citizens. The event jolted Picasso into action; by the end of June, he completed the mural-sized canvas of *Guernica* (FIG. **22-74**).

Picasso produced this monumental painting condemning the senseless bombing without specific reference to the event—depicting no bombs nor German planes. Rather, the collection of images in *Guernica* combine to create a visceral outcry of human grief. In the center, along the lower edge of the painting, lies a slain warrior clutching a broken and useless sword. A gored horse tramples him and rears back in fright as it dies. On the left, a shrieking anguished woman cradles her dead child. On the far right, a woman on fire runs screaming from a burning building, while another woman flees mindlessly. In the upper right-hand corner, a woman, represented only by a head, emerges from the burning building, thrusting forth a light to illuminate the horror. Overlooking the destruction is a bull, which, according to the artist, represents "brutality and darkness."[78]

Picasso used aspects of his Cubist discoveries to expressive effect in *Guernica,* particularly the fragmentation of objects and the dislocation of anatomical features. This Cubist fragmentation visualizes the horror. What happened to these figures in the artist's act of painting—the dissections and contortions of the human form—parallels what happened to

them in real life. To emphasize the scene's severity and starkness, Picasso reduced his palette to black, white, and shades of gray.

Revealing his political commitment and his awareness of the power of art, Picasso refused to allow exhibition of *Guernica* in Spain while Generalissimo Franco was in power. At the artist's request, *Guernica* hung in the Museum of Modern Art (see "The Museum of Modern Art and the Avant-Garde," page 847) in New York City after the World's Fair concluded. Not until after Franco's death (ending his right-wing dictatorship) in 1975 did Picasso allow the mural patriated to his homeland. It was moved in 1981 and hangs today in the Centro de Arte Reina Sofia in Madrid as a testament to a tragic chapter in Spanish history.

The Depression and Its Legacy

As a momentously catastrophic event in American history, the stock market crash of October 1929 and the subsequent Great Depression of the 1930s had a widespread national impact. Artists were particularly affected. The limited art market virtually disappeared, and museums curtailed both their purchases and exhibition schedules. Many artists sought financial support from the federal government, which established numerous programs to provide relief, aid recovery, and promote reform. Among the programs supporting artists were the Treasury Relief Art Project, founded in 1934 to commission art for federal buildings, and the Works Progress Administration (WPA), founded in 1935 to relieve all unemployment. Under the WPA, varied activities of the Federal Art Project paid artists, writers, and theater people a regular wage in exchange for work in their professions. Another important program was the Resettlement Administration (RA), later the Farm Securities Administration (FSA). The FSA

ART AND SOCIETY

The Museum of Modern Art and the Avant-Garde

The Museum of Modern Art in New York City is consistently identified as the institution most responsible for developing modernist art. Established in 1929, the Museum of Modern Art (or MoMA, as it is often called) owes its existence to a trio of remarkable women—Lillie P. Bliss, Mary Quinn Sullivan, and Abby Aldrich Rockefeller. These visionary and influential women, themselves art collectors, saw the need for a museum to collect and exhibit modernist art. Together they founded MoMA, which became (and continues to be) the most influential museum of modern art in the world. Their efforts and success are all the more extraordinary considering the skepticism and hostility greeting much of modernist art. Indeed, at the time, few American museums were inclined to show late-nineteenth- and twentieth-century art at all. Abby Aldrich Rockefeller's son Nelson (later governor of New York and involved with MoMA's administration) noted the boldness and courage required of these women: "It was the perfect combination. The three women among them had the resources, the tact, and the knowledge of contemporary art that the situation required. More to the point, they had the courage to advocate the cause of the modern movement in the face of widespread division, ignorance, and a dark suspicion that the whole business was some sort of Bolshevik plot."[1]

Over the years, MoMA has become a leader in museology and in promoting modernist art. Its ambitious exhibition schedule, trailblazing museum organization, and expansive collection place MoMA at the forefront of art institutions. In its quest to expose the public to the energy and challenge of modernist, particularly avant-garde, art, the museum developed unique and progressive exhibitions. Among the memorable exhibitions MoMA mounted were *Cubism and Abstract Art* and *Fantastic Art, Dada, Surrealism* in 1936. The museum also organized such groundbreaking exhibitions as *American Sources of Modern Art (Aztec, Maya, Inca)* in 1933 and *African Negro Art* in 1935, among the first exhibitions to deal with such artifacts in artistic rather than anthropological terms.

The organization of MoMA's administrative structure and scope of the museum's activities were also remarkable and were due, in large part, to the vision and energy of MoMA's first director, Alfred H. Barr Jr. Influenced by the Bauhaus and by art history courses he had taken emphasizing the interrelationship of all the arts, Barr insisted on establishing departments at MoMA not only for painting and sculpture but also for the other arts. He developed a library of books on modern art and a film library, which have become world-class collections, as well as an extensive publishing program. More recently, critic John Russell summarized the ambitious and landmark structure of MoMA:

> The Museum of Modern Art as it is today has certain clearly defined characteristics. It is truly international. It covers not only painting and sculpture, but photography, prints and drawings, architecture, design, the decorative arts, typography, stage design, and artists' books. It has its own publishing house, its own movie house, and its own department of film and video. It has a shop in which everyday objects of every kind may be on sale. . . . It is a palace of pleasure, but it is also an unstructured university. You don't get grades for going there, but in a mysterious, unquantifiable way, you become alert to the energies of modern art.[2]

Through exciting exhibitions and educational activities, MoMA succeeds in encouraging the public to make modernist art a regular part of their lives. While the museum pursues its founders' desire to appeal to a larger audience, it also works to establish itself within the scholarly community through publishing serious and high-quality books and catalogs.

It is the museum's art collection, however, that has drawn the most attention. By cultivating an enlightened and influential group of patrons, MoMA has developed an extensive and enviable collection of late-nineteenth- and twentieth-century art. Its collection includes such important works as Picasso's *Les Demoiselles d'Avignon* (FIG. 22-11), van Gogh's *Starry Night* (see FIG. 21-34), and Brancusi's *Bird in Space* (FIG. 22-70). Simply reading through the illustration captions in this textbook reveals how many significant artworks reside in the Museum of Modern Art.

The dominance of this institution also has made it the target of critics. Some observers believe MoMA's position as the preeminent collector of modernist art has made it an overly influential judge. They suggest that rather than simply documenting artistic developments, MoMA actively influences the direction of art through its exhibitions and acquisitions. Although the museum's influence cannot be denied, its enduring legacy will be the public access to a broad range of art it provides.

[1] Sam Hunter, *The Museum of Modern Art, New York: The History and Collection* (New York: Harry N. Abrams, 1984), 10.

[2] Ibid., 11–12.

oversaw emergency aid programs for farm families caught in the depression and provided information to the public about both the government programs and the plight of the people such programs served.

PERSONIFYING DEPRESSION SUFFERING The RA hired American photographer DOROTHEA LANGE (1895–1965) in 1936, sending her to photograph the dire situation of the rural poor the Great Depression displaced.

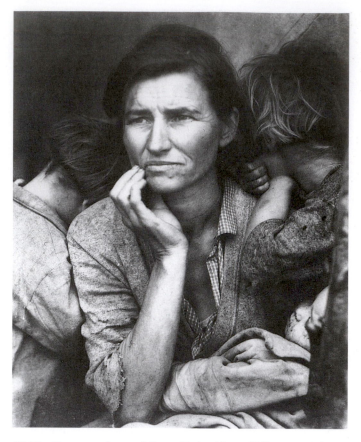

22-75 DOROTHEA LANGE, *Migrant Mother, Nipomo Valley*, 1935. Gelatin silver print. Copyright © the Dorothea Lange Collection, The Oakland Museum of California, City of Oakland (gift of Paul S. Taylor).

constructing a reassuring depiction of noble and undeserved suffering rather than focusing the spotlight on major economic problems. The response to this photo indicates the ability of *Migrant Mother, Nipomo Valley* to strike a sympathetic chord in viewers. Within days after this image was printed in a San Francisco newspaper, people rushed food to Nipomo to feed the hungry workers.

VISIONS OF LONELINESS AND ISOLATION

EDWARD HOPPER (1882–1967) produced paintings during the depression era evoking the national mindset. However, rather than depict historically specific scenes, Hopper took as his subject the more generalized theme of the overwhelming loneliness and echoing isolation of modern life in the United States. Trained as a commercial artist, Hopper studied painting and printmaking in New York and Paris before returning to the United States. He then concentrated on scenes of contemporary American city and country life, painting buildings, streets, and landscapes that are curiously muted, still, and filled with empty spaces. Motion is stopped and time suspended, as if the artist recorded the major details of a poignant personal memory. From the darkened streets outside a restaurant in *Nighthawks* (FIG. **22-76**), viewers glimpse the lighted interior through huge plate-glass windows, which lend the inner space the paradoxical sense of being both a safe refuge and a vulnerable place for the three customers and the counterman. The seeming indifference of Hopper's characters to one another and the echoing spaces that surround them evoke the pervasive loneliness of modern humans. Hopper invested works such as *Nighthawks* with the straightforward mode of representation, creating a kind of realist vision recalling that of nineteenth-century artists such as Thomas Eakins (see FIG. 21-11) and Henry Ossawa Tanner (see FIG. 21-14).

THE STRUGGLES OF AFRICAN AMERICANS

African-American artist JACOB LAWRENCE (1917–2000) found his subjects in modern history, concentrating on the culture and history of African Americans. Lawrence moved to Harlem, New York, in 1927 at about age ten. There, he came under the spell of the African art and the African-American history he found in lectures and exhibitions and in the special programs sponsored by the 135th Street New York Public Library, which had outstanding collections of African-American art and archival data. Inspired by the politically oriented art of Goya (see FIG. 20-39), Daumier (see FIG. 21-6), and Orozco (FIG. 22-80), Lawrence found his subjects in the everyday life of Harlem and his people's history. He defined his own vision of the continuing African-American struggle against discrimination.

In 1941, Lawrence began a sixty-painting series titled *The Migration of the Negro*. Unlike his earlier historical paintings depicting important figures in American history, such as Frederick Douglass, Toussaint L'Ouverture, and Harriet Tubman, this series called attention to a contemporaneous event—the ongoing exodus of black labor from the southern United States. Disillusioned with their lives in the South, hundreds of thousands of African Americans migrated north in the years following World War I, seeking improved economic opportunities and more hospitable political and social conditions. This subject had personal relevance to Lawrence. He explained: "I was part of the

At the end of an assignment to document the lives of migratory pea pickers in California, Lange stopped at a camp in Nipomo and found the migrant workers there starving because the crops had frozen in the fields. Among the pictures she made on this occasion was *Migrant Mother, Nipomo Valley* (FIG. **22-75**), which, like *American Gothic* (FIG. 22-78), has achieved iconic status. Generations of viewers have been moved by the mixture of strength and worry in the raised hand and careworn face of a young mother, who holds a baby on her lap. Two older children, who cling to her trustfully while turning their faces away from the camera, flank her. Lange described how she got the picture:

> [I] saw and approached the hungry and desperate mother, as if drawn by a magnet. I do not remember how I explained my presence or my camera to her, but I remember she asked me no questions. I made five exposures, working closer and closer from the same direction. . . . There she sat in that lean-to tent with her children huddled around her, and she seemed to know that my pictures might help her, and so she helped me.[79]

Although viewers often perceive such "documentary" photography as a reflection of reality, they must acknowledge that people always read visual images through the lens of cultural conditioning. With this in mind, it seems logical the one government-commissioned photograph that has emerged as representative of the depression experiences of millions depicts a mother with her children. Such an image draws strongly on cultural values associated with familial and social stability,

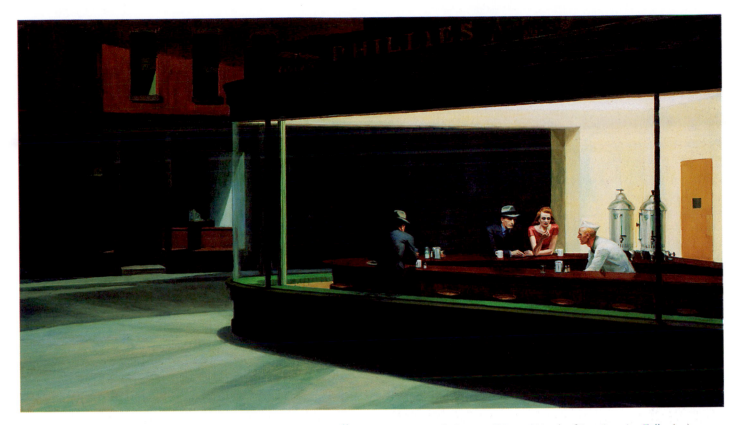

22-76 EDWARD HOPPER, *Nighthawks*, 1942. Oil on canvas, 2' 6" × 4' 8$\frac{11}{16}$". The Art Institute of Chicago, Chicago (Friends of American Art Collection).

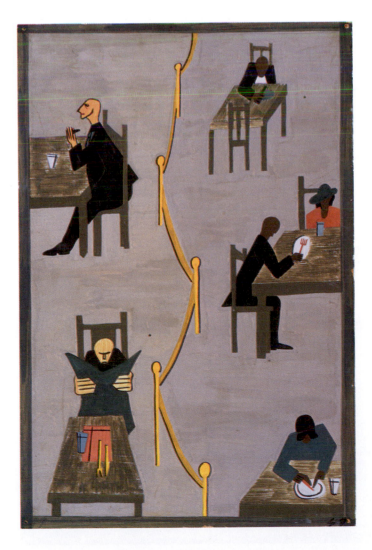

migration, as was my family, my mother, my sister, and my brother. . . . I grew up hearing tales about people 'coming up,' another family arriving. . . . I didn't realize what was happening until about the middle of the 1930s, and that's when the *Migration* series began to take form in my mind."[80]

The "documentation" of the period, such as the FSA program, ignored African Americans, and thus this major demographic shift remained largely invisible to most Americans. Of course, the conditions African Americans encountered both during their migration and in the north were often as difficult and discriminatory as those they had left behind in the South.

Lawrence's series provides numerous vignettes capturing the experiences of these migrating people. Often, a sense of bleakness and of the degradation of African-American life dominates the images. *No. 49* of this series (FIG. **22-77**) bears the caption "They also found discrimination in the North although it was much different from that which they had known in the South." The artist depicted a blatantly segregated dining room with a barrier running down the room's center separating the whites on the left from the African Americans on the right. To ensure a continuity and visual integrity among all sixty paintings, Lawrence interpreted his themes systematically in rhythmic arrangements of bold, flat, and strongly colored shapes. His style drew equally from his interest in the push-pull effects of Cubist space and his memories of the patterns made by the colored

22-77 JACOB LAWRENCE, *No. 49* from *The Migration of the Negro*, 1940–1941. Tempera on masonite, 1' 6" × 1'. The Phillips Collection, Washington.

scatter rugs brightening the floors of his childhood homes. Further, he unified the narrative with a consistent palette of bluish green, orange, yellow, and grayish brown throughout the entire series. Like every subject Lawrence painted during his long career, he believed this story had important lessons to teach viewers.

Regionalism

Although the city or rapidly developing technological advances enamored many American artists, such as the Precisionists (FIGS. 22-35, 22-36, and 22-37), others chose not to depict these aspects of modern life. The Regionalists, sometimes referred to as the American Scene Painters, turned their attention to rural life as America's cultural backbone. One of the Regionalists, GRANT WOOD (1891–1942), for example, published an essay titled "Revolt Against the City" in 1935. Although this movement was not formally organized, Wood acknowledged its existence in 1931, when he spoke at a conference. In his address, he announced a new movement developing in the Midwest known as Regionalism, which he described as focused on American subjects and as standing in reaction to "the abstraction of the modernists" in Europe and New York.[81]

THE APPEAL OF RURAL IOWA Grant Wood's paintings focus on rural scenes from Iowa, where he was born and raised. The work that catapulted Wood to national prominence was *American Gothic* (FIG. 22-78), which became an American icon. The artist depicted a farmer and his spinster daughter standing in front of a neat house with a small lancet window, typically found on Gothic cathedrals. The man and woman wear traditional attire—he appears in worn overalls and she in an apron trimmed with rickrack. The dour expression on both of their faces gives the painting a severe quality, which Wood enhanced with his meticulous brushwork. When *American Gothic* was exhibited, many people enthused about the work, which they perceived as "quaint, humorous, and AMERICAN," in the words of one critic.[82] Many saw the couple as embodying "strength, dignity, fortitude, resoluteness, integrity," and were convinced Wood captured the true spirit of America.[83]

Wood's Regionalist vision involved more than his subjects, extending to a rejection of avant-garde styles in favor of a clearly readable, realist style. Surely this approach appealed to many people alienated by the increasing presence of abstraction in art. Interestingly enough, despite the accolades this painting received, it also was criticized. Not everyone saw the painting as a sympathetic portrayal of midwestern life; indeed, some in Iowa felt insulted by the depiction. In addition, despite the seemingly reportorial nature of *American Gothic,* some viewed it as a political statement—one of staunch nationalism. In light of the problematic nationalism in Germany at the time, this perceived nationalistic attitude was all the more disturbing. In other words, the discourse Regionalism was embedded in was not simply stylistic but political as well.

22-78 GRANT WOOD, *American Gothic,* 1930. Oil on beaverboard, 2′ 5$\frac{7}{8}$″ × 2′ $\frac{7}{8}$″. Art Institute of Chicago, Chicago (Friends of American Art Collection).

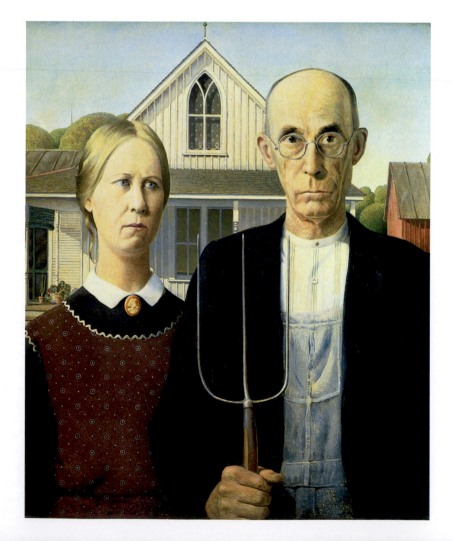

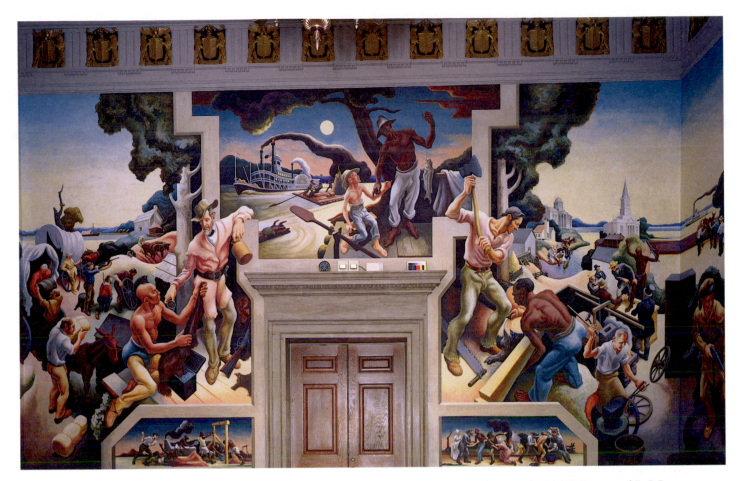

22-79 THOMAS HART BENTON, *Pioneer Days and Early Settlers*, State Capitol, Jefferson City, 1936. Mural. Copyright © T. H. Benton and R. P. Benton Testamentary Trusts/Licensed by VAGA, New York, NY.

CONSTRUCTING A HISTORY OF MISSOURI

THOMAS HART BENTON (1889–1975) was another of the major Regionalist artists. Whereas Wood focused his attention on Iowa, Benton turned to scenes from his native Missouri. Benton produced one of his major works, a series of murals titled *A Social History of the State of Missouri,* in 1936 for the Missouri State Capitol. The murals depict a collection of images from the state's true and legendary history, such as primitive agriculture, horse trading, a vigilante lynching, and an old-fashioned political meeting. Other scenes portray the mining industry, grain elevators, Native Americans, and family life. One segment, *Pioneer Days and Early Settlers* (FIG. **22-79**), shows a white man using whisky as a bartering tool with a Native American (at left), along with scenes documenting the building of Missouri. Part documentary and part imaginative, Benton's images include both positive and negative aspects of Missouri's history, as these examples illustrate. Although Regionalists were popularly perceived as dedicated to glorifying Midwestern life, that belief distorted their aims. Indeed, Grant Wood observed, "your true regionalist is not a mere eulogist; he may even be a severe critic."[84] Benton, like Wood, was committed to a visually accessible style, but he developed a highly personal aesthetic that included complex compositions, a fluidity of imagery, and simplified figures depicted in a rubbery distortion.

Not surprisingly, during the Great Depression of the 1930s, the Regionalist paintings had a popular appeal because they often projected a reassuring image of America's heartland. The public saw Regionalism as a means of coping with the national crisis through a search for cultural roots. Thus, people deemed acceptable any nostalgia implicit in Regionalist paintings or mythologies these works perpetuated because they served a larger purpose.

Mexican Muralists

VALIDATING MEXICAN HISTORY JOSÉ CLEMENTE OROZCO (1883–1949) was one of a group of Mexican artists determined to base their art on the indigenous history and culture existing in Mexico before Europeans arrived. The movement these artists formed was part of the idealistic rethinking of society that occurred in conjunction with the Mexican Revolution (1910–1920) and the lingering political turmoil of the 1920s. Among the projects these politically motivated artists undertook were vast mural cycles placed in public buildings to dramatize and validate the history of Mexico's native peoples. Orozco worked on one of the first major cycles, painted in 1922 on the walls of the National Training School in Mexico City. He carried the ideas of this mural revolution to the United States, completing many commissions for wall paintings between 1927 and 1934. From 1932 to 1934, he worked on one of his finest mural cycles in the Baker Library at Dartmouth College in New Hampshire, partly in honor of its superb collection of books in Spanish. The college let him choose the subject. Orozco

depicted, in fourteen large panels and ten smaller ones, a panoramic and symbolic history of ancient and modern Mexico, from the early mythic days of the feathered-serpent god Quetzalcóatl to a contemporary and bitterly satiric vision of modern education.

The imagery in the illustrated detail, *Epic of American Civilization: Hispano-America* (*panel 16*; FIG. **22-80**), revolves around the monumental figure of a heroic Mexican peasant armed to participate in the Mexican Revolution. Looming on either side of him are mounds crammed with symbolic figures of his oppressors—bankers, government soldiers, officials, gangsters, and the rich. Money-grubbers pour hoards of gold at the incorruptible peon's feet, cannons threaten him, and a bemedaled general raises a dagger to stab him in the back. Orozco's training as an architect gave him a sense of the framed wall surface, which he easily commanded, projecting his clearly defined figures onto the solid mural plane in monumental scale.

In addition, Orozco's early training as a maker of political prints and as a newspaper artist had taught him the rhetorical strength of graphic brevity, which he used here to assure that his allegory was easily read. His special merging of the graphic and mural media effects give his work an originality and force rarely seen in mural painting after the Renaissance and Baroque periods.

THE POWER OF PUBLIC ART DIEGO RIVERA (1886–1957), like his countryman Orozco, achieved great renown for his murals, both in Mexico and in the United States. A staunch Marxist, Rivera was committed to developing an art that served his people's needs. Toward that end, he sought to create a national Mexican style focusing on Mexico's history and also incorporating a popular, generally accessible aesthetic (in keeping with the Socialist spirit of the Mexican Revolution). Rivera produced numerous large murals in public buildings, among them a series (FIG. **22-81**) lining the staircase of the National Palace in Mexico City. In these images, painted between 1929 and 1935, he depicted scenes from Mexico's history. These scenes represent the conflicts between the indigenous people and the Spanish colonizers. Rivera included portraits of important figures in Mexican history and, in particular, in the struggle for Mexican independence. Although complex, the decorative animated murals retain the legibility of folklore—the figures consist of simple monumental shapes and areas of bold color.

ÉMIGRÉS AND EXILES: ENERGIZING AMERICAN ART AT MIDCENTURY

The Armory Show in 1913 in New York City, discussed earlier, was an important vehicle for disseminating information about developments in European art. Equally significant was the emigration of European artists around the European continent and across the Atlantic Ocean to America. The havoc Hitler and the National Socialists wreaked in the early 1930s forced artists to flee. The United States, among other countries, offered both survival and amore hospitable environment for producing their art.

Many artists gravitated to Paris and London, but when the threat of war expanded, the United States became an attractive alternative. Several artists and architects associated with the Bauhaus—Gropius, Moholy-Nagy, Albers, Breuer, Mon-

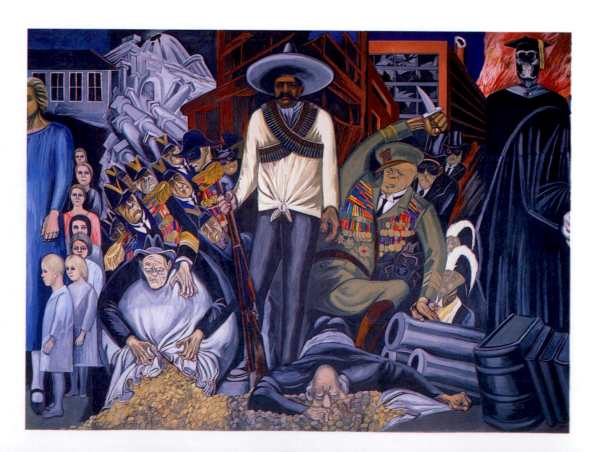

22-80 JOSÉ CLEMENTE OROZCO, *Epic of American Civilization: Hispano-America (panel 16)*, Baker Memorial Library, Dartmouth College, Hanover, ca. 1932–1934. Fresco. Copyright © Orozco Valladares Family/SOMAAP, Mexico/Licensed by VAGA, New York, NY.

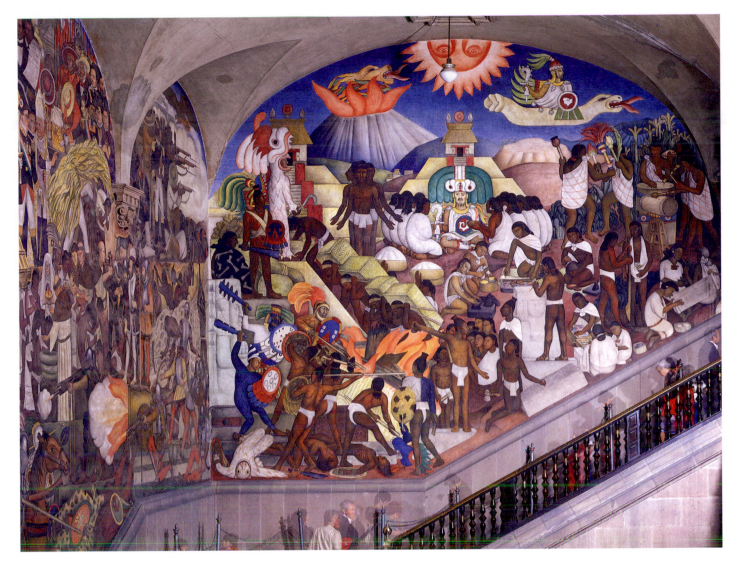

22-81 Diego Rivera, *Ancient Mexico,* from the History of Mexico fresco murals, National Palace, Mexico City, 1929–1935. Fresco.

drian, and Mies van der Rohe—came to the United States. Many accepted teaching positions, providing them a means of disseminating their ideas. Artists associated with other avant-garde movements—Neue Sachlichkeit (Beckmann and Grosz), Surrealism (Ernst, Dalí, Breton, and Chagall), and Cubism (Léger and Lipchitz)—all made their way to American cities.

Museums in the United States, wanting to demonstrate their familiarity and connection with the most progressive European art, mounted exhibitions centered on the latest European artistic developments. In 1938 alone, the City Art Museum of Saint Louis in Missouri presented an exhibition of Beckmann's work, the Art Institute of Chicago organized *George Grosz: A Survey of His Art from 1918–1938,* and the Museum of Modern Art in New York offered *Bauhaus, 1919–1928.* This interest in exhibiting the work of artists persecuted and driven from their homelands also had political overtones. In the highly charged atmosphere of the late 1930s leading to the onset of World War II, people often perceived support for these artists and their work as support for freedom and democracy. In 1942, Alfred H. Barr Jr., director of the Museum of Modern Art, stated:

Among the freedoms which the Nazis have destroyed, none has been more cynically perverted, more brutally stamped upon, than the Free-

dom of Art. For not only must the artist of Nazi Germany bow to political tyranny, he must also conform to the personal taste of that great art connoisseur, Adolf Hitler. . . . But German artists of spirit and integrity have refused to conform. They have gone into exile or slipped into anxious obscurity. . . . Their paintings and sculptures, too, have been hidden or exiled. . . . But in free countries they can still be seen, can still bear witness to the survival of a free German culture.[85]

Despite this moral support for exiled artists, once the United States formally entered the war, Germany officially became the enemy. Then it was much more difficult for the art world to promote German artists, however persecuted. Many émigré artists (for example, Ernst, Dalí, Léger, and Grosz) returned to Europe after the war ended. Their collective presence in the United States until then, however, was critical for the development of American art and contributed significantly to the extensive interest in the later twentieth century of many American artists in the avant-garde.

The dialogue between American and European artists thus did much to stimulate early-twentieth-century artistic ferment and experimentation. The Armory Show and the emigration of European artists to the United States were both important catalysts for the momentum and energy in the art world that carried on into the later twentieth century.

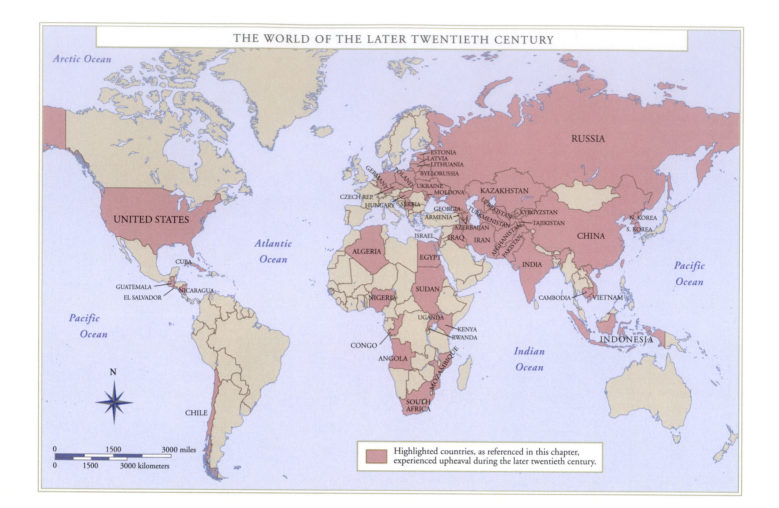

THE WORLD OF THE LATER TWENTIETH CENTURY

Arctic Ocean

RUSSIA

UNITED STATES

Atlantic
Ocean

Pacific
Ocean

Pacific
Ocean

CUBA

GUATEMALA
EL SALVADOR
NICARAGUA

ESTONIA
LATVIA
LITHUANIA
BYELORUSSIA
GERMANY
POLAND
UKRAINE
MOLDOVA
KAZAKHSTAN
CZECH REP.
HUNGARY
SERBIA
GEORGIA
ARMENIA
AZERBAIJAN
TURKMENISTAN
UZBEKISTAN
KYRGYZSTAN
TAJIKISTAN
ISRAEL
IRAQ
IRAN
AFGHANISTAN
PAKISTAN
ALGERIA
EGYPT
CHINA
N. KOREA
S. KOREA

INDIA

NIGERIA
SUDAN
CAMBODIA
VIETNAM

UGANDA
KENYA
RWANDA

CONGO

Indian
Ocean

INDONESIA

ANGOLA

MOZAMBIQUE

CHILE

SOUTH
AFRICA

N

0 1500 3000 miles
0 1500 3000 kilometers

Highlighted countries, as referenced in this chapter,
experienced upheaval during the later twentieth century.

1945 1950 1960

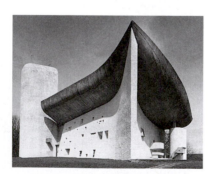

Le Corbusier
Notre Dame du Haut, 1950–1955

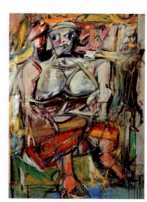

Willem de Kooning
Woman I, 1950–1952

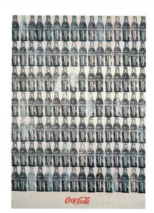

Andy Warhol
Green Coca-Cola Bottles, 1962

Existentialism, 1930–1950s

United Nations organized, 1945

Atomic bomb devastates Hiroshima
and Nagasaki, 1945

Transistor invented, 1948

State of Israel created, 1948

Republic of India begun, ca. 1949

People's Republic of China established, 1949

Korean conflict, 1950–1953

Crick and Watson, Structure
and function of DNA, 1954

Sputnik I launched, 1957

Computer chip invented, 1959

Lasers invented, 1960

First manned space flight, 1961

John F. Kennedy assassinated,
1963

Corporation for Public
Broadcasting formed, 1967

Martin Luther King
and Robert Kennedy
assassinated, 1968

Moon landing,
1969

THE EMERGENCE
OF POSTMODERNISM

THE LATER TWENTIETH CENTURY

1970 1980 1990

Robert Smithson
Spiral Jetty, 1970

David Em
Nora, 1979

Cindy Sherman
Untitled Film Still #35, 1979

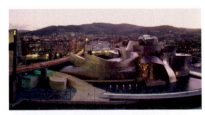

Frank Gehry
Guggenheim Museum, Bilbao, 1997

Postmodernism in art, literature, 1970s–

Watergate, 1972–1974

War in Vietnam ends, 1975

Personal computers introduced, 1975

Islamic Revolution in Iran, 1978–1979

Gorbachev comes to power
in Soviet Union, 1985

Opening of Berlin Wall, 1989,
collapse of Soviet Union

Tiananmen Square
massacre, 1989

US intervention,
Somalia, Haiti, 1990s

Gulf War, 1990s

Breakup of
Yugoslavia, 1990s

The "Cybernetic
Revolution," 1990s

WORLD WAR II AND ITS AFTERMATH

World War II was the most devastating catastrophe of the twentieth century, not only because of the destruction and extensive loss of life but also because of the long-term consequences on numerous levels—personal, cultural, political, and economic. The history of the later twentieth century, beginning with the end of World War II in 1945, is one of upheaval, change, and conflict. For much of that time, peoples of the world lived with the threat of nuclear war. The two superpowers, the United States and the Soviet Union, divided the world into spheres of influence, and each regularly intervened politically, economically, and militarily wherever and whenever it considered its interests at stake.

Disruption and Upheaval

Throughout the world, disruption and dislocation took place. In 1947, the British left India, which erupted in a murderous Hindu-Muslim war that divided the subcontinent into the new, still hostile, nations of India and Pakistan. After a catastrophic war, Communists came to power in China in 1949. North Korea tested the fledgling United Nations (UN), founded after the war, by invading South Korea in 1950 and fighting a grim war with the United States and its UN allies. The Soviets brutally suppressed uprisings in their subject nations—East Germany, Poland, Hungary, and Czechoslovakia. The United States intervened in disputes in Central and South America. Hardly had the previously colonized nations of Africa—Kenya, Uganda, Nigeria, Angola, Mozambique, the Sudan, Rwanda, and the Congo—won their independence than civil wars devastated them. In Indonesia civil war left more than a hundred thousand dead. Algeria expelled France in 1962 after a prolonged and vicious war with Algeria's Muslim natives. Following fifteen years of bitter war in Southeast Asia, the United States was defeated in Vietnam. In 1979, the Soviets invaded Afghanistan but were driven out. Arab nations, economically flourishing from oil wealth, fought wars with Israel in 1967, 1978, and the early 1980s. A revitalized Islam rose in the Arab world, inspired a fundamentalist religious revolution in Iran, and encouraged "holy war" with the West, using a new weapon—international terrorism. In 1991, West clashed with East in the Persian Gulf. South Africa formally abandoned apartheid in 1992.

Unrest continues to plague many countries worldwide. The ongoing conflict among the Serbs, Croats, and Muslims in the Balkans, the instability of the various Russian republics, and the divisive ethnic clashes in many African nations emphasize that international hostilities and political uncertainty still characterize the world situation.

This litany of worldwide upheaval reveals a fundamental characteristic of the second half of the twentieth century—change. In part because the United States emerged relatively unscathed from World War II (compared to European countries, Japan, and the Soviet Union), it could pursue its economic, political, and cultural agendas more aggressively and establish a global presence. But although North American culture seemed to take center stage during the latter part of the twentieth century, the United States was not immune from internal change and upheaval either. In the postwar years, people increasingly questioned the status quo. The struggle for civil rights for African Americans, for free speech on university campuses, and against the Vietnam War led to a rebellion of young Americans. They took to the streets in often raucous demonstrations, with violent repercussions, during the 1960s and 1970s. The prolonged ferment produced a new system of values, a "youth culture," expressed in radical rejection not only of national policies but often also of the society generating them. The young derided their elders' lifestyles and adopted unconventional dress (for that time—long hair, beards, and workers' jeans), manners, habits, and morals deliberately subversive of conventional social standards. The youth era witnessed the sexual revolution, the widespread use and abuse of drugs, and the development of rock music, then an exclusively youthful art form. Young people "dropped out" of regulated society, embraced alternative belief systems, and rejected "Western" university curricula as irrelevant.

This counterculture had considerable societal impact and widespread influence beyond its political phase. The Civil Rights movement and later the women's liberation movement reflected the spirit of rebellion, coupled with the rejection of racism and sexism. In keeping with the growing resistance to established authority, women systematically began to challenge the male-dominated culture, which they perceived as having limited their political power and economic opportunities for centuries. Feminists charged that Western society's institutions, particularly the nuclear family headed by the patriarch, perpetuated male power and subordination of women. Feminists observed that monuments of Western culture—its arts and sciences, as well as its political, social, and economic institutions—masked the realities of male power. The term "feminism," while convenient for generic usage, reflects neither the complexity of the issues involved nor the heated debate that emerged among feminists. Indeed, the term encompasses such a wide range of attitudes and ideas that its usefulness is limited.

The Dynamics of Power

Following patterns developed first in the Civil Rights movement and later in feminism, various ethnic groups and gays and lesbians all have mounted challenges to discriminatory policies and attitudes. Such groups have fought for recognition, respect, and legal protection and have battled discrimination with political action. These explorations into the politics of identity aim to increase personal and public understanding of how self-identifications, along with imposed or inherited identities, affect lives. The growing scrutiny in numerous academic fields—cultural studies, literary theory, and colonial and postcolonial studies—of the dynamics and exercise of power also have contributed to the dialogue on these issues. French philosopher-theorists, in particular Jacques Derrida and Michel Foucault, have become prominent from their publications examining the nature of the world's power structures.

THE ART WORLD'S FOCUS SHIFTS WEST

The period's emphasis on change carried over to the art world as well. The relative economic stability of the United States was a major factor in the shifting of the center of Western art from Paris to New York. This helps explain the predominance of American artists in the world markets, even while artists continued to create throughout the world. Only in the closing decades of the twentieth century, with the rising interest in multiculturalism and global economies, have countries outside the United States begun to exhibit art more broadly.

Modernism, Formalism, and Clement Greenberg

Modernism, so integral to art of the nineteenth century, shifted course in conjunction with the changing historical conditions and demands. In the postwar years, modernism increasingly became identified with a strict formalism—an emphasis on an artwork's visual elements rather than its subject—due largely to the prominence of the American Clement Greenberg (1909–1994). As an art critic who wielded considerable influence from the 1940s through the 1970s, Greenberg was instrumental in developing and articulating modernism's redefined parameters.

For Greenberg, late-twentieth-century modernist artists were those who refined the critical stance of the late-nineteenth- and early-twentieth-century modernists. This critical stance involved rejecting illusionism and exploring each artistic medium's properties. So dominant was Greenberg that scholars often refer to the general modernist tenets during this period as Greenbergian formalism. Although his complex ideas about art were modified over the years, certain basic concepts are associated with Greenbergian formalism. In particular, Greenberg promoted the idea of purity in art. He explained, "Purity in art consists in the acceptance, willing acceptance, of the limitations of the medium of the specific art."[1] In other words, he believed artists should strive for a more explicit focus on the properties exclusive to each medium—for example, two-dimensionality, or flatness in painting, and three-dimensionality in sculpture. To achieve this, artists had to eliminate illusion and embrace abstraction. Greenberg elaborated:

> It follows that a modernist work of art must try, in principle, to avoid communication with any order of experience not inherent in the most literally and essentially construed nature of its medium. Among other things, this means renouncing illusion and explicit subject matter. The arts are to achieve concreteness, "purity," by dealing solely with their respective selves—that is, by becoming "abstract" or nonfigurative.[2]

Greenberg avidly promoted the avant-garde, which he viewed as synonymous with modernism in the postwar years. Generally speaking, the spirit of rebellion and disdain for convention central to the historical avant-garde flourished in the sociopolitical upheaval and counterculture of the 1960s and 1970s. However, the acute sociopolitical dimension inherent in the avant-garde's early development had evaporated by this time (although many of the artists considered avant-garde aligned themselves with the Left). Thus the avant-garde (and modernism) became primarily an artistic endeavor. Still, the distance between progressive artists and the public widened. In his landmark 1939 article "Avant-Garde and Kitsch," Greenberg insisted on the separation of the avant-garde from kitsch (which Greenberg defined as "ersatz," or artificial, culture, such as popular commercial art and literature), thereby advocating the continued alienation of the public from avant-garde art.

The Emergence of Postmodernism

The modernists' intense criticism of the discipline and the unrelenting challenges to artistic convention eventually led to modernism's demise. To many, it seemed artistic traditions had been so completely undermined that modernism simply played itself out. From this situation emerged *postmodernism,* one of the most dramatic developments during the century. Postmodernism cannot be described as a style; it is a widespread cultural phenomenon. Many people view it as a rejection of modernist principles. Accordingly, postmodernism is far more encompassing and accepting than the more rigid confines of modernist practice. Postmodernism's ability to accommodate seemingly everything in art makes it extremely difficult to provide a clear and concrete definition of the term. In response to the elitist, uncompromising stance of modernism, postmodernism grew out of a naive and optimistic populism.

Whereas the audience for modernist art had dwindled due to the obscure meaning of abstract work, postmodern artists offer something for everyone. For example, in architecture, postmodernism's eclectic nature often surfaces in a whimsical mixture of styles and architectural elements (such as Greek columns juxtaposed with ornate Baroque decor). In other artistic media, postmodernism accommodates a wide range of styles, subjects, and formats, from traditional easel painting to video and *installation* (artwork creating an artistic environment in a room or gallery) and from the spare abstraction associated with modernism to carefully rendered illusionistic scenes. In addition, various investigations have been identified as particularly postmodern, including critiquing modernist tenets, reassessing the nature of representation, and exploring the ways in which meaning is generated. Although these inquiries are largely philosophical and theoretical, much of the art produced during the postmodern period is resolutely grounded in specific historical conditions. Thus, later in this chapter, art addressing issues of race, class, gender, sexual orientation, and ethnicity is discussed.

POSTWAR EXPRESSIONISM IN EUROPE

The end of World War II in 1945 left devastated cities, ruptured economies, and governments in chaos throughout Europe. These factors, coupled with the massive loss of life and the indelible horror of the Holocaust and Hiroshima/Nagasaki, resulted in a pervasive sense of despair,

disillusionment, and skepticism. Although many (for example, the Futurists in Italy) had tried to find redemptive value in World War I, it was virtually impossible to do the same with World War II, coming as it did so closely on the heels of the war that was supposed to "end all wars." Additionally, World War I was largely a European conflict that left more than eight million people dead, while World War II was a truly global catastrophe, leaving forty-five million dead in its wake.

Existentialism: The Absurdity of Human Existence

The cynicism emerging across Europe was reflected in the popularity of existentialism (Chapter 22, page 784), a philosophy asserting the absurdity of human existence and the impossibility of achieving certitude. Many existentialists also promoted atheism and questioned the possibility of situating God within a systematic philosophy. Existentialism's roots often are traced to the Danish theologian Søren Kierkegaard (1813–1855), and the writings of philosophers and novelists such as Friedrich Nietzsche (Chapter 22, page 784), Martin Heidegger, Fyodor Dostoyevsky, and Franz Kafka disseminated its ideas. In the postwar period, the writings of the French author Jean-Paul Sartre (1905–1980) most clearly captured the existentialist spirit. According to Sartre, people must consider seriously the implications of atheism. If God does not exist, then individuals must constantly struggle in isolation with the anguish of making decisions in a world without absolutes or traditional values.

This spirit of pessimism and despair emerged frequently in the European art of the immediate postwar period. A brutality or roughness appropriately expressing both the artist's state of mind and the larger cultural sensibility characterized much of this art.

AN INDICTMENT OF HUMANITY *Painting* (FIG. **23-1**) by British artist FRANCIS BACON (1910–1992) is a compelling and revolting image of a powerful figure who presides over a scene of slaughter. Painted in the year after World War II ended, this work can be read as an indictment of humanity and a reflection of war's butchery. The central figure is a stocky man with a gaping mouth and a vivid red stain on his upper lip, as if he were a carnivore devouring the raw meat sitting on the railing surrounding him. Bacon may have based his depiction of this central figure on news photos of Nazi leaders Joseph Goebbels and Heinrich Himmler, Benito Mussolini, or Franklin Roosevelt, which were an important part of media coverage during World War II and very familiar to the artist. The umbrella recalls wartime images of Neville Chamberlain, the British prime minister who so disastrously misjudged Hitler and was frequently photographed with an umbrella. Bacon suspended the flayed carcass hanging behind the central figure like a crucified human form, adding to the painting's visceral impact. Although the specific sources for the imagery in *Painting* may not be entirely clear, it is not difficult to see the work as "an attempt to remake the violence of reality itself" (as Francis Bacon often described his art), and the artist surely based it on what he referred to as "the brutality of fact."[3]

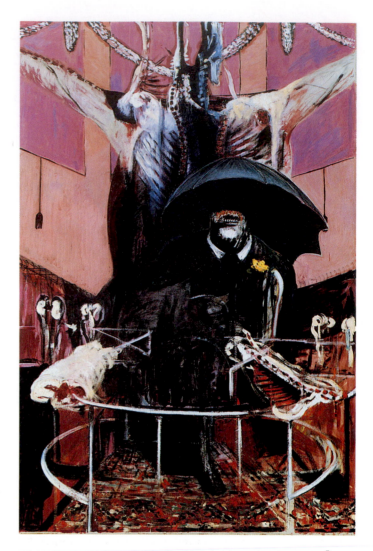

23-1 FRANCIS BACON, *Painting,* 1946. Oil and pastel on linen, 6′ 5 $\frac{7}{8}$″ × 4′ 4″. Museum of Modern Art, New York (purchase).

SCRAPED AND SMEARED CANVASES Although less specific, the works of French artist JEAN DUBUFFET (1901–1985) also express a somewhat tortured vision of the world through manipulated materials. In works such as *Vie Inquiète,* or *Uneasy Life* (FIG. **23-2**), Dubuffet presented a scene incised into thickly encrusted, parched-looking surfaces. He first built up an impasto (a layer of thickly applied pigment) of plaster, glue, sand, asphalt, or other common materials. Then, over that he painted or incised crude images of the kind children, the insane, or the scrawlers of graffiti produced. Scribblings interspersed with the images heighten the impression of smeared and gashed surfaces of crumbling walls and worn pavements marked by random individuals. Dubuffet believed the art of children, the mentally unbalanced, prisoners, and outcasts was more direct and genuine because it was unsullied by experience and untainted by conventional standards of art and aesthetic response. He promoted *Art Brut*—untaught, coarse, and rough art.

LOST IN THE WORLD'S IMMENSITY Existentialism's spirit is perhaps best expressed in the midlife sculpture of Swiss artist ALBERTO GIACOMETTI (1901–1966). Although Giacometti never claimed he pursued existentialist ideas in his art, it is hard to deny that his works capture the spirit of that

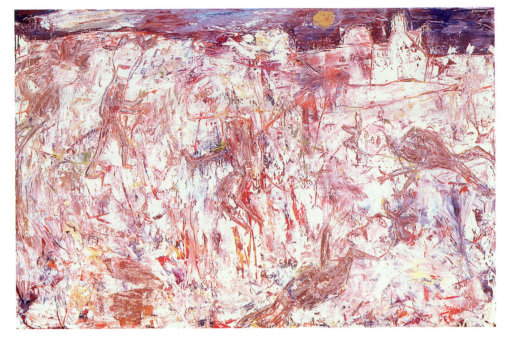

23-2 JEAN DUBUFFET, *Vie Inquiète*, 1953. Oil on canvas, approx. 4′ 3″ × 6′ 4″. Tate Gallery, London.

philosophy. Indeed, Sartre, Giacometti's friend, saw the artist's figurative sculptures as the epitome of existentialist humanity—alienated, solitary, and lost in the world's immensity. Giacometti had produced sculptures based on human models earlier in his career, but around 1940 he abandoned such direct observation and began to work from memory. His sculptures of the 1940s, such as *Man Pointing* (FIG. **23-3**), were thin, virtually featureless figures with rough, agitated surfaces. Rather than convey the solidity and mass of conventional bronze figurative sculpture, these severely attenuated figures seem swallowed up by the space surrounding them, imparting a sense of isolation and fragility. These sculptures represented quite a departure from Giacometti's earlier Surrealist-oriented work. Like much of European postwar art, Giacometti's later sculptures are evocative and moving, speaking to the pervasive despair in the aftermath of world war.

MODERNIST FORMALISM

Abstract Expressionism

As noted earlier, the center of the Western art world shifted in the 1940s from Paris to New York. This was due in large part to the devastation World War II inflicted across Europe, coupled with the influx of émigré artists escaping to the United States. American artists picked up the European avant-garde's energy, which movements such as Cubism and Dada had fostered. Interest in the avant-garde predominated much American art of the 1940s through 1970s.

Abstract Expressionism, the first major American avant-garde movement, emerged in New York (and hence is often referred to as the New York School) in the 1940s. As the name suggests, the artists associated with Abstract Expressionism produced paintings that are, for the most part, abstract but express the artist's state of mind. These artists also intended to strike emotional chords in viewers. The Abstract Expressionists tried to broaden their artistic processes to express what psychiatrist Carl Jung called the "collective

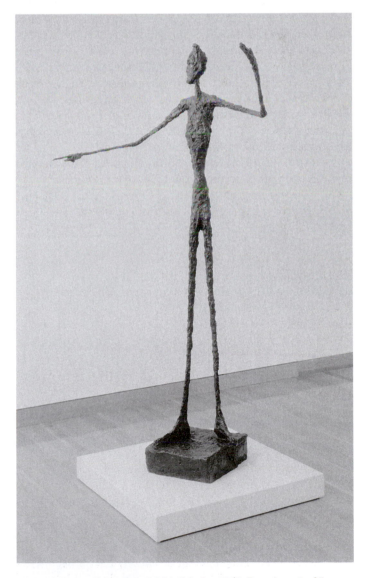

23-3 ALBERTO GIACOMETTI, *Man Pointing*, 1947. Bronze no. 5 of 6, 5′ 10″ × 3′ 1″ × 1′ 5⅝″. Nathan Emory Coffin Collection of the Des Moines Art Center, Des Moines. (Purchased with funds from the Coffin Fine Arts Trust.)

unconscious." To do so, they adopted Surrealist improvisation methods, such as "psychic automatism" (see Chapter 22, page 819), and used their creative minds as open channels for unconscious forces to make themselves visible. These artists turned inward to create. Their works had a look of rough spontaneity and exhibited a refreshing energy. The Abstract Expressionists meant for viewers to grasp the content of their art intuitively, in a state free from structured thinking. As the artist Mark Rothko eloquently wrote:

> We assert man's absolute emotions. We don't need props or legends. We create images whose realities are self evident. Free ourselves from memory, association, nostalgia, legend, myth. Instead of making cathedrals out of Christ, man or life, we make it out of ourselves, out of our own feelings. The image we produce is understood by anyone who looks at it without nostalgic glasses of history.[4]

The Abstract Expressionist movement developed along two lines—gestural abstraction and chromatic abstraction. The gestural abstractionists relied on the expressiveness of energetically applied pigment. In contrast, the chromatic abstractionists focused on color's emotional resonance.

THE PRIMACY OF PROCESS The artist whose work best exemplifies gestural abstraction was JACKSON POLLOCK (1912–1956). Although his early work reflects the influence of his teacher, Thomas Hart Benton (see FIG. 22-79), Pollock developed his unique signature style in the mid-1940s. By 1950, Pollock had refined his technique and was producing large-scale abstract paintings such as *Number 1, 1950* (*Lavender Mist*; FIG. **23-4**). These paintings are composed of rhythmic drips, splatters, and dribbles of paint, and the mural-sized fields of energetic skeins of pigment envelop viewers, drawing them into a lacy spiderweb. The

label gestural abstraction nicely describes Pollock's working technique. Using sticks or brushes, he flung, poured, and dripped paint (not only traditional oil paints but aluminum paints and household enamels as well) onto a section of unsized canvas he simply unrolled across his studio floor (FIG. **23-5**). Responding to the image as it developed, Pollock created both spontaneous and choreographed art. His working method highlights a particularly avant-garde aspect of gestural abstraction—its emphasis on the creative process. Indeed, Pollock literally immersed himself in the painting during its creation. Pollock explained, "I feel nearer, more a part of the painting, since this way I can walk around it, work from the four sides, and literally be *in* the painting."[5] Scholars have linked the idea, as Pollock's comments suggest, that he improvised his works and drew from his subconscious to his interest in Jungian psychology and the concept of the collective unconscious. Furthermore, the Surrealists who had relied heavily on the subconscious influenced him. The improvisational nature of Pollock's work also parallels the work of Kandinsky (see FIG. 22-7), who, appropriately enough, was described as an "abstract expressionist" as early as 1919.

In addition to Pollock's unique working methods, the lack of a well-defined compositional focus in his paintings significantly departed from conventional painting. He enhanced this rejection of tradition with the expansive scale of his canvases, a resolute move away from easel painting. These avant-garde dimensions of his work earned Pollock the public's derision and the nickname "Jack the Dripper." The title of a 1949 *Life* magazine article facetiously asked: "Jackson Pollock: Is He the Greatest Living Painter in the United States?"[6] Pollock's early death in a car accident at age forty-four cut short the development of his innovative artistic vision.

23-4 JACKSON POLLOCK, *Number 1, 1950 (Lavender Mist)*, 1950. Oil, enamel, and aluminum paint on canvas, 7′ 3″ × 9′ 10″. National Gallery of Art, Washington (Ailsa Mellon Bruce Fund).

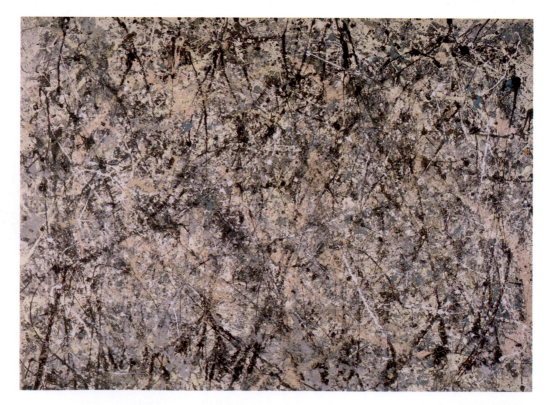

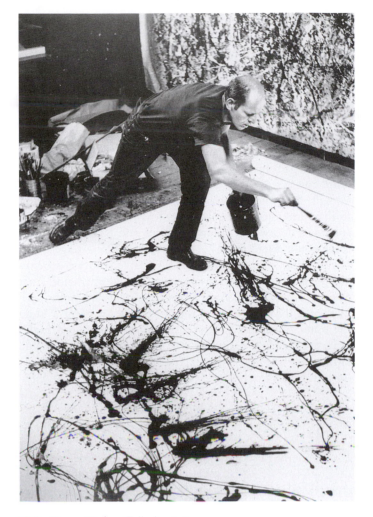

23-5 Photo of Jackson Pollock painting.

A FEROCIOUS AND INTENSE WOMAN Despite the public's skepticism about this art, other artists enthusiastically pursued similar avenues of expression. Dutch-born WILLEM DE KOONING (1904–1997) also developed a gestural abstractionist style. Even images such as *Woman I* (FIG. **23-6**), although rooted in figuration, display the sweeping gestural brushstrokes and energetic application of pigment typical of gestural abstraction. Out of the jumbled array of slashing lines and agitated patches of color appears a ferocious-looking woman with staring eyes and ponderous breasts. Her toothy smile, inspired by an ad for Camel cigarettes, seems to turn into a grimace. Female models on advertising billboards partly inspired *Woman I,* one of a series of female images, but de Kooning's female forms also suggest fertility figures and a satiric inversion of the traditional image of Venus, goddess of love.

Process was important to de Kooning, as it was for Pollock. Continually working on *Woman I* for almost two years, de Kooning painted an image and then scraped it away the next day and began anew. His wife Elaine, also a painter, estimated that he painted approximately two hundred scraped-away images of women on this canvas before settling on the final one.

In addition to this *Woman* series, de Kooning created nonrepresentational works dominated by huge swaths and splashes of pigment. His images suggest a rawness and intensity. His dealer, Sidney Janis, confirmed this impression, re-

calling that de Kooning occasionally brought him paintings with ragged holes in them, the result of overly vigorous painting. Like Pollock, de Kooning was very much "in" his paintings.

People also refer to gestural painting as "action painting," a term the critic Harold Rosenberg applied first to the work of the New York School. In his influential article of 1952, "The American Action Painters," Rosenberg described the attempts of these artists to get "inside the canvas." He elaborated:

> At a certain moment the canvas began to appear to one American painter after another as an arena in which to act—rather than as a space in which to reproduce, re-design, analyze or "express" an object, actual or imagined. What was to go on the canvas was not a picture but an event. The painter no longer approached his easel with an image in his mind; he went up to it with material in his hand to do something to that other piece of material in front of him. The image would be the result of this encounter.[7]

Although many critics (Clement Greenberg among them) objected to Rosenberg's analysis of "recent" American painting, the term "action painting" was adopted and widely used.

COLOR'S ENDURING RESONANCE In contrast to the aggressively energetic images of the gestural abstractionists, the work of the chromatic abstractionists exudes a quieter aesthetic, exemplified by the work of Barnett Newman and Mark

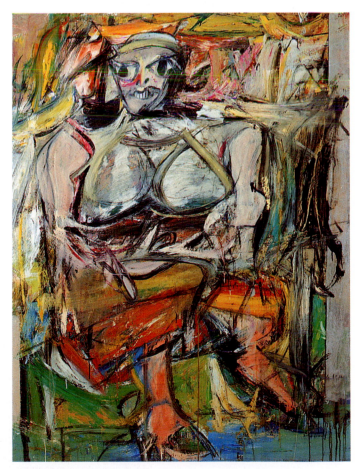

23-6 WILLEM DE KOONING, *Woman I,* 1950–1952. Oil on canvas, 6′ 3⅞″ × 4′ 10″. Museum of Modern Art, New York (purchase).

Rothko. The emotional resonance of their works derives from their eloquent use of color. In his early paintings, BARNETT NEWMAN (1905–1970) presented organic abstractions inspired by his study of biology and his fascination with Native American art. He soon simplified his compositions so that each canvas, such as *Vir Heroicus Sublimis* ("heroic sublime man"; FIG. 23-7), consists of a single slightly modulated color field split by narrow bands the artist called "zips," which run from one edge of the painting to the other. As Newman explained it, "The streak was always going through an atmosphere; I kept trying to create a world around it."[8] He did not intend for viewers to perceive the zips as specific entities, separate from the ground, but as accents energizing the field and giving it scale. By simplifying his compositions, Newman increased color's capacity to communicate and to express his feelings about the tragic condition of modern life and the human struggle to survive. He claimed: "[T]he artist's problem . . . [is] the idea-complex that makes contact with mystery—of life, of men, of nature, of the hard black chaos that is death, or the grayer, softer chaos that is tragedy."[9] Confronted by one of Newman's monumental colored canvases, viewers truly feel as if they were in the presence of the epic.

"TRAGEDY, ECSTASY, DOOM" The work of MARK ROTHKO (1903–1970) also deals with universal themes. Born in Russia, Rothko moved with his family to the United States when he was age ten. His early paintings were figurative in orientation, but he soon arrived at the belief that references to anything specific in the physical world conflicted with the sublime idea of the universal, supernatural "spirit of myth," which he saw as the core of meaning in art. In a statement cowritten with Newman and artist Adolph Gottlieb and sent to the *New York Times* critic Edward Alden Jewell, Rothko expressed his beliefs about art:

> We favor the simple expression of the complex thought. We are for the large shape because it has the impact of the unequivocal. . . . We

assert that . . . only that subject matter is valid which is tragic and timeless. That is why we profess spiritual kinship with primitive and archaic art.[10]

Rothko's paintings became compositionally simple, and he increasingly focused on color. In works such as *Untitled* (FIG. 23-8), Rothko created compelling visual experiences consisting of two or three large rectangles of pure color with hazy, brushy edges that seem to float on the canvas surface, hovering in front of a colored background. When properly lit, these paintings appear as shimmering veils of intensely luminous colors suspended in front of the canvases. Although the color juxtapositions are visually captivating, Rothko intended them as more than decorative. He saw color as a doorway to another reality, and he was convinced color could express "basic human emotions—tragedy, ecstasy, doom." He explained, "The people who weep before my pictures are having the same religious experience I had when I painted them. And if you, as you say, are moved only by their color relationships, then you miss the point."[11] Like the other Abstract Expressionists, Rothko produced highly evocative, moving paintings that relied on formal elements rather than specific representational content to raise emotions in viewers.

Post-Painterly Abstraction

Post-Painterly Abstraction, another American art movement, developed out of Abstract Expressionism. Indeed, many of the artists associated with Post-Painterly Abstraction produced Abstract Expressionist work early in their careers. Yet Post-Painterly Abstraction manifests a radically different sensibility from Abstract Expressionism. While Abstract Expressionism conveys a feeling of passion and visceral intensity, a cool, detached rationality emphasizing tighter pictorial control characterizes Post-Painterly Abstraction.

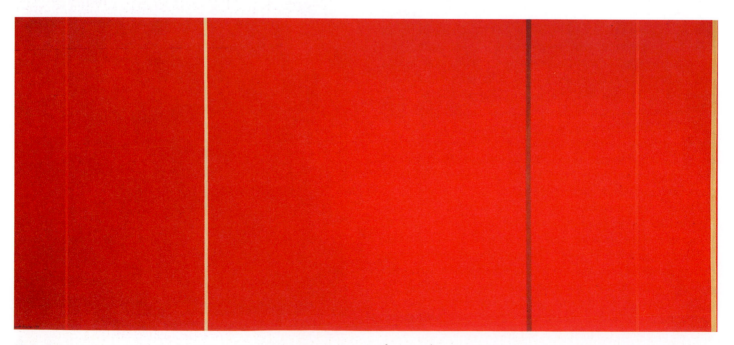

23-7 BARNETT NEWMAN, *Vir Heroicus Sublimis,* 1950–1951. Oil on canvas, 7′ 11 3/8″ × 17′ 9 1/4″. Museum of Modern Art, New York (gift of Mr. and Mrs. Ben Heller).

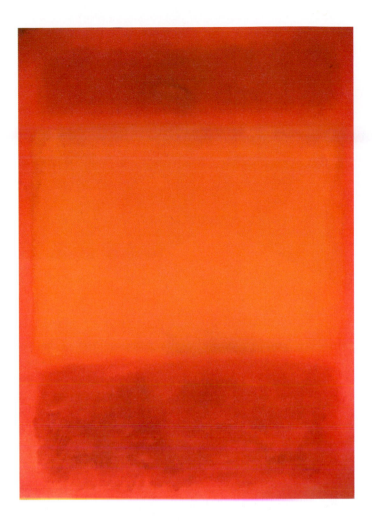

23-8 MARK ROTHKO, *Untitled,* 1961. Oil on canvas, 5′ 9″ × 4′ 2″. Collection of Mr. and Mrs. Lee V. Eastman.

The term "Post-Painterly Abstraction" was coined by the art critic Clement Greenberg, who saw this art as opposing the "painterly" concept, which refers to loose, visible pigment application. In contrast to the painterly quality of gestural abstraction, evidence of the artist's hand is conspicuously absent in Post-Painterly Abstraction. Greenberg championed this art form because it seemed to embody his idea of purity in art.

ELEMENTAL HARD-EDGE PAINTING Attempting to arrive at pure painting, the Post-Painterly Abstractionists distilled painting down to its essential elements, producing spare, elemental images. A good example of one variant of Post-Painterly Abstraction, hard-edge painting, is *Red Blue Green* (FIG. **23-9**) by ELLSWORTH KELLY (b. 1923), with its razor-sharp edges and clearly delineated shapes. This work is, appropriately, completely abstract and extremely simple compositionally. Further, the painting contains no suggestion of the illusion of depth—the color shapes appear resolutely two-dimensional.

"WHAT YOU SEE IS WHAT YOU SEE" FRANK STELLA (b. 1936), an artist associated with the hard-edge painters, pursued similar ideas in the 1960s. In works such as

23-9 ELLSWORTH KELLY, *Red Blue Green,* 1963. Oil on canvas, 6′ 11$\frac{5}{8}$″ × 11′ 3$\frac{7}{8}$″. Collection Museum of Contemporary Art, San Diego (gift of Dr. and Mrs. Jack M. Farris).

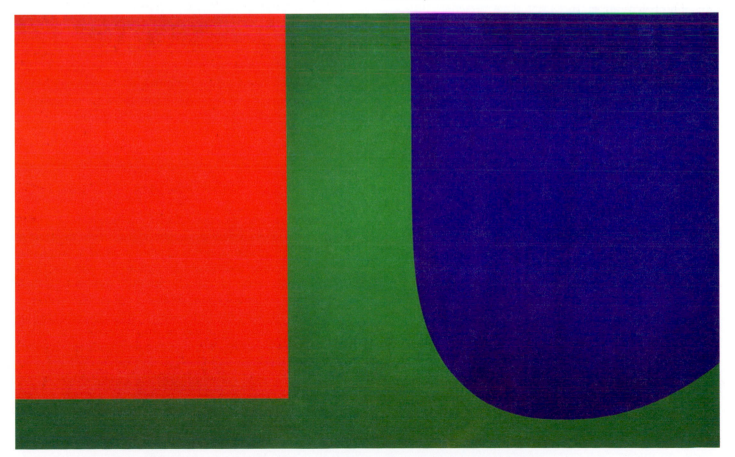

23-10 FRANK STELLA, *Nunca Pasa Nada,* 1964. Metallic powder in polymer emulsion on canvas, 9′ 2″ × 18′ 4½″. Collection Lannan Foundation.

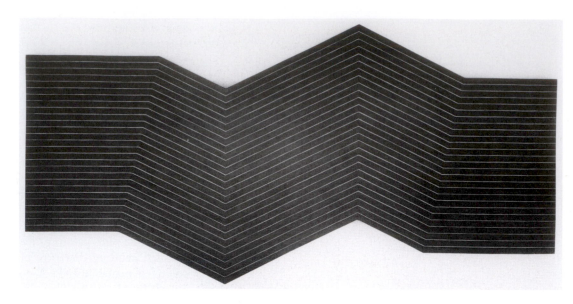

23-10 FRANK STELLA, *Nunca Pasa Nada,* 1964. Metallic powder in polymer emulsion on canvas, 9′ 2″ × 18′ 4½″. Collection Lannan Foundation.

Nunca Pasa Nada ("nothing ever happens"; FIG. **23-10**), Stella eliminated many of the variables associated with painting. His simplified images of thin, evenly spaced pinstripes on colored grounds have no central focus, no painterly or expressive elements, no surface modulation, and no tactile quality. Stella's systematic painting illustrates Greenberg's insistence on purity in art. The artist's own comment on his work, "What you see is what you see," reinforces the notions that painters interested in producing advanced art must reduce their work to its essential elements and that viewers must acknowledge that a painting is simply pigment on a flat surface.

FLAT COLOR FIELD PAINTING Color field painting, another variant of Post-Painterly Abstraction, also emphasized painting's basic properties. However, rather than produce sharp, unmodulated shapes as the hard-edge artists had done, the color field painters poured diluted paint onto unprimed canvas, allowing these pigments to soak into the

fabric. It is hard to conceive another painting method that results in such literal flatness. The images created, such as *Bay Side* (FIG. **23-11**) by HELEN FRANKENTHALER (b. 1928), appear spontaneous and almost accidental. These works differ from those of Rothko and Newman in that the emotional component, so integral to their work, is here subordinated to resolving formal problems.

STAINED CANVASES Another artist who pursued color field painting was MORRIS LOUIS (1912–1962). Greenberg, who was interested in Frankenthaler's paintings, took Louis to her studio, and there she introduced him to the staining technique's possibilities. Louis used this method of pouring diluted paint onto the surface of unprimed canvas in several series of paintings. *Saraband* (FIG. **23-12**) is one of the works in Louis's *Veils* series. By holding up the canvas edges and pouring diluted acrylic resin, Louis created billowy, fluid, transparent shapes that run down the length of the canvas. Like Frankenthaler, Louis reduced painting to the concrete fact of the paint-impregnated material. Artists could go no further in their quest to reduce painting to its physical essence.

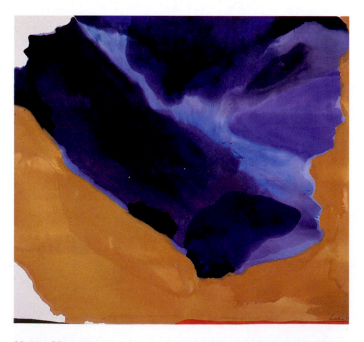

23-11 HELEN FRANKENTHALER, *Bay Side,* 1967. Acrylic on canvas, 6′ 2″ × 6′ 9″. Private Collection, New York.

Minimal Art

Painters were not the only artists interested in Clement Greenberg's ideas. American sculptors also strove to arrive at purity in their medium. While painters worked to emphasize flatness, sculptors, understandably, chose to focus on three-dimensionality as the unique characteristic and inherent limitation of the sculptural idiom. Minimal art, or Minimalism, a predominantly sculptural movement that emerged in the 1960s, was a clear expression of this endeavor. The movement's name reveals its reductive nature; people also have referred to Minimal art as primary structures, or ABC art.

EMPHASIZING OBJECTHOOD Minimalist TONY SMITH (1912–1980) created sculptures such as *Die* (FIG. **23-13**), a simple volumetric construction like other Minimal sculptures. Difficult to describe other than as three-dimensional objects, Minimal artworks often lack identifiable sub-

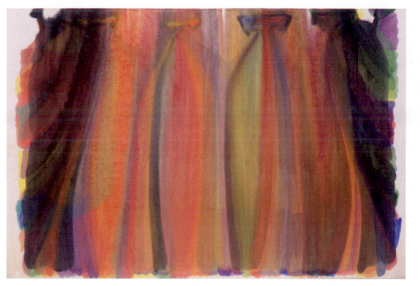

23-12 MORRIS LOUIS, *Saraband*, 1959. Acrylic resin on canvas, 8′ 5⅛″ × 12′ 5″. Solomon R. Guggenheim Museum, New York.

jects, colors, surface textures, and narrative elements. By rejecting illusionism and reducing sculpture to basic geometric forms, Minimalists emphatically emphasized their art's "objecthood" and concrete tangibility. In so doing, they reduced experience to its most fundamental level, preventing viewers from drawing on assumptions or preconceptions when dealing with the art before them.

AN UNAMBIGUOUS VISUAL VOCABULARY

DONALD JUDD (1928–1994) sought clarity and truth in his art, which led to a spare, universal aesthetic corresponding to Minimalist tenets. Judd's determination to arrive at a visual vocabulary that avoided deception or ambiguity propelled him away from representation and toward precise and simple sculpture. For Judd, a work's power derived from its character as a whole and from the specificity of its materials. *Untitled* (FIG. **23-14**) presents basic geometric boxes constructed of brass and red plexiglass, undisguised by paint or

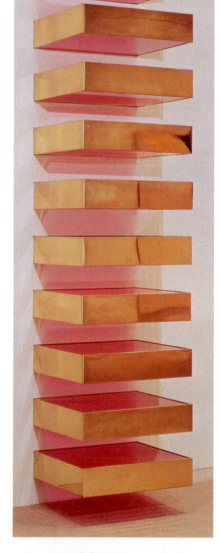

23-13 TONY SMITH, *Die*, 1962. Steel, 6′ × 6′ × 6′.

23-14 DONALD JUDD, *Untitled*, 1969. Brass and colored fluorescent plexiglass on steel brackets, ten units, 6⅛″ × 2′ × 2′ 3″ each, with 6″ intervals. Hirshhorn Museum and Sculpture Garden, Smithsonian Institution, Washington (gift of Joseph H. Hirshhorn, 1972). Art copyright © Donald Judd Estate/Licensed by VAGA, New York, NY.

23-15 Maya Ying Lin, Vietnam Veterans Memorial, Washington, D.C., 1981–1983. Black granite, each wing 246′ long.

other materials. The artist did not intend the work to be metaphorical or symbolic but a straightforward declaration of sculpture's objecthood. In works such as this, Judd used plexiglass because its translucency allows viewers access to the interior, thereby rendering the sculpture both open and enclosed. This aspect of the design was consistent with his desire to banish ambiguity or falseness. Judd's sculptures, like those of other Minimalists, provide viewers with a unique visual experience—one both immediate and enduring.

Despite the ostensible connections between Minimalism and Greenbergian formalism, Greenberg did not embrace this direction in art. He expressed his concern:

> Minimal Art remains too much a feat of ideation [the mental formation of ideas], and not enough anything else. Its idea remains an idea, something deduced instead of felt and discovered. The geometrical and modular simplicity may announce and signify the artistically furthest-out, but the fact that the signals are understood for what they want to mean betrays them artistically. There is hardly any aesthetic surprise in Minimal Art. . . . Aesthetic surprise hangs on forever—it is there in Raphael as it is in Pollock—and ideas alone cannot achieve it.[12]

HEALING PSYCHIC WOUNDS A sculpture that does indeed present this enduring impact is the Vietnam Veterans Memorial (FIG. **23-15**), designed by Maya Ying Lin (b. 1960) at age twenty-one in 1981. The austere, simple memorial, a V-shaped wall constructed of polished black granite panels, begins at ground level at each end and gradually rises to a height of ten feet at the center of the V. The names of the Vietnam War's fifty-seven thousand nine hundred thirty-nine casualties (and those still missing) incised on the wall, in the order of their deaths, contribute to the work's dramatic effect. Also, Lin set the wall into the landscape, creating a feeling of descent as visitors walk along the wall toward the center.

When Lin designed this pristinely simple monument, she gave a great deal of thought to the purpose of war memorials. She concluded that a memorial "should be honest about the reality of war and be for the people who gave their lives." She decided that she "didn't want a static object that people would just look at, but something they could relate to as on a journey, or passage, that would bring each to his own conclusions. . . . I wanted to work with the land and not dominate it. I had an impulse to cut open the earth . . . an initial violence that in time would heal. The grass would grow back, but the cut would remain . . ."[13] In light of the tragedy of the war, this unpretentious memorial's allusion to a wound and long-

The Power of Minimalism
Maya Lin's Vietnam Veterans Memorial

Although Minimal art first seemed to many to operate only in the realm of the formal, the immediacy and physical presence of Minimalist artworks often endows the works with an enduring resonance. Maya Lin's design for the Vietnam Veterans Memorial (FIG. 23-15) is, like other Minimalist sculptures, a simple geometric form. Yet the controversy engendered when her design was first publicized and the emotional public response to the completed memorial demonstrate how some Minimalist artworks can move beyond concrete objecthood. The monument, with its serene simplicity, actively engages viewers in a psychological dialogue, rather than standing mute. This dialogue gives viewers the opportunity to explore their feelings about the Vietnam War and arrive at some sense of closure.

The history of the Vietnam Veterans Memorial provides dramatic testimony to this monument's power. In 1981, a jury of architects, sculptors, and landscape architects selected Lin's design in a blind competition for a memorial to be placed in Constitution Gardens in Washington, D.C. Conceivably, the jury not only found her design compelling but also thought its unabashed simplicity would be the least likely to provoke controversy. When the selection was made public, however, heated debate ensued. Because of the stark contrast between the monumental, vertically oriented white memorials (the Washington Monument and the Lincoln Memorial bracketing the Vietnam Veterans Memorial) and the wall, some people saw Lin's design as criticizing the Vietnam War and, by extension, the efforts of those who fought in the war. Some of these critics perceived the wall's insertion into the earth as an admission of guilt about U.S. participation in the war. The wall's color came under attack as well; one veteran charged that black is "the universal color of shame, sorrow and degradation in all races, all societies worldwide."[1]

Due to the vocal opposition, a compromise was necessary to ensure the memorial's completion. The Commission of Fine Arts, the federal group overseeing such projects, commissioned an additional memorial from artist Frederick Hart in 1983. This larger-than-life-sized realistic bronze sculpture of three soldiers, armed and in uniform, was eventually installed approximately one hundred twenty feet from the wall. More recently, a group of nurses, organized as the Vietnam Women's Memorial Project, got approval for a sculpture honoring women's service in the Vietnam War. The seven-foot-tall bronze statue by Glenna Goodacre depicts three female figures, one cradling a wounded soldier in her arms. Unveiled in 1993, the work was placed about three hundred feet south of the wall.

Despite this controversy and compromise, the wall generates dramatic responses. Commonly, visitors react very emotionally, even those who know none of the soldiers named on the monument. Many visitors leave mementos at the foot of the wall in memory of loved ones they lost in the Vietnam War or make rubbings from the incised names. It can be argued that much of this memorial's power derives from its Minimalist simplicity. Like Minimalist sculpture, it does not dictate response and therefore successfully encourages personal exploration. The polished granite surface also prompts such individual soul-searching—viewers see themselves reflected among the names.

Given the contentiousness and divided sentiments about the Vietnam War, any memorial to that conflict surely would encounter opposition. Maya Lin's wall, however, has illustrated the ability of art—even Minimalist sculpture—to elicit emotions in a diverse population and to help heal a nation.

[1] Elizabeth Hess, "A Tale of Two Memorials," *Art in America*, vol. 71, no. 4 (April 1983), 122.

lasting scar contributes to its communicative ability (see "The Power of Minimalism: Maya Lin's Vietnam Veterans Memorial," above).

Diverse Sculptural Directions

COMPELLING, NONTRADITIONAL MATERIALS Although Minimalism was a dominant sculptural trend in the 1960s, many sculptors pursued other styles. EVA HESSE (1936–1970), a Minimalist in the early part of her career, moved away from the severity characterizing much of Minimal art. She created sculptures that, although spare and simple, have a compelling presence. Using nontraditional sculptural materials such as fiberglass, cord, and latex, Hesse produced sculptures whose pure Minimalist forms appear to crumble, sag, and warp under the pressures of atmospheric force and gravity. Born Jewish in Hitler's Germany, the young Hesse was hidden by a Christian family when her parents and elder sister had to flee the Nazis. She was not reunited with them until the early 1940s, just before her parents divorced. Those extraordinary circumstances helped give her a lasting sense that the central conditions of modern life are strangeness and absurdity. Struggling to express these qualities in her art, she created informal sculptural arrangements with units often hung from the ceiling, leaned against the walls, or spilled out along the floor. She said she wanted her pieces to be "non art, non connotative, non anthropomorphic, non geometric, non nothing, everything, but of another kind, vision, sort."[14]

23-16 EVA HESSE, *Hang-Up*, 1965–1966. Acrylic on cloth over wood and steel, 6′ × 7′ × 6′ 6″. Art Institute of Chicago, Chicago (gift of Arthur Keating and Mr. and Mrs. Edward Morris by exchange).

Amazingly, *Hang-Up* (FIG. **23-16**) fulfills these requirements. The piece looks like a carefully made empty frame sprouting a strange feeler that extends into the room and doubles back to the frame. Hesse wrote that in this work, for the first time, her "idea of absurdity or extreme feeling came

through."[15] In her words, "[*Hang-Up*] has a kind of depth I don't always achieve and that is the kind of depth or soul or absurdity of life or meaning or feeling or intellect that I want to get."[16] The sculpture possesses a disquieting and touching presence, suggesting the fragility and grandeur of life amid the pressures of the modern age. Hesse was herself a touching and fragile presence in the art world; she died of a brain tumor at the young age of thirty-four.

MONUMENTAL METAL SCULPTURES American sculptor DAVID SMITH (1906–1965) learned to weld in an automobile plant in 1925. He later applied to his art the technical expertise in handling metals he gained from that experience. In addition, working in large scale at the factories helped him visualize the possibilities for monumental metal sculpture. Smith created the series for which he is best known, his *Cubi* series, in the early 1960s. These works, including the examples *Cubi XVIII* and *Cubi XVII* (FIG. **23-17**), consist of simple geometric forms—cubes, cylinders, and rectangular bars. Made of stainless steel, piled haphazardly on top of one another, and then welded together, these forms create imposing large-scale sculptures. Although the metal elements of these *Cubi* sculptures reproduce the basic Minimalist vocabulary, Smith composed the works in a way that suggests human characteristics. To this end, his sculptures depart from Minimalism. In addition, Smith broke with the Minimalist program by burnishing the metal with steel wool, producing swirling random-looking gestural patterns that draw attention to the two-dimensionality of the sculptural surface. This treatment, which captures the light hitting the sculpture, activates the surface and imparts a texture to these sculptures.

MULTIPLICITY OF MEANING Russian-born LOUISE NEVELSON (1899–1988) created sculpture that combines a sense of the architectural fragment with the power of Dada and Surrealist found objects to express her personal sense of

23-17 DAVID SMITH, *Cubi XVIII* and *Cubi XVII*, 1963–1964. Polished stainless steel; *Cubi XVIII*, 9′ 7¾″ high; *Cubi XVII*, 8′ 11¾″ high × 5′ 4⅜″ × 3′ 2⅛″. Museum of Fine Arts, Boston, Massachusetts (gift of Susan W. and Stephen D. Paine), and Dallas Museum of Art, Dallas (The Eugene and Margaret McDermott Fund). Copyright © Estate of David Smith/Licensed by VAGA, New York, NY.

23-18 LOUISE NEVELSON, *Tropical Garden II*, 1957–1959. Wood painted black, 5′ 11½″ × 10′ 11¾″ × 1′. Musée National d'Art Moderne, Centre Georges Pompidou, Paris.

life's underlying significance. Multiplicity of meaning was important to Nevelson. She sought ". . . the in-between place. . . . The dawns and the dusks"[17]—the transitional realm between one state of being and another. By the late 1950s, she was assembling sculptures of found wooden objects and forms, enclosing small sculptural compositions in boxes of varied sizes, and joining the boxes to one another to form "walls," which she then painted in a single hue—usually black, white, or gold.

The monochromatic color scheme unifies the diverse parts of pieces such as *Tropical Garden II* (FIG. **23-18**) and creates a mysterious field of shapes and shadows. The structures suggest magical environments resembling the treasured secret hideaways dimly remembered from childhood. Yet, the boxy frames and the precision of the manufactured found objects create a rough geometric structure that the eye roams over freely, lingering on some details. The parts of a Nevelson sculpture and their interrelation recall the *Merz* constructions of Kurt Schwitters (see FIG. 22-27). The effect is also rather like viewing an apartment building's side wall from a moving elevated train or like looking down on a city from the air.

SENSUOUS ORGANIC FORMS In contrast to the architectural nature of Nevelson's work, French-American artist LOUISE BOURGEOIS (b. 1911) often presents viewers with sensuous organic forms recalling the evocative biomorphic Surrealist forms of Joan Miró (see FIG. 22-50). She once described her sculptural subjects as "groups of objects relating to each other . . . the drama of one among many."[18] *Cumul I* (FIG. **23-19**)

23-19 LOUISE BOURGEOIS, *Cumul I*, 1969. Marble, 1′ 10⅜″ × 4′ 2″ × 4′. Musée National d'Art Moderne, Centre Georges Pompidou, Paris. Copyright © Louise Bourgeois/Licensed by VAGA, New York, NY.

is a collection of roundheaded units huddled, with their heads protruding, within a collective cloak dotted with holes. The units differ in size, and their position within the group lends a distinctive personality to each. Although the shapes remain abstract, they refer strongly to human figures. Bourgeois uses a wide variety of materials in her works, including wood, plaster, latex, and plastics, in addition to alabaster, marble, and bronze. She exploits each material's qualities to suit the expressiveness of the piece.

In *Cumul I*, the marble's high gloss next to its matte finish increases the sensuous distinction between the group of swelling forms and the soft folds swaddling them. Like Barbara Hepworth (see FIG. 22-71), Bourgeois connects her sculpture with the body's multiple relationships to landscape: "[My pieces] are anthropomorphic and they are landscape also, since our body could be considered from a topographical point of view, as a land with mounds and valleys and caves and holes."[19] However, Bourgeois's sculptures are more personal and more openly sexual than those of Hepworth. *Cumul I* represents perfectly the allusions Bourgeois seeks: "There has always been sexual suggestiveness in my work. Sometimes I am totally concerned with female shapes—characters of breasts like clouds—but often I merge the activity—phallic breasts, male and female, active and passive."[20]

Performance Art

In the interest of challenging artistic convention, avant-garde artists in the 1960s sought innovative forms of expression. As discussed earlier, artists such as the Post-Painterly Abstractionists and the Minimalists explored the implications of two- and three-dimensionality in keeping with the modernist critique of artistic principles. Other artists produced Happenings and along with the group of Fluxus artists, both discussed later, developed the fourth dimension of time as an integral element of their artwork. These brief, temporary works eventually were categorized under the broad term Performance art. In such work, movements, gestures, and sounds of persons communicating with an audience, whose members may or may not participate in the event, replace physical objects. Generally, the only evidence remaining after these events is the documentary photographs taken at the time. Further, the informal and spontaneous nature of much of such work using the human body as primary material pushed art outside the confines of the mainstream art institutions (for example, museums and galleries). Actions, events, and Happenings in large measure derived from the spirit characterizing Dada and Surrealist work and anticipated the rebellion and youthful exuberance of the 1960s. Initially, it appeared these artworks might serve as antidotes to the preciosity of most art objects and challenge art's function as a commodity. In the later 1960s, however, museums commissioned performances with increasing frequency, thereby neutralizing much of this art form's subversive edge.

A COMPOSER'S INFLUENCE Many of the artists instrumental to developing Performance art were influenced by the charismatic teacher and composer JOHN CAGE (1912–1992). Cage encouraged his students at both the New School for Social Research in New York and Black Mountain College in North Carolina to link their art directly with life. He brought to music composition his interests in the thoughts of Duchamp and in Eastern philosophy. In his own work, Cage used methods such as chance to avoid the closed structures marking traditional music and, in his view, separating it from the unpredictable and multilayered qualities of daily existence. For example, the score for one of Cage's piano compositions instructs the performer to appear, sit down at the piano, raise the keyboard cover to mark the beginning of the piece, remain motionless at the instrument for four minutes and thirty-three seconds, and then close the keyboard cover, rise, and bow to signal the end of the work. The "music" would be the unplanned sounds and noises (such as coughs, whispers) emanating from the audience during the "performance."

HAPPENINGS AND FLUXUS One of Cage's students in the 1950s was American artist ALLAN KAPROW (b. 1927). Extremely knowledgeable about art history, Kaprow was inspired by his study of music composition with Cage. Kaprow was equally committed to the intersection of art and life, and this, along with his belief that Jackson Pollock's actions when producing a painting were more important than the finished painting, led Kaprow to develop a type of event known as a Happening. He described a Happening as

> an assemblage of events performed or perceived in more than one time and place. Its material environments may be constructed, taken over directly from what is available, or altered slightly; just as its activities may be invented or commonplace. A Happening, unlike a stage play, may occur at a supermarket, driving along a highway, under a pile of rags, and in a friend's kitchen, either at once or sequentially. If sequentially, time may extend to more than a year. The Happening is performed according to plan but without rehearsal, audience or repetition. It is art but seems closer to life.[21]

Happenings were largely participatory. One Happening consisted of a constructed setting with partitions on which viewers wrote phrases, while another involved spectators walking on a pile of tires.

Other Cage students interested in the composer's search to find aesthetic potential in the nontraditional and commonplace eventually formed the Fluxus group. Eventually expanding to include European and Japanese artists, this group's performances were more theatrical than Happenings. Many of these Fluxus performances followed a compositional "score" for events and focused on single actions, such as turning a light on and off or watching falling snow—what Fluxus artist La Monte Young (b. 1935) called "the theater of the single event."[22] The artists usually executed these events on a stage separating the performers from the audience but without costumes or added decor.

PERFORMANCE AS RITUAL German artist JOSEPH BEUYS (1921–1986) was strongly influenced by the leftist politics of the Fluxus group in the early 1960s. Drawing on Happenings and Fluxus, Beuys created actions aimed at illuminating the condition of modern humanity. He wanted to make a new kind of sculptural object that would include "Thinking Forms: how we mould our thoughts or Spoken Forms: how we shape our thoughts into words or Social

(1925–1991). Trained as a painter in his native Switzerland, Tinguely's interest gravitated to motion sculpture. In the 1950s, he made a series of "metamatic" machines, motor-driven devices that produced instant abstract paintings. He programmed these metamatics electronically to act with an antimechanical unpredictability when viewers inserted felt-tipped marking pens into a pincer and pressed a button to initiate the pen's motion across a small sheet of paper clipped to an "easel." Viewers could use different colored markers in succession and could stop and start the device to achieve some degree of control over the final image. These operations created a series of small works resembling Abstract Expressionist paintings.

In 1960, Tinguely expanded the scale of his work with a kinetic piece designed to "perform" and then destroy itself in a large courtyard area at the Museum of Modern Art in New York City. He created *Homage to New York* (FIG. **23-21**) with the aid of engineer Billy Klüver, who helped him scrounge wheels and other moving objects from a dump near Manhattan. The completed structure, painted white for visibility against the dark night sky, included a player piano modified into a metamatic painting machine, a weather balloon that inflated during the performance, vials of colored smoke, and a host of gears, pulleys, wheels, and other found machine parts.

This work was premiered (and destroyed) on March 17, 1960, in the sculpture garden of the Museum of Modern Art, with New York Governor Nelson Rockefeller, an array of

23-20 JOSEPH BEUYS, *How to Explain Pictures to a Dead Hare,* 1965. Photograph of Performance art. Schmela Gallery, Düsseldorf.

Sculpture: how we mould and shape the world in which we live."[23]

Beuys's commitment to artworks stimulating thought about art and life was partially due to his experiences during the war. While serving as a pilot, he was shot down over the Crimea, and claimed that nomadic Tatars nursed him back to health by swaddling his body in fat and felt to warm him. Fat and felt thus symbolized healing and regeneration to the artist, and he incorporated these materials into many of his sculptures and actions, such as *How to Explain Pictures to a Dead Hare* (FIG. **23-20**). This one-person event consisted of stylized actions evoking a sense of mystery and sacred ritual. Beuys appeared in a room hung with his drawings, cradling a dead hare he spoke to softly. Beuys coated his head with honey covered with gold leaf, creating a shimmering mask. In this manner, he took on the role of the shaman, an individual with special spiritual powers. As a shaman, Beuys believed he was acting to help revolutionize human thought so that each human being could become a truly free and creative person.

DESTRUCTION AS CREATION The notion of destruction as an act of creation surfaces in a number of kinetic artworks, most notably in the sculpture of JEAN TINGUELY

23-21 JEAN TINGUELY, *Homage to New York,* 1960, just prior to its self-destruction in the garden of the Museum of Modern Art, New York.

distinguished guests, and three television crews attending. Once the machine was turned on, smoke poured from its interior and the piano caught fire. Various parts of the machine broke off and rambled away, while one of the metamatics tried but failed to produce an abstract painting. Finally, Tinguely summoned a firefighter to extinguish the blaze and ensure the demise of *Homage to New York* with his axe. Like the artist's other kinetic sculptures, *Homage to New York* shared something of Duchamp's satiric Dadaist spirit (see FIG. 22-25) and the droll import of Klee's *Twittering Machine* (see FIG. 22-51). But Tinguely deliberately made the wacky behavior of *Homage to New York* more playful and more endearing. Having been given a "freedom" of eccentric behavior unprecedented in the mechanical world, Tinguely's creations often seem to behave with the whimsical individuality of human actors.

People first used the terms *Happening, action,* and *body art* to describe various kinds of artistic endeavors involving the body as aesthetic material. In the mid-1970s, people widely began to use the generic term *Performance art* to describe this broad range of creative activity. Extreme examples of Performance art involved artists who created various performance pieces centered on risk-taking activities with guns or broken glass. Such work dramatically challenged accepted definitions of art.

Conceptual Art

The relentless challenges to artistic convention fundamental to the historical avant-garde reached a logical conclusion with Conceptual art in the late 1960s. Conceptual artists asserted that the "artfulness" of art lay in the artist's idea, rather than in its final expression. Indeed, some Conceptual artists eliminated the object altogether. In addition, Conceptual artists rethought aesthetic issues, which long have formed the foundation of art. These artists regarded the idea, or concept, as the primary element of artistic production.

WHAT CONSTITUTES "CHAIRNESS?" American artist JOSEPH KOSUTH (b. 1945) was a major proponent of Conceptual art. His work operates at the intersection of language and vision, dealing with the relationship between the abstract and the concrete. In a broader sense, his art explores the ways in which aesthetic meaning is generated. For example, *One and Three Chairs* (FIG. **23-22**), consists of an actual chair flanked by a full-scale photograph of the chair and a photostat of a dictionary definition of the word *chair.* Kosuth asked viewers to ponder the notion of what constitutes "chairness." He explained, "It meant you could have an art work which was that *idea* of an art work, and its formal components weren't important. I felt I had found a way to make art without formal components being confused for an expressionist composition. The expression was in the idea, not the form—the forms were only a device in the service of the idea."[24] Kosuth explored these concepts further in a series of works titled *Art as Idea as Idea.* He elaborated:

> Like every one else I inherited the idea of art as a set of *formal* problems. So when I began to re-think my ideas of art, I had to re-think that thinking process, and it begins with the making process. . . . 'Art as Idea *as Idea*' [was] intended to suggest that the real

23-22 JOSEPH KOSUTH, *One and Three Chairs,* 1965. Wooden folding chair, photographic copy of a chair, and photographic enlargement of a dictionary definition of a chair; chair, $2'\ 8\frac{3}{8}'' \times 1'\ 2\frac{7}{8}'' \times 1'\ 8\frac{7}{8}''$; photo panel, $3' \times 2'\frac{1}{8}''$; text panel, $2' \times 2'\frac{1}{8}''$. Museum of Modern Art, New York (Larry Aldrich Foundation Fund).

creative process, and the radical shift, was in changing the idea of art itself. In other words, my idea of doing that was the real creative content.[25]

Other Conceptual artists pursued this idea that "the idea itself, even if not made visual, is as much a work of art as a product"[26] by creating works involving such invisible materials as inert gases, radioactive isotopes, or radio waves. In each case, viewers must base their understanding of the artwork on what they know about the properties of these materials, rather than on any visible empirical data, and depend on the artist's linguistic description of the work. In Conceptual artists' intellectual and aesthetic investigation of art's structure, they challenged the very foundations of art, pushing art's boundaries to a point where no concrete definition of *art* is possible.

ALTERNATIVES TO MODERNIST FORMALISM

The avant-garde provided a major directional impetus for art production in the postwar years. As seen in the work of the Abstract Expressionists, Post-Painterly Abstractionists, and Minimalists, artists most frequently expressed this interest in modernist experimental art in the vocabulary of resolute abstraction. Other artists, however, felt that the insular and

introspective attitude of avant-garde artists had resulted in public alienation. These artists were committed to the communicative power of art and to reaching a wide audience with their art. This is not to suggest that they created reactionary or academic work; indeed, people easily can find avant-garde aspects in their art. However, these artists (for example, Pop artists, Superrealists, and Environmental artists) were much less committed to the single-minded focus on formal issues characteristic of the modernist mindset.

The Development of Pop Art

The prevalence of abstraction and the formal experimentation in much of postwar art had alienated the public. Pop art reintroduced all of the artistic devices—signs, symbols, metaphors, allusions, illusions, and figurative imagery—traditionally used to convey meaning in art that recent avant-garde artists, in search of purity, had purged from their abstract and often reductive works. Pop artists not only embraced representation but also produced an art resolutely grounded in consumer culture, the mass media, and popular culture, thereby making it much more accessible and understandable to the average person. Indeed, the name Pop art (credited to the British art critic Lawrence Alloway, although he is unsure of the term's initial usage) is short for *popular art* and referred to the popular mass culture and familiar imagery of the contemporary urban environment. This was an art form firmly entrenched in the sensibilities and visual language of a late-twentieth-century mass audience.

BRITISH POP: THE INDEPENDENT GROUP

Pop art's roots can be traced to a group of young British artists, architects, and writers who formed the Independent Group at the Institute of Contemporary Art in London in the early 1950s. This group's members sought to initiate fresh thinking in art, in part by sharing their fascination with the aesthetics and content of such facets of popular culture as advertising, comic books, and movies.

Discussions at the Independent Group in London probed the role and meaning of symbols from mass culture and the advertising media. In 1956, a group member, RICHARD HAMILTON (b. 1922), made a small collage, *Just What Is It That Makes Today's Homes So Different, So Appealing?* (FIG. **23-23**), that characterized many of the attitudes of British Pop art. Trained as an engineering draftsman, exhibition designer, and painter, Hamilton was very interested in the way advertising shapes public attitudes. Long intrigued by Duchamp's ideas, Hamilton consistently combined elements of popular art and fine art, seeing both as belonging to the whole world of visual communication. The Pop artist created *Just What Is It* for the poster and catalog of one section of an exhibition titled *This Is Tomorrow*—an environment/installation filled with images from Hollywood cinema, science fiction, the mass media, and one reproduction of a van Gogh painting (to represent popular fine artworks).

The fantasy interior in Hamilton's collage reflects the values of modern consumer culture through figures and objects cut from glossy magazines. *Just What Is It* reconstructs the found images into a new whole. The artist included references to the mass media (such as the television, theater marquee

23-23 RICHARD HAMILTON, *Just What Is It That Makes Today's Homes So Different, So Appealing?*, 1956. Collage, $10\frac{1}{4}'' \times 9\frac{3}{4}''$. Kunsthalle Tübingen, Germany.

outside the window, and newspaper), to advertising (such as for Hoover vacuums, Ford cars, Armour hams, and Tootsie Pops), and to popular culture (such as the girlie magazine, Charles Atlas, and romance comic books). Scholars have written much about the possible deep meaning of this piece, and few would deny the work's sardonic effect, whether or not the artist intended to make a pointed comment. Such artworks stimulated viewers' wide-ranging speculation about society's values, and this kind of intellectual toying with mass-media meaning and imagery typified British and European Pop art.

American Pop Art and Consumer Culture

Although Pop originated in England, the movement found its greatest articulation and success in the United States, in large part because the more fully matured consumer culture provided a fertile environment in which the movement flourished through the 1960s. Indeed, Independent Group members claimed their inspiration came from Hollywood, Detroit, and Madison Avenue, New York, paying homage to America's predominance in the realms of mass media, mass production, and advertising.

Two artists pivotal to the early development of American Pop were Jasper Johns and Robert Rauschenberg. Both artists had produced earlier Abstract Expressionist work, and their forays into Pop retain the brushiness of gestural abstraction. Yet both of them introduced elements from popular culture into their art. These references add to their work's power and immediacy.

THINGS SEEN BUT NOT LOOKED AT In his early work, JASPER JOHNS (b. 1930) was particularly interested in drawing viewers' attention to common objects in the world—what he called things "seen but not looked at."[27] To this end, he did several series of paintings of targets, flags, numbers, and alphabets. For example, *Flag* (FIG. **23-24**) is an object people view frequently but rarely scrutinize. The work's surface is highly textured due to Johns's use of encaustic, an ancient method of painting with liquid wax and dissolved pigment. First, the artist embedded a collage of newspaper scraps or photographs in wax. He then painted over them with the encaustic. Because the wax hardened quickly, Johns could work rapidly, and the translucency of the wax allows viewers to see the layered painting process.

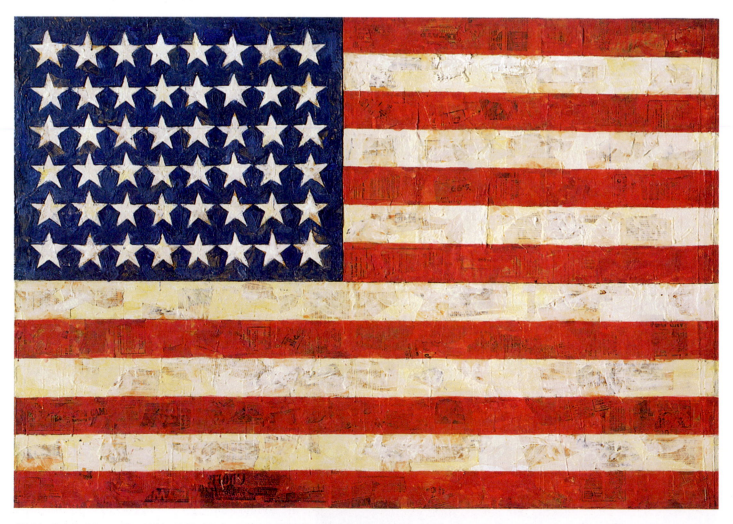

23-24 JASPER JOHNS, *Flag*, 1954–1955, dated on reverse 1954. Encaustic, oil, and collage on fabric mounted on plywood, 3′ 6¼″ × 5′ ⅝″. Museum of Modern Art, New York (gift of Philip Johnson in honor of Alfred H. Barr, Jr.). Copyright © Jasper Johns/Licensed by VAGA, New York, NY.

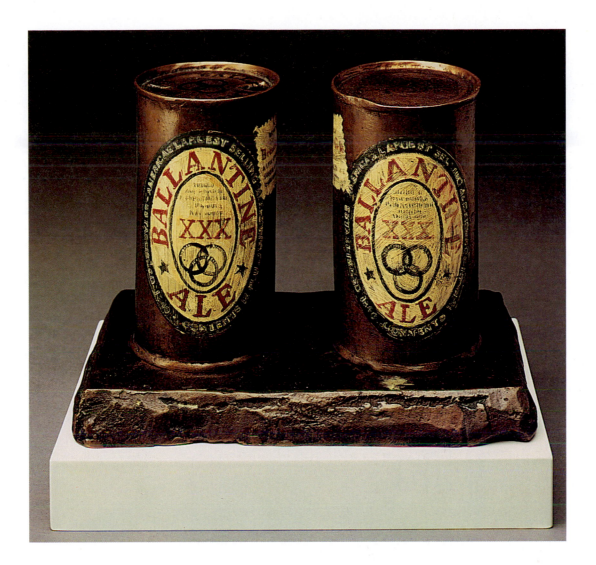

23-25 JASPER JOHNS, *Painted Bronze*, 1960. Cast bronze, paint, approx. $5\frac{1}{2}''$ high, 8″ wide, $4\frac{3}{4}''$ deep. Museum Ludwig, Cologne. Copyright © Jasper Johns/Licensed by VAGA, New York, NY.

BEVERAGES OF BRONZE Johns's *Painted Bronze* (FIG. **23-25**) also presents reassuringly familiar objects. However, by reproducing the Ballantine Ale cans in cast bronze, the artist rendered them functionless and elevated these common objects to the realm of high art, in a manner similar to Duchamp's *Fountain* (see FIG. 22-25). Because of such parallels, art scene observers in the 1960s often referred to Pop art as Neo-Dada. In *Painted Bronze*, Johns reconstituted what is customarily discarded as junk and resituated it as something worthy of the attention rarely given it. The artist solemnly exalted the banal by modeling the ale cans in plaster and then casting them in bronze, faithfully painting the commercial labels, and firmly mounting the cans upon a base. Like bronze baby shoes, the disposable container is monumentalized as a profoundly symbolic artifact of modern consumer culture.

The inspiration for *Painted Bronze* further reinforced the intersection between Pop art and consumer culture. According to Johns, he created the sculpture in response to a comment by Willem de Kooning about Johns's New York art dealer, Leo Castelli. Johns said, "Somebody told me that Bill de Kooning said that you could give that son-of-a-bitch two

beer cans and he could sell them. I thought, what a wonderful idea for a sculpture."[28] The concept of art as commodity, like the ale cans themselves, is thus an integral part of this artwork. Appropriately enough, Castelli did sell the sculpture for $960.

"COMBINING" PAINTING AND SCULPTURE Johns's friend ROBERT RAUSCHENBERG (b. 1925) began using mass-media images in his work in the 1950s. Rauschenberg set out to create works that would be open and indeterminate, and he began by making "combines," which intersperse painted passages with sculptural elements. At times, these works seem to be sculptures with painting incorporated into certain sections; other combines seem to be paintings with three-dimensional objects attached to the surface. In the 1950s, such works contained an array of art reproductions, magazine and newspaper clippings, and passages painted in an Abstract Expressionist style. In the early 1960s, Rauschenberg adopted the commercial medium of silk-screen printing, first in black and white and then in color, and began filling entire canvases with appropriated news images and anonymous

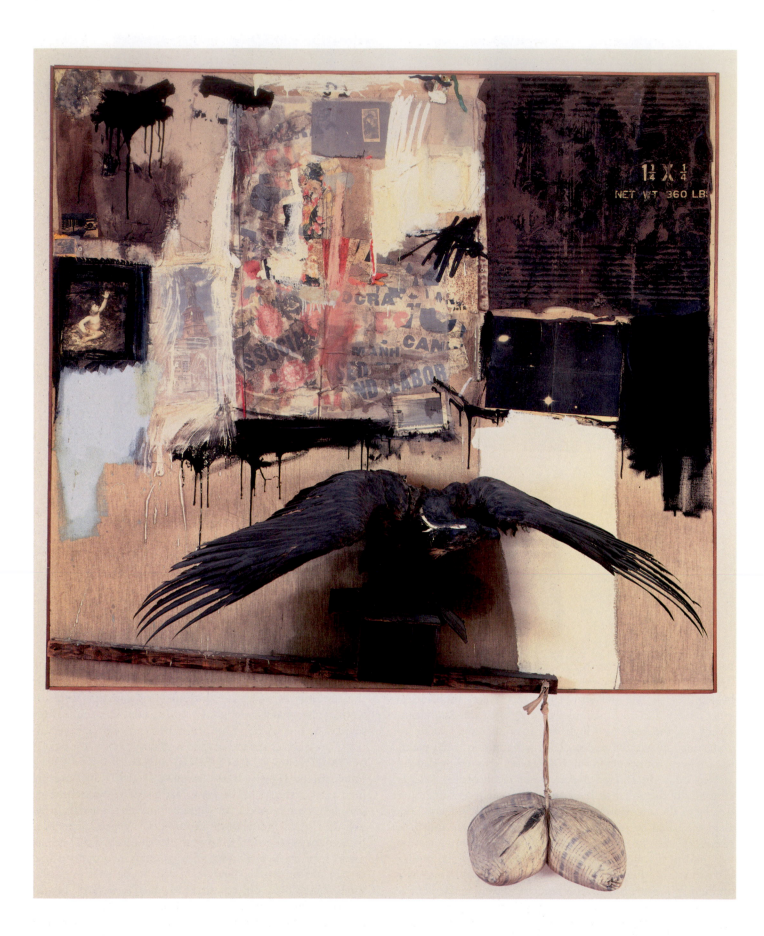

23-26 ROBERT RAUSCHENBERG, *Canyon,* 1959. Oil, pencil, paper, fabric, metal, cardboard box, printed paper, printed reproductions, photograph, wood, paint tube, and mirror on canvas, with oil on bald eagle, string, and pillow, 6′ 9¾″ × 5′ 10″ × 2′. Sonnabend Collection. Copyright © Untitled Press, Inc./Licensed by VAGA, New York.

photographs of city scenes. *Canyon* (FIG. **23-26**) is typical of his combines. Pieces of printed paper and photographs are attached to the canvas. Much of the unevenly painted surface consists of pigment roughly applied in a manner reminiscent of de Kooning's work (FIG. 23-6). A stuffed bald eagle attached to the lower part of the combine spreads its wings as if lifting off in flight toward viewers. Completing the combine, a pillow dangles from a string attached to a wood stick below the eagle. The artist presented the work's components in a jumbled fashion. He tilted or turned some of the images sideways, and each overlays or is invaded by part of another image. The compositional confusion may resemble that in a Dada collage, but the parts of Rauschenberg's combine paintings maintain their individuality more than those in a Schwitters piece (see FIG. 22-27). The various recognizable images and objects appear to be a sequence of visual non sequiturs, and it is virtually impossible to arrive at a consistent reading of a Rauschenberg combine. The eye scans a Rauschenberg canvas much as it might survey the environment on a walk through the city. As John Cage perceptively noted: "There is no more subject in a combine [by Rauschenberg] than there is in a page from a newspaper. Each thing that is there is a subject. It is a situation involving multiplicity."[29]

A "COMIC" FOCUS IN ART As the Pop movement matured, the images became more concrete and tightly controlled. ROY LICHTENSTEIN (1923–1997) turned his attention to the comic book as a mainstay of American popular culture. In paintings such as *Hopeless* (FIG. **23-27**), Lichtenstein excerpted an image from a comic book, a form of entertainment meant to be read and discarded, and immortalized the image in monumental scale. Aside from that

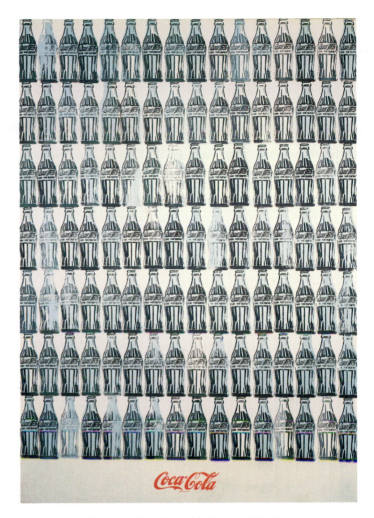

23-28 ANDY WARHOL, *Green Coca-Cola Bottles,* 1962. Oil on canvas, 6′ 10½″ × 4′ 9″. Collection of Whitney Museum of American Art, New York (purchase, with funds from the Friends of the Whitney Museum of American Art).

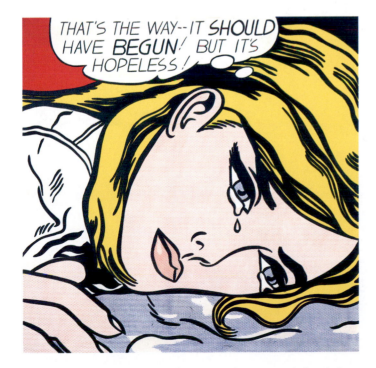

23-27 ROY LICHTENSTEIN, *Hopeless,* 1963. Oil on canvas, 3′ 8″ × 3′ 8″. Kunstmuseum, Basel (permanent loan from the Ludwig Foundation Collection).

modification, Lichtenstein was remarkably faithful to the original comic strip image. First, he selected a melodramatic scene common to the romance comic books that were exceedingly popular at the time. Second, he used the comic strip's visual vocabulary, with its dark black outlines and unmodulated color areas, and retained the familiar square dimensions. Third, Lichtenstein's printing technique, *benday dots,* calls attention to the mass-produced derivation of the image. Named after its inventor, the newspaper printer Benjamin Day, the benday dot system involves the modulation of colors through the placement and size of colored dots. Lichtenstein's work further reinforces the comic book's visual shorthand language.

THE ART OF COMMODITIES The quintessential American Pop artist was ANDY WARHOL (1928–1987). An early successful career as a commercial artist and illustrator grounded Warhol in the sensibility and visual rhetoric of advertising and the mass media, knowledge that proved useful for his Pop art. In paintings such as *Green Coca-Cola Bottles* (FIG. **23-28**), Warhol selected an icon of mass-produced, consumer culture of the time. Despite Coca-Cola's supremacy as

the best-selling cola soft drink in the early 1960s, its manufacturers felt compelled to launch a major advertising campaign to challenge the growing market share of its primary rival, Pepsi-Cola. Warhol's choice of the reassuringly familiar curved Coke bottle thus intersected with the visual imagery American consumers encountered frequently at that time. As Lichtenstein had done with his comic strip images, Warhol also used a visual vocabulary and a printing technique that reinforced the image's connections to consumer culture. The repetition and redundancy of the Coke bottle reflects the omnipresence and dominance of this product in American society. The silk-screen technique (also used by Rauschenberg) allowed Warhol to print the image endlessly. So immersed was Warhol in a culture of mass production that he not only produced numerous canvases of the same image, but he also named his studio "the Factory."

A MYTHICAL CELEBRITY Warhol often produced images of Hollywood celebrities, such as Marilyn Monroe. Like his other paintings, these works emphasize the commodity status of the subjects depicted. Warhol created *Marilyn Diptych* (FIG. **23-29**) in the weeks following the tragic suicide of the movie star in August 1962, capitalizing on the media

frenzy her death prompted. Warhol selected a publicity photo of Monroe, one that provides no insight into the real Norma Jean Baker. Rather, all viewers see is a mask—a persona the Hollywood myth machine generated. The garish colors and the flat application of paint contribute to the image's masklike quality. Like the Coke bottles, the repetition of Monroe's face reinforces her status as a consumer product, her glamorous, haunting visage seemingly confronting viewers endlessly, as it did to the American public in the aftermath of her death. The right half of this work, with its poor registration of pigment, suggests a sequence of film stills, referencing the realm from which Monroe derived her fame.

Warhol's own ascendance to the realm of celebrity underscored his remarkable and astute understanding of mass culture's dynamics and visual language. He predicted that the age of mass media would enable everyone to become famous for fifteen minutes. His own celebrity lasted much longer, long after his death at age fifty-eight in 1987.

SUPERSIZING SCULPTURE Pop artist CLAES OLDEN-BURG (b. 1929) has produced sculptures that have incisively commented on American consumer culture. His early works consisted of plaster reliefs of food and clothing items. Olden-

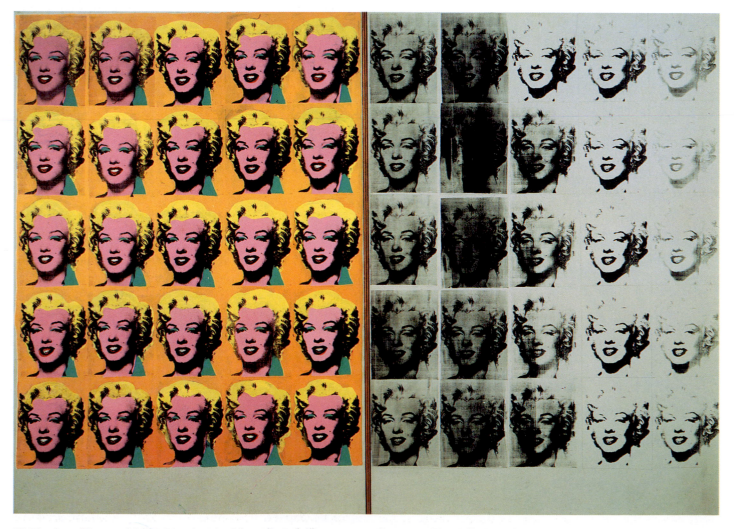

23-29 ANDY WARHOL, *Marilyn Diptych,* 1962. Oil, acrylic, and silk-screen enamel on canvas. Tate Gallery, London.

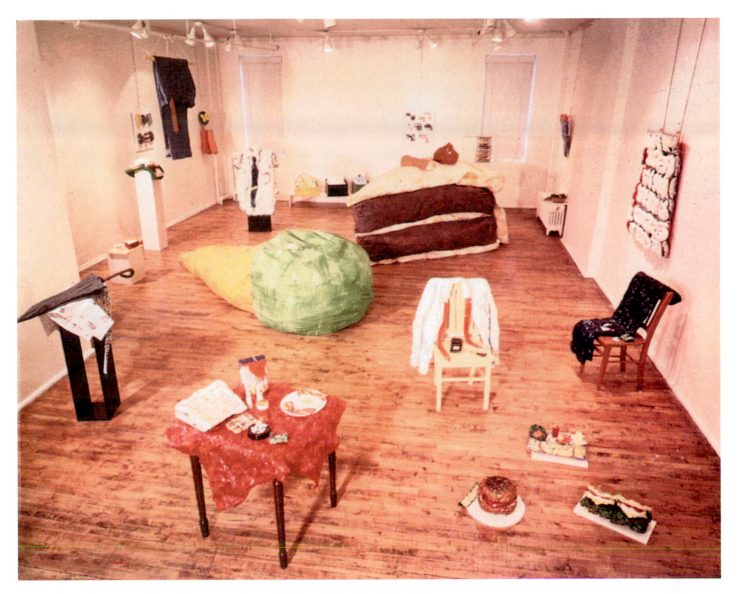

23-30 CLAES OLDENBURG, photo of one-person show at the Green Gallery, New York, 1962.

burg constructed these sculptures of plaster layered on chicken wire and muslin, painting them with cheap commercial house enamel. In later works, focused on the same subjects, he shifted to large-scale stuffed sculptures of sewn vinyl or canvas. Examples of both types of sculptures can be seen in the photograph of a one-person show (FIG. **23-30**) Oldenburg held at the Green Gallery in New York City in 1962. He had included many of the works in this exhibition in an earlier show he mounted titled *The Store*. *The Store,* an installation of Oldenburg's sculptures of consumer products, was an appropriate comment on art's function as a commodity in a consumer society. Over the years, Oldenburg's sculpture has become increasingly monumental. He, along with his wife and collaborator, COOSJE VAN BRUGGEN (b. 1942), are probably best known for the mammoth outdoor sculptures of familiar, commonplace objects, such as cue balls, shuttlecocks, clothespins, and torn notebooks, they have produced over the past few decades.

Superrealism

Like the Pop artists, the Superrealists were interested in finding a form of artistic communication that was more accessible to the public than the remote, unfamiliar visual language of the Abstract Expressionists or the Post-Painterly Abstractionists. The Superrealists expanded Pop's iconography in both painting and sculpture by making images in the late 1960s and 1970s involving scrupulous photographic fidelity to optical fact. Because many Superrealists used photographs as sources for their imagery, people also referred to the Superrealist painters as Photorealists. These artists reproduced in minute and unsparing detail the commonplace facts and artifacts that Pop art addressed.

EXPLORING "PHOTO-VISION" American artist AUDREY FLACK (b. 1931) was one of the movement's pioneers.

23-31 AUDREY FLACK, *Marilyn,* 1977. Oil over acrylic on canvas, 8′ × 8′. Collection of the University of Arizona Museum, Tucson (museum purchase with funds provided by the Edward J. Gallagher, Jr. Memorial Fund).

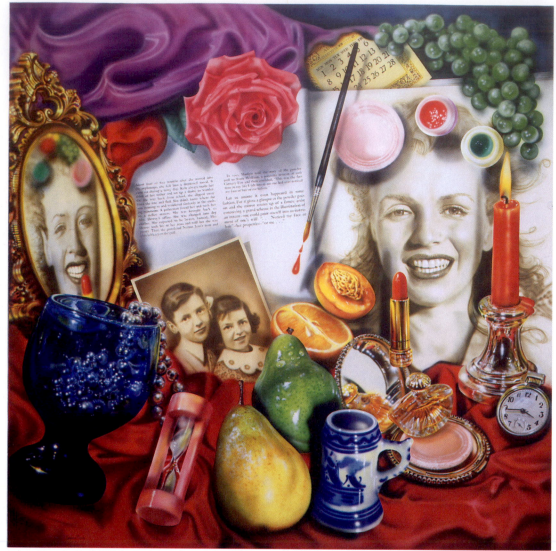

Her paintings, such as *Marilyn,* FIG. **23-31**, were not simply technical exercises but were also conceptual inquiries into the nature of photography and the extent to which photography constructs an understanding of reality. Flack noted: "[Photography is] my whole life, I studied art history, it was always photographs, I never saw the paintings, they were in Europe. . . . Look at TV and at magazines and reproductions, they're all influenced by photo-vision."[30] The photograph's formal qualities also intrigued her, and she used photographic techniques by first projecting an image in slide form onto the canvas. By next using an airbrush (a device originally designed as a photo-retouching tool), Flack could duplicate the smooth gradations of tone and color found in photographs. Her attention to detail and careful preparation resulted in paintings (mostly still lifes) that present viewers with a collection of familiar objects painted with great optical fidelity. *Marilyn* provides a different comment on the tragic death of Marilyn Monroe than does Warhol's *Marilyn Diptych* (FIG. 23-29). In Flack's still-life painting, she alludes to the traditional vanitas painting (see FIG. 19-54). As in Dutch vanitas paintings, *Marilyn* is replete with references to death. In addition to the black-and-white photographs of a youthful, smiling Monroe, fresh fruit (some of it cut), an hourglass, a burning candle, a

watch, and a calendar all refer to the passage of time and the transience of life on earth.

LARGE-SCALE PORTRAITS American artist CHUCK CLOSE (b. 1940), best known for his large-scale portraits, is another artist whose work has been associated with the Superrealist movement. However, Close felt his connection to the Photorealists was limited, because for him realism, rather than an end in itself, was actually the result of an intellectually rigorous, systematic approach to painting. He based his paintings of the late 1960s and early 1970s, such as his *Big Self-Portrait* (FIG. **23-32**), on photographs, and his main goal was to translate photographic information into painted information. Because he aimed simply to record visual information about his subject's appearance, he deliberately avoided creative compositions, flattering lighting effects, and revealing facial expressions. Close, not interested in providing great insight into the personalities of those portrayed, painted anonymous and generic people, mostly friends. By reducing the variables in his paintings (even their canvas sizes are a constant nine feet by seven feet), Close could focus on employing his methodical presentations of faces, thereby encouraging viewers to deal with his works' formal aspects. Indeed, be-

cause of the large scale of the artist's paintings, close scrutiny causes the images to dissolve into abstract patterns.

CASTS OF STEREOTYPICAL AMERICANS Superrealist sculpture has been best articulated in the work of DUANE HANSON (1925–1996). Like many of the other Superrealists, Hanson was interested in finding a visual vocabulary the public would understand. Once he perfected his casting technique, he created numerous life-size figurative sculptures. Hanson first made plaster molds from live models. He then filled the molds with polyester resin. After the resin hardened, the artist removed the outer molds and cleaned, painted with an airbrush, and decorated the sculptures with wigs, clothes, and other accessories. These works, such as *Supermarket Shopper* (FIG. **23-33**), depict stereotypical average Americans, striking chords with viewers specifically because of their familiarity. Hanson explained his choice of imagery: "The subject matter that I like best deals with the familiar lower and middle-class American types of today. To me, the resignation, emptiness and loneliness of their existence captures the true reality of life for these people. . . . I want to achieve a certain tough realism which speaks of the fascinating idiosyncracies of our time."[31] Due to Hanson's choice of imagery and careful production process, viewers often initially mistake his sculptures, when on display, for real people, accounting for his association with the Superrealist movement.

23-33 DUANE HANSON, *Supermarket Shopper,* 1970. Polyester resin and fiberglass polychromed in oil, with clothing, steel cart, and groceries, life-size. Nachfolgeinstitut, Neue Galerie, Sammlung Ludwig, Aachen.

23-32 CHUCK CLOSE, *Big Self-Portrait,* 1967–1968. Acrylic on canvas, 8′ 11″ × 6′ 11″ × 2″. Collection Walker Art Center, Minneapolis (Art Center Acquisition Fund, 1969).

Site-Specific Art and Environmental Art

Environmental art, sometimes called Earth art or earthworks, emerged in the 1960s and included a wide range of artworks, most site specific and existing outdoors. Many artists associated with these sculptural projects also used natural or organic materials, including the land itself. This art form developed during a period of increased concern for the American environment. The ecology movement of the 1960s and 1970s aimed to publicize and combat escalating pollution, depletion of natural resources, and the dangers of toxic waste. The problems of public aesthetics (for example, litter, urban sprawl, and compromised scenic areas) were also at issue. Widespread concern about the environment led to the passage of the National Environmental Policy Act in 1969 and the creation of the federal Environmental Protection Agency. Environmental artists used their art to call attention to the landscape and, in so doing, were part of this national dialogue.

As an innovative art form that challenged traditional assumptions about art making and artistic models, Environmental art clearly had an avant-garde, progressive dimension. It is discussed here with the more populist art movements such as Pop and Superrealism, however, because these artists insisted on moving art out of the rarefied atmosphere of museums and galleries and into the public sphere. Most Environmental artists encouraged spectator interaction with the works. Environmental artists such as Christo and Jeanne-Claude, whose work matured in the context of Nouveaux Realisme, a European version of Pop art, made audience participation an integral part of their works. Thus these artists, like the Pop artists and Superrealists, intended their works to

connect with a larger public. Ironically, the remote locations of many earthworks have limited public access.

THE ENDURING POWER OF NATURE

A leading American Environmental artist was ROBERT SMITHSON (1938–1973), who used industrial construction equipment to manipulate vast quantities of earth and rock on isolated sites. One of Smithson's best-known pieces is *Spiral Jetty* (FIG. **23-34**), a mammoth coil of black basalt, limestone rocks, and earth that extends out into Great Salt Lake in Utah. Driving by the lake one day, Smithson came across some abandoned mining equipment, left there by a company that had tried and failed to extract oil from the site. Smithson saw this as a testament to the enduring power of nature and to humankind's inability to conquer nature. He decided to create an artwork in the lake that ultimately became a monumental spiral curving out from the shoreline and running fifteen hundred linear feet into the water. Smithson insisted on designing his work in response to the location itself; he wanted to avoid the arrogance of an artist merely imposing an unrelated concept on the site. The spiral idea grew from Smithson's first impression of the location:

As I looked at the site, it reverberated out to the horizons only to suggest an immobile cyclone while flickering light made the entire landscape appear to quake. A dormant earthquake spread into the fluttering stillness, into a spinning sensation without movement. The site was a rotary that enclosed itself in an immense roundness. From that gyrating space emerged the possibility of the Spiral Jetty.[32]

The appropriateness of the spiral forms was reinforced when, while researching Great Salt Lake, Smithson discovered that the molecular structure of the salt crystals that coat the rocks at the water's edge is spiral in form. Smithson not only recorded *Spiral Jetty* in photographs, but also he filmed its construction in a movie that describes the forms and life of the whole site. The photographs and film have become increasingly important, because fluctuations in the Great Salt Lake's water level often place *Spiral Jetty* underwater.

SCULPTURE AS VOID

Although MICHAEL HEIZER (b. 1944) does not consider himself an Environmental artist, many of his sculptures do involve the landscape. One

23-34 ROBERT SMITHSON, *Spiral Jetty,* 1970. Black rock, salt crystals, earth, red water (algae) at Great Salt Lake, Utah. 1,500′ × 15′ × 3½′. Estate of Robert Smithson; courtesy James Cohan Gallery, New York; collection of DIA Center for the Arts, New York.

23-35 MICHAEL HEIZER, *Double Negative*, near Overton, Nevada, 1969–1970. 1,500′ × 50′ × 30′. Photo, Museum of Contemporary Art, Los Angeles.

such work, *Double Negative* (FIG. **23-35**), consists of two massive cuts in the Mormon Mesa near Overton, Nevada. Using earthmoving equipment, Heizer had each of these cuts, facing each other across a deep indentation in the cliflike ridge, excavated to a depth of fifty feet. Each cut is thirty feet wide, and the entire length of the piece is fifteen hundred feet. Thus, the sculpture exists purely as a void— space as opposed to mass or volume. While most monumental sculpture traditionally confronts viewers with a large mass, this sculpture literally allows visitors to be inside the work. Unfortunately, *Double Negative's* geographic remoteness does not permit many people to experience it; photographs in a New York gallery brought the sculpture to public attention in early 1970. Heizer, however, emphasized artistic rather than ecological issues. The conceptualization, scale, and location of this work force viewers to reconsider the nature of sculpture and to reevaluate their relationship to the land.

THE ART OF WRAPPING Like Heizer, CHRISTO JAVACHEFF and JEANNE-CLAUDE DE GUILLEBON, known as CHRISTO and JEANNE-CLAUDE (both b. 1935), intensify view-

ers' awareness of the space and features of natural and urban sites. However, rather than physically alter the land itself, as Heizer did, Christo and Jeanne-Claude prompt this awareness by modifying the landscape with cloth. Their pieces also incorporate the relationships among human sociopolitical action, art, and the environment. Christo studied art in his native Bulgaria and in Vienna. After a move to Paris, he began to encase objects in clumsy wrappings, thereby appropriating bits of the real world into the mysterious world of the unopened package whose contents can be dimly seen in silhouette under the wrap. In the 1970s, Christo and Jeanne-Claude, husband and wife, began to collaborate on large-scale projects.

Turning their attention to the environment, they created giant "air packages" in Minneapolis and Germany. Then they dealt with the land itself, carrying out projects such as wrapping more than a million square feet of Australian coast and hanging a vast curtain across a valley at Rifle Gap, Colorado. The land pieces required years of preparation, research, and scores of meetings with local authorities and interested groups of local citizens. The artists always considered the planning, the process of obtaining the numerous permits, and the visual documentation of each piece part of the artwork. These

23-36 CHRISTO and JEANNE-CLAUDE, *Surrounded Islands,* Biscayne Bay, Greater Miami, Florida, 1980–1983. Pink woven polypropylene fabric, $6\frac{1}{2}$ million sq. ft.

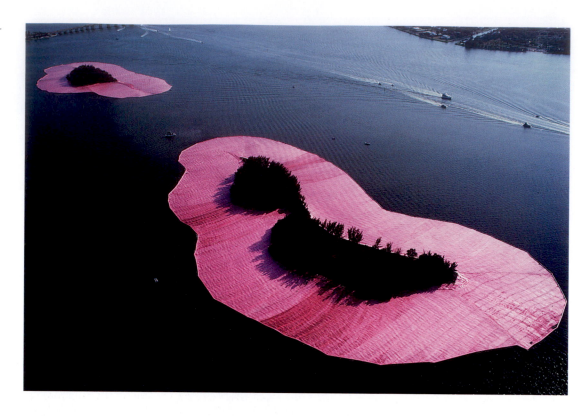

temporary works were usually on view for a few weeks. *Surrounded Islands* (FIG. **23-36**), created in Biscayne Bay in Miami, Florida, for two weeks in May 1983, typified Christo and Jeanne-Claude's work. For this project, they surrounded eleven small humanmade islands in the bay (from a dredging project) with specially fabricated pink polypropylene fabric.

This Environmental art project required two years of preparation to obtain the required permissions, to assemble the necessary labor force of unskilled and professional workers, and to raise the $3.2 million cost (accomplished by selling preliminary drawings, collages, and models). Huge crowds watched as crews stripped accumulated trash from the islands (to assure maximum contrast between their dark colors, the pink of the cloth, and the blue of the bay) and then unfurled the fabric "cocoons" to form magical floating "skirts" around each tiny bit of land. Despite the brevity of its existence, *Surrounded Islands* lives on in the host of photographs, films, and books documenting the piece.

A MASSIVE WALL OF STEEL While many works placed in the public domain (such as the Environmental artworks just discussed) sought to reawaken an appreciation of the land's power and beauty and to call attention to ecological problems, other artworks focused attention on art's role in public spaces. One sculpture that sparked national discussion about such art was *Tilted Arc* (FIG. **23-37**) by American artist RICHARD SERRA (b. 1939). It was commissioned by the General Services Administration (GSA), the federal agency responsible for, among other tasks, overseeing the selection and installation of artworks for government buildings. This enormous one hundred twenty foot curved wall of Cor-Ten steel stood twelve feet high and bisected the plaza in front of the Jacob K. Javits Federal Building in lower Manhattan. Serra situated the sculpture to significantly alter the space of the open plaza and the traffic flow across the square. This site-specific sculpture, the artist explained, was intended to

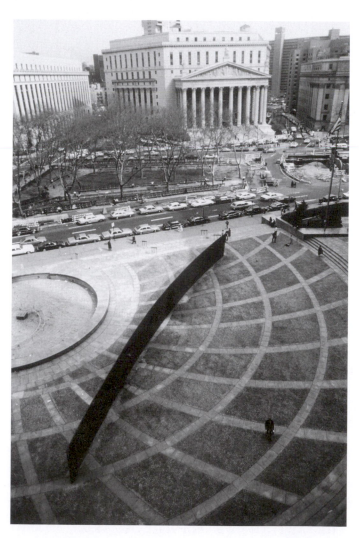

23-37 RICHARD SERRA, *Tilted Arc,* 1981. Cor-Ten steel, $12' \times 120' \times 2\frac{1}{2}''$. Installed Federal Plaza, New York City by the General Services Administration, Washington D.C. Destroyed by the U.S. Government 1989.

Tilted Arc and the Problems of Public Art

When *Tilted Arc* (FIG. 23-37) was installed in the plaza in front of the Jacob K. Javits Federal Building in 1981, much of the public immediately responded with hostile criticism. The chorus of complaints was prompted by the Minimalist sculpture's resolute and uncompromising presence bisecting the plaza. Many voiced the beliefs that *Tilted Arc* was ugly and attracted graffiti, that it interfered with the view across the plaza, and that it prevented using the plaza for performances or concerts. Due to the sustained barrage of protests and petitions demanding the removal of *Tilted Arc*, the GSA held a series of public hearings. Afterward, the agency decided to remove the sculpture despite its prior approval of Serra's maquette. This, understandably, infuriated Serra, who had a legally binding contract acknowledging the work's site-specific nature. "To remove the work is to destroy the work," the artist stated.[1]

This episode raised intriguing issues about the nature of public art, including the public reception of experimental art, the artist's responsibilities and rights when executing public commissions, censorship in the arts, and public art's purpose. If an artwork is placed in a public space outside the relatively private confines of a museum or gallery, do different guidelines apply? As one participant in the *Tilted Arc* saga asked, "Should an artist have the right to impose his values and taste on a public that now rejects his taste and values?"[2] One of the express functions of the historical avant-garde was to challenge convention by rejecting tradition and disrupting view-

ers' complacency. Will placing experimental art in a public place always cause controversy? From Serra's statements, it is clear he intended the sculpture to challenge the public.

Another issue *Tilted Arc* presented involved the rights of the artist, who in this case accused the GSA of censorship. Serra went so far as to file a lawsuit against the government for infringement of his First Amendment rights and insisted "the artist's work must be uncensored, respected, and tolerated, although deemed abhorrent, or perceived as challenging, or experienced as threatening."[3] Did removal of the work constitute censorship? A federal district court held that it did not.

Ultimately, who should decide what artworks are appropriate for the public arena? One artist argued, "we cannot have public art by plebiscite [popular vote]."[4] But to avoid recurrences of the *Tilted Arc* controversy, the GSA changed its procedures and now solicits input from a wide range of civic and neighborhood groups before commissioning public artworks. Despite the removal of *Tilted Arc* (now languishing in storage), the sculpture maintains a powerful presence in all discussions of the aesthetics, politics, and dynamics of public art.

[1] Grace Glueck, "What Part Should the Public Play in Choosing Public Art?" *New York Times*, 3 February 1985.

[2] Calvin Tomkins, "The Art World: Tilted Arc," *New Yorker*, 20 May 1985, 98.

[3] Ibid., 98–99.

[4] Ibid., 98.

"dislocate or alter the decorative function of the plaza and actively bring people into the sculpture's context."[33] By creating such a monumental presence in this large public space, Serra succeeded in forcing viewers to reconsider the plaza's physical space as a sculptural form (see "Tilted Arc and the Problems of Public Art," above).

NEW MODELS FOR ARCHITECTURE: MODERNISM TO POSTMODERNISM

Modernism

The progressive movement toward formal abstraction in media such as painting and sculpture during the twentieth century has been chronicled. In similar fashion, modernist architects became increasingly concerned with a formalism that stressed simplicity. They articulated this in buildings that retained intriguing organic sculptural qualities, as well as in buildings that adhered to a more rigid geometry.

SCULPTING A CONCRETE SPIRAL Frank Lloyd Wright, who described his architecture as "organic," ended

his long, productive career with his design for the Solomon R. Guggenheim Museum (FIGS. **23-38** and **23-39**), built in New York City between 1943 and 1959. Using reinforced concrete almost as a sculptor might use resilient clay, Wright designed a structure inspired by the spiral of a snail's shell.

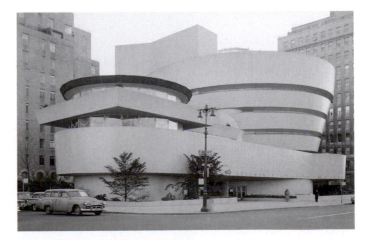

23-38 FRANK LLOYD WRIGHT, Solomon R. Guggenheim Museum (exterior view from the north), New York, 1943–1959 (photo 1962).

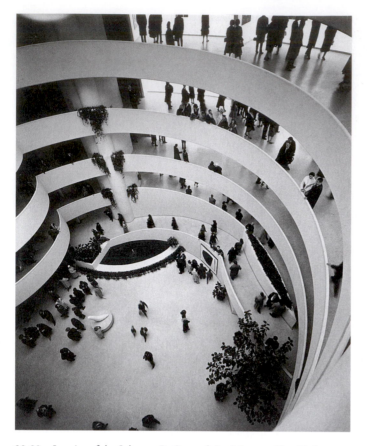

23-39 Interior of the Solomon R. Guggenheim Museum, New York, 1943–1959.

Wright had introduced curves and circles into some of his plans in the 1930s, and, as the architectural historian Peter Blake noted, "The spiral was the next logical step; it is the circle brought into the third and fourth dimensions."[34] Inside the building (FIG. 23-39), the shape of the shell expands toward the top, and a winding interior ramp spirals to connect the gallery bays, which are illuminated by a skylight strip embedded in the museum's outer wall. Visitors can stroll up the ramp or take an elevator to the top of the building and proceed down the gently inclined walkway, viewing the artworks displayed along the path. Thick walls and the solid organic shape give the building, outside and inside, the sense of turning in on itself. Moreover, the long interior viewing area opening onto a ninety-foot central well of space seems a sheltered environment, secure from the bustling city outside.

FUSING ARCHITECTURE AND SCULPTURE
The startling organic forms of Le Corbusier's Notre Dame du Haut (FIGS. **23-40** and **23-41**), completed in 1955 at Ronchamp, France, present viewers with a fusion of architecture and sculpture in a single expression. The architect designed this small chapel on a pilgrimage site in the Vosges Mountains to replace a building destroyed in World War II. The monumental impression of Notre Dame du Haut seen from afar is somewhat deceptive. Although one massive exterior wall contains a pulpit facing a spacious outdoor area for large-scale open-air services on holy days, the interior holds at most two hundred people. The intimate scale, stark and

23-40 LE CORBUSIER, Notre Dame du Haut, Ronchamp, France, 1950–1955.

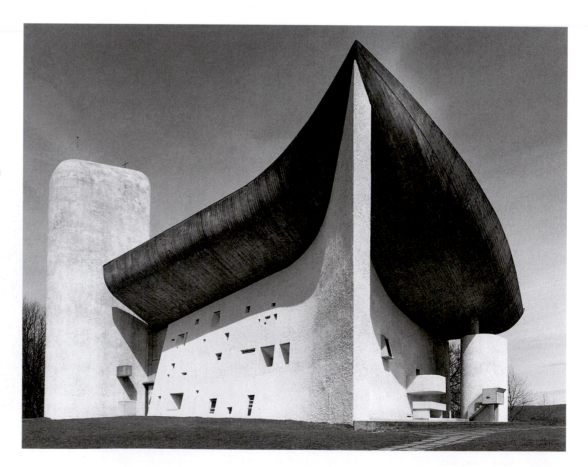

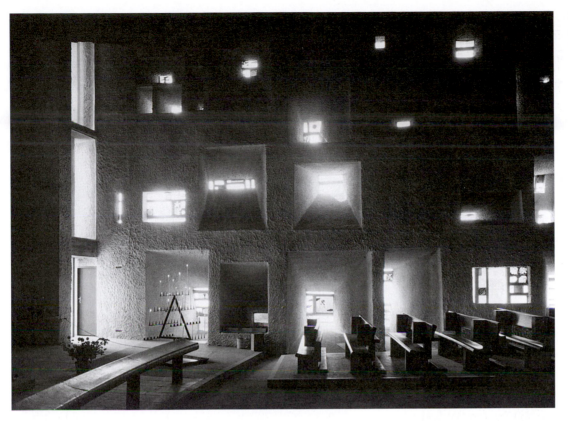

23-41 Interior of Notre Dame du Haut, Ronchamp, France, 1950–1955.

heavy walls, and mysterious illumination (jewel tones cast from the deeply recessed stained-glass windows) give this space (FIG. 23-41) an aura reminiscent of a sacred cave or a medieval monastery.

Notre Dame du Haut's structure may look free form to the untrained eye, but Le Corbusier actually based it, like the medieval cathedral, on an underlying mathematical system. The fabric was formed from a frame of steel and metal mesh, which was sprayed with concrete and painted white, except for two interior private chapel niches with colored walls and the roof, left unpainted to darken naturally with the passage of time. The roof appears to float freely above the sanctuary, intensifying the quality of mystery in the interior space. In reality, the roof is elevated above the walls on a series of nearly invisible blocks. Le Corbusier's preliminary sketches for the building indicate he linked the design with the shape of praying hands, with the wings of a dove (representing both peace and the Holy Spirit), and with the prow of a ship (a reminder that the Latin word used for the main gathering place in Christian churches is *nave,* meaning "ship"). The artist envisioned that in these powerful sculptural solids and voids, human beings could find new values—new interpretations of their sacred beliefs and of their natural environments.

SITE-SENSITIVE BUILDING METAPHORS The opera house in Sydney, Australia (FIG. **23-42**), designed by the Danish architect JOERN UTZON (b. 1918) in 1959, is a bold composition of organic forms on a colossal scale. Utzon worked briefly with Frank Lloyd Wright at Taliesin (Wright's Wisconsin residence), and the style of the Sydney Opera House resonates distantly with the Guggenheim Museum's graceful curvature. Two clusters of immense concrete shells rise from massive platforms and soar to delicate peaks. Utzon was especially taken with the platform architecture of Mesoamerica. Recalling at first the ogival shapes of Gothic vaults, the shells also suggest both the buoyancy of seabird wings and the sails of the tall ships that brought European settlers to Australia in the eighteenth and nineteenth centuries. These architectural metaphors are appropriate to the harbor surrounding Bennelong Point, whose bedrock foundations support the building. Utzon's matching of the structure with its site and atmosphere adds to the organic nature of this construction.

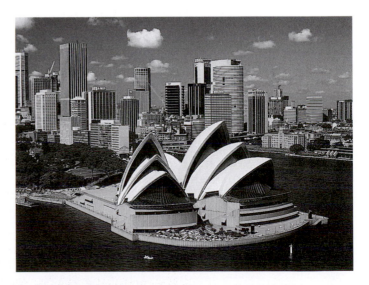

23-42 JOERN UTZON, Sydney Opera House, Sydney, Australia, 1959–1972. Reinforced concrete; height of highest shell, 200'.

23-43 EERO SAARINEN, TWA terminal, Kennedy Airport, New York, 1956–1962.

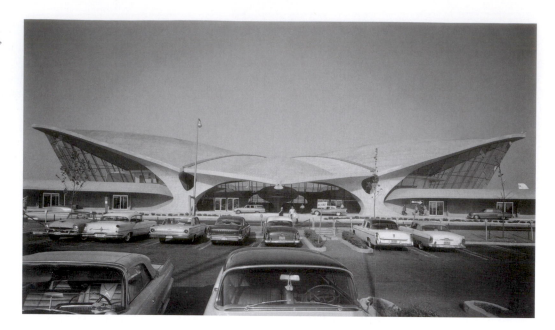

The building is not only a monument of civic pride but also functions as the city's cultural center. In addition to the opera auditorium giving the structure its name, it houses auxiliary halls and rooms for concerts, the performing arts, motion pictures, lectures, art exhibitions, conventions, and all other modern cultural activities.

Begun in 1959 and only completed in 1972, the facility took a long time to realize. From the beginning, Utzon's controversial design required unavailable constructional technology to meet the requirements of its daring innovations. Utzon left the project in 1966, and Australian architects completed it in 1972. Today it is accepted as Sydney's defining symbol.

CAPTURING MOTION IN CONCRETE Finnish-born architect EERO SAARINEN (1910–1961), responsible for selecting Utzon as the architect for the Sydney Opera House, designed his own version of the curvilinear shell building in the late 1950s. Saarinen based his design of the Trans World Airlines terminal (FIG. **23-43**) at the Kennedy Airport in New York on the theme of motion. It consists of two immense concrete shells split down the middle and slightly rotated, giving the terminal a fluid curved outline that fits its corner site. The shells immediately suggest expansive wings and flight. The architect designed everything on the interior, including the furniture, ventilation ducts, and signboards, with this same curvilinear vocabulary in mind.

From the mid-1950s through the 1970s, other architects created massive, sleek, and geometrically rigid buildings. They designed most of these structures following Mies van der Rohe's contention that "less is more," and the architecture presented pristine, authoritative faces to the public. Appropriately, such buildings and the powerful, heroic presence they exuded symbolized the monolithic corporations often inhabiting them.

A GLASS TOWER The "purest" example of these corporate skyscrapers is, undoubtedly, the rectilinear glass and bronze tower in Manhattan (FIG. **23-44**) designed for the

23-44 LUDWIG MIES VAN DER ROHE and PHILIP JOHNSON, Seagram Building, New York, 1956–1958.

23-45 SKIDMORE, OWINGS AND MERRILL, Sears Tower, Chicago, 1974 (photo 1975).

ONCE THE TALLEST IN THE WORLD The architectural firm Skidmore, Owings and Merrill (SOM) can be seen as the purest proponent of Miesian-inspired structures. This firm designed a number of these simple rectilinear glass-sheathed buildings, and its growth indicates the popularity of this building type. By 1970, SOM comprised more than one thousand architects and had offices in New York, Chicago, San Francisco, Portland, and Washington, D.C. In 1974 the firm completed the Sears Tower (FIG. **23-45**), a mammoth corporate building in Chicago. Consisting of nine clustered tubes soaring vertically, this one hundred ten floor building contains enough room to support more than twelve thousand workers. Original plans called for one hundred four stories, but the architects acquiesced to Sears's insistence on making the building the tallest (measured to the structural top) in the world, a distinction it held until recently. The tower's size, coupled with the black aluminum which sheathes it and the smoked glass, give it an intimidating appearance, appropriate for the imposing image corporations were trying to project.

Postmodernism

The restrictiveness of modernist architecture and the impersonality and sterility of many of these rectilinear corporate buildings led to a rejection of modernism's authority in architecture. Along with the apparent lack of responsiveness to the unique character of the cities and neighborhoods where the structures were placed, these reactions ushered in postmodernism. In contrast to the simplicity of modernist architecture, the terms most often invoked to describe postmodern architecture are *pluralism, complexity,* and *eclecticism*. Where the modernist program was reductive, the postmodern vocabulary of the 1970s and 1980s was expansive and inclusive.

Among the first to explore this new direction in architecture were Jane Jacobs (b. 1916) and Robert Venturi (see FIG. 23-49). In their influential books *The Death and Life of Great American Cities* (Jacobs, 1961) and *Complexity and Contradiction in Architecture* (Venturi, 1966), both argued that the uniformity and anonymity of modernist architecture (in particular, the corporate skyscrapers dominating many urban skylines) are unsuited to human social interaction and that diversity is the great advantage of urban life. Postmodern architecture accepted, indeed embraced, the messy and chaotic nature of urban life.

Further, when designing these varied buildings, many postmodern architects consciously selected past architectural elements or references and juxtaposed them to contemporary elements or fashioned them of high-tech materials, thereby creating a dialogue between past and present. Postmodern architecture incorporated not only traditional architectural references but references to mass culture and popular imagery as well. This was precisely the "complexity and contradiction" Venturi referred to in the title of his book. Venturi wrote:

> Architects can no longer afford to be intimidated by the puritanically moral language of orthodox Modern architecture. . . . A valid architecture evokes many levels of meaning and combinations of focus; its space and its elements become readable and workable in several ways at once.[35]

Seagram Company by Mies van der Rohe and American architect PHILIP JOHNSON (b. 1906). By the time this structure was built (1956–1958), the concrete, steel, and glass towers, pioneered in the works of Louis Sullivan (see FIG. 21-59) and in Mies van der Rohe's own model for glass skyscrapers (see FIG. 22-63), had become a familiar sight in cities all over the world. Appealing in its structural logic and clarity, the style, although often vulgarized, was easily imitated and quickly became the norm for postwar commercial high-rise buildings. The Seagram structure's architects deliberately designed it as a thin shaft, leaving the front quarter of its midtown site as an open pedestrian plaza. The tower appears to rise from the pavement on stilts; glass walls even surround the recessed lobby. The building's recessed structural elements make it appear to have a glass skin, interrupted only by the thin strips of bronze anchoring the windows. The bronze metal and the amber glass windows give the tower a richness found in few of its neighbors. Mies van der Rohe and Johnson carefully planned every detail of the Seagram Building, inside and out, to create an elegant whole. They even planned the interior and exterior lighting to make the edifice an impressive sight both day and night.

JUXTAPOSING PAST AND PRESENT A clear example of the eclecticism and the dialogue between traditional and contemporary elements found in postmodern architecture is the Piazza d'Italia (FIG. **23-46**) by American architect CHARLES MOORE (1925–1993). Designed in the late 1970s in New Orleans, the Piazza d'Italia is an open plaza dedicated to the city's Italian-American community. Appropriately, Moore selected elements relating specifically to Italian history, all the way back through ancient Roman culture.

Backed up against a contemporary high-rise and set off from urban traffic patterns, the Piazza d'Italia can be reached on foot from three sides through gateways of varied design. The approaches lead to an open circular area partially formed by short segments of colonnades arranged in staggered concentric arcs, which direct the eye to the composition's focal point—an exedra. This recessed area on a raised platform serves as a rostrum during the annual festivities of Saint Joseph's Day. Moore inlaid the Piazza's pavement with a map of Italy that centrally places Sicily, the island of origin of the Italian colony's majority. From there, the map's Italian "boot" moves in the direction of the steps that ascend the rostrum and geographically correspond to the Alps.

The Piazza's most immediate historical reference is to the Greek agora or the Roman forum (see FIG. 7-41). However, its circular form alludes to the ideal geometric figure of the Renaissance (see FIG. 17-8). The irregular placement of the concentrically arranged colonnade fragments inserts a note of instability into the design reminiscent of Mannerism (see FIG.

23-47 PHILIP JOHNSON and JOHN BURGEE with Simmons Architects, associated architects, a model of the AT&T Building, New York, 1978–1984.

17-26). Illusionistic devices, such as the continuation of the Piazza's pavement design (apparently through a building and out into the street), are Baroque in character (see FIG. 19-6). All of the classical orders are represented—most with whimsical modifications. Modern features, nevertheless, challenge the Piazza's historical character, such as the stainless-steel columns and capitals, neon collars around the column necks, and various parts of the exedra framed with neon lights.

In sum, Moore designed the Piazza d'Italia as a complex conglomeration of symbolic, historical, and geographic allusions—some overt and others obscure. Although the Piazza's specific purpose was to honor the Italian community of New Orleans, its more general purpose was to revitalize an urban area by becoming a focal point and an architectural setting for the social activities of neighborhood residents.

A MODERNIST EMBRACES POSTMODERNISM Even architects instrumental in the proliferation of the modernist idiom embraced postmodernism. Philip Johnson made one of the most startling shifts of style in twentieth-century architecture, eventually moving away from the Seagram Building's severe geometric formalism to a classicizing transformation of it in his AT&T (American Telephone and Telegraph) Building in New York City (FIG. **23-47**). Architect

23-46 CHARLES MOORE, Piazza d'Italia, New Orleans, Louisiana, 1976–1980.

JOHN BURGEE codesigned it with assistance from Simmons Architects. This structure was influential in turning architectural taste and practice away from modernism and toward postmodernism—from organic "concrete sculpture" and the rigid "glass box" to elaborate shapes, motifs, and silhouettes freely adapted from historical styles.

The six hundred sixty foot-high slab of the AT&T Building is wrapped in granite. In contrast to the modernist glass-sheathed skyscrapers, Johnson reduced the window space to some thirty percent of the building. His design of its exterior elevation is classically tripartite, having an arcaded base and arched portal; a tall, shaftlike body segmented by slender *mullions* (vertical elements dividing a window); and a crowning pediment broken by an *orbiculum* (a disclike opening). The arrangement refers to the base/column/entablature system of ancient Greek structures and Renaissance elevations (see FIGS. 5-42 and 16-43). More specifically, the pediment, indented by the circular space, resembles the crown of a typical eighteenth-century Chippendale high chest of drawers, familiar as "colonial" in any furniture store. It rises among the monotonously flat-topped glass towers of the New York skyline as an ironic rebuke to the rigid uniformity of modernist architecture. Critics favoring modernism were not at all amused, and controversy raged over the design's legitimacy and integrity. The AT&T Building's originality and bold departure from convention, however, seem related to the much earlier, and now respected, Chrysler Building (see FIG. 22-66).

AN "ENLARGED JUKEBOX"? Philip Johnson at first endorsed, then disapproved of, a building that rode considerably farther on the wave of postmodernism than did his AT&T tower. The Portland (Oregon) Building (FIG. **23-48**), the much smaller work of American architect MICHAEL GRAVES (b. 1934), reasserts the wall's horizontality against the verticality of the tall, fenestrated shaft. Graves favored the square's solidity and stability, making it the main body of his composition (echoed in the windows), resting upon a wider base and carrying a set-back penthouse crown. Narrow vertical windows tying together seven stories open two paired facades. These support capital-like large hoods on one pair of opposite facades and a frieze of stylized Baroque roundels tied by bands on the other pair. A huge painted keystone motif joins five upper levels on one facade pair, and painted surfaces further define the building's base, body, and penthouse levels.

The assertion of the wall, the miniature square windows, and the painted polychromy define the surfaces as predominately mural and carry a rather complex symbolic program. The modernist purist surely would not welcome either ornamental wall, color painting, or symbolic reference. These features, taken together, raised an even greater storm of criticism than that which greeted the Sydney Opera House or the AT&T Building. Various critics denounced Graves's Portland Building as "an enlarged jukebox," an "oversized Christmas package," a "marzipan monstrosity," a "histrionic masquerade," and a kind of "pop surrealism." Yet others approvingly noted its classical references as constituting a "symbolic temple" and praised the building as a courageous architectural adventure. City officials and citizens joined architectural critics in commending or blaming Graves. At present, historians regard the Portland Building, like the AT&T tower, as an early marker of postmodernist innovation.

23-48 MICHAEL GRAVES, The Portland Building, Portland, 1980.

23-49 ROBERT VENTURI, JOHN RAUCH AND SCOTT BROWN house in Delaware (west elevation), 1978–1983.

VINDICATING ARCHITECTURAL POPULISM It is important to note here the public's widening participation in the judging of new architecture, indicating an increasing awareness of the new, popular uses of the urban environment. Many observers of architectural developments have expressed the feeling that building design is none the worse for borrowing from the lively, if more-or-less garish, language of pop culture. The night-lit dazzle of entertainment sites such as Las Vegas, or the carnival colors, costumes, and fantasy of theme park props, might just as well serve as inspiration for the designers of civic architecture. ROBERT VENTURI (b. 1925) codified these ideas in his publication *Learning from Las Vegas* (1972). The Portland Building appeared to many viewers a vindication of architectural populism against the pretension of modernist elitism.

Venturi's own designs for houses show him adapting historical as well as contemporary styles to suit his symbolic and expressive purpose. A fundamental axiom of modernism is that a building's form must arise directly and logically from its function and structure. Against this rule, Venturi asserted that the form should be separate from the function and structure and that decorative and symbolic forms of everyday life should enwrap the structural core. Thus, for a Delaware residence (FIG. **23-49**) designed in 1978, with JOHN RAUCH and DENISE SCOTT BROWN, Venturi respected the countryside setting and its eighteenth-century history by recalling the stone-based barnlike, low-profile farm dwellings with their shingled roofs and double-hung multipaned windows. He fronted the house with an amusingly "cut-out" and asymmetrical parody of a Neoclassical portico. A building by Venturi is, in his own words, a kind of "decorated shed."

MAKING "METABOLISM" VISIBLE In Paris, the short-lived partnership of British architect RICHARD ROGERS (b. 1933) and Italian architect RENZO PIANO (b. 1937) involved using motifs and techniques from ordinary industrial buildings in their design for the Georges Pompidou National Center of Art and Culture, known popularly as the

"Beaubourg" (FIG. **23-50**), in Paris. The anatomy of this six-level building, which opened in 1977, is fully exposed, rather like an updated version of the Crystal Palace (see FIG. 20-60). However, the architects also made visible the Pompidou Center's "metabolism." They color coded pipes, ducts, tubes, and corridors according to function (red for the movement of people, green for water, blue for air-conditioning, and yellow for electricity), much as in a sophisticated factory.

Critics who deplore the Beaubourg's vernacular qualities disparagingly refer to the complex as a "cultural supermarket" and point out that its exposed entrails require excessive maintenance to protect them from the elements. Nevertheless, the building has been popular with people since it opened. The flexible interior spaces and the colorful structural body provide a festive environment for the crowds flowing through the building enjoying its art galleries, industrial design center, library, science and music centers, conference rooms, research and archival facilities,

23-50 RICHARD ROGERS and RENZO PIANO, Georges Pompidou National Center of Art and Culture (the "Beaubourg"), Paris, 1977.

movie theaters, rest areas, and restaurant (which looks down and through the building to the terraces outside). The sloping plaza in front of the main entrance has become part of the local scene. Peddlers, street performers, Parisians, and tourists fill this "square" at almost all hours of the day and night. The kind of secular activity once occurring in the open spaces in front of cathedral entrances interestingly has shifted here to a center for culture and popular entertainment—perhaps the most commonly shared experiences.

Deconstructivist Architecture

In the later decades of the twentieth century, art critics (such as Clement Greenberg and Harold Rosenberg) assumed a commanding role. Indeed, their categorization of movements and their interpretation and evaluation of monuments became a kind of monitoring, gatekeeping activity that determined, as well as described, what was going on in the art world. The voluminous and influential writing these critics (along with artists and art historians) produced prompted scholars to examine the basic premises of criticism. This examination has generated a field of study known as *critical theory*. Critical theorists view art and architecture, as well as literature and the other humanities, as a culture's intellectual products or "constructs." These constructs unconsciously suppress or conceal the actual premises that inform the culture, primarily the values of those politically in control. Thus, cultural products function in an ideological capacity, obscuring, for example, racist or sexist attitudes. When revealed by analysis, the facts behind these constructs, according to critical theorists, contribute to a more substantial understanding of artworks, buildings, books, and the overall culture.

Many critical theorists use an analytical strategy called *deconstruction*, after a method developed by French intellectuals, notably Michel Foucault and Jacques Derrida, in the 1960s and 1970s. For those employing deconstruction, all cultural constructs are "texts." People can read these texts in a variety of ways, but they cannot arrive at fixed or uniform meanings. Any interpretation can be valid, and readings differ from time to time, place to place, and person to person. Further, as cultural products, how texts signify and what they signify are entirely conventional. They can refer to nothing outside of themselves, only to other texts. Thus, no extratextual reality

exists that people can reference. The enterprise of deconstruction is to reveal the contradictions and instabilities of these texts, or cultural language (written or visual).

With primarily political and social aims, deconstructive analysis has the ultimate goal of effecting political and social change. Accordingly, critical theorists who employ this approach seek to uncover, to deconstruct, the facts of power, privilege, and prejudice underlying the practices and institutions of any given culture. In so doing, deconstruction reveals the precariousness of structures and systems, such as language and cultural practices, along with the assumptions underlying them.

Critical theorists are not unified about any philosophy or analytical method, because in principle they oppose firm definitions. They do share a healthy suspicion of all traditional truth claims and value standards, all hierarchical authority and institutions. For them, deconstruction means destabilizing established meanings, definitions, and interpretations while encouraging subjectivity and individual differences.

In architecture, deconstruction as an analytical strategy emerged in the 1970s (some scholars refer to this development as Deconstructivist architecture). It proposes, above all, to disorient observers. To this end, Deconstructionist architects attempt to disrupt the conventional categories of architecture and to rupture viewers' expectations based on them. Destabilization plays a major role in Deconstructivist architecture. Disorder, dissonance, imbalance, asymmetry, unconformity, and irregularity replace their opposites—order, consistency, balance, symmetry, regularity, and clarity, as well as harmony, continuity, and completeness. The haphazard presentation of volumes, masses, planes, borders, lighting, locations, directions, spatial relations, and disguised structural facts challenge viewers' assumptions about architectural form as it relates to function. According to Deconstructivist principles, the very absence of the stability of traditional categories of architecture in a structure announces a "deconstructed" building.

DISSONANCE AS AN AESTHETIC STRATEGY
British architect JAMES STIRLING (1926–1992) felt that society's current condition demands a juxtaposition of conflicting ideologies, not a resolution. Following Deconstructivist methods, Stirling explored dissonance as an aesthetic strategy in his designs. In his design for the New Staatsgalerie (New State Gallery; FIG. **23-51**) in Stuttgart, Germany, he combined

23-51 JAMES STIRLING, Neue Staatsgalerie, Stuttgart, Germany, 1977–1984.

classical forms (such as segmented arches and rustication) with bright green, pink, and blue painted elements and seemingly imbalanced lines—both straight and curvilinear—meeting at awkward and unpredictable angles. The effect is indeed disorienting, but it is also vivacious and engaging.

With deconstruction's destabilization of assumptions about architecture and examination of the premises underlying all cultural constructs, one can imagine deconstruction leading toward architectural designs incorporating the process of decay, thereby revealing deconstructive methods. When designing the air ventilation in the parking garage for the Neue Staatsgalerie, Stirling did just that. Rather than cut neat, symmetrical openings in the masonry, Stirling created irregular openings by having some of the masonry blocks removed and tossed on the ground below the vents to suggest ruins, reminiscent of those found in classical cultures.

AN ARCHITECTURE OF CHAOS More audacious in its dissolution of form, and farther along on the path of deconstruction, is another building in Stuttgart, the Hysolar Institute Building at the University of Stuttgart (FIG. **23-52**). GÜNTER BEHNISCH (b. 1922) designed it as part of a joint German–Saudi Arabian research project on the technology of solar energy. The architect intended to deny here the possibility of spatial enclosure altogether, and his apparently chaotic arrangement of the units defies easy analysis. The shapes of the Hysolar Institute's roof, walls, and windows seem to explode, avoiding any suggestion of clear, stable masses. Behnisch aggressively played with the whole concept of architecture and viewers' relationship to it. The disordered architectural elements that seem precariously perched and visually threaten to collapse frustrate observers' expectations of buildings.

DISORDER AND DISEQUILIBRIUM An architect whom scholars perhaps have most identified with Deconstructivist architecture is the Canadian-born FRANK GEHRY (b. 1929). Trained in sculpture, and at different times a collaborator with Claes Oldenberg and Donald Judd, Gehry works up his designs by constructing models and then cutting them up and arranging them until he has a satisfying composition. His most recent project is the Guggenheim Museum (FIG. **23-53**) in Bilbao, Spain. The immensely dramatic building appears as a mass of asymmetrical and imbalanced forms, and the irregularity of the main masses—whose profiles change dramatically with every shift of a visitor's position—

23-52 GÜNTER BEHNISCH, Hysolar Institute Building, University of Stuttgart, Stuttgart, Germany, 1987.

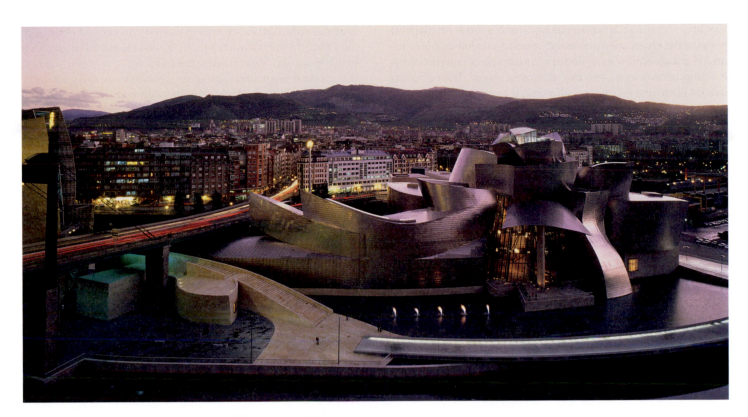

23-53 FRANK GEHRY, Guggenheim Museum, Bilbao, Spain, 1997.

seems like a collapsed or collapsing aggregate of units. The scaled limestone- and titanium-clad exterior, lends a space-age character to the building and highlights further the unique cluster effect of the many forms. A group of organic forms that Gehry refers to as a "metallic flower" tops the museum. Gehry was inspired to create the offbeat design by what he called the "surprising hardness" of the heavily industrialized city of Bilbao. The futuristic urban vision of a cold, mechanical industrial world of 2026 in Fritz Lang's film *Metropolis,* first released in 1926, also stimulated Gehry. In the museum's center, an enormous glass-walled atrium soars to one hundred sixty-five feet in height, serving as the focal point for the three levels of galleries (FIG. Intro-1) radiating from it. The seemingly weightless screens, vaults, and volumes of the interior float and flow into one another, guided only by light and dark cues. Overall, the Guggenheim at Bilbao is a profoundly compelling structure. Its disorder, its seeming randomness of design, and the disequilibrium it prompts in viewers fit nicely into postmodern and deconstructivist agendas.

POSTMODERNISM IN PAINTING, SCULPTURE, AND NEW MEDIA

The challenges to modernist doctrine that emerged in architecture have their own resolution in other artistic media. As with architecture, arriving at a concrete definition of postmodernism in other media is difficult. Historically, by the 1970s, the range of art—from abstraction to performance to figuration—was so broad that the inclusiveness central to postmodern architecture characterizes postmodern art as well. Just as postmodern

architects incorporate traditional elements or historical references, many postmodern artists reveal a self-consciousness about their place in the art historical continuum. They resurrect artistic traditions to comment on and reinterpret those styles or idioms. Writings about postmodern art refer to Neo-Minimalism, Neo-Pop, and Neo-Romanticism, among others, evidencing the prevalence of this reevaluation of earlier art forms.

Beyond that, however, artists, critics, dealers, and art historians do not agree on the elements comprising the vague realm of postmodern art. Many people view postmodernism as a critique of modernism. For example, numerous postmodern artists have undertaken the task of challenging modernist principles such as the avant-garde's claim to originality. In the avant-garde's zeal to undermine traditional notions about art and to produce ever more innovative art forms, they placed a premium on originality and creativity. Postmodern artists challenge this claim by addressing issues of the copy or reproduction and the appropriation of images or ideas from others.

Other scholars, such as Frederic Jameson, assert that a major characteristic of postmodernism is the erosion between high culture and popular culture—a separation Clement Greenberg and the modernists had staunchly defended. With the appearance of Pop art, that separation became more difficult to maintain. Jameson argues that the intersection of high and mass culture is, in fact, a defining feature of the new postmodernism. He attributes postmodernism's emergence to "a new type of social life and a new economic order—what is often euphemistically called modernization, postindustrial or consumer society, the society of the media or the spectacle, or multinational capitalism."[36]

Further, the intellectual inquiries of critical theorists serving as the basis for Deconstructivist architecture also impacted

the other media. For many recent artists, postmodernism involves examining the process by which meaning is generated and the negotiation or dialogue that transpires between viewers and artworks. Like the theorists using deconstructive methods to analyze "texts," or cultural products, many postmodern artists reject the notion that each artwork contains a single fixed meaning. Their work, in part, explores how viewers derive meaning from visual material.

Postmodern art, then, comprises a dizzying array of artworks. While some involve critiques of the modernist program, others present critiques of the art world, and still others incorporate elements of and provide commentary on previous art. A sampling of postmodern art in various media follows.

Neo-Expressionism

One of the first coherent movements to emerge during the postmodern era was Neo-Expressionism. This movement's name reflects postmodern artists' interest in reexamining earlier art production and connects this art to the powerful, intense works of the German Expressionists and the Abstract Expressionists, among other artists.

AN EXTENSION OF PAINT'S PHYSICALITY

The art of American artist JULIAN SCHNABEL (b. 1951), in effect, forcefully restates the premises of Abstract Expressionism. When executing his works in the 1980s, however, Schnabel experimented widely with materials and supports—from fragmented china plates bonded to wood to paint on velvet and tarpaulin. He was particularly interested in the physicality

of the objects, and by attaching broken crockery, as evident in *The Walk Home* (FIG. **23-54**), he found an extension of what paint could do. Superficially, the painting recalls the work of the gestural abstractionists—the spontaneous drips of Jackson Pollock (FIG. 23-4) and the agitated brushstrokes of Willem de Kooning (FIG. 23-6). The large scale of Schnabel's works is also reminiscent of Abstract Expressionism. The thick mosaiclike texture, an amalgamation of media, brings together painting, mosaic, and low-relief sculpture. In effect, Schnabel reclaimed older media for his expressionistic method, which considerably amplifies his bold and distinctive statement.

HORSES AS METAPHORS FOR HUMANITY

In the 1970s, American SUSAN ROTHENBERG (b. 1945) produced a major series of large paintings with the horse as the central image. The horse theme resonates with history and metaphor—from Roman equestrian sculpture to the paintings of German Expressionist Franz Marc. Like Marc, Rothenberg saw horses as metaphors for humanity. She stated, "The horse was a way of not doing people, yet it was a symbol of people, a self-portrait, really."[37] Rothenberg, however, distilled the image down to a ghostly outline or hazy depiction that is more poetic than descriptive. As such, her works fall in the nebulous area between representation and abstraction. In paintings such as *Tattoo* (FIG. **23-55**), the loose brushwork and agitated surface contribute to the image's expressiveness and account for Rothenberg's categorization as a Neo-Expressionist. The title, *Tattoo*, refers to the horse's head drawn within the outline of its leg—"a tattoo or memory image," according to the artist.[38]

23-54 JULIAN SCHNABEL, *The Walk Home*, 1984–1985. Oil, plates, copper, bronze, fiberglass, and bondo on wood, 9′ 3″ × 19′ 4″. Eli Broad Family Foundation and the Pace Gallery, New York.

23-55 SUSAN ROTHENBERG, *Tattoo*, 1979. Acrylic, flashe on canvas, 5′ 7″ × 8′ 7$\frac{1}{8}$″ × 1$\frac{1}{4}$″. Collection Walker Art Center, Minneapolis (purchased with the aid of funds from Mr. and Mrs. Edmond R. Ruben, Mr. and Mrs. Julius E. Davis, the Art Center Acquisition Fund and the National Endowment for the Arts, 1979).

CONFRONTING GERMAN HISTORY Neo-Expressionism was by no means an American movement. The number of artists who pursued this direction in their art indicates the compelling nature of this style. German artist ANSELM KIEFER (b. 1945) has produced some of the most lyrical and engaging works of the contemporary period. His paintings, such as *Nigredo* (FIG. **23-56**), are monumental in scale, thereby commanding immediate attention. On further inspection, the works draw viewers to the agitated surface, made more complex by the addition of materials such as straw and

23-56 ANSELM KIEFER, *Nigredo*, 1984. Oil paint on photosensitized fabric, acrylic emulsion, straw, shellac, relief paint on paper pulled from painted wood, 11′ × 18′. Philadelphia Museum of Art, Philadelphia (gift of Friends of the Philadelphia Museum of Art).

lead. Kiefer's paintings, like those of Schnabel, have thickly encrusted surfaces. It is not just the impressive physicality of Kiefer's paintings that accounts for his work's impact, however. His images function on a mythological or metaphorical level, as well as on a historically specific one. Kiefer's works of the 1970s and 1980s often involved a reexamination of German history, particularly the painful Nazi era of 1920–1945, and evoke the feeling of despair. Kiefer believes Germany's participation in World War II and the Holocaust left permanent scars on the souls of the German people and on the souls of all humanity.

Nigredo (a word which means "black") pulls viewers into an expansive landscape depicted using Renaissance perspectival principles. This landscape, however, is far from pastoral or carefully cultivated. Rather, it appears bleak and charred. While not making specific reference to the Holocaust, this incinerated landscape does indirectly allude to the horrors of that historical event. More generally, the blackness of the landscape may refer to the notion of alchemical change or transformation, a concept of great interest to Kiefer. Black is one of the four symbolic colors of the alchemist—a color that refers both to death and to the molten, chaotic state of substances broken down by fire. The alchemist, however, focuses on the transformation of substances, and thus the emphasis on blackness is not absolute, but can also be perceived as part of a process of renewal and redemption. Kiefer thus imbued his work with a deep symbolic meaning that, when combined with the intriguing visual quality of his parched, congealed surfaces, results in powerful, moving images.

TRANSFORMING ART HISTORY LESSONS Like that of the other Neo-Expressionists, the work of Italian artist SANDRO CHIA (b. 1946) echoes with the legacies of earlier artists—the German Expressionists and, most appropriately, the Italian Futurists. *Rabbit for Dinner* (FIG. **23-57**) is one

such work. At first glance, this painting's color, energy, and power captivate viewers. Further inspection reveals the connections to previous art—the vivid colors of Ernst Ludwig Kirchner (see FIG. 22-5), the agitated brushstrokes of Emil Nolde (see FIG. 22-6), and the dissection of form reminiscent of Gino Severini's work (see FIG. 22-23). Chia believes his strength as an artist lies in his ability to absorb art history's lessons and to reinterpret those images into new contemporary visual realities. The artist explained his use of past art: "We are living in a historical period where the sensation of accumulation is very strong. The present is like the entire history of art. . . . In my opinion, we should work . . . upon this accumulation, this labyrinth of styles."[39]

Art as a Political Weapon

With the renewed interest in representation ushered in by the Pop artists and Superrealists in the 1960s and 1970s, artists once again began to embrace the persuasive powers of art to communicate with a wide audience. In recent decades, artists have investigated more insistently the dynamics of power and privilege, especially in relation to issues of race, ethnicity, gender, and class. This section introduces artists addressing these issues, beginning with feminism.

In the 1970s, the feminist movement focused public attention on the history of women and their place in society. In art, two women—Judy Chicago and Miriam Schapiro—largely spearheaded the American feminist movement under the auspices of the Feminist Art Program. Chicago and a group of students at California State University, Fresno, founded this program, and Chicago and Schapiro coordinated it at the California Institute of the Arts in Valencia, California. In 1972, as part of this program, teachers and students joined to create projects such as Womanhouse, an abandoned house in Los Angeles they completely converted into a suite

23-57 SANDRO CHIA, *Rabbit for Dinner*, 1980. Oil on canvas, 6′ 9″ × 11′ 1½″. Collection of Stedilijk Museum, Amsterdam. Copyright © Sandra Chia/ Licensed by VAGA, New York, NY.

23-58 JUDY CHICAGO, *The Dinner Party*, 1979. Multimedia, including ceramics and stitchery, 48′ × 48′ × 48′ installed.

of "environments," each based on a different aspect of women's lives and fantasies.

A DINNER PARTY CELEBRATING WOMEN In her own work in the 1970s, JUDY CHICAGO (born Judy Cohen in 1939) wanted to educate viewers about women's role in history and the fine arts. She aimed to establish a respect for women and their art, to forge a new kind of art expressing women's experiences, and to find a way to make that art accessible to a large audience. Inspired early in her career by the work of Barbara Hepworth (see FIG. 22-71), Georgia O'Keeffe (see FIGS. 22-37 and Intro-4), and Nevelson (FIG. 23-18), Chicago developed a personal painting style that consciously included abstract organic vaginal images. In the early 1970s, Chicago began planning an ambitious piece, *The Dinner Party* (FIG. **23-58**), using craft techniques women traditionally practiced (such as china painting and stitchery) to celebrate the achievements and contributions women made throughout history. She originally conceived the work as a feminist Last Supper attended by thirteen women (the "honored guests"). The number thirteen also refers to the number

of women in a witches' coven. This acknowledges a religion (witchcraft) founded to encourage the worship of a female—the Mother Goddess. In the course of her research, Chicago uncovered so many worthy women that she expanded the number of guests threefold to thirty-nine and placed them around a triangular table forty-eight feet long on each side. The triangular form refers to the ancient symbol both for woman and for the Goddess. The notion of a dinner party also alludes to women's traditional role as homemakers. A team of nearly four hundred workers under Chicago's supervision assisted in the creation and assembly of the artwork to her design specifications.

The Dinner Party rests on a white tile floor inscribed with the names of nine hundred ninety-nine additional "women of achievement" to signify that the accomplishments of the thirty-nine honored guests rest on a foundation other women laid. Among the "invited" women at the table are O'Keeffe, the Egyptian pharaoh Hatshepsut, the British writer Virginia Woolf, the Native American guide Sacajawea, and the American suffragist Susan B. Anthony. Chicago acknowledged each guest with a place setting of identical eating utensils and a goblet. Each also has a unique oversized porcelain plate and a

23-59 MIRIAM SCHAPIRO, *Anatomy of a Kimono* (section), 1976. Fabric and acrylic on canvas, 6′ 8″ × 8′ 6″. Collection of Bruno Bishofberger, Zurich.

long place mat or table runner filled with imagery that reflects significant facts about her life and culture. The plates range from simple concave shapes with china-painted imagery to dishes whose sculptured three-dimensional designs almost seem to struggle to free themselves. The unique designs on each plate incorporate both butterfly and vulval motifs—the butterfly as the ancient symbol of liberation and the vulva as the symbol of female sexuality. Each table runner combines traditional needlework techniques, including needlepoint, embroidery, crochet, beading, patchwork, and appliqué.

The rigorous arrangement of *The Dinner Party* and its sacramental qualities draw visitors in and let them experience the importance of forgotten details in the history of women. While the individual place settings with their carefully constructed tributes to the thirty-nine women are impressive, the entire work—both in conception and presentation—provides viewers with a powerful launching point for considering feminist concerns. This work was exhibited for nearly a decade after its completion in the United States, Canada, Australia, and Europe. Since then it has found no permanent home, although it was exhibited in 1996 in Los Angeles.

"FEMMAGES" AND THE ROOTS OF COLLAGE Pursuing a somewhat different path than that Chicago undertook, MIRIAM SCHAPIRO (b. 1923) tried in her work since the 1970s to rouse viewers to a new appreciation of the beauty in materials and techniques women artists used throughout history. Schapiro enjoyed a thriving career as a hard-edge painter when she moved to California in the late 1960s and became fascinated with the hidden metaphors for womanhood she then saw in her abstract paintings. Intrigued by the materials she had used to create a doll's house for her part in Womanhouse, Schapiro began to make huge sewn collages, assembled from fabrics, quilts, buttons, sequins, lace trim, and rickrack collected at antique shows and fairs. She called these works "femmages" to make the point that women had been doing so-called collages long before Pablo Picasso introduced them to the art world. *Anatomy of a Kimono* (FIG. **23-59**) is one of a series of monumental femmages based on the patterns of Japanese kimonos, fans, and robes. This vast composition repeats the kimono shape in a sumptuous array of fabric fragments.

FEMALE BEAUTY AND THE "MALE GAZE" Early attempts at dealing with feminist issues in art tended toward essentialism, emphasizing universal differences—either biological or experiential—between women and men. More recent discussions have gravitated toward the notion of gender as a socially constructed concept—an extremely unstable one. Identity is multifaceted and changeable, making the discussion of feminist issues more challenging. Consideration of the many variables, however, results in a more complex understanding of gender roles. American artist CINDY SHERMAN (b. 1954) addresses in her work the way much of Western art has been constructed to present female beauty for the enjoyment of the "male gaze," a primary focus of contemporary feminist theory. She produced a series of more than eighty black-and-white photographs titled *Untitled Film Stills,* which she began in 1977. Sherman considered how representation constructs reality, and this led her to rethink how her own image was conveyed. She got the idea for the *Untitled Film Stills* series when she was shown some soft-core pornography magazines and the stereotypical ways they depicted women struck her. Sherman decided to produce her own series of photographs, designing, acting in, directing, and photographing the works. In so doing, she took control of her own image and constructed her own identity. In works from the series such as *Untitled: Film Still #35* (FIG. **23-60**), Sherman appears, often in costume and wig, in a photograph that seems to be a film still. Most of the images recall popular film genres but are sufficiently generic so that viewers cannot relate them to specific movies. Sherman often reveals the constructed nature of these images with the shutter release cable (the cord runs across the floor in our illustration) she holds in her hand to take the pictures. Although she is still the object of the viewer's gaze in these images, the identity is one she has chosen to assume.

EXPLORING CULTURAL NOTIONS OF GENDER Another artist who has also explored the male gaze and the culturally constructed notion of gender in her art is BARBARA KRUGER (b. 1945), whose best-known subject has been her exploration of the strategies and techniques of contemporary mass media. Kruger's serious art career began with fiber sculpture inspired by the works of Magdalena

23-60 CINDY SHERMAN, *Untitled Film Still #35,* 1979. Black-and-white photograph, 10″ × 8″.

23-61 BARBARA KRUGER, *Untitled (Your Gaze Hits the Side of My Face)*, 1983. Photostat, red painted frame, 6′ 1″ × 4′ 1″.

Abakanowicz (FIG. 23-71). She soon began creating pieces that drew on her early training and work as a graphic designer for the magazine *Mademoiselle.* Mature works such as *Untitled (Your Gaze Hits the Side of My Face*; FIG. **23-61**) incorporated layout techniques the mass media uses to sell consumer goods. Although Kruger favored the reassuringly familiar format and look of advertising, her goal was to subvert the typical use of such imagery. Rather, she aimed to expose the deceptiveness of the media messages viewers complacently absorb. Kruger wanted to undermine the myths—particularly those about women—the media constantly reinforces. Her huge word-and-photograph collages (often four by six feet in size) challenged the cultural attitudes embedded in commercial advertising.

In *Untitled (Your Gaze Hits the Side of My Face),* she overlaid a ready-made photograph of the head of a classically beautiful female sculpture with a vertical row of text composed of eight words selected by the artist. They cannot be taken in with a single glance. Reading them is a staccato exercise, with an overlaid cumulative quality that delays understanding and intensifies the meaning (rather like reading a series of roadside billboards from a speeding car). Kruger's use of text, of words, in her work is significant. Many cultural theorists have asserted that language is one of the most powerful vehicles for internalizing stereotypes and conditioned roles.

THE LANDSCAPE AND THE FEMALE BODY
Cuban-born artist ANA MENDIETA (1948–1985), like Sherman, used her body as a component in her artworks. Although she was concerned with gender issues, her art also dealt with issues of spirituality and cultural heritage. Mendieta's best-known series, *Silueta ("Silhouettes"),* consists of approximately two hundred earth and body works completed between 1973 and 1980. These works represented her attempt to carry on, as she described, "a dialogue between the landscape and the female body (based on [her] own silhouette)."[40]

Untitled, No. 401 (FIG. **23-62**) is a documentary photograph of one of the earth-body sculptures in the *Silueta* series. In this work, Mendieta outlined her body with gunpowder on a fallen log and then lit the gunpowder, creating a fiery silhouette of her body. As in Environmental art, objects and locations from the natural environment played an important role in Mendieta's art. In other works, she used flowers, clay,

23-62 ANA MENDIETA, *Untitled, No. 401,* 1977. Photograph, 1′ 1¼″ × 1′ 8″.

mud, and twigs. Mendieta explained the centrality of this connection to nature: "I believe this has been a direct result of my having been torn from my homeland during my adolescence. I am overwhelmed by the feeling of having been cast from the womb (nature). My art is the way I re-establish the bonds that unite me to the universe. It is a return to the maternal source. Through my earth/body sculptures I become one with the earth."[41]

The notion of burning suggests a connection to rituals of exorcism and purification, revealing the spiritual dimension of Mendieta's art. Beyond their sensual, moving presence, her works also generate a palpable spiritual force. In longing for her homeland, Mendieta sought the cultural understanding and acceptance of the spiritual powers inherent in nature that modern Western societies often seem to reject in favor of scientific and technological developments. Her art is lyrical and passionate, and operates at the intersection of cultural, spiritual, physical, and feminist concerns.

WHO CONTROLS THE BODY? Much of the art dealing with gender issues focuses on the objectification of women and, in particular, of the human body. American KIKI SMITH (b. 1954), for example, is very interested in the issue of who controls the body. Her early work consisted of sculptures referring to bodily organs and bodily fluids. This seemingly clinical approach was due, in part, to Smith's training as an Emergency Medical Service technician in New York. Smith, however, also wants to reveal the socially constructed nature of the body, and, in her more recent art, she encourages viewers to consider how external forces, such as the media, shape people's perceptions of their bodies. In works such as *Untitled* (FIG. **23-63**), the artist presents viewers with depictions of the body that dramatically depart from conventional representations of the body, both in art and in the media. *Untitled* consists of two life-size wax figures, one male and one female. Both are nude and appear suspended from metal stands. Smith marked each of the sculptures with long white drips— bodily fluids running from the woman's breasts and down the man's leg. She commented:

> Most of the functions of the body are hidden . . . from society. . . . [W]e separate our bodies from our lives. But, when people are dying, they are losing control of their bodies. That loss of function can seem

23-63 KIKI SMITH, *Untitled*, 1990. Beeswax and microcrystalline wax figures on metal stands, female figure installed height 6′ 1½″ and male figure installed height 6′ 4¹⁵⁄₁₆″. Collection Whitney Museum of American Art, New York (purchase, with funds from the Painting and Sculpture Committee).

23-64 FAITH RINGGOLD, *Who's Afraid of Aunt Jemima?*, 1983. Acrylic on canvas with fabric borders, quilted, 7′ 6″ × 6′ 8″. Private collection.

humiliating and frightening. But, on the other hand, you can look at it as a kind of liberation of the body. It seems like a nice metaphor—a way to think about the social—that people lose control despite the many agendas of different ideologies in society, which are trying to control the body(ies) . . . medicine, religion, law, etc. Just thinking about control—who has control of the body? . . . Does the mind have control of the body? Does the social?[42]

BOTH PERSONAL AND POLITICAL Faith Ringgold and Adrian Piper both use their art to explore issues associated with being African American and women in contemporary America. Inspired by the Civil Rights movement, FAITH RING-GOLD (b. 1930) produced numerous works in the 1960s that provided pointed and incisive commentary on the realities of racial prejudice. She increasingly incorporated references to gender as well and, in the 1970s, turned to fabric as the predominant material in her art. Using fabric allowed her to make more specific reference to the domestic sphere, traditionally associated with women, and to collaborate with her mother, Willi Posey, a fashion designer. After her mother's death in 1981, Ringgold created *Who's Afraid of Aunt Jemima?* (FIG. **23-64**), a quilt composed of dyed, painted, and pieced fabric. A moving tribute to her mother, this work combines the personal and the political. The quilt includes a narrative—the witty story of the family of Aunt Jemima, most familiar as the stereotypical black "mammy" but here a successful African-American businesswoman. Ringgold conveyed this narrative both through a text, written in black dialect, and embroidered portraits, all interspersed with traditional patterned squares.

This work, while resonating with personal, autobiographical references, also speaks to the larger issues of the history of African-American culture and the struggles of women to overcome oppression.

AN INSTALLATION CONFRONTING VIEWERS ADRIAN PIPER (b. 1948) has been committed to using her art to effect social change—in particular, to combat pervasive racism. Appropriately, her art is provocative and confrontational, such as the installation *Cornered* (FIG. **23-65**). This piece included a video monitor placed behind an overturned table. Piper appeared on the video monitor, literally cornered behind the table, as she spoke to viewers. Her comments sprang from her experiences as a light-skinned African-American female and from her belief that although overt racism had diminished, subtle and equally damaging forms of bigotry were still rampant. "I'm black," she announces on the sixteen-minute videotape. "Now let's deal with this social fact and the fact of my stating it together. . . . If you feel that my letting people know that I'm not white is making an unnecessary fuss, you must feel that the right and proper course of action for me to take is to pass for white. Now this kind of thinking presupposes a belief that it's inherently better to be identified as white," she continues. The directness of Piper's art forces viewers to examine their own behaviors and values.

COUNTERACTING OBJECTIFICATION The issues of racism and sexism are also central to the work of LORNA

23-65 ADRIAN PIPER, *Cornered,* 1988. Mixed-media installation of variable size; video monitor, table, and birth certificates. Collection of Museum of Contemporary Art, Chicago.

SIMPSON (b. 1960). Simpson has spent much of her career producing photographs that explore feminist and African-American strategies to reveal and subvert conventional representations of gender and race. Like Sherman (FIG. 23-60), she deals with the issue of the gaze, trying to counteract the process of objectification to which both women and African Americans are subject.

In *Stereo Styles* (FIG. **23-66**), a series of Polaroids and engravings, Simpson focuses on African-American hairstyles, often used to symbolize the entire race. Hair is a physical code tied to issues of social status and position. A scholar who has studied the cultural importance of hair pointed out,

"[h]air is never a straightforward biological 'fact' because it is almost always groomed, . . . cut, . . . and generally 'worked upon' by human hands. Such practices socialize hair, making it the medium of significant 'statements' about self and society."[43] Even further, regarding race, this same scholar argues, "where race structures social relations of power, hair—as visible as skin color, but also the most tangible sign of racial difference—takes on another forcefully symbolic dimension."[44] In *Stereo Styles,* Simpson also comments on the appropriation of African-derived hairstyles as a fashion commodity, and the personality traits listed correlate with specific hairstyles.

23-66 LORNA SIMPSON, *Stereo Styles,* 1988. 10 black-and-white Polaroid prints and 10 engraved plastic plaques, 5' 4" × 9' 8" overall. Collection of Raymond J. Learsy, Sharon, Connecticut.

23-67 MELVIN EDWARDS, *Some Bright Morning,* 1963. Welded steel, 1′ 2¼″ × 9¼″ × 5″. Collection of the artist.

"LYNCH FRAGMENTS" American MELVIN EDWARDS (b. 1937) also has sought to reveal a history of collective oppression through his art. One of Edwards's major sculptural series focused on the metaphor of lynching to provoke thought about the legacy of racism. This *Lynch Fragment* series encompassed more than one hundred fifty welded-steel sculptures produced in the years after 1963. Lynching as an artistic theme prompts an immediate and visceral response, conjuring up chilling and gruesome images from the past. Edwards sought to extend this emotional resonance further and in his art explored what lynching "means metaphorically or symbolically."[45]

He constructed his relatively small welded wall-hung sculptures in this series, such as *Some Bright Morning* (FIG. **23-67**), from found metal objects—for example, chains, hooks, hammers, spikes, knife blades, and handcuffs. Although Edwards often intertwined or welded together the individual metal components so as to diminish immediate identifiability, the sculptures still retain a haunting connection to the overall theme. Regarding *Some Bright Morning,* for example, the artist noted, "The dangling ball of steel at the bottom of the chain is the plastic metaphor of hanging. [And] the piece had to hang on the wall, which furthered the metaphor. I said to myself, 'It is hanging there like a lynching.'"[46]

While these works refer to a historical act that evokes a collective memory of oppression, they are also informed by and speak to the continuing contemporary struggle for civil rights and an end to racism. Growing up in Los Angeles, Edwards was surrounded by racial conflict. He picked up some of the metal objects incorporated into his *Lynch Fragments* sculptures in the streets in the aftermath of the Watts riots in 1965, thereby imbuing these disquieting, haunting works with an even greater intensity.

23-68 DAVID HAMMONS, *Public Enemy,* installation at Museum of Modern Art, New York, 1991. Photographs, balloons, sandbags, guns, and other mixed media.

CHALLENGING CULTURAL ICONS Nurturing viewer introspection is the driving force behind the art of DAVID HAMMONS (b. 1943). In his installations, he combines sharp social commentary with beguiling sensory elements to push viewers to confront racism in American society. He created *Public Enemy* (FIG. **23-68**) for an exhibition at the Museum of Modern Art in New York in 1991. Hammons enticed viewers to interact with the installation by scattering fragrant autumn leaves on the floor and positioning helium-filled balloons throughout the gallery. The leaves crunched underfoot, and the dangling strings of the balloons gently brushed spectators walking around the installation. Once drawn into the environment, viewers encountered the central element in *Public Enemy*—large black-and-white photographs of a public monument depicting Teddy Roosevelt triumphantly seated on a horse, flanked by an African-American man and a Native American man, both appearing in the role of servants. Around the installation's edge, circling the photographs of the monument, were piles of sandbags with both real and toy guns propped on top, aimed at the statue. By selecting evocative found objects and presenting them in a dynamic manner that encouraged viewer interaction, Hammons attracted an audience and then revealed the racism embedded in received cultural heritage and prompted reexamination of values and cultural emblems.

TRADING WITH THE WHITE MAN Exploring the politics of identity has been an important activity for people from many different walks of life. JAUNE QUICK-TO-SEE SMITH (b. 1940) is a Native American artist descended from the Shoshone, the Salish, and the Cree tribes and raised on the Flatrock Reservation in Montana. Quick-to-See Smith's native heritage always has informed her art, and her concern for the invisibility of Native American artists has led her to organize exhibitions of their art. Yet she has acknowledged a wide range of influences in her work, including "pictogram forms from Europe, the Amur [the river between Russia and China], the Americas; color from beadwork, parfleches [hide cases], the landscape; paint application from Cobra art, New York expressionism, primitive art; composition from Kandinsky, Klee or Byzantine art."[47] She even has compared her use of tribal images to that of the Abstract Expressionists.

Despite the myriad references and visual material in Quick-to-See Smith's art, her work retains a coherence and power, and, like many other artists who have explored issues associated with identity, she challenges stereotypes and unacknowledged assumptions. *Trade (Gifts for Trading Land with White People)*, FIG. **23-69** is a large-scale painting with collage elements and attached objects, reminiscent of a Rauschenberg combine (FIG. **23-26**). The painting's central image, a canoe, appears in an expansive field painted in loose Abstract Expressionist fashion and covered with clippings from Native American newspapers. Above the painting, as if hung from a clothesline, is an array of objects. These include Native American artifacts, such as beaded belts and feather headdresses, and contemporary sports memorabilia from teams with American Indian–derived names—the Cleveland Indians, Atlanta Braves, and Washington Redskins. The inclusion of these contemporary objects immediately recalls the vocal opposition to such names and to acts such as the Braves's

23-69 JAUNE QUICK-TO-SEE-SMITH, *Trade (Gifts for Trading Land with White People)*, 1992. Oil and mixed media on canvas, 5′ × 14′ 2″. Chrysler Museum of Art, Norfolk, Virginia (museum purchase 93.2).

"tomahawk chop." Like Edwards, Quick-to-See Smith uses the past—cultural heritage and historical references—to comment on the present.

BRUTAL VISIONS OF VIOLENT TIMES Other artists have used their art to speak out about pressing social and political issues, sometimes in universal terms and other times with searing specificity. In his art, American artist LEON GOLUB (b. 1923) has expressed a seemingly brutal vision of contemporary life through a sophisticated reading of the news media's raw data. The work he is best known for deals with violent events of recent decades—the narratives people have learned to extract from news photos of anonymous characters participating in atrocious street violence, terrorism, and torture. Paintings in Golub's *Assassins* and *Mercenaries* series suggest not specific stories but a condition of being. As the artist said,

> Through media we are under constant, invasive bombardment of images—from all over—and we often have to take evasive action to avoid discomforting recognitions. . . . The work [of art] should have an edge, veering between what is visually and cognitively acceptable and what might stretch these limits as we encounter or try to visualize the real products of the uses of power.[48]

Mercenaries (IV), FIG. **23-70**, a huge canvas, represents a mysterious tableau of five mercenaries (tough freelance military professionals willing to fight, for a price, for any political cause). The three clustering at the right side of the canvas react with tense physical gestures to something one of the two other mercenaries standing at the far left is saying. The dark uniforms and skin tones of the four black fighters flatten their figures and make them stand out against the searing dark red background. The slightly modulated background seems to

push their forms forward up against the picture plane and becomes an echoing void in the space between the two groups. The menacing figures loom over on-site viewers. Golub painted them so that these viewers' eyes are level with the mercenaries' knees, placing the men so close to the work's front plane that their feet are cut off by the painting's lower edge, thereby trapping such viewers with them in the painting's compressed space. Golub emphasized both the scarred light tones of the white mercenary's skin and the weapons. Modeled with shadow and gleaming highlights, the guns contrast with the harshly scraped, flattened surfaces of the figures. The rawness of the canvas reinforces the rawness of the imagery. Golub often dissolved certain areas with solvent after applying pigment and scraped off applied paint with, among other tools, a meat cleaver. The feeling of peril confronts viewers mercilessly. They become one with all the victims caught by today's political battles.

WEAVING AS A RECORD OF THE SOUL The stoic, everyday toughness of the human spirit has been the subject of figurative works by the Polish fiber artist MAGDALENA ABAKANOWICZ (b. 1930). A leader in the recent exploration in sculpture of the expressive powers of weaving techniques, Abakanowicz gained fame with experimental freestanding pieces in both abstract and figurative modes. For Abakanowicz, fiber materials are deeply symbolic: "I see fiber as the basic element constructing the organic world on our planet, as the greatest mystery of our environment. It is from fiber that all living organisms are built—the tissues of plants and ourselves. . . . Fabric is our covering and our attire. Made with our hands, it is a record of our souls."[49]

To all of her work, this artist brought the experiences of her early life as a member of an aristocratic family disturbed

23-70 LEON GOLUB, *Mercenaries (IV)*, 1980. Acrylic on linen, 10′ × 19′ 2″. Collection Mr. and Mrs. Ulrich Meyer, Chicago.

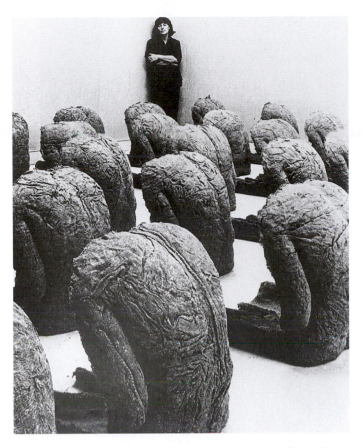

23-71 MAGDALENA ABAKANOWICZ, artist with *Backs,* at the Musée d'Art Moderne de la Ville de Paris, Paris, France, 1982. Copyright © Magdalena Abakanowicz/Licensed by VAGA, New York, NY/Marlborough Gallery, NY.

human forms—*Heads, Seated Figures,* and *Backs*—multiplying each type for exhibition in groups as symbols for the individual in society lost in the crowd yet retaining some distinctiveness. This impression is especially powerful in an installation of *Backs* (FIG. **23-71**). Abakanowicz made each piece by pressing layers of natural organic fibers into a plaster mold. Every sculpture depicts the slumping shoulders, back, and arms of a figure of indeterminate sex and rests legless directly on the floor. The repeated pose of the figures in *Backs* suggests meditation, submission, and anticipation. Although made from a single mold, the figures achieve a touching sense of individuality because each assumed a slightly different posture as the material dried and because the artist imprinted a different pattern of fiber texture on each.

DEALING WITH AIDS DAVID WOJNAROWICZ (1955–1992) devoted the latter part of his artistic career to producing images dealing with issues of homophobia and acquired immune deficiency syndrome (AIDS). As a gay activist and as someone who had seen many friends die of AIDS, Wojnarowicz created disturbing and eloquent works about the tragedy of this disease, such as *When I Put My Hands On Your Body* (FIG. **23-72**). In this image, the artist overlaid a photograph of a pile of skeletal remains with evenly spaced typed commentary that communicates his feelings about watching a loved one dying of AIDS. He movingly describes the effects of AIDS on the human body and soul. Wojnarowicz juxtaposed text with imagery, which, like the works of Barbara Kruger (FIG. 23-61) and Lorna Simpson (FIG. 23-66), paralleled the use of both words and images in advertising. The public's familiarity with this format ensured greater receptivity to the artist's message. Wojnarowicz's career was cut short when he also died of AIDS in 1992.

PUBLICLY EXPOSING POWER STRUCTURES When working in Canada in 1980, Polish-born artist KRZYSZTOF WODICZKO (b. 1943) developed artworks involv-

by the dislocations of World War II and its aftermath. Initially attracted to weaving as a medium that would adapt well to the small studio space she had available, Abakanowicz gradually developed huge abstract hangings she called Abakans that suggest organic spaces as well as giant pieces of clothing. She returned to a smaller scale with works based on

23-72 DAVID WOJNAROWICZ, *When I Put My Hands On Your Body,* 1990. Gelatin-silver print and silk-screened text on museum board, 2′ 2″ × 3′ 2″.

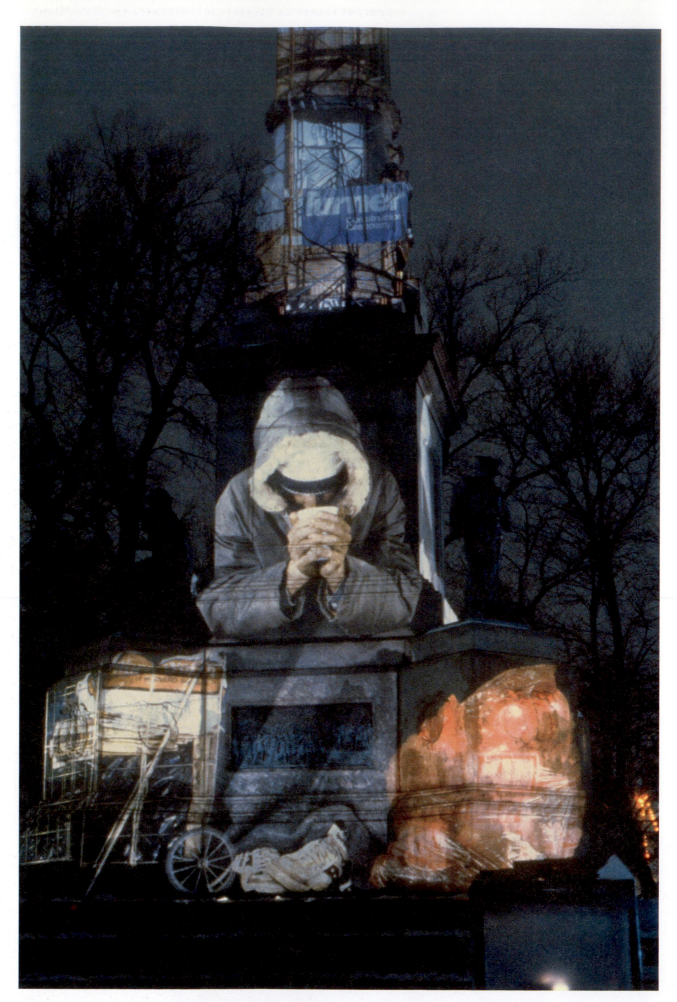

23-73 KRZYSZTOF WODICZKO, *The Homeless Projection,* 1986–1987. Outdoor slide projection at the Soldiers and Sailors Civil War Memorial, Boston, organized by First Night, Boston..

ing outdoor slide images. He projected photographs on specific buildings to expose how civic buildings embody, legitimize, and perpetuate power. When Wodiczko moved to New York in 1983, the pervasive homelessness troubled him, and he resolved to use his art to publicize this problem. In 1987, he produced *The Homeless Projection* (FIG. **23-73**) as part of a New Year's celebration in Boston. The artist projected images of homeless people on all four sides of the Soldiers' and Sailors' Civil War Memorial on the Boston Common. In these photos, plastic bags filled with their possessions flanked those depicted. At the top of the monument Wodiczko projected a local condominium construction site, which helped viewers make a connection between urban development and homelessness.

New Technologies: Video and Digital Imagery

Initially, video was available only in commercial television studios and only was occasionally accessible to artists. In the 1960s, with the development of relatively inexpensive portable video recording equipment and of electronic devices allowing manipulation of the recorded video material, artists began to explore in earnest the particularly expressive possibilities of this new medium. In its basic form, video technology involves a special motion-picture camera that captures visible images and translates them into electronic data that can be displayed on a video monitor or television screen. Video pictures resemble photographs in the amount of detail they contain, but, like computer graphics, a video image is displayed as a series of points of light on a grid, giving the impression of soft focus. Viewers looking at television or video art are not aware of the monitor's surface. Instead, fulfilling the Renaissance ideal, they concentrate on the image and look through the glass surface, as through a window, into the "space" beyond. Video images combine the realism of photography with the sense that the subjects move in real time in a deep space "inside" the monitor.

FROM VIDEO TO COMPUTER IMAGES When video introduced the possibility of manipulating subjects in real time, artists such as the Korean-born, New York-based videographer NAM JUNE PAIK (b. 1932) were eager to work with the medium. Inspired by American composer John Cage's ideas and after studying music performance, art history, and Eastern philosophy in Korea and Japan, Paik worked with electronic music in Germany in the late 1950s. He then turned to performances using modified television sets. In 1965, after relocating to New York City, Paik acquired the first inexpensive video recorder sold in Manhattan (the Sony Porta-Pak) and immediately recorded everything he saw out the window of his taxi on the return trip to his studio downtown. Experience acquired as artist-in-residence at television stations WGBH in Boston and WNET in New York allowed him to experiment with the most advanced broadcast video technology.

A grant permitted Paik to collaborate with the gifted Japanese engineer-inventor Shuya Abe in developing a video synthesizer. This instrument allows artists to manipulate and change the electronic video information in various ways, caus-

ing images or parts of images to stretch, shrink, change color, or break up. With the synthesizer, artists also can layer images, inset one image into another, or merge images from various cameras with those from video recorders to make a single visual kaleidoscopic "time-collage." This kind of compositional freedom permitted Paik to combine his interests in the ideas of Cage, painting, music, Eastern philosophy, global politics for survival, humanized technology, and cybernetics. Paik called his video works *physical music* and said that his musical background enabled him to understand time better than video artists trained in painting or sculpture.

Paik's best-known video work, *Global Groove* (FIG. **23-74**), combines in quick succession fragmented sequences of female tap dancers, poet Allen Ginsberg reading his work, a performance of cellist Charlotte Moorman using a man's back as her instrument, Pepsi commercials from Japanese television, Korean drummers, and a shot of the Living Theatre group performing a controversial piece called *Paradise Now*. Commissioned originally for broadcast over the United Nations satellite, the cascade of imagery in *Global Groove* was intended to give viewers a glimpse of the rich worldwide television menu Paik had predicted would be available in the future.

While some new technologies were revolutionizing the way artists could work with pictorial space, other technologies, especially those of computer graphics, were transforming how artists could create and manipulate illusionistic three-dimensional forms. Computer graphics as a medium uses light to make images and, like photography, can incorporate specially recorded camera images. Computer graphics allows artists to work with wholly invented forms, as painters can.

Developed during the 1960s and 1970s, computer graphics opened up new possibilities for both abstract and figurative art. It involves electronic programs dividing the surface of the computer monitor's cathode-ray tube into a grid of tiny boxes called "picture elements" (pixels). Artists can electronically address these picture elements individually to create a design, much as knitting or weaving patterns have a gridded matrix as a guide for making a design in fabric. Once created, parts of a computer graphic design can be changed quickly through an electronic program, allowing artists to revise or duplicate shapes in the design and to manipulate at will the color, texture, size, number, and position of any desired detail.

23-74 NAM JUNE PAIK, *Global Groove*, 1973. Video still.

23-75 DAVID EM, *Nora*, 1979. Computer-generated color photograph, 1′ 5″ × 1′ 11″. Private collection.

A computer graphic picture is displayed in luminous color on the cathode-ray tube. The effect suggests a view into a vast world existing inside the tube.

COMPUTER-GENERATED LANDSCAPES One of the best-known artists working in this electronic painting mode, DAVID EM (b. 1952), uses what he terms *computer imaging* to fashion fantastic imaginary landscapes. These have an eerily believable existence within the "window" of the computer monitor. As a former artist-in-residence at the California Institute of Technology's Jet Propulsion Laboratory, Em created brilliantly colored scenes of alien worlds using the laboratory's advanced computer graphic equipment. He also had access to software programs developed to create computer graphic simulations of the National Aeronautics and Space Administration missions in outer space. Creating images with the computer allows Em great flexibility in manipulating simple geometric shapes—shrinking or enlarging them, stretching or reversing them, repeating them, adding texture to their surfaces, and creating the illusion of light and shadow. In images such as *Nora* (FIG. **23-75**), Em created futuristic geometric versions of Surrealistic dreamscapes whose forms seem familiar and strange at the same time. The illusion of space in these works is immensely vivid and seductive. It almost seems possible to wander through the tubelike foreground "frame" and up the inclined foreground plane or hop aboard the hovering globe at the lower left for a journey through the strange patterns and textures of this mysterious labyrinthine setting.

THE EFFICIENCY AND AUTHORITY OF SIGNS
In conjunction with the growing popularity of digital imagery and the expanding interest in video technology, many artists have appropriated the mechanisms and strategies of these media. JENNY HOLZER (b. 1950) has been interested in reaching a wide audience with her art. Realizing the efficiency of signs, she created several series using electronic signs, most involving light-emitting diode (LED) technology. In 1989, Holzer did a major installation at the Guggenheim Museum in New York that included elements from her previous series and consisted of a large continuous LED display spiraling around the museum's interior ramp (FIG. **23-76**). Holzer's art focused specifically on text, and she invented sayings with an authoritative tone for her LED displays. Statements included "Protect me from what I want," "Abuse of power comes as no surprise," and "Romantic love was invented to manipulate women." The statements, which people could read from a distance, were purposefully vague and ambiguous and, in some cases, contradictory.

SUBVERTING MEDIA MESSAGES American DARA BIRNBAUM (b. 1946) also turned from traditional painting and sculpture to video early in her career. However, rather than focus on the aesthetic capabilities of this new technology, Birnbaum made commercial television her subject. Much of her work involved analyzing the medium's structure and the ideological basis of television content. *PM Magazine* (FIG. **23-77**), a large-scale installation, centered on footage from a network magazine-format show, *PM Magazine*. The modified footage appeared on two video monitors embedded in large photographic enlargements of scenes from the videos. Birnbaum's manipulation of the video—using pauses, freeze-frames, slow motion, wipes (lines signaling transitions), and dissolves—exposed both news and entertainment as formats exploiting women.

23-76 JENNY HOLZER, *Untitled* (Selections from *Truisms, Inflammatory Essays, The Living Series, The Survival Series, Under a Rock, Laments,* and *Child Text*), 1989. Extended helical tricolor LED electronic display signboard, 16″ × 162′ × 6″. Solomon R. Guggenheim Museum, New York, December 1989–February 1990 (partial gift of the artist, 1989).

23-77 DARA BIRNBAUM, *PM Magazine,* 1982. Installation at San Francisco Museum of Modern Art, May 9–September 16, 1997. Five-channel color video and sound installation, installation panel 6′ × 8′. San Francisco Museum of Modern Art (purchased through a gift of Rena Bransten and the Accessions Committee Fund; gift of Collectors Forum, Doris and Donald G. Fisher, Evelyn and Walter Haas, Jr., Byron R. Meyer, and Norah and Norman Stone.

23-78 BILL VIOLA, *The Crossing*, 1996. Installation with two channels of color video projection onto 16'-high screens.

few minutes, the water and fire increase in intensity until the man disappears in a torrent of water on one screen and flames consume the man on the other screen. The deafening roar of a raging fire and torrential downpour accompany these visual images. Eventually, everything subsides and fades into darkness. This installation's elemental nature and its presentation in a dark space immerse viewers in a pure sensory experience very much rooted in tangible reality.

Postmodernism and Commodity Culture

SYMBOLS OF EVERYTHING WRONG TODAY? In keeping with Fredric Jameson's evaluation of postmodern culture as inextricably linked to consumer society and mass culture, several postmodern artists have delved into the is-

23-79 JEFF KOONS, *Pink Panther*, 1988. Porcelain, 3' 5" × 1' 8½" × 1' 7". Collection Museum of Contemporary Art, Chicago (Gerald S. Elliot Collection).

SENSORY IMPACT OF DIGITAL IMAGING BILL VIOLA (b. 1951) has spent much of his artistic career exploring the capabilities of digitized imagery, producing many video installations and single-channel works. Often focusing on sensory perception, the pieces not only heighten viewer awareness of the senses but also suggest an exploration into the spiritual realm. Viola, an American, spent years seriously studying Buddhist, Christian, Sufi, and Zen mysticism. Because he fervently believes in art's transformative power and in a spiritual view of human nature, Viola designs works encouraging spectator introspection. His recent video projects involve techniques such as extreme slow motion, contrasts in scale, shifts in focus, mirrored reflections, staccato editing, and multiple or layered screens to achieve dramatic effects.

The power of Viola's work is evident in *The Crossing* (FIG. 23-78), an installation piece involving two color video channels projected on sixteen-foot-high screens. The artist either shows the two projections on the front and back of the same screen or on two separate screens in the same installation. In these two companion videos, shown simultaneously on the two screens, a man surrounded in darkness appears, moving closer until he fills the screen. On one screen, drops of water fall from above onto the man's head, while, on the other screen, a small fire breaks out at the man's feet. Over the next

The Art Market in the Later Twentieth Century

Art always has been a commodity, yet most people are reluctant to discuss it as such. Until the seventeenth century, commissions from patrons generated most art produced for public view. Because of the private nature of these arrangements, the public was not usually aware of the price of each work. Information about how much patrons paid artists traveled, rather unreliably, via word of mouth, if at all.

The growth of professions dedicated to selling art prompted the evolution of the modern art market. Art dealers, serving as intermediaries between artists and collectors or patrons, emerged in the Western art world in the seventeenth century. The auction house, although dating back to Imperial Rome, developed into a major force in the eighteenth century. With the increased participation of these "art sellers," the prices of artworks were disseminated more widely. The expansion of sophisticated communication networks—national and international newspapers and magazines, telephone systems, radio and television broadcasts, and, more recently, the Internet—has made information about artwork prices more readily available in the public domain. Further, because most buyers acquire their art from dealers who represent artists and display and sell art in galleries, the purchase of art today is often a straightforward financial transaction.

This wide dissemination of information about art prices, coupled with the allure of collecting art fostered by consumer culture, raises the issue of what, exactly, is the relationship between the price and the value of an artwork? Certainly, the value of art extends far beyond monetary worth. But the perception that cost reflects value or quality is a popular myth consumer culture perpetuates.

In recent decades, the amounts paid for art have risen dramatically. Prices for works of the Old Masters (such as Rembrandt, Leonardo, and Vélazquez) always have been high, but prices for modern artists, even contemporary living artists, also have soared. In part, the prosperity of the 1980s, a decade of corporate expansion and widespread speculative business ventures, drove this increase. Even the sobering stock market crash of October 19, 1987, known as Black Monday, did little to curb the momentum of the inflated art market. Among the works sold at auction during the early 1980s were the Gospels of Henry the Lion, purchased in 1983 by the West German government for $11.3 million. The phenomenal sale of van Gogh's *Sunflowers* a few years later in 1987 for $39.9 million stunned art lovers around the world. Some months later the sale of van Gogh's *Irises* for $53.9 million surpassed that. Eventually, the market peaked in 1989 and 1990, with the auctioning of Picasso's *Pierrette's Wedding* for $51.7 million, Renoir's *Le Moulin de la Galette* (see FIG. 21-23) for $78.1 million, and van Gogh's *Portrait of Dr. Gachet* for $82.5 million, the highest price ever paid for an artwork. Japanese collectors purchased these last three works.

The astonishing prices paid for artworks testifies to the importance of art in modern life. However, a downside exists. Higher prices for art reduce the ability of museums, on limited budgets, to purchase and insure artworks, thereby decreasing the opportunities the public has to view art. Museum directors have decried this development and now must work even harder to find ways to continue to make a wide range of art available to their audiences.

sues associated with commodity culture. American JEFF KOONS (b. 1955) first became prominent in the art world for a series of works in the early 1980s that involved exhibiting common purchased objects such as vacuum cleaners. Clearly following in the footsteps of artists such as Marcel Duchamp and Andy Warhol, Koons made no attempt to manipulate or alter the objects. Critics and other art world participants perceived them as representing the commodity basis of both the art world and society at large. Koons's experience as a commodities broker before turning to art and his blatant self-promotion have led to accusations that his art is market driven (see "The Art Market in the Later Twentieth Century," above).

More recently, Koons has produced several porcelain sculptures, such as *Pink Panther* (FIG. **23-79**). Here, Koons continued his immersion into contemporary mass culture by intertwining a magazine centerfold nude with a well-known cartoon character. He reinforced the trite and kitschy nature of this imagery by titling the exhibition of which this work was a part *The Banality Show*. Some art critics have argued that

Koons and his work instruct viewers because both artist and work serve as the most visible symbols of everything wrong with contemporary American society. Whether or not this is true, people must acknowledge that, at the very least, Koons's prominence in the art world indicates he, like Warhol before him, has struck a chord that resonates with many viewers.

Postmodernism and the Critique of Art History

Postmodern architecture often incorporates historical forms and styles. Art world participants have cited that awareness of the past frequently as a defining characteristic of postmodernism, both in architecture and art. Such awareness, however, extends beyond mere citation. People have described it as a self-consciousness on the part of artists about their places in the continuum of art history. Not only do artists demonstrate their knowledge about past art, but they also express awareness of the mechanisms and institutions of the art

23-80 MARK TANSEY, *A Short History of Modernist Painting,* 1982. Oil on canvas, three panels, each 4′ 10″ × 3′ 4″.

world. For many postmodern artists, then, referencing the past moves beyond simple quotation from earlier works and styles and involves a critique of or commentary on fundamental art historical premises. In short, their art is about making art.

EVIDENCING ART HISTORY IN ART In his *A Short History of Modernist Painting* (FIG. **23-80**), American artist MARK TANSEY (b. 1949) provides viewers with a summary of the various approaches to painting artists have embraced over the years. Tansey presents a sequence of three images, each visualizing a way of looking at art. At the far left, a glass window encapsulates the Renaissance ideal of viewing art as though one were looking through a window. In the center image, a man pushing his head against a solid wall visualizes the thesis central to much of modernist formalism—that the painting should be acknowledged as an object in its own right. Modernism, particularly that Clement Greenberg promoted in the 1960s and 1970s, was based on the rejection of imitation and illusion as a primary artistic goal. In the image on the right, Tansey summarizes the postmodern approach to art with a chicken pondering its reflection in the mirror. The chicken's action reveals postmodern artists' self-consciousness or awareness of their places in the art historical continuum.

SATIRICAL CERAMIC SCULPTURE ROBERT ARNESON (1930–1992) has spent his life in a small town north of San Francisco, and this fact provided the impetus for his ceramic work *California Artist* (FIG. **23-81**). By then, Arneson had developed a body of work over the years of predominantly figurative ceramic sculpture, often satirical or amusing and sometimes biting. In 1981, well-known art critic Hilton Kramer published a review of an exhibition including Arneson's work. Kramer's assessment of Arneson's art was searingly negative. Arneson decided to create *California Artist* as a direct response to the critic, particularly to Kramer's derogatory comments on the provincialism of California art. This ce-

ramic sculpture, a half-length self-portrait, incorporates all of the critic's stereotypes. The artist placed the top half of his likeness on a pedestal littered with beer bottles, cigarette butts, and marijuana plants. Arneson appears clad only in a denim jacket and sunglasses, looking very defiant with his arms crossed. By creating an artwork that responded directly to an art critic's comments, Arneson revealed his comprehension of the mechanisms (for example, art criticism) people use currently to evaluate and validate art.

CHALLENGING ORIGINALITY American artist SHERRIE LEVINE (b. 1947) has presented what is perhaps the most dramatic challenge to art's premises and legitimization. Levine appropriated well-known artworks by other artists for a series of works. For example, she produced *Untitled (After Walker Evans;* FIG. **23-82**), based on *Kitchen Corner, Tenant Farmers, Hale County, Alabama* (FIG. **23-83**) by WALKER EVANS (1903–1975). Evans took his photograph in 1936 as part of a Farm Security Administration assignment (see Chapter 22, pages 846–47) in Alabama during the Great Depression. Not only is Levine's version an exact duplicate, but it is also clear from her title that she wants viewers to know the source of her image. In so doing, Levine directly challenges the notions of originality and authorship. The concept of (or at least the myth of) originality was one of the bedrocks of modernism, and here the artist has announced her affiliation with postmodern theory in her rejection of modernist principles. One critic commented that Levine's photographs contain

no combinations, no transformations, no additions, no synthesis. . . . In such an undisguised theft of already existing images, Levine lays no claim to conventional notions of artistic creativity. She makes use of the images, but not to constitute a style of her own. Her appropriations have only functional value for the particular historical discourses into which they are inserted.[50]

This critical evaluation points out how Levine's work, like that of other postmodern artists, operates as part of a larger

23-81 ROBERT ARNESON, *California Artist,* 1982. Glazed stoneware, 5′ 8¼″ × 2′ 3½″ × 1′ 8¼″. San Francisco Museum of Modern Art (gift of the Modern Art Council). Copyright © Estate of Robert Arneson/Licensed by VAGA, New York, NY.

art historical discussion and that its importance can be truly understood only in that context.

Postmodernism and Art Institutions

Along with a conscious reappraisal of the processes of art historical validation, postmodern artists have turned to assessing art institutions, such as museums and galleries. Not only have such artists addressed issues associated with the role of these institutions in validating art, but also, in keeping with increased public concern about issues of race, class, gender and ethnicity, they have scrutinized the discriminatory policies and politics of these institutions.

MUSEUMS AND THE POLITICIZATION OF ART
German artist HANS HAACKE (b. 1936) has focused his atten-

23-82 SHERRIE LEVINE, *Untitled (After Walker Evans)*, 1981. Gelatin silver print. Metropolitan Museum of Art, New York (gift of the artist, 1995).

23-83 WALKER EVANS, *Kitchen Corner, Tenant Farmers, Hale County, Alabama,* 1936. Black-and-white photograph.

23-84 HANS HAACKE, *MetroMobiltan*, 1985. Fiberglass construction, three banners, and photomural, 11′ 8″ × 20′ × 5′. Collection Centre Georges Pompidou, Paris.

tion on the politics of art museums and how these politics affect the art exhibited and, ultimately, museum visitors' understanding of art history. The specificity of his works, based on substantial research, make them stinging indictments of the institutions whose practices he critiques. In *MetroMobiltan* (FIG. **23-84**), Haacke illustrated the connection between the realm of art (more specifically, the Metropolitan Museum of Art in New York) and the "real" world of political and economic interests. A large photomural of a funeral for South African black people provided the backdrop for a banner for the 1980 Mobil Oil–sponsored Metropolitan Museum show *Treasures of Ancient Nigeria*. In 1980, Mobil was a principal U.S. investor in South Africa, and this work suggests that their sponsorship of this exhibition was in part driven by the fact Nigeria was one of the richest oil-producing countries in Africa. In 1981, the public pressured Mobil's board of directors to stop providing

oil to the white South African military and police. Haacke provided the official corporate response to this demand on the blue banners hanging on either side of *MetroMobiltan*. He set the entire tableau in a fiberglass replica of the museum's entablature. By placing these disparate elements, both visual and textual, together, Haacke forced viewers to think about the connections among multinational corporations, political and economic conditions in South Africa, and the conflicted politics of corporate patronage of art exhibitions. The complicity of Mobil Oil and other corporations in perpetuating injustice extends to the museum world, one the public often views as exempt from political and economic concerns.

THE "CONSCIENCE OF THE ART WORLD" The New York–based GUERRILLA GIRLS, formed in 1984, bill themselves as the "conscience of the art world." This group

23-85 GUERRILLA GIRLS, *The Advantages of Being A Woman Artist*, 1988. Poster.

THE ADVANTAGES OF BEING A WOMAN ARTIST:

Working without the pressure of success.
Not having to be in shows with men.
Having an escape from the art world in your 4 free-lance jobs.
Knowing your career might pick up after you're eighty.
Being reassured that whatever kind of art you make it will be labeled feminine.
Not being stuck in a tenured teaching position.
Seeing your ideas live on in the work of others.
Having the opportunity to choose between career and motherhood.
Not having to choke on those big cigars or paint in Italian suits.
Having more time to work when your mate dumps you for someone younger.
Being included in revised versions of art history.
Not having to undergo the embarrassment of being called a genius.
Getting your picture in the art magazines wearing a gorilla suit.

A PUBLIC SERVICE MESSAGE FROM **GUERRILLA GIRLS** CONSCIENCE OF THE ART WORLD
532 LaGUARDIA PLACE, #237 • NY, NY 10012
www.guerrillagirls.com

23-86 RICHARD MEIER, Getty Center, Los Angeles, 1997.

sees it as their duty to call attention to injustice in the art world, especially what they perceive as the sexist and racist orientation of the major institutions. The women who are members of the Guerrilla Girls remain anonymous at all times and protect their identities by wearing gorilla masks in public. They employ guerrilla tactics (hence their name) by putting up posters and fliers in public places. This distribution network expands the impact of their messages. One poster that reflects the Guerrilla Girls's agenda facetiously lists "the advantages of being a woman artist" (FIG. **23-85**). Actually, the list itemizes for readers the numerous obstacles women artists face in the contemporary art world. The Guerrilla Girls hope their publicizing of these obstacles will inspire improvements in the situation for women artists.

Into the Twenty-First Century: The Future of Art and Art History

At the end of the nineteenth century, a unique fin-de-siècle culture emerged, followed by the emergence in the early twentieth century of prodigious artistic talents such as Matisse, Duchamp, and Picasso. What will the twenty-first century bring? Will a similarly fertile period in art and culture arise as we usher in the new century and the new millennium, as some people anticipate? It is, of course, impossible to predict anything with any certainty. Further, with the expansive scope of postmodernism, no single approach, style, or direction dominates.

A MONIED MUSEUM'S TOTAL INVOLVEMENT
One institution that may play a significant role in the future of art and art history is the Getty Center in Los Angeles. The recently completed buildings, housing both exhibition space and offices, and gardens (designed by American artist Robert Irwin) cover twenty-four acres. The work of American architect RICHARD MEIER (b. 1934), the sprawling complex of

buildings (FIG. **23-86**) incorporates both modernist and postmodern design elements. Much of the architecture recalls pristine modernism—clean lines, geometric rationality, and near-white walls. In postmodern fashion, Meier made each of the dozen pavilions on the site different from one another, creating an interesting dialogue between the architectural spaces and forms. The interior design reinforces the postmodern notion of eclecticism. Museum Director John Walsh requested traditional galleries, and Meier designed each gallery, with varying wall colors and surface treatments, to house a specific collection of artworks. He reconstructed historical rooms for some of the galleries, such as an elegantly decorative paneled room of the early eighteenth century.

The Getty Center is far more than a museum, and this aspect has many people speculating on the impact it may have on the art world in the twenty-first century. In addition to the J. Paul Getty Museum in Malibu, the new Getty Center houses five other programs—the Getty Research Institute for the History of Art and the Humanities, the Getty Conservation Institute, the Getty Education Institute, the Getty Grant Program, and the Getty Leadership Institute for Museum Management. The scope of these programs reveals the Getty's involvement in virtually every aspect of art and its presentation, including art history and art education. As such, it is positioned to have a dramatic effect on the future of art and its study. Further, the considerable funds the Getty Trust has access to (the result of J. Paul Getty's endowment of $700 million in Getty Oil stock on his death in 1976) has placed the Getty in a position to acquire art, exhibit it, study it, conserve it, and document it on a scale far beyond the means of any other museum in the world.

Appropriately enough, the Getty Center is perched high on a hill, allowing visitors to survey the expanse of Los Angeles that stretches out on every side. Only time will tell where art is headed, how scholars will reassess art history (necessitating new textbooks), and the extent of the Getty Center's influence.

NOTES

Chapter 14

1. Robert Gottfried, *The Black Death: Natural and Human Disaster in Medieval Europe* (New York: Free Press, 1985), xiii.

Chapter 15

1. Henry Dussart, ed., *Fragments inédits de Romboudt de Doppere: Chronique brugeoise de 1491 à 1498,* (Bruges, Belgium: L. de Plancke, 1892), 49.

2. Johan A. Huizinga, *The Waning of the Middle Ages,* (1924; reprint, New York: St. Martin's Press, 1988), 156.

Chapter 16

1. Elizabeth Gilmore Holt, ed., *Literary Sources of Art History* (Princeton, N.J.: Princeton University Press, 1947), 87–88.

2. Giorgio Vasari, *Lives of the Painters, Sculptors and Architects,* trans. Gaston du C. de Vere (New York: Alfred A. Knopf, 1996), 1:304.

3. Holt, *Literary Sources,* 90–91.

4. Vasari, 1:318

5. H.W. Janson, *The Sculpture of Donatello* (Princeton, N.J.: Princeton University Press, 1965), 154.

Chapter 17

1. Da Vinci to Ludovico Sforza, ca. 1480–81, *Literary Sources of Art History,* ed. Elizabeth Gilmore Holt (Princeton: Princeton University Press, 1947), 170.

2. Anthony Blunt, *Artistic Theory in Italy, 1450–1600* (London: Oxford University Press, 1964), 34.

3. Heinrich Wölfflin, *Classic Art: An Introduction to the Italian Renaissance,* 4th ed. (Ithaca, N.Y.: Cornell University Press, 1980), 27.

4. Erwin Panofsky, "Artist, Scientist, Genius," in *The Renaissance,* ed. Wallace K. Ferguson (New York: Harper & Row, 1962), 147

5. Bruce Boucher, *Andrea Palladio: The Architect in His Time* (New York: Abbeville Press, 1998), 229.

6. Holt, *Literary Sources,* 240.

7. James M. Saslow, *The Poetry of Michelangelo: An Annotated Translation* (New Haven, Conn.: Yale University Press, 1991), 195.

8. Ibid., 239.

9. Ibid., 407.

10. Vasari, 2: 736.

11. Robert J. Clements, *Michelangelo's Theory of Art* (New York: New York University Press, 1961), 320.

12. Francesco Valcanover, "An Introduction to Titian," in *Titian Prince of Painters* (Venice: Marsilio Editori, S.p.A., 1990), 23–24.

13. Vasari, 1: 860.

14. Holt, *Literary Sources,* 229.

Chapter 18

1. Jackson J. Spielvogel, *Western Civilization Since 1300,* 3rd ed., (Minneapolis: West Publishing Company, 1997), 465.

2. Wolfgang Stechow, *Northern Renaissance Art 1400–1600: Sources and Documents* (Evanston, Ill.: Northwestern University Press, 1989), 111.

3. Ibid., 118.

4. Ibid., 123.

5. Vasari, 2: 863.

Chapter 19

1. Wolfgang Stechow, *Rubens and the Classical Tradition* (Cambridge: Harvard University Press, 1968), 26.

2. David G. Wilkins, Bernard Schultz, and Katheryn M. Linduff, *Art Past, Art Present,* 3rd ed. (New York: Harry N. Abrams, 1997), 365.

3. Bob Haak, *The Golden Age: Dutch Painters of the Seventeenth Century* (New York: Abrams, 1984), 75.

4. Ibid., 450.

5. Robert Goldwater and Marco Treves (eds.), *Artists on Art,* 3rd ed. (New York: Pantheon Books, 1958), 155.

6. Ibid., 155.

7. Ibid., 151–153.

8. Jonathan Brown, *Kings and Connoisseurs: Collecting Art in Seventeenth-Century Europe* (Princeton, N.J.: Princeton University Press, 1995), 207.

9. Goldwater and Treves (eds.), 157.

Chapter 20

1. Thomas A. Bailey, *The American Pageant: A History of the Republic,* 2nd ed. (Boston: D.C. Heath and Company, 1961), 280.

2. *The Indispensable Rousseau,* compiled and presented by John Hope Mason (London: Quartet Books, 1979), 39.

3. Voltaire to Rousseau, 30 August 1755, *The Collected Writings of Rousseau,* Vol. 3, eds. Roger D. Masters and Christopher Kelly (Hanover, N.H.: University Press of New England, 1992), 102.

4. Elizabeth Gilmore Holt, *Literary Sources of Art History* (Princeton: Princeton University Press, 1947), 532.

5. Robert Goldwater and Marco Treves, *Artists on Art,* 3rd ed. (New York: Random House, 1958), 206.

6. Ibid., 205.

7. Ibid., 205.

8. Alexander Pope, *Epistles to Several Persons (Moral Essays),* ed. F. W. Bateson (London and New Haven: Metheun & Co. Ltd. and Yale University Press, 1961), 155.

9. Edgar Allen Poe, "To Helen" (1831).

10. Marcus Whiffen and Fredrick Koeper, *American Architecture 1607–1976* (Cambridge, MA: The MIT Press, 1981), 130.

11. Goldwater and Treves, 218.

12. Ibid., 216.

13. Gwyn A. Williams, *Goya and the Impossible Revolution* (London: Allen Lane, 1976), 175–77.

14. Walter Pach, trans., *Journal of Eugène Delacroix* (New York: Crown Publishers, 1948), 511.

15. Théophile Gautier, *Histoire de Romantisme* (Paris: Charpentier, 1874), 204.

16. Delacroix to Auguste Jal, 4 June 1832, *Art in Theory 1815–1900: An Anthology of Changing Ideas,* eds. Charles Harrison and Paul Wood with Jason Gaiger (Oxford: Blackwell Publishers Ltd., 1998), 88.

17. Théophile Silvestre, *Les Artistes Français-I: Romantiques* (Paris: Les Éditions G. Crès and C-ie, 1926). 75.

18. H. Borsch-Supan, *Caspar David Friedrich* (New York: Brazillier, 1974), 7.

19. Harrison and Wood with Gaiger, 54.

20. Brian Lukacher, "Nature Historicized: Constable, Turner, and Romantic Landscape Painting," in *Nineteenth Century Art: A Critical History,* ed. Stephen F. Eisenman (New York: Thames and Hudson, 1994), 121.

21. John W. McCoubrey, *American Art 1700–1960: Sources and Documents* (Englewood Cliffs, N.J.: Prentice-Hall, 1965), 98.

22. *The New York Weekly Tribune,* 30 September 1865.

23. Nikolai Cikovsky Jr. and Franklin Kelly, *Winslow Homer* (Washington, D.C.: National Gallery of Art, 1995), 26.

24. Holt, *Literary Sources,* 547, 548.

25. Nicholas Pevsner, *An Outline of European Architecture* (Baltimore, Md.: Penguin, 1960), 627.

26. Letter from Delaroche to François Arao, in Helmut Gernsheim, *Creative Photography* (New York: Bonanza Books, 1962), 24.

27. Naomi Rosenblum, *A World History of Photography* (New York: Abbeville Press, 1984), 69.

Chapter 21

1. Clement Greenberg, "Modernist Painting," *Art & Literature,* no. 4 (spring 1965): 193.

2. Ibid., 194.

3. Linda Nochlin, *Realism and Tradition in Art 1848–1900* (Englewood Cliffs, N.J.: Prentice-Hall, Inc., 1966), 39, 38, 42.

4. Goldwater and Treves, 295–97.

5. Comment by French critic Enault in Linda Nochlin, *The Nature of Realism* (New York: Penguin Books, 1971), 34.

6. Nochlin, *Realism and Tradition in Art,* 42.

7. In George Heard Hamilton, *Manet and His Critics* (New Haven, Conn.: Yale University Press, 1954), 45.

8. Stephen F. Eisenman, *Nineteenth Century Art: A Critical History* (London: Thames and Hudson, 1994), 242.

9. "On the Heroism of Modern Life" (the closing section of Baudelaire's *Salon of 1846,* published as a brochure in Paris in 1846).

10. Lloyd Goodrich, *Thomas Eakins, His Life and Work* (New York: Whitney Museum of American Art, 1933), 51–52.

11. In Kenneth MacGowan, *Behind the Screen* (New York: A Dell Book, Delta, 1965), 49.

12. In Robert A. Sobieszak, *Masterpieces of Photography from the George Eastman House Collection* (Rochester: International Museum of Photography, 1985), 214.

13. Linda Nochlin, *Realism* (Harmondsworth, England: Penguin Books, 1971), 28.

14. Linda Nochlin, *Impressionism and Post-Impressionism 1874–1904* (Englewood Cliffs, N J : Prentice Hall, 1966), 35.

15. Roy McMullan, *Degas: His Life, Times, and Work* (Boston: Houghton Mifflin Company, 1984), 293.

16. John McCoubrey, *American Art 1700–1960: Sources and Documents* (Englewood Cliffs, N.J.: Prentice Hall, 1965), 184.

17. Laurie Schneider Adams, *A History of Western Art,* 2nd ed. (Madison, Wis.: Brown & Benchmark, 1997), 443.

18. Goldwater and Treves, 322.

19. Van Gogh to Theo van Gogh, 3 September 1888, *Van Gogh: A Self-Portrait, Letters Revealing His Life as a Painter,* selected by W. H. Auden (New York: Dutton, 1963), 319.

20. Van Gogh to Theo van Gogh, 11 August 1888, *Van Gogh: A Self-Portrait, Letters Revealing His Life as a Painter,* 313.

21. Van Gogh to Theo van Gogh, 11 August 1888, *Van Gogh: A Self-Portrait, Letters Revealing His Life as a Painter,* 321.

22. Van Gogh to Theo van Gogh, September 1888, *The Complete Letters of Vincent van Gogh,* ed. J. van Gogh–Bonger and W. V. van Gogh (Greenwich, Conn.: 1979), 3: no. 534.

23. Van Gogh to Theo van Gogh, 8 September 1888, *Van Gogh: A Self-Portrait, Letters Revealing His Life as a Painter,* selected by W. H. Auden (New York: Dutton, 1963), 320.

24. Van Gogh to Theo van Gogh, 16 July 1888, ibid., 299.

25. Belinda Thompson, ed. *Gauguin by Himself* (Boston: Little, Brown and Company, 1993), 270–71.

26. Herschel B. Chipp, *Theories of Modern Art* (Berkeley: University of California Press, 1968), 72.

27. Maurice Denis, "The Influence of Paul Gauguin," in *Theories of Modern Art,* 103.

28. Goldwater and Treves, 375.

29. Ibid., 378.

30. Richard W. Murphy, *The World of Cézanne 1839–1906* (New York: Time-Life Books, 1968), 70.

31. Goldwater and Treves, 363.

32. Cézanne to Émile Bernard, 15 April 1904, *Theories of Modern Art,* 19.

33. Goldwater and Treves, eds., 361.

34. George Heard Hamilton, *Painting and Sculpture in Europe 1880–1940,* 6th ed. (New Haven: Yale University Press, 1993), 124.

35. V. Frisch and J.T. Shipley, *Auguste Rodin,* (New York: Stokes, 1939), 203.

36. Eileen Boris, *Art and Labor: Ruskin, Morris, and the Craftsman Ideal in America* (Philadelphia: Temple University Press, 1986), 7.

37. Siegfried Giedion, *Space, Time, and Architecture* (Cambridge, Mass.: Harvard University Press, 1965), 282.

Chapter 22

1. Benito Mussolini, "The Doctrine of Fascism," in *Italian Fascisms from Pareto to Gentile,* ed. Adrian Lyttleton, trans. Douglas Parmée (London: Cape, 1973), 42.

2. Herwarth Walden, "Kunst und Leben," *Der Sturm* (1919), 10: 2.

3. John Elderfield, *The "Wild Beasts": Fauvism and Its Affinities* (New York: Museum of Modern Art, 1976), 29.

4. John Russell and the editors of Time-Life Books, *The World of Matisse 1869–1954* (New York: Time-Life Books, 1969), 98.

5. Peter Selz, *German Expressionist Painting* (Berkeley: University of California Press, 1957), 95.

6. Chipp, 182.

7. Frederick S. Levine, *The Apocalyptic Vision: The Art of Franz Marc as German Expressionism* (New York: Harper & Row, 1979), 57.

8. Sam Hunter and John Jacobus, *Modern Art,* 3rd ed. (New York: Harry N. Abrams, 1992), 121.

9. Roland Penrose, *Picasso: His Life and Work,* rev. ed. (New York: Harper & Row, 1971), 122.

10. Hamilton, *Painting and Sculpture,* 246.

11. Edward Fry, ed., *Cubism* (London: Thames & Hudson, 1966), 112–13, 116.

12. Hamilton, *Painting and Sculpture,* 238.

13. Michael Hoog, *R. Delaunay* (New York: Crown, 1976), 49.

14. Françoise Gilot and Carlton Lake, *Life With Picasso* (New York: McGraw-Hill, 1964), 77.

15. From the *Initial Manifesto of Futurism,* first published 20 February 1909.

16. Ibid.

17. Umberto Boccioni, et al. "Futurist Painting: Technical Manifesto," *Poesia,* April 10, 1910.

18. Hans Richter, *Dada: Art and Anti-Art* (London: Thames & Hudson, 1961), 25.

19. Robert Short, *Dada and Surrealism* (London: Octopus Books, 1980), 18.

20. Robert Motherwell, ed., *The Dada Painters and Poets: An Anthology,* 2nd ed. (Cambridge, Mass.: Belknap Press of Harvard University, 1989).

21. Richter, 64–65.

22. Ibid., 57.

23. Arturo Schwarz, *The Complete Works of Marcel Duchamp* (London: Thames & Hudson, 1965), 466.

24. Charles C. Eldredge, "The Arrival of European Modernism," *Art in America* 61 (July-August 1973), 35.

25. Dorothy Norman, *Alfred Stieglitz: An American Seer* (Millerton, N.Y.: Aperture, 1973).

26. Ibid., 161.

27. Ibid., 9–10, 161.

28. Gail Stavitsky, "Reordering Reality: Precisionist Directions in American Art, 1915–1941," in *Precisionism in America 1915–1941: Reordering Reality* (New York: Harry N. Abrams, 1994), 12.

29. Carol Troyen and Erica E. Hirshler, *Charles Sheeler: Paintings and Drawings* (Boston: Museum of Fine Arts, 1987), 116.

30. Miles Orvell, "Inspired by Science and the Modern: Precisionism and American Culture," in *Precisionism in America,* 54.

31. Karen Tsujimoto, *Images of America: Precisionist Painting and Modern Photography* (Seattle: University of Washington Press, 1982), 70.

32. Matthias Eberle, *World War I and the Weimar Artists: Dix, Grosz, Beckmann, Schlemmer* (New Haven: Yale University Press, 1985), 65.

33. Ibid., 54.

34. Ibid., 22.

35. Ibid., 42.

36. William S. Rubin, *Dada, Surrealism, and Their Heritage* (New York: Museum of Modern Art, 1968), 64.

37. Hamilton, *Painting and Sculpture,* 392.

38. Richter, 155.

39. Ibid., 159.

40. Rubin, *Dada, Surrealism, and Their Heritage,* 111.

41. Hunter and Jacobus, 179.

42. William S. Rubin, *Miró in the Collection of the Museum of Modern Art* (New York: Museum of Modern Art, 1973), 32.

43. Chipp, 182–86.

44. Ibid., 341, 345.

45. Robert L. Herbert, ed., *Modern Artists on Art* (Englewood Cliffs, N.J.: Prentice Hall, 1965), 140–41, 145–46.

46. Chipp, 328, 334, 336.

47. Ibid., 332, 335.

48. Camilla Gray, *The Russian Experiment in Art 1863–1922* (New York: Harry N. Abrams, 1970), 216.

49. Ibid., 232–33.

50. Kenneth Frampton, *A Critical History of Modern Architecture* (London: Thames & Hudson, 1985), 142.

51. Ibid., 147.

52. Chipp, 349, and Michel Seuphor, *Piet Mondrian: Life and Work* (New York: Harry N. Abrams, 1956), 177.

53. Hamilton, *Painting and Sculpture,* 319.

54. Chipp, 349.

55. Ibid., 350.

56. Hans L. Jaffeé, comp., *De Stijl* (New York: Harry N. Abrams, 1971), 185–188.

57. Piet Mondrian, "Dialogue on the New Plastic," in *Art in Theory 1900–1990: An Anthology of Changing Ideas,* eds. Charles Harrison and Paul Wood (Oxford: Blackwell Publishers Ltd., 1992), 285.

58. Walter Gropius, from *The Manifesto of the Bauhaus,* April 1919.

59. Ibid.

60. Ibid.

61. László Moholy-Nagy, *Vision in Motion* (Chicago: Paul Theobald, 1969), 268.

62. Hamilton, *Painting and Sculpture,* 345.

63. Ibid.

64. *Josef Albers: Homage to the Square* (New York: Museum of Modern Art, 1964), n.p.

65. John Willett, *Art and Politics in the Weimar Period: The New Sobriety, 1917–1933,* (New York: Da Capo Press, 1978), 119.

66. Wayne Craven, *American Art: History and Culture* (Madison, Wis.: Brown and Benchmark, 1994), 403.

67. Vincent Scully, Jr., *Frank Lloyd Wright* (New York: George Braziller, Inc., 1960), 18.

68. Edgar Kauffmann, ed., *Frank Lloyd Wright, An American Architect* (New York: Horizon, 1955), 205, 208.

69. Philip Johnson, *Mies van der Rohe,* rev. ed. (New York: Museum of Modern Art, 1954), 200–201.

70. Hamilton, *Painting and Sculpture,* 462.

71. H. H. Arnason and Marla F. Prather, *History of Modern Art,* 4th ed. (Upper Saddle River, N.J.: Prentice Hall, 1998), 180.

72. Barbara Hepworth, *A Pictorial Autobiography* (London: The Tate Gallery, 1978), 9, 53.

73. Herbert, 139.

74. Herbert, 140–141, 145–146.

75. Herbert, 143.

76. Frances K. Pohl, *Ben Shahn: New Deal Artist in a Cold War Climate, 1947–1954* (Austin, Tex: University of Texas Press, 1989), 159.

77. Pablo Picasso, "Statement to Simone Téry," in *Art in Theory 1900–1990: An Anthology of Changing Ideas,* eds. Charles Harrison and Paul Wood (Oxford: Blackwell Publishers Ltd., 1992), 640.

78. Roland Penrose, *Picasso: His Life and Work,* rev. ed. (New York: Harper and Row, 1973), 311n.

79. Milton Meltzer, *Dorothea Lange: A Photographer's Life* (New York: Farrar, Strauss, Giroux, 1978), 133, 220.

80. Henry Louis Gates Jr., "New Negroes, Migration, and Cultural Exchange," in *Jacob Lawrence: The Migration Series,* ed. Elizabeth Hutton Turner (Washington, D.C.: The Phillips Collection, 1993), 20.

81. James M. Dennis, *Grant Wood: A Study in American Art and Culture* (Columbia, Mo.: University of Missouri Press, 1986), 143.

82. Wanda M. Corn, *Grant Wood: The Regionalist Vision* (New Haven: Yale University Press, 1983), 131.

83. Corn, Grant Wood, 131.

84. Matthew Baigell, *A Concise History of American Painting and Sculpture* (New York: Harper & Row, 1984), 264.

85. Vivian Endicott Barnett, "Banned German Art: Reception and Institutional Support of Modern German Art in the United States, 1933–45," in *Exiles + Emigrés: The Flight of European Artists from Hitler,* by Stephanie Barron (Los Angeles: Los Angeles County Museum of Art, 1997), 283.

Chapter 23

1. Clement Greenberg, "Toward a Newer Laocoon," *Partisan Review* 7, no. 4 (July/August 1940): 305.

2. Clement Greenberg, "Sculpture in Our Time," *Arts Magazine* 32, no. 9 (June 1956): 22.

3. Dawn Ades and Andrew Forge, *Francis Bacon* (London: Thames & Hudson, 1985), 8; and David Sylvester, *The Brutality of Fact: Interviews with Francis Bacon,* 3rd ed. (London: Thames & Hudson, 1987), 182.

4. Marcus Rothko and Adolph Gottlieb, in "The Realm of Art: A New Platform and Other Matters: 'Globalism' Pops into View," by Edward Alden Jewell, *New York Times,* 13 June 1943, x9.

5. Jackson Pollock, "My Painting," *Possibilities* 1 (Winter 1947), 79.

6. "Jackson Pollack: Is He the Greatest Living Painter in the United States?" *Life,* vol. 27 (August 8, 1949), 42–44.

7. Harold Rosenberg, *The Tradition of the New* (New York: Horizon Press, 1959), 25.

8. Thomas Hess, *Barnett Newman* (New York: Walker and Company, 1969), 51.

9. John P. O'Neill, ed., *Barnett Newman: Selected Writings and Interviews* (New York: Knopf, 1990), 108.

10. Mark Rothko, quoted in Sidney Janis, *Abstract and Surrealist Art in America* (New York: Reynal & Hitchcock, 1944), 118. Rothko and Gottlieb, in "The Realm of Art: A New Platform and Other Matters: 'Globalism' Pops into View," x9.

11. In Selden Rodman, *Conversations with Artists* (New York: Devin-Adair, 1957), 93–94.

12. Clement Greenberg, "Recentness of Sculpture," in *Minimal Art: A Critical Anthology,* ed. Gregory Battcock (New York: E. P. Dutton, 1968), 183–84.

13. Maya Lin, in *National Geographic* 167, no. 5 (May 1985): 557.

14. Lucy Lippard, *Eva Hesse* (New York: New York University Press, 1976), 165.

15. Ibid., 56.

16. Ibid., 56.

17. John Gordon, *Louise Nevelson* (New York: Frederick A. Praeger, 1967), 12.

18. Deborah Wye, *Louise Bourgeois* (New York: Museum of Modern Art, 1982), 22.

19. Ibid., 25.

20. Ibid., 22, 25, 27.

21. H. H. Arnason, *History of Modern Art,* 3rd ed., (Englewood Cliffs, N.J.: Prentice Hall, 1986), 472.

22. Barbara Haskell, *Blam! The Explosion of Pop, Minimalism, and Performance 1958–1964* (New York: Whitney Museum of American Art), 53.

23. Caroline Tisdall, *Joseph Beuys* (New York: Thames and Hudson, 1979), 6.

24. "Joseph Kosuth: Art as Idea as Idea," in *Artwords: Discourse on the 60s and 70s,* ed. Jeanne Siegel (Ann Arbor, Mich.: UMI Research Press, 1985), 225.

25. Ibid., 221.

26. Daniel Wheeler, *Art Since Mid-Century: 1945 to the Present* (Englewood Cliffs, N.J.: Prentice-Hall, 1991).247.

27. Richard Francis, *Jasper Johns* (New York: Abbeville Press, 1984), 21.

28. Ibid., 9.

29. John Cage, *Silence* (Middletown, Conn.: Wesleyan University Press, 1961), 101.

30. Christine Lindey, *Superrealist Painting and Sculpture* (London: Orbis, 1980), 50.

31. Ibid., 130.

32. Nancy Holt, ed., *The Writings of Robert Smithson* (New York: New York University Press, 1975), 111.

33. Calvin Tomkins, "The Art World: Tilted Arc," *New Yorker,* 20 May 1985, 100.

34. Peter Blake, *Frank Lloyd Wright* (Hammondsworth, England: Penguin Books, 1960), 115.

35. Robert Venturi, *Complexity and Contradiction in Architecture,* 2nd ed. (New York: Museum of Modern Art, 1977), 16.

36. Fredric Jameson, "Postmodernism and Consumer Society," in *The Anti-Aesthetic: Essays on Postmodern Culture,* ed. Hal Foster (Port Townsend, Wash.: Bay Press, 1983), 113.

37. Grace Glueck, "Susan Rothenberg: New Outlook for a Visionary Artist," *New York Times Magazine,* 22 July 1984, 20.

38. *Walker Art Center: Painting and Sculpture from the Collection* (Minneapolis: Walker Art Center, 1990), 435.

39. Gerald Marzorati, "Sandro Chia: The Last Hero," *Artnews* 82, no. 4 (April 1983): 60.

40. Susanna Torruella Leval, "Recapturing History: The (Un)official Story in Contemporary Latin American Art," *Art Journal* 51, no. 4 (Winter 1992): 74.

41. Ibid.

42. *Corporal Politics* (Cambridge: MIT List Visual Arts Center, 1993), 46.

43. Kobena Mercer, "Black Hair/Style Politics," in *Out There: Marginalization and Contemporary Culture,* ed. Russell Ferguson, Martha Gever, Trinh T. Minh-ha, and Cornel West (New York: New Museum of Contemporary Art, 1990), 248–49.

44. Ibid., 249.

45. Brooke Kamin Rapaport, "Melvin Edwards: Lynch Fragments," *Art in America* 81, no. 3 (March 1993): 62.

46. Ibid.

47. Jaune Quick-to-See Smith and Harmony Hammond, *Women of Sweetgrass: Cedar and Sage* (New York: American Indian Center, 1984), 97.

48. Richard Marshall and Robert Mapplethorpe, *50 New York Artists* (San Francisco: Chronicle Books, 1986), 448–49.

49. Mary Jane Jacob, *Magdalena Abakanowicz* (New York: Abbeville, 1982), 94.

50. Douglas Crimp, "Appropriating Appropriation," in *Image Scavengers: Photography* (Philadelphia: Institute of Contemporary Art, 1982), 30.

PRONUNCIATION GUIDE TO ARTISTS' NAMES

KEY

ŭ **a**b**u**t, kitt**e**n a c**o**t, c**a**rt ā b**a**ke ă b**a**ck au **ou**t
ch **ch**in e l**e**ss ē **ea**sy g **g**ift ĭ tr**i**p ī l**i**fe
j **j**oke ḵ ki**ck** ⁿ French vi**n** ng si**ng** o fl**aw** ō b**oa**t
ö b**i(r)**d oi c**oi**n u f**oo**t ū l**oo**t ü f**ew**
y yo**y**o zh vi**si**on

Artist's Name	Phonetic Pronunciation
Abakanowicz, Magdalena	a-ba-kan-ʹo-wits, mag-dŭ-ʹlā-nŭ
Aertsen, Pieter	ʹart-sen, ʹpē-tŭr
Alberti, Leon Battista	ăl-ʹber-tē, lā-ʹōn bat-ʹtēs-ta
Altdorfer, Albrecht	ʹalt–dor-fŭr, ʹal-breḵt
Andrea del Castagno	an-ʹdrā-ŭ del ka-ʹstan-yō
Angelico, Fra	an-ʹjel-li-kō, fra
Anguissola, Sofonisba	ang-gwēs-ʹsō-lŭ, sō-fō-ʹnēz-bŭ
Archipenko, Aleksandr	ar-ki-ʹpeng-kō, al-ik-ʹsan-dŭr
Arnolfo di Cambio	ar-ʹnol-fō dē ʹkam-byō
Arp, Jean	arp, zhaⁿ
Asam, Egid Quirin	ʹaz–am, ā-ʹgēt kvē-ʹrēn
Balla, Giacomo	ʹbal–la, ʹja-kō-mō
Barlach, Ernst	ʹbar–laḵ, ernst
Barye, Antoine-Louis	ba-ʹrē, aⁿ-ʹtwan lwē
Beckmann, Max	ʹbek-man, maks
Behnisch, Günter	ʹben-ish, ʹgun-tŭr
Bellini, Giovanni	bel-ʹlē-nē, jō-ʹvan-nē
Berlinghieri, Bonaventura	ber-ling-ʹgye-rē, bo-na-ven-ʹtū-ra
Bernini, Gianlorenzo	ber-ʹnē-nē, jan-lo-ʹren-zō
Beuys, Joseph	bois, ʹyō-zef
Bierstadt, Albert	ʹbēr-shtat
Boccioni, Umberto	bōt-ʹchō-nē, ūm-ʹber-tō
Boffrand, Germain	bo-ʹfraⁿ, zher-ʹmăⁿ
Bonheur, Rosa	bon-ʹur, ʹrō-zŭ
Borromini, Francesco	bor-rō-ʹmē-nē, fran-ʹches-kō
Bosch, Hieronymous	bash (or bosh), hŭ-ʹran-ŭ-mus
Botticelli, Sandro	bot-ti-ʹchel-ē, ʹsan-drō
Boucher, François	bū-ʹshā, fraⁿ-ʹswa
Bouguereau, William	bū-gŭ-ʹrō, wēl-ʹyam
Bourgeois, Louise	bor-ʹzhwa
Bouts, Dirk	bauts, dirk
Bramante, Donato d'Angelo	bra-ʹman-tā, do-ʹna-tō ʹdan-je-lō
Brancusi, Constantin	brăn-ʹkū-zē, kon-stan-ʹtēn
Braque, Georges	brak, zhorzh
Breuer, Marcel	ʹbroi-ŭr, mar-ʹsel
Broederlam, Melchior	ʹbrū-dŭr-lam, ʹmel-kyor
Bronzino, Agnolo	bron-ʹzē-nō, ʹanʸ-o-lō
Bruegel the Elder, Pieter	ʹbroi-gŭl, ʹpē-tŭr
Brunelleschi, Filippo	brŭn-ŭ-ʹles-kē, fē-ʹlēp-pō
Burgee, John	ʹbŭr-jē
Caillebotte, Gustave	ka-y(ŭ)-ʹbot, gū-ʹstav
Callot, Jacques	ka-ʹlō, ʹzhak
Campin, Robert	kaⁿ-ʹpeⁿ, rō-ʹber
Canaletto, Antonio	ka-na-ʹlet-tō, an-ʹtōn-yō
Canova, Antonio	ka-ʹnō-va, an-ʹtōn-yō
Caradosso, Christoforo Foppa	kar-ŭ-ʹdos-sō, krē-ʹsto-fo-rō, ʹfop-pa
Caravaggio	kar-ŭ-ʹvad-jō,
Carpeaux, Jean-Baptiste	kar-ʹpō, zhaⁿ bap-ʹtēst
Carracci, Annibale	ka-ʹrat-chē, an-ʹnē-bŭ-lā
Cassatt, Mary	kŭ-ʹsat
Cavallini, Pietro	ka-va-ʹlē-nē, ʹpye-trō

Artist's Name	Phonetic Pronunciation
Cellini, Benvenuto	chel-ʹlē-nē, ben-vŭ-ʹnū-tō
Cézanne, Paul	sā-ʹzan, pōl
Chagall, Marc	shŭ-ʹgal, mark
Chardin, Jean-Baptiste-Siméon	shar-ʹdăⁿ, zhaⁿ bapʹtēst si-mā-ʹōⁿ
Chia, Sandro	ʹkē-ŭ, ʹsan-drō
Chirico, Giorgio de	ʹkēr-i-kō, ʹjor-jō de
Christo	ʹkris-tō
Christus, Petrus	ʹkris-tŭs, ʹpet-rŭs
Cimabue	chē-ma-ʹbū-ā
Clodion	klō-dē-ʹoⁿ
Clouet, Jean	klū-ʹā, zhaⁿ
Corot, Jean-Baptiste-Camille	ko-ʹrō, zhaⁿ bapʹtēst kŭ-ʹmēl
Correggio, Antonio Allegri da	kor-ʹred-jō, an-ʹtō-nē-ō al-leg-rē da
Courbet, Gustave	kur-ʹbā, gū-ʹstav
Coypel, Antoine	kwa-ʹpel, aⁿ-ʹtwan
Cranach the Elder, Lucas	ʹkran-aḵ, ʹlū-kŭs
Cuvilliés, François de	kyū-vē-ʹyā, fraⁿ-ʹswa dŭ
Cuyp, Aelbert	koip, ʹel-bŭrt
Daddi, Bernardo	ʹdad-dē, ber-ʹnar-dō
Daguerre, Louis-Jacques-Mandé	da-ʹger, lū-ʹē zhak maⁿ-ʹdā
Dali, Salvador	ʹda-lē (or da-ʹlē) sal-vŭ-ʹdor
Daumier, Honoré	dō-ʹmyā, o-nor-ʹā
David, Jacques-Louis	da-ʹvēd, zhak lū-ʹē
De Kooning, Willem	dŭ ʹkū-ning, ʹwil-ŭm
Degas, Edgar	dŭ-ʹga, ed-ʹgar
Delacroix, Eugène	del-ŭ-ʹk(r)wa, ö-ʹzhen
Delaunay, Robert	dŭ-lō-ʹnā, rō-ʹber
Della Robbia, Andrea	ʹdel-la ʹrō-bē-ŭ, an-ʹdrā-ŭ
Della Robbia, Giovanni	ʹdel-la ʹrō-bē-ŭ, jō-ʹvan-nē
Della Robbia, Girolamo	ʹdel-la ʹrō-bē-ŭ, jē-ro-ʹlam-ō
Della Robbia, Luca	ʹdel-la ʹrō-bē-ŭ, ʹlū-ka
Demuth, Charles	dŭ-ʹmūth
Derain, André	dŭ-ʹrăⁿ, an-ʹdrā
Donatello	do-nŭ-ʹtel-lō
Dubuffet, Jean	ʹdū-bŭ-fā, zhaⁿ
Duccio di Buoninsegna	ʹdūt-chō dē bwo-nin-ʹsā-nya
Duchamp, Marcel	dū – ʹshaⁿ, mar-ʹsel
Dürer, Albrecht	ʹdü-rŭr, ʹal-breḵt
Durieu, Eugène	dūr-ʹyü, ö-ʹzhen
Eakins, Thomas	ʹā-kŭnz
Eiffel, Alexandre-Gustave	e-ʹfel, ʹal-ek-san-drŭ gū-ʹstav
El Greco	el ʹgre-kō (or ʹgrā-kō)
Ernst, Max	ernst, maks
Eyck, Jan van	ʹīk, yan văn
Fouquet, Jean	fū-ʹkā, zhaⁿ
Fragonard, Jean-Honoré	frăg-ŭ-ʹnar, zhaⁿ o-no-ʹrā
Frankenthaler, Helen	ʹfrăng-kŭn-tha-lŭr
Friedrich, Caspar David	ʹfrēd-riḵ, ʹkas-par ʹdav-it
Fuseli, Henry	ʹfüs-lē (or ʹfū-z(ŭ)-lē), ʹhen-rē
Gabo, Naum	ʹgab-ō, ʹna-ūm
Gaddi, Taddeo	ʹgad-dē, ʹtad-dā-ō
Garnier, J.L. Charles	gar-ʹnyā, sharl
Gaudí, Antonio	gau-ʹdē, an-ʹtōn-ē-ō
Gauguin, Paul	gō-ʹgăⁿ, pōl
Gaulli, Giovanni Battista	ʹgaul-lē, jō-ʹvan-nē bat-ʹtēs-ta
Gehry, Frank	ʹge-rē
Gentile da Fabriano	jen-ʹtē-lā da fab-rē-ʹan-ō
Gentileschi, Artemisia	jen-ti-ʹles-kē, art-ŭ-ʹmē-zhŭ
Gentileschi, Orazio	jen-ti-ʹles-kē, o-ʹrat-syō
Géricault, Théodore	zhe-ri-ʹkō, tā-ō-ʹdor
Ghiberti, Lorenzo	gi-ʹber-tē, lo-ʹren-zō
Ghirlandaio, Domenico	gir-lŭn-ʹda-yō, do-ʹmen-i-kō

Artist's Name	Phonetic Pronunciation
Giacometti, Alberto	ja-ko-'met-tē, ăl-'ber-tō
Giorgione da Castelfranco	jor-'jō-nā da kas-tel-'frang-kō
Giotto di Bondone	'jot-tō dē bon-'dō-nā
Giovanni da Bologna	jō-'van-nē da bo-'lōn-yŭ
Girardon, François	zhē-rar-'don, fran-'swa
Girodet-Trioson, Anne-Louis	zhē-rō-'dā trē-ō-'zon, an-lū-'ē
Goes, Hugo van der	gōz, 'hyū-gō văn dŭr
Gogh, Vincent van	gō, vin-'sent văn
Golub, Leon	'go-lŭb
González, Julio	'gon-sal-ās, 'hūl-yō
Gossaert, Jan	'gos-art, yan
Goujon, Jean	gū-'zhon, zhan
Goya y Lucientes, Francisco José de	'goi-yŭ ē lū-'syen-tās, fran-'sis-kō hō-'sā dā
Greenough, Horatio	'grē-nō, hŭ-'rā-shē-ō
Greuze, Jean-Baptiste	grŭz (or gröz), zhan bap-'tēst
Gropius, Walter	'grō-pē-us, 'wol-tŭr
Gros, Antoine-Jean	grō, an-'twan zhan
Grosz, George	grōs
Grünewald, Matthias	'grü-nŭ-valt, ma-'tē-ŭs
Guarini, Guarino	'gwar-ē-nē, 'gwar-ē-nō
Haacke, Hans	'ha-kŭ, hans
Hals, Frans	hals, frants
Hardouin-Mansart, Jules	ar-'dwăn -man-'sar, zhŭl
Heda, Willem Claesz	'hā-da, 'vil-ŭm klas
Hemessen, Caterina van	'hā-me-sŭn, ka-te-'rē-na văn
Herrera, Juan de	er-'rer-a, hwan dā
Höch, Hannah	hök, 'ha-na
Holbein, Hans the Younger	'hōl-bīn, hants
Holzer, Jenny	'hōlt-zŭr
Honthorst, Gerrit van	'hont-horst, 'gher-ŭt van
Horta, Victor	'hor-tŭ, 'vēk-tor
Houdon, Jean-Antoine	ū-'don, zhan an-'twan
Ingres, Jean-Auguste Dominique	'ăn(ng)grŭ, zhan o-'gūst do-mi-'nēk
Jeanne-Claude	zhăn-klod
Jones, Inigo	jōnz, 'in-ŭ-gō
Jouvin, Hippolyte	zhū-'văn, ēp-po-'lēt
Juvara, Filippo	yū-'var-a, fē-'lēp-pō
Kahlo, Frida	'ka-lō, 'frē-da
Kalf, Willem	kalf, 'vil-ŭm
Kandinsky, Vassily	kăn-'din(t)-skē, vŭs-'ēl-ē
Kaprow, Allan	'kăp-rō
Käsebier, Gertrude	'kāz-ŭ-bēr, 'ger-trūd
Kauffmann, Angelica	'kauf-man, an-'je-li-kŭ
Kiefer, Anselm	'kē-fŭr, 'an-selm
Kirchner, Ernst Ludwig	'kirk-nŭr, ernst 'lūd-vig
Klee, Paul	klā, pōl
Klimt, Gustav	klimt, 'gus-taf
Kollwitz, Käthe	'kol-vits, 'ket-ŭ
Kosuth, Joseph	kō-'sūth
L'Enfant, Pierre	lan-'fan, pyer
La Tour, Georges de	la 'tūr, zhorzh dŭ
Labrouste, Henri	la-'brŭst, an-'rē
Le Brun, Charles	lŭ 'brŭnn, sharl
Le Corbusier	lŭ kor-byū-zē-'ā
Le Nôtre, André	lŭ 'nōtr(ŭ), an-'drā
Le Nain, Louis	lŭ 'năn, lū-'ē
Le Vau, Louis	lŭ 'vō, lū-'ē
Léger, Fernand	lā-'zhā, fer-'nan
Lehmbruck, Wilhelm	'lām-bruk, 'vil-helm
Lemoine, J.B.	lŭ-'mwan
Leonardo da Vinci	lē-ŭ-'nar-dō da 'vin-chē
Lescot, Pierre	les-'kō, pyer
Leyster, Judith	'lī-stŭr, 'yū-dith
Lichtenstein, Roy	'lik-tŭn-stīn
Limbourg, Hennequin	'lim-burk, 'hen-ŭ-kăn
Limbourg, Herman	'lim-burk, 'her-man
Limbourg, Pol	'lim-burk, pol
Lin, Maya Ying	lin, 'mī-ŭ yēng
Lipchitz, Jacques	'lip-shits, zhak

Artist's Name	Phonetic Pronunciation
Lippi, Filippino	'lēp-pē, fē-lē-'pē-nō
Lippi, Fra Filippo	'lēp-pē, fē-'lēp-pō
Lochner, Stephan	'lok-nŭr, 'stā-fan
Lorenzetti, Ambrogio	lo-rent-'set-tē, am-'brō-jō
Lorenzetti, Pietro	lo-rent-'set-tē, pē-'ā-trō
Lorrain, Claude	lŭ-'răn, klōd
Mabuse, Jan	ma-'büz, yan
Machuca, Pedro	ma-'chū-ka, 'pā-drō
Maderno, Carlo	ma-'der-nō, 'kar-lō
Magritte, René	ma-'grēt, rŭ-'nā
Maiano, Giuliano da	'mī-a-nō, jū-lē-'a-nō dā
Maillol, Aristide	mī-'yōl, ar-ŭ-'stēd
Malevich, Kazimir	mŭl-'yāv-ich, 'kaz-ē-mēr
Manet, Édouard	ma-'nā, ā-'dwar
Mansart, François	man-'sar, fran-'swa
Mantegna, Andrea	man-'tān-yŭ, an-'drā-ŭ
Marc, Franz	mark, frants
Martini, Simone	mar-'tē-nē, sē-'mōn-ā
Masaccio	ma-'zat-chō
Masolino da Panicale	ma-sō-'lē-nō da pa-nē-'ka-lā
Massys, Quinten	'mat-zīs, 'kwin-tŭn
Master of Flemalle	flā-'mal
Matisse, Henri	ma-'tēs, an-'rē
Melozzo da Forlì	me-'lot-sō da for-'lē
Memling, Hans	'mem-ling, hants
Memmi, Lippo	'mem-mē, 'lēp-pō
Mendieta, Ana	men-dē-'e-ta, 'a-na
Michelangelo Buonarroti	mī-kŭ-'lăn-jŭ-lō (or mē-ke-'lan-jŭ-lō) bwo-nar-'rō-tē
Michelozzo di Bartolommeo	mē-ke-'lot-sō dē bar-tō-lōm-'mā-ō
Mies van der Rohe, Ludwig	mēz van dŭ-'rō(-ŭ) 'lud-vik
Millais, John Everett	mil-'ā
Millet, Jean-François	mē-'yā (or mi-'lā), zhan fran-'swa
Miró, Joan	mi-'rō, zhu-'an
Moholy-Nagy, László	mō-'hō-lē 'na-zhē, 'laz-lō
Mondrian, Piet	mon-drē-'an, pēt
Monet, Claude	mō-'nā, klōd
Moreau, Gustave	mo-'rō, gū-'stav
Morisot, Berthe	mo-rē-'zō, bert
Munch, Edvard	mungk, 'ed-vard
Muybridge, Eadweard	'mī-brij, 'ed-wŭrd
Nadar	na-'dar
Nanni di Banco	'nan-nē dē 'bang-kō
Natoire	na-'twar
Neumann, Balthasar	'noi-man, 'bal-tŭ-zar
Nolde, Emil	'nol-dŭ, 'ā-mēl
Olbrich, Joseph Maria	'ōl-brik, 'yō-zŭf ma-rē-a
Oldenberg, Claes	'ōl-dŭn-bŭrg, klas
Oppenheim, Meret	'ap-ŭn-hīm, 'mer-ŭt
Orcagna, Andrea	or-'kan-ya, an-'drā-ŭ
Orozco, José Clemente	o-'rōs-kō, hō-'sā kle-'men-tā
Paik, Nam June	pīk, nam jūn
Palladio, Andrea	pal-'la-dē-ō, an-'drā-ŭ
Parmigianino	par-mi-ja-'nē-nō
Patinir, Joachim	pa-ti-'nēr, 'yō-a-kēm
Perrault, Claude	pŭ-'rō, klōd
Perugino	per-ŭ-'jē-nō
Piano, Renzo	pē-'a-nō, 'ren-zō
Picasso, Pablo	pi-'kas-ō, 'pab-lō
Piero della Francesca	'pyer-ō 'del-lŭ fran-'ches-ka
Pietro da Cortona	'pyā-trō da kor-'tō-na
Piranesi, Giovanni Battista	pē-ra-'nā-zē jō-'van-nē bat-'tēs-ta
Pisano, Andrea	pē-'zan-ō, an-'drā-ŭ
Pisano, Giovanni	pē-'zan-ō, jō-'van-nē
Pisano, Nicola	pē-'zan-ō, nē-'ko-la
Pissarro, Camille	pŭ-'zar-ō, ka-'mēl (or ka-'mēy)
Pollaiuolo, Antonio	pol-lī-'wō-lō an-'tō-nē-ō
Pollock, Jackson	'pal-ŭk
Pontormo, Jacopo da	pon-'tor-mō, 'ya-ko-pō da
Porta, Giacomo della	'por-ta, 'ja-ko-mō 'del-la
Poussin, Nicolas	pū-'săn, ni-kō-'la

Artist's Name	Phonetic Pronunciation	Artist's Name	Phonetic Pronunciation
Pozzo, Fra Andrea	′pot-tsō, fra an-′drā-ŭ	Sluter, Claus	′slŭ-tŭr, klaus
Primaticcio, Francesco	prē-ma-′tēt-chō, fran-′ches-kō	Soufflot, Jacques-Germain	sŭ-′flō, zhak zher-′meⁿ
Pucelle, Jean	pū-′sel, zhaⁿ	Steen, Jan	stăn, yan
Puget, Pierre	pū-′zhā, pyer	Stieglitz, Alfred	′stĕg-lits
Pugin, A.W.N.	′pyū-jin	Stölzl, Gunta	′shtö(l)-tsŭl, ′gun-ta
Puvis de Chavannes, Pierre	pü-vē-dŭ-sha-′van, pyer	Stoss, Veit	shtōs, vēt
Quarton (or Charonton), Enguerrand	kar-′toⁿ (or sha-roⁿ-′toⁿ), aⁿ-ge-′raⁿ	Tanner, Henry Ossawa	ō-′sa-wa
Quick-to-See-Smith, Jaune	jōn	Tatlin, Vladimir	′tat-lin, ′vla-di-mir
Raphael	ra-fa-′yel (or ′răf-ē-ŭl)	Ter Brugghen, Hendrick	tŭr ′brŭ-gŭn, ′hen-drik
Rauch, John	rauch	Theotokópoulous, Doménikos	thā-o-to-′ko-pū-los, dō-′mā-nē-kŭs
Rauschenberg, Robert	′rau-shŭn-bŭrg	Tiepolo, Giambattista	tē-′ā-pŭ-lō, jam-bat-′tēs-ta
Redon, Odilon	rŭ-′doⁿ, ō-di-′loⁿ	Tinguely, Jean	′tăⁿ-glŭ, zhaⁿ
Regnaudin, Thomas	re-nyo-′dăⁿ, to-′ma	Tintoretto	tin-tŭ-′ret-tō
Rembrandt van Rijn	′rem-brănt van rīn	Titian	′tish-ŭn
Reni, Guido	′rā-nē, ′gwē-dō	Toledo, Juan Bautista de	tō-′lā-dō, hwan bau-′tēs-ta dā
Renoir, Pierre-Auguste	ren-′war, pyer-o-′gŭst	Toulouse-Lautrec, Henri de	tŭ-′lŭz-lō-′trek, aⁿ-rē dŭ
Ribera, José (Jusepe) de	rē-′be-ra, hō-′sā (jŭ-′se-pe) dā	Tournachon, Gaspar-Félix	tŭr-na-′shoⁿ, ga-′spar ′fā-lēks
Riemenschneider, Tilman	′rē-mŭn-shnī-dŭr, ′til-man	Uccello, Paolo	ūt-′chel-lō, ′pau-lō
Rietveld, Gerrit	′rēt-velt, ′ger-ŭt	Utzon, Joern	′ut-zōn, ′yor-(ŭ)n
Rigaud, Hyacinthe	rē-′gō, ē-ŭ-′seⁿt (or ya-′saⁿt)	Van Bruggen, Coosje	van ′brŭ-gŭn, ′kōs-zhŭ
Rivera, Diego	ri-′ve-ra, dē-′ā-gō	Van Dyck, Anthony	văn ′dīk, ′an-tŭ-nē
Rodin, Auguste	rō-′dăⁿ(n), o-′gŭst	Vanbrugh, John	văn-′brŭ
Romano, Giulio	rō-′man-ō, ′jŭl-yō	Vecelli, Tiziano	ve-′chel-ē, tēts-′ya-nō
Rossellino, Bernardo	ros-sŭl-′lē-nō, ber-′nar-dō	Velázquez, Diego	ve-′las-kez, dē-′ā-gō
Rosso Fiorentino	′ros-sō fyor-ŭn-′tē-nō	Venturi, Robert	ven-′tŭ-rē
Rouault, Georges	rŭ-′ō, zhorzh	Vermeer, Jan	vŭr-′mēr, yan
Rousseau, Henri	rŭ-′sō, aⁿ-′rē	Veronese, Paolo	ver-ŭ-′nā-zā, ′pau-lō
Rude, François	rüd, fraⁿ-′swa	Verrocchio, Andrea del	vŭr-′rok-kyō, an-′drā-ŭ del
Ruisdael, Jacob van	′rīz-dal, ′ya-kob van	Vigée-Lebrun, Élisabeth Louise	vē-zhā-lŭ-′bröⁿ, ā-lē-za-′bet lŭ-′ēz
Ruysch, Rachel	roish, rak-ŭl	Vignola, Giacomo da	vē-′nyō-lŭ, ′ja-kō-mō da
Saarinen, Eero	′săr-ŭ-nŭn, ′ār-ō	Vignon, Pierre	vin-′yoⁿ, pyer
Saint-Gaudens, Augustus	sānt ′god-ŭnz, ŭ-′gŭs-tŭs	Vitruvius	vŭ-′trū-vē-ŭs
Sangallo the Younger, Antonio da	sang-′gal-lō, an-′tō-nē-ō da	Warhol, Andy	′wor-hol
Sansovino, Jacopo	san-sō-′vē-nō, ′ya-ko-pō	Watteau, Antoine	wa-′tō, aⁿ-′twan
Schnabel, Julian	′shna-bŭl	Weyden, Rogier van der	′vī-dŭn, ′ra-jŭr van dŭr
Schongauer, Martin	′shōn-gau-ŭr, ′mar-tin	Witz, Konrad	vits, ′kon-rat
Schwitters, Kurt	′shvit-ŭrs, kurt	Wodiczko, Krzysztof	vō-′dĕtsh-kō, (k-)′shish-tof
Seurat, Georges	sŭ-′ra, zhorzh	Wojnarowicz, David	voi-na-′rō-vich
Severini, Gino	se-ve-′rē-nē, ′jē-nō	Wolgemut, Michel	′vōl-gŭ-mŭt, ′mik-ŭl
Signorelli, Luca	sē-nyo-′rel-lē, ′lŭ-ka	Wright of Derby, Joseph	rīt of ′dar-bē
Siloé, Gil de	sē-lō-′ā, hĕl dā	Zurbarán, Francisco de	zur-ba-′ran, fran-′sis-kō dā

GLOSSARY

Italicized terms in definitions are defined elsewhere in the glossary. A pronunciation guide is now included for a select number of technical terms and uses the key provided on page 925.

Abakans—(a-ba′kanz) Abstract woven hangings suggesting organic spaces as well as giant pieces of clothing made by Magdalena Abakanowicz.

abstract—In painting and sculpture, emphasizing a derived, essential character that has only a stylized or symbolic visual reference to objects in nature.

Abstract Expressionism—Also known as the New York School. The first major American avant-garde movement, Abstract Expressionism emerged in New York City in the 1940s. The artists produced abstract paintings that expressed their state of mind and were intended to strike emotional chords in viewers. The movement developed along two lines: *Gestural Abstraction* and *Chromatic Abstraction.*

Action Painting—Also called *Gestural Abstraction.* The kind of *Abstract Expressionism* practiced by Jackson Pollock, in which the emphasis was on the creation process, the artist's gesture in making art. Pollock stood on his canvases, pouring liquid paint in linear webs, thereby literally immersing himself in the painting during its creation.

additive—A kind of sculpture technique in which materials, e. g., clay, are built up or "added" to create form.

addorsed—Set back-to-back, especially as in heraldic design.

aerial perspective—See *perspective.*

aesthetic properties of works of art—The visual and tactile features of an object: form, shape, line, color, mass, and volume.

aesthetics—The branch of philosophy devoted to theories about the nature of art and artistic expression. Also referring to such theories.

aisle—The portion of a church flanking the *nave* and separated from it by a row of *columns* or *piers.*

alabaster—A variety of gypsum or calcite of dense, fine texture, usually white, but also red, yellow, gray, and sometimes banded.

altarpiece—A panel, painted or sculpted, situated above and behind an altar. See also *retable.*

ambulatory—(′ăm-byŭ-lŭ-to-rē) A covered walkway, outdoors (as in a *cloister*) or indoors; especially the passageway around the *apse* and the *choir* of a church.

amphitheater—Literally, a double theater. A Roman building type resembling two Greek theaters put together. The Roman *amphitheater* featured a continuous elliptical *cavea* around a central *arena.*

Analytic Cubism—The first phase of *Cubism,* developed jointly by Pablo Picasso and Georges Braque, in which the artists analyzed form from every possible vantage point to combine the various views into one pictorial whole.

anamorphic image—(ăn-ŭ-′mor-fik) A distorted image that must be viewed by some special means (such as a mirror) to be recognized.

aniconic—(ăn-ī-′kan-ik) Non-image representation.

apotheosis—(ŭ-path-ē-′ō-sŭs) Elevated to the rank of gods or the ascent to heaven.

apse—(ăps) A recess, usually singular and semi-circular, in the wall of a Roman *basilica* or at the east end of a Christian church.

arcade—A series of *arches* supported by *piers* or *columns.*

Arcadian (adj.)—In Renaissance and later art, depictions of an idyllic place of rural peace and simplicity. Derived from "Arcadia," an ancient district of the central Peloponnesus in southern Greece.

arch—A curved structural member that spans an opening and is generally composed of wedge-shaped blocks (*voussoirs*) that transmit the downward pressure laterally. A diaphragm arch is a transverse, wall-bearing arch that divides a *vault* or a ceiling into compartments, providing a kind of firebreak. See also *thrust.*

architrave—(′ar-kŭ-trāv) The *lintel* or lowest division of the *entablature;* sometimes called the epistyle.

arcuated—Of *arch-column* construction.

arena—In a Roman *amphitheater,* the central area where bloody gladiatorial combats and other boisterous events took place.

armature—(′ar-mŭ-chŭr) The crossed, or diagonal, arches that form the skeletal framework of a *Gothic* rib vault. In sculpture, the framework for a clay form.

arras—(′ar-ŭs) A kind of tapestry originating in Arras, a town in northeastern France.

Art Brut—(ar brū) A term coined by artist Jean Dubuffet to characterize art that is genuine, untaught, coarse, even brutish.

Art Deco—Descended from *Art Nouveau,* this movement of the 1920s and 1930s sought to upgrade industrial design in competition with "fine art" and to work new materials into decorative patterns that could be either machined or hand-crafted. Characterized by "streamlined" design, elongated and symmetrical.

Art Nouveau—(ar nū-′vō) A late nineteenth-/early twentieth-century art movement whose proponents tried to synthesize all the arts in an effort to create art based on natural forms that could be mass-produced by technologies of the industrial age.

asceticism—Self-discipline and self-denial.

assemblage—(a-sem-′blazh) A three-dimensional composition made of various materials such as *found objects,* paper, wood, and cloth. See also *collage.*

atmospheric or aerial perspective—See *perspective.*

atrium (pl. **atria**)—The court of a Roman house that is partly open to the sky. Also the open, colonnaded court in front of and attached to a Christian *basilica.*

attic—In architectural terminology, the uppermost story.

attribution—Assignment of a work to a maker or makers. Based on *documentary evidence* (e.g., signatures and dates on works and/or artist's own writings) and *internal evidence* (stylistic and iconographical analysis).

automatism—In painting, the process of yielding oneself to instinctive motions of the hands after establishing a set of conditions (such as size of paper or medium) within which a work is to be carried out.

avant-garde—(′ă-vaⁿ gard) Literally, the advance guard in a platoon. Late-nineteenth- and twentieth-century artists who emphasized innovation and challenged established convention in their work. Also used as an adjective.

axial plan—See *plan.*

baldacchino—(bal-da-′kē-nō) A canopy on columns, frequently built over an altar. See also *ciborium.*

balustrade—(′băl-us-trād) A row of vase-like supports surmounted by a railing.

baptistery—(′băp-tus-trē) In Christian architecture, the building used for baptism, usually situated next to a church.

bar tracery—See *tracery.*

Baroque—A blanket designation for the art of the period 1600 to 1750.

barrel or **tunnel vault**—See *vault.*

bas-relief—(′ba rŭ-′lēf) See *relief.*

base—In ancient Greek architecture, the lowest part of *Ionic* and *Corinthian* columns.

basilica—(bu-′sil-ŭ-kŭ) In Roman architecture, a public building for assemblies (especially tribunals), rectangular in plan with an entrance usually on a long side. In Christian architecture, a church somewhat resembling the Roman basilica, usually entered from one end and with an *apse* at the other, creating an axial *plan.*

Bauhaus—(′bau-haus) A school of architecture in Germany in the 1920s under the

aegis of Walter Gropius, who emphasized the unity of art, architecture, and design. The Bauhaus trained students in a wide range of both arts and crafts, and was eventually closed by the National Socialists in 1933.

bodhisattva—(bod-hē-sat-va) In *Buddhist* thought, one of the host of divinities provided to the *Buddha* to help him save humanity. A potential *Buddha*.

bottega—(bōt-ʹtā-gŭ) A shop; the studio-shop of an Italian artist.

breviary—(brē-vē-e-rē) A Christian religious book of selected daily prayers and psalms.

Buddha (adj. **Buddhist**)—The supreme enlightened being of Buddhism; an embodiment of divine wisdom and virtue.

burin—(ʹbyū-rin) A pointed tool used for *engraving* or *incising*.

buttress—(ʹbŭt-trŭs) An exterior masonry structure that opposes the lateral thrust of an *arch* or a *vault*. A pier buttress is a solid mass of masonry; a flying buttress consists typically of an inclined member carried on an arch or a series of arches and a solid buttress to which it transmits lateral *thrust*.

Byzantium (adj. **Byzantine**)—(biz-ʹan-te-um/ ʹbiz-un-tēn) The Christian Eastern Roman Empire, which lasted until 1453, when Constantinople was captured by the Ottoman Turks.

calotype—(ʹkă-lŭ-tip) A photographic process in which a positive image is made by shining light through a negative image onto a sheet of sensitized paper.

camera lucida—(ʹkă-mŭ-rŭ lū-ʹsē-dŭ) A device in which a small lens projects the image of an object downward onto a sheet of paper. Literally, "lighted room."

camera obscura—(ʹkă-mŭ-rŭ ŭb-ʹskyū-rŭ) An ancestor of the modern camera in which a tiny pinhole, acting as a lens, projects an image on a screen, the wall of a room, or the ground-glass wall of a box; used by artists in the seventeenth, eighteenth, and early nineteenth centuries as an aid in drawing from nature. Literally, "dark room."

campaniform—Bell-shaped.

campanile—(kam-pa-ʹnē-lā) A bell tower of a church, usually, but not always, free-standing.

canon—Rule, e.g., of proportion. The ancient Greeks considered beauty to be a matter of "correct" proportion and sought a canon of proportion, in music and for the human figure.

canon law—The law system of the Roman Catholic church, as opposed to civil or secular law.

canonization—In the Roman Catholic church, the process by which a revered deceased person is declared a *saint* by the pope.

capital—The uppermost member of a *column*, serving as a transition from the *shaft* to the *lintel*. The form of the capital varies with the *order*.

cartoon—In painting, a full-size preliminary drawing from which a painting is made.

catafalque—(kăt-u-fălk) The framework that supports and surrounds a deceased person's body on a bier.

cathedra—(ku-thē-drŭ) Literally, the seat of the bishop, from which the word *cathedral* is derived.

cavea—(kă-vē-ŭ) The seating area in ancient Greek and Roman theaters and *amphitheaters*. Literally, a hollow place or cavity.

cella—(ʹse-lŭ) The chamber (Greek—*naos*) at the center of an ancient temple; in a classical temple, the room in which the cult statue usually stood.

cement—See *concrete*.

central plan—See *plan*.

chancel—The elevated area at the altar end of a church reserved for the priest and choir.

chevet—The east, or apsidal, end of a *Gothic* church, including *choir*, *ambulatory*, and radiating chapels.

chiaroscuro—(kē-ă-rō-ʹskū-rō) In drawing or painting, the treatment and use of light and dark, especially the gradations of light that produce the effect of *modeling*.

choir—The space reserved for the clergy in the church, usually east of the *transept* but, in some instances, extending into the *nave*.

Chromatic Abstraction—A kind of *Abstract Expressionism* that focused on the emotional resonance of color, as exemplified by the work of Barnett Newman and Mark Rothko.

ciborium—(su-ʹbor-ē-ŭm) A canopy, often freestanding and supported by four columns, erected over an altar; also, a covered cup used in the sacraments of the Christian church. See *baldacchino*.

city-state—An independent, self-governing city that rules the surrounding countryside.

clerestory—(ʹklēr-sto-rē) The *fenestrated* part of a building that rises above the roofs of the other parts. In Roman *basilicas* and medieval churches, the windows that form the *nave's* uppermost level below the timber ceiling or the *vaults*.

cloison—(kloi-zŭn) Literally, a partition. A cell made of metal wire or a narrow metal strip soldered edge-up to a metal base to hold enamel or other decorative materials.

cloisonné—(kloi-zŭ-nā) A process of enameling employing *cloisons*.

cloister—A monastery courtyard, usually with covered walks or *ambulatories* along its sides.

coffer—A sunken panel, often ornamental, in a *soffit*, a *vault*, or a ceiling.

collage—(kō-ʹlazh) A composition made by combining on a flat surface various materials such as newspaper, wallpaper, printed text and illustrations, photographs, and cloth. See also *photomontage*.

colonnades—A series or row of *columns*, usually spanned by *lintels*.

colonnette—A small *column*.

color—See *primary*, *secondary*, and *complementary colors*. The value or tonality of a color is the degree of its lightness or darkness. The intensity or saturation of a color is its purity, its brightness or dullness.

color field painters—A variant of *Post-Painterly Abstraction* whose artists sought to reduce painting to its physical essence by pouring diluted paint onto unprimed canvas, allowing these pigments to soak into the fabric. Examples include the work of Helen Frankenthaler and Morris Louis.

colorito—(ko-lo-ʹrē-tō) Literally, "colored" or "painted." A term used to describe the application of paint, characteristic of sixteenth-century Venetian art. It is distinguished from *disegno*, which emphasizes careful design preparation based on preliminary drawing.

column—A vertical, weight-carrying architectural member, circular in cross-*section* and consisting of a base (sometimes omitted), a *shaft*, and a *capital*.

complementary colors—Those pairs of colors, such as red and green, that together embrace the entire spectrum. The complement of one of the three *primary colors* is a mixture of the other two. In pigments, they produce a neutral gray when mixed in the right proportions.

Composite capital—A capital with an ornate combination of *Ionic* volutes and *Corinthian* acanthus leaves that became popular in Roman times.

composition—The way in which an artist organizes *forms* in an art work, either by placing shapes on a flat surface or arranging forms in space.

compound pier—A *pier* with a group, or cluster, of attached *shafts*, or *responds*, especially characteristic of *Gothic* architecture.

computer imaging—A medium developed during the 1960s and 1970s that uses computer programs and electronic light to make designs and images on the surface of a computer or television screen.

conceptual approach to representation—See *descriptive approach to representation*.

Conceptual Art—An American avant-garde art trend of the 1960s that asserted that the "artfulness" of art lay in the artist's idea, rather than its final expression. A major proponent was Joseph Kosuth.

concrete—A building material invented by the Romans and consisting of various proportions of lime mortar, volcanic sand, water, and small stones. From the Latin *caementa*, from which the English "cement" is derived.

condottiere—(kon-da-ʹtyer-ē) A professional military leader employed by the Italian city-states in the early Renaissance.

confraternities—(kon-frŭ-ʹtŭr-nŭ-tēz) In late medieval Europe, organizations founded by laypeople who dedicated themselves to strict religious observances.

connoisseur—(kan-ŭ-'sūr) An expert on works of art and the individual styles of artists.

Constructivism—A movement in art formulated by Naum Gabo, who built up his sculptures piece by piece in space instead of carving or modeling them in the traditional way. In this way the sculptor worked with "volume of mass" and "volume of space" as different materials.

contextuality—The causal relationships among artists, art work, and the society or culture that conditions them.

contour line—In art, a continuous line defining an object's outer shape.

contrapposto—(kon-trŭ-'pas-tō) The disposition of the human figure in which one part is turned in opposition to another part (usually hips and legs one way, shoulders and chest another), creating a counter-positioning of the body about its central axis. Sometimes called weight shift because the weight of the body tends to be thrown to one foot, creating tension on one side and relaxation on the other.

corbel—('kor-bŭl) A projecting wall member used as a support for some element in the superstructure. Also, courses of stone or brick in which each course projects beyond the one beneath it. Two such structures, meeting at the topmost course, create a corbeled arch.

corbeled arch—See *corbel.*

corbeled vault—A *vault* formed by the piling of stone blocks in horizontal courses, cantilevered inward until the two walls meet in a pointed arch. No mortar is used, and the vault is held in place only by the weight of the blocks themselves, with smaller stones used as wedges.

Corinthian capital—A more ornate form than *Doric* or *Ionic;* it consists of a double row of acanthus leaves from which tendrils and flowers grow, wrapped around a bell-shaped *echinus.* Although this *capital* form is often cited as the distinguishing feature of the Corinthian *order,* there is, strictly speaking, no Corinthian order, but only this style of capital used in the *Ionic* order.

cornice—The projecting, crowning member of the *entablature* framing the *pediment;* also, any crowning projection.

Cosmati—(kos-'ma-tē) A group of twelfth- to fourteenth-century craftsmen who worked in marble and mosaic, creating work (known as **Cosmato work**) characterized by inlays of gold and precious or semi-precious stones and finely cut marble in geometric patterns.

cross vault—See *vault*

crossing—The space in a *cruciform* church formed by the intersection of the *nave* and the *transept.*

crossing square—The area in a church formed by the intersection (*crossing*) of a nave and a *transept* of equal width, often used as a standard measurement of interior proportion.

cruciform—Cross-shaped.

Crusades—In *medieval* Europe, armed pilgrimages aimed at recapturing the Holy Land from the Muslims.

crypt—A vaulted space under part of a building, wholly or partly underground; in *medieval* churches, normally the portion under an *apse* or a *chevet.*

Cubism—An early twentieth-century art movement that rejected naturalistic depictions, preferring compositions of shapes and forms "abstracted" from the conventionally perceived world. See also *Analytic Cubism* and *Synthetic Cubism.*

cultural constructs—In the reconstruction of the context of a work of art, experts consult the evidence of religion, science, technology, language, philosophy, and the arts to discover the thought patterns common to artists and their audiences.

culture—The collective characteristics by which a community identifies itself and by which it expects to be recognized and respected.

cupola—('kū-pō-lŭ) An exterior architectural feature composed of *drums* with shallow caps; a dome.

cutaway—An architectural drawing that combines an exterior view with an interior view of part of a building.

Dada—('da-da) An art movement that reflected a revulsion against the absurdity and horror of World War I. Dada rejected all art, modern or traditional, as well as the civilization that had produced it, to create an art of the absurd. Foremost among the Dadaists was Marcel Duchamp.

daguerreotype—(da-'ger-ō-tip) A photograph made by an early method on a plate of chemically treated metal; developed by Louis J. M. Daguerre.

De Stijl—(du stēl) Dutch for "the style." An early twentieth-century art movement (and magazine) founded by Piet Mondrian and Theo van Doesburg, whose members promoted utopian ideals and developed a simplified geometric style.

deconstruction—An analytical strategy developed in the late twentieth century according to which all cultural "constructs" (art, architecture, literature) are "texts." People can read these texts in a variety of ways, but they cannot arrive at fixed or uniform meanings. Any interpretation can be valid, and readings differ from time to time, place to place, and person to person. For those employing this approach, deconstruction means destabilizing established meanings and interpretations while encouraging subjectivity and individual differences.

Deconstructivist architecture—Using *deconstruction* as an analytical strategy, Deconstructionist architects attempt to disorient observers by disrupting the conventional categories of architecture. The haphazard presentation of volumes, masses, planes, lighting, etc. challenges viewers' assumptions about form as it relates to function.

découpage—(de-kŭ-'pazh) A technique of decoration in which letters or images are cut out of paper or some such material and then pasted onto a surface.

descriptive approach to representation—In artistic representation, that which is "known" about an object is represented. To represent a human profile "descriptively" would require the artist to depict both eyes rather than just one.

di sotto in sù—(dē 'sot-tō in 'sū) A technique of representing perspective in ceiling painting. Literally, "from below upwards."

diagonal rib—See *rib.*

diaphragm arch—See *arch.*

diptych—('dip-tik) A two-paneled painting or *altarpiece;* also, an ancient Roman, Early Christian, or Byzantine hinged writing tablet, often of ivory and carved on the external sides.

disegno—(dē-'zā-nyō) In Italian, "drawing" and "design." Renaissance artists considered drawing to be the external physical manifestation (*disegno esterno*) of an internal intellectual idea of design (*disegno interno*).

documentary evidence—In *attributions* of works of art, this consists of contracts, signatures, and dates on works as well as the artist's own writings.

doges—(dōzh) Rulers of *medieval* Venice and Genoa.

dome—A hemispheric *vault;* theoretically, an *arch* rotated on its vertical axis.

Doric—('dor-ik) One of the two systems (or *orders*) evolved for articulating the three units of the elevation of an ancient Greek temple—the platform, the *colonnade,* and the superstructure (*entablature*). The Doric order is characterized by, e.g., capitals with funnel-shaped *echinuses,* columns without bases, and a frieze of *triglyphs* and *metopes.* See also *Ionic.*

drum—The circular wall that supports a *dome;* also, one of the cylindrical stones of which a non-monolithic *shaft* of a *column* is made.

dry fresco—See *fresco.*

dry point—An engraving in which the design, instead of being cut into the plate with a *burin,* is scratched into the surface with a hard steel "pencil." See also *engraving, etching, intaglio.*

écorché—A figure painted or sculptured to show the muscles of the body as if without skin.

echinus—(ŭ-'kīn-ŭs) In architecture, the convex element of a *capital* directly below the *abacus.*

elevation—In drawing and architecture, a geometric projection of a building on a

plane perpendicular to the horizon; a vertical projection. A head-on view of an external or internal wall, showing its features and often other elements that would be visible beyond or before the wall.

embroidery—The technique of sewing threads onto a finished ground to form contrasting designs.

encaustic—(en-'kos-tik) A painting technique in which pigment is mixed with wax and applied to the surface while hot.

engaged column—A half-round *column* attached to a wall. See also *pilaster*.

engraving—The process of *incising* a design in hard material, often a metal plate (usually copper); also, the print or impression made from such a plate. See also *dry point, etching, intaglio*.

entablature—(in-'tăb-lŭ-chŭr) The part of a building above the *columns* and below the roof. The entablature has three parts: *architrave* or *epistyle, frieze,* and *pediment*.

Environmental or **Earth Art**—An American art form that emerged in the 1960s. Often using the land itself as their material, Environmental artists constructed monuments of great scale and minimal form. Permanent or impermanent, these works transform some section of the environment, calling attention both to the land itself and to the hand of the artist.

epistyle—('ep-ŭ-stil) See *architrave*.

escutcheon—(ŭ-'skŭt-chŭn) An emblem bearing a coat of arms.

esthetic properties of works of art—The visual and tactile features of an object: form, shape, line, color, mass, and volume.

etching—A kind of *engraving* in which the design is incised in a layer of wax or varnish on a metal plate. The parts of the plate left exposed are then **etched** (slightly eaten away) by the acid in which the plate is immersed after incising. See also *dry point, engraving, intaglio*.

Eucharist—('yū-ku-rist) In Christianity, the partaking of the bread and wine, which believers hold to be either Christ himself or symbolic of him.

exedra—(ek-'sē-drŭ) Recessed area, usually semi-circular.

exemplum virtutis—Example or model of virtue.

existentialism—A philosophy asserting the absurdity of human existence and the impossibility of achieving certitude.

Expressionism—Twentieth-century *modernist* art that is the result of the artist's unique inner or personal vision and that often has an emotional dimension. Expressionism contrasts with art focused on visually describing the empirical world. It is characterized by bold, vigorous brushwork, emphatic line, and bright color. Two important groups of early twentieth-century German *expressionists* were Die Brücke, in Dresden, and Der Blaue Reiter, in Munich.

extrados—(ek-'stra-das) The upper or outer surface of an arch. See *intrados*.

facade—(fŭ-'sad) Usually, the front of a building; also, the other sides when they are emphasized architecturally.

faïence—(fa-'an(t)s or fī-'aⁿs) Earthenware or pottery, especially with highly colored design (from Faenza, Italy, a site of manufacture for such ware). Glazed earthenware.

fan vault—See *vault*.

Fauvism—('fō-viz-ŭm) From the French word *fauves*, literally, "wild beasts." An early twentieth-century art movement led by Henri Matisse, for whom color became the formal element most responsible for pictorial coherence and the primary conveyor of meaning. The Fauves intensified color with startling contrasts of vermilion and emerald green and of cerulean blue and vivid orange, held together by sweeping brushstrokes and bold patterns.

femmage—(fem-'azh) A kind of feminist sewn collage made by Miriam Schapiro in which she assembles fabrics, quilts, buttons, sequins, lace trim, and rickrack to explore hidden metaphors for womanhood, using techniques historically associated with women's crafts (techniques and media not elevated to the status of fine art).

fenestration—('fen-ŭ-strā-shŭn) The arrangement of the windows of a building.

fête galante—(fet ga-'laⁿ) A type of *Rococo* painting depicting the outdoor amusements of upper-class society.

feudalism—The *medieval* political, social and economic system held together by the relationship of a liege-lord and vassal.

figura serpentinata—(fii-'gū-ra ser-pen-ti-'na-ta) In Renaissance art, a contortion or twisting of the body in contrary directions, especially characteristic of the sculpture and paintings of Michelangelo and the Mannerists.

fin de siècle—(făⁿ-dŭ-sē-'ek-lŭ) Literally, the end of the century. A period in western cultural history from the end of the nineteenth century until just before World War I, when decadence and indulgence masked anxiety about an uncertain future.

flute or **fluting**—Vertical channeling, roughly semicircular in cross-*section* and used principally on *columns* and *pilasters*.

Fluxus—A group of American, European, and Japanese artists of the 1960s who created *Performance Art*. Their performances focused on single actions, such as turning a light on and off or watching falling snow, and were more theatrical than *Happenings*.

flying buttress—See *buttress*.

foreshortening—(for-'shor-tŭ-ning) The use of *perspective* to represent in art the apparent visual contraction of an object that extends back in space at an angle to the perpendicular plane of sight.

form—In art, an object's shape and structure, either in two dimensions (a figure painted on a surface) or in three dimensions (such as a statue).

formalism—Strict adherence to, or dependence on, stylized shapes and methods of composition. An emphasis on an artwork's visual elements rather than its subject.

forum—The public square of an ancient Roman city.

found objects—Images, materials, or objects as found in the everyday environment that are appropriated into works of art.

freestanding sculpture—See *sculpture in the round*.

fresco—('fres-kō) Painting on lime plaster, either dry (dry fresco or fresco secco) or wet (true or buon fresco). In the latter method, the pigments are mixed with water and become chemically bound to the freshly laid lime plaster. Also, a painting executed in either method.

fresco secco—('fres-kō 'sek-ō) See *fresco*.

frieze—(frēz) The part of the *entablature* between the *architrave* and the *cornice*; also, any sculptured or ornamented band in a building, on furniture, etc.

frottage—(frō-'tazh) A process of rubbing a crayon or other medium across paper placed over surfaces with a strong and evocative texture pattern to combine patterns.

Futurism—An early-twentieth century movement involving a militant group of Italian poets, painters, and sculptors. These artists published numerous manifestoes declaring revolution in art against all traditional tastes, values, and styles and championing the modern age of steel and speed and the cleansing virtues of violence and war.

gable—See *pediment*.

genii—Guardian spirits.

genre—('zhaⁿ-rŭ) A style or category of art; also, a kind of painting realistically depicting scenes from everyday life.

gesso—('jes-sō) Plaster mixed with a binding material and used for *reliefs* and as a *ground* for painting.

Gestural Abstraction—Also known as *Action Painting*. A kind of abstract painting in which the gesture, or act of painting, is seen as the subject of art. Its most renowned proponent was Jackson Pollock. See also *Abstract Expressionism*.

glaze—A vitreous coating applied to pottery to seal and decorate the surface; it may be colored, transparent, or opaque, and glossy or *matte*. In oil painting, a thin, transparent, or semitransparent layer put over a color to alter it slightly.

glazed brick—Bricks painted and then kiln fired to fuse the color with the baked clay.

glory—See *nimbus*.

Golden Mean—Also known as the Golden Rule or Golden Section, a system of mea-

suring in which units used to construct designs are subdivided into two parts in such a way that the longer subdivision is related to the length of the whole unit in the same proportion as the shorter subdivision is related to the longer subdivision. The *esthetic* appeal of these proportions has led artists of varying periods and cultures to employ them in determining basic dimensions.

Gospels—The four New Testament books that relate the life and teachings of Jesus.

Gothic—Originally a derogatory term named after the Goths, used to describe the history, culture, and art of *medieval* western Europe in the twelfth to fourteeth centuries.

graver—A cutting tool used by engravers and sculptors.

Greek cross—A cross in which all the arms are the same length.

grisaille—(grŭ-ˈzīy) A monochrome painting done mainly in neutral grays to simulate sculpture.

groin—The edge formed by the intersection of two *vaults*.

groin or **cross vault**—Formed by the intersection at right angles of two barrel vaults of equal size. Lighter in appearance than the barrel vault, the groin vault requires less *buttressing*. See *vault*.

ground—A coating applied to a canvas or some other surface to prepare that surface for painting; also, background.

ground line—In paintings and reliefs, a painted or carved base line on which figures appear to stand.

Happenings—Loosely structured performances initiated in the 1960s, whose creators were trying to suggest the dynamic and confusing qualities of everyday life; most shared qualities of unexpectedness, variety, and wonder.

hard-edge painting—A variant of *Post-Painterly Abstraction* that rigidly excluded all reference to gesture, and incorporated smooth knife-edge geometric forms to express the notion that the meaning of painting should be its form and nothing else. Ellsworth Kelly is an example.

hatching—A technique used in drawing, engraving, etc., in which fine lines are cut or drawn close together to achieve an effect of shading.

Hellenistic—The term given to the culture that developed after the death of Alexander the Great in 323 B.C. and lasted almost three centuries, until the Roman conquest of Egypt in 31 B.C.

herm—A bust on a quadrangular pillar.

hierarchy of scale—An artistic convention in which greater size indicates greater importance.

hieratic—(hī-ŭ-ˈră-tik) A method of representation fixed by religious principles and ideas.

high relief—See *relief*.

Holy Spirit—In Christianity, the third "person" of the Trinity (with the Father and the Son), often symbolized by a dove.

hue—The name of a *color*. See *primary colors, secondary colors,* and *complementary colors.*

humanism—In the Renaissance, an emphasis on education and on expanding knowledge (especially of classical antiquity), the exploration of individual potential and a desire to excel, and a commitment to civic responsibility and moral duty.

icon—A portrait or image; especially in the Eastern Christian churches, a panel with a painting of sacred personages that are objects of veneration. In the visual arts, a painting, a piece of sculpture, or even a building regarded as an object of veneration.

iconoclasm—(ī-ˈkan-ˈŭ-klăz(-ŭ)m) The destruction of images. In *Byzantium* the period from 726 to 843 when there was an imperial ban on images. The destroyers of images were known as iconoclasts, while those who opposed such a ban were known as iconophiles or iconodules.

iconography—(ī-kŭn-ˈa-grŭ-fē) Literally, the "writing of images." The term refers both to the content, or subject, of an art work and to the study of content in art. It also includes the study of the symbolic, often religious, meaning of objects, persons, or events depicted in works of art.

iconostasis—(ī-kŭ-ˈnas-tŭ-sŭs) The large icon-bearing chancel screen that shuts off the sanctuary of a *Byzantine* church from the rest of the church. In the Eastern Christian churches, a screen or a partition, with doors and many *tiers* of *icons,* separating the sanctuary from the main body of the church.

idealization—The representation of things according to a preconception of ideal form or type; a kind of *esthetic* distortion to produce idealized forms. See also *realism*.

illumination—Decoration with drawings (usually in gold, silver, and bright colors), especially of *medieval* manuscript pages.

impasto—(im-ˈpas-tō) A style of painting in which the pigment is applied thickly or in heavy lumps, as in many paintings by Jean Dubuffet or Anselm Kiefer.

impost block—A stone with the shape of a truncated, inverted pyramid, placed between a *capital* and the *arch* that springs from it.

Impressionism—A late nineteenth-century art movement that sought to capture a fleeting moment by conveying the illusiveness and impermanence of images and conditions.

in situ—(in sŭ-ˈtū) In place; in the original position.

incise—(in-ˈsīz) To cut into a surface with a sharp instrument; also, a method of decoration, especially on metal and pottery.

incrustation—Wall decoration consisting of bright panels of different colors.

inscriptions—Texts written on the same surface as the picture or *incised* in stone (such as in ancient art).

installation—A *postmodernist* artwork creating an artistic environment in a room or gallery.

intaglio—(in-ˈta-lē-ō) A graphic technique in which the design is *incised,* or scratched, on a metal plate, either manually (*engraving, dry point*) or chemically (*etching*). The incised lines of the design take the ink, making this the reverse of the *woodcut* technique.

intarsia—(in-ˈtar-sē-ŭ) Inlay work, primarily in wood and sometimes in mother-of-pearl, marble, etc.

internal evidence—In *attributions* of works of art, what can be learned by stylistic and iconographical analysis, in comparison with other works, and by analysis of the physical properties of the medium itself.

International Style—A style of fourteenth- and fifteenth-century painting begun by Simone Martini, who adapted the French *Gothic* manner to Sienese art fused with influences from the North. This style appealed to the aristocracy because of its brilliant color, lavish costume, intricate ornament, and themes involving splendid processions of knights and ladies. Also a style of twentieth-century architecture associated with Le Corbusier, whose elegance of design came to influence the look of modern office buildings and skyscrapers.

intrados—(ˈin-trŭ-das) The underside of an *arch* or a *vault*. See *extrados*.

Ionic—(ī-ˈan-ik) One of the two systems (or *orders*) evolved for articulating the three units of the elevation of a Greek temple, the platform, the *colonnade,* and the superstructure (*entablature*). The Ionic order is characterized by, e.g., *volutes, capitals, columns* with *bases,* and an uninterrupted *frieze*.

jamb—In architecture, the side posts of a doorway.

keystone—The central, uppermost *voussoir* in an *arch*.

Kinetic Art—A kind of moving art. Closely related to *Op Art* in its concern with the perception of motion by visual stimulus, it was a logical step to present objects that actually moved. Characteristic of the work of Alexander Calder and the *Constructivists*.

lancet—(ˈlăn-sŭt) In *Gothic* architecture, tall narrow window ending in pointed arch.

landscape—A picture showing natural scenery, without narrative content.

lapis lazuli—(ˈlă-pŭs ˈlă-zhyŭ-lē) A rich, ultramarine, semiprecious stone used for carving and as a source for pigment.

letterpress—The technique of printing with movable type invented in Germany in the fifteenth century.

lierne—(lē-ʹŭrn) A short *rib* that runs from one main rib of a *vault* to another.

linear perspective—See *perspective*.

lintel—(ʹlin-tŭl) A beam used to span an opening.

loggia—(ʹlo-jŭ) A gallery with an open *arcade* or a *colonnade* on one or both sides.

longitudinal plan—See *plan*.

low relief—See *relief*.

lunette—(lū-ʹnet) A semi-circular area (with the flat side down) in a wall over a door, a niche, or a window.

maestà—(mī-ŭ-ʹsta) A depiction of the Virgin Mary as the Queen of Heaven enthroned in majesty amid choruses of angels and saints.

magi—(ʹmă-jī) The wise men from the East who present gifts to the infant Jesus.

Mannerism—A style of later Renaissance art that emphasized "artifice," contrived imagery not derived directly from nature. Such artworks showed a self-conscious stylization involving complexity, caprice, fantasy, and polish. Mannerist architecture tended to flout the classical rules of order, stability, and symmetry, sometimes to the point of parody.

mantle—A sleeveless, protective outer garment or cloak.

Mass—The Catholic and *Orthodox* ritual in which believers understand that Christ's redeeming sacrifice on the cross is repeated when the priest consecrates the bread and wine in the *Eucharist*.

matte (also **mat**)—In painting, pottery, and photography, a dull finish.

mausoleum—A central-plan, domed structure, built as a memorial.

medieval—See *Middle Ages*.

medium—The substance or agency in which an artist works; also, in painting, the vehicle (usually liquid) that carries the pigment.

memento mori—(mi-ʹment-ō ʹmo-rē) A reminder of human mortality, usually represented by a skull.

mendicants—In *medieval* Europe, friars belonging to the Franciscan and Dominican orders, who renounced all worldly goods, lived by contributions of laypeople (the word *mendicant* literally means "beggar"), and devoted themselves to preaching, teaching, and doing good works.

menorah—(mŭ-no-rŭ) The seven-branched candelabrum used in Jewish religious practices.

metope—(ʹmet-ŭ-pē) The panel between the *triglyphs* in a *Doric frieze*, often sculptured in *relief*.

Middle Ages (adj. **medieval**)—In European history, the period of roughly a thousand years (ca. A.D. 400–1400) from the end of the Western Roman Empire to the Renaissance.

miniatures—Small individual paintings intended to be held in the hand and viewed by one or two individuals at one time.

Minimalism (Minimal Art)—An American predominantly sculptural trend of the 1960s whose works consist of a severe reduction of form to single, homogeneous units called "primary structures." Examples include the sculpture of Tony Smith and Donald Judd.

mobile—(ʹmō-bēl) A sculpture with moving parts.

modeling—The shaping or fashioning of three-dimensional forms in a soft material, such as clay; also, the gradations of light and shade reflected from the surfaces of matter in space, or the illusion of such gradations produced by alterations of value in a drawing, painting, or print.

modern—In art, styles that break with traditional forms and techniques.

Modernism—A movement in Western art that developed in the second half of the nineteenth century and sought to capture the images and sensibilities of the age. Modernist art goes beyond simply dealing with the present and involves the artist's critical examination of the premises of art itself. After World War II modernism increasingly became identified with a strict *formalism*.

module—A basic unit of which the dimensions of the major parts of a work are multiples. The principle is used in sculpture and other art forms, but it is most often employed in architecture, where the module may be the dimensions of an important part of a building, such as a *column*, or simply some commonly accepted unit of measurement (the centimeter or the inch, or, as with Le Corbusier, the average dimensions of the human figure).

molding—In architecture, a continuous, narrow surface (projecting or recessed, plain or ornamented) designed to break up a surface, to accent, or to decorate.

monochromatic—(ma-nō-krō-ʹmăt-ŭk) Consisting of a single color.

monolith—A column that is all in one piece (not composed of *drums*).

monumental—In art criticism, any work of art of grandeur and simplicity, regardless of its size.

mosaic—(mō-ʹzā-ŭk) Patterns or pictures made by embedding small pieces of stone or glass (*tesserae*) in cement on surfaces such as walls and floors; also, the technique of making such works.

mosque—(mask) An Islamic religious building. From the Arabic word *masjid*, meaning a place for bowing down.

mullion—(ʹmŭl-yŭn) A vertical member that divides a window or that separates one window from another.

mural—A wall painting; a *fresco* is a type of mural medium and technique.

Muslim—A believer in Islam.

Nabis—The Hebrew word for prophet. A group of *Symbolist* painters influenced by Paul Gauguin.

narrative composition—Elements in a work of art arranged in such a manner as to tell a story.

narthex—(ʹnar-theks) A porch or vestibule of a church, generally *colonnaded* or *arcaded* and preceding the *nave*.

Naturalism—The doctrine that art should adhere as closely as possible to the appearance of the natural world. *Naturalism*, with varying degrees of fidelity to appearance, recurs in the history of Western art.

nave—The part of a church between the chief entrance and the *choir*, demarcated from *aisles* by *piers* or *columns*.

nave arcade—In *basilica* architecture, the series of *arches* supported by *piers* separating the *nave* from the side *aisles*.

Neo-Expressionism—A postmodern art movement that emerged in the 1970s and that reflects the artists' interest in earlier art, notably German *Expressionism* and *Abstract Expressionism*.

Neoplasticism—A theory of art developed by Piet Mondrian to create a pure plastic art comprised of the simplest, least subjective, elements, *primary colors*, primary values, and primary directions (horizontal and vertical).

Neue Sachlichkeit (New Objectivity)—(ʹnoi-ŭ ʹsak-lik-kīt) An art movement that grew directly out of the World War I experiences of a group of German artists who sought to show the horrors of the war and its effects.

nimbus—A halo, aureole, or *glory* appearing around the head of a holy figure to signify divinity.

nymphs—In classical mythology, female divinities of springs, caves, and woods.

oculus (pl., **oculi**)—(a-kyū-lus/a-kyū-lē) The round central opening or "eye" of a dome. Also, small round windows in *Gothic* cathedrals.

ogive (adj., **ogival**)—(ō-ʹjī-vŭl) The diagonal *rib* of a *Gothic vault*; a *pointed*, or Gothic, arch.

one-point perspective—See *perspective*.

Optical or **Op Art**—A kind of painting style in which precisely drafted patterns directly, even uncomfortably, affect visual perception.

optical approach to representation—In artistic representation, only that which is actually "seen" is represented, rather than what is "known" (e.g., a human profile depicted optically would reveal only one eye, whereas a profile depicted "descriptively" would feature two eyes). See *descriptive approach to representation*.

orbiculum—(or-ʹbik-yū-lŭm) A disc-like opening in a *pediment*.

order—In classical architecture a style represented by a characteristic design of the *columns* and *entablature*. See also *superimposed order*.

orrery—A special technological model to demonstrate the theory that the universe operates like a gigantic clockwork mechanism.

Orthodox—The trinitarian Christian doctrine established in *Byzantium.*

orthogonal—(or-ʹthag-ŭn-ŭl) A line imagined to be behind and perpendicular to the picture plane; the *orthogonals* in a painting appear to recede toward a vanishing point on the horizon.

pagan—A person who worships many gods.

palette—A thin board with a thumb hole at one end on which an artist lays and mixes colors; any surface so used. Also, the colors or kinds of colors characteristically used by an artist.

parapet—A low, protective wall along the edge of a balcony or roof.

pastels—Chalk-like crayons made of ground color pigments mixed with water and a binding medium. They lend themselves to quick execution and sketching and offer a wide range of colors and subtle variations of tone, suitable for rendering nuances of value.

patricians—Freeborn landowners of the Roman Republic.

pediment—In classical architecture, the triangular space (gable) at the end of a building, formed by the ends of the sloping roof above the *colonnade;* also, an ornamental feature having this shape.

pendentive—A concave, triangular piece of masonry (a triangular section of a hemisphere), four of which provide the transition from a square area to the circular base of a covering *dome.* Although they appear to be hanging (pendant) from the dome, they in fact support it.

Performance Art—An American avant-garde art trend of the 1960s that made time an integral element of art. It produced works in which movements, gestures, and sounds of persons communicating with an audience replace physical object. Documentary photographs are generally the only evidence remaining after these events. See also *Happenings.*

Perpendicular style—The last English *Gothic* style, also known as Tudor, characterized by a strong vertical emphasis and dense thickets of ornamental vault ribs that serve entirely decorative functions.

persistence of vision—Retention in the brain for a fraction of a second of whatever the eye has seen; it causes a rapid succession of images to merge one into the next, producing the illusion of continuous change and motion in media such as cinema.

personification—Abstract ideas codified in bodily form.

perspective—A formula for projecting an illusion of the three-dimensional world onto a two-dimensional surface. In linear (single vanishing point) perspective, the most common type, all parallel lines or lines of projection seem to converge on one, two, or three points located with reference to the eye level of the viewer (the horizon line of the picture), known as vanishing points, and associated objects are rendered smaller the farther from the viewer they are intended to seem. Atmospheric, or aerial, perspective creates the illusion of distance by the greater diminution of color intensity, the shift in color toward an almost neutral blue, and the blurring of contours as the intended distance between eye and object increases.

photomontage—(fŏ-tō-mon-ʹtaj) A composition made by fitting together pictures or parts of pictures, especially photographs. See also *collage.*

Photorealists—See *Superrealism.*

physical music—A kind of video narrative made by Nam June Paik which comprises in quick succession fragmented sequences of a variety of media: dance, advertising, poetry, street scenes, etc.

Pictorial style—An early style of photography in which photographers desired to achieve effects of painting, using centered figures, framing devices, and soft focus. Gertrude Käsebier was a noted proponent of this style of photography.

pier—A vertical, freestanding masonry support.

pier buttress—See *buttress.*

pietà—(pē-a-ʹta) A painted or sculpted representation of the Virgin Mary mourning over the body of Christ.

pietra serena—(pē-ʹet-rŭ sŭ-ʹā-nŭ) Literally, "serene stone," a type of gray stone used for its harmonious appearance when contrasted with stucco or other smooth finish in architecture.

pilaster—A flat, rectangular, vertical member projecting from a wall of which it forms a part. It usually has a *base* and a *capital* and is often *fluted.*

pillar—Usually a weight-carrying member, such as a *pier* or a *column;* sometimes an isolated, freestanding structure used for commemorative purposes.

pinnacle—In *Gothic* churches, a sharply pointed ornament capping the piers or flying buttresses; also used on church *facades.*

pittura metafisica—(pēt-ʹtū-ra me-ta-ʹfē-sē-ka) Literally, metaphysical painting. Exemplified by the work of Giorgio de Chirico, a precursor of *Surrealism.*

plan—The horizontal arrangement of the parts of a building or of the buildings and streets of a city or town, or a drawing or a diagram showing such an arrangement as a horizontal *section.* In an axial plan, the parts of a building are organized longitudinally, or along a given axis; in a central plan, the parts radiate from a central point.

plate tracery—See *tracery.*

plebeian—(pli-ʹbe-ŭn) In the Roman Republic, the social class that included small farmers, merchants, and freed slaves.

plein-air—(ʹplen-ār) An approach to painting much favored by the *Impressionists,* in which artists sketch outdoors to achieve a quick impression of light, air and color. The sketches were then taken to the studio for reworking into more finished works of art.

plinth—The lowest member of a *base;* also a square slab at the base of a *column.*

poesia—(pō-e-zē-ŭ) A term describing "poetic" art, notably Venetian Renaissance paintings, which emphasize the lyrical and sensual.

pointed arch—See *ogive.*

pointillism—(ʹpoin-tŭ-liz-ŭm) A system of painting that focused on color analysis, devised by the nineteenth-century French painter Georges Seurat. The artist separates color into its component parts and then applies the component colors to the canvas in tiny dots (points). The image only becomes comprehensible from a distance, when the viewer's eyes blend the pigment dots.

polychrome—(ʹpa-lē-krōm) Done in several colors.

polyptych—An *altarpiece* made up of more than three sections.

Pop Art—A term coined by British art critic Lawrence Alloway to refer to art, first appearing in the 1950s, that incorporated elements from popular culture, such as images from motion pictures, television, advertising, billboards, commodities, etc.

portico—(ʹpor-tŭ-kō) A porch with a roof supported by *columns;* an entrance porch.

post-and-lintel system—A *trabeated* system of construction in which two posts support a *lintel.*

Post-Painterly Abstraction—An American art movement that developed out of *Abstract Expressionism,* yet manifests a radically different sensibility. While Abstract Expressionist art conveys a feeling of passion and visceral intensity, a cool, detached rationality emphasizing tighter pictorial control characterizes *Post-Painterly Abstraction.* See also *color field painting* and *hard-edge painting.*

Postmodernism—A reaction against *Modernist* formalism, which is seen as elitist. Far more encompassing and accepting than the more rigid confines of modernist practice, postmodernism offers something for everyone by accommodating a wide range of styles, subjects, and formats, from traditional easel painting to *installation* and from abstraction to illusionistic scenes.

pottery—Objects (usually vessels) made of clay and hardened by firing.

Precisionists—A group of American painters, active in the 1920s and 1930s, whose work concentrated on portraying manmade environments in a clear and con-

cise manner to express the beauty of perfect and precise machine forms. Charles Sheeler is an example.

predella—(prŭ-'del-lŭ) The narrow ledge on which an *altarpiece* rests on an altar.

Pre-Raphaelite Brotherhood—A group of nineteenth-century artists, including John Everett Millais, who refused to be limited to contemporary scenes and chose instead to represent fictional, historical, and fanciful subjects using *realist* techniques.

primary colors—The colors—red, yellow, and blue—from which all other colors may be derived. *Secondary colors* result from mixing pairs of primaries.

Productivism—An art movement that emerged in the Soviet Union after the Revolution, whose members believed that artists must direct art toward creating products for the new society.

proscenium—(prō-'sē-nē-ŭm) The part of the stage in front of the curtain. The stage of an ancient Greek or Roman theater.

provenance—('prō-vŭ-naⁿs) Origin or source.

psalter—('sol-tŭr) A book containing the Psalms of the Bible.

putto (pl. **putti**)—('pū-tō/'pū-ti) A cherubic young boy, a favorite subject in Italian painting and sculpture.

quadrant arches—Arches whose curve extends for one quarter of a circle's circumference.

quadrant vault—Half-barrel vaults. See *vault*.

quadro riportato—('kwa-drō re-por-'ta-tō) A ceiling design in which painted scenes are arranged in panels resembling framed pictures transferred to the surface of a shallow, curved *vault*.

quatrefoil—A shape or plan in which the parts assume the form of a cloverleaf.

quoins—(kwoin) The large, sometimes *rusticated*, usually slightly projecting stones that often form the corners of the exterior walls of masonry buildings.

realism—The representation of things according to their appearance in visible nature (without *idealization*).

Realism—A movement that emerged in mid-nineteenth-century France. Realist artists represented the subject matter of everyday life (especially that which up until then had been considered inappropriate for depiction) in a realistic mode.

refectory—(rŭ-'fek-tŭ-rē) The dining hall of a Christian monastery.

Regionalism—A twentieth-century American movement that rejected avant-garde art and portrayed American rural life in a clearly readable, realist style. Major regionalists include Grant Wood and Thomas Hart Benton.

relics—In Christianity, the body parts, clothing, or objects associated with a saint or with Christ himself.

relief—In sculpture, figures projecting from a background of which they are part. The degree of relief is designated high, low (*bas*), sunken (hollow), or *intaglio*. In the last, the artist cuts the design into the surface so that the image's highest projecting parts are no higher than the surface itself. See also *repoussé*.

relievo—(rē-'lyā-vō) *Relief.*

reliquary—('rel-ŭ-kwe-rē) A container for keeping *relics*.

repoussé—(rŭ-pū-'sā) Formed in *relief* by beating a metal plate from the back, leaving the impression on the face. The metal is hammered into a hollow mold of wood or some other pliable material and finished with a *graver*. See also *relief*.

respond—An engaged *column, pilaster*, or similar element that either projects from a *compound pier* or some other supporting device or is bonded to a wall and carries one end of an *arch*.

retables—(rē-'tā-bŭlz) An architectural screen or wall above and behind an altar, usually containing painting, sculpture, carving, or other decorations. See also *altarpiece*.

rib—A relatively slender, molded masonry *arch* that projects from a surface. In *Gothic* architecture, the ribs form the framework of the *vaulting*. A diagonal rib is one of the ribs that form the X of a *groin vault*. A transverse rib crosses the nave or aisle at a ninety-degree angle.

rib vault—*Vaults* in which the diagonal and transverse *ribs* compose a structural skeleton that partially supports the still fairly massive paneling between them.

Rococo—(rō-kō-'kō) A style, primarily of interior design, that appeared in France around 1700. Interiors were designed as total works of art with elegant furniture, small sculpture, ornamental mirrors and easel paintings, and tapestry complementing architecture, reliefs, and wall painting.

Romanesque—(rō-mŭ-'nesk) Literally, "Roman-like." A term used to describe the history, culture, and art of *medieval* western Europe from about 1050 to about 1200.

Romanticism—A Western cultural phenomenon, beginning around 1750 and ending about 1850, that gave precedence to feeling and imagination over reason and thought. More narrowly, the art movement that flourished from about 1800 to 1840.

roundel—See *tondo*.

rusticate—To give a rustic appearance by roughening the surfaces and beveling the edges of stone blocks to emphasize the joints between them. A technique popular during the Renaissance, especially for stone courses at the ground-floor level.

sacra conversazione—('sa-kra kno-ver-sa-tsē-o-nä) Literally, "holy conversation," a style of *altarpiece* painting popular after the middle of the fifteenth century, in which saints from different epochs are joined in a unified space and seem to be conversing either with each other or with the audience.

saint—From the Latin word *sanctus*, meaning "made holy by God." Persons who suffered and died for their Christian faith or who merited reverence for their Christian devotion while alive. In the Roman Catholic church, a worthy deceased Catholic who is *canonized* by the pope.

sarcophagus (pl. **sarcophagi**)—(sar-'kof-ŭ-gŭs/sar-'kof-ŭ-gī) A coffin, usually of stone. From the Latin, "consumer of flesh."

satyr—A male follower of the ancient Greek god Dionysos, represented as part human, part goat.

school—A chronological and stylistic classification of works of art with a stipulation of place.

sculpture in the round—Freestanding figures, carved or modeled in three dimensions.

secondary colors—Orange, green, and purple, obtained by mixing pairs of *primary colors* (red, yellow, blue).

section—In architecture, a diagram or representation of a part of a structure or building along an imaginary plane that passes through it vertically. Drawings showing a theoretical slice across a structure's width are lateral sections. Those cutting through a building's length are longitudinal sections. See also *elevation* and *cutaway*.

serpentine (line)—The "S" curve, which was regarded by Hogarth as the line of beauty.

sfumato—(sfū-'ma-tō) A smokelike haziness that subtly softens outlines in painting; particularly applied to the painting of Leonardo and Correggio.

shaft—The part of a *column* between the *capital* and the *base*.

silverpoint—A *stylus* made of silver, used in drawing in the fourteenth and fifteenth centuries because of the fine line it produced and the sharp point it maintained.

single vanishing point perspective—See *perspective*.

soak stain—A technique of painting pioneered by Helen Frankenthaler in which the artist drenches the fabric of raw canvas with fluid paint to achieve flowing, lyrical, painterly effects.

socle—('sak-ŭl) A molded projection at the bottom of a wall or a *pier*, or beneath a pedestal or a *column base*.

soffit—The underside of an architectural member such as an *arch, lintel, cornice*, or stairway. See also *intrados*.

space—The bounded or boundless container of collections of objects.

spandrel—('spăn-drŭl) The roughly triangular space enclosed by the curves of adjacent *arches* and a horizontal member connecting

their vertexes; also, the space enclosed by the curve of an *arch* and an enclosing right angle. The area between the arch proper and the framing *columns* and *entablature*.

sphinx—(sfengks) A mythical Egyptian beast with the body of a lion and the head of a human.

springing—The lowest stone of an *arch*, resting on the *impost block*. In *Gothic* vaulting, the lowest stone of a diagonal or transverse *rib*.

squinch—(skwinch) An architectural device used as a transition from a square to a polygonal or circular base for a *dome*. It may be composed of *lintels, corbels*, or *arches*.

stanze—('stan-zā) The Italian word for "rooms."

stigmata—In Christian art, the wounds that Christ received at his crucifixion that miraculously appear on the body of a saint.

still life—A picture depicting an arrangement of objects.

stringcourse—A raised horizontal *molding*, or band in masonry, ornamental but usually reflecting interior structure.

stucco—('stŭk-kō) Fine plaster or cement used as a coating for walls or for decoration.

stylobate—('stī-lŭ-bāt) The uppermost course of the platform of a classical temple, which supports the *columns*.

stylus—('stī-lŭs) A needlelike tool used in *engraving* and *incising*.

subtractive—A kind of sculpture technique in which materials are taken away from the original mass, i.e., carving.

sunken relief—In sculpture, *reliefs* created by chiseling below the stone's surface, rather than cutting back the stone around the figures to make them project from the surface.

superimposed orders—*Orders* of architecture that are placed one above another in an *arcaded* or *colonnaded* building, usually in the following sequence: *Doric* (the first story), *Ionic*, and *Corinthian*. Superimposed orders are found in later Greek architecture and were used widely by Roman and Renaissance builders.

Superrealism—A school of painting and sculpture of the 1960s and 1970s which emphasized making images of persons and things with scrupulous, photographic fidelity to optical fact. The Superrealist painters were also called Photorealists because many used photographs as sources for their imagery.

Suprematism—A type of art formulated by Kazimir Malevich to convey his belief that the supreme reality in the world is pure feeling, which attaches to no object and thus calls for new, nonobjective forms in art—shapes not related to objects in the visible world.

Surrealism—A successor to *Dada, Surrealism* incorporated the improvisational nature of its predecessor into its exploration of the ways to express in art the world of dreams and the unconscious. Biomorphic Surrealists such as Joan Miro produced largely abstract compositions. Naturalistic Surrealists, notably Salvador Dalí, presented recognizable scenes transformed into a dream or nightmare image.

Symbolists—In the late nineteenth century, a group of artists and poets who shared a view that the artist was not an imitator of nature but a creator who transformed the facts of nature into a symbol of the inner experience of that fact.

Synthetic Cubism—In 1912 *Cubism* entered a new phase during which the style no longer relied on a decipherable relation to the visible world. In this new phase, called *Synthetic Cubism*, paintings and drawings were constructed from objects and shapes cut from paper or other materials to represent parts of a subject in order to play visual games with variations on illusion and reality.

tapestry—A weaving technique in which the *weft* threads are packed densely over the *warp* threads so that the designs are woven directly into the fabric.

technique—The processes that artists employ to create *form*, as well as the distinctive, personal ways in which they handle their materials and tools.

tempera—('tem-pŭ-rŭ) A technique of painting using pigment mixed with egg yolk, glue or casein; also the *medium* itself.

tenebrism—('ten-ŭ-briz(-ŭ)m) Painting in the "dark manner," using violent contrasts of light and dark, as in the work of Caravaggio.

terracotta—(te-rŭ-'ko-tŭ) Hard-baked clay, used for sculpture and as a building material. It may be *glazed* or painted.

tesserae—('tes-ŭ-rē) Tiny stones or pieces of glass cut to desired shape and size to use in *mosaics* to create design and composition.

texture—The quality of a surface (rough, smooth, hard, soft, shiny, dull) as revealed by light. In represented texture, a painter depicts an object as having a certain texture even though the paint is the actual texture.

tholos (pl. **tholoi**)—('thō-los/'thō-loi) A circular structure, generally in classical style; also, in Aegean architecture, a circular beehive-shaped tomb.

thrust—The outward force exerted by an *arch* or a *vault* that must be counterbalanced by *buttresses*.

tier—A series of architectural rows, layers, or ranks arranged above or behind one another.

tondo—('ton-dō) A circular painting or *relief* sculpture.

trabeated—('tra-bē-āt-ŭd) Of *post-and-lintel* construction. Literally, "beamed" construction.

tracery—Ornamental stonework for holding stained glass in place, characteristic of *Gothic* cathedrals. In plate tracery the glass fills only the "punched holes" in the heavy ornamental stonework. In bar tracery the stained-glass windows fill almost the entire opening and the stonework is unobtrusive.

transept—('trăn-sept) The part of a *cruciform* church with an axis that crosses the main axis at right angles.

transverse rib—See *rib*.

tribune—In *Romanesque* church architecture, galleries built over the inner *aisles*.

trident—The three-pronged pitchfork associated with the ancient Greek sea god Poseidon (Roman, Neptune).

triglyph—('tri-glif) A projecting, grooved member of a *Doric frieze* that alternates with *metopes*.

triptych—('trip-tik) A three-paneled painting or *altarpiece*.

triumphal arch—In Roman architecture, freestanding *arches* commemorating important events such as military victories.

trompe l'oeil—(troⁿp 'loi) A form of illusionistic painting that attempts to represent an object as existing in three dimensions at the surface of the painting; literally, "fools the eye."

true fresco—See *fresco*.

Tudor—See *perpendicular style*.

tunnel vaults—See *vaults*.

Tuscan column—Also known as Etruscan *column*. Resemble ancient Greek *Doric* columns, but made of wood, unfluted, and with *bases*. They were spaced more widely than were Greek columns.

tympanum—('tim-pŭ-nŭm) The space enclosed by a *lintel* and an *arch* over a doorway.

urna—('ŭr-nŭ) A whorl of hair, represented as a dot, between the brows of the *Buddha*; one of the *lakshanas* of the Buddha.

ushnisha—(ūsh-'nesh-ha) The knot of hair on the top of the *Buddha*'s head; one of the *lakshanas* of the Buddha.

value—See *color*.

vanitas—('va-nē-tas) A term describing paintings that include references to death.

vault—A masonry roof or ceiling constructed on the *arch* principle. A *barrel* or tunnel vault, semicylindrical in cross-*section* is, in effect, a deep arch or an uninterrupted series of arches, one behind the other, over an oblong space. A quadrant vault is a half-*barrel* vault. A *groin* or cross vault is formed at the point at which two barrel vaults intersect at right angles. In a ribbed vault, there is a framework of *ribs* or arches under the intersections of the vaulting sections. A sexpartite vault is a rib vault with six panels. A fan vault is a development of *lierne* vaulting characteristic of English Perpendicular *Gothic*, in which radiating ribs form a fan-like pattern.

veduta—(ve-'dū-ta) Type of naturalistic landscape and cityscape painting popular in

eighteenth-century Venice. Literally, "view" painting.

vestibule—See *portico*.

volute—A spiral, scroll-like form characteristic of the ancient Greek *Ionic* and the Roman *Composite capital*.

voussoir—(vū-ˈswar) A wedge-shaped block used in the construction of a true *arch*. The central voussoir, which sets the arch, is the *keystone*.

wall rib—The *rib* at the junction of the *vault* and the wall.

warp—The vertical threads of a loom or cloth.

weft—The horizontal threads of a loom or cloth.

weight shift—See *contrapposto*.

wet fresco—See *fresco*.

woodcut or **woodblock**—A wooden block on the surface of which those parts not intended to print are cut away to a slight depth, leaving the design raised; also, the printed impression made with such a block.

BIBLIOGRAPHY

This list of books is intended to be comprehensive enough to satisfy the reading interests of the beginning art history student and general reader, as well as those of more advanced readers who wish to become acquainted with fields other than their own. The resources listed range from works that are valuable primarily for their reproductions to those that are scholarly surveys of schools and periods. No entries for periodical articles appear, but some of the major periodicals that publish art-historical scholarship in English are noted.

SELECTED PERIODICALS

The following list is by no means exhaustive. Students wishing to pursue research in journals should contact their instructor, their college or university's reference librarian, or the online catalog for additional titles.

African Arts
American Indian Art
American Journal of Archaeology
Archaeology
Archives of Asian Art
Ars Orientalis
The Art Bulletin
Art History
The Art Journal
The Burlington Magazine
Journal of the Society of Architectural Historians
Journal of the Warburg and Courtauld Institutes
Latin American Antiquity

GENERAL STUDIES

Arntzen, Etta, and Robert Rainwater. *Guide to the Literature of Art History.* Chicago: American Library Association, 1981.

Bator, Paul M. *The International Trade in Art.* Chicago: University of Chicago Press, 1988.

Baxandall, Michael. *Patterns of Intention: On the Historical Explanation of Pictures.* New Haven: Yale University Press, 1985.

Bindman, David, ed. *The Thames & Hudson Encyclopedia of British Art.* London: Thames & Hudson, 1988.

Broude, Norma, and Mary D. Garrard, eds. *The Expanding Discourse: Feminism and Art History.* New York: Harper Collins, 1992.

———. *Feminism and Art History: Questioning the Litany.* New York: Harper & Row, 1982.

Bryson, Norman. *Vision and Painting: The Logic of the Gaze.* New Haven: Yale University Press, 1983.

Bryson, Norman, et al. *Visual Theory: Painting and Interpretation.* New York: Cambridge University Press, 1991.

Cahn, Walter. *Masterpieces: Chapters on the History of an Idea.* Princeton: Princeton University Press, 1979.

Chadwick, Whitney. *Women, Art, and Society.* New York: Thames & Hudson, 1990.

Cheetham, Mark A., Michael Ann Holly, and Keith Moxey, eds. *The Subjects of Art History: Historical Objects in Contemporary Perspective.* New York: Cambridge University Press, 1998.

Chilvers, Ian, and Harold Osborne, eds. *The Oxford Dictionary of Art.* Rev. ed. New York: Oxford University Press, 1997.

Cummings, P., *Dictionary of Contemporary American Artists.* 6th ed. New York: St. Martin's Press, 1994.

Derrida, Jacques. *The Truth in Painting.* Chicago: University of Chicago Press, 1987.

Deepwell, K., ed. *New Feminist Art.* Manchester: Manchester University Press, 1994.

Encyclopedia of World Art. 15 vols. New York: Publisher's Guild, 1959–1968. Supplementary vols. 16, 1983; 17, 1987.

Fielding, Mantle. *Dictionary of American Painters, Sculptors, and Engravers.* 2nd rev. and enl. ed. Poughkeepsie: Apollo, 1986.

Fleming, John, Hugh Honour, and Nikolaus Pevsner. *Penguin Dictionary of Architecture.* 4th ed. New York: Penguin, 1991.

Freedberg, David. *The Power of Images: Studies in the History and Theory of Response.* Chicago: University of Chicago Press, 1985.

Giedion, Siegfried. *Space, Time and Architecture: The Growth of a New Tradition.* 5th ed. Cambridge: Harvard University Press, 1982.

Gombrich, Ernst Hans Josef. *Art and Illusion.* 5th ed. London: Phaidon, 1977.

Haggar, Reginald G. *A Dictionary of Art Terms: Architecture, Sculpture, Painting, and the Graphic Arts.* Poole: New Orchard Editions, 1984.

Hall, James. *Dictionary of Subjects and Symbols in Art.* 2nd rev. ed. London: J. Murray, 1979.

Harris, Anne Sutherland, and Linda Nochlin. *Women Artists: 1550–1950.* Los Angeles: Los Angeles County Museum of Art; New York: Knopf, 1977.

Hauser, Arnold. *The Sociology of Art.* Chicago: University of Chicago Press, 1982.

Hind, Arthur M. *A History of Engraving and Etching from the Fifteenth Century to the Year 1914.* 3rd rev. ed. New York: Dover, 1963.

Holt, Elizabeth G., ed. *A Documentary History of Art.* 2nd ed. 2 vols. Princeton: Princeton University Press, 1981.

Hults, Linda C. *The Print in the Western World: An Introductory History.* Madison: University of Wisconsin Press, 1996.

Kostof, Spiro. *A History of Architecture: Settings and Rituals.* 2nd ed. Oxford: Oxford University Press, 1995.

Kronenberger, Louis. *Atlantic Brief Lives: A Biographical Companion to the Arts.* Boston: Little, Brown, 1971.

Kultermann, Udo. *The History of Art History.* New York: Abaris, 1993.

Lucie-Smith, Edward. *The Thames & Hudson Dictionary of Art Terms.* London: Thames & Hudson, 1984.

Murray, Peter, and Linda Murray. *A Dictionary of Art and Artists.* 5th ed. New York: Penguin, 1988.

Myers, Bernard Samuel, ed. *Encyclopedia of Painting: Painters and Painting of the World from Prehistoric Times to the Present Day.* 4th rev. ed. New York: Crown, 1979.

Myers, Bernard S., and Myers, Shirley D., eds. *Dictionary of 20th-Century Art.* New York: McGraw-Hill, 1974.

Osborne, Harold, ed. *The Oxford Companion to 20th Century Art.* New York: Oxford University Press, 1981.

Parker, Rozsika, and Griselda Pollock. *Old Mistresses: Women, Art, and Ideology.* London: Routledge & Kegan Paul, 1981.

Penny, Nicholas. *The Materials of Sculpture.* New Haven: Yale University Press, 1993.

Pevsner, Nikolaus. *A History of Building Types.* London: Thames & Hudson, 1987. Reprint of 1979 ed.

———. *An Outline of European Architecture.* 8th ed. Baltimore: Penguin, 1974.

———. *The Buildings of England.* 46 vols. Harmondsworth: Penguin, 1951–1974.

Pickover, C., ed. *Visions of the Future: Art, Technology and Computing in the Twenty-First Century.* New York: St. Martin's Press, 1994.

Pierce, James Smith. *From Abacus to Zeus: A Handbook of Art History.* Rev. 5th ed. Upper Saddle River: 1998.

Pierson, William H., Jr., and Martha Davidson. eds. *Arts of the United States, A Pictorial Survey.* 1960. Reprint. Athens: University of Georgia Press, 1975.

Placzek, Adolf K., ed. *Macmillan Encyclopedia of Architects.* 4 vols. New York: Macmillan, 1982.

Podro, Michael. *The Critical Historians of Art.* New Haven: Yale University Press, 1982.

Pollock, Griselda. *Vision and Difference: Femininity, Feminism and Histories of Art.* London: Routledge, 1988.

Preziosi, Donald, ed. *The Art of Art History: A Critical Anthology.* New York: Oxford University Press, 1998.

Read, Herbert, and Nikos Stangos. eds. *The Thames & Hudson Dictionary of Art and Artists.* Rev. ed. London: Thames & Hudson, 1988.

Reid, Jane D. *The Oxford Guide to Classical Mythology in the Arts 1300–1990s.* 2 vols. New York: Oxford University Press, 1993.

Roth, Leland M. *Understanding Architecture: Its Elements, History, and Meaning.* New York: Harper & Row, 1993.

Rosenblum, Naomi. *A World History of Photography.* New York: Abbeville, 1984.

Rubenstein, Charlotte Streifer. *American Women Artists from Early Indian Times to the Present.* Boston: G. K. Hall/Avon Books, 1982.

Slatkin, Wendy. *Women Artists in History: From Antiquity to the 20th Century.* 2nd ed. Englewood Cliffs: Prentice-Hall, 1985.

Smith, Alistair, ed. *The Larousse Dictionary of Painters.* New York: Larousse, 1981.

Smith, G. E. Kidder. *The Architecture of the United States: An Illustrated Guide to Buildings Open to the Public.* 3 vols. Garden City: Doubleday/Anchor, 1981.

Stangos, Nikos. *The Thames & Hudson Dictionary of Art and Artists.* Rev. ed. New York: Thames & Hudson, 1994.

Steer, John, and Antony White. *Atlas of Western Art History: Artists, Sites and Monuments from Ancient Greece to the Modern Age.* New York: Facts on File, 1994.

Stratton, Arthur. *The Orders of Architecture: Greek, Roman and Renaissance.* London: Studio, 1986.

Sutton, Ian. *Western Architecture: From Ancient Greece to the Present.* New York: Thames & Hudson, 1999.

Trachtenberg, Marvin, and Isabelle Hyman. *Architecture, from Prehistory to Post-Modernism.* New York: Abrams, 1986.

Tufts, Eleanor. *American Women Artists, Past and Present, A Selected Bibliographic Guide.* New York: Garland Publishers, 1984.

———. *Our Hidden Heritage, Five Centuries of Women Artists.* London: Paddington Press, 1974.

Turner, Jane, ed. *The Dictionary of Art.* 34 vols. New York: Grove Dictionaries, 1996.

Van Pelt, R., and C. Westfall. *Architectural Principles in the Age of Historicism.* New Haven: Yale University Press, 1991.

Waterhouse, Ellis. *The Dictionary of British 18th Century Painters in Oils and Crayons.* Woodbridge, England: Antique Collectors' Club, 1981.

Wilkins, David G. *Art Past, Art Present.* New York: Abrams, 1994.

Wittkower, Rudolf. *Sculpture Processes and Principles.* New York: Harper & Row, 1977.

Wölfflin, Heinrich. *The Sense of Form in Art.* New York: Chelsea, 1958.

Young, William, ed. *A Dictionary of American Artists, Sculptors, and Engravers.* Cambridge: W. Young, 1968.

CHAPTER 14
FROM GOTHIC TO RENAISSANCE: THE FOURTEENTH CENTURY IN ITALY

Andrés, Glenn, et al. *The Art of Florence.* 2 vols. New York: Abbeville Press, 1988.

Antal, Frederick. *Florentine Painting and Its Social Background.* London: Keegan Paul, 1948.

Bomford, David. *Art in the Making: Italian Painting before 1400.* London: National Gallery, 1989.

Borsook, Eve, and Fiorelli Superbi Gioffredi. *Italian Altarpieces 1250–1550: Function and Design.* Oxford: Clarendon Press, 1994.

Cennini, Cennino. *The Craftsman's Handbook (Il Libro dell'Arte).* Trans. Daniel V. Thompson, Jr. New York: Dover, 1954.

Cole, Bruce. *Sienese Painting: From Its Origins to the Fifteenth Century.* New York: HarperCollins, 1987.

Cole, Bruce. *Italian Art, 1250–1550: The Relation of Renaissance Art to Life and Society.* New York: Harper & Row, 1987.

Hills, Paul. *The Light of Early Italian Painting.* New Haven: Yale University Press, 1987.

Meiss, Millard. *Painting in Florence and Siena after the Black Death.* Princeton: Princeton University Press, 1976.

Norman, Diana, ed. *Siena, Florence, and Padua: Art, Society, and Religion 1280–1400.* New Haven: Yale University Press, 1995.

Panofsky, Erwin. *Renaissance and Renascences in Western Art.* New York: HarperCollins, 1972.

Pope-Hennessy, John. *Introduction to Italian Sculpture.* 3rd. ed. 3 vols. New York: Phaidon, 1986.

———. *Italian Gothic Sculpture.* 3rd ed. Oxford: Phaidon, 1986.

Smart, Alastair. *The Dawn of Italian Painting.* Ithaca: Cornell University Press, 1978.

Stubblebine, James. *Assisi and the Rise of Vernacular Art.* New York: Harper & Row, 1985.

White, John. *Art and Architecture in Italy 1250–1400.* 3rd ed. New Haven: Yale University Press, 1993.

CHAPTER 15
OF PIETY, PASSION, AND POLITICS: FIFTEENTH-CENTURY ART IN NORTHERN EUROPE AND SPAIN

Baxendall, M. *The Limewood Sculptors of Renaissance Germany.* New Haven: Yale University Press, 1980.

Blum, Shirley Neilsen. *Early Netherlandish Triptychs: A Study in Patronage.* Berkeley: University of California Press, 1969.

Campbell, Lorne. *The Fifteenth Century Netherlandish Schools.* London: National Gallery Publications, 1998.

Chatelet, Albert. *Early Dutch Painting.* New York: W. S. Konecky, 1988.

Cuttler, Charles P. *Northern Painting from Pucelle to Bruegel.* New York: Holt, Rinehart & Winston, 1968.

Friedlander, Max J. *Early Netherlandish Painting.* 14 vols. New York: Praeger/Phaidon, 1967–1976.

———. *From Van Eyck to Bruegel.* 3rd ed. Ithaca: Cornell University Press, 1981.

Huizinga, Johan. *The Waning of the Middle Ages.* 1924. Reprint. New York: St. Martin's Press, 1988.

Jacobs, Lynn F. *Early Netherlandish Carved Altarpieces, 1380–1550: Medieval Tastes and Mass Marketing.* Cambridge: Cambridge University Press, 1998.

Lane, Barbara G. *The Altar and the Altarpiece: Sacramental Themes in Early Netherlandish Painting.* New York: Harper & Row, 1984.

Meiss, Millard. *French Painting in the Time of Jean de Berry: The Limbourgs and Their Contemporaries.* New York: Braziller, 1974.

Müller, Theodor. *Sculpture in the Netherlands, Germany, France and Spain, 1400–1500.* New Haven: Yale University Press, 1986.

Panofsky, Erwin. *Early Netherlandish Painting: Its Origins and Character.* 2 vols. Cambridge: Harvard University Press, 1966.

Prevenier, Walter, and Wim Blockmans. *The Burgundian Netherlands.* Cambridge: Cambridge University Press, 1986.

Snyder, James. *Northern Renaissance Art: Painting, Sculpture, the Graphic Arts from 1350 to 1575.* New York: Abrams, 1985.

Wolfthal, Diane. *The Beginnings of Netherlandish Canvas Painting, 1400–1530.* New York: Cambridge University Press, 1989.

CHAPTER 16
HUMANISM AND THE ALLURE OF ANTIQUITY: FIFTEENTH-CENTURY ITALIAN ART

Adams, Laurie Schneider. *Key Monuments of the Italian Renaissance.* Denver: Westview Press, 1999.

Alberti, Leon Battista. *On Painting.* Trans. J. B. Spencer, Rev. ed. New Haven: Yale University Press, 1966.

———. *Ten Books on Architecture.* Ed. J. Rykwert. Trans. J. Leoni. London: Tiranti, 1955.

Ames-Lewis, Francis. *Drawing in Early Renaissance Italy.* New Haven: Yale University Press, 1981.

Baxandall, Michael. *Painting and Experience in Fifteenth Century Italy. A Primer in the Social History of Pictorial Style.* 2nd ed. New York: Oxford University Press, 1988.

Beck, James. *Italian Renaissance Painting.* New York: HarperCollins, 1981.

Blunt, Anthony. *Artistic Theory in Italy, 1450–1600.* Oxford: Clarendon Press, 1966.

Bober, Phyllis Pray, and Ruth Rubinstein. *Renaissance Artists and Antique Sculpture: A Handbook of Sources.* Oxford: Oxford University Press, 1986.

Borsook, Eve. *The Mural Painters of Tuscany.* New York: Oxford University Press, 1981.

Burckhardt, Jacob. *The Architecture of the Italian Renaissance.* Chicago: University of Chicago Press, 1987.

———. *The Civilization of the Renaissance in Italy.* 4th ed. 1867. Reprint. London: Phaidon, 1960.

Christiansen, Keith, Laurence B. Kanter, and Carl B. Strehle, eds. *Painting in Renaissance Siena, 1420–1500.* New York: Metropolitan Museum of Art, 1988.

Cole, Alison. *Virtue and Magnificence: Art of the Italian Renaissance Courts.* New York: Harry N. Abrams, 1995.

Cole, Bruce. *Masaccio and the Art of Early Renaissance Florence.* Bloomington: Indiana University Press, 1980.

Dempsey, Charles. *The Portrayal of Love: Botticelli's Primavera and Humanist Culture at the Time of Lorenzo the Magnificent.* Princeton: Princeton University Press, 1992.

Edgerton, Samuel Y., Jr. *The Heritage of Giotto's Geometry: Art and Science on the Eve of the Scientific Revolution.* Ithaca: Cornell University Press, 1991.

———. *The Renaissance Rediscovery of Linear Perspective.* New York: Harper & Row, 1976.

Gilbert, Creighton, ed. *Italian Art 1400–1500: Sources and Documents.* Evanston: Northwestern University Press, 1992.

Goldthwaite, Richard A. *The Building of Renaissance Florence: An Economic and Social History.* Baltimore: Johns Hopkins University Press, 1980.

Gombrich, E. H. *Norm and Form: Studies in the Art of the Renaissance.* 4th ed. Oxford: Phaidon, 1985.

Hall, Marcia B. *Color and Meaning: Practice and Theory in Renaissance Painting.* Cambridge: Cambridge University Press, 1992.

Hartt, Frederick. *History of Italian Renaissance Art: Painting, Sculpture, Architecture.* 4th ed. rev. by David G. Wilkins. Englewood Cliffs: Prentice-Hall, 1994.

Heydenreich, Ludwig H., and Wolfgang Lotz. *Architecture in Italy 1400–1600.* Harmondsworth: Penguin, 1974.

Hollingsworth, Mary. *Patronage in Renaissance Italy: From 1400 to the Early Sixteenth Century.* Baltimore: Johns Hopkins University Press, 1994.

Kemp, Martin. *Behind the Picture: Art and Evidence in the Italian Renaissance.* New Haven: Yale University Press, 1997.

Kempers, Bram. *Painting, Power, and Patronage: The Rise of the Professional Artist in the Italian Renaissance.* London: Penguin, 1992.

Kent, F. W., and Patricia Simons, eds. *Patronage, Art, and Society in Renaissance Italy.* Canberra: Humanities Research Centre & Clarendon Press, 1987.

Lieberman, Ralph. *Renaissance Architecture in Venice.* New York: Abbeville Press, 1982.

McAndrew, John. *Venetian Architecture of the Early Renaissance.* Cambridge: MIT Press, 1980.

Meiss, Millard. *The Painter's Choice, Problems in the Interpretation of Renaissance Art.* New York: HarperCollins, 1977.

Murray, Peter. *The Architecture of the Italian Renaissance.* Rev. ed. New York: Schocken, 1986.

———. *Renaissance Architecture.* New York: Electa/Rizzoli (paperback), 1985.

Murray, Peter, and Linda Murray. *The Art of the Renaissance.* London: Thames & Hudson, 1985.

Olson, Roberta J. M. *Italian Renaissance Sculpture.* London: Thames & Hudson, 1992.

Panofsky, Erwin. *Renaissance and Renascences in Western Art.* New York: HarperCollins, 1972.

Pater, Walter. *The Renaissance: Studies in Art and Poetry.* Ed. D. L. Hill. Berkeley: University of California Press, 1980.

Pope-Hennessy, John. *An Introduction to Italian Sculpture.* 3rd ed. 3 vols. New York: Phaidon, 1986.

Seymour, Charles. *Sculpture in Italy, 1400–1500.* New Haven: Yale University Press, 1966.

Thomson, David. *Renaissance Architecture: Critics, Patrons, and Luxury.* Manchester: Manchester University Press, 1993.

Turner, A. Richard. *Renaissance Florence: The Invention of a New Art.* New York: Harry N. Abrams, 1997.

Vasari, Giorgio. *The Lives of the Most Eminent Painters, Sculptors and Architects, 1550–1568.* 3 vols. New York: Abrams, 1979.

Wackernagel, Martin. *The World of the Florentine Renaissance Artist: Projects and Patrons, Workshops and Art Market.* Princeton: Princeton University Press, 1981.

Welch, Evelyn. *Art and Society in Italy 1350–1500.* Oxford: Oxford University Press, 1997.

White, John. *The Birth and Rebirth of Pictorial Space.* 3rd ed. Boston: Faber & Faber, 1987.

Wilde, Johannes. *Venetian Art from Bellini to Titian.* Oxford: Clarendon Press, 1981.

Wittkower, Rudolf. *Architectural Principles in the Age of Humanism.* 4th ed. London: Academy, 1988.

CHAPTER 17
BEAUTY, SCIENCE, AND SPIRIT IN ITALIAN ART: THE HIGH RENAISSANCE AND MANNERISM

Blunt, Anthony. *Artistic Theory in Italy, 1450–1600.* London: Oxford University Press, 1975.

Brown, Patricia Fortini. *Art and Life in Renaissance Venice.* New York: Harry N. Abrams, 1997.

Castiglione, Baldassare. *Book of the Courtier.* 1528. Reprint. New York: Viking Penguin, 1976.

Farago, Claire, ed. *Reframing the Renaissance: Visual Culture in Europe and Latin America 1450–1650.* New Haven: Yale University Press, 1995.

Freedberg, Sydney J. *Painting in Italy, 1500–1600.* 3rd ed. New Haven: Yale University Press, 1993.

———. *Painting of the High Renaissance in Rome and Florence.* Rev. ed. New York: Hacker, 1985.

Friedlaender, Walter. *Mannerism and Anti-Mannerism in Italian Painting.* New York: Schocken, 1965.

Goffen, Rona. *Piety and Patronage in Renaissance Venice: Bellini, Titian, and the Franciscans.* New Haven: Yale University Press, 1986.

Haskell, Francis, and Nicholas Penny. *Taste and the Antique: The Lure of Classical Sculpture, 1500–1900.* New Haven: Yale University Press, 1981.

Holt, Elizabeth Gilmore, ed. *A Documentary History of Art.* Vol. 2, *Michelangelo and the Mannerists.* Rev. ed. Princeton: Princeton University Press, 1982.

Humfry, Peter. *Painting in Renaissance Venice.* New Haven: Yale University Press, 1995.

Huse, Norbert, and Wolfgang Wolters. *The Art of Renaissance Venice: Architecture, Sculpture, and Painting.* Chicago: University of Chicago Press, 1990.

Levey, Michael. *High Renaissance.* New York: Viking Penguin, 1978.

Murray, Linda. *The High Renaissance and Mannerism.* New York: Oxford University Press, 1977.

Partner, Peter. *Renaissance Rome, 1500–1559: A Portrait of a Society.* Berkeley: University of California Press, 1977.

Partridge, Loren. *The Art of Renaissance Rome.* New York: Harry N. Abrams, 1996.

Pietrangeli, Carlo, et al. *The Sistine Chapel: The Art, the History, and the Restoration.* New York: Harmony Books, 1986.

Pope-Hennessy, John. *Italian High Renaissance and Baroque Sculpture.* 3rd ed. 3 vols. Oxford: Phaidon, 1986.

Rosand, David. *Painting in Cinquecento Venice: Titian, Veronese, Tintoretto.* New Haven: Yale University Press, 1982.

Shearman, John K. G. *Mannerism.* Baltimore: Penguin, 1978.

————. *Only Connect . . . Art and the Spectator in the Italian Renaissance.* Princeton: Princeton University Press, 1990.

Summers, David. *Michelangelo and the Language of Art.* Princeton: Princeton University Press, 1981.

Venturi, Lionello. *The Sixteenth Century: From Leonardo to El Greco.* New York: Skira, 1956.

Wölfflin, Heinrich. *The Art of the Italian Renaissance.* New York: Schocken, 1963.

————. *Classic Art: An Introduction to the Italian Renaissance.* 4th ed. Oxford: Phaidon, 1980.

CHAPTER 18
THE AGE OF REFORMATION: SIXTEENTH-CENTURY ART IN NORTHERN EUROPE AND SPAIN

Benesch, Otto. *Art of the Renaissance in Northern Europe.* Rev. ed. London: Phaidon, 1965.

————. *German Painting from Dürer to Holbein.* Geneva: Skira, 1966.

Blunt, Anthony. *Art and Architecture in France 1500–1700.* 4th ed. New Haven: Yale University Press, 1982.

Gibson, W. S. *"Mirror of the Earth": The World Landscape in Sixteenth Century Flemish Painting.* Princeton: Princeton University Press, 1989.

Harbison, Craig. *The Mirror of the Artist: Northern Renaissance Art in its Historical Context.* New York: Harry N. Abrams, 1995.

Hitchcock, Henry-Russell. *German Renaissance Architecture.* Princeton: Princeton University Press, 1981.

Landau, David, and Peter Parshall. *The Renaissance Print: 1470–1550.* New Haven: Yale University Press, 1994.

Smith, Jeffrey C. *German Sculpture of the Later Renaissance c. 1520–1580.* Princeton: Princeton University Press, 1993.

Stechow, Wolfgang. *Northern Renaissance Art, 1400–1600: Sources and Documents.* Englewood Cliffs: Prentice-Hall, 1966.

CHAPTER 19
OF POPES, PEASANTS, MONARCHS, AND MERCHANTS: BAROQUE AND ROCOCO ART

Adams, Laurie Schneider. *Key Monuments of the Baroque.* Denver: Westview Press, 1999.

The Age of Caravaggio. New York: Metropolitan Museum of Art, 1985.

Alpers, Svetlana. *The Art of Describing: Dutch Art in the Seventeenth Century.* Chicago: University of Chicago Press, 1984.

————. *Rembrandt's Enterprise: The Studio and the Market.* Chicago: University of Chicago Press, 1988.

Blunt, Anthony. *Art and Architecture in France: 1500 to 1700.* 4th ed. New Haven: Yale University Press, 1988.

Blunt, Anthony, ed. *Baroque and Rococo: Architecture and Decoration.* Cambridge: Harper & Row, 1982.

Brown, Christopher. *Scenes of Everyday Life: Dutch Genre Painting of the Seventeenth Century.* London: Faber & Faber, 1984.

Brown, Jonathan. *The Golden Age of Painting in Spain.* New Haven: Yale University Press, 1991.

————. *Kings and Connoisseurs: Collecting Art in Seventeenth-Century Europe.* Princeton: Princeton University Press, 1994.

Bryson, Norman. *Word and Image: French Painting of the Ancien Régime.* Cambridge: Cambridge University Press, 1981.

Duncan, Carol. *The Pursuit of Pleasure: The Rococo Revival in French Romantic Art.* New York: Garland, 1976.

Enggass, Robert, and Jonathan Brown. *Italy and Spain, 1600–1750: Sources and Documents.* Englewood Cliffs: Prentice Hall, 1970.

Franits, Wayne. *Looking at Seventeenth-Century Dutch Art: Realism Reconsidered.* Cambridge: Cambridge University Press, 1997.

Freedberg, Sydney J. *Circa 1600: A Revolution of Style in Italian Painting.* Cambridge: Harvard University Press, 1983.

Gerson, Horst, and E. H. ter Kuile. *Art and Architecture in Belgium 1600–1800.* Baltimore: Penguin, 1960.

Haak, Bob. *The Golden Age: Dutch Painters of the Seventeenth Century.* New York: Abrams, 1984.

Haskell, Francis. *Patrons and Painters: A Study in the Relations between Italian Art and Society in the Age of the Baroque.* Rev. ed. New Haven: Yale University Press, 1980.

Held, Julius, and Donald Posner. *17th and 18th Century Art: Baroque Painting, Sculpture, Architecture.* New York: Abrams, 1971.

Hempel, Eberhard. *Baroque Art and Architecture in Central Europe.* New York: Viking Penguin, 1977.

Hibbard, Howard. *Carlo Maderno and Roman Architecture, 1580–1630.* London: Zwemmer, 1971.

Hitchcock, Henry Russell. *Rococo Architecture in Southern Germany.* London: Phaidon, 1968.

Howard, Deborah. *The Architectural History of Venice.* London: B. T. Batsford, 1981.

Huyghe, René, ed. *Larousse Encyclopedia of Renaissance and Baroque Art.* See Reference Books.

Kahr, Madlyn Millner. *Dutch Painting in the Seventeenth Century.* New York: Harper & Row, 1978.

Kalnein, Wend, and Michael Levey. *Art and Architecture of the Eighteenth Century in France.* Harmondsworth: Penguin, 1972.

Kitson, Michael. *The Age of Baroque.* London: Hamlyn, 1976.

Krautheimer, Richard. *The Rome of Alexander VII, 1655–1677.* Princeton: Princeton University Press, 1985.

Lagerlöf, Margaretha R. *Ideal Landscape: Annibale Carracci, Nicolas Poussin and Claude Lorrain.* New Haven: Yale University Press, 1990.

Lees-Milne, James. *Baroque in Italy.* New York: Macmillan, 1960.

Levey, Michael. *Painting and Sculpture in France, 1700–1789.* New ed. New Haven: Yale University Press, 1993.

Martin, John R. *Baroque.* New York: Harper & Row, 1977.

Millon, Henry A. *Baroque and Rococo Architecture.* New York: Braziller, 1965.

Montagu, Jennifer. *Roman Baroque Sculpture: The Industry of Art.* New Haven: Yale University Press, 1989.

Muller, Sheila D., ed. *Dutch Art: An Encyclopedia.* New York: Garland Publishers, 1997.

Norberg-Schulz, Christian. *Baroque Architecture.* New York: Rizzoli, 1986.

————. *Late Baroque and Rococo Architecture.* New York: Electa/Rizzoli, 1985.

North, Michael. *Art and Commerce in the Dutch Golden Age.* New Haven: Yale University Press, 1997.

Pope-Hennessy, Sir John. *The Study and Criticism of Italian Sculpture.* New York: Metropolitan Museum, 1981.

Rosenberg, Jakob, Seymour Slive, and E. H. ter Kuile. *Dutch Art and Architecture, 1600–1800.* New Haven: Yale University Press, 1979.

Schama, Simon. *The Embarrassment of Riches: An Interpretation of Dutch Culture in the Golden Age.* Berkeley: University of California Press, 1988.

Stechow, Wolfgang. *Dutch Landscape Painting of the 17th Century.* 3rd ed. Oxford: Phaidon, 1981.

Summerson, Sir John. *Architecture in Britain: 1530–1830.* 7th rev. and enl. ed. New Haven: Yale University Press, 1983.

Varriano, John. *Italian Baroque and Rococo Architecture.* New York: Oxford University Press, 1986.

Waterhouse, Ellis Kirkham. *Baroque Painting in Rome.* London: Phaidon, 1976.

————. *Italian Baroque Painting.* 2nd ed. London: Phaidon, 1969.

————. *Painting in Britain, 1530–1790.* 4th ed. New Haven: Yale University Press, 1979.

Wittkower, Rudolf. *Art and Architecture in Italy 1600–1750.* 3rd ed. Harmondsworth: Penguin, 1982.

Wölfflin, Heinrich. *Principles of Art History: The Problem of the Development of Style in Later Art.* 7th ed. New York: Dover, 1950.

————. *Renaissance and Baroque.* London: Collins, 1984.

Wright, Christopher. *The French Painters of the 17th Century.* New York: New York Graphic Society, 1986.

BOOKS SPANNING THE FOURTEENTH THROUGH SEVENTEENTH CENTURIES

Campbell, Lorne. *Renaissance Portraits: European Portrait-Painting in the Fourteenth, Fifteenth, and Sixteenth Centuries.* New Haven: Yale University Press, 1990.

Dunkerton, Jill, Susan Foister, Dillian Gordon, and Nicholas Penny. *Giotto to Dürer: Early Renaissance Painting in the National Gallery.* New Haven: Yale University Press, 1991.

Gilbert, Creighton. *History of Renaissance Art throughout Europe.* New York: Abrams, 1973.

Haskell, Francis, and Nicholas Penny. *Taste and the Antique: The Lure of Classical Sculpture 1500–1900.* New Haven: Yale University Press, 1981.

Huyghe, René. *Larousse Encyclopedia of Renaissance and Baroque Art.* See Reference Books.

Kemp, Martin. *The Science of Art: Optical Themes in Western Art From Brunelleschi to Seurat.* New Haven: Yale University Press, 1990.

Paoletti, John T,. and Gary M. Radke. *Art in Renaissance Italy.* Upper Saddle River: Prentice Hall, 1997.

CHAPTER 20
THE ENLIGHTENMENT AND ITS LEGACY: NEOCLASSICISM THROUGH THE MID-NINETEENTH CENTURY

Bermingham, Ann. *Landscape and Ideology: The English Rustic Tradition, 1740–1850.* Berkeley: University of California Press, 1986.

Boime, A. *Art in the Age of Bonapartism, 1800–1815.* Chicago: University of Chicago Press, 1990.

————. *Art in the Age of Revolution, 1750–1800.* Chicago: University of Chicago Press, 1987.

Braham, Allan. *The Architecture of the French Enlightenment.* Berkeley: University of California Press, 1980.

Brion, Marcel. *Art of the Romantic Era: Romantcism, Classicism, Realism.* New York: Praeger, 1966.

Bryson, Norman. *Tradition and Desire: From David to Delacroix.* New York: Cambridge University Press, 1984.

Burchard, John, and Albert Bush-Brown. *The Architecture of America: A Social and Cultural History.* Boston: Little, Brown/The American Institute of Architects, 1965.

Clark, Kenneth. *The Romantic Rebellion: Romantic versus Classic Art.* New York: Harper & Row, 1973.

Clay, Jean. *Romanticism.* New York: Phaidon, 1981.

Conisbee, Philip. *Painting in Eighteenth-Century France.* Ithaca: Phaidon/Cornell University Press, 1981.

Cooper, Wendy A. *Classical Taste in America, 1800–1840.* Baltimore: Baltimore Museum of Art, 1993.

Crow, Thomas E. *Painters and Public Life in Eighteenth-Century Paris.* New Haven: Yale University Press, 1985.

Davis, Terence. *The Gothick Taste.* Cranbury: Fairleigh Dickinson University Press, 1975.

Eitner, Lorenz. *Neoclassicism and Romanticism, 1750–1850: An Anthology of Sources and Documents.* New York: Harper & Row, 1989.

Gaunt, W. *The Great Century of British Painting: Hogarth to Turner.* New York: Phaidon, 1971.

Herrmann, Luke. *British Landscape Painting of the Eighteenth Century.* New York: Oxford University Press, 1974.

Holt, Elizabeth Gilmore, ed. *From the Classicists to the Impressionists: A Documentary History of Art and Architecture in the Nineteenth Century.* Garden City: Anchor Books/Doubleday, 1966.

Honour, Hugh. *Neo-Classicism.* Harmondsworth: Penguin, 1968.

————. *Romanticism.* New York: Harper & Row, 1979.

Kalnein, Wend Graf, and Michael Levey. *Art and Architecture of the Eighteenth Century in France.* New York: Viking/Pelican, 1973.

Kroeber, Karl. *British Romantic Art.* Berkeley: University of California Press, 1986.

Levey, Michael. *Painting in Eighteenth-Century Venice.* Ithaca: Phaidon/Cornell University Press, 1980.

————. *Rococo to Revolution: Major Trends in Eighteenth-Century Painting.* London: Thames & Hudson, 1966.

Mendelowitz, Daniel M. *A History of American Art.* 2nd ed. New York: Holt, Rinehart & Winston, 1970.

Middleton, Robin, and David Watkin. *Neoclassical and 19th Century Architecture.* 2 vols. New York: Electa/Rizzoli, 1987.

Novotny, Fritz. *Painting and Sculpture in Europe, 1780–1880.* Harmondsworth: Penguin, 1980.

Pierson, William. *American Buildings and Their Architects.* Vol. 1, *The Colonial and Neo-Classical Style.* Garden City: Doubleday, 1970.

Porterfield, Todd. *The Allure of Empire: Art in the Service of French Imperialism 1798–1836.* Princeton: Princeton University Press, 1998.

Rosenblum, Robert. *Transformations in Late Eighteenth Century Art.* Princeton: Princeton University Press, 1970.

Roston, Murray. *Changing Perspectives in Literature and the Visual Arts, 1650–1820.* Princeton: Princeton University Press, 1990.

Rykwert, Joseph. *The First Moderns: Architects of the Eighteenth Century.* Cambridge: MIT Press, 1983.

Stillman, Damie. *English Neo-classical Architecture.* 2 vols. London: A Zwemmer, 1988.

Vaughn, William. *German Romantic Painting.* New Haven: Yale University Press, 1980.

Wilton, Andrew. *The Swagger Portrait: Grand Manner Portraiture in Britain from Van Dyck to Augustus John 1630–1930.* London: Tate Gallery, 1992.

Wolf, Bryan Jay. *Romantic Revision: Culture and Consciousness in Nineteenth-Century American Painting and Literature.* Chicago: University of Chicago Press, 1986.

CHAPTER 21
THE RISE OF MODERNISM:
THE LATER NINETEENTH CENTURY

Adams, Steven. *The Barbizon School and the Origins of Impressionism.* London: Phaidon, 1994.

Barger, M. Susan, and William B. White. *The Daguerreotype: Nineteenth-Century Technology and Modern Science.* Washington: Smithsonian Institution, 1991.

Baudelaire, Charles. *The Mirror of Art, Critical Studies.* Trans. Jonathan Mayne. Garden City: Doubleday & Co., 1956.

————. *The Painter of Modern Life, and Other Essays.* Trans. and ed. Jonathan Mayne. London: Phaidon, 1964.

Boime, Albert. *The Academy and French Painting in the 19th Century.* London: Phaidon, 1971.

Broude, Norma. *Impressionism: A Feminist Reading.* New York: Rizzoli, 1991.

Clark, Kenneth. *The Gothic Revival: An Essay in the History of Taste.* New York: Humanities Press, 1970.

Clark, T. J. *The Absolute Bourgeois: Artists and Politics in France, 1848–1851.* London: Thames & Hudson, 1973.

————. *Image of the People: Gustave Courbet and the 1848 Revolution.* London: Thames & Hudson, 1973.

————. *The Painting of Modern Life: Paris in the Art of Manet and His Followers.* Princeton: Princeton University Press, 1984.

Duncan, Alastair. *Art Nouveau.* New York: Thames & Hudson, 1994.

Eisenmann, Stephen F. *19th-Century Art: A Critical History.* New York: Thames & Hudson, 1994.

Farwell, Beatrice. *Manet and the Nude: A Study in the Iconology of the Second Empire.* New York: Garland, 1981.

Fried, Michael. *Courbet's Realism.* Chicago: University of Chicago Press, 1982.

————. *Manet's Modernism, or, The Face of Painting in the 1860s.* Chicago: The University of Chicago Press, 1996.

Friedlaender, Walter. *From David to Delacroix.* New York: Schocken Books, 1968.

Gerdts, William H. *American Impressionism.* New York: Abbeville Press, 1984.

Hamilton, George H. *Painting and Sculpture in Europe, 1880–1940.* 6th ed. New Haven: Yale University Press, 1993.

Herbert, Robert L. *Impressionism: Art, Leisure, and Parisian Society.* New Haven: Yale University Press, 1988.

Hilton, Timothy. *The Pre-Raphaelites.* New York: Oxford University Press, 1970.

Holt, Elizabeth B. *From the Classicists to the Impressionists: Art and Architecture in the Nineteenth Century.* Garden City: Doubleday/Anchor, 1966.

Holt, Elizabeth Gilmore, ed. *The Expanding World of Art 1874–1902.* New Haven: Yale University Press, 1988.

Janson, Horst W. *19th-Century Sculpture.* New York: Harry N. Abrams, 1985.

Jensen, Robert. *Marketing Modernism in Fin-de-Siècle Europe.* Princeton: Princeton University Press, 1994.

Klingender, Francis Donald and Elton, Arthur, ed. & rev. *Art and the Industrial Revolution.* London: Evelyn, Adams & MacKay, 1968.

Krell, Alain. *Manet and the Painters of Contemporary Life.* London: Thames & Hudson, 1996.

Leymarie, Jean. *French Painting in the Nineteenth Century.* Geneva: Skira, 1962.

Macaulay, James. *The Gothic Revival, 1745–1845.* Glasgow: Blackie, 1975.

Mainardi, Patricia. *Art and Politics of the Second Empire: The Universal Expositions of 1855 and 1867.* New Haven: Yale University Press, 1987.

————. *The End of the Salon: Art and the State in the Early Third Republic.* Cambridge: Cambridge University Press, 1993.

Middleton, Robin, ed. *The Beaux-Arts and Nineteenth-Century French Architecture.* Cambridge: MIT Press, 1982.

Miller, Angela L. *The Empire of the Eye: Landscape Representation and American Cultural Politics, 1825–1875.* Ithaca: Cornell University Press, 1993.

Needham, Gerald. *19th-Century Realist Art.* New York: Harper & Row, 1988.

Nochlin, Linda. *Impressionism and Post-Impressionism, 1874–1904: Sources and Documents.* Englewood Cliffs: Prentice-Hall, 1966.

————. *Realism and Tradition in Art, 1848–1900: Sources and Documents.* Englewood Cliffs: Prentice-Hall, 1966.

Novak, Barbara. *American Painting of the Nineteenth Century: Realism and the American Experience.* New York: Harper & Row, 1979.

Novotny, Fritz. *Painting and Sculpture in Europe: 1780–1880.* 2nd ed. New Haven: Yale University Press, 1978.

Pevsner, Nikolaus. *Pioneers of Modern Design.* Harmondsworth: Penguin, 1964.

Rewald, John. *The History of Impressionism.* New York: Museum of Modern Art, 1973.

————. *Post-Impressionism: From Van Gogh to Gauguin.* New York: Museum of Modern Art, 1956.

Rosen, Charles, and Henri Zerner. *Romanticism and Realism: The Mythology of Nineteenth-Century Art.* New York: Viking Press, 1984.

Rosenblum, Robert, and Horst W. Janson. *19th Century Art.* New York: Harry N. Abrams, 1984.

Schapiro, Meyer. *Modern Art: 19th & 20th Centuries.* New York: Braziller, 1978.

Schorske, Carl E. *Fin de Siècle Vienna: Politics and Culture.* New York: Alfred Knopf, 1980.

Shiff, Richard. *Cézanne and the End of Impressionism: A Study of the Theory, Technique, and Critical Evaluation of Modern Art.* Chicago: University of Chicago Press, 1984.

Silverman, Debora L. *Art Nouveau in Fin-de-Siècle France: Politics, Psychology, and Style.* Berkeley: University of California Press, 1989.

Sloane, Joseph C. *French Painting Between the Past and the Present: Artists, Critics, and Traditions from 1848 to 1870.* Princeton: Princeton University Press, 1973.

Smith, Paul. *Impressionism: Beneath the Surface.* New York: Harry N. Abrams, 1995.

Sullivan, Louis. *The Autobiography of an Idea.* New York: Dover, 1956.

Van Gogh: A Self Portrait: Letters Revealing His Life as a Painter. Selected by W. H. Auden. New York: E. P. Dutton, 1963.

Weisberg, Gabriel P. *The European Realist Tradition.* Bloomington: Indiana University Press, 1982.

Wilmerding, John, et al. *American Light: The Luminist Movement, 1850–1875: Paintings, Drawings, Photographs.* Washington: National Gallery of Art, 1980.

Wood, Christopher. *The Pre-Raphaelites.* New York: Viking Press, 1981.

CHAPTER 22
THE TRIUMPH OF MODERNIST ART:
THE EARLY TWENTIETH CENTURY

Antliff, Mark. *Cultural Politics and the Parisian Avant-Garde.* Princeton: Princeton University Press, 1993.

Baigell, Matthew. *The American Scene: American Painting of the 1930s.* New York: Praeger, 1974.

Barr, Alfred H., Jr. *Cubism and Abstract Art: Painting, Sculpture, Constructions, Photography, Architecture, Industrial Arts, Theatre, Films, Posters, Typography.* Cambridge: Belknap, 1986.

————. ed. *Fantastic Art, Dada, Surrealism.* Reprint of 1936 ed. by the Museum of Modern Art. New York: Arno Press, 1969.

Barron, Stephanie, ed. *Degenerate Art: The Fate of the Avant-Garde in Nazi Germany.* Los Angeles: Los Angeles County Museum of Art, 1991.

————. *Exiles + Emigrés: The Flight of European Artists from Hitler.* Los Angeles: Los Angeles County Museum of Art, 1997.

Bayer, Herbert, Walter Gropius, and Ise Gropius. *Bauhaus, 1919–1928.* New York: Museum of Modern Art, 1975.

Bearden, Romare, and Harry Henderson. *A History of African-American Artists from 1792 to the Present.* New York: Pantheon Books, 1993.

Breton, André. *Surrealism and Painting.* New York: Harper & Row, 1972.

Brown, Milton. *Story of the Armory Show: The 1913 Exhibition That Changed American Art.* 2nd ed. New York: Abbeville, 1988.

Campbell, Mary Schmidt, David C. Driskell, David Lewis Levering, and Deborah Willis Ryan. *Harlem Renaissance: Art of Black America.* New York: The Studio Museum, Harlem/Harry N. Abrams, 1987.

Carrá, Massimo, Ewald Rathke, Caroline Tisdall, and Patrick Waldberg. *Metaphysical Art.* New York: Frederick A. Praeger, 1971.

Davidson, Abraham A. *Early American Modernist Painting, 1910–1935.* New York: Harper & Row, 1981.

Eberle, Matthias. *World War I and the Weimar Artists: Dix, Grosz, Beckmann, Schlemmer.* New Haven: Yale University Press, 1985.

Elderfield, John. *The "Wild Beasts": Fauvism and Its Affinities.* New York: The Museum of Modern Art/Oxford University Press, 1976.

Elsen, Albert. *Origins of Modern Sculpture.* New York: Braziller, 1974.

Fer, Briony, David Batchelor, and Paul Wood. *Realism, Rationalism, Surrealism: Art Between the Wars.* New Haven: Yale University Press, 1993.

Frampton, Kenneth. *A Critical History of Modern Architecture.* London: Thames & Hudson, 1985.

Friedman, Mildred, ed. *De Stijl: 1917–1931, Visions of Utopia.* Minneapolis: Walker Art Center/New York: Abbeville Press, 1982.

Fry, Edward, ed. *Cubism.* London: Thames & Hudson, 1966.

Golding, John. *Cubism: A History and an Analysis, 1907–1914.* Cambridge: Belknap, 1988.

Gordon, Donald E. *Expressionism: Art and Idea.* New Haven: Yale University Press, 1987.

Gray, Camilla. *The Russian Experiment in Art: 1863–1922.* New York: Harry N. Abrams, 1970.

Gropius, Walter. *Scope of Total Architecture.* New York: Collier Books, 1962.

Hamilton, George Heard. *Painting and Sculpture in Europe, 1880–1940.* 6th ed. New Haven: Yale University Press, 1993.

Harrison, Charles, Francis Frascina, and Gill Perry. *Primitivism, Cubism, Abstraction: The Early Twentieth Century.* New Haven: Yale University Press, 1993.

Herbert, James D. *Fauve Painting: The Making of Cultural Politics.* New Haven: Yale University Press, 1992.

Hunter, Sam. *American Art of the 20th Century.* New York: Harry N. Abrams, 1972.

Hurlburt, Laurance P. *The Mexican Muralists in the United States.* Albuquerque: University of New Mexico Press, 1989.

Jaffé, Hans L. C. *De Stijl, 1917–1931: The Dutch Contribution to Modern Art.* Cambridge: Belknap, 1986.

Kahnweiler, Daniel H. *The Rise of Cubism.* New York: Wittenborn, Schultz, 1949.

Kandinsky, Wassily. *Concerning the Spiritual in Art.* Trans. M. T. H. Sadler. New York: Dover, 1977.

Krauss, Rosalind. *The Originality of the Avant-Garde and Other Modernist Myths.* Cambridge: MIT Press, 1986.

Kuspit, Donald. *The Cult of the Avant-Garde Artist.* Cambridge: Cambridge University Press, 1993.

Le Corbusier. *The City of Tomorrow,* Cambridge: MIT Press, 1971.

Lloyd, Jill. *German Expressionism: Primitivism and Modernity.* New Haven: Yale University Press, 1991.

Lodder, Christina. *Russian Constructivism.* New Haven: Yale University Press, 1983.

Martin, Marianne W. *Futurist Art and Theory.* Oxford: Clarendon Press, 1968.

Moholy-Nagy, László. *Vision in Motion.* Chicago: Paul Theobald, 1969, first published in 1946.

Mondrian, Pieter Cornelius. *Plastic Art and Pure Plastic Art.* 3rd ed. New York: Wittenborn, Schultz, 1952.

Motherwell, Robert, ed. *The Dada Painters and Poets: An Anthology.* 2nd ed. Boston: G. K. Hall & Co., 1981.

Myers, Bernard S. *The German Expressionists: A Generation in Revolt.* New York: Frederick A. Praeger, 1956.

Osborne, Harold. *The Oxford Companion to Twentieth Century Art.* New York: Oxford University Press, 1981.

Read, Herbert, ed. *Surrealism.* New York: Frederick A. Praeger, 1971.

Richter, Hans. *Dada: Art and Anti-Art.* London: Thames & Hudson, 1961.

Rosenblum, Robert. *Cubism and Twentieth-Century Art.* Rev. ed. New York: Harry N. Abrams, 1984.

Rubin, William S. *Dada and Surrealist Art.* New York: Harry N. Abrams, 1968.

———. *Dada, Surrealism and Their Heritage.* New York: Museum of Modern Art, 1968.

Rubin, William S., ed. *Pablo Picasso: A Retrospective.* New York: Museum of Modern Art/Boston: New York Graphic Society, 1980.

———. *"Primitivism" in 20th-Century Art: Affinity of the Tribal and the Modern.* 2 vols. New York: Museum of Modern Art, 1984.

Selz, Peter. *German Expressionist Painting.* 1957. reprint. Berkeley: University of California Press, 1974.

Silver, Kenneth E. *Esprit de Corps: The Art of the Parisian Avant-Garde and the First World War, 1914–1925.* Princeton: Princeton University Press, 1989.

Steinberg, Leo. *Other Criteria: Confrontations with 20th-Century Art.* New York: Oxford University Press, 1972.

Stott, William. *Documentary Expression and Thirties America.* New York: Oxford University Press, 1973.

Taylor, Brandon. *Avant-Garde and After.* New York: Harry N. Abrams, 1995.

Taylor, Joshua C. *Futurism.* New York: Museum of Modern Art, 1961.

Tisdall, Caroline, and Angelo Bozzolla. *Futurism.* New York: Oxford University Press, 1978.

Tsujimoto, Karen. *Images of America: Precisionist Painting and Modern Photography.* Seattle: University of Washington Press, 1982.

Tucker, William. *Early Modern Sculpture.* New York: Oxford University Press, 1974.

Vogt, Paul. *Expressionism: German Painting, 1905–1920.* New York: Harry N. Abrams, 1980.

Weiss, Jeffrey S. *The Popular Culture of Modern Art: Picasso, Duchamp, and Avant-Gardism.* New Haven: Yale University Press, 1994.

Whitford, Frank. *Bauhaus.* New York: Thames & Hudson, 1984.

Wright, Frank Lloyd; Edgar Kaufmann, ed. *American Architecture.* New York: Horizon, 1955.

CHAPTER 23
THE EMERGENCE OF POSTMODERNISM: THE LATER TWENTIETH CENTURY

Alloway, Lawrence. *American Pop Art.* New York: Whitney Museum of American Art/Macmillan, 1974.

———. *Topics in American Art Since 1945.* New York: W. W. Norton, 1975.

Anfam, David. *Abstract Expressionism.* New York: Thames & Hudson, 1990.

Ashton, Dore. *American Art Since 1945.* New York: Oxford University Press, 1983.

———. *The New York School: A Cultural Reckoning.* Harmondsworth: Penguin, 1979.

Battcock, Gregory, ed. *Idea Art: A Critical Anthology.* New York: E. P. Dutton, 1973.

———. *Minimal Art: A Critical Anthology.* New York: Studio Vista, 1969.

———. *The New Art: A Critical Anthology.* New York: E. P. Dutton, 1973.

———. *New Artists Video: A Critical Anthology.* New York: E. P. Dutton, 1978.

Battcock, Gregory, and Robert Nickas, eds. *The Art of Performance: A Critical Anthology.* New York: E. P. Dutton, 1984.

Beardsley, Richard. *Earthworks and Beyond: Contemporary Art in the Landscape.* New York: Abbeville Press, 1984.

Beardsley, John, and Jane Livingston. *Hispanic Art in the United States: Thirty Contemporary Painters and Sculptors.* Houston: Museum of Fine Arts/New York: Abbeville Press, 1987.

Benthall, Jeremy. *Science and Technology in Art Today.* New York: Frederick A. Praeger, 1972.

Brion, Marcel, Sam Hunter, et al. *Art Since 1945.* New York: Harry N. Abrams, 1958.

Broude, Norma, and Mary D. Garrard. *The Power of Feminist Art: The American Movement of the 1970s, History and Impact.* New York: Abrams, 1994.

Cockcroft, Eva, John Weber, and James Cockcroft. *Toward a People's Art.* New York: E. P. Dutton, 1977.

Cook, Peter. *New Spirit in Architecture.* New York: Rizzoli, 1990.

Cummings, Paul. *Dictionary of Contemporary American Artists.* 3rd ed. New York: St. Martin's Press, 1977.

Ferguson, Russell, ed. *Discourses: Conversations in Postmodern Art and Culture.* Cambridge: MIT Press, 1990.

Frascina, Francis, ed. *Pollock and After: The Critical Debate.* New York: Harper & Row, 1985.

Geldzahler, Henry. *New York Painting and Sculpture, 1940–1970.* New York: E. P. Dutton, 1969.

Guilbaut, Serge. *How New York Stole the Idea of Modern Art.* Chicago: University of Chicago Press, 1983.

Goldberg, Rose Lee. *Performance Art: From Futurism to the Present.* Rev. ed. New York: Abrams, 1988.

Goodman, Cynthia. *Digital Visions: Computers and Art.* New York: Harry N. Abrams, 1987.

Goodyear, Frank H., Jr. *Contemporary American Re-*

alism Since 1960. Boston: New York Graphic Society, 1981.

Green, Jonathan. *American Photography: A Critical History Since 1945 to the Present.* New York: Abrams, 1984.

Greenberg, Clement. *Clement Greenberg, The Collected Essays and Criticism.* Ed. J. O'Brien. 4 vols. Chicago: University of Chicago Press, 1986–93.

Grundberg, Andy. *Photography and Art: Interactions since 1945.* New York: Abbeville, 1987.

Hays, K. Michael, and Carol Burns, eds. *Thinking the Present: Recent American Architecture.* New York: Princeton Architectural, 1990.

Henri, Adrian. *Total Art: Environments, Happenings, and Performance.* New York: Oxford University Press, 1974.

Herbert, Robert L. *Modern Artists on Art.* Englewood Cliffs: Prentice-Hall, 1971.

Hertz, Richard, ed. *Theories of Contemporary Art.* 2nd ed. Englewood Cliffs: Prentice-Hall, 1993.

Hoffman, Katherine. *Explorations: The Visual Arts since 1945.* New York: HarperCollins, 1991.

Hughes, Robert. *The Shock of the New.* New York: Knopf, 1981.

Hunter, Sam. *An American Renaissance: Painting and Sculpture Since 1940.* New York: Abbeville, 1986.

Jacobus, John. *Twentieth-Century Architecture: The Middle Years, 1940–1964.* New York: Frederick A. Praeger, 1966.

Jencks, Charles. *Architecture 2000: Prediction and Methods.* New York: Frederick A. Praeger, 1971.

———. *The Language of Post-Modern Architecture.* 6th ed. New York: Rizzoli, 1991.

———. *What is Post-Modernism?* 3rd rev. ed. London: Academy Editions, 1989.

Johnson, Ellen H. *American Artists on Art: From 1940 to 1980.* New York: Harper & Row, 1980.

Jones, Amelia, ed. *Sexual Politics: Judy Chicago's Dinner Party in Feminist Art History.* Berkeley: University of California Press, 1996.

Kaprow, Allan. *Assemblage, Environments, and Happenings.* New York: Harry N. Abrams, 1966.

Kirby, Michael. *Happenings.* New York: E. P. Dutton, 1966.

Kramer, Hilton. *The Age of the Avant-Garde: An Art Chronicle of 1956–1972.* New York: Farrar, Straus & Giroux, 1973.

Leja, Michael. *Reframing Abstract Expressionism: Subjectivity and Painting in the 1940s.* New Haven: Yale University Press, 1993.

Lewis, Samella S. *African American Art and Artists.* Rev. ed. Berkeley: University of California Press, 1994.

Lippard, Lucy R. *Mixed Blessings: New Art in a Multicultural America.* New York: Pantheon Books, 1990.

———. *Pop Art.* New York: Frederick A. Praeger, 1966.

———, ed. *From the Center: Feminist Essays on Women's Art.* New York: E. P. Dutton, 1976.

———, ed. *Six Years: The Dematerialization of the Art Object from 1966 to 1972.* New York: Frederick A. Praeger, 1973.

Lovejoy, Margot. *Postmodern Currents: Art and Artists in the Age of the Electronic Media.* Ann Arbor: UMI Research Press, 1989.

Lucie-Smith, Edward. *Art Now.* Edison: Wellfleet Press, 1989.

———. *Movements in Art Since 1945.* new rev. ed. New York: Thames & Hudson, 1984.

Marder, Tod A. *The Critical Edge: Controversy in Recent American Architecture.* New Brunswick: Rutgers University Press, 1980.

———. *An International Survey of Recent Painting and Sculpture.* New York: Museum of Modern Art, 1984.

Meyer, Ursula. *Conceptual Art.* New York: E. P. Dutton, 1972.

Mitchell, William J. *The Reconfigured Eye: Visual Truth in the Post-Photographic Era.* Cambridge: MIT Press, 1992.

Norris, Christopher, and Andrew Benjamin. *What Is Deconstruction?* New York: St. Martin's, 1988.

Polcari, Stephen. *Abstract Expressionism and the*

Modern Experience. Cambridge: Cambridge University Press, 1991.

Popper, Frank. *Origins and Development of Kinetic Art.* Trans. Stephen Bann. Greenwich: New York Graphic Society, 1968.

Price, Jonathan. *Video Visions: A Medium Discovers Itself.* New York: New American Library, 1977.

Reichardt, Jasia, ed. *Cybernetics, Art & Ideas.* Greenwich: New York Graphics Society, 1971.

Risatti, Howard, ed. *Postmodern Perspectives: Issues in Contemporary Art.* Englewood Cliffs: Prentice-Hall, 1990.

Robbins, Corinne. *The Pluralist Era: American Art, 1968–1981.* New York: Harper & Row, 1984.

Rosen, Randy, and Catherine C. Brawer, eds. *Making Their Mark: Women Artists Move into the Mainstream, 1970–1985.* New York: Abbeville, 1989.

Rosenberg, Harold. *The Tradition of the New.* New York: Horizon Press, 1959.

Russell, John, and Suzi Gablik. *Pop Art Redefined.* New York: Frederick A. Praeger, 1969.

Sandler, Irving. *Art of the Postmodern Era.* New York: HarperCollins, 1996.

———. *The Triumph of American Painting: A History of Abstract Expressionism.* New York: Frederick A. Praeger, 1970.

Sayre, Henry M. *The Object of Performance: The American Avant-Garde since 1970.* Chicago: University of Chicago Press, 1989.

Schneider, Ira, and Beryl Korot. *Video Art: An Anthology.* New York: Harcourt Brace Jovanovich, 1976.

Shapiro, David, and Cecile Shapiro. *Abstract Expressionism: A Critical Record.* New York: Cambridge University Press, 1990.

Smagula, Howard. *Currents: Contemporary Directions in the Visual Arts.* 2nd ed. Englewood Cliffs: Prentice-Hall, 1989.

Sonfist, Alan, ed. *Art in the Landscape: A Critical Anthology of Environmental Art.* New York: E. P. Dutton, 1983.

Sontag, Susan. *On Photography.* New York: Farrar, Strauss & Giroux, 1973.

Stiles, Kristine, and Peter Selz, eds. *Theories and Documents of Contemporary Art: A Sourcebook of Artists' Writings.* Berkeley: University of California Press, 1996.

Tuchman, Maurice. *American Sculpture of the Sixties.* Los Angeles: Los Angeles County Museum of Art, 1967.

Venturi, Robert, Denise Scott-Brown, and Steven Isehour. *Learning from Las Vegas.* Cambridge, MA: MIT Press, 1972.

Waldman, Diane. *Collage, Assemblage, and the Found Object.* New York: Abrams, 1992.

Wallis, Brian, ed. *Art After Modernism: Rethinking Representation.* New York: New Museum of Contemporary Art in association with David R. Godine, 1984.

Wheeler, Daniel. *Art since Mid-Century: 1945 to the Present.* Englewood Cliffs: Prentice-Hall, 1991.

Wood, Paul. *Modernism in Dispute: Art Since the Forties.* New Haven: Yale University Press, 1993.

BOOKS SPANNING THE EIGHTEENTH, NINETEENTH, AND TWENTIETH CENTURIES

Antreasian, Garo, and Clinton Adams. *The Tamarind Book of Lithography: Art and Techniques.* Los Angeles: Tamarind Workshop and New York: Harry N. Abrams, 1971.

Armstrong, John, Wayne Craven, and Norma Feder, et al. *200 Years of American Sculpture.* New York: Whitney Museum of American Art/Boston: David R. Godine, 1976.

Arnason, H. H. *History of Modern Art: Painting, Sculpture, Architecture.* 4th ed. New York: Harry N. Abrams, 1998.

Ashton, Dore. *Twentieth-Century Artists on Art.* New York: Pantheon Books, 1985.

Brown, Milton, Sam Hunter, and John Jacobus. *American Art: Painting, Sculpture, Architecture, Decorative Arts, Photography.* New York: Harry N. Abrams, 1979.

Burnham, Jack. *Beyond Modern Sculpture. The Effects of Science and Technology on the Sculpture of This Century.* New York: Braziller, 1968.

Castelman, Riva. *Prints of the 20th Century: A History.* New York: Oxford University Press, 1985.

Chipp, Herschel B. *Theories of Modern Art.* Berkeley: University of California Press, 1968.

Coke, Van Deren. *The Painter and the Photograph From Delacroix to Warhol.* Rev. and enl. ed. Albuquerque: University of New Mexico Press, 1972.

Craven, Wayne. *American Art: History and Culture.* Madison: Brown & Benchmark, 1994.

Driskell, David C. *Two Centuries of Black American Art.* Los Angeles: Los Angeles County Museum of Art/New York: Alfred A. Knopf, 1976.

Elsen, Albert. *Origins of Modern Sculpture.* New York: Braziller, 1974.

Fine, Sylvia Honig. *Women and Art: A History of Women Painters and Sculptors from the Renaissance to the 20th Century.* Montclair: Alanheld & Schram, 1978.

Flexner, James Thomas. *America's Old Masters.* New York: McGraw-Hill, 1967.

Frascina, Francis, and Charles Harrison, eds. *Modern Art and Modernism: A Critical Anthology.* New York: Harper & Row, 1982.

Giedion, Siegfried. *Space, Time and Architecture: The Growth of a New Tradition.* 4th ed. Cambridge: Harvard University Press, 1965.

Goldwater, Robert, and Marco Treves, eds. *Artists on Art.* 3rd ed. New York: Pantheon, 1958.

Greenough, Sarah, Joel Snyder, David Travis, and Colin Westerbeck. *On the Art of Fixing a Shadow: One Hundred and Fifty Years of Photography.* Washington: The National Gallery of Art/Chicago: The Art Institute of Chicago, 1989.

Hamilton, George Heard. *Nineteenth- and Twentieth-Century Art.* Englewood Cliffs: Prentice-Hall, 1972.

Herbert, Robert L., ed. *Modern Artists on Art.* Englewood Cliffs: Prentice-Hall, 1964.

Hertz, Richard, and Norman M. Klein, eds. *Twentieth-Century Art Theory: Urbanism, Politics, and Mass Culture.* Englewood Cliffs: Prentice-Hall, 1990.

Hitchcock, Henry-Russell. *Architecture: Nineteenth and Twentieth Centuries.* 4th ed. New Haven: Yale University Press, 1977.

Hunter, Sam, and John Jacobus. *Modern Art: Painting, Sculpture, and Architecture.* 3rd ed. New York: Harry N. Abrams, 1992.

Jencks, Charles. *Modern Movements in Architecture.* Garden City: Anchor Press/Doubleday, 1973.

Kaufmann, Edgar, Jr., ed. *The Rise of an American Architecture.* New York: Metropolitan Museum of Art/Frederick A. Praeger, 1970.

Krauss, Rosalind E. *The Originality of the Avant-Garde and Other Modernist Myths.* Cambridge: MIT Press, 1985.

———. *Passages in Modern Sculpture.* Cambridge, MA: MIT Press, 1981.

Licht, Fred. *Sculpture, Nineteenth and Twentieth Centuries.* Greenwich: New York Graphic Society, 1967.

Lynton, Norbert. *The Story of Modern Art.* 2nd ed. Englewood Cliffs: Prentice-Hall, 1989.

McCoubrey, John W. *American Art, 1700–1960: Sources and Documents.* Englewood Cliffs: Prentice-Hall, 1965.

Mason, Jerry, ed. *International Center of Photography Encyclopedia of Photography.* New York: Crown Publishers, 1984.

Newhall, Beaumont. *The History of Photography.* New York: The Museum of Modern Art, 1982.

Peterdi, Gabor. *Printmaking: Methods Old and New.* New York: Macmillan, 1961.

Pierson, William. *American Buildings and Their Architects: Technology and the Picturesque.* Vol. 2. Garden City: Doubleday, 1978.

Read, Herbert. *Concise History of Modern Painting.* 3rd ed. New York: Frederick A. Praeger, 1975.

———. *A Concise History of Modern Sculpture.* Rev. and enl. ed. New York: Frederick A. Praeger, 1964.

Rose, Barbara. *American Art Since 1900.* rev. ed. New York: Frederick A. Praeger, 1975.

Rosenblum, Robert. *Modern Painting and the Northern Romantic Tradition: Friedrich to Rothko.* New York: Harper & Row, 1975.

Ross, John, and Clare Romano. *The Complete Printmaker.* New York: The Free Press, 1972.

Ross, Stephen David, ed. *Art and Its Significance: An Anthology of Aesthetic Theory.* Albany: SUNY Press, 1987.

Russell, John. *The Meanings of Modern Art.* New York: Museum of Modern Art/Thames & Hudson, 1981.

Scully, Vincent. *Modern Architecture.* rev. ed. New York: Braziller, 1974.

Spalding, Francis. *British Art Since 1900.* London: Thames & Hudson, 1986.

Spencer, Harold. *American Art: Readings from the Colonial Era to the Present.* New York: Charles Scribner's Sons, 1980.

Summerson, Sir John. *Architecture in Britain: 1530–1830.* 7th rev. and enl. ed. Baltimore: Penguin, 1983.

Szarkowski, John. *Photography Until Now.* New York: Museum of Modern Art, 1989.

Tuchman, Maurice, and Judi Freeman, eds. *The Spiritual in Art: Abstract Painting, 1890–1985.* Los Angeles: Los Angeles County Art Museum/New York: Abbeville Press, 1986.

Upton, Dell. *Architecture in the United States.* Oxford: Oxford University Press, 1998.

Weaver, Mike. *The Art of Photography: 1839–1989.* New Haven: Yale University Press, 1989.

Whiffen, Marcus, and Frederick Koeper. *American Architecture, 1607–1976.* Cambridge: MIT Press, 1983.

Wilmerding, John. *American Art.* Harmondsworth, England: Penguin, 1976.

Wilson, Simon. *Holbein to Hockney: A History of British Art.* London: The Tate Gallery & The Bodley Head, 1979.

CREDITS

The authors and publisher are grateful to the proprietors and custodians of various works of art for photographs of these works and permission to reproduce them in this book. Sources not included in the captions are listed here.

Introduction—The Solomon R. Guggenheim Foundation, New York, Photo, David Heald: 1; Aerofilms Limited: 2; Scala/Art Resource, New York: 3; Copyright © 2001 The Georgia O'Keefe Foundation/Artist Rights Society (ARS), New York: 4; Copyright © 2001 Ben Shahn/Licensed by VAGA, New York: 5; Copyright © 1981 M. Sarri/Photo Vatican Museums: 7; Photo copyright © Metropolitan Museum of Art: 9; Saskia Ltd Cultural Documentation: 10; Copyright © National Gallery, London: 12; MOA Art Museum, Shizuoka-ken, Japan: 13; Joachim Blauel/Arthothek: 14; Copyright © 1983 Metropolitan Museum of Art: 15; Saskia Ltd Cultural Documentation: 17; Scala: 18.

Chapter 14—AL: 1, 11, 12, 14; Canali: 2, 5, 13, 16, 18, 20; Ralph Lieberman: 3; Scala: 4, 6, 8, 9, 15, 17, 19, 21, 22; Summerfield Press, Ltd.: 7, 10.

Chapter 15—Gir: 1, 2, 7, 21; Scala: 3, 4, 9; Artothek: 5; Copyright © Museo del Prado: 6, 17; Paul Laes: 8; Erich Lessing/Art Resource, New York: 10; Photo Copyright © 1981 Metropolitan Museum of Art. All rights reserved: 11; Copyright © National Gallery, London: 12, 13, 15; Photo copyright © 1990 Metropolitan Museum of Art. All rights reserved: 14; Copyright © 1999 Board of Trustees, National Gallery of Art, Washington, D.C.: 16; Bildarchiv Preussischer Kulturbesitz, Photo Jorg P. Anders: 18; R.M.N.: 19; Foto Marburg/Art Resource, New York.: 20; Photo copyright © Musées d'art et d'histoire, Geneva: 22; Christopher Rennie/Robert Harding Picture Library, London: 23; Photo Verlag Gunderman, Würzburg: 24; Luraine Tansey: 25; Photo copyright © 1980 Metropolitan Museum of Art. All rights reserved: 26; Jean Dieuzaide: 27.

Chapter 16—HB Collection: 1, 2; Canali: 3, 8, 11, 12, 13, 25, 38, 40, 41, 45, 52; Scala: 4, 14, 19, 21, 31, 39, 48, 51, 53, 54; AL: 5, 9, 20, 24, 29, 33, 49, 50; Saskia Ltd Cultural Documentation: 6; Ralph Lieberman: 7, 17, 23, 35, 36; Erich Lessing/Art Resource, New York: 10, 22; Anderson/Art Resource, New York: 15; , Photo copyright © 1982 Metropolitan Museum of Art. All rights reserved: 26; Summerfield Press, Ltd.: Copyright © 27; 1999 Board of Trustees, National Gallery of Art, Washington, D.C.; Art Resource, New York: 32; © 1987 M. Sarri/Photo Vatican Museums: 34, 42; Bridgeman Art Library: 30; Foto Marburg/Art Resource, New York: 43; German Archeological Institute, Rome: 46; G. Giovetti: 47.

Chapter 17—Scala, 1, 18, 31, 34, 35, 36, 49, 52, 53, 56; Copyright © National Gallery, London; AP/Wide World: 3; The Royal Collection copyright © 2000, Her Majesty Queen Elizabeth II: 4; R.M.N.: 5, 11, 21, 33; Copyright © The British Museum; Canali: 8, 9, 20, 38, 41, 51, 54, 55; Summerfield Press, Ltd.: 10, 42; Photo Vatican Museums: 13; Copyright © Bracchietti-Zigrosi/Photo Vatican Museums: 14; Photo copyright © Victor Boswell, National Geographic Image Collection. Courtesy of Nippon Television Network Corporation, Tokyo and the Vatican Museums: 15; copyright © 1983 M. Sarri/Photo Vatican Museums: 17; Erich Lessing/Art Resource, New York: 19; Ralph Lieberman: 22, 23; Madeline Grimoldi, Rome: 24; Rotkin/PFI: 26; Art Resource, New York: 27; Leonard von Matt/Photo Researchers: 29; Photo copyright © 1990 Metropolitan Museum of Art. All

rights reserved.; 30, 44; Copyright © 1999 Board of Trustees, National Gallery of Art, Washington, D.C.: 32; Erich Lessing/Art Resource, New York: 37, 39, 58; AL: 40, 47, 59; Copyright © National Gallery, London; Photo James Methuen-Campbell; Gir: 46; Edwin Smith: 48.

Chapter 18—Gir: 1, 13, 15, 27; © Musée d'Unterlinden-F68000 Colmar, photo O. Zimmerman: 2; Copyright © British Museum: 3, 4, 6; Scala: 5, 14; Courtesy Museum of Fine Arts, Boston. Reproduced with permission. Copyright © 1999 Museum of Fine Arts, Boston. All rights reserved: 7; Bridgeman Art Library: 8; Photo © 1998 Metropolitan Museum of Art. All rights reserved: 9; Artothek: 10; Copyright © National Gallery, London: 11; R.M.N.: 12, 18; J. E. Bulloz, Paris: 16; Bildarchiv Preussischer Kulturbesitz, photo Jorg P. Anders: 17; photo Martin Buhler: 20; Copyright © Museo del Prado, Madrid: 21; Institut Amatller d'Art Hispanic, Barcelona: 24, 25, 26.

Chapter 19—AL: 1, 4, 12, 14; A. F. Kersting: 2, 67, 74, 76; Saskia Ltd Cultural Documentation/Art Resource, New York: 5; Canali: 6, 10, 15, 17, 18, 23, 24; Scala: 7, 9, 19, 20, 21, 22, 25, 26, 45, 61, 79, 80, 81, 84; Gabinetto Fotographico Nazionale, ICCD, Rome: 8; Copyright © G. E. Kidder Smith/CORBIS: 16; Summerfield Press, Ltd.: 27, 40; Copyright © Museo del Prado, Madrid; Courtesy of the Trustees of the Victoria and Albert Museum, London: 30; Gir: 31, 70; Copyright © The Frick Collection, New York: 32; Erich Lessing/Art Resource, New York: 33, 36, 43, 52; Peter Willi/Bridgeman Art Library: 34; Property of the Ambrosian Library. All rights reserved. Reproduction is forbidden: 35; Nimatallah/Art Resource, New York: 37; R.M.N.: 38, 57, 58, 60, 63, 64, 66, 82; Iv. #5088, Ernst Moritz, The Hague: 39; Photo Tom Haartsen: 41; Copyright © Rijksmuseum, Amsterdam: 44, 51, 53; Copyright © English Heritage Photographic Library: 46; Art Resource, New York: 47, 55; Copyright © 1999 Board of Trustees, National Gallery of Art, Washington, D.C.: 48; © National Gallery, London: 49; Photo copyright © Mauritshuis, The Hague: 50; J. E. Bulloz, Paris: 65; Aerofilms, Ltd.: 68; New York Public Library/Art Resource, New York: 69; HB Collection: 71; Saskia Ltd Cultural Documentation: 72; Crown Copyright National Monuments Record copyright © English Heritage: 73; Rapho Agence/Photo Researchers: 75; Hirmer Verlag, Munich: 78; Courtesy, Museum of Fine Arts, Boston. Reproduced with permission. Copyright © 1999 Museum of Fine Arts, Boston. All rights reserved: 83; Copyright © The Wallace Collection: 85, 86; Photo copyright © 1990 Metropolitan Museum of Art. All rights reserved: 87.

Chapter 20—Courtesy of the Trustees of the Victoria and Albert Museum, London: 1, 25, 60; By permission of the British Library: 2; Crown Copyright National Monuments Record copyright © English Heritage: 4, 22, 23; Copyright © The Wallace Collection: 5; R.M.N.: 6, 7, 15, 29, 31, 32, 33, 41, 44, 45, 46; Summerfield Press, Ltd.: 8; Copyright © National Gallery, London: 9, 11; © 1999 Board of Trustees, National Gallery of Art, Washington, D.C.: 10; Courtesy, Museum of Fine Arts, Boston. Reproduced with permission. Copyright © 1999 Museum of Fine Arts, Boston. All rights reserved: 13, 51; Copyright © Virginia Museum of Fine Arts: 14; Gir: 16, 17, 42, 48, 59; Erich Lessing/Art Resource, New York: 18, 30; J. E. Bulloz, Paris: 19, 47; Architectural Photography, Paris: 20, 58; AL: 21; Country Life Picture Library: 24; Photo Library of Virginia: 26; Courtesy Library of Congress: 27; Art Resource, New York: 28, 53, 65; Photo copyright © The Detroit Institute of the Arts: 35; Photo copyright © 1995 Metropolitan Museum of Art. All rights reserved: 37, 52, 55; Copyright © Museo del Prado, Madrid: 38, 39, 40; Bildarchiv Preussischer Kulturbesitz: 49; Copyright © National Gallery, London: 50; Copyright © The Cleveland Museum of

Art: 54; John Brownlie/Photo Researchers: 56; A. F. Kersting: 57.

Chapter 21—Bridgeman Art Library: 1; R.M.N.: 2, 3, 7, 23, 42; Photo Schecter Lee © 1986 Metropolitan Museum of Art. All rights reserved: 6, 46; Gir: 8, 17, 29; © Sterling and Francine Clark Art Institute, Williamstown, Mass., USA: 9; Photo © 1985 Metropolitan Museum of Art. All rights reserved: 10; Courtesy George Eastman House: 12, 22; Art Resource Technical Services, Hyattsville, MD: 14; Art Resource, New York: 15, 50; Copy print copyright © 2001 The Museum of Modern Art, New York: 16; Erich Lessing/Art Resource, New York: 18, 55, 56; Photo courtesy of The Art Institute of Chicago: 19, 30, 31, 37, 38, 40, 41; HB Collection: 20; Photo © 1980 Metropolitan Museum of Art. All rights reserved: 28; Photo © The Detroit Institute of Arts: 32; Photo copyright © 2001 The Museum of Modern Art, New York: 34, 44; Courtesy Museum of Fine Arts, Boston. Reproduced with permission. Copyright © 1999 Museum of Fine Arts, Boston. All rights reserved: 13, 36; Copyright © The Kroller—Muller Foundation: 43; Scala copyright © 2001 The Munch Museum/The Munch—Ellingsen Group/ARS: 45; Library of Congress: 47; Photo courtesy The Museum of Modern Art, New York: 52; Ralph Lieberman: 54, 59; Hulton—Deutsch Collection/CORBIS: 57; Chicago Architectural Photographing Company: 58; Chicago Historical Society/Photo Hedrich-Blessing HB-19321-E: 60; Photo courtesy The Preservation Society of Newport County: 61.

Chapter 22—Copyright © 2001 Succession H. Matisse, Paris/ARS: 1, 2; Photo copyright © 2001 The Museum of Modern Art, New York: 3, 5, 9, 16, 18, 22, 24, 32, 33, 38, 45, 46, 48, 50, 51, 52, 53, 70; Copyright © 2001 ARS/ADAGP, Paris: 3, 4, 9, 12, 15, 19, 20, 23, 45, 50, 52, 64, 65, 70; Copyright © Elke Walford, Hamburg: 6; Copyright © The Solomon R. Guggenheim Foundation, New York, Photo David Heald copyright © The Solomon R. Guggenheim Foundation, New York: 7; Öffentliche Kunstsammlung Basel, Martin Buhler: 8; Photo copyright © 1996 Metropolitan Museum of Art. All rights reserved: 10; Copyright © 2001 Estate of Pablo Picasso/ARS: 10, 11, 14, 15, 74; Photo courtesy of The Art Institute of Chicago: 13, 58, 76, 78; R.M.N.: 14, 15; © 2001 Estate of Alexander Archipenko/ARS: 18; Copyright © 2001 ARS/SIAE, Rome: 21, 44; Bridgeman Art Library: 23, 55, 56, 62; Copyright © 2001 ARS/VG Bild-Kunst, Bonn: 24, 26, 27, 39, 40, 41, 51, 58; Copyright © 2001 ARS/ADAGP, Paris/Estate of Marcel Duchamp: 25, 29; Photo Bildarchiv Preussischer Kulturbeitz: 26; Photo by Walter Pach, courtesy of The Museum of Modern Art, New York: 28; Copyright © 1981 Center for Creative Photography, Arizona Board of Regents: 31; Copyright © 2001 Man Ray Trust/ARS: 32; Photographic Services copyright © President and Fellows of Harvard University: 35; Photo copyright © 2000 Whitney Museum of American Art: 36, 59; Copyright © 2001 The Georgia O'Keeffe Foundation/ARS: 37; Photo by Walter Klein, Dusseldorf: 39; Photo Sachsesche Landesbibliothek: 40; Copyright © 1999 Board of Trustees, National Gallery of Art, Washington, D.C.: 42; HB Collection: 43; Copyright © 2001 ARS: 46; Copyright © 1993 Museum Associates, Los Angeles County Museum of Art. All rights reserved. Copyright © 2001 C. Herscovici, Brussels/ARS: 47; Copyright © 2001 ARS/Pro Litteris, Zurich: 48; Copyright © 1993 Schalkwijk/Art Resource, N.Y: 49; © The Solomon R. Guggenheim Collection, New York: 54; Copyright © 2001 ARS/Beeldrecht, Amsterdam: 56, 57; Copyright © 2001 The Josef and Anni Albers Foundation/ARS: 60, 61, 62; Photo courtesy The Mies van der Rohe Archive, The Museum of Modern Art, New York: 63; Saskia Ltd Cultural Documentation: 65; Copyright © Cervin Robinson: 66; Chicago Architectural

ILLUSTRATION CREDITS

INDEX

Boldfaced names refer to artists. Pages in italics refer to illustrations.